A Companion to Medieval Art

BLACKWELL COMPANIONS TO ART HISTORY

These invigorating reference volumes chart the influence of key ideas, discourses, and theories on art, and the way that it is taught, thought of, and talked about throughout the English-speaking world. Each volume brings together a team of respected international scholars to debate the state of research within traditional sub-fields of art history as well as in more innovative, thematic configurations. Representing the best of the scholarship governing the field and pointing toward future trends and across disciplines, the *Blackwell Companions to Art History* series provides a magisterial, state-of-the-art synthesis of art history.

1 *A Companion to Contemporary Art since 1945* edited by Amelia Jones
2 *A Companion to Medieval Art* edited by Conrad Rudolph

A Companion to
Medieval Art:
Romanesque and Gothic
in Northern Europe

Edited by

Conrad Rudolph

Blackwell Publishing

Editorial material and organization © 2006 by Blackwell Publishing Ltd

BLACKWELL PUBLISHING
350 Main Street, Malden, MA 02148-5020, USA
9600 Garsington Road, Oxford OX4 2DQ, UK
550 Swanston Street, Carlton, Victoria 3053, Australia

The right of Conrad Rudolph to be identified as the Author of the Editorial Material in this
Work has been asserted in accordance with the UK Copyright, Designs, and Patents Act 1988.

First published 2006 by Blackwell Publishing Ltd

2 2007

Library of Congress Cataloging-in-Publication Data

A companion to Medieval art : Romanesque and Gothic in Northern Europe / edited by
Conrad Rudolph.
p. cm. — (Blackwell companions to art history)
Includes bibliographical references and index.
ISBN 978–1–4051–0286–5 (hardcover : alk. paper)
1. Art, Medieval—Europe,
Northern. I. Rudolph, Conrad, 1951– II. Series.

N5970 C56 2006
709.02—dc22
2005033250

A catalogue record for this title is available from the British Library.

Set in 10.5/13pt Galliard
by Graphicraft Ltd, Hong Kong
Printed and bound in the United Kingdom
by TJ International Ltd, Padstow, Cornwall

The publisher's policy is to use permanent paper from mills that operate a sustainable forestry policy,
and which has been manufactured from pulp processed using acid-free and elementary chlorine-free
practices. Furthermore, the publisher ensures that the text paper and cover board used have met
acceptable environmental accreditation standards.

For further information on
Blackwell Publishing, visit our website:
www.blackwellpublishing.com

Contents

Illustrations

Notes on Contributors

Tina Waldeier Bizzarro is Professor of the History of Art at Rosemont College, Pennsylvania, where she has taught the history of art since she received her Ph.D. from Bryn Mawr College in 1985. She has also been attached to Villanova University for the last 20 years – in the Irish Studies Program, teaching courses on the Art of Ireland and also in the Russian Studies Program, having designed courses on the meaning and making of icons. She has lectured widely and published on the history of medieval architectural criticism through the second decade of the nineteenth century (*Romanesque Architectural Criticism: A Prehistory* [1992]) and is preparing a second, pendant critical volume dealing with concepts of the medieval through World War I. She has been a Commonwealth Speaker for the Pennsylvania Humanities Council, and also annually directs and teaches in her month-long Summer Program in Sicily, based in Messina. She has been a Fulbright Scholar in Sicily from February through June 2006, working on a book on the Roadside Shrines of Sicily.

Bruno Boerner received his Ph.D. from the Univerversity of Fribourg, Switzerland, in 1994. He is currently Professor of Art History at the Technische Universität, in Dresden. His publications on medieval art include: *Par caritas par meritum, Studien zur Theologie des gotischen Weltgerichtsportals in Frankreich-am Beispiel des mittleren Westeingangs von Notre-Dame in Paris* (1998); "Réflexions sur les rapports entre la scholastique naissante et les programmes sculptés du XIIIe siècle," in Yves Christe, ed., *De l'art comme mystagogie*, Actes du Colloque de la Fondation Hardt tenu à Genève du 13 au 16 février 1994, Civilisation Médiévale III (1996), pp. 55–69; "Eschatologische Perspektiven in mittelalterlichen Portalprogrammen," *Miscellanea Mediaevalia* 22 (2001), pp. 301–20.

Michelle P. Brown, FSA, was Curator of Illuminated Manuscripts at the British Library, London, for more than 17 years and now fronts its regional outreach program. She is Visiting Professor at the Institute of Medieval Studies at Leeds University and a Senior Research Fellow at the Courtauld Institute and the School of Advanced Studies at the University of London. She is also a Lay Canon and Member of Chapter at St Paul's Cathedral. She has lectured and published widely on medieval history, art history, and manuscript studies, has curated several major exhibitions, and had co-responsibility for setting up the

exhibition galleries at the new British Library building at St Pancras in 1998. Her publications include: *A Guide to Western Historical Scripts from Antiquity to 1600* (1990; rev. edns. 1994, 1999); *Understanding Illuminated Manuscripts: a Glossary of Technical Terms* (1994); and *The Lindisfarne Gospels: Society, Spirituality and the Scribe* (2003).

Martin Büchsel is Professor of Art History at the Kunstgeschichtliches Institut of the University of Frankfurt, a member of the Mediävistischen Arbeitskreises of the Herzog August Bibliothek Wolfenbüttel, and Chair of the "Historische Emotionsforschung" project. He has published on early Christian art, early medieval art, and Gothic art (most recently, *Die Entstehung des Christusporträts. Bildarchäologie statt Bildhypnose* [2003–4]), as well as in the area of philosophy (doctoral dissertation, "Die Kategorie der Substanz in der Kritik der reinen Vernunft").

Brigitte Buettner is Priscilla Paine Van der Poel Associate Professor of Art History at Smith College. Her areas of research include late medieval secular manuscripts, Valois court culture, female patronage, and, now, medieval precious arts. In addition to various articles, she is the author of *Boccaccio's "Des cleres et nobles femmes": Systems of Signification in an Illuminated Manuscript* (1996), and is currently preparing a translation of Guillebert de Mets' description of Paris (with Michael T. Davis) as well as a study on the meanings and uses of precious stones in the Middle Ages.

Jill Caskey is Associate Professor of Fine Art at the University of Toronto. She is the author of *Art and Patronage in the Medieval Mediterranean: Merchant Culture in the Region of Amalfi* (2004), as well as numerous articles that have appeared in European and North American publications. Recently, she has received research grants from the Getty Grant Program and the Social Science and Humanities Research Council of Canada. She is also a Fellow of the American Academy in Rome.

Madeline Harrison Caviness is Mary Richardson Professor and Professor of Art History at Tufts University. Among her numerous books and articles are: *Medieval Art in the West and its Audience* (2001); *Visualizing Women in the Middle Ages: Sight, Spectacle and Scopic Economy* (2001); and *Reconfiguring Medieval Art: Difference, Margins, Boundaries* (2001). She is currently President of the International Council of Philosophy and Humanistic Studies (CIPSH), and a past President of the International Academic Union (UAI, 1998–2001).

Adam S. Cohen is Assistant Professor in the Department of Fine Art at the University of Toronto. His research has focused on Northern European art of the tenth and eleventh centuries, with publications that include *The Uta Codex: Art, Philosophy and Reform in Eleventh-Century Germany* (2000) and articles in *Speculum*, *Gesta*, and *Scriptorium*. He is currently writing a book on twelfth-century visual exegesis and ritual practice.

Thomas E. A. Dale is Professor of medieval art at the University of Wisconsin-Madison. His publications on Romanesque art include: *Relics, Prayer and Politics in Medieval Venetia: Romanesque Mural Painting in the Crypt of Aquileia Cathedral* (1997); "Monsters, Corporeal Deformities and Phantasms in the Romanesque Cloister of St-Michel de Cuxa," *Art Bulletin* 83:3 (2001): 402–36; "Rudolf von Schwaben, the Individual and the Resurrected Body in Romanesque Portraiture," *Speculum* 77:3 (2002): 707–43; and as editor/contributor with John Mitchell, *Shaping Sacred Space and Institutional Identity in Romanesque Mural Painting. Essays in Honour of Otto Demus* (2004). He is currently writing a book, provisionally

entitled *Romanesque Corporealities: The Body as Image and Dissimilitude in European Art, ca.1050–1215.*

Peter Fergusson teaches in the Art Department at Wellesley College, where he holds the Theodora and Stanley Feldberg Chair in Art History. Aside from his interests in the Cistercians, he has also published on the architecture of the reform movement in England, and on nineteenth- and twentieth-century garden history. His *Architecture of Solitude: Cistercian Abbeys in Twelfth Century England* (1984) was awarded the Charles Rufus Morey Book Award of the College Art Association, and his *Rievaulx Abbey: Community, Architecture, Memory* (1999; with Stuart Harrison) was awarded the Alice Hitchcock Prize of the Architectural Historians of Great Britain, and the Haskins Medal of the Medieval Academy of America.

Eric Fernie is Professor and Director Emeritus of the Courtauld Institute of Art, University of London. His books include: *The Architecture of the Anglo-Saxons* (1983); *An Architectural History of Norwich Cathedral* (1993); *Art History and its Methods* (1995); and *The Architecture of Norman England* (2000). He has also published more than 50 papers in refereed journals.

Jaroslav Folda is N. Ferebee Taylor Professor of the History of Art at the University of North Carolina. He has published on the art and architecture of the Crusaders in the Holy Land in a series of studies, which have appeared as books and articles, and essays and entries in exhibition catalogues. His book, *Art of the Crusaders in the Holy Land: 1098–1187* (1995), was awarded the Haskins Medal by the Medieval Academy of America. His new book, *Crusader Art in the Holy Land, from the Third Crusade to the Fall of Acre: 1187–1291* was published in 2005.

Paula Gerson is Professor and Chair of the Department of Art History at Florida State University. Her many years of research on the pilgrimage to Santiago de Compostela have resulted in three collaborative volumes: *The Pilgrim's Guide to Santiago de Compostela: A Gazetteer*, with A. Shaver-Crandell and A. Stones (1995), and *The Twelfth-century Pilgrim's Guide to Santiago de Compostela*, translation and critical edition, 2 vols., with J. Krochalis, A. Shaver-Crandell, and A. Stones (1998). She has also worked extensively on issues related to the abbey church of St Denis. She was a contributor and the editor of the fundamental volume *Abbot Suger and Saint-Denis, A Symposium* (1986). She is currently completing an article on Abbot Suger's Great Cross.

Cynthia Hahn is Gulnar K. Bosch Professor of Art History at Florida State University. She has published two books on saints' lives in manuscripts, including *Portrayed on the Heart* (2001). She is presently preparing a study of Medieval Reliquaries to *c.* AD 1204.

Anne D. Hedeman is Professor of Medieval Art History at the University of Illinois. Her research centers on French thirteenth- to fifteenth-century illuminated manuscripts and has concerned royal patronage, illuminations of Mirrors of Princes, and the relationships between the first French humanists and the arts around 1400. Her books include: *The Royal Image: Illustrations of the Grandes chroniques de France, 1270–1422* (1991); *Of Counselors and Kings: Three Versions of Pierre Salmon's Dialogues* (2001); and a book to be published by the Getty Center, *Boccaccio in Context: Laurent de Premierfait and the "De cas de nobles hommes et femmes."*

Colum Hourihane is Director of the Index of Christian Art at Princeton University. He received his Ph.D. in Art History from the Courtauld Institute of Art in 1984 for a study on Gothic Irish art, which was subsequently published as *Gothic Art*

in Ireland 1169–1550: Enduring Vitality (2003). His most recent publication is an examination of the role and iconography of the processional cross in late medieval England: *The Processional Cross in Late Medieval England, The "Dallye Cross"* (2004). He is currently working on a monograph on Pontius Pilate in medieval art.

Christopher G. Hughes is a Research Associate at the Getty Research Institute. He received his Ph.D. in English from Princeton in 1995 and his Ph.D. in Art History from Berkeley in 2000. He taught art history at UCLA and USC before taking his current position at the Getty. He is currently preparing a book-length study on biblical typology and early Gothic art.

Laura Kendrick, Professor at the Université de Versailles, is the author of *Animating the Letter: The Figurative Embodiment of Writing from Late Antiquity to the Renaissance* (1999) and several shorter studies on the relationship between medieval texts and the visual aspects of their manuscript contexts.

Herbert L. Kessler is Professor of the History of Art at Johns Hopkins University. He has written more than 125 articles and reviews and has published the following books: *The Illustrated Bibles from Tours* (1977); *The Cotton Genesis* (with Kurt Weitzmann; 1986); *The Frescoes of the Dura Synagogue and Christian Art* (with Kurt Weitzmann; 1990); *Studies in Pictorial Narrative* (1994); *The Poetry and Paintings in the First Bible of Charles the Bald* (with Paul E. Dutton; 1997); *The Holy Face and the Paradox of Representation* (with Gerhard Wolf; 1998); *Rome 1300: On the Path of the Pilgrim* (with Johanna Zacharias; 2000); *Spiritual Seeing: Picturing God's Invisibility in Medieval Art* (2000); *Old St. Peter's and Church Decoration in Medieval Italy* (2002); and *Seeing Medieval Art* (2004).

Dale Kinney is Professor of History of Art and Dean of the Graduate School of Arts and Sciences, Bryn Mawr College. She has published numerous studies of *spolia* as a critical concept and as an architectural practice in medieval Italy. Other recent publications include essays on the semiotics of the early Christian basilica (*Acta ad archaeologiam et artium historiam pertinentia*, n.s. 1, 15 [2001]); the medieval reception of the equestrian statue of Marcus Aurelius (*Word & Image*, 18 [2002]); and a visual analysis of the apse mosaic of Santa Maria in Trastevere (*Reading Medieval Images* [2002]).

Brigitte Kurmann-Schwarz is a research fellow at the Swiss Center for Research and Information on Stained Glass in Romont, Switzerland, and teaches at the University of Zürich. She is currently President of the International Committee of the Corpus Vitrearum, a member of the Swiss National Committee of the Corpus Vitrearum, and an associate member of the French National Committee. She is the author of many books and articles, which include studies on medieval and modern stained glass, late medieval sculpture, and more general problems such as conservation and restoration, courtly art, and issues of research policy.

Suzanne Lewis is Professor Emerita at Stanford University, and a Fellow of the Medieval Academy of America. She is the author of many articles and reviews, as well as several books: *The Art of Matthew Paris in the Chronica Majora* (1987); *Reading Images: Narrative Discourse and Reception in the Thirteenth-Century Illuminated Apocalypse* (1995); *The Rhetoric of Power in the Bayeux Tapestry* (1998); and *Apocalypsis Gulbenkian* (with Nigel Morgan; 2002). As Andrew Mellon Research Fellow, 2004–6, she is currently working on a new book, *Illuminating the End in Thirteenth-Century*

Apocalypses, which will be followed by *Picturing Visions: The Illustrated Apocalypse in the Early Middle Ages, c.800–1200.*

Pierre Alain Mariaux is Assistant Professor at the Institut d'histoire de l'art at the Université de Neuchâtel, Switzerland. He is the author of "Warmond d'Ivrée et ses images. Politique et création iconographique autour de l'an mil" (2002) and of "Deo operante. Le travail de l'art à l'époque romane. Etudes sur l'image de l'artiste, IXe–XIIe siècle" (forthcoming). He is currently working on a book-length study of church treasure, its history and functions.

Robert A. Maxwell is Assistant Professor of the History of Art at the University of Pennsylvania. He has published articles on illuminated manuscripts, Romanesque sculpture, and architecture, as well as on medieval art's historiography (*Art History*, 2003). A forthcoming book, titled *The Art of Urbanism in Medieval France*, examines the role of monumental art in shaping the Romanesque cityscape.

Stephen Murray is Professor of Medieval Art History at Columbia University and currently serves as Director of the Media Center for Art History, Archaeology, and Historic Preservation. His publications include books on the cathedrals of Amiens, Beauvais, and Troyes; his current work is on medieval sermons, story-telling in Gothic, and the Romanesque architecture of the Bourbonnais. His field of teaching includes Romanesque and Gothic art, particularly involving the integrated understanding of art and architecture within a broader framework of economic and cultural history. He is currently engaged in projecting his cathedral studies through the electronic media using a combination of three-dimensional simulation, digital imaging, and video.

Tassos C. Papacostas is a Research Associate on a British Academy project based at King's College London, on the prosopography of the Byzantine world. He is the author of, among others, "Secular Landholdings and Venetians in 12th-century Cyprus", *Byzantinische Zeitschrift* 92 (1999): 479–501; "A Tenth-Century Inscription from Syngrasis, Cyprus," *Byzantine and Modern Greek Studies* 26 (2002): 42–64; "Architecture et communautés étrangères à Chypre, XIe–XIIe siècles", in Y. Portier, ed., *Identités croisées en un milieu méditerranéen: le cas de Chypre* (forthcoming); and "Middle Byzantine Nicosia," in a volume on the history of the city edited by D. Michaelides (forthcoming).

Elizabeth Carson Pastan is Associate Professor of Art History at Emory University. Her scholarship includes numerous articles on medieval stained glass and its reception, and these have appeared in such periodicals as *Speculum, Gesta, Word & Image*, and the *Journal of the Society of Architectural Historians*. In addition, she has worked extensively in museum collections and has contributed entries to *Gothic Sculpture in America, the Museums of the Midwest* as well as *Stained Glass before 1700 in the Collections of the Midwest States*. Her book, *Les Vitraux du choeur de la cathédrale de Troyes (XIIIe siècle)*, co-authored with Sylvie Balcon, is the first study of stained glass by an American scholar solicited for publication by the French Corpus Vitrearum (2006).

Conrad Rudolph is Professor of Medieval Art History at the University of California, Riverside. He has held Guggenheim, J. Paul Getty, and Mellon research fellowships. He is the author of: *The "Things of Greater Importance": Bernard of Clairvaux's Apologia and the Medieval Attitude Toward Art* (1990); *Artistic Change at St-Denis: Abbot Suger's Program and the Early Twelfth-*

Century Controversy over Art (1990); *Violence and Daily Life: Reading, Art, and Polemics in the Cîteaux Moralia in Job* (1997); *"First, I Find the Center Point": Reading the Text of Hugh of Saint Victor's The Mystic Ark* (2004); and *Pilgrimage to the End of the World: The Road to Santiago de Compostela* (2004) (the latter being an account of his experience undertaking the grueling medieval pilgrimage on foot from Le Puy in south-central France to Santiago de Compostela in northwestern Spain, a journey of two and a half months and a thousand miles). He is currently at work on *The Mystic Ark: Hugh of Saint Victor and the Multiplication and Systematization of Imagery in the Twelfth Century.*

Linda Seidel is Hanna Holborn Gray Professor Emerita in the Department of Art History at the University of Chicago. Her books include: *Songs of Glory: The Romanesque Facades of Aquitaine* (1981); *Jan van Eyck's Arnolfini Portrait: Stories of an Icon* (1993); and *Legends in Limestone: Lazarus,* *Gislebertus and the Cathedral of Autun* (1999).

Marie-Thérèse Zenner is an independent scholar. In 1984, under the inspiration of Jean Gimpel and guidance of Lynn White, Jr., she co-founded AVISTA (<www.avista.org>), an international society for promoting cross-disciplinary studies in medieval technology, science, architecture, and art. She is the editor of *Villard's Legacy. Studies in Medieval Technology, Science and Art in Memory of Jean Gimpel,* AVISTA Studies in the History of Medieval Technology, Science, and Art, vol. 2 (2004). Her publications on architectural layout, such as "Imaging a Building. Latin Euclid and Practical Geometry," in *Word, Image, Number. Communication in the Middle Ages* (2002) and "Villard de Honnecourt and Euclidean Geometry," *Nexus Network Journal* 4.4 (Autumn 2002) were made possible by a 1996–7 J. Paul Getty Postdoctoral Fellowship for the study of medieval quantified sciences.

Series Editor's Preface

Blackwell Companions to Art History is a series of edited collections designed to cover the discipline of art history in all its complexities. Each volume is edited by specialists who lead a team of essayists, representing the best of leading scholarship, in mapping the state of research within the sub-field under review, as well as pointing toward future trends in research.

This *Companion to Medieval Art* presents a challenging set of essays that give a clear analytical survey of what is happening in this major area of Western art history. Attention is paid to the historiography of the period; theories of the image, reception, and vision; architectural design; and the concept of revival with particular reference to a broad range of Northern European examples. Together, these themes combine to provide an exciting and varied study that will be essential reading for students and teachers of Medieval Art.

As one of the first volumes to appear, *A Companion to Medieval Art* sets the tone and pace for new and innovative approaches offered in this series.

Dana Arnold, 2005

Preface

In a work specifically devoted to the theory and practice of learning, Hugh of St Victor, the great Parisian scholar and polyhistor, wrote in around 1125: "The number of books is infinite – don't chase after the infinite." A few pages later, however, this ally of Bernard of Clairvaux and apparent advisor to Abbot Suger on his famous art program at St Denis also said: "Learn everything . . . nothing is superfluous!" Herein lies the sometimes almost overwhelming challenge to the scholar. To say that scholarship has grown a bit since the early twelfth century would be facetious. We all know that there is too much to read, that it is impossible to keep current with the vast output of a given field, something that is no less true for the medieval art historian than it is for the scholar of any other field. (Cf. the words of the exceptionally well-read Willibald Sauerländer in *The Cloisters*, ed. E. Parker, p. 29.) Yet, as scholarship grows, it seems as if there has never been a greater desire, even necessity, to understand the issues and arguments that have contributed to the formation of the current state of the field. The present book is an attempt to respond to this dilemma for the medieval art historian, to help strike a balance between the desire to have a broad and informed historiographical grasp of the field and the near impossibility of achieving this.

There have been a number of good historiographical studies on medieval art in the past, both overviews and more narrowly focused pieces. But there has been nothing in English that has attempted the breadth of this work, nothing that has approached the subject through such a wide variety of discrete themes and media, topics both that have been of concern for many generations and that are of more recent interest. This volume is one of the first in an ambitious new series whose goal is "to map the state of research" throughout world art history. It has as its geographical and chronological limits Northern Europe during the Romanesque and Gothic periods (*c.*1000–1300). It will later be joined by a volume covering the Early Christian through Ottonian and Byzantine periods,

as well as by one that incorporates the later Middle Ages. It is aimed at both scholars and advanced undergraduates.

Aside from the series' limits on chronology, geography, and the number and length of the essays, there were very few other restrictions imposed on this volume. I conceived of it in a way that I hope will address the needs of the field as broadly as possible. After a broad introduction are a number of chapters on current methodological or conceptual issues (vision, reception, narrative, etc.). These are followed by several thematic pieces that might be thought of as unconnected to any specific media (image theory, patronage, collecting, etc.), some presentations of long-established sub-fields (architecture, sculpture, painting, the sumptuous arts, the Crusader states), a few thematic studies that are either sub-sets or groupings of the sub-fields (architectural layout, sculptural programs, pilgrimage art, etc.), and finally two chapters on medieval art in the modern era (modern revivals of medieval architecture and the modern medieval museum). In all this, there has been a conscious mix of older and younger scholars.

Unfortunately, for a number of reasons, not every topic that I would like to have had covered was able to be included. And while it is my belief it is virtually impossible to have a truly satisfying organization with this particular material because of the fundamental conceptual unity of so much of medieval art and the resultant interlocking nature of much of its scholarship, I certainly might have conceived of the selection of essays differently after having gone through the experience of participating in this project, an undertaking with its own challenges.

In the same way that I was given nearly complete freedom as editor, so I used this as a guiding principle for the contributing authors, believing that it is not only impossible to impose universal standards on independent-minded scholars in a case like this, but that it is wrong to try. I asked them to trace out past issues, current trends, and, when possible, what might seem to be future directions. I also asked them to find a balance between a "factual" recounting of the previous literature and their own scholarly opinions, so that the essays would be both of value to students and of interest to scholars. This was not an easy charge, especially given the strict length limits imposed by the series. Nor were the basic parameters of each essay similar. Some authors were heavily burdened with nineteenth-century precedent, while others dealt with topics that have not yet found headings in the periodical indexes. In the end, one chapter may approach its subject in such a way as to be a model of analysis of the secondary literature, another may give a great deal of attention to the establishment of crucial formative institutions, and another still may approach the topic from the angle of the work of art. Some pull the literature together in a way not done before, contributing a dimension of additional analysis and so take the subject further than before. All reveal how generation after generation of scholars approached the subject – archaeological strata of understanding that have shaped our conception of the field today. As a group, they exemplify perhaps every mindset (and combinations of mindsets) that can be applied to the subject:

traditional and innovative, pragmatic and creative, clinically analytical and broadly reflective. Ultimately, this is not a systematic historiography of medieval art – something that could only be written by a single author – but a collection of essays covering a broad number of topics and taking a varied number of approaches. But it is also one that, I hope, will help build bridges between the different sub-fields of medieval art history for those of us who are increasingly forced to pursue our own areas of study in seeming isolation.

Finally, while scholars have always recognized the importance of a historiographical understanding of the field, there seems to be an increasingly strong feeling today that such an understanding also helps facilitate learning on the part of students. Many of the concepts and issues that run throughout this book represent, for me, some of my earliest memories of the study of art history. Working with these concepts and issues in the course of producing this volume has underscored for me the excitement of studying medieval art history, reminded me why I got into the field in the first place – something I hope will also be the case with the younger scholars who use this book.

A work like this is the result of many debts. I would first like to thank the authors of this volume themselves. I know that each one of them had his or her own research waiting when I first approached them, research that was set aside in order to take on this work as a service to the field. Three, in particular, worked on through personal adversities of the most trying kind. Another, the late Harvey Stahl, courageously took up his essay though he knew he might be unable to complete it. I would also like to express my gratitude to those colleagues who generously suggested potential authors for some of the essays in this book, including Dana Arnold, Stacy Boldrick, Michelle Brown, Caroline Bruzelius, Brigitte Buettner, Annemarie Weyl Carr, Paul Crossley, Eric Fernie, Jaroslav Folda, Roberta Gilchrist, Christa Grössinger, Cynthia Hahn, Anne D. Hedeman, Anne Higonnet, Herb Kessler, Peter Kurmann, and Elizabeth Pastan. And I would most particularly like to thank the tireless and supportive series editor, Dana Arnold, for the important role she played in the production of both the series and this volume.

Conrad Rudolph

1

Introduction: A Sense of Loss: An Overview of the Historiography of Romanesque and Gothic Art

Conrad Rudolph

Little Jack Horner
Sat in the corner,
Eating a Christmas pie;
He put in his thumb
And pulled out a plum,
And said, What a good boy am I!

So began for Glastonbury, as it had for countless other monasteries, the destruction of the ancient, wealthy, and powerful institution of monasticism – or, according to a different view, the defeat of an oppressor, or, according to another still, the transition of Christianity into the modern age. But it was also, in a way, the birth of medieval art historiography, a birth with a very long period of labor. When Jack (or Thomas) Horner (as the nursery rhyme is popularly and probably correctly understood to relate) rode into London from Glastonbury in 1539, three years after the Dissolution of the Monasteries had begun and one before it would end, he carried with him a gift from Abbot Richard Whiting of Glastonbury for King Henry VIII. The gift was a mince pie and, apparently having a sweet tooth, Horner, the abbot's steward, extracted one of twelve manorial deeds (the one for Mells Manor, a real "plum," as we still say today)

hidden in the pie before delivering it in accord with the abbot's intention of sweetening Henry's decision regarding Glastonbury in the Dissolution process.[1] A man of prodigious appetite, Henry's hunger was not so easily satisfied and – even before Horner had served on the jury in a sham trial that condemned the abbot, his master, to death – he consumed Glastonbury as well, perhaps the oldest and one of the wealthiest abbeys in England. Among the last monasteries to hold out during the Dissolution – a great pilgrimage place with legendary associations with the beginnings of Christianity in the British Isles, Joseph of Arimathaea, St Patrick, King Arthur, and Dunstan – Glastonbury's riches were plundered, its lands sold, and its great buildings demolished. (Little Jack Horner's descendants still live in the manor at Mells.) In all, 577 religious houses were suppressed by Henry – 200 of them great institutions with substantial holdings – their buildings torn down, their artworks destroyed, and their libraries dispersed.[2] With this, one of the great cultural institutions of Britain ceased to exist.

Around the same time, the medieval patrimony of Northern and Central Europe suffered irreparably from a series of wars, uprisings, and acts of iconoclasm that took place following the momentous posting of Luther's 95 theses at Wittenberg in 1517. And in France, the Wars of Religion (1562–98) were virtually unrivalled in their destruction of the French artistic inheritance.

The breadth and finality of this destruction would bring about a sense of loss that combined with a number of other vital factors such as incipient antiquarianism, the early development of national identity, and a general spread of education that would lead, eventually, to the formation of the field of medieval art history as we have it today. This field, however, can be a multifaceted one, and the times since the Reformation have been no less complex than those in which the very first "medievalists" worked. In the hope that the chapters in this book might be better understood by those readers unfamiliar with the general history of the writing of medieval art history, this introduction will attempt to give a brief overview of this history, a basic narrative, to explain, as best it can, how we got here from there.

The Pre-History of Medieval Art Historiography

Already in the midst of the wreckage that followed in the wake of the Reformation, the first steps were taken to preserve from total loss the vestiges, both documentary and physical, of a rapidly disappearing culture, a culture seen as both compelling and threatening, even at the same time. This spontaneous and erratic rescue arose first in Britain and only later elsewhere in Western Europe, originally always the result of individuals operating on their own initiative, whatever their professional positions and institutional support may have been. But, in a sense, the historiography of medieval art began long before its writing, and the rescue of medieval culture's remains in the formation and continuation of the authority of Classical art. This was an authority so overwhelming that it acted as

an almost insurmountable barrier to an acceptance of the standards of medieval artistic culture in general and of the aesthetic basis of medieval art in particular. It was also an authority that had a long and venerable ancestry in the historiography of Western art.

Not long after what is now called the Late Classical period, the first known history of Greek art was written by Xenocrates (fl. 280 BC), a history that is believed to have taken as its basic theme the systematic progress toward the perfection of naturalistic or illusionistic rendering through the solving of formal problems by a succession of famous artists. Xenocrates' writing has not survived, nor have those of his contemporaries, such as Douris of Samos (c.340–260 BC), who is thought to have put the history of art that he wrote into the form of a series of biographies. However, both Xenocrates and Douris, among others, were heavily used by Pliny the Elder in his great *Natural History* (71–7 AD). Pliny continued the concept found in their work of a clear trajectory of phases of broad stylistic development from initial formation to perfection, and from perfection to decline, this perfection being seen as reaching its high point in the High and Late Classical periods. He also generally followed the biographical format, which was a very popular one. Unlike most of the other early writings on art, Pliny's did survive and served as an enormously influential model in the first centuries of early modern art historical writing. In no small part because of this, from the very beginning of early modern art history and for more than two hundred years to come, the standards by which art was judged were those of naturalism, and the format in which the history of art was presented was typically that of the biography. Or, put another way, the paradigm of art historical writing was that of the historically known individual advancing the naturalistic and illusionistic standards of the Classical period. Equally as critical for the historiography of medieval art was the stylistic developmental model of initial formation, naturalistic perfection, and eventual decline. From the very beginning, the deck was stacked against the art of the Middle Ages with a standard that was generally foreign to medieval culture, which, for much of its history, privileged the abstract and the iconic over the naturalistic and illusionistic; and which saw the role of the artist as that of a craftsman, irredeemably below those individuals within medieval culture – saints, great ecclesiastics, and the most important nobles – who were thought of as worthy of having their lives and deeds recorded.

The changes that the naturalistic and biographical paradigms underwent in the beginning of early modern art historical writing were, for the purposes of this introduction, moderate. But the stylistic developmental model of initial formation, perfection, and decline was to be reconceived in a way that Pliny and his contemporaries could never have imagined at the height of the Roman Empire. In the mid fourteenth century, with Petrarch, an awareness arose in Italian humanist circles not only of the decline of civilization that accompanied the fall of Rome, which had never been in question, but also of a Classical (that is, "Roman") cultural revival in their own time. Petrarch referred to the decline

as a time of "darkness," a time of almost unrelieved ignorance – this first articulation of the idea of "the Dark Ages" being, clearly, a negative one (1337–8).[3] Soon, Boccaccio (1348–53) and others applied this concept to the history of art, although in an unsystematic way, most notably in regard to Giotto (1267/75–1337). It was only a matter of time before historians such as Flavio Biondo came to see the interval between the Empire and their own time as a distinct period (posthumous 1483), something Biondo's contemporaries and immediate followers gradually formalized with terms such as *media tempestas* (1469), *media aetas* (1518), and *media tempora* (1531). (The actual term *medium aevum*, the direct Latin of "the Middle Age" or "the Middle Ages" as the source of the word "medieval," is first found at least by 1604; with the English equivalent appearing immediately afterwards with "the Middle Age" being used by William Camden in 1605 and "the Middle Ages" by Henry Spelman in 1616.[4]) By the early fifteenth century, Niccolò Machiavelli presented a flexible cyclical theory of history (posthumous 1531), largely based on the work of the Greek historian of ancient Rome, Polybius.[5]

In regard to the historiography of medieval art, these developments took their definitive form in the work of Giorgio Vasari, considered by some to be the founder of modern art history. There had been earlier writings on the history of art from Italian humanist circles, including by the sculptor Lorenzo Ghiberti (begun *c.*1447), but Vasari's *Le vite de più eccellenti architetti, pittori, et scultori* (1550; rev. edn. 1568) is regarded as the first modern history of art because of its broader, more synthetic, and more critical nature. Following the authority of Pliny, Vasari presents a history of (largely Italian) art employing a standard of naturalistic progress and a format based on biographies of the artists. On the one hand, his emphasis on technical knowledge and aesthetic judgment gave an enormous impetus to the practice of connoisseurship with its estimation of quality and the determination of attribution that was to dominate art historical discourse for so long. On the other, the biographical format, encouraged by the Italian humanist affinity for the individual, opened the biographical paradigm to the new topos of the artist as genius. (This realm of genius was apparently open only to practitioners of painting, sculpture, and architecture; Vasari is considered to be the source of the distinction between the so-called major and minor arts, a distinction that every period potentially faces but that is particularly disadvantageous to the medieval, whose book painting was considered a "minor art" until the late nineteenth century.) At the same time, in also employing a variation of Pliny's stylistic developmental model of initial formation, perfection, and decline, Vasari was forced to address something Pliny never was: the millennium and a half of artistic activity since Pliny's death in the eruption of Mount Vesuvius.

If Pliny could interpret a few hundred years of what he saw as an artistic decline in his own time simply as the result of an essentially moral decline, Vasari was compelled to explain more than a thousand years of what he saw as an artistic decline of morally superior Christian culture with reference to both the Classical period and his own time – as well as in light of recent developments in

the Italian humanist view of history. He did this by accounting for artistic decline in general not in moral terms but by conceiving of the pattern of artistic change as a biological cycle (birth, growth, old age, and death) superimposed on the history of the fall of the Western Roman Empire. Thus, the periods of initial formation and naturalistic perfection of the Classical world were followed by that of the decline of the arts of the Middle Ages (begun before the fall but fully realized through the destruction and culture of the Germanic invaders); the cycle then beginning again around the time of Giotto and others who strove toward the ideal of naturalistic perfection with a new sequence of initial formation, increasing perfection, and, finally, perfection itself (embodied in the work of Michelangelo). Vasari describes this process of the re-establishment of naturalistic standards as a "rebirth" (*rinascita*), our "Renaissance" – a concept that not only recognizes a self-conscious view toward the present and future, but also signals a consciousness of a break with the Classical past, any sense of continuity irrevocably ruptured by the Middle Ages. In an attempt to account for major artistic change as something more than technical advances, Vasari attributes this change to "the very air of Italy," a very unphilosophical and conceptually unrelated predecessor of Hegel's *Zeitgeist* and Riegl's *Kunstwollen*, mentioned below. Vasari is, perhaps, most notoriously known among medievalists for his characterization of what is now called Gothic architecture as an invention of the Goths (or Germans), who "filled all Italy with these damnable buildings"; the reference to the Goths – including through the use of the adjective – being one that had been made by other writers earlier (and by Vasari himself) to indicate a much broader variety of forms of medieval architecture with which Italian humanists were out of sympathy.[6] But his great importance for the historiography of medieval art lies in the fact that his work was so enormously influential throughout Europe that it gave the impression there was only one methodology, only one way of looking at art. This was a way that, in the emulation of Vasari's own particular naturalistic and biographical paradigms and cyclical model of stylistic development, removed art from its cultural context and relegated medieval art to the low point of Western culture for more than two hundred years to come.

The Reformation and its Aftermath

What was to Vasari only too ubiquitous, Gothic, was – in the broader sense of medieval culture – to many others now in danger of being lost. Since the mandate of this volume is Romanesque and Gothic art and architecture in Northern Europe, let's return to England of the Dissolution to look at John Leland, the person who is generally described not as the first medieval art historian, but as the first modern English antiquary.

In 1527, after eighteen years of marriage without a male heir to the throne, Henry VIII began a series of efforts aimed at having his marriage with Catherine

of Aragon annulled and his association with Anne Boleyn legitimized. Unable to achieve this end after seven years of contesting the issue (including a great deal of public pressure on the Church in England), he broke with Rome in 1534, and began preparations for the Dissolution of the Monasteries mentioned at the opening of this introduction in that same year. The "visitations" began in 1535 and the monasteries were incrementally suppressed from the weakest to the strongest from February 1536 to March 1540. (In the end, the monasteries lasted longer than Anne, the second of the king's six wives, who was beheaded in May 1536.) It was in the midst of this gradually escalating state of affairs, from 1534 to 1543, that John Leland undertook a project with the king's support to research the libraries of all the monasteries and colleges of England, so that "the monuments of auncient writers as welle of other nations, as of this yowr owne province mighte be brought owte of deadly darkenes to lyvely lighte" (the latter possibly being a reference to Petrarch). Leland, who had been in Holy Orders and had been appointed Henry's librarian around 1530, was an antiquarian (antiquarianism being a form of the study of the past that is based on physical as well as literary remains, typically with an aim toward classification rather than a comprehensive historical view). His antiquarian proposal, however, seems to have received an urgent impetus from the Dissolution, of which he approved but whose destruction of the ancient libraries he deeply regretted (even as he contributed to it himself in his acquisition of books for the king's library). In the end, this already daunting project expanded its goals to include everything from libraries to inscriptions, important buildings, artistic remains, coins, and geography, in both England and Wales. The result is considered to be a significant innovation in antiquarian method, even if an uncritical one.[7] Far less a study of art and architecture than it was a broad review of the topography and antiquities of the kingdom, Leland's project remained unfinished when he was declared insane in 1547 at the age of around 44, dying five years later. His extensive notes, however, were widely known to the next generation of antiquaries who used them, cited them, and even indexed them. These were finally published in nine volumes from 1710 to 1712 as the *Itinerary*, further notes were published in six volumes in 1715 as the *Collectanea*. Some scholars believe that Leland's insanity was the result of distress at the equivocal role he played in the destruction of his beloved libraries. However this may be, what is not in doubt is that the impetus for this seminal work was Leland's strong sense of nationalism, and that its purpose was to contribute to an awakening of English national identity.

This sense of nationalism and of a need for a more clearly defined national identity in the face of an irrevocably changing world was a common factor in much of the work (from both sides of the aisle) on British antiquities and topography that followed Leland. It was a time of first beginnings, and the progress – however much erudition and initiative was involved – gives, in historiographical retrospect, something of the impression of intellectually feeling around in the dark. Two scholars who emerge most strongly from this challenging

period before the English Civil War were William Camden and Robert Bruce Cotton. Camden built upon Leland's manuscript notes to produce what Leland never managed: a comprehensive and coherent antiquarian study of England, and one that was extremely popular (1607). Cotton was a great antiquarian and collector who is known to every medieval art historian from the cataloguing of his famous manuscript collection according to the Classical busts, particularly of Roman emperors, that stood on top of the bookcases that housed the manu-scripts. (Cotton also bought and moved the room in which Mary, Queen of Scots, had been executed at Fotheringay Castle to his own house at Connington, perhaps the first "period room.") A vital part of the great activity of this formative era was the creation of a number of modern institutions, if only in their nascent forms. Cotton's collection, which was actively used by contem-poraries in the manner of a modern research library, would later become an important part of the manuscript collection of the British Library. Together, Camden and Cotton were part of the founding of the Society of Antiquaries in 1586, an important institution in the encouragement and dissemination of scholarship at this time of early development (dissolved in 1614 but to be re-established).

But there were also a number of other scholars who, if less well known than Camden and Cotton, contributed perhaps more directly to the foundation of an art historical base of methodologies, terminology, and periodization. For example, William Somner wrote on a number of medieval churches, including the Cathedral of Canterbury, distinguishing between Romanesque and Gothic elements (though not using these terms) and trying to use architectural form as a means of dating (1640), a method that was to have a long history. It is from this time that we have the first recorded use of the term "Gothic" in English: in 1641 as an adjective and in 1644 as a noun, although it is not clear from the passages whether the author, John Evelyn, was using the word specifically in the sense that we understand it today or more generally in the meaning of "medieval."[8] William Laud, Archbishop of Canterbury and Chancellor of Oxford University, left his valuable collection of manuscripts to the Bodleian Library in Oxford and helped to obtain the Great Charter for Oxford University Press before being beheaded for Royalist support by order of Parliament in 1645. And John Webb, in an edition of some of Inigo Jones's writings on Stonehenge of 1655, incorporated the distinction between round and pointed arches already made (though unsystematically) by Somner in 1640 into a broader conception of architectural style, calling them "Saxon" and "Norman," respectively.

But the potential prejudice against medieval art remained, and not just on the intellectual level. With the outbreak of the English Civil War (1642–48) and its aftermath, the Protectorate (1653–9), the destruction of the medieval patri-mony continued, attention now turning to the British cathedrals, since the monasteries had already been destroyed in the Reformation. From the symbolic cutting down of the famous Glastonbury Thorn (said to have sprung from

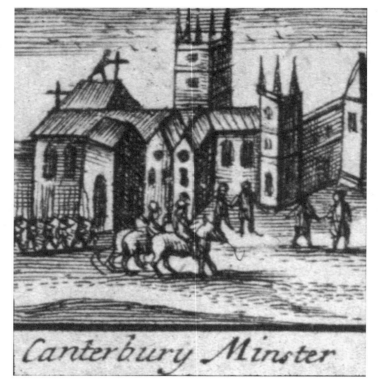

FIGURE 1-1 Puritans "slighting" ("disrespecting," in the current vernacular)
Canterbury Cathedral, 1642. From *Mercurius Rusticus*, a series of Royalist reports
about Parliamentary depredations, particularly those involving the great medieval
cathedrals. These reports began the same year as this slighting, and from 1646 to
1732 were published in book form. The depiction here is from the frontispiece of
the 1685 edition.

Joseph of Arimathaea's staff) on the Tor (where Abbot Whiting had been
executed and dismembered) during the Civil War by a member of Cromwell's
New Model Army to "rattling down proud Becket's glassy bones" (the partial
smashing of the stained-glass windows of Canterbury Cathedral in 1643) by an
iconoclastic Puritan minister, the losses continued to mount up (fig. 1-1 shows
a 1642 "slighting").[9] But Cromwell's death in 1658, in the old Somerset House
on the Thames in London, symbolically marked the end of the conscious political
destruction of medieval art. The Lord Protector's effigy lay in state – his funeral
being described by Evelyn as "the joyfullest funeral I ever saw" – and his body
(or at least one answering to that description) was disinterred from Westminster
Abbey, publicly hanged, and then decapitated. Despite the efforts of the iconoclasts
– or, rather, because of them – this second phase of destruction of medieval art
in England had the same effect as the devastations of the earlier Dissolution, and

acted as an impetus to further scholarship, although one that was still largely limited to England at this time.

On the Continent, the Thirty Years War raged (1618–48), taking its toll as well. Yet ancient and Renaissance scholarship was in full swing by now, with important implications for the development of medieval art history. This was the time of the beginning of modern biblical criticism. The Early Church became a subject of great study as a result of both the Reformation and the Counter-Reformation. The catacombs of Rome were accidentally rediscovered in 1578, and Antonio Bosio's great work on the catacombs, *Roma sotteranea*, was published in 1632–4. Historical terms such as "BC" (Bousset, 1681) and "century" began to be used. The quality of published reproductions of artworks improved, and archaeological reconstructions began to be used in publications. The antiquarian societies that had been popular in Italy for some time were beginning to spread throughout Europe. The Académie Royale de Peinture et de Sculpture was established in Paris in 1648. Collecting increased at a dramatic rate, the art market developed, more collections began to be opened to a select public, buildings began to be designed specifically as museums, catalogues were sometimes even printed for visitors (Villa Borghese, 1650), and the Grand Tour became an institution. In the Low Countries and Germany, the influential histories of art written by Karel van Mander (1604) and Joachim von Sandrart (1675–9) included Northern artists in their biographical formats, contributing to a loosening of the grip of Classical and Renaissance dominance. All of this helped build an intellectual atmosphere and professional structure that encouraged the growth of the discipline of medieval art history, if only indirectly.

In France, in particular, much work was done under the stable regimes of Louis XIII and Louis XIV and in the less secure region of present-day Belgium to save the medieval heritage, even if little of it was immediately related to art and architecture. The Jesuit Bollandists in Antwerp published the first volume of the renowned *Acta Sanctorum* in 1643 (we eagerly await the final volume, whose introduction was written in 1940) in order to provide dependable primary sources of the lives of the saints as part of the defense of the Church in the Counter-Reformation. The Benedictine Maurists, of whom the best known is Jean Mabillon – who said of Cluny at the absolute low point of popularity of medieval art, "If you see it a hundred times, you are overwhelmed by its majesty just as often" (1682) – set new standards of historical methodology, Mabillon himself being especially prominent for his work in paleography and diplomatics. Operating out of Saint-Germain-des-Prés in Paris, they distinguished themselves with such works as the *Acta SS. Ordinis Sancti Benedicti* (1668–1701), the *Annales Ordinis Sancti Benedicti* (1703–39), and the *opera* of many Fathers, which quickly became part of the essential foundation for medieval studies for generations of scholars. Among lay scholars, Charles Ducange published his *Glossarium ad Scriptores Mediae et Infimae Latinitatis* in 1678, still an authority in the field. In the area of art history generally speaking, the first scholarly art historical bibliography was compiled (by Raphaël Trichet du Fresne on Leonardo

in 1651). The grave of Childeric, rich in Merovingian jewelry, was accidentally discovered in Tournai in 1653, causing a sensation. In the debate known as the Quarrel of Ancients and Moderns, Charles Perrault (an influential voice in French artistic circles and the "author" of Mother Goose) declared that contemporary architecture was superior to Classical, and that, alongside absolute beauty, there was a relative beauty that could change with time (1688) – an idea that led to an increasing subjectivity of standards, contributing to the undermining of the Classical ideal as the sole authority. Roger de Piles did much to counter the assumption that the history of art could only be written by artists, an idea that owed its basis to the Italian precedent, and, like van Mander and Sandrart before him, included Northern artists in his work, thus helping to weaken the near monopoly of Mediterranean artistic authority in the Northern conception (1699, 1708). But more significantly for the development of the field of medieval art history in particular, Jean-François Félibien des Avaux differentiated (for the first time in French scholarship) between systems of structure based on round and pointed arches, which he termed *gothique ancienne* and *gothique moderne*, respectively (1687). Although this strain of thought was not taken further at the time in France, it was across the Channel.

England after the death of Cromwell was more concerned than ever with better understanding its medieval art historical past, something largely manifested through a very gradual awareness and articulation of architectural styles and their origins. In this effort, by far the most influential English antiquary of his generation was William Dugdale, the intellectual heir of Camden and Cotton. Dugdale is the primary author of the *Monasticon Anglicanum* (written with Roger Dodsworth; 1655–73), a deeply researched history of monasticism in England that incorporated a discussion of the building histories and the destruction of the various institutions with which he was concerned. A Royalist who had at one time been commissioned to make a record of the monuments of the leading churches of England in anticipation of the Civil War – an action not so different from the removal of stained glass from the great churches during World Wars I and II – Dugdale's book both employed the work of Leland and went beyond it in setting new standards for documentation and quality of illustration, even being called "the first illustrated architectural history of a mediaeval style" (figs. 1-2 and 1-3).[10] While the three-volume work was being released, Dugdale also published a history of St Paul's Cathedral, which was the first illustrated monograph on a work of English ecclesiastical architecture and an important step in the beginnings of medieval art history (1658).[11] Aside from this, John Aubrey wrote an important, inclusive history of English architecture in the 1670s in which the round and pointed styles were clearly distinguished, a history that was widely known among scholars despite the fact that it was not published at the time.[12] Roger North took the differentiation between the two forms further, characterizing rounded-arch structures as "elder Gothick" (1698; apparently following Félibien) and associating what is now called English Romanesque with Roman architecture for the first time in print, this connection

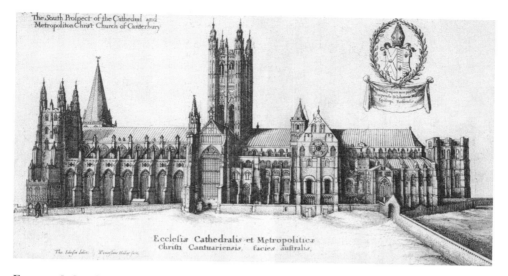

FIGURE 1-2 Canterbury Cathedral, engraving by Thomas Johnson and Wenceslaus Hollar from William Dugdale's *Monasticon Anglicanum* (1682 edition). The engravings in Dugdale's edition are perhaps the first reproductions of medieval art intended for serious scholarly study.

contributing to the intellectual respectability of medieval architecture in a time of classicizing standards. Even so, the approaching Enlightenment was not sympathetic to the study of medieval architecture, seeing it as the irrational antithesis of its rational self in its darkness, its absence of Classical proportions, its particular use of architectural sculpture and detail, and its delight in monstrous forms.

The Age of the Enlightenment

It was, ironically, precisely this "irrational" quality that spearheaded a broader acceptance of medieval architecture on the part of a more general public at the time of the Enlightenment. This was a social phenomenon of unexpected origins and complex development, one that must have seemed extraordinary to its contemporaries. In 1711, Joseph Addison introduced the philosophical concept of the Sublime into the discussion of architecture, a concept that distinguished between the traditional concept of beauty (as understood from the principles of Classical art) and awe (the Sublime). Generally speaking, this new appreciation for the Sublime permitted the qualities of vastness, irregularity, and obscurity commonly associated with Gothic architecture to be opposed positively to the qualities of human proportions, regularity, and clarity universally associated with Classical standards. This obviated the almost unshakable principle that associated

FIGURE 1-3 Detail of frontispiece engraving by Wenceslaus Hollar from William Dugdale's *Monasticon Anglicanum* (1682 edition). If Dugdale's *Monasticon* is "the first illustrated architectural history of a mediaeval style" (Frankl), it may also contain the first pointed juxtaposition of images, and in no less a place than its frontispiece. On the left, a good king (perhaps Edward the Confessor, mentioned in the coronation oath in connection with the liberties of the Church) places what seems to be a deed of foundation for a monastery (seen in the background) on an altar (whose triptych appears to include a monk and another robed figure, perhaps Augustine of Canterbury and Gregory the Great, shown elsewhere in the frontispiece), dedicating this work "To God and the Church." On the right, Henry VIII is shown ordering the destruction of a monastic church (perhaps meant as Glastonbury, with the Tor in the background), declaring, "As I will," an apparent reference to "As I will, so I command," from Juvenal (*Sat.* 6: 223), a passage occasionally cited at the time in the characterization of tyranny. Henry is thus said to have put his own will above the rule of law in the Dissolution of the Monasteries; this is made even more pointed through a scene (not shown here) at the top of the frontispiece of the signing of Magna Carta, whose first article guarantees the liberties of the Church for all time.

both Classical and Renaissance art with beauty as an expression of truth – or Beauty and Truth, as the terms are often rendered. A theme given significant development by Edmund Burke (1756) and Immanuel Kant (1790) over such a period of time as to ensure its continued viability, the concept of the Sublime gave an intellectual respectability to Gothic architecture that was extremely important in the slow process of breaking down the walls that shut off medieval architecture from mainstream artistic thought.

The undeniable legitimacy that the concept of the Sublime gave to Gothic architecture contributed to its further acceptance on the popular level through the Gothic Revival movement. The Gothic Revival began at least as early as 1717 with the Gothic Temple at Shotover, Oxfordshire, an overtly political monument (as were others, whether Whig or Tory). But for the purposes of this introduction, perhaps the most interesting example of this phase of the Gothic Revival is that of Strawberry Hill (1753–76), the country residence of Horace Walpole, an enthusiastic and astute advocate of the movement and the author of

the first Gothic novel, *The Castle of Otranto: A Gothic Story* (1764). More historicist than many contemporary examples of the Gothic Revival (often described as "follies") but less than would generally be the case in the nineteenth century, Strawberry Hill and other Revivalist works employed Gothic as a novel source of inspiration for contemporary design – one that broke away from the old Mediterranean precedent in its search for a new indigenous style as part of a gradually evolving and very self-conscious conception of national identity. "Gothic" was clearly no longer a term of criticism, at least to some. The pointed arch that had earlier distanced medieval architecture negatively from the Classical precedent with its round arch now did so in a positive way, one that was soon to spread throughout Europe (fig. 1-4).

Germany, too, began to build in the Gothic Revival style, but it was to be a while, if only a short while, before any truly broader recognition of Gothic would be achieved on the Continent, and then even as period styles earlier than Gothic were typically considered "decadent." In other ways, however, the general infrastructure of art history, of which medieval is a part, began to develop significantly. In Germany, art began to be studied at the university level, most notably with Johann Friedrich Christ at the University of Leipzig (1734).

In France, Michel de Frémin's architectural theory of rationalism (the idea that beauty is based on the degree to which the form of a building expresses its function and materials; 1702), which included medieval in its discussion, further continued the process of chipping away at the Classical stranglehold, as did Marc-Antoine Laugier's recognition of the role of rationalism in Gothic architecture (1753), a subject that would be argued for generations. The Abbé Mai first presented the idea of French regional schools of architecture (1774), also a topic that would continue to receive attention. The Maurists carried on their work, including *Gallia Christiana* (1715–65), the *Histoire littéraire de la France* (1733–68), and Bernard de Montfaucon's *Les Monumens de la monarchie françoise* (1729–33), the latter essentially presenting a history of the French monarchy through its artistic monuments. The latter also produced what might be called the first attempt at a national union catalogue of manuscripts (1739). And Rousseau's writings on nature did much to prepare the way for the Romanticists.

In Italy, interest in things medieval was scant, but writing about art began to be undertaken less by artists, as had traditionally been the case, and more by connoisseurs – the often conflicting relationship between artists and non-artists in the writing of the history of art being one that would continue for some time. Greek art began to be distinguished from Roman. The evacuation of Herculaneum started in 1738, and of Pompeii in 1748.

Everywhere, museums were opening up to an increasingly wide segment of the public, although just what museum collections and their publics constituted varied greatly over the years. The Ashmolean was established in Oxford in 1683 by Elias Ashmole, son-in-law of William Dugdale. The Capitoline Museum (the first formal public art collection since antiquity, founded in 1471) was opened to the public in 1734 (by the Pope), the Uffizi was founded in 1743 (building

FIGURE 1-4 *The Entry of Prince Frederick into the Castle of Otranto*, pen and wash drawing by John Carter (1790). As fanciful as any medieval architectural drawing, this literally illustrates both the impact Horace Walpole's book had on the Romantic conception of Gothic and one of the means of the diffusion of that conception. Reproduced courtesy of the Lewis Walpole Library, Yale University.

designed by Vasari for court use in 1559), the Louvre in 1750, the British Museum in 1753, the Museo Pio-Clementino in 1770, the Albertina in Vienna in 1773, and the Schloss Belvedere in Vienna in 1781, to name a few. Proper layout of collections was an ongoing issue, particularly the question of aesthetic versus chronological layout – a manifestation of the ongoing conflict between connoisseurship and art history, the two principal and often contending approaches to the study of art at the time. Encyclopedias and dictionaries began to include or even be exclusively devoted to art, artists, and iconography. And some of the great medieval buildings began to be restored on a scholarly basis.

As the eighteenth century progressed, the terminology of Saxon, Norman, and Gothic architecture continued to develop in England. Browne Willis wrote a series of studies on British cathedrals that provided an extensive body of plans and elevations for further study (esp. 1727–30). After a period of irregular association, the Society of Antiquaries received a royal charter in 1751 and began meeting in Somerset House, where Cromwell had died. The Cotton collection was finally acquired by the British Museum in 1753, as was the fine manuscript collection of Robert and Edward Harley. Thomas Gray advanced the study of what is now called Romanesque and theorized the origin of the pointed arch (1754, published 1814), work that was employed and furthered by James Bentham (1771). The journal *Archaeologia*, which published many medieval studies, was established in 1770. And William Stukeley helped raise the standard of scholarship through new attention to the differentiation of primary and secondary sources, as well as going beyond a gathering of strictly factual information through the analysis of those facts (1776), something of a new proposition.[13]

But, actually, the greatest change affecting the study of medieval art at this time of the Age of the Enlightenment was the work of a classicist, Johann Joachim Winckelmann, considered by some to be the founder of modern art history (as is Vasari by others, though Winckelmann might best be thought of as modern and Vasari early modern). In major publications of 1755 and 1764, Winckelmann wrote the first modern histories of figural art, more or less initiating the German dominance of the study of the history of art that was to last for so long and to be so distinguished. Choosing to write on Classical sculpture but forced to come to terms with the anonymity of the limited extant works that were available to him, he presented his study as an inclusive, synthetic analysis rather than a series of artists' biographies or discussion of individual works. The basis of this synthetic analysis was Winckelmann's periodization of Greek art on the cyclical model, a stylistically based methodology that became extremely influential in both art history and archaeology. Central to his conception of art was the notion of the Classical ideal of beauty, to or from which all art was understood to either adhere or deviate. Both the cyclical model and the standard of Classical beauty were almost insurmountable obstacles to the development of the study of medieval art. Winckelmann himself, however, applied these standards to all of ancient art, seeing Roman art – previously only poorly distinguished from Greek – as a distinct second to Greek. Thus, despite the unchanging

ideal of the Classical that he set up, Winckelmann – with an almost unimpeachable authority – shattered the myth of the Classical period as a time of consistent artistic standards and so unintentionally opened the way, eventually, for the recognition of the respectability of the artistic production of other historical periods. At the same time, he explained the basis of the changes in his periodization as the product of historical context – social, political, and religious factors, including the concept of freedom.

Both Winckelmann's attention to historical context and his demonstration of the utility of stylistic analysis were interpretive devices that had seen no systematic use before, and were strongly counter to the antiquarianism of the time. To these important new methods, he added a new interest in iconography, a scholarship free of nationalism, and the model of original research (as opposed to a rehashing of previous work). Before Winckelmann, the writing of the history of art had largely been the exclusive domain of the artist, one that generally followed the biographical format established by Vasari two hundred years before. Winckelmann broke with these two very substantial traditions, even if he did try to approach a given artwork with the "eye" of the artist. It was only once this constricting situation had been left behind that the history of art as a history of society and culture could begin to be written. But Winckelmann also called for the imitation of the ancients, and in so doing gave an unprecedented impetus to the establishment of neo-Classicism, whose underlying mind-set was by definition inimical to medieval. The result of this was, to a large extent, to firmly reinforce the already strongly entrenched idea that there was but one standard, the Classical.

Romanticism

The virtually unquestioned position of Classical as the only standard by which art might be judged was irrevocably shattered with Johann Wolfgang von Goethe's essay *On German Architecture* of 1772. Gothic had traditionally been seen as the negative counterpart to Classical. In this essay, Goethe argued that it was the positive counterpart. He sharply criticized the fact that his German education had taught him to disdain Gothic architecture and, through the vehicle of Strasbourg Cathedral – despite a very imperfect knowledge of the historical details involved – he praised Gothic structure as based on necessity, Gothic ornament as appropriate to the structural framework, and Gothic variety within an overall harmonious unity, all of these subjects having been traditional points of criticism of Gothic in the past. It was, however, not the neo-Classical that Goethe was consciously challenging, but what he saw as the tyranny of contemporary tastes, particularly the "effete" French Rococo. Gothic was German architecture, the product and expression of the German psyche, and it was upon this – and not the expressions of other cultures – that German national identity should be based. Goethe later distanced himself from this identification with

medieval (though he would eventually return to a limited acceptance of it), but the impact of this essay on others was profound and lasting. The influential *Sturm und Drang* movement – which had been heavily influenced by Rousseau – was especially affected by Goethe's essay in its furtherance of the right of artistic genius not to be impeded by rules, of the importance of the potential emotional power of art, of a rejection of the universality of the standards of Classical culture, and of the legitimacy of the artistic production of other periods, particularly the medieval. Any pejorative sense to "that misunderstood word 'Gothic'" was now laid aside forever. But, more to the point, the universal primacy of the fundamental premise of Classical – rationality – was brought into question. Goethe's championing of an art form that should be "felt rather than measured" was, in its very emotion, contrary to the neo-Classical ideal.[14] It was also a sentiment that was eminently better suited to this new Age of Revolution than it ever could have been before, in the Age of Reason.

A reaction to what some saw as the excessive Enlightenment emphasis on rationality had been forming for some time and culminated in the essentially emotional approach to history, literature, and art known as Romanticism. The beginnings of Romanticism are variously dated from around 1750 to 1800, depending on the particular aspect of this reaction, but it was given an enormous impetus by the French Revolution and by the Napoleonic wars that followed (1789–1815). The term was coined by Friedrich von Schlegel in 1798 as a means of indicating the basis in the medieval romance of an "irrational" strain within contemporary German poetry. Romanticism was, however, a very broad and rather amorphous movement, and it was not limited in its interests to medieval culture. In its "irrationality," it encompassed, among other things, a deep attraction to nature and even to Classicism (in what has been called Romantic Classicism). It was concerned with the individual, but also became an important vehicle for national identity. It was a major cultural and political movement, but had no defined goal or universally recognized political association. And it was seen as being furthered by many contemporary artists and writers who claimed no affiliation with it. Medieval art, however, was ultimately central to who the Romantics were, an important part of their breaking free, intellectually and culturally, from the dominance of the Mediterranean precedent.

Perhaps the most dramatic example of this use of art in the formation of national identity in the early and mid-nineteenth century arose in Germany in the completion of the construction of Cologne Cathedral. In 1816, a movement sprang up to complete the cathedral, whose Gothic reconstruction had begun in 1248 but which had been left unfinished since 1560. Conceived by Johann Joseph von Görres, furthered by Sulpiz Boisserée, and supported by such influential public figures as Goethe and Karl Friedrich Schinkel and by the state of Prussia, actual reconstruction began in 1842 using the recently discovered plans of *c.*1300 (fig. 1-5). By the time the cathedral was completed in 1880, the project had become a symbol of German unity during this formative period of the German nation (federal state established 1871), contributing greatly to

FIGURE 1-5 Building of Cologne Cathedral, engraving of 1842/6 by Wilhelm von Abbema. The continuation of the construction of the cathedral in 1842 was one of the most dramatic uses of art in the formation of national identity in the nineteenth century. This engraving depicts a ceremony of 1824 in a way that dramatically captures both the excitement of the event and the Romantic conception of the Gothic cathedral as one of the great unifying expressions of the human spirit. Reproduced courtesy of Rheinisches Bildarchiv, Köln.

a sympathetic view of medieval art among the general public in the process. One of the leading voices in this rehabilitation of medieval art in Germany was von Schlegel who, along with his brother, August Wilhelm, argued for a greater recognition of the historicity of art and of the relation between art and religion. Historiographically, Friedrich von Schlegel is also especially important for his discussion of Gothic architecture as the representation of the infinite. The von Schlegels influenced and were influenced by many, including Boisserée and his brother Melchior, who built up an important collection of Northern European art from the medieval period to the Northern Renaissance. These developments in art history were an integral part of a much wider medievalizing movement. Romanesque revival architecture had begun to spread in Germany, where it was known as the *Rundbogenstil*. Caspar David Friedrich, Philipp Otto Runge, and the Nazarenes (one of the first secessionist groups) were influential in painting. And Ludwig Tieck, Wilhelm Heinrich Wackenroder, and Novalis, among others, made important statements in literature. In much of this, ties to the strong Catholic revival of the early nineteenth century both helped and hindered the movement.

As Görres and Sulpiz Boisserée were contemplating the completion of Cologne Cathedral in Germany, in France the great Romanesque abbey church of Cluny was being systematically dynamited and sold for construction material (1811–23). Feelings were still very bitter on the part of many in France in regard to the *ancien régime*, and French Romanticism took a course different from that in England or Germany. Some French Romanticists were Catholic revivalists, such as the highly influential Chateaubriand, who saw Christian art in general and medieval art in particular as not just equal to Classical art, but superior (esp. 1802). Others, such as Nicolas Chapuy (1824–30) and the team of Charles Nodier, J. Taylor, and Alphonse de Cailleux (1820–78), produced important illustrated studies of the regions and cathedrals of France that were heavily influenced by the Picturesque movement and that took advantage of the new technology of lithography. Artists such as Géricault and Delacroix were outstanding in the area of painting, even if the latter would later distance himself from the movement. Less renowned but more medievalizing were the artists of the Troubadour style. Sensational "Romantic" gestures were made to the past; for example, the reinterment of Abelard and Heloise from the Paraclete (indirectly) to Paris around 1796 in a newly constructed tomb in the Musée des Monuments Français (see below), made of *spolia* from St Denis (Abelard was then known as a famous lover, not a scholar, still awaiting rehabilitation as a philosopher by Victor Cousin in 1836).

But by far the single most influential incident in regard to French Romanticism was the publication of Victor Hugo's *Notre-Dame de Paris* in 1831. Hugo, who established his reputation with the drama *Cromwell*, created a sensation in regard to medieval art with this book, both through his own explicit digressions on the subject and through the role of the cathedral in the story (fig. 1-6). (Hugo was active in bringing about the restoration of the cathedral, which

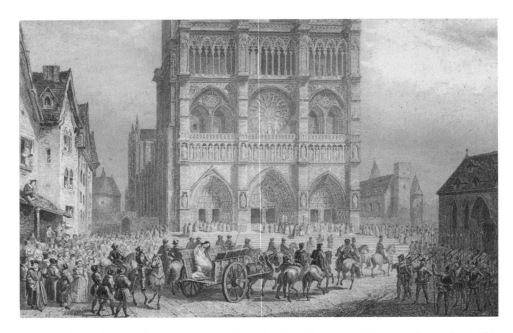

FIGURE 1-6 *Esmeralda before Notre-Dame* by Daubigny and Thomas, from the 1850
Perrotin edition of Victor Hugo's *Notre-Dame de Paris*. The publication in 1831 of
Notre-Dame de Paris, in which the cathedral plays such an important part, was one of
the most influential events in the rehabilitation of medieval art. Here, Esmeralda is
taken to the place of both her execution and her salvation, the cathedral. In one of
the most dramatic episodes of the novel, Hugo makes a point of mentioning the
"Gothic portal," the "Romanesque pillars," the reliefs of the main doorway – and
Quasimodo watching from the Gallery of Kings, equated with one of the building's
monstrous gargoyles.

began in 1843, arguing against over-restoration.) Now it was the architecture of
the Renaissance that was "decadent," and pre-modern architecture that was the
"book of stone," the "great book of humanity," in which every human thought
found a page. The Gothic cathedral, in particular, was a book in which the artist
was free as never before to express his own imagination, often in a non-religious
way.

In Britain, Romanticism resonated deeply with the increasingly historicist
Gothic Revival architecture that was rising throughout the island, but nowhere to
better effect than in the work of Charles Barry and A. W. N. Pugin (most notably
in the Houses of Parliament, designed 1835). In the visual arts, medievalism
affected William Blake (esp. 1792–1827), the Pre-Raphaelites (esp. 1848–53),
and the Arts and Crafts Movement (particularly William Morris, esp. 1861–96)
in prints, paintings, books, stained glass, and furniture of often unsurpassed
design. Sir Walter Scott and Alfred, Lord Tennyson were but two among many
who popularized the Middle Ages in literature. And John Ruskin was of enormous

influence in his many publications throughout his life, particularly *The Stones of Venice* (1851–53), which spoke of the freedom of the medieval artist, among other things. Ruskin, in 1869 the first Slade Professor of Fine Art at Oxford, was also strongly opposed to over-restoration. But the pull of the medieval past went way beyond the arts in the profound impact of the Oxford Movement (esp. 1833–45), a religious reform movement that, as one of its goals, sought to restore (according to some) certain "medieval" or Roman Catholic rituals to the Anglican Church – a proposal so threatening that it resulted in occasional riots and the imprisonment of members who refused to recognize the parliamentary court that sought to suppress these efforts.

Nineteenth-century Non-Romantic Developments

If Romanticism had helped legitimize medieval art in the course of the nineteenth century, medieval art contributed to the development of a total view of the history of art distinct from Romantic concerns – and not just of Europe, but of the world. It was no longer a question of some perceived need to justify medieval art in face of Classical standards. Art history was in the process of significant change – begun by Winckelmann, but with his Enlightenment blinders now left behind – and no field profited more than medieval. There was now a greater emphasis on methodology, historical documentation, the publication of primary sources (including *Monumenta Germaniae Historica*, 1826f.; *Patrologia Latina*, 1844–64; the Rolls Series, 1858f.; and *Corpus Scriptorum Ecclesiasticorum Latinorum*, 1866f.), encyclopedias, and bibliographies. Scholars focused increasingly on such issues as periodization, dating, regionalism, and the use of exegesis in interpretation. In architecture, techniques such as the reading of molding profiles, among others, began to be used. The modern sciences of archaeology and philology developed out of antiquarianism. Historical, social, and philosophical theories were articulated that remain influential to this day. And access was continually improved through the opening up of collections, the founding of new museums (stimulated initially partly through their establishment by Napoleonic regimes, later partly through the return of Napoleonic war booty), the increasing ease and safety of travel, and the introduction of photography (1839).

Of the many developments of this time, a few deserve specific mention. In France, the Musée des monuments français opened in 1796 under the direction of Alexandre Lenoir (disestablished 1816). The museum was a direct result of the French Revolution in that it both appropriated its holdings from the institutions of the old regime and protected them from the unstable social situation of the new (the government began efforts to preserve the artistic patrimony already in 1790). The collection – which included some of the royal tombs and stained glass of St Denis – represented all periods of French history, and was structured on a room-by-room organization, each room representing a given century. Although this layout was meant to visualize Winckelmann's cyclical model of

growth and decline, with medieval representing decline, the museum had an enormous effect on the acceptance of medieval art in France. For the purposes of this introduction, perhaps the most important influence was on the Hôtel de Cluny, the first museum of medieval art (1832; reorganized in 1844 by Lenoir's son, Alexandre-Albert, as the Musée de Cluny).[15] Equally important, Jean-Baptiste Seroux d'Agincourt published his *Histoire de l'art par les monumens* from 1811 to 1823, a work that is generally considered to be the first comprehensive study of medieval art. Actually written from 1779 to 1789, however, the book really looked more to the past than the future in regard to medieval, being conceived of as a continuation up through the Renaissance of Winckelmann's work, and still retaining the old characterization of medieval art as decadent. Even so, the times were changing, and it, too, caused a positive sensation for the art of the Middle Ages. Other important writings include a history of medieval painting by Paillot de Montabert in 1812, influenced by Seroux d'Agincourt; and a study of French architecture through the Middle Ages by Alexandre de Laborde of 1816, which first put forth the idea of the monk-architect. The Ecole des Chartes, founded in 1821, provided the educational basis for a flood of fundamental documentary research on medieval art, typically of a non-interpretive nature. In 1824, the Norman scholar Arcisse de Caumont called for a halt to the destruction of French monuments and for their preservation, a call that was repeated by Charles de Montalembert, among others, in a published letter to Victor Hugo entitled "Du Vandalisme en France"; the latter being a condemnation of those who destroyed the architectural patrimony as Vandals, a theme first put forth by Hugo, and whose ethnic re-characterization was undoubtedly made with Vasari in mind (1833). The government responded to the wide public support for this position through the creation of the post of *Inspecteur général des monuments historiques* by the historian and conservative minister François Guizot in 1830, to which the art historian Ludovic Vitet was appointed in 1831 and the author Prosper Mérimée in 1834 (redefined as a *Commission* in 1837). In 1834, the Société française d'archéologie was founded, immediately publishing *Bulletin monumental* and working to preserve medieval monuments. And Jean-François-Auguste de Bastard d'Estang began to publish a comprehensive series of facsimiles of manuscript illumination (largely medieval) in 1835. While he never completed this project, a fuller study of book painting did appear not too long after by Ferdinand Denis, one that drew attention to the importance of the twelfth century in the history of manuscript illumination (1857).[16]

In Britain, the working out of crucial terminology continued. Thomas Rickman's *English Architecture* of 1817 established the widespread use of such terms as Norman, Decorated, and Perpendicular. The origins of the term "Romanesque" are more complex but, in short, the word was first used in the sense we employ today by William Gunn by 1813 in his *Origin and Influence of Gothic Architecture*, which, however, was published only in 1819. The French *romane* appeared at almost exactly the same time, apparently under British influence, in the correspondence of Charles de Gerville of 1818; the use of the

term being propagated in France by de Caumont through a public lecture of 1823 (published 1824).[17] In each case, the word was meant to associate Romanesque architecture with "legitimizing" Roman architectural precedents. It was also around this time that the adjective "medieval" (or "mediæval") first appeared in English (1827) – some time before the definitive use of *renaissance* by Jules Michelet in 1855 (though the latter is found in a looser sense earlier).

It was, however, in Germany that the most profound changes were taking place in the early and mid-nineteenth century. There were, at this time, two leading approaches to the study of art.[18] The first was historically based. Art history had long been used as a vehicle of patronal, regional, and national identity, and would continue to be in varying degrees. But with the French Revolution, historicism began to be seen as a means of a broader cultural understanding, though often in very different ways – something that allowed art history to break free of earlier paradigms. The great historical theorist at this time was Georg Wilhelm Friedrich Hegel, who saw change (including artistic change and its resultant form) as the progressive development of an informing spirit (*Zeitgeist*) throughout history. According to Hegel's idealist view, the process of historical change is a dialectical one: a given thesis (or historical factor) is confronted by its antithesis (or opposing historical factor), resulting in a synthesis – which then becomes the thesis of a new process of dialectical synthesis. On a broader historical level, artistic change, in particular, takes place through three ages (the Symbolic, Classic, and Romantic), each of which has three phases of development (youth, maturity, and decline). In this very complex and detailed theory, Gothic architecture represents the highest phase of architectural development; and both the medieval and the Renaissance periods are seen as belonging to the Romantic age, because they are both concerned with human rationality and emotion. The second leading approach of the time turned to the artwork's more immediate examination through connoisseurship, especially for reasons of attribution and the judgment of quality. Both of these approaches, and every possible combination of them, form the basis of the best contemporary work.

Perhaps the most influential art historians at this time – the time when art history began to be integrated into the university curriculum and chairs in art history began to be established (the first, according to some, was Johann Fiorillo, at Göttingen, 1813) – were the members of the so-called Berlin School. Gustav Friedrich Waagen, director of the Altes Museum and professor at the University of Berlin (sometimes said to be the first chair, 1844), wrote an important monograph on Hubert and Jan van Eyck in 1822 that was based on both connoisseurship and historical documentation, and that contains a study of medieval painting from the Carolingian period up to the Northern Renaissance, with the latter now being put forth as a synthesis of the medieval and Classical traditions and as the basis of the modern artistic conception.[19] Karl Friedrich von Rumohr, considered to be the founder of art historical archival research, wrote on Italian medieval art in a more general study of Italian art (1827–31) that set new standards for objectivity through a critical connoisseurship. In this work, he

expressed his strong opposition to both the Hegelian view and the more tend-entious approaches of the Romanticists, who, by mid-century, were widely beginning to be seen as too subjective. Franz Kugler saw medieval art as equal to Classical art and superior to Renaissance – a view he expressed in the first world art historical survey, an important, technically oriented survey that ex-tended from prehistoric to contemporary, including pre-Columbian, Asian, and Oceanic (1842). In contrast was Karl Schnaase's survey of the following year, one that ran through medieval and was more philosophically based (1843–64). Strongly Hegelian, this work was known and criticized for beginning each chap-ter with a general historical introduction, rather than having this material inform the discussion of individual artworks. Here, also, only Classical and medieval art were said to have attained the highest spiritual expression, the dialectical synthesis of which was contemporary European art.[20]

Outside of the Berlin School, Anton Springer rejected both Romantic and Hegelian approaches (esp. 1857, 1879). Critical of studies that he felt actually separated art from its historical context through the use of generalized historical introductions, he sought to integrate the formal analysis of art with its specific historical conditions.[21] He also advocated the employment of iconography in the art historical endeavor, and was perhaps the first to note the survival of Classical traditions in medieval art. One of the most influential art historians of the nineteenth century was the Swiss scholar Jacob Burckhardt, a student of Kugler (and Leopold von Ranke). Burckhardt, also a historian, worked on medieval early in his career, but his most significant work is on the art of the Italian Renais-sance (esp. 1860, 1867). In this, he employed historical and cultural (including philosophical and religious) contexts to a degree not seen before, emphasizing the importance of the secular dynamic in Italian Renaissance culture and paying greater attention to individual artworks. Despite his enormously successful syn-thesis of the period, Burckhardt saw his work as "problem solving." Considering himself to be pragmatic rather than theoretical, he was primarily interested in concepts, rejecting both Hegelian idealism and the straightforward accumula-tion of facts.[22] Burckhardt is generally considered to have struck a middle ground between the broad theoretical views of history and the narrower approach of connoisseurship.

Another theory of history that came out of German-speaking culture in this period that was to have an impact on the study of art – though only within limits and only after some time – was that put forth by Karl Marx. Influenced by Hegel's dialectic but rejecting *Zeitgeist* as a motivating force, Marx saw an inevitable progress of social change in history through a dialectical process of class struggle. He conceived of society as composed of base (economic factors) and superstructure (religion, philosophy, law, art, etc.), with the base determin-ing the superstructure. Marx argued that the elements of the superstructure, including art, tend to advance the ideological system of which they are a part, whether directly or indirectly, consciously or unconsciously (esp. 1848, 1867; most of Marx's writings on art have been lost). While strict Marxist thought has

not had a major impact on medieval art history, it has been important because of the impetus it has given to a more generalized social history of art, one that attempts to explain art through its social context without a dogmatic emphasis on class struggle.

In mid-nineteenth-century France, meanwhile, efforts were being made in different directions. If Gothic had been a term of abuse in the centuries following Vasari, now Britain, Germany, and France all wanted to claim it as their own. Gradually, the French origins and the nature of Gothic began to be articulated – a process that was not worked out by the French alone. In 1843, the German architect Franz Mertens identified the origins of Gothic, as we understand it today, in St Denis (*c*.1135–44). Around the same time, important analyses of Gothic structural dynamics were being given by the German Johannes Wetter (1835) and the Cambridge professor Robert Willis, the latter also writing many important studies of the English cathedrals, particularly Canterbury (1845). And, in 1842, the French scholar de Caumont gave an influential expression of the so-called French schools in his *Abécédaire ou rudiment d'archéologie*. These and other studies like them provided the beginning of a much needed structural, geographical, chronological, and conceptual foundation upon which to build a fuller understanding of medieval architecture – a better distinction between Gothic and what had come before, as well as an informed beginning of an architectural chronology of Gothic.

But certainly the most brilliant figure in France at this time in medieval archaeology – as medieval art history was called by the French – was the architect and scholar, Eugène-Emmanuel Viollet-le-Duc. Among his many influential writings are the *Dictionnaire raisonné de l'architecture* (1854–68) and *Entretiens sur l'architecture* (1863–72), two works that give full expressions of Romanesque and Gothic structure, function, and design. These writings are best known for Viollet-le-Duc's theory of the rationality of Gothic architecture, a theory that would be debated far into the twentieth century, particularly the question of the structural versus the aesthetic function of the ribbed groin vault. Also, like Hugo, Viollet-le-Duc saw the sculpture of the Gothic cathedral as providing a field for not just artistic freedom, but even "a kind of freedom of the press" (using Hugo's phrase). His written work was, in general, extremely well received. However, he was deeply involved in the restoration of many of the greatest Romanesque and Gothic churches that was then being undertaken in France; and his belief that restoration meant the restoration of a building as he considered it to have existed at a particular moment in history – not as it stood at the time of restoration – met with a far less popular reaction.

Equally as influential, though far less controversial, Adolphe-Napoléon Didron, considered the founder of a systematically researched iconographical method, produced the ground-breaking *Iconographie chrétienne* (1843), as well as a number of other works and initiatives, including the *Annales archéologiques* (1844f.). Taking up Hugo's idea of the cathedral as a book for the illiterate, he tried to show in his unfinished iconographic study that the basis of the sculptural program

of Chartres Cathedral was Vincent of Beauvais's *Speculum Maius* (1247–59). Didron's iconographic method brought a far broader outlook to art historical research, leading to a deeper investigation of the literature related to theology, scripture, and natural science than had ever been the case before. Interest in iconography stimulated work on stained glass, the serious study of which began at this time and was second only to architecture.[23] The investigation of manuscript illumination also increased dramatically, both because of iconographic interests and because of the belief that manuscript illuminations had served as models for medieval monumental sculpture. It is not often realized today just how thoroughly the iconographical meaning of even very prominent images had been forgotten; for example, no less a figure than Alexandre Lenoir could describe the kings of the Jesse window of St Denis as a series of images of God the Father (among other striking misidentifications). What structure was becoming to architecture, iconography was becoming to the visual arts, allowing the study of the art of the "renaissance of the Middle Ages" (Didron) to extend further and deeper than the old limits of antiquarianism.

The Later Nineteenth and Early Twentieth Century

Didron's efforts were brought to fruition in Emile Mâle's great iconographic work of 1898, *L'Art religieux du XIIIe siècle*, described as the first comprehensive study of medieval French visual art and as the culmination of nineteenth-century scholarship on the subject.[24] Explicitly following in the footsteps of Hugo and Didron, Mâle attempted to show that the same encyclopedic program that informed Vincent of Beauvais's *Speculum Maius* also informed the sculptural programs of the Gothic cathedrals. He did, however, challenge Hugo and Viollet-le-Duc on the idea that elements of the great Gothic sculptural programs were the result of the imagination of the artist, free of Church control, something Mâle admitted only for "purely decorative work." This was a book of enormous impact and an important step in deepening our understanding of the interpenetration of the literary and artistic cultures of the Middle Ages. In this study, Mâle expressed an attitude that was common for most of the nineteenth century: that it was only with thirteenth-century Gothic that medieval art attained its highpoint, or, as an earlier generation might have said, even respectability.

However, beginning with de Gerville – and greatly developed with the work of de Caumont and Mérimée's *Commission des monuments historiques* – the Romanesque art of France began to be seriously catalogued and studied.[25] This effort was continued enthusiastically in the research of many scholars, of whom only a few can be mentioned here. Louis Courajod's lectures of 1887 to 1894 at the Ecole du Louvre (posthumous 1899–1903) emphasized the Gallic component over the Roman in the development of Romanesque in unabashedly nationalistic terms.[26] Eugène Lefèvre-Pontalis helped establish a chronology of

Romanesque architecture (esp. 1899). With a nationalism consonant with the colonialism of the Third Republic, Camille Enlart strove to show that Romanesque architecture originated in France and was disseminated from there, including to the Crusader states (1902–27).[27] André Michel oversaw the production of a collaborative survey from the Early Christian to the modern era, giving full attention to all periods of medieval and contributing to a wider popular recognition of pre-Gothic medieval (1905–29). Robert de Lasteyrie, among many others, played an important part in the ongoing discussion of the French regional schools of architecture (esp. 1912).[28] The influence of the new abstract movements of painting provided a contemporary intellectual and artistic justification of medieval abstraction, and, in a work on the Romanesque sculpture of Burgundy (not yet a popular subject), Victor Terret went so far in accepting the abstract basis of Romanesque art as to condemn the previous rejection of the style's lack of naturalism (1914).[29] In fact, such a change had come about that, in 1901, Emile Molinier, curator of the Département des objets d'art at the Louvre, could describe the twelfth century as superior to the "sterile" thirteenth. And Courajod could declare, "Nous sommes tous des barbares"[30] – quite a change from Vasari's "Goths" and Montalembert's "Vandals." To this came Mâle's *L'Art religieux du XIIe siècle en France* in 1922. If his book on the thirteenth century was the culmination of nineteenth-century medieval art historical scholarship, this one looked forward to the twentieth.[31] In it, Mâle masterfully rehabilitated Romanesque visual art as the art of a great period, a subject that retains the interest of scholars to the present day. The themes he wove throughout his text included monasticism, the pilgrimage, the cult of saints, various aspects of the liturgy, and the question of Eastern influence. He concluded with a still important discussion of Suger and St Denis, and the role of all this in the making of the art of the thirteenth century.

None of this went unchallenged, either from inside or outside France. The distinguished German art historian Wilhelm Vöge – with whom Erwin Panofsky wrote his doctoral dissertation – rejected the prevailing French view that monumental sculpture arose at Chartres, arguing instead for origins in Burgundy and Languedoc, particularly Provence (1894).[32] The American Arthur Kingsley Porter disputed French proprietary claims to the origins of Romanesque architecture (which was generally seen by French scholars of this time as arising in northern France) and to the predominant role of the so-called schools. In a series of important publications (esp. 1915–17) he demonstrated the priority of the architecture of Lombardy, Spain, and Southern France, a position in which he was joined by Josep Puig y Cadafalch, who gave to this architecture the term "First Romanesque" (1928). In his *Romanesque Sculpture of the Pilgrimage Roads* (1923), Porter argued that the vehicle for this cultural transmission was not the French "schools" but the intellectual traffic of the pilgrimage roads aided by the interests of monasticism.[33] He offered a radical new dating of certain key works of sculpture, characteristically based on documentary evidence and stylistic analysis (rather than simply fitting the works into the current French

theoretical constructs of stylistic development), and giving precedence to Spain and Burgundy over Languedoc, contrary to the mainstream French position, including that of Mâle (the "Spain or Toulouse" controversy).[34]

More radical still were the theoretical developments that were taking place in the German-speaking countries, in general, and in Vienna, in particular. The interest in the historical and cultural context of art as exemplified in Burckhardt's work found its counterpart in two major trends. The first was a more rigorously conceived version of traditional connoisseurship, the self-proclaimed "scientific" method of Giovanni Morelli, a French-Italian of largely German-Swiss and German education, who, even in 1890, described the irreconcilable differences between connoisseurs and art historians as of very long standing. After spending most of his life either studying medicine or in politics, Morelli began to apply the methods of comparative anatomy that he had learned in medicine in Germany and France (and the arrogance he apparently had learned in politics in Italy) to the study of art, achieving phenomenal success in the attribution of artworks. His method consisted of the minute analysis of figurally complex but otherwise often insignificant elements of a composition such as ears, hands, and drapery folds whose depiction, he claimed, were unique to a given artist and so acted to identify the artist. (Bernard Berenson, who did at least some work in medieval and late Roman, was, perhaps, Morelli's best-known disciple.) A revitalized connoisseurship, whether following Morelli's method or not, had a strong base in the thriving sphere of the museums, its natural home today. The second trend was based on the theorization of artistic form. This was given an important impetus by Konrad Fiedler, who was strongly opposed to historicism and who postulated that artistic form is autonomous, independent of its historical context, and that it comprises an ordering of experience on a level equal to that of language (esp. 1887).

Franz Wickhoff, sometimes described as the founder of the Vienna School of art history, could be said to have been strongly influenced by both trends. Wickhoff combined the study of form and Morellian connoisseurship – which he saw as a means of creating a "scientific" basis for the study of art – with cultural and intellectual history in his desire to demonstrate uniform principles of artistic development for all periods.[35] More particularly, he legitimized the study of Roman art, which had been discredited since Winckelmann, seeing it as a discrete period with its own artistic methods and goals. This he achieved largely through his famous study of the Vienna Genesis (1895, with Wilhelm von Hartel), a work that integrated the terms "illusionism" and "continuous narrative" into the art historical vocabulary. Wickhoff's colleague, Alois Riegl, was also concerned with articulating universal artistic laws (esp. 1893, 1901). He explicitly rejected the old cyclical theories of perfection and decline – which contemporary abstract art had helped undermine – seeing instead a Hegelian *Kunstwollen* at operation (an artistic urge, whether of a culture or of an individual), an extremely well-known concept that, however, has not been taken up by the discipline. The primary vehicle through which Riegl explained this new

theory of artistic change was his idea of the progression from the haptic to the optic, an idea based on contemporary perceptual psychology.[36] A relatively complex theory that applies to all media, it might be briefly described in terms of the medium of sculptural relief as the development of a given form from relatively strongly outlined, linear, and flat figures isolated in the single picture plane in Egyptian art to relatively well modeled, three-dimensional figures integrated into multiplanar illusionistic space in early Imperial Roman. Riegl stressed that no period is inherently superior to another, emphasized the continuity of the antique with the medieval, denied the distinction between the major and the minor arts, and rejected contemporary attempts to model art historical methodology and theory on the sciences. While much of what he wrote was formulated in response to certain contemporary materialist theories (especially those of the students of Gottfried Semper, who exaggerated Semper's emphasis on the roles of function, material, and technique in artistic creation), he also directed some of his later writings against Josef Strzygowski, who replaced Wickhoff at the University of Vienna and with whom Riegl clashed as well.

Rather than see continuity between the Antique and the medieval, Strzygowski saw certain elements of the great artistic changes of Late Roman and early medieval as the result of the introduction of Eastern influences, especially from Syria, Armenia, and Iran (a subject that would later interest Jurgis Baltrušaitis, a student of Henri Focillon). The exchange has come to be known as the "*Orient oder Rom?*" controversy, one of the key debates of turn-of-the-century medieval art history. It is now generally accepted that while the change took place from within late Roman culture – and while there were some Eastern influences – other internal factors not identified by Riegl were operative, such as popular culture. (Toward the end of Strzygowski's highly successful career, as the Nazis rose to power, his original ethnic interests began to take on racist overtones.) Other Vienna School medievalists also made important contributions to the field. Max Dvořák once said that a sense of history was something a person was born with, that it could not be taught,[37] and in this he may be right. Originally close to Riegl in his theoretical position, a study of Goya's *Disasters of War* during World War I led Dvořák away from Riegl's one-sided emphasis on a virtually autonomous evolution of form to make the relation between style and the Christian world-view the driving force of his medieval work, especially as seen in his major medieval study, *Idealismus und Naturalismus in der gotischen Skulptur und Malerei* (1917).[38] Seeing the interrelation of all aspects of culture – theology, patristics, philosophy, literature – Dvořák felt that it was necessary to critically study all of these aspects, ultimately seeing *Kunstgeschichte als Geistesgeschichte* (the history of art as the history of ideas, the title of his last book). This approach, as obvious as it may seem to many today, was in strong contrast at the time to most previous scholarship, which, with some exceptions, typically came from the strong anti-clerical tradition of post-Enlightenment and post-Revolutionary Europe. Finally, Julius von Schlosser, another distinguished member of the Vienna School, should be mentioned,

being particularly well known for his *Die Kunstliteratur* (1924), an important discussion of art historiography from the medieval period through the eighteenth century.[39]

Outside of the Vienna School and even of medieval, Heinrich Wölfflin, the Swiss contemporary of Wickhoff and Riegl, did important work that had reverberations in the field of medieval. Wölfflin wanted an "objective," "scientifically" based art history, one whose goal is the explanation of artistic change through the art object, a purely visual concern with little reference to historical or cultural context. Continuing in the path of Fiedler, his was a history of the autonomous evolution of pure form, influenced by recent work in psychology, an "art history without names." His best-known articulation of this is his theory of the development of form using a number of dichotomies to express change, such as the progression from the linear to the painterly, from planarity to depth, and so on; a progression he saw in the context of a non-biological and non-qualitative cycle of "early, classic, and baroque" phases for each Western period style (esp. 1898, 1915). Though his principles are no longer employed in the sense that he originally espoused, the influence of Wölfflin, perhaps more than any of the other grand theorists of his time, does live on in the institutionalization of the practice of looking and describing as the explicit first stages in art historical study, and in the ubiquitous use of juxtaposed images in classes and lectures, for which he is generally believed to be the source. Theories claiming universal validity, however, were hardly universally accepted by contemporaries. It was against such theories that Georg Dehio – the influential author of the widely used *Die kirchliche Baukunst des Abendlandes* (1884–1901) – railed as "the cold, clinical concepts in art history, which only an unfeeling dilettante could adopt with any confidence."[40]

Equally influential in his time was Henri Focillon, a scholar who worked in a number of fields but who is best known for his studies of Romanesque sculpture (esp. 1931, 1938). Focillon's work was in strong reaction to the currently popular iconographic and contextual study of art, despite the fact that he was the immediate successor of Mâle at the Sorbonne. In contrast, he was interested in finding basic rules governing the nature and development of form (esp. 1934, 1943). He did this in a way that was at times related to Riegl and Wölfflin, expressing himself in a variation of the developmental model of initial formation, perfection, and decline – calling them experimental, classic, and baroque – although he explicitly rejected any basis in Hegelian thought, which was increasingly losing prominence at this time.[41] In the process, Focillon articulated the basic relation between Romanesque sculpture and architecture (medieval architectural sculpture, in particular, had been seen earlier as contrary to general classicizing principles), broadly established a new level of aesthetic acceptance for Romanesque sculpture (which had been low), and gave a new legitimacy to the art of the eleventh century (in distinction to Mâle's twelfth). His work had an especially great impact in the United States, where he taught from just before the war until his death in 1943.

Even more widely received were the methods of Focillon's contemporary, Adolph Goldschmidt. Like so many before him, Goldschmidt wanted an objective, "scientific" approach to the artwork, one that, to one degree or another, borrowed from and could claim to be the equal of the scientific methods of the time. And, like others (especially Dehio), Goldschmidt was concerned with establishing the documentary evidence of his subject. He did this by combining unusually precise stylistic analysis (as opposed to the formal analysis of Wölfflin), iconographical investigation, and comparison with other artworks to group, localize, date, and relate large bodies of works that had never been systematically studied before. This was an approach that both revealed and allowed the study of the interrelation of the "major" and "minor" arts. Toward this end, Goldschmidt undertook work of lasting importance particularly on Carolingian, Ottonian, Romanesque, and Byzantine ivories (writing several distinguished corpora that showed the interaction between East and West; 1918, 1930–4), Carolingian and Ottonian illuminated manuscripts (1928), German Romanesque bronze doors, and German Romanesque and Gothic sculpture. Believing that art historical study begins with the individual artwork, he preferred practice to theory. Because of the wide reception of his methodology, of his role as perhaps the first major art historian in Germany who was primarily concerned with the Romanesque and Gothic periods, and of the almost one hundred dissertations completed under his direction, Goldschmidt was of great importance in the development of medieval art history in Germany and the United States, where he taught as a visiting professor on three different occasions.[42]

The Twentieth Century

As influential as Goldschmidt was – and he was very influential – perhaps Germany's greatest contribution to art history, including medieval, was the iconological method originating from Aby Warburg and those associated with him. Warburg, who was strongly influenced by Burckhardt's cultural history of art, first applied the term "iconology" to his method in 1912. Though not a medievalist, he set before the discipline a new approach to the study of art, one that went beyond either stylistic analysis or iconography and that fundamentally ran counter to the theories of Riegl and Wölfflin on the autonomous development of artistic form. In the field of art history properly speaking, Warburg did important work on the meaning of antique survivals in Renaissance art. He was, however, a scholar of enormous breadth, with very diverse interests that included religion, magic, philosophy, cosmology, astrology, science, literature, psychology, and memory, among others. He believed that art can only be understood in its broad historical and cultural contexts, and toward this end incorporated all branches of learning and all forms of visual representation – as well as the patron and the patron's general goals – in his radical vision of an interdisciplinary cultural history of art.

Warburg was a man of independent wealth and enormous enthusiasm for his subject, both of which enabled him to establish first a library and then a research institute in Hamburg, the Bibliothek Warburg, which opened to the public in 1926, shortly before his death in 1929. In 1933, the scholars of the Bibliothek Warburg, under the direction of Fritz Saxl (who did important work on medieval astrological manuscripts), were forced to flee the waking nightmare of National Socialism with their library, and, like so many others, found refuge in England. Here, re-established as the Warburg Institute, they soon began to publish their distinguished journal (1937). They were joined in this publication effort a few years later (1939) by the Courtauld Institute, which was founded in 1932 and which eventually took up residence in the (new) Somerset House, the site of the death of Cromwell and the former quarters of the Royal Society of Antiquaries. More than any other approach to the study of art from this period of vital intellectual experimentation, the cultural history of art as conceived of by Aby Warburg – his interdisciplinary blend of iconography and iconology – retained its influence, if not its form, over the years.

One of the reasons, only one, that Warburg's method became so strongly integrated into the historiographical tradition of art history was that it was taken up and refined by a man considered by many to be the most brilliant art historian in the history of the discipline, Erwin Panofsky. Panofsky wrote on art theory, the Italian Renaissance, and the Northern Renaissance, as well as medieval. He was not a student of Warburg's, but he met and was influenced by Warburg at the Bibliothek Warburg when Panofsky held the first professorship in art history at the University of Hamburg (which continues the tradition of distinction to this day). Panofsky took Warburg's method further and theorized it, in this way both demonstrating its applicability and broadening its appeal. As differentiated in his famous *Studies in Iconology* (1939), there are three levels of visual interpretation. Though more complex than explained here, pre-iconographical description deals with a relatively direct reading of the artistic motifs of an image; this was characterized by Panofsky as a history of style. Iconography is the study of the themes or concepts of imagery as conveyed through the literary and visual traditions; this is a history of types. Iconology is the "intrinsic" meaning or content related to the "symbolical" values, that which was the impetus to the selection of the iconography and which is understood by determining the "underlying principles of a nation, a period, a class, a religious or philosophical persuasion . . . which are generally unknown to the artist himself and may even emphatically differ from what he consciously intended to express"; this is a history of "cultural symptoms – or 'symbols.'"[43] Employing all branches of learning, as in Warburg's method, this is very much a cultural history of art, but it is not one that attempted to interpret specific artworks in light of their more immediate social and political contexts. As it pertains to medieval, this approach is most effectively seen in Panofsky's discussion of medieval renascences in *Renaissance and Renascences* (1960), a study that transcended not just the fields of Renaissance and medieval but the discipline

of art history itself. Less successful was his *Gothic Architecture and Scholasticism* (1951), which attempted to explain the subdivision, division, and totality of the physical structure of the Gothic cathedral as a display of "visual logic," the result of the same mentality that brought about the intellectual structure of the Gothic *summa* – a theory that has not received broad acceptance. Though certain points of his *Abbot Suger* (1946) have also long been questioned in Europe – and increasingly so in the United States – it is nevertheless one of the seminal books of medieval art history of the twentieth century, his discussion of the relation of Pseudo-Dionysian mysticism and the art program of St Denis still being one of the central issues in medieval art history today.[44]

Panofsky was enormously influential in the United States in no small part because of his presence in America for 35 years, after having been forced to flee Germany in 1933. This period, before and after World War II, was an extremely active one for medieval art history, and Panofsky was, tragically, joined in his flight by a large number of distinguished art historians, many of them medievalists, scholars who had an important effect on art history in the US. It is impossible to present the scholarship of either these individuals or those others who continued to work in their home countries in this present paper, authors whose names and significance will be covered in greater detail in the chapters of this volume.[45] But let me mention one last scholar, known equally well for his work in medieval as in modern, Meyer Schapiro.

One of the most influential art historians of his time, Schapiro managed to address contemporary interests in form, style, and artistic change in a truly fundamental way, one that had no need to resort to theories of autonomous laws of art. He did this by accepting many of the techniques used by previous historians of form and style while rejecting the universalizing claims of their theories. At the same time, he followed the practice of the members of the Vienna School and others of employing methods from outside art history proper, especially psychology, although he strongly cautioned against excess in this general practice. Perhaps most persuasively for many, he was instrumental in introducing the approach of social art history to the art of the Middle Ages, even if he himself followed it only inconsistently. For the purposes of this introduction, this process shows up most clearly in his studies of the French monastery of Moissac and the Spanish monastery of Silos, both of which present penetrating examinations of Romanesque style. In 1931, Schapiro attempted to explain the sculpture of Moissac not as a point in an autonomous development of form or as a complex of iconographical puzzles to be deciphered, but as an art whose principle of abstraction was as intentional as that of the art of Schapiro's own time. But he was not concerned with the dynamics of this purposeful abstraction alone, emphasizing as well – on a level of sophistication that had not been seen before – a realism that he saw emerging from this abstraction, and that he saw as in opposition to it. In 1939, however, in his famous study of the art of Silos, he took his exploration of style further, no longer limiting himself to the visual component of style alone. Introducing a more contextually explicit

approach than the excellent, though typically more general, cultural history of Warburgian iconology, he explained two competing styles – one indigenous (Mozarabic) and the other foreign (Romanesque) – as the result of competing ideologies within the same institution in this period of fundamental political and social change in Northern Spain. In the process, he provided a historical basis to an emerging realism, seeing it as a manifestation of artistic freedom attributable to the rising bourgeoisie in the face of the traditional Church establishment; at the same time, he also attempted to counter the dominant view that art production was entirely subject to Church control. His reading is shaped by Marxist theory, though not in the sense of simplistic or forced theories of class struggle. However, by the time of his article on the aesthetic attitude in Romanesque art (1947), his arguments for a culture of artistic freedom were now largely based on testimony that came from the same establishment Church that he had earlier seen as fundamentally opposed to such freedom.[46] Schapiro's Marxist art history was short-lived and his themes of the freedom of the artist, the interaction of styles, and psychology had all been broached before. But it was all used to such effect – even if many of the individual arguments have been shown to be incorrect – that his work still commands enormous respect today and is seen both as a model of formal and stylistic analysis and as a crucial stage in the development of a social history of art.

Finally, the period from the beginning of the Vienna School to around 1968 (the date usually given as marking, in however symbolic a way, the great changes that took place in Western culture in the years following World War II) or a bit later was also an important one in the continued development of the art historical infrastructure, without which the discipline would not have developed in the way that it has. In 1873, the first International Congress of the History of Art of the Comité international d'histoire de l'art (CIHA) was held in Vienna. Other national and international organizations followed, as did a number of journals. Let me cite only a few, aside from those already mentioned: the Deutsche Verein für Kunstwissenschaft in 1908; the College Art Association in 1911, the first professional organization of academic art historians (*Art Bulletin* really was a bulletin when it first began in 1913; scholarly articles appeared only in 1917); the Medieval Academy of America in 1925 (*Speculum*, 1926); the *Zeitschrift für Kunstgeschichte* in 1932; the Verband Deutscher Kunsthistoriker in 1948; the Centre d'études supérieures de civilisation médiévale in Poitiers in 1953 (*Cahiers de civilisation médiévale*, 1958); the International Center of Medieval Art in 1956 (originally the International Center of Romanesque Art; *Gesta*, 1963/1964); the (British) Association of Art Historians in 1974 (*Art History*, 1978); and *Arte medievale* in 1983. The development of university art history departments and university presses is a story in itself.[47] Important research guides, such as periodical indices, were established: the *Répertoire d'art et d'archéologie* (1910–89) and the *International Repertory of the Literature of Art* (*RILA*, 1975–89) merged in 1991 to form the *Bibliography of the History of Art* (*BHA*, covering from 1973). Efforts in the area of iconography continued: the Index of Christian

Art was founded at Princeton University in 1917 through the efforts of Charles Rufus Morey, primarily a scholar of Early Christian art; and other important iconographical aids were produced by Karl Künstle (1926–8), Louis Réau (1955–9), Gertrud Schiller (1966–80), and Engelbert Kirschbaum (1968–76). Indispensable reference works appeared: *The Catholic Encyclopedia* (1907f.), Fernand Cabrol and Henri Leclercq's *Dictionnaire d'archéologie chrétienne et de liturgie* (1907–53), *The Oxford Dictionary of the Christian Church* (first edn. 1957; word for word, the best medieval reference work available), the *Encyclopedia of World Art* (1959), *The New Catholic Encyclopedia* (1967), and *The Dictionary of Art* (Grove, 1996), to name only a few. Many distinguished catalogues appeared and continue to appear (of which I will mention only two series, *A Survey of Manuscripts Illuminated in the British Isles*, 1975f. and *Manuscrits enluminés de la Bibliothèque nationale*, 1980f.), as well as corpora (most notably the *Corpus Vitrearum* series, 1952f.[48]). New editions of sources, also, continue to be published (*Corpus Christianorum*, 1953f., being only the most prominent), as do many translation series.

With the great changes that began to emerge in the 1960s, changes that affected almost every aspect of Western culture, came an increasingly complex environment for medieval art history. There were many reasons for these far-reaching changes. But as they apply to art history – which was especially affected by them in the 1970s and throughout the 1980s – one of the initial causes may be said to be the relativism that has for so long been a central factor in Western thought. Although a recognition of the impossibility of achieving an objective historical reality appeared already with Herodotus – the "Father of History," considered to have written the first comprehensive, more or less critical history in the West – an increasing appreciation of this issue had a particularly destabilizing effect on art history at this time. The claim of a universal standard for Classical art that had been so taken for granted from the first history of Western art by Xenocrates to at least the late nineteenth century was now seen as thoroughly invalidated, as was that of a "scientific" basis to so many late nineteenth- and early twentieth-century theories of art. Not only did the universal theories of the leading scholars of earlier generations seem hopelessly antiquated, but the basic necessity of continuing to identify, document, and classify the vast body of artistic remains from the past seemed lacking to some as the primary mission of art history. And while most of the great theorists of the earlier generations would never have insisted that a given approach was the only way, a reaction set in to what seemed to some to be attempts to put forth a single way of viewing and interpreting art. A new art history that was socially relevant and intellectually current was being called for, and the discipline seemed to be in a crisis.

While the "new art history" would have been quite impossible without the gains of the "old" – the indispensable work on authentication, localization, dating, periodization, style, attributions, biography, and so on – the "new" has revitalized the field and opened up new areas of research by asking new questions. This has come about through the adoption of interdisciplinary methodologies

that have transformed other areas of the humanities and social sciences, typically described under such designations as literary criticism, structuralism, deconstruction, post-structuralism, linguistic theory, semiotics, reception theory, narratology, psychology, psychoanalysis, cultural studies, post-colonialism, feminism, the new historicism, Marxism, and social art history. What these new methodologies all have in common is that they have often redirected attention from very circumscribed approaches regarding questions of style, form, dating, the œuvre of the artist, biography, and so on to broader concerns of the function of the artwork in its historical context – economic, social, cultural, ideological, gender, perceptual concerns – while reading the artwork as an active agent in the construction of that context.

However, these new "theories," as they are sometimes called, are not always compatible, with one stating that the meaning of an artwork is constructed by the viewer (not the artist), another that the original meaning is unknowable, another still that meaning is found only deeply beneath the surface of the subject, and still another that the meaning of a given artwork is based in a generally recoverable historical reality even if formed by a complex and variable dynamic of economic, social, and political conditions. Structuralism, for example, looks beneath surface content at social relationships in terms of an abstract system of signs, whose meaning lies in the relationships between these signs. Deconstruction, in contrast, analyzes the text, or in the case of artworks, the "text," in terms of binary oppositions, revealing a number of contradictory meanings that subvert the hierarchy that is the basis of the oppositions, ultimately hoping to show that there is no single authoritative reading of a given text (or "text"). And Marxism and social art history in general (which are not new at all, although they are usually associated with these other methodologies as part of the "new art history") find very specific meanings in texts and images, though they typically see those texts and images in relation to contemporary ideologies.

Most of these new theories originated in the study of modern or contemporary culture, and, generally speaking, they were first introduced into the discipline of art history through those same fields of modern and contemporary. Whether because the medieval field already had a tradition of image theory and exegetical interpretation[49] or because some of the new theories are so strongly based in modern (as opposed to medieval) modes of thought, medieval has taken up some methodologies more quickly than it has others.[50] These new approaches have resonated, in particular, in the areas of vision, reception, narratology, and gender.[51] Other areas might be said to be affected in a significant, if relatively indirect, way by post-colonial theory.[52]

New issues have also arisen, sometimes as a result of the new environment of interdisciplinarity, sometimes as a development of earlier issues that were never worked out, such as patronage and collecting, which, at times, may now investigate the relation between art and society with regard to a wide range of social and political issues beyond the immediate identification of a given patron or pieces of a collection.[53]

But none of this means that proven methodologies have simply been cast aside – *non omnia grandior aetas, quae fugiamus, habet*, "Not everything old age has is to be spurned," as Dugdale so boldly stated (see fig. 1-3).[54] Good, often excellent, work continues on stylistic analysis, attribution, dating, biography, and iconography, whether as discrete topics or as part of broader studies. At the same time, subjects and issues that have been of interest to medieval art historians for generations continue to be of interest, although, now, they are often informed by the so-called new theories in such a way that they would not be characterized as overtly dependent on these theories. The study of Romanesque architecture may address questions of economics, that of Romanesque sculpture may ask questions about the subjectivity of the viewer of an artwork, and that of Romanesque manuscript illumination may take up feminist issues.[55] Work on Gothic architecture may reflect the new interests in the function of the artwork in its historical and social contexts, Gothic manuscript illumination may be concerned with the reception of the image, and stained glass may employ narratology.[56] This is true for all the areas of architecture, sculpture, painting, stained glass, and the sumptuous arts.[57] Some subjects that were of concern in the past have now become virtually distinct areas of research, including architectural layout, sculptural programs, *spolia*, the monstrous, and the marginal.[58] While important monographic studies continue to appear, specific groups of artworks – sometimes institutionally based, sometimes thematically – have taken on a new interest, such as the art of the Cistercian Order, the illustration of saints' lives, and the art of the pilgrimage.[59] The primary sources continue to be given attention. And the interest in medieval has extended into the modern period in the study by medievalists of medieval revival movements and the modern medieval museum.[60] Of all the recent changes, perhaps the most conspicuous is the increasingly wide and deep acceptance of one form or another of social art history. This interest in the social function of art has been on every point of the spectrum – typically not Marxist, although usually with a more specific focus than Burckhardt's cultural history or Panofsky's iconology. Its subjects may range from specific social interactions to broad social control to the particular spirituality associated with a specific social group, all of which may be seen as reinforcing the current social system, though often interpreted through different dynamics and understood in different degrees, according to the different authors. What has fallen by the wayside is an exaggerated concern with explaining medieval art through universally applicable artistic standards, cyclical theories of history, the exaltation of medieval art in the formation of national identities, studies of the artist as genius, and universal theories regarding autonomous artistic form.

Concluding Remarks

In trying to come to terms with the basic difference between Middle Eastern and Western modes of thought, T. E. Lawrence perceptively identified the

underlying characteristic of modern Western thought as relativism, describing it strikingly as, "doubt, our modern crown of thorns" (private edn. 1926, public 1935). His analysis of Middle Eastern thought would now be seen as open to question in a number of ways. But Lawrence – "Lawrence of Arabia," who wrote what today might loosely be thought of as an MA in medieval art history at Oxford in 1910[61] – was on target with his representation of relativism (which he accepted), implying that it both marks a certain level of attainment for Western culture and punishes and perhaps even mocks its bearer at the same time. Today, the multiplicity of approaches within art history, whose basic impetus has been, in large part, modern relativism, suggests to some that the discipline is in crisis. But as this historiography has shown, there has never been a time since Winckelmann – that is, since the generally accepted beginning of modern art historical studies – that art history did not seem to be in crisis. It is a commonplace that each generation conceives of itself in reaction to the previous one. Indeed, these are not crises in the sense of an uncertainty over the nature of the discipline, but the periodic tensions of re-addressing attitudes and focuses of study to correspond to current interests and perceived gaps of knowledge; such current interests, of course, not being in any way monolithic or accepted uncritically. For some, methodological positions are like a religion – there is no other way. For most, however, there has been a distinct rejection of dogmatism and a willingness to use differing methodologies according to the demands of the problem chosen, seeing methodology and theory as means to shed light on objects of study, rather than the other way around. Whatever the negative aspects of this problematic relativism may be, it has resulted in a positive multiplicity of approaches as called for, most notably, by Hans Belting in 1983, whether or not this has matched Belting's personal conception. While some of these new theories will be with us in the future and some, like the grand theories of the past, will be discarded, a multiplicity of approaches is as characteristic of the early twenty-first century as Romanticism was of the early nineteenth.

The current environment, however, is not explained so easily as simply one in which anything goes. It is not the same world it was when medieval art history began to establish itself so many years ago. Times have changed – including more than academic theories. The world-view of the educated public has also changed, and the major Western cultures that could look to the past as well as the present for national identity in the nineteenth century increasingly look only to the present and the future in the twenty-first. If, in the early nineteenth century, Hugo's popular novel could electrify the public in regard to medieval art and architecture, in the late twentieth, Umberto Eco's novel, *The Name of the Rose* (1980), elicited no such reaction. In a key incident in *The Name of the Rose*, a foreshadowing of the main events of the novel is conveyed through the experience of one of the protagonists (Adso) of viewing a medieval sculpted portal based directly on the twelfth-century south porch of Moissac

(the same one studied so remarkably by Schapiro). And, later, the introduction of one of the crucial figures (Jorge) culminates with his vehement condemnation of the potential of medieval art to distract the monk from spiritual pursuits, using the words of Bernard of Clairvaux's famous *Apologia*.[62] But, despite the popularity of this book (nine million copies sold; the basis of a major motion picture), it had no discernible effect in stimulating an appreciation or even an awareness of medieval culture on the part of the modern public. Admittedly, Eco does not provide such a gloss on medieval art and architecture as Hugo did in his chapter, "This Will Kill That" (book 5, chapter 2). Yet medieval art and architecture are a constant in *The Name of the Rose*, a key part of the narrative, even of the plot.

The real difference lies in the fundamental change of social and political dynamics since Hugo's time. Medieval culture does not relate to modern Western cultures – especially American – in the present day in the same way that it did in the nineteenth century, at a time of tumultuous formation of national identities. We, today, are no longer drawn to medieval by the Romanticism of an earlier century or by the nationalism; or by the desire to establish universal theories – the often captivating theories of previous scholars that are, generation after generation, called into question. Rather, we are drawn to the Middle Ages because the art and architecture speak to us differently from that of other times and places: the seeming contradictions of simplicity and complexity, stability and change, domination and freedom, the looking backward and the looking forward, the memory of empire and the growth of urbanism, regionalism and internationalization, superstition and the beginnings of modern thought, the differences from and the similarities to our own culture. And we are drawn by a sense of loss, the same sense of loss that motivated our predecessors, the first medievalists. Relevancy, in any field, is the same as it ever was, even if a given field cannot spearhead national movements: addressing issues of contemporary concern, asking new questions, filling in the gaps of knowledge (both newly perceived and of long standing). And here, medieval seems wide open. Having only recently emerged, with the aid of relativism, that double-edged sword, from the need to compete with the standards of Classical and Renaissance art – and the need to seek justification in modern abstract art – a new history of medieval art is now being written, one step at a time. Whether we look at art history for social relevancy or in terms of Burckhardt's "problem solving," this is an exciting time for medieval. A new critical awareness has combined with a dedication to historical research that was not always the case in the past, though there have been eminent exceptions. In many ways, the field is open as never before. The issues of the time are varied and point no less than those of the past both to the heart of medieval art history and to its future. The destruction of the medieval patrimony with the Reformation and its aftermath was a great loss for Western culture. But it is a destruction from which many a plum is still waiting to be plucked.

Notes

To Françoise Forster-Hahn, on the occasion of 40 years of distinguished scholarship, curatorship, and teaching.

My thanks to my friends and colleagues, Françoise Forster-Hahn and Steven Ostrow, for their critical reading of drafts of this chapter.

It was not possible to fully reference this chapter for reasons of space. The vast majority of the historiographical information in it, however, is common knowledge. For this, I have consulted a large number of original authors and secondary studies. The works of the original authors will be clear enough to anyone wishing to read further. Among the secondary studies, unless otherwise cited, see especially the following (referred to in the notes by author name and short title).

For general art historiographical studies: W. Eugene Kleinbauer, ed., *Modern Perspectives in Western Art History* (New York, 1971); Heinrich Dilly, *Kunstgeschichte als Institution: Studien zur Geschichte einer Disziplin* (Frankfurt, 1979); Michael Podro, *The Critical Historians of Art* (New Haven, 1982); Hans Belting, *The End of the History of Art?*, trans. Christopher S. Wood (Chicago, 1987); Gert Schiff, ed., *German Essays on Art History* (New York, 1988); Udo Kultermann, *The History of Art History* (New York, 1993); Vernon Hyde Minor, *Art History's History* (Englewood Cliffs, 1994); Eric Fernie, ed., *Art History and Its Methods: A Critical Anthology* (London, 1995); Donald Preziosi, ed., *The Art of Art History: A Critical Anthology* (Oxford, 1998); Peter Betthausen et al., eds., *Metzler kunsthistoriker Lexikon* (Stuttgart, 1999).

For specifically medieval art historiography: Paul Frankl, *The Gothic: Literary Sources and Interpretations through Eight Centuries* (Princeton, 1960); Erwin Panofsky, *Renaissance and Renascences in Western Art* (Stockholm, 1960); Wayne Dynes, "Tradition and Innovation in Medieval Art," in James Powell, ed., *Medieval Studies: An Introduction* (Syracuse, 1976), pp. 313–42; Harry Bober, "Introduction," in Emile Mâle, *Religious Art in France: The Twelfth Century, A Study of the Origins of Medieval Iconography* (Princeton, 1978), pp. v–xxi; Tina Waldeier Bizzarro, *Romanesque Architectural Criticism: A Prehistory* (Cambridge, 1992) (especially for the early historiography of England and France); W. Eugene Kleinbauer, "Introduction," in Helen Damico, ed., *Medieval Scholarship: Biographical Studies on the Formation of a Discipline*, 3 vols. (New York, 1995–2000), vol. III, pp. 215–29. A number of other more narrowly focused medieval art historiographies are cited in the notes.

The dates in parentheses in the text are normally original publication dates, not references to works cited in a bibliography; I have given these in the hope of providing a better sense of the chronological progression of the historiographical issues than might be the case with the usual birth and death dates of authors.

1 Iona and Peter Opie, eds., *Oxford Dictionary of Nursery Rhymes*, new edn. (Oxford, 1997), pp. 275–9.
2 James Gairdner, *The English Church in the Sixteenth Century* (London, 1924), pp. 419–30.
3 Theodor E. Mommsen, *Medieval and Renaissance Studies* (Ithaca, NY, 1959), pp. 106–29.

4 Paul Lehmann, "Mittelalter und Küchenlatein," *Historische Zeitschrift* 137 (1928), pp. 197–213; Nathan Edelman, "The Early Uses of *Medium Aevum, Moyen Age, Middle Ages*," *The Romanic Review* 29 (1938), pp. 3–25; *Oxford English Dictionary*, "middle age."

5 Harvey C. Mansfield, *Machiavelli's New Modes and Orders: A Study of the Discourses on Livy* (Chicago, 2001), pp. 35–41.

6 Giorgio Vasari, *Le vite de più eccellenti architetti, pittori, et scultori, Dell'Architettura* 3, ed. Gaetano Milanesi, 9 vols. (Florence, 1878–85), vol. I, pp. 137–8; trans. Frankl, in *The Gothic*, pp. 290–1. The terms "Baroque" and "Enlightenment" were also used in a pejorative sense at one time.

7 T. D. Kendrick, *British Antiquity* (London, 1950), p. 63.

8 *Oxford English Dictionary*, "gothic."

9 Margaret Aston, *England's Iconoclasts: Laws Against Images* (Oxford, 1988), p. 86.

10 Frankl, *The Gothic*, p. 352.

11 Bizzarro, *Romanesque Architectural Criticism*, p. 59.

12 Thomas Cocke, "Rediscovery of the Romanesque," in *English Art 1066–1200* (London, 1984), pp. 360–6, esp. p. 361.

13 Bizzarro, *Romanesque Architectural Criticism*, p. 47.

14 All quotations from Goethe are from John Gage, ed., *Goethe on Art* (Berkeley, 1980), pp. 103–12, esp. pp. 105, 108–9.

15 On the modern medieval art museum, see chapter 30 by Brown in this volume.

16 Walter Cahn, *Romanesque Manuscripts: The Twelfth Century*, 2 vols. (London, 1996), vol. I, pp. 28–30.

17 Bizzarro, *Romanesque Architectural Criticism*, esp. pp. 132–49.

18 Kultermann, *History of Art History*, p. 62.

19 Mitchell Schwarzer, "Origins of the Art History Survey Text," *Art Journal* 54:3 (1995), p. 25.

20 Ibid., p. 27.

21 Françoise Forster-Hahn, "Moving Apart: Practicing Art History in the Old and New Worlds," in Michael F. Zimmermann, ed., *The Art Historian: National Traditions and Institutional Practice* (Williamstown, 2003), pp. 67–77, esp. pp. 69–70.

22 Fernie, *Art History*, p. 85.

23 See chapter 21 by Pastan in this volume.

24 Bober, "Introduction," pp. v–xxi, esp. p. xi.

25 Ibid., pp. vii–xi. For the state of research on Romanesque art in France, see Marcel Durliat, "L'art roman en France (Etat des questions)," *Annuario de estudios medievales* 5 (1968), pp. 609–27.

26 Louis Grodecki, "La sculpture du XIe siècle en France: Etat des questions" (1958), reprinted in *Le Moyen Age retrouvé* (Paris, 1986), pp. 49–67, esp. p. 49.

27 See chapters 23 and 24 by Folda and Papacostas, respectively, in this volume.

28 See chapter 16 by Maxwell in this volume.

29 Bober, "Introduction," pp. ix, xix.

30 Cited by Thomas Lyman, *French Romanesque Sculpture: An Annotated Bibliography* (Boston, 1987), p. 4.

31 Bober, "Introduction," pp. xi–xii.

32 Kathryn Brush, *The Shaping of Art History: Wilhelm Vöge, Adolph Goldschmidt, and the Study of Medieval Art* (Cambridge, 1996), pp. 63–5. For the state of

research on early Gothic sculpture, see Willibald Sauerländer, "Sculpture on Early Gothic Churches: The State of Research and Open Questions," *Gesta* 9 (1970), pp. 32–48.

33 Walter Cahn and Linda Seidel, "Introduction," *Romanesque Sculpture in American Collections* (New York, 1979), pp. 1–16, esp. p. 9.

34 Linda Seidel, "Arthur Kingsley Porter," in Damico, ed., *Medieval Scholarship*, pp. 273–86. See also Seidel, "Arthur Kingsley Porter: Life, Legend and Legacy," in Craig Hugh Smyth and Peter M. Lukehart, eds., *The Early Years of Art History in the United States* (Princeton, 1993), pp. 97–110.

35 On formalism, see chapter 5 by Seidel in this volume.

36 Margaret Olin, "Alois Riegl," in Damico, ed., *Medieval Scholarship*, pp. 231–44, esp. p. 236.

37 Cited by Kultermann, *History of Art History*, p. 167.

38 Schiff, *German Essays on Art History*, pp. xlix–l.

39 On the successor to the Vienna School, the New Vienna School (particularly the medievalists Hans Sedlmayr and Otto Pächt), see the introduction by Christopher S. Wood, ed., to *The Vienna School Reader: Politics and Art Historical Method in the 1930s* (New York, 2000), pp. 9–72.

40 Cited by Kultermann, *History of Art History*, p. 138.

41 This was not without some contradiction; see Walter Cahn, "Henri Focillon," in Damico, ed., *Medieval Scholarship*, pp. 259–71, esp. pp. 263, 267, 269. For more on Focillon, see also chapters 15 and 16 by Hourihane and Maxwell, respectively, in this volume.

42 Kathryn Brush, "Adolph Goldschmidt," in Damico, ed., *Medieval Scholarship*, pp. 245–58, esp. pp. 254–5. See also Kathryn Brush, *The Shaping of Art History: Wilhelm Vöge, Adolph Goldschmidt, and the Study of Medieval Art* (Cambridge, 1996).

43 Erwin Panofsky, *Studies in Iconology: Humanistic Themes in the Art of the Renaissance* (New York, 1939), pp. 3–17.

44 For a recent review of the literature on the architecture of St Denis, see Lawrence R. Hoey, "A Critical Account of Suger's Architecture at Saint-Denis," *AVISTA Forum* 12 (1999), pp. 12–19.

45 On this intellectual diaspora, see Colin Eisler, "*Kunstgeschichte* American Style: A Study in Migration," in Donald Fleming and Bernard Bailyn, eds., *The Intellectual Migration: Europe and America, 1930–1960* (Cambridge, Mass., 1969), pp. 544–629. For a detailed review of medieval art historical scholarship from approximately 1978 to 1988, see Herbert L. Kessler, "On the State of Medieval Art History," *Art Bulletin* 70 (1988), pp. 166–87. For approximately 1988–2004, see Kessler, *Seeing Medieval Art* (Peterborough, 2004), which – in an unintended challenge to the statement of Sauerländer cited in the Preface, that no one can read everything – is an extended essay explicitly intended as a review of the scholarship covering 16 years, whose subject is a number of issues that have been central to the study of medieval art during this time.

46 Karl Werckmeister, review of Meyer Schapiro, *Romanesque Art*, in *The Art Quarterly* n.s. 2 (1979), pp. 211–18; John Williams, "Meyer Schapiro in Silos: Pursuing an Iconography of Style," *Art Bulletin* 85 (2003), pp. 442–68.

47 On the development of art history in Europe in general, see Kultermann, *History of Art History*; in Germany, see Dilly, *Kunstgeschichte*, and Betthausen et al., eds.,

Metzler kunsthistoriker Lexikon; and in the US, see Smyth and Lukehart, eds., *The Early Years of Art History.*

48 On the *Corpus Vitrearum* series, see chapter 21 by Pastan in this volume.

49 See chapters 7 and 8 by Kessler and Hughes, respectively, in this volume.

50 On the distance, at times, of medieval from the rest of the discipline of art history, see Kessler, "On the State of Medieval Art History," p. 166. On modernism as the source of the dichotomy between pre-modern and modern art history, see Belting, *End of the History of Art?*, pp. 34–46.

51 See chapters 2, 3, 4, and 6 by Hahn, Caviness, Lewis, and Kurmann-Schwarz, respectively, in this volume.

52 See chapters 23 and 24 by Folda and Papacostas, respectively, in this volume.

53 See chapters 9 and 10 by Caskey and Mariaux, respectively, in this volume.

54 Ovid, *Metamorphoses* 6: 28–9.

55 See chapters 14, 15, 16, and 17 by Fernie, Hourihane, Maxwell, Cohen, respectively, in this volume.

56 See chapters 18, 20, and 21 by Murray, Hedeman and Pastan, respectively, in this volume.

57 See chapters 19 and 22 by Büchsel and Buettner, respectively, in this volume.

58 See chapters 25, 26, 11, 12, and 13 by Zenner, Boerner, Kinney, Dale, and Kendrick, respectively, in this volume.

59 See chapters 27 and 28 by Fergusson and Gerson, respectively, in this volume.

60 See chapters 29 and 30 by Bizzarro and Brown, respectively, in this volume.

61 On Lawrence's Master's thesis, see chapter 23 by Folda in this volume.

62 Umberto Eco, *The Name of the Rose* (New York, 1983), pp. 40–5, 78–83.

2

Vision

Cynthia Hahn

Some understanding of what it means "to see" underlies any concept of art. In recent years it has been argued, however, that sight is not the immutable and ahistoric sense that it was once understood to be. Rather, as "visuality," it has a history. This chapter will examine some of the ways that conceptions of vision and visuality have shaped and driven scholarship on medieval art.[1]

Before beginning, it should be noted that vision has two distinct meanings in medieval art, both important to our purposes here. The first concerns the theological, scientific, and cultural understanding of the means and possibilities of sight or the gaze. The second meaning, related, but often treated quite separately, concerns mental and revelatory or nightmarish experiences. These *visions*[2] are important theologically and culturally, but are only a subset of an understanding of the more abstract issue of the meaning of vision.

An intriguing starting point for the understanding of vision derives from its negation. That is, in a recent book, Moshe Barasch has treated the "mental image" of blindness. Just as vision has a history, so too does blindness – one which illuminates some of the issues that will concern us in discussing sight. Barasch clarifies that blindness in antiquity might be a physical failing but also could represent special qualities of vision, as for example, those of a "seer"; in his analysis of the Gospels and early Christian era, he shows that blindness can represent a state of sin or a temporary state of nothingness, as when Paul is struck blind on the road to Damascus. Later medieval meanings shift yet again, continuing the notion of the blind sinner but introducing a new ambiguity with the figure of the itinerant beggar who can be either devious or virtuous. The Middle Ages additionally creates the category of noble and allegorical figures, such as Synagogue, that represent a condition of disastrous blindness signified by a blindfold.

Just as these meanings vary from seer to sinner, so cultural perceptions of the utility and status of sight vary widely throughout the Middle Ages and even

verge upon contradiction. They range from the insistence on the "eye of the mind" and lowered eyes in early medieval work, to the wary use of the visual, to the culturally determined "gaze" and a full confidence in the epistemological potential of physical sight in the later Middle Ages. Although our charge here is to consider discussions of art from the Romanesque to the Gothic, it will be necessary to include some scholarship on earlier and later art in order fully to understand the impetus for discussions of vision in medieval art.

One of the striking qualities of the literature on vision is how often the wheel has been reinvented. The core of scholarship has been produced in religious studies and history of science. Art historians have turned to this material for insight and have not, for the most part, built upon previous art historical studies. One might hope that a chapter like this, and the increasing interest in concepts of vision that it reflects, will help to make our discipline aware of the valuable work that has been done within its own boundaries.

Given the impossibility of constructing a coherent historiography because of the reasons noted above, I will not attempt to treat the subject chronologically, either in terms of bibliography or in terms of any "development" of the history of vision within the Middle Ages. Rather, I will rely upon disciplinary and conceptual categories to outline the complexities of the topic.

Of course, the first task must be a definition of terms. The fundamental understanding of vision for the Middle Ages develops from writings by the Church Fathers, principally Augustine. Sixten Ringbom's seminal book, *Icon to Narrative*, represents an early treatment of this material by an art historian. A fuller and more contextually grounded treatment can be found in an article on Augustine by Margaret Miles, a scholar of religion. Finally, Jeffrey Hamburger has contributed significantly to this tradition by clarifying the limits and possibilities of the application of Augustine's ideas to the treatment of art.[3]

Augustine's treatment of vision occurs in his treatise *On the Literal Meaning of Genesis*.[4] In that treatise, the Church Father discusses Paul's visions from 2 Corinthians 12, in which the Apostle is lifted to the seventh heaven. (Already we see the importance of the intermingled ideas of vision and visions.) In a text fundamental to all of Christian theology on sight, Augustine clarifies that there are three sorts of seeing: The lowest level, "corporeal vision," consists of what one sees with the eyes of the body. "Spiritual vision" is the occurrence of images in dreams or the imagination, largely but not exclusively dependent on the recollections of corporeal vision. As the first level functions in the second, so the second level is interpreted in the third, although it may also work independently. The third level, "intellectual vision," occurs exclusively in the highest levels of the mind and is the only site where Augustine admitted the possible perception of divine truths. It is not visual in the normal sense of the word but concerns divine knowledge. In fact, Augustine did not discuss art at all in this commentary; he was primarily interested in the imagery of dreams and prophecies.

Related religious commentary on visions and dreaming is essential to understanding the significance of Augustine's categories. This has been a fruitful area

of discussion in recent years, particularly distinguished by the work of Steven Kruger.[5] Again Augustine's treatise on Genesis takes a central place.

For Augustine dreams are a middle ground of mixed nature with the potential to reveal both the human and the divine.[6] Made up of images, garnered from corporeal vision, they have the potential for "prophetic insight" (XII.21.44). In Augustine if such dreams/visions emanate from a "spirit" source (i.e., an angel as opposed to a demon) and are "used" rather than "enjoyed," they may lead to the highest form of sight, the non-sensory intellectual vision. Augustine's dream theory is repeated almost without change in theological sources throughout the Middle Ages.[7]

Some later sources, however, shift emphasis. For example, Richard of St Victor, following other early medieval traditions in Tertullian and Prudentius, argues that the reliability of dreams is correlated to the relative cleanliness of the soul.[8] Albertus Magnus and others even discuss relative levels of individual perception. As Kruger summarizes the *De divinatione per somnum*:

> the human [imaginative soul] receives the celestial "lumen," or "motus" or "forma" in images, perceiving celestial truths more or less clearly [according to what is appropriate and possible for each individual].[9]

The terminology that Albertus uses is identical to that of both cosmology (with origins in Plato's *Phaedrus*) and optics. The discussion of visions and dreams, therefore, leads to much larger questions of meaning and epistemology.

The types and contents of visions have been summarized[10] and art historians such as Ringbom and Carloyn Carty have concerned themselves with the representation of dreams and visions. Ringbom has described conventions of such imagery and Carty has gone from the history of dream representations to linking visions to the initiation of narrative.[11]

Perhaps the most potentially productive extension of the interrelationship of visions and art is Mary Carruthers's work on memory and imagination. She has shown the interdependence of visions and the process or "craft" of thought. Most importantly, she has been able effectively to link these mental processes that lie at the core of medieval thought and religion to the visual and even to art.[12]

As noted above, discussions of dreams and visions in the Middle Ages share a vocabulary with the medieval science of optics. Whereas the theology of vision and visions remained relatively stable (i.e., Augustinian) throughout the Middle Ages, optics, in its guise as natural philosophy, evolves in significant ways.

The foremost historian of optics for the Middle Ages has been David Lindberg, who ardently asserts the centrality of his material: "Because optics could reveal the essential nature of material reality, of cognition, and indeed of God himself, its pursuit became not only legitimate, but obligatory."[13] Optical theory of the Middle Ages consists primarily of a series of variations upon two major theories of sight: that of extramission and that of intromission. The extramission theory contends that the eye emits a visual ray. This ray, strengthened by the presence

of light, goes out to encounter its visual object, is shaped by that object, and finally returns to the eye. Lindberg explains that in this, the Augustinian tradition which he characterizes as the epistemology of light, "the process of acquiring knowledge of unchanging Platonic forms is considered analogous to corporeal vision, through the eye."[14] The intromission theory is Aristotelian in origin and is transmitted through the Arab scholar Alhazen to the Oxford school. It is based on a visual pyramid originating in the visible object. Rays leaving all parts of the object enter the eye. The perpendicular rays are the strongest and dominate reception.[15] Again, light and its divine origin plays an important part.

Thus far, I have given a very crude sketch of some of the theological and scientific bases for the medieval understanding of vision. However, for cultural historians, it is of course, the implications of these ideas for medieval art and expression that are of the highest interest.

Literary historians have been more active than art historians in thinking about how such theories, dogmas, and cultural constructions might affect artistic creation. For example, the early medieval literary scholar Giselle de Nie, in attempting to understand the power of images and how they might differ from words, has delved into anthropology, philosophy, and psychology. Following René Devisch, she argues for the embedding of meaning in the body by means of vision which can be subsequently revealed through ritual: "Ritual symbols . . . arise from a potential which, akin to the dream, unconceals both images and inner energy woven into the texture of the body."[16] Or taking the derivation from perception to image, that is, from the other direction as does Paul Ricoeur, in his *Rule of Metaphor*, she argues that an apt mental image or a combination of images can bring awareness or experience into focus.[17] De Nie concludes that both modern anthropology and philosophy can help to explain the antique and early medieval belief that God communicated through dreams and miracles: "the visible could be regarded as a figure – congruous or inverted – of the invisible, and was thereby thought to participate in the latter's qualities."[18] She uses the example of a miracle in which a man was healed through the contemplation of a candle flame. The man's gaze "generated not only some mental picture of the saint as a person, but also an affect-laden mental image of the powerful mystic fire . . . [combined with] the central early Christian imaginative model of illumination by Christ." Thus "affectively enacting a metaphor + a mental image."[19] Nevertheless, de Nie rarely discusses art images, and the complications of transferring these provocative ideas about vision to art are many.[20]

As long as three decades ago, another literary scholar, Ruth Cline, demonstrated the connection between looking and love in medieval texts, an association forged through theories of vision.[21] Current scholarship links similar, but significantly different categories – desire and the gaze. Among medieval literary scholars, Sarah Stanbury has done important work on determining the operation of the gaze and its implication in structuring gender in medieval literature from the twelfth century and later. In an article using the methodology of film theory to investigate Chrétien's *Erec et Enide,* she concludes that: "descriptions of

women's bodies in medieval texts are shaped by gendered social conventions governing the rights and restrictions on looking."[22] Through the gaze of the court, Stanbury argues that Enide is "transformed from a natural girl to the courtly maiden . . . a constructed woman" and concludes that, "gaze [is] a generative process, one that creates self through its very apprehension of the other."[23] The literary critic become art historian, Norman Bryson, established the gaze as an art historical issue. He defined the gaze as a means of apprehending art, distinguished in its aloofness from the emotionally laden glance through which the perception of the "real" is gleaned.[24] Medieval art historians, such as Madeline Caviness, have also described the gaze and its constructs, but in general, that interest has been more productive for issues of concern to feminist art history than for those of visuality.[25] Very recently, the historian Suzannah Biernoff has integrated this material, describing the interrelationship of the gaze, especially as it is grounded in the body, gender, and carnality, with scientific and theological theories of vision. For example, theories of extramission allow "carnal vision [to extend] the appetite and attributes of the flesh beyond the boundaries of individual bodies." She forcefully reasserts the idea that, rather than a physiological process, "vision is always mediated by discourses about vision."[26]

Hal Foster most decisively defined this concept of the cultural construction of vision for art history, using the term *visuality*. He noted, "difference, many differences, among how we see, how we are able, allowed or made to see, and how we see this seeing or the unseen therein."[27] In the substantial wake of other historians of modern art, including Jonathan Crary and Martin Jay, medieval art historians have begun to explicate modes of visuality operant in medieval art. Two notable moves in this direction have included Marvin Trachtenberg's use of visuality in discussing architecture and urban space dependent upon a new "viewing subject" and the "scopic power" of Florentine civic planning;[28] and the organization of a symposium by Robert Nelson at the University of California Los Angeles in 1995 to consider a wide variety of aspects of pre-modern visuality. The introduction of the published volume and five of its essays concern the Middle Ages or its antecedents.[29]

Jas Elsner argues against the exclusivity of the "voyeurism" of naturalism in ancient art and suggests that in ritual settings such as pilgrimage (as described by Pausanias) an alternate "medieval" visuality obtained that was "oracular, liturgical, and epiphanic."[30] In an intentional confrontation with the frontal image that returns the viewer's gaze, "viewing the sacred is a process of divesting the spectator of all the social and discursive elements that distinguish his or her subjectivity from that of the god into whose space the viewer will come."[31]

Also concerned with pilgrimage, but of the early Christian era, Georgia Frank's "The Pilgrim's Gaze in the Age Before Icons" emphasizes that "vision was believed to contain the power to conjure, constitute, and respond to the presence of the divine. . . . The physical sense of sight was anything but a passive activity in antiquity; it was a form of physical contact between the viewer and the object."[32]

Robert Nelson, like Elsner, wants to treat the "cultural construction and maintenance" of visuality in the Byzantine world. Using evidence from *ekphrasis*, he argues that vision was more important than hearing in Byzantium because it was "dynamic, forceful, consequential, and even performative."[33]

In my own contribution to the Nelson volume, without trying to explain the mechanism of change, I make use of the medieval theological presumption of vision as a means of knowing to show that the understanding of the operation of sight shifts in the later Middle Ages from the possibility of an epiphany of divine truth perceived in the sudden glance to an appreciation of divine truth growing with the contemplative gaze.[34]

Finally, in his contribution to the same volume, an essay much expanded from the talk originally presented at a symposium at Northwestern University in 1994,[35] Michael Camille generally offers an argument about the crucial role of vision to Gothic perception and therefore to Gothic art. He weaves together medieval scientific texts and observations of artworks to describe medieval psychology and its resultant images that "were so much more powerful, moving, and instrumental, as well as disturbing and dangerous, than later works of art."[36]

Camille later expanded and generalized these ideas in a survey text, *Gothic Art: Glorious Visions*, arguing that "[Gothic people] were enraptured witnesses to a new way of seeing" (12).[37] His discussion of the thirteenth-century under-standing – Roger Bacon via Avicenna – of the completion of vision in the brain is essential to an understanding of Gothic scholastic vision:

> One only perceived something when the "species" traveled to the brain, where the internal senses were located. The system of five cells or ventricles . . . illustrates how the visible species passed first into the . . . *sensus communis*, which appre-hended appearances, located at the front of the brain. Next came the . . . *ymaginatio vel formalis*, which retained these forms; above it, the *estimativa* judged them. Further back, linked to the first kind of imagination, was a second kind, labeled *cogitativa*, which composed and combined images. . . . Finally, at the back of the head was the storehouse of memory, the *vis memorativa* with its little flap . . . which opened to let the images flow in and out.[38]

Camille shows how important this understanding is to the increasing "transpar-ency" of images and to their reception in the human brain.

Elsner was concerned to describe two competing modes of vision in the ancient world. Camille, Frank, Hahn, and Nelson look at particular periods, documents, and scientific theories to allow a characterization of visualities dominant in various periods. Clearly, Nelson's volume provides no single understanding of what the concept of visuality offers, but certain themes domin-ate the volume. Perhaps the most important conclusion is that discussions of the way sight works can readily be expanded into what sight can mean and what sight can allow us to know – that is, the epistemological dimension of vision in a given era.

Of course epistemology in the Middle Ages was essentially the realm of theology. In trying to trace the significance of modern scholarly thought on these issues, one must turn to a larger cluster of work on medieval "image theory" that attempts to understand what medieval viewers believed about art and what it could do. This material, of course, is best read against ecclesiastical image policy and theology. Although it is by no means always cast in terms of "visuality," image theory is essential to the understanding of the cultural history of vision, especially within the Christian tradition.

A fundamental text in the theology of the medieval image is Paul's pronouncement in 1 Corinthians 13: 12 that "For now we see through a glass, darkly; but then face to face." This prophecy of clear and divine vision after death, when the faithful will see their Lord directly and without mediation, is subject to much controversy in medieval theological discussion, culminating in a fourteenth-century papal constitution.[39] In contrast to the confidence in vision of the late medieval period, in the early Middle Ages, this same text is treated very differently. One might begin with art, but any vision of God was founded in prayer and the exercise of the "interior eyes." The corporeal eyes were lowered, even perhaps pressed into the dust of the earth in a symbolic abasement of the corporeal sense.

In his *Spiritual Seeing*, Herbert Kessler is concerned with the cluster of theological ideas variously characterized as "interior sight," seeing with the "eyes of the mind," spiritual sight, etc. He characterizes this interior phenomenon, which might or might not be prompted by a corporeal stimulus such as art, as "spiritual seeing," in a chapter entitled "Real Absence: Early Medieval Art and the Metamorphosis of Vision," an important survey of early medieval attitudes both positive and negative toward art's possibility to contribute to "spiritual seeing," Kessler builds on the work of Celia Chazelle, Jean-Paul Schmitt, Gerhard Wolf, and Jean-Marie Sansterre, among others.[40]

Of central importance to this discussion as the foundation and origin of Western theology on the image are Gregory the Great's renowned letters to Serenus of Marseilles that established papal approval for narrative and commemorative art.[41] The relationship is not a complicated one: those that are illiterate can "read" in images as others do in books and thereby be reminded of religious truths. Complications arise in aspects of the way that Gregory presents his case. He notes an emotional element and the striking quality of visual imagery. Memories of edifying stories are stirred and strengthened by the narrative images. Many modern scholars have understood Gregory's policy to be very limited and conservative, but when all the Father's writings are considered, Gregory evinces a much more powerful and sympathetic vision of art. Instead of the simple reaction of the memory, he speaks of "revolving images in the mind until they are portrayed on the heart."[42] He also demonstrates a belief in the power and potential of the visual to change the soul of the viewer, if that soul is first prepared with prayer and "acts of faith." These "tangential" issues are the ones that later medieval commentators turn to and build upon.[43]

One aspect of the commentary tradition on the letters that deserves particular attention is the privileging of certain categories of objects within the realm of Christian vision. Gregory himself mentioned pictures of Bible stories and lives of holy persons, praising their commemorative quality. In an eighth-century forged addition to a letter from Gregory the Great to Secundinus, additional sorts of artworks are mentioned and it is claimed that they have the power to lift the mind to higher things:

> Your request pleased us greatly, because you seek with all your heart and all intentness Him, whose picture you wish to have before your eyes, so that every day, the corporeal sight renders Him visible; thus, when you see the picture, you are inflamed in your soul with love for Him whose image you wish to see. We do no harm in wishing to show the invisible by means of the visible. . . . Thus, we have sent you two images: one of the Savior and Mary the Holy Mother of God and the other of the blessed apostles Peter and Paul, and a cross. CCSL 1110f.[44]

Perhaps it is not surprising that the representation of the cross and icons of Christ and Mary stand above other art objects in their status as access to the divine. This text, however, in mentioning an icon of the apostles Peter and Paul, opens the door to yet other images.

In contrast to this textual (or theological) validation, it should be noted that medieval ritual and cult importance testify to the special possibilities of vision offered by certain other categories of objects. These objects include relics (and reliquaries); *acheiropoietae*, that is images that avoid the taint of human manufacture in their origin as miraculous images "made without hands";[45] and once again, the cross.

The cross is exceptional among manufactured images – it is at once an image but also, in its physicality, it is like a relic (and of course, crosses often serve as reliquaries). It is allowed a particular status as an enduring and revealing sign, already promoted by Paul himself in the first letter to the Corinthians (1: 18): "For the word of the cross is foolishness to those who are perishing, but to us who are being saved it is the power of God." However, in early medieval images of devotion to the cross (fig. 2-1), it is notable that the devotee's eyes are not even lifted to gaze upon the sign of salvation. Instead, the hand grasps and the eyes are averted, focusing attention away from corporeal eyes, turning to the "eyes of the heart," in contrast, later medieval art allows and even encourages contemplation of the cross and the crucifixion, arguing that such contemplation, a type of prayer, will bring faith.[46]

One particular example of the crucifixion as means of divine access through vision is discussed by Jeanne-Marie Musto. Musto relies on the Carolingian theologian John Scottus Eriugena, who describes a hierarchical status of vision: "each shall behold that Vision in his own way . . . through certain apparitions of Himself appropriate to the capacity for contemplation of each one of the Saints, shall God be seen."[47] Musto argues that the upper cover of the Lindau Gospels

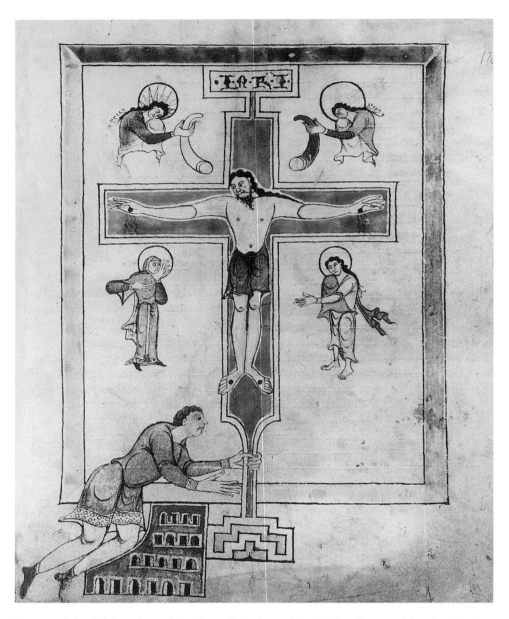

FIGURE 2-1 "Adoration of the Cross," Psalter of Louis the German (the drawing is a late ninth-century addition). Berlin: Staatsbibliothek MS lat. theol. fol. 58, fol. 120r. Reproduced courtesy of Bildarchiv Foto Marburg.

in the Morgan Library represents an early medieval version of the relative access of persons to the divine vision, dependent on the perfection of their souls. Thus angels, floating at the top, view directly. In the mortal realm, saints are granted sight but mere mortals must turn away and look for guidance to the saints. Although Musto's example is a particularly concrete instance of the special status of the cross or crucifixion, presumably all of the crosses produced in the Middle Ages, although not explicitly presented with such interpretive supplements, were held in similar regard.

In striking contrast to such approved objects of vision, some subjects seem to have been represented due to their negative status. Thomas Dale argues for the importance of the mechanism of "sublimation" in the operation of monastic viewing in the Romanesque period. Monks looked at images of vices, nudes, monsters, etc., in order to overcome sensual temptation and weakness.[48]

Such functionality of images, working on the mind of the viewer, leads us from categories of images to types of imagery privileged by image theory. Here we return to Gregory's original letters and the intimation that he is particularly interested in the edifying possibilities of narrative: "the deeds of holy persons." This is one of the elements that has been exploited in recent studies on narrative in medieval art, including those of Caviness and Hahn.[49] In the *Life of Saint Alban* by Matthew Paris, the saint's sight of the cross leads to a narrative that explicates and realizes a series of concepts about faith and Christian meaning.[50] Furthermore, the investigation of certain isolated narrative scenes, particularly moments of Christ's divine epiphany such as the Transfiguration and the Ascension, has proven particularly fruitful in revealing possible mental processes set in motion by medieval images. Such studies include Jas (then John) Elsner's treatment of the Transfiguration at Sinai as well as Robert Deshman's discussion of the Ascension in Anglo-Saxon art.[51] In the latter, for example, Deshman argued that the English monastic reform, in warning of the dangers of corporeal vision, held that the Apostles themselves were distracted by Christ's physical presence. The miniatures of the Ascension depict, not Christ's presence but his "disappearance," allowing the viewer to begin to see His true and divine nature with the "eyes of mind."[52]

If images can tell "effective" narratives and work to lift the mind to God, a final question concerning image theory remains. Can images convey the intricacies of theological meaning? And in particular, can art explicate or facilitate the relationship of sight and knowledge? In "Medieval Art as Argument," Kessler expands on the possibilities of dogmatic or epiphanic images. He argues that art can be used to evoke "spiritual seeing" through its ability to "synthesize diverse sacred texts" and its capability, even in the early medieval period, to have an anagogical effect.[53] For example, he argues that in the Apocalypse frontispiece from the Touronian Bible in London (BL Add. Ms. 10546, fol, 449 recto) the mysterious figure in the lower register, from whom the four evangelical beasts pull the veil, is a composite figure of Moses, John, and Paul, representing the *videntes,* or seers, of the Bible, both Old and New Testament. In a "subversion"

of the author portrait type, the figure ends the manuscript with a portent of the vision to come in which the veil of both text and image will be lifted in order that the faithful will at last gain sight of the divine. However, far from thus creating a comprehensive and sufficient vision for the faithful, Kessler also contends that artists consistently reminded their audiences of the shortcomings of their media. He cites a series of Roman images of Christ's face on board that were inserted into frescoes to argue that medieval artists consciously highlighted the materiality of their artistic product, denying that it actually represented a vision of the Lord's face. Kessler compares these uses of images to Byzantine icon theory. He emphasizes: "Western image theory [was differentiated] absolutely from Byzantine notions that the icon was transparent, a window onto the higher reality." "If the sacred image in the West was a bridge, then it was a drawbridge drawn up, if a window, then only with a shade pulled down. It marked the existence of the 'world out there,' but it also revealed its own inability to transport the faithful into that world."[54]

Such ambitious, densely intellectual, and self-reflexive images tend to be the exception in the early medieval period. A symposium at Princeton University in 2001, sponsored by Anne-Marie Bouché and Jeffrey Hamburger, attempted to make a stronger case for such imagery in the art of the High and Late Middle Ages. Although "over recent years the interpretation of medieval art in terms of theological discourse has fallen out of favor," they contended that:

> Given all the uncertainties inherent in the interpretation of images, it seems significant that such important theological material [on the nature of Christ, the Eucharist and the meaning of the Incarnation] was entrusted to the visual realm. . . . Instead of using theology to explain art, we are now beginning to consider art as a special kind of language for communicating theology.[55]

The conference allowed a variety of approaches to that end. Mary Carruthers argued that in *De Archa Noe mystica*, Hugh of St Victor speaks of the ark in terms of its construction, using active verbs of craft and painting in a "pre-imaginative" process similar to that which craftsmen were taught to use in the Middle Ages. She argued that no material diagram was ever intended to accompany the text but that the visualization was a form of theological thought. In contrast, Bernard McGinn argued that Joachim of Fiore's diagrams were communicated to him by vision and scripture and that these *figura* were intended to allow fleshly eyes to open spiritual eyes. Images could be used to go beyond images in a distinctly theological setting. (This approach is, of course, reminiscent of the early, important work of Anna Esmeijer.) Further in this vein, Christopher Hughes presented typology as a "cognitive style," using Augustine's *City of God* to argue that the comparative approach represents essential aspects of the structure of knowledge and encourages the viewer to think more deeply about the world. Anne-Marie Bouché even argued that the Floreffe Bible frontispieces directed their own interpretation in a puzzle-like procedure that

privileged hermeneutic processes. In a talk that discussed primarily popular and liturgical sources of the fourteenth and fifteenth centuries, Thomas Lentes focused on the spiritual senses and discussed how vision – "you are what you see" – shaped the person. (Of particular interest is how these ideas have precedents in the earlier Middle Ages.[56]) Katherine Tachau discussed scientific and theological aspects of the work of Grosseteste, Bacon, and others, showing its profound importance in the medieval understanding of the possibility of divine know-ledge. Again, the conference had no single message about the status of "vision" in the Middle Ages, but instead, in these and other papers, provided a remark-ably rich picture of the possibilities of medieval images in explicating and even advancing theology.[57]

Surprisingly, at the Princeton conference, one of the richest veins of theolog-ical imagery concerning vision from the Middle Ages remained untapped. We can end here with a further consideration of "Last Things": illustrations of the Revelation of John. Suzanne Lewis has discussed the manuscript history of the many versions of the fantastic book, finding particular interest and narrative richness in the thirteenth- and fourteenth-century Anglo-Norman examples.[58] According to Barbara Nolan, in her groundbreaking book *The Gothic Visionary Perspective*, however, issues concerning vision were already broached in Apocalypse manuscripts and frescoes from the Romanesque period. Nolan detects shared "visionary" elements in literature and art, largely based on Apocalypse comment-ary,[59] and writes in her preface that she became "aware that common spiritual backgrounds must have supported the pervasive and long-lived persistence of the several 'arts of vision' once they had been invented during the twelfth century."[60] Nolan is particularly interested in the theology of Richard of St Victor who, in a variation upon the standard description of Augustine (whom she does not discuss), adds a "fourth mode of seeing." Richard's third mode involves the "eyes of the heart," the *oculi cordis*, which "by means of forms and figures and the similitudes of things," sees the "truth of hidden things." His fourth mode is anagogical following Pseudo-Dionysius in which "anagogy is the ascent or elevation of the mind for supernatural contemplation,"[61] but this ascent is through imagery: "Fixed on that light of eternity, he draws into himself the likeness of the image he perceives."[62] As Nolan clarifies, this "visionary approach to God was personal and vertical rather than social and historical".[63] Indeed, in this material we see the beginnings of a focus on the devotional use of vision.[64]

Despite her primary interest in the thinkers of the twelfth century, Nolan does draw attention to earlier commentators on the Apocalypse, especially singling out Bede, Alcuin, and Haimo of Auxerre. Bede and Alcuin both characterize the Apocalypse as concerned with "intellectual vision."[65] But Bede was also inter-ested in the possible action of this vision. In his Lives of the Abbots of Wearmouth and Jarrow, he remarks that when Benedict Biscop imported models including Apocalypse imagery and portraits of Christ, Mary, and the Apostles from Rome for the decoration of his church at Wearmouth in 674, his intention was to

better contemplate a certain "*amabilem . . . aspectum*," to recall the grace of the Incarnation, and to allow viewers to judge themselves when they see the Last Judgment.[66] In the same vein of personal involvement through sight, Haimo claims that John's suffering on Patmos enabled him to see the heavenly secrets and will also serve as an example to allow others to share in this vision.[67]

Perhaps reflecting this possibility, an abbreviated text of Revelation that introduces a copy of Haimo of Auxerre's commentary is illustrated with miniatures (Bodleian Library Ms. Bodley 352.). Folio 5v. shows John speaking to the Churches of Asia in two upper registers and, below, the Apostle receives the command "*Ascende huc*" ("Come up here"). He ascends to see a vision of God in the Heavenly Glory of his court.[68] The miniature shows the figure of John adjacent to the court of heaven with the scroll carrying the words *Ascende huc* above him and the abbreviated biblical text squeezed into the borders of the miniature. John stands outside the "door into heaven" which the Apocalypse text specifies that he *looked through* ("After these things I looked and saw a door opened in heaven": Rev 4: 1). Rather than peer through the door, John points to his eye – an early occurrence of a gesture that came to signify interior contemplation in contrast to corporeal sight (fig. 2-2).

Although he notes that Beatus, the most famous of Apocalypse commentators, has no particular understanding or theory of vision and the figure of John as "seer" does not occur in the Spanish manuscripts, Peter Klein sets Nolan's earlier insights into the context of Augustinian commentaries on sight.[69]

By the time of Rupert of Deutz (*c.*1075–1130), Nolan claims that the Apocalypse has become "an intricately organized book of meditation – a systematic guide to spiritual consolation, and finally, to beatitude," and in particular, "the images have become signs of spiritual progress, leading by ordered stages to the experience of beatitude."[70] In other words, Rupert is already focusing on the operation of the narrative in allowing the individual, through devotional study, to approach the divine, an aspect that will come to the fore in the Anglo-Norman manuscripts (and is remarkably similar to the "narratives" developed in the sequences of devotional images for women in the Rothschild Canticles, as explicated by Jeffrey Hamburger).

In *St. John the Divine*, Hamburger further amplified his many insights on the questions of medieval vision and devotion, recovering the history of "elitist" images "open only to initiates" which proposed to invite the viewer to "look beyond the rhetoric of imitation and think in terms of full and complete identification [with God]." He describes the pathway, images of the divinized John the Evangelist, as: "A figure of contemplative ascent, [who] incorporates, anticipates, and enacts the process of elevation [for the viewer]," in escaping mere similitude and reaching identity, the purified soul uses John's exemplar because, as Aquinas held, his vision was high, wide, and perfect (*alta, ampla, perfecta*).[71] Hamburger's chapter, "Images and the 'Imago Dei'," reveals how Christian theologians have found such possibilities in images even as they have resisted them, discussing Athanasius, Augustine, Bernard of Clairvaux, Bonaventure,

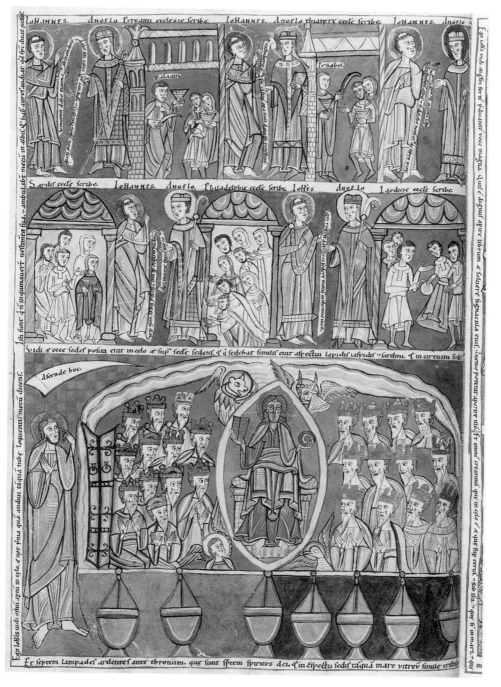

FIGURE 2-2 "John receives the command 'Ascende huc'," Revelation with Haimo of Auxerre's commentary, twelfth century. Oxford: Bodleian Library MS Bodley 352, fol. 5v. Reproduced courtesy of the Bodleian Library, University of Oxford.

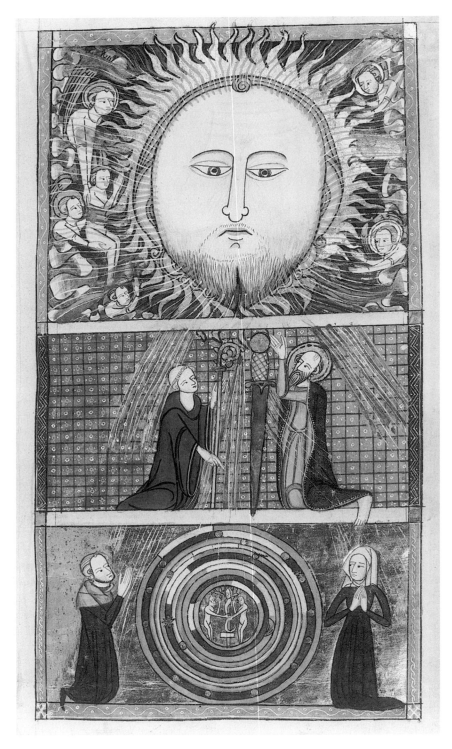

FIGURE 2-3 *Omne Bonum*, fourteenth century. London: British Library, Royal MS 6 E VI, fol. 16r. Reproduced courtesy of the British Library.

William of St Thierry, Eckhardt, Tauler, and Suso and, fittingly, ending with Eckhardt's principle of invisibility.

Ultimately, however, in the thirteenth and fourteenth centuries, attention shifts decisively from the *Imago Dei* to the *Visio Dei* – from the nature of the image to the nature and possibility of sight itself, and "gazing upon the divine face" became an all-consuming goal for the devout, in imitation of John and other saints.[72] The *Omne Bonum*, an illuminated fourteenth-century encyclopedia of "All that is Good" discussed by Lucy Freeman Sandler, includes a remarkable image that could be said to diagram issues of vision in the Middle Ages (fig. 2-3).[73] It illustrates a papal constitution of 1336 which settled a controversy over whether the Christian would see God with corporeal eyes after the resurrection. At the top is the face of God represented as, in effect, the sun of "divine illumination." The vision illuminated by divine radiance is enjoyed by angels and one naked soul after death. In the middle register representing mundane life, some of the divine illumination descends upon two *saintly* figures: Paul engaged in the vision that Augustine discussed, and St Benedict during a vision of the death of Germanus discussed by Gregory in the *Dialogues*. Both saints look upward with open eyes and provide an essential mediation for less saintly viewers as indicated by the downward but welcoming gesture of Benedict's right hand. Below, on a lower rung of earthly existence and merit, Christians gather and direct their eyes toward a sphere illuminated by other sources of light including the sun and stars and centered on Adam and Eve as signs of fallen vision. Nevertheless, some divine illumination escapes the upper registers to illuminate even the fallen vision of earthly things (just as one learns of God in viewing his creation).[74] At this moment in the fourteenth century, expectations of the possibilities of vision had reached a high water-mark for the Middle Ages. As never before, knowing God was *seeing* God.

Notes

1 I would particularly like to thank Jeffrey Hamburger for sharing a bibliography that he produced for a seminar at Harvard, although any errors of omission are mine alone. Unfortunately, neither "vision" nor "visuality" has yet become a key word in bibliographic tools or in titles (except in its sense as visions) and too much of the bibliography that I discuss here has come to my attention by chance. I am certain that I have missed other equally interesting studies and I ask that their authors excuse my oversight.

2 I will use "visions" for the latter meaning.

3 Ringbom, *Icon to Narrative*; Miles, "Vision"; Hamburger, *Rothschild Canticles*, p. 165.

4 An English translation can be found in *St Augustine. The Literal Meaning of Genesis*, pp. 41–2.

5 Kruger, *Dreaming*. See also the last chapter of Schmitt, *Ghosts in the Middle Ages*, and Miller, *Dreams in Late Antiquity*. For dreams as a higher level of vision and purity see Elliott, *Fallen Bodies*.

6 Kruger, *Dreaming*, esp. pp. 41, 130.
7 Ibid., p. 62.
8 Ibid., pp. 79, 80, 49, 54.
9 Ibid., p. 190.
10 Aubrun, "Caractères."
11 Ringbom, "Some Pictorial Conventions," and Carty, "Dream Images." See also Carty's University of Michigan dissertation. [On narrative, see chapter 4 by Lewis in this volume (ed.)]
12 Carruthers, *The Book of Memory*.
13 Lindberg, *Theories of Vision*, p. 99.
14 Ibid., p. 95.
15 Ibid., p. 109.
16 De Nie, "Iconic Alchemy," p. 159, quoting Devisch, *Weaving the Threads of Life*, p. 280.
17 De Nie, "Iconic Alchemy," p. 246.
18 Ibid., p. 160.
19 Ibid., pp. 162, 163.
20 See De Nie, "Poet as visionary," as well as Hahn, "*Visio Dei*," Kessler, *Spiritual Seeing*, and Dale, "Monsters."
21 Cline, "Heart and Eyes."
22 Stanbury, "Feminist Film Theory," p. 47; see also Stanbury, *Seeing the Gawain-Poet* and "Feminist Masterplots."
23 "Feminist Film Theory," pp. 54, 63.
24 Bryson, *Vision and Painting*, esp. ch. 5; see also Bryson, "The Gaze."
25 [On gender and medieval art, see chapter 6 by Kurmann-Schwarz in this volume (ed.).]
26 Biernoff, *Sight and Embodiment*, pp. 41, 44.
27 Foster, *Vision and Visuality*, ix.
28 Trachtenberg, *The Dominion of the Eye*.
29 Nelson, ed., *Visuality Before and Beyond*.
30 Elsner, "Between Mimesis and Divine Power: Visuality in the Greco-Roman World," p. 46. (Jas Elsner, formerly John Elsner.)
31 Ibid., p. 61.
32 Frank, "The Pilgrim's Gaze in the Age Before Icons," p. 108; see also Frank, *The Memory of the Eyes*.
33 Nelson, "To Say and to See," pp. 145, 155.
34 Hahn, "*Visio Dei*: Changes in Medieval Visuality."
35 As was my essay, then called "Structuring Medieval Vision."
36 Camille, "Before the Gaze," p. 217.
37 Camille, *Gothic Art: Glorious Visions*, p. 12.
38 Ibid., p. 23.
39 Dondaine, "L'Objet et le 'medium' de la vision béatifique." See also Sandler, "Face to Face with God."
40 See Kessler's notes for his bibliography in *Spiritual Seeing*, 225ff.
41 [On Gregory the Great and image theory, see chapter 7 by Kessler in this volume (ed.).]
42 *Pastoral Care*, 81 (II.10). This passage discusses the correction of sin, but Gregory's aside on images is not any less interesting for that. Immediately afterwards he gives

a visual example with which a "teacher" will reveal "vision" to "mundane hearts" (p. 83). Furthermore, he repeats the idea almost verbatim in the *Moralia in Iob*, XXVI.VI.65.

43 Hahn, *Portrayed on the Heart*, pp. 48–9. Also see Kessler, *Spiritual Seeing*, 118–25.

44 Kessler puts this forgery into context within Hadrian's efforts to counter the icono-clastic thrust of the *Libri Carolini*. He quotes it in his letter to Charlemagne: see Kessler, *Spiritual Seeing*, p. 123.

45 Again Kessler discusses the latter in terms of the importance of the "copy" within the discourse of "images made without hands." These images, although they justify the making of art – they are after all material images created miraculously – none-theless in some sense are not "material." Kessler notes that they "float" above their supposed material matrix and are only seen in copies, sometimes pairs or multiple copies together that collectively reference their divine origin: *Spiritual Seeing*, p. 83.

46 Hahn, "*Visio Dei*," pp. 178–83.

47 Musto, "John Scottus Eriugena," p. 13, quoting the *Periphyseon* V, ed. Migne *PL* CXXII, 945, trans. Sheldon Williams, p. 624.

48 Dale, "Monsters, Corporeal Deformities and Phantasms." [On the monstrous, see chapter 12 by Dale in this volume (ed.).]

49 Caviness, "Simple Perception"; see also Hahn, *Portrayed*.

50 See Hahn, "Absent No Longer."

51 Elsner, "The Viewer and the Vision"; Deshman, "Another Look at the Disappear-ing Christ."

52 Deshman, "Another Look at the Disappearing Christ," pp. 533f.

53 In *Spiritual Seeing*, pp. xv.

54 Ibid., pp. 124, 144.

55 Flyer for the conference, "The Mind's Eye: Art and Theological Argument in the Medieval West."

56 Rahner, "Début d'une doctrine" and "La Doctrine des 'sens spirituels'."

57 The organizers have promised that the papers from this conference at Princeton will be published. The Utrecht conference papers will also be published.

58 Lewis, *Reading Images*.

59 Nolan, *The Gothic Visionary Perspective*, p. 5.

60 Ibid., p. xv.

61 Ibid., p. 37 (*In apocalypsim*, 687).

62 Ibid., p. 34 (Ben Maj. IV, ii in PL CXCVI 147–8).

63 Ibid., p. 4.

64 Caviness has also discussed the "third mode" of seeing and its potential for the interpretation of medieval art that attempts to portray the divine: "Images of divine order." She discusses the first mode in "The Simple Perception of Matter"; in other essays she suggests feminist dimensions of vision: see, for example, "Artist: 'To See, Hear, and Know All at Once'."

65 Nolan, *Gothic Visionary Perspective*, pp. 5, 7.

66 Ibid., pp. 56–7 (PL XCIV 718).

67 Ibid., p. 9.

68 Ibid., pp. 55 n32, pp. 65–7, and figure 9.

69 Klein, "From the Heavenly to the Trivial."

70 Nolan, *Gothic Visionary Perspective*, pp. 16–17, 19.

71 Hamburger, *St. John*, pp. 203, 164, 56.
72 Dondaine, "L'Objet et le 'medium' de la vision béatifique."
73 Sandler, "Face to Face with God."
74 Hamburger, "Speculations on Speculation."

Bibliography

Michael Aubrun, "Caractères et porté religieuses et sociale des visions en Occident du Ve au XIe siècles," *Cahiers de Civilisation Médiévale, Xe–XIIe Siècles* 23 (1980), pp. 109–30.

St Augustine. The Literal Meaning of Genesis. Ancient Christian Writers, trans. J. H. Taylor (New York, 1982).

M. Barasch, *Blindness: The History of a Mental Image in Western Thought* (New York, 2001).

Suzannah Biernoff, *Sight and Embodiment in the Middle Ages* (New York, 2002).

Norman Bryson, *Vision and Painting: The Logic of the Gaze* (New Haven, 1983).

——, "The Gaze in the Expanded Field," in Hal Foster, ed., *Vision and Visuality* (Seattle, 1988), pp. 87–113.

Michael Camille, "Before the Gaze: The Internal Senses and Late Medieval Practices of Seeing." in Nelson, ed., *Visuality Before and Beyond the Renaissance: Seeing as Others Saw* (Cambridge, 2000).

——, *Gothic Art: Glorious Visions* (Prentice-Hall, 1997).

Mary Carruthers, *The Book of Memory: A Study of Memory in Medieval Culture* (Cambridge, 1990).

Carolyn M. Carty, "Dream Images, Memoria, and the Heribert Shrine," in. E. Valdez del Alamo and C. Stamatis Pendergast, eds., *Memory and the Medieval Tomb* (Hants, 2000), pp. 227–47.

Madeline H. Caviness, "Artist: 'To See, Hear, and Know All at Once'," in B. Newman, ed., *Voice of the Living Light: Hildegard of Bingen and her World* (Berkeley, 1998), pp. 110–24.

——, "Images of Divine Order and the Third Mode of Seeing," *Gesta* 83 (1983), pp. 99–120.

——, "'The Simple Perception of Matter' and the Representation of Narrative *ca*.1180–1280," *Gesta* 30 (1991), pp. 48–64.

Ruth H. Cline, "Heart and Eyes," *Romance Philology* 25 (1971–2), pp. 262–97.

Thomas Dale, "Monsters, Corporeal Deformities and Phantasms in the Romanesque Cloister of St-Michel de Cuxa," *Art Bulletin* 83 (2001), pp. 402–36.

Robert Deshman, "Another Look at the Disappearing Christ: Corporeal and Spiritual Vision in Early Medieval Images," *Art Bulletin* 79 (1997), pp. 518–46.

R. J. Devisch, *Weaving the Threads of Life. The Khita Gyn-Eco-Logical Healing Cult Among the Yaka* (Chicago, 1993).

H.-F. Dondaine, "L'Objet et le 'medium' de la vision béatifique chez les théologiens du XIIIe siècle," *Recherches de théologie ancienne et médiévale* 19 (1952), pp. 60–129.

D. Elliott, *Fallen Bodies: Pollution, Sexuality, and Demonology in the Middle Ages* (Philadelphia, 1999).

Jas Elsner, *Art and the Roman Viewer: The Transformation of Art from the Pagan World to Christianity* (Cambridge, 1995).

——, "Between Mimesis and Divine Power: Visuality in the Greco-Roman World," in Nelson, ed., *Visuality Before and Beyond the Renaissance: Seeing as Others Saw* (Cambridge, 2000).

John Elsner, "The Viewer and the Vision: The Case of the Sinai Apse," *Art History* 17 (1994), pp. 81–101.

Anna C. Esmeijer, *Divina quaternitas; A Preliminary Study of Method and Application of Visual Exegesis* (Assen, 1978).

Hal Foster, ed., *Vision and Visuality* (Seattle, 1988).

Georgia Frank, *The Memory of the Eyes: Pilgrims to Living Saints in Christian Late Antiquity* (Berkeley, 2000).

——, "The Pilgrim's Gaze in the Age Before Icons," in Nelson, ed., *Visuality Before and Beyond the Renaissance: Seeing as Others Saw* (Cambridge, 2000).

Gregory the Great, *Pastoral Care (Regula Pastoralis)*, ed. H. Davis (Westminster MD, 1955).

Cynthia Hahn, "Absent No Longer. The Saint and the Sign in Late Medieval Pictorial Hagiography," in G. Kerscher, ed., *Hagiographie und Kunst: Der Heiligenkult in Schrift, Bild und Architektur* (Berlin, 1993), pp. 152–75.

——, *Portrayed on the Heart: Narrative Effect in Pictorial Lives of Saints from the Tenth through the Thirteenth Century* (Berkeley, 2001).

——, "*Visio Dei*: Changes in Medieval Visuality," in R. Nelson, ed., *Visuality Before and Beyond the Renaissance: Seeing as Others Saw* (Cambridge, 2000), pp. 169–96.

Jeffrey F. Hamburger, *The Rothschild Canticles: Art and Mysticism in Flanders and the Rhineland Circa 1300* (New Haven, 1990).

——, "Speculations on Speculation: Vision and Perception in the Theory and Practice of Mystical Devotion," in W. Haug and W. Schneider-Lastin, eds., *Deutsche Mystik im abendländischen Zusammenhang. Kolloquium Kloster Fischingen, 1998* (Tübingen, 2000), pp. 353–408.

——, *St. John the Divine: The Deified Evangelist in Medieval Art and Theology* (Berkeley, 2002).

——, *The Visual and the Visionary: Art and Female Spirituality in Late Medieval Germany* (New York, 1998).

Martin Jay, *Downcast Eyes: The Denigration of Vision in Twentieth-Century French Thought* (Berkeley, 1993).

Herbert Leon Kessler, *Spiritual Seeing: Picturing God's Invisibility in Medieval Art* (Philadelphia, 2000).

Peter K. Klein, "From the Heavenly to the Trivial: Vision and Visual Perception in Early and High Medieval Apocalypse Illustration," in H. Kessler and G. Wolf, eds., *The Holy Face and the Paradox of Representation: Papers from a Colloquium Held at the Bibliotheca Hertziana, Rome, and the Villa Spelman, Florence, 1996* (Bologna, 1998), pp. 247–78.

S. F. Kruger, *Dreaming in the Middle Ages* (Cambridge, 1992).

Suzanne Lewis, *Reading Images: Narrative Discourse and Reception in the Thirteenth-Century Illuminated Apocalypse* (Cambridge, 1995).

David C. Lindberg, *Theories of Vision from Al-Kindi to Kepler* (Chicago, 1976).

Margaret Miles, "Vision: The Eye of the Body and the Eye of the Mind in Saint Augustine's *De trinitate* and *Confessions*," *The Journal of Religion* 63 (1983), pp. 125–42.

P. C. Miller, *Dreams in Late Antiquity. Studies in the Imagination of a Culture* (Princeton, 1994).

Jeanne-Marie Musto, "John Scottus Eriugena and the Upper Cover of the Lindau Gospels," *Gesta* 40 (2001), pp. 1–18.

Robert Nelson, "To Say and to See: Ekphrasis and Vision in Byzantium," in Nelson, ed., *Visuality Before and Beyond the Renaissance: Seeing as Others Saw* (Cambridge, 2000), pp. 143–68.

——, ed., *Visuality Before and Beyond the Renaissance: Seeing as Others Saw* (Cambridge, 2000).

Giselle de Nie, "Iconic Alchemy: Imaging Miracles in Late Sixth-Century Gaul," *Studia Patristica* 30 (1997), pp. 158–66.

——, "The Poet as Visionary: Venantius Fortunatus's 'new mantle' for Saint Martin," *Cassiodorus* 3 (1997), pp. 49–83.

Barbara Nolan, *The Gothic Visionary Perspective* (Princeton, 1977).

Karl Rahner, "Le Début d'une doctrine des cinq sens spirituels chez Origène," *Revue d'ascétique et de mystique* 13 (1932), pp. 113–45.

——, "La Doctrine des 'sens spirituels' du moyen âge: en particulier chez Saint Bonaventure," *Revue d'ascétique et de mystique* 14 (1933), pp. 263–99.

Sixten Ringbom, *Icon to Narrative: The Rise of Dramatic Close-up in Fifteenth-Century Devotional Painting* (Abo, Finland, 1965).

——, "Some Pictorial Conventions for the Recounting of Thoughts and Experiences in Late Medieval Art," *Medieval Iconography and Narrative: A Symposium*. Proceedings for the Fourth International Symposium Organized by the Center for the Study of Vernacular Literature in the Middle Ages (Odense, 1980), pp. 38–69.

Lucy Freeman Sandler, "Face to Face with God: A Pictorial Image of the Beatific Vision," in *England in the Fourteenth Century: Proceedings of the Harlaxton Symposium* (Woodbridge, Suffolk, 1986), pp. 224–35.

Gudrun Schleusener-Eichholz, *Das Auge im Mittelalter*, Münstersche Mittelater-Schriften, 35, 2 vols. (Munich, 1985).

J. C. Schmitt, *Ghosts in the Middle Ages* (Chicago, 1998).

Sarah Stanbury, "Feminist Film Theory: Seeing Chrétien's Enide," *Literature and Psychology*, 36 (1990), pp. 47–66.

——, "Feminist Masterplots: The Gaze on the Body of *Pearl's* Dead Girl," *Feminist Approaches to the Body in Medieval Literature*, ed. L. Lomperis and S. Stanbury (Philadelphia, 1993), pp. 142–67.

——, *Seeing the Gawain-Poet: Description and the Act of Perception* (Philadelphia, 1991).

Marvin Trachtenberg, *The Dominion of the Eye. Urbanism, Art, and Power in Early Modern Florence* (New York, 1997).

Reception of Images by Medieval Viewers

Madeline Harrison Caviness

Notions as to how medieval objects and buildings functioned for their first users, and how they looked to their first viewers, have expanded very rapidly in recent decades. Much art history followed literary criticism in a shift of focus from the planning and creation of a work – including its pictorial and textual sources – to the processes of constructing meanings and assigning values through reader/viewer responses.[1] This paradigm shift has been broadly defined as "the transformation of the history of art into a history of images."[2] The central tenet is that "the meaning of a work of literature [or art], rather than inhering statically in the text [or image] itself or being recoverable from the author's [or artist's] intentions, is produced dynamically through the interaction between text [or image] and reader (or viewer)."[3] We might think of this as a move from interrogation of all that lay "behind" the creation of the work, including any sources believed by earlier scholars to fix meanings in it, to a consideration of the varied readings that have arisen from viewing positions in front of the work after its completion, during its display or use. Art *historians* have predictably developed historical models that go further than literary reader-response *criticism* in attempting to (re)construct medieval readings.[4] Thus the paradigm continues to be central to our field even though the theoretical debates go back to the 1980s.

Either mode of interrogation, whether of the circumstances leading to production, or of the "after-life" of the image, can be virtually infinite. Sources can extend back to classical antiquity; influences can be long lasting, while viewers have continued to provide different responses up to our own time. I will endeavor to restrict "reception" here to responses by the generation or two that viewed the work in its original cultural and spatial context. When reader/viewer responses are traced down to the present time they constitute a reception history

(*Rezeptionsgeschichte*), and this branch of inquiry has claimed the term "reception theory."[5] Art historians have learned to examine their own biases by attention to historiography and reception history, and such perceptions are needed to historicize our understanding of reader/viewer response. Thus, even in this discussion of medieval reception, it is necessary to consider how, for instance, the mid-twelfth-century writings on art by the Cistercian Abbot of Clairvaux and the Benedictine Abbot Suger of St Denis have been mediated through such influential modern scholars of iconography as Emile Mâle and Erwin Panofsky.[6] As Arthur Watson and Peter Kidson have pointed out, they exaggerated Suger's creative role, the "originality" of his projects, and therefore the influence of St Denis elsewhere.[7] The power of Suger's textualization of the St Denis projects, the availability of this text to modern scholars, and the allure of having a name that could displace anonymity, must have contributed to these easily repeated claims. However, stepping aside from such debates about primacy and attribution, it is possible to find new ways to read both the texts and the visual objects associated with them, from the perspective of their medieval reception. Broadly speaking, there are two avenues of approach to reception: As medieval historians we can weigh modern notions of decoding visual symbols according to semiotics, psychoanalysis, cognitive science, and so on, along with medieval theories of signs, personae, and optics. And we can attempt to contextualize the medieval experience of a work of art by constructing an individual viewer (for instance the young queen who owned it), or a group that might have had a shared experience of the work.

What kinds of sources exist to indicate how medieval viewers reacted to visual objects? Functions that have been proposed for works of art range from providing spontaneous pleasure, altered consciousness, instruction, to even salutary terror. Yet clear and specific documents charting the immediate reception of a particular work of art by a medieval audience are very uncommon, at least before the late fourteenth century. There was nothing comparable to our modernist discourse of judicial criticism, largely because works did not circulate as commercial production. Praise of a new enterprise tended to be couched in generalities like variety, or well-worn topoi, such as the one claiming the richest materials, and even more superior craftsmanship. T. A. Heslop brought together a variety of such comments, as well as some of the negative criticism detailed below, noting the "ambivalence and contradictions inherent in medieval attitudes."[8] Since 1935 Ananda Coomaraswamy, Edgar de Bruyne, Meyer Schapiro, and most recently Umberto Eco are among scholars who have drawn on such texts to formulate some notion of medieval aesthetics.[9] Schapiro claimed "a conscious taste of the spectators for the beauty of workmanship, materials, and artistic devices, apart from the religious meanings."[10] He posited medieval viewers of different stations and classes, some of whom had much in common with a modern secular audience. In his eagerness to claim a delight in non-religious motifs, Schapiro almost overlooked the cultural distance that separates a medieval audience from us. Eco, on the other hand, was determined to historicize

medieval viewers, but depended on a surprisingly traditional array of theological and philosophical texts to posit top-down changing values. His account is historically grounded yet utterly impersonal, since he makes no attempt to substantiate pleasurable responses in a particular medieval audience.[11]

One of the best indications we have of an appreciative audience is imitation, so works themselves have been viewed as contributions to critical discourse. Yet the motivation for copying may not have been aesthetic. Richard Krautheimer long ago noted that the many buildings that medieval viewers claimed as imitations of the Holy Sepulcher vary so much in composition that he raised the question whether the form of the original had much importance in itself (as some modernists have assumed), or whether the essential similarity was numerical (twelve columns; eight sides, etc.) or conceptual (hexagonal and round, both being central-planned).[12] Accounts by travelers proved to be useful in plotting reception because their descriptions were as "inaccurate" as the built copies.

The tendency to build ever more resplendent churches in northern France in the twelfth and thirteenth centuries has an element of competition attested to in the works themselves. Suger's contemporary, Abbot Odo of St Remi in Reims, redecorated his Carolingian choir, including tomb effigies of ancient rulers.[13] Then, within twenty years of the completion of the choir that engulfed the Carolingian crypt of St Denis in 1144, Abbot Peter of Celle rebuilt the choir of St Remi as an even more sumptuous entity. If these churchmen competed over a suitable enclosure for royal tombs, their competition over the prestigious cults of two apostles to France, St Denis and St Remigius, was more commonplace. Gervase, writing toward the end of the century, of the destroyed choir of Canterbury Cathedral that had been "gloriously completed" by 1124 under Prior Conrad, apologized for giving the impression that he was interested in "the mere arrangement of stones," and assured his readers that his principal concern was the suitable placement of the relics of the saints.[14] In those terms, buildings that look as different as the great Byzantinizing church of San Marco in Venice and the Romanesque pilgrim church of Santiago in Compostela may have had a dialogic relationship, as rival houses for apostolic relics. This assumption is supported by Suger, who wished his altar furnishings in St Denis to rival those of Hagia Sophia in Istanbul, though he must have known they would not look alike; he concentrates on their costliness, but says nothing of outdoing the Western pilgrim churches by employing the new rib vaulting and supplying the portals with column statues.[15]

However, we cannot assign higher truth-value to the text than to the effort invested in the new components of the building; the contrast demonstrates the rhetorical and political aspects of Suger's writing project. Gervase's text has also been submitted to scrutiny, revealing its justificatory and even post-factum nature; the rhetorical purpose of Gervase's praise of the various phases of the building becomes clearer with the late dating (c.1199) argued by Carol Davidson Cragoe.[16] Thus such texts can be seen as vehicles for the manipulation of viewers' reception, rather than truthful accounts of the motivation for a building campaign.

What of negative reactions? These usually stemmed from a long-standing Christian anxiety about icons, images, and idols, as well as about the expenditure of money on church decorations when it might be given to the poor.[17] The best-known verbal attack on "art" from the High Middle Ages is the famous *Apologia* of St Bernard.[18] Even without it, we could assume that the unadorned Cistercian enclaves satisfied very different communities from those of the great Benedictine abbey churches and the cathedrals. Indeed the disagreement was not about some fundamental notion of the role of images in the spiritual life of Christians (such as brought about Protestant iconoclasms), but a clear distinction drawn by both sides between different groups that we would now call "viewing communities"; St Bernard stated this clearly when he wrote: "For certainly bishops have one kind of business, and monks another. We know that since they [the bishops] are responsible for both the wise and the foolish, they stimulate the devotion of a carnal people with material ornaments because they cannot do so with spiritual ones."[19] He firmly believed that lavish and attractive "decorations" were not necessary for churchmen as aids to contemplation or to understanding scripture, but there is a note of disdain in Bernard's characterization of the laity.

Another aspect that emerges from the occasional verbal attacks on new building programs, as well as from the silences in Suger's text, is that novelty and inventiveness had no currency per se in a world that regarded departures from accepted wisdom as heretical.[20] In this critical climate it is all the more likely that texts such as Suger's, that praise new works and their patrons, should be regarded as self-justificatory rhetoric.[21] Barbara Abou-el-Haj has cast doubt on the "cult of carts" which was said to have motivated ordinary lay people to pull the carts of building materials to sites such as Chartres Cathedral in order to honor the Virgin. She sees this often-repeated topos as part of "an expanding rhetorical curve in the clergy's accounts."[22] We are thus confronted with the irony that sharper attention to textual sources in order to tease out medieval viewer responses has led to greater skepticism as to the authority of texts. If we apply ideology critique equally to texts and works of art, both are seen to have contributed to the construction and maintenance of social differences, an approach that has been clearly charted by Jonathan Alexander.[23] We have to conclude that the silent lay people of the period between 1140 and 1240 were neither as devoid of spirituality as St Bernard feared, nor as totally committed to the cult of the Virgin as Bishop Hugh of Rouen claimed.

The clearest indication of disapprobation is iconoclasm, but it was severely punished as heresy prior to the Reformation and thus quite rare. One of the charges against the Templars who were burned early in the fourteenth century is that they defiled the cross.[24] As with the later Lollards and Hussites, we are plunged into issues concerning devotion that verged on *latria* (worship) on one hand, and a profound skepticism about mere carvings on the other.[25] Sarah Stanbury uses the desecration and burning of a wooden statue of St Katherine by alleged Lollards, as described in Henry Knighton's Chronicle of 1337–96, to

elucidate these tensions, and notes a new source of anxiety, the beginnings of a market for such costly objects.[26] Eamon Duffy has shown how dynamic were the relationships between people of various ranks, and the cross or crucifixion: they prayed to it in private and in churches for miracles, they bowed before it, they used Christ's sufferings to come to terms with their own, and were often buried with it.[27] This quintessential Christian icon was so revered that disrespect for it was punished by burning the iconoclast, but in this exchange the crosses were eventually stripped from the churches and burned by the Protestants, as pointed out by Margaret Aston.[28]

During the High Middle Ages occasional censorship of images was accompanied by a decree of the church. Michael Camille has pointed to the Y-shaped cross and to the "Vierge Ouvrante" with the Trinity inside her as instances of unacceptable representations.[29] The former may have been of the type mentioned as having produced a frenzy of popular devotion in a village near London in 1306, such that the churchmen decided to hide it away. This is a very interesting case, showing that the Church struggled to maintain control over the use and form of images. In the fifteenth century Jean Gerson criticized the opening Virgin statues for a theological error that made it appear as though Mary gave birth to God the Father and the Holy Spirit as well as Christ. In 1502 a bishop declared a painting of Joachim and Anna kissing when she greeted him at the Golden Gate to be heretical, because it lent support to popular belief held that the kiss, rather than a miracle, made her pregnant with the Virgin Mary.[30]

Prudishness was on the increase during the later Middle Ages. Despite a considerable tolerance of – even liking for – scatology in texts and representations, there are instances of bowdlerism such as the erasure of genitalia that may be expressions of fear or disgust on the part of some medieval viewer.[31] Such actions hint at a gulf between the Western theological position on images that did not allow them, as mere signs, any power in themselves, and popular beliefs that attributed magic-working powers to them as if they were the referent. There is a growing literature on the power of images that invited destructive as well as devotional acts.[32] The institutionalization of ritual curses directed at relics when they failed to answer people's prayers was revealed by Patrick Geary, and the discovery aided our understanding of the process of embellishing reliquaries in order to empower the relics.[33]

In fact, the attitudes to the material objects made for the cult of saints have received much attention.[34] Ilene Forsyth's book on portable wooden sculptures of the Virgin and Child was a precursor. Although she does not emphasize reception, her chapter on "Function" cites medieval texts to indicate their occasional use as reliquaries, and their roles in devotional practices, religious processions, and secular rituals.[35] The reliquary statue of St Foi that resided in her church in Conques has become a paradigmatic case-study, and the literature on it also indicates how such interest can change the canon (fig. 3-1). St Foi stubbornly resisted any focus on a moment of creation, since she is a composite

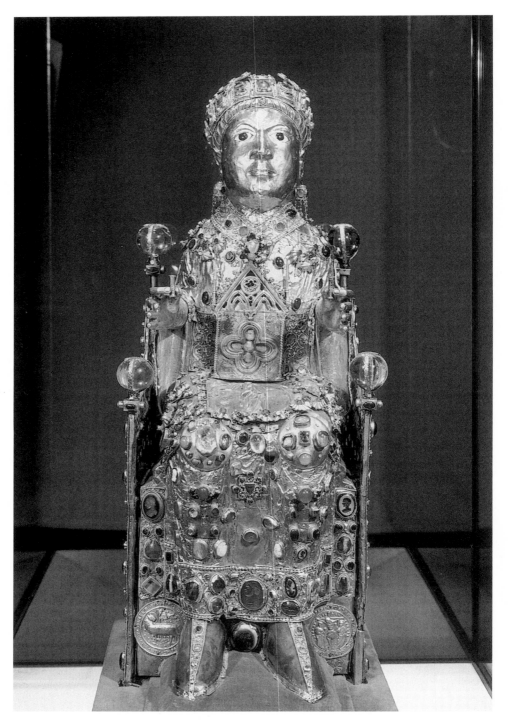

FIGURE 3-1 Reliquary statue of St Foi (St Faith), ninth/tenth century, with additions. Conques Abbey, treasury. Photo: Erich Lessing/Art Resource, NY.

work, an assemblage built up on a Roman core with accretions of gemstones throughout the Middle Ages that constitute a material record of reception. Her archaeology has now been firmly established by Jean Taralon.[36] But it is in the area of reception that the most impressive work has been done. In a series of articles and books, Pamela Sheingorn and Kathleen Ashley have elucidated the role played by this reliquary statue in local ritual and belief systems, as indicated in her life and miracle book.[37] Bernard of Angers, who wrote the first two books of the miracles some time after 1010, explained in a letter to Bishop Fulbert of Chartres – which serves as a preface – that he went to Conques full of skepticism "partly because it seemed to be the common people who promulgated these miracles and partly because they were regarded as new and unusual."[38] He also feared that statues such as hers were idols worthy of Jupiter or Mars.[39] The texts in the *Book of Sainte Foi* give innumerable insights into the powers that people believed were invested in the relics and their precious encasing, and reveal the strength of belief in the necessity of its presence for cures, and even for civil transactions. The case has now passed into at least one introductory textbook.[40]

Medieval imagery has been a constant source of puzzlement and revelation to modern scholars, but it is only recently that there has been much focus on the ways in which the original devotees actually understood it. Decoding a work of art implies an encoding. Traditional iconography assumed that the two processes inevitably mirrored each other, as if meanings were fixed in the object. Deconstruction assumed they would not, and that each decoding brings new meanings. But to what extent did the iconographic conventions of medieval art ensure a degree of common response among an informed community of viewers? We cannot make the assumption that the silences surrounding reception in the High Middle Ages indicate some sort of transparency that merely allowed works to speak for themselves. A sculpture of the Virgin and Child may have been widely recognized as Mary and Jesus, but for some viewers a knowledge of Latin texts would add layered theological meanings, of a kind that have been elucidated by Adolf Katzenellenbogen for the Marian programs of Chartres Cathedral.[41] A widespread tradition of twelfth-century exegesis constructed four levels of meaning for sacred symbols.[42] In this case, a highly educated person of the time could distinguish an immediate physical signification (the historical Mary and Jesus), an allegorical one (she is the Seat of Wisdom that had been associated with King Solomon), a moral or tropological level (she is the life-giving Church), and an association with eternal salvation such as that she will be crowned by Christ in heaven and mediate his judgment at the end of time.[43] Thus about the time modern semioticians were arguing for the multivalence of the sign, medievalists were positing multivalence based on medieval theories of reading.

However, keeping in mind the example "Virgin and Child," postmodern scholars have been concerned with a different kind of multivalence, arising from resonances that may be specific to various medieval viewing communities. Contextual art history provided a major step toward the exploration of medieval

audiences, as in Linda Seidel's pioneering article on the view canons might have taken of a sculpted figure of Salome.[44] In studying the medieval cult of the Virgin, Marina Warner took into consideration the ways in which its ideology would inflect the lives of real women.[45] She suggested that the unique status of Mary, as virgin and mother, could serve neither ordinary mothers nor ordinary nuns as a role model. And in the eyes of men, the Virgin Mary represented an ideal unattainable by real women who were thus always seen to fall short. On the other hand, I have suggested that there were other learned – as opposed to learnèd – responses to this serenely seated female figure with an infant on her lap: To a pregnant or recently birthed mother approaching a portal such as the one on the west façade of Chartres Cathedral, the Virgin's seated position with knees wide apart could connote safe and painless birthing.[46] Such responses cannot be proven by texts concerning the Virgin Mary (although of course she was prayed to for fertility and safe birthing), but they can be supported from images of birthing and by non-theological discourses such as that of gynecology. Construction of a woman's viewing position has also informed Kathleen Nolan's study of the mothers whose grief is vividly depicted in the scene of the massacre of the innocents; in this case they may be supposed to have provided a model for performative identification, at the same time covertly condemning women in the community who heartlessly committed infanticide.[47]

Yet another dimension has been added to French Gothic portal sculpture and stained glass by studies of the liturgy, especially the ordinaries or processionals.[48] Analyses such as those by Margot Fassler serve to situate these works at Chartres in a performative space, where cyclic rituals animate them on a temporary basis, much as the later altarpieces were successively opened and closed during the liturgical year.[49] This hermeneutic posits meanings that are constructed in specific viewing contexts. The works were interactive with their audience, a function that is more easily grasped in relation to the smaller pieces that were taken from the sacristy only during the feasts of the Church. One such example, once in the treasury of St Denis, is the elaborate enameled base whose Old Testament scenes were completed by New Testament antitypes when the processional cross was placed in it.[50] Yet for liturgical objects, it has to be remembered how elitist the user-group was, restricted in fact to the priesthood, with a viewing community of those in close proximity to the altar. The eyes of the laity were diverted from the High Altar that was used for daily mass by choir screens that divulged little of the mystery. The objects most gloated over by Abbot Suger were seen by very few, just as his text justifying the expenditures on them was scarcely read in the Middle Ages. Konrad Hoffmann long ago suggested that the famous stained-glass windows that gave "new light" to his choir were so esoteric that their primary function may have been for learned contemplation by the monastic community that had the possibility of studying the Latin verses painted in them.[51] Some of these inscriptions reiterated the sung text that they knew from the liturgy, and one window seems to have been moved up from the crypt in the thirteenth century so that it could be included in processions (fig. 3-2).[52]

FIGURE 3-2 The Apotheosis of St Benedict, *c*.1144, from the Abbey Church of
St Denis; the scroll is inscribed with a verse from his mass. Paris: Musée national du
moyen âge – thermes et hôtel de Cluny. Photo: Réunion des musées nationaux/
Art Resource, NY.

Yet stained glass was such a monumental and brilliant medium that it could resonate on a less learned level for a wider audience. Vast Gothic windows lent themselves to elaborate narratives that seldom had any text for identification of the events. Wolfgang Kemp used the term "sermo corporeus" to invoke the materiality of stained glass as a medium for preaching.[53] In a sermon written in about the mid-thirteenth-century, Cardinal Eudes de Châteauroux recalled that as a child a layman explained to him the misfortunes of the man saved by the Good Samaritan, as represented in a window.[54] Kemp explored a wide range of visual signs that made it possible to "read" such a window without recourse to a text. My own study of biblical windows, notably those that expand on the story of Joseph in Egypt, goes in the same direction.[55] Michael Camille made another major contribution to this question by considering the different attitudes and experience of illiterate and literate people in the presence of art.[56] Even those who could not read might be impressed by inscriptions, yet he argues that the largely illiterate audiences of the High Middle Ages believed pictures more readily than writings, and respected books as objects.

Several scholars have raised another very significant problem of alterity: Is our visual perception the same as that of medieval people? A propos Abbot Suger's St Denis, both Meredith Lillich and John Gage pointed out that the blue glass extolled in Suger's text would have been regarded by a learned audience as next to black; Lillich ingeniously suggests it was a conscious reference to the version of Pseudo-Dionysius the Areopagite's treatise that was probably known in St Denis, which posited Divine Darkness as the necessary corollary of Divine Light.[57] Suger's use of the term *clarus* for light/bright in relation to his windows has also been re-evaluated in the context of medieval theories of transparency.[58] Yet modern notions of the wavelength of different colors, complimentary colors, and the impact of reduced light or distance on hue, have also been deemed relevant to the perception of medieval stained glass.[59] We are not yet in a position to resolve the contradiction between the learned belief that blue was the darkest color in some absolute sense and Purkinje's empirical finding that a shift occurred in reduced light whereby blue appears brighter than red.[60] Is it possible that theological truth overrode optical events that we take to be scientifically true? The discussion has shifted from optics to visuality, such that Michel Pastoureau recently referred to color perception as a "complex cultural construct."[61]

There may have been other fundamental differences that framed medieval perceptions of images, as indicated in the range of essays in a recent collection published by Robert Nelson.[62] Camille pointed out that medieval visuality assumed an impact on the viewer much stronger than the mere perception of form and color; through extramission, the viewer risked being enthralled or fascinated, which had almost as threatening connotations as being bewitched, or even of becoming like the object of view.[63] Suzannah Biernoff has written the first history of medieval sight and vision (as distinct from optics) that takes alterity fully into account, coining the term "carnal vision."[64] I have adapted

gaze theory to medieval frameworks, even though it originated with Laura Mulvey's application of Freudian precepts to gendered viewing in the context of modern cinema.[65] It provided rich ground to look at hegemonic viewing situations in the High Middle Ages, and to understand some of the fears surrounding sight(s).

A mnemonic function for images is more intuitive to a present-day audience, since we are familiar with it in our textbooks. Mary Carruthers's extensive work on medieval textual practices, and the attention she paid to images in books, was paralleled by art historians such as Suzanne Lewis, who pursued the question in relation to visual recall.[66] Yet it has been more popular to see images as aids to devotion. Hans Belting, Nigel Morgan, and Jeffrey Hamburger are among those who have consistently used late medieval texts to elucidate this practice.[67] Hamburger has studied the use of images in the "pastoral care" of nuns (*cura monialium*) as evoked by the writings of a Dominican, Henry Suso. He is at pains to identify the different communities who would have had access to this text (orally or otherwise), and to indicate its value for nuns.[68] His study of the medieval reception history of a Byzantine icon, as recounted in the *Liber miraculorum* of Unterlinden is even more clearly focused.[69] In a more recent article he reexamined the use of two images from Hildegard of Bingen's *Scivias* by Joannis Tauler, whose sermon was preached to Dominican nuns in Cologne in 1339.[70] Tauler's text leaves little doubt about the expectation that such visionary images, even 150 years after their making, could lead the viewer's mind away from worldly things to higher truths, and to a higher state of consciousness. Suger had made the same claim for his precious, jeweled furnishings 200 years earlier, but the concept is elaborated by Tauler.[71]

A disadvantage of this approach is that it once more emphasizes the orthodox religious aspect of medieval visual culture, and privileges texts over images – as Mâle's generation had done. This logocentrism is exacerbated when there is a gender distinction between the (male) author of an oral guide and the (female) audience for the image; we should not assume that this was a one-way channel for ideas.[72] The example of Tauler suggests the extent to which these preachers garnered inspiration from the writings and pictures produced by saintly women "mystics," so they, as much as the women, deserve to be analyzed as a viewing community.

Postmodern readings allow for reactions to "devotional images" that medieval and modern discourses have suppressed. Examined against the dominant culture, they may be viewed as pornographic, erotic, sadoerotic, abject, or masochistic. The humorous has often been added for marginalia. One example of such divergent readings must suffice here, though it is part of a larger enterprise to "queer" the Middle Ages: Whereas Morgan and Hamburger insist on the gaping side wound of Christ as only-a-bleeding-wound, Karma Lochrie and I have associated it with a life-giving vulva, especially when it is isolated from his body (fig. 3-3).[73] Even though Hamburger allows a sexual attraction between Catherine of Siena adoring a bloodied Christ on the cross, his phrasing

FIGURE 3-3 Christ's side wound and instruments of the Passion, Psalter, and Prayer Book of Bonne of Luxembourg, probably before 1349. New York: The Metropolitan Museum of Art, The Cloisters Collection, 69.86, fol. 331r. Photo: The Metropolitan Museum of Art.

FIGURE 3-4 St Catherine sucking Christ's side wound, Raymund of Capua, *Life of St Catherine of Siena*, fifteenth century. Paris: Bibliothèque nationale de France, MS All. 34, f. 43v. Photo: Bibliothèque nationale de France.

as "a nubile woman passionately devoted to Christ" vigorously suppresses the possibility of a homosexual attraction; but when she sucks the side wound, he can "imagine why reformers seem to have preferred that most manuscripts of St. Catherine's *Vita* remained without illustrations" (fig. 3-4).[74] Lochrie's reading of texts and images plausibly argues "an open mesh of polysemy"; a Franciscan treatise known as the *Stimulus Amoris* refers to the union (*copulo*) of mouth and wound, queering the reading. Once more, a pioneering contextual study by Ilene Forsyth had opened up the question of homosexual desire in the monasteries.[75]

One other category of medieval art cannot be left out, because its multivalence and openness has made it one of the most contested: Images in the margins, whether of manuscript pages, embroideries, portals, stained-glass windows, ivories, or choir stalls. These motifs were not always in the service of a text, but the debate as to whether or not they had higher meanings for their audience was engaged in the nineteenth century.[76] Some modern exegetes claimed the margins as a zone for dialogic laughter, unconscious doodles, or pagan survivals.

Recent trends epitomize the available models for constructing medieval reception: universal, community-based, or individual. It is the latter that I want to emphasize in closing.

In an article on the Hours of Jeanne d'Evreux published in 1993 I presented a construction of an individual pubescent girl's reading of the images in the book given to her around the time of her marriage to a much older king in 1324.[77] Jonathan Culler's notion of "reading as a woman" had usefully suggested that resisting readings are not easily produced (or subjective), but are the result of a conscious act of constructing oneself as a reader.[78] However, his project was suspect since it risked essentializing "women" as a monolithic community. Hence my aim was to "imagine" the impact of this imagery on Jeanne at the age of 14, given her background and education, and the specific context of the Capetian court at the time. That the laughter we had all so long enjoyed at the exploits of hybrid creatures in the margins could be displaced by fear and revulsion was not at first popular. Yet the model has proved useful in other case-studies, such as Anne Rudloff Stanton's work on the Psalter of Isabelle (Jeanne's sister-in-law).[79] Several scholars' findings extend convincingly to the choices of religious subjects, that operated like *exempla* in sermons, as Lilian Randall long ago argued.[80] Yet if we posit a confessor as designer and mediator of the work, have we come full circle to regard reception by the owner as the mirror of intention? What distinguishes current notions of reception is a willingness to allow for shifting and contrary readings, and to speculate about subversive elements.[81]

Notes

1 Reader-response criticism, or affective stylistics, originated in *Rezeptionsästhetik* in the early 1960s Konstanz school. Its early history has been outlined by Paul de Man in the introduction to the translation of one of the works most concerned with history, Jauss, *Toward an Aesthetic of Reception*, pp. vii–xxix. Jauss's chapter "Art History and Pragmatic History" appeals for "a history of art that is to be based on the historical functions of production, communication, and reception, and is to take part in the process of continuous mediation of past and present art" (p. 62).

2 "Introduction," to Bryson et al., *Visual Culture*, p. xvii.

3 Malina, "Reader-Response Criticism," and Rabinowitz, "Reader-Response Theory" give very clear synopses of various approaches to the construction of meaning. For my purposes, "texts" as discussed by literary critics are interchangeable with "images."

4 Bennett, ed., *Readers and Reading*, pp. 4, 6–15, has outlined the directions taken by textual critics in the 1990s, when many did problematize the notion of a universal reader by positing responses by contemporary groups, such as women, and to some degree by historical audiences. This anthology contains a useful list of "Key Concepts" (pp. 235–40), and suggestions for "Further Reading" (pp. 241–53). See also Malina, "Reader-Response Criticism."

5 Malina, "Reader-Response Criticism," p. 338. A fuller account of the German contributions to the field of reception history and theory is given by Geert Lernout, "Reception Theory," in Groden and Kreiswirth, eds., *The Johns Hopkins Guide*, pp. 610–11.

6 Mâle, *L'Art religieux*, pp. 168–70, 174–5. Suger, *De Administratione* 27, pp. 46–8, commentary pp. 164–5. In order to ground this theoretical discussion, I will refer a range of interpretive strategies to this example of North European art.

7 Watson, "Suger and the First Tree of Jesse," pp. 77–82; Kidson, "Panofsky, Suger and St Denis."

8 Heslop, "Attitudes to the Visual Arts."

9 Coomaraswamy, "Medieval Aesthetic"; de Bruyne, *Ètudes d'esthétique Médiévale*, esp. II, pp. 69–107.

10 Schapiro, "On the Aesthetic Attitude," p. 2.

11 Eco, *Art and Beauty*. This is despite his wish to separate aesthetic theories from "the realities of the age" (p. 1).

12 Krautheimer, "Introduction to an Iconography."

13 Caviness, *Sumptuous Arts*, pp. 23–6, 36–7.

14 Gervase, "History of the Burning." Interestingly, his translator finds it necessary to apologize for this viewpoint (p. xiii), but does not challenge Gervase's view – one suspects not only as a gesture to historicity but also because the contemporary High Anglican movement in Britain valued hagiography.

15 Suger, *De Administratione* 33, p. 64. [On pilgrimage art, see chapter 28 by Gerson in this volume (ed.).]

16 Cragoe, "Reading and Rereading Gervase."

17 Characteristic arguments are included in Mango, *The Art of the Byzantine Empire*, pp. 149–77; and Davis-Weyer, *Early Medieval Art*, pp. 37–49.

18 Rudolph, *The Things of Greater Importance*, pp. 10–12, 232–87 (Latin and English).

19 Ibid., pp. 10, 278–81.

20 Critical comments on the new constructional style, by Alexander Neckham and Peter the Chanter who would have been in Paris when Notre-Dame was being rebuilt, are given in translation by Frisch, *Gothic Art*, pp. 30–3.

21 [On patronage, see chapter 9 by Caskey in this volume (ed.).]

22 Frisch, *Gothic Art*, p. 25; cf. Abou-el-Haj, "Artistic Integration," p. 221.

23 Alexander, "Art History."

24 Caviness, "Iconoclasm and Iconophobia," p. 100, with sources.

25 Kamerick, *Popular Piety and Art*, esp. pp. 13–42 for disputes concerning the Lollards.

26 Sarah Stanbury, "The Vivacity of Images," pp. 131–50.

27 Duffy, "Devotion to the Crucifix," pp. 21–5.

28 Aston, "Iconoclasm in England," p. 183.

29 Camille, *Gothic Idol*, pp. 231–2. Heslop, "Attitudes to the Visual Arts," p. 26, has more details about the problematic crucifix.

30 Molanus, *De historia SS*, p. 393.

31 Camille, "Obscenity under Erasure"; Caviness, "Obscenity and Alterity."

32 Freedberg, *The Power of Images*; Caviness, "Iconoclasm and Iconophobia," pp. 99–100.

33 Geary, "Humiliation of Saints."

34 See for instance the articles in *Gesta* 36 (1997), with bibliography.

35 Forsyth, *Throne of Wisdom*, pp. 31–60.

36 Taralon, "La Majesté d'or."

37 Ashley and Sheingorn, *Writing Faith*, "Sainte Foy on the Loose"; "An Unsentimental View"; Sheingorn, *The Book of Sainte Foy*.

38 Sheingorn, *The Book of Sainte Foy*, p. 39.

39 Ibid., p. 77.

40 Diebold, "Brother, What Do You Think?" pp. 139–48.

41 Katzenellenbogen, *The Sculptural Programs*, pp. 9–12, 15, 56–67, 95–102. [For more on Gothic sculpture in general and the sculpture of Chartres Cathedral in particular, see chapter 19 by Büchsel in this volume (ed.).]

42 Caviness, *Art in the Medieval West*, p. xxx, chs. 2 and 3. [For more on art and exegesis, see chapter 8 by Hughes in this volume (ed.).]

43 Although I know of no single text that provides all these readings, each one is repeated in different contexts, often in anthems and hymns to Mary.

44 Seidel, "Salome and the Canons."

45 Warner, *Alone of All Her Sex*, esp. part 5.

46 Caviness, *Visualizing Women*, p. 8, figs. 5–7.

47 Nolan, "Ploratus et Ululatus."

48 Sauerländer, "Reliquien, Altäre und Portale"; Caviness, "Stained Glass Windows." [On sculptural programs and stained glass, see chapters 21 and 26 by Pastan and Boerner respectively in this volume (ed.).]

49 Fassler, "Liturgy and Sacred History"; "Mary's Nativity." Pioneering work on the functions and settings of altarpieces was done by van Os, *Sienese Altarpieces 1215–1460: Form, Content, Function, I: 1215–1344; II: 1344–1460*.

50 Suger, *De Administratione* 32, p. 58.

51 Hoffmann, "Suger's 'Anagogisches Fenster'."

52 Caviness, "Stained Glass Windows," pp. 135–9.

53 Kemp, *Sermo Corporeus*; translated as *Narratives of Gothic Stained Glass*.

54 Kemp, *Narratives*, pp. 71–2. [For more on narrative, see chapter 4 by Lewis in this volume (ed.).]

55 Caviness, "Biblical Stories in Windows."

56 Camille, "Seeing and Reading"; "Visual Signs of the Sacred Page."

57 Lillich, "Monastic Stained Glass"; Gage, "Gothic Glass."

58 Vasiliu, "Le Mot et le Verre."

59 Frodl-kraft, "Farbsprache"; Johnson, *Radiance of Chartres*, pp. 16–24.

60 Caviness, "Stained Glass Windows," p. 140.

61 Gage, "Colour in History"; Pastoureau, *Blue*, p. 7. [On vision, see chapter 2 by Hahn in this volume (ed.).]

62 Nelson, ed., *Visuality*, notably the pieces by Nelson, Hahn, and Camille.

63 Camille, *Gothic Idol*, pp. 23–4; Huët, "Living Images." A pioneer in the understanding of extramission as an optical theory was Lindberg, *Studies in the History of Medieval Optics*, esp. ch. 4.

64 Biernoff, *Sight and Embodiment*.

65 Caviness, *Visualizing Women*, with extensive bibliographies.

66 Carruthers, *Book of Memory*, notably ch. 7, "Memory and the Book," pp. 221–57. See also Carruthers, *The Craft of Thought*; Lewis, *Reading Images*, pp. 242–59.

67 Belting, "In Search of Christ's Body," esp. pp. 377–490. Belting's earlier pioneering work, much of it addressing the function of icons in the West, cannot be dealt with adequately here. See Belting, *The Image and Its Public*.
68 Hamburger, *The Visual and the Visionary*, pp. 198–278.
69 Ibid., pp. 279–315.
70 Hamburger, "Various Writings of Humanity."
71 Suger, *De Administratione* 33, pp. 60–2.
72 [On medieval art and gender, see chapter 6 by Kurmann-Schwarz in this volume (ed.).]
73 Morgan, "Longinus and the Wounded Heart"; Hamburger, *The Visual and the Visionary*, pp. 140–3, fig. 2.22; Caviness, *Visualizing Women*, pp. 158–62, fig. 74; Lochrie, "Mystical Acts," fig. 9.2.
74 Hamburger, *The Visual and the Visionary*, pp. 460–4, figs. 9.20, 9.22, Pl. V.
75 Forsyth, "The Ganymede Capital at Vézelay."
76 An overview of this literature, up to the present time, is available in my e-book: Caviness, *Reframing Medieval Art*, ch. 3, sect. "The Shivaree of the Margins." [For more on the marginal, see chapter 13 by Kendrick in this volume (ed.).]
77 Caviness, "Patron or Matron."
78 Culler, *On Deconstruction*, pp. 43–64. See Malina, "Reader-Response Criticism," with bibliography.
79 Stanton, "The Psalter of Isabelle"; Jones and Alexander, "The Annunciation to the Shepherdess."
80 Randall, "Exempla as a Source of Gothic Marginal Illumination."
81 For example: Camille, "Play, Piety and Perversity."

Bibliography

Barbara Abou-el-Haj, "Artistic Integration inside the Cathedral Precinct: Social Consensus Outside?" in Virginia Raguin, Kathryn Brush, and Peter Draper, eds., *Artistic Integration in Gothic Buildings* (Toronto, 1995), pp. 214–35.

Jonathan J. G. Alexander, "Art History, Literary History, and the Study of Medieval Illuminated Manuscripts," *Studies in Iconography* 18 (1997), pp. 51–66.

Kathleen M. Ashley and Pamela Sheingorn, *Writing Faith: Text, Sign and History in the Miracles of Sainte Foy* (Chicago, 1999).

——, "*Sainte Foy* on the Loose, or, the Possibilities of Procession," in Kathleen Ashley and Wim Hüsken, eds., *Moving Subjects. Processional Performance in the Middle Ages and the Renaissance* (Amsterdam and Atlanta, Ga., 2001), pp. 53–67.

——, "An Unsentimental View of Ritual in the Middle Ages or, Sainte Foy Was No Snow White," *Journal of Ritual Studies* 6:1 (Winter 1992), pp. 63–85.

Margaret Aston, "Iconoclasm in England: Rites of Destruction by Fire," in Bob Scribner, ed., *Bilder und Bildersturm im Spätmittelalter und der frühen Neuzeit* (Wiesbaden, 1990).

Hans Belting, *The Image and Its Public in the Middle Ages: Form and Function of Early Paintings of the Passion*, trans. Mark Bartusis and Raymond Meyer (New Rochelle, 1990).

——, "In Search of Christ's Body. Image or Imprint?" In Herbert Kessler and Gerhard Wolf, eds., *The Holy Face and the Paradox of Representation: Papers from a Colloquium*

Held at the Bibliotheca Hertziana, Rome and the Villa Spelman, Florence, 1996 (Bologna, 1998), p. 340.

Andrew Bennett, ed., *Readers and Reading* (London, 1995).

Suzannah Biernoff, *Sight and Embodiment in the Middle Ages* (Basingstoke, 2002).

Nicolas Bock, Sible de Blaauw, Christophe Luitpold Frommel, and Herbert Kessler, eds., *Kunst und Liturgie im Mittelalter*, vol. 33, supplement, *Römisches Jahrbuch der Bibliotheca Hertziana* (Munich, 2000).

Norman Bryson, Michael Ann Holly, and Keith P. F. Moxey, *Visual Culture: Images and Interpretations* (Hanover, NH, 1993).

Michael Camille, *The Gothic Idol: Ideology and Image-Making in Medieval Art*, Cambridge New Art History and Criticism (New York, 1989).

——, "Obscenity under Erasure: Censorship in Medieval Illuminated Manuscripts," in Jan M. Ziolkowski, ed., *Obscenity: Social Control and Artistic Creation in the European Middle Ages* (Leiden, 1998), pp. 139–54.

——, "Play, Piety and Perversity in Medieval Marginal Manuscript Illumination," in Katrin Kröll and Hugo Steger, eds., *Mein ganzer Körper ist Gesicht: Groteske Darstellungen in der Europäischen Kunst und Literatur des Mittelalters* (Freiburg im Breisgau, 1994), pp. 171–92.

——, "Seeing and Reading: Some Implications of Medieval Literacy and Illiteracy," *Art History* 8 (1985), pp. 26–49.

——, "Visual Signs of the Sacred Page: Books in the *Bible Moralisée*," *Word & Image* 5:1 (1989), pp. 111–30.

Mary Carruthers, *The Book of Memory: A Study of Memory in Medieval Culture*, ed. Alastair Minnis, Cambridge Studies in Medieval Literature (Cambridge, UK, 1990).

——, *The Craft of Thought: Meditation, Rhetoric, and the Making of Images, 400–1200*, Cambridge Studies in Medieval Literature, vol. 34 (Cambridge, UK, 1998).

Madeline H. Caviness, *Art in the Medieval West and Its Audience*, Variorum Collected Studies 718 (Aldershot, UK, 2001).

——, "Biblical Stories in Windows: Were They Bibles for the Poor?" In B. S. Levy, ed., *The Bible in the Middle Ages* (Binghamton, 1992), pp. 103–47.

——, "Iconoclasm and Iconophobia: Four Historical Case Studies," *Diogenes* 50:199 (2003), pp. 99–114.

——, "Obscenity and Alterity: Images That Shock and Offend Us/Them, Now/Then?" In Jan M. Ziolkowski, ed., *Obscenity: Social Control and Artistic Creation in the European Middle Ages* (Leiden, 1998).

——, "Patron or Matron: A Capetian Bride and a *Vade Mecum* for Her Marriage Bed," *Speculum* (1993), pp. 333–62.

——, *Reframing Medieval Art: Difference, Margins, Boundaries* (Medford, 2001), <http://Nils.Lib.Tufts.Edu/Caviness>.

——, "Stained Glass Windows in Gothic Chapels, and the Feasts of the Saints," in Nicolas Bock, Sible de Blaauw, Christophe Luitpold Frommel, and Herbert Kessler, eds., *Kunst und Liturgie im Mittelalter*, vol. 33, supplement, *Römisches Jahrbuch Der Bibliotheca Hertziana* (Munich, 2000), pp. 135–48.

——, *Sumptuous Arts at the Royal Abbeys in Reims and Braine* (Princeton, 1991).

——, *Visualizing Women in the Middle Ages. Sight, Spectacle and Scopic Economy* (Philadelphia, 2001).

Ananda Coomaraswamy, "Medieval Aesthetic," *The Art Bulletin* I (1935), pp. 31–47.

Carol Davidson Cragoe, "Reading and Rereading Gervase of Canterbury," *Journal of the British Archaeological Association* 154 (2001), pp. 40–53.

Jonathan Culler, *On Deconstruction: Theory and Criticism after Structuralism* (Ithaca, 1982).

Caecilia Davis-Weyer, *Early Medieval Art 300–1150: Sources and Documents* (Toronto, 1986).

Edgar de Bruyne, *Etudes d'esthetique Médiévale* (Bruges, 1946).

William J. Diebold, "Brother, What Do You Think of This Idol?" In *Word and Image. An Introduction to Early Medieval Art* (Boulder, 2000), pp. 139–48.

Jeremy Dimmick, James Simpson, and Nicolette Zeeman eds., *Images, Idolatry, and Iconoclasm in Late Medieval England* (Oxford, 2002).

Eamon Duffy, "Devotion to the Crucifix and Related Images in England on the Eve of the Reformation," in Bob Scribner, ed., *Bilder und Bildersturm im Spätmittelalter und in der frühen Neuzeit* (Wiesbaden, 1990), pp. 21–35.

Umberto Eco, *Art and Beauty in the Middle Ages* (New Haven, 1986).

Margot Fassler, "Liturgy and Sacred History in the Twelfth-Century Tympana at Chartres," *Art Bulletin* LXXV (1993), pp. 499–520.

——, "Mary's Nativity, Fulbert of Chartres, and the *Stirps Jesse*: Liturgical Innovation Circa 1000 and Its Afterlife," *Speculum* 75 (2000), pp. 389–434.

Ilene H. Forsyth, "The Ganymede Capital at Vézelay," *Gesta* 15 (1976), pp. 241–6.

——, *The Throne of Wisdom: Wood Sculptures of the Madonna in Romanesque France* (Princeton, NJ, 1972).

David Freedberg, *The Power of Images: Studies in the History and Theory of Response* (Chicago and London, 1989).

Teresa G. Frisch, *Gothic Art 1140–c.1450: Sources and Documents* (Toronto, 1987).

E. Frodl-kraft, "Die Farbsprache der gotischen Malerei," *Wiener Jahrbuch für Kunstgeschichte* 20/21 (1977–8), pp. 90–178.

John Gage, "Colour in History: Relative and Absolute," *Art History* 1 (1978), pp. 104–9.

——, "Gothic Glass: Two Aspects of a Dionysian Aesthetic," *Art History* 5 (1982), pp. 36–58.

Patrick J. Geary, "Humiliation of Saints," in Stephen Wilson, ed., *Saints and Their Cults: Studies in Religious Sociology, Folklore, and History* (Cambridge, 1983), pp. 123–40.

Gervase, "History of the Burning and Repair of the Church of Canterbury," in Robert Willis, ed., *The Architectural History of Canterbury Cathedral* (London, 1845), p. 42.

Michael Groden and Martin Kreiswirth, eds., *The Johns Hopkins Guide to Literary Theory and Criticism* (Baltimore and London, 1994).

Jeffrey F. Hamburger, "The 'Various Writings of Humanity': Johannes Tauler on Hildegard of Bingen's Liber Scivias," in Kathryn Starkey and Horst Wenzel, eds., *Visual Culture and the German Middle Ages* (New York, 2005), pp. 161–205.

——, *The Visual and the Visionary: Art and Female Spirituality in Late Medieval Germany* (New York, 1998).

T. A. Heslop, "Attitudes to the Visual Arts: The Evidence from Written Sources," in Jonathan Alexander and Paul Binski, eds., *Age of Chivalry: Art in Plantagenet England 1200–1400* (London, 1987), pp. 26–32.

Konrad Hoffmann, "Suger's 'Anagogisches Fenster' in Saint-Denis," *Wallraf-Richartz Jahrbuch* (1910), pp. 57–88.

Marie-Hélène Huët, "Living Images: Monstrosity and Representation," *Representations* 4 (1973), pp. 73–83.

Hans Robert Jauss, *Toward an Aesthetic of Reception*, trans. Timothy Bahti, ed. Wlad Godzich and Jochen Schiulte-Sasse. Vol. 2: *Theory and History of Literature* (Minneapolis, 1982).

James Rosser Johnson, *The Radiance of Chartres: Studies in the Early Stained Glass of the Cathedral*, vol. 4, Columbia University Studies in Art History and Archaeology (London, 1964).

Leslie C. Jones and Jonathan J. G. Alexander, "The Annunciation to the Shepherdess," *Studies in Iconography* 24 (2003), pp. 165–98.

Kathleen Kamerick, *Popular Piety and Art in the Late Middle Ages: Image Worship and Idolatry in England 1350–1500* (Basingstoke, 2002).

Adolf Katzenellenbogen, *The Sculptural Programs of Chartres Cathedral* (New York, 1964).

Wolfgang Kemp, *The Narratives of Gothic Stained Glass*, trans. Caroline Dobson Saltzwedel, Cambridge Studies in New Art History and Criticism (Cambridge, UK, and New York, 1997).

——, *Sermo Corporeus: Die Erzählung mittelalterlicher Glasfenster* (Munich, 1987).

Peter Kidson, "Panofsky, Suger and St Denis." *Journal of the Warburg and Courtauld Institutes* 50 (1987), pp. 1–17.

Richard Krautheimer, "Introduction to an Iconography of Medieval Architecture," in *Studies in Early Christian, Medieval and Renaissance Art* (New York, 1942), pp. 115–50, 392–409.

Suzanne Lewis, *Reading Images: Narrative Discourse and Reception in the Thirteenth-Century Illuminated Apocalypse* (Cambridge, 1995), esp. pp. 242–59.

Meredith Parsons Lillich, "Monastic Stained Glass: Patronage and Style," in Timothy G. Verdon, ed., *Monasticism and the Arts* (Syracuse, 1984), pp. 207–54.

David C. Lindberg, *Studies in the History of Medieval Optics* (London, 1983).

Karma Lochrie, "Mystical Acts, Queer Tendencies," in Karma Lochrie, Peggy McCracken, and James A. Schultz, eds., *Constructing Medieval Sexuality* (Minneapolis and London, 1977), pp. 180–200.

Emile Mâle, *L'Art religieux du XIIe siècle en France* (Paris, 1928).

Debra Malina, "Reader-Response Criticism," in Elizabeth Kowalski-Wallace, ed., *Encyclopedia of Feminist Literary Theory* (New York and London, 1997), pp. 338–9.

Cyril Mango, *The Art of the Byzantine Empire 312–1453: Sources and Documents* (Toronto, 1986).

J. Molanus, *De historia SS. Imaginum et picturam libror quatuor* (Louvain, 1771).

Nigel Morgan, "Longinus and the Wounded Heart," in *Wiener Jahrbuch Für Kunstgeschichte* (Köln, Weimar, 1993/4), pp. 507–18, 817–20.

Robert S. Nelson, ed., *Visuality Before and Beyond the Renaissance: Seeing as Others Saw* (Cambridge, 2000).

Kathleen Nolan, "'Ploratus et Ululatus': The Mothers in the Massacre of the Innocents at Chartres Cathedral," *Studies in Iconography* 17 (1996), pp. 95–141.

Henk van Os, *Sienese Altarpieces 1215–1460: Form, Content, Function, I: 1215–1344* (Groningen, 1984); *II: 1344–1460* (Groningen, 1990).

Michel Pastoureau, *Blue. The History of a Color* (Princeton, 2001).

Peter J. Rabinowitz, "Reader-Response Theory and Criticism," in Michael Groden and Martin Kreiswirth, eds., *The Johns Hopkins Guide to Literary Theory and Criticism* (Baltimore and London, 1994), pp. 606–9.

Lilian M. C. Randall, "Exempla as a Source of Gothic Marginal Illumination," *Art Bulletin* 39 (1957), pp. 97–107.

Conrad Rudolph, *The Things of Greater Importance: Bernard of Clairvaux's Apologia and the Medieval Attitude toward Art* (Philadelphia, 1990).

Willibald Sauerländer, "Reliquien, Altäre und Portale," in Nicolas Bock, Sible de Blaauw, Christophe Luitpold Frommel, and Herbert Kessler, eds., *Kunst und Liturgie im Mittelalter*, vol. 33, supplement, *Römisches Jahrbuch der Bibliotheca Hertziana* (Munich, 2000), pp. 121–34.

Meyer Schapiro, "On the Aesthetic Attitude in Romanesque Art (1947)," in *Selected Papers: Romanesque Art* (New York, 1977), pp. 1–27.

Linda Seidel, "Salome and the Canons," *Women's Studies* 11 (1984), pp. 29–66.

Pamela Sheingorn, *The Book of Sainte Foy* (Philadelphia, 1994).

Sarah Stanbury, "The Vivacity of Images: St Katherine, Knighton's Lollards, and the Breaking of Idols," in Jeremy Dimmick, James Simpson, and Nicolette Zeeman, eds., *Images, Idolatry, and Iconoclasm in Late Medieval England* (Oxford, 2002), pp. 131–50.

Anne Rudloff Stanton, "The Psalter of Isabelle, Queen of England 1308–1330: Isabelle as the Audience," *Word & Image* 18:1 (January–March 2002), pp. 1–27.

Suger, *Abbot Suger on the Abbey Church of St-Denis and Its Art Treasures*, ed. Erwin Panofsky, and Gerda Panofsky-Soergel, 2nd edn. (Princeton, 1979).

Jean Taralon, "La Majesté d'or de Sainte Foy de Conques," *Bulletin Monumental* 155 (1997), pp. 11–73.

A. Vasiliu, "Le Mot et le verre: une définition médiévale du Diaphane," *Journal des Savants* (Jan–June 1994), pp. 135–62.

Marina Warner, *Alone of All Her Sex: The Myth and the Cult of the Virgin Mary* (New York, 1983).

Arthur Watson, "Suger and the First Tree of Jesse," in *The Early Iconography of the Tree of Jesse* (Oxford, 1934), ch. VII, pp. 77–82.

Narrative

Suzanne Lewis

To launch an inquiry into the subject of narrative is to confront a formidable, exponentially expanding body of largely theoretical work. Notwithstanding the classical formulation of narrative as art in Aristotle's *Poetics*, most contemporary writers begin by asserting its universality, its presence, and indeed necessity in almost all human discourse, often quoting Roland Barthes's pivotal essay which eloquently pronounced: "Like life itself, it is there, international, transhistorical, transcultural."[1] If we can define narrative as "the representation of an event or a series of events,"[2] it is no wonder that "telling stories" occurs in almost infinitely diverse forms in literature, history, the visual arts (including film and comics), mass media, and ordinary conversation.

Although this all-encompassing view has recently re-emerged as increasingly more prevalent, foundational works on modern/postmodern narrative have been rooted in literary and linguistic theory under the rubric "Narratology," a sub-field of communication theory focused primarily on written or oral texts.[3] Within the parameters of narratology, the salient property of narrative is double structuring, that is, the story (*histoire*) and its telling (discourse or *récit*) by a narrator who may or may not be identified or present. Although grounded in semiotics, narratology itself is based on the premise of dichotomous time, creating multiple barriers to the study of narrative images which, even within picture cycles, are inherently fixed and static, and are thus constructed to be seen rather than read. Since, in the words of Wolfgang Kemp, "visual art sets out to be an agent of optimal, unconditional visibility,"[4] the analysis of pictorial narrative must of necessity center on the problematics of the spatialization of time. On the other hand, the anthropological studies of Claude Lévi-Strauss, the film studies of Seymour Chatman, and the work of Scott McCloud on comics laid the groundwork for the recent reintroduction of theoretical writing on pictorial narrative.[5] As we shall see, however, the study of story-telling in images has never been the exclusive domain of art historians, but rather, from the outset has been claimed by

a wide range of scholars in other fields, opening narrative to a number of inter-disciplinary approaches to encompass issues of communication and reception.[6]

Whereas the central task of art history is the study of visual images, the issue of "word and image" refocuses attention on the problematic relation of visual representation to language. As W. J. T. Mitchell points out, contemporary culture has rendered the interplay of word and image more volatile, complex, and pervasive, as well as more immediate and demanding: "Whatever else movies may be, they are clearly complex suturings of visual images and speech, sight and sound, and (especially in the silent era) image and writing."[7] What Richard Rorty characterized as the "linguistic turn" in the 1960s[8] has now shifted to what Mitchell has chosen to call "the pictorial turn," which he sees as emanating from Foucault's exposure of the rift between the discursive and the "visible," the crucial fault-line in the "scopic regimes" of modernity.[9]

Notwithstanding the recent paradigmatic shift to a renewed recognition of the power of images within the larger theoretical discourses on narrative, we are still left with Horace's ancient formulation, "Ut pictura poesis" and the modern problematic first explored in Lessing's mid-eighteenth-century *Laocoon*.[10] Nothing seems more obvious than his claim that literature is an art of time, painting an art of space. Since 1766, few critics have challenged Lessing's time–space dichotomy.[11] In response to the venerable query, "Can pictures tell a story?" the answer is still another "No."[12] But in the century-and-a-half since Lessing, the distinction between spatial and temporal arts has become relative, softened and blurred – witness the screen titles in silent film and comic-strip balloons. In a largely unsuccessful effort to break down the barriers between *Raum* and *Zeit*, Dagobert Frey in 1929 proposed another binary opposition by characterizing the Gothic method of representation as "successive" in its dominance of narrative *Streifenbild* against the notion of "simultaneous" unity developed in the Renaissance.[13]

The critical challenge came in 1960 when E. H. Gombrich shifted the locus of pictorial meaning from the visual image to the viewer's perception.[14] Although several decades lapsed before Gombrich's revolutionary step took hold, it was his probing of the spectator's cognitive apparatus that enabled us to link narrative meaning and interpretation within a framework of cognitive psychology and cultural conditioning.[15] Once the viewer entered the equation of narrator, story, and receptor, our theoretical understanding of pictorial narrative could be opened to a wider problematic and range of possibilities. Indeed, we now encounter the following seemingly unproblematic reversal of the process:

> Narrative is so much a part of the way we apprehend the world in time that it is virtually built into the way we see. . . . Even when we look at something as static and completely spatial as a picture, narrative consciousness comes into play. . . . This human tendency to insert narrative time into static, immobile scenes seems almost automatic, like a reflex action. We want to know not just what is there, but also what happened. . . . But even when we don't already know the specific story depicted

in a painting, we can still be tempted to look for a story. We have many narrative templates in our minds and, knowing this, an artist can activate one or another.[16]

In approaching the art of narrative in the Middle Ages, Stephen Nichols in his innovative work from 1983, argued that its revitalization in eleventh-century Europe functioned as a vital part of a larger ideological program,

> to make the past present to show that the present belonged to a coherent cosmogony, that it manifested a divine plan of the universe. The key to this plan lay in certain transcendent events in the past, particularly the Christ story, which [was] interpreted as revealing the whole trajectory of Salvation history, from the beginning to the end of the world.[17]

As Nichols further observes, medieval narrative is a closed system, a continuing image, "a specular reflection of humanity situated . . . within the larger order of the universe." Because no discursive system capable of being understood can emerge from a semiotic vacuum, it is essential for the art historian to benefit from the insights provided by scholars of medieval texts to establish traditional patterns of past discourse as a ground against which and from which the idea of an illustrated text was generated.[18] However, as Barbara Herrnstein Smith cautions, "for any particular narrative, there is no single basic story subsisting beneath it but rather an unlimited number of other narratives that can be constructed in response to it or perceived as related to it."[19] Operating within a belief system that regards time as the sequential revelation of God acting purposefully in history is the medieval conviction that every sequence of events that occurs is a "story," that all event have causality, meaning, and finality, although they are often known only to God.[20]

Although modern art historical investigations of narrative have been largely related to identifying the text(s) that generated the picture(s),[21] thus constituting a sub-field of iconography, the critical differentiating edge lies not in asking *what* is the text, but *how* images relate the story. Indeed, the earliest historiography of pictorial narrative springs from that very question, although its beginnings are rooted exclusively within the study of Early Christian and Byzantine art.

The art history of narrative begins in 1895 with the first systematic investigation and description of the episodic biblical stories in the sixth-century Vienna Genesis by Franz Wickhoff.[22] In his attempt to establish a system of classification, Wickhoff defined three basic methods of telling stories in pictures: (1) "complementary" in which events before and after a unit scene are indicated without repeating characters within a single frame; (2) "epic" representation of an isolated dramatic moment; and (3) "continuous" in which successive episodes and characters are repeated within an ongoing space. Derived from ancient roll illustration or the spiraling events on a Roman triumphal column, Wickhoff's "continuous" narrative is characterized as a flow of images, like a stream of text.[23] As Karl Clausberg remarks, it is no accident that the earliest optical

analysis of pictorial narrative appears at the same time as the emergence of the first moving pictures at the end of the nineteenth century.[24]

Wickhoff's terminology remained current in art historical practice until 1947, when Kurt Weitzmann revised the stylistic categories of narrative form as "polyscenic/cyclical" versus "monoscenic," arguing that Wickhoff's "continuous" method of picture-writing was merely a bringing together of single vignetted scenes without creating a sense of moment through an interior dynamic of pictorial language.[25] In terms of our current transactional approaches, however, Weitzmann's challenge failed to produce substantive results for the future. As Wolfgang Kemp points out, although the early analysis of pictorial narratives was much further advanced than that of literary narratives, it remained fixed in an obstructive kind of formalism into the 1970s.[26]

Such a sweeping dismissal of formalism in dealing with visual narrative must, however, be tempered by a recognition of the ground-breaking innovations of the so-called New Vienna School. In an attempt to reinvigorate and extend the methodological project of the formalist art historian Alois Riegl (1858–1905), whose terms of close formal analysis already seemed to reconnect the beholder to the image with an initial perceptual event, Otto Pächt (1902–88) formulated an early structuralist approach that hinged on the direct participation of the viewer.[27] Now that Riegl's work has become more accessible through translations and critical exposition, he is widely admired for "his willingness to ground his historical interpretations in the present-tense reception of the image."[28] Moreover, the recent translation and availability of Walter Benjamin's recognition of a "new Art History" in the Vienna School has refocused attention on Pächt's concept of structure as capable of achieving an original and unexpected recasting of the basic visual encounter between beholder and image.[29]

Impatient with Panofsky's discursive models of pictorial meaning (iconography/iconology), Pächt argued that perception itself is already interpretive – "seeing and thinking are indivisible."[30] In his new approach to the art of pictorial narrative,[31] Pächt explored what he called the unparalleled and sudden outburst of full-fledged picture-cycles in the early twelfth century within a reconfigured context of the ancient space–time dichotomy. Rather than seeking to break it down, he closely interrogated and defined the problematic experience of the differentiating gap. At the outset of *The Rise of Pictorial Narrative in Twelfth-Century England*, Pächt restates the dilemma faced by pictures, which are fundamentally immobile and silent, in attempting to convey a story that unfolds in time:

A story encompasses a sequence of events, but is more than their mere succession. It is the change and the transition from one episode to the next . . . the passing of time, which we must be made to feel if the story is to become alive in our mind. . . .

Since pictorial form cannot move, ingenious devices have been developed for enlisting the onlooker's help in supplying motion or movement, particularly in cyclical representations.[32]

For the Middle Ages, however, Pächt's method was premised on acquiring "unfamiliar habits of looking."[33] What mattered was not the temporal aspect, but what it typified for all time.[34] Because the subject matter of Christian art consists entirely of miracles, medieval art had to "create a pictorial world of its own, with its own visual logic."[35] Pächt explored the temporal anomalies of narrative unity and plausibility contradicted by symbolic display. Within his open-ended mapping of the circuit boards of interpretive perception, reading could compel the viewer to hold in mind two irreconcilable conceptions of time.[36]

For Pächt, along with his friend and contemporary, Meyer Schapiro, "the image they were looking for was at once very far away, the product of a remote and frankly alien Christian culture, and yet very near at hand in the art of their own time."[37] While their vision was deeply impacted by the spatio-temporal dissonances and disjunctions of modern art, their visual expectations were equally and perhaps even more profoundly conditioned by film, whose theoretical explication along with that for comics lay in the future. As Pächt recreates the production and reception of the narrative cycle of full-page illustrations in the St Albans Psalter as "speaking pictures" or "dialogues without sound,"[38] his implicit trajectory of visual perception seems clearly to plot two parallel tracks – one embedded in the medieval viewer's witnessing experience of liturgical drama and the other shaped by the modern viewer's experience of silent film. In a similar vein, Pächt could assert that the dramatic figural gesturing throughout the Bayeux Tapestry addresses not the other characters, but the beholder, guiding him to grasp the meaning of the narrative events.[39] What is anticipated here is not only a semiotics of art but a modern cinematic framing of the experience of medieval art which, like the movies, in Panofsky's words "re-established that dynamic contact between art production and art consumption."[40]

As the most important art historical statement on film made in his generation, Panofsky's influential essay, "Style and Medium in the Motion Pictures," first published in 1934,[41] merits a brief digression in an effort to understand not only the unacknowledged impact of cinema on Pächt's work on pictorial narrative but the future course of the study of visual narration in medieval art. In contrast to theater, Panofsky first defined the unique and specific possibilities of film art as the "dynamization of space" and the "spatialization of time."

> The spectator occupies a fixed seat, but only physically . . . Aesthetically, he is in permanent motion as he identifies himself with the lens of the camera. . . . Not only bodies move in space, but space itself does, approaching, receding, dissolving and recrystallizing as it appears through the controlled locomotion and focussing of the camera and through the cutting and editing of the various shots – not to mention . . . special effects.[42]

It is not difficult to draw parallels between Panofsky's analysis of film and Pächt's close looking at medieval images as "an act of seeing that is also a re-creation of the artist's perception.[43] Just as Panofsky rejected the notion of film

as an enacted text, Pächt insisted that the whole point of making pictures was to generate meanings and responses beyond the frontiers of language.[44] Indeed, Panofsky frequently used references to medieval art in his explication of film. For example, in making an analogy between the problem faced by silent film and the medieval image, "for the public of around 1910 . . . the producers employed means of clarification similar to those we find in medieval art . . . printed titles or letters, striking equivalents of the medieval *tituli* and scrolls."[45] Even more pertinent to Pächt's project are Panofsky's assertions concerning the cinematic introduction of a fixed iconography in well-remembered types of characters and generic plot constructions.[46] In a number of different contexts, Pächt argued for the same kinds of recognitive process at work in the viewer's perceptions of meanings already embedded in pictorial types beyond the point where they are affixed to texts: like film, art is a statement in its own terms, *sui generis.*[47]

One of Pächt's most profound art historical insights into medieval narrative involves an obvious but unacknowledged notion later encountered in film ana- lysis and narratology – the gap. *Lacunae* occur everywhere in narrative. Whether in text, pictures, or film, there is no way a narrator can avoid requiring the reader or viewer to help bridge one gap after another.[48] Indeed, the illusion of motion in cinema involves this process, otherwise known as the "persistence of vision," on a "molecular level."[49] In his brilliant interrogation of how twelfth- century illustrated saints' lives work, Pächt observed that "continuous narration" is structured "not on a gradual transition but on abrupt change."[50] Pairs of separately framed scenes appear side by side in a paratactic arrangement that creates an empty interval between them – a gap perceived as a dynamic element which carries the mind rather than the eye from one moment in time and place to the next. Just as Sergei Eisenstein cut disparate film shots next to each other in a technique he called *montage* to convey deep and powerful meaning,[51] so the open space between facing pictures on opposing verso and recto pages in a medieval manuscript enlists the beholder's imagination in linking and trans- ferring them into a single idea through a technique known as *parataxis.*[52]

Although we might readily agree that pictures rely on the active engagement of the viewer, Pächt would urge that we not overlook the powerful ways in which the intrinsic visual structures and strategies of the images themselves shape their perception. His point can be demonstrated by suggesting how the juxtaposition of two contrasting full-page images in the twelfth-century Morgan Passion of St Edmund might be seen to work in affecting the viewer's consciousness. The pivotal pair of facing images on folios 10v and 11r (fig. 4-1) reveals the passage of time from one brief moment to another, movement from one place to another, cause and effect, as well as a striking contrast in moral character.[53] The paratactic arrangement of the two pictures also creates a montage effect that, unlike continuous narration, transports the viewer's gaze from one scene to the next across a literal "gutter" or gap.

On the left, following the victory of the invading Danes, their leader Ingvar demands that Edmund capitulate and pay him homage. At the pivotal moment

FIGURE 4-1 Ingvar commanding his messenger (left) and Edmund refusing Ingvar's command (right) from "Life, Passion, and Miracles of St Edmund." New York: The Pierpont Morgan Library MS M.736, fol. 10v (left) and fol. 11 (right).

of the story at the right, the Anglo-Saxon king refuses, making the righteous decision that leads to his martyrdom. As Ingvar instructs his armed messenger to deliver the ultimatum, he pulls together his military might beneath the sword raised on his shoulder behind him. At the same time he looks beyond the vertical barrier of the tree and the dividing frames, his gaze locked upon Edmund's reciprocal gaze across the page to the facing recto. Whereas Edmund dominates the center of his space, enthroned and crowned as king of East Anglia, Ingvar stands at the left (*sinister*). Both profile gazes are dramatically silhouetted against deeply colored grounds. Each protagonist is also similarly fixed within the gaze of another – Ingvar and his henchmen at the left, Edmund and his bishop at the right. Because all the heads in both images are turned away from us, we are manipulated as spectators, turning this way and that as we are guided by the constant gesturing within the two opposing frames. At the left, Ingvar brings our attention to the huge tree that bifurcates the world of the Danes, symbolizing the wild, uncivilized terrain of the "barbarian other,"[54] confirmed by the presence of naked "wildmen," their shoulders covered by animal skins. The branching forest canopy contrasts vividly with the elaborate vaulted structure

within which Edmund is revealed. The king echoes the Dane's gesture, albeit pointing upward to a higher power in heaven, symbolized by the dome, in response to the bishop's query. The element of time has been almost imperceptibly incorporated into the pictorial representation of the event by repeating the figure of the messenger at the right in each scene. Unmistakably identifiable in his short vermilion tunic, purple leggings, and bizarre open-toed boots, he points at King Edmund in both frames. His vigorous turns signify an abrupt but temporary closure to the sequential pair of events. But, just as Ingvar's raised sword signals impending violence, so the messenger's upturned lance alerts us to a continuation of the narrative ending in Edmund's martyrdom.

Ultimately, the viewer must "leave time behind" to absorb the spiritual meaning as an eternal truth. Since the 32 full-page illustrations in the Morgan St Edmund precede a collection of hagiographical documents, they literally constitute a pictorial *vita* without a text and thus demand close "reading" in purely visual terms. Images can only evoke a story the viewer already knows; the narrative lies in the perception of the pictorial rhetoric of bodies, gesture, and gazes enacting the drama of the moment within a strategically constructed framed space. Pächt's approach does not ask us to return to a past formalism but rather to a renewed focus on looking, with a view to asking not what happens within the frame but how the image actively works to affect and implicate the viewer. Of course, texts form critical components of our interrogative visual analysis, but they are not the end points of the new art historian's inquiry. Narrative involves reading more than one scene at a time, whether they are widely separated in space and time or not. Resonance between images remains critical to the reader's perception and understanding of multiple layers of meaning.

In the past few decades, art historians have begun to analyze not only image and text but also context in dealing with narrative in saints' lives. For example, in her several studies on pictorial hagiography, Magdalena Carrasco links changing ideals of spirituality and institutional history to her interpretation of the images.[55] The ground-breaking work of Barbara Abou-El-Haj moves beyond the historical conditions and function at specific sites by integrating her narrative analyses into an account of changing cult practices in the spectacular rise of shrines and pilgrimages in the late eleventh and twelfth centuries.[56] Thus, for example, she was able to offer a compelling explication of the illustrations in the Morgan St Edmund within the context of Bury St Edmunds's role as the exclusive caretaker of the saint's pilgrimage shrine.[57]

Manuscript illustrations of saints' lives continued to play an influential role in the development of pictorial narrative in the thirteenth century. As Cynthia Hahn has argued, Matthew Paris can be regarded as the culmination of a long tradition on the brink of change and innovation.[58] In his remarkable *Vie de Seint Auban* in Dublin, Matthew created a new, almost cinematic narrative as the viewer's gaze is drawn across the half-page images in each opening, moving from "action to reaction to inevitable consequences."[59] In support of the contention that Matthew Paris bridges the worlds of both Benedictine monasticism

and the secular court, Hahn convincingly interprets his interpolation of sub-texts as powerful extensions of St Alban's *Vita* into the contemporary regime of chivalric narrative. Indeed, as Hahn asserts, Matthew's primary legacy is to be found in the later manuscripts of Westminster.[60]

Paramount among such productions was the sudden outpouring of illustrated Apocalypses made by court designers and artists who were probably commissioned by the king, queen, or someone else close to the crown, to create the earliest illuminated Books of Revelation inspired by the three-volume *Bible moralisée* given by Queen Marguerite of Provence to her sister Eleanor, or brother-in-law (Henry III) during their visit to Paris in 1254 at the invitation of Louis IX.[61] The English Illustrated Apocalypse clearly had its origins partly in St John's text at the end of the Parisian moralized Bible in London, MS Harley 1527.[62] But equally important is its use of the life of St John as a narrative frame for the exiled prophet's *récit* of his visions on Patmos, functioning both as pretext and context.[63] Unlike the Book of Revelation at the end of the *Bible moralisée*, the English Apocalypses were clearly conceived as forming the centerpiece of an illustrated life of St John leading up to his exile and then followed by episodes after his return to Ephesus preceding his death at the end, as in Fr. 403 as well as in the Getty and Add. 35166 versions. Indeed, the illustrations of the Apocalypse itself clearly derive their *mis-en-page* from the half-page format of Matthew Paris's saints' lives, available at the court in the exemplar of his *Vie de Seint Ædward* created for Queen Eleanor of Provence and now known in the Cambridge copy dating *c*.1260, probably made for Eleanor of Castile.[64]

In *Reading Images*, I analyzed the complexities of narrative discourse and reception in the thirteenth-century Apocalypses as a visually conceptualized paradigm structured by the intertextual relationship of the scriptural allegory and its medieval exegesis, the image, and the reader-viewer.[65] Contemporary theories of vision invested narrative images with the power to articulate and activate dominant ideological positions regarding the self, society, and the "other."[66] As the Apocalypse narrative was transformed into a pictured allegory, it became a powerful paradigm within which problematic contemporary experiences, such as the later Crusades and expectations of the world's end, could be defined. Thus, the illustrated Apocalypse could be explored as a medieval narrative realm in which visual representation becomes an agent rather than a reflector of social change.

For example, the Douce illustration (fig. 4-2) of the angel casting the millstone into the sea (Rev. 18: 21–4), literally adheres to the text's description of the action in two sequential gestures marking the destruction of Babylon: "Then a powerful angel picked up a boulder like a great millstone and he hurled it into the sea." The commentary explains that the angel is Christ "whose strength is beyond human comprehension" and the millstone represents the weight of the "whole great multitude of sins." The two phases of the action are developed in full cyclical style, where the Herculean angel is represented twice,

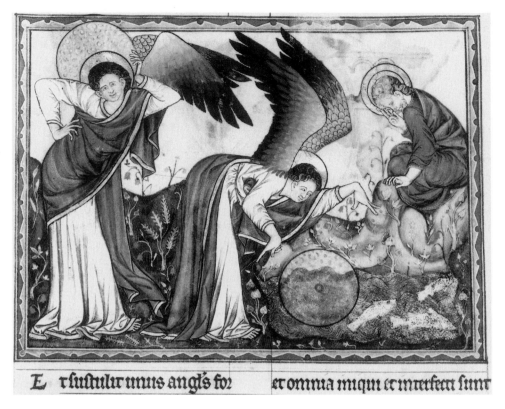

E rſuſtulit unus angts foz et omnia nimqui et intrfeett ſunt

FIGURE 4-2 Apocalypse: Angel Casting the Millstone. The Bodleian Library, University of Oxford, MS Douce 180, p. 77. Reproduced courtesy of the Bodleian Library, University of Oxford.

first lifting the huge stone at the left and then dropping it into the water. The successive movements of contraction and release are graphically plotted in the upward sweeping drapery of the first angel followed by the downward arc of the second figure. As Christ bends under the metaphorical weight of human wickedness, he confronts the viewer with an accusatory gaze. Acting as the reader's surrogate, John responds by closing his eyes as he feebly mimics the angel's splayed fingers over the submerged stone. John's turning inward at the right provides a gesture not only of closure to the entire sequence of events in Revelation 18, but also of internalized meditation responding to the last part of the gloss advising the reader that "all these things are to be understood in a spiritual sense."[67]

Just as historical and ideological contexts are critical to a reading of medieval pictorial narrative, when we move outside the pages of illuminated manuscript cycles, physical context plays an even more controlling role in engaging the

viewer. The veritable explosion of pictorial story-telling in thirteenth-century stained glass presents a particular challenge to art historians of medieval narrative.[68] As Wolfgang Kemp observes, although the great windows of cathedrals such as Chartres and Bourges contained continuous and consecutive pictorial cycles of monumental proportions, their "precast" armatures of interlocking geometric forms caused their narratives to be constructed of fragments spread over the many broken surfaces of the entire window.[69] Coming into existence piece by piece before the viewer's eyes, the individual image, like the single frame in film, has no autonomous status within the whole.[70] Unlike film, however, the vertically structured grid of stained glass cells inevitably works at odds with the chronological order of sequential actions.

Whether, as Kemp would argue, such geometric schemata can evoke meaning, or, as Madeline Caviness would counter, simply create narrative confusion,[71] the contemporary art history of stained-glass narrative has yet to develop productive strategies of analysis. Two possible avenues of approach have been tentatively opened by Wolfgang Kemp, although they might be more effectively pursued outside his neo-structuralist framework. In the absence of an accompanying text, the viewer plays an active role in constructing a new intertextuality of the image by bringing into play other narrative media, such as sermons or liturgical drama, as argument, *exemplum*, or typology.[72] In the further absence of an unequivocal chronological ordering of events, temporal connections become a theme in their own right,[73] thus reopening as yet unexplored applications of film theory, whether the spatial juxtaposition of images be paratactic *montage*, or continuous *mis-en-scène*. Lastly, their physical location within the functional spaces of their architectural milieu might yield some critical insights into their intended audiences and meaning beyond the more straightforward paths that have been adduced for their donors.

In contrast to the vast extent of painted glass surviving from the major churches of the thirteenth century, the most important and productive advances in our understanding of the relationships between monumental narrative cycles and their architectural ambience has been made by Marcia Kupfer in her groundbreaking studies of the fragmentary Romanesque frescoes surviving in the rural parish churches in central France.[74] Her close analyses of the virtually unpublished but diverse programs at Chalivoy-Milon, Brinay, and Vicq constitute brilliant paradigms of interpretation in which narrative representation is perceived to see the building itself perform as part of a totalizing semiotic system. Whether the mural topography is continuous or disjunct, "telling collapses into the told" in the relationships of narrative line and picture surface involving location, path of sutures, as well as stratification and framing. Whereas the presentation of Gospel events at Brinay configures episodic coherence and thematic patterns from succession, the disruptions of surface narrative at Vicq literally open its pictorial world to the viewer's realm of exegesis. Based on a series of rich and intensely detailed formal, iconographical, archaeological, and

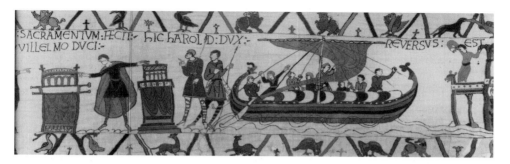

FIGURE 4-3 Harold swears an oath of loyalty to William and returns to England, Bayeux Tapestry, after 1066. Bayeux: Musée de la tapisserie. Photo: Bridgeman-Giraudon/Art Resource, NY.

historical analyses of these twelfth-century fresco programs, Kupfer reveals how "the open-endedness of the meaning of images and the permanence of the pictorial medium combine to activate the enduring hermeneutic potential of narratives unfolding across church walls and through architectural space."[75]

In conclusion, we will now turn our attention to the secular realm in which we encounter what must be the best-known, most studied but still problematic pictorial narrative to survive from the Middle Ages – the Bayeux Tapestry (fig. 4-3). In 1966 C. R. Dodwell's profoundly insightful essay proposed reading the work within the feudal terms and conventions of the French *chansons de geste*.[76] Following a 20-year hiatus, a veritable barrage of studies appeared in the 1980s and '90s, each in its own way exploring the narrative structure of this 232-foot-long strip of embroidery and its enigmatic account of the Norman Conquest of England in 1066.[77]

In coming to terms with new theoretical turns taken by narratological and film studies, Michel Parisse centers on the Bayeux Tapestry as a filmic conception in a succession of tableaux, an eleventh-century documentary in which the Latin inscriptions function as a "sound-track," a narrator who gives a running "voice-over" account of the events.[78] A work of political propaganda, narrative is seen as an eye-witness cinematic *récit*, replete with flashbacks, bringing this astonishing work within the comprehensible realm of modern as well as medieval audiences. In contrast, David Bernstein situates what he sees as a smooth-running series of interconnected historical events within the tradition of Roman triumphal columns with their strip narration continuous within a long, narrow pictorial field.[79] As he interprets the structural narrative as a drama in two long acts, Bernstein also develops an analysis of the subtext of animal fables that frames the main story in the borders.[80] Indeed, the Bayeux Tapestry's enigmatic pictorial borders constituted an important subject of separate study long before as well as within investigations of the main narrative.[81]

Although the Bayeux Tapestry had been compared to chronicles, *chansons de geste*, and Roman triumphal columns, J. Bard McNulty argued that, because the work was probably unique in its own day, with no obvious antecedents, the internal narrative structures and strategies should be treated on their own terms.[82] Along with Shirley Ann Brown,[83] he abandons the idea of the work as an historical document subject to investigations of its reliability or "truth" and concentrates instead on interpreting the larger story unfolding in its own eclectic style.

The question of audience remains implicit in all these studies, but it was Bernstein who first raised the problematic issue of physical context and the necessity of display.[84] Rejecting the earlier assumption that the long embroidered strip decorated the walls of Bayeux Cathedral, Bernstein plausibly argued for its exhibition in a great baronial hall. Made of flexible materials, the 20-inch-wide fabric could be folded over upon itself like a ribbon and transported from one Norman castle to the next on either side of the Channel. Further arguing for public display in its entirety, Richard Brilliant extended this line of argument to include the probability of an accompanying oral performance of the story.[85] As both Bernstein and Cowdrey point out, however, the narrative with accompanying inscriptions and pictorial borders was designed for close viewing and could instead have been unrolled in sections on a long table like an illustrated manuscript roll on vellum.[86]

In 1999 I took another close look at this fascinating work, arguing that history is not reflected in the images but produced by them.[87] The pictorial narrative of the Bayeux Tapestry presents not so much an illusion of reality as a constructed work of problematic fiction, shot through with inconsistencies and ruptures. Analyzed in terms not only of what it presents but also of what it leaves out, the work's most powerful rhetoric lies in its silences and empty spaces. The Bayeux Tapestry's rhetoric of power was dependent not only upon the operation of a complex culturally coded apparatus, both verbal and visual, but also, perhaps even more critically, upon the active engagement of its contemporary audiences as producers of meaning.

In its present state, the "embroidered" story seems unfinished, ending literally on a jagged edge of unfulfilled expectations. Within the medieval conventions upon which the visual narrative in the Bayeux Tapestry is structured, its form is inherently fragmental, a discontinuity of continuing presentness. It can end, but it cannot be concluded or resolved. Like all medieval texts, the Bayeux Tapestry was most likely appropriated and absorbed as an experience without closure.[88] Premised on the recognition of a radical discontinuity of time between sense and reference, surface and deep structure, the Bayeux Tapestry's imaged discourse constitutes a deliberate attempt to conflate past and present, here and there, speaker, audience, and characters, in a transparency of meaning that can be felt to exist beyond the text, beyond words.

From the very beginning of the study of pictorial narrative at the end of the nineteenth century to our own time, theoretical as well as practical investigation has been culturally conditioned and shaped by visual experiences in contem-

porary time. Faced with the perplexing disjunct and convoluted structures of medieval narrative, art historians increasingly tended to approach its ambiguity and lacunae within the experiential context of modern/postmodern fiction, film, and comics, as well as medieval texts. Each new generation of scholars places before its audiences a world that seeks to connect itself with the present as well as the past. Because all story-telling is a work of imagination rather than a reflection of what might be termed "reality," medieval narrative belongs to the realm of an internal subjectivity that for many twenty-first-century viewers may involve an exotic or alien spirituality, but one that can nevertheless open itself to our understanding as a treasured cultural relic of human discourse, still capable of making itself accessible and of affecting our perception, intellect and feeling. More often than not, we are surprised, impressed, and even delighted to discover unexpected nuances and sophistication through analytical interpretation. Like a medieval narrative, the historiography of any area of scholarly inquiry is a story without closure, but at the same time richly laden with consequences for the future.[89]

Notes

1 Barthes, "Introduction to the Structural Analysis of Narrative." See, for example, Cobley, *Narrative*, pp. 33–7; Kemp, "Narrative," pp. 58–69.

2 Abbott, *Cambridge Introduction to Narrative*, pp. 12–13, who largely depends on the definitions formulated by Genette, *Narrative Discourse*, pp. 25–32; see also Prince, *Dictionary of Narratology*, pp. 57–61.

3 See Bal, *Narratology*.

4 Kemp, "Narrative," p. 68.

5 Lévi-Strauss, *Structural Anthropology*; Chatman, *Story and Discourse*; McCloud, *Understanding Comics*.

6 [On reception, see chapter 3 by Caviness in this volume (ed.).]

7 Mitchell, "Word and Image," p. 50.

8 Rorty, *Philosophy and the Mirror of Nature*, p. 263.

9 Mitchell, *Picture Theory*, pp. 11–34. See Deleuze, *Foucault*, pp. 47–69. On the concept of "scopic regime," see Jay, "Scopic Regimes of Modernity"; Lyotard, *Discourse/Figure*. On complexity and divergence of views concerning "ocular-centrism" and modernism, see the various essays in Levin, ed., *Modernity and the Hegemony of Vision*; also Jay, *Downcast Eyes*, pp. 543–86.

10 Lessing, *Laocoon*, p. 91.

11 See Mitchell, *Iconology*, pp. 95–115.

12 See the negative position taken by Svetlana and Paul Alpers in "Ut pictura noesis?"

13 Frey, *Gotik und Renaissance*, p. 34.

14 Gombrich, *Art and Illusion*.

15 See Clausberg, "Erfurter Codex," pp. 35–6; Mitchell, "The Ambiguities of Representation and Illusion: An E. H. Gombrich Retrospective," *Critical Inquiry* 11 (December 1984), pp. 181–94; idem, *Iconology*, pp. 75–94.

16 Abbott, *Cambridge Introduction to Narrative*, pp. 6–7, 11.

17 Stephen G. Nichols, Jr., *Romanesque Signs: Early Medieval Narrative and Iconography* (New Haven, 1983), p. xi.

18 See Lewis, *Reading Images*, pp. 45–58.

19 Barbara Herrnstein Smith, "Narrative Versions, Narrative Theories," in *On Narrative*, ed. W. J. T. Mitchell (Chicago, 1981), p. 217.

20 Evelyn Birge Vitz, *Medieval Narrative and Modern Narratology: Subjects and Objects of Desire* (New York, 1989), pp. 111–12.

21 See, for example, *Texte et image: Actes du Colloque international de Chantilly* (Paris, 1984); *Pictorial Narrative in Antiquity and the Middle Ages*, ed. Herbert L. Kessler and M. Simpson, Studies in the History of Art 16 (Washington, DC, 1985).

22 Franz Wickhoff, *Die Wiener Genesis* (Vienna, 1895), trans. in part as *Roman Art: Some of Its Principles and Their Application to Early Christian Painting* (London, 1900), pp. 13 et passim.

23 Clausberg, "Erfurter Codex," p. 30; Karpf, *Strukturanalyse*, p. 13.

24 Clausberg, "Erfurter Codex," p. 29.

25 Weitzmann, *Illustrations in Roll and Codex*. See also Clausberg, "Erfurter Codex," pp. 30–1; Karpf, *Strukturanalyse*, p. 14.

26 Kemp, "Narrative," p. 67. As Pächt, *Pictorial Narrative*, p. 2, n.3, noted much earlier, "[Weitzmann's] new terminology unfortunately makes no allowance for the possibility of the time-element as a style-conditioning factor." [On Formalism, see chapter 5 by Seidel in this volume (ed.).]

27 Along with his colleague Hans Sedlmayr (1896–1984), from whom he parted company with the rise of Nazism in 1933, Pächt developed the notion of *Struktur*, arguing that a close analysis of the rhetoric and structure of the individual work of art can in principle unfold into an analysis of culture or ideology. See Wood, ed., *Vienna School Reader*, pp. 9–10 and 17.

28 As pointed out by Wood, ed., *Vienna School Reader*, p. 14.

29 Benjamin, "Rigorous Study of Art."

30 Pächt, *Practice of Art History*, p. 70.

31 Pächt, *Pictorial Narrative*.

32 Ibid., p. 1.

33 Pächt, *Practice of Art History*, p. 86.

34 Pächt, *Pictorial Narrative*, p. 3.

35 Pächt, *Practice of Art History*, p. 45.

36 Ibid., p. 17; for a contrasting view of Pächt's notions of narrative time, see Cynthia Hahn, "Picturing the Text: Narrative in the Life of the Saints," *Art History* 13 (1990), pp. 2–3.

37 Pächt, *Practice of Art History*, p. 18. See also Schapiro, *Words and Pictures*.

38 Pächt, *Pictorial Narrative*, p. 59, asserts that the revival of story-telling in the twelfth century started with an enactment of spoken narrative in visual form.

39 Ibid., p. 10; see also Lewis, *Power of Rhetoric*, pp. 52–3.

40 Panofsky, "Style and Medium," p. 16.

41 Panofsky's essay grew out of a talk made before a Princeton audience to enlist interest in the Film Library of the Museum of Modern Art in New York. In his preface to the version published in his film anthology, Daniel Talbot (p. 15) observes, "In a phrase here, a suggestion here, Erwin Panofsky opens up a world of insight into the complex nature of the movie medieval and its context in the history of art." See also Prange, "Stil und Medium.".

42 Panofsky, "Style and Medium," pp. 18–19.

43 Pächt, *Practice of Art History*, pp. 67–8.

44 Ibid., p. 98; Panofsky, "Style and Medium," p. 20.

45 Panofsky, "Style and Medium," p. 25.

46 Ibid.

47 Pächt, *Practice of Art History*, pp. 14 and 70.

48 Abbott, *Cambridge Introduction to Narrative*, p. 114.

49 Ibid., p. 115: "Moving pictures don't really move. All the motion that we think we see on the screen is in fact a succession of still pictures" projected at 24 frames per second.

50 Pächt, *Pictorial Narrative*, p. 16.

51 On the art of *montage* in film, see Konigsberg, *Complete Film Dictionary*, pp. 246–7; Bordwell, *On the History of Film Style*, pp. 51–3 et passim; Eisenstein, *Film Form*.

52 Perhaps an even closer paradigm can be seen in the space, or "gutter," between the panels in comic strips. As McCloud, *Understanding Comics*, forcefully explains, "Despite its unceremonious title, the gutter plays host to much of the magic and mystery that are at the very heart of comics" (p. 66).

53 [For more on the Morgan *Passion of St Edmund*, see chapter 17 by Cohen in this volume (ed.).]

54 Hahn, *Portrayed on the Heart*, p. 246.

55 See, for example, Carrasco, "Spirituality in Context"; "Sanctity and Experience in Pictorial Hagiography."

56 Abou-El-Haj, *The Medieval Cult of Saints*.

57 Abou-El-Haj, "Bury St Edmunds Abbey between 1070 and 1124."

58 Hahn, *Portrayed on the Heart*, pp. 282–317.

59 See Lewis, *The Art of Matthew Paris*, p. 386; Hahn, *Portrayed on the Heart*, p. 284.

60 Hahn, *Portrayed on the Heart*, p. 285.

61 See Lowden, *The Making of the Bibles Moralisées*, I, pp. 139–87.

62 I first proposed this idea in "Spheres of Influence: The Bibles moralisées and the Thirteenth-Century English Apocalypses," at the conference entitled "Under the Influence," held at the Courtauld Institute on July 3–5, 2003. See also Lewis, *Reading Images*, pp. 199–203.

63 Lewis, *Reading Images*, pp. 58–66.

64 Ibid., p. 37.

65 Ibid. On the notion of intertextuality (inspired by Bakhtin and developed by Julia Kristeva), see Allen, *Intertextuality*; Riffaterre, *Fictional Truth*; Genette, *Paratexts*. [On art and exegesis, see chapter 8 by Hughes in this volume (ed.).]

66 [On vision, see chapter 2 by Hahn in this volume (ed.).]

67 Lewis, *Reading Images*, pp. 170–2.

68 Hahn, *Portrayed on the Heart*, pp. 327–31 and esp. nn.28 and 33.

69 Kemp, *Stained Glass*, pp. 220–6.

70 Ibid., p. 223; see Panofsky, "Style and Medium," p. 29.

71 Caviness, "Biblical Stories in Windows", p. 117.

72 Kemp, *Stained Glass*, pp. 220–1.

73 Ibid., p. 225.

74 Kupfer, *Romanesque Wall Painting in Central France*, based on her 1983 dissertation. See also Kupfer, "Spiritual Passage."

75 Kupfer, *Romanesque Wall Painting*, p. 150.

76 Dodwell, "Bayeux Tapestry."
77 Many of the shorter works have been reprinted in Gameson, ed., *The Study of the Bayeux Tapestry*.
78 Parisse, *La tapisserie de Bayeux*.
79 Bernstein, *Mystery of the Bayeux Tapestry*, pp. 89–107; see Werckmeister, "The Political Ideology of the Bayeux Tapestry."
80 Bernstein, *Mystery of the Bayeux Tapestry*, pp. 124–35; Dodwell, "Bayeux Tapestry," p. 559.
81 See Abraham and Letienne, "Les Bordures de la Tapisserie de Bayeux"; Chefneux, "Les Fables"; Herman, *Les Fables antiques*; Hicks, "The Borders of the Bayeux Tapestry"; Terkla, "Cut on the Norman Bias."
82 McNulty, *Narrative Art*.
83 Brown, "The Bayeux Tapestry"; also Cowdrey, "Towards an Interpretation"; cf. Brooks and Walker, "The Authority and Interpretation."
84 Bernstein, *Mystery*, pp. 104–7.
85 Brilliant, "The Bayeux Tapestry."
86 Bernstein, *Mystery of the Bayeux Tapestry*, p. 107, n.57; Cowdrey, "Towards an Interpretation," p. 65.
87 Lewis, *Power of Rhetoric*.
88 Ibid., pp. 131–4.
89 In the past decade, a few attempts have been made to compile detailed histories of medieval pictorial narrative, based on the accumulated wisdom of past and present scholarship. Although the reader might find them useful, none offers any new insights drawn from their respective historiographical surveys. See, for example, Karpf, *Strukturanalyse*; Götz Pochat, *Bild-Zeit: Zeitgeist und Erzählungstruktur in der bilden Kunst von den Anfängen bis zur frühen Neuzeit* (Vienna, 1996); and Kumiko Maekawa, *Narrative and Experience: Innovations in Thirteenth-Century Picture Books* (Frankfurt-am-Main, 2000).

Bibliography

H. Porter Abbott, *The Cambridge Introduction to Narrative* (Cambridge, 2002).
Barbara Abou-El-Haj, "Bury St Edmunds Abbey between 1070 and 1124: A History of Property, Privilege, and Monastic Art Production," *Art History* 6 (1983), pp. 1–29.
——, *The Medieval Cult of Saints: Formations and Transformations* (Cambridge, 1997).
Jeanne Abraham and A. Letienne, "Les Bordures de la Tapisserie de Bayeux," *Normannia* 3 (1929), pp. 483–518.
Graham Allen, *Intertextuality* (London, 2000).
Svetlana and Paul Alpers, "Ut pictura noesis? Criticism in Literary Studies and Art History," *New Literary History* 3 (1971), pp. 437–58.
Mieke Bal, *Narratology: Introduction to the Theory of Narrative* (Toronto, 1985).
Roland Barthes, "Introduction to the Structural Analysis of Narrative," *New Literary History* 6 (1974–5), pp. 237–72; originally published in *Communications* 8 (1966).
Walter Benjamin, "Rigorous Study of Art: On the First Volume of *Kunstwissenschaftliche Forschungen* (1931–3)," trans. Thomas Y. Levin, *October* 47 (1988), pp. 84–90;

reprinted in Christopher S. Wood, ed., *The Vienna School Reader: Politics and Art Historical Method in the 1930s* (New York, 2000), pp. 439–51.

David Bernstein, *The Mystery of the Bayeux Tapestry* (Chicago, 1986).

David Bordwell, *On the History of Film Style* (Cambridge, MA, 1997).

Richard Brilliant, "The Bayeux Tapestry: A Stripped Narrative for Their Eyes and Ears," *Word & Image* 7 (1991), pp. 98–126.

N. P. Brooks and H. E. Walker, "The Authority and Interpretation of the Bayeux Tapestry," *Proceedings of the Battle Conference on Anglo-Norman Studies* 1 (Ipswich, 1979), pp. 1–24, 191–9.

Shirley Ann Brown, "The Bayeux Tapestry: History or Propaganda?" in J. Douglas Woods and David Pelteret, eds., *The Anglo-Saxons: Synthesis and Achievement* (Waterloo, Ont., 1985), pp. 11–25.

Magdalena Carrasco, "Sanctity and Experience in Pictorial Hagiography: Two Illustrated Lives of Saints from Romanesque France," in Renate Blumenfeld-Kosinski and Timea Szell, eds., *Images of Sainthood in Medieval Europe* (Ithaca, 1991), pp. 33–66.

——, "Spirituality in Context: The Romanesque Illustrated Life of St. Radegund of Poitiers," *Art Bulletin* 72 (1990), pp. 414–35.

Madeline Caviness, "Biblical Stories in Windows: Were They Bibles for the Poor?" in Barnard S. Levy, ed., *The Bible in the Middle Ages: Its Influence on Literature and Art* (Binghamton, NY, 1992).

Seymour Chatman, *Story and Discourse: Narrative Structure in Fiction and Film* (Berkeley, 1978).

Hélène Chefneux, "Les Fables dans la tapisserie de Bayeux," *Romania* 60 (1934), pp. 1–35, 153–94.

Karl Clausberg, "Der Erfurter Codex Aureus, oder: Die Sprache der Bilder," *Städel-Jahrbuch* n.f. 8 (1981), pp. 22–56.

Paul Cobley, *Narrative* (London, 2001).

H. E. J. Cowdrey, "Towards an Interpretation of the Bayeux Tapestry," *Anglo-Norman Studies* 10 (1987), pp. 49–65.

Gilles Deleuze, *Foucault* (Minneapolis, 1988).

C. R. Dodwell, "The Bayeux Tapestry and the French Secular Epic," *Burlington Magazine* 108 (1966), p. 549–60.

Sergei Eisenstein, *Film Form: Essays in Film Theory*, trans. Jay Leyda (New York, 1949).

Dagobert Frey, *Gotik und Renaissance als Grundlagen der modernen Weltanschauung* (Augsberg, 1929).

Richard Gameson, ed., *The Study of the Bayeux Tapestry* (Rochester, NY, 1997).

Gérard Genette, *Narrative Discourse: An Essay in Method* (Ithaca, 1980).

——, *Paratexts: Thresholds of Interpretation* (Cambridge, 1997).

E. H. Gombrich, *Art and Illusion: A Study in the Psychology of Pictorial Representation* (Princeton, 1960).

Cynthia Hahn, *Portrayed on the Heart: Narrative Effect in Pictorial Lives of Saints from the Tenth through the Thirteenth Century* (Berkeley, 2001).

Léon Herman, *Les Fables antiques de la broderie de Bayeux* (Brussels, 1964).

Carola Hicks, "The Borders of the Bayeux Tapestry," in *England in the Eleventh Century* (Stamford, 1992), pp. 251–65.

Martin Jay, *Downcast Eyes: The Denigration of Vision in Twentieth-Century French Thought* (Berkeley, 1993).

——, "Scopic Regimes of Modernity," in Hal Foster, ed., *Vision and Visuality* (Seattle, 1988), pp. 3–27.

Jutta Karpf, *Strukturanalyse der mittelalterlichen Bilderzählung: Ein Beitrag zur kunsthistorischen Erzählforschung* (Marburg, 1994).

Wolfgang Kemp, "Narrative," in Robert S. Nelson and Richard Schiff, eds., *Critical Terms for Art History* (Chicago, 1996), pp. 58–69.

——, *The Narratives of Gothic Stained Glass* (Cambridge, 1997).

Ira Konigsberg, *The Complete Film Dictionary*, 2nd edn. (New York, 1997).

Marcia Kupfer, *Romanesque Wall Painting in Central France: The Politics of Narrative* (New Haven, CT, 1993).

——, "Spiritual Passage and Pictorial Strategy in the Romanesque Frescoes at Vicq," *Art Bulletin* 68 (1986), pp. 36–53.

Gotthold Ephraim Lessing, *Laocoon: An Essay upon the Limits of Poetry and Painting*, trans. E. Frothingham (New York, 1969).

David Michael Levin, ed., *Modernity and the Hegemony of Vision* (Berkeley, 1993).

Claude Lévi-Strauss, *Structural Anthropology* (New York, 1963).

Suzanne Lewis, *The Art of Matthew Paris in the Chronica Majora* (Berkeley, 1987).

——, *The Power of Rhetoric in the Bayeux Tapestry* (Cambridge, 1999).

——, *Reading Images: Narrative Discourse and Reception in the Thirteenth-Century Illuminated Apocalypse* (Cambridge, 1995).

John Lowden, *The Making of the Bibles Moralisées*, I (University Park, PA, 2000), pp. 139–87.

Jean-François Lyotard, *Discourse/Figure* (Paris, 1971).

Kumiko Maekawa, *Narrative and Experience: Innovations in Thirteenth-Century Picture Books* (Frankfurt-am-Main, 2000).

Scott McCloud, *Understanding Comics: The Invisible Art* (New York, 1993).

J. Bard McNulty, *The Narrative Art of the Bayeux Tapestry* (New York, 1989).

W. J. T. Mitchell, *Iconology: Image, Text, Ideology* (Chicago, 1986).

——, *Picture Theory: Essays on Verbal and Visual Representation* (Chicago, 1994).

——, "Word and Image," in *Critical Terms for Art History* (Chicago, 1996).

Otto Pächt, *The Rise of Pictorial Narrative in Twelfth-Century England* (Oxford, 1962).

——, *The Practice of Art History* (London, 1999).

Erwin Panofsky, "Style and Medium in the Motion Pictures," in Daniel Talbot, ed., *Film: Anthology* (New York, 1959), pp. 15–32.

Michel Parisse, *La tapisserie de Bayeux: Un documentaire du XIe siècle* (Paris, 1983).

Götz Pochat, *Bild-Zeit: Zeitgeist und Erzählungstruktur in der bilden Kunst von den Anfängen bis zur frühen Neuzeit* (Vienna, 1996).

Regine Prange, "Stil und Medium: Panofsky 'On Movies'," in Bruno Reudenbach, ed., *Erwin Panofsky: Beiträge des Symposiums Hamburg 1992* (Berlin, 1994), pp. 171–90.

Gerald Prince, *Dictionary of Narratology* (Lincoln, NB, 1987).

Michael Riffaterre, *Fictional Truth* (Baltimore, 1990).

Richard Rorty, *Philosophy and the Mirror of Nature* (Princeton, 1979).

Meyer Schapiro, *Words and Pictures: On the Literal and Symbolic in the Illustration of a Text* (The Hague, 1973).

Daniel Talbot, ed., *Film: Anthology* (New York, 1959).

Daniel Terkla, "Cut on the Norman Bias: Fabulous Borders and Visual Glosses in the Bayeux Tapestry," *Word & Image* 11 (1995), pp. 264–90.

Kurt Weitzmann, *Illustrations in Roll and Codex* (Princeton, 1947).

Otto-Karl Werckmeister, "The Political Ideology of the Bayeux Tapestry," *Studi medievali*, 3rd ser. 17 (1976), pp. 535–95.

Christopher S. Wood, ed., *The Vienna School Reader: Politics and Art Historical Method in the 1930s* (New York, 2000).

Formalism

Linda Seidel

A number of principles delineating the study of visual art cluster together under the rubric Formalism. These precepts focus on such immediately accessible aspects of objects and images as material, color, line, and shape, elements that construct appearance and function as expressive agents. They are the features that set works regarded as art apart from other forms of creativity and, for Formalists, are the critical determinants of any work's significance. As the key components of the process called formal analysis, these aspects of a work figure in the initial stages of art historical study; they are not commensurable however with the more extensive agenda of inquiry that is encompassed by the term Formalism.[1]

The question of workmanship – the distinct manner in which an object's maker handles materials and configures pattern – constitutes Formalism's central concern. Single-minded pursuit of this issue comprises a sub-set of Formalist practice familiarly termed Connoisseurship. What is at stake in this work is characterization of an artist's manner of representation along with an assertion of its independence from cultural influences. Formalists consider the social, political, and religious circumstances in which art is produced to lie outside of the object and reject empiricist inquiries into such issues as being extrinsic to it. Instead, Formalists subscribe to the notion of art's self-sufficiency, in terms of both a work's individuality and its maker's autonomy.

Yet awareness that art has a history and that it changes over time is very much a part of Formalism's brief; from the earliest years of scholarship, the mysteries of style's continuities and disruptions have remained one of Formalism's most vexing issues. The first scholars whom we now consider to have been Formalists examined the part played by the artist in transforming the properties of a given medium in an effort to define constant elements in works of art; at the same time, they sought to articulate the relationship of art to the material and spiritual conditions of its particular moment and its specific place of production.

Formalism is more a way of thinking about the nature of art than a compre-
hensive methodology; it is not subject, consequently, to simple description.[2]
Nor is Formalism a term restricted to art historical practice in the way that
Connoisseurship, which operates with certain closely related concerns, can be
considered to be; neither is it as single-minded in its goal. The term Formalism
originally identified a prominent literary movement closely tied to the study of
language and the branch of philosophical inquiry called aesthetics. Yet even
before Formalism received its name, at the time of World War I, issues central to
its definition were being championed by German and Austrian scholars of art in
an effort to formulate a new and systematic study of the visual arts.

Accordingly, the account of Formalism that I present here begins with the
emergence of the term in Russia in 1915 in conjunction with a revolutionary
literary movement, and moves temporally forward to the United States. There,
in the aftermath of World War II, Formalism became a preoccupation of mod-
ernist critics as the legitimate basis for proper valuation of non-representational
painting; at the same time, it made a profound impression on the practice of
art historians working in other fields. I then return to Europe to examine
Formalism's importance in German-speaking areas of the Continent during the
foundational moment of medieval art history's development in the 1890s. At
that instant, coincidental with the emergence of expressionism in art, scholarship
on previously scorned non-classical imagery, such as that offered by Gothic art,
provided the fertile ground for novel critical attention. The non-naturalistic
forms of late medieval art served as superior instructional exemplars for new
theories being developed about the nature of art.

The final portion of this chapter examines the writings of the distinguished
medievalist Meyer Schapiro, whose essays on Romanesque art have been exten-
sively analyzed in relation to the predominantly Marxist political interests that
characterized the intellectual circles in which he was known to move in the
1930s. I shall argue here that Schapiro's early formation, which took place
during the preceding decade, allies him more properly with the interests and
practices of the Formalists, whose papers he read as a young man and whose
profoundly philosophical inquiries remained his highest priority throughout the
six decades of his innovative scholarship.

The appellation Formalism emerged during World War I as a term of ridicule
for the pronouncements of a reform literary movement in Moscow that sought
to define its critical practice by differentiating the object of its interest – liter-
ature – from the spoken and written communication of ordinary life. The young
Russian scholars who came to be known as the Moscow Linguistic Circle
challenged then popular Symbolist emphasis on the importance of words and
sounds and decried their argument in behalf of literature's mystic nature and
higher reality. They stressed instead the centrality of language to writing
and regarded its structures and forms as determinative of content. In their view,
literature as opposed to other kinds of texts possessed, first and foremost, a
special organization of language, one that departed from ordinary usage in its

formal or structural devices and did not in any way reflect reality. Whether its content comprised fact or fiction, philosophical inquiry, authorial biography, or current events, literature, from their perspective, was not distinguished by being "a vehicle for ideas, a reflection of social reality, [or] the incarnation of some transcendent truth."[3] Its fundamental character and importance lay elsewhere.

Attention to visual material held a reduced presence in the Moscow Circle's interests, but writings of a few members enunciated engagement with art's distinctive constructive qualities. For these individuals, visual art, like poetry, was defined as a special way of thinking and knowing by means of images. They paid attention to its intrinsic properties by examining these aspects apart from any relationship to either subject matter or to an artist. One of the group's members, Victor Shklovsky, recommended examination of a given work not in terms of its content but as a "complex of devices." This, he argued, would impede perception through a process of defamiliarization or estrangement, divorcing the object from authorial biography and literary description and facilitating a critical approach that imitated scientific inquiry in its self-consciousness.[4] Arguing on behalf of seeing in place of focusing on the seen, the Russian Formalists rejected dependence upon fact-based empirical evidence regarding place of production and dating in their studies.[5]

The Moscow Linguistic Circle's reformational activities engaged issues that bear on an understanding of Formalism's significance for the study of visual images; in some instances, these challenge aspects of inquiry into medieval art that have, for long, gone without sufficient scrutiny. Critical among these is the distinction the Russian Formalists made between the high art of literature, with its carefully structured forms, and the low – even non-art – status of other kinds of writing. Distinction between high and low has long informed display practices in museums where objects are frequently grouped according to their materials; painted objects receive pride of place in this system, even when they were not the most valued objects in their own time. Formalism's espousal of a hierarchical differentiation among works of art facilitated the elevation of manuscript painting and ecclesiastical architecture as fields of study over and above engagement with metalworking and weaving or embroidery, pursuits which were considered to be craft rather than art because of the "applied" or functional nature of their products.

In scholarship on medieval art, the narrative miniatures of Romanesque and Gothic illumination and the carving of tympana have usually garnered attention as the most elite kinds of artistic production at the expense of adjacent imagery. For decades, they have been seen as more worthy of study than border ornamentation in the margins of books, or voussoirs on arches and corbels on the cornices of churches.[6] These subordinate elements failed to engage the attention of Emile Mâle in his researches into twelfth- and thirteenth-century art because of their invariably secular subjects.[7] Following Formalist principles, they may also have escaped the need for serious study because of their lack of imposingly structured composition.[8]

Formalist acceptance of the autonomy of artistic creativity, belief in the independence of artists from constraints on their inventiveness, presents a particular challenge for medievalists. Scholars like Mâle subscribed to ideas of Church dominance in the sphere of medieval art because almost all known work was either produced in, on, or for places within the ecclesiastical compound – the church, the cloister, the scriptorium. A medieval artist's freedom to create spontaneously was unimaginable so long as he was in the service of sovereign and authoritative Christian authority. Meyer Schapiro, the foremost American medievalist of the twentieth century, took up the apparent contradiction posed by the Formalist notion of artistic freedom in Church art in an effort to develop an art historical practice that participated in wide-ranging art historical debates. Schapiro's singular contributions embraced what appeared to others to be incompatible if not irreconcilable matters; these included a masterful examination of a carved relief at the church of Souillac that did not adhere to the norms expected of high art, as well as an unprecedented explanation of some seemingly secular music-making figures on the pier reliefs at Silos. These works, which have reverberated throughout medieval scholarship, are touched on in the final section of this chapter.

The principles that Formalism's literary adherents promulgated served to reinforce distinctions and decisions at play in diverse humanistic pursuits, at a time when several forms of intellectual inquiry had not yet secured a place as fully independent academic disciplines. The way in which the Russian Formalists' grounding of the study of literature in systematic analysis of a text's structure professionalized its practice helped to secure for it an existence as a distinct discipline. Their efforts paralleled those that had been made by German-speaking scholars of art a decade or two earlier in a comparable effort to establish a rigorous mode of argument for their own practice, one that would be distinct from archaeological and philological methodology on the one hand, and amateurish, romantic description on the other. Scrupulous definition of the intrinsic qualities of visual material and elaboration of the utility of such definitions in the analysis of individual works facilitated the establishment of art history as a rigorous branch of knowledge, one that was separate and distinct from classical literature, intellectual history, and belles-lettres.[9]

Formalist principles as established by both the early German and Russian scholars imply acceptance of a viewer's direct sensorial involvement with a painting, object, or monument. The results of such eyewitness encounters provide the grounds for analysis of a work's structure and defining characteristics, thereby enabling determinations regarding stylistic affiliations and value. In the hands of scholars eager to assert the intellectual rigor and scientific nature of the study of art, observations gleaned in this manner have frequently been put forth as objective data and used to categorize works in a definitive manner in regard to date and place of production. But in so far as these sorts of judgments are based on observations that result from subjective experience, they risk opening up Formalism to claims of relativity. Formalist scholarship, which has at times

overlooked this implication, has attended to it more recently through the theorization of spectatorship, arguing for a process by which viewers achieve their insights into a work through interaction with the work's structures.[10]

The ideas of the Moscow Circle did not immediately penetrate the thinking of European intellectuals, and their critical writings remained for the most part unknown, silenced by the inaccessibility of the language in which they had been written. More significantly, constraints on speech and artistic practice put in place in Russia immediately after World War I marginalized the precepts of the Formalists in their homeland. Art's content rather than its formal properties was Communism's politically preferred choice, and Formalism did not sufficiently concern itself with historical considerations from the government's point of view. After World War II, however, as the result of a number of migrations from Eastern bloc countries, a group of young multi-national scholars of literature and anthropology working in Paris under the leadership of Lévi-Strauss saw links between their own interests in linguistic theory and aspect of Russian Formalism.[11]

Their rigorous and systematic mode of analysis endorsed principles earlier espoused by the Moscow Circle and, in recognition of this affiliation, they initiated translations of the group's papers. In this way, a critical movement once undervalued as "the child of the revolutionary period," and silenced for decades by Stalinist propaganda, came to be appreciated in the West for its distinctive contributions to intellectual thought.[12] Recovered from the dustbin to which its ideas had been relegated, Russian Formalism was newly perceived as "a central trend of a broad critical movement" in literary and artistic theory in the early twentieth century.[13] The term of scorn by which it had originally been designated has since come to serve as the umbrella under which approaches to art and literature that prize structural and sensorial properties over and above other historical and thematic elements hold center stage.

During the decade of the 1940s, Formalism was introduced into American art criticism by Clement Greenberg as a brief in favor of abstract painting. This art, which he termed "avant-garde," was valid, he wrote, "solely on its own terms . . . independent of meanings." In it, "content is to be dissolved so completely into form that the work of art or literature cannot be reduced in whole or in part to anything not itself."[14] Greenberg thus rejected any ascription of significance to incidents that lay outside the frame of the physical object. He was committed instead to the centrality of the irreducible material elements that artists employ in their conceptualization and realization of individual works and which they do, he wrote, "in search of the absolute." In the early 1960s, Michael Fried amplified Greenberg's argument and popularized it through his championship of the work of an emerging group of young non-representational painters.[15]

The spare and focused terms in which this criticism is presented are directly indebted to the writing of the English critic and curator Roger Fry, one of the earliest champions of post-Impressionist painting and, seen in retrospect, one of the first Formalists.[16] Fry, who was introduced to the work of Cézanne at an

exhibition in London in 1906, was immediately captivated by the "insistence on the decorative value" that he found in one of the artist's still lifes, both in the use of opposing local colors and "a quite extraordinary feeling for light." He sensed that the artists whose works he brought together in an exhibition in 1912 "do not seek to imitate form but to create form, not to imitate life, but to find an equivalent for life." Fry was stimulated by the conflicted reception their painting received to continue work on an aesthetic theory, "attacking poetry to understand painting. I want to find out what the function of content is, and am developing a theory . . . that it is merely directive of form and that all the essential aesthetic quality has to do with pure form," he wrote to a friend. Fry's belief in artistic experience as detached from real life, his attention to such design components as color, plane, and rhythmic line, his appreciation of their connection with "essential conditions of our physical existence" and thus their capacity to elicit emotional response, all ally him with positions the Russian Formalists were simultaneously espousing.[17]

In the 1960s, American scholars working on the art of earlier periods were growing weary of the data-driven erudition of text-based iconographic study that was being produced by newly emigrated German academics. Their approach required linguistic skills and intellectual assumptions that were no longer a part of educational preparation on these shores. Some objected as well to the limitations inherently imposed by this work on the notion of artistic creativity and excellence. Such scholars found support for a reinvigorated practice of visual analysis in the descriptive language of contemporary Formalism. This alternative approach was particularly apt for discussion of the distorted, seemingly non-mimetic figural imagery of early medieval and Romanesque work.

Thus, in the most widely used survey book of the second half of the twentieth century, a miniature of the Gospel writer St Mark, made in northern France in the early eleventh century, is described in terms of the "twisting and turning movement of the lines which pervades not only the figure of the Evangelist but the winged lion, the scroll, and the curtain" (fig. 5-1). The author continues, praising the miniature's "firmly drawn contours filled in with bright solid colors, so that the three-dimensional aspects of the picture are reduced to an overlapping of flat planes." As a result of this "abstract clarity and precision," the text informs the reader, the "representational, the symbolic and the decorative elements of the design are knit together into a single, unified structure."[18]

This language, which approximates an account of modernist painting, succeeds so well in drawing our attention to the geometric patterns of figure and drapery that we easily overlook the absence of anything more than the most minimal passing reference to other recognizable aspects of the miniature. The spiral columns, capped with acanthus leaf designs, that frame the seated figure go unmentioned, and the description likewise avoids discussion of the contested position of the central element in the design: the scroll to which both St Mark and the somersaulting lion hold fast. Textual silence discourages us from inquiring into the fusion of elements that culminates in, or emanates from, the intense

FIGURE 5-1 St Mark from a Gospel Book produced at Corbie, *c*.1025–50. Amiens: Municipal Library. Photo: Bridgeman-Giraudon/Art Resource, NY.

stare that locks the animal and the man's eyes on the object they both grasp. While we likely sense the way in which the glance functions as the generative element in the miniature, providing the fulcrum from which stable and chaotic forms emerge, the text, as written, provides no opening for further consideration of this relationship.

Formal analysis is here restricted to a description of surface pattern and the miniaturist's handling of color. It is a helpful technique for elucidating the composition or construction of an object or image so that other questions may be asked of it. Such analysis can help relate an object or image to a larger body of works – a workshop or regional school – by disclosing patterns of organiza- tion that the work shares with other works and which help to classify all of them according to specific characteristics. Formal analysis in this way provides grist for Connoisseurship, the skill of discriminating distinct artistic handwriting and then attributing specific works to artists living at a given moment in a certain place. Such procedures of attribution are fundamental to the cataloguing of works of art, but too readily they obscure aspects of an image or object that escape encapsulation in a characterization of arrangements of shapes, lines, and colors. While the procedures of Connoissseurship invariably celebrate the individual skill of the artist, a principle that Formalism endorses, they trample on other issues that a Formalist agenda holds forth as critical to the study and definition of art.

In the case at hand, formal analysis assumes art's dependence upon the things of the world as a "given." We scarcely notice in the description of the miniature the affirmation it implicitly lends to the existence, in the unknown artist's imag- ination, of a real figure, one that is independent of and prior to the one rendered here. Earlier European proponents of a Formalist approach to art, at work even before the name of the movement had been put into place, had explicitly eschewed such notions, arguing that the artist's interaction with material alone generates form. The implication that the artist has a pre-existent idea in mind to which he gives visible form is one that was rejected insofar as it relegated the work of art to a second tier role.

This had been the concern of one of the nineteenth-century German writers on art, Konrad Fiedler, who emphasized the distinction between art and ordin- ary life and our perceptions of each. For him, the interactive relation between an artist's ideas and the material through which he explored them and ultimately gave form to them, was a central, non-negotiable issue. The notion that the artist had something in mind that he then "copied" into his work fell prey to the mechanization of society, he argued, and did not succeed in adequately engag- ing either the active potentialities of the material with which the artist was working or the moral underpinnings of the artistic enterprise itself.[19]

In the case of the Northern French miniature, such an assumption disregards the capacity of artistic energy, expressed through the explosive pattern of pen lines and colored washes, to create a previously unseen and unknown creature who, in turn, functions as the generative center of unbounded activity. The design conjures up before the viewer the linear tangle in which both the seated

figure and the gyrating animal participate; this coursing energy also produces the inspired Gospel text found on successive folia. Content is transmitted directly via the language of visual imagery and occurs without the intervention of an independent, pre-existent source.

Both form and meaning are made at the moment of creative invention; they are then seized by the viewer in a process of realization that emerges through engagement with the image and scrupulous apprehension of its design. The latter does not have identity prior to or outside of artistic activity. Especially when figurative imagery is at issue, the artist's creation should not be seen as imitative of something that has a reality elsewhere and which it is attempting to simulate. Forms in nature are to be taken neither as standards of representation nor as models for it. Artworks themselves provide guidance for insight into their makers' practices and offer clues as well to their own expressive purposes.

Accordingly, if images are sites of creativity in their own right, then artists are not merely technicians who execute the ideas of others even when they are following prescriptions set down by programmers, the church officials and learned men of their time.[20] Scholarly recourse to theological or literary texts to articulate the content of images should not assume that religious images exclusively illustrate knowledge that has already been articulated in verbal form, or are without meaning if, like grotesques or decorative arabesques, they fail to do so. Certainly images may act as substitute texts for the illiterate; they may be artistically uninteresting and Formalists may question whether, in their judgment, they constitute "art" at all. But extrapolating from precepts laid down by literary Formalists, man-made visual imagery ineluctably sets out distinguishing features that differentiate it from things of the natural world, even those that it may appear ostensibly most closely to imitate. It follows then that to depict something is different from either description of the thing or the thing itself; it needs to be examined according to a different set of rules.

Rather than a methodology, Formalism is an epistemology; it questions our ways of thinking about representation and perception, and examines assumptions about the relationship between art and nature. Mere description of how images look as conveyed through formal analysis, no matter how detailed, is an inadequate exercise in Formalism's name and distracts from engagement with the larger issues involved in the making and study of art.

Concern for fundamental issues regarding the nature of artistic creativity was one of the hallmarks of Wilhelm Vöge's ground-breaking scholarship on Romanesque and Gothic sculpture during the early decades of its developing practice more than a century ago. In his magisterial book on the emergence of Gothic style, Vöge established systematic terms for a descriptive analysis of medieval sculpture as part of an inquiry into the sources and nature of artistic creativity. Vöge brilliantly orchestrated a combination of concerns in his work on sculpture at Chartres, bringing together sensitive characterization of previously unanalyzed figurative carving and compelling identification of individual style – evidence of distinct hands at work on different portals. Limned in the richness of Vöge's

written language, Chartres' Headmaster could stand alongside the most modern one.[21]

Vöge's orderly observations, though based on nascent Formalist principles, in effect provided the foundation for the efficient categorization and definition of large bodies of sculpture in a practice that served the needs of archaeologists sorting through the detritus of Europe's wars as well as museum curators organizing their national collections.[22] The importance of establishing categories for material that, in some cases, had never been studied in a systematic way before, as well as of constructing regional lines of affiliation for groups of work – manuscripts and sculpture especially – that were dispersed across the landscape, proved to be the pressing requirement for a generation of scholars eager to enhance claims to the scientific grounds and rigorous possibilities of their practice.[23]

In the wake of Vöge's debut study, the anonymous makers of elongated, geometrically distorted Romanesque sculpture concretized in the minds of scholars as individual personalities whose technique was marked by distinct manners of workmanship. Study of a particular monument did not encourage inquiry into the articulation of more general principles, however. Instead, in the immediate aftermath of Vöge's achievement, admiring successors transformed his approach into a tool for the well-regulated and more limited exposition of relationships between sculpture and architecture and for prescriptive description of the treatment of body and drapery.

Scholars who succeeded Vöge after the turn of the century spun off the descriptive aspects of his practice into a self-sufficient form of investigation into local characteristics of art. This style criticism, or stylistic analysis, provided the basis for decades of writing about Romanesque as well as Gothic Art on both sides of the Atlantic. The work of the next generation of scholars comes to mind here, in particular that of Arthur Kingsley Porter and Henri Focillon.[24]

In Porter's work on art of the Pilgrimage Roads, characterization and categorization of regional styles replaced dating as his narrowly defined goal, although chronology still played a role in his investigations.[25] Study of style as an end in itself failed to acknowledge the roots of its authority, avoiding indication of why it was doing what it was doing or indicating towards what end, loftier or otherwise, it was doing it.

In the early 1950s, when contemporary artists were concentrating almost exclusively on issues of form in their work, and Structuralists were rediscovering the writings of the Russian Formalists, Louis Grodecki, a Polish immigrant who had taken up residence in Paris after World War II, reintroduced Vöge's work to a new audience of medieval scholars as a model of diligent description, one that kept larger issues of artistic creativity in mind. Grodecki re-engaged with the careful procedures of scrupulous analysis that Vöge had inaugurated in his own work on French sculpture in an effort to further enhance our knowledge of the emergence of new forms of architectural production at the turn of the first millennium; he urged others to do the same.[26]

After Vöge's death in 1952, just two years after Emile Mâle's demise, Erwin Panofsky, Vöge's most celebrated student, dedicated his study of Netherlandish painting to the teacher under whom he had studied in Freiburg and for whom he had written his doctoral dissertation on Albrecht Dürer. Panofsky then contributed a stirring appreciation of Vöge's life and work to a collection of the latter's essays, published in Germany in 1959. In it, Panofsky stressed for the reader the significance of Vöge's two-year stay in France in preparation for the writing of his book on early Gothic sculpture. Visits to the great cathedrals had provided Vöge with first-hand encounters with twelfth-century sculpture, Panofsky noted, and these enabled the perceptions out of which Vöge's thinking about the development of early Gothic statuary emerged. Panofsky was here presenting Vöge to the reader as a Formalist before the fact.

Russian Formalism was critiqued within a decade of its promulgation for concentrating on the formal organization of art and failing to consider its role within social communication. Although this was not a fair statement, the matter was one of considerable urgency in post-Revolutionary Russia and, for a long time, concern over this issue succeeded in removing Formalist works from view and silencing their claims. In an effort to address the situation without abandoning the achievement of the Moscow Group, two Russian scholars, P. N. Medvedev and Mikhail Bakhtin, co-authored a book in 1925 in which they defended Formalism's practices while advancing the claim for close ties between literature and society.

The authors recognized that Formalism was not a precise methodology or tidy regime of practices, arguing that it needed to be viewed as encompassing diverse lines of inquiry.[27] They drew on intimate knowledge of recent German scholarship to establish the relationship between Russian Formalism and a widespread pan-European movement in art scholarship, and demonstrated that there was no fundamental hostility between form and content in the logic of Formalist thinking. The basic positions of Formalism in Western art scholarship, they wrote, "give no grounds whatsoever for the denial of content in art."[28]

Medvedev and Bakhtin did not see evidence of any direct relationship between recent Russian and German scholarship, but argued that they were connected through shared changes in their "ideological horizon." They associated Russian Formalism with *Kunstwissenschaft*, the rigorous practice of art-science (or art-knowledge) that German-speaking scholars had begun to develop in the closing decades of the nineteenth century in opposition to traditional *Kunstgeschichte* or art history, an unexacting practice that they regarded as excessively absorbed with documentary and biographical matters. In the eyes of the German scholars and their Russian sympathizers as well, the shortcomings of *Kunstgeschichte* cast a shadow over the intellectual validity of the study of art, thereby tarnishing the reputation of its practitioners.

Medvedev and Bakhtin identified the "constructive aims of art" as the nucleus of recent Western art scholarship; these, in their view, regarded the work of art as a closed-off unity but one that is part of real space. They saw nothing

exclusionary in this definition. "Realistic art is just as constructivist as constructivist art," they wrote, indicating that content need not be excluded from Formalist works or Formalist practice. And they emphasized the deep ideological meaning that German scholars attributed to form in contrast to the "simplistic realist view" of form as an "embellishment of content . . . a decorative accessory lacking ideological meaning of its own," that was held by supporters of contemporary Russian figurative painting. In summarizing the central tenets of what they called European Formalism, Medvedev and Bakhtin recognized Fiedler as one of the first theoreticians of the movement.

Responsibility for the 1925 book is now attributed primarily to Bakhtin, who came to be recognized as a major literary theorist in the last third of the twentieth century. One of the German writers whose work he cited in the co-authored publication is Wilhelm Worringer, whose pioneering studies on the dynamic relationship between abstraction and naturalism in art and the psychology of Gothic style had been published a decade and a half before and reissued in numerous printings in response to public demand.[29]

In the first work, originally published in 1908, Worringer differentiated between art that imitated things in nature (classicism) and art that alienated itself from them (abstraction), identifying these as the two basic, divergent poles of artistic experience that emerge from instinctive feelings about the world and express themselves in artistic impulse. This "latent inner demand," he observed, which he credits Aloïs Riegl for introducing, is the primary factor in all artistic creativity. Its expression collapses distinctions between form and content by linking inner urges of the art to outward appearances. In his next work, which he described as a sequel to the first, Worringer applies the questions raised in the earlier publication to that "complex of abstract art which is closest to us, namely Gothic." He calls Gothic architecture the perfect expression of an unimpeded impulse toward abstraction, since no organic or natural model opposed itself to it.

The notion of internal mechanisms by which art changes was instrumental to the work of the Viennese art historian, Aloïs Riegl, a successor to Fiedler and forerunner of Worringer, whose theories developed over more than a decade of significant publication at the turn of the century and whose writings were central to the European Formalist enterprise. His ideas were seminal to the art historians who were educated in Germany and Austria around the time of World War I, and who then came to prominence on the American intellectual landscape in the decades after World War II. Riegl's complex theorizing about art was fully absorbed into the work of scholars like Panofsky and Gombrich, each of whom pursued questions, in their own distinct ways, about the self-sufficient nature of art that Riegl had put into play.[30]

Meanwhile, Riegl's work, written in a dense German, disappeared behind English language representations of it, particularly in relation to questions concerning artistic style – its definition and development. At the same time, the work of Bernard Berenson, formulated at the identical turn-of-the-century

moment as Riegl's and eminently more accessible in its straightforward pro-
nouncements, came into prominence as the native authority in matters of
Connoisseurship and style, aspects of the larger Formalist enterprise.

Riegl's ideas were further elided during these decades by the differently framed
claims of American Formalism; these, as we have seen, followed a more narrowly
defined line of inquiry earlier articulated by Roger Fry and developed by Clive
Bell. In the last decade, scholars whose interests have shifted away from the
examination of the relationship between art and society have rediscovered Riegl;
that issue, we recall, was one that Formalism, at its inception, rejected. Riegl's
relevance for a new generation lies in his study of visual perception, the changing
nature of how we see – a concern that is bound up with representation and with
issues of form. His works, now in translation, dominate current interests in
visuality and reception theory, as well as historiography – art history's self-
reflective engagement with its own past.[31]

Riegl argued that art is a transformation not an imitation of nature, and that
it continues to be transformed from within in "a search for interconnectedness,
variation, and symmetry."[32] Individual artistic performance, he believed, is con-
trolled by an inner need for pattern, order, and symmetry and is not generated
by outside elements – historical, cultural, or otherwise. In order to account for
change in art, Riegl introduced the idea of *Kunstwollen*, artistic volition or will.
In one form or another, this notion of art's inner drive has remained his most
enduring and challenging contribution to art scholarship; we have just considered
its importance for Worringer. Riegl saw this internal dynamic, which produces
change as it develops through history, as part of a given society's world-view; he
employed it to define the changing qualities in particular kinds of art over a
period of time. Riegl's suggestion that it accounts for national characteristics in
art came close to endorsing racial stereotypes, which followers like Strzygowski
went on to do and for which he was criticized, by Schapiro as well as Gombrich.
Yet his theories were egalitarian in other important ways: they accommodated
both high art as well as lesser applied or decorative forms in their argument at a
time when Formalists espoused a hierarchical ordering that restricted the desig-
nation art to certain types of creation. And, although Riegl's ideas changed over
the course of a decade, his engagement with meticulous observation of the
details of individual works and his concern for the historic trajectory of artistic
production never wavered.

Otto Pächt, who was initially trained by Riegl's successors in Vienna, and who
identified in his later years with Riegl's sweeping project for art history, pursued
diverse aspects of Riegl's theories, more as policy guides than as theoretical
inquiries. He remained committed to detailed structural or stylistic analysis in
his work; supported the notion of regional or national characteristics in art; and
he stayed skeptical of the idea that styles change through the impact of external
influences. Upon his return to Vienna late in his career, after more than two
decades at work in England, Pächt wrote in praise of Riegl's close engagement
with individual objects, saying: "I know of few more instructive things than to

watch Riegl in his efforts to learn from the works of art the questions which they want to be asked and elicit from them the answers. Perhaps the most helpful thing in art history is this kind of dialogue with the object and not the monologues of the most brilliant art critics."[33] In his numerous studies of Romanesque and Gothic manuscript, fresco, and panel painting, Pächt, following Riegl, persisted in the belief that regional or national schools display distinct characteristics in their art through the activity of the *Kunstwollen*. Such belief assisted him in a career largely devoted to the production of manuscript catalogues, a task to which he had turned out of necessity upon exile from Germany in 1938.[34]

Meyer Schapiro staked out a different position from Pächt and Riegl in regard to the relationship between ethnicity and art, contesting, on several occasions, arguments in support of the existence of national characteristics in style. But he resembles Riegl more than he does any other scholar of art in the way in which he wrestled with the issue of artistic creativity and change throughout his career. He displayed enormous and unusual sympathy for the vast range of his predecessor's work and its intellectual seriousness in one of his papers, calling him "the most constructive and imaginative of the historians who have tried to embrace the whole of artistic development as a single continuous process."[35] Numerous aspects of Riegl's theories endure as significant issues in Schapiro's own writings, especially those inquiring into artistic creativity.

Schapiro's graduate studies at Columbia University had not brought him under the direct tutelage of scholars of medieval sculpture, since they were in short supply on this side of the Atlantic at the time; art history itself was just emerging as an independent field of study at the fringes of work in Classical philology.[36] During a lengthy study trip through Europe in 1926 and 1927, Schapiro endeavored to make contact with scholars at work on medieval material in each country he visited: Gomez Moreno and Walter Whitehill in Spain, Hamann in Germany, Deschamps in Paris, Berenson in Italy. Through them, he developed contacts with like-minded others. In this way, he entered into a lengthy correspondence with Kingsley Porter, with whom he exchanged letters filled with concerns and ideas about the dating of southern French and Spanish sculpture, among other matters.

In one of his early communications to Porter, Schapiro wrote that he had heard of the senior scholar's lectures on monastic centers and the diffusion of medieval art, and confessed: "I regret all the more that I am not at Harvard, for there is no one occupied with medieval art, and no one sufficiently bold to speculate on the interrelations of fields so vast as east Christian and Romanesque art."[37] Porter clearly invited him to come to Cambridge because Schapiro wrote a few months later declining the offer: "I regret exceedingly that I will be unable to study at Harvard next year. My duties as a teacher will make it impossible for me to visit Cambridge except during vacation periods."[38]

Schapiro made his debut as an art historian in the late 1920s as a scrupulous observer and impeccable historian of Romanesque sculpture. He remarked later in life that he was drawn to Romanesque by its vigor and inventiveness, its

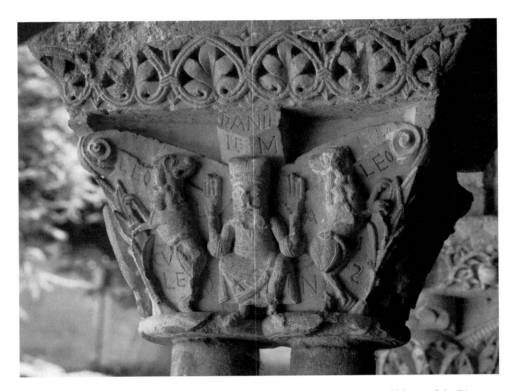

FIGURE 5-2 Capital with Daniel at the lion's den, cloister at the Abbey of St Pierre at Moissac, West Gallery, *c*.1100. Photo: Erich Lessing/Art Resource, NY.

interplay between folk art and high art, and the starkness of its simple forms.[39] His dissertation, completed in 1929 and published, in part, in the *Art Bulletin* two years later, was a study of the extensive carvings at the southern French abbey of Moissac (fig. 5-2).[40] Its published portion remains a model of visual analysis in the tradition of turn-of-the-century German scholars more than of French ones. In the notes, Schapiro cites Vöge's book on Chartres along with numerous references to both French and German texts of a more archaeological nature and slightly later date. However, he identifies, in the opening pages, a work on early Greek art as the exacting model for his own investigation, observing that he is following Emmanuel Löwy in the use of the term "archaic" "as a designation of a formal character in early arts."[41]

Schapiro's introductory summary of his aims and achievements in the study of the sculpture demonstrates his interest in systematically understanding, instead of dismissing, the disproportional, non-mimetic figurative imagery that populates the capitals of the abbey's cloister and the walls of its church entry. "In the present work," he writes, "the postures, costumes, expressions, space, perspective and grouping of the figures have been described . . . to demonstrate that their departures from natural shapes have a common character

which is intimately bound up with the harmonious formal structure of the works."

The most comparable scholarly undertaking that comes to mind in reading Schapiro's text is Riegl's study of ornament. Both texts are equally comprehensive in theoretical scope, similarly detailed in their performance of close analysis, and both take as their subject an equivalently overlooked body of visual material. Although Schapiro does not cite Riegl, since his work did not substantively touch on the sculpture at Moissac, late in life Schapiro explained what he recognized to be the importance of Riegl's contributions:

> He described a perceptual world in the visual arts that was dynamic, and he tried to show how the broad development of art has been between these two poles. . . . Starting from that conception, Riegl analyszed in careful details the structure of forms in succeeding styles which enabled one to see how things changed and moved, what the structure was in each period.[42]

Moissac's sculpture offered an unusually extensive, carved figural corpus, one that is situated at the beginning of a development that moves quickly toward more faithful natural depiction. It was thus ripe for the kind of foundational study that a dissertation in the tradition of German scholarship, as represented by the work of both Vöge and Riegl, demanded. Schapiro's dissertation on Moissac should be regarded as an English-language chapter in the ambitious and ground-breaking project of Formalist study that had begun in Vienna more than half a century earlier and which is now being re-engaged in art history's ongoing self-evaluation of its interests and methods.

Schapiro had also read the essays of Roger Fry on post-Impressionism as a student and saw parallels between the inventiveness and simple forms of Romanesque sculpture and the achievements of twentieth-century art. These he observed closely as a teacher to and friend of artists, and as a practitioner in his own right. Direct engagement with the gestures of art-making and the independent decisions of art-makers, along with close analysis of discrete works of art – all precepts of Formalist criticism – consistently drove his argument even when the goal of his inquiry was artistic change, not the characterization of what was constant in a monument or series of objects.

His studies of Romanesque art at Souillac and at Silos are dominated by pages of scrupulous and insightful analysis of sculpted relief and miniature painting in an effort to examine reasons for stylistic change at these abbeys: in the one case this involves deviation from related work at Moissac, and, in the other, the co-existence in a single place, and for a brief moment, of two different visual languages of expression. To aver that Schapiro's project in these path-breaking articles is "a comprehensive sociological explanation of Romanesque style," as Werckmeister has done, while not incorrect, elides the critical process by which Schapiro constructs analyses, dissolving an appreciation of his means into a celebration of apparent ends.[43]

As Schapiro's career progressed, he devoted more and more time to the analysis of contemporary painting. In the 1940s, he grew "increasingly disturbed by Greenberg's dogmatic formalism, by his refusal to grant artistic intention or social context, much less iconography, any place in analysis."[44] His own efforts to study this art in relationship to its social bases galvanized a politicized public and, in time, overshadowed the efforts he continued to make to engage art on Formalist grounds. Yet he never wavered in those interests and they persisted, long after his engagement with Marxist analysis in art historical study had dissipated. His important paper of the late 1960s on image-signs explores non-mimetic elements of artistic composition, some of which might be characterized as "sub-formal" in nature, and makes implicit reference to Romanesque and Gothic imagery. It was published with a note that some of the observations had been presented in his classes at Columbia thirty years before.[45]

In one of Schapiro's most celebrated papers, "On the Aesthetic Attitude in Romanesque Art," Formalism trumps historic functionalism in a playful tour de force of observation and citation. Published in 1947, the paper was written for a volume of studies that honored Schapiro's friend, the mystical philosopher and curator of Indian art Ananda Coomaraswamy.[46] In it, Schapiro cites numerous medieval texts that display, as he notes, "keen observation of the work itself, the effort to read the forms and colors and to weigh their effects." One text quoted at length is a description of the textile wrappings around St Cuthbert's relics at the time of their translation to the new cathedral of Durham, an event that had occurred in 1104 and was recounted 70 years later by the monk Reginald – either through eye-witness testimony or his own privileged access to the tomb. Reginald noted the unusual and fresh reddish-purple tone of the saint's garments which "when handled make a kind of crackling sound because of the solidity and compactness of the fine skilful weaving." Reginald also remarked on the charming variation provided by scattered spots of yellow which seem "to have been laid down drop by drop" and which contrasted with the purple, conferring on the background greater vigor and brilliance.

This twelfth-century description sounds suspiciously similar to comments one might read about mid-twentieth-century work written by Greenberg, one of the points Schapiro was making in an effort to expand the grounds on which medieval art could be appreciated. His evocation of Formalist concerns challenges the persistent focus on religious content in Romanesque art on the part of European scholars, in particular Emile Mâle. Reference to craft work rather than high art, such as the textile wrappings around Cuthbert's relics, makes a subtle nod in Riegl's direction since the latter's book on ornament, *Stilfragen*, had been based on his experiences as curator of carpets and textiles in Vienna.

At the same time, Schapiro's paper toys with materialist preoccupations with luxury goods and elite patronage and ignores issues of functionality.[47] Schapiro once told me of the circumstances surrounding his decision to write the paper. These involved a private joke between the two men concerning their divergent

approaches to the study of art and are not irrelevant to the matter at hand. Coomaraswamy, with whom Schapiro had been corresponding since the early 1930s, had often called the younger man a "materialist" and chided him for the turn his work had taken in the preceding decade with the publication of papers exploring the changing material conditions in which a particular object or monument had been produced. Schapiro recounted with glee his decision to counter Coomaraswamy's expectations by transforming a study of the displaced material wealth of the Church into an examination of perception and taste. His own appreciation of the physical properties of medieval objects is here embedded in analysis of design, color, contrast, and artistic imagination, and he hoped it would appeal to the refined interests of his friend. Sadly, Coomaraswamy died before reading it.

Close looking, the fruits of visual engagement with an image or object, whether for the purposes of attribution or for understanding expressive meaning and stylistic change, constitutes the fundamental obligation of Formalist inquiry and provides the irreducible basis for any appreciation of visual art's unique achievement. The closing lines of Schapiro's paper evoke St Augustine's support for an aesthetic conception of art as an object for the eye, not just for the mind, and provide a terse yet appropriate epigram for both Formalism's and Schapiro's legacies: "For when you have looked at a picture, you have seen it all and have praised it."

Notes

1 These aspects were set out and formalized into something approaching a method in a student handbook that has been reprinted countless times (Taylor, *Learning to Look*, pp. v, vi).

2 Michael Podro succinctly remarked that the early Formalists regarded their concepts as "necessary but not exhaustive": *The Critical Historians of Art*, p. 209. For Whitney Davis's differentiation of these interests into aesthetic, stylistic, and psychological Formalism, see "Formalism: Formalism in Art History."

3 Eagleton, *Literary Theory, An Introduction*, p. 2; Bennett, *Formalism and Marxism*, pp. 18–25.

4 See the seminal text written by Viktor Shklovsky in 1917, "Art as Technique or Art as Device," in Harrison and Wood, *Art in Theory*, pp. 277–81.

5 Bowlt, "Russian Formalism."

6 [On the marginal, see chapter 13 by Kendrick in this volume (ed.).]

7 *L'Art religieux du XIIe siècle en France.*

8 More recent scholarship understands art as a socially rather than qualitatively constructed category and is interested not in drawing distinctions between high and low forms of image-making, but in inquiring how the visual as a category is articulated. Tom Gretton summarizes this thinking based on the work of Pierre Bourdieu in his paper "New Lamps for Old."

9 Kathryn Brush provides an account of this material in her book, *The Shaping of Art History*.

10 Davis and Womack, *Formalist Criticism*. See also Preziosi's discussion of relevant aspects of Raymond Williams's work in *Rethinking Art History*, pp. 81–2). [On reception theory, see chapter 3 by Caviness in this volume (ed.).]

11 See Jameson, *The Prison-House of Language*, pp. 43–4, 101; Bennett, *Formalism and Marxism*, pp. 26–7, where he remarks on the publication of Tzvetan Todorov's *Textes des formalistes russes* in 1965.

12 See Stephen Bann's introductory remarks to the collection of texts he assembled with John E. Bowlt; I repeat here Bann's citation of Victor Erlich's remark in the latter's ground-breaking study of 1955 (*Russian Formalism*, 1).

13 Lubomír Dolezal, "Narrative Composition: A Link between German and Russian poetics," in *Russian Formalism*, 73. The article was written for the publication of Bann and Bowlt's collection. [On narrative, see chapter 4 by Lewis in this volume (ed.).]

14 "Avant-Garde and Kitsch," vol. 4, p. 8.

15 Formalist work of the 1950s and '60s was generally distinguished by the term "criticism" to set it off from the work of either "art history or scholarship" by its central advocate, Clement Greenberg. He further defined the distinctions as concern with "art as art, and not as a 'subject' or 'field.'" This explanation is set out in his review of a book on Andrea del Sarto, the Renaissance painter, by S. J. Freedberg (*Clement Greenberg: The Collected Essays and Criticism*, vol. 4, p. 198). Fried presented his views most cogently in the essay he wrote for an exhibition catalogue, *Three American Painters*). See also excerpts from Fried's work and commentary on it in Harrison and Wood, *Art in Theory, 1900–2000*.

16 For thumbnail sketches of the work of both Fry and Greenberg, and of the relationship between them, see Hyde Minor, *Art History's History*, pp. 133–9.

17 Woolf, *Roger Fry*, pp. 111–12, 177, 183. The citations come from "autobiographical fragments" as well as letters made available to Mrs Woolf by the family.

18 Janson, *History of Art*, p. 226.

19 For the pioneering work in English on Fiedler see Podro, *The Manifold in Perception* and the expansion of his inquiry to include the next generation of German scholars, with remarks on Fiedler's contribution to the later work (*The Critical Historians*, pp. 69–70 and 110–11). Daniel Adler discusses the moral implications of the early Formalists' desire to reconcile neo-Kantian (i.e., intuitive and speculative) goals with Positivist esteem for measurable data in an effort to systematize art historical scholarship ("Painterly Politics").

20 [On sculptural programs, see chapter 26 by Boerner in this volume (ed.).]

21 Vöge, *Die Anfänge*.

22 [On the modern medieval museum, see chapter 30 by Brown in this volume (ed.).]

23 [On Romanesque and Gothic manuscript illumination, see chapters 17 and 20 by Cohen and Hedeman, respectively, in this volume (ed.).]

24 Porter's most relevant publication, in which he cited Vöge's work, is *Romanesque Sculpture of the Pilgrimage Roads*. See the discussion of Porter's relationship to German modes of scholarship by Brush in *The Shaping of Art History*, pp. 145–8. A book by one of Focillon's students constitutes the foremost example of the application of Formalist compositional analysis to medieval architectural sculpture, although its relationship to German scholarship is not at all clear. See Baltrusaitis, *La Stylistique Ornementale* and the probing review of its method published in German

the following year by Meyer Schapiro. This essay appeared in translation 40 years later ("On Geometrical Schematism in Romanesque Art")

25 [On pilgrimage art, see chapter 28 by Gerson in this volume (ed.).]

26 [On Romanesque and Gothic architecture, see chapters 14 and 18 by Fernie and Murray, respectively, in this volume (ed.).]

27 *The Formal Method in Literary Scholarship*, p. xxvi.

28 For what follows, see ibid., chap. 3, "The formal method in European Art Scholarship," pp. 41–53.

29 I have used here *Abstraction and Empathy* and *Form Problems of the Gothic*.

30 For Panofsky, see Podro, *The Critical Historians*, pp. 178–208, and Iverson, *Aloïs Riegl*, pp. 154–66. Gombrich's engagement with Riegl's challenging work and a critique thereof are central to the premises of his own influential book, *Art and Illusion*; see the introduction, especially pp. 16–22.

31 See especially in this regard, Olin, *Forms of Representation*.

32 For discussion of Riegl's complex ideas, see Podro, *The Critical Historians*, pp. 71–97; Iverson, *Aloïs Riegl* and *Framing Formalism*. The citation in the text is from Podro, *The Critical Historians*, p. 71.

33 Art historical lineage may be traced through historiographical commentary. See Pächt's evaluation of Riegl ("Art Historians and Art Critics") and Jonathan Alexander's obituary for his teacher, "Otto Pächt."

34 Alexander describes Pächt's peregrinations in search of work in the memorial note referred to above. Pächt's own appreciation of Riegl, quoted above, appeared in the year in which he left the Bodleian Library at Oxford to take up the chair in Art History at Vienna, the post Riegl had himself once held. This marked, in a sense, the return of the "New Vienna School," with whose work he had been intimately identified thirty years before. See Christopher Wood's characterization of these relationships in his introduction to *The Vienna School Reader*, pp. 9–81.

35 Schapiro critiques the use of racial characteristics in discussions of artistic style in more than one place. His essay, "Style," is the most relevant to the issues under consideration here; in it he separates his laudatory characterization of Riegl's contributions to the study of style from his critique of racial categorization.

36 [On Romanesque and Gothic Sculpture, see chapters 15, 16, and 19 by Hourihane, Maxwell, and Büchsel, respectively, in this volume (ed.).]

37 Schapiro's letters to Porter are preserved in the collection of Porter's Papers in the Harvard University Archives and are cited here with the archivist's permission. The quotation here is taken from a letter of November 10, 1927 at the beginning of their correspondence (HUG 1706.102, box 10). [On the relation between East and West, see chapters 23 and 24 by Folda and Papacostas, respectively, in this volume (ed.).]

38 Letter of April 4, 1928 (HUG 1706. 102, box 12).

39 Epstein, "Meyer Schapiro," p. 79.

40 The unpublished portion of the dissertation examines in historical detail the iconography of each sculpture. The published portion has been reprinted, along with Schapiro's other major studies of Romanesque art, in *Selected Papers. Romanesque Art*.

41 "The Romanesque Sculpture of Moissac," in *Romanesque Art*, pp. 131–3.

42 "A Passion to Know and Make Known," p. 78.

43 Werckmeister, Review of Schapiro's *Romanesque Art*, p. 214.
44 Schapiro et al., "A Series of Interviews," p. 162.
45 "On Some Problems in the Semiotics of Visual Art"; the sparsely illustrated paper includes photos of the trumeau at Souillac, the Psalter of St Louis, and the earlier Symbol of Matthew in the Echternach Gospels. The note referencing class lectures he had given long before appears in the initial publication of the paper which had been presented as a talk at the Second International Colloquium on Semiotics in Poland in 1966 (*Semiotica* I, 3 (1969), pp. 223–4).
46 Schapiro chose this paper to introduce the volume on Romanesque (*Romanesque Art*, pp. 1–27). The citations in what follows come from pp. 13 and 12.
47 [On patronage, see chapter 9 by Caskey in this volume (ed.).]

Bibliography

Daniel Adler, "Painterly Politics: Wölfflin, Formalism and German Academic Culture, 1885–1915)," *Art History* 27:3 (June 2004), pp. 431–56.
Jonathan Alexander, "Otto Pächt," *Proceedings of the British Academy* 80 (1991), pp. 453–72.
Jurgis Baltrusaitis, *La Stylistique Ornementale dans la Sculpture Romane* (Paris, 1931).
Tony Bennett, *Formalism and Marxism* (London, 1979).
John E. Bowlt, "Russian Formalism and the Visual Arts," in Stephen Bann and John E. Bowlt, eds., *Russian Formalism. A Collection of Articles and Texts in Translation* (Edinburgh, 1973), pp. 131–8.
Kathryn Brush, *The Shaping of Art History, Wilhelm Vöge, Adolph Goldschmidt, and the Study of Medieval Art* (New York, 1996).
Todd E. Davis and Kenneth Womack, *Formalist Criticism and Reader Response Theory* (New York, 2002).
Whitney Davis, "Formalism: Formalism in Art History," in *Encyclopedia of Aesthetics* (New York, 1998).
Terry Eagleton, *Literary Theory, An Introduction* (Minneapolis, 1983).
Helen Epstein, "Meyer Schapiro: A Passion to Know and Make Known," *Art News* 82 (May 1983), pp. 60–85.
Michael Fried, *Three American Painters: Kenneth Noland, Jules Olitski, Frank Stella* (Cambridge, Mass.: 1965).
Ernst Gombrich, *Art and Illusion; A Study in the Psychology of Pictorial Representation*. Bollingen Series XXXV.5 (Princeton, NJ, 1960).
Clement Greenberg, "Avant-Garde and Kitsch," in John O'Brian, ed., *Clement Greenberg. The Collected Essays and Criticism*, 4 vols. (Chicago, 1986).
Tom Gretton, "New Lamps for Old," in A. L. Rees and Frances Borzello, eds., *The New Art History* (Atlantic Highlands, NJ, 1988), pp. 63–74.
Charles Harrison and Paul Wood, *Art in Theory 1900–2000* (Malden, Mass., 2004).
Vernon Hyde Minor, ed., *Art History's History*, 2nd edn. (Upper Saddle River, NJ, 2001).
Margaret Iverson, *Aloïs Riegl: Art History and Theory* (Cambridge, Mass. and London, 1993).
——, *Framing Formalism: Riegl's Work*. Critical Voices in Art, Theory and Culture, ed. Saul Ostrow (Amsterdam, 2001).

Frederic Jameson, *The Prison-House of Language. A Critical Account of Structuralism and Russian Formalism* (Princeton, 1972).

H. W. Janson, *History of Art. A Survey of the Major Visual Arts from the Dawn of History to the Present Day* (New York and Englewood, NJ, 1962).

Emile Mâle, *L'Art religieux du XIIe siècle en France. Etude sur l'origine de l'iconographie du Moyen Age* (Paris, 1922).

——, *L'Art religieux du XIIIe siècle en France. Etude sur l'iconographie du Moyen Age et sur ses sources d'inspiration* (Paris, 1919).

P. N. Medvedev and Mikhail Bakhtin, *The Formal Method in Literary Scholarship; A Critical Introduction to Sociological Poetics*, trans. Albert J. Wehrle (Cambridge, Mass., 1978).

Margaret Olin, *Forms of Representation in Aloïs Riegl's Theory of Art* (University Park, Penn., 1992).

Otto Pächt, "Art Historians and Art Critics – vi. Aloïs Riegl," *The Burlington Magazine* 105 (May 1963), pp. 188–93.

Michael Podro, *The Critical Historians of Art* (New Haven and London, 1982).

——, *The Manifold in Perception; Theories of Art from Kant to Hildebrand* (Oxford, 1972).

Arthur Kingsley Porter, *Romanesque Sculpture of the Pilgrimage Roads*, 10 vols. (Boston, 1923).

Donald Preziosi, *Rethinking Art History: Meditations on a Coy Science* (New Haven and London, 1989).

Meyer Schapiro, "On Geometrical Schematism in Romanesque Art," *Selected Papers. Romanesque Art* (New York, 1977), pp. 265–84.

——, "On Some Problems in the Semiotics of Visual Art: Field and Vehicle in Image-Signs," *Theory and Philosophy of Style, Artist, and Society. Selected Papers, 4* (New York, 1984), pp. 1–32.

——, *Selected Papers. Romanesque Art* (New York, 1977).

——, "Style," in A. L. Kroeber, ed., *Anthropology Today. An Encyclopedic Inventory* (Chicago, 1953), pp. 79, 85–9.

Meyer Schapiro and Lillian Milgram Schapiro with David Craven, "A Series of Interviews (July 15, 1992–January 22, 1995)," *Res* 31 (Spring 1997), pp. 159–68.

Joshua Taylor, *Learning to Look. A Handbook for the Visual Arts* (Chicago, 1957).

Wilhelm Vöge, *Die Anfänge des monumentalen Stiles im Mittelalter. Eine Untersuchung über die erste Blütezeit der französischen Plastik* (Strasbourg, 1894).

O. K. Werckmeister, "Review of Schapiro's *Romanesque Art*," *Art Quarterly* II:2 (1979), pp. 211–18.

Christopher Wood, ed., *The Vienna School Reader: Politics and Art Historical Method in the 1930s* (New York, 2000).

Virginia Woolf, *Roger Fry. A Biography* (London, 1940).

Wilhelm Worringer, *Abstraction and Empathy. A Contribution to the Psychology of Style.* Trans. Michael Bullock, intro. Hilton Kramer (Chicago, 1997).

——, *Form Problems of the Gothic* (New York, 1918).

6

Gender and Medieval Art[1]

Brigitte Kurmann-Schwarz

It is only in the last three decades that gender has come to be used as a historical perspective, in the context of research into history.[2] In theory, to reveal the effect of gender as a historical category, interactions between men and women should be analyzed; however, since the biggest gaps in our knowledge relate to the activities of women, it is on this area that gender studies has tended to focus.[3] Moreover, in the last 30 years the questions posed have been reformulated and the methodological approaches have multiplied.[4] Research often takes women's history as its subject, uses gender as a category of analysis, and adopts a feminist viewpoint according to location.[5] However, these three components do not have to occur simultaneously and do not necessarily even belong together; where researchers in gender studies have questioned the bipolar gender model, they have actually moved away from the decidedly feminist stance.[6]

Art historical gender studies have up until now concentrated largely on the modern age, and the theoretical system and conceptual tools have been developed in relation to the art of this later period.[7] It is no mean task to transfer this to a medieval framework and, at the same time, to furnish a historical interpretation which corresponds to the actual relationship between women and art in the various periods of the Middle Ages.[8] It must be emphasized that gender, as well as the perception of "male" and "female," are just as dependent on the historical period as are most other aspects of life, and hence should be interpreted in their historical context.

There are several reasons for the fact that gender studies has looked askance at medieval art. Not only did the established discipline of medieval studies long resist considering gender as an analytical perspective,[9] but the sparse source material extant from the Middle Ages only served to reinforce this reluctance. Artistic activities in general were poorly recorded and the lives of women, unless they were of noble birth, were barely acknowledged – or were even deliberately excluded from mention – by medieval authors.[10]

The investigation of the relationship between women and art in the Middle Ages is additionally complicated by the fact that the art historian needs not only to be thoroughly familiar with the actual works of art, but also to have a clear picture of the general mentality prevalent at that time with regard to women, and of their legal, social, economic, religious, and cultural status. For this, it is absolutely essential to study the contemporary sources, which are, however, seldom available in translation, and often not even in printed form. Thus, so as to be able properly to analyze the role of women in medieval art, art history needs, even more than modern theories and methods, to turn to the questions being asked and the results obtained in related disciplines. The subject requires scholars to be ready and willing to work in an interdisciplinary mode, sometimes even to the extent of undertaking primary research in another discipline, since, even though, for example, gender studies in history is relatively advanced, it is still far from supplying all of the results needed to write the history of women and art in the central centuries of the Middle Ages. There is, for example, a dearth of biographies of the famous women of this period written from the consistent perspective of gender (Eleanor of Aquitaine[11] and Blanche of Castile[12] are prominent examples) as well as of monographs on some of the fundamental works of art connected with women – such as the *Hortus Deliciarum* from Hohenbourg Abbey in Alsace.[13]

Women Artists

Primary place in what we now like to call art historical gender studies was initially accorded to the search for forgotten women artists pursued within the framework of traditional art history.[14] However, subsequent works by women authors adopting a radically feminist position have gone far beyond these initial steps. They realized that evaluating female artists from the traditional art historical viewpoint meant that they could never occupy any place other than outsider, at best. It therefore became necessary radically to question the concept of artistic greatness as defined by men, as well as the established canon for teaching this in universities.[15] Researchers studying both male and female artists were required to pay more attention to the social environment in which men and women lived and worked,[16] and to show how women managed, in the midst of a world where all the major decisions were taken by men, to create a situation in which they were able to develop their artistic and intellectual abilities and to become artists themselves or to exert some influence, be it active or passive, upon art.

The question as to whether or not it is worthwhile researching women artists from the Middle Ages is debatable, since so little information about them is available (as indeed is also the case for male artists). The starting point of research on medieval women artists was a now famous lecture by Dorothy Miner entitled "Anastaise and Her Sisters," which is still a main source for most authors writing on the subject. Her examples serve to demonstrate that both

religious and secular women were involved in the production of books during the Middle Ages.

Among the women artists of the twelfth century, some researchers count two of the great names of the day: Hildegard of Bingen (1098–1196) and Herrad of Landsberg, Abbess of Hohenbourg/Mount St Odile in Alsace (1117–97). Their status as artists is, however, the subject of much contention and I will therefore discuss them separately in the next section.[17] Even if the involvement of these two prominent abbesses in the manufacture of books went unnoticed, the transcription and illustration of books were certainly among those artistic activities in which women participated in large numbers throughout the entire Middle Ages. Women manifested considerable self-confidence in this area, and in certain cases, such as the painter and scribe Guda in a Frankfurt Homiliary, this is expressed in both word and image.[18]

It seems fair to assume that the self-image, relatively well documented, of scribes and illuminators can be transposed to women artists in other fields. Along with book production, it was in the textile arts that women were most frequently active; but in this area there is a lack of written source material, so that very little can be directly deduced about the self-awareness of an embroiderer or a weaver – although their work was often greatly appreciated by highly placed patrons (for example, Mabel of Bury St Edmunds at the court of Henry III of England, 1216–72).[19]

The best-known embroidery of the Middle Ages, the Bayeux Tapestry (fig. 6-1), made shortly after the Battle of Hastings in 1066, has also been linked to women. However, there is no mention of the tapestry in any contemporary source (the first reference is in 1478[20]), and the identity of the person who commissioned it as well as of the place where it was made have been the subject of controversy since the eighteenth century. Nowadays, the predominant view is that the tapestry was made in England (probably at St Augustine's, Canterbury) and that it was designed by a monk who was familiar with the manuscript illuminations at Canterbury. The romantic notion that it was Queen Mathilda and her ladies who embroidered the tapestry has long been refuted; it is nowadays thought that Bishop Odo of Bayeux, the half-brother of William the Conqueror, commissioned the work – but how far women actually participated in the embroidering is still under debate.[21]

Apart from those working on books or textiles, only a very small number of women can be identified as artists in other fields. In the Paris tax lists, there is mention of female glass-painters and glass-makers,[22] and several women are listed as working in the building trade, termed *maçonne* or *charpentière* (the female forms of mason and carpenter). Women on the building sites, however, mostly constituted an unskilled and poorly paid part of the workforce and as such can hardly be regarded as having assumed an artistic role.[23] Their lack of mobility was, furthermore, a barrier to their participation in the monumental arts; hence it is hardly surprising to discover that the sculptress Sabina von Steinbach was in fact a figment of the imagination of a sixteenth-century chronicler.[24]

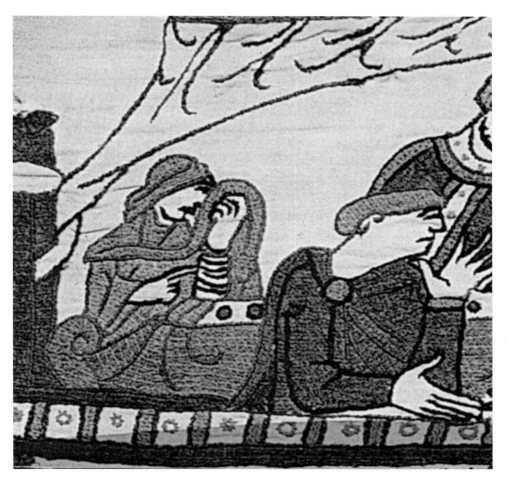

FIGURE 6-1 Mourning woman at the deathbed of King Edward the Confessor,
Bayeux Tapestry, after 1066. Bayeux: Musée de la tapisserie.

Finally, we must ask why art history up until now has treated women artists as,
at the best, marginal. From the time of the Renaissance and above all from the
nineteenth century onwards, when art history became established as an academic
discipline, those arts involved in the production of books and textiles have been
attributed a lowly status in comparison with the "high" arts of painting, monu-
mental sculpture, and architecture. The patrons of art in the Middle Ages,
however, recognized no such modern idea of hierarchy.[25] The goldwork of
the *vasa sacra* and reliquaries, the precious textiles for use in the decoration
of churches and altars or as liturgical vestments, stained glass, and beautifully
presented books were all prized above painting as such (which was also out-
ranked by sculpture as the traditional medium of the cult image). It is therefore
an anachronism on the part of modern art historians to treat these medieval

precious art objects as marginal works of inferior artistic value.[26] If the hierarchy of the arts that was prevalent in the eleventh to thirteenth centuries is taken seriously, then the artistic work of women at that time accordingly assumes central importance.

Hildegard of Bingen and Herrad of Hohenbourg

Three illustrated manuscripts of works by Hildegard are known: two of these date from the thirteenth century, the third is a copy of the twelfth-century Rupertsberg *Liber Scivias*. This manuscript was perhaps produced in the lifetime of the authoress, and possibly even in the convent at Rupertsberg itself; however the original disappeared during World War II, and now only a copy is available for study.

The question of Hildegard of Bingen's role in the illustration of her manuscripts is highly contentious, and today splits academic circles into two factions.[27] Saurma-Jeltsch and Suzuki give priority to the text:[28] in their opinion, Hildegard made notes on what she had seen and heard in her visions and had these transcribed, and then, based on these descriptions, professional illustrators created the images. Caviness, however, ascribes to Hildegard a distinct artistic role, assuming that she provided the illustrators with detailed sketches on which to base their work.[29] The dating of the manuscript is essential to the validation of either hypothesis, but this too is open to debate. Most authors do agree that the *Liber Scivias* of Rupertsberg was created during Hildegard's lifetime, but the exact dates advanced vary between 1160 and 1181. Saurma-Jeltsch comes down categorically on the side of the later date. Whereas Caviness considers the illustrations as a direct representation of Hildegard's mystical experiences, Saurma-Jeltsch sees them as an interpretation of these experiences based on the text. Caviness, on the contrary, interprets the illustrations as Hildegard's own intellectual and artistic expression, and associates their unusual character with the aura typical of migraine. Hildegard, however, described her visions as an intellectual achievement, as defined by St Augustine.[30] A more finely differentiated idea of Hildegard's part in the creation of the texts and illustrations is given recently. Hildegard presents herself in both the prologue and the author's portrait as a divinely inspired author, by making allusion to the images of Moses, Gregory the Great, St John and the Sybils.[31] In this interpretation, text and images are copies of the divine exemplar, and so the two mediums can be deemed equally valuable, being nourished by the same source.

The *Hortus Deliciarum*, in which Herrad compiled the theological knowledge of her time, presents similar problems. Like the *Liber Scivias*, it is unique and no longer available in the original. The *Hortus* was destroyed in 1870 and partially reconstructed in 1979 based on copies of the text and the images made in the nineteenth century.[32] As is the case for Hildegard, the role of Herrad in the

creation of the illustrations is disputed. While the occasional author refers to Herrad without prevarication as the artist,[33] others regard her primarily as the compiler of the texts.[34] Up until now it has only been possible to link the copies of the original miniatures with some of the stained glass in Strasbourg Cathedral, and with a parchment flabellum in the British Library.[35] Since the stained glass would hardly have been made anywhere other than Strasbourg itself, it can be concluded that the painters of the images in the *Hortus* were also active in northern Alsace. Therefore, the possibility should be considered that Herrad may well have been able to call in illuminators (from Strasbourg?) to carry out the commission. To sum it up, it is questionable whether Hildegard and Herrad can properly be called artists – unless the term is redefined for the Middle Ages to contain the idea that the mental conception of a work of art is just as much an artistic activity as is its material execution.

Women Patrons

For some time now it has been evident that, because of the available sources, research on medieval women patrons would probably be more fruitful. This has indeed been verified in many case-studies,[36] but there have been few wide-reaching surveys of female patronage which would allow an analysis of trends and patterns. Two exceptions are the book by Loveday Lewes Gee, which researches a group of English women patrons in the thirteenth and fourteenth centuries; and an extensive article by Madeline Caviness devoted to the period from the eleventh to the early fourteenth century.[37] These two texts present a very different picture of the opportunities open to female patrons. While Gee is convinced that women, given the will, the necessary network of relationships, and the corresponding financial means, could express their own ideas through their commissions, Caviness regards these women's choices as extremely limited.[38]

The biographies of women like the German queens Anna (d.1281; fig. 6-2) and Elisabeth (d.1313; fig. 6-3), consorts of the two first kings of the Hapsburg Dynasty,[39] as well as Eleanor of Aquitaine (d.1204),[40] Blanche of Castile (d.1252),[41] or Marguerite of Burgundy (d.1308),[42] to name but a few, provide abundant material for the study of female patronage. I will limit my observations to only one aspect of the subject, which was heavily shaped by gender – namely, the responsibilities of medieval noblewomen for the preparation of the tombs for deceased relatives, and for the donations made in memory of the dead.[43] Fasting, the giving of alms, prayer, and the donation of masses for the deceased were already mentioned by the chronicler Thietmar von Merseburg (975–1018) as being among a woman's duties, and those belonging to the social elite were obliged to emulate this ideal to a high degree. With the consent of husband or son, they endowed monasteries, where the religious communities were placed

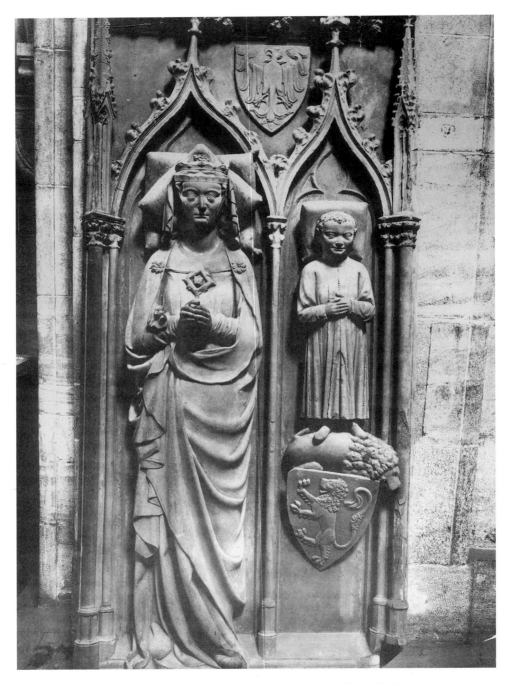

FIGURE 6-2 Tomb of Queen Anna, Basel Cathedral, c.1280. © Basler
Denkmalpflege, Sammlung Münsterphoto. Photo: J. Koch, c.1893.

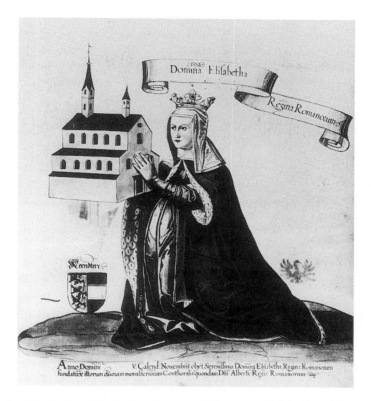

FIGURE 6-3 Elisabeth of Carinthia, Queen of Germany († 1313), 1555 after a stained-glass panel of *c*.1360. Vienna: Österreichische Nationalbibliothek, cod. 8614*, fol. 233r. Photo: Bildarchiv Österreichische Nationalbibliothek.

under obligation to remember and pray for the souls of the deceased family members. Women who belonged to the higher social classes disposed of enough wealth to enable them to bestow rich gifts on these institutions: Eleanor's stained glass, which she donated for the central window at Poitiers Cathedral, is but one example of this (fig. 6-4).[44]

Moreover, the female patrons nearly always wanted to secure a home for themselves in widowhood and prepare their own burial place. With the exception of Queen Anna, who was buried in Basel Cathedral (fig. 6-2),[45] all of the ladies mentioned above chose as their resting place institutions which they had themselves founded or endowed. The German queen Elisabeth was interred in the crypt of the abbey church at Königsfelden in 1316 (fig. 6-3).[46] Eleanor of Aquitaine chose to be buried in Fontevrault Abbey at the side of her husband and her son.[47] Blanche of Castile established the tradition of double burial in the French royal family, by deciding on the abbey which she had founded at Maubuisson near Pontoise for the burial of her body, and Lys Abbey, near

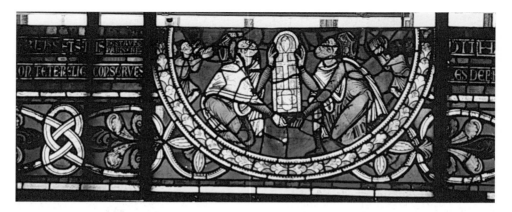

FIGURE 6-4 Eleanor of Aquitaine and Henry II with their children as donors of a stained-glass window, stained glass, Poitiers Cathedral, *c.*1165. Paris: UMR 8150 – Centre André Chastel. Photo: Karine Boulanger.

Melun, as the resting place for her heart.[48] She entrusted both institutions to Cistercian nuns. Marguerite of Burgundy had her tomb prepared in the hospital at Tonnerre, founded in 1293.[49]

The women mentioned above were involved, often intensively, in the planning and construction of their monasteries. It was, for example, in all probability Blanche of Castile who chose as builders for the monasteries of Lys and Maubuisson the team who had previously worked on the abbey of Royaumont.[50] Gee, too, was able to demonstrate that women patrons were actively involved in the choice of craftsmen.[51] On the other hand, the style of a building does not necessarily permit an easy interpretation of the wishes of the benefactor. Precisely the institutions mentioned here, such as Maubuisson, Lys, or the hospital at Tonnerre, offer few concrete stylistic details which would enable them to be associated with any specific model.

The express wishes of female patrons are often no easier to determine with regard to the visual arts. Eleanor of Aquitaine survived both her husband and her son Richard the Lionheart. It would seem reasonable to assume that the Queen would have arranged a suitable monument for her relatives in the nuns' choir of the church. However, the dating and status of preservation of the funeral effigies is still open to dispute.[52] Nevertheless, the late dating of the tombs to 1220 should be reconsidered in the light of the particular responsibilities of women toward their dead. Moreover, in contrast to the effigies of her husband and son, the effigy of Eleanor depicts her with eyes open, reading a book. Could this mean that she was still alive when she commissioned the three tomb effigies? Feminist art historians are in the habit of underscoring her self-representation in the reading of the book. This motif has been entirely restored with the help of a drawing in the Gaignières collection.[53]

FIGURE 6-5 Portrait of a queen, stained glass, Tonnerre Hospital, *c*.1295. Paris: UMR 8150: Centre André Chastel, Inventory No. 14. Photo: Françoise Gatouillat.

The tombs of Blanche of Castile and Marguerite of Burgundy were destroyed in the turmoil of the French Revolution.[54] The patrons of the monastery of Königsfelden, Queens Elisabeth and Agnes, found their final resting place there, in the crypt under a simple sarcophagus, void of images, which served as the focus for the ceremonies in memory of the deceased members of the Hapsburg family.[55] The treasury records and the few remaining textiles from this period afford but a glimpse of the pomp and magnificence of these memorial services.[56] In Königsfelden and in Tonnerre (fig. 6-5), some of the original stained glass has survived.[57] However, neither glazing scheme incorporates any specifically female theme: in Königsfelden the accent is placed on general aspects of piety, and in both locations the royal status of the founders is given pre-eminence. This observation can in fact be regarded as a generalization when considering the wishes of patrons in the Middle Ages: both men and women perceived themselves primarily as members of a certain social class, and only in second place as representatives of their gender;[58] their attitudes and behavior were therefore shaped accordingly.

The Role of Women in the Use of Devotional Images

In the changing spirituality of the monasticism of the eleventh and twelfth centuries can be found the roots of what has been dismissively labeled "popular

piety." A characteristic of this was the use of devotional images, primarily by the laity, which stood in marked contrast to the austere Cistercian proscription of images. The phenomenon was perceived as resulting from the decline of the monasticism of the High Middle Ages and, because of its permeation by the vernacular, as the opposite of "high" Latin culture. A strict differentiation was made between this popular piety and the devoutness of the elite. Jeffrey Hamburger, in the closing chapter of his masterly study on the Rothschild Canticles (created for a woman in c.1300) considered anew this idea, which had long been accepted by art historians and specialists in religious history alike.[59] He actually presents no less than a new, positively oriented history of the use of devotional images in the late Middle Ages; and he demonstrates how, in particular, the communities of nuns in the Rhineland made a significant contribution to this field.[60] Nevertheless, women alone could not have been totally responsible for the change in attitude to images, for, as nuns, the care of their souls was dependent on men, who alone were authorized to administer the sacraments. Hamburger therefore stresses that the way in which women related to images and to their use must be studied within this framework, assuming thereby the cooperation between the nuns and their spiritual advisors.[61]

Men wrote books for women to use as guidance in their devotional practices from the eleventh century onwards. Anselm of Canterbury composed his prayers for Matilda of Tuscany (1046–1115).[62] Mention should also be made of the richly illustrated psalter, made in the monks' scriptorium at St Albans, for the use of the anchoress Christina of Markyate (Albani Psalter: St Godehard's at Hildesheim).[63] However, Hamburger emphasizes that these women were not merely passive recipients of the manuscripts, but took an active part in the transcription of the texts and the creation of the illustrations. In the case of the Rothschild Canticles, he was able to show that the compiler incorporated German texts[64] that were so unusual that they can only have been included at the express wish of the German-speaking owner. Her influence also extended to the illustrations, which are informed by the metaphorical language of the mystics.[65]

A close connection between the images created for female mystics and the visions they experienced has long been noted in research.[66] Since authors have, however, assumed that the definitive spirituality of the Middle Ages was predicated upon a standard without images, as ordained by St Bernard of Clairvaux, the role which images played in visions has necessarily been evaluated as negative. Thus, most authors have judged these women on a criterion which has been devised by modern research but which for the women themselves was completely irrelevant. They in fact deliberately shaped their visions with the aid of real pictures. In the same way, they made use of accepted, familiar biblical and liturgical metaphors to describe their mystical experiences in writing. Without this picturesque language, they would not have been able to communicate their experiences in a comprehensible manner. Gertrude of Helfta quoted Christ himself as the authority for this, when she had him say in a vision that sensual

devotional experience should not be disparaged, because only through such experience can the human soul apprehend invisible truths.[67]

Although Jeffrey Hamburger's research focuses on the period after 1300, he does address the beginnings of the development of the use of devotional images by women in one important study.[68] Until the thirteenth century, the psalter was the usual prayer book of the nuns and of the laity.[69] The first psalters to include a series of full-page miniatures (mostly of the life of Christ) at the front originated in England around 1050. To the early examples of this type can be counted the psalter of Christina of Markyate (c.1120/30) mentioned above. At almost the same time, the first illustrated prayer books were produced; they display an even closer connection between prayer and image than do the psalters, by presenting an illustration on the facing page to one or more texts. In the first half of the twelfth century, the copious illustration of a prayer book was such an innovation that the compiler of the St Albans Psalter found it necessary to include one of Gregory the Great's letters, in which he justifies the use of images.[70]

In analyzing the justification of the use of images in monastic circles, Hamburger identifies two relevant groups: nuns and male novices.[71] Whereas the latter abandoned the use of images in their devotional practices after a certain time, the women remained permanently attached to devotional imagery. Medieval theologians explained this continued need for the support of images in their devotions as resulting from the more sensual and corporeal nature of women, which rendered them incapable of intellectual prowess. Hamburger's observations based on the Rothschild Canticles are proof that the use of images from the twelfth, perhaps even the eleventh, century onwards by the confessors and the spiritual advisors in the context of the *cura monialium*, or pastoral care, of nuns, corresponded to a real demand on the part of the women and was not simply forced upon them.[72] This positive reception of imagery by the nuns and their position between the clerics and laity predestined them for mediation between the two, so that their devotional practices based on images passed into general use by the thirteenth century at the latest.[73] Women were therefore in large part responsible for the promotion of works of visual art to the status of objects which were greatly treasured as helping the soul in its efforts to find the way to God.

Monastic Architecture for Women

Right up until most recent times, female monastic buildings have scarcely been noticed by art historians, much less researched.[74] Almost all of the large-scale surveys of monastic architecture have ignored the existence of nunneries;[75] a comprehensive study of the architectural context in which nuns lived and prayed is therefore absolutely essential and well overdue. The general neglect of the history of female monasticism probably also partially explains the fact that, over

time, the physical vestiges of these institutions have more or less disappeared. Nevertheless, the few remaining examples furnish enough architectural evidence to evoke a vivid picture of the life of the devout female members of the various orders. If the archives of the convents which have not disappeared are added to this, there is ample scope for future research.[76]

The master builder of the Middle Ages was confronted with a fundamental problem when planning the construction of either a double or female monastery, in that he had strictly to separate several groups of inhabitants or users: the male and female occupants of the monastery in the first case, the nuns and their male spiritual advisors within the *cura monialium* in the second.[77] Similarly, the buildings for the lay sisters and for the employees, as well as the agricultural buildings, had to be completely separate from the nuns' living area. Furthermore, the observance of enclosure became more and more strict between the years 1100–1300 (it was made obligatory in 1298), and necessitated adaptations in the arrangement of spaces within the convents.[78]

For the founding of a women's monastery, the patron would generally obtain the consent of the bishop of the diocese. The endowment would have to contain provision for a priest or a community of monks for the *cura monialium*, and the charter would usually grant visiting rights to the bishop or his representative. This illustrates how the female convents, even though usually founded by women, had nevertheless in many respects to fit in with, and submit to, a structure defined by men; which in turn explains why the church and convent buildings of female monasteries were generally influenced by the architectural forms prevalent among the male orders. They were, however, nearly always built in a simplified form. The reason for this often lies in the smaller endowments made to female monasteries, but even the exceptions to this rule constituted by the institutions funded by highly placed patrons did not usually deviate from the ideal of simplicity. This is clearly illustrated by a previously mentioned group of Cistercian monasteries, male and female, which were founded under the patronage of Blanche of Castile and St Louis: whereas the abbey church of Royaumont, a male institution, adopts the kind of construction typical of the Gothic cathedrals, the female abbeys of Maubuisson and Lys are much simpler. However, an evaluation of these edifices based solely on their architectural style would be mistaken, for Maubuisson, as the burial place of the Queen, was of more importance than the much larger and more magnificent construction at Royaumont, which was founded to house the tombs of the royal children who had died prematurely.[79]

The layout of monastery buildings for women and the structure of their churches differed by order and by region. Often it had to accommodate a complicated topography, or perhaps to incorporate an already existing church, as was the case for the convent of Wienhausen and for the nunnery at St Peter's in Salzburg.[80] Roberta Gilchrist emphasizes the greater flexibility of the plans for female as opposed to male monasteries; often, not even the classical arrangement around a cloister is in evidence.[81]

In convent churches, the disposition and furnishing of the liturgical spaces posed a particular problem. Since many of these churches have now either completely lost their furnishings and fittings, or indeed stand only in ruin, the original form and position of the nuns' choir is often difficult to determine. The builders working for the religious orders came up with many, often highly individual, solutions for its location.[82] Cistercian convents in the German-speaking regions often had churches built to a single-vessel plan, with a simple choir, and a gallery with stalls at the west end. This model was also adopted by the mendicant orders, although it never became compulsory.[83] In France, for example, the nuns' choir was almost always placed on the same level as the liturgical choir.[84]

While some valuable individual studies of the churches in female monasteries have been made, little research has been undertaken on the convent buildings in which the women lived. These buildings, far more so than the churches, have been altered in the course of time, so that uncovering their original layout would probably be difficult. On the other hand, recent research confirms that bringing together clues and facts in this area can greatly contribute to our understanding of medieval convent life.[85]

The Female Image in Romanesque and Gothic Art

In studying the art of the Middle Ages, the question soon arises as to what image of woman is conveyed in the visual arts of the period.[86] It should of course be borne in mind that these portrayals do not represent reality, but rather convey the ideals and norms of the age.[87] These in turn were primarily determined from a theological, and hence male, viewpoint, since the vast majority of the depictions of women originated in a religious context. Moreover, medieval images are rarely socially representative, their subject matter being heavily informed by the culture of the upper classes. The most important function of these images was to provide an appropriate role model for women. Research into medieval female image has led to two diametrically opposed conclusions: Frugoni and Caviness form a fairly negative impression of women's position,[88] whereas McKitterick and Goetz tend to the positive.[89] A more finely differentiated idea of what Romanesque and Gothic images reveal about women would need further study, taking into account the changes in the status of women throughout the Middle Ages.[90]

Numerous portrayals of women have survived in the funerary arts or as donor or owner portraits. The oldest extant figural tombs date back to the eleventh century,[91] and among them can be found monuments for female founders, for example, the abbesses of Quedlinburg from c.1100.[92] A comprehensive study of women's tombs from the eleventh to the thirteenth century, identifying their particular features and examining the differences in comparison to men's tombs of the same era, has yet to be made.[93] In addition to the religious theme of hope

that the soul would be judged worthy of joining the just, the images on the tombs primarily denote the women's worldly position.

Extant works of art designed for secular use, from which we could gain an insight into the female image outside of religion, are also few and far between for the period from 1100 to 1300. The most important is probably the previously mentioned Bayeux Tapestry. The latter can however be taken as evidence that society at that time accorded women a purely marginal role in public life: of the 626 figures depicted, a mere four are women (fig. 6-1).[94] A much more useful group of pictures of women on non-religious objects is constituted by personal seals.[95] On the seals the women were nearly always pictured standing, and easily identified as female by their physical characteristics. Abbesses in general, queens, and empresses in the Holy Roman Empire were depicted with the symbols of their office.[96]

The concepts of vision and "the gaze" are of great importance in the visual arts. With regard to women, both had negative connotations from a medieval viewpoint, for, particularly in the relationship between the sexes, they were considered dangerous.[97] A woman was not supposed to attract a man's attention with provocative glances; she should on the contrary be completely invisible to male eyes. The proscription, on moral grounds, of looking is in contradiction to all of the guidance on devotional practice given to the women by their spiritual supervisors.[98] They were advised to imagine the Life of Christ and the saints in both mental and actual images. Thus, in a religious context, vision and looking could only have had positive connotations. This view is confirmed in the writings of St Bonaventura, who ascribed positive qualities to the faculty of sight when it fostered pious sentiments. Hence women visionaries were no longer inclined to accept the gaze as a male privilege.[99]

Recently, the idea of scopophilia has been associated with the images of female martyrs, to postulate that the depicted torture of these sensual virgins actually fulfilled hidden sexual longings. However, this view fails to take into account the internalized piety of the eleventh century and later, which demanded affective participation in the sufferings of Christ and the martyrs. Also, if these images of the torture of holy maidens really did serve to satisfy the sado-erotic desires of clerics, this would have to be authenticated by the medieval sources, over and above any explanation based on Freudian theory.[100] From what has been said until now, it seems to me that the interpretation of these images as stimuli for empathy, or as souvenirs of personal experience, is more convincing,[101] particularly in those pictures, created for women, in which the expression of the *compassio*, or affective compassion, constituted a central element.

Conclusion

An overview of gender and art in the Romanesque and Gothic periods clearly reveals that art historical research from the perspective of gender has already

yielded some initial findings, but that, given the wide scope of the subject, there are still many gaps in our knowledge. Scholars interested in women's and gender history must therefore base a large part of their work on older research and try their best to reinterpret the information appropriately. Other researchers are attempting to integrate the material from the three central centuries of the Middle Ages into a highly intellectual theoretical framework and in this way to extract new understanding from the images. Both of these approaches are legitimate, but the results generated can only be regarded as credible if they withstand comparison with the original sources. The content and import of these set clearly defined limits to gender–oriented interpretation.

Notes

1　I thank Anne Christine George for her excellent translation.
2　Goetz, *Moderne Mediaevistik*, pp. 318–29; Gouma-Peterson and Mathew, "The Feminist Critique," pp. 326–57; and Ruby, "Feminismus," pp. 17–28.
3　Duby and Perrot, *Histoire des femmes en occident*; Goetz, *Frauen im frühen*; Wiesner-Hanks, *Gender in History*.
4　Söntgen, *Rahmen*, pp. 7–23.
5　Goetz, *Moderne Mediaevistik*, p. 320.
6　Ruby, "Feminismus," p. 26.
7　Parker and Pollock, *Old Mistresses*. See also the essays in *Speculum* 68 (1993) pp. 305–471.
8　Caviness, *Visualizing Women*.
9　*Speculum* 68 (1993), pp. 309–31.
10　Morrison, *History as a Visual Art*, pp. 154–95.
11　Owen, *Eleanor of Aquitaine*.
12　Sivéry, *Blanche de Castille*.
13　Green et al., *Hortus Deliciarum*, was published when gender studies was still in its infancy. For a summary, see Evans, "Herrad," pp. 358–9.
14　Gouma-Peterson and Mathews, "The Feminist Critique," p. 350.
15　Pollock, "Women and Art History," pp. 307–16.
16　Nochlin, "Why Have There Been No Great Women Artists?" pp. 480–510.
17　Havice, "Approaching Medieval Women," pp. 366–7.
18　Graf, *Bildnisse*, pp. 50–60.
19　Parker, *Subversive Stitch*, pp. 48–9.
20　Brown, *The Bayeux Tapestry*.
21　Weyl Carr, "Women as Artists," p. 6.
22　Lillich, "Gothic Glaziers," pp. 72–92.
23　Schöller, "Frauenarbeit," pp. 305–20.
24　Geyer, "Le mythe d'Erwin de Steinbach." Pollock, "Women and Art History," p. 308, and Havice, "Women and the Production of Art," pp. 72–5, claim, on the contrary, that Sabina was a legendary medieval artist. However Havice, in "Approaching Medieval Women," p. 372, corrects her earlier assumption.
25　[On patronage, see chapter 9 by Caskey in this volume (ed.).]

26 For a medieval *Paragone*, see Theophilus, *The Various Arts*, pp. 37 and 61–4. [In regard to Romanesque manuscript illumination and the sumptuous arts, see chapters 17 and 22 by Cohen and Buettner, respectively, in this volume (ed.).]

27 Caviness, "Hildegard of Bingen"; Heerlein, "Hildegard von Bingen."

28 Saurma-Jeltsch, *Die Miniaturen*, pp. 12–15; Suzuki, *Bildgewordene Visionen*, pp. 222–5.

29 Caviness, "Hildegard as Designer," pp. 29–62, and "Gender Symbolism."

30 Graf, *Bildnisse*, pp. 101–9.

31 Ibid., pp. 92–189.

32 See note 13 above.

33 McGuire, "Two Twelfth Century Women," pp. 97–105.

34 Most recent: Griffiths, "Nuns' Memories," pp. 132–49, and "Herrad of Hohenbourg," pp. 221–43.

35 Beyer et al., *Les vitraux de la cathédrale Notre-Dame de Strasbourg*, pp. 25–31, 48–51, 125–8; Cahn, *Romanesque Manuscripts*, pp. 180–1.

36 Lord, *Royal French Patronage*, pp. 56–65 (Royal Female Patronage); Caviness, "Anchoress," p. 107.

37 Gee, *Women*; Caviness, "Anchoress," pp. 105–54.

38 Caviness, "Anchoress," p. 107.

39 New material on the German queens is to be found in Fößel, *Die Königin*.

40 Owen, *Eleanor of Aquitaine*.

41 Sivéry, *Blanche de Castille*; see also Gajewsky-Kennedy, "Recherches," pp. 223–54.

42 Lillich, *The Queen of Sicily*, pp. 68–74.

43 Althoff, *Adels und Königsfamilien*, pp. 133–78; Fößel, *Die Königin*, pp. 222–49; Nelson, "Medieval Queenship."

44 Caviness, "Anchoress," pp. 128–31.

45 Grütter, "Das Grabmal."

46 Kurmann-Schwarz, "Die Sorge."

47 Bienvenu, "Aliénor d'Aquitaine et Fontevraud."

48 Gajewsky-Kennedy, "Recherches."

49 Lillich, *The Queen of Sicily*, pp. 68–75, 110–12.

50 Gajewsky-Kennedy, "Recherches," p. 241.

51 Gee, *Women*, pp. 93–108.

52 Sauerländer and Kroos, *Gotische Skulptur*, pp. 130–1; Prunet and de Maupeou, "Présentation des Gisants," pp. 51–67 (with Bibliography).

53 Mérimée: "Le haut du corps est tellement endommagé qu'il est difficile de juger sa position": see Prunet and de Maupeou, p. 63.

54 Erlande-Brandenburg, "Le tombeau"; Gajewsky-Kennedy, "Recherches," pp. 223–54; Lillich, *The Queen of Sicily*, p. 112, note 21.

55 Kurmann-Schwarz, "Die Sorge," pp. 17–18.

56 Marti, "Königin Agnes."

57 Kurmann-Schwarz, *Glasmalerei*; Lillich, *The Queen of Sicily*, pp. 77–95.

58 Goetz, *Moderne Mediaevistik*, p. 329.

59 Hamburger, *Rothschild Canticles*, pp. 155–67.

60 Hamburger, *The Visual and the Visionary*, pp. 111–48.

61 Hamburger, *Rothschild Canticles*, p. 164; Bynum, *Holy Feast and Holy Fast*.

62 Hamburger, *Rothschild Canticles*, p. 160, and "Liber Precum," p. 220; Carrasco, "Imagery," pp. 75–6.

63 Pächt et al., *The Saint Albans Psalter*; Hamburger, *Rothschild Canticles*, p. 160; Caviness, "Anchoress," pp. 107–13; Hamburger, "Liber Precum," pp. 228–30; Carrasco, "Imagery," pp. 67–80.

64 Hamburger, *Rothschild Canticles*, pp. 99–100, 161.

65 Ibid., pp. 105–17.

66 Hamburger, *The Visual and the Visionary*, pp. 111–48.

67 Hamburger, *Rothschild Canticles*, pp. 165–6.

68 Ibid., pp. 149–95.

69 Oliver, *Gothic Manuscript Illumination*, pp. 29–119.

70 Pächt et al., *The Saint Albans Psalter*, pp. 137–8; Carrasco, "Imagery," p. 71. [On Gregory the Great and image theory, see chapter 7 by Kessler in this volume (ed.).]

71 Hamburger, "Liber Precum," p. 232.

72 Hamburger, *Rothschild Canticles*, pp. 164–5.

73 Southern, *Saint Anselm and His Biographers*, p. 37.

74 Bruzelius and Berman, "Monastic Architecture," pp. 73–5.

75 For example, Braunfels, *Monasteries of Western Europe*.

76 Venarde, *Women's Monasticism and Medieval Society*.

77 Hamburger, *The Visual and the Visionary*, pp. 44–57.

78 Concerning legislation on enclosure, see: Huyghe, *La Clôture*; Tibbetts Schulenburg, "Strict Active Enclosure"; Johnson, "La Théorie de la clôture."

79 Gajewsky-Kennedy, "Recherches," pp. 223–54.

80 Hamburger, *The Visual and the Visionary*, pp. 44–57.

81 Gilchrist, *Gender and Material Culture*, pp. 92–127.

82 Bruzelius, "Hearing is Believing," pp. 83–91.

83 Descoeudres, "Mittelalterliche Dominikanerinnenkirchen," pp. 39–77.

84 Simmons, "The Abbey Church," pp. 99–107.

85 Gilchrist, *Gender and Material Culture*, pp. 128–69.

86 Caviness, *Visualizing Women*; Havice, "Approaching Medieval Women," pp. 347–59.

87 Goetz, *Frauen im frühen*, pp. 284–5.

88 Frugoni, "La Femme imaginée," in Duby and Perrot, *Histoire des femmes en occident*, pp. 357–437; Caviness, "Anchoress," pp. 105–8.

89 McKitterick, "Women in the Ottonian Church"; Goetz, *Frauen im frühen*, pp. 281–323.

90 See contributions in Duby and Perrot, *Histoire des femmes en occident*.

91 Schubert, *Die ältesten Personen-Denkmäler*, pp. 4–8.

92 Ibid., pp. 9–13; Havice, "Approaching," pp. 345–7, 355.

93 Gee, *Women*, pp. 109–22.

94 Morrison, *History as a Visual Art*, pp. 164–71.

95 Bedos-Rezak, "Medieval Women," pp. 1–36.

96 Fößel, *Die Königin*, Ill. 11.

97 Caviness, *Visualizing Women*, pp. 18–44. [On vision, see chapter 2 by Hahn in this volume (ed.).]

98 Hamburger, *Rothschild Canticles*, p. 167.

99 Ibid., p. 163.

100 Caviness, *Visualizing Women*, pp. 84–124.

101 Stones, "Nipples, Entrails," pp. 47–64, and *Le Livre d'images*; Braem, *Das Andachtsbuch*.

Bibliography

Gert Althoff, *Adels und Königsfamilien im Spiegel ihrer Memorialüberlieferung. Studien zum Totengedenken der Billunger und Ottonen*, Münstersche Mittelalterschriften 47 (München, 1984).

Brigitte Bedos-Rezak, "Medieval Women in French Sigillographic Sources," in Joel T. Rosenthal, *Medieval Women and the Sources of Medieval History* (Athens and London, 1990), pp. 1–36.

Victor Beyer, Christiane Wild-Block, and Fridtjof Zschokke, *Les Vitraux de la cathédrale Notre-Dame de Strasbourg*, Corpus Vitrearum France 9–1, Département du Bas-Rhin 1 (Paris, 1986).

Jean-Marc Bienvenu, "Aliénor d'Aquitaine et Fontevraud," *Cahiers de Civilisation médiévale* 29 (1986), pp. 15–27.

Andreas Braem, *Das Andachtsbuch der Marie de Gavre, Paris, Ms. nouv. acq. fr. 16521. Buchmalerei in der Diözese Cambrai im letzten Viertel des 13. Jahrhunderts* (Wiesbaden, 1997).

Wolfgang Braunfels, *Monasteries of Western Europe: The Architecture of the Orders* (London, 1972).

Shirley Ann Brown, *The Bayeux Tapestry. History and Bibliography* (Woodbridge, 1988).

Caroline Bruzelius, "Hearing is Believing: Clarissan Architecture, *ca.*1213–1340," *Gesta* 31 (1992), pp. 83–91.

Caroline Bruzelius and Constance H. Berman, "Monastic Architecture for Women, Introduction," *Gesta* 31 (1992), pp. 73–5.

Caroline Walker Bynum, *Holy Feast and Holy Fast, The Religious Significance of Food to Medieval Women* (Berkeley, Los Angeles, and London, 1987).

Walter Cahn, *Romanesque Manuscripts. The Twelfth Century*, vol. 2 (London, 1996).

Magdalena E. Carrasco, "The Imagery of the Magdalen in Christina of Markyate's Psalter (Saint Albans Psalter)," *Gesta* 38 (1999), pp. 67–80.

Madeline H. Caviness, "Anchoress, Abbess, and Queen: Donors and Patrons or Intercessors and Matrons?" in June Hall McCash, ed., *The Cultural Patronage of Medieval Women* (Athens and London, 1996), pp. 105–54.

——, "Gender Symbolism and Text Image Relationships: Hildegard of Bingen's Scivias," in *Art in the Medieval West and Its Audience* (Aldershot and Burlington, 2001), pp. 71–111.

——, "Hildegard," in Delia Gaze, ed., *A Concise Dictionary of Women Artists* (London and Chicago, 2001), pp. 363–7.

——, "Hildegard of Bingen: Some Recent Books," *Speculum* 77 (2002), pp. 113–120.

——, "Hildegard as Designer of the Illustrations to Her Work," in Charles Burnett and Peter Dronke, eds., *Hildegard of Bingen. The Context of her Thought and Art* (London, 1998), pp. 29–62.

——, *Visualizing Women in the Middle Ages. Sight, Spectacle, and Scopic Economy* (Philadelphia, 2001).

Whitney Chadwick, "The Middle Ages," *Women, Art and Society*, 2nd edn. (London, 1966).

Georges Descoeudres, "Mittelalterliche Dominikanerinnenkirchen in der Zentra- und Nordostschweiz," *Mitteilungen des Historischen Vereins des Kantos Schwyz* 81 (1989), pp. 39–77.

George Duby and Michèle Perrot, *Histoire des femmes en occident 2, Le Moyen Age*, ed. Christiane Klapisch-Zuber (Paris, 1991).

Alain Erlande-Brandenburg, "Le Tombeau de coeur de Blanche de Castille à l'abbaye de Lys," *Art et architecture à Melun au Moyen Age* (Paris, 2000), pp. 255–7.

Michael Evans, "Herrad, Abbess of Hohenbourg," in Delia Gaze, ed., *A Concise Dictionary of Women Artists* (London and Chicago, 2001), pp. 358–9.

Amalie Fößel, *Die Königin im mittelalterlichen Reich, Herrschaftsausübung, Herrschaftsrechte, Handslungsspielräume* (Stuttgart, 2000).

Alexandra Gajewsky-Kennedy, "Recherches sur l'architecture cistercienne et le pouvoir royal. Blanche de Castille et la construction de l'abbaye de Lys," *Art et Architecture à Melun au Moyen Age*, Actes du colloque d'histoire de l'art et d'archéologie tenu à Melun, ed. Yves Gallet (Paris, 2000), pp. 223–54.

Loveday Lewes Gee, *Women, Art and Patronage from Henry III to Edward III, 1216–1377* (Woodbridge, 2002).

Marie-Jeanne Geyer, "Le Mythe d'Erwin de Steinbach," in Roland Recht, ed., *Les Bâtiseurs des cathédrales* (Strasbourg, 1989), pp. 322–9.

Roberta Gilchrist, *Gender and Material Culture. The Archaeology of Religious Women* (London and New York, 1994).

Hans-Werner Goetz, *Frauen im frühen Mittelalter. Frauenbild und Frauenleben im Frankenreich* (Weimar, Köln, and Wien, 1995).

——, *Moderne Mediaevistik. Stand und Perspektiven der Mittelalterforschung* (Darmstadt, 1999).

Thalia Gouma-Peterson and Patricia Mathew, "The Feminist Critique of Art History," *Art Bulletin* 69 (1987), pp. 326–57.

Katrin Graf, *Bildnisse schreibender Frauen im Mittelalter 9. bis Anfang 13. Jahrhundert* (Basel, 2002).

Rosalie Green, Michael Evans, Christine Bischoff, and Michael Curschmann, eds., *Herrad von Hohenburg, Hortus Deliciarum*, 2 vols., Reconstruction and Commentary (London, 1979).

Fiona Griffiths, "Nuns' Memories or Missing History in Alsace (*c.*1200): Herrad of Hohenbourg's Garden of Delights," in Elisabeth van Houts, ed., *Medieval Memories. Men, Women and the Past 700–1300* (Harlow, 2001), pp. 132–49.

——, "Herrad of Hohenbourg: A Synthesis of Learning in the Garden of Delights," in Constant J. Mews, ed., *Listen Daughter. The Speculum Virginum and the Formation of Religious Women in the Middle Ages* (New York, 2001), pp. 221–43.

Daniel Grütter, "Das Grabmal der Königin Anna von Habsburg im Basler Münster," *Kunst und Architektur in der Schweiz* 53 (2002), pp. 60–3.

Jeffrey F. Hamburger, "A Liber Precum in Sélestat and the Development of the Illuminated Prayer Book in Germany," *Art Bulletin* 73 (1991), pp. 209–36 (reprinted in *The Visual and the Visionary*, under the title "Before the Book of

Hours: The Development of the Illustrated Prayer Book in Germany," pp. 149–95).

——, *The Rothschild Canticles. Art and Mysticism in Flanders and the Rhineland circa 1300* (New Haven and London, 1990).

——, *The Visual and the Visionary. Art and Female Spirituality in Late Medieval Germany* (New York, 1998).

Christine Havice, "Approaching Medieval Women Through Medieval Art," in Linda E. Mitchell, ed., *Women in Medieval Western European Culture* (New York and London, 1999), pp. 345–73.

——, "Women and the Production of Art in the Middle Ages: The Significance of Context," in Natalie Harris Bluestone, ed., *Double Vision. Perspectives on Gender and the Visual Arts* (London and Toronto, 1995), pp. 67–94.

Karin Heerlein, "Hildegard von Bingen (1098–1179). Erträge des Jubiläumsjahres," *Kunstchronik* 53 (2000), pp. 549–60.

Gérard Huyghe, *La Clôture des moniales des origines à la fin du XIIIe siècle. Etude historique et juridique* (Roubaix, 1944).

Penelope D. Johnson, "La Théorie de la clôture et l'activité réelle des moniales françaises du XIe au XIIIe siècle," in *Les Religieuses dans le cloître et dans le monde* (Saint-Etienne, 1994), pp. 491–505.

Brigitte Kurmann-Schwarz, "Die Sorge um die Memoria. Das Habsburger Grab in Königsfelden im Lichte seiner Bildausstattung," *Kunst und Architektur in der Schweiz* 50 (1999), pp. 12–23.

——, *Glasmalerei im Kanton Aargau, Bd. 1, Königsfelden – Zofingen – Staufberg* (Aarau, 2002).

Meredith P. Lillich, "Gothic Glaziers: Monks, Jews, Taxpayers, Bretons, Women," *Journal of Glass Studies* 27 (1985), pp. 72–92.

——, *The Queen of Sicily and Gothic Stained Glass in Mussy and Tonnerre*, Transactions of the American Philosophical Society 88, Part 3 (Philadelphia, 1998).

Carla Lord, *Royal French Patronage of Art in the Fourteenth Century. An Annotated Bibliography* (Boston, 1988).

Susan Marti, "Königin Agnes und ihre Geschenke – Zeugnisse, Zuschreibungen und Legenden," *Kunst und Architektur in der Schweiz* 47 (1996), pp. 169–80.

Thérèse McGuire, "Two Twelfth Century Women and their Books," in Lesley Smith and Jane H. M. Taylor, eds., *Women and the Book. Assessing the Visual Evidence* (London and Toronto, 1996), pp. 97–105.

Rosamond McKitterick, "Women in the Ottonian Church: An Iconographic Perspective," in W. J. Sheils and Diana Wood, eds., *Women in the Church. Studies in Church History* (Oxford, 1990), pp. 79–100.

Dorothy Miner, *Anastaise and Her Sisters. Women Artists of the Middle Ages*, Walters Art Gallery (Baltimore, 1974).

Karl F. Morrison, *History as a Visual Art in the Twelfth-Century Renaissance* (Princeton, 1990).

Janet L. Nelson, "Medieval Queenship," in Linda E. Mitchell, ed., *Women in Medieval Western European Culture* (New York and London, 1999), pp. 179–207.

Linda Nochlin, "Why Have There Been No Great Women Artists?" in Vivian Gornick and Barbara Moran, eds., *Women in Sexist Society. Studies in Power and Powerlessness* (New York, 1971), pp. 480–510.

Judith H. Oliver, *Gothic Manuscript Illumination in the Diocese of Liège (c.1250–c.1330)*, 2 vols. (Leuven, 1988).

D. D. R. Owen, *Eleanor of Aquitaine. Queen and Legend* (Malden, 1993).

Otto Pächt, Charles Reginald Dodwell, and Francis Wormald, *The Saint Albans Psalter* (London, 1960).

Rozsika Parker, *The Subversive Stitch: Embroidery and the Making of the Feminine* (London, 1984).

Rozsika Parker and Griselda Pollock, *Old Mistresses. Women, Art and Ideology* (London, 1981).

Griselda Pollock, "Women and Art History," *Dictionary of Art* 33 (1996), pp. 307–16.

Pierre Prunet and Catherine de Maupeou, "Présentation des Gisants des Plantagenêts, abbaye de Fontevraud," *Monumental* (1993–2), pp. 51–67.

Sigrid Ruby, "Feminismus und Geschlechterdiffenrenzforschung," *Kunsthistorische Arbeitsblätter* (2003), pp. 17–28.

Willibald Sauerländer and Renate Kroos, *Gotische Skulptur in Frankreich 1140–1270* (München, 1970).

Lieselotte Saurma-Jeltsch, *Die Miniaturen im "Liber Scivias" der Hildegard von Bingen: Die Wucht der Vision und die Ordnung der Bilder* (Wiesbaden, 1998).

Wolfgang Schöller, "Frauenarbeit in der mittelalterlichen Bauwirtschaft," *Archiv für Kulturgeschichte* 76 (1994), pp. 305–20.

Ernst Schubert, *Die ältesten Personen-Denkmäler des Mittelalters in Sachsen*, Sitzungsberichte der Sächsischen Akademie der Wissenschaften zu Leipzig, Philologisch-historische Klasse 136 (Leipzig and Stuttgart, 1999).

——, "Inschrift und Darstellung auf Quedlinburger Äbtissinnengrabsteinen des 12. und 13. Jahrhunderts," *Deutsche Inschriften, Vorträge und Berichte*, Akademie der Wissenschaften zu Mainz, Abhandlungen der Geistes- und Sozialwissenschaftlichen Klasse (Mainz and Stuttgart, 1987), pp. 131–51.

Lorraine N. Simmons, "The Abbey Church at Fontevraud in the Later Twelfth Century: Anxiety, Authority and Architecture in the Female Spiritual Life," *Gesta* 31 (1992), pp. 99–107.

Gérard Sivéry, *Blanche de Castille* (Paris, 1990).

Beate Söntgen (ed.), *Den Rahmen wechseln. Von Kunstgeschichte zur feministischen Kulturwissenschaft* (Berlin, 1996).

Richard William Southern, *Saint Anselm and His Biographers: A Study of Monastic Life and Thought 1059–c.1130* (Cambridge, 1963).

Alison Stones, *Le Livre d'images de Madame Marie* (Paris, 1997).

——, "Nipples, Entrails, Severed Heads, and Skin: Devotional Images for Madame Marie," in *Image and Belief. Studies in Celebration of the Eightieth Anniversary of the Index of Christian Art*, ed. Colum Hourihane (Princeton, 1999), pp. 47–64.

Keiko Suzuki, *Bildgewordene Visionen oder Visionserzählungen: Vergleichende Studie über die Visionsdarstellungen in der Rupertsberger "Scivias"-Handschrift und im Luccheser "Liber Divinorum operum"-Codex der Hildegard von Bingen* (Bern, 1998).

Theophilus, *The Various Arts*, translated from the Latin with Introduction and Notes by Charles Reginald Dodwell (London, 1961).

Jane Tibbetts Schulenburg, "Strict Active Enclosure and Its Effects on the Female Monastic Experience (*ca.*500–1100)," in John A. Nichols and Lillian Thomas Shank, eds., *Distant Echoes, Medieval Religious Women*, vol. 1 (Kalamazoo, 1984), pp. 51–86.

Bruce L. Venarde, *Women's Monasticism and Medieval Society. Nunneries in France and England, 890–1215* (Ithaca and London, 1997).

Annemarie Weyl Carr, "Women as Artists in the Middle Ages: 'The Dark Is Light Enough'," in Delia Gaze, ed., *A Concise Dictionary of Women Artists* (London and Chicago, 2001), pp. 3–20.

Merry E. Wiesner-Hanks, *Gender in History* (Malden, Mass., 2001).

Gregory the Great and Image Theory in Northern Europe during the Twelfth and Thirteenth Centuries

Herbert L. Kessler

In two letters written around the year 600 to Serenus, Bishop of Marseilles, Pope Gregory the Great provided material for a defense of images that was seldom challenged during the Middle Ages and that came to serve as a foundation of art making.[1] According to the venerable Pope, like other material things, pictures must not be adored; but they should also not be destroyed because representations of sacred events and saintly persons are useful for teaching the faith to gentiles and illiterate Christians, "who read in them what they cannot read in books," and can serve to recall sacred history to the minds of the indoctrinated. Moreover, they activate emotions which, when properly channeled, lead the faithful toward contemplation of God.

A practical response to a particular act of iconoclasm, Gregory's statements about the value of art are not original, nor are they systematic or altogether clear. But they invested diverse earlier ideas about images with the authority of a "doctor ecclesiae," thereby providing an unassailable response to Byzantine iconoclasm during the eighth and ninth centuries and to later criticisms of art. Bede cited them as early as 731, and they were continuously invoked from then on.[2] Moreover, around the middle of the eighth century, someone in the Lateran, it would seem, interpolated a further defense of art into Gregory's authentic letter to the recluse Secundinus, which came to be included in the *Registrum Gregorii*. Transferring to images the Pope's claim (in his *Homilies on Ezekiel*, II.4.20) that Christ had "appeared visible to show us the invisible,"[3] the Pseudo-Gregory linked pictures directly to the Incarnation and underscored

art's function for stirring the emotions of believers:[4] "When you see the picture, you are inflamed in your soul with love of him whose image you wish to see. We do no harm in wishing to show the invisible by means of the visible."[5]

Because the Gregorian dicta did not constitute a reasoned theory, one aspect or another could be emphasized to suit a particular context of discussion or tradition of art production;[6] and even though the letters themselves were circulated in the *Registrum*, the Pope's statements about images were generally known through excerpts introduced in debates on the subject. Thus, Theodulf of Orleans abridged the Serenus letters to suit his generally hostile stance toward religious art in the *Libri carolini*,[7] while, in his reaction, Pope Hadrian adduced selected passages as evidence of the Church's traditional support of pictures.[8] Gregory was cited in favor of images at the Paris Council of 825,[9] but his "middle way" was also evoked to constrain those at the (erased) Eighth Ecumenical Council of 870 who had gone too far by advocating the "necessity of images."[10] In his influential *Decretals* (1008–12), Burchard of Worms provided a synopsis of the reply to Serenus (wrongly citing it as from the Secundinus letter);[11] and at the Synod of Arras in 1025, Bishop Gerard I of Cambrai apparently delivered a sermon (incorporated in the council's acts) in which he conflated the authentic dicta with the Pseudo-Gregory.[12]

Transmitted in various forms, Gregory's defense was taken for granted by the twelfth century when it was quoted by Gratian,[13] Honorius Augustodunensis,[14] and others. At mid-century, Herman-Judah put it into the mouth of Rupert of Deutz to justify Christian art to a skeptical Jew;[15] and 50 years later, the Cistercian author of the *Pictor in Carmine* began his tract with condensed paraphrases of Gregory's claims that images can serve pedagogical and affective roles.[16] In the thirteenth century, Alexander of Hales,[17] Bonaventure,[18] and Thomas Aquinas[19] promulgated three basic arguments in support of images, the so-called *triplex ratio*, that Honorius had distilled from the letters: instruction, affect, and recall.[20] At the start of his discussion of church decoration, William Durandus still deferred to Gregory: "Pictures and ornaments in churches are the lessons and scriptures of the laity" and then quoted the Serenus letter.[21] Even within such seemingly mechanical repetition, the Gregorian claims acquired new shades of meaning, however; for example, when Honorius reduced the Pope's premises to three, he was tacitly acknowledging that iconoclasm was no longer much of an issue.[22]

Gregory the Great's defense of art had its own history during the twelfth and thirteenth centuries, generated by the general acceptance of art, changing notions of the sacred, an evolving image cult, shifts in audience, and the growth of vernacular culture.[23]

An important part of that history was the melding with Greek image theory.[24] While Gregory had himself drawn on Eastern fathers to formulate his responses to the Bishop of Marseilles,[25] the incorporation of Basil the Great's essential claim that "the honor given to the image ascends to the prototype" is largely the Pseudo-Gregory's addition to the dicta, which actually subverts the Augustinian

separation of physical sign and holy archetype underlying Gregory's real state-ments. Pope Hadrian buttressed the imported notion of *transitus* with teachings from the Second Council of Nicaea (787) and citations from the most influential of all Greek writers, Dionysius the Pseudo-Areopagite.[26] From the ninth century, the writings of the Pseudo-Dionysius held a particular fascination in France where they were considered works of the patron saint, Denys; Hugh of St Victor wrote a commentary on them which surely influenced Suger, who twice used the expression found in the ninth-century Latin translations "de materialibus ad immaterialia."[27] By his day, however, the abbot of St Denis would also have known the principle of anagogy from many other sources as well.[28] Genuine Greek iconodulic theory re-emerged in the twelfth century when Burgundio da Pisa translated John of Damascus's *De fide orthodoxa*,[29] and it entered the main-stream through Peter Lombard's *Sentences*.[30] Thomas Aquinas incorporated Aristotelian ideas into this newly expanded defense of images, asserting among other things that the devout could distinguish the physical object from the "rational creature" represented on it and, therefore, could be led to venerate not the representation but God himself.[31] In this, he was attacked by Durandus of St Pourçain and others who reiterated the basic tenet that images are arbitrary signs and hence veneration of them was idolatry.[32]

The infusion of Greek theory reinforced the relationship between material images and Christ's two natures suggested in the Serenus letters and made explicit in the Pseudo-Gregory; God can be pictured because he had assumed human form, but veneration is channeled mentally to his ineffable divinity. Pope Hadrian had already linked the image cult to Christ's incarnation,[33] a con-nection later strengthened through the appropriation of John the Damascus's reasoned argument. It was not merely a theory. Already *c*.1000, an opening in the Hitda Codex (Darmstadt, Hessische Landes- und Hochschulbibliothek, MS 1640, fols. 6v–7r) applied it to a picture of Christ in Majesty and pro-claimed its essence in the accompanying titulus:

> This visible image represents the invisible truth
> Whose splendor penetrates the world through the four lights (Gospels) of his new doctrine.[34]

Not long afterward, the customary of the monastery of Fruttaria made the same distinction between the physical apprehension of a material image and seeing God himself with inner eyes.[35] Alan of Lille gave formal expression to the idea: "they depict the image of Christ so that people can be led through those things seen to the invisible, and through signs, the archetypes are venerated";[36] and an illumination that must have resembled the initial cut from a twelfth-century Rhenish Sacramentary (fig. 7-1) brought the same idea to the mind of Sicard of Cremona: "In some books, the majesty of the Father and the cross of the crucifix are portrayed so that it is almost as if we see present the one we are calling to, and the passion that is depicted imprints itself on the eyes of the

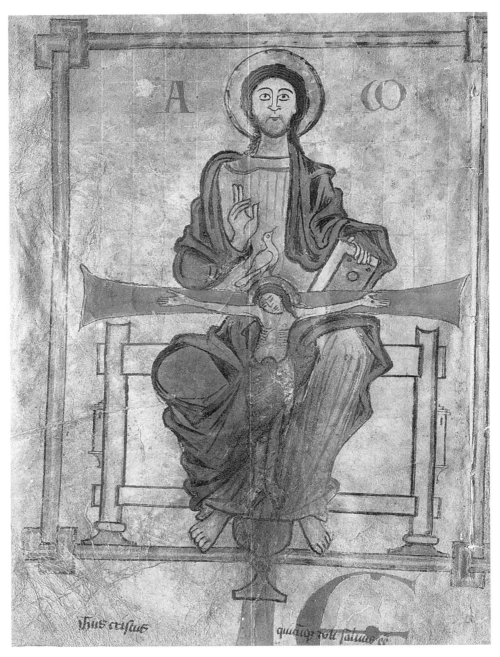

FIGURE 7-1 Cutting from a Sacramentary. Vienna: Albertina (inv. 22864r).

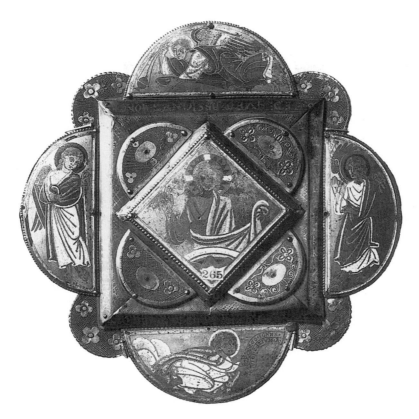

FIGURE 7-2 Mosan enamel. St Petersburg: Hermitage (inv. Φ 171).

heart."[37] A popular early twelfth-century distich stresses art's basis in the christological economy. Inscribed on the back of a phylactery picturing Christ in heaven made *c*.1165 in Liège (fig. 7-2), it reads:

> What you see here is not a representation of a god or a man;
> this sacred image represents both god and man at one and the same time.[38]

Gregory had already linked the dual aspects of material images to bodily reactions before them, distinguishing physical prostration before the object from mental veneration of the person depicted on it. Appropriating Byzantine distinctions and terminology, Alan of Lille differentiated between the worship due to God from that properly accorded to images: "Christians should not exhibit to the creature the kind of adoration which is owed God (latria), but what the Greeks call dulia, which is owed to man and angel"[39] – and he was followed in this by Thomas Aquinas among others.[40] In a general counterclaim to those who held that Christian images were idolatrous, this response became central;[41] thus, an inscription around the portrait of Christ exhorts viewers to "revere the image of

Christ by kneeling before it when you pass by it; but in doing this make sure you do not worship the image but rather him whom it represents."[42]

More than any other element of his letters, Gregory's equation of pictures with sacred writ resonated in the later reiterations.[43] The Majestas Domini at the front of the Hitda Codex, for example, renders visual the point spelled out in the titulus: the essential unity of the four written accounts that follow in the manuscript derives from the person of Christ, whose earthly history they record. In the Albertina miniature, word and image are actually made one. The cross on which Christ hangs is the T of the "Te igitur," the opening prayer of the Mass; and the picture of the "Throne of Mercy" embellished with a chalice realizes the very essence of the words that in the performed liturgy connected Christ's historic sacrifice to God alive in heaven.[44]

Gregory had *imagines* of the sort depicted in the Hitda Gospels and on the Vienna cutting and St Petersburg enamel less in mind, however, than depictions of events that had taken place in the world and had been witnessed by humans; and his claims about *historiae* were particularly influential on later theory. Narrative art was deemed both less likely than portraiture to provoke dangerous veneration and more effective for teaching because it could capture attention with its drama and then lead the faithful to an understanding of the meaning of the pictured event.[45] Thus, in advocating the picturing of scriptural events in churches, the *Pictor in Carmine* asserted: "since the eyes of our contemporaries are apt to be caught by a pleasure that is not only vain, but even profane . . . it is an excusable concession they should enjoy at least that class of pictures that can put forward divine things to the unlearned."[46] And Peter of Celle maintained that, because of their mnemonic capacity, images abrogate the prohibition of images in Deuteronomy.[47]

How narrative art worked is evident in frescoes painted *c.*1200 in the church of St Johann at Müstair in south Tirol (fig. 7-3).[48] Painted at eye level in the apse, the martyrdom of the dedicatory saint is staged in a highly dramatic fashion, not only the beheading but also Salome's dance before Herod. The backdrop of profane music, dancing, chatting people, and banqueting immediately engages the senses, providing a stark contrast to the ghastly execution and hence meditating on the relationship between earthly pleasures and holy sacrifice. His head shown being brought to the table on a charger, John is identified with the Sacraments; and his whole body is offered for contemplation in the depictions of his funeral procession and solemn burial. Herod Antipas, in turn, is portrayed as a kind of anti-Christ, flanked by Herodias and a man of Galilee, that is, by two anti-intercessors demanding John's life. Literally inverted like a personification of Pride, the dancing Salome signals the result of sensual preoccupation and, in so doing, suggests the viewers' proper response, which is to turn their own heads and thoughts away from the earth and toward heaven. There above, flanking a window, depictions of the five wise virgins and five foolish virgins (Matthew 25: 1–13) remind them that, as preparation for meeting the celestial Judge, they must forsake worldly pleasures.

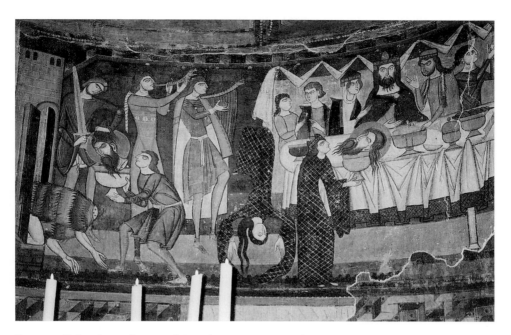

FIGURE 7-3 Central apse of St Johann, Müstair. Photo: Herbert L. Kessler.

The dramatically presented events and saint's pain would surely have evoked in pious believers at Müstair the "ardor of compunction" that Gregory had hoped would result from making past happenings present and that was explicitly extended to depictions of saints at the Synod of Arras: "through them minds are excited interiorly to contemplation of the working of divine grace, and also through their deeds we are influenced in our own behavior."[49] Alluding to Horace through Gregory, William Durandus summed up art's affective role succinctly: "painting seems to move the soul more than writing; by a painting a deed done is set before the eyes."[50] As the Pseudo-Gregory had already pointed out, by recalling the saint's presence, simple portraits too evoked compassion: "like scripture, the image returns the Son of God to our memory and equally delights the soul concerning the resurrection and softens it concerning the passion." In 1249, imitating "Gregory's" gift to Secundinus, Jacques Pantéléon of Troyes (later Pope Urban IV) sent a copy of the Mandylion to his sister in the monastery of Montreuil-les-Dames near Laon, so that "through contemplation of the image the nuns' pious affections might be more inflamed so that their minds might be made purer."[51] Around the same time, Matthew Paris included a representation of the Holy Face in a Psalter (London, British Library, Ms. Arundel 157) "in order for the soul be stirred to devotion."[52] Emotions aroused by pictures facilitated the transfer of contemplation from the object before the eyes to the spiritual reality beyond and piqued and fixed memory. The Pseudo-Gregory had likened an image of Christ to the portrait of a departed

lover; and in the middle of the twelfth century, Nicholas Maniacutius applied the same idea when he compared the Lateran *Acheropita* to portraits of the deceased kept by mourners.[53]

When Gregory defended art to Serenus of Marseilles at the end of the sixth century, the audience he imagined comprised pagans, peasants, and perhaps Jews;[54] as Christianity became firmly planted in Gaul and elsewhere, the target group was continually redefined.[55] The dicta were invoked in the *adversos Judaeos* disputes, such as Herman-Judah's encounter with Rupert of Deutz; but with art now an article of orthodox faith, they were also used as a weapon against heresy, as in Gerard of Cambrai's sermon and Alan of Lille's anti-Albigensian *De fide catholica*.

Steadily, the dicta were redirected toward the Christian laity. Gerard had already pointed toward "illiterati" as well as "simplices," presumably to distinguish true rustics from those simply unable to read; and, recognizing that pictures served the whole Christian community, Honorius replaced Gregory's "gentes" and "idiotae" with "laici" and, substituting "clerici" for "litterati,"[56] contrasted the laity with clerics.[57] In this, he was followed not only by William Durandus, but also Alan of Lille,[58] John Beleth,[59] Sicard of Cremona,[60] and, a little after 1233, by Guillaume, Bishop of Bourges, who asserted that "we make images because, just as scripture is the words of clerics, so images are the words of the lay."[61] About the same time, the dicta entered secular histories such as the Hohenburg chronicle;[62] with Gregory in mind, Matthew Paris explained that he had translated the life of King Edward into French for those who could not read Latin and into pictures for "ceux qui les lettres ne scavent."[63]

The lay audience itself was not uniformly illiterate. The Council of 870 had already included the learned (*sapientes*) along with the uneducated (*idiotae*) in its discussion of images. The *Pictor in Carmine* is explicit that the "libri laicorum" were useful for both "simplices" and "literati," teaching the one group and eliciting the love of scripture in the other; and it imagined an audience able to identify episodes from the New Testament by means of simple labels. The ubiquitous captions in medieval art and the inclusion of material images within books establish that pictures were intended also for those able to read.[64] Thus, while defending pictures as "the books of the lay," Peter Comestor assumed that the readers of his *Historia Scholastica* were iconographically as well as textually literate when he explained the presence of the ox and ass at the birth of Christ.[65] Abbot Suger noted that the reliefs on the (now lost) altar of St Denis were "intelligible only to the literate";[66] and his stained-glass windows are ample evidence that only those capable of understanding the inscribed words would have comprehended the full meaning of his art.

Pictures served the clergy, as well.[67] Suger remarked that Christ depicted on the front of his golden crucifix was to be "in the sight of the sacrificing priest";[68] and the illuminated initial in Vienna was intended for an officiant at Mass versed in Trinitarian speculations.[69] Because they were both literate and had rejected the sensual world, monks, of all groups, were thought not to need art.[70] Even

while permitting bishops to introduce pictures in churches to "stimulate the devotion of a carnal people with material ornaments because they cannot do so with spiritual ones," Bernard of Clairvaux, for example, disallowed art in monasteries";[71] and the *Pictor in Carmine* implied the same distinction when it permitted "paintings in churches, especially cathedral and parish churches." In fact, however, art thrived in monasteries throughout the Middle Ages. The *Moralia in Job* illustrated at Cîteaux *c.*1111 (Dijon, Bib. Mun. MS 168–70, 173), for instance, deploys a range of fantastic and mundane figures to gloss the text as spiritual struggle and monastic meditation.[72] Jerome's Commentary on Daniel, Minor Prophets, and Ecclesiastes (Dijon, Bib. Mun. MS 132) produced in the same monastery a decade or so later is adorned with complex frontispieces that, in accord with the accompanying text, use sophisticated visual devices to represent the harmony of scripture and the relationship of written prophecy to the liturgy.[73] Hugh of St. Victor's *Mystic Ark* comprises lectures delivered to monks in which an elaborate wall painting was the principal didactic instrument;[74] and Adam the Premonstratensian's *De tripartito tabernaculo* is organized around a diagram of Moses' tabernacle so that the monks can construct a harmony between "what they read in the book and saw in the picture."[75] Propelled by new forms of female spirituality, images such as the Holy Face given to the monastery of Montreuil-les-Dames acquired special importance during the thirteenth century in the devotional practices of nuns.[76]

Like the distinction between literate and illiterate, the difference between secular and lay was not clear cut. Thus, while advising that "Genesis is to be read in a book, not on the wall" and rejecting art's utility for "teachers," Hugh of Fouilloy addressed the illustrated *Aviarium* to a lay-brother of his Augustinian monastery and, accordingly, adjusted the argument to persons with some education but still needing pedagogical aids. For members of such intermediary groups, pictures are useful because they clarified complicated texts: "For just as the learned man delights in the subtlety of the written word, so the intellect of simple folk is engaged by the simplicity of a picture."[77] Building on the Gregorian discussion of the two watchtowers of faith,[78] the prologue miniature in a late twelfth-century Burgundian exemplar of the *Aviarium* pictures the imagined system (Heiligenkreuz, Abbey, MS 226, fol. 129v): A knight brings the laity (symbolized by the birds) to be converted to the monastic rule through words and pictures.[79]

As the miniature and diagrams in the Heiligenkreuz manuscript attest, mundane themes were also not always separated from religious ones. The psalter illuminated between 1121 and 1145 at St Alban's monastery (Hildesheim, Dombibliothek, St Godehard, Ms. 1, p. 72), for instance, deploys a chivalric motif to make a spiritual argument; prefacing the scripture, a picture of two battling knights is glossed as evidence that things of this world seen carnally are to be understood spiritually.[80] What that understanding might be remains ambiguous; like the Müstair fresco and Dijon *Moralia in Job*, the illumination engages the viewer/reader purposely in a personal struggle with worldly

temptation.[81] The psalter also includes Burchard's synopsis of Gregory's letter to Serenus; the mistaken ascription to the holy hermit Secundinus must have appealed to the anchoress Christine of Markyate when she prayed from her illustrated book of Psalms.[82]

In the St Alban's psalter, the Gregorian text is transcribed in a Norman French translation, rendering it available to anyone who could read even if they were unable to understand the Latin version that is also included. It is possible that the dicta had been translated into the vernacular even earlier; whether or not Gerard of Cambrai actually delivered his defense of images at the synod as a Latin sermon, he may have read a short version of it in French.[83] The dicta certainly entered vernacular preaching later; a mid-thirteenth-century German compendium includes one sermon that maintains that God had provided church paintings for the laity as "another form of writing" and that argues that these are particularly effective in redirecting vain thoughts toward the divine.[84] Cited also during the following century, the image texts were used to direct an appropriate reading of verbal imagery often incorporated in vernacular preaching and of stories actually pictured nearby.[85] Itself a basic pedagogical instrument, preaching thus engaged with pictures in a mutually reinforcing didactic strategy. As Opicino de Canistris pointed out, however, the vivid exempla deployed to animate sermons held the danger of idolatry if they were not subjected to an elevating imagination.[86]

Prepared by the redirection of the Gregorian dicta toward the laity and its insertion in oral pedagogy, Thomasin von Zerclaere took the next logical step in 1215–16 by adopting the Gregorian dicta to advance the educational value of true "litteratura laicorum," arguing in *Der welsche Gast* that mundane tales, too, could teach moral lessons:[87] "Whoever cannot comprehend higher things ought to follow the example [of the romances]. . . . As the priest looks at writing, so should the untaught man look at the pictures, since he recognizes nothing in the writing."[88] The contemporary stained-glass window donated by the furriers' guild in the ambulatory of Chartres cathedral (fig. 7-4) bears him out;[89] there, scenes of battle alternate with ecclesiastical ceremonies to demonstrate the consonance of clerical with chivalric missions. And a miniature in Wolfram von Eschenbach's *Willehalm* painted later in the century (fig. 7-5) pictures the reciprocity of word and image that Thomasin imagined when he manipulated variants on the Gregorian claims to justify secular narrative. The German tales previously known in oral versions are fixed in words and pictures set down in ink and paint on parchment, their mutuality linked through the very person of the author tied by large red Ws to the relevant text passage and pointing toward the pictorial dramatization of the words.[90]

These examples make clear that, by the High Middle Ages, pictures were, in fact, no longer simply "books of the illiterate," but, rather, multivalent devices used by various groups in diverse ways and deeply implicated in oral as well as written culture.

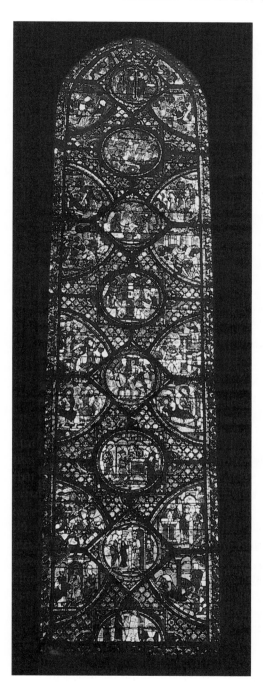

FIGURE 7-4 Charlemagne window, Notre-Dame, Chartres. Photo: Bridgeman Art Library.

How might they have functioned? At Müstair, medieval viewers recognizing the saint from the church's dedication and his halo and hair coat,[91] would have been able to follow the action through the repeated figures; and, if they knew even the outlines of the story, could have reconstructed from it the sacred narrative. If they participated in the liturgy, especially on the saint's feast day, they would have learned from the paintings about the relationship established in Church doctrine between martyrdom of saints and Christ's own sacrifice and the connection between John's burial in his tomb and the relics encased in the altar. And snatched away from the lure of the pictured banquet by the true beauty of the sacramental liturgy with its antiphons, ordered recitation, and sacred meal conducted at the altar, they would have been led toward contemplation of higher things. Likewise, pilgrims on the way to Santiago de Compostela, attracted first by the gem-like glow of the Chartres window, could have parsed the narrative constructed of well-known conventions for dream-visions and chivalric jousts; and the most attentive among them, illiterate and literate alike, would have discovered in the kaleidoscopic ordering of the vignettes a simultaneous temporal unfolding and an anagogical ascent.[92] Those who had followed sermons organized around main themes and secondary explanatory references would have possessed a cognitive structure suited to reading the peripheral narratives as glosses on the subjects in the principal medallions.[93] And the single word DURENDAL inscribed on one knight's sword would

d helm ist och benennet nicht.
floch and wapfen noch d'schilt.
Ob uch des urowe nicht beuilt.
gebet mir sus unver stwte.
do gelobete im diu gehwre.
von silb von golde von andrem folde.
des antwort ich dir genoch.
Ger dan ich des ie gewoch.

Wolt ir nv horen wiez gestte.
Vmbe den zorn den ir horet e.
Wer den zv sune brachte.
Vne dem markise nachte.
browede vn hoher miut.
Vn wie ir lip vn ir gut.
Vn ir gynst nut herren sinne.
div romische kunigenne.
Ohr truwen gap in sin gebet.
des was kyburge not.
Ob dem markise wol gelanc.
den nunne vn iamer twanc.
Was pfandes her h gelazen doir.
siv pruvet ouch den grozen mort.
d uf alytschanz geschach.
dar zv dar noerdhich ungemach.
da kyburt inne bleip.
div in nach helfe von ir ueip.
kyburc was sin liebste pfant.
flach ir im sin urowe swant.
ungeduldichlich muse h leben.
gen esse im nieman uber geben.

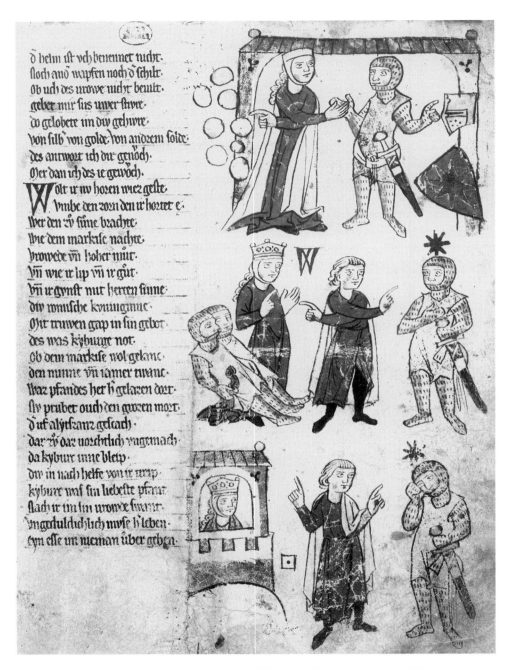

FIGURE 7-5 Wolfram von Eschenbach, *Willehalm*, thirteenth century. Munich,
Bayer. Staatsbibliothek, Germ. 193, III, 1r.

have enabled those with even the most rudimentary reading ability to anchor the narrative in the story of Roland, passed on to them orally or through a performance;[94] and it would have allowed those familiar with the Latin legend of Charlemagne and the Pseudo-Turpin chronicle, or a vernacular version, to recognize, in the generic combat scene within the central medallion, Charlemagne's victory over the Saracen giant Ferragut.[95]

Pictures would have rendered the words in the Munich *Willehalm* more readily comprehensible to those who could follow Wolfram's vernacular text, while the "Throne of Mercy" in the Albertina Sacramentary would have put before the eyes of the priest celebrating Mass a clear diagram of the fluid and complicated relationship invoked in the "Te igitur," between the liturgy, Christ's crucifixion, and God in heaven.

Twelfth- and thirteenth-century pictures served the uneducated, those who knew only vernacular languages, lay-brethren and other intermediary communities, the secular clergy, and monks. Affirming Christ's dual nature in their very essence, material images channeled contemplation from this world to the next. They provided authorized versions of stories, including happenings reported in the Bible itself, that otherwise were known to illiterates only through fluid, often embellished oral accounts. By means of details seamlessly integrated into the visual accounts, they offered their own readings of texts. And for those such as Suger's literates at St Denis, they presented sophisticated new interpretations of scripture.[96] Whatever Gregory meant when he wrote his defense of images,[97] by the High Middle Ages his dicta enabled the makers of pictures to teach the entire community of believers many important things that "they could not read in books."

Notes

1 Letter IX, 209 and XI, 10; *Registrum epistularum*, pp. 768 and 873–6. Two decades ago, when Michael Camille and I published articles on the subject almost simultaneously, Camille began his important essay by noting correctly that Gregory's dictum had "stimulated little research"; as this bibliography attests, scholarship on the subject has ballooned since then. For the original letters, see especially Chazelle, "Pictures, Books, and the Illiterate"; Cavallo, "Testo e immagine"; Mariaux, "L'image selon Grégoire" and "Voir, lire et connaître." On their influence, Schmitt, "L'Occident"; "Ecriture et image"; and "Question des images"; Chazelle, "Memory, Instruction, Worship"; Hamburger, *Visual and the Visionary*, pp. 111–13 et passim; Wataghin, "Biblia pauperum."

2 Meyvaert, "Bede and the Church Paintings"; Duggan, "'Book of the Illiterate," pp. 229–30.

3 Gregory the Great, *Registrum epistularum*, p. 272; Kessler, *Spiritual Seeing*, p. 121; Mariaux, "Voir, lire et connaître"; Krüger, *Das Bild als Schleier*, p. 13.

4 Appleby, "Instruction and Inspiration," pp. 89–90.

5 *Registrum epistularum*, pp. 1110–11. Kessler, *Spiritual Seeing*, pp. 124–35.

6 Duggan, "Book of the Illiterate."

7 *Opus caroli regis contra synodum (Libri carolini)*, ed. Ann Freeman (MGH, Concilia, vol. II, suppl. 2) (Hanover, 1998), pp. 277–80; see also Freeman, "Scripture and Pictures." See, in general, Wirth, *L'Image medievale* and Rudolph, "La resistenza."

8 *Epistolae karolini aevi*, vol. 3, ed. Karl Hampe (MGH, Epistolae, vol. V) (Berlin, 1899), pp. 5–57; Appleby, "Instruction and Inspiration," pp. 88–95.

9 MGH, Legum sectio III. Concilia, vol. II (Hanover and Leipzig, 1906), pp. 475–551.

10 Canon III; MGH, Leges, Sectio III, Concilia, vol. II, part 2 (Hanover and Leipzig, 1906), p. 527. Although the Eighth Ecumenical council was canceled for reasons largely unrelated to the incorporation of Byzantine image theory in its third canon, Hincmar of Rheims focused on that issue in his account of the synod; *The Annals of St-Bertin*, trans. Janet Nelson (Manchester, 1991), p. 179. Cf. Schmitt, "L'Occident."

11 Chap. 36; PL 140.679.

12 *Acta synodi* 13; PL 142.1304–07; trans. Walter Wakefield and Austin Evan, *Heresies of the High Middle Ages* (New York, 1969), pp. 84–5. Cf. Stock, *The Implications of Literacy*, pp. 128–9; Fulton, *From Judgment to Passion*, pp. 120–39.

13 *De consecratione*, dist. III; PL 94.1790.

14 *Gemma animae*, ch. 132; PL 172.586.

15 *Opusculum de conversione sua* MGH, SS, 12, ed. Ph. Jaffé (Berlin, 1856), pp. 513–30.

16 James, "*Pictor in Carmine*," p. 141.

17 *Glossa in quatuor libros Sententiarum Petri Lombardi* (Florence, 1954), vol. III, pp. 104–16.

18 *Comm. in IV Libros Sententiarum*, Liber III, dist. 9, in *Opera omnia* (Florence, 1882–1892), vol. III, p. 203.

19 Ibid., quaest. 1, art 2, qla, in *Opera omnia*, vol. IX, pp. 152–5.

20 Gilbert, *The Saints' Three Reasons*, pp. 13–16.

21 *Rationale divinorum officiorum*, I, 3, 1; CCCM, p. 34; Faupel-Drevs, *Rechten Gebrauch*, pp. 255–8 et passim.

22 The concern never disappeared completely. In 1306, the Bishop of London ordered the removal of a wooden crucifix because it was being adored (Heslop, "Attitudes to the Visual Arts," p. 26); and later in the century, John Wycliffe was worried that "dallying in imagery conceals the poison of idolatry" (Aston, *Lollards and Reformers*). Citing Gregory's dicta and later glosses on them, however, Wycliffe defended the right kind of pictures.

23 Duggan, "'Book of the Illiterate.'"

24 Wolf, *Salus populi romani*, pp. 152–4.

25 Kessler, "Pictorial Narrative," p. 76; Duggan, "Book of the Illiterate," pp. 228–9.

26 Boiadjiev et al., eds., *Die Dionysius-Rezeption im Mittelalter*.

27 Cf. Meier, "Malerei des Unsichtbaren."

28 Cf. Rudolph, *Artistic Change at St-Denis*; Speer et al., eds., *Abt Suger von Saint-Denis*; Poirel, "*Symbolice et anagogice*."

29 Wolf, *Salus populi romani*, p. 293.

30 *Sententiae in IV libris distinctae*, III, dist. IX, art. I, quast. 2 (Grottaferrata, 1981), vol. II, p. 70. Cf. Albertus Magnus, *In III Sentent.*, dist. 9, 4 (*Opera omnia*, ed. August Borguet [Paris, 1890–9], vol. XIII, p. 18), and Philip the Chancellor, *Summa de bono*, p. 2, IV, quast. 6, a. 3 (ed. N. Wicki [Bern, 1985], vol. II, p. 972).

31 *Summa theologica*, 3a, quast. 25, art. 4; 4:2149. Feld, *Ikonoklasmus*, pp. 63–5; Wirth, "Structure et fonctions" and "Peinture et perception visuelle."

32 Wirth, "La Critique scholastique."

33 Appleby, "Instruction and Inspiration," p. 90.

34 Diebold, *Word and Image*, pp. 124–6.

35 *Consuetudines Fructuarienses-Sanblasianae*, ed. Luchesius G. Spätling and Peter Dinter (Siegburg, 1985), vol. I, pp. 149–51; Lipsmeyer, "Devotion and Decorum."

36 *De fide catholica contra haereticos*, IV, ch. 12; PL 210.427.

37 Mitrale, III, ch. 6; PL 213.124; Belting, *The Image and Its Public*, p. 6; Boespflug and Załuska, "Le dogme trinitaire."

38 Bugge, "Effigiem Christi"; Arnulf, *Versus ad Picturas*, pp. 273–85. A gloss in a thirteenth-century manuscript (Vatican, Biblioteca Apostolica, Cod. Reg. lat. 1578) returns the "nec Deus" distich to the original Gregorian context: "against Jews, heretics, and Muslims who say that we adore idols."

39 Hugh of St Victor had already introduced the distinction in his commentary on the Second Commandment; PL 176.9–10.

40 *In III Sentent.*, dist. 9, quast. 1, art. 2, q. 4.

41 Hrabanus Maurus distinguished between *bowing* before a colored painting of Christ and *adoring* Him whom the image represents; Carmen 61: cf. Palazzo, "Pratiques liturgiques." A similar separation of physical and mental veneration underlies the canon of the Synod of Arras.

42 Van Os, *The Way to Heaven*, pp. 119–22.

43 Cf. Thümmel, "Annuncio della parola"; Cavallo, "Testo e immagine."

44 Boespflug and Załuska, "Le dogme trinitaire," pp. 203–5.

45 Cf. Carruthers, *Book of Memory* and *Craft of Thought*; Freedberg, "Holy Images and Other Images."

46 James, *Pictor in Carmine*, p. 141.

47 Carruthers, *Craft of Thought*, pp. 206–9.

48 Brenk, *Die romanische Wandmalerei*; Goll, "Bei Salome in Müstair." [For more on narrative, see chapter 4 by Lewis in this volume (ed.).]

49 Cf. Carruthers, *Book of Memory*, pp. 222 et passim.

50 *Rationale divinorum officiorum*, I, iii, 4; Faupel-Drevs, *Rechten Gebrauch*, pp. 254–5. Cf. Freedberg, *Power of Images*, pp. 161–2.

51 Grabar, *La Sainte Face de Laon*; Klein, "From the Heavenly to the Trivial."

52 Wolf, "From Mandylion to Veronica."

53 Kessler, "Real Absence," pp. 135–6.

54 Baschet, "Introduction: L'image-objet"; Brown, "Images as a Substitute"; Wood, "Reply."

55 Krüger, "Die Lesbarkeit von Bildern."

56 *Gemma animae*, chap. 132; PL 172.586.

57 On the problem of defining these groups, see Grundmann, "Litteratus-illitteratus"; Turner, "The *Miles Literatus* in Twelfth- and Thirteenth-Century England"; Steer, "Zum Begriff 'Laie'."

58 *De fide catholica*, IV, chap. 12; PL 210.427.

59 *Summa de ecclesiasticis officiis*, chap. 85; ed. Herbert Douteil (CCCM, 41), pp. 154–5.

60 *Mitrale*, chap. 12; PL 213.40; Eberlein, *Miniatur und Arbeit*, p. 322.

61 *Liber bellorum Domini*, ed. Gilbert Dahan (Paris, 1981), p. 224.

62 Bloch, *Die elsässischen Annalen*, p. 116.

63 Camille, "Seeing and Reading," p. 41; Alexandre-Bidon, "Images et objets," p. 1158.

64 Duggan is wrong in his claim that the "association between word and images . . . which was indeed characteristic of later medieval art, was still infrequent in Gregory's own age": see "Reflections." Cf. Arnulf, *Versus ad Picturas*, pp. 9–145.

65 Ch. 5; PL 198.1540.

66 Panofsky, *Abbot Suger*, pp. 62–3; Duggan, "'Book of the Illiterate'?" p. 233; Arnulf, *Versus ad Picturas*, pp. 286–93.

67 Caviness, "Biblical Stories"; Diebold, *Word and Image*; Bolzoni, *Rete delle immagini*.

68 Panofsky, *Abbot Suger*, pp. 58–9.

69 Boespflug and Załuska, "Dogme trinitaire"; Belting, *The Image and Its Public*, p. 6.

70 Schmitt, "Question des images."

71 *Summa de ecclesiasticis officiis*, p. 155; Rudolph, *"Things of Greater Importance"*, pp. 278–81.

72 Załuska, *Manuscrits enluminés*, pp. 56–61; Rudolph, *Violence and Daily Life*.

73 Travis, "Daniel in the Lions' Den."

74 Rudolph, *First, I Find the Center Point*.

75 PL.198.626; Antoine, *"Ad perpetuam memoriam,"* p. 555.

76 Hamburger, *Visual and Visionary*, pp. 111–48 et passim.

77 Curschmann, *"Pictura laicorum litteratura?"*; *Aviarium*, pp. 118–19; Cahn, *Romanesque Manuscripts*, vol. 2, pp. 95–6 and fig. 184.

78 Cf. Rudolph, *Violence and Daily Life*, pp. 46–8.

79 *Aviarium*, pp. 118–19.

80 Pächt et al., *St. Alban's Psalter*, pp. 138, 163–4; Camille, "Gregorian Definition."

81 Alexander, "Ideological Representation."

82 Curschmann, *"Pictura laicorum litteratura?"* Camille, "Philological Iconoclasm." Tellingly, David is portrayed as a type of Gregory the Great, with an enormous bird speaking into his ear.

83 "Quae Latina oratione dicebantur, non satis intelligere poterant, audita per interpretem vulgarem" (PL 142.1312C); cf. Stock, *Implications of Literacy*, pp. 128–9. Albertus Magnus' reference to pictures as books of the laity occurs in an Advent sermon, albeit in Latin.

84 An argument found later also in the *Pictor in Carmine. Der sogenannte St. Georgener Prediger aus der Freiburger und der Karlsruher Handschrift*, ed. Karl Rieder (Berlin, 1908), pp. 248–54; Frühwald, *Der St. Georgener Prediger*, pp. 94–7; Hamburger, "Introduction," pp. 3–10.

85 Owst, *Literature and Pulpit*, pp. 139–41; Bolzoni, *Rete delle immagini*. The twelfth-century life of Hugh of Lincoln reports that the bishop instructed John Lackland on the need to pray for forgiveness by pointing to a pictured Last Judgment; cf. *Magna vita*, ed. Decima Douie and Hugh Farmer (Oxford, 1985), vol. 2, p. 137. A sermon preached in French at Amiens in the middle of the thirteenth century, also focused on judgment, and would have made the complex cathedral façade comprehensible; cf. Murray, *Notre-Dame, Cathedral of Amiens* and "Pourquoi la polychromie?"

86 Morse, "Seeing and Believing."

87 Curschmann, *"Pictura laicorum litteratura?"* and *"Der aventiure bilde nemen"*; Wenzel, *"Schrift* und *Gemeld."*

88 Rushing, *Images of Adventure*, p. 8.

89 Kemp, *Sermo Corporeus*, pp. 115–19 et passim; Kurmann-Schwarz and Kurmann, *Chartres. La cathédrale*, pp. 245–6; Bogen, *Träumen und Erzählen*, pp. 270–5.
90 Ott, "Texte und Bilder."
91 The life of St John Therista reports that the camel-skin cape alone enabled the identification of the Forerunner in a painting; Antoine, "Ad perpetuum memoriam," pp. 550–2.
92 Nichols, *Romanesque Signs.*
93 Cf. Lillich, *Rainbow like an Emerald*; Caviness, "Biblical Stories."
94 The *Pictor in Carmine* points out that, for familiar subjects, only a name is needed.
95 Maines, "The Charlemagne Window"; Caviness, "Biblical Stories," n.24; Kurmann-Schwartz and Kurmann, *Chartres*, 245–7.
96 Some of which, such as the "Throne of Mercy," were therefore attacked by theologians; cf. Wirth, "Critique scolastique," p. 105.
97 Cf. Duggan's attempt to distinguish Gregory from the later medieval use of his words: see "Reflections."

Bibliography

Primary sources

Thomas Aquinas, *Opera omnia*, ed. S. E. Fretté (Paris, 1875).
Gregory the Great, *Registrum epistularum*, ed. Dag Norberg (CCSL 140–140A) (Turnhout, 1982).
Guillaume Durand, *Rationale divinorum officiorum*, ed. Anselm Davril and Timothy Thibodeau (CCCM, 140) (Turnhout, 1995).
Hugh of Fouilloy, *Aviarium*, ed. and trans. Willene B. Clark (Binghamton, NY, 1992).
Pictor in Carmine, trans. M. R. James in *Archaologia* 94 (1951), pp. 141–66.

Secondary sources

J. J. G. Alexander, "Ideological Representation of Military Combat in Anglo-Norman Art," *Anglo-Norman Studies* 15 (1992), pp. 1–24.
Daniel Alexandre-Bidon, "Une Foi en deux ou trois dimensions? Image et objets du faire coire à l'usage des laïcs," *Annales* (1998), pp. 1155–90.
Jean-Philippe Antoine, "*Ad perpetuam memoriam*. Les nouvelle fonctions de l'image peinte en Italie: 1250–1400," *Mélanges de l'École française de Rome* 100 (1988), pp. 541–615.
David Appleby, "Instruction and Inspiration through Images in the Carolingian Period," in John J. Contreni and Santa Casciani, eds., *Word, Image, Number. Communication in the Middle Ages* (Turnhout, 2002), pp. 85–111.
Arwed Arnulf, *Versus ad Picturas. Studien zur Titulusdichtung als Quellengattung der Kunstgeschichte von der Antike bis zum Hochmittelalter* (Munich, 1997).
Margaret Aston, *Lollards and Reformers. Images and Literacy in Late Medieval Religion* (London, 1984).
Jérôme Baschet, "Introduction: L'image-objet," in Jérôme Baschet and Jean-Claude Schmitt, eds., *L'image. Fonctions et usages des images dans l'Occident medieval* (Paris: Léopard d'Or, 1996), pp. 7–57.

Hans Belting, *The Image and Its Public in the Middle Ages. Form and Function of Early Paintings of the Passion*, trans. Mark Bartusis and Raymond Meyer (New Rochelle, NY, 1990).

Hermann Bloch, *Die elsässischen Annalen der Stauferzeit* (Innsbruck, 1908).

François Boespflug and Yolanta Załuska, "Le Dogme trinitaire et l'essor de son iconographie en Occident de l'époque carolingienne au IVe Concile du Latran (1215)," *Cahiers de civilisation médiévale. Xe-XIIe siècle* 37 (1994), pp. 181–240.

Steffen Bogen, *Träumen und Erzählen. Selbstreflexion der Bildkunst vor 1300* (Munich, 2001).

Tzotcho Boiadjiev et al., eds., *Die Dionysius-Rezeption im Mittelalter* (Turnhout, 2000).

Lina Bolzoni, *La Rete delle immagini. Predicazione in volgare dalle origini a Bernardino da Siena* (Turin, 2002).

Beat Brenk, *Die romanische Wandmalerei in der Schweiz* (Bern, 1963).

Peter Brown, "Images as a Substitute for Writing," in Evangelos Chrysos and Ian Wood, eds., *East and West: Modes of Communication* (Leiden, 1999), pp. 15–34.

Ragne Bugge, "Effigiem Christi, qui transis, semper honora. Verses Condemning the Cult of Sacred Images in Art and Literature," *Acta ad Archaeologiam et Artium Historiam Pertinentia* 6 (1975), pp. 127–39.

Walter Cahn, *Romanesque Manuscripts* (London, 1996).

Michael Camille, "The Gregorian Definition Revisited: Writing and the Medieval Image," in *L'image. Fonctions et usages des images dans l'Occident médiéval* (Paris, 1996), pp. 89–107.

——, "Philological Iconoclasm: Edition and Image in the *Vie de Saint Alexis*," in Howard Bloch and Stephen G. Nichols, eds., *Medievalism and the Modernist Temple* (Baltimore, 1996), pp. 371–401.

——, "Seeing and Reading: Some Visual Implications of Medieval Literacy and Illiteracy," *Art History* 8 (1985), pp. 26–49.

Mary Carruthers, *The Book of Memory. A Study of Memory in Medieval Culture* (Cambridge, 1990).

——, *The Craft of Thought. Meditation, Rhetoric, and the Making of Images, 400–1200* (Cambridge, 1998).

Guglielmo Cavallo, "Testo e immagine: una frontiera ambigua," in *Testo e immagine nell'alto medioevo* (Settimane di studio del Centro italiano di studi sull'alto medioevo, XLI) (Spoleto, 1994), pp. 31–62.

Madeline H. Caviness, "Biblical Stories in Windows: Were They Bibles for the Poor?" in Bernard S. Levy, ed., *The Bible in the Middle Ages. Its Influence on Literature and Art* (Binghamton, 1992), pp. 103–47.

Celia Chazelle, "Memory, Instruction, Worship: Gregory's Influence on Early Medieval Doctrines of the Artistic Image," in *Gregory the Great. A Symposium* (Notre Dame, 1995), pp. 181–215.

——, "Pictures, Books, and the Illiterate: Pope Gregory I's Letters to Serenus of Marseille," *Word and Image* 6 (1990), pp. 138–53.

Michael Curschmann, "*Der aventiure bilde nemen*: The Intellectual and Social Environment of the Iwein Murals at Rodenegg Castle," in Martin Johnes and Roy Wisbey. eds., *Chrétien de Troyes and the German Middle Ages* (Cambridge, 1993), pp. 219–27.

——, "*Pictura laicorum litteratura*? Überlegungen zum Verhältnis von Bild und volkssprachlicher Schriftlichkeit im Hoch- und Spätmittelalter bis zum Codex Manesse,"

in Hagen Keller et al., eds., *Pragmatische Schriftlichkeit im Mittelalter. Erscheinungsformen und Entwicklungsstufen* (Munich, 1992), pp. 211–29.

William J. Diebold, *Word and Image. An Introduction to Early Medieval Art* (Boulder, 2000).

Lawrence Duggan, "Reflections on 'Was Art Really the Book of the Illiterate?'" in *Reading Images and Texts. Medieval Images and Texts as Forms of Communication* (Third Utrecht Studies in Medieval Literacy) (Turnhout: Brepols, 2005).

——, "Was Art Really the 'Book of the Illiterate'?" *Word and Image* 5 (1989), pp. 227–51.

Johann Konrad Eberlein, *Miniatur und Arbeit. Das Medium Buchmalerei* (Frankfurt am Main, 1995).

Kirsten Faupel-Drevs, *Vom rechten Gebrauch der Bilder im liturgischen Raum* (Leiden, 2000).

Helmut Feld, *Der Ikonoklasmus des Westens* (Leiden, 1990).

David Freedberg, "Holy Images and Other Images," in Susan C. Scott, ed., *The Art of Interpreting* (University Park, PA, 1995), pp. 68–87.

——, *The Power of Images. Studies in the History and Theory of Response* (Chicago, 1989).

Ann Freeman, "Scripture and Images in the Libri Carolini," in *Testo e immagine nell'alto medioevo* (Settimane di studio del Centro italiano di studi sull'alto medioevo, XLI) (Spoleto, 1994), pp. 163–88.

Wolfgang Frühwald, *Der St. Georgener Prediger: Studien zur Wandlung des geistlichen Gehaltes* (Berlin, 1963).

Rachel Fulton, *From Judgment to Passion. Devotion to Christ & the Virgin Mary, 800–1200* (New York, 2003).

Creighton Gilbert, *The Saints' Three Reasons for Paintings in Churches* (Ithaca, NY, 2001).

Jürg Goll, "Bei Salome in Müstair," in *Wege zur Romanik* (Innsbruck-Bozen, 2001), pp. 87–98.

André Grabar, *La Sainte Face de Laon: Le Mandylion dans l'art orthodoxe* (Prague, 1931).

Herbert Grundmann, "Litteratus-illitteratus: Der Wandel einer Bildungsnorm vom Altertum zum Mittelalter," *Archiv für Kulturgeschichte*, 40 (1958), pp. 1–65.

Jeffrey Hamburger, *The Visual and the Visionary* (New York, 1998).

Jeffrey Hamburger and Anne-Marie Bouché, eds., *The Mind's Eye: Art and Theological Argument in the Middle Ages* (Princeton, 2005).

T. A. Heslop, "Attitudes to the Visual Arts: The Evidence from Written Sources," *Age of Chivalry. Art in Plantagenet England 1200–1400* (London, 1987).

Wolfgang Kemp, *Sermo Corporeus* (Cambridge, 1987).

Laura Kendrick, *Animating the Letter. The Figurative Embodiment of Writing from Late Antiquity to the Renaissance* (Columbus, 1999).

Herbert L. Kessler, "Real Absence: Early Medieval Art and the Metamorphosis of Vision," in *Morfologie sociali e culturali in Europa fra tarda antichità e alto medioevo* (*XLV Settimana internazionale di studi*) (Spoleto, 1998), pp. 1157–1211; reprinted in *Spiritual Seeing. Picturing God's Invisibility in Medieval Art* (Philadelphia, 2000), pp. 104–48.

——, "Pictorial Narrative and Church Mission in Sixth-Century Gaul," in *Pictorial Narrative in Antiquity and the Middle Ages* (*Studies in the History of Art*, 16 (1985)), pp. 75–91; reprinted in *Studies in Pictorial Narrative* (London, 1994), pp. 1–32.

Peter K. Klein, "From the Heavenly to the Trivial: Vision and Visual Perception in Early and High Medieval Apocalypse Illustration," in Herbert L. Kessler and Gerhard Wolf, eds., *The Holy Face and the Paradox of Representation* (Bologna, 1998), pp. 247–78.

Klaus Krüger, *Das Bild als Schleier des Unsichtbaren. Ästhetische Illusion in der Kunst der frühen Neuzeit in Italien* (Munich, 2001), p. 13.

——, "Die Lesbarkeit von Bildern. Bemerkungen zum bildungssoziologischen Kontext von kirchlichen Bildausstattungen im Mittelalter," in Christian Rittelmeyer and Erhard Wiersing, eds., *Bild und Bildung. Ikonologische Interpretationen vormoderner Dokumente von Erziehung und Bildung* (Wiesbaden, 1991), pp. 105–33.

Meredith Lillich, *Rainbow like an Emerald: Stained Glass in Lorraine in the Thirteenth and Early Fourteenth Centuries* (University Park, PA, 1991).

Elizabeth Lipsmeyer, "Devotion and Decorum: Intention and Quality in Medieval German Sculpture," *Gesta* 34 (1995), pp. 20–7.

Clark Maines, "The Charlemagne Window at Chartres Cathedral: New Considerations on Text and Image," *Speculum* 52 (1977), pp. 801–23

Pierre-Alain Mariaux, "L'Image selon Grégoire le Grand et la question de l'art missionaire," *Cristianismo nella storia* 14 (1993), pp. 1–12.

——, "Voir, lire et connaître selon Grégoire le Grand," *Etudes de Lettres* 3–4 (1994), pp. 47–59.

Christel Meier, "Malerei des Unsichtbaren. Über den Zusammenhang von Erkenntnistheorie und Bildstruktur im Mittelalter," in Wolfgang Harms, ed., *Text und Bild, Bild und Text* (Stuttgart: J. B. Metzler, 1990), pp. 35–64.

Paul Meyvaert, "Bede and the Church Paintings at Wearmouth-Jarrow," *Anglo-Saxon England* 8 (1979), pp. 63–77.

Victoria M. Morse, "Seeing and Believing. The Problem of Idolatry in the Thought of Opicino de Canistris," in Susanna Elm et al., eds., *Orthodoxie, Christianisme, Histoire* (Rome, 2000), pp. 163–76.

Stephen Murray, *Notre-Dame, Cathedral of Amiens. The Power of Change in Gothic* (Cambridge, 1996).

——, "Pourquoi la polychromie? Réflexions sur le rôle de la sculpture polychromée de la cathédrale d'Amiens," in *La couleur et la pierre. Polychromie des portails gothiques* (Paris, 2002), pp. 207–12.

Stephen Nichols, *Romanesque Signs. Early Medieval Narrative and Iconography* (New Haven, 1983).

Henk van Os, *The Way to Heaven. Relic Veneration in the Middle Ages* (Amsterdam, 2000).

Norbert H. Ott, "Texte und Bilder. Beziehungen zwischen den Medien Kunst und Literatur in Mittelalter und früher Neuzeit," in Horst Wenzel et al., eds., *Die Verschriftlichung der Welt. Bild, Text, und Zahl in der Kultur des Mittelalters und der frühen Neuzeit* (Vienna, 2000), pp. 104–43.

Gerald R. Owst, *Literature and Pulpit in Medieval England* (Cambridge, 1933).

Otto Pächt, Charles Reginald Dodwell, and Francis Wormald, *The Saint Albans Psalter* (London, 1960).

Éric Palazzo, "Les Pratiques liturgiques et devotionnelles et le decor monumental dans les eglises du Moyen Age," in *L'emplacement et la fonction des images dans la peinture murale du Moyen Age* (Saint-Savin, 1993), pp. 45–56.

Erwin Panofsky, *Abbot Suger On the Abbey Church of St.-Denis and its Art Treasures*, 2nd edn. (Princeton, 1979).

Dominique Poirel, "*Symbolice et anagogice*: l'école de Saint-Victor et la naissance du style gothique," in *L'Abbé Suger, le manifeste gothique de Saint-Denis et la pensée victorine* (Turnhout, 2002), pp. 141–70.

Conrad Rudolph, *Artistic Change at St-Denis* (Princeton, 1990).

——, *"First, I Find the Center Point": Reading the Text of Hugh of Saint Victor's* The Mystic Ark (Philadelphia, 2004).

——, "La resistenza all'arte nell'Occidentale," in Enrico Castelnuovo and Giuseppe Sergi, eds., *Arti e storia nel medioevo*, 4 vols. (Turin, 2002–4), v. 3, pp. 49–84.

——, *The "Things of Greater Importance." Bernard of Clairvaux's* Apologia *and the Medieval Attitude Toward Art* (Philadelphia, 1990).

——, *Violence and Daily Life. Reading, Art, and Polemics in the Cîteaux* Moralia in Job (Princeton, 1997).

James A. Rushing, Jr., *Images of Adventure. Ywain in the Visual Arts* (Philadelphia, 1995).

Jean-Claude Schmitt, "Ecriture et image: les avatars médiévaux du modèle gregorien," in *Théories et pratiques de l'écriture au Moyen Âge* (Paris, 1988), pp. 119–50.

——, "L'Occident, Nicée II et les images du VIIIe au XIIIe siècle," in *Nicée II* (Paris, 1987), pp. 271–301.

——, "La Question des images dans les débats entre juifs et chrétiens au XIIe siècle," in S. Burghartz et al., eds., *Spannungen und Widersprüche. Gedenkschrift für Frantisek Graus* (Sigmaringen, 1992), pp. 245–54.

Andreas Speer et al., eds., *Abt Suger von Saint-Denis. Ausgewählte Schriften: Ordinatio, De consecratione, De administratione* (Darmstadt, 2001).

Georg Steer, "Zum Begriff 'Laie' in deutscher Dichtung und Prosa des Mittelalters," in Ludger Grenzemann and Karl Stackmann, eds., *Literatur und Laienbildung um Spätmittelalter und in der Reformationszeit* (Stuttgart, 1984), pp. 764–8.

Brian Stock, *The Implications of Literacy. Written Language and Models of Interpretation in the Eleventh and Twelfth Centuries* (Princeton, 1983).

Hans Georg Thümmel, "Annuncio della parola ed immagine nel primo Medieovo," *Cristianismo nella storia* 14 (1993), pp. 505–33.

William Travis, "Daniel in the Lions' Den. Problems in the Iconography of a Cistercian Manuscript. Dijon, Bibliothèque Municipale, MS 132," *Arte medievale*, II ser., 14 (2000), pp. 49–71.

Ralph Turner, "The *Miles Literatus* in Twelfth- and Thirteenth-Century England: How Rare a Phenomenon?" *American Historical Review* 83 (1978), 928–45.

Gisella Cantino Wataghin, "Biblia pauperum: Some Observations on Early Christian Art," *Antiquité tardive* 9 (2001), pp. 259–74.

Horst Wenzel, "*Schrift* und *Gemeld*. Zur Bildhaftigkeit der Literatur und zur Narrativik der Bilder," in *Bild und Text im Dialog* (Passau, 1993), pp. 29–52.

Jean Wirth, "La Critique scholastique de la théorie thomiste de l'image," in Olivier Christin and Dario Gamboni, eds., *Crises de l'image religieuse. De Nicée II à Vatican II* (Paris, 1999), pp. 93–109.

——, *L'Image medievale. Naissance et développements (Ve–XVe siècle)* (Paris, 1989).

——, "Peinture et perception visuelle au XIIIe siècle," *Micrologus* 6 (1998), pp. 113–28.

——, "Structure et fonctions de l'image chez Saint Thomas d'Aquin," in Jérôme Baschet and Jean-Claude Schmitt, eds., *L'image. Fonctions et usages des images dans l'Occident médiéval* (Paris, 1996), pp. 39–57.

Gerhard Wolf, "From Mandylion to Veronica: Picturing the 'Disembodied' Face and Disseminating the True Image of Christ in the Latin West," in Herbert L. Kessler and Gerhard Wolf, eds., *The Holy Face and the Paradox of Representation* (Bologna, 1998), pp. 153–79.

——, *Salus populi romani. Die Geschichte römischer Kultbilder im Mittelalter* (Weinheim, 1990).

Ian Wood, "Images as a Substitute for Writing: A Reply," in Evangelos Chrysos and Ian Wood, eds., *East and West: Modes of Communication* (Leiden, 1999), pp. 35–46.

Yolanta Załuska, *Manuscrits enluminés de Dijon* (Paris, 1991).

Art and Exegesis
Christopher G. Hughes

Definitions and Period Terminology

This chapter sets out to describe the relationship between art and biblical exegesis as it is expressed in the Romanesque and Gothic periods, as well as in the modern art historical literature on the subject. Two remarks must be made at the outset. Unlike such subjects as, say, Gothic architecture or Romanesque manuscripts, there is no distinct body of literature on art and exegesis; instead, we have individual scholarly works that address the issue to a greater or lesser degree as part of other projects. Secondly, there is a question of period versus modern terminology, and I offer the following not to be pedantic, but because one wants to be clear about how modern critical discourses correspond – or do not – to medieval concepts. It is important to note that both "art" and "exegesis" are terms medieval writers used either in a different sense from ours or not at all. As for art, to a medieval ear, the Latin *ars* signified something more of a skill or craft. Writing around 1100, the Benedictine monk Theophilus entitled his technical treatise *De Diversis Artibus*, the word *ars* here carrying none of the modern associations with creativity or self-expression. Instead of art, one might substitute pictorial or visual modes of expression.

Similarly, the term "exegesis" requires clarification. A word of Greek origin, exegesis is not commonly used by the Latin writers of the Middle Ages. A survey of the titles of some exegetical works gives us a sense of the range of words they employed instead: Augustine's *Enarrationes in Psalmos*; Hrabanus Maurus' *Expositiones in Leviticum*; Rupert of Deutz's *Commentaria in Evangelium Sancti Iohannis*; Hugh of St Victor's *Quaestiones in Epistolas Pauli*. In the *Didascalicon*, a handbook for study written in the late 1120s, Hugh of St Victor uses another range of verbs to describe the act of what we call exegesis, among them *iudicare, investigare, studiare,* and *interpretare*. What is clear from all of these Latin terms – and the texts that follow them – is what exegesis means: the interpretation of

sacred scripture, and not theology. In the *Didascalicon*, Hugh of St Victor, quoting Boethius and Isidore of Seville, defines theology as "discourse concerning the divine," or the "searching into the contemplation of God and the incorporeality of the soul," concluding that "it is theology, therefore, when we discuss with deepest penetration some aspect . . . of the inexpressible nature of God."[1] Therefore this chapter will restrict itself to works of art bearing some relation to exegesis, or the systematic interpretation of scripture, and not consider the relation of art to theology.

Certain terminological adjustments having been made, it is clear that throughout the High Middle Ages a deep connection was felt and then effected between what we call art and exegesis. Twelfth-century authors make clear that pictorial or visual modes were viewed as an effective way of expressing exegetical thought. For example, the probably English and Cistercian author of the *Pictor in Carmine* (*c*.1200) recommends typological programs (and typology, as we shall see, is the most common form of exegesis to be represented in art) for church decoration, not only because he believes this subject matter to be more edifying than others, but also because the representation of typologies in pictures will imprint exegetical concepts on the mind more forcefully than by other means.[2] Similarly, Hugh of St Victor, who seemingly had a developed sense of the powers of visual exegesis,[3] makes use of an elaborate, extended pictorial metaphor to explicate the allegorical sense of Noah's Ark in his commentary *De Archa Noe*, again working with the assumption that the mental construction and visualization of a picture will fix the exegetical content of his work more securely in the mind of the reader. In this text, Hugh claims to be drawing and painting an elaborate, quasi-diagrammatic picture of the ark, which he then harmonizes with his exegetical interpretation. At the end of *De Archa Noe*, Hugh offers a spiritual reason for attending to this picture:

> And now, then, as we have promised, we must put before you the pattern of our ark. Thus you may learn from an external form, which we have visibly depicted, what you ought to do inwardly, and when you have impressed the form of this pattern on your heart, you may rejoice that the house of God has been built in you.[4]

This passage suggests that the contemplation of a visual image – in this case, an extremely complicated one which may or may not have ever been executed[5] – will clarify for the "viewer" the moral or tropological sense of scripture.

A similar medieval conjoining of the visual and the exegetical occurs in the lengthy inscription found on Nicholas of Verdun's Klosterneuburg Altar (finished 1181). The opening hexameters of the dedicatory inscription by the donor, Prior Rudiger, makes this abundantly clear: in the inscription, he not only explains the traditional exegetical habit of dividing sacred history in three eras (before the Law, under the Law, under grace), he also tries to focus vision and attention on certain features of the work's pictorial decoration. These beginning

verses not only refer to an abstract exegetical system but also direct our visual experience of the object before us: "You see in this work" how the events of sacred history mirror each other, Rudiger tells us. To see, we are instructed to "seek" the time before the Law in the upper zone; below that we will find the time under the Law; and "in between the two" stands the era of grace. These detailed instructions inform the viewer where, according to Rudiger, the main visual interest lies, which is in how the system of the three ages has been translated into a pictorial program. The verses also suggest a schedule for studying the various regions of the work. Taken as a whole, the inscription not only lays out the exegetical foundation for the work's iconography, but strongly encourages us to experience it visually, and not just conceptually. The underlying reason for insisting on the visual perception of exegesis can only have been a strong belief in the efficacy of that relationship.

Further evidence for the medieval connection of pictorial exposition and exegesis can be seen in the many Romanesque manuscripts that rely heavily on visual devices such as *schemata* or diagrams to make exegetical points in a way that was clearly thought to be more forceful and expeditious than textual exposition. As Michael Evans has argued, diagrammatic exposition makes clear that medieval exegetes believed that certain ideas could be expressed visually, but less effectively verbally, which implies that the modern emphasis on prose as the primary medieval medium for the transmission of knowledge is overstated.[6] Finally, certain works of art make their relationship to exegesis explicit. For instance, when the designer of the so-called "anagogical" window at St Denis (*c*.1140–4; see below) frames an image of Moses receiving the Law with an inscription which makes direct reference to Paul's dictum "the letter killeth, but the spirit giveth life" (II Corinthians 3: 7–8, 16–17), the viewer is obliged to interpret the image in the light of scriptural exegesis, in this case concerning the transition from the Old to the New Dispensations.[7]

All of this suggests that "Art and Exegesis" is a topic with an authentic medieval pedigree (as opposed to, say, the study of iconography). However, given the fact that there is no established modern bibliography or methodology concerning the relationship of art to exegesis, this chapter will sketch out the ways the problem has been addressed by scholars by looking at three categories in which the two terms have been brought together in art historical research, and then give examples of each. These categories, which overlap each other at times, are: (1) art or decoration found in Romanesque and Gothic exegetical manuscripts; (2) art that illustrates or gives visual expression to exegetical ideas found in texts, or, to put it another way, art that adopts exegetical ideas as its iconography; (3) art that functions as a visual form of exegesis. Before proceeding to examples, I would like to offer a caveat about discussing the relation of art to a textual tradition such as scriptural exegesis (this issue will be touched upon again below). Georges Didi-Huberman reminds us that medieval exegetes did not view sacred texts as, to use his idiosyncratic terminology, *lisible*, or open to an immediate and complete apprehension. Instead, they viewed the interpretation of scripture

as an ongoing mystery which would never completely reveal itself. In painting, a similar distinction can be made between what Didi-Huberman calls the *visible* and the *visuel*: an iconographic approach to art history considers pictures to be *visible*, or fully understandable once we have deciphered their subject matter. Pictures, however, are, in fact, *visuel*, a distinction meant to stress the irreducible, resistantly non-verbal, visual nature of a picture.[8] When speaking of art's relation to exegesis, this analogy not only reminds us of the medieval attitude towards the interpretation of scripture, but also asks us to think of works of art as manifesting a visuality that functions very differently from textuality, and finally suggests that because of this distinction, exegetical art will proceed by means of its own visual logic, never merely illustrating exegetical texts. This will become mostly apparent in my third group of examples, works of art that embody a notion of visual exegesis.

Scriptural Exegesis

Before turning to works of art, a brief descriptive history of the practice of biblical exegesis is in order. Generally speaking, the Christian interpretation of scripture is, at its heart, allegorical. That is to say, the events of both the Old and New Testaments are thought to have not only a literal or historical meaning, but a "spiritual" or "mystical" sense as well. Usually, the New Testament is taken to be the allegorical sense of Old Testament; that is to say, the New Testament is viewed as a fulfillment of the prophetic Old Testament. This idea of the mystical concord of the two Testaments gives rise to the idea of biblical typology, which permeates scriptural exegesis throughout Early Christianity and the Middle Ages. It is not always easy to sort out the differences between typology and allegory and it is not clear that medieval exegetes felt a need to do so.

A system for the hidden meaning of scripture was developed very early on and remained in place well beyond our period. This system, referred to as the "four senses of scripture," sees in scripture a literal sense, an allegorical sense, a moral or tropological sense, and an anagogical or eschatological sense.[9] The significance of each sense is nicely summed up in a much-quoted couplet by Nicholas of Lyra, writing about 1330 at the end of a very long tradition:

> Littera gesta docet, quid credas allegoria,
> Moralis quid agas, quo tendas anagogia.[10]
>
> (The letter shows acts, allegory shows what to believe,
> The moral shows what to do, anagogy what to strive for.)

Theoretically, every utterance in scripture can be interpreted in terms of all four senses, although in practice it was recognized that some were better suited to certain senses than others. One finds the three spiritual senses of scripture

explicated in straightforward terms throughout, for example, the *Glossa Ordinaria*, each sense introduced by *allegorice* (allegorically), *moraliter* (morally), or *mystice* (mystically), depending on what the glossator wishes to stress in a given passage. One should also note that all three of the non-literal senses were thought to be sub-categories of a more general allegorical or spiritual sense. In terms of practice, this means that in the many commentaries on the Bible written in the patristic period and in the early Middle Ages, one can find a verse-by-verse exposition of scripture that explains each sense of that verse. On the other hand, certain commentaries, such as Gregory the Great's *Moralia in Job* (*c*.590) could transform the ostensible explication of a biblical text into a work of extended theological meditation.

Closely related to the allegorical sense of scripture is what modern scholars call biblical typology (referred to again, somewhat vaguely, as *allegoria* in medieval usage), a more specialized practice that seeks to elucidate parallels between the Old and New Testaments. According to Augustine, the typological or figural meaning of scripture is closely related to the allegorical sense.[11] This approach is founded on the idea, promulgated by Christ, the evangelists, and Paul, that the truths of the new Christian dispensation are latent in the events of the "old" Jewish one. Typology was not only one of the most common and enduring ways of understanding the allegorical sense of scripture, it was also, for reasons we shall see shortly, the exegetical type that had the greatest impact on the visual arts. In order to do justice to the textual-exegetical aspect of this chapter, and given the pre-eminence of typology in this world, it seems useful to pause and briefly consider a representative example of typological exegesis. This is taken from Hrabanus Maurus' ninth-century explication of Abraham's sacrifice of Isaac (Genesis 22). After discussing the literal sense of the passage, including information provided by Jews concerning the location of the incident's mountain setting, Hrabanus notes the parallels between this Old Testament event and one from the New – the Crucifixion. The father, willing to sacrifice his only son for God, is likened to God himself sacrificing his son, Christ, for the sake of human salvation. Hrabanus also notes that the very wood carried by Isaac up the mountain resembles the cross carried by Christ. There is a further allegorical meaning to be discovered in this typology as well – the two servants dismissed by Abraham "signify" the Jews who "do not understand the humanity of Christ."[12] This conclusion is typical of typological exegesis in that it stresses not only mystico-structural similarities between the Old and New dispensations, but also stresses the superiority of the New.

The voluminous commentaries on the Bible, as well as other types of texts like the City of God, written over centuries by authors who had assimilated and repeated the work of their forebears, constitutes a kind of culture of exegesis, or a shared set of texts, practices, and paradigms that give this world its distinctive flavor. However, the harmony (or homogeneity, depending on your point of view) of this culture broke down sometime in the twelfth century as the emphases and aims of scriptural exegesis changed. Masters such as Peter Lombard

increasingly inserted *quæstiones*, or theological discussions, into their explications, thereby combining exegesis and theology in a manner quite different from their early medieval counterparts. In the early thirteenth century, a new trend in glosses of scripture, partly as a tool for preaching, emerged in the circle of Stephen Langton in Paris. This combination of interests in the moralizing of scripture and preaching naturally found an eager audience among the Dominicans and Franciscans, and certain masters such as the Dominican Hugh of St Cher became famous as authors of *postillae*, or running commentaries on the Bible, meant to complement the more atomized glosses. In the meantime, the pursuit of the spiritual or allegorical sense, beloved in the old monasteries declined in influence and practice, and in the thirteenth and fourteenth centuries, emergent noble and bourgeois approaches to scripture focused new attention on books of the Bible previously neglected by the Church Fathers, which spoke to new interests in politics and kingship.[13]

Historiography of Art and Exegesis

Although never attaining the status of an "approach" or method, the use of exegetical texts to interpret works of Romanesque and Gothic art goes back to the early days of the systematic study of medieval art. Consequently, if the following historiographic overview of the relation of art and exegesis seems thin, it is because the bulk of the study on the subject has concentrated less on paradigms and more on individual cases. Nevertheless, a provisional history of the topic can be attempted. A prominent nineteenth-century example of exegetical texts being brought to bear on the interpretation of a work of art is found in the monumental study of the stained-glass windows at Bourges Cathedral by the Jesuit Charles Cahier (1807–82), who makes his interpretive stance clear by giving the typological window (*c*.1215) pride of place, devoting more than 100 pages to its explication.[14] Cahier offers no methodological statement explaining his decision to discuss the window in light of exegetical texts (ranging from Tertullian to Rupert of Deutz), because he views exegesis as an expression of the truths of the faith, not as a body of material to be brought to bear on a historical problem. Similarly, he sees the artist's representation of exegetical thought as a parallel affirmation of the "correct" way to convey the tenets of Catholicism. To put it another way, Cahier feels that both exegesis and art depicting exegetical ideas respond naturally to the reality of sacred scripture.[15] In some sense, it is fair to say that Cahier works as an exegete himself, and not as an art historian.

The most influential medievalist to champion not only the use of exegetical texts in the interpretation of works of art, but also to reveal the extent to which works of art themselves should be viewed as forms of exegesis was Emile Mâle (1862–1954). Particularly in his magisterial *L'Art religieux du XIIIe siècle en France: Étude sur l'iconographie du moyen âge et sur ses sources d'inspiration*

(1898), Mâle proposed a view of medieval art that remains very much with us to this day:

> Everything essential said by the theologians, encyclopedists, and the interpreters of the Bible was expressed in stained glass and sculpture. We shall attempt to show how artists translated the thoughts of the Church Doctors, and do our utmost to present a full picture of the abundant teaching the thirteenth-century cathedral furnished to all.[16]

Choosing Vincent of Beauvais as a model for a totalizing vision of all medieval knowledge, and citing *inter alia* Paul, Hilary of Poîtiers, Origen, Augustine, Ambrose, Jerome, Gregory the Great, and Isidore of Seville, Mâle interprets the art of the Gothic cathedrals as a complete visualization of "the immense chain of Catholic tradition."[17] As this statement makes clear, Mâle viewed most medieval art not simply as the visualization of theology and exegesis, but as didactic, rather than decorative, in purpose. In fact, for Mâle, exegesis practically drives or determines Gothic art. In his view, it is impossible to understand medieval art simply in stylistic or cultural terms because this approach misses that original impulse behind those works.

Perhaps the most thoroughgoing theoretical or methodological debate of the last century about the use of exegetical texts to elucidate works of art appears not in the study of Romanesque and Gothic art, but in the discussion of so-called "disguised symbolism" in fifteenth-century Netherlandish painting. In the wake of the chapter in Erwin Panofsky's *Early Netherlandish Painting* (1953) devoted to "Reality and Symbol in Early Flemish Painting," some scholars began routinely to adduce exegetical texts as sources for the purportedly arcane "symbolic" iconography of works of later medieval art. When pursued in a mechanical or uncritical way, this practice led to interpretations of works of art that implied a naive relation of exegesis to image.[18] Pursuing this thought, Brendan Cassidy notes that iconographic method's recourse to exegetical texts often glosses over another important issue, the relationship of medieval texts to medieval images. He reminds us that "the visual is more intractable, offering only ambiguous answers to many of the questions that the text-bound historian is inclined to ask. However, it is not the appeal to texts for clarification of the meaning of an image that is the issue, for iconography would scarcely be possible without texts." Cassidy also warns that, "the texts among which meanings were sought were predominantly the writings of medieval churchmen, and classical authors and their humanist admirers; again this approach is warranted only in some contexts."[19] This caveat reminds us that an expanded conception of the audience for a particular image, reflecting the social realities of literacy, class, and gender, means that certain exegetical texts might not be appropriate in the reconstruction of an artwork's reception. This debate, however, has calmed somewhat, for, as Jeffrey Hamburger has recently observed:

[T]he interpretation of medieval art in terms of theology has fallen out of favor. The aversion to theology has many causes; not the least are disbelief and disinterest, allied with a general discrediting (and occasional abuse) of the iconographic method, which in turn entails a healthy disinclination to explain images through texts. Instead, popular piety, oral traditions, and the beliefs of marginal groups command scholarly attention.[20]

Finally, the tendency to view exegetical texts as sources for iconography, and not to understand (as was the case in the Middle Ages) exegesis as a cognitive act, misunderstands the degree to which works of art actively constructed exegetical meaning, rather than passively representing it.

Three Conceptions of the Study of Art and Exegesis

The illustration of exegetical texts

This is certainly the least important area of our topic, but it would seem remiss not to mention what kind of art appears in actual exegetical texts. Compared with the great bibles, psalters, and service books made in the Romanesque period, generally speaking exegetical works were not as lavishly painted. There are, however, notable exceptions. For example, for a copy of Richard of St Victor's *In Ezechielem* (Paris, Bibliothèque Nationale Ms lat. 14516), produced *c.*1150–75, Richard wanted Ezechiel's temple illustrated by plans, elevations, and exterior views in order to prove the literal sense of the text. However, the extensive illustration seen in this exegetical manuscript is unusual, owing to the polemical nature of the text.[21]

Art illustrating exegetical writing and thought

Art may also give visual form to an interpretation of scripture, as opposed to a scene or event from scripture. A pair of stained-glass windows ordered by Abbot Suger around 1140 for the choir of the abbey church at St Denis illustrates exegetical thought with great sophistication. One of the windows, variously referred to as the "anagogical window," or more accurately as the window of the "Pauline Allegories," contains five roundels which visualize typologies and allegories of the concord of the two testaments. One roundel, now lost, depicted the "Mystic Mill" of St Paul, which Mâle, and after him Louis Grodecki, correctly interpreted in the light of Paul's writings as a symbolic statement of how the Old Testament is metaphorically transformed into the New. (This subject is also depicted on a slightly earlier capital at Vézelay.) In order to insure a correct reading of the image, Suger appended a verse which states that "the wheat of Moses and the prophets became the pure flour with which the church nourishes mankind."[22] A surviving panel showing Christ crowning Ecclesia and unveiling the eyes of Synagoga similarly gives visual form to a variety of verses

from the Pauline Epistles that deal with the transition from the Old to New dispensations. Throughout his authoritative discussion of this window's iconography, Grodecki insists that its exegetical sources in the Epistles are as clear as they are venerable, and he thoroughly rejects Erwin Panofsky's "anagogical" reading of the windows as overly-complicated and institutionally unlikely.[23] By placing the emphasis instead on traditional allegorical readings of scripture, Grodecki returns the St Denis window to its proper place in the history of illustrating established biblical commentary. This type of iconography was already present at St Denis in the Carolingian altar frontal refurbished by Suger at this time, as well as in the subject matter of the great twelfth-century cross, now lost, which was, to quote Suger, "enameled with exquisite workmanship, and [on it] the history of the Savior, with the testimonies of the allegories of the Law [*cum antiquae legis allegoriarum*] indicated, and the capital above looking up, with its images, to the death of the Lord."[24] Grodecki's analysis of the windows also has the virtue of reminding scholars that the exegetical sources for twelfth-century art need not be contemporary – for example, the Victorines are often pressed into this service – and the New Testament and the patristic authors remained a vital source for iconographic ideas throughout the Romanesque and Gothic periods.[25] On the opposing window, dedicated to stories from the life of Moses, the panel of Moses receiving the Law is accompanied by an inscription, cited by Suger, which alludes to II Corinthians 3: 6: "Lege data Moysi, juvat illam Gratia Christi/Gratia vivificat, littera mortificat." This orthodox statement makes it clear that Suger wishes for the Exodus scenes to be interpreted in the light of traditional typological exegesis as well. As Grodecki says, it is clear that in some respects the "allegorical" window provides exegetical methods for interpreting the Exodus window, and others have argued for specific cross-window interpretive structures.[26] Finally, it should be noted that Suger's choice of conservative interpretations of scripture for the iconography of the windows and his cross is in part a response to criticisms concerning the place of art in the monastery leveled at St Denis by Bernard of Clairvaux.[27]

A later example (fig. 8-1) from an English Gothic manuscript shows another way in which exegetical thought could be rendered pictorially. An illumination from the Queen Mary Psalter (*c.*1315) accompanying Psalm 68 shows the marriage at Cana; the historiated initial S beginning the first verse contains the story of Jonah and the Whale. At first glance, it is difficult to figure out why these two biblical stories have been chosen to illustrate this psalm. It turns out that the image presumes a familiarity with (which is different from saying something "is derived from") a bit of exegesis derived from Jerome's commentary on Jonah. Explicating Jonah 2: 1–11, which Christ had already interpreted typologically (Matthew 12: 40), Jerome says that "The Lord explains the mystery of this topic (*mysteriorum loci*) in the Gospels, so it's superfluous to repeat it either in the same terms, or in different ones."[28] Recognizing that the obvious typology – Jonah's three days in the whale foreshadow Christ's three days in the earth – is well-known, Jerome turns to the allegorical significance of other aspects of the

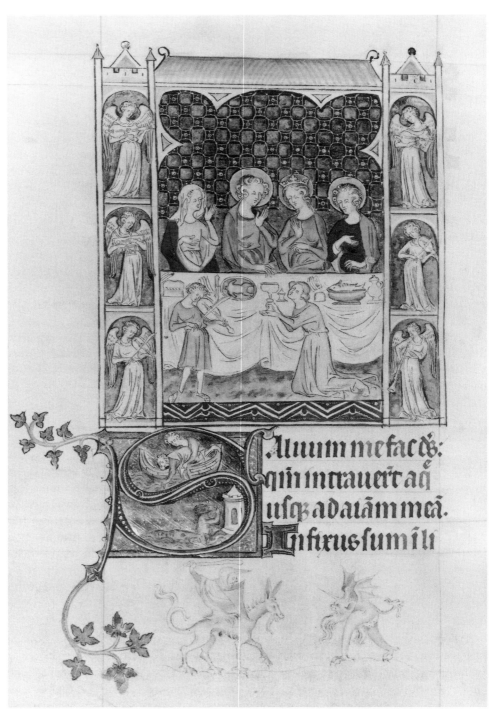

FIGURE 8-1 Psalm 68, Queen Mary Psalter, *c.*1315. London: British Library, MS Royal 2.B.VII, fol. 168v.

story: "If Jonah is compared to the Lord, and his passing three days and three nights in the whale is a sign of his passion, then Jonah's prayer should be a figure of the Lord's prayer." In his prayer, Jonah cries out, saying the Lord has "cast me forth into the deep heart of the sea, and a flood hath encompassed me" (Jonah 2: 4). This suggests to Jerome a passage from Psalm 69: "Save me, O God, for the waters are come in even unto my soul . . . I am come into the depth of the sea: and a tempest hath overwhelmed me" (Psalm 69: 2–3). So far, we have two Old Testament texts but no New, yet Jerome intends a typological reading. He brings this about by reminding us that the psalms not only proph- esy Christ, but that the psalmist, David, is a prefiguration of Christ. Therefore, the Psalms can be attributed to Christ. He speaks of "the person of Christ who, under the name of David, sings the psalm."[29] The psalm prayer, uttered by David-Christ, is the typological equivalent of Jonah's prayer in the whale. It is therefore not surprising that we should find Jonah at the beginning of Psalm 68 in the Queen Mary Psalter – or in other Gothic psalters.[30] However, this crypto- typology is further complicated by the marriage at Cana miniature above, given that the marriage at Cana was customarily interpreted as an allegory of the water of the Old Testament being changed into the wine of the New by Christ. The watery psalm verse and Jonah anecdote, both from the Old Testament, support the typological reading of water in the gospel scene above, which, as has been noted, unusually represents only a goblet of wine.[31] This is a rather complex set of exegetical ideas to present to the viewer of the page without any textual hint as to its intended meaning. Nevertheless, we must assume that the designer of the Queen Mary Psalter expected the images to be understood in some way.

Art as visual exegesis

The third way in which art and exegesis can be related to each other is to think of works of art performing a kind of visual exegesis. That is to say, beyond the simple representation of an idea gleaned from an exegetical text, these works, through their formal arrangements, act as an exegetical mode themselves. As Marcia Kupfer has said in relation to Romanesque murals, visual exegesis is "a nonlinear mode of narration that correlates the dynamics of perception and interpretation. The viewer comprehends the various particular elements in light of the global arrangement in which they are subsumed."[32] It is in this area that "exegetical" art shines most brightly, constructing scriptural interpretations as ingenious and compelling as anything found in a text – and often more so.

Made around 1160 in the valley of the Meuse, possibly to contain a long- vanished relic of the True Cross, the Alton Towers triptych (fig. 8-2) is a noteworthy example of how visual exegesis might work. Its iconography is both allegorical and typological. Complemented by allegorical voices, typology asserts itself as the featured pictorial program of the triptych. The central panel is dedicated to events from Christ's Passion: the Crucifixion, the Harrowing of Hell, and the Three Maries at the Tomb. The left and right wings provide each

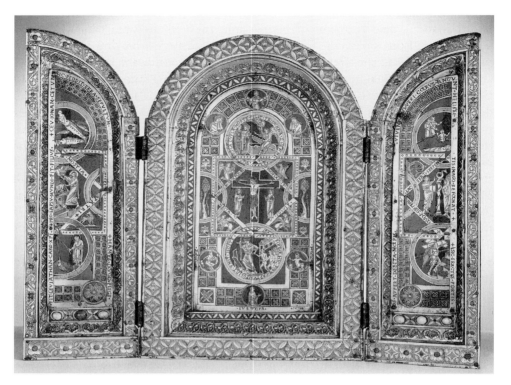

FIGURE 8-2 Alton-Towers Triptych, *c.*1160. London: Victoria & Albert Museum.

New Testament event with an Old Testament prototype. These particular matchings of Old and New Testament events is conventional, repeated through-out the patristic and early medieval commentaries. They also occur regularly in twelfth-century Mosan enameled metalwork. What is original about the Alton Towers triptych is the *format* in which these exegetical commonplaces are pre-sented: they are accompanied by unusually ornate inscriptions and arranged in a diagrammatic network of roundels. This combination of inscription, diagram, and image give the work its distinctive exegetical power.

 The inscriptions draw our attention to parallels in the Old and New Testa-ments by creating a system of verbal rhymes and echoes – in other words, formal structures meant to suggest a meaningful relationship. Similarly, the appearance of the Alton Towers triptych's imagery works by means of an equivalent visual process. Drawing on the rich tradition of medieval diagrams, or *figurae*, the abstract system of connecting bars and roundels on the triptych encourages the viewer to consider why various subjects are compared or contrasted. Both designer and audience would sense that roundels of similar size and position implied a formal comparison of their contents. Formal differences would register themselves as well: the roundels on the wings are blue, while those in the center are white. Those on the wings are incomplete, while those in the center are

complete; this probably denotes the approved belief that the revelation of the Old Testament was incomplete, while that of the New is complete and perfect. These distinctions correspond to the Old/New dispensation distinction, or, to put it another way, one visual type of *figura* is used to elaborate an exegetical one.

Finally, the center panel of the triptych includes allegorical imagery that sets the Crucifixion and Resurrection in a cosmic setting. In the top and bottom borders appear personifications of Charity, who bears a scroll inscribed with her name, and Justice, with an identifying inscription just below her, two of the four cardinal virtues. Justice, a worldly virtue, occupies the lower place, ceding the higher, spiritual position to Charity. Versions of this allegorical schema, derived from patristic exegesis and reinforced by later commentators including Rupert of Deutz, were incorporated into early medieval representations of subjects such as the *Majestas Domini*, giving the Christ in Glory a broader setting.[33] The designer of the Alton Towers triptych complicates this theme by framing the retable's New Testament subjects with quasi-classical personifications of the Sun, Moon, Earth, and Sea, complete with inscriptions in the panel's outer border. Also present on the central panel are the symbols of the four evangelists, inserted into the corners of the box framing the Crucifixion. The two trees in half-roundels flanking the Crucifixion may be the Trees of Life and Knowledge. All of these symbols and images offer different perspectives on the narrative events depicted in the main column of roundels.

Compositional strategies closely related to those found in Mosan enamels can be found in early Gothic stained-glass windows as well. Windows at Canterbury, Bourges, and Chartres have complex, usually diagrammatic, typological pro-grams.[34] Another popular "exegetical" subject for glazing programs is the parable of the Good Samaritan complemented by a series of Old and New Testament typologies.[35] This interest in interpreting the parable – itself already an allegory – along typological lines lacks textual precedent; that is to say, the windows deviate from the conventional ways of explicating the text found in the early Christian and medieval glosses. Thus, they truly act as an independent form of visual exegesis. Deviating from contemporary works such as the late twelfth-century *Hortus Deliciarum* of Herrad of Hohenbourg, which accompanied literal illustrations of the story of the Good Samaritan with an allegorical gloss from Honorius Augustodunensis' *Speculum Ecclesiae*, the Good Samaritan stained-glass windows at Sens (*c.*1200) and Bourges (*c.*1215) visually engage the literal and allegorical senses of the parable at once.

Along the central axis of the Bourges window are arranged in descending order five scenes from the parable. In the large half-roundels which stand on either side of the parable scenes we see Old and New Testament scenes. Ten of the Old Testament scenes illustrate the story of Creation, beginning with God creating the sun and the moon and ending with the angel shutting the gate of Paradise after the Expulsion of Adam and Eve. This abbreviated Genesis cycle corresponds to the first three Good Samaritan roundels – the quitting of Jerusalem and the attacks on the pilgrim. The fourth parable scene, the priest

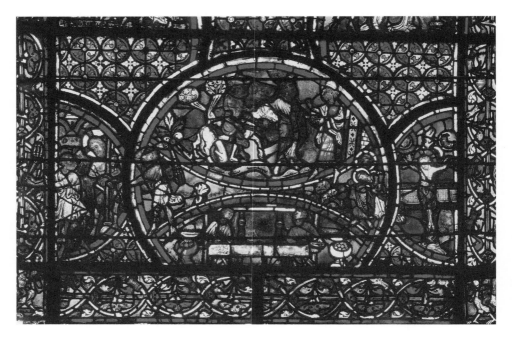

FIGURE 8-3 Typological window, *c*.1215. Bourges Cathedral.

and the Levite before the wounded pilgrim, is framed by four scenes from
Exodus: Moses and the burning bush, Moses breaking the tablets of the law,
Aaron collecting the jewels of the Israelites, and the worship of the golden calf.
At the bottom of the Bourges window (fig. 8-3) we see two New Testament
events, the Flagellation and the Crucifixion, placed on either side of the Samaritan
leading the man to the inn. The meaning of these juxtapositions is clear. Two
scenes of God creating the prelapsarian world suggest that the city of Jerusalem
(at center) is like Paradise; the man's ordeals on his journey recall the sins of
Adam and Eve, whose creation and fall parallel those scenes; the priest and the
Levite, who signify the failures of Judaism for Honorius, find analogies in
the scenes of Moses, Aaron, and the Israelites. Finally, the merciful deeds of the
Good Samaritan are likened to the events of Christ's passion, events that stress
the meaning of his sacrifice for humanity.

An even clearer pictorial version of this interpretation of the parable appears in
the choir at Sens Cathedral. Here, the parable narrative proceeds clearly down
the vertical axis, as at Bourges. The groups of typologies, arranged in four partial
roundels abutting each of the three scenes of the parable, attain an even greater
level of internal logic than those found at Bourges, in that the Old and New
Testament "glossing" scenes read in a linear narrative (left-to-right and top-to-
bottom). The result is one narrative serving as a commentary on another – quite
a feat to accomplish within a rigid diagrammatic framework. It should be noted
that typological exegesis exists side by side with more pure narrative in these

windows of the early decades of the thirteenth century, suggesting it would be wrong to oppose an "old-fashioned" typological mode with a "progressive" narrative one. The popularity of allegorical and typological subject matter in diverse media at this time strongly contradicts this teleological notion.

Surely the most ambitious example of visual exegesis of the Gothic period is the *Bible moralisée*.[36] The intention of the original manuscripts' designers was to illustrate in roundels biblical texts (the number of which far exceeds previous biblical cycles), which were then paired with both a textual and pictorial exegetical gloss.[37] The result, in the case of the exemplars made in Paris in the 1230s and '40s, is a vast exegetical work that functions on both a textual and visual level. The visual system constructs exegetical meaning out of clear rhymes, correspondences, and parallels, whereas the textual glosses state their exegetical points more plainly. The designers of this vast book have created an infinitely extendable, seductive mode of visual exegesis, one that engages the eye and mind in an open-ended way. The texts inform the reader in one way, while the possibilities inherent in the visual imagery encourage a kind of engaged looking that was clearly thought to be a useful skill in thirteenth-century Paris.[38] One sees, for example, similar validations of visual interpretation in stained glass and in the great sculptural programs of the French Gothic cathedrals.

Postscript: Art and Exegesis in the Later Middle Ages

Just as in the later Middle Ages forms of monastic worship were increasingly imitated by the laity (most conspicuously in the recitation of the canonical hours), types of biblical exegesis originating and perfected in monastic circles found their way into personal devotional books. These developments were also influenced by such widely read fourteenth-century texts as the *Biblia Pauperum* and the *Speculum Humanae Salvationis*, which presented exegetical thought in a more moralizing, homiletic context than had been the case in the twelfth and thirteenth centuries.[39] An ambitious early fifteenth-century example of a devotional work flavored with exegetical imagery would be the Rohan Hours (Paris, Bibliothèque Nationale, ms. lat. 9471), in which a reduced version of a *Bible moralisée* cycle is interwoven with the more traditional imagery associated with the various hours. This means that at any given hour, the owner of the book would not only consider the imagery found at that point in the book's temporal structure, but would also be asked to consider an atemporal, typological relationship of Old and New Testaments as well. This dual activity must have considerably enriched the owner's conception of the place of his or her devotions within a much larger and quite complex Christian world-view. The presence of such an exegetical cycle in a Book of Hours confirms the general sense of intellectual innovation found in the ultra-lavish personal books of this later period, and reminds us that private "devotional" manuscripts were hardly removed from the more professional and erudite world of scriptural exegesis.

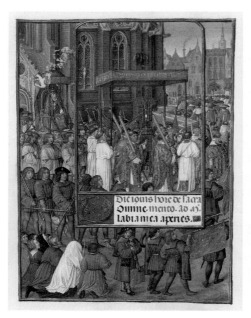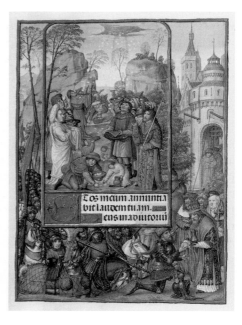

FIGURE 8-4 Spinola Hours, Eucharistic procession (*left*) and gathering of the manna (*right*), *c*.1515. Los Angeles: J. Paul Getty Museum, MS Ludwig IX 18, fol. 48v–49r. © by The J. Paul Getty Museum.

By the early sixteenth century, the combination of exegetical and devotional imagery in private devotional manuscripts reached new levels of interpretive as well as pictorial subtlety in the Low Countries. For example, the Spinola Hours (*c*.1515), features an unusually rich cycle of double-page openings for the Weekday Hours which represent cleverly paired scenes from the Old and New dispensations.[40] Two openings stand out in term of their seriousness of visual exegesis. At the Thursday Office of the Eucharist (fig. 8-4), one finds on the left a picture of a Eucharistic procession, complete with the host displayed in an elaborate monstrance, and on the right the Gathering of the Manna. The latter image is complicated by the inclusion of the meeting of Abraham and Melchisidech, from Genesis, in the border, which not only mirrors the ritual procession leading from left to right in the Eucharistic scene, but also deepens the meaning of the Exodus story in that Melchsidech is often shown in medieval art as a priest offering Abraham the host and a chalice in return for his tithe. Another opening for the Tuesday Office of the Holy Spirit compares the Pentecost to a scene of Elias calling down fire from heaven, which ignites a sacrificial offering on an altar. The link between the Old and New Testament scenes here is clear enough, but again, it is the border of the recto page that deepens the meaning of the whole. Here, we see illustrated the building of the Tower of Babel, the negative inverse of the speaking in tongues brought on by the descent of the Holy Spirit

at the Pentecost. It is also worth noting in both cases that the New Dispensation scene always appears on the left side of the opening, with the one from the Old on the right. This deliberate inversion of the scriptural commentary reflects the by now ancient belief that the relationship of Old to New is not strictly chronological, but also allegorical and timeless. It was also considered appropriate for the New, or "correct" Dispensation to be given precedence over the Old. (It should also be said that this verso/recto arrangement of images is also informed by conventions of books of hours.) Finally, while it is true that many aspects of both these complex sets of cross-readings of the Bible and Christian ritual had appeared in both earlier art and exegesis, it is only with the ingenious development of the border in later Flemish illumination as a space both complementary to and separate from the main image, that these imaginative and highly visual types of devotional exercise are made possible. This reminds us that two characteristically "medieval" endeavors – namely, interest in traditional exegetical thought and creativity in the field of book illumination – extended beyond our period and well into the Renaissance.

Notes

1 *Didascalicon*, 62–3.
2 James, "Pictor in Carmine," pp. 141–66.
3 See Zinn, "Suger, Theology"; and Rudolph, *Artistic Change*, p. 95, n.24.
4 *De Archa Noe*, p. 117. English translation taken from Hugh of St Victor, *Selected Spiritual Writings*, p. 153.
5 For a skeptical view of the picture's existence, see Evans, "Fictive Painting." A comprehensive study of Hugh's ark is being prepared by Conrad Rudolph.
6 Evans, "The *Ysagoge in Theologiam*," pp. 1–42.
7 On this window and its relationship to exegetical sources, see Grodecki, "Les Vitraux Allégoriques."
8 Didi-Huberman, *Devant L'image*, pp. 29–32.
9 The authoritative account of this method is Lubac's *Exégèse médiévale*. See also Smalley, *Study of the Bible*, pp. 1–66. It should be noted that a threefold interpretation of scripture, practiced from Origen to Hugh of St Victor, was practiced as well.
10 Quoted in Lubac, *Exégèse médiévale*, vol. I, p. 23.
11 Hoefer, *Typologie im Mittelalter*, pp. 85–6.
12 Hrabanus Maurus, *Commentaria in Genesim*, PL 107:566B–569D.
13 These thirteenth-century developments are reviewed in Smalley, *Study of the Bible*, pp. 264–355.
14 Cahier, *Monographie*, pp. 19–132.
15 Ibid., pp. 22–5.
16 Mâle, *Religious Art in France: The Thirteenth Century*, p. vi.
17 Ibid., p. 143.
18 See Panofsky, *Early Netherlandish Painting*, pp. 131–48; Marrow, "Symbol and Meaning."
19 Cassidy, *Iconography at the Crossroads*, pp. 6–7.

20 Hamburger, *St. John the Divine*, p. 1. For an extended meditation on the relationship of art to theology as a methological issue, see Hamburger's introductory essays in Bouché and Hamburg, eds., *The Mind's Eye*.

21 See Cahn, "Architecture and Exegesis," pp. 53–68.

22 Mâle, *Religious Art in France: The Twelfth Century*, pp. 155–77 and Grodecki, "Les Vitraux allégoriques."

23 Panofsky, *Abbot Suger*, pp. 1–37. Despite his use of the Panofskian label, Konrad Hoffmann, "Suger's 'Anagogisches Fenster'," clearly agrees with Grodecki's interpretation of this window.

24 Panofsky, *Abbot Suger*, pp. 58–9. Translation slightly adapted by me.

25 Hugh of St Victor's thoroughgoing revival of Augustine in the early twelfth century and Louis IX's stocking of the Ste-Chapelle in the mid-thirteenth century with works by all the early Church fathers attest to the fact that, despite new trends in biblical study in this period, the patristic writers never lost their authority.

26 Hoffmann, "Suger's 'Anagogisches Fenster'," p. 76.

27 On this conflict, see Rudolph, *Artistic Change*, pp. 8–31.

28 Jerome, *Sur Jonas*, p. 77.

29 Ibid., p. 81.

30 For illustrations of Jonah and the whale found at Psalm 68, see Haseloff, *Die Psalterillustration im 13*, tables 2 and 16; and Oliver, *Gothic Manuscript Illumination*, vol. I, pp. 69–70.

31 Warner, *Queen Mary's Psalter*, p. 26.

32 Kupfer, *Romanesque Wall Painting*, p. 127. The notion of visual exegesis is given a more theoretical treatment in Berdini, *Religious Art of Jacopo Bassano*, pp. 1–35.

33 Esmeijer, *Divina Quaternitas*, pp. 47–61.

34 For a discussion of a typological window and its connections to Mosan art, see Kline, "Typological Window," pp. 83–130. The iconography of the 12 typological choir windows at Canterbury (which are now largely lost) is reconstructed by Madeline Caviness, who also lays out the methods and topics shared among the Canterbury windows and those in France (*Early Stained Glass*, pp. 115–38).

35 For an introductory study of these windows, see Manhes and Deremble, *Le Vitrail du Bon Samaritain*.

36 [On the *Bible moralisée*, see chapter 20 by Hedeman in this volume (ed.).]

37 On the institutional and cultural background of the *Bibles moralisées*, see Hausherr, "Sensus litteralis" and "Über die Auswahl."

38 For a further discussion of this aspect of the *Bible moralisée*, see Hughes, "Typology and Its Uses."

39 See Schmidt, *Die Armenbibeln*, pp. 88–101.

40 On the manuscript in general, see Kren and McKendrick, *Illuminating the Renaissance*, pp. 414–17.

Bibliography

Paolo Berdini, *The Religious Art of Jacopo Bassano: Painting as Visual Exegesis* (Cambridge, 1997).

Anne-Marie Bouché and Jeffrey Hamburger, eds., *The Mind's Eye: Art and Theological Argument in the Middle Ages* (Princeton, 2005).

Helmut Buschhausen, *Der Verduner Altar* (Munich, 1980).

Heide and Helmut Buschhausen, "Studien zu den typologischen Kreuzen der Ile-de-France und das Maaslandes," *Die Zeit der Staufer.* 5 vols. (Stuttgart, 1977–9).

C. Cahier, *Monographie de la Cathédrale de Bourges: Vitraux du XIIIe Siècle* (Paris, 1841–4).

Walter Cahn, "Architecture and Exegesis: Richard of St. Victor's Ezechiel Commentary and Its Illustrations," *Art Bulletin* 76 (1994), pp. 53–68.

Brendan Cassidy, ed., *Iconography at the Crossroads* (Princeton, 1993).

Madeline Caviness, *The Early Stained Glass Canterbury Cathedral* (Princeton, 1977).

M. D. Chenu, *La Théologie au Douzième Siècle* (Paris, 1957).

Jean Danielou, *From Shadows to Reality: Studies in the Biblical Typology of the Fathers* (London, 1960).

Georges Didi-Huberman, *Devant l'image* (Paris, 1990).

Anna Esmeijer, *Divina Quaternitas: A Preliminary Study in the Method and Application of Visual Exegesis* (Amsterdam, 1978).

Michael Evans, "Fictive Painting in Twelfth-Century Paris," in *Sight and Insight, Essays in Honour of E. H. Gombrich on his 85th Birthday* (London, 1994), pp. 73–87.

——, "The Geometry of the Mind," *Architectural Association Quarterly* 12/4 (1980), pp. 32–55.

——, "The *Ysagoge in Theologiam* and the Commentaries attributed to Bernard Silvestris," *Journal of the Warburg and Courtauld Institutes* 54 (1991), pp. 1–42.

Louis Grodecki, *Études sur les Vitraux de Suger à Saint-Denis* (Paris, 1995).

——, "Les Vitraux allégoriques de Saint-Denis," *Art de France* 1 (1961), pp. 19–41.

Gerald Guest, *Bible Moralisée: Codex Vindobonensis 2554, Vienna Österreichische Nationalbibliothek* (London, 1995).

Jeffrey Hamburger, *St. John the Divine: The Deified Evangelist in Medieval Art and Theology* (Berkeley, 2002).

Günther Haseloff, *Die Psalterillustration im 13. Jahrhundert* (Kiel, 1938).

Reiner Hausherr, "Sensus litteralis und Sensus spiritualis in der Bible Moralisée." *Frühmittelalterliche Studien* 6 (1972), pp. 356–77.

——, "Über die Auswahl des Bibeltextes in der Bible Moralisée," *Zeitschrift für Kunstgeschichte* 51 (1988), pp. 126–46.

Hartmut Hoefer, *Typologie im Mittelalter: Zur Übertragbarkeit typologischer Interpretation auf weltliche Dichtung* (Göppingen, 1971).

Konrad Hoffmann, "Suger's 'Anagogisches Fenster' in St. Denis," *Wallraff-Richartz Jahrbuch* 30 (1968), pp. 57–88.

Hugh of St Victor, *De Archa Noe* and *Libellus de Formatione Arche*, Corpus Christianorum Continuatio Mediaevalis, vol. 176, ed. Patrice Sicard (Turnhout, 2001).

——, *Didascalicon*, ed. and trans. Jerome Taylor (New York, 1961).

——, *Selected Spiritual Writings* (London, 1962).

Christopher Hughes, "Typology and Its Uses in the *Moralized Bible*," in Anne-Marie Bouché and Jeffrey Hamburger, eds., *The Mind's Eye: Art and Theological Argument in the Middle Ages* (Princeton, 2005).

——, "Visual Typology: An Ottonian Example," *Word and Image* 17 (September 2001), pp. 185–98.

M. R. James, "Pictor in Carmine," *Archeologia* 94 (1951), pp. 141–66.

Jerome, *Sur Jonas*, ed. and trans. Paul Antin (Paris, 1956).

Wolfgang Kemp, *The Narratives of Gothic Stained Glass* (Cambridge, 1997).

Naomi Reed Kline, "The Typological Window of Orbais L'Abbaye: The Context of Its Iconography," *Studies in Iconography* 14 (1995), pp. 83–130.

Thomas Kren and Scot McKendrick, *Illuminating the Renaissance: The Triumph of Flemish Manuscript Painting in Europe* (Los Angeles, 2003).

Annette Krüger and Gabriele Runge, "Lifting the Veil: Two Typological Diagrams in the Hortus Deliciarum," *Journal of the Warburg and Courtauld Institutes* 60 (1997), pp. 1–22.

Marcia Kupfer, *Romanesque Wall Painting in Central France: The Politics of Narrative* (New Haven, 1993).

John Lowden, *The Making of the* Bibles Moralisées (University Park, Penn., 2000).

Henri de Lubac, *Éxégèse Médiévale: Les Quatre Sens de L'Écriture*, 2 vols. (Paris, 1959–61).

——, "Typologie et Allégorisme." *Recherches de Science Réligieuse* 34 (1947), pp. 180–226.

Émile Mâle, *Religious Art in France: The Twelfth Century* (Princeton, 1978).

——, *Religious Art in France: The Thirteenth Century* (Princeton, 1984).

Colette Manhes and Jean-Paul Deremble, *Le Vitrail du Bon Samaritain: Chartres, Sens, Bourges* (Paris, 1986).

Colette Manhes-Deremble, *Les Vitraux Narratifs de la Cathédrale de Chartres* (Paris, 1993).

James Marrow, "Symbol and Meaning in Northern European Art of the Late Middle Ages and the Early Renaissance," *Simiolus* 16 (1986), pp. 150–69.

Judith Oliver, *Gothic Manuscript Illumination in the Diocese of Liège, c.1250–c.1330* (Leuven, 1988).

Erwin Panofsky, ed. *Abbot Suger on the Abbey Church of St-Denis and its Art Treasures.* 2nd edn. (Princeton, 1979).

——, *Early Netherlandish Painting: Its Origins and Character* (Cambridge, Mass., 1953).

Conrad Rudolph, *Artistic Change at St-Denis: Abbot Suger's Program and the Early Twelfth Century Controversy over Art* (Princeton, 1990).

Gerhard Schmidt, *Die Armenbibeln des XIV. Jahrhunderts* (Graz/Cologne, 1959).

Beryl Smalley, *The Study of the Bible in the Middle Ages* (Oxford, 1952).

Neil Stratford, "Three English Romanesque Enamelled Ciboria," *Burlington Magazine* 126 (April 1984), pp. 204–16.

George Warner, *Queen Mary's Psalter* (London, 1912).

O. K. Werckmeister, "The Lintel Fragment Representing Eve from Saint-Lazare, Autun." *Journal of the Warburg and Courtauld Institutes* 35 (1972), pp. 1–30.

Grover A. Zinn, "Suger, Theology, and the Dionysian Tradition," in Paula L. Gerson, ed., *Abbot Suger and Saint-Denis* (New York, 1986), pp. 33–40.

Whodunnit? Patronage, the Canon, and the Problematics of Agency in Romanesque and Gothic Art

Jill Caskey

Studies of patronage occupy a critical niche in the history of medieval art, since they function as alternatives to the formalist and iconographic interpretations that have shaped the discipline for over a century. But like so many other approaches to art history, they also derive from dominant paradigms and the field's ever-changing methodological priorities. Patrons and their monuments were often integrated into the evolutionary model of art history around 1900, for instance.[1] Similarly, an emphasis on the spending habits of powerful men followed the lead of Renaissance scholarship shaped by Vasari and Burckhardt.[2] Since the 1970s, scholars have been seeking to identify a greater variety of patron groups and reconstruct more specific connections between works of art and the intentions, ideologies, demands, and desires of the individuals who paid for them or were their primary users.[3]

Given these contextual concerns, patronage studies have often coincided with the aims of the so-called Social History of Art.[4] But while that movement has seen its ups and downs, the subject of patronage never disappeared from studies of medieval art. This staying power derives in part from the impact of the Annales School and the long-standing interdisciplinarity of scholarship on the Middle Ages. Recently, studies of patronage have characterized art as constitutive of social, political, economic, and other ideas; they have engaged a host of

disciplines (such as literary, religious, gender, and other histories), and with them, attendant subject formations, foundational texts, and theoretical models.

Despite the recent flourishing of patronage studies, there have been few attempts to discuss the theme broadly. The largest obstacle to such a project is the sheer variety of contexts, types of patronal involvement, and artworks found during the Middle Ages. An overview of reference materials suggests that the specialization of academic discourse also has hampered such efforts. Whereas the *Encyclopedia of World Art* (1966) featured a synthesizing entry on patronage in Western art,[5] the most recent reference work of that genre, the Grove *Dictionary of Art* (1996), does not. Only a handful of topics explored in its "Romanesque" and "Gothic" entries deal expressly with patronage issues.[6] A rare attempt to generalize about medieval patronage is Brenk's short essay in the *Enciclopedia dell'arte medievale* (1994).[7] Beyond such reference works, some focused studies contain in-depth examinations of patterns and types of patronage.[8] But none offers as highly developed a model for understanding the phenomenon as early modern settings have inspired for decades.[9]

Still, this subfield has coalesced in the postwar era around salient themes. The principal loci of patronage examined in the literature are the primary institutions on which medieval society was constructed – court, cathedral, and monastery – many of which established their own aesthetic conventions. Within and outside of these contexts, patronal categories have multiplied. Queens are differentiated from kings, as are canons from bishops, and the impact of the laity has come to the fore. The taste and intentions of each group are seen as contingent upon many internal and external factors.

Despite this trend toward fragmentation and its result, our greater awareness of the variety of contemporaneous art forms, dominant narratives of medieval art still emphasize eschatological meanings. This structure makes sense for obvious reasons, but it comes at a price. Things outside that framework, such as secular monuments, continue to occupy the margins of the discipline, despite our increasingly liberal definitions of material and visual cultures.[10]

This chapter probes these and other problems relating to patronage, artistic production, and agency in the later Middle Ages. It begins by discussing some of the major themes that emerged at St Denis and their implications for how art history has been written. It then investigates debates surrounding artistic patronage, including the problem of agency, sites of patronage, and motivations for it. First, however, a caveat: this historiographical journey takes its cue from generations of art historians, and, like them, concentrates on elite patrons of religious art. An accompanying bibliography invites wider views of the subject, although it, too, is far from comprehensive.

Shaping the Canon: Suger and St Denis

When the glorious and famous King of the Franks, Dagobert, notable for his royal magnanimity in the administration of his kingdom and yet no less devoted to the

church of God . . . had learned that the venerable images of the Holy Martyrs who rested there [at St Denis] – appearing to him as very beautiful men clad in snow-white garments – requested his service and unhesitatingly promised him their aid with words and deeds, he decreed with admirable affection that a basilica of the Saints be built with regal magnificence.[11]

The abbey of St Denis constitutes a critical juncture between Romanesque and Gothic in narratives of medieval art, a pivotal moment illuminated by Suger's writings. In this passage from *De consecratione*, Suger (d.1151) summarized paradigms of artistic patronage operative in the later Middle Ages. He also suggested the ideologies and conventions that had long sustained such paradigms and would continue to do so well into the fourteenth century. As such, the passage articulates many of the themes that have shaped our understanding of patronal motives in medieval art and the priorities of art historians.

First and foremost, this account characterizes the Merovingian king Dagobert (d.639) as a pious and generous sovereign. This is a familiar trope; the principal motives behind royal and lay patronage generally claim to derive from Christian ideals, in which almsgiving, donations of all types (money, materials, land), and endowments of liturgical celebrations were perceived as fundamental duties of the faithful. For the wealthiest members of medieval society, these pious expressions and largesse on a grander scale (such as the foundation of monasteries) articulated one's social station in life. But they were also essential responsibilities of that social station.[12] Here, then, patronage is naturalized as an attribute of a Christian king. Suger, in citing Dagobert's prestigious name, also strove to codify and reinforce the tradition of royal support of the abbey.

Using a variety of strategies and motifs, including the convention of visionary experience, Suger's passage establishes the intimacy between royal patrons and large-scale building projects. Imperial or royal commissions shape most narratives of medieval art, from Old St Peter's in Rome to the Chartreuse de Champmol outside Dijon. This is not surprising, since so many extant medieval monuments derive from royal patronage, due to the concentration of human, economic, and material resources in the hands of monarchs. Royal settings are also better preserved and documented than more humble ones, thereby creating a wider interpretive framework for analysis. But the contours of the canon also reflect attitudes regarding originality and quality. Interpretations of medieval art tend to begin with the assumption that taste and related cultural practices were established at the pinnacle of society and inevitably trickled down to its more humble sectors. Works of *munificentia* are often assumed to derive from regal settings, and royal art is equated with quality. Given such historical and historiographical factors, it is not surprising that royal contexts have dominated patronage studies.

Although Suger and St Denis introduce many of the major themes in the literature, Suger's precise role in artistic production remains a matter of debate. As a reasonably learned man in charge of an important monastic center, was he well enough versed in theological matters to invent iconographic programs?

Were more accomplished theologians working for him, and if so, who were they? Was he responsible for locating and hiring the diverse teams of artists and builders on the site and supervising their activities? Or was he merely empowered as the holder of the purse (and pen)?[13]

Scholars have addressed such questions since Panofsky's work on Suger appeared in 1946. His interpretation of the abbot as an erudite philosopher well versed in Pseudo-Dionysian theology, as well as von Simson's vision of Suger as all-encompassing intellect behind the building campaign, have been questioned and revised.[14] The abbot's indebtedness to Augustine and Hugh of St Victor has come to the fore, as have more nuanced views of the reception of Cistercian ideology in mainstream Benedictine settings.[15] But while some consensus has emerged concerning Suger's circumscribed role as guiding intellect in the reconstruction of St Denis, basic questions concerning the dynamics of patronage and production there remain unanswered.

As such, the abbey is representative of many key Romanesque and Gothic monuments in which the nature of a patron's participation is unclear. For more than a quarter of a century, conceptualizations of what could be called the patronal field have expanded to help address this problem of agency. Scholars have come to emphasize that the individuals or institutions traditionally seen as great patrons – Bernward of Hildesheim, Louis IX, the mendicant orders, and so on – acted within a cultural fabric into which myriad threads were woven. Theoretical or multidisciplinary perspectives have provided critical tools for reconstructing and assessing this enlarged patronal field.

Agency and Patronage

The question of agency lies at the heart of patronage studies. Whose actions had the greatest impact on the appearance of a work of art? Who could claim credit, particularly for a large-scale project? Efforts to characterize agency have taken many forms. Marxist concerns with who controls the means of production and thereby determines whether or not a work is made seem straightforward enough. But such conditions are difficult to reconstruct. As Caviness notes regarding the Shaftesbury Psalter (*c*.1130–40), the image of a woman praying below Christ in Majesty should not be identified as the patron until the genesis of this manuscript is better understood.[16] If the woman received the book as a gift, then our interpretive strategies must change (see below). And given the large scale and long gestation of so many medieval projects, rarely could a single person act as what Warnke has called a superpatron.[17]

Brenk avoids rigid paradigms by differentiating between the "patron-*concepteur*" as overriding intellect/manager, and donor as financial contributor (likely one of many for large-scale projects).[18] This distinction is critical for creating more nuanced assessments of agency, but it can underestimate the impact of "mere" donors. Modest gifts of land to monasteries were common following the rise of

feudal elites in the Romanesque period. Tracing the patterns of such donations and their impact on monastic coffers can illuminate the formation of local religious allegiances,[19] as well as the chronology of building campaigns.[20] Such gifts also facilitated the expansion of libraries and treasuries.[21] Donors often had little control over how their contributions were utilized, but many institutions depended on them to advance their artistic agendas.

One problem lurking behind discussions of art and agency concerns terminology. Whereas scholars tend to utilize "patron" or "donor" to characterize initiators of art-making, this practice corresponds neither to the complex circumstances of production in the Middle Ages, nor to medieval usage. Records and inscriptions instead tend to express the role of the patron in verbs. Suger, for instance, characterized his role – and Dagobert's – through a series of actions: "we undertook to renew," "we caused to be composed," "he decreed," and so on.[22] Similarly, the foundation charter for Notre-Dame at Ecouis (c.1310), written by Philip the Fair's Superintendent of Finances Enguerran de Marigny, expresses Enguerran's patronage as a series of differentiated acts: "I . . . do establish, found, and endow," "I grant and give," "I establish and ordain," "I institute," and so forth, as he touches upon all matters regarding the creation and ongoing liturgical and financial operations of his collegiate church in Normandy.[23] Inscriptions on works of art show comparable patterns.[24] These representative samples suggest that medieval sources yield more complexity and often less certainty regarding matters of agency than our habitual use of the monolithic term "patron" might imply.

Patron, Artist, and Agency

In discussions of objects large and small, much of the scholarly literature modulates between empowering the patron or the artist. At stake is the division of labor, which was traditionally perceived as the patron's jurisdiction over subject and the artist's over form.[25] This dynamic is often observed through the lens of historiographic debates and contemporary intellectual concerns. Panofsky's portrait of Suger as theorist has been seen as a challenge to Viollet-le-Duc's emphasis on Gothic as structure,[26] and investigations into artistic freedom flourished around World War II.[27] Assessments of the individuality of artists are again coming to the fore,[28] in tandem with our attempts to understand the meaning of authorship and ownership in a digital culture.

The question of agency in monastic art production is particularly fraught. Long-held views fueled by critiques of industrialization held that monks labored selflessly in closed environments to create buildings and objects for their own use.[29] Distinctions between patron, artist, and user collapse, thereby upholding the Marxist ideal that monks were not alienated from their work.

Early Cistercian regulations seemingly corroborate this view, since they specify that communities be established far from existing human settlements. But since

the publication of Mortet's *Recueil de textes* (1911), scholars have come to emphasize that the monks could not realize their spiritual agenda without involving the secular in their artistic endeavors.[30] An account of the construction of Clairvaux II (*c*.1133–45) narrates that, "The bishops of the region, noblemen, and merchants of the land heard of it, and joyfully offered rich aid in God's work. Supplies were abundant, workmen quickly hired, the brothers themselves joined in the work in every way."[31] Studies of Cistercian expansion in England and Germany have stressed similar lay/monastic interplay.[32] Despite the involvement of lay donors and builders, the order was still able to maintain stylistic consistency and austerity, due to the cooperation of monks, lay brothers (*conversi*), and professional artisans, as well as frequent communication between parent houses and new ones.[33]

Later contexts illuminate these dynamics. A contract of 1398 for a dormitory at Durham clarifies that the prior and convent established the parameters of the project, including window locations, variations in masonry, and the form of a tower; the master mason offered solutions to those needs.[34] Monastic patrons should be given credit, Shelby argues, for urging lay masons "onward by setting more and more difficult tasks."[35] The discussions of specialized branches of knowledge (structural, financial, liturgical, aesthetic, etc.) that ensued in such circumstances have been seen as a critical moment in intellectual history.[36]

The nineteenth-century elision of monastic artist and patron has reemerged in studies of religious women, albeit from a feminist perspective. For some time, abbesses and nuns have been appreciated as sophisticated patrons and users rather than creators of art.[37] Recent debates over Hildegard of Bingen's role in the creation of the Rupertsberg *Scivias* (*c*.1165) provide another perspective. It has been suggested that the idiosyncratic style of the now-lost manuscript complements Hildegard's textual descriptions of visions and must be attributed to her own hand.[38] Any attribution of this sort is fraught, since the manuscript is known only through copies made between 1927 and 1933. But codifying Hildegard's artistic agency not only would establish the significance of the abbess in a new realm of activity – in painting, versus music, theology, medicine, and administration, her other areas of expertise; it would also expand our knowledge of women artists in Romanesque monasticism. As such, the production of the *Scivias* possibly anticipates women's artistic experiences at St Walburg in Eichstätt around 1500 as reconstructed by Hamburger.[39]

Hierarchies of Agency, Webs of Production

Studies since the 1970s have rendered the issue of agency more complex by emphasizing the webs of interaction that led to the creation of medieval art. Considering the social and political overtones of the word "patronage" helps reconceptualize the dynamics of artistic production.[40] The relationship between

patron and artist was not asymmetrical, oppositional, and merely economic, but also potentially about both participants gaining distinction, access to other artists/patrons, intellectual camaraderie, and so on.[41] Furthermore, this model expands the artist/patron binary to incorporate third parties, such as theological advisors working in courts, cathedrals, and monasteries.

A folio from the Toledo *Bible moralisée* idealizes this hierarchical model of patronage and production (fig. 9-1). In this work of *c*.1234–5, Blanche of Castile and Louis IX are enthroned in an arcade above two figures. Blanche's demonstrative, open-handed gesture toward her more passive son suggests her control over the project.[42] Below her, a theological advisor looks down at his book and points toward the figure on the right; he is clearly dictating the manuscript's complex typological and exegetical principles. Lowden has identified the figure on the lower left as a secular ecclesiastic and the lower right a lay artist, who is creating the manuscript's circular underdrawings.

These two figures must be understood as generalizations, since so many people were involved in the creation of these densely illustrated works.[43] The hieratic image also suggests that Blanche's commanding presence was somewhat abstract during the making of the book. As such, the circumstances of production differed from some outside royal settings. As Stones recently construed, the many additions made to the Book of Madame Marie indicate that its patron (Marie de Rethel? d.1315) and her Franciscan advisor consulted with the illuminators while the book was in process and likely convinced them to make changes.[44] This difference in production also signals difference in type: whereas a variety of complex intellectual formulations informed the *Bibles moralisées*, mendicant-inflected prayer books emphasized emotional connections with Mary and Christ.[45]

The literature on Gothic cathedrals explores tensions between the intellect(s) who developed thematic programs and the donors/patrons who contributed to the church fabric.[46] In contrast to monasteries, cathedrals are often characterized as urban monuments in which lay participation was prominent. This view derives in part from the "cult of carts," which held that all members of Christian society were moved by their faith to perform hard labor on cathedral construction sites.[47] There are some examples of unity and participation, as at Amiens in the 1220s and '30s.[48] But scholars have questioned how such participation unfolded, given the centralization of power in the hands of the bishop and the small scale of lay commissions (stained glass, wall paintings, side chapels, etc.).

Recent studies have disentangled these threads of agency by examining episcopal hierarchies. Bishops tended to initiate and manage building campaigns (they also contributed significant amounts of their personal wealth to the projects), while canons engaged in small fund-raising activities and supervised the flow of building materials, money, and labor through the vestry or *fabbrica*.[49] But given the number of participants involved, how did Great Churches achieve the coherence of the sort described by iconographers like Mâle and von Simson? What choices did patrons of lesser stature than, say, kings, bishops, or deacons have in

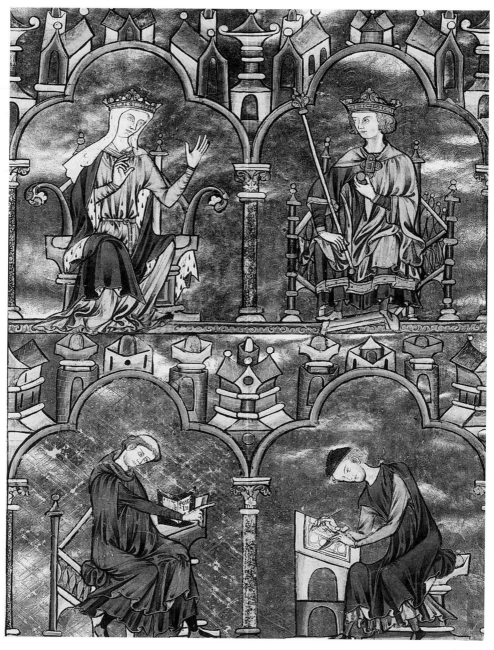

FigURE 9-1 Hierarchies of agency as represented in the creation of the Toledo *Bible moralisée*. New York: The Pierpont Morgan Library, MS 240, fol. 8r.

shaping their commissions? The windows at Chartres illuminate the problematics of agency in episcopal settings after 1200.

Representations of artisans plying their trades and knights on horseback bedecked with armor and heraldry have prompted the windows to be interpreted as "donor portraits" that commemorate diverse contributors to the building campaign. Questions about who developed such imagery and why have fueled considerable debate.[50] Mahnes-Deremble has argued convincingly that the chapter itself determined the content of the windows, which articulate the church's view of proper modes of royal and lay behavior. Iconographic choice, then, rested in the hands of the chapter, rather than in those of financial contributors.

Gifts and Patronal Identity Politics

Questions of agency increase in complexity in the widespread practice of gifting, a problem that scholars have addressed in creative ways. As Camille points out, gifts are ambiguous, as they range from concretizations of a giver's desires, idealizations, and assumptions to reasonable fulfillments of the needs, taste, or wishes of the recipient.[51] They also act as abstract currency, imposing a debt of a political, economic, or other sort on the recipient, and as a means of cultural-artistic transmission.[52]

Consequently, the "first owners" of objects must not be construed automatically as patrons. Extensive notations in a Bible in Troyes indicate that the manuscript belonged to St Bernard. But it is full of color, gold, and grotesques, the very features he railed against in monastic settings. Cahn has hypothesized that the book was a gift to Bernard and the product of a lay atelier – hence its deviations from his ascetic ideals.[53]

Caviness has argued that works of art given to women must be scrutinized to determine "whether their messages were encoded for, by, or 'against'" their recipient.[54] Her feminist inquiry illuminates canonical works of art, the St Albans Psalter and the Hours of Jeanne d'Evreux, which previously had been discussed primarily in iconographic and stylistic terms.[55] She argues that the psalter (c.1120–30) was made with the precise needs of Christina of Markyate in mind, whether for her or for the monk Roger, who perhaps used it for her spiritual instruction. Carrasco's work corroborates this view by demonstrating that the psalter's representations of the Magdalen typified new interpretations of the sinner-saint as a penitential paradigm for women.[56] Hence the appropriateness of such imagery for and "pro" Christina. In contrast, Caviness argues that much of the imagery in the Hours of Jeanne d'Evreux (c.1324) works "against" the young queen, as its ribald marginalia caters less to her spiritual interests than to the desire of her new husband to shape her views of marriage, sexuality, and reproduction.[57] This famous book may bear the name of Jeanne, but its texts and images divulge the agency and agenda of Charles IV.

Representing Agency: Donor Imagery

Images of patrons/donors on many late medieval works of art assert ownership of or affiliation with the object in question, regardless of the complexity of its production process. Studies of this feature of patronage illustrate the discipline's movement away from Vasarian paradigms. Classic investigations of donor imagery sought to identify patrons and relate them iconographically to Early Christian or imperial prototypes, in which patrons generally offer a model of the commissioned work to holy figures or kneel before them.[58] In contrast, recent work highlights the semiotics of such scenes. Some studies focus on manipulations of hierarchy in presentational imagery; others examine how donor images structure or represent visionary experience.[59] Still other scholars have emphasized the salvational dynamics of such imagery or considered a wider range of patron groups.

Studies of the tympanum of Mervilliers (first half of the twelfth century) reveal the web of financial and spiritual relationships generated around patronage.[60] Replacing the holy figures usually displayed on tympana, here a knight offers a gift to St George; an inscription states that "Rembald, the knight . . . conferred on me [St George] present treasures in order to have [treasures] without end."[61] Although rarely represented in this literal way, such contractual arrangements multiplied after the codification of the doctrine of Purgatory (1215).[62]

Within this salvational matrix, burials and family chapels of the late thirteenth and fourteenth centuries often included effigies, personalized inscriptions, and heraldry in order to clarify for whom surviving family members, the religious, and faithful should pray. Morganstern has shown that some Gothic tombs conveyed legal meaning, as their figural displays of lineage provided focal points for future generations of liturgical caretakers.[63] The new and increasingly elaborate visual language of heraldry articulated this literal type of lineage, while also displaying webs of political affiliation and projecting social status. And as Michael has demonstrated, the proximity of shield to images of holy figures articulated connections between the patron and his or her heavenly intercessors, thereby expediting the process of salvation.[64]

Motivating Patronal Agency: Power and Family

Royal initiatives began to dominate patronage studies in the first half of the last century, as the foundational works of Schramm, Kantorowicz, and others on the iconography of power indicate.[65] Now, however, authority is no longer seen in purely iconographic terms; the semantic field has expanded to include styles, references, monument types, materials, and motifs. Furthermore, newly accessible settings in Central and Eastern Europe have expanded the canon beyond its narrow postwar boundaries, as have studies of East–West relations.[66] Interpretive

models informed by literary criticism, cultural studies, and feminism cluster alongside ones of traditional but interdisciplinary derivation.

Take the case of St Louis. Whereas Branner's influential study argued that the modern style and luxuriousness of the Sainte-Chapelle were de facto royal characteristics and thus emulated beyond the Île-de-France, later studies have sought to understand the wider circumstances and abstract references embedded in the royal foundation which legitimate the sacral foundations of Capetian kingship.[67] For instance, Weiss emphasizes the chapel's evocations of the Holy Land, which were intended to frame its relics of the Passion and promote conceptions of Louis IX as anointed ruler of a new Chosen Land.[68] Jordan's study of narrativity in the chapel's stained glass links the windows to contemporary Parisian literary circles and the *ars poetriae*.[69]

Although these studies take different paths, they magnify the underpinnings of French regal authority as articulated visually through "ideological, material, and formal integration," as Brenk observed.[70] As such, the Sainte-Chapelle can be seen as overlapping with other areas of Capetian patronage: the *Bibles moralisées*, *Grandes Chroniques*, new tombs at St Denis, and so on.[71] Thematic and iconographic consistency possibly derived from the involvement of the king, as Jordan hypothesized for the Sainte-Chapelle; but it also speaks to the vast resources that the Capetians channeled into artistic production and the resulting ability to complete projects quickly – and under the aegis of a few advisors, say, rather than generations of them. It is vexing that the advisors who shaped such multilayered, propagandistic representations often remain unknown.[72]

Studies of power patronage in Germany and England have uncovered other dynamics at play. Rather than asserting authority through sumptuousness or modern visual and literary idioms, the Landgrave Hermann of Thuringia (d.1217) utilized imposing, imperial design elements for his palaces.[73] Meanwhile, Binski has emphasized the appropriational character of Plantagenet art, which drew from a wide range of sources and ideologies and recontextualized them for home consumption.[74]

Scholarship on royal and other women moves away from power paradigms. While women commissioned innovative and large-scale projects (i.e., Blanche of Castile's *Bibles moralisées* and Cistercian monasteries),[75] recent studies have reconstructed more subtle activities, including how women fueled private piety and its attendant material culture, and transmitted cultural-artistic practices from their places of birth to where they spent their adult lives.[76]

Women commissioned small projects, such as prayer books and liturgical objects used in private chapels, because they were in charge of the "spiritual and moral welfare of their families," as Gee has emphasized.[77] English women often conferred with mendicant confessors while creating religious environments appropriate to the home. Works of art such as the Clare Chasuble (after 1270), attributed on the basis of heraldry to the patronage of Margaret de Clare,[78] demonstrate the potential richness of such environments. Others, such as the de Brailes Hours (*c.*1240), define new types of objects that historians have come to associate with women's spirituality.[79]

Conclusions

As with other branches of art history, studies of patronage have followed the trajectories of the discipline as a whole. Supplementing strictly formalist or iconographic interpretations, foundational scholars such as Meiss and Branner tended to focus on elite, male patrons and the artworks associated with them. In the last 30 or more years, research has encompassed more diverse patron groups, including the laity and women of varied status.

This new inclusiveness is but one feature of the widening patronal field. Scholars have also examined mechanisms of art production and negotiations of agency within complex economic, social, intellectual, and theological systems. Motives for patronage likewise have come to the fore with greater specificity; scholars have endeavored to reconstruct the personal or cultural circumstances which fueled patronage, rather than simply characterizing the resulting art as generic expressions of concern with the afterlife. Similarly, others have emphasized the motives, means, and impact of recontextualizing pre-existing works or artistic conventions, and helped define patronage as an act of consumption as well as production. Feminism, Marxism, and other theoretical models of contemporary resonance have fueled these processes, as have creative perspectives drawn from a variety of historical disciplines. Through various means, then, patronage studies have consistently evaluated the myriad functions and roles of art, and in so doing challenged canonical views of both medieval art and society.

Notes

Many thanks to Adam Cohen, who read an earlier draft of this essay, and to the Social Science and Humanities Research Council of Canada, which supported aspects of this project.

1 E.g., the stylistic precocity of the Normans. Bilson, "The Beginnings of Gothic Architecture in England," pp. 259–69 and 289–326; Bony, "La Technique normande," pp. 153–88.
2 For example, Meiss, *French Painting*.
3 Macready and Thompson, eds., *Art and Patronage*; Camille, "For Our Devotion and Pleasure."
4 Foundational studies: see Burckhardt, *Kultur der Renaissance*; Antal, *Florentine Painting*; Hauser, *Social History of Art*. Critical fortunes of Hauser and movement: see Jonathan Harris, "General Introduction," pp. xv–xxx.
5 Haskell, "Patronage."
6 See D. Park on Romanesque wall painting (vol. 26, p. 656); C. M. Kauffmann on Romanesque manuscripts (vol. 26, pp. 659–60); P. Binski on Gothic painting (vol. 13, pp. 127–8), and D. Sandron on Gothic sculpture (vol. 13, pp. 76–7). See also Turner, ed., *Dictionary of Art*.

7 Brenk, "Committenza."

8 E.g., studies by Bell, Bergmann, Binski, Caviness, Gee, and McCash (cited below).

9 For example, Haskell, *Patrons and Painters.*

10 Notable exceptions: Hindman, *Sealed in Parchment*; Fernie, *Architecture of Norman England*, ch. 3.

11 Suger, *Abbot Suger on the Abbey Church*, pp. 86–7.

12 Duby, *Early Growth*, pp. 48–57, and "Culture of the Knightly Class."

13 For Suger as guiding force, see Gerson, "Suger as Iconographer," in Gerson, ed., *Abbot Suger and Saint-Denis*, pp. 183–95; versus Skubiszewski, "L'Intellectuel et l'artiste" and Rudolph, *Artistic Change*. For the middle ground, see Grant, *Abbot Suger.*

14 Kidson, "Panofsky, Suger." Also see Grodecki, "Les Vitraux allégoriques"; Rudolph, *Artistic Change*; and von Simson, *The Gothic Cathedral*, ch. 4.

15 Rudolph, *Artistic Change*; Grant, *Abbot Suger.*

16 Caviness, "Anchoress, Abbess, and Queen," p. 113; also p. 107. British Library, Lansdowne Ms 383, fol. 14v.

17 Warnke, *Bau und Überbau*, p. 58.

18 Brenk, "Committenza"; see also Bergmann, "Prior Omnibus Autor."

19 Bouchard, "Knights."

20 E.g., Carlson, "A Charter for Saint-Etienne," pp. 11–14; Hill, "Lay Patronage and Monastic Architecture."

21 Cahn, "*Rule* and the Book."

22 Suger, *Abbot Suger*, pp. 66–7, 76–7, 86–7.

23 Gillerman, *Enguerran de Marigny*, Appendix A.

24 E.g., Herimann Cross (1056) from Werden, inscribed "Herimann Archiep(iscopu)s me fieri iussit" – versus artists' signatures, "Eilbertus coloniensis me fecit" on a portable altar in the Guelph treasury (*c*.1150).

25 For historiographic analysis, see Cahn, "Artist as Outlaw"; see also Kessler, "On the State of Medieval Art History." See an extension of this idea in Henning, "Patronage and Style in the Arts."

26 Kidson, "Panofsky, Suger, and St. Denis."

27 Key studies are discussed in Gilbert, "Statement of Aesthetic Attitude." See also note 25.

28 E.g., articles in *Gesta* 41 (2002), ed. Sherry Lindquist and Stephen Perkinson.

29 Montalembert, *Les Moines d'occident*; Morris, "Art and Socialism"; foundations are in Bizzarro, *Romanesque Architectural Criticism*, p. 130. For early revisions, see Mortet, *Recueil de textes*; Swarthout, *Monastic Craftsman.*

30 Fergusson, *Architecture of Solitude*, ch. 1; other works cited below.

31 *S. Bernardi vita prima* quoted/translated in Brooke, "St Bernard," p. 21.

32 See Brooke, "St Bernard"; Burton, "Foundation of the British Cistercian Houses"; Davis, "The Choir of the Abbey of Altenberg."

33 Brooke, "St Bernard"; Hill, "Lay Patronage." [On the question of Cistercian stylistic consistency, see chapter 27 by Fergusson in this volume (ed.).]

34 Shelby, "Monastic Patrons."

35 Ibid., p. 95.

36 Price, "Effect of Patronage."

37 E.g., Cohen, *The Uta Codex*. Also Hamburger, "Introduction," in his *Visual and the Visionary.*

38 Caviness, "Hildegard as Designer." Also see Caviness, "Hildegard of Bingen."

39 Hamburger, *Nuns as Artists*. [For more on Hildegard of Bingen, see chapter 6 by Kurmann-Schwarz in this volume (ed.).]

40 Cooper, "*Mecenatismo* or *Clientelismo*?"

41 Martindale, *Rise of the Artist;* Warnke, *Hofkünstler;* Chartier, *Forms and Meanings*.

42 Lowden sees the gesture as conveying her political stature during the regency. On her patronage of the earliest *Bibles moralisées*, see Lowden, *Making of the Bibles moralisées*.

43 Ibid., p. 130.

44 Stones, *Le Livre d'images*, pp. 36–8.

45 [For more on the *Bibles moralisées*, see chapter 20 by Hedeman in this volume (ed.).]

46 [On the Gothic cathedral, see chapter 18 by Murray in this volume (ed.).]

47 Noted in the twelfth century around repairs at the Cathedral of Chartres; introduced a utopian ideal celebrated by Romanticist writers and proponents of Gothic Revival such as Pugin, Viollet-le-Duc, and Henry Adams. Documents translated in Frisch, *Gothic Art*, pp. 23–30. For a Marxist critique of the consensual model, see Abou-El-Haj, "Urban Setting." Also see Kraus, *Gold was the Mortar*.

48 Kraus, *Gold was the Mortar*, ch. 2; Kimpel and Suckale, *Gotische Architektur*, ch. 1.

49 Erlande-Brandenburg, *The Cathedral*, ch. 5; also, Kurmann-Schwarz, "Récits, programme," p. 67.

50 E.g., Brenk, "Bildprogrammatik"; Williams, *Bread, Wine, and Money;* Kemp, *Sermo corporeus;* Mahnes-Deremble, *Vitraux narratifs*. For a critique, see Kurmann-Schwarz, "Récits, programme"

51 Camille, *Medieval Art of Love*, ch. 2.

52 Mauss, *The Gift*; Bell, "Medieval Women Book Owners;" von Euw and Schreiner, eds., *Kaiserin Theophanu*.

53 Troyes, Bibl. Mun. Ms. 458. Cahn, *Romanesque Bible Illumination*, p. 234; see also Cahn, "*Rule* and the Book," esp. Appendix of donors.

54 Caviness, "Anchoress, Abbess, and Queen," p. 108.

55 Hildesheim, St Godehard; and New York, Cloisters 54.1.2. See classic studies of Pächt et al., *The Saint Albans Psalter*, and Mâle, *L'art religieux*, pp. 3–13.

56 Carrasco, "Imagery of the Magdalen." [For more on Christina of Markyate, see chapter 6 by Kurmann-Schwarz in this volume (ed.).]

57 Caviness, "Patron or Matron?" Holladay's "Education of Jeanne d'Evreux" sees a different instructional function; the Hours of St Louis provides behavioral role models for Jeanne.

58 For example, Prochno, *Schreiber- und Dedikationsbild*; Ladner, *Papstbildnisse*.

59 E.g., Buettner, "Profane Illustrations," p. 78; Gee, *Women, Art*, p. 46 and fig. 5.

60 Maines, "Good Works"; and Skubiszewski, "L'Intellectuel et l'artiste."

61 Transcription/translation in Maines, "Good Works," pp. 82–3; p. 91, n.64.

62 Le Goff, *La Naissance*.

63 Morganstern, *Gothic Tombs*; for an overview of the literature on tombs, see Holladay, "Tombs and Memory."

64 Michael, "Privilege of 'Proximity'."

65 Schramm, *Herrschaftszeichen*; Kantorowicz, *The King's Two Bodies*. For National Socialist problems, see Cantor, *Inventing the Middle Ages*, ch. 3.

66 Crossley, "Architecture of Queenship." Also see Rosario, *Art and Propaganda*; Lillich, "Gifts of the Lords of Brienne."

67 Branner, *St. Louis and the Court Style*. Significant critiques of Branner's "court style" include Colvin, "'Court Style' in Medieval English Architecture;" Bruzelius, *Thirteenth-Century Church*, ch. 7; and most forcefully, Binski, *Westminster Abbey*. For diverse takes on his legacy, see *Gesta* 39 (2000), ed. Paula Gerson and Stephen Murray.

68 Weiss, *Art and Crusade*.

69 Jordan, *Visualizing Kingship*.

70 Brenk, "Sainte-Chapelle," p. 196.

71 Erlande-Brandenburg, *Le Roi est mort*, III.2, and Wright, "Royal Tomb Program"; Hedeman, *The Royal Image*; Lowden, *Making of the Bibles Moralisées*.

72 Similar observations in Rosario, *Art and Propaganda*.

73 Holladay, "Hermann of Thuringia."

74 Binski, *Westminster Abbey*. Draws upon foundations as diverse as Elias's theories of civilizing influences and contemporary consumption theory.

75 See Gajewski-Kennedy, "Recherches sur l'architecture," and Kimpel and Suckale, *Gotische Architektur*, pp. 382–3, on Blanche's architectural innovations; versus Branner, *St Louis*. For the manuscripts, see Lowden, *Making of the Bibles Moralisées*.

76 See Bell, "Medieval Women Book Owners," for comparable arguments regarding manuscripts.

77 Gee, *Women, Art*, p. 39.

78 Ibid., p. 66.

79 British Library Ms Add. 49999. Donovan, *De Brailes Hours*; Gee, *Women, Art*, ch. 3; Hamburger, "Before the Book of Hours."

Bibliography

Barbara Abou-El-Haj, "The Urban Setting for Late Medieval Church Building: Reims and its Cathedral between 1210 and 1240," *Art History* 11 (1988), pp. 17–41.

Frederick Antal, *Florentine Painting and its Social Background* (London, 1948).

Maurice Barley, *Houses and History* (London, 1986).

Susan Bell, "Medieval Women Book Owners. Arbiters of Lay Piety and Ambassadors of Culture" (1982), reprinted in Mary Ehler and Maryanne Kowelski, eds., *Women and Power in the Middle Ages* (Athens, Ga., 1988), pp. 148–87.

Ulrike Bergmann, "Prior Omnibus Autor – an höchster Stelle aber steht der Stifter," in Anton Legner, ed., *Ornamenta Ecclesiae. Kunst und Künstler der Romanik* (Cologne, 1985), pp. 117–48.

John Bilson, "The Beginnings of Gothic Architecture in England," *Journal of the Royal Institute of British Architects*, 3rd series, 6 (1899).

Paul Binski, *Westminster Abbey and the Plantagenets. Kingship and the Representation of Power* (New Haven, 1995).

Tina Waldeier Bizzarro, *Romanesque Architectural Criticism. A Prehistory* (Cambridge, 1992).

Jean Bony, "La Technique normande du mur épais," *Bulletin monumental* 98 (1939), pp. 153–88.

Constance Bouchard, "Knights and the Foundation of Cistercian Houses in Burgundy," in John Sommerfeldt, ed., *Erudition at God's Service* (Kalamazoo, 1987), pp. 315–22.

Robert Branner, *St Louis and the Court Style in Gothic Architecture* (London, 1965).

Beat Brenk, "Bildprogrammatik und Geschichtsverständnis der Kapetinger im Querhaus der Kathedrale von Chartres," *Arte medievale* 5 (1991), pp. 71–96.

——, s.v. "Committenza," in *Enciclopedia dell'arte medievale*, vol. 5 (Rome, 1994), pp. 203–18.

——, "The Sainte-Chapelle as Capetian Political Program," in Virginia Raguin, Kathryn Brush, and Peter Draper, eds., *Artistic Integration in Gothic Buildings* (Toronto, 1995), pp. 195–213.

Christopher Brooke, "St. Bernard, the Patrons, and Monastic Planning," in Christopher Norton and David Park, eds., *Cistercian Art and Architecture in the British Isles* (Cambridge, 1986).

Caroline Bruzelius, *The Thirteenth-Century Church at St-Denis* (New Haven, 1985).

Brigitte Buettner, "Profane Illustrations, Secular Illusions: Manuscripts in Late Medieval Courtly Society," *Art Bulletin* 74 (1992), pp. 75–90.

Jacob Burckhardt, *Die Kultur der Renaissance in Italien* (Basel, 1862).

Jane Burton, "The Foundation of the British Cistercian Houses," in Christopher Norton and David Park, eds., *Cistercian Art and Architecture in the British Isles* (Cambridge, 1986).

Walter Cahn, "The Artist as Outlaw and *Apparatchik*: Freedom and Constraint in the Interpretation of Medieval Art," in Stephen Scher, ed., *The Renaissance of the Twelfth Century* (Providence, 1969), pp. 10–14.

——, *Romanesque Bible Illumination* (Ithaca, 1982).

——, "The *Rule* and the Book. Cistercian Book Illumination in Burgundy and Champagne," in *Monasticism and the Arts,* ed. T. G. Verdon (Syracuse, 1984), pp. 139–72.

Jacqueline Caille, *Hôpitaux et charité publique à Narbonne au Moyen Âge* (Toulouse, 1978).

Michael Camille, *The Medieval Art of Love* (New York, 1998).

——, "For Our Devotion and Pleasure: The Sexual Objects of Jean, Duc de Berry," *Art History* 24 (2001), pp. 169–94.

Norman Cantor, *Inventing the Middle Ages* (New York, 1991).

Eric G. Carlson, "A Charter for Saint-Etienne, Caen: A Document and its Implications," *Gesta* 15 (1976), pp. 11–14.

Magdalena Elizabeth Carrasco, "The Imagery of the Magdalen in Christina of Markyate's Psalter (St. Albans Psalter)," *Gesta* 38 (1999), pp. 67–80.

Sophie Cassagnes, *D'art et d'argent. Les artistes et leurs clients dans l'Europe du Nord, XIVe-XVe siècles* (Rennes, 2001).

Madeline Caviness, "Anchoress, Abbess, and Queen: Donors and Patrons or Intercessors and Matrons?" in *The Cultural Production of Medieval Women*, ed. June Hall McCash (Athens, Ga., 1996), pp. 105–54.

——, "Hildegard of Bingen: Some Recent Books," *Speculum* 77 (2002), pp. 113–20.

——, "Hildegard as Designer of the Illustrations of her Works," in Charles Burnett and Peter Dronke, eds., *Hildegard of Bingen: The Context of her Thought and Art* (London, 1998).

——, "Patron or Matron? A Capetian Bride and a Vade Mecum for her Marriage Bed," *Speculum* 68 (1993), pp. 333–62.

Roger Chartier, *Forms and Meanings. Texts, Performances, and Audiences from Codex to Computer* (Philadelphia, 1995).

Adam S. Cohen, *The Uta Codex* (University Park, Penn., 2000).

Adam S. Cohen and Anne Derbes, "Bernward and Eve at Hildesheim," *Gesta* 40 (2001), pp. 19–38.

H. M. Colvin, "The 'Court Style' in Medieval English Architecture: A Review," in V. J. Scattergood and J. W. Sherborne, eds., *English Court Culture in the Later Middle Ages* (New York, 1983), pp. 129–39.

Tracy E. Cooper, "*Mecenatismo* or *Clientelismo*? The Character of Renaissance Patronage," in David Wilkins and Rebecca L. Wilkins, eds., *The Search for a Patron in the Middle Ages and Renaissance* (Lewiston, NY, 1996), pp. 19–32.

Paul Crossley, "The Architecture of Queenship: Royal Saints, Female Dynasties and the Spread of Gothic Architecture in Central Europe," in *Queens and Queenship in Medieval Europe*, ed. Anne J. Duggan (Woodbridge, 1997), pp. 263–300.

Michael Davis, "The Choir of the Abbey of Altenberg: Cistercian Simplicity and Aristocratic Iconography," in Meredith Parsons, ed., *Studies in Cistercian Art and Architecture*, vol. 2 (Kalamazoo, 1984), pp. 130–60.

Claire Donovan, *The de Brailes Hours: Shaping the Book of Hours in Thirteenth-Century Oxford* (London, 1991).

Georges Duby, "Culture of the Knightly Class: Audience and Patronage," in Robert L. Benson and Giles Constable with Carol D. Lanham, eds., *Renaissance and Renewal in the Twelfth Century* (Cambridge, 1982; Toronto, 1991), pp. 248–62.

——, *The Early Growth of the European Economy: Warriors and Peasants from the Seventh to the Twelfth Century* (Ithaca, 1978).

Alain Erlande-Brandenburg, *The Cathedral. The Social and Architectural Dynamics of Construction* (1989), trans. Martin Thom (Cambridge, 1994).

——, *Le Roi est mort. Étude sur les funérailles, les sépultures et les tombeaux des rois de France jusqu'à la fin du XIIIe siècle* (Paris, 1975).

Anton von Euw and Peter Schreiner, eds., *Kaiserin Theophanu: Begegnung des Ostens und Westens um die Wende des ersten Jahrtausends*, 2 vols. (Cologne, 1991).

Peter Fergusson, *Architecture of Solitude. Cistercian Abbeys in Twelfth-Century England* (Princeton, 1984).

Eric Fernie, *The Architecture of Norman England* (Oxford, 2000).

Teresa Frisch, *Gothic Art, 1140–c.1450, Sources and Documents* (Toronto, 1987).

Alexandra Gajewski-Kennedy, "Recherches sur l'architecture cistercienne et le pouvoir royal: Blanche de Castille et la construction de l'abbaye du Lys," in Yves Gallet, ed., *Art et architecture à Melun au Moyen Âge*: Actes du colloque l'histoire de l'art et d'archéologie tenu à Melun les 28 et 29 novembre 1998 (Paris, 2000), pp. 223–54.

Loveday Lewes Gee, *Women, Art and Patronage. From Henry III to Edward III: 1216–1377* (Woodbridge, 2002).

Paula Gerson, ed., *Abbot Suger and Saint-Denis: A Symposium* (New York, 1986).

——, "Suger as Iconographer," in Gerson, ed., *Abbot Suger and Saint-Denis*, pp. 183–95.

Creighton Gilbert, "A Statement of Aesthetic Attitude around 1230," *Hebrew University Studies in Literature and the Arts* 13 (1985), pp. 125–52.

Dorothy Gillerman, *Enguerran de Marigny and the Church of Notre-Dame at Ecouis. Art and Patronage in the Reign of Philip the Fair* (University Park, Penn., 1994).

——, "The Portal of St-Thibault-en-Auxois: A Problem of Thirteenth-Century Burgundian Patronage and Founder Imagery," *Art Bulletin* 68 (1986), pp. 567–80.

Lindy Grant, *Abbot Suger of St-Denis. Church and State in Early Twelfth-Century France* (London, 1998).

——, "Le patronage architectural d'Henri II et de son entourage," *Cahiers de civilisation médiévale, X-XII siècles* 37 (1994), pp. 73–84.

Louis Grodecki, "Les vitraux allégoriques de Saint-Denis," *Art de France* 1 (1961), pp. 19–46.

Jeffrey Hamburger, "Before the Book of Hours: The Development of the Illustrated Prayer Book in Germany," in *The Visual and the Visionary. Art and Female Spirituality in Late Medieval Germany* (New York, 1998), pp. 149–96.

——, *Nuns as Artists* (Berkeley/Los Angeles, 1997).

Jonathan Harris, "General Introduction," in Arnold Hauser, *Social History of Art*, vol. 1 3rd edn. (London, 1999).

Francis Haskell, s.v. "Patronage," in *Encyclopedia of World Art*, vol. XI (New York, 1966), cols. 118–24.

——, *Patrons and Painters* (1963) (New Haven, 1980).

Arnold Hauser, *The Social History of Art* (1951), 3rd edn. (London, 1999).

Anne D. Hedeman, *The Royal Image. Illustrations of the* Grandes Chroniques de France, *1274–1422* (Berkeley/Los Angeles, 1991).

Edward B. Henning, "Patronage and Style in the Arts: A Suggestion Concerning their Relations" (1960), in M. C. Albrect et al., eds., *The Sociology of Art and Literature: A Reader* (New York, 1970), pp. 353–62.

Bennett Hill, "Lay Patronage and Monastic Architecture. The Norman Abbey of Savigny," in T. G. Verdon, ed., *Monasticism and the Arts* (Syracuse, 1984), pp. 173–87.

Sandra Hindman, *Sealed in Parchment. Rereadings of Knighthood in the Illuminations of Chrétien de Troyes* (Chicago, 1994).

Lawrence Hoey, "Style, Patronage, and Artistic Creativity in Kent Parish Churches Architecture, *c.*1180–*c.*1260," *Archaeologia Cantiana* 115 (1995), pp. 45–70.

Joan Holladay, "The Education of Jeanne d'Evreux. Personal Piety and Dynastic Salvation in her Book of Hours at the Cloisters," *Art History* 17 (1994), pp. 585–611.

——, "Hermann of Thuringia as Patron of the Arts," *Journal of Medieval History* 16 (1990), pp. 181–216.

——, "Tombs and Memory: Some Recent Books," *Speculum* 78 (2003), pp. 440–50.

Alyce A. Jordan, *Visualizing Kingship in the Windows of the Sainte-Chapelle* (Turnhout, 2002).

Fabienne Joubert, ed., *L'artiste et le commanditaire aux derniers siècles du Moyen Âge, XIII–XIV siècles* (Paris, 2001).

Ernst Kantorowicz, *The King's Two Bodies* (Princeton, 1957).

Wolfgang Kemp, *Sermo corporeus. Die Erzählungen der mittelalterlichen Glasfenster* (Munich, 1987).

Herbert Kessler, "On the State of Medieval Art History," *Art Bulletin* 70 (1988), pp. 166–87.

Peter Kidson, "Panofsky, Suger, and St. Denis," *Journal of the Warburg and Courtauld Institutes* 50 (1987), pp. 1–17.

Dieter Kimpel and Robert Suckale, *Die gotische Architektur in Frankreich, 1130–1270* (Munich, 1985).

Henry Kraus, *Gold was the Mortar. The Economics of Cathedral Building* (1979) (New York, 1994).

Brigitte Kurmann-Schwarz, "Récits, programme, commanditaires, concepteurs, donateurs: Publications récentes sur l'iconographie des vitraux de la cathédrale de Chartres," *Bulletin monumental* 154 (1996), pp. 55–71.

Gerhard Ladner, *Die Papstbildnisse des Altertums und des Mittelalters* (Vatican City, 1941).

Jacques Le Goff, *La Naissance du purgatoire* (Paris, 1981).

Meredith Lillich, "Gifts of the Lords of Brienne: Gothic Windows," *Arte medievale* 12/13 (1998–9), pp. 173–92.

John Lowden, *The Making of the Bibles Moralisées* (University Park, Penn., 2000).

June Hall McCash, "The Cultural Patronage of Medieval Women: An Overview," in McCash, ed., *The Cultural Patronage of Medieval Women* (Athens, Ga., 1996), pp. 1–49.

S. Macready and F. H. Thompson, eds., *Art and Patronage in the English Romanesque* (London, 1986).

Colette Mahnes-Deremble, *Les Vitraux narratifs de la cathédrale de Chartres. Étude iconographique* (Paris, 1993).

Clark Maines, "Good Works, Social Ties, and the Hope for Salvation: Abbot Suger and Saint-Denis," in Paula Gerson, ed., *Abbot Suger and Saint-Denis: A Symposium* (New York, 1986), pp. 77–94.

Emile Mâle, *L'Art religieux de la fin du Moyen Age en France* (Paris, 1922).

Andrew Martindale, "Patrons and Minders: The Intrusion of the Secular into Sacred Spaces in the Late Middle Ages," in *The Church and the Arts*, Studies in Church History 28, ed. Diana Wood (Oxford, 1991), pp. 143–78.

——, *The Rise of the Artist in the Middle Ages and Early Renaissance* (New York, 1972).

Marcel Mauss, *The Gift: The Form and Reason for Exchange in Archaic Society*, trans. W. D. Halls (London, 1990).

Millard Meiss, *French Painting in the Time of Jean de Berry*, 4 vols. (London/New York, 1967–74).

Michael Michael, "The Privilege of 'Proximity:' Towards a Re-definition of the Function of Armorials," *Journal of Medieval History* 23 (1997), pp. 55–75.

Comte de Montalembert, *Les Moines d'occident* (Paris, 1877).

Anne McGee Morganstern, *Gothic Tombs of Kinship in France, the Low Countries, and England* (University Park, Penn., 2000).

William Morris, "Art and Socialism" (1884), in A. L. Morton, ed., *Political Writings of William Morris* (London, 1973), pp. 109–33.

Victor Mortet, *Recueil de textes relatifs à l'histoire de l'architecture et à la condition des architectes en France au Moyen Âge* (Paris, 1911 and 1929).

Christopher Norton and David Park, eds., *Cistercian Art and Architecture in the British Isles* (Cambridge, 1986).

Otto Gerhard Oexle, "Memoria und Memorialbild," in Karl Schmid and Joachim Wollasch, eds., *Memoria* (Munich, 1984), pp. 384–440.

Otto Pächt, C. R. Dodwell, and Francis Wormald, *The St. Albans Psalter* (London, 1960).

B. B. Price, "The Effect of Patronage on the Intellectualization of Medieval Endeavors," in David Wilkins and Rebecca L. Wilkins, eds., The *Search for a Patron in the Middle Ages and Renaissance* (Lewiston, NY, 1996), pp. 5–18.

Joachim Prochno, *Das Schreiber- und Dedikationsbild in der deutschen Buchmalerei*, vol. 1 (Leipzig/Berlin, 1928).

Virginia Chieffo Raguin, "Mid-Thirteenth Century Patronage at Auxerre and the Sculptural Program of the Cathedral," *Studies in Iconography* 14 (1995), pp. 131–51.

Annie Renoux, ed., *Palais royaux et princiers au Moyen Âge*. Actes du colloque international tenu au Mans, 1994 (Le Mans, 1996).

Iva Rosario, *Art and Propaganda: Charles IV of Bohemia, 1346–1378* (Woodbridge, 2000).

Conrad Rudolph, *Artistic Change at St-Denis. Abbot Suger's Program and the Early Twelfth-Century Controversy over Art* (Princeton, 1990).

——, *The "Things of Greater Importance": Bernard of Clairvaux's Apologia and the Medieval Attitude toward Art* (Philadelphia, 1990).

Corine Schleif, "Hands that Appoint, Anoint, and Ally: Late Medieval Donor Strategies for Appropriating Approbation through Painting," *Art History* 16 (1993), pp. 1–32.

Percy Ernst Schramm, *Die deutschen Kaiser und König in Bildern ihrer Zeit* (1928), new edn. (Munich, 1983).

——, *Herrschaftszeichen und Staatsymbolik: Beiträge zu ihrer Geschichte vom dritten bis zum sechzehnten Jahrhundert* (Stuttgart, 1954).

Lon R. Shelby, "Monastic Patrons and their Architects: A Case Study of the Contract for the Monk's Dormitory at Durham," *Gesta* 15 (1976), pp. 91–6.

P. Skubiszewski, "L'Intellectuel et l'artiste face à l'oeuvre à l'époque romane," in *Le travail au Moyen Âge. Une approche interdisciplinaire* (Louvain, 1990), pp. 262–321.

Alison Stones, *Le Livre d'images de Madame Marie* (Paris, 1997).

Suger, *Abbot Suger on the Abbey Church of St.-Denis and its Art Treasures*, ed. Erwin Panofsky, 2nd edn. (Princeton, 1979).

R. E. Swarthout, *The Monastic Craftsman: An Inquiry into the Services of Monks to Art in Britain and in Europe North of the Alps during the Middle Ages* (Cambridge, 1932).

Georg Swarzenski, "Aus dem Kunstkreis Heinrichs des Löwen," *Städel Jahrbuch* 7–8 (1932), pp. 241–397.

Jane Turner, ed., *The Dictionary of Art* (New York, 1996).

Otto von Simson, *The Gothic Cathedral* (New York, 1956).

Martin Warnke, *Bau und Überbau. Soziologie der mittelalterlichen Architektur nach den Schriftquellen* (Frankfurt am Main, 1976).

——, *Hofkünstler: zur Vorgeschichte des Modernen Kunstlers* (Cologne, 1985).

Daniel Weiss, *Art and Crusade in the Age of St. Louis* (Cambridge, 1998).

Jane Welch Williams, *Bread, Wine, and Money. The Windows of the Trades at Chartres Cathedral* (Chicago, 1993).

Georgia Sommers Wright, "A Royal Tomb Program in the Reign of St. Louis," *Art Bulletin* 56 (1974), pp. 224–43.

Collecting (and Display)

Pierre Alain Mariaux

The history of collecting in the Middle Ages has only rarely been the subject of sustained research. There are of course publications on the history of museums and the original, though isolated, works of Kryzsztof Pomian. Generally speaking, however, the subject has remained a *terra incognita* where one may find a few discreet and repetitive hints about collections but without any critical basis to their study. One of the subjects regularly brought up is the collection of antique statues which the Bishop of Winchester, Henry of Blois, assembled on his journey to Rome between 1149 and 1150;[1] another case is the clever display of some of the items belonging to the treasure of St Denis, after the Abbey was reconstructed by Abbot Suger; also often mentioned are the Crusaders in Constantinople, their greed mingled with wonder when they discovered the riches of the city and its churches, true *emporia* of relics.[2] The secondary literature is full of similar accounts, dispersed within a multitude of monographs which should without any doubt be part of that history. Yet much material remains to be analyzed and synthesized. This chapter endeavors to suggest the initial steps toward this goal.

Introduction

Is it correct to talk of "collecting" in the Middle Ages? Admittedly, if we define the collection as an assembly of *chosen* objects (for their beauty, rarity, curious character, documentary value, or expense), no such thing existed during that period. Assembling a body of objects presupposes the presence of an individual, a collector. It is he or she who makes a deliberate choice. Between the private collections to be found in antique Rome (which also survive in Constantinople after the fall of the Roman Empire[3]) and the emergence of the lay collector in the fourteenth century, one of the signs of early Humanism,[4] the only medieval

collections of which we have documentary evidence are treasures, which may be seen as collections without collectors.[5] Be they princely or royal, or assembled by ecclesiastical institutions, these treasures are not considered the product of single individuals, but of an institution. However, some scholars suggest that the medieval treasury should, all the same, be included in the history of collections because it contains objects which no longer take part in an economic exchange, which have lost their utilitarian function, and which are subjected to definite regulations in order to be displayed in well-defined sites.[6] Not all medieval treasure fulfills these conditions, and therefore we cannot speak of collections in all cases. Until at least the eleventh century, both Church and lay treasuries were accumulations of objects whose value lies precisely in the fact that they are made up of a mass of miscellaneous items.[7] From the twelfth century onwards, the arrangement of treasures began to change. This development allows us to infer that, instead of being simply accumulated, these objects (mostly assembled by the Church) became subject to a reorganization according to certain principles of symbolic order, often because they were now on view.

The terminology for our modern concept of collection hardly existed in the Middle Ages: the term *collectio* means assembly, or congregation, and, more specifically, the collection of money in church or some form of feudal dues. A *collector* is the person who collects taxes or tithes. As a medical term, *collection* was used in French at the beginning of the fourteenth century to mean the collection of some material (e.g., collection of pus) – in this case, it seems certain that a more general meaning is intended, that of an amassment (*collection* from the Latin *collectio [colligere]*, the action of assembling, gathering, or collecting). *Collection* in the sense of the gathering or collection of objects does not appear until the eighteenth century. In medieval Latin the word used is either *corpus*, to indicate a collection of art or scientific objects, in particular literary collections, or *thesaurus* for books and artworks, though the latter term is often applied to the place where precious objects are kept. We find the word *thesaurus* for an assembly of precious objects, for the first time ever, in the Capitulary of Nijmegen in 806, but we must wait until the thirteenth century to find it again with the same meaning. Romanesque sources talk of treasure as a body of material goods belonging to a church. In the thirteenth century, however, the term indicates with greater precision the portable yet inalienable goods of a single church, such as sacred vessels, liturgical ornaments, and precious objects, particularly reliquaries. From the thirteenth century on, and throughout the following century, *thesaurus* meant, above all, a special room – the treasury – usually separated from the sanctuary, where precious objects were kept.

To gather diverse objects to form a whole is variously referred to as *colligere*, *conquirere*, even sometimes *comparare* in classical Latin. Over time, however, these words take on a more precise definition: in the Middle Ages *colligere* still meant to assemble (men and things), but *conquirere* meant to acquire and then to conquer, while *comparare* meant to buy. A more productive direction seems to lie in the study of the vocabulary of the conservation of things, e.g., *thesaurus*,

thesaurarium, gazophylacium, gaza, sacrestia, sacrarium, scrinium, armarium, theca, loculus, etc., for some of which Isidore of Sevilla already suggests definitions, and their lexical field. For instance, *thesaurus* clearly reflects the accumulative character of medieval treasures, as the word includes all possessions without any distinction as to their nature, form, or function: funds, land, buildings, and ornaments all form an ecclesiastic treasure.

Rather than talk of collecting in the twelfth and thirteenth centuries, we ought to agree with Caroline W. Bynum and speak of an "impulse to collect," which can also be detected in the expansion of the Cult of Relics,[8] for the phenomenon is not limited to treasure in the narrow sense of the term. Medieval collecting comprises several activities, one of the most remarkable being the reuse of objects, a process that removes the subject from its original context and makes it "marvelous."[9] Others include the special use of *spolia* for remembrance, the enthusiastic gathering of miraculous objects (particularly relics), and acquisition of natural curiosities. These activities are all meant to create multiple connections with the past, with the collective memory of the community that possesses the treasure and, above all, with the invisible.[10] As has been demonstrated by anthropologists, all treasure leads back to the past through the use of names that act as elements of a legendary heritage of myths and events. We may therefore wonder if collecting in the Middle Ages does not do very much the same thing: more than a mere physical action, the gathering of these objects is the invocation of the memory of individual people, be they kings, saints, or heroes.

Collecting in the Middle Ages: The Treasury

Previous scholarship commonly assumes that medieval treasuries, particularly Church treasuries, are the origin of the *Wunderkammer*, the cabinet of curiosities, and museums in the modern sense, which flourished from the eighteenth century onwards.[11] Yet we are forced to admit that it is impossible to establish a typology that could include the medieval collection.[12] To consider the medieval treasury as a chapter in the history of museums gives the false impression that this history is linear, implying a continuous progression, while instead it is irregular. In fact, there are a number of ruptures, for example after the fall of Constantinople in 1204, which resulted in the amassing of precious bounties and of their expedition to the West. Previous scholarship also does not entirely take into account the polymorphic character of the medieval collection. Treasuries, especially Church treasuries, are in fact more than the bringing together of precious objects to be preserved, as most of these maintain their original function. They do possess a value of exchange, but at the same time they retain their usefulness.[13] Without taking into account its sacred dimension, medieval treasure is nothing more than the immobilization of capital in the form of artifacts. It is under constant threat of being melted down; furthermore it becomes the expression of value and possession that may inspire wonder and admiration.

As far as Church treasures are concerned, primary sources tell us they can be categorized into *ornamenta* (or *ornamentum*), that is to say a collection of objects destined to ornament the Church, or as *apparata* (or *ministerium*), that is, all the necessary furnishings to ensure the smooth running of the liturgical ceremony. The treasury can also be used as a place to deposit *regalia*.[14] We therefore find an assembly of very diverse objects, such as *antependia*, portable altars, sacred vessels, relics in diverse forms and sizes, liturgical vestments, objects of devotion like images and statues, chandeliers, crowns, processional crosses, illuminated manuscripts with gold bindings, etc. There are also rare fabrics, gold or silver objects (sometimes decorated in enamel), antique gems and precious stones, and ivory. To these, secular artworks may be added, whose function may or not be converted to religious purposes, and objects of curiosity. The main body of Church treasure is therefore made up of precious objects (*clenodia* and *utensilia*), which continue or not to play a role in religious practice. But the true treasure remains the relics of the saints' bodies, around which the collection is organized.[15] What enables a treasury to be built up are the economic and religious fluctuations of a spiritual center; its wealth is in fact linked to the prosperity and the reputation of the center: the success of a pilgrimage favors the prestige and opulence of the place. If imperial, princely, or ecclesiastic patronage play a major role in the formation of a church's treasury, private gifts must certainly not be forgotten. All gifts offered to the Church – at the tomb of the saint, at the altar, to the clergy, or to the monks who officiate in the sanctuary – add to its patrimony. A gift constitutes both a homage of the faithful to God, through His saints, and the financial capital of the Church.

Thus defined, a medieval treasury fulfills various functions. First, it is the visible expression of the temporal or spiritual power of the authority that assembles it: from Antiquity to the Middle Ages, similar objects are collected for the same reasons; collections are created for prestige, to conserve financial resources, to establish status, and probably also, though less frequently, for study. A second function continues a strong tradition that exists between the creation of a treasury in an antique temple and that of a medieval church, even if the conditions of collecting and the situation in which the treasure is displayed differ: both institutions preserve the memory of noteworthy or heroic times. For example, Orpheus' lyre, Helen's sandal, and Leda's eggs all herald, in a certain way, Virgil's mirror and the pitcher of Cana in the treasure of St Denis. Medieval treasuries are, furthermore, monetary reserves that can be delved into; this again is a sign of continuity. However, what is different is the fact that certain objects can be transformed, as the faithful do not make a gift of the object itself but of the matter of which it is made. Other items, due to their sumptuous aspect (for example ivory leaves) or the finesse of the workmanship (engraved precious stones), are kept in order to be used again. The medieval treasury is, finally, a place of conservation.

Because of these different uses, scholars must ask questions about the function of assembled objects as well as of the collections they form. For if certain objects

are understood by their cultures as rising above the ordinary, it becomes neces-
sary to define clearly what is sacred and what is profane, as well as to categorize
the wonderful, the monstrous, the miraculous, and the curious, so as to be able
to apply these concepts to the Middle Ages. The first instinct of a collector is to
hoard goods, especially rare and precious artworks, and to amass *unica* (that is,
whatever is unique). The symbolic value of the collected pieces then determines
their destiny as "potential museum pieces," transforms them into museological
objects, and suggests a display status. The treasury – with liturgical instruments,
curiosa, and *pretiosa* as centerpieces – attracts crowds of pilgrims, the curious,
and even thieves. The criteria of choice for both sacred and secular treasures
seem to be the same: their rarity and degree of preciousness, as much as their
mercantile value, which transform relics, the marvelous, or manufactured objects
into items with a price which can be offered, exchanged, lost, or stolen.

State of Research and Prospects

With the studies of Jules Antoine Dumesnil, Clément de Ris, Edmond Bonnafé,
Eugène Müntz, Adolfo Venturi, Otto Hirschfeld, Ludwig Friedländer, and Jacob
Burckhardt,[16] among many others, the nineteenth century showed a consistent
interest in the idea of the collection as a general phenomenon. These scholars
concentrated their research on important collections as well as on amateurs and
collectors since the Renaissance, yet they were little interested in the Middle
Ages. Only the analytical presentations of the catalogues and the bibliographies
of inventories published by Fernand de Mély and Edmund Bishop, and to a
lesser degree by Guiseppe Campori, give importance to medieval documents.[17]
Yet since David Murray and Julius von Schlosser's interesting contributions to
the study of medieval collections, both published at the beginning of the twen-
tieth century, no other complete analysis of the phenomenon has been made.

The most recent studies of church treasure have mostly come from historians
of heritage, who have the dual aim of conserving precious objects as well as
displaying them in modern settings. Therefore, historical research is fundamen-
tally interested in the transformation of the ecclesiastic treasury into a diocesan
museum or a museum of sacred art, since the study of inventories makes it
possible for the vicissitudes of a treasure to be traced and for displaced objects to
be tracked. For a better understanding of the phenomenon of collecting in the
Middle Ages, a certain number of inquiries must be undertaken.[18] The field of
study concerned with the content of medieval treasuries is by far the most
generally pursued line. But we must insist on the fact that the objects are
generally considered in themselves, independently from their context, to establish
the history of decorative arts. These studies very rarely concentrate on the
notion of the treasury as a whole. It is only since the early 1990s that this
tendency has been reversed: recent exhibitions have shown the interest in starting
from the sources and in studying the treasury diachronically.[19] First of all, the

analysis of inventories that began in the nineteenth century should be continued, following the founding studies of Fernand de Mély and Edmund Bishop. This work was halted after the publication of an initial volume by Bernhard Bischoff which deals with inventories of treasuries north of the Alps up to the end of the thirteenth century. Regrouping inventories in one corpus would make it feasible to study their typology – whether they are inventories of cathedrals, monasteries, or royal chapels, etc. – so as to establish the most specific characteristics of each.[20] In this way, it would be possible to establish the existence or non-existence of symbolic relationships between the objects according to their place in the inventory, their physical position vis-à-vis other objects, or their display during particular liturgical ceremonies. Typological analysis is necessary to establish the general history of the medieval treasury; in fact, it enables us to understand a set of recurrent facts and to operate horizontal cross-checking between treasuries, countries, and types of objects collected, by donors presumed or proven. An inquiry into these documents would be incomplete without a search for narrative sources: annals, chronicles, lives of saints and abbots, *gesta episcoporum*, wills, donations, the financial accounts of the cathedral workshop, etc., without forgetting the *descriptiones*, legal deeds, accounts of the circumstances of invention, translation, or exposure of relics, and liturgical sources.

Architectural analysis of the buildings should also be undertaken with the aid of archeology and the history of architecture to determine the position of the treasury, the sacristy, and, if applicable, the archive room which held precious objects. Then the architectural layout should be reconstructed, showing the physical and visual access to the treasure. This part of the analysis should also be concerned with the specific furniture in which objects were kept (cupboards, recesses, relic cupboards, chests, shrines, and reredos for relics, etc.) (fig. 10-1).[21] The study of the architectural layout should be accompanied by an analysis of primary sources for two reasons: on the one hand, to compensate for monuments that have disappeared (the documents may mention places as well as lost or dispersed treasures, like the treasure of the Abbey of St Riquier) and, on the other, to establish the specific technical vocabulary that is still needed.

From Medieval Treasures to Cabinets of Curiosity

Both David Murray and Julius von Schlosser agree that the first traces of collections of art objects and curiosities in the Middle Ages are to be found in royal residences and in church treasuries, as each contain both works of nature and works of art. The Church, where miracles might be a daily event, keeps *mirabilia* for display and in order to stage them to draw in the faithful. Since the thirteenth century there has been written evidence to this effect; for example, Durandus of Mende, who talks about ostrich eggs: "In certain churches, ostrich eggs and other such items which cause admiration and which are seldom seen

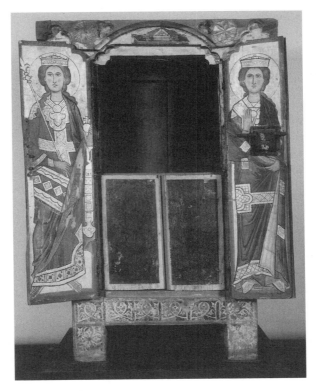

FIGURE 10-1 Cupboard, Saxony, *c*.1230. Halberstadt, cathedral treasure, inv. Nr. 42.
Landesamt für Denkmalpflege und Archäologie Sachsen-Anhalt. Photo: Gunar Preuss.

are hung up in order to attract the people to church and to touch them [through
the sight of these objects]."[22] The Church conserves what is rare, marvelous, or
monstrous, and in some churches we may find, side by side, embalmed croco-
diles, flints, meteorites, antelope and unicorn horns, griffon claws, huge teeth and
bones, etc. Most of these *mirabilia* seem to have been placed in a conspicuous
position, as they would be later in encyclopedic museums; others were kept in
the treasury cupboards. Yet can it be said that medieval treasures prepare the
way for the *Wunderkammer*, the curiosity cabinet, and the modern museum, as
is assumed by a major part of current research?[23]

Murray sees the Church as a conservatory of the Creation, while von Schlosser
finds in medieval treasures the justification for people's taste for things strange
and curious. Indeed, in his attempt to determine the historical foundations of
the *Wunderkammer*, von Schlosser evokes the medieval treasury as an example
of the collecting curiosity of humankind. However, to see in church treasuries
the ancestor of the cabinet of curiosities is the result of too narrow an inter-
pretation. The fact that the objects are similar is certainly an indication, as von
Schlosser notes, that the cabinet of curiosities partly takes over the representative

function of medieval treasuries, while adding the taste for the marvelous. However, the *Wunderkammer* is not situated halfway between the medieval treasury and the modern museum. The origin of the museum is in the collections of Italian amateurs, who maintain a clear distinction between objects of art and objects of nature in order to build a coherent image of the world. Adalgisa Lugli quite rightly sees the cabinet of curiosities as a place of experimentation clearly situated outside the historical evolution of museums.[24] The medieval treasury has nothing to do with either.

It is true that sacristies preserve all sorts of objects in their cupboards (straw wisps, clumps of earth, stones, knives, pieces of cloth, etc.). These objects have an obvious judicial function: they signify a gift. As a matter of fact, the great number of such gifts provoked the anger of the Bishop of Rodez in the thirteenth century. He threatened to excommunicate any giver of old rags, hay, or straw. These objects are not kept for themselves but rather as pieces of evidence, *testimonia*. The same is true for most objects which seem "bizarre" to the modern eye and which could fit in the *Wunderkammer*.[25] As treasuries in the twelfth century were still made up of many miscellaneous objects, it is difficult to decide on the connection between these "improbable relics" or curiosities and the nature of the treasury. For example, a unicorn horn was apparently kept in the abbey church of St Denis, fixed to a column of gilded copper and placed near Suger's great crucifix, but there is no written confirmation before the sixteenth century.[26] A griffon claw that was part of the same treasury and very likely one of the Abbey's liquid measures was mounted as a drinking cup in the thirteenth century and so excluded from display.[27] Another griffon claw hanging from the vault of the Sainte-Chapelle in Paris in the sixteenth century is not mentioned before 1433.[28]

Medieval *Curiositas* and Curiosities

The existence of rare objects (as well as others) in treasures is attested from the beginning of the fifteenth century onwards. At this time, *curiositas*, again intellectually acceptable, starts taking on the meaning of "curiosity, curious thing." In the twelfth century, the Latin word *curiositas* was associated with an excessive desire of knowledge and exaggerated preoccupation or worry. Its negative connotation was stressed by moralists, who labeled it as "vain," but from the middle of the following century it included the meaning of wanting to acquire new knowledge.[29] In calling *curiositas* the origin of pride, St Bernard[30] and the monastic tradition follow in Augustine's footsteps, who defines it as *concupiscentia oculorum* (1 John 2: 15–16).[31] This is still the meaning that Odo of Deuil ascribes to it in 1148. When describing the behavior of the Crusaders on entering the churches of Constantinople, he paraphrases a passage from the Book of Numbers: "alii curiositate videndi, alii veneratione fideli."[32] Odo distinguishes between viewers (or even *voyeurs*) and the faithful. The latter approach the

shrine to venerate; the former are not necessarily "curious" in the meaning given to the word since the eighteenth century, but it is already a first sign of a positive appreciation which announces the changes to come in the Gothic period.

The assembling of *naturalia* and monstrosities is also linked to an archeological inclination nourished by biblical stories. Preserving a rib of a whale signals a desire to display a bone of the monster that swallowed Jonah (Jonah 2: 1). But if the interest for things strange and marvelous is constant in the course of the Middle Ages, conditions change as time goes by: from the twelfth century onwards, the interest in natural curiosities increases.[33] Natural rarities and curiosities in medieval treasuries – like the tooth of a narwhale (or unicorn horn), the nautilus, or the ostrich egg – are meant to show divine wisdom and power made manifest through the Creation.[34] But once the ontological distinction between *miracula* and *mirabilia* is established in about 1200, as Caroline W. Bynum has shown, natural curiosities function as *exempla*, seen henceforth through the moralizing filter of lapidaries and bestiaries. The ostrich egg is a perfect example in this respect. Looking through the table of inventories compiled by Bernhard Bischoff, we see that they existed in several churches north of the Alps. They were described either as *struthio* or as *ovum struthionis*.[35] In most cases they seem to have been receptacles (pyxes or reliquaries) (fig. 10-2). Most sources are not explicit about how they were displayed. Durandus of Mende, however, tells us that the common practice was to suspend them. In his presentation of church ornaments, he gives precise reasons why a treasury is shown to the people on certain feast days: for security reasons, because of the solemnity of the occasion, and above all for the sake of memory, to remember past donations, and to celebrate the *memoria* of the donors. The role of ostrich eggs (and other rare objects, *huiusmodi*) is to attract the faithful and to incite admiration, yet with a moral intent. An ostrich has a forgetful nature, but when a certain star appears it is recalled to its duty to return and sit on its eggs while they are hatching; likewise man, enlightened by the grace of the Holy Spirit, enjoins God to remember him by performing *bona opera*. The eggs are there to admonish the wandering spirit, just like a picture – *qua imago* – and to cause good works.[36]

Objects of a treasury lose their earthly function and are kept because they are signs that refer to something invisible, to which they give access. They have the capacity to "pass on to" somewhere above, like the good deeds that follow their makers; in other words, they are "convertible."[37] To acquire a treasure in heaven (Luke 12: 33; Matt. 6: 2) – that is, to arrive in paradise – was one of the desires of the medieval person. One means of attaining this celestial treasure was to begin on earth by making a series of donations to the altar, because through them pilgrims could prepare the salvation of their souls. Before ending up in the ecclesiastical treasure trove, these gifts passed through the hands of the mediators of the sacred, the priests, and, like the Eucharistic species, they were transformed, increasing their value. One of the essential functions of the treasure was precisely to ensure good communication between the terrestrial below and the celestial above, between the material Church and the heavenly Jerusalem.[38] The

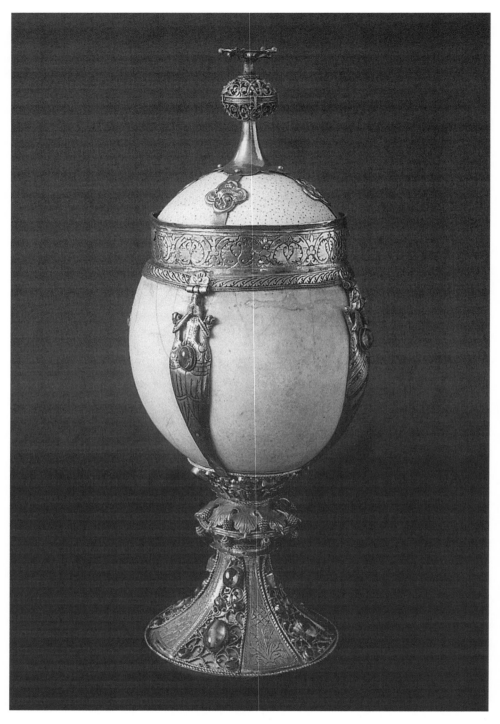

FIGURE 10-2 Egg-reliquary, Saxony, *c*.1210–20. Halberstadt, cathedral treasure, inv. Nr. 47. Landesamt für Denkmalpflege und Archäologie Sachsen-Anhalt. Photo: Gunar Preuss.

treasury thus stands at the threshold between the visible and the invisible, between the human being's temporal life and life beyond. As a sacred repository, it mediates between this world and the one to come, the accumulation of earthly treasures matching spiritual ones, since both seem to be indissolubly mixed together.[39]

It seems that there is a correlation between the development of acts of mercy – for which the theology is slowly put in place in the course of the eleventh century before attaining a tremendous development in the following[40] – and the phenomenon of rearranging ecclesiastic treasures in the twelfth century. A look at Abbot Suger's activities in overseeing and building St Denis seems to confirm this theory. One of the aims of his *good* deeds was to establish a reciprocal link between the saint and Suger himself.[41]

Manipulating the Objects: Memory Made Visible

The history of architecture tells us that, from the end of the twelfth century onwards, the choirs of numerous churches have been rearranged. (One of the consequences of this phenomenon was the progressive disappearance of crypts, many of which were filled in, as in the cathedral of Troyes). There is no doubt that this architectural rearrangement brought about a change in the location and exhibition of a certain number of objects of the treasury, though we must be very careful to distinguish these objects clearly from those that were never taken out of their cupboards. Furthermore, vaulted and closed treasure chambers were now being built inside the sanctuaries themselves (for instance in the cathedral of Trier, *c.*1200), or near the choirs (as in Notre-Dame of Noyon, *c.*1170, placed against the northern arm of the transept); at Saints-Pierre-et-Paul of Troyes, the first radiating chapel to the south served as a treasury from the beginning of the thirteenth century – and sometimes it is the sanctuary itself which becomes the treasure chamber, as in the case of the Sainte-Chapelle of Paris (1239–48).[42] The end of the twelfth century heralds a new age of visibility, as can be seen from the new perception of the body of Christ, exemplified by the raising of the consecrated host, and by the progressive transformation of reliquaries into monstrances. There is a desire to recognize the divine or saintly presence, and this implies actually seeing the relic, which in turn leads to a multiplication of monstrances and phylacteries in the thirteenth century. The precious remains are exhibited in their shrines, visible through a crystal window.[43] This interest in visibility results in a reorganization of treasures. In the history of their formation, the twelfth century is a turning point: we notice everywhere an effort to restore objects and to make the past attractive, the emphasis being on remembrance. The phenomenon concerns objects and the ways of exhibiting them.

Treasuries portray "History" or the past through objects and images staged as relics of that past. A striking example is Suger's restoration of Dagobert's throne

that he found in the St Denis treasury. He restored it both for the excellence of its function and its value (*tum pro tanti excellentia officii, tum pro operis ipsium precio*), and also because it was supposed to be a gift made by the legendary founder of St Denis.[44] Legend seems to turn into flesh: the most precious symbols of the past become objects that can be touched, admired, or traded. These heroic relics are still perceived through the filter of the marvelous and the legendary,[45] but, by recalling immemorial times, they possess the faculty of connecting the community with History. Moreover, forging a prestigious past in order to inscribe an object in the collective memory, a process that Amy G. Remensnyder has termed as the "imaginative memory," is an activity that might involve any object. In this way, an object is transformed into a memorial which is then given a name, generally a prestigious one.[46] For example, the sardonyx vessel that St Martin supposedly entrusted to St Maurice Abbey, according to a twelfth-century legend, was given to him by an angel. The precious gemstone material and the rarity of such a reliquary certainly helped the monks to assume that its origin was celestial and its provenance holy.[47] But the process may also have been an "operative action": in the 1160s, the oval reliquary casket of St Viktor in Xanten was purposely fashioned in antique style in order to make it look older than it was (fig. 10-3). There were also imitations of Roman triumphs. The holy relics that Bishop Konrad von Krosigk (1201–8) brought back from Constantinople in 1205 were carried on a *feretrum* (or bier) and then exposed in Halberstadt Cathedral so that everyone would recognize the

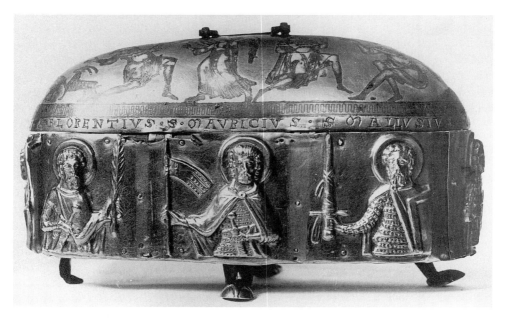

Figure 10-3 Reliquary casket, probably from Cologne, *c*.1160–70. Xanten, St Victor, inv. Nr. Hölker B6. Photo: Bildarchiv Foto Marburg, Nr. Z.17.012.

Bishop's exploit. The *publicatio* of these *spolia opima* had several functions: to serve as commemoration, and to maintain or support the *religio*, that is the care for the churches and worship, as well as to incite donations.[48] The impact of such proceedings – *adventus*, *publicatio* – on medieval religious practice should also be assessed when it comes to collecting and display.

At St Denis, Abbot Suger moved the major relics from the crypt to the choir, where there was more light. He restored or transformed some pieces in the treasury and also enriched it with new ones. He then placed some of the items at strategic points in the church. Suger's description resembles an imaginary journey through the abbey, and it is the liturgy that ensures the spatial unity of the unfinished building and the display of chosen objects. This makes the church the theater of an experience of the senses, sometimes to saturation point, as Conrad Rudolph has shown.[49] Through the mediation of the objects which it possesses, the community is linked to history and claims the continuity that this implies. Consequently, "visual points of memory" are created and displayed, which also serve as so many liturgical stations. It is my belief that liturgy motivated the rearranging of church treasuries in the twelfth century, though it seems that its impact on medieval collecting has been greatly neglected. At the beginning of the thirteenth century, the distinction was made between objects considered as liturgical instruments, as curiosities, and as marvels within the treasure. It is only from then on that we may truly speak of "collecting" in the Middle Ages.

Notes

1 John of Salisbury, *Historia pontificalis* IV, p. 79: ". . . veteres statuas emit Rome, quas Wintoniam deferri fecit."
2 The most recent studies concerning medieval collections and collectors repeat the same anecdotes without really offering an analysis: see for example Rheims, *Les collectionneurs* and Cabanne, *Les Grands Collectionneurs*, two publications in the line of nineteenth-century studies in their search for amateurs of the past. Pearce and Bournia (eds.) repeat the same approach in *The Collector's Voice*, where medieval sources are practically absent.
3 For Roman collections, see Stähli, "Sammlungen ohne Sammler" (with the preceding bibliography), and Bruneau, "Les Collections d'art"; for Byzantine collections, in particular the collection of Lausos, see Bassett, "Excellent Offerings."
4 For the "reinvention" of private collections in the fourteenth century, see Pomian, *Des saintes reliques*, pp. 35ff.
5 Pomian, "Collezionismo," p. 157. Cumming ("Collecting") mentions the Middle Ages in the context of accumulations only.
6 Pomian, *Collectionneurs*, p. 18: a collection is an "ensemble d'objets naturels ou artificiels, maintenus temporairement ou définitivement hors du circuit d'activités économiques, soumis à une protection spéciale dans un lieu clos aménagé à cet effet, et exposés au regard."
7 See the studies in Tyler, ed., *Treasure*.

8 Bynum, "Wonder," p. 18. Laymen collected relics throughout the Middle Ages, even though the Church kept on questioning the legitimacy of such collections. The commerce of relics must have been flourishing in the wake of the Crusades, above all after the fourth one, as the Fourth Lateran Council (1215) forbade their sale without papal consent. On relics in general, see Geary, *Furta sacra* and "Sacred Commodities"; Legner, ed., *Reliquien* and *Reliquien in Kunst*; Angenendt, *Heilige und Reliquien*; Bozóky and Helvétius, eds., *Les Reliques*; and *Reliques et reliquaires du XIIe au XVIe siècle.*

9 Reuse was a general practice: in architecture, under the dual apparition of dismemberment for glorification and for conversion; architectonic material is reused for aesthetic or ideological purposes, and so is furniture, in particular funerary furniture, or sculpture. Written testimony proves that precious objects, in particular ivory and stones (gems, entaglios, cameos) are permanently reused (see Heckscher, "Relics of Pagan Antiquity"). The first indication of the existence of an art market goes back to the middle of the thirteenth century and concerns precisely collections of such small objects, which seems to prove that there were *connoisseurs* at that time. On the sale of 550 carved stones, some of which came from the treasury of the Holy Roman Emperor Frederic II, in Genoa in 1253, see Byrne, "Some Mediaeval Gems," and Esch, "Friedrich II."

10 Pearce speaks of collecting as a "spiritual pilgrimage" (*On Collecting*, p. 108), whereas Pomian sees in the history of collecting the history of the relationships that we entertain with the invisible (*Collectionneurs*, p. 126).

11 On this "genetic lineage," see the henceforth classical studies by Murray (*Museums*) and von Schlosser (*Kunst- und Wunderkammern*), and, to a lesser extent, Lesne (*Histoire de la propriété ecclésiastique*) and Taylor (*The Taste of Angels*). See also Pearce, *On Collecting*, pp. 405–6. [On the modern medieval museum, see chapter 30 by Brown in this volume (ed.).]

12 Olmi, "Die Sammlung."

13 *Contra*, see Pomian, *Collectionneurs*, p. 19: "les objets de collection possèdent une valeur d'échange sans valeur d'usage."

14 *Regalia* refers to an ensemble of objects symbolizing royalty, formed by royal garments, and liturgical and coronation instruments.

15 Gauthier, *Routes*, p. 94: "La muséologie débute par les collections de reliques." The phenomenon is at least attested since the beginning of the fourteenth century.

16 For a complete bibliography before 1900, see Lugli, *Naturalia et Mirabilia.*

17 De Mély and Bishop, *Bibliographie*; Campori, *Raccolta di cataloghi*. See also Klemm, *Zur Geschichte*, and Furtwängler, *Über Kunstsammlungen.*

18 See Caillet, "Le Trésor," and Sire, "Les Trésors des cathédrales."

19 In particular Gaborit-Chopin (ed.), *Le Trésor de Saint-Denis*, and Durand (ed.), *Le Trésor de la Sainte-Chapelle*; see also Ehlers (ed.), *Der Welfenschatz*, and *Der Basler Münsterschatz.*

20 Palazzo, "Le Livre." On collections of books, see for instance Stirnemann, "Les Bibliothèques," and Tesnière, "Medieval Collections."

21 On furniture for conservation, see among others Polonovski and Perrault, "Le Trésor," and Krause, "Zur Geschichte." Other famous pieces include the painted cupboard in the Cathedral of Bayeux and the sacristy chest in the Cistercian Abbey of Aubazine (Corrèze).

22 Durandus of Mende, *Rationale divinorum officiorum* I, III, 43: "In nonnullis ecclesiis ova structionum et huiusmodi, quæ admirationem inducunt et quæ raro videntur, consueverunt suspendi, ut per hoc populus ad ecclesiam trahatur et magis afficiatur" (p. 49).

23 Lorraine Daston and Katharine Park come to the same conclusion: "Medieval collections bore little resemblance to early modern or modern musuems. They functioned as repositories of wealth and of magical and symbolic power rather than as microcosms, sites of study, or places where the wonders of art and nature were displayed for the enjoyment of their proprietors and the edification of scholars and amateurs" (*Wonders and the Order of Nature*, p. 68; cf. p. 383, n.3).

24 See Jennifer Greitschuhs, "Bemerkungen"; Lugli, *Naturalia et Mirabilia*.

25 For many years a pear was seen to be hanging from the narthex wall at St Denis, as Hincmar reports in his compilation of the miracles of the saint (Hincmar of Rheims, *Miracula sancti Dionysii* I, 18; see also I, 7 [oats sheaf in the narthex], I, 8 [ram's horn hanging from the abbey door], etc.).

26 Suger, *Le trésor de Saint-Denis*, pp. 310–11.

27 Ibid., pp. 223–5.

28 Suger, *Le trésor de la Sainte-Chapelle*, pp. 182–3.

29 On the *curiositas* in the Middle Ages, beside Oberman, *Contra vanam curiositatem*, see Cabassut, "Curiosité," II, 2: cols. 2654–61; Labhardt, "Curiositas"; Zacher, *Curiosity and Pilgrimage*, pp. 18–41; Newhauser, "Towards a History of Human Curiosity"; Peters, "*Libertas Inquirendi*"; Kenny, *Curiosity in Early Modern Europe*, pp. 33–49; Peters, "The Desire to Know"; Krüger (ed.), *Curiositas*.

30 Bernard, *De gradibus humilitatis et superbiae*, X, 28: "primus itaque superbiæ gradus est curiositas." Cf. idem, III, 14, 2–3: "Curiositas, cum oculis ceterisque sensibus vagatur in ea quæ ad se non attinent," and therefore anything that draws a monk from himself can but remove him from God. On St Bernard and curiosity, see Leclercq, "Curiositas."

31 Oberman, *Contra vanam curiositatem*, p. 23.

32 Numbers 4: 20: "Alii nulla curiositate videant quæ sunt in sanctuario priusquam involvantur, alioquin morientur." Odo of Deuil, *De profectione*, pp. 64–6.

33 In the period between 1180 and 1320 there are more and more stories of marvels, monsters, miracles, and ghosts: Bynum, "Wonder." See Kenseth, ed., *The Age of the Marvelous* and Findlen, *Possessing Nature*.

34 Daston, "Marvelous Facts."

35 Bischoff, *Mittelalterliche Schatzverzeichnisse*, ad v. *struthio, ovum struthionis*. Sometimes these eggs are supposed to be griffon eggs.

36 This parallelism is mentioned in certain bestiaries at the end of the thirteenth century, in particular in the *Libro della natura degli animali*, XXXVIII; see Morini, ed., *Bestiari medievali*, pp. 460–1.

37 Buc, "Conversion of Objects."

38 As evidence, there is the chalice emperor Henry II offered to St Laurent (of Merseburg?): see Scheller, *Die Seelenwägung*.

39 Pearce, *On Collecting*, p. 99.

40 The cause of this correlation may be found in the teaching of Christ (Matt. 25: 31ff.) which shows the transitive character of acts of charity (good deeds) and divine mercy: "... quamdiu fecistis uni de his fratribus meis minimis mihi fecistis" (ibid., 25: 40).

41 Maines, "Good Works"; see also Gasparri, "L'Abbé Suger." On art as similar to almsgiving, see Rudolph, *Things of Greater Importance*, pp. 97–103.

42 On the display of objects, see Bandmann, "Über Pastophorien," and "Früh- und hochmittelalterliche," vol. I, pp. 371–411; Ronig, "Die Schatz- und Heiltumskammern," vol. I, pp. 134–5; Kosch, "Zur spätromanischen."

43 Examples by Gauthier, *Routes.*

44 The discovery of Arthur's tomb at Glastonbury Abbey in 1191 is another example that testifies to the investigation into the space of memory. See Albrecht, *Die Inszenierung*, pp. 93–102 (Arthur's tomb) and pp. 161–4 (Dagobert's throne). From around 1300 at least, we have testimonies of sovereigns paying visits to Church treasuries to see the "antiquities" and, indeed, learn history, guided by the Prior or the Treasurer who appear to be true "*periegetes.*"

45 Schnapp, *La conquête*, p. 98. The manipulation of objects, mostly reliquaries, is only one sign of the general investigation into the remote *loci* of memory. It becomes stronger and more effective from the twelfth century on, and prepares for the rediscovery of Antiquity in the next.

46 Remensnyder, "Legendary Treasure," esp. pp. 884–5: "Memorial or monument is a physical object to which a commemorative meaning is attached; it is inherently instable and fluid, as memory itself." See also idem, *Remembering Kings Past.*

47 Schwarz, "Die Onyxkanne."

48 *Gesta episcoporum Halberstadensium, ad a. 1205* (MGH, SS, XXIII, pp. 120–1); see Andrea, *Contemporary*, pp. 239–64. On art to attract donations, see Rudolph, *Things of Greater Importance*, pp. 20ff.

49 Rudolph, *Things of Greater Importance*, pp. 63ff.

Bibliography

Stephan Albrecht, *Die Inszenierung der Vergangenheit im Mittelalter. Die Klöster von Glastonbury und Saint-Denis* (Berlin, 2003).

Alfred J. Andrea, *Contemporary Sources for the Fourth Crusade* (Leiden, 2000).

Arnold Angenendt, *Heilige und Reliquien. Die Geschichte ihres Kultes vom frühen Christentum bis zur Gegenwart* (Munich, 1997).

Horst Appuhn, *Schatzkammern in Deutschland, Österreich und der Schweiz* (Düsseldorf, 1984).

Günther Bandmann, "Über Pastophorien und verwandte Nebenräume im mittelalterlichen Kirchenbau," in *Kunstgeschichtliche Studien für Hans Kauffmann* (Berlin, 1956), pp. 19–58.

——, "Früh- und hochmittelalterliche Altaranordnung als Darstellung," in *Das erste Jahrtausend. Kultur und Kunst am Rhein un Ruhr*, 3 vols. (Düsseldorf, 1962).

Der Basler Münsterschatz (Basel, 2001).

Sarah Guberti Bassett, " 'Excellent Offerings': The Lausos Collection in Constantinople," *Art Bulletin* LXXXII: 1 (2000), pp. 6–25.

Bernhard Bischoff, *Mittelalterliche Schatzverzeichnisse* (Munich, 1967).

Edina Bozóky and Anne-Marie Helvétius, eds., *Les Reliques. Objets, cultes, symboles* (Turnhout, 1999).

Philippe Bruneau, "Les Collections d'art dans l'antiquité gréco-romaine," in O. Bonfait, ed., *Curiosité. Etudes d'histoire de l'art en l'honneur d'Antoine Schnapper* (Paris, 1998), pp. 257–64.

Philippe Buc, "Conversion of Objects," *Viator* 28 (1997), pp. 99–143.

Caroline W. Bynum, "Wonder," *American Historical Review* CII: 1 (1997), pp. 1–26.

E. H. Byrne, "Some Mediaeval Gems and Relative Values," *Speculum* 10 (1935), pp. 177–87.

Pierre Cabanne, *Les Grands Collectionneurs, I: Du Moyen-Âge au XIXe siècle* (Paris, 2003).

André Cabassut, "Curiosité," *Dictionnaire de Spiritualité* (Paris, 1953).

Jean-Pierre Caillet, "Le Trésor, de l'antiquité tardive à l'époque romane: bases de la recherche actuelle et éléments de problématique," in Jean Taralon, ed., *Les Trésors de sanctuaires, de l'antiquité à l'époque romane* (Paris, 1996), pp. 5–18.

Giuseppe Campori, *Raccolta di cataloghi ed inventarii inediti di quadri, statue, disegni, bronzi, dorerie, smalti, medaglie, avorii, ecc. dal secolo XV al secolo XIX* (Modena, 1870).

Robert Cumming, "Collecting," in *The Dictionary of Art* (New York and London, 1996), vol. 4, pp. 560–5.

Lorraine Daston, "Marvelous Facts and Miraculous Evidence in Early Modern Europe," *Critical Inquiry* 18 (1991), pp. 93–124.

Lorraine Daston and Katharine Park, *Wonders and the Order of Nature, 1150–1750* (New York, 1998).

Jannic Durand, ed., *Le Trésor de la Sainte-Chapelle* (Paris, 2001).

Durandus of Mende, *Rationale divinorum officiorum* I, III, 43, in *Guillelmi Duranti Rationale divinorum officiorum* (CCCL, CXL), ed. A. Davril and T. M. Thibodeau (Turnhout, 1995).

Jean Ebersolt, *Sanctuaires de Byzance, recherches sur les anciens trésors de Constantinople* (Paris, 1921).

Joachim Ehlers, ed., *Der Welfenschatz und sein Umkreis* (Mainz, 1998).

Arnold Esch, "Friedrich II. und die Antike," in A. Esch and N. Kamp, eds., *Friedrich II. Tagung des Deutschen Historischen Instituts in Rom im Gedenkjahr 1994* (Tübingen, 1996), pp. 201–34.

Paula Findlen, *Possessing Nature. Museums, Collecting, and Scientific Culture in Modern Italy* (Berkeley, 1994).

Anatole Frolow, *Les Reliquaires de la Vraie Croix* (Paris, 1965).

Adolf Furtwängler, *Über Kunstsammlungen in der alten und neuen Zeit* (Munich, 1899).

Danielle Gaborit-Chopin, ed., *Le Trésor de Saint-Denis* (Paris, 1991).

Françoise Gasparri, "L'Abbé Suger de Saint-Denis. Mémoire et perpétuation des œuvres humaines," *Cahiers de Civilisation Médiévale* XLIV: 175 (2001), pp. 247–57.

Marie-Madeleine Gauthier, *Les Routes de la foi. Reliques et reliquaires de Jérusalem à Compostelle* (Fribourg, 1983).

Patrick J. Geary, *Furta sacra. Thefts of Relics in the Central Middle Ages* (Princeton, 1978).

——, "Sacred Commodities: The Circulation of Medieval Relics," in A. Appadurai, ed., *The Social Life of Things. Commodities in Cultural Perspective* (Cambridge, 1986), pp. 169–91.

Jennifer Greitschuhs, "Bemerkungen zum Fortschrittsglauben der Kunst- und Wunderkammern-Forschung," *Kritische Berichte* 4 (1988), pp. 36–40.

W. S. Heckscher, "Relics of Pagan Antiquity in Medieval Settings," *Journal of the Warburg and Courtauld Institutes* 1 (1937–8), pp. 204–21.

John of Salisbury, *The* Historia Pontificalis *of John of Salisbury*, ed. and trans. Marjorie Chibnall (Oxford, 1986).

Neil Kenny, *Curiosity in Early Modern Europe* (Wolfenbüttel, 1998).

Joy Kenseth, ed., *The Age of the Marvelous* (Hanover, NH, 1991).

Gustav Klemm, *Zur Geschichte der Sammlungen für Wissenschaft und Kunst in Deutschland* (Zerbst, 1837).

Clemens Kosch, "Zur spätromanischen Schatzkammer (dem sog. Kapitelsaal) von St. Pantaleon: eine vorläufige Bestandsaufnahme," *Colonia Romanica* 6 (1991), pp. 34–63.

Hans-Joachim Krause, "Zur Geschichte und Funktion des spätromanischen Schranks im Halberstädter Domschatz," *Sachsen und Anhalt* 19 (1997), pp. 454–94.

Klaus Krüger, ed., *Curiositas. Welterfahrung und ästhetische Neugierde in Mittelalter und früher Neuzeit* (Göttingen, 2002).

André Labhardt, "Curiositas. Note sur l'histoire d'un mot et d'une notion," *Museum Helveticum* 17 (1960), pp. 206–24.

Jean Leclercq, "'Curiositas' et le retour à Dieu chez saint Bernard," in *Recueil d'études sur saint Bernard et ses écrits* (Rome, 1992), vol. V, pp. 319–29.

Anton Legner, ed., *Reliquien in Kunst und Kult zwischen Antike und Aufklärung* (Darmstadt, 1995).

——, *Reliquien. Verehrung und Verklärung* (Cologne, 1989).

Emile Lesne, *Histoire de la propriété ecclésiastique en France*, III: *L'inventaire de la propriété. Églises et trésors des églises du commencement du VIIIe à la fin du XIe siècle* (Lille, 1936).

Adalgisa Lugli, *Naturalia et Mirabilia. Il collezionismo enciclopedico nelle Wunderkammern d'Europa* (Milan, 1983).

Clark Maines, "Good Works, Social Ties, and the Hope for Salvation. Abbot Suger and Saint-Denis," in *Abbot Suger and Saint-Denis. A Symposium* (New York, 1986), pp. 77–94.

Fernand de Mély, Edmund Bishop, *Bibliographie générale des inventaires imprimés*, 3 vols. (Paris, 1892–5).

Luigina Morini, ed., *Bestiari medievali* (Turin, 1996).

David Murray, *Museums. Their History and Their Use*, 3 vols. (Glasgow, 1904).

Richard Newhauser, "Towards a History of Human Curiosity: A Prolegomenon to its Medieval Phase," *Deutsche Vierteljahrsschrift für Literaturwissenschaft und Geistesgeschichte* LVI: 4 (1982), pp. 559–75.

Heiko Augustinus Oberman, *Contra vanam curiositatem. Ein Kapitel der Theologie zwischen Seelenwinkel und Weltall* (Theologische Studien, 113) (Zurich, 1974), p. 23.

Odo of Deuil, *De profectione Ludovici VII in orientem*, IV, ed. V. G. Berry (New York, 1948), pp. 64–6.

Giuseppe Olmi, "Die Sammlung – Nutzbarmachung und Funktion," in A. Groote, ed., *Macrocosmos in Microcosmo. Die Welt in der Stube. Zur Geschichte des Sammelns 1450 bis 1800* (Opladen, 1994).

Henk van Os, *Der Weg zum Himmel. Reliquienverehrung im Mittelalter* (Regensburg, 2001).

Eric Palazzo, "Le Livre dans les trésors du Moyen Âge. Contribution à l'histoire de la *Memoria* médiévale," in Jean Taralon, ed., *Les Trésors de sanctuaires, de l'antiquité à l'époque romane* (Paris, 1996), pp. 137–60.

Susan M. Pearce, *On Collecting. An Investigation into Collecting in the European Tradition* (London and New York, 1995).

Susan M. Pearce and Alexandra Bournia, eds., *The Collector's Voice. Critical Reading in the Practice of Collecting, I: Ancient Voices* (Aldershot, 2000).

Edward Peters, "The Desire to Know the Secrets of the World," *Journal of the History of Ideas* LXII (2001), pp. 593–610.

——, "*Libertas Inquirendi* and the *Vitium Curiositatis* in Medieval Thought," in *La Notion de liberté au Moyen Âge. Islam, Byzance, Occident* (Paris, 1985), pp. 89–98.

Max Polonovski and Gilles Perrault, "Le Trésor de la cathédrale de Noyon retrouvé. Un ensemble rarissime de mobilier médiéval," *L'Estampille* 208 (1987), pp. 32–53.

Krzysztof Pomian, *Collectionneurs, amateurs et curieux: Paris, Venise, XVIe–XVIIIe siècle* (Paris, 1987).

——, "Collezionismo," in *Enciclopedia dell'arte medievale* (Rome, 1994), vol. V, pp. 156–60.

——, *Des saintes reliques à l'art moderne. Venise–Chicago, XIIIe–XXe siècle* (Paris, 2003).

Donald Preziosi, "Collecting/Museums," in Robert S. Nelson and Richard Shiff, eds., *Critical Terms for Art History* (Chicago, 2003), pp. 407–18.

Reliques et reliquaires du XIIe au XVIe siècle. Trafic et négoce des reliques dans l'Europe médiévale (Saint-Riquier, 2000).

Amy G. Remensnyder, "Legendary Treasure at Conques: Reliquaries and Imaginative Memory," *Speculum* 71 (1996), pp. 884–906.

——, *Remembering Kings Past. Monastic Foundations Legends in Medieval Southern France* (Ithaca and London, 1995).

Maurice Rheims, *Les Collectionneurs. De la curiosité, de la beauté, du goût, de la mode et de la spéculation* (Paris, 2002).

Franz J. Ronig, "Die Schatz- und Heiltumskammern. Zur ursprünglichen Aufbewahrung von Reliquien und Kostbarkeiten," in *Rhein und Maas. Kunst und Kultur, 800–1400*, 2 vols. (Cologne, 1972).

Conrad Rudolph, *The "Things of Greater Importance". Bernard of Clairvaux's Apologia and the Medieval Attitude Toward Art* (Philadelphia, 1990), pp. 97–103.

Luigi Salerno, "Musei e Collezioni," in *Enciclopedia Universale dell'Arte* (Venice and Rome, 1963), vol. IX, cols. 738–72.

Pierre Salmon, *De la Collection au musée* (Neuchâtel, 1958).

Robert W. Scheller, *Die Seelenwägung und das Kelchwunder Kaiser Heinrichs II* (Amsterdam, 1997).

Julius von Schlosser, *Die Kunst- und Wunderkammern der Spätrenaissance* (Vienne, 1908).

Alain Schnapp, *La Conquête du passé. Aux origines de l'archéologie* (Paris, 1993).

Gerda Schwarz, "Die Onyxkanne in Saint-Maurice d'Agaune," *Helvetia archeologica* 85 (1991), pp. 17–31.

Marie-Anne Sire, "Les Trésors des cathédrales: salles fortes, chambres aux reliques ou cabinets de curiosités?," in *20 siècles en cathédrales* (Rheims, 2001), pp. 191–202.

Adrian Stähli, "Sammlungen ohne Sammler. Sammlungen als Archive des kulturellen Gedächtnisses im antiken Rom," in A. Assmann, M. Gomille and G. Rippl, eds., *Sammler – Bibliophile – Exzentriker* (Tübingen, 1998), pp. 55–86.

Patricia Stirnemann, "Les Bibliothèques princières et privées aux XIIe et XIIIe siècles," in A. Vernet, ed., *Histoire des bibliothèques françaises. Les bibliothèques médiévales, du VIe siècle à 1530* (Paris, 1989), pp. 173–91.

Hanns Swarzenski, *Monuments of Romanesque Art. The Art of Church Treasures in North-Western Europe* (Chicago, 1974).

Jean Taralon, *Les Trésors des églises de France* (Paris, 1966).

——, ed., *Les Trésors de sanctuaires, de l'antiquité à l'époque romane* (Paris, 1996).

Francis Henry Taylor, *The Taste of Angels: A History of Collecting from Rameses to Napoleon* (Boston, London, 1948).

Marie-Hélène Tesnière, "Medieval Collections of the Bibliothèque Nationale de France: From the Eighth to the Fifteenth Century," in *Creating French Culture. Treasures from the Bibliothèque nationale de France* (Paris, 1995), pp. 19–32.

Le Trésor de Saint-Denis (Paris, 1991).

Le Trésor de la Sainte-Chapelle (Paris, 2001).

Elizabeth M. Tyler, ed., *Treasure in the Medieval West* (Woodbrige and Rochester, 2000).

Christian K. Zacher, *Curiosity and Pilgrimage. The Literature of Discovery in Fourteenth-Century England* (Baltimore and London, 1976).

The Concept of *Spolia*

Dale Kinney

Spolia are hot. An eruption of conferences, seminars, and publications in the past two or three decades has put a once obscure antiquarian subject in the limelight. Yet despite the increasing familiarity of the word *spolia*, the subject remains difficult to grasp in its entirety. Textbooks do not include it. The Grove *Dictionary of Art* has no main entry for *spolia*, only a few paragraphs buried under other headings: "Masonry, II" (vol. 20), and "Rome, VII. Antiquarian revivals" (vol. 26). Most of the literature on *spolia* is in German, followed by Italian and French, with hardly any English or American publications before the 1990s. The only comprehensive monograph is in Italian.

The subject denoted by *spolia* is materials or artifacts in reuse. As indicated by the subheading in the *Dictionary of Art*, initially *spolia* were reused bits of ancient Rome: the second-century reliefs on the fourth-century Arch of Constantine, or the ancient column shafts and capitals in St Peter's and other Christian basilicas.[1] Contemporary art historians use the word *spolia* more loosely, to refer to any artifact incorporated into a setting culturally or chronologically different from that of its creation.

As a label, *spolia* is both metaphorical and anachronistic. A Latin word meaning "spoils" or anything "stripped" from someone or something, "*spolia*" was coined as a term for reused antiquities by artist-antiquarians active in Rome around 1500. This use of *spolia* postdates medieval Latin, in which the word retained its classical, military meaning of "things taken by force." In medieval texts, reused objects or materials are called by their proper names, "columns," "marble," "sarcophagi," etc. This point would be merely pedantic if the metaphor did not have connotations that favor or even foster triumphalist and appropriationist interpretations.

Spolia are not an exclusively medieval topic; on the contrary, reuse is a universal response to limitations of technology or resources. If stone blocks, bricks, and roof tiles are more easily obtained secondhand than manufactured, builders will

reuse them. It is far less laborious to melt down existing coins or vessels for recasting than it is to mine new gold and silver. Parchment can be scraped clean for new writing, and ivory plaques can be recarved. It is obvious why such forms of expedient reuse can be found in all cultures that employ durable materials.

Harder to explain is the reuse of culturally specific objects for non-pragmatic purposes, as ornament, especially when, like the reliefs of pagan emperors on the Arch of Constantine, the reused objects seem to contradict the message or purpose of their new setting. Such is the case with the gems, cameos, ivory plaques, and sarcophagi carrying profane or pagan imagery that were frequently reused in Christian contexts during the Middle Ages. The seemingly subversive effects of this practice have intrigued scholars of *spolia* for centuries.

Despite a long historiography, *spolia* are not a unified field of study. Modern scholarship on reused artifacts tends to form national traditions: with notable exceptions, Germans write about Ottonian art and architecture, the French write about medieval France, the Italians about Italy, the English about England. With no medieval patrimony of their own, Americans have ventured into all of these discourses occasionally. Although they frequently intersect, the separate threads of scholarship do not all have the same source or take the same directions. There is no common methodology. Rather than a coherent category, *spolia* might better be considered a theme of categories like architecture and sculpture, a theme that tends to be brought up in conjunction with other themes like the survival of classical antiquity or *renovatio*. *Spolia* also resonate with prominent themes of postmodern cultural criticism, such as appropriation, *bricolage*, historicism, the fragment, and ruin.

History

The label *spolia* applies most clearly to objects and materials that are obtained by despoliation, that is by robbing them from another object or site. This form of reuse is typically architectural, and in the Roman colonies of Gaul and Britain it was begun by the Romans themselves. The defensive city walls thrown up throughout Gaul in the third century were packed with stone recovered from damaged or abandoned cemeteries, temples, baths, and other public structures. In the Middle Ages these same walls became quarries for church builders tempted by the well-cut facing blocks that concealed the rubble inside. A twelfth-century chronicle reports that Charlemagne's chapel at Aachen was built with the "squared stones" of the wall of Verdun, and a document (817–25) of Louis the Pious grants permission to Archbishop Ebbo of Reims to take material from his city's wall to reconstruct Reims Cathedral.[2]

When rising walls were not available for spoliation, builders might dig for stone on the known sites of Roman habitation. One frequently cited episode is the excavation of Roman Verulamium, across the river from St Albans Abbey, by successive tenth-century abbots planning to build a new church. Abbot Eadmar

unearthed not only the squared stones, roof tiles, and columns that he needed, but also clay vessels, glass cinerary urns, "idols," coins, jewels, and carved gems.[3]

The reuse of Roman stone for building was normal until the late eleventh and twelfth centuries, especially in Britain. At that point it tapered off due to depleted supply, the technological and economic recovery that made it possible to resume new quarrying, and the novel design demands of Romanesque (or Norman) and Gothic architects.

Marble was always a special case. It was a luxury stone and its reuse was ornamental, not expedient. Even in Italy it had to be obtained secondhand, as the Mediterranean quarries that produced it were abandoned in late antiquity. Probably the best-known primary source pertaining to *spolia* is the passage in Einhard's biography of Charlemagne (*c*.825?) that reports that when the king "could not obtain the columns and marble for [his chapel at Aachen] from any place else," "he took the trouble to have them brought from Rome and Ravenna." A close second in familiarity is the claim by Abbot Suger of St Denis (*c*.1145), that when he rebuilt his abbey's church he was prepared to go to the Baths of Diocletian in Rome for columns to match those in the original seventh-century basilica, had the Lord not spared him the trouble by revealing a good source of marble in nearby Pontoise. Suger's ambition echoed Charlemagne's, as did that of the German King (and later Emperor) Otto I, who imported "precious marble, gold, and gems" to the church that he founded at Magdeburg in 955.[4]

Charlemagne probably intended the display of Roman marble (as well as porphyry and granite) *spolia* in his Palatine Chapel as a political gesture. Its scarcity and aesthetic appeal made marble desirable for other purposes as well, as an attribute of luxury or status. Marble was prized for the same qualities that drew medieval beholders to gems: its hardness, its capacity to take a glistening polish, and the variety and brilliance of color that polishing brings forth. The *Metrical Life of St Hugh of Lincoln* (bishop 1186–1200) praised the black stone that seemed like "an aristocrat of marbles" in Hugh's cathedral, "more polished than a fresh-growing fingernail, present[ing] a starry brilliance to the dazzled sight . . ."[5] This stone was not true marble, but a limestone quarried in England on the Isle of Purbeck. On the Continent, Romanesque and Gothic architecture virtually did away with marble, creating new aesthetic effects with spatial geometry and the virtuosic handling of local limestone and sandstone. Already in Ottonian architecture, marble played a diminished role compared to the previous millennium.

Outside the realm of architecture, reuse is most conspicuous in the treasury arts: reliquaries, Gospel book covers, processional and standing crosses, and jewelry.[6] Many of these artifacts incorporate older valuables such as Roman gems and cameos, Byzantine or early medieval metalwork and enamels, and Islamic rock crystals. Sensational examples include the Lothar Cross in Aachen (fig. 11-1), named for the intaglio portrait inscribed "King Lothar" (II? d.869) on the lower staff, which sports a magnificent three-layered sardonyx cameo portrait of the Roman Emperor Augustus (d.14) in the crossing; the Herimann

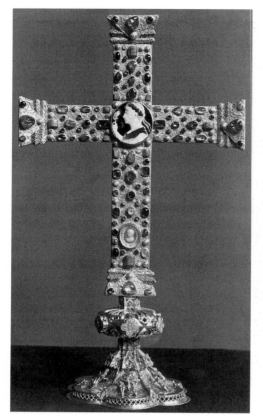

FIGURE 11-1 The Lothar Cross,
c.980–1000. Aachen Domschatz. Photo:
Bildarchiv Foto Marburg/Art Resource, NY.

Cross in Cologne (fig. 11-2), donated by Archbishop Herimann and his sister Ida, Abbess of St Maria im Kapitol (d.1060), on which a lapis lazuli female portrait, possibly of Augustus' wife Livia, functions as the head of Christ; and the Eagle Vase now in the Louvre (fig. 11-3), created for Abbot Suger by fitting an ancient porphyry vessel with the head, wings, and feet of an eagle made of gold.

Some composite objects seem blatantly syncretistic, like the golden pulpit ornamented with late antique ivory relief images of Isis, Bacchus, and Nereids that was given to the Palace Chapel at Aachen by King Henry II (r.1002–14); or the Shrine of the Three Kings in Cologne Cathedral (*c*.1200), which has large cameo images of Mars and Venus and the coronation of Nero prominently set on its front facade. Occasionally, inscriptions or other evidence show that pagan images were "converted" for Christian purposes by creative misreading, a process that modern scholars call *interpretatio christiana*. For example, the Gospel quotation "in principio erat verbum," added to a first-century sardonyx cameo donated to Chartres Cathedral in 1367, transformed an ancient relief of Jupiter with his eagle into St John and his symbol.[7]

Medieval thinking about gems is preserved in such inscriptions and in other texts. Treatises called "lapidaries" – like the especially popular verse example by Marbode, Bishop of Rennes (d.1123) – spell out the many medicinal and magical powers attributed to gemstones. Some lapidaries provide such detailed information about pagan iconography that their readers could have deciphered many of the ancient carvings on gems as well as we can today, if they were not misled by other factors. The *Book of Minerals* by the thirteenth-century Dominican philosopher Albertus Magnus updated the lapidary tradition with scientific, Aristotelian explanations, but also perpetuated the beliefs that the innate forces of stones could be enhanced by images and that some of the images seen on

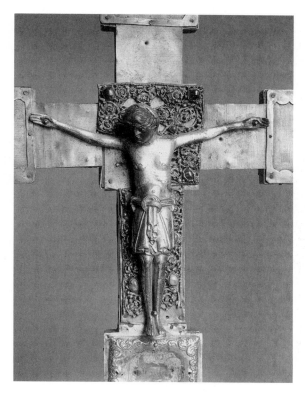

FIGURE 11-2 The Herimann Cross, *c*.1049. Cologne: Erzbischöfliches
Diözesanmuseum. Photo: Bildarchiv Foto Marburg/Art Resource, NY.

gems were produced not by carving but by astrological influence during the
formation of the stone. Albert thought that he had found one such "natural"
image in an ancient portrait cameo on the Shrine of the Three Kings, known
today as the Cameo of the Ptolemies.[8]

A different, emotional, and sensory relation to gems is recorded in the writ-
ings of Abbot Suger, who added many precious confections to the treasury of
St Denis (fig. 11-4). Suger's memoirs describe his delight in materials, nostalgic
appreciation of lost standards of craftsmanship, and pleasure at getting a good
bargain.[9]

Except in the realm of craftsmanship, Abbot Suger did not distinguish old
objects from new ones; all works in lustrous materials functioned equally as
ornamenta. It is questionable whether he or any other medieval patron or
craftsman thought of his ancient and other exotic ornaments as "reused."[10]
Technically speaking, gems were reset rather than reused. For this and other
reasons it is even more uncertain whether precious ornaments really belong to

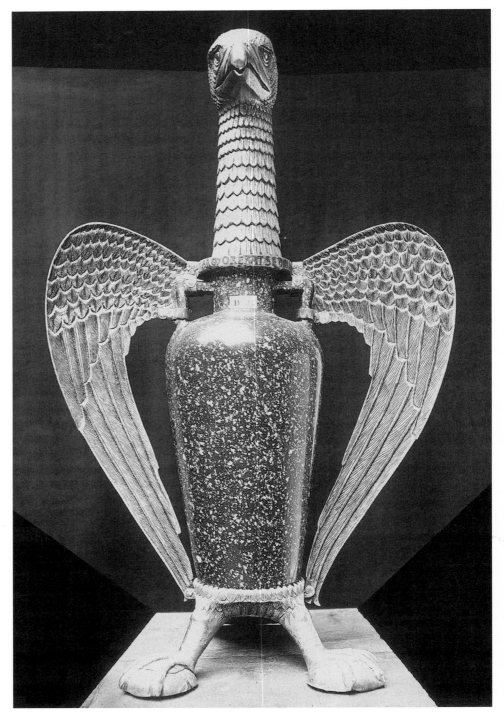

FIGURE 11-3 The Eagle Vase of Suger, *c.*1140–4. Paris: Louvre. Photo: Bridgeman-Giraudon/Art Resource, NY.

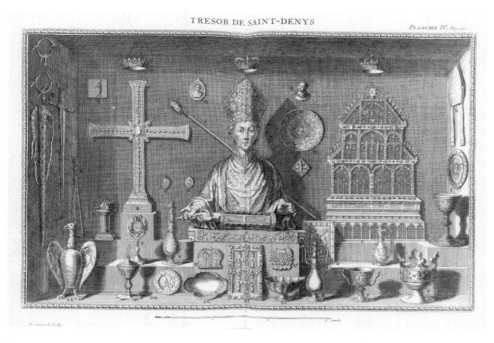

FIGURE 11-4 The Treasury of St Denis, including the Eagle Vase and other objects made for Abbot Suger. From Michel Félibien, *Histoire de l'abbaye royale de Saint-Denis en France*, plate IV. Paris: 1706. Photo: Biblioteca Apostolica Vaticana (Vaticano).

the discussion of *spolia*. Most Roman gems and other curios must have come into their donors' possession by inheritance, gift, commerce – all attested to by Suger – and excavation, as at Verulamium. Exceptions would include the treasures that came west after 1204 as a result of the Crusaders' plunder of Constantinople, which might be classified as true *spolia*, that is, *spolia* in the classical (and medieval) sense of the word. The same might be said of objects obtained via the Seljuk dispersion of the Fatimid treasury in Cairo in 1061, and of the Islamic luxury items that passed into Christian treasuries as a result of the Reconquest of Spain.

Historiography

The first general book on *spolia* was published in 1744 by Giovanni Marangoni: *Delle cose gentilesche e profane trasportate ad uso ed adornamento delle chiese*. Marangoni, an ecclesiastic, sought to demystify the presence of "pagan and profane" objects in Christian sacred spaces. The opposition of pagan and Christian became one of the most enduring themes in the study of *spolia*. In 1844 the antiquarian Thomas Wright invoked "the superstition of a barbarous age" to explain the appeal of Roman artifacts in nominally Christian Britain. In what he

described as the first archaeological analysis of ancient figured gems on liturgical objects (1932), G. A. S. Snijder proposed that the presence of each gem "prove[d] that somebody has gained a deeper insight into the power of God Almighty."[11]

The modern study of *spolia* began shortly after Snijder's article appeared, with an essay on the sculptural decoration of the Arch of Constantine by Hans Peter L'Orange (1939) and an article on spoliate colonnades in early Christian basilicas by F. W. Deichmann (1940). Both postulated the coherence of antique objects and their post-antique settings, rather than stressing oppositions. L'Orange maintained that the reuse of older figural reliefs on the fourth-century Arch of Constantine was deliberate and intelligible, not, as had been assumed, a makeshift response to lack of time or skill. He pointed to thematic echoes of the *spolia* in the reliefs newly made for the Arch, and proposed that they revealed a subtext in which both the original and the secondary meanings of the *spolia* are in play. The viewer who knows their original subjects can see the recontextualized second-century reliefs as images of Constantine the new Trajan, the new Hadrian, and the new Marcus Aurelius; that is, Constantine in the mold of the great good emperors of the past.[12]

Deichmann's similarly innovative article on "Columns and Order" in early Christian architecture argued that while the recycling of building materials was practiced in all ancient cultures, going back to Egypt and Persia, the incorporation of *spolia* into early Christian basilicas signaled something new. In conjunction with a new aesthetic preference for diversity and pattern, early Christian *spolia* constituted a new "order" that undermined and replaced the uniform Greek and Roman Orders. According to Deichmann, the new architectural order prevailed all around the Mediterranean from the fourth century to the eighth, when it degenerated into "chaotic" combinations of reused parts.[13]

Important as they were for the study of *spolia*, these essays had no perceptible effect on the scholarship on gems or architecture north of the Alps. Attention to architectural *spolia* was inhibited by national prejudices in favor of authentically French or German – that is, non-Roman – buildings, as well as by a paucity of examples after the eleventh century. Viollet-le-Duc (1859) observed the haphazard combinations of *spolia* in early medieval French churches with disdain: "Antique columns, often hewn of precious materials, were luxury objects, a sort of spoil with which they sought to embellish their homely buildings." Since he considered the Gothic style to be the supreme medieval architectural achievement, Viollet-le-Duc found any desire for marble among later medieval builders atavistic, and he dismissed Abbot Suger's scheme to import marble columns from Italy as a grandiose literary fiction.[14]

If they attended to *spolia* at all, twentieth-century architectural historians tended to follow Viollet-le-Duc in considering *spolia* an impediment to the development of new, characteristically medieval styles. Thus for Hans Jantzen (1947), Otto I's Magdeburg Cathedral with its imported columns and marble was a Carolingian throwback, as opposed to the church of St Michael at Hildesheim, where "a German architectural feeling drives out the Latin-antique."[15] Günter

Bandmann, however, devoted a page to *spolia* in a book that considered medieval architecture not as a progression of styles but as bearer of meaning (1951). Bandmann noted that the taking of architectural *spolia* was a means of empowering or "consecrating" a new building by transferring to it pieces of a holy site that had existed somewhere else; Charlemagne's use of columns from Ravenna at Aachen was an example.[16] It was Bandmann's work rather than Deichmann's that ultimately stimulated interest in *spolia* in northern medieval architecture, at least in Germany.

An example of Bandmann's influence is Wolfgang Götz's interpretation of the east end of Magdeburg Cathedral (1966), where the spoliate column shafts originally imported by Otto I were reused again in the early thirteenth century as supports for statues in the upper stories of the choir. The interruption of the Gothic elevation by these relics had baffled and annoyed earlier scholars because, as Götz observed, they judged it only on the criterion of style. Götz explained the *spolia* as embodiments of the authority of their place of origin, understood in the thirteenth century to be the prior cathedral of Otto I as well as imperial Rome. By their presence in the choir they conferred upon the thirteenth-century bishop the same rights and status enjoyed by his tenth-century predecessor.[17] Götz was a pioneer; it was not until the 1980s that this type of interpretation became familiar.

The second dominant theme associated with *spolia*, after the pagan/Christian opposition, is the survival or influence of classical antiquity. Developed in German art history before World War II, this interest was transplanted to England and America when German-Jewish scholars fled the Nazis. The library of Aby Warburg, relocated from Hamburg to London in 1933, became an institute that is still dedicated to the classical tradition, "the theme which unifies the history of Western civilization."[18]

The first volume of the *Journal of the Warburg Institute*, published in 1937–8, contained an article by William Heckscher that responded to Snijder's interpretation of ancient gems on medieval book covers. Heckscher introduced a philosophical justification, noting that gems possessed the principal qualities of beauty prescribed by neo-Platonic aesthetic theory: wholeness and clarity or translucence. Intact, unblemished gems were the antithesis of ruin, the broken or imperfect, which was repugnant. Heckscher applied this rationale not only to book covers but also to Abbot Suger's scheme to take columns from the Baths of Diocletian to St Denis:

> The modern romanticist may protest that by breaking up [i.e., taking away] columns from the baths of Diocletian, Sugerius would have impaired recklessly the beauty of an antique site. Sugerius, however, considered the columns as units, beautiful in themselves, whereas the condition of the place as a whole . . . ranged for him under the category of disintegration and therefore worthlessness.

Heckscher stressed the conviction of medieval thinkers that their world was continuous with that of ancient Rome. The Roman past was "pagan," but its

relics could be adapted by *interpretatio christiana*, as in the case of Suger's Eagle Vase. "Needless to say the eagle...superimposed upon the antique relic, is meant as a symbol of Christ."[19]

Another Warburg publication transposed the theme of classical influence into French. Jean Adhémar's *Influences antiques dans l'art du moyen âge française* of 1939 is a survey of the archaeological and literary evidence for the survival of classical ("Western") culture, especially Gallo-Roman artifacts, in medieval France. It includes many instances of Roman objects in medieval settings – altars, tombstones, sarcophagi, columns and capitals, statues, gems, diptychs – without distinguishing them from other, similar objects that survived without being reused. Preservation was Adhémar's driving interest, and he subsumed what we today might call *spolia* into the larger categories of "antiquities" and their "survival," as was typical of the Warburgian approach.[20]

Adhémar's book inspired some French followers, notably René Crozet, but the future of the Warburg school of scholarship was in English. William Heckscher's teacher, Erwin Panofsky, published his translation of Abbot Suger's writings on St Denis in Princeton in 1946. Brilliantly paralleling Suger's words with those of the fifth-century neo-Platonic philosopher "Pseudo-Dionysius," Panofsky claimed that the abbot understood the "light" and "clarity" of gems, precious metals, and glass as a means of neo-Platonic ascent from the world of matter to the immaterial world of God.[21] The neo-Platonic rationale applied to all precious objects, old and new, and like Suger himself, Panofsky paid no particular attention to reuse.

German scholars who remained in Germany tended to be skeptical of high-flown Warburgian intellectualism and to take a more intuitive and empirical approach to the same issues and objects. Hans Wentzel began his pioneering wartime article on medieval gems (1941) with a rebuff of Heckscher's "very wide-ranging speculations," asserting that his own conclusions were based on "the monuments alone." He declared flatly that with few exceptions, "the pre-Christian origin and pagan significance of the stones were unknown to the middle ages," when ancient gems were valued only for the rarity and beauty of their materials and for their amuletic effects. Wentzel claimed that most pagan gems were genuinely believed to be Christian, and gave the Herimann Cross as an example:[22]

> [The Cross] bears an antique Venus cameo as the head of Christ. This beautiful fully rounded head gives the Crucified an entirely unmedieval aspect.... It must have been an equally unusual sight around 1040.... This unique use can only have been prompted by the assumption that the cameo (doubtless discovered in the ground) was and could only be the head of the Saviour.

Of the numerous German publications on the theme of antiquity and the Middle Ages that appeared after World War II, only Richard Hamann-MacLean's long article of 1949–50 found a particular role for *spolia*. Calling them the

earliest, "most basic, most material stage of the connection between the middle ages and antiquity," Hamann-MacLean offered a list of reasons why *spolia* might have been used: convenience, economy, aesthetic appreciation of materials or workmanship, the collecting impulse, and the belief in miracles and the magic of things (*Dingzauber*). Anticipating Bandmann, he identified Charlemagne's appropriation of Roman marbles for his church at Aachen as a "magic-political" use of *spolia*, unlike the incorporation of ancient marbles into eleventh-century churches, which he saw as strictly pragmatic. He observed that gems continued to be valued for their antiquity, exquisite craftsmanship, and supernatural powers long after the reuse of other ancient artifacts had ceased. The Herimann Cross was one example; he called it "a form of reified mystery," in which the antipathy of pagan and Christian was broken down by "the timeless numen of a precious substance."[23]

The decades of the 1950s and 1960s were marked by a few impressive monographic studies and particular discoveries, including Jean Taralon's stunning revelation (1955) that the golden head of the reliquary statue of St Foi at Conques is late antique, and Joseph Hoster's demonstration (1967) that the Cameo of the Ptolemies, stolen from the Shrine of the Three Kings in 1574, is in Vienna.[24] The most enduring monograph is Josef Deér's article on the Lothar Cross (1955). Refuting earlier opinions that the central sardonyx cameo was "converted" by *interpretatio christiana* (becoming the head of Christ), Deér argued that the cameo was actually recognized and employed for what it was, a Roman imperial portrait, knowingly "appropriated" by the Ottonian donor to represent himself.

On a more abstract level, Erwin Panofsky's grand synthesis of 1965, *Renaissance and Renascences in Western Art*, introduced the inspired aphorism "principle of disjunction" to describe the dissociation of classical form from classical content, which, in his view, made it possible for classical art to survive the Christian middle ages:

> [W]herever in the high and later Middle Ages a work of art borrows its form from a classical model, this form is almost invariably invested with a non-classical, normally Christian, significance; wherever in the high and later Middle Ages a work of art borrows its theme from classical poetry, legend, history or mythology, this theme is quite invariably presented in a non-classical, normally contemporary form.

Although it was not meant to explain *spolia*, Panofsky believed that the "principle of disjunction" accounted for antique gems that were relieved of their original meaning by *interpretatio christiana*, and he cited the Lothar Cross as an example.[25] The "principle of disjunction" continues to tease scholars of *spolia*, who were still responding to it in the 1990s.

At the time, however, *spolia* studies were more affected by an unexpected and compelling article of 1969 by the German historian Arnold Esch. Drawing on an extraordinary knowledge of mostly Italian examples, Esch deduced five

essential explanations for *spolia*: convenience and availability; profanation or exorcism of demonic force; *interpretatio christiana*; retrodating or political legitimation (Bandmann's Rome "transferred in pieces"); and aesthetic wonderment or admiration ("reuse at any cost"). All of these motives had already been suggested; indeed, Hamann-MacLean produced almost the same list twenty years before. The originality of Esch's contribution lay in the recognition of *spolia* as a distinctive cultural practice, which could be isolated and analyzed on its own terms rather than as a subset of classical survival. His article defined a field.

As often happens, the impact of Esch's article was not seen for over a decade. Victor Lassalle's book of 1970 on the influence of antiquity on Romanesque art in Provence remained in the framework created by Adhémar, although it recognized "reuses" (*remplois*) as a distinctive category. Like Viollet-le-Duc, Lassalle attributed most reuse to the technical impoverishment of early medieval masons and sculptors, but in some twelfth-century examples he discerned "the intention to present . . . especially notable antique vestiges for everyone's admiration." He did not believe that reuse could be creative, however, and he dismissed the topic after only four pages.[26]

In 1983, in an essay directly influenced by Esch, Beat Brenk extended the notion of *spolia* as "art politics" (*Kunstpolitik*) to Abbot Suger's plan to bring columns from Rome to St Denis.[27] This was the first lap of what quickly became a flood of *spolia* studies, composed of publications so diffuse that they are difficult to track and even harder to categorize. Joachim Poeschke attributed the new fascination with *spolia* to the turn of art history in the 1980s to content and program (as opposed to form), as well as to the "language of materials."[28] There were other motivations as well, including an Anglo-Italian revival of interest in Warburgian problems, and a vogue for treasury exhibitions and their catalogues, which made objects like the Herimann Cross more prominent. Not surprisingly, such diverse and uncoordinated stimuli produced multiple, erratically connected lines of scholarship.

The neo-Warburgian strain is represented by the three-volume *Memoria dell'antico nell'arte italiana* (1984–6), sponsored by Salvatore Settis in Pisa. Settis' own essay, "Continuity, distance, knowledge. Three uses of the antique," is an intellectual *tour de force* that takes on Warburg, Panofsky, and the whole of German scholarship on the afterlife of classical antiquity, offering brilliant insights into *spolia* along the way. As an authentic medieval metaphor for excerpting what was usable from classical authors, *spolia* is Settis' leitmotif for the Middle Ages, the period of continuity. Citations and topoi are *spolia*; conversely, spoliate objects are citations. Excised from their original (ruined) context, citations assume the authority (*auctoritas*) of the no longer usable whole.

> The ancient fragment, enclosed within a new system of values, immediately tends to occupy the center; but its imperfect, mutilated state invites you . . . to complete it, beginning an exegetical process . . . of conjecture. It is an almost empty center,

and to fill it it is not enough to squeeze from that single fragment all of the norms that it contains; it lets you make out that there were other [norms], and challenges you to find them.

Thus the single spoliate column embodied Rome in all its aspects: "the *auctoritas* that the Roman column carried with it was that of the city – . . . capital of the imperial majesty and of Christianity; but also, at the same time, the *auctoritas* of a technical proficiency and of decorative and structural norms that were of one body with that majesty."[29]

Like many scholars, Settis assigned gems a special place. He argued that placing them in crosses or reliquaries was a deliberate means of neutralizing their pagan significance, which made *interpretatio christiana* unnecessary or after the fact. As objects of intrinsic value, gems were the model for "all reuse of antiquities for preservation or display."[30]

Settis' reflections on *spolia*, arguably the most challenging of the present era, have not yet received the attention they deserve outside Italy. More influential was Michael Greenhalgh's book of 1989, which also stands within the Warburgian framework although at the opposite pole of intellectual pretension. Explicitly devoted to "objects not ideas," Greenhalgh's overview of the survival of antiquities in Italy, Northern Europe, and England differs from previous efforts like Adhémar's in being restricted to material remains, ignoring literary, ideological, and other purely verbal components of the classical legacy.[31] Like Adhémar, Greenhalgh focused on survival, but reuse and *spolia* are much more prominently featured in his account. Greenhalgh's compendium made the topic of reuse visible and easily accessible in English, and despite occasional inaccuracies, it is a goldmine of primary and secondary sources for researchers.

Outside the Warburg tradition, the survival of Rome ceased to drive interest in reuse. Medieval treasuries contain artifacts from many eras and cultures, and scholars began to address this.[32] In the late 1980s, Hiltrud Westermann-Angerhausen, Lieselotte Stamm-Saurma, and others expanded the definition of *spolia* to include objects that were virtually new at the time of their reuse (e.g., a tenth-century Byzantine ivory in an eleventh-century book cover).[33] Julie Harris drew attention to the Islamic caskets that entered Spanish church treasuries as true *spolia* – as booty of the Christian Reconquest; and Avinoam Shalem provided a more comprehensive view of the means by which such objects passed into treasuries throughout Europe.[34]

At the same time, attention to ancient gems continued to be strong, liberated by new interpretive strategies from the strict dualities of pagan/Christian and classical/medieval. Most of this new scholarship is in German. Antje Krug's overview of ancient gems in the Middle Ages (1993) refreshed the standard account by introducing such contemporary concepts as status symbols, charisma, and heirlooms, in addition to grave-robbing, trade, connoisseurship, and humor. Her portrait of medieval collectors firmly contradicts the stereotype of credulous ignorance:[35]

We find here not a naive inability to recover the original sense of the pagan representations, nor superstitious fear of the reality of the old images that one sought to oppose with Christian content . . . but the capacity to recognize [pagan subjects] and to read them in more than one sense.

Taking a different approach, Erika Zwierlein-Diehl went back to Panofsky's principle of disjunction to restate the case for *interpretatio christiana*: "we may take it for granted that . . . gems . . . were given a Christian meaning when placed in medieval sacred objects."[36] Her reconstruction of the *interpretatio christiana* that might have been applied to the gems on the Shrine of the Three Kings in Cologne brings this interpretive model up-to-date with an understated application of semiotic principles and reception theory.[37]

North American and British scholars made their belated entrance into *spolia* studies in the 1990s. American contributions tend to reflect the larger discourse of art history on that continent, especially its preoccupation with the political instrumentality of history. George Beech's account of the "Eleanor of Aquitaine Vase" given by Abbot Suger to St Denis is an example; so is William Clark's interpretation of the reuse of marble column shafts in twelfth-century churches in Paris (1997).[38] A finely worded essay by Ilene Forsyth characterizes a number of Ottonian objects, including the crosses of Lothar and Herimann and the ambo of Henry II, as "art with history": "made up of concrete remains of ancient Roman, Early Christian, Byzantine, Fatimid, Frankish, Anglo-Saxon, Merovingian, Carolingian, and/or earlier Ottonian artifacts which in sum represent the cultural foundations of the Ottonian era." Forsyth proposed that these "aggregates" were "artistic statement[s] expressing a triumph of the whole over its own component parts, the present over its varied past."[39]

By contrast, the British discovery of *spolia* seems critically innocent, even of the prior literature on *spolia*. David Stocker's seminal article on building stone proposed three categories of reuse: casual, functional, and iconic, without reference to any previous categorizations such as Esch's. In Stocker's scheme, "casual" reuse occurs when "the function of the original stone is disregarded"; it is "functional" when an element is reused for the purpose for which it was made; and it is "iconic" when a particular stone is reused because of its associations, history, or "superstitious power." Stocker's categories seem roughly equivalent to Esch's motives of convenience (= casual and functional), *interpretatio christiana*, exorcism and legitimation (= iconic); they do not explicitly recognize aesthetic beguilement.[40]

Tim Eaton's *Plundering the Past* (2000) provides a useful synthesis of recent British scholarship on architectural reuse, and also debunks some common assumptions about the practice and its motivations. He is critical of Stocker's classification, noting that it confuses descriptive labels ("casual" and "functional") with explanation. Eaton's remedy is drastic, collapsing all possibilities into just two categories of intention: "practical" (which includes "economy, convenience, professional preference [and] technological necessity")

and "meaningful" (including "an appreciation of the material's age-value [and] esotericism").[41]

Books on *spolia* are still rare. Lucilla de Lachenal's was the first attempt to survey the entire subject, but it is overwhelmingly focused on Italy. The few remarks on Ottonian art are dominated by the paradigm of "the antique as the legitimation of [political] power" and are out of touch with contemporary scholarship on objects like the Lothar Cross.[42]

While de Lachenal treats all perpetuations of ancient Roman material and literary culture as *spolia*, the multi-authored *Antike Spolien* promotes a much narrower definition, confined to the reuse of materials in architecture.[43] Of the dozen essays in this volume, three discuss buildings in post-millennium Northern Europe. Cord Meckseper inventories *spolia* imported for the Ottonian cathedral at Magdeburg; Joachim Poeschke briefly discusses Magdeburg's thirteenth-century choir and the façade of St Remi at Reims; and Thomas Weigel responds to Thomas Raff's position that *spolia*, like relics, were valued for authenticity and venerability rather than for aesthetic reasons. Weigel marshals primary sources to show that even a programmatic use of *spolia* did not exclude regard for their beauty, quality, or size.

Another conference publication, the acts of the forty-sixth annual "Study Week" of the Italian Center for Study of the Early Middle Ages in Spoleto (1999), though mostly about Italy, contains some papers of broader relevance.[44] Umberto Eco offers a semiotic model for medieval approaches to citation (a form of reuse), which he illustrates with a metaphorical garment. The life of a jacket can be prolonged by reversal, mending, patching, adaptation, and, finally, dismemberment to be incorporated elsewhere as patchwork or *bricolage*. All of these processes alter the original, and Eco's point is that medieval citation always expresses new content disguised by reuse.[45]

Anthony Cutler's call for a distinction between reuse and use is especially relevant to the discussion of gems. In Cutler's view, the difference turns on the intention of the (re)user and the reception of the altered or recontextualized artifact. He maintains that unlike people today, medievals accepted the "mutability" of objects and valued them "as much [for their] utility in the present and in the foreseeable future as [for their] antiquity."[46]

Conclusion

The study of *spolia* is in a dynamic state of becoming, working itself out through what might be called a trialectic of specific, general, and theoretical publications. The process is illustrated by a recent series of attempts to recover the meaning of the Lothar Cross.

On the basis of a systematic study of all gemmed crosses, Theo Jülich argued that these objects were multilayered signs alluding to the crucifixion, second coming, and heavenly dominion of Christ. He concluded that a portrait in the

center of such a cross could not have represented a donor, as had been the prevailing opinion of the Lothar Cross since Deér. Citing a medieval exegete who interpreted sardonyx as a sign of the two natures of Christ, Jülich insisted that the sardonyx cameo on the Lothar Cross must have represented Christ as ruler in heaven.[47]

Approaching the "iconology as a *spolium*" of the same cameo, Norbert Wibiral began with the semiotic premise, grounded in an eighth-century source, that "expressions of content in art are often polyvalent." He asserted that in its Ottonian adaptation, the central cameo represented the Emperor Augustus, not (only) as himself but in his medieval Christian function as *figura*, the image of Christ in his first and second coming.[48]

Both interpretations employ appropriate historical sources and reasoning, so on purely historical grounds it is impossible to choose between them. Ilene Forsyth's explanation operates on another plane; it provides a general pattern for interpreting the Lothar Cross and other objects like it. The pattern accommodates Wibiral's specific interpretation but not Jülich's. Forsyth's categorical account depends on a conception of *spolia* as – in medieval eyes – embodiments of history.

Philippe Buc's article on the "Conversion of Objects" operates on the same plane but offers a somewhat different model, informed by social-historical theories of the "life of things." Buc proposes that "object-conversion [as when an ancient Roman object is given to a church treasury] establishes a relationship of superiority" of the object's present status over its past, and "signifies a transfer of power one hopes to freeze into eternity." In the particular case of object-donations to St Denis, such as the Eagle Vase, Buc argues that the objects' illustrious past ownership and varied histories created a "memorial network" for Abbot Suger, auguring salvation by commemorating his place "at the center of a web defined by his age's most famous figures of power."[49]

The categorical explanations of Forsyth and Buc both posit history as an essential attribute of *spolia* or converted objects. In this respect both are challenged by the still more abstract question posed by Cutler: were ancient gems, vessels, and other such objects *reused* by their medieval donors, or just *used*? In Cutler's distinction, reuse is "at least in part, a historicist gesture," while use is driven by present value or need.

Theo Jülich undoubtedly would opt for use. Like Antje Krug and Erika Zwierlein-Diehl, Jülich avoids the term *spolia*, preferring "gems" or "cameos" or the name of the material – "sardonyx," "amethyst," etc. Items of use are open to a broader array of interpretive models than *spolia*, as seen in Thomas Raff's exposition of the medieval "iconology of materials." Defining the "iconology of materials" as the "semantics, symbolism, and allegory" of the substances of which art is made, Raff explicitly addresses *spolia* in an excursus. He explains that he did not reserve a particular chapter for *spolia* because he finds the fact of reuse less significant than the properties of a material and the reasons for choosing it. Consequently he dispersed cases of reuse among chapters on

other topics: "Material as Relic," "Materials as Topographical References," and "Materials as Historical References."[50]

These and other examples indicate that the historiography of *spolia* cannot be confined to *spolia*. Raff rejects the category and Buc never uses the word. Avinoam Shalem showed that *spolia* ("trophies") would be far too restrictive a label for Islamic treasury objects, which were also gifts, commodities, and souvenirs. Rather than a corpus of objects, *spolia* is a still evolving analytic concept, which functions like a spotlight to make objects appear momentarily different. The objects themselves are both more and less than they appear.

Notes

1　Kinney, "*Spolia*," pp. 121–2.
2　"Chronicon Hugonis monachi virdunensis et divionensis abbatis flaviniacensis," in Pertz, ed., *Monumenta*, pp. 351–2; Schlosser, *Schriftquellen*, p. 248.
3　Lehmann-Brockhaus, *Lateinische Schriftquellen*, pp. 410–11.
4　Dutton, trans., *Charlemagne's Courtier*, p. 32; Panofsky, *Abbot Suger*, pp. 90–1; Warner, trans., *Ottonian Germany*, p. 104.
5　Garton, trans., *Metrical Life*, pp. 54–7.
6　[On the sumptuous arts, see chapter 22 by Buettner in this volume (ed.).]
7　Wentzel, "Mittelalterliche Gemmen," p. 49.
8　Riddle, *Marbode of Rennes*; Wickoff, trans., *Albertus Magnus*, pp. 65, 128, 131.
9　Panofsky, *Abbot Suger*, pp. 56–67, 72–3, 76–9, 102–9.
10　[On patronage, see chapter 9 by Caskey in this volume (ed.).]
11　Wright, "Antiquarian Excavations," p. 447; Snijder, "Antique and Medieval," p. 17.
12　L'Orange, *Spätantike Bildschmuck*, pp. 161–91.
13　Deichmann, "Säule und Ordnung."
14　Viollet-le-Duc, *Dictionnaire raisonné*, vol. 3, pp. 491–6; vol. 6, p. 317.
15　Jantzen, *Ottonische Kunst*, pp. 17–18, 23–7.
16　Bandmann, *Mittelalterliche Architektur*, p. 145.
17　Götz, "Magdeburger Domchor."
18　<http:www.sas.ac.uk/warburg/institute/institute_introduction.htm> (consulted August 2004).
19　Heckscher, "Relics of Pagan Antiquity," pp. 220, 217.
20　Adhémar, *Influences antiques*.
21　Panofsky, *Abbot Suger*, pp. 15–26.
22　Wentzel, "Mittelalterliche Gemmen," p. 46, n.1 *bis*, p. 49.
23　Hamann-MacLean, "Antikenstudium," pp. 161–73.
24　Taralon, "La Nouvelle Présentation," pp. 123–4; Taralon and Taralon-Carlini, "La Majesté d'or"; Hoster, "Wiener Ptolemäerkameo."
25　Panofsky, *Renaissance and Renascences*, pp. 84, 88.
26　Lassalle, *L'Influence antique*, pp. 13–16.
27　Brenk, "Sugers Spolien."
28　Poeschke, "Einleitung," in *Antike Spolien*, p. 9.
29　Settis, "Continuità," pp. 421–2.

30 Ibid., pp. 478–80.
31 Greenhalgh, *Survival*, p. 7.
32 [On treasuries, see chapter 10 by Mariaux in this volume (ed.).]
33 Westermann-Angerhausen, "Spolie und Umfeld"; Stamm-Saurma, "Die 'auctoritas' des Zitates."
34 Harris, "Muslim Ivories"; Shalem, *Islam Christianized*.
35 Krug, "Antike Gemmen," p. 167. [On collecting, see chapter 10 by Mariaux in this volume (ed.).]
36 Zwierlein-Diehl, "*Interpretatio christiana*," p. 70.
37 [On reception, see chapter 3 by Caviness in this volume (ed.).]
38 Beech, "The Eleanor of Aquitaine Vase"; Clark, "Defining National Historical Memory."
39 Forsyth, "Art with History," p. 153.
40 Stocker and Everson, "Rubbish Recycled."
41 Eaton, *Plundering the Past*, p. 135.
42 De Lachenal, *Spolia*, pp. 7, 152.
43 Poeschke, "Einleitung," in *Antike Spolien*, pp. 7–9.
44 *Ideologie e pratiche del reimpiego nell'alto medioevo. 16–21 aprile 1998* (Settimane di Studio del Centro Italiano di Studi sull'alto Medioevo, 46) (Spoleto, 1999), 2 vols.
45 Eco, "Riflessioni."
46 Cutler, "Reuse or Use?"
47 Jülich, "Sakrale Gegenstände," pp. 254–6.
48 Wibiral, "*Augustus patrem figurat*," pp. 105–6, 119–20.
49 Buc, "Conversion of Objects," pp. 110, 138, 123–7.
50 Raff, *Sprache der Materialien*, pp. 9, 72–4.

Bibliography

Jean Adhémar, *Influences antiques dans l'art du moyen âge française. Recherches sur les sources et les thèmes d'inspiration* (London, 1939).

Günter Bandmann, *Mittelalterliche Architektur als Bedeutungsträger* (Berlin, 1951).

George T. Beech, "The Eleanor of Aquitaine Vase, William IX of Aquitaine, and Muslim Spain," *Gesta* 32 (1993), pp. 3–10.

Beat Brenk, "Sugers Spolien," *Arte medievale* 1 (1983), pp. 101–7.

Philippe Buc, "Conversion of Objects," *Viator* 28 (1997), pp. 99–143.

William W. Clark, "Defining National Historical Memory in Parisian Architecture (1130–1160)," in Nancy Gauthier and Henri Galinié, eds., *Grégoire de Tours et l'espace gaulois. Actes du Congrès International Tours, 3–5 novembre 1994* (Tours, 1997), pp. 341–58.

Anthony Cutler, "Reuse or Use? Theoretical and Practical Attitudes Toward Objects in the Early Middle Ages," in *Ideologie e pratiche del reimpiego nell'alto medioevo. 16–21 aprile 1998*, 2 vols. (Settimane di Studio del Centro Italiano di Studi sull'alto Medioevo, 46) (Spoleto, 1999), vol. 2, pp. 1055–83.

Josef Deér, "Das Kaiserbild im Kreuz. Ein Beitrag zur politischen Theologie des früheren Mittelalters," *Schweizer Beiträge zur allgemeinen Geschichte* 13 (1955), pp. 48–110.

Friedrich Wilhelm Deichmann, "Säule und Ordnung in der frühchristlichen Architektur," *Roemische Mitteilungen* 55 (1940), pp. 114–30.

Paul Edward Dutton, trans., *Charlemagne's Courtier. The Complete Einhard* (Peterborough, Canada, 1998).

Tim Eaton, *Plundering the Past. Roman Stonework in Medieval Britain* (Stroud, 2000).

Umberto Eco, "Riflessioni sulle tecniche di citazione nel medioevo," in *Ideologie e pratiche del reimpiego nell'alto medioevo. 16–21 aprile 1998*, 2 vols. (Settimane di Studio del Centro Italiano di Studi sull'alto Medioevo, 46) (Spoleto, 1999), vol. 1, pp. 461–84.

Arnold Esch, "Spolien. Zur Wiederverwendung antiker Baustücke und Skulpturen im mittelalterlichen Italien," *Archiv für Kulturgeschichte*, 51 (1969), pp. 1–64.

Ilene H. Forsyth, "Art with History: The Role of Spolia in the Cumulative Work of Art," in Christopher Moss and Katherine Kiefer, eds., *Byzantine East, Latin West. Art-Historical Studies in Honor of Kurt Weitzmann* (Princeton, 1995), pp. 153–62.

Charles Garton, trans., *The Metrical Life of Saint Hugh of Lincoln* (Lincoln, 1986).

Wolfgang Götz, "Der Magdeburger Domchor. Zur Bedeutung seiner monumentalen Ausstattung," *Zeitschrift des Deutschen Vereins für Kunstwissenschaft* 20 (1966), pp. 97–120.

Michael Greenhalgh, *The Survival of Roman Antiquities in the Middle Ages* (London, 1989).

Richard H. L. Hamann-MacLean, "Antikenstudium in der Kunst des Mittelalters," *Marburger Jahrbuch* 15 (1949–1950), pp. 157–245; repr. in Peter Cornelius Claussen, ed., *Stilwandel und Persönlichkeit. Gesammelte Aufsätze 1935–1982* (Stuttgart, 1998), pp. 83–171.

Julie Harris, "Muslim Ivories in Christian Hands: the Leire Casket in Context," *Art History* 18 (1995), pp. 213–21.

W. S. Heckscher, "Relics of Pagan Antiquity in Mediaeval Settings," *Journal of the Warburg Institute* 1 (1937–8).

Joseph Hoster, "Die Wiener Ptolemäerkameo – einst am Kölner Dreikönigenschrein," in Frieda Dettweiler, Herbert Köllner and Peter Anselm Riedl, eds., *Studien zur Buchmalerei und Goldschmiedekunst des Mittelalters. Festschrift für Karl Hermann Usener zum 60. Geburtstag am 19. August 1965* (Marburg an der Lahn, 1967), pp. 55–64.

Ideologie e pratiche del reimpiego nell'alto medioevo. 16–21 aprile 1998 (Settimane di Studio del Centro Italiano di Studi sull'alto Medioevo, 46) (Spoleto, 1999), 2 vols.

Hans Jantzen, *Ottonische Kunst* (Munich, 1947).

Theo Jülich, "Sakrale Gegenstände und ihre Materialen als Bedeutungsträger," *Rheydter Jahrbuch für Geschichte, Kunst und Heimatkunde* 19 (1991), pp. 254–6.

Dale Kinney, "Spolia. *Damnatio* and *renovatio memoriae*," *Memoirs of the American Academy in Rome* 42 (1997), pp. 117–48.

Antje Krug, "Antike Gemmen und das Zeitalter Bernwards," in Michael Brandt and Arne Eggebrecht, eds., *Bernward von Hildesheim und das Zeitalter der Ottonen. Katalog der Ausstellung Hildesheim 1993*, vol. 1 (Hildesheim, 1993), pp. 161–72.

Lucilla de Lachenal, *Spolia. Uso e reimpiego dell'antico dal III al XIV secolo* (Milan, 1995).

Victor Lassalle, *L'Influence antique dans l'art roman provençal* (Paris, 1970).

Otto Lehmann-Brockhaus, *Lateinische Schriftquellen zur Kunst in England, Wales und Schottland vom Jahre 901 bis zum Jahre 1307*, vol. 2 (Munich, 1956).

Hans Peter l'Orange, with Armin von Gerkan, *Der spätantike Bildschmuck des Konstantinsbogens* (Berlin, 1939).

Erwin Panofsky, *Abbot Suger on the Abbey Church of St.-Denis and its Art Treasures* (Princeton, 1946); ed. G. Panofsky-Soergel (Princeton, 1979).

——, *Renaissance and Renascences in Western Art* (London, 1965).

Georg Heinrich Pertz, ed., *Monumenta Germaniae Historica. Scriptores*, vol. 8 (1848, repr. Leipzig, 1925).

Joachim Poeschke, ed., *Antike Spolien in der Architektur des Mittelalters und der Renaissance* (Munich, 1996).

Thomas Raff, *Die Sprache der Materialien. Anleitung zu einer Ikonologie der Werkstoffe* (Munich, 1994).

John M. Riddle, *Marbode of Rennes' (1035–1123) De lapidibus considered as a medical treatise with text, commentary and C. W. King's translation* (Wiesbaden, 1977).

Julius von Schlosser, *Schriftquellen zur Geschichte der karolingischen Kunst* (Vienna, 1892).

Salvatore Settis, "Continuità, distanza, conoscenza. Tre usi dell'antico," in Settis, ed., *Memoria dell'antico nell'arte italiana*, vol. 3, *Dalla tradizione all'archeologia* (Turin, 1986), pp. 373–486.

Avinoam Shalem, *Islam Christianized. Islamic Portable Objects in the Medieval Church Treasuries of the Latin West*, 2nd edn. (Frankfurt am Main, 1996).

G. A. S. Snijder, "Antique and Medieval Gems on Bookcovers at Utrecht," *Art Bulletin* 14 (1932).

Lieselotte Stamm-Saurma, "Die 'auctoritas' des Zitates in der berwardinischen Kunst," in *Bernwardinische Kunst. Bericht über ein wissenschaftliches Symposium in Hildesheim vom 10.10 bis 13.10.1984* (Göttingen, 1988), pp. 105–26.

David Stocker, with Paul Everson, "Rubbish Recycled: A Study of the Re-Use of Stone in Lincolnshire," in David Parsons, ed., *Stone: Quarrying and Building in England AD 43–1525* (Chichester, 1990), pp. 83–101.

Jean Taralon, "La Nouvelle Présentation du trésor de Conques," in *Les Monuments historiques de la France* (Paris, 1955).

Jean Taralon and Dominique Taralon-Carlini, "La Majesté d'or de Sainte Foy de Conques," *Bulletin monumental* 155 (1997), pp. 23–30.

Eugène-Emanuel Viollet-le-Duc, *Dictionnaire raisonné de l'architecture française du XI^e au XVI^e siècle*, vol. 3 (Paris, 1859); vol. 6 (Paris, n.d.).

David A. Warner, trans., *Ottonian Germany. The Chronicon of Theitmar of Merseburg* (Manchester, 2001).

Hans Wentzel, "Mittelalterliche Gemmen. Versuch einer Grundlegung," *Zeitschrift des Deutschen Vereins für Kunstwissenschaft* 8 (1941), pp. 45–98.

Hiltrud Westermann-Angerhausen, "Spolie und Umfeld in Egberts Trier," *Zeitschrift für Kunstgeschichte* 50 (1987), pp. 305–36.

Norbert Wibiral, "*Augustus patrem figurat*. Zu den Betrachtungsweisen des Zentralsteines am Lotharkreuz im Domschatz zu Aachen," *Aachener Kunstblätter* 60, *Festschrift für Hermann Fillitz zum 70. Geburtstag* (1994).

Dorothy Wickoff, trans., *Albertus Magnus. Book of Minerals* (Oxford, 1967).

Thomas Wright, "On Antiquarian Excavations and Researches in the Middle Ages," *Archaeologia* 30 (1844).

Erika Zwierlein-Diehl, "'Interpretatio christiana': Gems on the *Shrine of the Three Kings* in Cologne," in Clifford Malcolm Brown, ed., *Studies in the History of Art*, 54, *Engraved Gems: Survivals and Revivals* (Washington, DC, 1997), pp. 63–83.

12

The Monstrous

Thomas E. A. Dale

Since the mid-nineteenth century, the interpretation of the monstrous in Roman-esque and Gothic art has been significantly influenced by a single text: St Bernard of Clairvaux's *Apologia* composed in 1125 for Abbot William of St Thierry. After a broader critique of religious art, Bernard asks:

> [I]n the cloisters, before the eyes of the brothers while they read – what is that ridiculous monstrosity doing, an amazing kind of deformed beauty and yet a beautiful deformity? What are the filthy apes doing there? The fierce lions? The monstrous centaurs? The creatures part man part beast? . . . You may see many bodies under one head, and conversely many heads on one body. On one side the tail of a serpent is seen on a quadruped, on the other side, the head of a quadruped is on the body of a fish. Over there an animal has a horse for the front half and a goat for the back; here a creature which is horned in front is equine behind. In short, everywhere so plentiful and astonishing a variety of contradictory forms is seen that one would rather read in the marble than in books, and spend the whole day wondering at every single one of them than in meditating on the law of God.[1]

Without describing any particular cloister, Bernard evokes beautifully both the diversity of the monstrous and the complex reactions to it. His account high-lights three categories that defined the monstrous for Christian writers since the early Middle Ages, including Augustine and Isidore of Seville: animals made monstrous by the superfluity or absence of parts such as the double-bodied lions joined to a single head; hybrid animals combining different species; and finally, one semi-human hybrid, the centaur. To his representative examples one could add the ubiquitous sirens and the Plinian races inhabiting the margins of the known world; indeed, by the fourteenth century, Sir John Mandeville could define the monster quite simply as "a thing deformed against kind, both of man or of beast or of anything else."

FIGURE 12-1 Historiated initial "P,"
Moralia in Job, made at Cîteaux. Dijon:
Bibliothèque Municipale, MS 173, fol. 66.
Photo: Bibliothèque Municipale, Dijon.

To broaden our picture of the monstrous it is also necessary to take into account the changing functional contexts of the monstrous. In Romanesque art, monsters are particularly associated with monasticism. Although they are sometimes relegated to the margins – the socle zone of mural painting, the archivolts of doorways, or exterior corbels (modillions) – they are also frequently depicted in more central fields of representation. Thus, a satyr-like creature confronts a goat-headed man within an initial in the early twelfth-century manuscript of Gregory the Great's *Moralia in Job*, now in Dijon (fig. 12-1); and a cloister capital from St Michel-de-Cuxa (*c.*1140) displays at eye-level Bernard's double-bodied lions (fig. 12-2). In Gothic art, while patronage expands to encompass public and private works for lay elites, there is also a significant displacement of monsters to the margins. Monsters that inhabited historiated initials in Romanesque texts are banished to the margins of Gothic manuscripts such as the Luttrell Psalter (fig. 12-3). Here we also see a greater playfulness: a human-headed hybrid wearing an inverted kettle is combined with a metallic blue body and the webbed feet of an aquatic bird.

As to the meaning and function of the monstrous, Bernard is ambivalent. He is clearly attracted to the sculptures that he criticizes: not only does he accurately describe the creatures that appear in cloisters (fig. 12-2); he also responds with wonder (*mira, mirando*) to the paradoxical "beautiful deformity" of monsters.[2] Bernard's ambivalence stems from the fact that even though monsters in stone potentially distracted monks from reading or meditation, they could also be meaningful. The term *monstrum* in medieval Latin refers to that which *demonstrates* or points to something else, and it is the contradictory form of the monster that makes it a particularly effective sign.[3] By the twelfth century, monstrosity was so integral to metaphorical thinking that Bernard could describe himself as a "chimera" of his time in reflecting on his own hybrid social status as contemplative monk and worldly diplomat.[4]

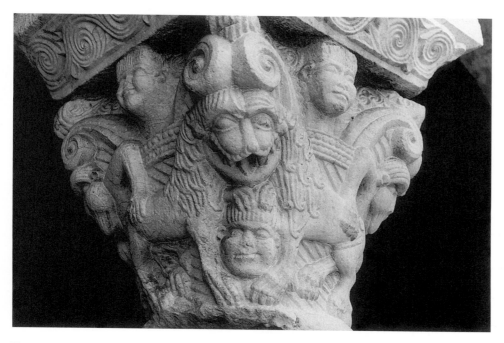

FIGURE 12-2 Capital with double-bodied lions threatening men, from the Cloister of St Michel-de-Cuxa. New York: The Metropolitan Museum of Art, The Cloisters Collection, 25.120.855. Photo: author.

Modern scholarly opinion has been divided between those who insist on the essentially decorative role of monsters and those who invest them with meaning, and further between those for whom the monstrous is integral to the dominant religious culture and those who see it as manifesting popular dissent. This chapter begins with an assessment of Bernard's impact on nineteenth- and twentieth-century historiography as a voice against meaning. It then traces the changing interpretation of the monstrous on a thematic basis. Finally, it concludes with a case-study which responds to Bernard's question concerning the purpose of monsters in monastic art.

St Bernard and the Critique of the Monstrous

As Schapiro and others have observed, the paradox of Bernard's text is that he so powerfully articulates the essence of the monstrous forms that he condemns.[5] It has also been noted that elsewhere in the *Apologia*, Bernard does support art that is addressed to the laity.[6] Since the nineteenth century, however, Bernard's *Apologia* has consistently been cited in favor of the assumption that monsters served no religious purpose but represented the fantasy of artists. As Rudolph

no: domine deus meus magnifi
catus es uehementer.
Confessionem ⁊ decorem induisti:
amictus lumine sicut uestimento:
Extendens celum sicut pellem:
qui tegis aquis superiora eius.
Qui ponis nubem ascensum tuū:
qui ambulas super pennas uen
torum
Qui facis angelos tuos spiritus:
⁊ ministros tuos ignem urentem.
Qui fundasti terram super stabi
litatem suam: non inclinabitur
in seculum seculi.

FIGURE 12-3 *Babewyns* in the Luttrell Psalter. London: British Library Add.
MS 42130 fol. 182v. Photo reproduced by permission of the British Library.

FIGURE 12-4 Engraving of a Gargoyle, from Ste Chapelle, Paris. Reproduced from Viollet-le-Duc, *Dictionnaire raisonné de l'architecture française*, vol. VI, fig. 6. Paris: 1866.

has shown, the earliest scholarship on Bernard's *Apologia*, dating back as far as Mabillon's 1690 introduction to the text, explained the critique of religious art as a reaction against the dangers of visual curiosity and distraction.[7] This notion was repeated by other French commentators in the mid-nineteenth century, but it was Eugène-Emmanuel Viollet-le-Duc who recast Bernard's text as an attack on monstrous images that were irrational and meaningless. Viollet understood Bernard to be attacking the "most strangely sculpted images" in Cluniac mona-steries because they were "contrary to the Christian spirit."[8] He argued that it was largely due to Bernard's protests that the iconography of sculpture in Gothic cathedrals was "controlled under the supreme authority of bishops." Banished from cathedral interiors, monsters appeared primarily in exterior sculpture such as gargoyles (fig. 12-4), and these he attributed to the enduring popular taste for ancient monsters kept alive by lay artists.[9]

Viollet-le-Duc made a number of questionable, but subsequently influential, arguments. He assumed that Bernard condemned monsters because they repres-ented superstitious belief and had no meaning. As Rudolph has shown, however, Bernard's primary complaint is that monstrous images will distract the monk from his reading and meditation.[10] The association of the monstrous exclusively with the Cluniacs is also misleading, since Bernard was clearly disturbed by the monsters that appeared in earlier Cistercian art itself under Stephen Harding – most notably in the Cîteaux *Moralia in Job* (fig. 12-1).[11] Viollet-le-Duc also drew an untenable distinction between the "superstitious" use of monsters in Romanesque art and the rationalism of Gothic art, ignoring the extensive display of monsters in cathedrals themselves.

Emile Mâle, the leading figure of a second generation of French medievalists, had a more nuanced view of the monstrous in Romanesque and Gothic art. Amplifying the method of Adolphe-Napoléon Didron, the important early developer of systematic iconography, Mâle affirmed that most images in medieval art could be explained by religious texts.[12] In his volume on Romanesque art, he interpreted animals both domestic and fantastic on the basis of the moralizations in the bestiary. When it came to more inventive hybrids, however, he cited Bernard's *Apologia* as evidence that "hybrid monsters on capitals had no meaning."[13] In his book on Gothic art, Mâle further argued that "grotesques" in gargoyles, misericords, and marginalia in thirteenth-century manuscripts were "of essentially popular origin."[14] He connected the more humorous inventions with the creativity of competitive, young sculptors. His emphasis on artistic license is common to a broader current of late nineteenth-century French scholarship that saw in medieval monsters the origins of the contemporaneous art of caricature. Champfleury, for example, had evoked Bernard's name in 1872 as proof that monstrous gargoyles were nothing more than "useless caprices" of sculptors.[15]

Here we see the kernel of an idea that was later articulated in its most influential form by Meyer Schapiro. In his 1947 essay "On the Aesthetic Attitude in Romanesque Art," Schapiro argued that Bernard was particularly disturbed by monstrous images because they were the product of a profane, "thoroughly unreligious" imagination.[16] Schapiro assumed that cloister capitals were carved by lay artists who had free rein to express themselves in one of the most sacred spaces of the monastery. He further argued that the monstrous combat scenes found in Cistercian manuscripts such as the Cîteaux *Moralia in Job* (fig. 12-1) were "entirely independent of the accompanying text" and "astoundingly modern in their freedom of conception."

Schapiro applied the same theory to Gothic marginalia.[17] Contrary to Mâle's notion of medieval art being governed by order and piety, Schapiro described the margins as "open to primitive impulses and feelings"; he also stressed again that marginalia manifested the "artist's liberty, his unconstrained possession of space." Schapiro's insistence on the freedom and "modernity" of medieval artists clearly reflects his engagement with the art of his own time.[18] His flirtation with Marxist ideology also led him to see the artist in opposition to the Church hierarchy; he thus downplayed the particular historical and religious contexts in which the images were used. Ignoring Bernard's careful distinctions between monastic and lay viewers, Schapiro ultimately cast monsters both in the monastic cloister and in books for the laity as products of the same profane imagination.

Ornament and Formalism

A second response that downplays meaning in the monstrous focuses on ornament. Emile Mâle assimilated the most common, heraldically posed beasts and

monsters in Romanesque art to a vast ornamental repertory, ranging from ancient Mesopotamian and Sassanian art to more recent Byzantine textiles, which made their way to France as objects of gift exchange, as imported ornament for liturgical vestments, or as wrappings for relics. The German scholar Richard Bernheimer arrived at similar conclusions, evoking again Bernard of Clairvaux's critique.[19] Paralleling Riegl's universalizing theories of ornament, Bernheimer argued that monsters in Romanesque sculpture had their origins in Near Eastern art and that the distant cultures were related not so much by shared religious meaning as by the "will to form" (*Formwille*) of the artist.

A more systematic theory of the formal development of the monstrous in Romanesque and Gothic art was forged during the 1930s by Jurgis Baltrušaitis, a pupil of Henri Focillon. In his first book on the topic, Baltrušaitis argued that Romanesque sculpture entails a dialectic between geometry and nature and that organic forms are distorted or deformed to conform to the surrounding frame and an inner "ornamental" logic.[20] He suggested that Romanesque artists created monsters either by combining elements of known species or by transforming an ordinary creature to conform with the internal rhythms of an ornamental vinescroll or the natural geometry of a capital. The impulse towards symmetrical compositions could lead further to the creation of double-bodied creatures joined to a single head, such as those described by St Bernard (fig. 12-2). In a second work focused on Gothic art, Baltrušaitis documented the debt of medieval artists to ancient Greek, Roman, and Mesopotamian sources, as well as Chinese and Japanese motifs. Most convincing are the parallels between the fantastic hybrids found on ancient intaglios and their counterparts in Gothic marginalia known as *grylli*.[21] These creatures, which are particularly common in the margins of late thirteenth- and fourteenth-century English, French, and Flemish manuscripts, substitute an enlarged head for a body combined with other heads and features of different species (figs. 12-3, 12-4). Baltrušaitis contended that such borrowings would have been facilitated during the thirteenth century by the growing appreciation for ancient intaglios and their magical properties.

Baltrušaitis' teacher, Henri Focillon, incorporated the monstrous into a more influential, formalist definition of Romanesque art as ornament or decoration. Focillon argued that Romanesque monsters in which the body or head are doubled, coincide with the "ornamental dialectic" between the organic and the logic of the geometric frame. The frame, in turn, constrains the monstrous and "assures the intertwining and interpretation of the parts so well that each ornamental block . . . is like a little enclosed world . . . which carries within it its own law."[22] This dialectic play between the monstrous and the frame, he suggested, paralleled the structure of scholastic thought.

No one since Baltrušaitis and Focillon has traced so thoroughly the formal development of the monstrous. It would seem that the moment of formalist analysis of the monstrous had passed by the second half of the twentieth century, when contemporary art itself expanded beyond "decoration" and abstraction to

embrace the figural subject again. More recent scholarship, questioning the search for sources as far afield as the ancient Near East and China, has emphasized the influence of indigenous, pre-Christian Celtic, Scandinavian, and Germanic traditions.[23]

Monstrous Iconography

Writing around the middle of the nineteenth century, the Abbé Charles-Auguste Auber was amongst the first commentators to propose an iconography of the monstrous. Auber contended that Bernard disparaged monsters in the cloister only because they constituted an unnecessary expense.[24] At the same time, he showed that Bernard was aware of the significance of monsters when he deployed them as metaphors for heretics or associated them with demonic powers.[25] On this basis, Auber suggested that the hybrids Bernard described in cloister capitals should be understood as images of heretics.[26] In gargoyles (fig. 12-4) Auber found a perfect synthesis of practical and metaphorical function: monsters are placed outside the church, because they represent the expulsion of demons or the possessed from the sanctuary.[27] Their monstrous forms and their grimaces represent their evil natures and the convulsions they suffer when exorcized from the church. Anticipating recent explanations of gargoyles as reflections of "popular culture," Auber suggested that their monstrous forms might have been inspired by the fantastic serpents and dragons carried in urban festivals to celebrate the triumph of Christianity over paganism.[28]

While Auber provides a useful framework for understanding the monstrous, his interpretations lack the specificity required by Mâle's iconographic method. Although Mâle dismissed Gothic gargoyles and marginalia as artistic fantasy, he did interpret those monsters mentioned in biblical or bestiary texts and in the great thirteenth-century encyclopedias as negative moral signs or vices.[29] His method was also adapted by German-language scholarship in the mid-twentieth century. Herbert Schade, like Mâle, drew largely upon biblical exegesis to suggest that monsters were susceptible to the fourfold interpretation of scriptural texts in terms of historical (literal), allegorical, tropological, and anagogical meanings.[30] He also emphasized the connection between monsters and demons.

More recent iconographical studies have expanded the range of textual sources. Lillian Randall's seminal essays on marginalia in Gothic manuscripts consider monsters as one of many types of marginal motifs which draw not only on the bestiary and monster literature such as the *Marvels of the East* but also *fabliaux* and *exempla* designed to embellish sermons.[31] Randall accepts Schapiro's notion that Bernard's critique of monsters in the monastery stemmed from their association with "profane imagination," but she goes on to show how themes from ostensibly secular literature came to be incorporated into ecclesiastical art under the influence of *exempla* from sermon literature. Randall attributes the inclusion of such motifs in the margins of religious and secular texts to the increasing lay

audience for books drawn from an emerging upper middle class in Northern Europe.

While iconography is still a necessary first step in decoding conventional monsters, the more inventive creations such as the marginalia of the Luttrell Psalter (fig. 12-3) defy easy classification. Furthermore, as Leclercq-Marx has shown, in the rare instances in which inscriptions are included, the text is often at odds with the image and serves, at best, to identify a general category of monster.[32] The indeterminacy of much monstrous iconography has led Michael Camille to posit an "anti-iconography" based on Walter Ong's theories of orality.[33] Focusing on the ravenous beasts in the Romanesque trumeau of Souillac, Camille proposed a host of oral associations for the monk, ranging from the monastic discipline of *ruminatio* to vices such as oral gratification of both sexual and culinary appetites, and the monk's anxieties over being devoured by wild animals in this world or fantastic monsters in hell. The advantage of Camille's approach is that it recognizes the potential polyvalence of unconventional monsters.

Another "anti-iconography" is proposed by David Williams. Instead of assuming that monsters are negative moral signs, Williams proposes that they are paradoxical signs alluding to the invisible God.[34] Citing the negative theology of Pseudo-Dionysius the Areopagite, as translated for the Latin West by John Scottus Eriugena, Williams argues that hybrid monsters reveal the unknowable God by showing that which He is not. It is the negation of form, order, hierarchy, and reason itself that also causes the monstrous to elicit the derision of churchmen such as Bernard.[35] Although Williams has been criticized for exaggerating the impact of the Pseudo-Dionysius, his approach is echoed in a number of recent essays. Robert Mills, for example, has suggested that three-headed images of the Christian Trinity cast Christ as hybrid "monster."[36] Beyond representing literally the three persons in one, such images, he suggests, furnished palpable metaphors for the paradoxical admixture of diverse natures in Christ's body.

Psychology and the Apotropaic

Long before Sigmund Freud had published his theories of psychoanalysis, French scholars saw a general psychological basis for representations of monsters. As early as 1884, Elphège Vacandard embraced A. Joly's view that the monsters in the historiated initials of the Cîteaux *Moralia in Job* (fig. 12-1) presented "a startling image of the deepest side of our nature, of our brutality, violence."[37] Since the early twentieth century, Freudian psychology has played a pre-eminent role in trying to understand the function of monsters as a kind of cathartic expression of the inner workings of the artist's unconscious mind. Meyer Schapiro was amongst the first art historians to apply this approach to monsters in Romanesque and Gothic art. In an essay on the sculpture of Souillac, he described the monstrous combats of the trumeau as manifesting a collective respect for, and fear of violence in feudal society which was "sublimated in mythical themes

of divine protection." Schapiro similarly affirmed that Bernard's monstrous cloister capitals manifested "a world of projected emotions, psychologically significant images of force, play, aggressiveness, anxiety, self-torment and fear."[38]

While Schapiro focused on aggression and violence, two scholars of the Vienna School, Ernst Kris and Sir Ernst Gombrich, analyzed the monstrous in relation to caricature and the comic. Following Freud's theory of laughter, Kris viewed the comic as a mechanism for coping with anxiety. The satyrs, goat demons, cock dancers and comic devils in medieval art and literature thus revealed for him "another more sinister shape once feared and dreaded." He also argued that grinning Gothic gargoyles (fig. 12-4) simultaneously turned away evil with laughter and terrified the spectator.[39]

Ernst Gombrich focused on the recuperative aspect of monsters in a larger study of ornament. Gombrich called the margins "zones of license" and he contended that the majority of monsters should be seen as "creations in their own right" and the "dream work" of the artist. Like Schapiro, he understood the monsters described by Bernard as a tool for mastering instinctual urges by "giving them an outlet of an acceptable shape."[40] But he also emphasized a certain ambivalence which upsets our sense of order: understood as real monsters, the images inspire fear of the unknown and demonic, but seen as playful inventions, they elicit laughter. Ultimately, he answered Bernard's question regarding the purpose of monsters in the cloister by recalling a more universal, apotropaic function.

Gombrich's apotropaic theory is echoed in much recent scholarship. Peter Dinzelbacher argues that demonic and monstrous creatures were "imprisoned in stone" to assure the faithful that evil powers would be vanquished by the church.[41] He also cites concrete evidence for associating gargoyles (fig. 12-4) with exorcism: a German "Hexenbuchlein" (c.1500) records that gargoyles, like magical spells, turn away witches, cats, wolves, and other malevolent creatures. In a broad-ranging study, which considers monstrous hybrids together with disembodied heads or masks, animals, entertainers, and scatological imagery, Ruth Mellinkoff likewise argues that the entire range of "grotesques" and "drolleries" served as talismans.[42] By variously evoking laughter or fear, confusion or distraction, monsters both represent demons and avert their attacks.

More specific interpretations are preferred for monstrous images accompanied by texts. For Elizabeth Valdez del Alamo, a capital in the Silos cloister depicting birds attacking harpies and lions' masks, dramatizes the prayer inscribed on its abacus: text and image evoke Santo Domingo's power to protect the faithful from harm.[43] Focusing on monastic spirituality, Conrad Rudolph has shown how monsters in the Cîteaux *Moralia in Job* relate to the monk's own interior "spiritual struggle" outlined in Gregory the Great's commentary.[44] Rudolph interprets semi-hominal hybrids as warning the monks of their potentially irrational or "bestial" behavior. This descent to the bestial is illustrated in the initial heading of Book 28 (fig. 12-1): at the base of the initial a naked man appears on all fours, ridden like a beast of burden, and higher up, the human body is

transformed into semi-hominal hybrids including a bull-headed satyr attacking a goat-headed man. Although not all of the hybrid initials can convincingly be related to adjacent texts, Rudolph's method of psychological interpretation is constructive, because it sets the images concretely within the monastic milieu in which they were used.

Popular Culture

While the images in the Cîteaux *Moralia* can be linked directly to the text's commentary on monastic life, it is often argued that inventive marginalia in Gothic manuscripts such as the Luttrell Psalter (fig. 12-3) were addressed primarily to the laity. An alternative to dismissing marginalia as the product of the artistic fantasy has gained currency in the past 20 years under the banner of popular culture. The most influential exponent of this approach, the Russian literary scholar Mikhail Bakhtin, saw the carnivalesque and laughter as keys to understanding popular culture as a ritualized release from the official controls of social, sexual, and religious behavior. According to Bakhtin, medieval popular or "folk" culture is manifested in three distinct forms: ritual spectacles such as the Feast of Fools or carnival before Lent; comic verbal compositions, including both oral and written parodies of sacred texts; and various genres of Billingsgate–type curses, oaths, and popular blazons.[45] Furthermore, like all forms of "grotesque realism," the "people's laughter," he argued, was a debasement of the higher, literally bringing it down to earth and the "bodily lower stratum." It was also simultaneously recuperative or reproductive.[46]

Bakhtin's work came to the forefront of medieval studies after the appearance of the first English translation in 1968. Yet, it must be noted that many of his sources, including the *fabliaux*, mystery plays, and medieval festivals, had already been used selectively by literary historians as early as the late eighteenth century. Karl Floegel's *Geschichte des groteskekomischen* (1788) held that the "grotesque-comedy," manifested in medieval mystery plays, secular guild and religious festivals such as the Feast of Fools, met an essential human need shared with other cultures throughout human history to "let off steam" and protest authority. Floegel's theory was extended to the visual arts in 1865 by Thomas Wright's history of caricature and the grotesque.[47] Wright argued that English caricature in his own day was rooted in medieval drolleries of illuminated manuscripts (fig. 12-3) and entertainments like the mystery plays; both visual images and performances parodied official clerical culture.

Michael Camille was the most influential exponent of popular culture's role in medieval art. In his 1992 survey of marginalia, Camille drew upon anthropological theory to define the margins as a "liminal" zone bridging the sacred and the profane, high and low, textual and oral; he further explored how popular culture both critiques and sustains the elite and sacred culture it frames.[48] Amplifying Leslie Bridaham's discussion of gargoyles in relationship to "popular" festivals

such as the Feast of Fools, Camille interpreted monsters in Gothic sculpture as depicting an "inverted order" of the clergy's hierarchically structured lives.[49] He affirmed that the exterior of a church, like the margins of a page, allowed for a certain amount of free play because it lay at the intersection of sacred and secular space in the city.

In his monograph on the Luttrell Psalter, Camille appealed again to Bakhtin's notion of popular culture providing an officially sanctioned space for social criticism, parody, and protest.[50] He connected the hybrid *babewyns* such as those on the margins of folio 182v (fig. 12-3), with folk plays performed by peasants from Lincolnshire, where the psalter was made. Their theatrical metamorphosis from one species to another was also understood as alluding to the inversion of social roles. The monsters' large open mouths and orifices might parody the mouths of the readers reciting psalms, but their prominent display of bottom parts of animals could also evoke the regenerative function of Bakhtin's "lower bodily stratum." The human-headed monster at the base of 182v (fig. 12-3) illustrates this quite literally in that a great leaf sprouts like a tail from his behind. Echoing Aaron Gurevich's critique of Bakhtin,[51] Camille saw no contradiction in the representation of "low" or "folk" culture images in the pages of an "elite" knight's psalter, because the knight was inextricably linked to the land and the people he controlled. In the end, Camille understood the *babewyns* of the Luttrell Psalter as an unofficial discourse appropriated by official culture for its own ends, manipulated and "kept in place" by logocentric culture.

Katrin Kröll has recently revived Kris's approach to the monstrous as a manifestation of the comic mode.[52] She argues that Bernard was principally concerned that the simultaneously ugly and comic aspects of monsters in the cloister would stimulate the monk in ways that would hinder his spiritual meditations. At the same time, she argues that Church authorities generally considered monstrous images to be acceptable as a "coping mechanism" for the laity within certain boundaries. Monstrous creatures on the margins of sacred images functioned much like the temporary inversions of social order represented within officially sanctioned masking rituals during the Feast of Fools and mystery plays.

While Kröll and Camille see popular culture as integral to elite culture, both challenging and reinforcing its boundaries, Nurith Kenaan-Kedar argues that the monsters and deformed humans sculpted in Romanesque modillions and Gothic gargoyles were created by lay artists in opposition to official clerical culture.[53] Because of their functional and supporting roles in the architectural structure, Kenaan-Kedar reasons, modillions and gargoyles naturally encompass "a lower category of art" distinct from the "official" art of façades, portals, and capitals. She also hypothesizes different readings of the sculptures by clerical patrons, lay audiences, and artists: the former would have understood the marginal images as representing the punishment of vice; the artists and lay public, by contrast, would have sympathized with the images of secular society as a form of protest.

What seems difficult to justify is Kenaan-Kedar's clear distinctions of audience responses to the monstrous. Is it really possible that the clergy who

commissioned this sculpture would have been oblivious to the "subversive" messages of some of the images? Kröll's and Camille's model is more pragmatic: popular culture can hardly be seen in complete isolation from elite culture when the only textual sources describing it come from elite culture, and the images themselves appear within an ecclesiastical framework.

Ideology, Race, and Gender

Reflecting the postmodern era's preoccupation with alterity and hybridity, medievalists, since the late 1980s, have increasingly associated the representation of monsters with the denigration of deviant or marginal social groups.[54] Friedman interprets the depiction of monstrous races on the eastern margins of *Mappae Mundi* as a medieval example of Edward Said's "orientalism."[55] Monstrous races were viewed not merely as "wonders" of nature or as moralizations of sinfulness, but also as the means of labeling and distancing disparate social groups and non-Christian religious groups. As such, the monstrous races were more extreme examples of the caricatured bodies that were used more generally to represent non-Christians and heretics within and outside Europe.[56] As Debra Strickland has shown, it was particularly during the period of the Crusades, when conflicts were escalated between European Christians and foreign non-Christians, that Saracens, Mongols, black Africans ("Ethiopians"), Muslims, and Jews alike were quite literally transformed in art into monstrous hybrids, befitting their status as "barbarous," morally debased, and demonic opponents of Christendom.[57] Examining the monstrous closer to home, Rhonda Knight has similarly argued that the thirteenth-century manuscripts of Gerald of Wales's *Topographia Hibernica* cast the Irish as hybrid beasts in need of being civilized by British colonizers and their Welsh surrogates.[58]

Recent feminist scholarship has affirmed either that women were assimilated to the monstrous or that monstrous images were designed to intimidate them. According to Margaret Miles, medieval clerics cast the female body as quintessentially "grotesque" as a result of Eve's role in the Fall, and her embodiment of sexuality.[59] For this reason, John Mandeville included female prodigies in his *Travels*, such as the daughter of Hippocrates, who revealed her monstrous nature by transforming herself into a dragon. Because women were viewed as the cause of lust in men, they were also represented with grotesquely enlarged genitals, as in the case of sheela-na-gigs, or as half-human hybrids such as the siren.

Madeline Caviness argues against what she terms the "masculinist" interpretations of monsters in comical terms.[60] Focusing on the margins of the Hours of Jeanne d'Evreux, Caviness interprets monsters here as sexually charged images that terrorized and controlled the behavior of the female viewer. The constant allusion to masculine sexuality in the form of monsters with phallic tails and weapons, engaged in aggressive combat, would have been sufficiently repulsive to draw the female reader back to the words on the page and her devotions.

Against this gender-specific interpretation of monsters, however, Lucy Sandler notes that the same kind of monstrous hybrids in combat appear in the margins of books designed for male patrons.[61]

Vision, Imagination, and Memory

Most recent scholarship assumes that monstrous images are not merely text illustrations, but also palpably affect the eyes and minds of the beholder. It is only since the 1990s that art historians have seriously explored the ramifications of vision for the representation of the monstrous. Michael Camille suggested that staring *grylli* in the margins of fourteenth-century prayer books such as the Luttrell Psalter (fig. 12-3) both warned against the susceptibility of the eyes to demonic gazes and potentially distracted the reader's eyes from the sacred, deliberately countering the pious gaze of lay donors depicted in the same manuscripts.[62] Camille also explained the proliferation of hybrid monsters through the mechanics of vision.[63] The imagination or *phantasia*, he noted, was understood by scientists of vision such as Albert the Great as a force that could create new images. As an intermediary between the imagination and memory, *phantasia* had the capacity to generate images of a man with two heads or a hybrid with a human body, a lion's head, and the tail of a horse.

As Mary Carruthers has shown, images of monsters held in memory could also be used to stimulate the process of thought.[64] The fearful monsters so frequently represented around the margins of Gothic prayer books might serve to generate anxiety as a prelude to meditation.[65] Yet they were also potentially amusing and could be used in didactic contexts to stimulate productive thinking. As early as the eleventh century, drawings of hybrid monsters appeared alongside verbal descriptions in pedagogical texts known as the *versus rapportati*, which were elementary exercises designed to practice cognitive pattern formation.[66] The parts that make up the hybrids provide a visual cue to the "division" of verses into smaller parts which must be recombined in order to make any sense of them. Monstrous exercises thus facilitated the ability to invent or recombine familiar material in new ways.

Sandy Heslop's essay on the "chimera" capital in the Canterbury Cathedral crypt (*c.*1100) furnishes a concrete application of comparable theories.[67] Citing the writings of the patron of the crypt, St Anselm, Heslop proposes that the sculptor represented the most inventive "chimeras" in a figural capital closest to the altar as an allusion to the creative process and the Divine Creator himself. Anselm had argued that whereas the Creator conceived of all creatures *ex nihilo* before physically creating them, artists, even when they produced hybrids that never existed, could only combine parts of creatures that already existed in memory. The chimera-hybrid, which had no natural antecedent, was as close as the artist could come to divine invention. This positive view of the imagination, Heslop further argues, was eclipsed in the mid-twelfth century by

the authoritative texts of Bernard and others such as John of Salisbury, who saw chimeras either as distractions from spiritual matters, or as the product of dreams, impaired mental or physical health. What Heslop leaves unexplained is the continuing popularity of monsters in monastic art in spite of the protests of Bernard and his adherents.

A Response to St Bernard

Although it is now clear that Bernard particularly deplored the visualization of monsters because of their potential to distract the monk, it remains to be understood what purpose monstrous images served for iconophile Benedictine monks. Focusing on the Romanesque cloister of St Michel-de-Cuxa, I propose that the monstrous capitals served both moralizing and cathartic functions.[68]

The Cuxa cloister offers an unusually wide range of the subjects censured by Bernard: double-bodied lions joined to a single head (fig. 12-2), "filthy apes" seated adjacent naked men, semi-human hybrids such as the siren, and monstrous mouths devouring human torsos (fig. 12-5). Conventional iconographical analysis helps us interpret individual motifs as negative moral signs: the siren may be identified with lust, the apes with the devil and fallen men, the threatening lions with those of Psalm 55; the monstrous mouths evoke the Hell-mouth and its biblical precursors, Leviathan and Behemoth (Job 41: 14; 40: 15–24), and the mouths of Sheol (Num. 16: 30–2; Ps. 106: 17). Taking into account the psychoanalytical perspectives of Kris, Gombrich, and Schapiro, it is also possible to see in these grinning monsters an allusion both to monastic anxieties over diabolical interventions, and a certain comic aspect designed to ward off those same fears. But in order to understand why such negative images would have been represented in cloister sculpture, we need to examine monastic psychology in more concrete terms.

An essential clue to understanding how the monstrous images functioned in the minds of the monks is offered by the juxtaposition of monstrous and human bodies in the Cuxa capitals. In some instances, naked monks squat in the poses of adjacent apes; yet on the same capitals, the center of each face is marked by more athletic figures who stand in erect poses and even attempt to lift their squatting brothers up. In still other examples naked and clothed figures appear threatened by double-bodied monsters (fig. 12-2) or more directly assimilated to monstrous creatures in the form of hybrids. These images suggest a deeper reality within monastic thought in which the body and its verbal and visual representations functioned as an image of the spiritual, inner man and externalized its conflicts and anxieties. William of St Thierry, for example, argued that man was distinguished from beasts principally by the faculty of reason; yet, he could still be influenced by the lower "animal power" of sensations associated with the imagination and thus "put on" a bestial image.[69] We see William's

FIGURE 12-5 Capital with monstrous heads mounted on human arms. New York: The Metropolitan Museum of Art, The Cloisters Collection, 25.120.849. Photo: author.

notion of "putting on" a bestial image translated quite literally into the capitals juxtaposing naked men with apes and monstrous beasts.

Monsters did more than embody theological ideas, though. By the twelfth century, monastic writers insisted that monstrous phantasms were imprinted in the physical fabric of the memory by diabolical intervention, and thus had the potential to influence adversely one's behavior. Nightmares and visions manifested

the monk's battles with demonic powers, as was graphically illustrated in contemporaneous monastic accounts of dreams such as those found in Peter the Venerable's *De miraculis*, they also mirrored the vices that he was trying to purge in his ongoing struggle for spiritual perfection.[70] It is not surprising that visual equivalents to the monsters in the imagination are represented in the cloister, for it was here that the monk was tested in his personal, spiritual life as he meditated upon scripture and digested the lessons of such texts as Gregory the Great's *Moralia in Job*. The visualization of monsters in this text (fig. 12-1), as well as in cloister capitals, exposed the diabolical fantasies of dreams and the imagination so that the monk would be prompted to deal with them and neutralize their power.

Mary Carruthers has suggested a model for this process from memory theory.[71] She points out that monastic writers such as St Anselm and St Bernard believed that true conversion to the religious life could be achieved only by first recalling past vices and sins. Since one could never really eradicate sins completely from the memory, it was necessary to seek God's forgiveness and then change one's "intention" toward them, transforming them from producers of guilt into agents of conversion. It may be argued that beholding monstrous capitals in the cloister facilitated this process. The monk would have initially been caused to "wonder" over their monstrosity, as Bernard had predicted, but he would also be inspired to contemplate the malevolent spirits which led him to misbehave. Exposed to light, the monks' inner demons and phantasms might ultimately be neutralized.

Conclusion: A Monstrous Methodology

What this historiographic survey reveals is that monsters are susceptible to, and even require a wide range of interpretive strategies.[72] This is not to say that all approaches are equally valid in all cases, but rather that it is necessary to adapt method to particular functional, social, and historical contexts. As pictorial signs that admonish or point to absent beings, monsters are ultimately one of the most significant means by which medieval viewers could explore the boundaries between body and soul, the sensual and the spiritual, the sacred and the profane, the real and the imaginary. More than a distraction, monsters were essential stimuli for thinking.

Notes

1 *Apologia ad Guillelmum Abbatem*, ed. and trans. Rudolph, *Things of Greater Import-ance*, pp. 282–3. [On Romanesque sculpture in general, see chapters 15 and 16 by Hourihane and Maxwell, respectively, in this volume (ed.).]
2 Bynum, *Metamorphosis and Identity*, pp. 117–19.
3 Friedman, *Monstrous Races*, pp. 108–30.
4 Bynum, *Metamorphosis and Identity*, pp. 119–20.

5 Schapiro, "On the Aesthetic Attitude."
6 See Rudolph, "Bernard of Clairvaux's *Apologia*."
7 Ibid., p. 92.
8 Viollet-le-Duc, "Cathédrale," in *Dictionnaire raisonné*, vol. II, pp. 279–92, esp. p. 300.
9 Idem., "Sculpture," in *Dictionnaire raisonné*, vol. VIII, pp. 96–276, esp. 244–5.
10 Rudolph, *Things of Greater Importance*, pp. 104–24, esp. 120–2.
11 Ibid., pp. 1–14, 161–71.
12 See Bober's introduction to Mâle, *Religious Art in France*, pp. xiii–xx.
13 Mâle, *L'Art religieux du XIIe siècle*, pp. 341ff.
14 Mâle, *The Gothic Image*, pp. 58–63.
15 Champfleury, *Histoire de la caricature*, pp. 10–11.
16 Schapiro, *Romanesque Art*, pp. 1–27, esp. 6–7. [On marginalia, see chapter 13 by Kendrick in this volume (ed.).]
17 Schapiro, "Marginal Images," pp. 196–8.
18 Camille, "How New York Stole the Idea of Romanesque Art."
19 Bernheimer, *Romanische Tierplastik*.
20 Baltrušaitis, *La Stylistique ornementale*, esp. pp. 95–162 and 273–97.
21 Baltrušaitis, *Le Moyen-Age fantastique*.
22 Focillon, *L'Art d'occident*, pp. 104–5.
23 E.g., Henderson, *Early Medieval*; Zarnecki, "Germanic Animal Motifs."
24 Auber, *Histoire et théorie*, vol. 2, pp. 588–605.
25 Ibid., pp. 2, 604.
26 Ibid., vol. 1, pp. 344–5.
27 Ibid., pp. 377, 384.
28 Ibid., p. 259.
29 Mâle, *L'Art religieux du XIIe siècle*, pp. 333–4.
30 Schade, *Dämonen und Monstren*.
31 Randall, *Images in the Margins*.
32 Leclercq-Marx "Les Oeuvres romanes."
33 Camille, "Mouths and Meanings".
34 Williams, *Deformed Discourse*.
35 Ibid., p. 77.
36 Mills, "Jesus as Monster."
37 Vacandard, "Saint-Bernard"; cited by Rudolph, *Violence and Daily Life*, p. 11.
38 Schapiro, "On the Aesthetic Attitude," p. 10.
39 Kris, *Psychoanalytic Explorations*, pp. 204–16, esp. 213–14.
40 Gombrich, *Sense of Order*, p. 276.
41 Dinzelbacher, "Monster und Dämonen am Kirchenbau," pp. 117–19.
42 Mellinkoff, *Averting Demons*, vol. 1, pp. 41–51.
43 Valdez del Alamo, "The Saint's Capital."
44 Rudolph, *Violence and Daily Life*.
45 Bakhtin, *Rabelais and His World*, p. 5.
46 Ibid., p. 21.
47 Wright, *A History of Caricature*, pp. 200ff.
48 Camille, *Image on the Edge*.
49 Ibid., pp. 92–3.

50 Camille, *Mirror in the Parchment*, pp. 232–75.
51 Gurevich, *Medieval Popular Culture*, ch. 6.
52 Kröll, "Die Komik des grotesken Körpers," pp. 11–105.
53 Kenaan-Kedar, *Marginal Sculpture*, pp. 1–8, 30, 53–4, 70–3, 134–57.
54 Cf. Freedman, "The Medieval Other."
55 Friedman, *Monstrous Races*, pp. 64–95.
56 See Mellinkoff, *Outcasts*.
57 Strickland, *Saracens, Demons, Jews*.
58 Knight, "Werewolves, Monsters, and Miracles."
59 Miles, *Carnal Knowing*, pp. 145–68.
60 Caviness, "Patron or Matron?"
61 Sandler, "Study of Marginal Imagery," p. 33.
62 Camille, *Image on the Edge*, pp. 37–42.
63 Camille, "Before the Gaze," esp. 212–14.
64 Carruthers, *Craft of Thought*.
65 Ibid., pp. 164–5.
66 Ibid., pp. 140–2; cf. Heslop, "Contemplating Chimera," pp. 153–4.
67 Heslop, "Contemplating Chimera."
68 The following summarizes Dale, "Monsters, Corporeal Deformities and Phantasms."
69 *De natura corporis et animae*, ed. *PL* 180: 695–726.
70 Peter the Venerable, *De miraculis libri duo*, ed. Denise Bouthillier in *Corpus Chris-tianorum, Continuatio medievalis*, vol. 83 (Turnhout, 1988).
71 Carruthers, *Craft of Thought*, pp. 272–6.
72 Varela, "Leer o contemplar," esp. pp. 358–9; Camille, *Image on the Edge*, p. 9; Dinzelbacher, "Monster und Dämonen am Kirchenbau."

Bibliography

Charles-Auguste Auber, *Histoire et théorie du symbolisme religieux avant et depuis le christianisme* (1870–1), 4 vols., 2nd edn. (Paris, 1884).

Mikhail Bakhtin, *Rabelais and His World*, trans. Helene Iswolsky (Bloomington, Ind., 1984).

Jurgis Baltrušaitis, *Le Moyen-Age Fantastique. Antiquités et exotismes dans l'art gothique* (Paris, 1955).

——, *La Stylistique ornementale dans la sculpture romane* (Paris, 1931).

Richard Bernheimer, *Romanische Tierplastik und die Ursprünge ihrer Motive* (Munich, 1931).

Leslie B. Bridaham, *Gargoyles, Chimera, and the Grotesque in French Gothic Sculpture* (New York, 1930).

Caroline Walker Bynum, *Metamorphosis and Identity* (New York, 2001).

Michael Camille, "Before the Gaze. The Internal Senses and Late Medieval Practices of Seeing," in Robert S. Nelson, ed., *Visuality Before and Beyond the Renaissance*. (Cambridge, 2000), pp. 197–223.

——, "How New York Stole the Idea of Romanesque Art," *Oxford Art Journal* 17 (1994), pp. 65–75.

——, *Image on the Edge. The Margins of Medieval Art* (Cambridge, Mass., 1992).

——, *Mirror in the Parchment. The Luttrell Psalter and the Making of Medieval England* (Chicago, 1998).

——, "Mouths and Meanings: Towards an Anti-Iconography of Medieval Art," in *Iconography at the Crossroads*, ed. Brendan Cassidy (Princeton, 1993), 43–58.

Mary Carruthers, *The Craft of Thought. Meditation, Rhetoric, and the Making of Images, 400–1200* (Cambridge, 1998).

Madeline Caviness, "Patron or Matron? A Capetian Bride and a Vade Mecum for Her Marriage Bed," *Speculum* 68 (1993), pp. 333–62.

Jules Champfleury (=Jules Fleury), *Histoire de la caricature au moyen-âge* (Paris, 1872).

Thomas E. A. Dale, "Monsters, Corporeal Deformities and Phantasms in the Cloister of St-Michel-de-Cuxa: A Response to Saint Bernard," *Art Bulletin* 83 (2001), pp. 402–36.

Peter Dinzelbacher, "Monster und Dämonen am Kirchenbau," in Ulrich Müller and Werner Wunderlich, eds., *Dämonen, Monster, Fabelwesen* (St Gallen, 1999), pp. 103–26.

Henri Focillon, *L'Art d'occident. Le Moyen Age roman et gothique* (Paris, 1938).

Paul Freedman, "The Medieval Other: The Middle Ages as Other," in Thomas S. Jones and David A. Sprunger, eds., *Marvels, Monsters, and Miracles. Studies in the Medieval and Early Modern Imaginations* (Kalamazoo, Mich., 2002), pp. 1–24.

John Block Friedman, *The Monstrous Races in Medieval Art and Thought* (Cambridge, Mass. and London, 1981).

Ernst Gombrich, *The Sense of Order. A Study in the Psychology of Decorative Art* (Oxford, 1979).

A. Gurevich, *Medieval Popular Culture*, trans. János M. Bak and Paul Hollingsworth (Cambridge, 1988).

George Henderson, *Early Medieval: Style and Civilization* (Harmondsworth, 1972).

T. Alexander Heslop, "Contemplating Chimera in Medieval Imagination: St. Anselm's Crypt at Canterbury," in Laura Golden, ed., *Raising the Eyebrow: John Onians and World Art Studies* (Oxford, 2001), pp. 153–68.

Nurith Kenaan-Kedar, *Marginal Sculpture in Medieval France. Towards the Deciphering of an Enigmatic Pictorial Language* (Aldershot, Hants., 1995).

Rhonda Knight, "Werewolves, Monsters, and Miracles: Representing Colonial Fantasies in Gerald of Wales's *Topografia Hibernica*," *Studies in Iconography* 22 (2001), pp. 55–86.

Ernst Kris, *Psychoanalytic Explorations in Art* (New York, 1952).

Katrin Kröll, "Die Komik des grotesken Körpers in der christlichen Kunst des Mittelalters," in *Mein ganzer Körper ist Gesicht. Groteske Darstellungen in der europäischen Kunst und Literatur des Mittelalters* (Freiburg, 1994), pp. 11–105.

Jacqueline Leclercq-Marx "Les Oeuvres romanes accompagnées d'une inscription. Le cas particulier des monstres," *Cahiers de civilisations médiévale* 40 (1997), pp. 91–102.

Emile Mâle, *L'Art religieux du XIIe siècle en France* (1922), 7th edn. (Paris, 1966).

——, *L'Art religieux du XIIIe siècle en France. L'étude de l'iconographie médiévale et ses sources d'inspiration* (Paris, 1898).

——, *The Gothic Image. Religious Art in France of the Thirteenth Century*, trans. Dora Nussey (New York, 1972).

——, *Religious Art in France. The Twelfth Century. A Study of the Origins of Medieval Iconography*, ed. Harry Bober, trans. Marthiel Mathews (Princeton, 1978).

Ruth Mellinkoff, *Averting Demons. The Protective Power of Medieval Visual Motifs and Themes*, 2 vols. (Los Angeles, 2004).

——, *Outcasts: Signs of Otherness in Northern European Art of the Late Middle Ages*, 2 vols. (Berkeley, Calif., 1993).

Margaret Miles, *Carnal Knowing. Female Nakedness and Religious Meaning in the Christian West* (Boston, 1989).

Robert Mills, "Jesus as Monster," in Bettina Bildhauer and Robert Mills, *The Monstrous Middle Ages* (Cardiff, 2003), pp. 28–54.

Lillian M. C. Randall, *Images in the Margins of Gothic Manuscripts* (Berkeley and Los Angeles, Calif., 1966).

Conrad Rudolph, "The Scholarship on Bernard of Claivaux's *Apologia*," *Cîteaux: Commentarii Cistercienses* 40 (1989), pp. 69–111.

——, *The "Things of Greater Importance": Bernard of Clairvaux's Apologia and the Medieval Attitude Toward Art* (Philadelphia, 1990).

——, *Violence and Daily Life. Reading, Art, and Polemics in the Cîteaux Moralia in Job* (Princeton, 1997).

Lucy Freeman Sandler, "The Study of Marginal Imagery: Past, Present, and Future," *Studies in Iconography* 18 (1997), pp. 1–49.

Herbert Schade, *Dämonen und Monstren; Gestaltungen des Bösen in der Kunst des frühen Mittelalters* (Regensburg, 1962).

Meyer Schapiro, "On the Aesthetic Attitude in Romanesque Art" (1947). repr. in Schapiro, *Romanesque Art*, pp. 1–27.

——, "Marginal Images and Drôlerie" (1970), in *Late Antique, Early Christian and Medieval Art: Selected Papers* (New York, 1979), pp. 196–8.

——, *Romanesque Art. Selected Papers* (New York, 1977).

Debra Higgs Strickland, *Saracens, Demons, Jews. Making Monsters in Medieval Art* (Princeton, 2003).

Eugène Vacandard, "Saint-Bernard et l'art chrétien," *Précis analytique des travaux de l'Académie de Sciences, Belles-lettres et Arts de Rouen* 87 (1884), pp. 215–44.

Elizabeth Valdez del Alamo, "The Saint's Capital, Talisman in the Cloister," in Stephen Lamia and E. V. del Alamo, eds., *Decorations for the Holy Dead. Visual Embellishments on Tombs and Shrines of Saints* (Turnhout, 2002), pp. 111–28.

Gerardo Boto Varela, "Leer o contemplar. Los monstruos y su público en los templos tardorrománicos castellanos," in *La cabecera de la Catedral calceatense y el Tardorrománico hispano* (Santo Domingo de la Calzada, 1998), pp. 357–87.

Eugène-Emanuel Viollet-le-Duc, *Dictionnaire raisonné de l'architecture*, 10 vols. (Paris, 1867–70).

David Williams, *Deformed Discourse. The Function of the Monster in Mediaeval Thought and Literature* (Montréal, 1996; pbk. edn. Exeter, 1999).

Thomas Wright, *A History of Caricature and Grotesque in Literature and Art* (London, 1865; repr. New York, 1968).

George Zarnecki, "Germanic Animal Motifs in Romanesque Sculpture," in *Further Studies in Romanesque Sculpture* (London, 1992), pp. 261–371.

13

Making Sense of Marginalized Images in Manuscripts and Religious Architecture

Laura Kendrick

Why should the margins of devotional books ... be loaded with incongruous distortions of natural or fabulous forms of life and why did not the sense of propriety in the possessors of such books revolt at the ill-timed, and even inde- cent, merriment of the artist? The only answer to be given to this question is that the ornamentation of a manuscript must have been regarded as a work having no connection whatever with the character of the book itself. *Its details amused or aroused the admiration of the beholder who ... took no thought whether the text was sacred or profane.*[1]

It has taken art historical study of the imagery in the margins of Romanesque and Gothic manuscripts, as well as in the figurative margins of religious architec- ture and furniture, nearly 70 years to get beyond this response to the question so many viewers have asked, as phrased by E. M. Thompson, Keeper of Manu- scripts for the British Museum, in his 1896 essay "The Grotesque and the Humorous in Illuminations of the Middle Ages." A few years later, Louis Maeterlinck opened his own study of satire in Flemish painting by paraphrasing Thompson's question and answer, and then elaborating on the reasons for this compartmentalization: different zones of the manuscript page were intended for different audiences; the text written in the center was meant for the education of the men in the family, while the extraneous marginal imagery was meant for the entertainment of the women and children.[2] Such a view surely says more about

the leisure occupations of a nineteenth-century bourgeois family than about those of medieval monks or rich laypeople. However, it may go a long way toward explaining why progress in the analysis of marginal imagery was slow at first: it was considered to be beneath study by men.

The Battle Over the Meaning of Monsters

Today we feel ill at ease reading Emile Mâle's ridicule of his *bête noire*, Félicie d'Ayzac, one of the earliest women to venture into the nascent field of art history (still called "archeology"), for her "ingenious" efforts to explain as symbols the monstrous hybrids carved in the "marginal" space of religous architecture:

> In her *Mémoire sur trente-deux statues symboliques observées dans les parties hautes des tourelles de Saint-Denis*, she made most clever use of texts. The statues of Saint-Denis are hybrid monsters. Mme Félicie d'Ayzac broke them down into their components: lion, goat, billy goat, horse. Then, armed with the mystical dictionary of Saint Eucher or of Rhabanus Maurus, she discovered the allegorical sense of them. . . .
>
> Mme Félicie d'Ayzac thought she had found a method and created a science of symbolism. In reality, she demonstrated only one thing: never were our ancient artists as subtle as their modern exegetes. How likely is it that they wanted to express so many things, and such refined things, through figures that can be seen from below only with good opera-glasses![3]

In this attack published in 1898 in *L'art religieux du XIIIe siècle en France* (his doctoral dissertation), Mâle also singled out Charles-Auguste Auber, for his attempt to explain the symbolism of corbels ornamented with animal and human heads on the cathedral of Poitiers and other churches;[4] Charles Cahier, for a volume devoted to *Curiosités mystérieuses* in which he used bestiaries and theological texts to explain "works that are nothing but artists' fantasies";[5] and Count Bastard d'Estang for falling into the same error in his *Etudes de symbolique chrétienne*.[6] These men were named along with Félicie d'Ayzac as perpetrators of a "mania for symbols" that threatened to discredit scientific *archéologie*. Mâle charged: "they have turned it into a novel."

Bastard d'Estang's oral report of 1849 to the *Comité historique des arts et monuments* concerning certain plates in Auber's study of the Poitiers Cathedral opened the polemic. In this report, he defended Auber for trying to reproduce in engravings the monstrous sculpted figures of the cathedral's corbels, which "antiquarians have treated until now with a disdain these figures surely do not deserve."[7] Bastard d'Estang argued that these corbel sculptures are analogous to the imagery in the margins of liturgical manuscripts, images which he called *vignettes* and claimed "frequently have an explanation . . . drawn from textual passages on the same page as the vignette, often beside or directly opposite the symbol."[8] Bastard d'Estang called for comparison of corbel figures both with

other sculpted figures and with painted figures in the margins of manuscripts from the thirteenth century on. He predicted that such comparative study would prove "on the authority of the Church Fathers and of numerous connections, that caprice alone is not the creator of these peculiar compositions."[9]

To support his view that bizarre marginal imagery can often be explained by the textual context where it appears (a point so novel – and so poorly demonstrated – that it convinced no one), Bastard d'Estang narrated how he resolved the mystery of one monstrous figure in a Breviary of the late thirteenth century (see fig. 13-1):[10]

> [I]n the office of Saint Stephen protomartyr, beside the historiated initial that encloses the depiction of his death, the calligrapher has placed, as an ornament in the upper margin, a monster of such a bizarre shape that I was on the point of attributing it to the hand of a delirious illuminator: it is a red beast; its head is cut off, and from its breast emanates a long blue neck terminated by a human head. The figure being new to me, I thought I should turn to the text in order to verify whether, by chance, it was justified; I had the satisfaction of reading, on the same page, the following sentence from a sermon of Saint Fulgentius: *Hodie miles [Stephanus], de tabernaculo corporis exiens, triumphator migravit ad cœlum*. Here, then, we have an allegory of Saint Stephen dying and "already seeing the glory of God," or, what is sometimes called an apotheosis. The peculiarity of the monster helps to call attention to the symbol.[11]

To Bastard d'Estang, the human head on the very elongated blue neck, which he showed in a drawing,[12] symbolized the migration of the soul to heaven, and he found support for this symbolism in the images at the bottom of the same page. This *bas de page* depicts an archer preparing to shoot at a snail coming out of its shell, which Bastard d'Estang understood, in this instance and others, as "certainly having to do with resurrection." He went even further to argue, in a footnote, that marginal imagery may serve as a visual commentary by the painter upon the text it borders, and likewise for "marginal" sculpture:

> Long experience has convinced us that marginal figures, very often inspired by the reading of the page itself, can serve as commentaries; often the passages relating to the miniatures, if one knows how to find them, reveal in turn the dominant thoughts of the painter at the time he was working. By allowing ourselves to be guided by analogy, we arrive at an explanation of fantastic creatures, which a similar intention has lavished on the corbels of churches. It is not rare, indeed, to encounter equally bizarre and monstrous compositions in liturgical books . . . The understanding of a word, the sudden comprehension of a textual or figural analogy, suffice to guide the reader on the path of the sculpted symbol, there where he had thought he saw only a meaningless grotesque.[13]

These allegorizing explanations did not convince (for elongated necks ending in human heads are not uncommon on marginal monsters), and some antiquarians were offended by Bastard d'Estang's regretful admission that medieval marginal

FIGURE 13-1 Breviary page with marginal images. Paris: Bibliothèque nationale de France, MS lat. 1258:179v. Photo: Bibliothèque nationale de France.

imagery is not always symbolic (emblematic or allegorical) in intention, but that there are also figures "purely burlesque, presenting faults or, if one prefers, qualities of caricature, with the unique aim of provoking laughter." To Bastard d'Estang, comic marginal imagery was "a symbolic aberration and a scandal in temples as well as in liturgical and prayer books."[14]

It is no wonder that Champfleury, a student of caricature in all its forms, took Bastard d'Estang to task for "excessive, sectarian symbolism" and for his "bizarre analogies," particularly those involving the snail. Like other antiquarians, Champfleury was convinced of the utility of comparative study of motifs as they appeared across the spectrum of material supports:

> This comparison of different monuments is surely rational. The miniatures, drawings, sculpture, pottery, and metalwork of a period are held together by the bonds of ornament. In order to furnish his mind with the favorite forms of a period, the archeologist can never study various arts too much.[15]

Champfleury concluded that Bastard d'Estang had demonstrated his good archeological sense in theory, but not in practice, for the results of his explanatory method were ridiculous.

Interdisciplinary studies devoted to the transgeneric history of satire, caricature, and the grotesque flourished in the nineteenth century. In these, scholars such as Thomas Wright, Champfleury (who published the first edition of his history of caricature in 1876), and the Belgian Louis Maeterlinck made abundant use of, and thus called public attention to, "marginal" imagery from the pages of illuminated manuscripts and from the carvings on the capitals, corbels, portals, and misericords of religious buildings.[16] These entertaining surveys treat monstrosity as a type of exaggeration and a mark of ridicule, but they are less interested in the monstrous or fantasized than in Gothic marginal images of a more mundane, everyday sort: entertaining or satirical "genre" scenes. These are presented in the form of drawings of specific details copied from vaguely identified medieval contexts. More scrupulous than the others on this point, Wright identified manuscripts by collection, number, and sometimes name, but never did he give a folio number for the medieval image copied in any engraving.

None of these antiquarian scholars believed there was the slightest connection between the written text on a manuscript page and the marginal imagery surrounding it. Wright, for example, explained that it was "only natural," considering the influence of the medieval minstrels and entertainers on "the people's minds generally, with their stories and satirical pieces, their grimaces, their postures, and their wonderful performances," that "when a painter had to adorn the margin of a book, or the sculptor to decorate the ornamental parts of a building, we might expect the ideas which would first present themselves to him to be those suggested by the jougleur's performance. . . . The same wit or satire would pervade them both."[17] On the other hand, Maeterlinck's interest in marginal imagery as a reflection of popular traditions had a more tendentious,

nationalistic motivation: to demonstrate an original Flemish genius for satire, which led to the great paintings of a Bosch or a Breughel the Elder.

In his review of the state of "archeological" studies in 1898, Mâle criticized both Wright and Champfleury (Maeterlinck came too late) for not paying enough attention to periodization: "All the epochs are mixed together."[18] However, he commended Champfleury for perceiving that much symbolic interpretation was beside the point; not only had Champfleury attacked Bastard d'Estang, but he had openly rejected his own initial error of "revolutionary neosymbolism": "I began these studies [of the history of caricature] with the idea that the stones of cathedrals were speaking witnesses to the state of the people's revolt; I ended it no longer believing in such seditious eloquence."[19] Mâle used Champfleury, in spite of his shortcomings, to bolster his own judgment that "if ever works were devoid of thought, it was surely these." For Mâle, all symbolic explanations of monstrous and fantastic marginal imagery were "condemned in advance."[20]

To clinch his argument against taking too seriously hybrid monsters and other "purely ornamental" features of Romanesque and Gothic art, Mâle quoted part of St Bernard's famous tirade against monstrous sculptures in the cloister – "what are these ridiculous monsters doing here . . . what is the meaning of these unclean apes . . . ?"[21] Mâle took this highly rhetorical passage at face value and concluded that, if St Bernard did not understand such sculpture, modern interpreters should not even try, for it was never intended to have any sense:

> The great mystic, the interpreter of the *Song of Songs*, the preacher who spoke only in symbols, admits that he does not understand the bizarre creations of the artists of his time. . . . Such a testimony decides the question. It is obvious that the flora and fauna of the Middle Ages, real or fantastic, usually have only a decorative value.[22]

Mâle argued that naturalistic or fantastic flora and fauna are the result of unreflective imitation on the part of artisans "closely supervised when it came to expressing the religious thought of their time," but "left free to ornament the cathedral just as they pleased."[23] This ornamentation took the form of copying pleasing forms, either from nature (for plant leaves and the like) or from available visual designs (whether of Oriental textiles or of manuscript pages). In Mâle's judgment, such images are purely formal solutions to the problem of how to fill space: "Hence so many hybrid monsters, whose supple limbs, easy to fling in every direction, had the merit of occupying all the parts of the field to be filled."[24] By insisting heavily on the meaninglessness and pure formality of this marginal imagery as sheer ornament, Mâle was not only trying to put a stop to what he considered to be a dangerous drift in the new science of iconography, but also to discredit an older antiquarian trend that saw in marginal imagery (in genre scenes, as well as in monstrosity) documentary evidence of mockery of certain aspects of life in the Middle Ages, as well as signs of popular resistance to domination (especially by the Catholic Church, the priesthood, the friars).

Mâle may have felt that his argument was not entirely convincing, for he attempted to nuance and bolster it in his study of twelfth-century religious art, first published in 1922, where he suggested pictorial, literary, or real-life models for numerous motifs of Romanesque sculpture, "the most virile of the arts," hence the primary focus of his research.[25] As sources for images of warriors or jongleurs and acrobats carved on capitals or façades, for example, he posited the real presence of jongleurs entertaining and reciting epics to the crowds in front of churches on the pilgrimage routes. To some monstrous carvings Mâle now allowed a moralizing intention; these he traced to descriptions and images from early Bestiaries and writings on natural history and the peoples of the world. Nevertheless, Mâle concluded his chapter on the Romanesque imagery of "The World and Nature" by reiterating his earlier views, this time backed with photographs and drawings of motifs borrowed from Oriental textiles:

> It has become obvious today that the efforts of a whole generation of scholars have been fruitless. They worked in a vacuum, and it was Saint Bernard who was right. Our greater understanding today of Oriental decorative art leaves no doubt as to the truth of this. It is clear that, almost always, the peculiar animals of our Romanesque churches reproduce, more or less freely, the magnificent animals of Oriental textiles. Our sculptors were not always thinking of teaching; most of the time they were thinking only of decorating. This is the point it is important to establish.[26]

As sheer ornament, the pagan, monstrous imagery of Romanesque and Gothic sculpture merited scholarly attention only to identify its foreign sources and to appreciate its lines or style.

The Return of the Repressed

After Mâle, much scholarly effort was directed toward the discovery of distant sources of decorative motifs and to analysis of the "stylistics" of ornamentation. Questions of artistic intent or meaning were left aside. These new research parameters are evident in the publications of Jurgis Baltrušaitis on monstrous plastic and painted imagery of the Romanesque and Gothic periods.[27] Nevertheless, Baltrušaitis took a certain delight in complicating the conventional nineteenth-century narrative of the progress or organic "evolution" toward naturalism of medieval Western art. Using a vast number of drawings and photographs, some reproduced in the margins of his own text in imitation of medieval marginalia, others showing entire manuscript pages rather than mere details, Baltrušaitis demonstrated that ancient stocks of stylized, "fantastic" (meaning fantasized or unnatural) imagery were continually recycled and varied in new schemes, to purely decorative ends, throughout the medieval period. He used words like *réveil* (resurgence, revival), *recrudescence* (upsurge or outbreak), *renaissance* (rebirth), and *libération des refoulements* (liberation from repressions) to describe

this phenomenon, which made it seem to have a life – and a psychology – of its own: "the revivals are due, strictly speaking, to an organic evolution. They happen like a liberation from repressions, at the moment when barriers are let down, in an atmosphere of effervescence, immediately after a time of serenity and peace."[28]

Baltrušaitis paid lip service to the division of medieval art, whether plastic or painted, into two distinct categories of different value. Statues and figures representing religious doctrine were considered to be of central importance. Ornament or "decor" was considered to be marginal, whatever its spatial position. The case of "decorated" initial letters formed by or enclosing struggling, stylized beasts, birds, plants, and humans in early medieval illuminated Bibles and liturgical manuscripts is instructive. Even though these initial letters were the center of attention and sometimes took up the greater part of the page, they were treated by most art historians as incidental or marginal, as meaningless ornament, like the monstrous sculptures of cloister capitals. Even when they appeared in a central position on medieval pages or monuments, fantastic images were considered extraneous and evacuated into the "margins" of art historical discourse as sheer decoration. The progress toward greater naturalism from Romanesque to Gothic art and beyond depends partly on these categorizations conventional to nineteenth- and early twentieth-century art historical discourse.

The Gothic tendency to develop fantastic imagery in the margins of the page, rather than in major initials (as in earlier periods), was interpreted as conducive to greater naturalism in manuscript art. Baltrušaitis explained this, for example, in the opening of his chapter on the revival of the fantastic in the decor of the book:

> A double development, determining the two independent and stylistically opposed aspects of architectural sculpture – its statuary and its decor, strictly speaking – also dominates the evolution of painting in manuscripts, where we see, on the one hand, illustration (the miniature) withdrawing progressively to its domain of storytelling in lifelike forms, and on the other hand, ornamentation (illumination) discovering nearby, in the borders of the page, a space of escape to the limitless distance of the impossible.[29]

Yet Baltrušaitis was much more interested in the margins than in the center, and he chose to describe this displacement of fantastic imagery as an escape rather than an exclusion. Drawing support from a 1941 review by Francis Wormald, Baltrušaitis remarked that the creatures which appear in the margins of the manuscript page beginning in the mid-thirteenth century are not a sudden creation, but a "freeing," a "liberation" of the fantastic living forms that had earlier been "imprisoned" in initial letters.[30] In effect, Baltrušaitis's choice of the psychoanalytic concept of a lifting of repression to account for the multiple revivals and revisions of fantastic imagery (whose origins he identified in Hellenic, Saracen, and Far Eastern ornament) may reveal his own implicit

project: to break out of the ideological parameters defined by turn-of-the-century art historians. In their often bewildering profusion, his studies of fantastic, stylized ornament are a kind of "return of the repressed," that is, of a subject that had been treated as marginal and minor.

As successive twentieth-century artistic movements found ever new ways of rejecting naturalism, there seemed to be less and less sense in a nineteenth-century evolutionary theory that posited exact imitation of nature as the highest stage of development and the supreme value in art, that judged earlier art by how nearly it approached this ideal, and that constructed a theory of development on that basis. If the point of farthest "development" was not realism but, for example, Abstract Expressionism, there was no reason for histories of art to devalue expressive medieval stylization, no reason to marginalize the fantastic or monstrous. In an essay of 1947, Meyer Schapiro announced his intention to re-evaluate certain aspects of medieval art in the light of modern art:

> What concerns us here . . . is not the defense of modern art, but rather the inquiry into the common view that mediaeval art was strictly religious and symbolical, submitted to collective aims, and wholly free from the aestheticism and individualism of our age. I shall try to show that by the eleventh and twelfth centuries there had emerged in western Europe within church art a new sphere of artistic creation without religious content and imbued with values of spontaneity, individual fantasy, delight in color and movement, and the expression of feeling that anticipate modern art.[31]

Schapiro agreed with Mâle's rejection of any programmatic theological or moral symbolism in monstrous sculptures and marginal imagery, but he tried to define the ornamental in a less denigrating way. It is not necessarily without meaning simply because it does not have a didactic religious sense:

> Are the religious and the ornamental the only alternatives of artistic purpose? Apart from the elements of folklore and popular belief in some of these fantastic types, they are a world of projected emotions, psychologically significant images of force, play, aggressiveness, anxiety, self-torment and fear, embodied in the powerful forms of instinct-driven creatures, twisted, struggling, entangled, confronted, and superposed. Unlike the religious symbols, they are submitted to no fixed teaching or body of doctrine. We cannot imagine that they were commissioned by an abbot or bishop as part of a didactic program. They invite no systematic intellectual apprehension, but are grasped as individual, often irrational fantasies, as single thoughts and sensations. These grotesques and animal combats stand midway between ancient and modern art in their individualized, yet marginal character.[32]

Schapiro suggested a new history of the development of art, this time focused on the expression of individual subjectivity, a history in which what was marginal eventually becomes central.

In Schapiro's contrast between the absolute regularity of classical Greek ornament and the deliberate variety of Romanesque ornament, which can be understood as a "fruitful instance of liberty of individual conception,"[33] there are echoes of John Ruskin's chapter on "The Nature of Gothic" from *The Stones of Venice* (London, 1851–3), wherein Ruskin argued that the variety of Gothic ornament (as opposed to "servile" Greek, Ninevite, and Egyptian ornament) is a sign of the artist's freedom. The medieval commentaries Schapiro offered as evidence of an aesthetic appreciation of art emphasize the medieval viewer's delight in variation, but also in fine workmanship, in the expertise of the craftsman. St Bernard's tirade against monstrous sculptures in cloisters is interpreted as proof of his opposition to "idle" or useless aesthetic expression devoid of didactic content or religious symbolism: "the monsters are not regarded by Bernard as symbols of evil; nor is there reason to suppose that the sculptors conceived them deliberately as such." Schapiro also pointed out that Bernard would have had occasion to encounter the same sort of monstrous imagery in the initial letters of Cistercian religious manuscripts, where they were "entirely independent of the accompanying text."[34]

From Romanesque to Gothic, From Monstrous to Droll

In *Apes and Ape Lore in the Middle Ages and the Renaissance*, H. W. Janson devoted a whole chapter to "The Ape in Gothic Marginal Art" and stressed the inadequacy of iconographical study that either relies solely on theological sources to explain marginal imagery or else treats it as purely decorative, conveying no thought:

> This rigid division has been broken down more and more in recent years. We have come to realise increasingly that mediaeval painters and sculptors, even though their status as craftsmen excluded them from the exalted realm of the *artes liberales*, did not simply carry out the commands of the clergy; that they enjoyed, in fact, considerable freedom in exercising their own imagination, so that their work must be regarded as complementary to the literary sources in expressing the thoughts and emotions of the era.[35]

However, as Janson admitted, to concede individual intention to the medieval creator of *drôleries* causes major difficulties for the modern interpreter: "How, then, is he to determine the level of meaning appropriate to a given design? . . . Even if the source of a motif is known, he has no assurance that its meaning has not been submerged in the free play of forms so characteristic of Gothic marginal art."[36]

Janson chose to focus on the motif of the ape because, as he claimed, "apes play a more conspicuous part in marginal grotesques than any other animal" and because he hoped, by studying one type of imagery, to "contribute . . . to a

better understanding of the nature of Gothic *drôlerie* and thus help to pave the way for more comprehensive studies of the subject-matter of marginal art as a whole."[37] The ape is a kind of test case for the revised narrative of the development of Western art suggested by Schapiro, a narrative showing how individual subjectivity is finally granted center stage. Whereas in Romanesque marginal imagery the ape appears rarely and is engaged in serious struggle with monstrous creatures or vegetation, in Gothic *drôleries* the omnipresent ape is treated in a more diverse and playful manner – in short, with more liberty of imagination and with reference to a wide range of literary sources or real-life situations.

Janson was the first to devote a whole chapter to the study of one motif in manuscript margins (exclusive of other material supports) and to try to analyze simian representations by categorizing them: parodies, performing apes, illustrations of fables and anecdotes, apes and birds. Yet Janson agreed with the predominant view that there was no meaningful connection between the text and the visual images of its margins, and he did not search for any: "a study of the texts is apt to be . . . fruitless, since *drôleries*, with rare exceptions, have no illustrative function."[38]

Lillian Randall's *Images in the Margins of Gothic Manuscripts* is the first book devoted exclusively to marginal imagery in manuscripts, leaving aside stone, wood, and all other supports. It is a vast extension of Janson's effort to categorize one motif. Originating in a 1955 Radcliffe dissertation, Randall's study catalogues and classifies marginal imagery from 226 Gothic manuscripts, both religious and secular in content, all made in Northern Europe between 1250 and 1350 (with a few later exceptions).[39] "Isolated renderings of inactive creatures" are considered to be "purely ornamental detail" and are not taken into account. Randall focuses, instead, on "scenes depicting humans, animals, or hybrids in some sort of activity," which "constitute the essence of marginal subject matter." These she classifies into four principle groups based on "religious sources, secular literature, daily life, and parody."[40] With its voluminous subject index, comprising hundreds of themes and subthemes, *Images in the Margins of Gothic Manuscripts* provides what remains today a fundamental reference tool; it describes marginal imagery in detail, classifies it iconographically, and clearly identifies its manuscript location. As Randall pointed out, such a catalogue was badly needed to make more comprehensive analysis of marginal imagery possible.[41] Although far more images are indexed than reproduced, Randall also provided more than 700 photographic reproductions of details from the margins of manuscripts, thus demonstrating the great variety of themes and offering examples for further study.

In her introduction, Randall suggested a broadly aesthetic explanation for much Gothic marginal imagery: "the medieval propensity for juxtaposition of contrasting elements," and she stressed the generally entertaining nature of this imagery, as she had done in an article pointing out the analogous use of profane *exempla* to spice friars' sermons, thereby "dispelling the lethargy of the congregation."[42] With respect to the scenes she classed as parody, Randall wrote:

No matter how outrageous the distortion, the function of the travesties which constitute the bulk of the iconographic repertory of marginal illustrations was less overtly didactic than in analogous subjects preserved in fabliaux and exempla. An element of humor was seldom absent, in the rendering if not in the theme, and the aim was both to divert and to elevate.[43]

Like Schapiro and Janson, Randall viewed the margins as a space permitting individual artistic freedom: "the margins afforded an opportunity for more spontaneous individualistic expression, whether in the realm of sacred imagery, social commentary, or fantastic invention."[44] She went on to say that she believed further exploration might discover a specific reason for seemingly inappropriate motifs "in a surprising number of instances," and that the enigma of intention is "most easily solved when the subjects in the margin are directly related to their adjoining text or miniature."[45] Probably to reduce expense and bulk in this catalogue, Randall squeezed many photographed details onto each page rather than trying to reproduce whole manuscript pages, which would have enabled preliminary analysis of relationships between texts, miniatures, and marginal imagery.

Randall also published a series of articles exploring particular motifs. In the earliest of these, she tried to discover a general explanation for the motif by reference to contemporary literature and other historical documents. For example, in "A Mediaeval Slander,"[46] Randall took up the late thirteenth-century French and Franco-Flemish marginal motif of a man sitting on a nest of eggs, which she explained as a slander of the English (as "hatched" and as cowardly egg-hatchers), a slander deriving from the much better-known medieval taunt against the "tailed" English. The point of connection between the two debasing images is the medieval French word *cové* meaning both "hatched" (modern French *couvé*) and "tailed" (modern French *coué*). These particular images in the margins visualize familiar taunts against the English enemy. In "The Snail in Gothic Marginal Warfare,"[47] Randall returned to one of the earliest debates about the meaning of a marginal image (between Champfleury and Bastard d'Estang) and proposed a new solution: images of warfare against snails, chiefly in northern French and Franco-Flemish manuscripts from 1290 to 1310, could satirize the Lombards, the new bankers of Europe, whose cowardice was exemplified ironically in vernacular literature by their "prowess" at fighting or fleeing "armored" (shell-encased) snails.

Such wide-ranging studies of the cultural background behind a motif enrich our understanding and, in their mastery of detail, go far beyond nineteenth-century interdisciplinary studies of satire and caricature featuring marginal motifs. However, they leave aside the questions of why the motif under consideration appears on a particular page of a particular manuscript, and how and why it may vary from one manuscript context to another. Randall's later articles tend to focus on single manuscripts. "Humour and Fantasy in the Margins of an English Book of Hours" uses a manuscript from around 1300 to demonstrate the general trend in marginal imagery from Romanesque to Gothic: "the intense

ferocity of earlier *motifs* waned in the wake of the dominant new interest in anecdotic detail . . . [while] dragons and grotesques . . . became tamer and . . . often designedly comical in appearance."[48] A final example out of many, "Games and the Passion in Pucelle's Hours of Jeanne d'Evreux," analyzes two *bas de page* drawings, their cultural references, and their relationship to other images in the same fourteenth-century manuscript.[49]

Closer Readings, Case Studies

Most of the published research of Lucy Freeman Sandler falls outside the period of this volume, being devoted to Gothic manuscripts illuminated in England after 1300. However, Sandler's work illustrates the trend toward closer examination of marginal imagery within its particular manuscript context, in relationship both to the words of the central text block and to other images in the same manuscript (in framed miniatures, in initial letters, after line endings, or in the margins). In "A Series of Marginal Illustrations in the Rutland Psalter,"[50] Sandler proposed that certain marginal scenes are burlesque variations on or "expansions" of the elements of a courtly calendar scene that appears earlier in the Psalter. "Reflections on the Construction of Hybrids in English Gothic Marginal Illustration"[51] compares the method of construction of the "non-descript" monsters (those with no classical names) in certain English manuscripts in order to categorize them into six different types. In more recent articles devoted to the analysis of single manuscripts, such as "Pictorial and Verbal Play in the Margins,"[52] Sandler has offered a variety of explanations for marginal imagery in particular contexts. In Stowe MS 49, a *Legenda sanctorum* copied around 1300 in a monastic environment and filled with marginal sketches, Sandler found that only "a few of the marginalia . . . clearly respond to the meanings of words and phrases in the text . . . yet many of the marginal images make a kind of sense when they are considered as a group independent of the text."[53] In effect, the margins of this book of saints' lives are the space into which the unsaintly – wayfarers, beggars, women, and people and creatures engaged in sexual activities prohibited to monks – is deliberately expelled and excluded by "depicting it with contemptuous familiarity, and presenting it by turns as grotesquely funny, and disgustingly sinful."[54] The notion that marginal imagery should represent sin or behavior to be avoided is not new, but here it is explored in a specific manuscript context, not stated as a general rule.

Nigel Morgan studied a key witness in the history of the development of marginal imagery, the Rutland Psalter illuminated in England around 1260, the earliest manuscript to present such fully elaborated border images.[55] Close comparison of technique, style, and choice of subjects for marginal figures allowed Morgan to distinguish personal preferences in the five different artists, and thus to define individual artistic subjectivity more precisely than had previously been done, as well as to demonstrate that the artists were not subject to the same

regime, but free to differ in how and what they designed. For example, Morgan distinguished Artist A from Artist B in terms of the greater naturalism of the latter's images:

> Artist B . . . prefers genre subjects and clearly defined actions. Even in fantasy subjects, the men, animals, and hybrids are involved in recognizable activities, and hold proper weapons, musical instruments, and other accessories. Artist A likes animals and birds as decorative features, but above all chooses pure fantasy subjects in which the action has little or no contact with reality.[56]

A series of tabular appendices presents each artist's work for easier comparison. Yet verbal categorizations of the visual are not always entirely satisfactory. For example, the monkey riding an ostrich on the verso of one page is tilting toward the facing recto, toward the butt of a nude man, whose hand seems to want to shield the target (see fig. 13-2). In the table of Appendix B, devoted to

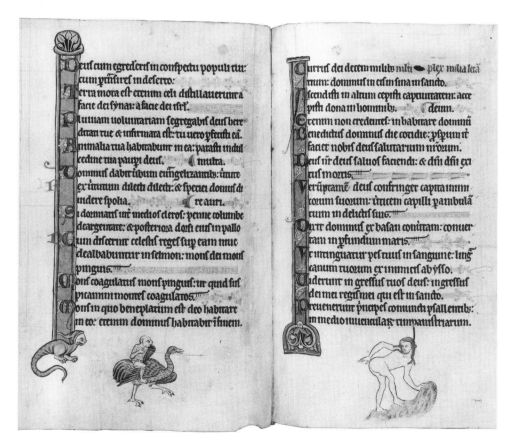

FIGURE 13-2 Double page view of Rutland Psalter. London: British Library, MS 62925:66v–67r.

comparison of *bas de page* subjects by different artists, this double-page spread is presented, with no acknowledgement of interaction, as two entirely separate images, both by Artist B, one a "fantasy subject" ("hybrid riding bird") and the other a "genre scene" ("nude man with hand over posterior").

After long ignoring manuscript contexts and giving visual images a wide berth as the subject matter of a different discipline, scholars of medieval vernacular literature have begun to try to understand marginal images as evidence of medieval reactions to or interpretations of texts, in short, as a kind of visual commentary. For example, in a 1985 essay on the image of women in manuscripts of troubadour verse, Angelica Rieger noted a coherent system of illustrative marginal drawings, keyed to the text by red marks, in one thirteenth–century manuscript (Pierpont Morgan Library M. 819), where the metaphoric language of the poet concerning his experience of love is "transformed directly by the designer into a symbolic image."[57] Figures of speech prompt marginal figures. In a tabular annex, Rieger juxtaposed a brief description of each marginal image with a citation of the lines of Occitan verse that evoked it. Sylvia Huot[58] returned to the same manuscript to try to explain why figurative language should be materialized in images this way; she suggested that the images might "help to fix the song in the mind of the reader by providing visual cues for key words and phrases," but that they also serve as a "visual gloss" that "reflect[s] an impulse toward an allegorical reading of the songs."[59] In *The Game of Love*, I discussed evidence of historicizing as well as facetious interpretative traditions provided by the illuminations, especially the figures of initial letters, in thirteenth- and fourteenth-century anthologies of troubadour verse.[60]

Suzanne Lewis has also explained some of the figures within initial letters, this time in a thirteenth-century Biblical text, as playful, punning interpretations of the adjacent words or phrases – such as the Latin noun for heaven (*celo*), which may be confounded with the Latin word for arrow or missile (*telo*) figured in images of shooting. She suggested that "rebus-like images that pun visually on certain words or themes in the text" may serve as a mnemonic device,[61] like the Cuerdon Psalter's initials (*c.*1270), as Mary Carruthers demonstrated.[62] Until Lewis's essay, the historiated initials of the Getty Apocalypse had "passed unnoticed," all critical attention being focused on the framed miniatures illustrating the text and on the figure of St John peering into the frames.

Exploration of the possible senses of the figures of initial letters in medieval manuscripts was long hampered by their marginalizing designation as "decoration." It was not until the 1970s that figurative initial letters began to emerge as a subject for analysis, with Carl Nordenfalk's catalogue and classification of the earliest figural motifs, J. J. G. Alexander's historical overview introducing an anthology of color plates, and Howard Helsinger's revisionist essay, "Images on the *Beatus* Page."[63] Helsinger demonstrated that, at least on the *Beatus vir* page of the Psalter, *bas de page* scenes of deer hunting, which appear from the late thirteenth century on, should not be taken as irrelevant genre scenes. Like other scenes of spiritual struggle against sin and the devil (for example, David

overcoming Goliath or the lion), these deer hunts emerge from the initial B, and they retain an allegorical sense even when displaced to the margins. On the evidence provided by the twelfth-century St Albans Psalter, where a marginal commentary explains as a figure of spiritual struggle the two knights fighting on horseback in the upper margin of the *Beatus* page, Helsinger extended allegorical signifance to other profane scenes of struggle in the margins, such as jousts, on the *Beatus* pages of later Psalters. In a chapter entitled "Sacred Letters as Dangerous Letters and Reading as Struggle," I treat the spiritual combat of monastic psalmody, but also the struggle to achieve spiritual understanding of the text (and to overcome the "killing letter" of literal understanding) represented in initials that embody or enclose struggle in Romanesque and early Gothic Psalters.[64]

Conrad Rudolph has provided a case study of figurative initials in their relation to the text of a single manuscript.[65] Whereas these had been "traditionally interpreted as ornamental or generic because they were typically not seen as illustrating the text of the *Moralia in Job*," Rudolph's closer reading discovered that "virtually all the initials of the Cîteaux *Moralia* are related either to specific passages of the books that they head or to the general sense of one of the issues raised in those books, although sometimes in an idiosyncratic or seemingly arbitrary way."[66] These initials represent spiritual struggle as Gregory conceived it in the adjacent text, which can be used to explain specific details of the initials.

Margins and Marginality

Written for a broad audience, Michael Camille's *Image on the Edge* presents past and present research on marginal imagery, including Camille's own eclectic approach, which here takes on a strong anthropological and sociological cast, with margins (or "edges" or "fringes") interpreted as liminal social spaces.[67] Like the earliest art historians, Camille discusses carved images as well as drawn and painted ones, the figurative margins of medieval buildings, furniture, and artifacts as well as the margins of medieval pages. Regardless of their different material supports, he groups marginal images according to the different medieval "centers of power" for which they were produced: the monastery, the cathedral, the court, and the city. On the first page of his preface, Camille points out that he is not interested in exploring the general meaning of particular motifs (like Randall and others), but rather in "their function as part of the whole page, text, object or space in which they are anchored." His reproductions are a model in this respect, often providing separate photos of the detail enlarged and the detail in its context, whether that be a full manuscript page, a double-page spread (see fig. 13-2), a façade, or other architectural unit. In this way, Camille is able to demonstrate how marginal figures interact with other marginal figures on opposite or nearby pages, with other elements on the same page (large miniatures, the words or syllables of the text), or with other features

of a sculptural program. Although it analyzes a mid-fourteenth-century manu-
script, and thus falls outside the scope of this volume, Camille's subsequent case
study, *Mirror in Parchment*, carries to new limits cultural contextualization of
the marginal imagery of a single manuscript.[68]

Since the publication of Randall's *Images in the Margins of Gothic Manu-
scripts*, marginal imagery in manuscripts has received more scholarly attention
than "marginal" sculpture and has usually been treated separately. In a series of
articles followed by a book, Nurith Kenaan-Kedar has returned to the subject of
corbel sculptures.[69] Her neo-Bakhtinian interpretation of the carved animals,
monsters, and humans (chiefly "people from the margins of society – jongleurs,
acrobats, musicians, female drunkards, fools and beggars") allows for the possi-
bility of different meanings for different audiences. To ecclesiastical patrons,
"these distorted figures could be understood as punished sinners, although their
punishment was expressed only metaphorically, implicit in the burdens they had
to bear [as architectural supports]."[70] However, to the Romanesque artists who
first created these provocative, boldly expressive, unstylized images, they rep-
resented both a protest against and a deliberate transgression of the codes of
"official culture."[71] Since the late 1960s in the West, renewed interest in under-
standing the sense of medieval marginal images is part of a much broader
interest in all aspects of marginality. For the current generation of art historians,
restoring significance to the marginal is a symbolic act.[72]

Notes

1 Thompson, "The Grotesque," p. 309; my emphasis.
2 Maeterlinck, *Le genre satirique*, p. 2, paraphrasing Mr Lapidoth, a reviewer of the
 first edition of the book (1903). [On Romanesque and Gothic manuscript illumina-
 tion, see chapters 17 and 20 by Cohen and Hedeman, respectively, in this volume
 (ed.).]
3 Mâle, *L'Art religieux du XIIIe siècle*, p. 105. All translations from French in this
 essay are mine. [On the monstrous, see chapter 12 by Dale in this volume (ed.).]
4 Auber's *Histoire de la cathédrale de Poitiers* dates from 1849; his four-volume *Histoire
 et théorie du symbolisme religieux* was published in 1870–1.
5 Cahier, *Nouveaux mélanges*. The offending material appeared in volume two of this
 work.
6 Bastard d'Estang, *Etudes*.
7 Bastard d'Estang, "Rapport," p. 169.
8 Ibid., pp. 172–4.
9 Ibid., p. 172.
10 Paris, BNF *ancien fonds latin* MS lat. 1258.
11 Bastard d'Estang, "Rapport," pp. 172–3.
12 Ibid., unnumbered illustration on p. 172.
13 Ibid., p. 174.
14 Ibid., p. 176.

15 Champfleury, *Histoire de la caricature*, p. 31.
16 Wright, *History of Caricature*; Champfleury, *Histoire de la caricature*; Maeterlinck, *Le genre satirique dans la peinture flamande* and *Le genre satirique, fantastique et licencieux*.
17 Wright, *History of Caricature*, p. 118.
18 Mâle, *L'Art religieux du XIIIe siècle*, p. 136, n.117.
19 Champfleury, *Histoire de la caricature*, pp. 173–4.
20 Mâle, *L'Art religieux du XIIIe siècle*, p. 124.
21 Ibid., p. 107. This passage from Bernard's letter to William of St Thierry is analyzed, reproduced, and translated in Rudolph, *Things of Greater Importance*.
22 Mâle, *L'Art religieux du XIIIe siècle*, p. 107.
23 Ibid., p. 114.
24 Ibid., p. 124.
25 Mâle, *L'Art religieux du XIIe siècle*, p. 2. [On Romanesque sculpture, see chapters 15 and 16 by Hourihane and Maxwell, respectively, in this volume (ed.).]
26 Mâle, *L'Art religieux du XIIe siècle*, p. 341.
27 Baltrušaitis, *La Stylistique ornementale*; *Le Moyen-Age fantastique*; and *Réveils et prodiges*. Although *Réveils et prodiges* takes into account the most recent criticism, including that of Schapiro, Janson, an essay by Randall, and even Bakhtin, Baltrušaitis's organicist, evolutionary argument belongs to an earlier phase of art history, characterized by the works of Henri Focillon, to whom Baltrušaitis dedicated *La stylistique ornementale*.
28 Baltrušaitis, *Réveils et prodiges*, rev. edn. (Paris, 1988), p. 335.
29 Ibid., p. 197.
30 Ibid., pp. 154 and 352, n.101. This displacement had been remarked as early as 1896 by Thompson, "The Grotesque," pp. 309–12, and also by Haseloff, *Psalterillustration*, p. 5.
31 Schapiro, "Aesthetic Attitude," p. 1.
32 Ibid., p. 10.
33 Ibid., p. 4.
34 Ibid., p. 6.
35 Janson, *Apes and Ape Lore*, p. 42.
36 Ibid., p. 163.
37 Ibid., p. 164.
38 Ibid., p. 163.
39 Although nearly all the features of Gothic border imagery had been developed by 1300 (the cut-off date for the present volume), the period from 1300 to 1350 saw the making of most of the best-known and most studied manuscripts, such as the Hours of Jeanne d'Evreux, the Luttrell Psalter, the Smithfield Decretals, to name but a few.
40 Randall, *Images*, p. 15.
41 Ibid., p. 10.
42 Ibid., pp. 8, 14, 18. See also Randall, "Exempla," p. 98.
43 *Images*, p. 19.
44 Ibid., p. 20.
45 Ibid., pp. 16, 19.
46 Randall, "A Mediaeval Slander."

47 Randall, "The Snail."
48 Randall, "Humour and Fantasy," p. 482.
49 Randall, "Games."
50 Sandler, "Series of Marginal Illustrations."
51 Sandler, "Reflections."
52 Sandler, "Pictorial and Verbal Play."
53 Ibid., p. 56.
54 Ibid., p. 62.
55 Morgan, "The Artists of the Rutland Psalter."
56 Ibid., p. 169.
57 Rieger, "Ins e.l cor port, dona, vostra faisso," p. 399.
58 Huot, "Visualization and Memory."
59 Ibid., pp. 3, 5.
60 Kendrick, "*Lo Gay Saber*."
61 Lewis, "Beyond the Frame," pp. 73–4.
62 Carruthers, *The Book of Memory*.
63 Nordenfalk, *Die spätantiken Zierbuchstaben*; Alexander, *The Decorated Letter*; Helsinger, "Images."
64 Kendrick, "Sacred Letters."
65 Rudolph, *Violence and Daily Life*.
66 Ibid., pp. 9, 12.
67 Camille, *Image on the Edge*.
68 Camille, *Mirror in Parchment*.
69 Kenaan-Kedar, *Marginal Sculpture in Medieval France*.
70 Kenaan-Kedar, "The Margins of Society," pp. 15, 18.
71 Kenaan-Kedar, *Marginal Sculpture*, p. 1. For the concept of "official culture," see Bakhtin, *Rabelais and His World*.
72 For further historiography, see Sandler, "Study of Marginal Imagery"; Wirth, "Les marges à drôleries."

Bibliography

J. J. G. Alexander, *The Decorated Letter* (New York, 1978).

Charles-Auguste Auber, *Histoire de la cathédrale de Poitiers* (Paris, 1849).

——, *Histoire et théorie du symbolisme religieux avant et depuis le christianisme*, 4 vols. (Paris, 1870–1).

M. M. Bakhtin, *Rabelais and His World*, trans. H. Iswolsky (Bloomington, 1965).

Jurgis Baltrušaitis, *Le Moyen-âge fantastique: Antiquités et exotismes dans l'art gothique* (Paris, 1955).

——, *Réveils et prodiges: Le gothique fantastique* (Paris, 1960).

——, *La Stylistique ornementale dans la sculpture romane* (Paris, 1931).

Auguste, Count Bastard d'Estang, *Etudes de symbolique chrétienne* (Paris, 1861).

——, "Rapport de M. Auguste de Bastard, membre du comité, sur les planches I, II, III, IV, VI, VIII, IX, et X de *L'histoire de la cathédrale de Poitiers* par M. l'abbé Auber, président de la Société des Antiquaires de l'Ouest, correspondant du ministère pour les travaux historiques," *Bulletin du comité historique des arts et monuments: archéologie, beaux-arts* 2 (1850), pp. 166–82.

Charles Cahier, *Nouveaux Mélanges d'archéologie, d'histoire et de littérature sur le moyen âge*, 4 vols. (Paris, 1874–7).

Michael Camille, *Image on the Edge: The Margins of Medieval Art* (Cambridge, Mass., 1992).

——, *Mirror in Parchment: The Luttrell Psalter and the Making of Medieval England* (Chicago, 1998).

Mary Carruthers, *The Book of Memory: A Study of Memory in Medieval Culture* (Cambridge, 1990).

Jules Champfleury, *Histoire de la caricature au moyen âge et sous la renaissance*, 2nd edn. (Paris, 1898).

Günter Haseloff, *Die Psalterillustration im dreizehnten Jahrhundert: Studien zur Buchmalerei in England, Frankreich und den Niederlanden* (Kiel, 1938).

Howard Helsinger, "Images on the *Beatus* Page of Some Medieval Psalters," *The Art Bulletin* 53 (1971), pp. 161–76.

Sylvia Huot, "Visualization and Memory: The Illustration of Troubadour Lyric in a Thirteenth-Century Manuscript," *Gesta* 31 (1992), pp. 3–14.

H. W. Janson, *Apes and Ape Lore in the Middle Ages and the Renaissance* (London, 1952).

Nurith Kenaan-Kedar, *Marginal Sculpture in Medieval France: Toward the Deciphering of an Enigmatic Pictorial Language* (London, 1995).

——, "The Margins of Society in Marginal Romanesque Sculpture," *Gesta* 31 (1992), pp. 15–24.

Laura Kendrick, "*Lo Gay Saber* in Words and Pictures," in *The Game of Love: Troubadour Wordplay* (Berkeley, 1988).

——, "Sacred Letters as Dangerous Letters and Reading as Struggle," in *Animating the Letter: The Figurative Embodiment of Writing from Late Antiquity to the Renaissance* (Columbus, 1999).

Suzanne Lewis, "Beyond the Frame: Marginal Figures and Historiated Initials in the Getty Apocalypse," *The J. Paul Getty Museum Journal* 20 (1992), pp. 53–76.

Louis Maeterlinck, *Le genre satirique dans la peinture flamande* (Brussels, 1903; 2nd edn. 1907).

——, *Le genre satirique, fantastique et licencieux dans la sculpture flamande et wallonne: Les miséricordes de stalles* (Paris, 1910).

Emile Mâle, *L'Art religieux du XIIIe siècle en France: Etude sur l'iconographie du moyen âge et sur ses sources d'inspiration*, vol. 1, 8th edn. (Paris, 1958).

——, *L'Art religieux du XIIe siècle en France: Etude sur l'origine de l'iconographie du moyen âge*, 4th ed. (Paris, 1940).

Nigel Morgan, "The Artists of the Rutland Psalter," *The British Library Journal* 13 (1987), pp. 159–85.

Carl Nordenfalk, *Die spätantiken Zierbuchstaben* (Stockholm, 1970).

Lillian Randall, "Exempla as a Source of Gothic Marginal Illumination," *The Art Bulletin* 39 (1957), pp. 97–107.

——, "Games and the Passion in Pucelle's Hours of Jeanne d'Evreux," *Speculum* 47 (1972), pp. 246–61.

——, "Humour and Fantasy in the Margins of an English Book of Hours," *Apollo* 84 (1966), pp. 482–8.

——, *Images in the Margins of Gothic Manuscripts* (Berkeley, 1966).

——, "A Mediaeval Slander," *The Art Bulletin* 42 (1960), pp. 25–40.

——, "The Snail in Gothic Marginal Warfare," *Speculum* 37 (1962), pp. 358–67.

Angelica Rieger, " 'Ins e.l cor port, dona, vostra faisso': Image et imaginaire de la femme à travers l'enluminure dans les chansonniers de troubadours," *Cahiers de civilisation médiévale* 28 (1985), pp. 385–415.

Conrad Rudolph, *"The Things of Greater Importance": Bernard of Clairvaux's* Apologia *and the Medieval Attitude toward Art* (Philadelphia, 1990).

——, *Violence and Daily Life: Reading, Art, and Polemics in the Cîteaux* Moralia in Job (Princeton, 1977).

Lucy Freeman Sandler, "Pictorial and Verbal Play in the Margins: The Case of British Library, Stowe MS 49," in Michelle P. Brown and Scott McKendrick, eds., *Illuminating the Book: Makers and Interpreters* (London, 1998), pp. 52–68.

——, "Reflections on the Construction of Hybrids in English Gothic Marginal Illustration," in Moshe Barash and Lucy Freeman Sandler, eds., *Art, the Ape of Nature: Studies in Honor of H. W. Janson* (New York, 1981), pp. 51–65.

——, "A Series of Marginal Illustrations in the Rutland Psalter," *Marsyas: Studies in the History of Art* 8 (1959), pp. 70–4.

——, "The Study of Marginal Imagery: Past, Present, and Future," *Studies in Iconography* 18 (1997), pp. 1–49.

Meyer Schapiro, "On the Aesthetic Attitude in Romanesque Art," in *Romanesque Art: Selected Papers* (London, 1977).

E. M. Thompson, "The Grotesque and the Humorous in Illuminations of the Middle Ages," *Bibliographica* 2 (1896), pp. 309–32.

Jean Wirth, "Les marges à drôleries des manuscrits gothiques: problèmes de méthode," in Axel Bolvig and Phillip Lindley, eds., *History and Images: Towards a New Iconology* (Turnhout, 2003), pp. 277–300.

Thomas Wright, *A History of Caricature and Grotesque in Literature and Art* (London, 1865).

Romanesque Architecture
Eric Fernie

There is something very odd about the Romanesque style as it is currently defined, namely how it is supposed to have begun. As originally used, in the eighteenth century, the word "Romanesque" referred to the Romance languages, those which had become what were considered corrupted versions of late Latin over the course of the first millennium. Thus when William Gunn in 1819 first applied the term "Romanesque" to architecture, he used it to cover all the masonry buildings of Western Europe between the Roman period and the Gothic. To underline the parallel with the languages, he cited the difference drawn in the Rome of his day between a *Romano*, someone who was unarguably a citizen, and a *Romanesco*, an inhabitant of dubious origins. Romanesque therefore meant not properly Roman, or literally Roman-ish.[1] The current definition, introduced in France in the late nineteenth century, is very different in that it restricts the style to the last two or three centuries of the longer period. Whereas the old long period was a continuation of the Roman arising directly out of changes in Roman culture, the new short one, while retaining a strong link with the Roman past, has no obvious historical context or period of social change to help explain it. In addition, for some scholars it begins as late as the middle of the eleventh century and for others as early as the second quarter of the tenth, while proposed places of origin lie as far apart as Lombardy, the Loire Valley, and Saxony.

Given these uncertainties it is worthwhile asking if the new style is a convincing historical phenomenon or merely the result of an academic exercise. It is supported by the clarity of its main characteristic, which is most often seen, in all the visual arts but especially in architecture, as the articulation of parts from smallest to largest, forming clear geometrical shapes which relate to one another in understandable ways.[2] The early eleventh-century church of St Vincent at Cardona in Catalonia can be used to exemplify the style, in that it is composed of clearly readable masses and volumes and has an interior which can be determined from the exterior. Equally important is the consistency of the changes

which take place within it, as for example with the differences between the late eleventh-century portal of St Etienne in Caen and the portal of a century later in the castle hall in Durham, two Norman buildings which illustrate a classic development from simple to complex. Patterns of change like these imply no mystical "life" of forms, but rather the psychology of use and enjoyment, of boredom and invention, as such establishing that the masons responsible were working within a tradition. This evidence leaves little doubt, then, that we are dealing with a recognizable phenomenon, and from now on in this chapter I shall be using the term Romanesque for this restricted meaning and period, with uncertainty only over the date of the start of the period.

The diffusion in time and space of the origins of the Romanesque suggests that they are likely to have been caused or accompanied by a major, all-pervading change, so it is appropriate to begin by looking at what has been called the most momentous change in the history of the West in the first millennium, that is, the end of antiquity (bearing in mind that all periods are artificial impositions on the past, which we need, as Wölfflin put it, to keep us sane). The end of antiquity in the West has traditionally been associated with the deposing of the last western Roman emperor in 476, but the old administrative, social, and trading structures clearly continued beyond this date. A more significant break has therefore been identified in the Islamic invasions of the seventh and eighth centuries. They are seen as a symptom in that they only happened because of the weakness of the Empire, but they are also seen as a cause: as the Roman Empire consisted not so much of an area of land as of the Mediterranean sea plus the territories around its shores, when the invasions cut control of the sea in two they severely affected the world-view of its inhabitants, one which had kept the structure, if not the name, of the western empire going in even the most dire of circumstances. For anyone used to thinking of Carthage, Alexandria, Jerusalem, and Antioch as part of their world, the invasions must have had a devastating effect (figs. 14-1, 14-2). The rupture had the effect of forcing the Frankish rulers of the northern parts of this lingering remnant of antiquity back on themselves, leading them to form a state which, under Charlemagne in the year 800 and in alliance with the Western Church, revived the western Roman Empire in Carolingian form, a new polity with its centre of gravity firmly north of the Alps rather than on the Mediterranean (fig. 14-3).[3]

For these reasons, consolidation of the Carolingian dynasty in the late eighth century can be said to mark the end of antiquity in the West and therefore the start of a new era. This new post-antique period is normally identified as the Middle Ages, but there is a daunting problem with the legacy of this concept. I am not referring to the pejorative connotations which make it a trough of low culture between antiquity and the Renaissance, as these have long been abandoned; it is rather the major break which is still implied between the Middle Ages and the Renaissance. On the contrary, there appear to be few if any grounds for the view that there was a change in the fourteenth and fifteenth centuries of equivalent scope and depth to that marked by the end of antiquity.

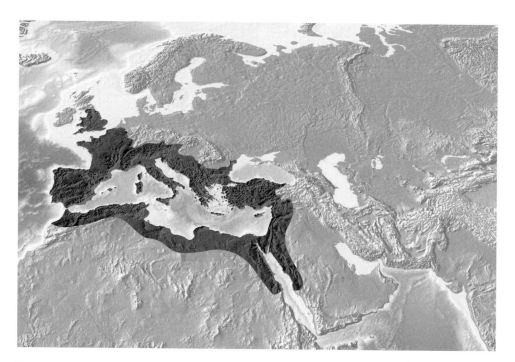

FIGURE 14-1 The Roman Empire, c.395. © by Eric Fernie and Chris Kennish.

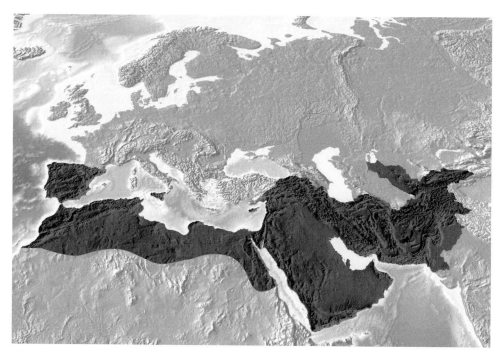

FIGURE 14-2 The Caliphate of Cordoba, c.750. © by Eric Fernie and Chris Kennish.

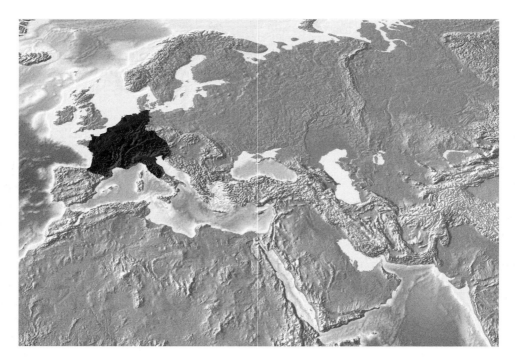

FIGURE 14-3 The Carolingian Empire, 814. © by Eric Fernie and Chris Kennish.

The Renaissance makes more sense as part of a single development from the Carolingian era to the present day, which can, eventually, be identified as the culture of Europe.

This conclusion is supported by the evidence of the boundaries of the Carolingian Empire, which dissociate it from the past and associate it with what were to become the nations of Europe. While the prefectures of the Roman Empire provide a basis for the shapes of the future European political units of France, Spain, Italy, and Britain, the land boundaries of the Carolingian Empire nonetheless have no parallels at all with those, internal or external, of the Roman Empire, and even parallels between the boundaries consisting of coastlines are limited. Conversely, the Carolingian boundaries have a fundamental relevance for the future, both in terms of the extent of the states and of the continuity of administrative structures. In 843 Charlemagne's empire was divided into three parts (fig. 14-4). Of these, the western and eastern kingdoms provided the basis for France and Germany respectively, while the kingdom between, Lotharingia, contained the areas of the smaller states, provinces, duchies, and counties which subsequently became the Netherlands, Brabant, Lorraine, Alsace, Burgundy, Lombardy, Tuscany, and so on.[4]

If the Carolingian state can be said to represent the political aspect of the formation of European culture, changes in its economic life were no less significant. It is difficult to exaggerate the poverty into which this part of the world had

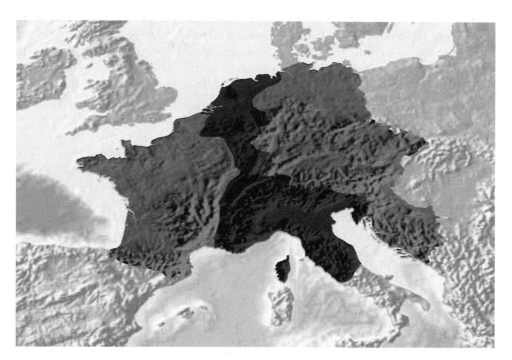

FIGURE 14-4 The Carolingian Empire, 843. © Eric Fernie and Chris Kennish.

fallen, with the long decline of the western Roman economy finally reaching a nadir in the eighth century. Then, in the ninth century, an economic revival began, and, though it was curtailed almost immediately by the invasions of the Vikings and Hungarians, it resumed in the tenth century to grow almost unbroken until the thirteenth. The causes of this revival are difficult to identify, but technological innovation must have played a major role. Indeed, the five centuries from the ninth to the thirteenth deserve to be known as the first industrial revolution, as more machines and techniques were adopted or invented in the West in this period than at any time before the Industrial Revolution itself. Among many other things, the ninth and tenth centuries saw watermills being exploited on a large scale for the first time, the heavy-wheeled plough made its appearance, and the collar harness increased the pulling power of horses fivefold, aiding not only agriculture but also transport and the mining industry.[5]

Along with these signs of a major break in politics and the economy, there is the evidence of the architecture. In the Carolingian period the articulation of forms and volumes which is a feature of some monuments of the Roman period takes a major step toward its consistent use, new features like the outer crypt, the westwork and the crossing provided the basis for some of the most characteristic developments of the tenth, eleventh, and twelfth centuries, and (in one of the most marked changes of any date to the Western architectural vocabulary), the silhouette of the building is for the first time treated as a feature of the design.

In addition to this evidence from the buildings, the building industry itself underwent a revolution. It has been estimated that "quarrying was by far the most important mining industry in Europe, more important possibly than all the others combined. The mining of stone in the Middle Ages can only be compared to the mining of coal in the nineteenth century and the drilling for oil in the twentieth."[6] In the centuries of greatest economic weakness, from the fifth to the eighth, stone buildings were largely restricted to the patronage of the ruling elite, yet by the eleventh century almost every parish church was built of stone, while dwellings and shops soon came to be constructed of stone as well as wood. This huge expansion in the provision of cut stone suggests that the industry may have seen an invention as influential as those in agriculture and manufacture, such as an improved metal for the cutting edges of chisels, just as between the ninth century and the eleventh wooden hoes and pitchforks were replaced by their iron equivalents. While high-quality masonry was produced throughout the poorer centuries, it was largely restricted to the dressing of corners, whereas once the working of stone had been established on a new scale it became easier to build whole walls of a regular character. Features like pilasters would have underlined the regularity by subdividing and paralleling the wall, with their corners expressing the exactness of the cutting. In other words the masons' concentration on clarity and articulation, the chief characteristics of the Romanesque style, could have been strengthened if not caused by the opportunities offered by improvements in quarrying in the Carolingian economic revolution.

This theory of the dependence of the Romanesque on a masonry and hence Roman tradition differs from that proposed by Walter Horn, according to which Romanesque articulation derived from the bays of the tradition of building in wood. Such a source is certainly plausible, as many more structures were built of wood than stone at the time, and every stone building in addition required large amounts of carpentry, for construction, roofing, and fittings. The weakness of Horn's theory lies in the fact that, apart from the bays, which are available in Roman masonry buildings in any case, there is little or nothing in the Roman-esque masonry repertoire which can be derived from wooden construction, which has, for example, no clear equivalent for a feature as basic as the pilaster.[7]

If this hypothesis is sustainable, then the occurrence of the style in the other visual arts would be dependent on the changes in architecture. Architectural articulation would have made itself felt first in stone sculpture on the buildings, in the designing of capitals, tympana, jambs, and so on, as frameworks for foliage, figures, and scenes.[8] The painting adorning that sculpture could then have taken on the same characteristics, and finally manuscript illumination, metal-work, and ivory carving, a sequence supported by the fact that, on the whole, the more precious the material the less Romanesque the style or the later its development. There is, however, a major problem with this sequence: while the link between building and sculpture is direct, that between sculpture and paint-ing is not. It is not at all clear that those responsible for painting books would

have appropriated styles from those who painted masonry, because of the greater delicacy of the work in the scriptorium and because the illuminators worked with scribes who were literate or were literate themselves, with all the status which that implies. That the production of manuscripts needs to be considered in a different context is also indicated by the history of lettering, in that the Carolingian minuscule, beautifully articulated in the Romanesque manner, was invented already in the early ninth century and used almost universally in the West up to the rise of black letter in the twelfth. While this complicates the question of the origins of the Romanesque style in different media, it is also, of course, another example of consistency in an aspect of the visual arts in the period *c.*800 to *c.*1200.

To sum up, if the Carolingian period marks the start of a new culture, not only in politics and economics but also in architecture, providing a historical context for the origins of the Romanesque style, it has to be asked what utility is served by maintaining a major hiatus between styles called Carolingian and Romanesque. If this and similar breaks are ignored, then the differences which have led to widely varied starting dates for the Romanesque cease to be contentious and take their place in a continuum of stages in the development of a style. The case is supported in many apparently minor ways, by, for example, the number of books on Romanesque subjects which use or mention the date brackets 800 and 1200, or by the words of Robert de Lasteyrie, writing in 1929: "Si donc je respecte l'usage qui est de faire commencer l'époque romane au XIe siècle, je prie mes lecteurs de bien retenir qu'une foule de détails propres à l'art roman se rencontrent déjà au IXe et au Xe siècles."[9]

Political Units and Stylistic Subdivisions

This discussion of definitions provides a basis for attempting an overview of the areas and periods into which the Romanesque architecture of *c.*800 to *c.*1200 can be divided.[10] In any attempt of this kind, it needs to be borne in mind that, while one of the central tasks of anyone studying the Romanesque period is to understand what is happening in terms of the political units of the time, most of the literature is ordered almost exclusively by modern countries and even on occasion with nationalistic motives.[11]

The Carolingian era begins with a period of political unity in the late eighth and early ninth centuries. Although many important monuments, including revivals of Early Christian basilicas, emulate buildings of the Roman period which avoid articulation, the period also sees the laying of the groundwork of the new style in all major aspects of its treatment of form and use of features. Thus the palace chapel built by Charlemagne at Aachen between 786 and 805 is traditional in the sense that it is based on Roman centralized structures such as the sixth-century buildings of SS Sergius and Bacchus in Constantinople or San Vitale in Ravenna. It is also, however, possible to describe it in strictly

Romanesque terms, as the clarity of its spatial organization and the differentiation and articulation of its parts stand in sharp contrast to the billowing ambiguous spaces and filigree capital carving of the buildings in Constantinople and Ravenna. The late eighth-century gatehouse at Lorsch provides a similar example of very early Romanesque design.

The St Gall Plan, of the 820s, provides more varied evidence of breaks with the past, in at least four ways. The first is the relationship between the church, the cloister, and the monastic buildings. This is a masterpiece of articulation, with the cloister fitted into the angle between the nave and the transept and the ranges for the main functions set out around the sides of the square. While the ideal of order which lies behind the Plan is of course Roman, the arrangement of the three parts has no known precedents and conversely became the standard formula for monastic design in the Romanesque period and after. The second indication is the placing of the north and south passages of the crypt outside the main structure. This is a simple version of the outer crypt which in its fullest form is almost a separate building beyond the sanctuary and which provided the basis for the designing of eastern arms of churches from the tenth century on. The third is the representation of a crossing at the intersection between the axis of the transept on the one hand and that of the east arm and the nave on the other. The crossing is common in centralized churches from the earliest dates, but is new in the Carolingian period in unambiguously basilican churches. The fourth is the west end of the church, where there are two towers and a curved colonnade, an arrangement which creates a greater focus of importance than a façade which simply represents the cross section of the nave, and which again relates to more complex future developments.[12]

The period of unity came to an end in 843 with the triple division of the Empire into the East Frankish, Lotharingian, and West Frankish kingdoms. This division set the pattern not only in political terms but also in architecture, producing the main areas of the whole Romanesque period and underlining the appropriateness of beginning the period with the Carolingian dynasty. In the eastern, German, kingdom and subsequently Empire, in many buildings stress was laid on the west end of the church as well as the east. The westwork at Corvey on the Weser, after 870, with its dramatic silhouette, exemplifies the type. Alternation was equally important, as at Bishop Bernward's church at Hildesheim, of 1010–33, which also has a western apse.[13]

In the course of the eleventh century in many of the noteworthy buildings built in the Rhineland, classicizing elements were increasingly employed, as in the Emperor Conrad's cathedral at Speyer of 1030–61, and even more so in Henry IV's reworking of the building in the 1080s. The chief aim seems to have been to support the legitimacy of the imperial line by using elements not only from the Roman period but also from contemporary buildings in Lombardy. Thus Henry's Speyer has large groin vaults over the nave reminiscent of those in thermae, giant-order arcades like those of the Roman basilica at Trier, and sculptural decoration on eleventh-century buildings in Lombardy such as

St Abbondio in Como. It is not clear whether these last parallels were mistaken for monuments of classical date or if they were simply considered classical because of their provenance. Cologne in the eleventh and early twelfth centuries also saw a great building boom in Romanesque churches. After this period of activity, the German tradition produced one of the clearest and most inventive instances of Romanesque baroque, as with the western apses of the cathedrals of Worms and Mainz.[14]

While the German Empire became the strongest political force of the time in the West, with an architecture markedly shaped by political considerations, the middle of the three kingdoms, the Lotharingian, had by the tenth century been absorbed into the other two kingdoms. Despite this, it is significant for two reasons, first because it included many of the economically most advanced parts of the Carolingian states, and second because of the substantial degree of overlap between it and what has been called the First Romanesque style (fig. 14-5). The largely passive role previously ascribed to this style has been replaced with a positive view of its contribution. It appears to have originated in Lombardy and the Po valley in the ninth and tenth centuries, developing directly out of late Roman sources, including the arched corbel-tables which were to become its leitmotiv. The style spread from Italy west to Catalonia which made precocious use of it from the middle of the tenth century, while the early eleventh saw the

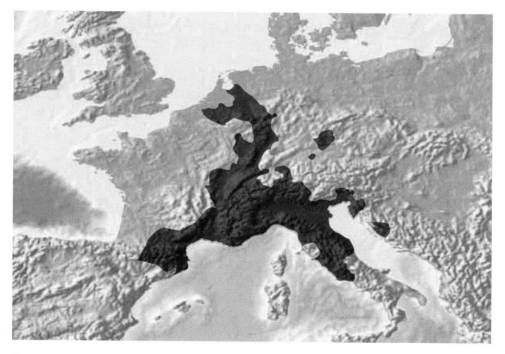

FIGURE 14-5 The extent of the "First Romanesque" style. © by Eric Fernie and Chris Kennish.

building of churches as ambitious and international, as those at Cardona and Ripoll. The importance of the Byzantine Empire for the First Romanesque is indicated by the similarities between tenth-century Constantinopolitan churches such as the Bodrum Camii and buildings of the late tenth and eleventh centuries on the Adriatic and Ligurian coasts and in Catalonia. The style spread from Italy up the valleys of the Rhône and the Saône, into Burgundy and the alpine regions, to the monastery at Romainmôtier among others, and to the Rhineland. There, First Romanesque features such as the arched corbel-table tend to be superficially applied to buildings of a more "imperial" character, including, for example, St Pantaleon in Cologne, which may be as early as the late tenth century.[15]

By the middle of the eleventh century the First Romanesque style had changed sufficiently, in terms of quality of masonry and use of half-shafts and sculpture, to warrant a new label, what has been called straightforwardly the Second Romanesque. North Italy again appears to have been in the vanguard. Architects in Lombardy and Piedmont contributed innovations in rib-vaulting, Milan, Pavia, and Novara, for example, having a number of buildings of the late eleventh and early twelfth centuries which have close connections in the north at Speyer and Utrecht and distant ones with Norman examples such as Durham. In most other areas of north and central Italy, wooden ceilings were preferred, in churches like San Miniato near Florence, of the mid-eleventh century, and the cathedral of Modena of 1099 on, with very similar elements, and of course most especially in Rome, where the conservative forms of the Early Christian period continued in use into the thirteenth century. Buildings of this kind indicate that, despite the popularity of vaults, wooden ceilings were in no way considered inferior. Southern Italy and Sicily, in keeping with their political history, developed an amalgam of the Byzantine, the Islamic, and the Norman. The Normans introduced northern French work at places like the cathedrals of Aversa and Acerenza, while the major churches of Bari in Apulia illustrate the importance of pilgrimage in the distribution of architectural forms.[16]

Italian commercial dominance of the Mediterranean, which was almost complete by the late eleventh century, depended entirely on the success of Italian towns, places such as Venice, Bari, Pisa, Genoa, Milan, Piacenza, Parma, and Verona. Venice was especially prominent, with St Marks, begun in 1063, being based on the sixth-century Holy Apostles in Constantinople, a model which may also lie behind San Nazaro, previously the Holy Apostles, in Milan (refurbished after a fire in 1075), and that of Canosa in Apulia (consecrated 1101).[17]

In the third kingdom, the western, the Carolingian dynasty lasted until 987 when it was succeeded by the Capetian, the first dynasty of the kingdom of France. Despite sharing a common base with the eastern kingdom in the architecture of the Carolingian empire, the architecture of the western kingdom proceeded along very different lines. The buildings indicate a special interest in the popularity of relics, accompanied by changes in regulations governing the use of altars. These led in the course of the tenth and early eleventh centuries to

the reworking of the outer crypt into the fully articulated design of the ambulatory with radiating chapels. This was achieved by the simple geometric expedient of using the central point of the main apse for plotting both the curves of the ambulatory walls and the radiating axes of the chapels, as in the early examples of the cathedrals of Clermont-Ferrand, Orléans, and Chartres. In Anjou there is precocious work in Angers itself, at the cathedral of *c*.1040, with its aisleless nave, and the Ronceray with its complete set of eleventh-century barrel vaults and a vaulted crossing.[18] The Normans, fast learners, adopted the architecture of these and other areas along with a fervour for monastic reform.[19]

While the French crown, centered on Paris and Orléans, theoretically controlled territory as far as and even beyond the Pyrenees, in reality the southern half of the country (broadly the Duchy of Aquitaine, south of the valley of the Loire) was virtually independent as well as being culturally self-confident. This division between north and south is fairly clear except at its eastern end, as the territories occupied by the Burgundians from the sixth century on are probably politically the most complicated region of the whole Romanesque period. This is due to the fact that their name is attached to a duchy, a county, and a kingdom, the first of which was in France and the other two in the Empire, and that the duchy has a large contingent of First Romanesque buildings closely related to those on the other side of the border. This complex position is simplified at least for the art historian by the fact that most of the Romanesque buildings of importance in the region, whether early or late, lie in the modern French province of Burgundy. Noteworthy First Romanesque buildings include St Philibert at Tournus, with an articulated crypt and experimental vaults of the earlier and later eleventh century respectively, and St Bénigne at Dijon, with its gigantic eastern rotunda, of 1001/2–18. The second church at Cluny, begun in the 950s, is important as the source of a plan type which, along with monastic reform, penetrated much of Western Europe, from Farfa near Rome to Bernay in Normandy and Hirsau in the German Empire.[20] The late eleventh century in Burgundy saw dramatic changes from First Romanesque formulae, with the introduction of a newly interpreted repertoire of forms from antiquity. One might have expected these developments to derive from parallels in Provence, given the more extensive Roman remains there and the likely Islamic sources of the pointed arch in Sicily and southern Italy. Yet all the evidence places the Provençal monuments later than the Burgundian ones and leaves us to explain Burgundian primacy by the institutional power of the Cluniac order, exemplified by the vast, structurally daring and classically decorated third church at Cluny begun in 1088.

The most idiosyncratic group of buildings in the south is that vaulted with domes. These appear to be a response to the challenge of vaulting buildings with a tradition of wide, aisleless naves. The linking of the domes to the prestige of the Byzantine Empire is, however, suggested by the fact that two of the most striking structures, the cathedral of Cahors and St Front in Périgueux, are very similar respectively to the Hagia Sophia and the Holy Apostles in Constantinople. Finally, there are a number of eleventh-century buildings known for

their location on the pilgrimage route to Santiago, based on north French structures like St Martin at Tours (large, wood-roofed with ambulatory and radiating chapels, transept arms with aisles, and galleries all the way round the church), with the addition of vaults from the First Romanesque tradition. They include St Sernin in Toulouse, St Foi at Conques and St Martial in Limoges. The main church buildings of the twelfth century in the Auvergne are of a related type.[21]

The Spanish kingdoms lay outside the boundaries of the Carolingian kingdoms and their successor states, but they were soon, through the involvement of the Cluniac order, brought into the French ambient. The cathedral at Compostela, for instance, goal of a pilgrimage which was as important as those to Rome and Jerusalem, is basically the same as St Sernin. There are also numerous buildings on a smaller scale along the route from the Pyrenees, the *camina francés*, for example, at Jaca in Aragon and Frómista in Castile. It used to be assumed that all Romanesque art in northern Spain was French in origin, and there is much to be said for the view, but the cultural power of the Caliphate in Córdoba made the courts of Christian Spain into centers of cultural importance in their own right.[22] England in the tenth and early eleventh centuries developed its own version of the Romanesque on the basis of models from Germany, before also being brought into the French sphere by the Norman Conquest of 1066, with the Norman style then being imposed on or imported into Wales, Scotland, and Ireland.[23] The styles of the German Empire, with their imposing, classicizing character, were exported to the newly converted countries of Bohemia and Poland from the tenth century on, and, via Bremen, to Norway, Denmark, and Sweden in the course of the eleventh and twelfth centuries, with Lund Cathedral, for instance, being closely modeled on Speyer. Italy exported its version of the style to Hungary and Croatia, in buildings such as the cathedrals of Pécs and Dubrovnik.[24]

Secular Buildings

Numerous aspects of the Romanesque style have their own literature, including monastic architecture, iconography, planning and vaults.[25] The most important in terms of historiography, however, is secular architecture. This has been less studied than ecclesiastical architecture, probably because the buildings are less accessible and more altered, with a literature which is often difficult and obscure. In what may admittedly be an extreme case, the author of what was until recently one of the few books to cover castles across Europe was, in the words of one reviewer, "an Estonian who wrote in Swedish a book actually published in German, and the final translation into English cannot be trusted to express his mind." The position has recently changed out of all recognition with, for example, a string of publications which treat castles as designs meeting the social priorities of a warrior caste and not just as steps in an arms race.[26]

Boundaries

Most if not all studies of Romanesque architecture as a whole understandably begin by concentrating on those parts of Western Europe in which the style is assumed to have had its origins and main development, leaving the study of the areas on the periphery to a series of slots toward the end of each major regional section. Thus the limits of the style are likely to be considered separately in the chapters on Spain, southern Italy, the German Empire, Scandinavia, and so on. Some form of this arrangement is necessary, but a case can be made for examining all the boundaries of the style together, both because this may indicate links between contiguous areas on the periphery and because of what it can reveal about the character of the style itself.

The boundaries of the Romanesque are natural to the north and west and cultural to the south and east, marked respectively by the Arctic, the Atlantic, Islam, and Orthodoxy. Restricting comment to the eastern boundary (because of the importance for the Romanesque of the architecture and politics of the Byzantine empire), while Byzantine culture had a marked effect across the southern parts of the boundary, in the north this was reversed, with Polish Romanesque showing little if any sign of adopting Orthodox elements. On the contrary, Romanesque forms are evident in the twelfth and thirteenth centuries as far east as Novgorod, Vladimir Suzdal, and Yuryev-Polski in Russia. Despite the extensive importance of the Byzantine Empire for the West, the Byzantine buildings which most closely parallel Romanesque examples, those of the fifth century on in Georgia and Armenia, have no obvious connections with their Romanesque counterparts. They are apparently instead similar responses in masonry (as opposed to the brick almost standard elsewhere in the Byzantine Empire) to the Roman past shared with the Romanesque tradition.[27]

Romanesque and Gothic

Unlike the Romanesque, with its vague, broad, social, and economic beginnings, the Gothic style has specifically identifiable origins in a particular place and at a particular time, in the area around Paris in the 1130s and 1140s, and probably at Suger's St Denis. It was developed out of the Romanesque of northern France and Norman England, as is evident from a comparison of, for example, the use of wall passages in the transept arms of St Etienne in Caen (of the 1070s) and Noyon Cathedral (of the 1150s), or the use of shafts and the stress on verticality at the cathedrals of Ely (1080s) and Laon (*c*.1160).[28] From these beginnings the Gothic style was imported into all other parts of Europe, in some cases, as in the German Empire, to a resistance which appears to have been ideological, but by the middle of the thirteenth century the old style had almost everywhere been replaced by the new. In this the Gothic

style was aided by numerous factors including the prestige of the French monarchy, though there is disagreement over the extent to which the spread of the Burgundian Romanesque architecture of the Cistercian order was instrumental in its success.[29]

The Romanesque is often described as an age of monasteries and the Gothic as one of cathedrals. This contrast is accurate in that there was a great deal more monastic reform in the Romanesque period than in the Gothic, and in that the Gothic as a style was formed, at least initially, primarily in cathedrals. Yet the implication that cathedrals were not important in the Romanesque period is seriously misleading. One need only consider the importance of towns in the history of Romanesque architecture in Italy, or the fact that in the German Empire the Romanesque cathedrals of Mainz, Speyer, and Trier have a status and historical importance rivaled by few if any monasteries. The false picture of the preponderance of monasteries in the Romanesque period is due in part to the large numbers of Romanesque cathedrals demolished to make way for their Gothic successors.

Conclusion

If we are justified in associating the "short" Romanesque with the origins, in the Carolingian period, of the culture which became that of Europe, then this new definition is clearly more than an academic refinement. It can be described as the first "European" style because of the number of identifiable architectural links it displays across Western and Central Europe, links explicable by the effects of political and religious power. Thus the belief on the part of the German emperors that they had inherited the mantle of the Roman Empire ensured a constant interchange across the Alps with Italy, while their prestige dispersed the styles of their patronage to Scandinavia and Eastern Europe; pilgrimages to Rome and Jerusalem created opportunities for exchange down the length of Italy, while that to Santiago formed a school of architects and sculptors extending north across the Pyrenees into France and Italy; Norman control of Normandy, England, and Sicily produced an extraordinary series of connections; monastic reform movements were even more wide-ranging, and the bureaucratic requirements of the bishops of Rome entailed a constant flow of dignitaries and emissaries across Western Christendom on even the most trivial of matters. If we are uncertain of the extent to which contemporaries were aware of this Romanesque style, that it was recognized at least by the early fifteenth century, by whatever name, is made graphically clear by the Master of Flémalle's *Betrothal of the Virgin* in the Prado. In this, the betrothal of Mary and Joseph, representing the start of the new dispensation, takes place in the portal of a Gothic church which is under construction, while the Old Law is represented by a complete building standing behind, in a style which is clearly Romanesque.

Notes

My warm thanks go to Judson Emerick, Kristen Collins, Michael Herren, Alison Langmead, Robert Maxwell, Elisabeth Monroe, Richard Plant, and David Thompson for comments and suggestions (and Richard Plant also for his help with the bibliography), to Chris Kennish for so expertly producing the maps, to Conrad Rudolph for his incisive comments, his editing, and his hospitality, to the British Academy for a research grant, and to the Getty Research Institute for their facilities and support.

1 *OED*: Romanesque. For Gunn, and for his French contemporary Charles de Gerville, see Bizzarro, *Romanesque Architectural Criticism*, p. 142. As it is put by de Caumont, *Abécédaire*, p. 7: "la période de six siècles (du Ve au XIIe) à laquelle je donne le nom de romane." The oldest use of the term "Romanesque" for an architectural style of which I am aware occurs in Corrozzet, *Les Antiquitez*, p. 22: "Il y a de present autres excellents bastiments faits à la Romanesque, à la Grecque et à la Moderne . . . ," but it is not clear that he means anything by it other than "Roman" (quoted in Thompson, *Renaissance Paris*, p. 11).

2 de Lasteyrie, *L'architecture réligieuse*, ch. 8; Focillon, *Art of the West*, ch. 1; Vergnolle, *L'art roman*, ch. 1.

3 Pirenne, *Medieval Cities*; McCormick, *Origins of the European Economy*, pp. 576–7 and passim. There is also a view that the end of antiquity should be placed in the tenth century.

4 Dawson, *Making of Europe*.

5 Reuter, "Introduction."

6 Gimpel, *Medieval Machine*, 69. On quarrying, see Ward-Perkins, "Quarrying in Antiquity"; Gem, "Canterbury"; Parsons, *Stone Quarrying*; and Vergnolle, "La Pierre de taille."

7 Horn, "On the Origins" (on wooden Romanesque buildings, see also n.22). For the Roman material see Ward-Perkins, *Roman Imperial Architecture*; and, for its Byzantine continuation, see Krautheimer, *Early Christian and Byzantine Architecture*.

8 [On Romanesque sculpture, see chapters 15 and 16 by Hourihane and Maxwell, respectively, in this volume (ed.).]

9 de Lasteyrie, *L'architecture réligieuse*, pp. 227–8. Examples of books covering 800 to 1200 include Swarzenski, *Monuments of Romanesque Art*, and Lasko, *Ars Sacra*, while Kubach and Verbeek, *Romanische Kirchen*, have Aachen Palace Chapel as the first building in the chronologically arranged illustrations; Conant, *Carolingian and Romanesque Architecture*, uses both Carolingian and Romanesque in the title, but chapter 1 is entitled "Carolingian Romanesque." The prefixes "pre-" and "proto-" express this ambivalent attitude to the ninth and tenth centuries. On the definition of Romanesque, see also Trachtenburg, "Suger's miracles."

10 In this regard see Bizzarro, *Romanesque Architectural Criticism*, p. 13 and passim, and the helpful bibliography in Stalley, *Early Medieval Architecture*, pp. 247–55.

11 For overviews, see Clapham, *Romanesque Architecture*; Conant, *Carolingian and Romanesque Architecture*; Kubach, *Romanesque Architecture*; Stalley, *Early Medieval Architecture*. The series *La Nuit des Temps*, begun in 1954, now covers the whole of Europe. For documents see Davis-Weyer, *Early Medieval Art*, and for bibliography, see Davies, *Romanesque Architecture*.

L. Grodecki, *L'Architecture ottonienne* (Paris, 1958).

C. Heitz, *L'Architecture religieuse carolingienne* (Paris, 1980).

J. Henriet, "Saint-Philibert de Tournus," *Bulletin Monumental* 148 (1990), pp. 229–316, and 150 (1992), pp. 101–64.

T. A. Heslop, "Orford Castle, Nostalgia and Sophisticated Living," *Architectural History* 34 (1991), pp. 36–58.

C. Hohler, "A Bibliography for the Study of Romanesque and Early Gothic Art up to *c.*1250," typescript, Courtauld Institute of Art, 1962.

W. Horn, "On the Origins of the Mediaeval Bay System," *Journal of the Society of Architectural Historians* XVII (1958), pp. 2–23.

W. Horn and E. Born, *The Plan of St Gall*, 3 vols. (Berkeley, 1979).

P. Kidson, "The Mariakerk at Utrecht, Speyer, and Italy," in E. de Bièvre, ed., *Utrecht Britain and the Continent, Archaeology, Art and Architecture*, British Archaeological Association Conference Transactions, 18 (Leeds, 1996), pp. 123–36.

R. Krautheimer, "The Carolingian Revival of Early Christian architecture," *Art Bulletin* 24 (1942), pp. 1–38.

——, *Early Christian and Byzantine Architecture*, 4th edn. (with S. Ćurčić) (Yale, 1986).

——, An Introduction to an "Iconography of Medieval Architecture," *Journal of the Warburg and Courtauld Institutes* 5 (1942), pp. 1–33.

H. Kubach, *Romanesque Architecture* (1979; repr. London, 1988).

H. Kubach and W. Haas, *Der Dom zu Speyer*, 3 vols. (Munich, 1972).

H. Kubach and A. Verbeek, *Romanische Kirchen an Rhein und Maas* (Neuss, 1971).

P. Lasko, *Ars Sacra 800–1200* (Harmondsworth, 1972).

R. de Lasteyrie, *L'Architecture réligieuse en France á l'époque romane* (1911; repr. Paris, 1929).

C. B. McClendon, "Carolingian Art, II, Architecture," *Dictionary of Art* (London, 1996).

M. McCormick, *Origins of the European Economy: Communications and Commerce AD 300–900* (Cambridge, 2001).

J. McNeill and D. Prigent, eds., *Anjou: Medieval Art, Architecture and Archaeology*, British Archaeological Association Conference Transactions, 126 (Leeds, 2003).

C. Malone, "The Rotunda of Sancta Maria in Dijon as 'Ostwerk'," *Speculum* 75 (2000), pp. 285–317.

J. Mesqui, *Châteaux et enceintes de la France médiévale*, 2 vols. (vol. 1: Paris, 1991).

M. d'Onofrio, "Precisazioni sul deambulatorio della cattedrale di Aversa," *Arte Medievale*, 2nd ser., VII (1993), pp. 65–79.

F. Oswald, L. Schaefer, and H. Sennhauser, *Vorromanische Kirchenbauten: Katalog der Denkmäler bis zum Ausgang der Ottonen*, 3 vols. (Munich, 1966–90).

D. Parsons, *Stone Quarrying and Building in England AD 43–1525* (Chichester, 1990).

H. Pirenne, *Medieval Cities: Their Origins and the Revival of Trade* (Garden City, 1925; repr. New York, 1956).

A. K. Porter, *Lombard Architecture* (1917; repr. New York, 1967).

J. Puig i Cadafalq, *Le Premier Art roman* (Paris, 1929).

T. Reuter, "Introduction: Reading the Tenth Century," in Reuter, ed., *The New Cambridge Medieval History, II, c.900–c.1024* (Cambridge, 1999), pp. 1–26.

C. Sapin, ed., *Avant-nefs et espaces d'accueil dans l'église entre le IVe et le XIIe siècle* (Auxerre, 2002).

R. Stalley, *The Cistercian Monasteries of Ireland* (London and Yale, 1987).

——, *Early Medieval Architecture* (Oxford, 1999).

N. Stratford, "The Documentary Evidence for the Building of Cluny III" and "La Sculpture des partis orientales de l'église Cluny III d'après les fouilles de K. J. Conant," in *Studies in Burgundian Romanesque Sculpture*, 2 vols. (London, 1998), pp. 41–59 and 61–3.

H. Swarzenski, *Monuments of Romanesque Art* (London, 1954).

D. Thompson, *Renaissance Paris* (London, 1984).

H. Thümmler, "Die Baukunst des 11. Jahrhunderts in Italien," *Römisches Jahrbuch für Kunstgeschichte* 3 (1939), pp. 141–224.

——, "Carolingian Art," *Encyclopaedia of World Art*, vol. III (New York, London and Toronto, 1960), pp. 82–103.

M. Thurlby, "Roger of Pont l'Évêque, Archbishop of York (1154–81) and French Sources for the Beginnings of Gothic Architecture in Northern Britain," in John Mitchell, ed., *England and the Continent in the Middle Ages: Studies in Memory of Andrew Martindale* (Stamford, 2000), pp. 35–47.

M. Trachtenburg, "Suger's miracles, Branner's Bourges: Reflections on 'Gothic Architecture' as Medieval Modernism," *Gesta* 39 (2000), pp. 183–205.

A. Tuulse, *Castles of the Western World* (Vienna and Munich, 1958; repr. Dover, 2002).

E. Vergnolle, *L'Art roman en France* (Paris, 1994).

——, "La Pierre de taille dans l'architecture religieuse de la première moitié du onzième siècle," *Bulletin Monumental* 154 (1996), pp. 229–34.

N. Voronin, *Yuryev-Polskoi* (Moscow, 1971).

J. B. Ward-Perkins, "Quarrying in Antiquity: Technology, Tradition and Social Change," *Proceedings of the British Academy* 57 (1971), pp. 137–58.

——, *Roman Imperial Architecture* (Harmondsworth, 1981).

A. Wharton Epstein, "The Date and Significance of the Cathedral of Canosa in Apulia, South Italy," *Dumbarton Oaks Papers* 37 (1983), pp. 79–89.

W. Whitehill, *Spanish Romanesque Architecture of the 11th Century* (Oxford, 1941).

R. Willis, "On the Construction of Vaults in the Middle Ages," *Architectural History of Some English Cathedrals: A Collection of Papers . . . 1842–63* (Chicheley, 1973), appendix.

C. Wilson, "The Cistercians as 'Missionaries of Gothic'," in C. Norton and D. Park, eds., *Cistercian Art and Architecture in the British Isles* (Cambridge, 1986), pp. 88–116.

N. Wu, ed., *Ad Quadratum: The Practical Application of Geometry in Medieval Architecture* (Aldershot, 2002).

Encyclopaedias and series

Encyclopaedia of World Art (New York, London and Toronto, 1960).

Macmillan Dictionary of Art (London, 1996).

La Nuit des Temps (La-Pierre-qui-Vire: Zodiaque, from 1954).

Romanesque Sculpture in Northern Europe

Colum Hourihane

The most useful historiographical studies for Romanesque sculpture up to the early nineteenth century, at which stage the study of sculpture starts to separates from architecture, are those which are specifically focused on the architecture of the period.[1]

Without doubt, the most comprehensive such work is by Bizzarro, which looks specifically at the formative centuries in France and England.[2] Frankl, on the other hand, deals mainly with the medieval appreciation of the style and also provides a general background.[3] When it comes to looking at Romanesque sculpture, the most valuable study has to be the annotated bibliography on French Romanesque sculpture by Lyman, which parallels that of Glass for Italy.[4] A short but good introduction on the historiography of this subject especially for the appreciation of the style in the United States is given in Cahn and Seidel,[5] while an interesting essay by Forsyth[6] outlines a number of recent trends, developments, and issues in the historiography of French Romanesque sculpture and that of cloister studies in particular.[7]

If France has not fared well, the subject has been almost entirely neglected in neighboring Germany. This is not unique in that little historiographical research has been undertaken there and certainly not by German scholars. What has been undertaken is by American scholars, and deals with German contributions to the development of style or research in countries other than their own. One such work, which has tangential bearing on Romanesque sculpture, is by Brush, who has written on the contributions of Vöge and Goldschmidt against a general historiographic background of their period.[8]

Apart from Bizzarro, Cocke is one of the few scholars to have dealt with the subject in England. He has documented its historical development and Kahn has extended his work into the modern and more theoretical period.[9] Apart from these three countries, historiographic studies of Romanesque sculpture remain

almost totally neglected in Austria, Ireland, the Low Countries, and Scandinavia apart from some general asides.[10]

Up to the start of the twentieth century Romanesque sculpture was primarily studied in terms of its architectural associations and was never treated as a separate entity. It is true that most Romanesque sculpture is indeed architectural[11] and as such has always played a secondary position to its context.[12] Unlike Gothic sculpture, which in many ways came to assume an equal role with the architecture of that period, that of the Romanesque period never received the same universal acclaim.[13]

Romanesque sculpture was never seen as a distinct style in itself but rather as a formative phase in the development of the Gothic. The taste for Romanesque sculpture, it is claimed, has to be acquired – it is a style that cannot be easily understood and the viewer does not immediately relate to it (fig. 15-1). It is easy to see how this style, with its elements of stylization and distance from the classicizing beauty of what preceded and followed it, could be described as "barbarous" and "unfinished." It is not a style that is easily understood because of its break with the traditional canons of representation and this has also acted against its wider acceptance (fig. 15-2).

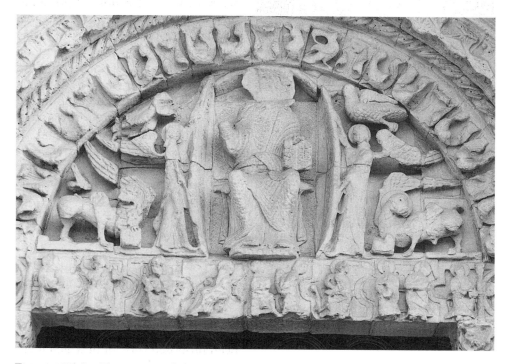

FIGURE 15-1 Tympanum showing Christ and the Four Beasts surrounded by fantastic animals and grotesques above the lintel with the twelve apostles, Rochester Cathedral, c.1160. Photo © by Colum Hourihane.

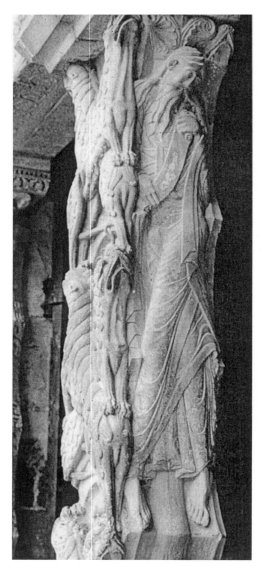

Romanesque sculpture was viewed as being less forceful and lacking any redeeming features – its emphasis on capital sculpture, tympana, and absence of portal figures, archivolts, or large iconographic programs meant that it was relegated to a secondary role in the early phases of art history.[14] In terms of production, its relatively short history of approximately two centuries, uneven distribution, and lack of documentary material did not give it popular standing.

Scholars of this style would be amazed to see the difficult history that it has undergone to gain the recognition that it presently has. It does not, as a general rule, appeal to the mass audience – unlike the Gothic. There are few surviving sculptural programs that match the importance of Moissac, Vézelay, or Autun and more often than not its appreciation is dependent on isolated fragments or small buildings in remote locations (fig. 15-3). Much of what survives is still *in situ* and it is not well represented in museum collections. On the other hand, it should be said that some more recent large-scale exhibitions and effective museum displays are adding to its popular profile.[15]

The historiography of Northern Romanesque sculpture is essentially that of France, Germany, and England[16] with a focus on stone rather than the many fine wooden carvings which have only recently entered the mainstream of scholarly study. Different chronological phases have been proposed (not all of which focus on art), but which usually divide the period into three. This chapter will propose yet another refinement, and

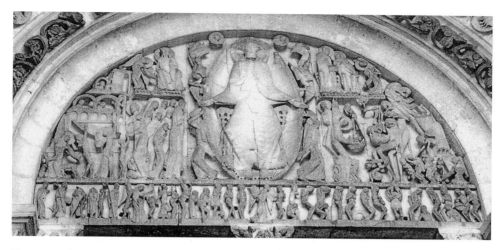

FIGURE 15-3 The Last Judgment, attributed to Giselbertus, tympanum, Cathedral of St Lazare, Autun, *c.*1120–35. Photo © by Jane Vadnal.

attempt to merge some of the overlap between existing proposals. Proposals such as those by Mortenson[17] (for Latin historiography from 1500 to the present) and Lyman (the historiography of Romanesque French sculpture from 1700 to the present) stress the gradual process of refinement and definition. Understandably, my historiographical analysis is based on what has been published, and attempts to take into consideration trends and changes in scholarship.

The four phases are:

1 The Age of the Antiquarian (The Renaissance to 1820)
2 The Age of Structure (1820–1900)
3 The Age of Theory (1900–45)
4 The Age of Modernism (1945–present)

All are dominated by the influence of major scholars such as Evans, Focillon, Kingsley Porter, Mâle, Montfaucon, and Schapiro, to name just a few, and each phase has its own characteristics, which in many cases were instigated by such figures. The first phase was the age of the antiquarian – or to use Lyman's terminology, "The Age of Documentation." At this stage, all medieval architecture and sculpture had been undefined in terms of style, period, or region; this would only begin to happen with the amassing of a substantial corpus of material. It also has to be remembered that the whole concept of style, and indeed its use as a term of definition, did not start until the Renaissance. Most of the work undertaken in this phase was by archaeologist-antiquarians who were driven mainly by nationalistic ideals to define not only the history of the Middle Ages but also to document their own cultural background and to achieve artistic

superiority. The second phase is marked by a more structured approach to documentation with the creation of a nomenclature. It is heralded by the actual definition of the stylistic term "Romanesque" and has been seen as marking the independence of this period from the Gothic and the gradual separation of sculptural from architectural studies. This was also the period in which art history developed as a formal discipline and the whole field of medieval studies opened up on an unparalleled scale. It was soon followed by the most crucial of all four phases, characterized by some of the most innovative ideas and thinkers of the entire period, whose work was fortunately based on an understanding and appreciation of Romanesque sculpture. This phase is marked by iconographical studies with a strong background in Christian values and nationalism and an opening up of the field to international scholarship. It is claimed that this phase was "marked by hermeneutics and an interest in the history of ideas." It is difficult to characterize the fourth and final phase, as we are still in the middle of it. Some old issues have been re-evaluated, some new ideas proposed, some aspects of previous scholarship have fallen by the wayside, and the work goes on.

In many ways the backdrop to these four phases has been a series of political, ideological, and nationalistic factors, which have strongly influenced its development. Its historiography has evolved in terms of a few specific major themes, including a search for its origins, a need to apply a dating structure, and the more recent socio-cultural analysis of sculpture. In between these two bookends lie a number of paths which scholarship has taken and which include categorization, cataloguing, chronology, political influences, religious iconography, reception, and the role of the artist, all of which will be discussed below.

Phase I, The Age of the Antiquarian

We know very little of how the medieval mind actually viewed their art forms,[18] and it is clear that many of the comments that survive deal with architecture rather than sculpture.[19] The art and architecture of the Romanesque period was clearly recognized as being different from the Gothic before the end of the Middle Ages.[20] These comments have been described by Frankl and van der Grinten, who have used such terms as *opus francigenum, opus arcatum*, and *opera romano* to describe Romanesque architecture.[21] By the end of the Middle Ages, however, the past centuries could be viewed more objectively and it was at the start of the sixteenth century that the whole concept of a *medium aevum* or Middle Ages was first defined and with that the first chronological and stylistic breakdown of the preceding centuries. It was also at this time that the term "Gothic" was first used to describe the sculpture, but principally the architecture, from late antiquity to the Renaissance.[22] Romanesque sculpture was not to be defined for at least a further three hundred years.[23]

In the post-medieval period, the historiography of Romanesque sculpture is largely given over to antiquarian studies. Problems of terminology and classification

were being tackled, and although some of these studies illustrate sculptural elements it is always in secondary positions. Typical of such scholarship is the work of John Aubrey (1626–97) who is generally credited as the first cataloguer of the Romanesque in England. His asides are few and unillustrated, and are included in his pioneering study *Monumenta Britannica*, a work largely documenting Roman rather than Romanesque antiquities. Another whose research attempted to define and catalogue English Romanesque was William Wilkins the Elder (1778–1839), whose studies separated the early Romanesque or Saxon from the later architecture of the period then referred to as Norman. Implicit in his division, which has lasted to the present, albeit with a different emphasis nowadays, is a stylistic development and elaboration. His work on Norwich Castle (1795)[24] sheds considerable light on all the architectural components of the building and on its stylistic development and was to provide a base line for other studies (fig. 15-4).

These studies – whether in England, France, or Germany – are largely concerned with documentation rather than analysis of style or form, but they attempted to be as scientific as possible. Where any analysis takes place, it varies from a general appreciation of the style to the more commonly found criticism of it as a debased version of a Roman original. One critic who was not afraid to voice a positive opinion on Romanesque sculpture was Roger North (1653–1734) who wrote *c*.1698 about Durham and Gloucester Cathedrals as well as Norwich Castle and, indeed, of Romanesque architecture in general that it "hath a strength and reasonableness beyond the other [Gothic]."[25]

In France of the same period a number of scholars were attempting to document architecture and to record and disentangle different schools and styles. Here, as elsewhere, the historiography of medieval art takes on a strongly nationalistic bias, which was to develop even further throughout the century. French antiquarian studies begin not with sculpture but with painting[26] and were soon followed with the establishment of formal bodies to promote and document the arts. Typical of these is the founding in 1648 of the Académie Royale de Peinture et de Sculpture, from which most of the principal art historical works in France were to emanate.[27] One scholar whose work stands out in this period is Dom Bernard de Montfaucon, whose two main works – *L'Antiquité expliquée et représentée en figures* (1721–2) and *Les Monumens de la monarchie françoise* (1729–33) – were to provide one of the first illustrated histories of French art. Contemporaries such as Blondel (1705–74) and Ducarel (1713–85) were to provide a platform for future cataloguing and documentation and it was also at this time that the trend for non-nationals to study the art of other countries started, with Cotman and Ducarel being amongst the first.

If England and France had their topographical and antiquarian studies, art history as a formal discipline was to develop in leaps and bounds in Germany of the mid-eighteenth century, thanks to the studies and influence of Johann Joachim Winckelmann (1717–68), the father of art history. Winckelmann was to move beyond his contemporaries' "mere narratives of the chronology and alterations"[28]

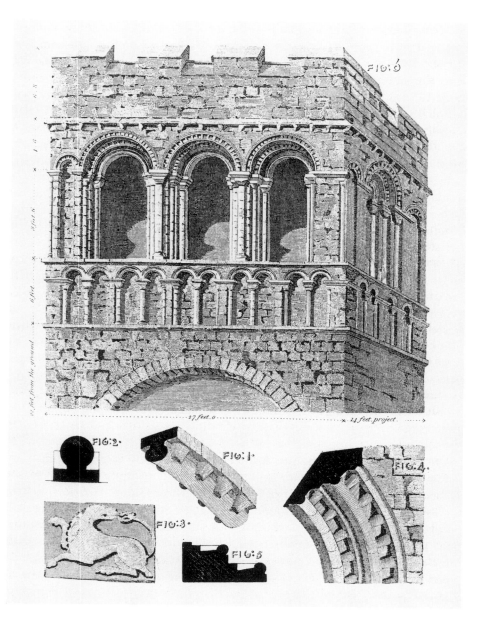

FIGURE 15-4 Bigods Tower, Norwich Castle, 1795. Studies such as this by William Wilkins on Norwich Castle, with their focus on architecture, are typical of eighteenth-century antiquarian research. From Wilkins, "An Essay towards an History of the Venta Icenorum of the Romans and of Norwich Castle," *Archaeologia* XII (1795), plate XXVI, p. 154.

into formulating a systematic analysis of the history of art history. His influence was to pave the way for future work in this whole field, especially iconography and the evolution of style and his avoidance of the role of artist or maker, which was to shape the work of numerous scholars in the following centuries particularly in the field of Romanesque sculpture. Romanesque sculpture or architecture failed to capture the imagination of Goethe, all of whose writings stress the verticality and uniqueness of the Gothic style in what he mistakenly believed was a manifestation of German creativity.

Phase II, The Age of Structure

There has been much dispute as to who first coined the term Romanesque, but it is now accepted that it was William Gunn (1750–1841), an English parson, who first published this term in 1819.[29] At around the same time, the term *romane* was coined and promoted to describe the same period in France, and it was not long after that the term *romanische* was used in Germany.[30] With a stylistic definition in place, the boundaries of this style expanded beyond national borders and its acceptance seemed to be ensured. Bizzarro has written of her belief that the application of such a term to the architecture of this period was its saving point. The separation of Romanesque from Gothic – and it has to be remembered that the former was initially applied only to the architecture of the period – was certainly a major advantage, but it was not to herald the instant acceptance of arts other than architecture at this time.

For most of the nineteenth century, the study of Romanesque sculpture was still largely neglected when it is compared to that of the thirteenth century. Romanesque sculpture in particular was rejected because of the overriding acceptance that Classicism was the ideal and that the sculpture of the eleventh and twelfth centuries was the antithesis of this. On the other hand, it has to be acknowledged that this style was promoted thanks to the simmering belief that all French art was good and representative of the genius of that country.

The political struggles in the first three decades of the nineteenth century highlighted many studies which now became even more Franco-centric. The interest in the art of the medieval period in Germany coincided with the same development in France and has been seen as growing out of the strong nationalist movement, which led to the foundation of the German Empire in 1871. Three national schools were defined, centering on Saxony, the Lower Rhineland, and the South, including Switzerland and Austria. Classical art belonged to Greece and Rome, and the Renaissance had its birth in the south, but early medieval art and that of the Romanesque period in particular was believed to have had its origins in the Holy Roman Empire.

Scholarly research into Romanesque art in Germany and France in the late 1880s and early 1890s coincided with a popular interest in the subject outside the university environment. Carolingian and Ottonian art was to the fore in

this nationalistic movement, and much of this research was initially based in Normandy and the northwest – an area that was then seen as the most important center for Romanesque sculpture in France. It was here that the Service des monuments historiques de France, founded in 1830, was first based and from which it extended to all areas. This national inventory of sculpture, which to this day is still one of the most complete and thorough catalogues of French monuments, highlighted the importance of Romanesque sculpture, which now began to assume its rightful place. It was also at this time that art history was first taught as a university subject in the United States, where the initial focus was either on the Classical or medieval period. Such survey works as that written by Allan Marquand and Arthur Frothingham in 1896 are typical of the period.[31] Although Romanesque sculpture is dealt with briefly, it is clear that the recognition of this period as a time of revival would open up the field to future studies.

One such study to deal significantly with the subject, albeit in relation to architecture and style, was that by Karl Schnaase (1798–1875). Direct in line to Hegel's theories, Schnaase devoted the entire second volume of his *magnum opus* to "Die Romanische Kunst." There is nothing iconographical in a study such as this, but it does provide the background that would enable Emile Mâle to undertake his work some 50 years later, and in many ways Schnaase's belief that the visual arts complement religious thought also links these two scholars.[32]

The work undertaken in the museum world by scholars such as Alexandre Lenoir (1761–1839) and the slightly later and more significant Louis Courajod (1841–96), director of the Department of Sculpture at the Louvre, did much to help promote this neglected area. Courajod, like Lenoir, used his position as museum director to publicize French sculpture and, whereas their initial works are largely descriptive catalogues, they were instrumental in making the wealth of this pre-Gothic corpus publicly known.[33] Courajod was strongly influenced by Vöge's theories and the need to unravel the origins of style. There was at this time a growing preoccupation with the issue of style, partly in response to Vöge's theories, which influenced not only his German colleagues but also his French compatriots. Ironically for Vöge, Romanesque sculpture did not exist – for him, the sculpture at Chartres was of the utmost importance and in many ways prevented him from seeing anything other than the works at that site. Such theories, highlighted more by other scholars than by Vöge, form a distinct historiographical nucleus, which looked specifically at this art and sculpture from a Christian perspective. This nucleus can really be credited with defining the importance and acceptance of Romanesque sculpture, and their interest was primarily driven by the subject matter.

From the middle of the nineteenth century there were two distinct views of Romanesque sculpture, which were to change with its acceptance as a fully fledged style. It was, first, perceived as a phase of the Gothic and not really a style in itself. Its barbarous treatment of its subject matter was little but an exploratory phase in the evolution to the Gothic. On the other hand, there were

some who were prepared to see it as a distinct style, which was fully developed and required an adjustment in perception as to its relations with what preceded and followed it. The development of modern art and the break in the traditional means of representation have been seen as pivotal in influencing our acceptance of what was unusual in Romanesque sculpture. Inherent in much of the writings on sculpture of this period is the belief that even though figures such as those at Vézelay are "barbarous," they also have an element of genius. This was to change later in the century with the belief that this barbarous element should not be viewed as negative but as a positive counterbalance to Classicism. What is also interesting is the fact that many of the scholars such as Baltrušaitis, Cahn, Focillon, Panofsky, Seidel, and Schapiro, who wrote on Romanesque art and most significantly on its sculpture, also researched modern art.

Phase III, The Age of Theory

Searching for origins in the Byzantine world, the Near East, and Italy, French scholars such as Fernand Cabrol (1855–1937), Charles Cahier (1807–82), François-René de Chateaubriand (1769–1848), Alphonse-Napoléon Didron (1806–67), Émil Mâle (1862–1954), Albert Marignan (1858–1936), Barbier de Montault (1830–1901), and Walter Pater (1839–94) were the first to look at the entire range of medieval sculpture and not just that of the Gothic period. This group of scholars suddenly approached the works from the perspective of their subject matter and shifted the emphasis using Christian dogma. One of the most influential of these writers, and one who paved the way, was Chateaubriand, in his *Génie du Christianisme* (1802) in which Neo-classicism and rationalism were weighed against the concept of genius and spirit as represented by the world of medieval art. If Chateaubriand justified the study of art in all its forms from a slightly conceptual stance, it was Didron who actually enforced a more comprehensive iconographical approach. Suddenly, the concept of beauty in sculpture such as those at Vézelay and Moissac was discovered in the Christian ideas they personified and embodied. The makers of these works and their role in Church organization were also looked at, but to a significantly lesser degree. There is a noticeable paucity of any stylistic analysis, which is in complete contrast with the general scholarship of this period. Based largely in France, this group worked independently of German scholarship, which was more focused at defining form and the problems of stylistic development. Nevertheless, it was to be a school of thought that was to influence general scholarship for many decades to come and was to create a unique identity for Romanesque sculpture.

They were also to be the first iconographers of Romanesque sculpture which culminated in Mâle's *L'Art religieux du XIIIe siècle en France* (1898). The publication of this work in advance of what should have been the first volume in his study – on the twelfth century (1922) – has been explained in a semi-apologetic way by Mâle. While admitting that he should have written the second volume

first, he also says that he was drawn instinctively to the thirteenth century where "all is order and light."[34] It was not until the start of the twentieth century that scholars accepted that the eleventh and twelfth centuries were not to be viewed as a transitory and ill-defined period. Mâle admitted in 1922 that "monumental sculpture was born in the eleventh century in southwestern France." After many years, the sculpture of this period was defined as that of a renaissance and was heralded as being in a direct line to that of the Classical period. All of his studies went some way toward correcting the view that the sculpture of the twelfth was "unfinished," whereas that of the following century was "a finished system."[35] It was also at this time that iconography, and indeed the study of Romanesque sculpture, became irrevocably text driven – a feature for which Mâle is generally either credited or criticized.[36]

Mâle has been seen as heralding this interest in twelfth-century sculpture, which indeed he did, but his studies were also a factor of the age and an increasing research into the eleventh and twelfth centuries. He was the scholar who capitalized on the research undertaken in the fields of archaeology, history, and Christian studies. The 1880s and '90s saw the establishment of art history as an academic discipline throughout Germany, Switzerland, and Austria, paralleling what has been defined as a period of critical self-examination that swept through the whole field.[37] This period also saw the publication of a number of large-scale scientific surveys of medieval art in both Germany and France, with Romanesque sculpture taking its place in the wider art historical picture and also being studied by itself. A typical study is Beenken's 1924 semi-scientific survey of some 135 works.[38] With its focus on the development of style, it is also one of the earliest works to look at the role of the creator. The immediate period after World War I was particularly fertile in research and publications, which resulted from the crisis in the liberal arts that ensued after the war. It was also an attempt by Germany to regain its position and realm of influence, especially in the area of Romanesque studies.

It was also at this time that Schnaase's work of some 30 years earlier was extended, with the writings of scholars such as Bode, Braun, Léon, Molinier, Enlart, Brutails, Hasak, Von Reber, and Goldschmidt. Some of these were contemporary with Schnaase, others were slightly later and bridge the nineteenth and twentieth centuries, but they are all similar in their belief that the arts of the Middle Ages were built upon and indeed mirrored those of previous periods. While most German scholars of this period wrote on French monuments, there were also signs of a burgeoning interest in the Romanesque sculpture of their own lands – a movement which was badly affected by both world wars and from which research never really recovered. German studies on Romanesque sculpture never equaled that of France or England, and the insightful initiatives of some 20 years earlier were later reduced to the level of localized studies.[39]

The start of the twentieth century saw the arrival of some eminent scholars, including Robert de Lasteyrie (1849–1921) and Eugène Lefèvre-Pontalis (1862–1923), who along with François Deshoulières were responsible for establishing

the relative chronological development of the period and hierarchical structure for the monuments. It was this that was questioned and countered by Arthur Kingsley Porter (1883–1933), the American scholar. His work, based on a stylistic comparison as well as a robust use of documentation and dating, offered an alternative to the progressive and gradual evolution of Romanesque architecture and sculpture throughout the entire country on a regional basis and instead looked at monasticism and pilgrimage as influential forces.[40] Porter's beliefs of a possible origin for French Romanesque sculpture in Burgundy was not to be accepted until well into the next historiographical phase, with the admission by Francis Salet that he might have been right. The origins of Porter's theory brings us to one of the most eminent historians of the whole period, Henri Focillon (1881–1943), whose research on style in particular has remained significant to the present.[41] This was driven by a strong belief in an analysis of style and technique and he theorized on a widely dispersed evolutionary pattern of stylistic development.[42] Kingsley Porter's studies have suffered most and are now seen as being slightly outdated. After his untimely death, the mantle was taken up by Paul Deschamps (1888–1974), whose work in 1947 on the regional nature of French sculpture has also come in for recent criticism.[43]

By the third decade of the twentieth century, Romanesque sculpture had became one of the most important areas for research.[44] Publications studied individual monuments and also included relatively large-scale catalogue-type studies. A favorite platform for such studies was the *Bulletin Monumental*, first published in 1834 under the auspices of the Société française d'archéologie, Musée des Monuments Français, and which to this day is still one of the most important avenues for new research.

The interest in Romanesque sculpture in England at the turn of the nineteenth and twentieth centuries is not heralded by any comparable studies, and the division between the antiquarian works of the preceding period and this phase is imperceptible. Romanesque sculpture in England and Ireland differs considerably from that of mainland Europe. Organized on a more localized regional and school-type structure than France, different influences came into play at various times and in different areas with little uniformity. Its popular and indeed scholarly acceptance was impeded to a certain extent by these influences. Cahn has further theorized how this sculpture fared worse than book illumination in England and has proposed that the Reformation, Puritan movement, iconoclasm, and weather all militated against its popular acceptance.[45] Its entry even into the museum world is also relatively late in England, with the first display of Romanesque sculpture in the Victoria and Albert Museum taking place as late as 1916. Its study in the academic world was similarly neglected until the founding of the Courtauld Institute of Art in 1932. It is not surprising therefore to find that catalogue-type works predominated at the start of the century and were to do so for many decades. Instead of having the antiquarian stance of the nineteenth century, they instead tried to analyze form and iconography from a more focused perspective. Typical of such scholarship are those by

Keyser and Bond with their formative studies on tympana and fonts. World War II was naturally to disrupt scholarship in the entire world of art history, but it was also to prove to be a benchmark period in which scholarship took on a new emphasis and life.

Phase IV, The Age of Modernism

Even though his work belongs largely to the third phase, the influence of Meyer Schapiro is felt most in this final phase with the legacy that he was to impart with his publications and through his many students. Beginning in 1935 with a study on Moissac, Forsyth has summarized Schapiro's approach as being very much based on the belief that form and meaning were inseparable.[46] He lacks many of the entrenched views prior to the outbreak of World War II.[47] Both world wars were adversely to affect scholarship on Romanesque sculpture, especially in Europe, but also with positive results for its future study in America where interest increased. France was naturally to retain its pre-eminent role in scholarship on the subject after World War II, and was also to hold onto its slightly entrenched Franco-centric view. The focus once again was the ongoing issue of the origins of the style, and numerous studies both reinforced the belief of a French genesis and its gradual movement throughout the rest of the country.

This was also a period of controversy in France with various official and unofficial theories forwarded as to the origins of monumental sculpture in terms of place and dispersal, with Francis Salet, head of the Société française d'archéologie, playing a central role.[48] Despite the series of disputes and controversies, Lyman has documented how this was a period in which Romanesque sculpture entered popular acceptance and was no longer under the sole control of the scholar.[49] It was also at this time that a number of studies began to use the socio-historical approach that was first developed in relation to history by such scholars as Georges Duby. The need and value of having a complete documentary and photographic record of all Romanesque sculpture was first proposed by Focillon and its aims remain as valid today as when they were first stated well over half a century ago. The publication in 1954 by Jean Baudry of the first volume in a regional survey of French Romanesque sculpture titled *Bourgogne Romane* began one of the foremost surveys of this subject, which has since moved outside its national borders with the publication in 1999 of volume 88 on Westphalia. It has paved the way for a similar series of hardcopy publications in the United States[50] and the more recent large-scale electronic undertaking in Britain of the Corpus of Romanesque Sculpture in Britain and Ireland which was founded by George Zarnecki some 20 years ago. All of these undertakings are adding significantly to our understanding of this sculpture and in many ways continue the role of the antiquarian started some 300 years ago.

More recent French research by scholars such as Baylé, Boss-Favre, Cabanot, Durliat, Fain, Gould, Vergnolle, and Wirth has focused on the general as well as

the regional nature of the sculpture and is now being driven from a greater understanding of what exactly has survived and how it can be viewed in relation to the broader picture.[51] These studies have looked at the functionality and creative powers behind such works from an interdisciplinary perspective, which has blended archaeology and art history with slightly less of an emphasis on iconography.[52] The great period of iconographical research certainly seems to have gone and its role now appears to be secondary or equal to such issues as form or function.

French sculpture has continued to attract foreign scholars such as Borg, Cahn, Evans, Montagu, Rupprecht, Seidel, Stratford, Tcherikover, Travis, and Zarnecki, to name just a few, who have helped in removing some of the nationalism attached to such studies in the past and have also opened up the field to different issues. Our perceptions of the material have changed and there seems to be less of an emphasis on developing an absolute chronology for the entire period. Many of "the chronological implications of some general theories on the nature of Romanesque (were) formulated in the early decades of this (last) century"[53] and have tended to overshadow subsequent research and directed the approach of scholarship which is now being questioned. Occasional studies such as Anne Prache's recent work still place a high emphasis on the search for the origins of the style, which is going to be a question that will remain with us for a long time.[54]

Studies have also looked at the more localized monument or group of carvings, and we are developing a more organized and paced approach to understanding the development of style. If research continued in France after the war, it was not to be so in Germany, where some of the country's most established scholars fled their own lands and in many ways also left the subject of Romanesque sculpture behind them. Erwin Panofsky, for example, was one such scholar whose earliest work was on German Romanesque sculpture,[55] but who was never to write on the subject again after he moved to America. Nowadays, German scholarship on the subject is limited, little remains *in situ*, and the pre-war nationalistic associations that it evokes may lie in the modern avoidance of scholarship on the subject. Apart from the work of Kiesow, Legner, Lobbedey, Schütz, Müller, and von Winterfeld, little else has been written on this subject.

The highpoint of research on Romanesque sculpture in England began in the middle of the twentieth century with the general survey-type works on sculpture by scholars such as Prior and Gardner (1912), Gardner (1935), Zarnecki (1951, 1953), Saxl (1954), and Stone (1955) and after a short hiatus, interest was revitalized with the exhibition on Romanesque art that was held in 1984.[56] Localized studies now also predominate which are very much driven from an archaeological perspective and, as in France, there is an emphasis on understanding form, style, and function with little work being done on iconography or reception. Ireland, like England, after the pioneering work by Françoise Henry and more recently by O'Keeffe, has eagerly awaited the completion of the

Corpus of Romanesque Sculpture, and scholarship here as elsewhere has been diverted into adding to this resource.[57]

 We may have identified the hands of a few more sculptors since the pioneering work of the early part of the century, but this is an area that could benefit from greater research. Unusually for a topic so current in other areas of medieval scholarship, little study has been undertaken on reception issues in Romanesque sculpture.[58] We still remain relatively ignorant as to how these programs were viewed from the variety of contexts that exist and this is an area of research that will pay dividends in the future. Similarly, the need to contextualize this sculpture in the broader framework of Romanesque art still remains. Manuscript and metalwork studies have been linked, but sculpture still remains the isolated medium in the broader picture. The historiography of Romanesque sculpture has been guided by the attempts of the early historians to impose far-reaching rules regarding creation, date, dispersal, form, and style, which have recently been questioned with greater research into the *minutiae* of the style. This is a process which will only increase with time and greater knowledge, and will add to our understanding of what is clearly one of the most important periods in the history of sculpture.

Notes

This essay is dedicated to George Zarnecki, doyen of British Romanesque art history, for all his help and encouragement. Thanks are due to Conrad Rudolph for inviting to me to contribute to this volume. Many colleagues have helped with my queries and these include Jens Bove, Bildarchiv Foto Marburg, Christian Heck, University of Lille, Alison Stones, University of Pittsburgh, Adelaide Bennett, Giovanni Freni, Andrea Campbell, Index of Christian Art, Princeton University, and Andreas Petzold, Open University. I would like to thank Jane Vadnal, University of Pittsburgh, for permission to reproduce the images and to John Blazejewski, Index of Christian Art, Princeton University, for his help with photography.

1 [On Romanesque architecture, see chapter 14 by Fernie in this volume. See also chapter 16 on the modern origins of Romanesque sculpture by Maxwell in this volume (ed.).]
2 Bizzarro, *Romanesque Architectural Criticism.*
3 Frankl, *The Gothic.*
4 Lyman, *French Romanesque Sculpture*; Glass, *Italian Romanesque Sculpture.*
5 Cahn and Seidel, *Romanesque Sculpture.*
6 Forsyth "Monumental Arts."
7 After a long period of relative neglect it is rewarding to see an increasing interest in individual scholars such as Meyer Schapiro, whose extensive studies on the sculpture of this period were the subject of a session at a College Art Association meeting (Philadelphia, February 23, 2002) entitled "Reassessing the Legacy of Meyer Schapiro." Two of the papers, by Forsyth ("Narrative at Moissac") and Cahn ("Schapiro and Focillon"), were subsequently published in *Gesta*. The work and

character of Arthur Kingsley Porter, after a long period of neglect, was also recently studied by Richardson ("The Fate of Kingsley Porter") and Neuman de Vegvar ("Shadow of the Sidhe") and he was the subject of a paper at the 38th International Congress on Medieval Studies at Kalamazoo 2003 (session 203, "Michael Camille and Kingsley Porter: Modernity, Medieval Margins and the Monstrous," Janice Mann).

8 Brush, *Shaping of Art History.*

9 Cocke, "Pre-19th-Century Attitudes in England" and "The Rediscovery of the Romanesque." See also Kahn, "La Sculpture Romane."

10 See the *Grove Dictionary of Art*: <http://www.groveart.com/index.html>.

11 Largely consisting of capitals, corbels, bases, jambs, lintels, cornices, and relief panels such as those found on tympana. The repertoire also includes liturgical furniture including fonts, altars, pulpits, and thrones as well as funerary slabs, but can also include freestanding figures such as those found in twelfth-century Germany.

12 The term "Romanesque" was first applied only to the architecture of this period, which of course included elements of the sculpture and was only applied to all the arts of the period at a later stage.

13 [On Gothic sculpture, see chapter 19 by Büchsel in this volume (ed.).]

14 [On sculptural programs in general, see chapter 26 by Boerner in this volume (ed.).]

15 See Forsyth, "Monumental Arts," p. 23.

16 Romanesque sculpture is sparsely represented in the Low Countries (with little surviving outside the Tournai and Meuse regions, and what is there being largely derivative), Switzerland (where historically it was part of the Holy Roman Empire and would have come under the influence of France and Italy), and Austria (which again was part of the Holy Roman Empire and has significantly more and better quality carvings surviving). Scandinavia has similarly been neglected in terms of scholarship and little has been written of this sculpture, which represents the first relief sculpture in that area (see <http://www.groveart.com>).

17 Although not published since first given at the First European Congress of Medieval Studies at Spoleto, Mortenson's ideas have fortunately been preserved by Constable ("Introduction," p. xiii).

18 See Rudolph, *Things of Greater Importance.*

19 See Frankl, *The Gothic*; van der Grinten, *Elements of Art*, pp. 5–7, Doolittle, "Relations Between Literature and Medieval Studies"; Edelman, *Attitudes of Seventeenth Century France*; and Cocke, "Pre-19th-Century Attitudes."

20 There have been no historiographical studies of Romanesque sculpture per se in contrast to that of the Gothic period. Bober gives one of the best general outlines in the preface to the English language edition of Mâle (*Religious Art in France*, pp. v–xxiv). Also of interest are Beer, "Gothic," and Cocke, "The Rediscovery of the Romanesque." See also Fernie, "Contrasts" and *Romanesque Architecture.*

21 Frankl, *The Gothic*; van der Grinten, *Elements of Art.*

22 One of the most comprehensive studies on the negative application of the term "Gothic" is given in Frankl, *The Gothic*. For Vasari, the word "Gothic" was defined as non-Roman or Barbarian – it was an art and period which lay outside the Classical or Roman world (see also Bizzarro, *Romanesque Architectural Criticism*).

23 Whereas post-medieval scholarship may not have chosen to distinguish between the Romanesque and Gothic, it is clear that the two styles were viewed separately in the Middle Ages where both Panofsky ("Friedsam Annunciation") and Fernie

(*Romanesque Architecture*, p. 1) have pointed out the use of Romanesque architectural and sculptural forms, especially in fifteenth-century Northern painting, to denote a period removed from their own.

24 Wilkins, "An Essay."

25 North, *Of Building*, p. 111.

26 Typical of these early works are Pierre Monier's "Histoire des arts qui ont rapport au dessin" (1698).

27 Also founded at this time were the École des Chartres (1804), the Société des antiquaries de France (1821), Congrès archeologique de France (1834), and the Commission des monuments historiques (1837).

28 Preziosi, ed., *The Art of Art History*, p. 22.

29 See Frankl, *The Gothic*, p. 345; Bizzarro, *Romanesque Architectural Criticism*, pp. 155–6; Gidon, "L'Invention du terme," pp. 268–88.

30 Prior to Gunn, this style was referred to in England as Saxon, Anglo-Norman, Gothic, Monastic, or *Opus Romanorum* (see Cocke, "Rediscovery of the Romanesque," p. 360).

31 Marquand and Frothingham, *A Text-Book*.

32 Schnaase, *Geschlichte der Bildenden*; Mâle, *L'Art religieux du XIIIe siècle*; *Religious Art in France*.

33 One of Lenoir's most significant contributions is his *Description historique et chronologique des monument de sculpture réunis a Musée des monumens Français* (1803).

34 Mâle, *Religious Art in France*, p. xxix.

35 Mâle, *L'Art religieux du XIIIe siècle*, pp. iv, v.

36 It was Mâle who first described the sculptors of the Middle Ages as "writers in stone" – an approach later discussed by Camille, "Mouths and Meanings," pp. 43–54.

37 Brush, *Shaping of Art History*, p. 1.

38 Beenken, *Romanische skulptur*.

39 Isolated regional studies of Romanesque sculpture such as that by Fastenau, *Romanische Steinplastik*, were certainly under way before World War I, but were to be disrupted until the early 1930s. Pinder's 1925 study, *Deutsche plastik*, is one of the first to post-date the war, but was sadly not followed by other works in this area.

40 Porter, *Les Débuts* and *Romanesque Sculpture*.

41 One of the most revelatory documents from a historiographical perspective is a bibliography on Romanesque sculpture compiled by Focillon while lecturing at New York University. Divided under headings such as "Principles of Style" and "Historical Development," it provides a personal documentation of what he considered important works on the subject (see Focillon, *Romanesque Sculpture in France*).

42 Focillon, *L'Art des sculpteurs Romans*. See also Francastel, *L'Humanisme roman*, pp. 194–200.

43 Tcherikover, *High Romanesque Sculpture*, pp. 1–2, provides a synopsis of the changing perspectives on this theory in general and shows how she believes it has hindered modern scholarship in that it was accepted verbatim.

44 One of the pivotal studies in the reversal of this theory was by Terret in 1914.

45 Cahn, "English Romanesque Art," p. 276.

46 Forsyth, "Narrative at Moissac."

47 See Cahn, "Focillon's Jongleur," and Schmitt, "Images and the Historian."

48 Lyman, *French Romanesque Sculpture*, pp. 159–60.

49 Ibid., pp. 160–1.
50 Cahn and Seidel, *Romanesque Sculpture.*
51 Although Grodecki's insightful work (*Le Moyen-Age retrouvé*) is now slightly dated, it still remains an invaluable study on this subject.
52 This shift in emphasis is nicely demonstrated when studies on Romanesque Normandy with their changing perspectives are examined: e.g., Gould, *La Sculpture romane*; Musset, *Normandie romane*; Baylé, *Les Origines, Architecture normande.*
53 Tcherikover, *High Romanesque Sculpture*, p. 1. This is reinforced by a number of similar statements from other scholars. Her study is typical of the current trend in reassessing published corpora, especially in France by scholars such as Baylé, Borg, Boss-Favre, and Vergnolle.
54 Prache, *Initiation à l'art roman.*
55 Panofsky, *Die Deutsche Plastik.*
56 See Cocke, "Rediscovery of the Romanesque" for all these works, except Gardner, *A Handbook.* Interestingly, the number of carvings in the actual exhibition (some 81) reflects an unusually high and unparalleled emphasis which must reflect that of the organizers.
57 Henry, *Irish Art*; O'Keeffe, "Lismore and Cashel." The historiography of Romanesque Irish art is dealt with in detail in O'Keeffe, *Romanesque Ireland.*
58 One of the foremost treatments of this subject is in Kahn, *Romanesque Frieze.*

Bibliography

Maylis Baylé, *Architecture normande au moyen âge: Acts du Colloque de Cerisy-la-Salle, 28 Septembre–2 Octobre 1994,* 2 vols. (Condé-sur-Noireau, 1997; 2nd edn. 2001).
——, *Les Origines et les premières dévelopements de la sculpture romane en Normandie* (Caen, 1971; 2nd edn. 1991).
Hermann Theodor Beenken, *Romanische skulptur in Deutschland (11. Und 12. Jahrhundert)* (Leipzig, 1924).
E. S. de Beer, "Gothic: Origin and Diffusion of the Term; The Idea of Style in Architecture," *Journal of the Warburg and Courtauld Institutes,* 11 (1948), pp. 143–62.
Tina Bizzarro, *Romanesque Architectural Criticism. A Prehistory* (Cambridge, 1992).
Francis Bond, *Fonts and Font Covers* (London, 1908).
Kathryn Brush, *The Shaping of Art History. Wilhelm Vöge, Adolph Goldschmodt, and the Study of Medieval Art* (Cambridge, 1996).
Walter Cahn, "English Romanesque Art 1066–1200. Review of the Exhibition," *Art Journal* (1984) pp. 275–8.
——, "Focillon's Jongleur," *Art History* 18 (1995), p. 345.
——, "Schapiro and Focillon," *Gesta* XLI/1 (2002), pp. 129–36.
Walter Cahn and Linda Seidel, *Romanesque Sculpture in American Collections,* 2 vols. (New York, 1979–).
Michael Camille, "Mouths and Meanings: Towards an Anti-Iconography of Medieval Art," in Brendan Cassidy, ed., *Iconography at the Crossroads.* Papers from the Colloquium Sponsored by the Index of Christian Art Princeton University 23–24 March 1990 (Princeton, 1993), pp. 43–58.

Thomas Cocke, "Pre-19th-Century Attitudes in England to Romanesque Architecture," *Journal of the British Archaeological Association*, 3rd series 36 (1973), pp. 72–3.

——, "The Rediscovery of the Romanesque," in George Zarnecki, Janet Holt, and Tristram Holland, eds., *English Romanesque Art 1066–1200: Hayward Gallery, London, 5 April–8 July 1984* (London, 1984), pp. 360–6.

Giles Constable, "Introduction," in H. Damico and J. B. Zavadil, eds., *Medieval Scholarship: Biographical Studies on the Formation of a Discipline*, vol. 1 (New York, 1998).

Benedetto Croce, *Theory and History of Historiography*, trans. Douglas Aunslie (London, 1921).

Paul Deschamps, *French Sculpture of the Romanesque Period Eleventh and Twelfth Centuries* (Florence, 1930).

——, *La Sculpture française, époque romane; photographies prises par Eliane Janet-Le Caisne* (Paris, 1947).

Dorothy Winn Doolittle, "The Relations between Literature and Medieval Studies in France from 1820 to 1860" (Ph.D. Thesis, Bryn Mawr College, 1953).

Nathan Edelman, *Attitudes of Seventeenth Century France towards the Middle Ages* (New York, 1946).

J. Fastenau, *Die Romanische Steinplastik in Scwaben* (Esslingen, 1907).

Eric Fernie, "Contrasts in the Methodology and Interpretation of Medieval Ecclesiastical Architecture," *Archaeological Journal* 145 (1988) pp. 344–64.

——, *Romanesque Architecture: Design, Meaning and Metrology* (London, 1995).

Henri Focillon, *L'Art des sculpteurs Romans, recherches sur l'histoire des formes* (Paris, 1931).

——, *Romanesque Sculpture in France*. A course of lectures given in April–May 1936 at the Metropolitan Museum of Art (New York, 1936).

Ilene H. Forsyth, "The Monumental Arts of the Romanesque Period: Recent Research. The Romanesque Cloister," in Elizabeth C. Parker, ed., with the assistance of Mary B. Shephard, *The Cloisters, Studies in Honor of the Fiftieth Anniversary* (New York, 1992), pp. 3–25.

——, "Narrative at Moissac: Schapiro's Legacy," *Gesta* XLI/1 (2002), pp. 71–94.

Pierre Francastel, *L'Humanisme roman; critique des théories sur l'art du XIe siècle en France* (Paris, 1942).

Paul Frankl, *The Gothic: Literary Sources and Interpretations Through Eight Centuries* (Princeton, 1960).

——, *The Historical Works of Gervase of Canterbury*, ed. William Stubbs (London, 1879).

Arthur Gardner, *A Handbook of English Medieval Sculpture* (Cambridge, 1935).

M. F. Gidon, "L'Invention du terme l'architecture Romane par Gerville (1818)," *Bulletin de la Société des antiquaries de Normandie* (1935), pp. 268–88.

Dorothy F. Glass, *Italian Romanesque Sculpture. An Annotated Bibliography* (Boston, 1983).

Philip Gould, "*La Sculpture romane* in Basse Normandie" (Ph.D. dissertation, Université de Paris, 1953).

Evert F. van der Grinten, *Elements of Art Historiography in Medieval Texts: An Analytic Study* (The Hague, 1969).

Louis Grodecki, *Le Moyen-Age retrouvé* (Paris, 1986).

Françoise Henry, *Irish Art in the Romanesque Period (1020–1170 AD)* (London, 1970).

Deborah Kahn, ed., *The Romanesque Frieze and the Spectator, The Lincoln Symposium Papers* (London, 1992).

——, "La Sculpture romane en Angleterre: état des questions," *Bulletin Monumental,* 146 (1988), pp. 307–40.

Charles Edward Keyser, *A List of Norman Tympana and Lintels, with Figure or Symbolical Sculpture still or till recently existing in the Churches of Great Britain* (London, 1927).

Thomas Lyman, with Daniel Smartt, *French Romanesque Sculpture. An Annotated Bibliography* (Boston, 1987).

Emile Mâle, *L'Art religieux du XIIIe siècle en France; étude sur l'iconographie du Moyen Age et sur ses sources d'inspiration par Émile Mâle* (Paris, 1898).

——, *Religious Art in France, The Twelfth Century, A Study of the Origins of Medieval Iconography* (Princeton, 1978).

Allan Marquand and Arthur Frothingham, *A Text-Book of the History of Sculpture* (New York, 1896).

Lucien Musset, *Normandie romane, photographies inédites de Zodiaque. Traduction Anglaise de Paul Veyrriras et David Rowe. Traduction Allemand de Hilaire de Vos,* 2 vols. (Saint-Léger-Vauban, Yonne, 1967–74).

Roger North, *Of Building: Roger North's Writings on Architecture,* ed. H. M. Colvin and J. Newman (Oxford, 1981).

Tadgh O'Keeffe, "Lismore and Cashel: Reflections on the Beginnings of Romanesque Architecture in Munster," *Journal of the Royal Society of Antiquaries of Ireland* 24 (1990), pp. 118–52.

——, *Romanesque Ireland: Architecture and Ideology in the Twelfth Century* (Dublin, 2003).

Erwin Panofsky, *Die Deutsche Plastik des elften bis dreizehnten Jahrhunderts* (Munich, 1924).

——, "The Friedsam Annunciation and the Problem of the Ghent Altarpiece," *The Art Bulletin* 17 (1935), pp. 433–40.

——, "Wilhelm Vöge: A Biographical Memoir," *The Art Journal* 28 (1968), p. 30.

Wilhelm Pinder, *Die Deutsche plastik des Vierzehnten Jahrhunderts* (Munich, 1925).

Michael Podro, *The Critical Historians of Art* (New Haven, 1982).

Arthur Kingsley Porter, *Les Débuts de la Sculpture Romane* (Paris: 1919).

——, *Romanesque Sculpture of the Pilgrimage Roads* (Boston, 1923).

Anne Prache, *Initiation à l'art roman, Architecture et sculpture sous la direction d'Anne Prache* (Paris, 2002).

Donald Preziosi, ed., *The Art of Art History: A Critical Anthology* (Oxford, 1998).

Hilary Richardson, "The Fate of Kingsley Porter," *Donegal Annual* 45 (1993), pp. 83–7.

Conrad Rudolph, *The "Things of Greater Importance": Bernard of Clairvaux's Apologia and the Medieval Attitude toward Art* (Philadelphia, 1990).

Gert Schiff, ed., *German Essays on Art History* (New York, 1988).

Jean-Claude Schmitt, "Images and the Historian," in A. Bolvig and P. Lindley, eds., *History and Images Towards a New Iconology* (Turnhout, 2003).

Karl Schnaase, *Geschlichte der Bildenden Künste im Mittelalter* (Düsseldorf, 1871).

Anat Tcherikover, *High Romanesque Sculpture in the Duchy of Aquitaine c.1090–1140* (Oxford, 1997).

Carol Neuman de Vegvar, "In the Shadow of the Sidhe Arthur Kingsley Porter's Vision of Exotic Ireland," *Irish Arts Review Yearbook* 17 (2001), pp. 49–61.

William Wilkins, "An Essay Towards an History of the *Venta Icenorum* of the Romans and of Norwich Castle," *Archaeologia* XII (1795), pp. 132–80.

Modern Origins of Romanesque Sculpture

Robert A. Maxwell

Ever since archaeologists adopted the term "Romanesque" in the early nineteenth century, the label has profoundly influenced the study of eleventh- and twelfth-century sculpture. The act of naming a new style shaped research by signaling the discovery of an art identified as different from Gothic (the period label to which scholars previously attached these works).[1] The nature of the difference, however, remained to be explored. The neologism also implied that the sources of the art were to be found in Roman traditions; nonetheless, even that seemingly straightforward notion raised many questions, not the least of which was the actual relationship to Roman building. Romanesque needed definition, more than a name alone could supply.

Archaeologists looked first primarily to the architecture, folding sculpture into the taxonomic layers used to describe arches, vaults, and wall surfaces, but before long discussion of stylistic sources raised questions regarding the role of sculpture in Romanesque development.[2] Scholars noted high and low phases – birth, maturity, and decline – in step with art history's foundational theory of evolutionary progress, but in this schema the birth of Romanesque sculpture was the most perplexing. After all, scholars understood that the production of monumental sculpture had fallen off in the post-antique period. Its resuscitation needed explanation. Identifying the origins could thus offer clues to Romanesque art's particularity and contribute to an understanding of the distinct qualities that marked it from the art that came before and after.

This chapter surveys several ways scholarship has addressed the origins of monumental sculpture in the Romanesque period, limiting its discussion to three specific approaches to the problem. One approach looked to different geographic regions to explain the style's distant sources; another considered the problem more philosophically and searched to define sculptural characteristics in metaphysical

terms; and a third approach attributed the rebirth of sculpture to a shift in iconographic or signifying value. All three attracted debate, and on occasion doctrinal entrenchment obfuscated the substance of the quarrels, but there is little doubt that these polemics propelled further research and indelibly shaped the field.

The Place of Origins

From its earliest concerted study, Romanesque art was identified with geography. The Englishman William Gunn and the Frenchman Charles de Gerville first applied the terms "Romanesque" and "*roman*" in the 1810s to signal a relationship to Roman building traditions.[3] Both understood the term in the philological sense as marking both the debased Latinity of post-antique language and the derivative quality of Romance languages. In France, *roman* also found an analogue in the popular word *romanesque*, or novel-like, equally at ease describing a tortuous series of events, a dreamy attitude, or an eccentric person. The use of *roman* for eleventh- and twelfth-century art carried with it some of these connotations: it hinted at the curiousness of this art (in the sense of *romanesque*) while framing it in the philological sense of cultural erosion.

The impression that this art was somehow derivative, one or more steps removed from Rome itself, received widespread support from the outset, notably in the early lectures of Arcisse de Caumont (1830), the widely influential founder of the Société française d'archéologie.[4] His discussion of architecture classified eleventh- and twelfth-century buildings into chronological periods and regional types, categories formulated in relation to the Roman tradition. Sculpture fell into his purview, earning brief stylistic commentary, yet it figured as little more than architecture's accessory for classificatory purposes. Certain scholars pushed Caumont's theory even further by contending that Romanesque art in France was more Roman-like than the art produced in other countries.[5] In a tradition stretching back to Chateaubriand and forward to Emile Mâle (1917, 1922), the modern Catholic nation as a new Rome partly explained the special success of medieval art on French soil.

Although Caumont was probably Europe's most influential medievalist, his taxonomy did not satisfy all scholars. In Great Britain, for example, terms such as "Saxon" and "Norman" had long circulated in antiquarian circles and grounded this art in the indigenous history of the British Isles.[6] Terms like "byzantine" and "oriental" were also not uncommon in the late eighteenth century, yielding period classifications like "romano-Byzantine primordial" (i.e., 400–1000) and "romano-Byzantine secondaire" (1000–1100) that lingered until the start of the twentieth century.[7] All such terms reflected the idea that this art's pedigree may not have been purely Roman.[8] Some scholars considered the Eastern impulse much more decisive. Eugène-Emmanuel Viollet-le-Duc, for one, argued that the Crusades provided the conduit of exchange, enabling the West's interaction

with the East. Only when the Latin tradition received this new impetus did it flourish as a new and distinctive style.[9]

Some scholarship also steered away from Latin and Byzantine sources to discover a distinctly "Northern" quality. Viollet-le-Duc believed, in addition to his Crusades theory, in a northern contribution: after the death of Charlemagne, each region's people regained its "natural allure," enabling each country to translate its own genius for the regeneration of its art.[10] Louis Courajod developed this notion with greater precision by examining the specific traits of the northern impulse, arguing that Romanesque art drew its influences from the Celts, various Germanic tribes, and also Muslims.[11] The search for Northern European sources also found general support among some German and English scholars, including Franz Kugler (1842), Franz von Reber (1886), and William Lethaby (1904), who all described Romanesque at least in part as a "Northern" product. The American Arthur Kingsley Porter wrote an essay in 1909 strongly in favor of the general northern view, claiming that "five centuries of barbarism [were] the only conceivable force that could have had the power to free Western architecture from the trammels of Roman formula." Owing to the cultural vacuum of the Dark Ages, Porter claimed, art could be reborn, "cut loose from the classical canons."[12]

With such sentiments, discussion occasionally tipped into explicit commentary on the race of nations, as in the 1901 work of Josef Strzygowski. Strzygowski championed the Syrian and Palestinian influences on Western Christian art, but he also posited the special innate qualities of the "Nordic" man.[13] The increasingly overt racial theories draped a noxious pall over his later studies in particular. Far less sulfurous but no less nationalistic, Emile Mâle answered the Viennese-based scholar, as well as Porter, by saying that Germany was not the privileged birthplace of Romanesque; its origins were in the East and this Eastern impulse took root first on French soil.[14] Henri Focillon expressed similarly impassioned opinions and accentuated an East–West rift in geographic debates when he argued that Romanesque art (and all medieval art of quality) was distinct to the West (*l'Occident*) and foreign to Germanic lands whose rudimentary arts reflected the barbarism of the people.[15]

In 1911 the Catalan architect and archaeologist Josep Puig i Cadafalch advanced a reverse position with his theory of the *primer art romànic* or *premier art roman*.[16] He argued that the earliest recognizable Romanesque forms could be found around the Mediterranean, particularly in northern Italy and Catalonia at the start of the tenth century (fig. 16-1). Thereafter, the movement progressed north into Gaul and the Germanic Empire as far as the Moselle. If one wanted to search further for the origins of this first wave, he asserted, one would need to look eastward.[17] "One could say that Romanesque art is a Mesopotamian art in the same way that French art of the eighteenth century is a Greek art."[18] Though primarily an architecturally based theory, founded upon types of construction, wall decoration, and vaulting, the idea implicated sculpture by proposing the conditions of the medium's genesis.

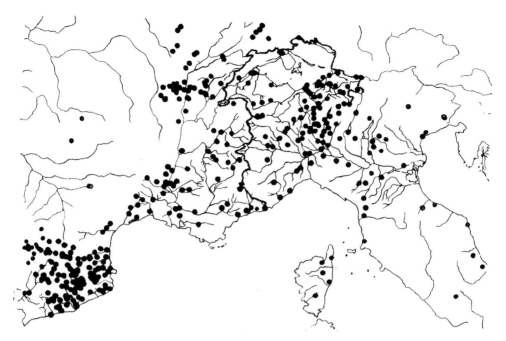

FIGURE 16-1 Map showing the spread of the "First Romanesque" style, from
J. Puig i Cadafalch, *La Géographie*.

While the number of pan-Continental theories multiplied, scholars also paid
growing attention to local geographic developments. In France the search for
regional stylistic trends became tantamount to uncovering regional identities
within national borders. Support for regional schools had much to do with the
spread of local antiquarian societies, beginning with Caumont's own Société des
antiquaires de Normandie in 1824 (becoming the Société française d'archéologie
in 1834),[19] followed within a few years by a dozen regional archaeological asso-
ciations throughout the country. Since Caumont's lectures in Normandy stressed
classification into regional styles, this approach found its response at the local
societies: hometown antiquarian-cum-archaeologists quickly got busy plumbing
the distinct qualities of their familiar monuments. Nave tribunes and half-barrel
vaults, for example, became defining characteristics of Auvergnat Romanesque
and in Poitou, the "hall" church typified the local style.

 Caumont's "geography of styles" won over many archaeologists, though they
often disagreed, sometimes quite vehemently, on the number of schools. Caumont
identified seven distinct regions (North, Northwest, West, Southwest, Auvergne,
Germanic, and Burgundian). Viollet-le-Duc, on the other hand, named seven in
one of his *Dictionnaire* entries and eight in another; in still other essays, he cited
eleven and thirteen schools.[20] Jules Quicherat, for his part, objected to Caumont's
intuitive deductions and, borrowing terms from Linnaean classification, sought

to ground identifications in more scientific data.[21] Camille Enlart, one of the most outspoken proponents of the regional approach along with Robert de Lasteyrie, drew distinctions along very old (including Gallic) territorial divisions, thereby suggesting that something special in the soil, climate, and people produced differences among varieties of Romanesque art.[22] Although all such regional divisions depended primarily on architectural qualities, scholars understood that sculpture added substantial corroborative evidence. The absence of carved tympana, for example, was typical of Aquitaine, while Burgundian portals exhibited a penchant for Majestas imagery, Auvergnat doorways favored carved, pedimental-shaped lintels, and Languedocian cloisters encouraged historiated capitals. Carving style was a less determinant but implicit part of this categorization.

England's scholars, too, attached great importance to regional traditions and to the local learned institutions established to study them, but with very different art historical results. After the refounding of the national Society of Antiquaries in 1717, regionalism received a boost with the 1751 incorporation of London's own Society of Antiquaries that in turn spurred the foundation of other local groups.[23] These societies sponsored comprehensive county surveys, such as Edward Hasted's four volumes on the county of Kent,[24] but sculpture was largely subordinate to the authors' interests (if present at all). Instead, these publications focused mainly on monuments' history and building accounts. Even into the nineteenth century, when single-edifice monographs such as those by Robert Willis on Canterbury and Glastonbury came to join the regional surveys, authors only considered sculpture as a complement to the architectural construction.[25] The first comprehensive sculptural studies did not appear until the twentieth century, and even then Romanesque sculpture did not foster the kinds of partisan border skirmishes that flared up in France.[26] If anything, the county studies in England championed not distinctions among counties, but distinctions between English and Continental Romanesque. Centuries-old traditions of stone carving in Britain, stretching back to the Anglo-Saxon period, provided grounds for this attitude, but British scholars nonetheless failed to reckon fully with the incumbent period categories like "Norman" or "Saxon"; the relation of twelfth-century sculpture to Anglo-Saxon or Irish high crosses, for example, remained problematic and unexplained. It was only in the twentieth century that, with the appearance of good surveys of this material, research began to entertain such questions.

Scholars of all nationalities reserved their fiercest debates for French monuments. The most famous volley came from the American Porter, seen (aside from its art historical merits) as an assault on the French academic establishment.[27] Porter overturned the usual hierarchies and argued for Spanish and Lombard priority in sculptural matters, and, within France itself, Burgundy's precedence over Languedoc. He based his position on scrupulous analysis of works and corroborating texts (dated foundation charters, altar consecrations, etc.). And rather than posit merely natural evolution touching one region after another, he believed social phenomena such as pilgrimage and monastic reform helped explain stylistic progress and exchange.[28]

The French academy bristled at Porter's rejection of their regional hierarchy and assailed his stylistic judgment and reading of texts. Paul Deschamps led the charge, publishing virulent corrections of Porter's textual evidence,[29] while others, such as François Deshoulières, Charles Dangibeaud, and Eugène Lefèvre-Pontalis, produced essays to reassert the schools classification.[30] When a few French scholars, such as the widely respected Georges Gaillard working on Spanish sculpture and Charles Oursel working on Burgundy,[31] offered research that supported some of Porter's theses, the tension ebbed; true détente did not reign, however, until the deaths of Porter and Deschamps in the 1930s. The dispute nonetheless left traces in subsequent scholarship and continues to mark especially Burgundian, Languedocian, and northern Spanish studies.

In Germany, Romanesque sculpture was late to garner specialized interest. When it did, the majority of nineteenth-century scholars remained attached to the study of abstract and formal qualities (cf. infra), rather than geographic sources.[32] After all, many believed that Romanesque sculpture represented simply a continuation of Ottonian forms and types, so the gradual distinctions that arose between the two periods could be explored best on aesthetic terms. A number of scholars in the early twentieth century, however, did pronounce on sculpture's geography and joined these debates. Julius Baum (1910), for one, stood behind Roman and Latinate origins, while Paul Frankl (1926) was perhaps Germany's strongest exponent of the "northern" theory. Frankl, building upon the studies of Courajod and others, sketched broad historical genealogies within Europe but tied regional styles to local conditions. Germany, in this view, held on longer to the Carolingian traditions, and thus continued a style consistent with the older forms. This was important since there were significant sculptural examples from tenth- and eleventh-century Germany, including works in stucco, that remained to be considered against the full Romanesque style. France and Italy, according to Frankl, likewise maintained traditions little different in form from Carolingian art, but by about 1080 developed their own regional styles – dependent on local temperament and conditions – that yielded the mature Romanesque. Frankl thus wove the study of regional specificity into a pan-European theory, melding the two outlooks most widely favored at this time.

Interest in geographic origins remained a constant, although less polemical, concern through much of the twentieth century. Kenneth John Conant maintained that Romanesque art had strong northern, Carolingian roots, and Charles Rufus Morey in 1942 echoed earlier scholars when he argued that the putatively Roman quality of Romanesque art was really a Germanic interpretation of late Classical traditions.[33] Partisans of southern theories were not lacking either. Edson Armi traced the origins of the new style to the appearance of "continuous orders" in Catalonian and southern French churches,[34] while Roberto Salvini drew parallels between the *premier art roman* and linguistic forms of provincial Latin that developed in particular social climates of southern Europe.[35] Such studies from the second half of the century, however, began to integrate the

search for origins with other concerns, initiatives begun already in the 1920s and 1930s to which we turn below.

Origins as a Hermeneutic

Categorization had dominated the study of Romanesque art since the day of Gerville and Gunn, yet ongoing partisanship in geography discussions distracted somewhat from advances made in other areas of scholarship. In Germany, for example, nineteenth-century scholars were more steeped in aesthetics and stylistic qualities than in geographic (or scientific) explanations for Romanesque sculpture. F. W. Hegel's philosophy inspired scholars such as Carl Schnaase to discuss Romanesque sculpture in terms of stages in aesthetic evolution, and others under Heinrich Wöfflin's influence sought to define the style on purely formal terms. Some, such as Richard Hamann-MacLean (1908), Margret Burg (1922), and Eugen Lüthgen (1923), speculated on the particularities of sculpture as a medium,[36] particularly in relation to Carolingian and Ottonian sculptural traditions. Explanations of origins therefore occupied only the margins of such studies. Nonetheless, one scholar (also Hegel-inspired) who did address formal stylistic origins in a profound way was Henri Focillon, arguing that the new style was born of sculpture's own material conditions.

Focillon was convinced that the historicist, archaeological endeavors of the nineteenth century unsatisfactorily served works of art. In his first book-length publication on a medieval subject, he argued instead that history experienced strong and weak periods, as well as moments of rupture, paroxysm, and *repli* that defied linear stylistic progress. Most significant, he believed, were "breakthrough" moments, those periods or episodes that revealed history's structure. As he said, there were several stages of humanity, or of human geology whose stratigraphy must be taken apart to find the "present and the hidden" structure.[37] Form expressed itself through adherence to certain principles, guided for example by the exigencies of the sculptural canvas ("law of the frame") or the architectural field ("law of architecture"), and understanding these might hold the key to understanding the essence of Romanesque sculpture. The way to discern the patterns or laws was to attend to forms, their origins, survivals, and reawakenings, and from these patterns – a kind of structure or logic – one would arrive at an understanding of the history of a style, the history of art *tout court*.

In an important 1938 article, Focillon set the research agenda, as well as the method, for generations of scholars to come. He identified the year 1000 as crucial, one of those moments of both rupture (with the immediate past) and reawakening (of more distant traditions). Close study of this period's sculpture, therefore, should offer rare insight into the universe of forms specific to Romanesque and provide a basis for understanding the special logic that separated this art from Gothic. His students (notably J. Baltrušaitis) consequently adopted the

eleventh century as their field of predilection, publishing on the formal and geometric qualities of early sculpture in France.[38]

Following this methodological course were two Polish-born scholars, Louis Grodecki, one of Focillon's students, and the Courtauld-trained scholar George Zarnecki. They were perhaps their generation's most influential advocates of research into the rise of Romanesque sculpture as a distinct medium. Whether discussing sculpture in England, France, Switzerland, or Germany, both sought out the evidentiary forms that would demonstrate the evolution from early, rustic blocked-out capitals to fully mature historiated works of the twelfth century. The debt to Focillon surfaces in much of their work, whether in Grodecki's methodological essay on the inherent duality of Romanesque carving (described as both figure and architecture) or in case-studies, such as on Bernay's sculpture, or in Zarnecki's research into the early sculptural group at Payerne, Switzerland (fig. 16-2).[39] Even this latter choice of subject derives from concerns laid out in Focillon's own writings, as in his reflections on Dijon's crypt capitals (fig. 16-3). When these scholars looked across the Channel, they also applied their Continental perspective to English sculpture.[40] Zarnecki, for example, argued that the impulses that gave rise to Romanesque sculpture were not indigenous to Britain, but brought from Normandy; for this reason English Romanesque sculpture does not properly begin until after 1066.[41] Viking and Anglo-Saxon art, he felt, were simply "quite out of step with the new architectural sculpture evolving on the Continent."[42] For these scholars, Romanesque production marked a new stylistic stage that wedded material and formal exigencies to produce works of unprecedented figural complexity.

These studies framed research for the next generation of scholars, although perhaps with more lasting effect in France than in England. Few in England maintained the interest in material origins along these lines, in spite of Zarnecki's status as one of Great Britain's most influential scholars.[43] When, for example, scholars addressed the distinctive character of Romanesque sculpture, as in Deborah Kahn's 1991 study of Canterbury Cathedral's earliest sculptural group, contextual considerations weighed more heavily than formalist study. In France, on the other hand, Grodecki published an influential "state of the question" essay that outlined in very clear terms the important issues facing the study of French sculpture for the next generation of students.[44] Like Focillon's similar essay 20 years earlier, Grodecki championed the value of renewed research into the experimental impulses and ancient traditions that spurred on a slowly changing art form in the early years of the eleventh century.

Two subsequent generations have continued this interest, first in the work of Marcel Durliat, one of Grodecki's protégés, and in the work of Durliat's own students. Durliat, whose research has focused on southern France and northern Spain, also in time published a "state of the question" article in 1968 setting out for future generations the issues that needed attention.[45] This article, however, demonstrates how far the orientation initiated by Focillon had strayed, for Durliat, while noting that research into origins had turned fruitfully to the Loire valley,

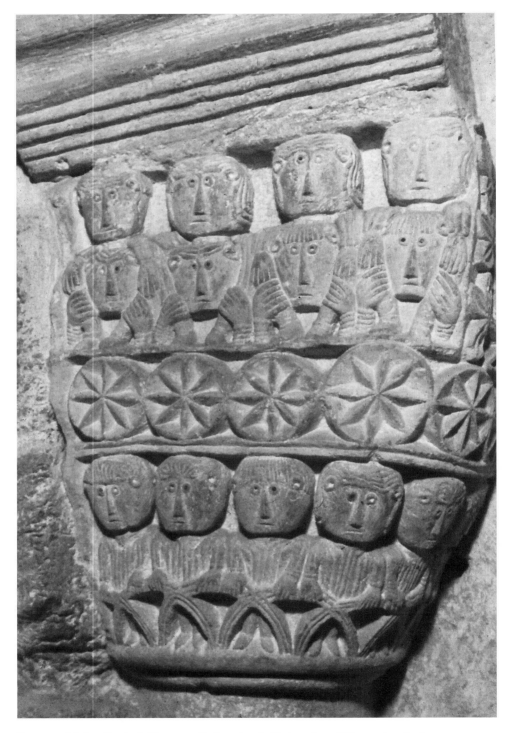

FIGURE 16-2 Capital. Payerne, Switzerland. University of Pennsylvania Image
Collection. Photo: David Robb.

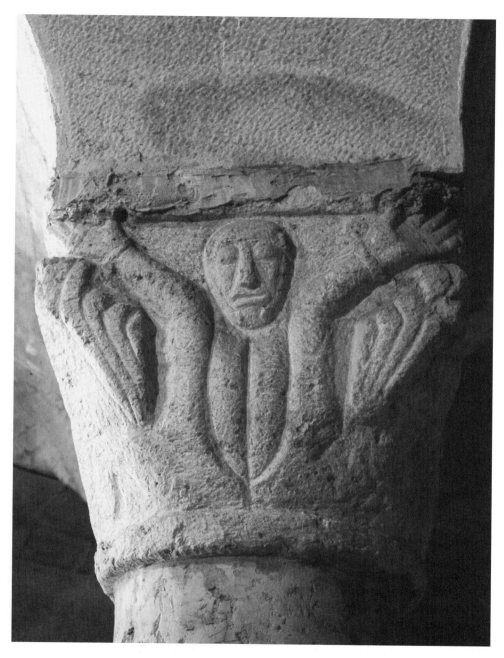

FIGURE 16-3 Crypt Capital, Orans figure, Dijon, France. Photo: Robert A. Maxwell.

hoped to draw attention to other issues, such as the role of pilgrimage, the identity of sculptors, and the still unshakeable "schools" debate.[46]

Even with this expanded query, however, the subsequent generation has continued to refine formalist inquiry to understand the qualities that make the sculpture Romanesque. Their research has produced a series of impressive regional studies: Maylis Baylé on Normandy, Eliane Vergnolle on the Loire valley, Jean Cabanot on Bordelais and southwest sculpture, and Marie-Thérèse Camus on Poitou.[47] Each explored the kinds of formal and material-based qualities that so intrigued the earlier scholars, while also bringing texts and other source material to bear, notably on proposed chronologies. Characteristic of these works is their careful attention to artists' working practices, particularly the preparatory blocking out of capitals (*épannelage*), interpreted as affecting the choice of decoration and its manner of display (fig. 16-4). This series of scholarly volumes,

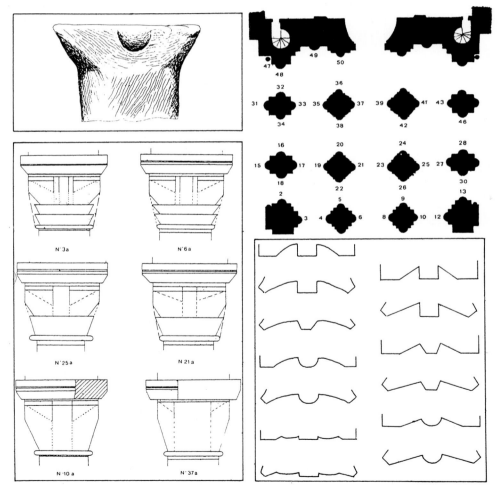

FIGURE 16-4 Diagram of capital profiles and *épannelage*. Reproduced from E. Vergnolle, *Saint-Benoît-sur-Loire*.

though independent projects, offer interconnecting pictures of the eleventh-century sculptural revival, and they fulfill in many ways the wish uttered by Focillon in 1938 that an understanding of sculpture's formative development would only come once scholars had at their disposal detailed surveys of regional foyers.

This focus on the emergence of sculptural forms sometimes relegated iconographic questions to the background, although increasingly since the 1980s research has looked to reconcile form with issues of content. Rows of men crouched under a capital's abacus appeared to conform to the "law of the frame," but was this all there was to the figural impulse in early sculpture? The rich portal at Moissac, already the subject of much text-based research, would prove a prime test subject: Grodecki, Durliat, and Vergnolle all published on the abbey's portal group and argued that the tympanum's Last Judgment was not simply a translation from other pictorial sources, as Mâle had insisted (see below).[48] Instead, the tympanum's organization and its elaboration of eschatological themes had much to do with the constraints of the sculptural field and how those constraints engendered certain iconographical solutions; for them, neither a pre-existing text nor a chain of formal evolutions could alone "explain" the decorative program. In this sense, Focillon's legacy was coming full circle: it had initially set new formal study at a distance from iconographic interpretation as practiced by Mâle, yet now decades later a muted formalism reintegrated iconographic study. This approach received confirmation in a recent survey of Romanesque monumental arts, in which Vergnolle addressed on equivalent methodological terms the early sculpture of St-Génis-des-Fontaines and later work at Cluny.[49] Although not slavishly faithful to Focillon's work, this latest discussion continues the exploration of form's origins as an interpretative means for unlocking the defining qualities of the Romanesque as a distinct period style.

Content, Context, and the Sculptural Revival

For many nineteenth-century amateurs of the Middle Ages, religious meaning, not form, was medieval art's greatest legacy. The task of the archaeologist was to uncover the theological bases for the assorted beasts, plants, and tunic-clad figures that decorated these millennium-old objects. This line of research produced voluminous compendia of iconographic interpretations, yet such works on the whole failed to consider subject matter as a defining quality of Romanesque sculpture or to entertain the possibility that content or meaning was somehow related to the condition of the period style. This position changed dramatically at the start of the twentieth century and within just a few decades scholarship's preoccupation with texts and contexts inflected even geographic and formalist approaches to sculpture's origins.[50]

This shift owed a great deal to Emile Mâle, whose publications made an important contribution to the specific definition of Romanesque sculpture in

iconographic terms. Resurgent enthusiasm for Catholic teaching in France, as well as the philological underpinning of much art historical practice, drew Mâle and others to look specifically for sculpture's origins in religious texts.[51] Although some simplified the matter to a purely philological issue, viewing pictures as just another form of textual transmission, Mâle viewed the rise of sculptural imagery as linked additionally to the survival of iconography in other visual media, especially from early Christian sources. "Christian iconography, born in the Near East, came to us ready-made," kept alive for centuries in the West through illuminated manuscripts (fig. 16-5). Romanesque sculptors incorporated novel motifs and ideas for the new medium, but all the same, the illuminated miniature "explains both the contorted aspect of our nascent sculpture and profoundly traditional character of our iconography."[52] The "rebirth" of sculpture was thus crucially bound to iconographic expression in a textual mode. It is no wonder then that Mâle considered monasticism crucial to this revival, for the religious orders were the link to early Christian textual/iconographic traditions. "Twelfth-century art is above all a monastic art,"[53] and sculpture was its religious codex in stone.

This codicological view of origins overlapped with another growing concern, namely the relation of monumental sculpture to the minor arts.[54] Comparisons to other media showed that the art of monumental carving, considered to have been entirely lost since late antiquity, was perpetuated in miniature form through metalwork, ivories, and gemstones. German scholars in particular had for a long time acknowledged sculpture's debt to Carolingian and Ottonian art production,[55] an orientation that reflected that country's long-standing scholarly commitment to those periods. German specialists understood the revival of sculpture in the eleventh century as simply part of a continuous chain of stylistic and technical development, and so, whether researching the sculpture of the Rhineland, Saxony, or the Netherlands, drew upon the corpus of surviving *Kleinkunst* to demonstrate continuity with ninth- and tenth-century art.[56]

Some authors working in this tradition sought more than stylistic comparisons, however, and attempted to understand the traits that set eleventh- and twelfth-century work apart. For them, the decisive change in Romanesque art was its new conception of scale and its mastery of volume that projected a truly sculptural presence. Wilhelm Vöge developed an approach to address these changes in his discussion of the "monumental" quality of early Gothic sculpture.[57] Although he applied this term to the mid-twelfth-century figures of the Royal Portal at Chartres, it effectively articulated the sentiment that large sculpture was but a translation in scale of precious objects. In Germany, Vöge's evocative writings profoundly influenced a generation of students, including Hermann Beenken and a young Erwin Panofsky.[58] There was in these works a formalist strain, and many scholars, applying *Stilkritik* indebted as much to Wölfflin as to the evolutionary aesthetics of Schnaase, produced stylistic categories without so much furthering discussion of monumentality or the material origins of the period style.[59]

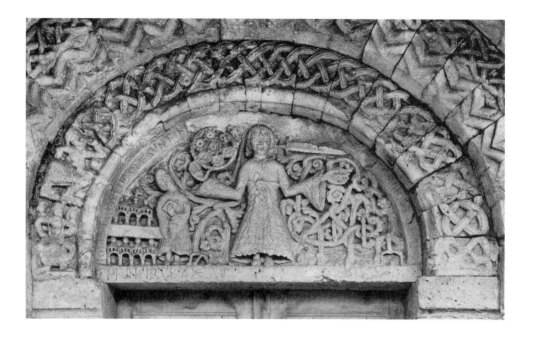

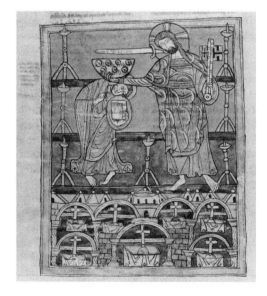

FIGURE 16-5 Vision of St John: comparison of sculptural (*above*) and manuscript iconography (*below*). Tympanum, south portal from La Lande-de-Fronsac, Pierre (*above*) and from Beatus Apocalypse, Bibliothèque nationale de France, MS nouv.acq.lat. 1366, fol.12v (*below*). Reproduced with permission from James Austin, the Bibliotèque nationale de France, and Princeton University Press. Reproduced from E. Mâle, *Religious Art in France: The Twelfth Century*, figs. 7, 8.

A more contextual strain of German and French scholarship viewed the issue slightly differently. Some authors viewed the problem as one of religious value, attributing the rise of freestanding sculpture to a shift in importance of cult objects. Louis Bréhier was one of the first to draw attention to the statues of the seated Madonna – "Vierges reliquaires" – as signal elements for the rebirth of

sculpture,[60] and a number of scholars followed in this path. In Harald Keller's important study of Ottonian precedents,[61] the reliquary function legitimated sculpture in the eyes of the Church; it is only through this specific liturgical role that sculpture gained a foothold among accepted artistic forms. Some scholars, though, such as Paul Deschamps[62] and Hubert Schrade[63] (whose essay directly challenged Keller's thesis), while more or less acknowledging that liturgical function played some role in sculpture's rebirth, diluted the effects of this one cause by setting it within broader considerations. Schrade emphasized changes in religious experience and belief, and for Deschamps, among many others, material and technical aspects illuminated sculpture's affinities with other types of object. These latter discussions therefore considered monumental reliefs and metal retables as a single class of object (namely cultic) that naturally shared traditions of technique and craft; as the role of monumental productions grew, sculptors merely graduated to ever grander lapidary exploits.[64] A number of surveys, such as those by Arthur Gardner (1931) and Millard F. Hearn (1981), endorse this general perspective. Thomas Lyman (1978) offered a qualifying note to the theory when he asserted that it was precisely a decline in metal arts that made skilled artists available.[65]

Origins for these scholars lay not in geographical explanations or philosophical approaches, but in material developments that addressed religious needs and functions. Over the course of the twentieth century, liturgical use, patronage, and artist's techniques occupied an increasingly important place in sculpture studies as scholars looked outward from the object to understand the conditions of its production.[66] Whereas Bréhier had drawn in 1912 a parallel in form and sacrality between large-scale sculpture and small, tenth-century Marian cult statues, when Ilene Forsyth treated the same subject in 1972, the methodological gulf between them had widened considerably. Forsyth's attention to a complex set of cultural conditions, chief among them changes in liturgy, doctrinal theology, popular devotion, and sculptural praxis, evinced a profoundly contextual turn, for which the origin of sculpture was not reducible either to form or content alone.

Although Mâle's text-bound studies did much to promote interest in areas such as pilgrimage, monastic spirituality, and liturgical drama, Meyer Schapiro's studies collectively provided an equally important model for the contextual, or social-historical, approach. They addressed the specific problem of sculptural revival in terms of social critique. Pointing to images of secular musicians carved in the cloister at Silos and gestures of feudal homage at Souillac, and drawing upon the history, liturgy, and economics of those two sites, Schapiro drew attention to a set of social circumstances that he felt conditioned, even enabled, the sculptural revival.[67] These specific sculptures provided testimony to the clash of the sacred and secular worlds, irrevocably brought together in the new twelfth-century economy, and, most important of all, of the rise of the artist as an individual within an emerging class structure. The irruption of profane motifs into traditionally religious themes and settings marked for Schapiro not only a defining moment of Romanesque sculpture, but of history itself.

For other scholars, particularly in the 1930s and 1940s, the contextual view produced a different result. Sculpture's revival was, if not an expression of the tensions caused when rising secular society invaded the once hermetic domain of religious art, as Schapiro believed, at least emblematic of an awakened human spirit. Jean Adhémar and Pierre Francastel discerned a self-consciousness in the iconographic developments of the eleventh century, particularly in the reuse of motifs from antiquity.[68] For Francastel, the manipulation in the twelfth century of lingering Classical traditions marked a significant shift in artistic consciousness. On one hand, he said, the late eleventh-century sculptural programs (such as at Toulouse) represented a monumentality that was a burden to the artist, too much under the weight of tradition; yet the sculptural play later (as at Charlieu) bore witness to a new freedom from tradition's constraints.[69] There is no way to explain this "miracle," not by reference to Near Eastern iconographic roots or the belief in a genius artist, other than by the rise of a liberated spirit, the collective soul of a humanistic Renaissance. It is worth recalling that a similarly hopeful nostalgia, but in formal terms, framed Focillon's writings of about the same date, as when he saw in an early eleventh-century capital at Dijon the human form emerging from material bonds, creative humanity awakening after a long slumber.

Conclusion

Focillon's approach had little in common with the methodological positions of Mâle or Schapiro; yet, as this final example demonstrates, the various theories of origins often shared some common intellectual ground. Different positions overlapped and they certainly did so with more complexity than this brief chapter can adequately portray. Many of the scholars named above weighed in on not one but several approaches to the problem of origins. Focillon, for example, shared beliefs in the geographic sources of iconography with Mâle, just as Puig i Cadafalch and Baum understood their architectural research as contributions to the definition of Romanesque sculpture as a distinct medium. The methodological lines drawn above, therefore, should be considered not as reflective of absolute doctrines but as representative of the intellectual spaces in which conflicting and complementary theories struggled to understand a style that had been introduced into academic discussion only relatively recently.

What is clear, however, is that these queries on origins were set in motion from the moment the art "became" Romanesque through the coining of that term. The discovered style (and period) required definition and clarification, whether through formal or iconographic criteria and whether tracing the style's genesis to a place, a metaphysical essence, or a context. Some of these queries set about trying to understand Romanesque sculpture *après la lettre*; that is, the descriptive term determined the manner of research. This is particularly evident in the geographic research, for the name pressed the art historian onward to seek out what was Roman and what was not. The question of course could only have

been so posed once the art was called Romanesque. Even those opposed to the notion of a Roman inheritance, looking to the North or the Near East for the style's origins, placed too much faith in the heuristic value of the modern term, and they took to arguing against the term as if it were as determined as the style itself. The intertwined invocations of nations, regions, and race, resembled a search as much for Romanesque art's origins as modern cultural ones.

Scholarship since the 1970s has focused less on resolving the specific place or time of Romanesque sculpture's genesis. Many would agree that the reappearance of monumental sculpture on a wide scale in the eleventh century was a form of continuity with cultures past – Anglo-Saxon and Carolingian, for example. Certain factors (social or political), as pointed out by Mâle and Schapiro among others, may have provided a special impetus along the way, giving a boost to sculpture as a crucial artistic commodity in evolving cultural contexts. It is perhaps not without some significance that content and contextual studies, such as those by Mâle, Francastel, and Schapiro, as well as a few of those that look to the minor arts as precursors, "postpone" the revival of sculpture until the twelfth century. These scholars' interests in iconography and context find better examples in that later period than in the abstract or geometric sculpture of the early eleventh century. Whereas discussion of geographic origins drew the Romanesque style back in time to Rome or the Near East, contextual studies brought the so-called birth of Romanesque sculpture out of the eleventh century and into the twelfth. So much so, that Schapiro's and Francastel's studies even attribute to this sculpture qualities that are often also associated with the Gothic period: the secularization of a new bourgeois Christendom, on the one hand, and individualistic humanism, on the other. Students of context brought Romanesque forward, closer to their era, and there too the search for Romanesque origins seemed at times equally as much a search for modern ones.

Notes

It is a pleasure to acknowledge the assistance of Marie-Thérèse Camus, Claude Andrault-Schmitt, and Eliane Vergnolle, who in warm conversations shared with me their perspectives on a number of issues addressed above. I am especially grateful to Eric Fernie and Walter Cahn, who very kindly read an earlier draft and whose suggestions greatly improved the essay.

1 [See also chapter 15 on Romanesque sculpture in Northern Europe by Hourihane in this volume. On Gothic sculpture and sculptural programs in general, see chapters 19 and 26 by Büchsel and Boerner (ed.).]
2 [On Romanesque architecture, see chapter 14 by Fernie in this volume (ed.).]
3 Bizarro, *Romanesque Architectural Criticism*. I thank also W. Cahn for his valuable input on this subject.
4 Caumont, *Cours*, vols. 4 and 6.
5 Courajod, *Leçons*, pp. 13–14.
6 Cocke, "The Rediscovery."

7 Bourassé, *Archéologie chrétienne*. As applied esp. to sculpture, see de Verneilh, *Des Influences byzantines*.

8 Cf. references infra; also, Maxwell, "Misadventures."

9 Viollet-le-Duc, *Dictionnaire*, VIII, esp. p. 166. [For more on medieval art and the relation between East and West, see chapters 23 and 24 by Folda and Papacostas, respectively, in this volume (ed.).]

10 Ibid., p. 119.

11 Courajod, *Leçons*.

12 Porter, *Medieval Architecture*, vol. I, p. 165.

13 Strzygowski, *Orient*; *Ursprung*.

14 Mâle, *L'Art allemand*.

15 Cahn, "L'Art français."

16 Puig i Cadafalch et al., *L'Arquitectura romànica*.

17 Puig i Cadafalch, *Le Premier art roman*, p. 154.

18 Puig i Cadafalch, *La géographie*, p. 401, with other references to Eastern origins; cf. Focillon, *Art of the West*, p. 112ff, with similar observations.

19 Preceded by the Société d'Emulation de Caen, 1823.

20 De Lasteyrie, *L'Architecture religieuse*, p. 407; see also Deshoulières, "La Théorie."

21 Quicherat, *Mélanges*, pp. 99ff, 484.

22 Enlart, *Manuel d'archéologie*; de Lasteyrie, *L'Architecture religieuse*. Among critics, see, Crozet, "Problèmes de méthode," and Francastel, *L'Humanisme*.

23 Evans, *A History*.

24 E.g., Ormerod, *The History of the County Palatine*; Surtees, *The History and Antiquities*.

25 Willis, "The Architectural History."

26 Prior, *An Account*; Keyser, *A List of Norman Tympana*.

27 Porter, "The Rise"; "La Sculpture."

28 [On pilgrimage art, see chapter 28 by Gerson in this volume (ed.).]

29 Cf. Deschamps, "Notes sur la sculpture romane."

30 E.g., Deshoulières, "Nouvelles remarques," and "La Théorie"; Dangibeaud, "L'Ecole."

31 Oursel, *L'Art roman*, pp. 203ff.

32 [On formalism, see chapter 5 by Seidel in this volume (ed.).]

33 Morey, *Medieval Art*, pp. 180, 228ff.

34 Armi, "Orders and Continuous Orders."

35 Salvini, "Pre-Romanesque."

36 Burg and Lüthgen were especially influenced by Riegl. Burg, for example, sought to understand the "Willen zur Monumentalen" and analyzed the various stages in the "Drang nach rundplastischer Gestaltung." Cf. also Sauerlandt (*Deutsche Plastik*, p. vi), who viewed early Romanesque plasticity as a struggle between ground-bound forms and "liberated" expression.

37 Focillon, *L'Art des sculpteurs*; *Art of the West*.

38 Quarré, *La Sculpture romane*; G. Micheli, *Le Décor géométrique*; Baltrušaitis, *La Stylistique ornementale*.

39 Grodecki, "Dualité" and "Les Débuts"; Zarnecki, "1066" and "Sculpture," p. 146.

40 Grodecki, "L'Art roman en Angleterre."

41 Zarnecki, *English Romanesque*, pp. 8ff.; "Romanesque Sculpture"; "1066"; "Sources of English Romanesque."

42 Zarnecki, "Sculpture," p. 146.

43 Exceptions: Borg, "The Development of Chevron"; Henry, *La Sculpture irlandaise* and *Irish Art*; cf. also Cherry, "Recent Works," and Kahn, "La Sculpture romane."

44 Grodecki, "La Sculpture du XIe siècle."

45 Durliat, "Les Premiers Essais"; "Les Débuts de la sculpture romane"; "L'Art roman en France."

46 Cf. also Durliat's more recent *bilan*, "La Sculpture du XIe siècle."

47 Baylé, *La Trinité de Caen*; Vergnolle, *Saint-Benoît-sur-Loire*; Cabanot, *Les Débuts de la sculpture romane*; Camus, *Sculpture romane du Poitou*.

48 Grodecki, "Le Problème"; Durliat, "Les Premiers Essais"; Vergnolle, "Chronologie et méthode"; see also Mézoughi, "Le Tympan."

49 Vergnolle, *L'Art roman en France*.

50 Cf., for example, the effect on Ganter's formalist perspective (*Romanische Plastik*), or Porter's (*Romanesque Sculpture*) emphasis on pilgrimage as a stylistic catalyst.

51 [On art and exegesis, see chapter 8 by Hughes in this volume (ed.).]

52 Mâle, *Religious Art*, p. xxxi.

53 Ibid., p. xxx.

54 [On the sumptuous arts, see chapter 22 by Buettner in this volume (ed.).]

55 E.g., Kugler, *Handbuch der Kunstgeschichte*; Reber, *Kunstgeschichte des Mittelalters*.

56 Bachem, "Sächsische Plastik"; Klein, *Die romanische Steinplastik*; Wesenberg, *Frühe mittelalterliche*; Ligtenberg, *Die romanische Steinplastik*.

57 Vöge, *Die Anfänge*.

58 Beenken, *Romanische Skulptur;* Panofsky, *Die deutsche Plastik*. See also n.36 above.

59 Novotny, *Romanische Bauplastik*, offered a different solution: he believed that close formalist study of regional developments (Austrian, in this case) would correct the sweeping evolutionist (and too aesthetic to his taste) views advanced by Panofsky and Beenken.

60 Bréhier, "Les Origines de la sculpture romane"; "La Cathédrale de Clermont."

61 Keller, "Zur Entstehung."

62 Deschamps, "Etude sur la renaissance de la sculpture"

63 Schrade, "Zur Frühgeschichte."

64 E.g., Wesenberg, *Frühe mittelalterliche*, pp. 96f, 102–3 and passim; Durliat, "Les Débuts"; Pächt, "The Pre-Carolingian Roots"; Schapiro, "A Relief."

65 Gardner, *Medieval Sculpture*; Hearn, *Romanesque Sculpture*; Lyman, "Arts somptuaires."

66 [On patronage, see chapter 9 by Caskey in this volume (ed.).]

67 Schapiro, "From Mozarabic to Romanesque"; "The Sculpture of Souillac."

68 Adhémar, *Influences antiques*; Francastel, *L'Humanisme*.

69 Francastel, *L'Humanisme*, pp. 199 and 202; cf. Cahn, "The Artist."

Bibliography

Jean Adhémar, *Influences antiques dans l'art du Moyen-Age français* (London, 1937).

C. Edson Armi, "Orders and Continous Orders in Romanesque Architecture," *Journal of the Society of Architectural Historians* 34 (1975), pp. 173–88.

Johannes Bachem, "Sächsische Plastik vom frühen Mittelalter bis nach Mitte des 13. Jahrhunderts," Inaugural-Dissertation, Friedrich-Wilhelms-Universität, Berlin, 1908.

Jurgis Baltrušaitis, *La Stylistique ornementale dans la sculpture romane* (Paris, 1931).

Julius Baum, *Romanesque Architecture in France* (London, 1912).

Maylis Baylé, *La Trinité de Caen: sa place dans l'histoire de l'architecture et du décor romans* (Paris, 1979).

Hermann T. Beenken, *Romanische Skulptur in Deutschland (11. und 12. Jahrhundert)* (Leipzig, 1924).

Tina Waldeier Bizzarro, *Romanesque Architectural Criticism: A Prehistory* (New York, 1992).

Alan Borg, "The Development of Chevron Ornament," *Journal of the British Archaeological Association*, 3rd ser., 30 (1967), pp. 122–40.

Jean-Jacques Bourassé, *Archéologie chrétienne* (Tours, 1841).

Louis Bréhier, "La Cathédrale de Clermont au Xe siècle et sa statue d'or de la Vierge," *La Renaissance de l'art français* 7 (1924), pp. 205–10.

——, "Les Origines de la sculpture romane," *Revue des deux mondes* 82 (1912), pp. 870–901.

Margret Burg, *Ottonische Plastik* (Bonn, 1922).

Jean Cabanot, *Les Débuts de la sculpture romane dans le sud-ouest de la France* (Paris, 1987).

Walter Cahn, "The Artist as Outlaw and *Apparatchik*: Freedom and Constraint in the Interpretation of Medieval Art," in Stephen K. Scher, ed., *The Renaissance of the Twelfth Century* (Providence, 1969), pp. 10–14.

——, "L'Art français et l'art allemand dans la pensée de Focillon," in Matthias Waschek, ed., *Relire Focillon* (Paris, 1998), pp. 27–51.

Marie-Thérèse Camus, *Sculpture romane du Poitou. Les grands chantiers du XIe siècle* (Paris, 1992).

Arcisse de Caumont, *Cours d'antiquités monumentales*, vols. 4 and 6 (Paris, 1831, 1841).

B. Cherry, "Recent Works on Romanesque Art and Architecture in the British Isles," *Anuario de Estudios Medievales* 4 (1967), pp. 467–86.

Thomas Cocke, "The Rediscovery of the Romanesque," in George Zarnecki, ed., *English Romanesque Art 1066–1200* (London, 1984), pp. 360–6.

Kenneth J. Conant, *Carolingian and Romanesque Architecture, 800 to 1200* (Baltimore, 1959).

Louis Ch. Courajod, *Leçons professées à l'Ecole du Louvre (1887–1896)* (Paris, 1899).

René Crozet, "Problèmes de méthode: les théories françaises sur les écoles romanes," *Boletín del Seminario de Estudios de Arte y Arqueológica* 21/22 (1954–6), pp. 39–45.

Charles Dangibeaud, "L'Ecole de sculpture romane saintongeaise," *Bulletin archéologique du Comité des travaux historiques et scientifiques* (1910), pp. 22–62.

Paul Deschamps, "Notes sur la sculpture romane en Bourgogne," *Gazette des Beaux-Arts* 5th ser, 6 (1922), pp. 61–80.

——, "Etude sur la renaissance de la sculpture en France à l'époque romane," *Bulletin monumental* 84 (1925), pp. 5–98.

François Deshoulières, "Nouvelles remarques sur les églises romanes du Berry," *Bulletin monumental* 81 (1922), pp. 5–27.

——, "La Théorie d'Eugène Lefèvre-Pontalis sur les écoles romanes," *Bulletin monumental* 84 & 85 (1925 & 1926), pp. 197–252, 5–65.

Marcel Durliat, "L'Art roman en France (État des questions)," *Anuario de estudios medievales* 5 (1968), pp. 611–27.

——, "Les Débuts de la sculpture romane dans le Midi de la France et en Espagne," *Les Cahiers de Saint-Michel de Cuxa* 9 (1978), pp. 101–14.

——, "Les Premiers Essais de décoration de façades en Roussillon au XIe siècle," *Gazette des Beaux-Arts*, 6th ser., 67 (1966), pp. 65–78.

——, "La Sculpture du XIe siècle en Occident," *Bulletin monumental* 152 (1994), pp. 129–213.

Camille Enlart, *Manuel d'archéologie française depuis les temps mérovingiens jusqu'à la renaissance* (Paris, 1902–4).

Joan Evans, *A History of the Society of Antiquaries* (Oxford, 1956).

Henri Focillon, *L'Art des sculpteurs romans: recherches sur l'histoire des formes* (Paris, 1931).

——, *The Art of the West in the Middle Ages* (London, 1963 [1938]).

——, "Recherches récentes sur la sculpture romane en France au XIe siècle," *Bulletin monumental* 97 (1938), pp. 49–72.

Ilene H. Forsyth, *The Throne of Wisdom: Wood Sculptures of the Madonna in Romanesque France* (Princeton, 1972).

Pierre Francastel, *L'Humanisme roman: critique des théories sur l'art du XIe siècle en France* (Rodez, 1942).

Paul Frankl, "Die Entstehung der romanischen Formengattungen," *Die frühmittelalterliche und romanische Baukunst* (Potsdam, 1926), pp. 57–63.

Joseph Gantner, *Romanische Plastik: Inhalt und Form in der Kunst des XI. und XII. Jahrhunderts* (Vienna, 1941).

Arthur Gardner, *Medieval Sculpture in France* (Cambridge, 1931).

Louis Grodecki, "L'Art roman en Angleterre," repr. in *Le Moyen-âge retrouvé*, I (1986 [1953]), pp. 167–82.

——, "Les Débuts de la sculpture romane en Normandie: Bernay," repr. in *Le Moyen-âge retrouvé*, I (1986 [1950]), pp. 69–114.

——, "Dualité de l'art roman," repr. in *Le Moyen-âge retrouvé*, I (1986 [1957]), pp. 33–48.

——, "Le Problème des sources iconographiques du tympan de Moissac," repr. in *Le Moyen-âge retrouvé*, I (Paris, 1986 [1963]), pp. 151–60.

——, "La Sculpture du XIe s. en France. État des questions," repr. in *Le Moyen-âge retrouvé*, I (1986 [1958]), pp. 49–67.

Richard Hamann-MacLean, "Das Wesen des Plastischen," *Zeitschrift für Aesthetik und allgemeine Kunstwissenschaft* 3 (1908), pp. 1–46.

Edward Hasted, *The History and Topographical Survey of the County of Kent*, 4 vols. (Canterbury, 1779–99).

Millard F. Hearn, *Romanesque Sculpture: The Revival of Monumental Stone Sculpture in the Eleventh and Twelfth Centuries* (Ithaca, NY, 1981).

Françoise Henry, *Irish Art in the Romanesque Period, 1020–1170* (Ithaca, NY, 1970).

——, *La Sculpture irlandaise pendant les douze premiers siècles de l'ère chrétienne* (Paris, 1933).

Deborah Kahn, *Canterbury Cathedral and its Romanesque Sculpture* (Austin, 1991).

——, "La Sculpture romane en Angleterre: état des questions," *Bulletin monumental* 146 (1988), pp. 307–40.

Harald Keller, "Zur Entstehung der sakralen Vollskulptur in der ottonischen Zeit," in K. Bauch, ed., *Festschrift für Hans Jantzen* (Berlin, 1951), pp. 71–91.

Charles E. Keyser, *A List of Norman Tympana and Lintels*, 2nd edn. (London, 1927).

Johannes Klein, *Die romanische Steinplastik des Niederrheins* (Strassburg, 1916).

Franz Kugler, *Handbuch der Kunstgeschichte* (Stuttgart, 1842).

Robert de Lasteyrie, *L'Architecture religieuse en France à l'époque romane* (Paris, 1912).

William R. Lethaby, *Mediaeval Art* (London, 1904).

Raphael Ligtenberg, *Die romanische Steinplastik in den nördlichen Niederlanden. Band I, Die Reliefplastik und der Bauornamentik* (Haag, 1918).

Eugen Lüthgen, *Romanische Plastik in Deutschland* (Bonn, 1923).

Thomas Lyman, "Arts somptuaires et art monumental: bilan des influences auliques," *Les Cahiers de Saint-Michel de Cuxa* 9 (1978), pp. 115–28.

Emile Mâle, *L'Art allemand et l'art français du moyen-âge* (Paris, 1917).

——, *Religious Art in France: The Twelfth Century. A Study of the Origins of Medieval Iconography* (Princeton, 1978 [1922]).

Robert A. Maxwell, "Misadventures of a Style: Romanesque Art and the Druids in Eighteenth-Century France," *Art History* 26 (2003), pp. 609–37.

Noureddine Mézoughi, "Le Tympan de Moissac: études d'iconographie," *Les Cahiers de Saint-Michel de Cuxa* 9 (1978), pp. 171–200.

Geneviève Micheli, *Le Décor géométrique dans la sculpture de l'Aisne et de l'Oise au XIe siècle* (Paris, 1939).

Charles Rufus Morey, *Mediaeval Art* (New York, 1942).

——, "The Sources of Romanesque Sculpture," *Art Bulletin* 2 (1919), pp. 10–16.

Fritz Novotny, *Romanische Bauplastik in Österreich* (Vienna, 1930).

George Ormerod, *The History of the County Palatine and City of Chester*, 3 vols. (London, 1819).

Charles Oursel, *L'Art roman de Bourgogne* (Dijon, 1928).

Otto Pächt, "The Pre-Carolingian Roots of Romanesque Art," in *Romanesque and Gothic Art*, vol. I (Princeton, 1963), pp. 67–75.

Erwin Panofsky, *Die deutsche Plastik des elften bis dreizehnten Jahrhunderts* (Munich, 1924).

Arthur Kingsley Porter, *Medieval Architecture, Its Origins and Development* (New York, 1909).

——, "The Rise of Romanesque Sculpture." *American Journal of Archaeology* 22 (1918), pp. 399–427.

——, *Romanesque Sculpture of the Pilgrimage Roads*, 10 vols. (Boston, 1923).

——, "La Sculpture du XIIe siècle en Bourgogne," *Gazette des Beaux-Arts* 5th ser., 2 (1920), pp. 73–94.

Edward S. Prior, *An Account of Medieval Figure-Sculpture in England* (Cambridge, 1912).

Josep Puig i Cadafalch, *La geografia i els orígens del primer art romànic* (Barcelona); *La géographie et les origines du premier art roman*, trans. J. Vrellard (Paris, 1935).

——, *Le Premier Art roman, l'architecture en Catalogne et dans l'occident méditerranéen aux Xe et XIe siècles* (Paris, 1928).

Josep Puig i Cadafalch et al., *L'Arquitectura romànica a Catalunya*, vol. 2 (Barcelona, 1911).

Pierre Quarré, *La Sculpture romane de la Haute Auvergne* (Aurillac, 1939).

Jules Quicherat, *Mélanges d'archéologie et d'histoire, archéologie du moyen-âge* (Paris, 1886).

Franz von Reber, *Kunstgeschichte des Mittelalters* (Leipzig, 1886).

Roberto Salvini, "Pre-Romanesque, Ottonian and Romanesque," *The Journal of the British Archaeological Association*, 3rd ser., 33 (1970), pp. 1–20.

Max Sauerlandt, *Deutsche Plastik des Mittelalters* (Düsseldorf, 1911).

Meyer Schapiro, "From Mozarabic to Romanesque in Silos," repr. in *Romanesque Art: Selected Papers* (New York, 1977 [1939]), pp. 28–101.

——"A Relief in Rodez and the Beginnings of Romanesque Sculpture in Southern France," repr. in *Romanesque Art* (New York, 1977 [1963]), pp. 285–305.

——, "The Sculpture of Souillac," repr. in *Romanesque Art: Selected Papers* (New York, 1977 [1939]), pp. 102–30.

Hubert Schrade, "Zur Frühgeschichte der mittelalterlichen Monumentalplastik," *Westfalen* 35 (1957), pp. 33–64.

Josef Strzygowski, *Orient oder Rom* (Leipzig, 1901).

——, *Ursprung der christlichen Kirchenkunst* (Leipzig, 1920).

Robert Surtees, *The History and Antiquities of the County Palatine of Durham*, 4 vols. (London, 1816–40).

Eliane Vergnolle, "Chronologie et méthode d'analyse: doctrines sur les débuts de la sculpture romane en France," *Les Cahiers de Saint-Michel de Cuxa* 9 (1978), pp. 141–62.

——, *Saint-Benoît-sur-Loire et la sculpture du XIe siècle* (Paris, 1985).

——, *L'Art roman en France* (Paris, 1994).

Félix de Verneilh, *Des Influences byzantines* (Paris, 1855).

Eugène-Emmanuel Viollet-le-Duc, *Dictionnaire raisonné de l'architecture française du XIe au XVIe siècle* (Paris, 1866); vol. 8 "Sculpture," pp. 97–279.

Wilhelm Vöge, *Die Anfänge des monumentalen Stils im Mittelalter* (Strassburg, 1894).

Rudolf Wesenberg, *Frühe mittelalterliche Bildwerke: die Schulen rheinischer Skulptur und ihre Ausstrahlung* (Düsseldorf, 1972).

Robert Willis, "The Architectural History of Canterbury Cathedral (1845)," repr. in *Architectural History of Some English Cathedrals.* (Chicheley, 1972), pp. v–141.

George Zarnecki, "1066 and Architectural Sculpture," *Proceedings of the British Academy* LII (1966a), pp. 87–104.

——, *English Romanesque Sculpture, 1066–1140* (London, 1951).

——, "Romanesque Sculpture in Normandy and England in the Eleventh Century," *Proceedings of the Battle Conference, 1, 1978* (1979), pp. 168–90.

——, "Sculpture," in Zarnecki, ed., *English Romanesque Art, 1066–1200* (London, 1984), pp. 146–8.

——, "La Sculpture à Payerne," in Colin Martin, ed., *L'Abbatiale de Payerne* (Lausanne, 1966), pp. 139–64.

——, "Sources of English Romanesque Sculpture," *Actes du XVIIe Congrès international d'Histoire de l'Art* (The Hague, 1955), pp. 171–8.

The Historiography of Romanesque Manuscript Illumination

Adam S. Cohen

The term "Romanesque" conjures images of rounded arches and contorted figural sculpture, and a glance at any modern survey text underscores the primary place of architecture and relief in the presentation of Romanesque art. Manuscripts, on the other hand, seem to be included almost as an afterthought. As this chapter documents, this has long been the case. A historiographic examination of manuscript illumination of the eleventh and twelfth centuries reveals that considerations of style only slowly gave way to other concerns. In the process, Romanesque illuminations have gone from being disparaged medieval curiosities in the nineteenth century to valued historical artifacts in the present. I offer as a case-study one well-known illuminated manuscript, the Life of St Edmund in the Pierpont Morgan Library in New York (MS M. 736), whose reception and treatment in the modern period is emblematic of the history of Romanesque manuscript illustration as a whole. This focus will be supplemented by broader analyses that highlight additional issues and important literature in the field.

Early Disparagement

The St Edmund manuscript (hereafter called the VSE – *Vita Sancti Eadmundi*) is a collection of texts and 32 full-page miniatures that tell the story of England's ninth-century martyr king.[1] The earliest modern mention of the manuscript was

in the 1814 sales catalogue of the John Towneley Collection, in which the book is described as "Life of St. Edmund, King of the East Angles, a most curious and valuable manuscript upon Vellum, executed about the year 1100 and illustrated with a series of singularly curious paintings emblematic of Edmund's History, Legend and Miracles."[2] In 1817, the great bibliophile Thomas Frognall Dibdin referred to the VSE as a manuscript "of extraordinary interest and curiosity" (which suggests he knew of the book only from the Towneley sales catalogue).[3] In 1841 the VSE was sold to an eminent collector, Robert Holford, and soon discussed in print by Gustav Waagen, first professor of art history in Berlin and director of its Gemäldegalerie.[4] Although Waagen considered it "a rich and well-preserved specimen of the Old English art of the twelfth century," at the same time he disparaged the style of the miniatures, speaking of the clumsy compositions and the "childish" execution of the forms with their long proportions and meager limbs (fig. 17-1).

As Hindman et al. have demonstrated, most nineteenth-century writers clung to the Vasarian paradigm in which medieval art was the unfortunate interlude between classical and Renaissance art.[5] This is evident in one of the earliest English publications devoted to reproducing medieval manuscripts, Henry Shaw's *Illuminated Ornaments: Selected from Manuscripts and Early Printed Books from the Sixth to the Seventeenth Centuries* (1833). The introduction was written by the authoritative Sir Frederic Madden, keeper of manuscripts at the British Museum, whose highest praise was for Cimabue and Giotto; consequently, Italian Renaissance manuscript illuminations were most prized. Notably, Madden subdivided the Middle Ages into smaller categories. For the early period he used such geographic, ethnographic, or political terms as Visigothic, Franco-Gallic, Irish or Hiberno-Saxon, Lombardic, or the period of Charlemagne. But from the eleventh century on the terms are simply chronological – eleventh century, twelfth century, and so on. This basic schema, with minor differences, reappeared in other mid-nineteenth century works.[6]

Nor was this a specifically English perspective. The most ambitious nineteenth-century attempts to reproduce medieval manuscripts were by two Frenchmen: Jean-Baptiste-Louis-George Seroux d'Agincourt in 1823 and Comte Jean-François-Auguste Bastard d'Estang from 1837 to 1846. In Seroux d'Agincourt's comprehensive history of art, which began with a consideration of architecture, all manuscript painting from the eighth through thirteenth centuries was lumped together and characterized as being replete with bizarre figures and extravagant compositions; it was "the interval in which art appears to have reached the most miserable state."[7] In a more specialized work on manuscripts, Bastard d'Estang used terms similar to those of his English contemporaries: Merovingian and Lombardic for the early Middle Ages, century divisions for the later material.[8] Bastard d'Estang was motivated primarily by the idea of preserving and disseminating the heritage of French culture, and other nineteenth-century treatments of medieval art were also rife with nationalistic concerns.

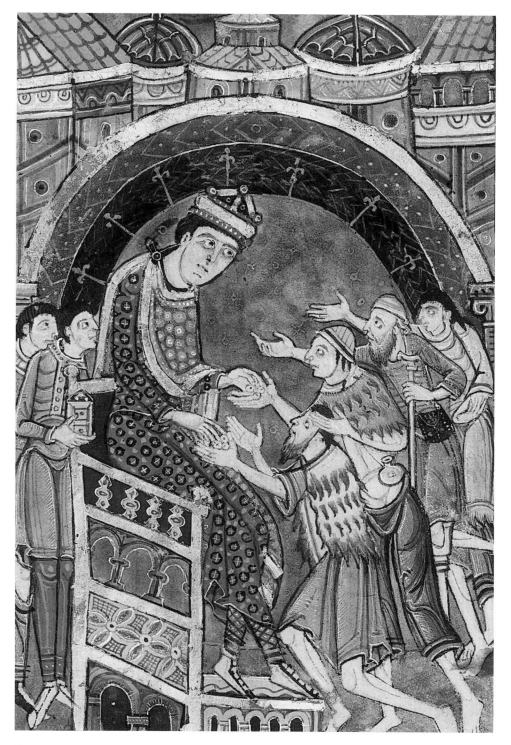

FIGURE 17-1 Charity of St Edmund, from the Life of St Edmund. New York: Pierpont Morgan Library, MS M 736, fol. 9r: Charity of Edmund.

"Romanesque"

Despite the introduction of the term "Romanesque" into learned discourse about architecture toward the beginning of the nineteenth century,[9] it was some time before the label was applied to manuscripts. This is evident in Paul Lacroix's encyclopedic *Les arts au moyen age et à l'époque de la Renaissance* (1871).[10] For architecture, a chapter subheading is called "Age de transition du roman au gothique," though sculpture after the year 1000 is only divided into various regional schools without reference to Romanesque or Gothic. The first of two chapters on manuscripts was devoted to palaeography, then considered the most important aspect of manuscript study. Such terms as Lombardic and Gothic appear, but not Romanesque. The second chapter focused on miniatures, and it is apparent that a fairly clear sense of the chronology and stylistic development of medieval manuscript painting was already taking the shape familiar today, although the terminology still reflected clear biases against certain medieval material. The explicit goal "is to signal the principal phases of perfection and decadence" in medieval painting, and it is evident that by the 1870s Gothic was a far less pejorative term than it had been earlier in the nineteenth century. After a consideration of painting under Charlemagne, there is a section on "the decadence of the miniature in the tenth century," a period of utter debasement in art that only began to emerge from its fascination with grotesques around the third quarter of the twelfth century. This was "the birth of gothic art" that was noted for "beautiful manuscripts of the time of Saint Louis." Furthermore, Lacroix's nationalistic perspective is evident in the comparison of French manuscript painting with its "delicacy and taste" to the "most naive compositions" of German illumination.

A survey of the nineteenth-century scholarship on Romanesque manuscript illumination reveals several points of contact with the intellectual trends that animated studies of architecture and sculpture.[11] These reveal the nationalistic and regional motivations of many authors, and the general opprobrium accorded to medieval art in general and to eleventh- and twelfth-century art in particular. In large measure this was the continued legacy of Vasari's authority, but it also reflected contemporary concerns. The monarchical and statist impulses that drove a good deal of French scholarship tilted authors toward periods that were rich in royal products. They thus emphasized the ninth century under the Carolingians (one of the manuscripts of Charles the Bald is, notably, MS lat. 1 in the Bibliothèque nationale), and the thirteenth century under Louis IX. In England, medieval book illumination was viewed negatively as a largely Catholic and foreign enterprise, in contrast to the "native" British ethos that was exemplified by medieval examples of naturalism.[12] Consequently, late medieval painting was valued more highly than that of the eleventh and twelfth centuries, which likewise in England was a weak period for royal patronage of manuscripts.

Nationalistic motivations resulted in monumental efforts to collect, preserve, and publish the documents of national patrimonies throughout Europe. Thus the VSE was included in an 1897 volume of the English Rolls series. Whereas the pictures had once attracted the attention of Dibdin and Waagen, the text of the Miracles was of primary interest to Thomas Arnold, who was responsible for collecting all available materials about St Edmund's Abbey.[13] Despite his intention to give "an exact account of the contents," Arnold offered a brief description of only a handful of the illuminations.

Public and scholarly awareness of the VSE was assured at the beginning of the twentieth century by its inclusion in the ambitious folio volumes of 250 plates published by the New Palaeographical Society.[14] In keeping with preferences for naturalistic and classicizing art, post-Carolingian products were assessed rather negatively. The VSE is described as "executed in a peculiar style," while works of the thirteenth century, on the other hand, are "refined," "graceful," and "beautiful." Despite the overall negative view of the twelfth century, and the Society's primary interest in palaeography, Sir George Frederic Warner, keeper of manuscripts at the British Museum, did provide a meticulous analysis of the textual and pictorial contents of the VSE, which serves as the basis for the Morgan Library's current records.

The relationship between palaeography and art is likewise seen in one of the first scholarly works dedicated to a study of manuscript illumination. In his 1885 *Les manuscrits et la miniature*, Albert Lecoy de la Marche, of the National Archives, sought to place manuscript illumination on the same scientific footing already accorded palaeography. His intellectual approach, clearly derived from palaeography's methods, emphasized stylistic characteristics in delineating "schools" of miniature painting. Lecoy de la Marche also was among the very first to transfer the term Romanesque to manuscript painting of the eleventh and twelfth centuries.

In his account, miniatures from the Merovingian, Carolingian, and Romanesque periods constituted a "first phase" characterized by a hieratic style that communicated spirituality and symbolism in books made by and for churchmen. Romanesque illumination was notable for a slow expansion of subject matter, progress in drawing and the imitation of nature, and above all the development of luxurious and fantastic initials filled with grotesques. While there is little objectionable in his descriptions, the style is still regarded negatively in comparison to Gothic art, which Lecoy de la Marche hailed as the second, "naturalistic" phase.[15] The relation is summarized in an analogy (attributed to Léopold Delisle, the prolific curator of the Bibliothèque nationale), in which Romanesque is characterized as a chrysalis in winter wrapped in a sheath awaiting the spring.[16] For Lecoy de la Marche, as for most writers of the nineteenth century, Romanesque manuscripts suffered by having neither the patina of late antique and early Christian manuscripts nor the incipient naturalism of Gothic manuscripts as precursors to the Renaissance.

Forming the Canon

In the first third of the twentieth century two phenomena contributed to the appreciation of Romanesque manuscripts: an increase in encyclopedic survey texts and also in specialized museum and library exhibitions. Both modes of presentation shared a fundamental similarity in approach in the continuing struggle to define and classify Romanesque art.

One of the most ambitious surveys was the *Histoire de l'art* edited by André Michel. The second part of volume one was dedicated to "Romanesque art" and contained a chapter on manuscript painting in northern Europe by Arthur Haseloff.[17] According to Haseloff, the new Romanesque period began in the middle of the tenth century and lasted until about 1100, roughly coinciding with the period of the Ottonian rulers in Germany. English manuscript illumination also flourished in this period until it became more continental around 1100, a date that also saw a marked change toward the Gothic style in France. Haseloff's approach expanded upon that of his nineteenth-century predecessors; after briefly discussing the political and historical circumstances, he remarked on manuscript illumination in general before treating individual schools. Haseloff tried to provide a positive assessment of the Romanesque period's lack of interest in naturalism, and he even addressed the issue of the relationship of texts and images, though he was primarily interested in tracing stylistic sources and developments, categorizing manuscripts in terms of schools, and tracking the intricacies of the historiated initial.

In one of several medieval volumes of the *Handbuch der Kunstwissenchaft*, Julius Baum offered a more refined division of Romanesque art than that found in similar works.[18] Now the term was split into three separate categories: Early, Middle, and Late Romanesque, each treated according to regional schools. Baum directly tackled the meaning of the word *romanisch*, acknowledging but not adequately explaining the connection to Rome. Instead, he relied upon a noxious assessment by Georg Dehio and Gustav von Bezold that the earliest and highest flowering of the Romanesque style occurred in Germany and in those adjacent lands regenerated by German blood, spirit, and knowledge.[19] When Baum turned to specific analyses of individual works or schools, however, his language was free of such sentiments, and he provided, like Haseloff, meticulous analyses of stylistic connections that would not be out of place in more recent surveys. On manuscripts like the VSE, he wrote, "the earlier style is represented by the St. Albans Psalter and Bury Bible with their long, stretched out figures, turned mostly in profile and sometimes exaggerated, and whose parallel arrangement makes them appear conspicuously and uniformly agitated."

The exhibition of medieval manuscripts organized by the Burlington Fine Arts Club in 1908 marked a watershed in the appreciation of Romanesque art.[20] In his introduction to the catalogue, Sydney Cockerell wrote that this exhibition was meant to surpass the 1904 Paris exposition devoted to "*Primitifs Français*,"

which was limited to French manuscripts from the thirteenth century and later. The London show had its own nationalistic bias in highlighting English products (though not to the exclusion of French and Italian works); the fact that England produced so many illuminated manuscripts from the seventh through thirteenth centuries likely motivated the more comprehensive chronological scope of the exhibition. Cockerell wrote that several twelfth-century manuscripts, including the VSE, "show a mastery of technique and an energy of imagination which cannot be too much admired. It may be well to point out that the very last of them was finished about seventy years before the birth of Giotto."[21] So much for Vasari, at least temporarily.

That Cockerell's point was taken is evident from a review of the exhibition by Roger Fry, the champion of modernism. For Fry, who was so concerned with the formal qualities of painting, twelfth-century English work presented the greatest achievement in manuscript illumination, the perfect fusion of "barbaric" color and "traditional" classicism.[22] The formalist analysis in this review sounds very much like an appraisal of the Fauves, whose first exhibition had been just three years earlier; it is no coincidence that Romanesque art was increasingly valued by avant-garde artists seeking to subvert the classical heritage.[23] Nonetheless, Fry's description of the VSE, which included references to "childish delight" and "primitive feeling," shows that while Romanesque style was beginning to be appreciated, the rehabilitation of the period's products was not wholesale.

In 1927 the Bibliothèque nationale in Paris mounted a major exhibition of material from the early medieval through Romanesque periods. In the catalogue, Philippe Lauer provided a general history of manuscripts before the Romanesque, including a lengthy section on the Carolingians, presumably because of the library's rich holdings in that area.[24] The tenth and eleventh centuries under the Ottonians are not included in Romanesque, nor is English painting of the time (a result, perhaps, of a nationalistic perspective). While Lauer spoke of "the romanesque age," "romanesque art," and "the romanesque style," nowhere does he actually use the term "romanesque manuscript." This suggests that, unlike "Gothic," "Romanesque" was not yet universally employed as an umbrella term for the period between the Carolingians/Ottonians and the Gothic. More important is Lauer's explicit recognition that French Romanesque painting is characterized by a lack of unity, an assessment implicit in earlier treatments of the multiple schools of painting during the eleventh and twelfth centuries.

It was in 1927 also that the VSE was purchased for the Pierpont Morgan Library in New York. In his introduction to a 1933–4 exhibition catalogue of Morgan manuscripts, Princeton's Charles Rufus Morey provided an overview of the history of manuscript illumination that in many ways was much in keeping with contemporary European ideas like those of Baum: "As time goes on, racial force asserts itself, and the figures become more savage and Teutonic, finally evolving that strong, solid type which passes into Romanesque sculpture."[25]

By the middle of the twentieth century, scholars had largely accomplished what their nineteenth-century predecessors had sought to do: map the stylistic

and regional contours of Romanesque art. This is evident in some of the special-
ized investigations of illuminated manuscripts from this period. Among the
earliest was Albert Boeckler's *Abendländische Miniaturen bis zum Ausgang der
Romanischen Zeit*. In his treatment of the VSE, Boeckler grouped the manu-
script with a series of drawings in a manuscript (MS 120) belonging to Pembroke
College, Cambridge, and the so-called St Albans Psalter.[26] In his analysis
of these works, Boeckler characterized them as "monotonous" because of the
uniformity in composition and the stale repetition of figures that displayed little
movement. In addition, "rarely does a fan-like, fluttering piece of drapery break
loose. The movement remains stiff and clumsy with regard to the intensely
vehement gestures as well."[27] Such descriptive language, especially the allitera-
tion in German, is exquisite, though the perception is hardly more favorable
than earlier attitudes about the VSE. Moreover, it would constitute the norm
for decades to come.[28] Only in the middle of the twentieth century did writers
begin to describe the style of the VSE and other Romanesque paintings without
negative value judgments.

As long as style was the primary consideration of scholars of Romanesque
art, three interrelated concerns dominated discourse in the field. First, to what
extent could Morellian connoisseurship distinguish the hands of different artists?
Second, what were the sources and channels of stylistic transmission between
artists and regions? And third, when did Romanesque style begin and end?

Perhaps the supreme example of the first two issues is the treatment of the
artists of the Winchester Bible, especially by Walter Oakeshott (fig. 17-2).[29]
Scholars generally agree that some of the same artists worked on the Winchester
Bible in the 1160s and the frescoes in the chapter house in Sigena, Spain, in the
1180s. Analyses of individual hands led to broader theories about the itinerant
nature of professional lay artists in the twelfth century: their freedom of move-
ment, contrasted with the cloistering of monastic artists in previous centuries,
enabled such artists to absorb styles from different regions and to spread them
throughout Europe. Above all, the motor that propelled Romanesque style was
contact with Byzantine art, often through the intermediary of Norman Sicily.[30]

Explicating the relationship of Western European art to Byzantine models had
long been a central preoccupation of twentieth-century scholars,[31] including
Otto Pächt in the magisterial study on the St Albans Psalter written in collab-
oration with C. R. Dodwell and Francis Wormald.[32] In a wide-ranging icono-
graphic and stylistic analysis of the miniatures, Pächt identified sources in Anglo-
Saxon, Carolingian, Ottonian, and Byzantine art, though he pinpointed
the most important models in the Italo-Byzantine sphere. For Pächt, the con-
fluence of iconographic and stylistic models in Italy led him to state that
"the conclusion seems inescapable that the founder of the St. Albans school of
painting had experienced that art in the flesh and that he had gone through a
period of Italian training of some sort." Based on a stylistic analysis of this artist,
dubbed the Alexis Master, Pächt assembled an oeuvre that included the min-
iatures of the VSE.

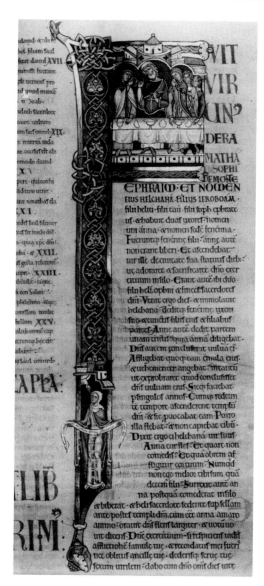

FIGURE 17-2 Elkhanah and his wives;
Hannah (I Samuel), from the Winchester
Bible. Winchester Cathedral Library,
fol. 88r. Reproduced by permission of
the Dean and Chapter of Winchester/
Winchester Cathedral Library.

At the heart of such analysis is the idea that individual artists can be identified and distinguished, and that entire periods can be similarly characterized and distinguished from others. Such a Hegelian view posits that there is something definable specifically as "Romanesque," which partakes of the particular zeitgeist of that period and cannot, by definition, be "Gothic."[33] This premise compelled scholars to define precisely when Romanesque art, including its manifestations in manuscript painting, could be said to begin and end. Basic disagreement well into the twentieth century about what the term meant with regard to book painting and which historical periods composed "the Romanesque" did not stop scholars from accepting the validity of the Hegelian imperative and continuing to proffer working definitions.[34]

This overriding desire for categorization and definition resulted in a view of Romanesque art that privileged certain objects – like the Winchester Bible – that were understood as conforming to and shaping the prevailing norm and that marginalized others that fell outside the parameters of the paradigm. A case in point is a British Museum publication devoted to Romanesque book painting, in which D. H. Turner stated: "If we want to assign arbitrary dates to the beginning and end of the Romanesque period – and a style knows, of course, no exact limits – 1049 and 1180 are convenient."[35] The fact that such categorization was incompatible with stylistic concerns did not give Turner pause. The dates chosen are grounded in historical phenomena: the Gregorian

reform of the church and the ascendance of Philip Augustus to the throne of France. The latter date was meant to indicate the second "fundamental characteristic[s] of Romanesque. . . . [I]t was art in the creation of which France did not play the centralizing role she did in the Gothic period." In other words, what characterized Romanesque art was that it was not French Gothic art, the teleological end to which Romanesque was destined. For Turner, as for so many scholars, "Romanesque" was an abstract, almost Platonic idea whose essential characteristics were formal and stylistic. Consequently, such objects as Montecassino manuscripts are described as "too freakish to be regarded as a true manifestation of Romanesque" – despite the fact that they conform to Turner's chronological timeline and to his characterization of Romanesque as a decidedly ecclesiastical period (fig. 17-3).

Carl Nordenfalk provided the classic articulation of this stylistic approach in a lengthy essay in the popular Skira series, which brought generous color reproductions to the familiar survey format.[36] Although Nordenfalk was one of the twentieth century's most astute and prolific scholars of medieval manuscripts, in his wide-ranging survey of Romanesque illumination stylistic analysis remained the crux of the matter. His comparison of two eleventh- and twelfth-century illustrations is a *tour de force* of stylistic analysis:

> Fundamental to the High Romanesque style is a consistent effort to build up form by means of separate compartments or panels, like pieces of a jigsaw puzzle. . . . Most of these [units] are given the form of rounded-off triangles, circumscribed by soft "V" folds whose contours are duplicated on occasion. Here and there we find a group of nested "V" folds.[37]

Nordenfalk also treated at length the development of the exuberant initials common in Romanesque manuscripts, and, in an important departure from previous overviews, provided an extensive consideration of the principal types of manuscripts, including the illustrated saint's life, of which the VSE was one example.

The VSE had already been included in a survey of illustrated saint's lives by Francis Wormald, whose 1952 article was a catalyst for the shift toward concern with book type and manuscript function.[38] Wormald offered an iconographic insight when he compared the Flagellation of Edmund in the VSE to the Flagellation of Christ in the St Albans Psalter, which to him demonstrated the reliance of the vita artist on the representation of the Passion. The ideological implications of this comparison would be brought out by later scholars; Wormald was more concerned with sketching the contours of the vita genre. His conclusion that this type of book flourished from 950 to 1200 as a "mirror for monks, part of the relics of the monastery" would make it the Romanesque book *par excellence* according to prevailing definitions in the mid-twentieth century.

Beginning in the 1960s, monographic treatments of individual manuscripts became increasingly common. Whereas previous generations of scholars had sought to delineate the major contours of a given region or artistic school

FIGURE 17-3 Initial "D," from a Montecassino Psalter. London: British Library, Add. MS 18859, fol. 24v. Reproduced by permission of the British Library.

(a process that continued for those few schools remaining to be "catalogued"[39]), scholars began to delve deeper into the place of a particular manuscript within a given group. For example, Elizabeth Parker McLachlan used iconographic and stylistic analyses to disentangle the various hands of the Bury St Edmunds scriptorium and the connections of the VSE to contemporary St Albans manuscripts.[40] A summary version of this approach can be found in the magisterial catalogue of English Romanesque manuscripts by C. M. Kauffmann, which, like its counterparts by Elisabeth Klemm and Walter Cahn, contains a synthetic overview, generous pictures, detailed bibliographic information, and a wealth of insights on individual manuscripts.[41]

An increasing emphasis on iconography is seen in studies from the 1970s.[42] Iconography had long been a topic of interest among medieval scholars, represented most forcefully by Emile Mâle, who sought nothing less than a complete decoding of the symbolism of medieval art.[43] Though later generations of scholars have rejected many of Mâle's premises – that there is a unified thought process behind all medieval art, or that one must find contemporary medieval texts upon which to base interpretations of specific objects – the impact of the iconographic method can hardly be underestimated. Although more iconographic analysis has been devoted to Romanesque tympanum sculpture than to manuscript painting, work by Adolf Katzenellenbogen, for example, or Walter Cahn demonstrates the possibilities for understanding illuminations through this interpretive mode.[44]

Beyond Style and Iconography

In the past several decades, such issues as patronage, function, reception, and gender have dominated the field. Studies addressed to these concerns are notable for breaking down disciplinary boundaries and often incorporate more than one interpretive method. Unlike earlier analyses of style or iconography, which sought to assign any given object with a single classification or meaning, studies that embed medieval art in historical and cultural contexts demonstrate that objects can have multiple audiences and meanings that allow for multiple interpretations. Barbara Abou-el-Haj, for example, situated the creation of the VSE in the context of conflict between the Abbey of St Edmunds and both the king and local bishopric over control of the abbey's holdings.[45] According to this reading, the manuscript's pictures, like the ambitious new twelfth-century church building and the renewed interest in the hagiographic literature on St Edmund, were products of the monastery's attempts to assert its rights and promote the authority and power of their saint to fend off royal and episcopal challenges.

Studies of corporate patronage have produced important results especially for Cistercian monasticism. Investigations range from Conrad Rudolph's analysis of a particular book, the famous Cîteaux *Moralia in Job*,[46] to Yolanta Zaluska's

consideration of the entire scriptorium,[47] to Nigel Palmer's investigation of an important Cistercian library.[48] Patronage studies, however, focus most frequently on individuals.[49] Recently, considerations of patronage have often been intertwined with feminist perspectives. The St Albans Psalter is a case in point. Although Christina of Markyate had already been linked to the manuscript by Adolph Goldschmidt in his 1895 *Der Albanipsalter in Hildesheim*, Madeline Caviness has argued that the continued use of the name "St Albans Psalter," as propagated by Pächt et al., marginalizes Christina in modern discourse.[50] Such scholars as Magdalena Carrasco have tried to recover how Christina's ownership of the psalter might have played a role in the pictorial program and function of the book.[51] Most recently, Kristine Haney has denied to Christina any role in the manufacture of the psalter; instead, she combines a traditional study of sources with newer considerations derived from reader-response theory to emphasize how the psalter would have functioned within the "pedagogical, intellectual and devotional practices of the Anglo-Normans."[52] While debate over Christina continues, feminist scholarship can be credited with reintroducing Hildegard of Bingen into the art historical discourse (fig. 17-4).[53]

Feminists have not been the only ones to challenge the inherited paradigms that have guided medieval art history. Michael Camille's study of the historical bifurcation of texts and images in scholarship on the St Albans/Christina of Markyate Psalter demonstrates how disciplinary boundaries have hampered a better understanding of this manuscript.[54] Similarly, Jonathan Alexander has considered the VSE in his critique of an essentialist ethnic view of medieval art that prevailed in earlier art history; his criticism of Pächt's assertion that the Alexis Master had to be a Norman calls into question the often unspoken view of artistic style as genetically determined.[55]

While most studies of the last quarter-century overtly claim to be rectifying some historiographic error, those that make the greatest contributions do so by building on scholarship of the past and keeping the medieval material, not the scholarly discourse, at the center of the argument. Cynthia Hahn, for example, has focused on how the VSE embodied institutional ideas and values not just as a political tool, but as a hagiographic instrument to advance the claim that Edmund was a national saint *par excellence*.[56] In her original article and subsequent book,[57] Hahn gauged the meaning of the manuscript by considering the narrative structure of the pictorial program. The issue of narrative is not a new one; in 1962 Pächt published *The Rise of Pictorial Narrative in Twelfth-Century England*, a work that continues to command scholarly attention.[58] But Hahn masterfully integrated a consideration of how narrative works within a framework that elucidates how illuminated saints' lives functioned as critical components of religious devotion and affective piety. In her reading, manuscripts like the VSE become unparalleled documents for understanding the cultural context of a twelfth-century monastic community and the role its illustrated vitae would have played in the ritual practices of its members.

Figure 17-4 Hildegard of Bingen and Volmer from the "Scivias" ["Know the ways of the Lord"]. Hessisches Landesbibliothek, MS 1, fol. 1r. Photo: Erich Lessing/Art Resource, NY.

Another genre of illustrated book, the bestiary, was especially popular in England. Xenia Muratova has considered these manuscripts not only in terms of style and iconography, but also of text and image and especially of patronage and workshop practice.[59] More recently, Ron Baxter has focused on the structure and use of the manuscripts,[60] while Debra Higgs Strickland has suggested that people in the Middle Ages, particularly in the context of the Crusades, used images of monstrous beasts as a paradigm for constructing negative views of non-Christian "others."[61]

The Romanesque period is noted above all for its Bibles. These were the subject of a full-scale study by Walter Cahn, in which iconography and patronage are considered alongside style, artistic production, and regional affiliation.[62] Richer results are possible, naturally, in monographic treatments of individual Bibles. In their studies of the Floreffe and Gumbertus Bibles, Anne-Marie Bouché and Veronika Pirker-Aurenhammer have demonstrated the deeply learned and intricate programs that could be embedded in eleventh- and twelfth-century manuscripts (fig. 17-5).[63] Their investigations, though based on traditional iconographic analysis, consider didactic programs and narrative strategies to reveal how visual exegesis would have been understood and used by viewers as an exercise in visual theology.

In sum, recent scholarship offers nuanced reconsiderations of old questions and brings new insights to familiar books like Bibles and missals or to newly considered genres like illustrated commentaries or cartularies.[64] Romanesque style is being re-examined to assess how meaning is embedded in form and style and how philosophical and exegetical discourse both inform and are expressed through pictorial means.[65] Re-evaluations of the relationship of Western to Byzantine art explore not only the stylistic connections but also the motivations for artists to appropriate and manipulate Byzantine models.[66] And, of course, scholars continue to offer interpretations of the iconographic or symbolic meaning of individual monuments, themes, and even Romanesque art as a whole.[67]

Looking Forward

In the nineteenth century, the VSE was considered a curiosity and disparaged because of its figural style. Although exhibitions and new reproduction techniques made manuscripts more available for public and scholarly scrutiny, it was some time before the style and meaning of eleventh- and twelfth-century manuscripts began to be appreciated and understood on their own terms. Exhibitions involving Romanesque art were and continue to be products of national or local interests. Although there has been a notable shift from concerns with style[68] to those of production and function in such exhibitions,[69] it seems that Romanesque exhibitions are once again in disfavor compared with early Christian, Byzantine, early medieval, and Gothic art, all of which have been the subject of

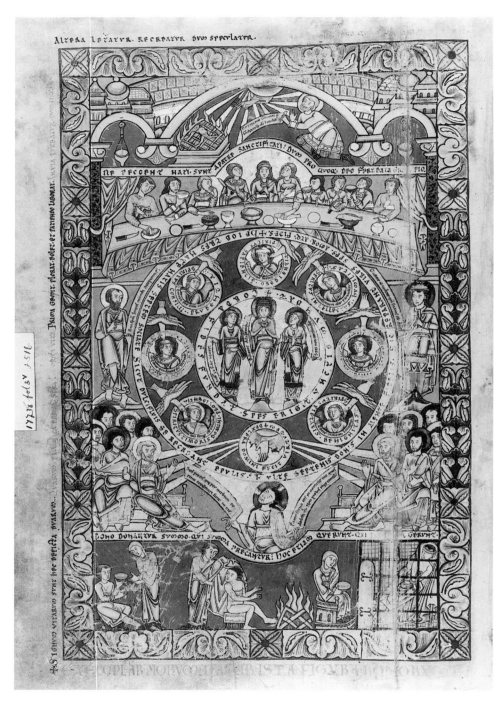

FIGURE 17-5 Personification of the Virtues and Works of Mercy, from the Floreffe Bible. London: British Library, Add. MS 17738, fol. 3v. Reproduced by permission of the British Library.

important international exhibitions in the last several years. On the other hand, such technologies as computers and the World Wide Web are making medieval manuscripts increasingly available on a global scale. As part of a research project on St Edmund, the Richard Rawlinson Center for Anglo-Saxon Studies and Manuscript Research at Western Michigan University has made available 18 color images from the VSE website.[70] Even more impressive is the virtual facsimile of the St Albans Psalter produced by the University of Aberdeen, with page-by-page transcriptions and essays by noted scholars that provide an updated version of the original Pächt, Wormald, and Dodwell volume.[71]

As the Aberdeen site demonstrates, new technology is especially welcome for the ease with which it can bring together scholars from different disciplines. Some of the most important work on the VSE and other English illuminated manuscripts, for example, has been by Rodney Thomson, who is not an art historian.[72] Similarly, Mary Carruthers's intellectual history of medieval memory provides an important perspective for understanding Romanesque manuscripts,[73] and scholarship dealing with such media as textiles and sculpture can potentially cast light on the style and function of manuscript illumination.[74]

Inevitably, scholars will continue to critique the modern reception and interpretation of Romanesque manuscripts and to integrate these objects into broader understandings of medieval art. *Manuscript Illumination in the Modern Age* by Hindman et al., for example, fundamentally alters our view of the modern status of the medieval manuscript, although its focus on England and France perpetuates a longstanding emphasis on those countries; attention to Germany, for example, would have revealed that perhaps the very first modern manuscript facsimiles were produced in Bamberg before 1738.[75] Future scholarship will certainly have to direct more attention not only to German material, but also to eastern European works that have received scant attention in Western literature.

Despite the conceptual expansion of art historical literature in the past 30 years, questions of terminology and definition remain as vexing as they were two centuries ago. Throughout the nineteenth century, authors were slow to apply the architectural and sculptural term "Romanesque" to manuscripts, but by the end of the twentieth the concept had become fixed in the survey books. In the 2001 edition of H. W. and Anthony Janson's *History of Art*, manuscript illumination takes a back seat to architecture and sculpture and fits uneasily into the book's overall definition of Romanesque.[76] But the pendulum may be swinging: in *Medieval Art*, Veronica Sekules abjured "Romanesque" and "Gothic" for art between the eleventh and fifteenth centuries. With regard to manuscript illumination, I would argue that "Romanesque" is meaningless and that no single term adequately conveys the richness and complexity of this material. A twenty-first-century scholar may yet devise better nomenclature, but until then it would be wise to combine nineteenth-century chronological terms with the more sophisticated intellectual constructs of the late twentieth-century.

Notes

1 For a complete description of the manuscript's textual and pictorial contents, see the catalogue pages on the Corsair Online Research Resource <http://corsair.morganlibrary.org/>. [For more on the Vita Sancti Eadmundi, see chapter 4 by Lewis in this volume (ed.).]

2 *Bibliotheca Towneliana. A Catalogue of the Library of the Late John Towneley, Esq.*, Pt. 1 (London, 1814), lot 904.

3 *The bibliographical decameron*, esp. p. lxxx for the Life of St Edmund. On Dibdin, see Hindman et al., *Manuscript Illumination*, pp. 25–6, 38–44.

4 *Treasures of Art in Great Britain*, vol. 2, esp. pp. 215–16 (Letter XVII).

5 For the nineteenth-century reception of medieval manuscripts, see Hindman et al., *Manuscript Illumination*, which expands considerably on an earlier exhibition and catalogue by Alice Beckwith (*Victorian Bibliomania*).

6 On the works of J. O. Westwood and Henry Noel Humphreys, see Hindman et al., *Manuscript Illumination*, pp. 123–5, 165–9.

7 *Histoire de l'Art*, esp. vol. 2, p. 47. This work originally was issued in 24 parts between 1810 and 1823.

8 D'Estang, *Peintures et ornements*. On d'Estang's ambitious project, see Hindman et al., *Manuscript Illumination*, pp. 129–32. For French efforts to catalogue national holdings, see Cahn, *Romanesque Manuscripts*, vol. 1, pp. 29–32.

9 Tina Waldeier Bizzarro, *Romanesque Architectural Criticism*, esp. pp. 132–49.

10 This was a popular abridgement (running to seven editions and two English translations) of Lacroix, ed., *Le Moyen-âge et renaissance*, with chapters by noted scholars, including two on manuscripts by, respectively, Jacques-Joseph Champollion-Figeac and his son Aimé-Louis, both of the Bibliothèque nationale.

11 [On Romanesque sculpture and architecture, see chapters 14, 15, and 16 by Fernie, Hourihane, and Maxwell, respectively, in this volume (ed.).]

12 Rowan Watson, in Hindman et al., *Manuscript Illumination*, pp. 188–92.

13 *Memorials of St. Edmund's Abbey*, esp. pp. xxxvi–xxxix.

14 See Thompson et al., eds., *Facsimiles of Ancient Manuscripts*, esp. p. 19.

15 [On Gothic manuscript illumination, see chapter 20 by Hedeman in this volume (ed.).]

16 Lecoy de la Marche, *Manuscrits*, pp. 162–3.

17 For an appreciation of this essay, see Cahn, *Romanesque Manuscripts*, vol. 1, p. 31.

18 Baum, *Malerei und Plastik*.

19 The citation, on p. 125, is to Dehio and von Bezold, *Die kirchliche Baukunst*, p. 147. On the VSE, see p. 228.

20 The term "watershed" is used by Hindman et al., *Manuscript Illumination*, p. 210.

21 *Exhibition of Illuminated Manuscripts*, pp. x–xi.

22 Review in *Burlington Magazine* 13 (Apr.–Sep. 1908), pp. 128–9. Fry was referring specifically to the Winchester Bible.

23 See Caviness, "Erweiterung."

24 Lauer, *Les Enluminures romanes*.

25 Morey, *Exhibition of Illuminated Manuscripts*, p. x.

26 Boeckler built to some degree on the work of Millar, *English Illuminated Manuscripts*, esp. pp. 28–30.

27 *Abendländische Miniaturen*, 90.

28 As late as 1967, David Diringer (*The Illuminated Book*, p. 255), could quote verbatim an assessment from a half-century earlier (Herbert, *Illuminated Manuscripts*, p. 135).

29 Oakeshott, *Artists*; *Sigena*; *Two Winchester Bibles*. See also Ayres, "The Work of the Morgan Master," and Donovan, *The Winchester Bible*.

30 See, e.g., Dodwell, *The Pictorial Arts*, p. 373.

31 See especially Demus, *Byzantine Art*, and Kitzinger, "The Byzantine Contribution."

32 Pächt et al., *The St. Albans Psalter*. Comparable collaborative efforts on Romanesque manuscripts include Green, ed., *Hortus Deliciarum*, and Gibson et al., eds., *The Eadwine Psalter*.

33 The classic statement was the influential work of Foçillon (*Art d'Occident*) translated as *The Art of the West in the Middle Ages*.

34 Countless twentieth-century overviews admitted the difficulty of defining termini for the Romanesque period. See, for example, Zarnecki, *Romanesque*.

35 Turner, *Romanesque Illuminated Manuscripts*, pp. 7, 25.

36 Grabar and Nordenfalk, *Romanesque Painting*, pp. 133–206.

37 Ibid., p. 186.

38 Wormald, "Some Illustrated Manuscripts," esp. pp. 251–2 and 261 for the VSE.

39 Gaborit-Chopin, *Le Décoration*, is representative.

40 McLachlan, *Scriptorium*, an unrevised version of her 1965 dissertation with a "Bibliographic Supplement: Relevant Scholarship since 1965." See also Bateman, "Pembroke 120 and Morgan 736."

41 Kauffmann, *Romanesque Manuscripts*, esp. pp. 72–4 for the VSE; this was updated in part by Kauffmann's historiographic review, "English Romanesque Book Illumination." For German manuscripts, see Klemm, *Romanischen Handschriften*. For France, see Cahn, *Romanesque Manuscripts*.

42 See, for example, Klemm, *Romanischer Miniaturenzyklus*; Haney, *The Winchester Psalter* (based on her 1978 dissertation).

43 Mâle, *L'Art religieux du XIIe siècle*.

44 Katzenellenbogen, *Allegories*. Many of Cahn's essays, originally published between 1964 and 1994, are gathered in his *Studies in Medieval Art*, with postscripts for each article.

45 Abou-el-Haj, "Bury St Edmunds Abbey." Another excellent analysis of institutional conflict and manuscript production is Carrasco, "Spirituality in Context."

46 Rudolph, *Violence and Daily Life*.

47 Zaluska, *L'Enluminure*.

48 Palmer, *Zisterzienser*.

49 E.g., Kauffmann, "British Library MS Lansdowne 383."

50 Caviness, "Anchoress, Abbess." Pächt et al., *St. Albans Psalter*, pp. 135–44, explained the inclusion of the Alexis legend in the psalter with reference to events in Christina's life, but historical contextualization played only a minor role in his work. [For more on Christina of Markyate, see chapters 6 and 9 by Kurmann-Schwarz and Caskey, respectively, in this volume (ed.).]

51 Carrasco, "Imagery of the Magdalen." See also Nilgen, "Psalter."

52 Haney, *The St. Albans Psalter*. This rich work focuses on the psalter's initials and also provides a historiographic review of the manuscript and medieval psalter illustration.

53 See the remarks by Madeline Caviness, in "Artist," on the historiographic reasons for Hildegard's previous exclusion from the art-historical canon. There is now a cottage industry on Hildegard: see, e.g., Saurma-Jeltsch, *Die Miniaturen*, and Suzuki, *Bildgewordene Visionen*. [For more on the feminist view of Hildegard of Bingen, see chapter 6 by Kurmann-Schwarz in this volume (ed.).]

54 Camille, "Philological Iconoclasm."

55 Alexander, "Medieval Art."

56 Hahn, "Peregrinatio et Natio."

57 Hahn, *Portrayed on the Heart.*

58 [On narrative, see chapter 4 by Lewis in this volume (ed.).]

59 See, among others, Muratova, "Les Manuscrits-frères."

60 Baxter, *Bestiaries and their Users.* The first chapter includes a useful historiographic review of bestiaries and the *Physiologus.*

61 Strickland, *Saracens.* [On the monstrous, see chapter 12 by Dale in this volume (ed.).]

62 Cahn, *Romanesque Bible Illumination.* [On patronage, see chapter 9 by Caskey in this volume (ed.).]

63 Bouché, "*Vox Imaginis*"; Pirker-Aurenhammer, *Die Gumbertusbibel.*

64 See, fundamentally, Camille, "Seeing and Reading." On individual books, see Reilly, "Picturing the Monastic Drama"; Teviotdale, "The Pictorial Program"; Sears, "Portraits in Counterpoint"; Maxwell, "Sealing Signs," a most original and provocative essay.

65 See the essays by Caviness, "Images of Divine Order," and "The Simple Perception." [On formalism, see chapter 5 by Seidel in this volume (ed.).]

66 Klein, "The So-called Byzantine Diptych"; Nilgen, "Byzantinismen."

67 Heslop, "Brief in Words"; Klein, "Les Apocalypses"; Petzold, "Significance of Colours"; Wirth, *L'Image.*

68 E.g., Porcher, *French Miniatures.*

69 E.g., Zarnecki et al., eds., *English Romanesque Art*; Legner, ed., *Ornamenta ecclesiae.* [On the modern medieval museum, see chapter 30 by Brown in this volume (ed.).]

70 <http://www.wmich.edu/medieval/research/rawl/edmund/>.

71 <http://www.abdn.ac.uk/stalbanspsalter/index.shtml>.

72 See, among others, Thomson, "Early Romanesque," and *The Bury Bible.*

73 Carruthers, *Book of Memory; Craft of Thought.*

74 Such studies have been done for the Gothic period, but not the Romanesque: Oliver, "Worship of the Word," and the works of Jeffrey Hamburger; see his essays collected in *The Visual and the Visionary.*

75 These were made by Johann Graff, subcustodian of the Bamberg Cathedral from 1722 until 1749. For his manuscript copies, see Baumgärtel-Fleischmann, ed., *Ein Leben*, esp. pp. 166–79. I thank Dr Bernhard Schemmel, Director of the Staatsbibliothek Bamberg, for this reference.

76 See also Mazal, *Buchkunst der Romanik*; Kauffmann, "Romanesque."

Bibliography

Barbara Abou-el-Haj, "Bury St Edmunds Abbey between 1070 and 1124: A History of Property, Privilege, and Monastic Art Production," *Art History* 6 (1983), pp. 1–29.

Jonathan Alexander, "Medieval Art and Modern Nationalism," in G. R. Owen-Crocker and T. Graham, eds., *Medieval Art: Recent Perspectives. A Memorial Tribute to C.R. Dodwell* (Manchester, 1998), pp. 206–23.

Thomas Arnold, *Memorials of St. Edmund's Abbey* (Rolls Series), vol. 3 (London, 1897).

Larry Ayres, "The Work of the Morgan Master at Winchester and English Painting of the Early Gothic Period," *Art Bulletin* 56 (1974), pp. 201–23.

Jean-François-Auguste Bastard d'Estang, *Peintures et ornements des manuscrits classés dans un ordre chronologique pour servir à l'histoire des arts du dessin depuis le quatrième siècle de l'ère chrétienne jusqu'à la fin du seizième; manuscrits, français* (Paris, 1837–46).

Katherine Bateman, "Pembroke 120 and Morgan 736: A Reexamination of the St. Albans Bury St. Edmunds Dilemma," *Gesta* 17 (1978), pp. 19–26.

Julius Baum, *Die Malerei und Plastik des Mittelalters II: Deutschland, Frankreich und Britannien* (Wildpark-Potsdam, 1930).

Renate Baumgärtel-Fleischmann, ed., *Ein Leben für den Bamberger Dom. Das Wirken des Subkustos Graff (1682–1749)* (Bamberg, 1999).

Ron Baxter, *Bestiaries and their Users in the Middle Ages* (Stroud, Gloucestershire, 1998).

Alice Beckwith, *Victorian Bibliomania* (Providence, 1987).

Tina Waldeier Bizzarro, *Romanesque Architectural Criticism: A Prehistory* (Cambridge, 1992).

Albert Boeckler, *Abendländische Miniaturen bis zum Ausgang der Romanischen Zeit* (Berlin and Leipzig, 1930).

Anne-Marie Bouché, "*Vox Imaginis*: Anomaly and Enigma in Romanesque Art," in Jeffrey Hamburger and Anne-Marie Bouché, eds., *The Mind's Eye: Art and Theological Argument in the Middle Ages* (Princeton, 2005), pp. 306–35.

Walter Cahn, *Romanesque Manuscripts: the Twelfth Century*, 2 vols. (London, 1996).

——, *Romanesque Bible Illumination* (Ithaca, NY, 1982).

——, *Studies in Medieval Art and Interpretation* (London, 2000).

Michael Camille, "Philological Iconoclasm: Edition and Image in the Vie-de-Saint-Alexis," in R. H. Bloch and S. Nichols, eds., *Medievalism and the Modernist Temper* (Baltimore, 1996).

——, "Seeing and Reading: Some Visual Implications of Medieval Literacy and Illiteracy," *Art History* 8 (1985), pp. 26–49.

Magdalena Carrasco, "The Imagery of the Magdalen in Christina of Markyate's Psalter (St. Albans Psalter)," *Gesta* 38 (1999), pp. 67–80.

——, "Spirituality in Context: The Romanesque Illustrated Life of St. Radegund of Poitiers (Poitiers, Bibl. Mun., MS 250)," *Art Bulletin* 72 (1990), 414–35.

Mary Carruthers, *The Book of Memory: A Study of Memory in Medieval Culture* (Cambridge, 1990).

——, *The Craft of Thought: Meditation, Rhetoric, and the Making of Images, 400–1200* (Cambridge, 1998).

Madeline Caviness, "Anchoress, Abbess, and Queen: Donors and Patrons or Intercessors and Matrons?" in June H. McCash, ed., *The Cultural Patronage of Medieval Women* (Athens, Ga., 1996), pp. 105–54.

——, "Artist: 'To See, Hear, and Know All At Once,'" in Barbara Newman, ed., *Voice of the Living Light: Hildegard of Bingen and her World* (Berkeley, 1998).

——, "Erweiterung des 'Kunst'-Begriffs. Die Rezeption mittelalterlicher Werke im Kontext nachimpressionistischer Strömungen," *Österreichische Zeitschrift für Kunst und Denkmalpflege* 49 (1986) (Festschrift Eva Frodl Kraft), pp. 204–15.

——, "Images of Divine Order and the Third Mode of Seeing," *Gesta* 22 (1983), pp. 99–120.

——, "The Simple Perception of Matter in Representations *ca.*1180–1280: Narrative Mode or Gothic Style?" *Gesta* 30 (1991), pp. 48–64.

Sydney Cockerell, *Exhibition of Illuminated Manuscripts*, Burlington Fine Arts Club (London, 1908).

Georg Dehio and Gustav von Bezold, *Die kirchliche Baukunst des Abendlandes*, vol. 1 (Stuttgart, 1892).

Otto Demus, *Byzantine Art and the West* (New York, 1970).

Thomas Frognall Dibdin, *The bibliographical decameron, or, Ten days pleasant discourse upon illuminated manuscripts, and subjects connected with early engraving, typography, and bibliography*, 3 vols. (London, 1817).

David Diringer, *The Illuminated Book: Its History and Production*, new edn. revised and augmented by R. Regensburger (London, 1967).

C. R. Dodwell, *The Pictorial Arts of the West 800–1200*, 2nd edn. (New Haven and London, 1993).

Claire Donovan, *The Winchester Bible* (Toronto and Buffalo, 1993).

Henri Foçillon, *Art d'Occident: le moyen âge, roman et gothique* (Paris, 1938); trans. as *The Art of the West in the Middle Ages*, ed. and intro. J. Bony (London, 1963; repr. Ithaca, NY, 1980).

Danielle Gaborit-Chopin, *Le Décoration des manuscrits à S. Martial de Limoges et en Limousin du 9e au 12e siècle* (Paris, 1969).

Margaret Gibson, T. A. Heslop, and Richard Pfaff, eds., *The Eadwine Psalter: Text, Image, and Monastic Culture in Twelfth-Century Canterbury* (London and University Park, Pa., 1992).

Adolph Goldschmidt, *Der Albanipsalter in Hildesheim* (Munich, 1895).

André Grabar and Carl Nordenfalk, *Romanesque Painting from the Eleventh to the Thirteenth Centuries* (Geneva, 1958).

Rosalie Green, ed., *Hortus Deliciarum*, 2 vols. (London, 1979).

Cynthia Hahn, "Peregrinatio et Natio: the Illustrated Life of Edmund, King and Martyr," *Gesta* 30 (1991), pp. 119–39.

——, *Portrayed on the Heart: Narrative Effect in Pictorial Lives of Saints from the Tenth through the Thirteenth Century* (Berkeley, 2001).

Jeffrey Hamburger, *The Visual and the Visionary: Art and Female Spirituality in Late Medieval Germany* (New York, 1998).

Kristine Haney, *The St. Albans Psalter: An Anglo-Norman Song of Faith* (New York, 2002).

——, *The Winchester Psalter: An Iconographic Study* (Leicester, 1986).

John A. Herbert, *Illuminated Manuscripts* (London, 1911).

T. A. Heslop, "'Brief in Words but Heavy in the Weight of its Mysteries,'" *Art History* 9 (1986), pp. 1–11.

Sandra Hindman, Michael Camille, Nina Rowe, and Rowan Watson, *Manuscript Illumination in the Modern Age: Recovery and Reconstruction* (Chicago, 2001).

H. W. and Anthony Janson, *History of Art* (2001).

Adolf Katzenellenbogen, *Allegories of the Virtues and Vices in Medieval Art* (London, 1939; repr. Toronto, 1989).

C. M. Kauffmann, "British Library MS Lansdowne 383: the Shaftesbury Psalter?" in Paul Binski and William Noel, eds., *New Offerings, Ancient Treasures: Studies in Medieval Art for George Henderson* (Stroud, Gloucestershire, 2001), pp. 256–79.

——, "English Romanesque Book Illumination: Changes in the Field 1974–1984," in S. Macready and F. H. Thomson, eds., *Art and Patronage in the English Romanesque* (London, 1986), pp. 61–70.

——, "Romanesque, IV, 2: Manuscript Painting," in Jane Turner, ed., *The Grove Dictionary of Art* (New York, 1996), vol. 26, pp. 658–79.

——, *Romanesque Manuscripts 1066–1190* (London, 1975).

Ernst Kitzinger, "The Byzantine Contribution to Western Art of the Twelfth and Thirteenth Centuries," *Dumbarton Oaks Papers* 20 (1966), pp. 25–47; repr., with a postscript, in W. E. Kleinbauer, ed., *The Art of Byzantium and the Medieval West: Selected Studies by Ernst Kitzinger* (Bloomington, 1976), pp. 358–78, 395.

Holger Klein, "The So-called Byzantine Diptych in the Winchester Psalter, British Library, MS Cotton Nero C. IV," *Gesta* 37 (1998), pp. 26–43.

Peter Klein, "Les Apocalypses romanes et la tradition exégétique," *Les Cahiers de Saint-Michel de Cuxa* 12 (1981), pp. 123–40.

Elisabeth Klemm, *Die Romanischen Handschriften der Bayerischen Staatsbibliothek*, 4 vols. (Wiesbaden, 1980–8).

——, *Ein romanischer Miniaturenzyklus aus dem Maasgebiet* (Vienna, 1973).

Paul Lacroix, *Les Arts au moyen age et à l'époque de la Renaissance* (3rd edn., 1871).

——, ed., *Le Moyen-âge et renaissance, histoire et description des moeurs et usages, du commerce et de l'industrie, des sciences, des arts, des littératures et des beaux-arts en Europe*, ed. P. Lacroix, 5 vols. (Paris, 1848–51).

Philippe Lauer, *Les Enluminures romanes des manuscrits de la Bibliothèque nationale* (Paris, 1927).

Albert Lecoy de la Marche, *Les Manuscrits et la miniature* (Paris, 1885).

Anton Legner, ed., *Ornamenta ecclesiae: Kunst und Künstler der Romanik*, 3 vols. (Cologne, 1985).

Elizabeth Parker McLachlan, *The Scriptorium of Bury St. Edmunds in the Twelfth Century* (New York, 1986).

Emile Mâle, *L'Art religieux du XIIe siècle en France. Etude sur l'origine de l'iconographie du Moyen Age* (Paris, 1922); trans. as *Religious Art in France: the Twelfth Century; A Study of the Origins of Medieval Iconography* (Princeton, 1978).

Robert Maxwell, "Sealing Signs and the Art of Transcribing in the Vierzon Cartulary," *Art Bulletin* 81 (1999), pp. 576–97.

Otto Mazal, *Buchkunst der Romanik* (Graz, 1978).

André Michel, *Histoire de l'art*, vol. I (Paris, 1905).

Eric Millar, *English Illuminated Manuscripts from the Xth to XIII Century* (Paris, 1926).

Charles Rufus Morey, *Exhibition of Illuminated Manuscripts Held at the New York Public Library*, The Pierpont Morgan Library (New York, 1934).

Xenia Muratova "Les Manuscrits-frères: un aspect particulier de la production des Bestiaires enluminés en Angleterre à la fin du XIIe siècle," in Xavier Barral i Altet, ed., *Artistes, artisans et production artistique au moyen age: colloque international*, 3 vols. (Paris, 1986), vol. 3, pp. 69–92.

Ursula Nilgen, "Byzantinismen im westlichen Hochmittelalter. Das 'Byzantinische Diptychon' im Winchester-Psalter," in *Lithostroton: Studien zur byzantinischen Kunst und Geschichte: Festschrift für Marcell Restle* (Stuttgart, 2000), pp. 173–90.

——, "Psalter der Christina von Markyate (sogennanter Albani-Psalter)," in *Der Schatz von St. Godehard Hildesheim* (Hildesheim, 1988), pp. 152–65.

Walter Oakeshott, *The Artists of the Winchester Bible* (London, 1945).

——, *Sigena: Romanesque Paintings in Spain and the Winchester Bible Artists* (London, 1972).

——, *The Two Winchester Bibles* (Oxford, 1981).

Judith Oliver, "Worship of the Word: Some Gothic Nonnenbücher in their Devotional Context," in Jane Taylor and Lesley Smith, eds., *Women and the Book: Assessing the Visual Evidence* (London and Toronto, 1997), pp. 106–22.

Otto Pächt, *The Rise of Pictorial Narrative in Twelfth-Century England* (Oxford, 1962).

Otto Pächt, C. R. Dodwell, and Francis Wormald, *The St. Albans Psalter (Albani Psalter)* (London, 1960).

Nigel Palmer, *Zisterzienser und ihre Bücher: die mittelalterliche Bibliotheksgeschichte von Kloster Eberbach im Rheingau unter besonderer Berücksichtigung der in Oxford und London aufbewahrten Handschriften* (Regensburg, 1998).

Andreas Petzold, "'Of the Significance of Colours': The Iconography of Color in Romanesque and Early Gothic Book Illumination," in Colum Hourihane, ed., *Image and Belief: Studies in Celebration of the Eightieth Anniversary of the Index of Christian Art* (Princeton, 1999), pp. 125–34.

Veronika Pirker-Aurenhammer, *Die Gumbertusbibel: Codex 1 der Universitätsbibliothek Erlangen: ein Regensburger Bildprogramm des späten 12. Jahrhunderts* (Regensburg, 1998).

Jean Porcher, *French Miniatures from Illuminated Manuscripts* (London, 1960).

Diane Reilly, "Picturing the Monastic Drama: Romanesque Bible Illustrations of the Song of Songs," *Word + Image* 17 (2001), pp. 389–400.

Conrad Rudolph, *Violence and Daily Life: Reading, Art, and Polemics in the Cîteaux Moralia in Job* (Princeton, 1997).

Lieselotte Saurma-Jeltsch, *Die Miniaturen im "Liber Scivias" der Hildegard von Bingen: Die Wucht der Vision und die Ordnung der Bilder* (Wiesbaden, 1998).

Elizabeth Sears, "Portraits in Counterpoint: Jerome and Jeremiah in an Augsburg Manuscript," in E. Sears and Thelma Thomas, eds., *Reading Medieval Images: The Art Historian and the Object* (Ann Arbor, 2002), pp. 61–74.

Veronica Sekules, *Medieval Art* (Oxford, 2001).

Jean-Baptiste-Louis-George Seroux d'Agincourt, *Histoire de l'Art par les monumens depuis sa décadence au IVe siècle jusqu'à son renouvellement au XVIe*, 6 vols. (Paris, 1823).

Henry Shaw, *Illuminated Ornaments: Selected from Manuscripts and Early Printed Books from the Sixth to the Seventeenth Centuries* (London, 1833).

Debra Higgs Strickland, *Saracens, Demons, and Jews: Making Monsters in Medieval Art* (Princeton, 2003).

Keiko Suzuki, *Bildgewordene Visionen oder Visionserzählungen: Vergleichende Studien über die Visionsdarstellungen in der Rupertsberger "Scivias"-Handschrift und im Luccheser "Liber divinorum operum"-Codex der Hildegard von Bingen* (Bern, 1998).

Elizabeth Teviotdale, "The Pictorial Program of the Stammheim Missal," in Colum Hourihane, ed., *Objects, Images, and the Word: Art in the Service of the Liturgy* (Princeton, 2003), pp. 79–93.

Edward Maunde Thompson et al., eds., *Facsimiles of Ancient Manuscripts, etc.*, ser. 1, 2 vols. (London, 1903–12).

Rodney Thomson, "Early Romanesque Book Illustration in England. The Dates of the Pierpont Morgan 'Vitae Sancti Edmundi' and the Bury Bible," *Viator* 2 (1971), pp. 211–25.

——, *The Bury Bible* (Woodbridge, Suffolk, 2001).

D. H. Turner, *Romanesque Illuminated Manuscripts in the British Museum* (London, 1966; repr. 1971).

Gustav Waagen, *Treasures of Art in Great Britain. Being an Account of the Chief Collections of Paintings, Drawings, Sculptures, Illuminated mss., &c. &c.*, 3 vols. (London, 1854).

Jean Wirth, *L'Image à l'époque romane* (Paris, 1999).

Francis Wormald "Some Illustrated Manuscripts of Lives of the Saints," *Bulletin of the John Rylands Library* 35 (1952), pp. 248–68.

Yolanta Zaluska, *L'Enluminure et le scriptorium de Cîteaux au XIIe siècle* (Cîteaux, 1989).

George Zarnecki, *Romanesque* (New York, 1971; repr. 1989).

George Zarnecki et al., eds., *English Romanesque Art 1066–1200* (London, 1984).

18

The Study of Gothic Architecture

Stephen Murray

What is Gothic?

The understanding of "Gothic" architecture involves the assessment of *product* and *process.* The first approach, systematized over the past two centuries, applies a checklist of required features including the pointed arch, lightweight ribbed vault, highly developed buttressing (perhaps including flyers), and structure based upon a skeleton of cut stone (ashlar) rather than the massive rubble walls of earlier "Romanesque."[1] This combination produces a light-filled and spacious interior and jagged exterior massing. The story of Gothic, told in traditional terms, recounts the mid-twelfth-century assembly of these features to create a radically new structural *system* in and around the Ile-de-France, the perfection of that system *c.*1200, its "triumph" and "spread" to England, Germany, Spain, and Italy, its transformation over time, and its demise *c.*1500.

The second approach (*process*) – manifestly more attractive to modern audiences – focuses upon the cultural framework of architectural production, correlating economic transformations, new agrarian methods, industry, commerce and the growth of towns, technology and rationalized production, the newly expanded mission of the Church and new forms of liturgical and devotional practice, the increasing power of the French monarchy, and supra-regional interactions that led to intense interest in a common set of forms that might be appropriated and exploited to meet a wide range of regional needs. Process meets product, of course, in our own experiential response to the building itself.

The challenge is to deal with the full range of cultural variations that accompanied construction while at the same time recognizing and accounting for the power of that unmistakable Gothic "look."

Problems and Resources

The principal resource for the study of Gothic architecture lies in the buildings themselves. More than *metonymy* where the *idea* of the Middle Ages can be conveyed by a building or a group of buildings, the edifice provides direct physical access to the spaces, and contact with the material substance of the past. Buildings, moreover, may possess the power to *affect* us: not just through the miracle of survival and the "message" that might be found "encoded" in their spaces and forms, but also because the artifice of builders who may have endowed the edifice with the power to move us to a sense of the beautiful or sublime. Our first problem is reconciling our experiential responses with the task of dealing with buildings as entities that can go beyond the written document in providing vital access to the past.

The student must form a direct and personal relationship with the raw material of his study, the buildings themselves, visiting as many as possible and developing a systematic way of looking, understanding, documenting, and *interpreting* what he sees. These abilities cannot be learned entirely in the classroom or from a book; they are acquired through an extended dialectic between the buildings, the written sources, and interactions with the *community of scholars*: between the active and the contemplative lives. Work must, of course, begin with an evaluation of the extent to which our buildings have been transformed physically, existing now in a context (urban and cultural) that may have little to do with the situation in which they were created.

"Interpretation" brings the assessment of the relationship between the monument and similar contemporaneous edifices ("style") as well as the search for an understanding of that building in relation to the physical and cultural circumstances that attended its construction and use ("context"). Unable to visit countless edifices, the student quickly becomes dependent upon various kinds of *representation*. First, are images of buildings made using mechanical means. Slides and photographs have long been accepted – sometimes thoughtlessly – as surrogates for the building.[2] And then there are graphic images made manually – plans, sections, axonometric renderings, and, from an earlier age, lithographs, engravings, paintings and sketches.[3]

"Representation," of course, brings not only images, but also the *secondary sources* written by post-medieval (art) historians. As far as the *story* of Gothic is concerned, the pages of the book impose a linear structure upon the phenomenon with two-dimensional linkages between buildings that are three dimensional, creating deceptive order out of ambiguity and complexity. An impressive array of recently published works combine ever-more spectacular photographic reproductions with texts that provide a predictable set of permutations around themes of "development" and "context."[4]

Then, the student must become a historian of medieval life, addressing problems of function, the role of the patron, the artisan, sources of revenue, mechanics of construction, the dynamic political, economic and religious

contexts, and what the building might have meant to medieval builder and user.[5] This leads to *primary written sources* from the time of construction, scattered in countless libraries and archives – including great centralized collections (for example, the Public Records Office or the British Library in London, or in Paris the Bibliothèque nationale or Archives nationales) – and also local collections: for example, the French Archives départementales. First consult published anthologies such as Mortet and Deschamps, Frisch, Panofsky, and Frankl.[6] The student may then proceed to the inventories of the archive(s) that pertain(s) to the object of his study.

Primary written sources are narrative or non-narrative. The *narrative* source provides a contemporary account of construction: for example, Gervase of Canterbury's story of the reconstruction of the cathedral choir,[7] or Abbot Suger's writings on St Denis.[8] The *non-narrative* source results from the process of construction: building accounts, contracts, chapter deliberations, and legal documents. Works that depend heavily upon such sources include Colvin, Ackerman, Panofsky, Murray, and Erskine.[9] Of particular importance are building (or fabric) accounts, fiscal documents left by the day-to-day record-keeping for Gothic construction. The earliest such accounts belong to the mid-thirteenth century: the prolific material of the fourteenth and fifteenth centuries provides enormous amounts of information about sources of revenue, as well as expenses for artisans and materials.

From the written sources we learn that medieval people might be perfectly aware of the visual differences between "Romanesque" and "Gothic" "styles." Descriptive epithets for the phenomenon will, of necessity, refer to time (newness) and place. Thus, Gervase of Canterbury provided a systematic comparison between the old cathedral choir and new edifice built after the 1174 fire. By the later thirteenth century we find an epithet that embodies the idea of place and cultural identity: the German chronicler, Burkhard von Hall (d.1300) described the new construction at Wimpfen-in-Tal as "French Work."[10]

Graphic sources begin in the first part of the thirteenth century with the famous album or "portfolio" of drawings left by Villard de Honnecourt and his followers.[11] By the end of the thirteenth century such plans and drawings become more common; German Late Gothic generated huge amounts of material.[12]

While we have differentiated three avenues – work on the building, relating that building to others, and locating it within a range of contexts, meanings, and functions – the student will probably undertake all tasks simultaneously. In finding various kinds of working method and synthesizing framework, the student will place himself within the history of *interpretation* or historiography.

Historiography

How did "Gothic" get its name? The earliest applications of the epithet to Northern architecture were associated with disapproval fostered in the decades

around 1500 by Italian humanists for whom "Germanic" or "Gothic" was synonymous with rustic, or barbaric.[13] Raphael, in a letter of 1519, derided a form of architecture said to have resulted from the tying together of the branches of forest trees to create forms akin to pointed arches, yet conceded that such architecture could not be altogether bad, as derived from Nature, the only legitimate inspiration for all art.

Students might be troubled by the apparent absurdity of naming an architectural phenomenon of the twelfth and later centuries after fifth-century Germanic invaders of the Roman Empire – the Goths who fostered no tradition in stone architecture. Yet despite attempts to find an alternative ("Saracenic," "Ogival," "Pointed"), "Gothic" has stuck. Indeed, with its power to collapse time and to link form with alleged ethnic roots and function, this is a most powerful and appropriate epithet. The elements of the classical orders embodied in the first mid-twelfth-century "Gothic" buildings pointed emphatically to the past – the Late Roman Empire and Gothic migrations that had seen the first establishment of the Northern Church through the agency of the saints. And there is a distinct possibility that ideas concerning natural origins (the forest) were deliberately nurtured by the patrons and builders of Late Gothic churches in Germany and possibly elsewhere.[14]

One is led to expect an "end" to Gothic in the early sixteenth century, followed by a period of negative reaction, then revival in the late eighteenth to nineteenth centuries.[15] Yet the Northern skyline was still dominated by the churches and cathedrals of the earlier age. And by the seventeenth century local antiquarians began to unravel the history of the monuments that formed local identity – the writing of the history of Gothic architecture had begun.[16]

A series of interlocking concerns led people to look at Gothic architecture with new vision.

Romanticism in literature

Expressions of appreciation of Gothic were rendered eloquent by (for example) Johann Wolfgang von Goethe (1749–1832) and Johann Gottfried von Herder (1744–1803).[17] Gothic was viewed as a personal affective experience as well as the expression of cultural or national identity (German, English, French, etc.).

The French Revolution lent additional poignancy to the romantic yearning for the past. François René Chateaubriand (1768–1848) expressed it most beautifully:

> One could not enter a Gothic church without a kind of shudder and a vague consciousness of God. One would find oneself suddenly carried back to the times when cloistered monks, after they had meditated in the forests of their monasteries, cast themselves down before the altar and praised the Lord in the calm and silence of the night.[18]

Scientific approaches

These sought to identify the internal logic (*system*) of a building and to locate it within a class or "type," matching parallel methods in the natural sciences. Classification was only possible when large numbers of edifices had been "collected" as specimens – visited, studied and published. John Britton (1771– 1857) pioneered the mass production of cheaply produced engravings.[19] The similar enterprise for French monuments came a little later with the *Voyages pittoresques*.[20] Thomas Rickman (1776–1841) provided the equipment necessary to classify the hundreds of monuments that were now becoming available in published form based upon the establishment of "styles" with common characteristics that could be fixed chronologically.[21]

By the early nineteenth century it was realized that Gothic should be assessed as an organic *system* responding to functional, aesthetic, and structural requirements. The breakthrough to the critical monograph may be associated with names like Johannes Wetter (1806–97) and Robert Willis (1800–78). Wetter aligned the forms of Mainz Cathedral with datable monuments elsewhere, analyzing its structure as a skeleton of stone efficiently conceived from the top downwards in relation to vertical load and outward thrust.[22] Willis's monograph on Canterbury Cathedral still provides a model combination of the critical written sources (the *Chronicle* of Gervase of Canterbury) and careful study of the forms of the building itself.[23]

The institutionalization of the study of medieval architecture was furthered by the establishment in 1823 of the Société des antiquaires de Normandie, an organization that provided the model for the much more famous Société française d'archéologie, with its *Bulletin monumental* and Congrès archéologique, which from 1834 met annually in different cities, providing a vital framework for research and publication.

Conservation and restoration

The French Revolution had nationalized assets necessary to sustain the fabric of the Church. The convergence (1830s) of the pressing physical needs of neglected or mutilated edifices with the increasing sensitivity to the cultural value of such monuments led to the development of a *métier* – that of the restorer. Jean-Baptiste Lassus (1807–57) and Eugène Emmanuel Viollet-le-Duc (1814–79) are prime examples of the nineteenth-century restorer in France.[24]

Rationalism

In 1840 the young Viollet-le-Duc assumed direction of the restoration of La Madeleine at Vézelay.[25] The theoretical understanding that he developed and published in his *Dictionnaire* must be understood in relation to his practice at Vézelay, Notre-Dame of Paris and scores of other projects.[26] He concluded that

the ribs of a quadripartite vault served as a scaffold to steady the four vault fields during construction. Each of the vault fields was then built up using lightweight mobile wooden centering. Arches and ribs actually carried the vault. Romanesque architecture is *capricious*, Gothic is *rational* – pinnacles provided stability for the buttress uprights and all elements were designed around similar rational principles.

Critics argued that flying buttresses do not work by opposing the thrust of the vault by means of a counter-load: they merely transmit the load to the exterior pylons.[27] Engaged shafts only *appear* to carry; they express "aesthetic logic" but perform no structural role. Gables, pinnacles, tabernacles all come under the same understanding. Accusing Viollet-le-Duc of a romanticized notion of mechanics, Pol Abraham and others open the way for the understanding of Gothic as an architecture of illusionism.

Architecture, morality and religion[28]

In Augustus Welby Pugin's (1812–52) *Contrasts* the moral and religious force of Gothic is everywhere manifest: Gothic is *the* Christian style.[29] The linkage between appropriateness of form and Christian dogma led to an outpouring of creativity in England with the establishment of the Camden and Ecclesiological Societies to adjudicate on the creation of "good" buildings. John Ruskin (1819–1900) set out to define guiding principles such as "truth to materials."[30] The needs of growing urban populations in mid-nineteenth-century England and the perceived dangers of socialism/Marxism produced a vast need for new churches, which was met by architects such as George Edmund Street (1824–81), William Butterfield (1884–1900), and George Gilbert Scott (1811–78).[31] Gothic was also a force in the establishment of national identity, particularly in England and Germany.

The establishment of an art historical métier: archaeology and theory

The twentieth century was dominated by two streams of thought: "archaeological," associated especially with the French tradition, and the "theoretical" approaches of German writers. By 1900, in a field dominated by the Ecole des Chartres (1821), with its chair of archaeology (1846), the requirements of the French archaeological study had been clearly established. E. Lefèvre-Pontalis (1862–1923) addressed the question "How should one write a monograph on a church?"[32] The elements of the study should include: (1) determination of the campaigns of construction; (2) analytical analysis (dismemberment) of the edifice; and (3) connection of the edifice with a particular school. Methods that included an exacting study of molding profiles, capitals, and tracery as evidence of chronology were similar to those applied in the natural sciences (zoology, botany, and mineralogy) to the understanding of groups of fossils or living organisms, and similar language developed to deal with relationships

over time: "change," "development," or "evolution." Such methods produced a procession of studies that remain valuable to our own day, including works by Marcel Aubert (1884–1962), Robert de Lasteyrie (1849–1921), and Camille Enlart (1862–1927).[33] Henri Focillon (1881–1951) brought to such work his astonishing powers of observation and analysis, systematizing the overarching theory of form derived from the organic metaphor of evolution or development.[34]

Paul Frankl (1878–1962) sought to derive Gothic from one basic principle, creating a "system" for classification of style and locating that transcendent "essence" that determines architectural form much as the laws of the natural sciences determine the form of living organisms.[35] The essential quality of a thing is revealed by contrasting it with what it *is not*. Frankl's creation of three juxtaposed opposites for Romanesque and Gothic – addition/division, structure/texture, and frontality/diagonality provided a powerful expository method for the teacher equipped with two slide projectors.

For Frankl it was the aesthetic implications of the rib that provided the mechanism for change. An internal dialectic imposed reconciliation and integration: each new edifice embodied corrections of the previous one until a synthesis was reached in the nave of Amiens and the choir of Cologne. The extrinsic mechanism lay in cultural history understood as a wheel where the hub is understood as the "spirit of the times." That central theme was identified in the life and teaching of Jesus Christ. Man is a fragment of creation; the multiple forms of the cathedral expressed this coordination of many elements in one. "Gothic" takes on a metonymic relationship with society as a whole.

Focusing upon St Denis, Sens, and Chartres, Otto von Simson (1912–93) dealt with the image of the cathedral as the revelation of the kingdom of God on earth.[36] The vehicle for this revelation was provided by light and the linear forms of diaphanous architecture conceived around clear geometric principles, allowing the cathedral to reflect the Platonic image of the Cosmos.

Erwin Panofsky's (1892–1968) translation of Abbot Suger's writings remains an essential text to this day and represented a massive achievement at the time. *Gothic Architecture and Scholasticism* is a provocative attempt to parallel two of the most important cultural manifestations of the day: the use of unrelenting logic to make "truth" manifest, and the new architectural forms of the twelfth and thirteenth centuries which he saw as bound together in a cause-and-effect relationship.[37]

American Goths

In the United States a powerful alliance developed between the moral/mystical response to Gothic associated with the work of Henry Adams and the actual construction of Gothic Revival edifices by builders like Ralph Adams Cram.[38] Gothic is today alive and well on many an American university campus.[39]

In the Academy it was the French archaeological approach that dominated. Sumner Mcknight Crosby (1909–82) studied at Yale with Aubert and Focillon, who directed his doctoral thesis (1937) on St Denis. Crosby conducted extensive excavations in the 1930s, completing the first accurate plans and sections of this most important Gothic edifice and reconstructing the history of the monument from the fifth to the twelfth century.[40]

Robert Branner (1927–73) studied with Sumner Crosby at Yale, completing his dissertation on Bourges Cathedral. Branner brought the archaeological investigation of the single building to a high level of sophistication, looking beyond the traditional parameters of the discipline to find a context for "style" in the form of the patronage of the royal court.[41] Closely aligned with the French archaeological tradition, he sharply criticized certain German theorizing approaches. Through his acute powers of observation, his dynamic writing, and his powers as a teacher at Columbia, Branner energized the field through the 1960s until his untimely death.[42]

Jean Bony's years at Berkeley also left an important legacy. A critical milestone in the study of Gothic architecture was marked by the 1983 appearance of Jean Bony's *magnum opus*.[43] Written and re-written over decades, *French Gothic Architecture* still provides the student with the best demonstration of the use of rhetoric to convey the "look" of an individual building as well as the connective tissue binding together multiple buildings. To demonstrate what Gothic is, Bony turned to Soissons Cathedral, providing a masterly account of the elements that add up to form the system. He tracked the development of each element, concentrating upon spaciousness and linear organization – horizontal and mural as well as vertical. Aware of the dangers of determinism, Bony developed his "accidental" theory – that the new architecture resulted from the attempt to impose a heavy vaulted superstructure in the Anglo-Norman tradition upon a slender infrastructure of the kind favored in and around Paris. Gothic was invented in this atmosphere of danger and went on being invented as a kind of modernism.

Gothic Architecture in the "Crisis" of Art History: Prophets of the Millennium

The 1980s brought a sea change in the conservative world of art historians as "theoretical" approaches developed in contiguous disciplines (literature, philology, philosophy, anthropology, sociology) were enthusiastically (if sometimes naively) applied to visual culture. The imminent millennium provoked a series of forcefully written statements that provide useful stimuli for the student, who should, however, be wary of the sometimes monolithic panaceas recommended.

Willibald Sauerländer's review of Bony's *French Gothic Architecture* provides the most audible initial trumpet blast.[44] While he praised Bony's "brilliant

book" as the culmination of the French archaeological approach, Sauerländer focused upon its limitations: excessive concentration upon major monuments in France; the suggestion that the "rise" of the great Gothic cathedrals came from some kind of inner yearning for increased spaciousness. He questioned Bony's reliance upon figurative language to convey the essential qualities of the building described: of the ambulatory of Chartres Bony had written that it is "as though the interior space, in an effort to expand outwards, had managed to break through the restraining cage of buttresses at three points." Such words revealed much about modern sensitivities – yet spaces in the Middle Ages were divided by screens and encumbered by liturgical furniture tombs.

Von Simson was also the object of Sauerländer criticism – for having spiritualized the history of architecture, ignoring the technical, material, and historical circumstances. In 1995 Sauerländer berated a discipline that had remained too committed to the "positivistic" approaches advocated by scholars such as Lefèvre-Pontalis. He challenged the assumption that Gothic resulted from a twelfth-century avant-garde or that it expressed a kind of anti-classicism, stressing rather the multiple references to antique architecture in early Gothic buildings, especially the cylindrical column.

Marvin Trachtenberg also aimed to provide the intellectual mechanism necessary for the "redefinition of the Gothic and, consequently, also of the Romanesque."[45] Interestingly, Trachtenberg emphatically advocated an approach that was diametrically opposed to Sauerländer's. Whereas the latter found revivalism or historicism as the principal catalyst, the former stressed "medieval modernism" returning to the anti-classical essence of "Gothic" as associated with the destroyers of Rome. For Trachtenberg the essential modernity of Gothic was more germane to the "essence of the matter" than later "scientific" scholarship preoccupied with rib vaulting, skeletal structure, scholasticism, diaphaneity, geometry, diagonality, and so forth.

Michael Davis based his very useful and positive survey of recent trends upon conflicting "prophetic" declarations, juxtaposing Michael Camille's condemnation of the alleged narrowness and positivism of architectural historians with Alain Guerreau's call for renewed rigor ("positivism?") in dealing with the material properties, masonry, mortar, and design principles of the buildings under study.[46]

In the clash between theorists and formalists, Davis advocated abandoning the story of Gothic told in linear fashion and giving due attention to the regions and to internal connections within those regional entities. Most attractive is Davis's advice that the student should not be alarmed by "radical" attempts to realign the study of medieval architecture with current monolithic agendas. Instead, the student should disregard the restrictive "border police," recognizing the astonishing breadth of the discipline, and should continue to experiment with new approaches.

Current Approaches[47]

The monograph has played, and should continue to play, a most important role, allowing the writer to provide a full introduction to the experience of visiting a particular building using a combination of words and images and opening multiple avenues of scholarly investigation around that building. Such monographs are associated with the scholarly activities of, for example, Seymour, Branner, Wolf, Hamman-McClean, van der Meulen, Bruzelius, Sandron, and Murray.[48] Particularly useful are the monographic British Archaeological Association publications, combining description, archaeology, chronology, design and context.[49] More recently Gillerman dealt with Ecouis in relation to the artistic activity of the court of Philip the Fair and the devotional program of Engerran de Marigny.[50] Brachmann, on Metz, puts the cathedral in its context both historical and architectural.[51]

Surveys that set out to present multiple buildings and to find the connective tissue linking these buildings present a particular challenge, since one is forced to attempt to represent a complex three-dimensional phenomenon in the linear format of the book. Recent broad-ranging surveys include Binding, Wilson, Toman, and Coldstream. Grodecki's older survey is still very useful.[52]

Regional studies have long formed a key part of the work of medieval architectural historians: one thinks particularly of the *Congrès archéologique*. Branner's *Burgundian Gothic* provided a useful focus upon a regional expression of Gothic. Bruzelius and Krüger have focused on Italian Gothic, Freigang on southern France, Recht on Alsace. There has been recent interest in Central Europe. National studies include Boase and Harvey on English Gothic, Bony and Coldstream on English decorated, Stalley on Ireland, Nussbaum and Busch on German Gothic, and Lambert and Freigang on Spain.[53]

Artistic Integration generated some useful studies and the student would be well advised to consider the essays in it by Sauerländer, McGinn, Reynolds, Clark, and others.[54] However they tended at times to neglect the wealth of existing publications. Recent authors who include a careful treatment of the architectural envelope of the building as well as figurative cycles and/or furniture, include Caviness on St Remi at Reims, Binski on Westminster Abbey, Köstler on St Elizabeth at Marburg, Jung on Naumburg, and Tripps on the figurative outfitting of the Gothic church.[55]

Primary sources. The work of correlating the primary written sources with the building itself is the most rigorous, but potentially one of the most valuable pursuits of the student of Gothic architecture. Some of the older secondary sources have been cited above; recent work that returns to an intense study of the primary sources includes Bechmann on the portfolio of drawings made by Villard de Honnecourt and his followers. Binding and Speer have assembled important textual material on the medieval experience of art. Coenen has worked

on late Gothic master masons' work books.[56] There has been an astonishing recent burst of activity focused upon the written accounts of the administration and consecration of the abbey of St Denis left by the Abbot Suger, including works by Kidson, Neuheuser, Büchsel, Grant, Markschies, Tammen, and Rudoph.[57]

Liturgy. The best general introductions are provided by Harper and Dix. Reynolds addressed the problems of integrating liturgical studies with architecture.[58] One of the most spectacular essays of the recent past was by Fassler, who reinterpreted the north portal of the Chartres west façade in light of liturgical sources.[59] On the extent to which liturgical and institutional demands fixed architectural form the architecture of the mendicants provides an interesting case study: see the recent works by Sundt and Schenlun. Kroos published key liturgical sources for Cologne Cathedral, and Speer dealt with the interaction of art and liturgy. Craig Wright provided a delightful introduction to the music and liturgy of Notre-Dame of Paris.[60]

The search for meaning. The most valuable account of the allegorical meanings attached to the various parts of the church and its furnishings was written by William Durandus, Bishop of Mende (1230–96).[61] Some of the meanings listed by Durandus may seem obscure or improbable to the modern reader. The *Gestalt* language of the cathedral can be just as powerful for the modern viewer as the medieval user. Thus the plan of the church with its rounded eastern end, its transept, and longitudinal nave can be understood as an image of the human body; the church is the body of Christ. Similarly, the boat-like qualities of the edifice point to Noah's Ark, a prototype for the Church.[62] Sedlmayr brought attention to the *baldachin*: the spatial unit composed of a concave canopy supported upon columns to create the impression of an interior that is not bound to the earth, but which floats, suspended from above creating a portrait (*Abbild*) of the Heavenly City.[63] Bandmann attempted an ambitious survey of the power of the cathedral as a vehicle for meaning.[64] Buildings also carry meaning through their resemblance to other buildings – Krautheimer's pioneering work on the "iconography" of architecture (1942) is still of enormous importance, especially as updated by Paul Crossley.[65] Hans-Joachim Kunst dealt with resemblances between buildings in terms of "quotations."[66]

Materialism. The economic underpinnings of cathedral construction were discussed by Kraus and by Murray. Warnke provided a sociology of medieval architecture.[67] Marxism brought very different results on both sides of the Atlantic. Kimpel, standing in line with Benjamin, emphasized the means of production that facilitated mass production, particularly with respect to the working of stone.[68] Abou-El-Haj and Williams, students of Weckmeister, stressing the abusive relations between clergy and townsfolk, presented the cathedral as a sign of crushing control of the means of economic production on the part of the clergy.[69] On the legal framework, see Schöller. On the institutional organization of the cathedral, Erlande-Brandenburg. On the business of building, Binding. On the urbanistic context of the cathedral, see Mussat.[70]

Useful recent work has addressed the material and the artisans of Gothic. On wooden roofs, see Binding. On the artisan, Barral I Altet and Nicola Coldstream. On construction, see Fitchen. On color, see Michler.[71]

Design and metrology. Pioneering work was done by Bucher. Kidson and Fernie offer useful methodological overviews. Most recently, see the anthology edited by Wu.[72]

Structure. This field has been dominated by Robert Mark at Princeton and Jacques Heymann at Cambridge.[73] Their writings provide an overview of the old debates and the application of new ideas and technologies.

Gender. On women's space in medieval architecture, see the special edition of *Gesta* edited by Bruzelius.[74]

Secular architecture. On Florence, see, for example, Braunfels and Trachtenberg. On castles, see Jean Mesqui. On the interaction between castles and churches, Sheila Bonde. See Albrecht on French palace architecture.[75]

Anthropology/sociology. See Maines and Bonde on Soissons, Fergusson on Rievaulx, and Bob Scott on the sociology of construction.[76]

Representation; language. This is a vast and most fertile topic. The recent anthology edited by Crossley and Clarke provides a start.[77]

"Late" Gothic architecture. The idea of "style" anchors a set of visual forms to a unity of time and place and brings the assumption that a period of experiments (Early Gothic) will be followed by synthesis (High Gothic); routine production (Rayonnant; regional Gothic), decline (Late Gothic,) and death. The earliest definitions of "Flamboyant" or "Late Gothic" depended very much upon a morphology of individual forms, particularly window tracery; Late Gothic was associated with double-curved shapes. The style-based study of Late Gothic led to a futile competition as to whether the French, English or Germans had led the way to a new formal synthesis.[78] But there is so much more than this. Germany and England both produced the distinctive forms of "Perpendicular" and "Sondergotik." Bialostocki[79] first laid out a critical and pluralistic interpretative framework and in 1971 Roland Sanfaçon set out to find a broader interpretation of "Flamboyant," arguing that the definition of a "style" based upon the curves and countercurves of tracery cannot do justice to the originality and real meaning of the phenomenon. He found in the forms of architecture in the years around 1300 the unifying principle of "individualism," or *détente.*[80] The most recent studies in the field, while still putting Late Gothic buildings in relation to their predecessors, concentrate more on problems of production, patronage, liturgy, devotional practices and urban context.[81]

Digital studies. The historian must engage in the impossible undertaking of holding each building suspended in the intelligence while it can find its multiple levels of relationship with the hundreds of other buildings under construction at the same time. The most valuable tool in this task will be systematically collected data, the organization of a database and the synthesizing power of the computer. Columbia students and faculty are currently experimenting with a databased corpus of Romanesque churches in central France.[82]

Conclusion

Half a century ago Paul Frankl wrote:

> The essence of Gothic is, in a few words, that cultural and intellectual background insofar as it entered into the building and was absorbed by it: it is the interpenetration, the saturation, of the form of the building by the meaning of the culture.[83]

Everything has changed, yet little has changed. Today we would assign more importance to the culture and presuppositions of the viewer/interpreter, and we would challenge Frankl's underlying idea of "style" as Platonic "essence." As we pursue the question as to *how the ideas got into the building*, we will learn to deal more fully with the underlying structures and mechanics of human relations. But allow me to end as I began: it is the buildings themselves, with their amazing pull upon the curiosity and the awe of the spectator, that remain the most important raw material of our study. They continue to beckon us to return, even after a lifetime of work, to ask new questions and apply new approaches.

Notes

1 [On Romanesque architecture, see chapter 14 by Fernie in this volume (ed.).]

2 The Conway Library at the Courtauld Institute of Art; the Marburg Photo Archive; the *Services photographiques* of the *Caisse National des Monuments Historiques*, Paris. The promise of the future lies in the digital collections currently being formed by ArtStore sponsored by the Andrew W. Mellon Foundation.

3 Dehio and von Bezold, *Kirchliche Baukunst*.

4 See notes 64–8 below.

5 The works of certain historians have proved particularly rich as far as the student of Gothic architecture is concerned: particularly Richard Southern, John Baldwin, Jacques Le Goff, Elizabeth Brown etc. [On patronage, see chapter 9 by Caskey in this volume (ed.).]

6 Mortet and Deschamps, *Recueil des textes*; Frisch, *Gothic Art*; Panofsky, *Abbot Suger*; Frankl, *The Gothic*.

7 Gervase of Canterbury, *Burning and Repair*; Willis, *Architectural History*.

8 Panofsky, *Abbot Suger*.

9 Colvin, *Building Accounts*; Ackerman, "Ars Sine Scientia Nihil Est"; Panofsky, *Abbot Suger*; Murray, *Building Troyes Cathedral*; Erskine, ed., *Accounts*.

10 Frankl, *The Gothic*, pp. 55–6.

11 Bechmann, *Villard de Honnecourt*.

12 Koepf, *Gotische*.

13 Rowland, *Culture*.

14 Crossley, "Return to the Forest."

15 Frankl, *The Gothic*. [On revivals of medieval architecture, see chapter 29 by Bizzarro in this volume (ed.).]

16 Edelman, *Attitudes.*
17 Frankl, *The Gothic*, pp. 417–22.
18 Chateaubriand, *Génie du christianisme*; citation from Frankl, *The Gothic*, p. 482.
19 Britton, *Architectural Antiquities.*
20 Nodier et al., *Voyages pittoresques.*
21 Rickman, *Attempt to Discriminate.*
22 Wetter, *Geschichte und Beschreibung.*
23 Willis, *Architectural History.*
24 Leniaud, *Cathédrales au XIXe siècle*; *Viollet-le-Duc.*
25 Murphy, *Memory and Modernity.*
26 Viollet-le-Duc, *Dictonnaire raisonné.*
27 Critics of rationalism included A. Hamlin, V. Sabouret, and, above all, Pol Abraham (*Viollet-le-Duc*). See also Masson "Le Rationalisme"; Aubert, "Les plus anciennes Croisées"; and Focillon, "Le Problème de l'ogive."
28 Watkin, *Morality and Architecture.*
29 Pugin, *Contrasts*; *True Principles.*
30 Ruskin, *Seven Lamps of Architecture*; *Stones of Venice.*
31 The standard older source on the Gothic revival is Clark, *Gothic Revival.* More recently see Brooks, *Gothic Revival.*
32 Lefèvre-Pontalis, "Comment doit-on rediger la monographie?"
33 Aubert, *Monographie*; *Notre-Dame de Paris*; de Lasteyrie, *L'Architecture religieuse*; Enlart, *Manuel d'archéologie.*
34 Focillon, *Vie des formes*; *Life of Forms in Art*; *Art d'Occident*; *Art of the West.*
35 Frankl, *The Gothic*; *Gothic Architecture.*
36 Simson, *Gothic Cathedra.*
37 Panofsky, *Gothic Architecture.*
38 Jackson Lears, *No Place of Grace.*
39 Turner, *Campus.*
40 Crosby, *The Royal Abbey.*
41 Branner, *Saint Louis.*
42 Edson Armi, William Clark, Paula Gerson, Meredith Lillich, Georgia Wright, etc., etc.
43 Bony, *French Gothic Architecture.*
44 Sauerländer, "Mod Gothic"; "Integration."
45 Trachtenberg, "Gothic/Italian 'Gothic'"; "Suger's Miracles."
46 Davis, "Sic et non."
47 See especially Crossley's excellent introduction to the new edition of Frankl, *Gothic Architecture.*
48 Seymour, *Notre-Dame of Noyon*; Branner, *La Cathédrale de Bourges*; Wolf, "Chronologie"; Hamman-McClean, *Kathedrale von Reims*; van der Meulen, *Chartres*; Bruzelius, *Thirteenth-Century Church*; Sandron, *La Cathédrale de Soissons*; *Beauvais Cathedral*; *Notre-Dame, Cathedral of Amiens.*
49 *Transactions*, Leeds: Ely (1979); Durham (1980); Winchester (1983); Gloucester and Tewkesbury (1985); Lincoln (1986); London (1990); Exeter (1991); Chester (2000) etc.
50 Gillerman, *Enguerran de Marigny.*
51 Brachmann, *Gotische Architektur.*

52 Binding, *High Gothic*; Wilson, *The Gothic Cathedral*; Toman, ed. *The Art of Gothic*; Coldstream, *Medieval Architecture*; Grodecki, *Gothic Architecture*.

53 Branner, *Burgundian Gothic Architecture*; Bruzelius, "*Ad modum franciae*"; "Il gran Rifuto"; Krüger, *S. Lorenzo*; Freigang, *Imitare Ecclesias Nobiles*; Recht, *L'Alsace gothique*; Crossley, *Gothic Architecture*; Brieger, *English Art*; Harvey, *Gothic England*; Coldstream, *Decorated Style*; Bony, *English Decorated Style*; Stalley, *Cistercian Monasteries of Ireland*; Nussbaum, *German Gothic Architecture*; H. Busch, *Deutsche Gotik*; E. Lambert, *L'Art gothique*; C. Freigang, ed., *Gotische Architektur*.

54 Raguin and Draper, eds., *Artistic Integration*.

55 Caviness, *Sumptuous Arts*; Binski, *Westminster Abbey*; Köstler, *Austattung*; Jung, "Beyond the Barrier"; Tripps, *Der handelne Bildwerk in dem Gotik*.

56 Bechmann, *Villard de Honnecourt*; G. Binding and A. Speer, eds., *Mittelalterlicher*; Coenen, *Spätgotische Werkmeisterbücher*.

57 Kidson, "Panofsky, Suger and Saint-Denis"; Neuheuser, "Die Kirchenweihbeschreibungen"; Büchsel, *Die Geburt der Gotik*; Grant, *Abbot Suger*; Markschies, *Gibt es eine Theologie*; Tamman, "Gervasius von Canterbury"; Rudolph, *Artistic Change*.

58 Dix, *Shape of the Liturgy*; Harper, *Forms and Orders*; Reynolds, "Liturgy and the Monument."

59 Fassler, "Liturgy and Sacred History."

60 Sundt, "Jacobins Church"; Schenkluhn, *Architektur der Bettelorden*; Kroos, *Dom zu Regensburg*; "Liturgische"; Speer, "Kunst als Liturgie"; Wright, *Music and Ceremony*.

61 Durandus, *Symbolism*.

62 Zinn, "Hugh of St. Victor."

63 Sedlmayr, *Die Entstehung der Kathedrale*.

64 Bandmann, *Mittelalterliche Architektur*.

65 Krautheimer, "Introduction"; Crossley, "Medieval Architecture."

66 Kunst, "Freiheit und Zitat."

67 Kraus, *Gold Was the Mortar*; Murray, *Building Troyes Cathedral*; Warnke, *Bau und Uberbau*.

68 Kimpel and Suckale, *Die gotische Architektur*.

69 Abou-el-Haj, "Urban Setting"; Williams, *Bread, Wine and Money*.

70 Schöller, *Die rechtliche Organisation*; Erlande-Brandenburg, *Cathédrale*; Binding, *Baubetrieb im Mittelalter*; Mussat, "Les Cathédrales."

71 Binding, *Das Dachwerk*; Barral I Altet, ed., *Artistes*; Coldstream, *Medieval Craftsmen*; Fitchen, *Construction*; Michler, *Elisabethkirche zu Marburg*.

72 Bucher, "Design in Gothic Architecture" [on this subject in general, see also chapter 25 by Zenner in this volume (ed.).]; Kidson, "Metrological Investigation"; Fernie, "Beginner's Guide"; Wu, ed., *Ad Quadratum*.

73 Mark, *Experiments in Gothic Structure*; *High Gothic Structure*; Heyman, *Arches, Vaults and Buttresses*; Courtenay. ed., *Engineering of Medieval Cathedrals*.

74 Bruzelius, "Monastic Architecture."

75 Braunfels, *Mittelalterliche Stadtbaukunst*; Trachtenberg, *Dominion of the Eye*; Mesqui, *Châteaux forts*; *Château et la ville*; Bonde, *Fortress-Churches*; Albrecht, *Von der Burg*.

76 Bonde and Maines, "Centrality and Community"; Fergusson and Harrison, *Rievaulx Abbey*; Scott, *Gothic Enterprise*.

77 *Architecture and Language*.

78 Tamir, "English Origin."
79 Bialostocki, "Late Gothic."
80 Sanfacon, *L'Architecture flamboyante.*
81 Neagley, *Disciplined Exuberance.*
82 <www.learn.columbia.edu/Bourbonnais>
83 Frankl, *The Gothic.*

Bibliography

B. Abou-el-Haj, "The Urban Setting for Late-Medieval Church Building: Reims and Its Cathedral between 1210 and 1240," *Art History* 11 (1988), pp. 17–41.

P. Abraham, *Viollet-le-Duc et le rationalisme médiéval* (Paris, 1934).

J. Ackerman, "'Ars Sine Scientia Nihil Est,' Gothic Theory of Architecture at the Cathedral of Milan," *Art Bulletin* 31 (1949), pp. 84–111.

U. Albrecht, *Von der Burg zum Schloss. Französische Schlossbaukunst im Spätmittelalter* (Worms, 1986).

M. Aubert, *Monographie de la cathédrale de Senlis* (Senlis, 1910).

——, *Notre-Dame de Paris, sa place dans l'histoire de l'architecture du XIIe au XIV siècle* (Paris, 1920).

——, "Les Plus Anciennes Croisées d'ogives, leur role dans la construction," *Bulletin monumental* 93 (1934), pp. 5–67 and 137–237.

G. Bandmann, *Mittelalterliche Architektur als Bedeutungsträger* (Berlin, 1951).

X. Barral I Altet, ed., *Artistes, artisans et production artistique au moyen âge*, Colloque international, Rennes, 1983 (Paris, 1986).

R. Bechmann, *Villard de Honnecourt. La pensée technique au XIIIe siècle et sa communication* (Paris, 1991).

J. Bialostocki, "Late Gothic, Disagreements about the Concept," *Journal of the British Archaeological Association*, 3rd ser., 29 (1966), pp. 76–105.

G. Binding, *Baubetrieb im Mittelalter* (Darmstadt, 1993).

——, *Das Dachwerk auf Kirchen im Deutschen Sprachraum vom Mittelalter bis zum 18ten. Jahrnundert* (Munich, 1991).

——, *High Gothic. The Age of the Great Cathedrals* (Taschen, 1999).

G. Binding and A. Speer, eds., *Mittelalterlicher Kunstererleben nach Quellen des 11ten bis 13ten Jahrhunders* (Stuttgart, 1994).

P. Binski, *Westminster Abbey and the Plantagenets: Kingship and the Representation of Power* (New Haven, 1995).

S. Bonde, *Fortress-Churches of Languedoc: Architecture, Religion and Conflict in the High Middle Ages* (Cambridge, 1994).

S. Bonde and C. Maines, "Centrality and Community, Liturgy and Gothic Chapter Room Design at the Augustinian Abbey of Saint-Jean-des-Vignes, Soissons," *Gesta* 29 (1990), pp. 189–213.

J. Bony, *The English Decorated Style, Gothic Architecture Transformed, 1250–1350* (Oxford, 1979).

——, *French Gothic Architecture of the Twelfth and Thirteenth Centuries* (Berkeley, 1983).

C. Brachmann, *Gotische Architektur in Metz unter Bischof Jacques de Lorraine (1239–1260): der Neubau der Kathedrale und seine Folgen* (Berlin, 1998).

R. Branner, *Burgundian Gothic Architecture* (London, 1960).

——, *La Cathédrale de Bourges et sa place dans l'architecture gothique* (Paris/Bourges, 1962).

——, *Saint Louis and the Court Style* (London, 1965).

W. Braunfels, *Mittelalterliche Stadtbaukunst in der Toskana* (Berlin, 1979).

P. Brieger, *English Art, 1216–1307*, Oxford History of Art (Oxford, 1957).

J. Britton, *The Architectural Antiquities of Great Britain, represented and illustrated in a series of views, elevations, plans, sections, and details of ancient English Edifices, with historical and descriptive accounts of each* (London, 1807–14).

C. Brooks, *Gothic Revival* (London, 1999).

C. Bruzelius, "*Ad modum franciae*: Charles of Anjou and Gothic Architecture in the Kingdom of Sicily," *Journal of the Society of Architectural Historians* 50 (1991), pp. 402–20.

——, "'Il gran Rifuto,' French Gothic in Central and Southern Italy in the Last Quarter of the Thirteenth Century," in P. Crossley and G. Clark, eds., *Architecture and Language: Contructing Identity in European Architecture* (Cambridge, 2000), pp. 36–45.

——, "Monastic Architecture for Women, An Introduction," *Gesta*, 31 (1992), pp. 73–5.

——, *Thirteenth-Century Church at St-Denis* (New Haven, 1985).

F. Bucher, "Design in Gothic Architecture: A Preliminary Assessment," *Journal of the Society of Architectural Historians* 27 (1968), pp. 49–71.

M. Büchsel, *Die Geburt der Gotik: Abt Sugers Konzept für die Abreikirche St. Denis* (Freiburg-im-Breisgau, 1997).

H. Busch, *Deutsche Gotik* (Vienna and Munich, 1969).

M. Caviness, *Sumptuous Arts at the Royal Abbeys in Reims and Braine "Ornatus elegantiae, varietate stupendes"* (Princeton, 1990).

F. R. Chateaubriand, *Génie du christianisme* (Paris, 1801).

K. Clark, *The Gothic Revival: An Essay in the History of Taste* (London, 1995).

U. Coenen, *Spätgotische Werkmeisterbücher in Deutschland als Beitrag zur mittelalterlichen Architekturtheorie: Untersuchung und Edition des Lehrshriften für Entwurf und Ausführung von Sakralbauten* (Aachen, 1989).

N. Coldstream, *The Decorated Style: Architecture and Ornament, 1240–1460* (Toronto, 1994).

——, *Medieval Architecture* (Oxford, 2002).

——, *Medieval Craftsmen, Masons and Sculptors* (London, 1991).

H. Colvin, *Building Accounts of Henry III* (London, 1985).

L. Courtenay, ed., *Engineering of Medieval Cathedrals* (Aldershot, 1997).

S. M. Crosby, *The Royal Abbey of Saint-Denis from Its Beginnings to the Death of Suger, 475–1151* (New Haven and London, 1987).

P. Crossley, *Gothic Architecture in the Reign of Kasimir the Great: Church Architecture in Lesser Poland, 1320–1380* (Krakow, 1985).

——, "Medieval Architecture and Meaning: The Limits of Iconography," *Burlington Magazine* 130 (1988), pp. 116–21.

——, "The Return to the Forest. Natural Architecture and the German Past in the Age of Dürer," *Kunstlerischer Austausch. Akten des XXVIII Internationalen Kongress für Kunstgeschichte* (Berlin, 1992), pp. 71–80.

P. Crossley and G. Clark, eds., *Architecture and Language: Contructing Identity in European Architecture* (Cambridge, 2000).

M. Davis, "Sic et non. Recent Trends in the Study of Gothic Ecclesiastical Architecture," *Journal of the Society of Architectural Historians* 58 (1999), pp. 414–23.

G. Dehio and G. von Bezold, *Kirchliche Baukunst des Abendlandes: historisch and sytematische dargestellt* (Stuttgart, 1901).

G. Dix, *The Shape of the Liturgy* (London, 1945).

W. Durandus, *Symbolism of Churches and Church Ornaments: A Translation of the First Book of the Rationale Divinorum Officiorum. With an Introductory Essay, Notes and Illustrations by Jahn Mason Neale and Benjamin Webb* (Leeds, 1843; New York, 1973).

N. Edelman, *Attitudes of Seventeenth-Century France toward the Middle Ages* (New York, 1946).

C. Enlart, *Manuel d'archéologie français depuis le temps mérovingien jusqu'à la renaissance*, 2 vols. (Paris, 1905).

A. Erlande-Brandenburg, *Cathédrale* (Paris, 1989).

A. M. Erskine, ed., *The Accounts of the Fabric of Exeter Cathedral, 1279–1353*, Part I, Devon and Cornwall Record Society, n.s. 24–6 (Torquay, 1981–3).

M. Fassler, "Liturgy and Sacred History in the Twelfth-Century Tympana at Chartres," *The Art Bulletin* 75 (1993), pp. 499–520.

P. Fergusson and S. Harrison, *Rievaulx Abbey: Community, Memory, Architecture* (New Haven, 2000).

E. Fernie, "A Beginner's Guide to the Study of Architectural Proportions," in E. Fernie and P. Crossley, eds., *Medieval Architecture in Its Intellectual Context: Studies in Honor of Peter Kidson* (London, 1990), pp. 229–37.

J. Fitchen, *The Construction of Gothic Cathedrals* (Oxford, 1961).

H. Focillon, *Art d'Occident, le moyen âge, roman et gothique* (Paris 1938).

——, *The Art of the West*, ed. J. Bony, 2 vols. (London, 1969).

——, *The Life of Forms in Art*, trans. C. B. Hogan and G. Kubler (New Haven and Oxford, 1942).

——, "Le Problème de l'ogive," *Recherche* 1 (Paris, 1939).

——, *Vie des formes* (Paris, 1934).

P. Frankl, *Gothic Architecture*, Pelican History of Art (Harmondsworth, 1962; new edn. ed. P. Crossley, New Haven, 2000).

——, *The Gothic: Literary Sources and Interpretations through Eight Centuries* (Princeton, 1959).

C. Freigang, *Imitare Ecclesias Nobiles: Die Kathedralen von Narbonne, Toulouse und Rodez und die norfranzösische Rayonnantgotik im Languedoc* (Worms, 1992).

——, ed., *Gotische Architektur in Spanien/La arquitectura gótica en Espana* (Madrid, 1999).

T. Frisch, *Gothic Art, 1140–c.1450: Sources and Documents* (Englewood Cliffs, NJ, 1971).

Gervase of Canterbury, *On the Burning and Repair of the Church of Canterbury in the Year 1174, from the Latin of Gervase, a Monk of the Priory of Christ Church, Canterbury*, ed. Charles Cotton (Canterbury, 1930; Cambridge, 1932).

D. Gillerman, *Enguerran de Marigny and the Church of Notre-Dame at Ecouis: Art and Patronage in the Reign of Philip the Fair* (University Park, Penn., 1994).

L. Grant, *Abbot Suger of Saint-Denis: Church and State in Early Twelfth-Century France* (London, 1992).

L. Grodecki, *Gothic Architecture* (New York, 1976).

R. Hamman-McClean, *Die Kathedrale von Reims, die Architektur* (Stuttgart, 1993).

J. Harper, *The Forms and Orders of the Liturgy from the Tenth to the Eighteenth Century: A Historical Introduction and Guide for Students and Musicians* (Oxford, 1991).

J. Harvey, *Gothic England. A Survey of National Culture, 1300–1550* (New York, 1957).

J. Heyman, *Arches, Vaults and Buttresses: Masonry Structures and Their Engineering* (Brookfield, Vt., 1996).

T. J. Jackson Lears, *No Place of Grace: Antimodernism and the Transformation of American Culture* (New York, 1981).

J. Jung, "Beyond the Barrier: the Unifying Role of the Choir Screen in Gothic Churches," *Art Bulletin* 82 (2000), pp. 622–57.

P. Kidson, "A Metrological Investigation," *Journal of the Warburg and Courtauld Institutes* 53 (1990), pp. 71–97.

——, "Panofsky, Suger and Saint-Denis," *Journal of the Warburg and Courtauld Institutes* 50 (1987), pp. 1–17.

D. Kimpel and R. Suckale, *Die gotische Architektur in Frankreich 1130–1270* (Munich, 1985).

H. Koepf, *Gotische Planrisse der Wiener Sammlungen* (Vienna, 1969).

A. Köstler, *Austattung der Marburger Elisabethkirche: zur Asthetisierung des Kultraums im Mittelalter* (Berlin, 1995).

H. Kraus, *Gold Was the Mortar: The Economics of Cathedral Building* (London and Boston, 1979).

R. Krautheimer, "Introduction to the 'Iconography' of Medieval Architecture," *Journal of the Warburg and Courtauld Institutes* 5 (1942), pp. 1–33.

R. Kroos, *Dom zu Regensburg: vom Bauen und Gestalten einer gotischen Kathedrale* (Regensburg, 1995).

——, "Liturgische Quellen zum Kölner Domchor," *Kölner Domblatt* 44/45 (1979), pp. 35–203.

J. Krüger, *S. Lorenzo in Neapel. Ein Franziskanerkirche zwischen Ordensideal und Herrschaftsarchitektur* (Werl, 1986).

H.-J. Kunst, "Freiheit und Zitat in der Architektur des 13. Jahrhundert," in K. Clausberg, ed., *Bauwerk und Bildwerk im Hochmittelalter* (Giessen, 1981), pp. 87–102.

E. Lambert, *L'Art gothique en Espagne aux XIIe. et XIIIe. siècles* (Paris, 1931).

R. de Lasteyrie, *L'Architecture religieuse en France à l'epoque gothique*, 2 vols. (Paris, 1926–7).

E. Lefèvre-Pontalis, "Comment doit-on rediger la monographie d'une église?" *Bulletin monumental* 70 (1906), pp. 452–82.

J.-M. Leniaud, *Cathédrales au XIXe siècle* (Paris, 1993).

——, *Viollet-le-Duc, ou, les délires du système* (Paris, 1994).

R. Mark, *Experiments in Gothic Structure* (Cambridge, 1982).

——, *High Gothic Structure: A Technological Reinterpretation* (Princeton, 1984).

C. Markschies, *Gibt es eine Theologie der gotischen Kathedrale. Nochmals Suger von Saint-Denis und Sankt Dionysius vom Areopag* (Heidelberg, 1995).

H. Masson "Le Rationalisme dans l'architecture du moyen âge," *Bulletin monumental* 94 (1935), pp. 29–50.

J. Mesqui, *Châteaux forts et fortifications en France* (Paris, 1997).

——, *Château et la ville: conjonction, opposition, juxtaposition, Xie–XVIIIe siècle*, 125e congrès des sociétés historiques et scientifiques, section archéologie et histoire de l'art, Lille, 2000, ed. G. Blieck and P. Contamine (Paris, 2002).

J. van der Meulen, *Chartres. Biographie der Kathedrale* (Cologne, 1984).

J. Michler, *Elisabethkirche zu Marburg in ihrer ursprünglichen Farbigkeit* (Marburg, 1984).

V. Mortet and P. Deschamps, *Recueil des textes relatifs à l'histoire de l'architecture et à la condition des architectes en France au moyen âge, Xe–XIIe siècles* (Paris, 1911).

K. Murphy, *Memory and Modernity: Viollet-le-Duc at Vézelay* (University Park, Penn., 2000).

S. Murray, *Beauvais Cathedral. Architecture of Transcendence* (Princeton, 1989).

——, *Building Troyes Cathedral. The Late Gothic Campaigns* (Bloomington, 1986).

——, *Notre-Dame, Cathedral of Amiens. The Power of Change in Gothic* (Cambridge, 1996).

A. Mussat, "Les Cathédrales dans leurs cités," *Revue de l'Art* 55 (1982), pp. 9–22.

L. Neagley, *Disciplined Exuberance: The Parish Church of Saint-Maclou and Late Gothic Architecture in Rouen* (University Park, Penn., 1988).

H. P. Neuheuser, "Die Kirchenweihbeschreibungen von Saint Denis und ihre Aussagefähigkeit für des Schönheitsempfinden des Abtes Suger," in *Mittelalterliches Kunstlerleben*, pp. 116–83.

C. Nodier, I. Taylor, and A. de Cailleux, *Voyages pittoresques et romantiques dans l'ancienne France* (Paris, 1819).

N. Nussbaum, *German Gothic Architecture* (New Haven, 2000).

E. Panofsky, *Abbot Suger on the Abbey Church of Saint-Denis and Its Art Treasures* (Princeton, 1979).

——, *Gothic Architecture and Scholasticism* (Latrobe, 1951).

A. W. Pugin, *Contrasts, or a Parallel between the Noble Edifices of the Middle Ages and the Correspondent Buildings of the Present Day during the Present Decay of Taste* (London 1836).

——, *The True Principles of Pointed or Christian Architecture* (London, 1843).

V. Raguin and P. Draper, eds., *Artistic Integration in Gothic Buildings* (Toronto, 1995).

R. Recht, *L'Alsace gothique de 1300 à 1365* (Colmar, 1976).

R. E. Reynolds, "Liturgy and the Monument," in V. Raguin and P. Draper, eds., *Artistic Integration in Gothic Buildings* (Toronto, 1995), pp. 57–68.

T. Rickman, *An Attempt to Discriminate the Styles of Architecture in England from the Conquest to the Reformation* (London, 1817).

I. Rowland, *Culture of the Italian High Renaissance* (Cambridge, 1998).

C. Rudolph, *Artistic Change at Saint-Denis: Abbot Suger's Program and the Early Twelfth-Century Controversy Over Art* (Princeton, 1990).

J. Ruskin, *The Seven Lamps of Architecture* (New York, 1849).

——, *The Stones of Venice* (London, 1851–3).

D. Sandron, *La Cathédrale de Soissons. Architecture de pouvoir* (Paris, 1998).

R. Sanfacon, *L'Architecture flamboyante en France* (Quebec, 1971).

W. Sauerländer, "Integration: A Closed or Open Proposal?" in V. Raguin and P. Draper, eds., *Artistic Intergration in Gothic Buildings* (Toronto, 1995), pp. 3–18.

——, "Mod Gothic," *New York Review of Books* 17 (Nov. 1984), pp. 43–4.

R. Scott, *The Gothic Enterprise: A Guide to Understanding the Medieval Cathedral* (Berkeley, 2003).

W. Schenkluhn, *Architektur der Bettelorden. Die Baukunst der Dominikaner und Franziskaner in Europa* (Darmstadt, 2000).

W. Schöller, *Die rechtliche Organisation des Kirchenbaues im Mittelalter vornehmlich des Kathedralbaues* (Cologne and Vienna, 1989).

H. Sedlmayr, *Die Entstehung der Kathedrale* (Zurich, 1950).

C. Seymour, *Notre-Dame of Noyon in the Twelfth Century* (New Haven, 1939).

O. von Simson, *The Gothic Cathedral: Origins of Gothic Architecture and the Medieval Concept of Order* (New York, 1964).

A. Speer, "Kunst als Liturgie. Zur Entstehung und Bedeutung der Kathedrale," in *Kein Bildnis Machen. Kunst und Theologie im Gespräch* (Würzburg, 1987), pp. 104–8.

R. Stalley, *The Cistercian Monasteries of Ireland: An Account of the History, Art and Architecture of the White Monks of Ireland from 1142 to 1540* (London and New Haven, 1987).

R. Sundt, "The Jacobins Church of Toulouse and the Origins of Its Double-Nave Plan," *The Art Bulletin* 71 (1989), pp. 185–207.

M. H. Tamir, "The English Origin of the Flamboyant Style," *Gazette des Beaux Arts*, ser. 6, 29 (1946), pp. 257–68.

B. R. Tamman, "Gervasius von Canterbury und sein *Tractatu de Combustione et Reparatione Cantuariensis Ecclesiae*," in *Mittelalterliches Kunsterleben*, pp. 264–309.

R. Toman, ed., *The Art of Gothic* (Cologne, 1998).

M. Trachtenberg, *Dominion of the Eye: Urbanism, Art and Power in Early Modern Florence* (Cambridge, 1997).

——, "Gothic/Italian 'Gothic': Toward a Redefinition," *Journal of the Society of Architectural Historians* 50 (1991), pp. 22–36.

——, "Suger's Miracles, Branner's Bourges: Reflections on "Gothic Architecture" as Medieval Modernism, *Gesta* 39 (2000), pp. 183–205.

J. Tripps, *Der handelne Bildwerk in dem Gotik. Forschungen zu den Bedeutungsschichten und der Funktion des Kirchengebäudes und seiner Ausstattung in der Hoch-und Spätgotik* (Berlin, 1998).

P. V. Turner, *Campus: An American Planning Tradition* (New York, 1984).

E. E. Viollet-le-Duc, *Dictonnaire raisonné de l'architecture française du Xe au XVIe siècle*, 10 vols (Paris, 1854–68).

M. Warnke, *Bau und Uberbau, Soziologie der mittelalterlichen Architektur nach den Schriftquellen* (Frankfurt, 1976).

D. Watkin, *Morality and Architecture: The Development of a Theme in Architectural History and Theory from the Gothic Revival to the Modern Movement* (Oxford, 1977).

J. Wetter, *Geschichte und Beschreibung des Domes zu Mainz, begleitet mit Betrachtungen über die Entwicklung des Spitzbogenstiles* . . . (Mainz, 1835).

J. W. Williams, *Bread, Wine and Money: The Windows of the Trades at Chartres Cathedral* (Chicago, 1993).

R. Willis, *The Architectural History of Canterbury Cathedral* (London, 1845).

C. Wilson, *The Gothic Cathedral: The Architecture of the Great Church, 1130–1530* (London, 1992).

A. Wolf, "Chronologie der esten Bauzeit des Kölner Domes," *Kölner Domblatt* 28–29 (1968), pp. 7–229.

C. Wright, *Music and Ceremony at Notre-Dame of Paris, 500–1500* (Cambridge, 1989).

N. Wu, ed., *Ad Quadratum: The Practical Application of Geometry in Medieval Architecture* (Aldershot and Burlington, Vt., 2002).

G. Zinn, "Hugh of St. Victor and the Ark of Noah: A New Look," *Church History* 40 (1971), pp. 261–72.

Gothic Sculpture from 1150 to 1250

Martin Büchsel

The sculpture of the period from *c*.1150 to *c*.1250 is usually labeled "Gothic." Primarily associated with the cathedral, sculpture developed rapidly until around 1250. Most of the leading workshops of Gothic sculpture were attached to cathedrals, and their artistic leadership came from French abbeys after the Romanesque period.[1] The exteriors of Gothic cathedrals became the setting for large sculptural projects of a size that had never before been seen. The outside of Chartres Cathedral displays about 2,000 pieces of sculpture; Reims Cathedral has even more. Rood-screens (*jubés*), too, were covered with sculpture. Unfortunately, only fragments are left in France to tell us about their once lavish programs; most of them were destroyed during the seventeenth century. Rood-screens functioned as barriers to restrict the view of the chancel from the nave at the celebration of the Mass.

Defining sculpture of this period as "cathedral sculpture" becomes even more convincing once we notice the changes in the character of such work after 1250, when the outsides of church buildings were no longer covered with large amounts of sculpture. For example, Sainte-Chapelle at Paris, which functioned as a chapel for the royal palace and which was built to house the Crown of Thorns (recently brought from Constantinople), marks the end of our period. Its sculptural program consists primarily of statues of the twelve Apostles which flank the shrine where the crown was located. Elsewhere as well, sculptures inside churches, often made for chantry chapels, became more dominant.

Although monumental architectural sculpture is the main subject of our considerations, we should note that other forms of sculpture were not without importance between 1150 and 1250. Sculptured altarpieces – wooden Madonnas, for example – played a significant role, and the same is true for the work of goldsmiths. Delicate ivory carvings appear at the end of our period, particularly

in Paris.[2] But the exterior sculptural decoration of the cathedral has a very different developmental potential from that of the more restricted liturgical art. Exterior sculpture has no actual liturgical function. While it often represents the liturgy, it also includes programs that are far removed from the liturgical, such as the masks of Reims. Sculpture between 1150 and 1250, therefore, allows for a varied vocabulary.

France is the starting-point of the Gothic sculpture that soon found its way to England (Wells, Winchester, London), Spain (Sangüesa, Burgos, Léon), and the Empire (Strasbourg, Bamberg, Naumburg, Magdeburg). "Gothic" became more and more the common language of European sculptural production.

Early Gothic Sculpture

Gothic sculpture of French cathedrals has been interpreted according to a number of different themes, including its subordinate relation to architecture, its otherworldly spirituality, realism, the study of nature, the discovery of the individual, the reception of the antique, and proto-humanism.[3] These sometimes opposing ideas have two different causes: first, the fact that Gothic sculpture is not homogenous and, second, a desire to convey a general idea of what the cathedral is.

The portals of the west façades at St Denis, Chartres, and Paris[4] have a clear arrangement, consisting of tympana, lintels, archivolts, and jambs. This arrangement seems to represent the new spirit of these portals. But it is in fact the jamb statue which is the new invention, being both an element and a sign of the new, more clearly articulated arrangement. Discussion of Gothic sculpture often revolves around the column (jamb) statue. The new porch of Abbot Suger's abbey church was dedicated in 1140.[5] The invention of jamb statues and their great influence on the development of Gothic sculpture allows us to distinguish the sculptures of these portals as "early Gothic," in contrast to the Romanesque sculpture that had come before. Jamb statues are connected to the column behind them but appear nevertheless to be in front of the column. They are a form of relief sculpture, although this is visually far from obvious.[6]

The column statues at St Denis were removed during the eighteenth century and only some fragments of the heads are preserved. But we know something about them thanks to the engravings of Montfaucon. The series of jamb statues which extended over three portals created a new monumentality. Each statue was distinct from the others. Jamb statues were only frontally arranged during the early Gothic period, and the creation of series of column statues proclaims a new message, which has not yet been fully interpreted. The tympanum of the central portal at St Denis depicts the Last Judgment, the one at Chartres the Majestas Domini – subjects that were both well known from Romanesque portal programs. A new invention, however, is the desire to show a series of witnesses. Jamb statues represent typological figures from the Old Testament, members of

the *ordo propheticus*, and saints. This is, however, not the place to discuss the meaning of jamb statues in detail.[7]

Contemporaries were apparently impressed by the portals of St Denis. We can find successors not only in Chartres and Paris but also in such different places as the French capitals of the Plantagenets – Le Mans and Angers – and in Champagne, Burgundy, and Berry. But even though an epoch always has a real starting point, it is only succession that produces the beginning.[8] It is therefore not important whether the jamb statue is an original invention of St Denis or whether it has forerunners in Romanesque sculpture.[9]

The royal portals of Chartres, dating from the middle of the twelfth century, are famous by virtue of how well preserved they are (fig. 19-1). The rebuilding of the cathedral in 1194, however, probably caused several changes.[10] Five of the jamb statues were lost and were replaced by columns in 1830. Today we can find 19 column statues in situ, some of them casts whose originals are now deposited in the crypt. The central portal as a whole conveys an impression of great harmony. Most of the jamb figures have not been identified in spite of how well preserved they are. Only the figure of Moses is certain. There are a surprising number of queens, something for which no convincing interpretation has yet been given. The great number of kings and queens is responsible for the term "royal portals," evoking the idea of a representation of the French monarchy. The queens in particular have continued to fascinate scholars. The romantic Joris-Karl Huysmans admired the fresh, enchanting smile of the so-called Queen of Sheba. He also called her a fragile spindle, a stem of celery that has been put over a waffle pattern which has been carved in wax; the queen's soul is apparently filled with the glory of God.[11] So far from such a poetic conception did the German art historian Wilhelm Lübke take these jamb statues to be that he described them as servants who have received a command. But he also noticed the high quality of the expressions on their faces.[12] This description, continued by Wilhelm Vöge,[13] is even present in modern interpretations.[14]

What is the reason behind such a controversial perception? The queens of the west central portal demonstrate a new style of figure: they are attached to columns and at the same time present a new intensity of facial expression. They are works of the "Headmaster"[15] – but this traditional attribution says nothing about the organization of the workshop: it is only acceptable as a "stylistic term." Nor do we know anything about the organization of the cathedral's workshops.[16]

The concentration upon the central axis, denying completely every traditional device meant to indicate pose, is significant. There is no need for any indication of weight breaking the stance since all movement is aligned along the central axis. The drapery of the queens emphasizes the vertical composition of very fine folds. The differences between these statues and those at St Denis are obvious, since the movement of the jamb statues is in significant contrast to their relation to the column. At St Denis the "dancing" of the Romanesque figural vocabulary seems to have bound the statues to the column.[17] The architecture seems to

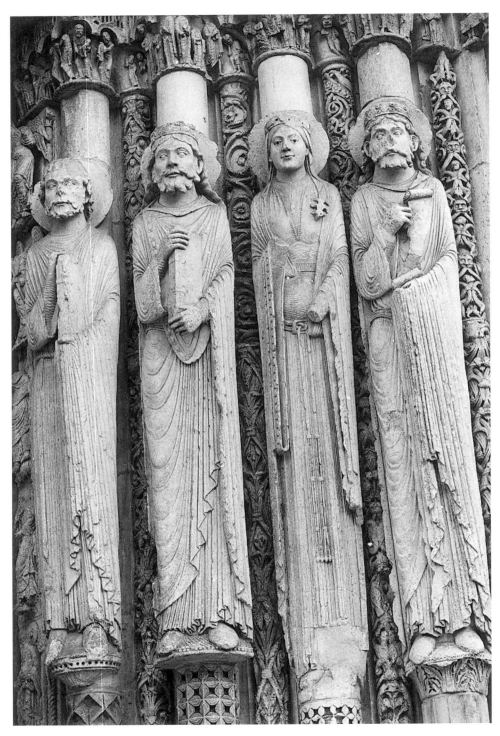

FIGURE 19-1 Central west portal, Chartres Cathedral, *c.*1150.

present the sculpture in a new arrangement. But at Chartres, the sculptor has created a fresh style for the jamb statues. The static element has been reduced. The foot hangs down over a sloping basis; the bare parts of the body, the head and the hands, have become the dominant features. The clothed body is a foil in front of which the hands form their gestures and present objects to explain their texts. The faces are of a wonderful beauty. The queens wear contemporary clothes in spite of their vertical styling and the upper parts of their bodies know something of the charms of wearing these clothes.

The sculpture shows no sign that the body might have been understood as a totality. Each part of the body has in fact a different expression and meaning. This is no invention of Chartres, but can be found since the middle of the eleventh century – as the so-called "Siechhaus Madonna" in the Liebieghaus of Frankfurt demonstrates.[18] The jamb statues of Chartres are in this sense comparable with the contemporary wooden Madonnas of the Auvergne. Up to the latest period of Gothic sculpture, it is normal for the upper part of the body to be clothed in modern dress. But, below the waist, the rhetoric of the drapery frees itself increasingly from any semblance of naturally hanging folds.

The Antique Tendency of the Early Thirteenth Century

The vocabulary of the early Gothic style is rarely seen after *c.*1200, with the cathedrals of Paris, Laon, and Sens demonstrating a great interest in the antique or in antique models (fig. 19-2).[19] The orientation toward the antique is not the only significant phenomenon of this period. Although other ideas become dominant later, the recourse to the antique still existed and explains many significant compositions. It is not only found in monumental sculpture. The works of goldsmiths show the same tendency, as the so-called altar of Verdun in Klosterneuburg, dated to 1181, and the Shrine of the Three Kings in Cologne produced by the same artist around 1200, demonstrate. The legal code, known as the Constitutiones Augustales, of Emperor Fredrick II is a famous example of the imitation of antiquity. Some scholars believe that kings and emperors in particular were responsible for the promotion of the use of antique models.[20] But it is possible in only a few cases to demonstrate that a figure from antiquity has been directly copied. Job's head from a relief of Notre Dame in Paris, showing him amongst his wife and friends, comes very close to an antique portrait bust.[21] Only the sculptors of Reims between 1220 and 1233 seem to have concentrated on a more direct connection with the antique.[22] But here, too, the number of antique models used is very small. The sculpture of Laon from around 1200 is comparable to the images of the Ingeborg Psalter.[23] Objects of early Christian and Byzantine art preserved in church treasuries may have had some influence. The depiction of finely rendered drapery and graceful movement is impressive after the linearism of the early Gothic. The question whether

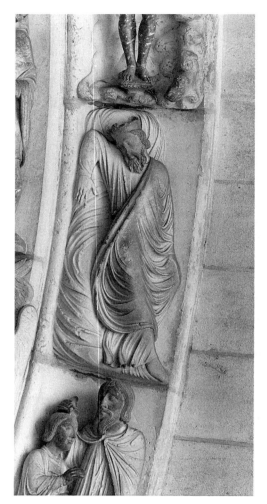

FIGURE 19-2 Nebukadnezar, from left west portal, Laon Cathedral, *c*.1200.

the antique style was meant to be understood as consciously imitating antique models is still under discussion. It seems impossible to find in the famous Visitation of Reims, which is very similar to antique statues, a spirituality that is very different from those in other images of Mary and Elizabeth which are not based on antique models. The Gothic sculptors avoided the mythological aspect in contrast to the Carolingian reception of the antique. Gothic sculpture showing Christian subject matter does not repeat mythological personification, the sculptors distinguishing between style and iconography.[24]

The antique tendency represents a great change, but it was not the only course of artistic development at the beginning of the thirteenth century. The sculpture of the transept of Chartres Cathedral shows that, while it was possible for the antique style to become schematic, another workshop might give it new life. The very rich sculptural decoration of the two façades of the transept is part of the ambitious rebuilding after 1194. The decoration extends over six portals and the projecting porch. The sculptures, if we follow the recent theory of Kurmann, were for the most part put in place only after both they and all the ashlar masonry had been carved.[25] The sculptures were probably made over a period of 40 years.

The north transept consists of three sculpted portals, with that of the Triumph of Mary in the center and the Epiphany and the story of Job on either side. The south transept has the Last Judgment in the center flanked by those of the Martyrs and Confessors. Workshops from Laon and Sens were responsible for the execution of the sculptures, each developing very differently.

The workshop of Laon presents a new conception of jamb statues based on the antique style. Its masters were responsible for the Annunciation and the Visitation groups of the Epiphany portal. In both groups, the address of Gabriel

and Elizabeth mitigates the frontality of the compositions as their bodies are turned toward Mary. The sculptures give the appearance of being less attached to the column behind them than those discussed above. The antique style of Gabriel culminates in a head of curly hair.[26] But this style is less pronounced in the tympanum of the Triumph of Maria by the same workshop. A new kind of linearism dominates this tympanum, which is the programmatic center of the portal. It seems to reflect the desire for a new style. Around the same time, the Virgin portal at Notre-Dame in Paris achieved a general similarity in facial depiction, something that gives a strong sense of harmony to the entire portal and is felt to have a positive meaning.[27]

Similarity is also the driving force behind the Last Judgment of the south central portal at Chartres. The jamb statues mirror those of the royal portals of the west façade. The feet, again, hang down. The Beau Dieu, the most characteristic sculpture of the new movement, has a body that is again a foil against which large hands carry a voluminous book. The axially arranged head has achieved full natural proportions and demonstrates the underlying principles of symmetry and uniformity.[28] It seems to realize nearly the same idea as the early Gothic jamb figures of the west central portals,[29] but was produced by a workshop whose tradition was based on the antique style.

The new schematism is combined with another novel phenomenon. The many figures of the Last Judgment portal apparently forced the sculptors to create more simply composed sculptures. Most of them are of a much lower quality than the Beau Dieu. The Apostles at the jamb accompanying Christ have been called stereotypical or uniform by some scholars.[30] They are not in fact uniform, but rather repeat a few motifs over and over.[31] The necessity of producing a great number of sculptures was also responsible for the lower quality at Amiens.

The other workshop at Chartres, coming from Sens, took a very different direction. Their first work comprised the sculptures of the Job-Solomon portal (fig. 19-3).[32] The differences between these and those of the first workshop appear all the greater since the Sens sculptures were produced at the same time as those of the Last Judgment. The Job-Solomon portal is unique in that it is the only portal of a French Gothic cathedral to show scenes from the Old Testament exclusively. While the element of the antique style is no less obvious than before, the sculptors have employed a very different vocabulary. It is not possible to characterize the style in general, since the vocabulary took its distinctive forms from many sources. The positive connotation of stylistic similarity shown in the Last Judgment of the south transept is employed here to characterize the angels of the inner archivolt in contrast to evil, whose appearance is much more "realistic." The Queen of Sheba in the same portal is one of the most charming and lively sovereigns of the Gothic period, who, in the process of walking, picks up her clothes, gently pulls on the corded clasp of her cape and addresses herself to King Solomon. The antique style made the sculptors aware of nature. But this does not seem to constitute a sufficient explanation. This female figure, with her full heavy hair and a fleshy face, stands in contrast to the

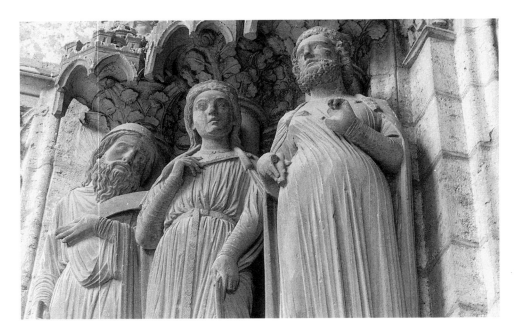

FIGURE 19-3 Balaam, Queen of Sheba, and King Solomon, from right northern portal, Chartres Cathedral, *c*.1220.

slender young Judith at the other side of the jamb. And never before has evil found such an intensive expression in a Gothic portal as in those who torment Job in the tympanum and in the heads of the tyrants in the archivolts. Pejorative characterization is the driving force behind this individualization. It has drastically formed the faces of two of the friends of Job, who is sitting on the manure heap, scratching his abscesses, given over to Satan's claws. Pejorative physiognomies separate the bad from the evil counselors inside the scene of the Judgment of Solomon, located in the lintel. The "counterface" to all this can be seen in the jamb statue of Solomon, with his wonderful curly hair and eyes of enormous visual power, whose sockets have been deeply carved out. That the face of Solomon is the "counterface" to the evil faces becomes obvious when we compare it with the heads of the tyrants in the lowest voussoirs of the archivolts. The discovery of the "Königsköpfe" by Wilhelm Vöge has shown a new aspect of Gothic sculpture. Physiognomic and pathognomic mediums[33] formulate the visages of the tyrants. In contrast to Solomon, one king with a contemporary hairstyle has a shriveled beard and a turgid eye. Two others show signs of anger.[34] This is not the place for a discussion of the program of the portal. Nevertheless, the typological aspect of the imagery does make some allusions to contemporary history, with the blind Job or the hero-like Samson becoming figures of multiple meanings,[35] something that must be kept in mind if we are to understand these types.

The so-called "divergence of style" phenomenon became famous through the sculpture of the transept of Chartres Cathedral. Wilhelm Vöge was the first to remark on this divergence,[36] thereby influencing the discussion of scholars for a long time. Sauerländer saw here a style existing beside the "mainstream," whose route we can follow from Sens to Strasbourg.[37] The idea that the vocabulary of the workshop of the Job-Solomon portal might be related to its typological program suggests that the portal is an integration of stylistic elements of very different sources, which are used to distinguish the different types within the portal.[38] Vöge characterized the "Master of the Kings' Heads" as an artist of unusual genius, a forerunner of the artists of the Renaissance, a visionary, removed from the sculptors who were mere servants of the overarching spiritual unity of the cathedral.[39] The "Master of the Kings' Heads" would deny this idea of an overarching unity without individualism, without an interest in nature. Emile Mâle begins the first chapter of his book about thirteenth-century French art with the statement that art of this period was organized like a dogma which excludes every individual artistic fantasy.[40] But Vöge found in the "Master of the Kings' Heads" an artist with just such an individual attitude. Vöge accepted, however, the characterization of medieval art that Mâle and others have given with regard to mainstream art. The dominant workshops were, according to this theory, responsible for carving the sculptures in all the prominent places of the south façade, whereas the workshop of the Job-Solomon portal was responsible for the less important portal on the north side.

While Vöge has found an artist of the proto-Renaissance, it was Erwin Panofsky who found the proto-humanistic patron. This role was assigned to Abbot Suger, who supposedly anticipated the Platonism of the Renaissance in his use of Pseudo-Dionysian thought.[41] Not much is left today of the picture of the proto-humanistic Abbot Suger.[42]

It is necessary here to discuss again the question of what realism in Gothic sculpture is. The study of nature is not the antithesis of the spirituality prevalent in the art of the time. The interest in individualism, as in the Job-Solomon portal and the so-called masks of Reims, demonstrates a conception of individuality that was supposed to be a deviation from the will of heaven. Considered a vice, it was seen as self-destructive, a kind of sinful fantasy. Many theologians therefore identify fantasy with heresy. Medieval theology has views not only about "*ordo*", but also about individualism and fantasy. The latter were both thought of as vices. We find the same idea and the same kind of realism in Dante's *Divina Commedia*.[43]

Realism, as art historical discussion has demonstrated,[44] has as many stereotypes as so-called non-realistic art. The realism of physiognomy and pathognomy can be transformed into a rhetorical system. The masks of Reims are full of pejorative projections, as is the imagery of the passion of the saints. In the Job-Solomon portal, the idea of similarity is bound to the images of angels. But it is problematic to distinguish between Gothic sculptures along the lines of "ideal" and "realistic," which are the terms usually employed in art history. There are

too few representations of living persons to allow a discussion as to whether depictions of contemporary persons employ the iconographical types found in hagiographical imagery.

Reims and Paris: The New Dignity and Statuary Presence of Sculpture in the mid-Thirteenth Century

The constitution of rhetorical stereotypes seems to be the main impetus behind the "pathognomical revolution" at Reims. The rebuilding of Reims Cathedral took place between 1210 and the beginning of the second half of the thirteenth century.[45] The sculpture of Reims documents a period of about 50 years. The early years were still very much influenced by the Triumph of Mary at Chartres. The years around 1230 saw an orientation toward antiquity. The use of models from Amiens starts some years later. The figures, which are of great statuary presence, were carved during the final period – perhaps between 1245 and 1255. The creation of a rich and authoritative body of sculptures at the cathedrals is obvious.

No other cathedral can boast a number of sculptures comparable to Reims. The entire west façade is covered with sculptures up to the figures in the buttress *aediculae* of the towers. Sculptures are located in the buttress *aediculae* above the choir ambulatory and in the *aediculae* of the high buttresses of the nave. The reveals of the rose windows include reliefs. The blind triforium of the transept has console-figures of busts and heads, the so-called masks, which we can also find in the archivolts of the clerestory windows and below the eaves of the towers of the transept. Atlantes can be found above the buttresses of the choir and the nave. The sculptures are not restricted to the portals alone, as they were in the early Gothic sculptural programs. Even the inner side of the west façade is decorated with niches for figures. The wealth of places for sculptural display enables every kind of sculptural art to find a place in the cathedral.

The smiling angels, in particular, are very famous.[46] The way in which they display emotion is entirely new. Theologians had determined that the blessed in heaven, too, have emotions: the emotion of joy, which is indicated through smiling.[47] The passions of martyrs also received a new intensive expression. Dionysius' half-closed eyes and the half-opened mouth without lips – at the jamb of the west left portal – expresses the passion of a man whose head has been chopped off and who has brought this head to the place where he wants to found his place of patronage. The masks are the counterparts to the smiling angels and the suffering saints. These are almost invisible to the average visitor at the church. They are without any liturgical function. They were nevertheless a great influence upon later Gothic art as models for facial expressions. Their interpretation leads to the same problem of understanding realism as has been discussed above. Some scholars see only the decorative results of the study of nature; in contrast, others interpret these images as pictures of the vices and of outcasts.[48] No other facial expression of the masks is shown as often as is the

expression of laughing. Laughing was apparently used as a sign to denote the vices in contrast to the smile of the blessed.[49] To characterize vices only through facial expression was entirely new. It seems as if the artists had studied the pantomime of the jongleurs.[50] The composite creatures, typical of Romanesque sculptures, are transformed into animal-like physiognomies. Similar examples of the study of facial expressions can be found in the archivolts which depict the Apocalypse and which date only slightly later. Never before did Gothic sculpture produce such an image of the terror of the Last Days.

Some sculpture has great statuary presence and dignity. The so-called Vierge dorée of the south portal of Amiens Cathedral is no longer a relief but stands free in front of the trumeau, emancipated from the architecture.[51] The Madonna is related to the Madonna of the trumeau of the northern portal of Notre-Dame in Paris, but the Vierge dorée is a new composition. The Vierge dorée addresses herself to the child, not only with her face but also with her whole bearing, in contrast to earlier trumeau Madonnas who present the child frontally – the same feature can be seen in the case of the Madonna of the west right portal of Amiens. The enormous volume and weight of the body contribute to the staging of this address. The Vierge dorée had a great influence upon the work of goldsmiths and ivory carvers.

Most of the jamb statues of Reims from the years 1245–55 are sculpturally very expressive, even though they are fixed to the columns. John the Evangelist of the west left portal (fig. 19-4) reminds one almost of an orator of antiquity. The book becomes a minor attribute compared to the freestanding leg. The folds of the flowing drapery which cover the weight-bearing leg are dominant. John turns his head to the side of his weight-bearing leg, where his equally flowing hair falls in fashionable curls. One of the preconditions of this new depiction of presence in the sculpture is the recent method of representing drapery which had been devised by the sculptors of Amiens.[52] In the beginning, the "large-fold style"[53] was developed as a means of simplifying the depiction of drapery necessitated by the demands of mass production. But the resultant ability to depict volume led to new means of expression. Drapery was no longer an ornamental structure applied to the figure; it now adopts the aspect of a material which takes its form according to the movement of the body. The reliefs of the Creator in the archivolts of the porch of the north right portal of Chartres demonstrate how effective this drapery style could be in depicting the volume of seated figures.[54] Soon, a new rhetorical vocabulary of drapery was created through large dish-shaped folds.

The sculptors of the mid-thirteenth century used the cathedral like an enormous model book. Recourse to an older vocabulary can be frequently found. One of the latest sculptures of the north porch of Chartres, St Modesta, borrows some elements from the sculpture of the north central portal, incorporating them into the new style.[55] The head of one of the Apostles of Sainte-Chapelle – today in the Musée de Cluny – reverts to an older type, probably in order to achieve a greater differentiation.

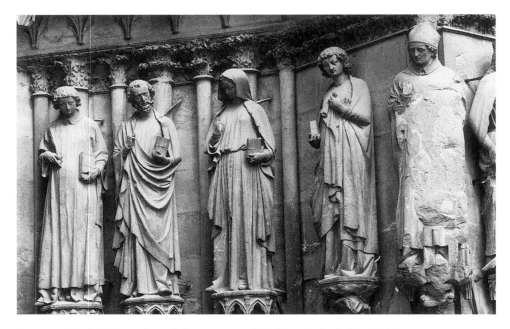

FIGURE 19-4 Saints, from left west portal, Reims Cathedral, *c*.1250.

These Apostles flank the shrine of the Crown of Thorns. Attached to the pillars of the upper church, they demonstrate the eagerness of the patron to find new places and functions for sculptures which could bring new meaning to their character. The leading workshops of the Empire show the same phenomenon. The sculptures of the Judgment Pillar of Strasbourg Cathedral are closely linked to the tradition of the workshop which came from Sens to work at Chartres.[56] The Gothic sculpture of Bamberg mirrors the classicizing sculpture of Reims.[57] The workshop of the donor-figures of Naumburg demonstrates the same dignity and statuary presence as the sculpture at Reims around the middle of the thirteenth century, although there are no specific connections. The context, nevertheless, has brought about significant changes. The unusual idea of displaying, inside the choir, images of nobles who had died long before, probably in order to honor them as patrons, resulted in an apparently arbitrary selection of figures. Their unusual position inside the choir seems to reflect the transformation of the position of the Apostles at Sainte-Chapelle.

It is also in the middle of the thirteenth century that we find divergent interests in studying the body and in creating a hieratic mode. There were few opportunities to present the nude in the Middle Ages. Adam and Eve in paradise is one. The sculptor of the Adam of the south transept of Notre-Dame in Paris – now in the Musée de Cluny – took advantage of the new possibilities. This life-sized statue demonstrates an interest in the nude combined with the study of an antique model never to be seen again until the beginning of the

Quattrocento. The figure is not without Gothic elements, but it also shows many anatomical details similar to those found in works from antiquity.[58] But we would miss the point if we tried to define the period on the basis of figures like this one alone. Realism more often entails a single expressive motif than an original mentality. For example, the various levels of sanctity may be distinguished in the depiction of holy figures. The late sculptures of Reims give us the opportunity to understand better the way in which this is done. It has been remarked that the head of the Virgin on the trumeau of the west central portal and the head of a figure not far away – identified as a servant of the Virgin, part of a Presentation scene – both employed the same model. But the fleshiness of the face found in the servant has been altered in the case of the Virgin. The cheeks are less full, the smile is formed almost without lips. The eyebrows are nothing more than the upper part of the eye-sockets. The depiction of the Virgin is the result not so much of a general stylistic conception as a characterization of Mary as the patron of the church in her central position in the trumeau.[59]

The hieratic mode of the middle of the thirteenth century is known as "court style."[60] This term derives from the fact that Paris was the seat of the French court. Indeed, Paris, the royal capital, becomes more and more the center of art. Book painters, ivory carvers, goldsmiths: they all went to Paris as the place with the best opportunities for their skills. The production of art in the city increasingly focused on style to the exclusion of other possibilities. It is still open to discussion whether we can really find the ideal of the court in the face of the court-style Virgin, or whether we can talk of a sublimation of the French Gothic.[61] The works of ivory carvers and goldsmiths are based on the sculptures of the cathedrals. This is demonstrated by the Virgin of Sainte-Chapelle, today in the Louvre, and the Virgin of St Denis, now in Cincinnati. The appearance of these works becomes more important at a time when the large sculptural projects in the cathedrals were coming to an end. Ivories now became the leading expressions of French Gothic. This change can hardly be underestimated: the end of the large sculptural programs of the cathedrals marked the end of an epoch, and, with it, a wide range of sculptural production ceased to be produced. It becomes difficult to find after this period artistic undertakings of an ecclesiastical nature in which experiments like the Reims masks were possible. The cathedral tradition in the German Empire, in contrast, was not broken. This is one of the premises of the great importance of the sculptures of the west portals of Strasbourg Cathedral which were executed at the end of the thirteenth century. After this, German sculpture could no longer be described as a reflection of the development in France.

Notes

1　[On Romanesque sculpture, see chapters 15 and 16 by Hourihane and Maxwell respectively in this volume (ed.).]

2 [On the sumptuous arts, see chapter 22 by Buettner in this volume (ed.).]

3 [On Gothic architecture, see chapter 18 by Murray in this volume (ed.).]

4 Vöge, *Anfänge*; Stoddard, *Sculptors of the West Portals*; Sauerländer, *Königsportal in Chartres*; Villette, *Portails de la cathédrale*; Grodecki, "Première sculpture gothique". Erlande-Brandenburg, *Notre Dame de Paris*, pp. 27–8, dates the right west portal of Paris to before 1148, whereas it was usual to date the portal to 1163; cf. Sauerländer, *Gotische Skulptur*, pp. 87–9. Erlande-Brandenburg's argument is convincing. [On sculptural programs in general, see chapter 26 by Boerner in this volume (ed.).]

5 Hoffmann, "Königsportale in Saint-Denis," pp. 29–38; Crosby, *Royal Abbey of Saint-Denis*, pp. 167–213; Blum, *Early Gothic Saint-Denis*; Büchsel, *Geburt der Gotik*, pp. 135–80; Brown, *Saint-Denis*, pp. 77–112.

6 Kurmann-Schwarz and Kurmann, *Chartres*, p. 208. The central aspects of the description of the jamb statues have been around for more than 100 years.

7 Beaulieu, "L'iconographie des statues-colonnes," pp. 273–307.

8 It is therefore always easy to criticize the stylistic distinction between periods; cf. Suckale, "Unbrauchbarkeit der gängigen Stilbegriffe," pp. 231–50. But most critics cannot produce an alternative solution.

9 Sauerländer, *Jahrhundert der grossen Kathedralen*, p. 56, sees it as an original creation; Vöge, *Anfänge*, pp. 8–49, as the transformation of Romanesque concepts as at Arles and Toulouse. Kurmann-Schwarz and Kurmann, *Chartres*, p. 213, give no answer but ask for a new discussion. See also Watson, "Origins of the Headmaster," pp. 363–81.

10 Kurmann-Schwarz and Kurmann, *Chartres*, pp. 209–11, summarize the whole discussion of the creation and changes of the west façade and find a new explanation for the irregularities. The reasons might be found in the problem of the transportation of the stones, which were brought from quarries around Paris.

11 Huysmans, *La Cathédrale*, p. 200; Viollet-le-Duc, *Dictionnaire*, p. 118, described the column statues as the remains of a schematic Byzantinism, calling them "bunches of asparagus," "mummies wrapped in bandages."

12 Lübke, *Geschichte der Plastik*, p. 375.

13 Vöge, *Anfänge*, pp. 9–10.

14 Sauerländer, *Königsportal in Chartres*, pp. 5–12; Villette, *Portails de la cathédrale*, p. 25.

15 Vöge, *Anfänge*, p. 67–69; Stoddard, *Sculptors of the West Portals*, p. 130.

16 Kurmann-Schwarz and Kurmann, *Chartres*, p. 211.

17 Büchsel, *Geburt der Gotik*, p. 164; Kurmann-Schwarz and Kurmann, *Chartres*, p. 212, observe the same difference comparing the Chartres figures with those at Autun.

18 Büchsel, *Ottonische Madonna*, p. 25.

19 Hoffmann, *Year 1200*, talks about "style 1200."

20 Sauerländer, *Jahrhundert der grossen Kathedralen*, pp. 77–8.

21 Ibid., p. 94; Erlande-Brandenburg, *Notre-Dame de Paris*, pp. 114–15.

22 Sauerländer, "Antiqui et Moderni," pp. 19–37, is more inclined to see a connection to Trier, which would have been introduced by goldsmiths.

23 Kitzinger, "Byzantine Contribution," p. 39; Sauerländer, "Sculpture on Early Gothic Churches," p. 43.

24 Büchsel, *Skulptur des Querhauses*, pp. 112–13.

25 Kurmann-Schwarz and Kurmann, *Chartres*, pp. 79–94.

26 Büchsel, *Skulptur des Querhauses*, pp. 23–5.

27 Sauerländer, "Kunsthistorische Stellung," pp. 23–5.

28 Büchsel, *Skulptur des Querhauses*, pp. 20–7.

29 Vöge, "Bahnbrecher," p. 72, has already remarked on this phenomenon. This is discussed by Gosebruch, "Bedeutung des Gerichtsmeisters," pp. 142–86. Kurmann-Schwarz and Kurmann, *Chartres*, pp. 213–20.

30 Vöge, "Bahnbrecher," p. 74.

31 Büchsel, *Skulptur des Querhauses*, pp. 27–9; Kurmann-Schwarz and Kurmann, *Chartres*, believe that it is incorrect to describe the figures of the Last Judgment as being of lesser quality.

32 Büchsel, *Skulptur des Querhauses*, pp. 54–93.

33 Giuliana, *Bildnis und Botschaft*, has introduced a distinction between physiognomy and pathognomy into the archaeological discussion.

34 Büchsel, "Königsbilder," pp. 127–33.

35 Katzenellenbogen, *The Sculptural Programs*, p. 67; Levis-Godechot, *Chartres*, pp. 155–6, 173–6.

36 Vöge, "Bahnbrecher," pp. 63–97.

37 Sauerländer, *Von Sens bis Strassburg*.

38 Büchsel, *Skulptur des Querhauses*, pp. 79–93.

39 Vöge, "Bahnbrecher," p. 67.

40 Mâle, *L'Art religieux du XIIIe siècle*, p. 29.

41 Panofsky, *Abbot Suger*.

42 Büchsel, "Ecclesiae symbolorum," pp. 74–5; Büchsel, "Die von Abt Suger," pp. 57–63; Markschies, *Suger von Saint-Denis*, pp. 46–60.

43 Büchsel, *Skulptur des Querhauses*, pp. 70–4; Büchsel, "Königsbilder," pp. 127–33.

44 Giuliani, *Bildnis und Botschaft*; Himmelmann, *Realistische Themen*; "Das realistische Porträt."

45 The question of dating is under discussion: Kurmann, *Façade de la cathédrale*, pp. 19–25; Hamann-MacLean and Schüssler, *Reims*, vol. II, pp. 317–21; Decrock and Demouy, *Reims*, pp. 170–3, 211–19. Hamann-MacLean/Schüssler and Sauerländer date the sculpture of the west portals – without the early group – to between 1230 and 1255, Kurmann and Decrock/Demouy to between 1235/45 and 1275. Kurmann dates the classicizing sculpture to between 1241 and 1245.

46 Svanberg, "Gothic Smile," pp. 357–70.

47 Büchsel, "Königsbilder," p. 137.

48 Reinhardt, *Reims*, p. 156, sees only a decorative function of the masks; Hamann-MacLean and Schüssler, *Reims*, p. 67, see more the result of an intensive study of nature. Fraenger, *Masken von Reims*, Sauerländer, "Physiognomik," p. 104, and Büchsel, "Königsbilder," pp. 133–9, stress the pejorative dimension. Wadley, *Reims Masks*, p. 30, has found undoubted examples of virtue–vice representations.

49 Sauerländer, "Gelächter des Teufels," pp. 36–42.

50 Fraenger, *Masken von Reims*, p. 13; Sauerländer, "Physiognomik," p. 104.

51 Kimpel and Suckale, "Vierge Dorée," pp. 217–19, date the Vierge dorée to between 1235 and 1240; Sauerländer, *Jahrhundert der grossen Kathedralen*, p. 267, to around 1250.

52 Kurmann, *Reims*, pp. 174–9.

53 Branner, *Manuscript Painting*, p. 97.
54 Büchsel, *Skulptur des Querhauses*, pp. 129–32.
55 Ibid., pp. 139–41.
56 Sauerländer, *Gotische Skulptur in Frankreich*, pp. 124–5; *Von Sens bis Strassburg*.
57 The question of how the strong relation between Reims and Bamberg can be explained is under discussion; cf. Sauerländer, "Reims und Bamberg," pp. 167–92; Suckale, "Bamberger Domskulpturen," pp. 27–92; Feldmann, *Bamberg und Reims*, pp. 63–76.
58 Erlande-Brandenburg, *Notre-Dame de Paris*, p. 190.
59 Büchsel, *Skulptur des Querhauses*, pp. 116–17. Kurmann, *Façade de la cathédrale de Reims*, p. 268, explains the similarity between the faces of the Madonna and the servant by introducing the idea of a specialist for chiseling heads.
60 Branner, *Saint Louis*; Sauerländer, *Jahrhundert der grossen Kathedralen*, p. 89; Adams, "Column Figures of Chartres," pp. 153–62.
61 Sauerländer, *Jahrhundert der grossen Kathedralen*, pp. 254, 267.

Bibliography

Roger J. Adams, "The Column Figures of Chartres Northern Foreportal and the Monumental Representation and Saint Louis," *Zeitschrift für Kunstgeschichte* 36 (1973), pp. 153–62.

Michele Beaulieu, "Essai sur l'iconographie des statues-colonnes de quelques portails du premier art gothique," *Bulletin monumental* 142 (184), pp. 273–307.

Pamela Z. Blum, *Early Gothic Saint-Denis, Restorations and Survivals* (Berkeley, LA, Oxford, 1992).

Robert Branner, *Saint Louis and the Court Style* (London, 1965).

——, *Manuscript Painting in Paris during the Reign of Saint Louis* (Berkeley, LA, London, 1977).

Elisabeth A. R. Brown, *Saint-Denis, La basilique* (Saint-Léger-Vauban, 2001).

Martin Büchsel, "Die von Abt Suger verfassten Inschriften. Gibt es eine ästhetische Theorie der Skulptur im Mittelalter?" in Herbert Beck and Kerstin Hengevoss-Dürkop, eds., *Studien zur Geschichte der Europäischen Skulptur im 12./13. Jahrhundert*, vol. I (Frankfurt, 1994), pp. 57–63.

——, "Ecclesiae symbolorum cursus completus", *Städel-Jahrbuch*, N.F. 9, (1989), pp. 69–87.

——, *Die Geburt der Gotik, Abt Sugers Konzept für die Abteikirche Saint-Denis* (Freiburg i. Br. 1993.

——, "Nur der Tyrann hat sein eigenes Gesicht, Königsbilder im 12. und 13. Jahrhundert in Frankreich und Deutschland," in Martin Büchsel and Peter Schmidt, eds., *Das Porträt vor der Erfindung des Porträts* (Mainz, 2003).

——, *Ottonische Madonna*, Liebieghaus Monographie, 15 (Frankfurt, 1993).

——, *Die Skulptur des Querhauses der Kathedrale von Chartres* (Berlin, 1995).

Summer McKnight Crosby, ed., with Pamela Z. Blum, *The Royal Abbey of Saint-Denis* (New Haven and London, 1987).

Bruno Decrock and Patrick Demouy, "Die Skulptur," in Patrick Demouy, ed., *Reims, Die Kathedrale* (Regensburg, 2001).

Alain Erlande-Brandenburg. *Notre-Dame de Paris* (Paris, 1997).

Hans Christian Feldmann, *Bamberg und Reims, Die Skulpturen 1220–1250, Zur Entwicklung von Stil und Bedeutung der Skulpturen in dem unter Bischof Ekbert (1203– 37) errichteten Neubau des Bamberger Doms unter besonderer Berücksichtigung der Skulpturen an Querhaus und Westfassade der Kathedrale von Reims* (Hamburg, 1992).

Wilhelm Fraenger, *Die Masken von Reims, Mit 38 Abbildungen, Einer Einleitung und der Legende "Tänzer unserer Lieben Frau"* (Erlenbach, Zürich, Leipzig, 1922).

Luca Giuliani, *Bildnis und Botschaft, Hermeneutische Untersuchungen zur Bildniskunst der römischen Republik* (Frankfurt, 1986).

Martin Gosebruch, "Zur Bedeutung des Gerichtsmeisters am südlichen Querhaus der Kathedrale von Chartres," in *Argo*, Festschrift für K. Badt (Köln, 1970), pp. 142–86.

Louis Grodecki, "La 'première sculpture gothique', Wilhelm Vöge et l'état actuel des problèmes," *Bulletin monumental* 117 (1959), pp. 265–89.

Richard Hamann-MacLean and Ilse Schüssler, *Die Kathedrale von Reims*, vol. II, *Die Skulpturen* (Stuttgart, 1996).

Nikolaus Himmelmann, "Das realistische Porträt als Gattungserscheinung in der griechischen Kunst," in Martin Büchsel and Peter Schmidt, *Das Porträt vor der Erfindung des Porträts* (Mainz, 2003) pp. 19–28.

——, *Realistische Themen in der griechischen Kunst der archaischen und klassischen Zeit* (Bonn, 1994).

Konrad Hoffmann, "Zur Entstehung der Königsportale in Saint-Denis," *Zeitschrift für Kunstgeschichte* 48 (1985), pp. 29–38.

——, *The Year 1200, A Centennial Exhibition at the Metropolitan Museum of Art* (New York, 1970).

Joris-Karl Huysmans, *La Cathédrale* (Paris, 1980).

Adolf Katzenellenbogen, *The Sculptural Programs of Chartres Cathedral, Mary, Christ, Ecclesia* (Baltimore, 1959).

Dieter Kimpel and Robert Suckale, "Die Skulpturenwerkstatt der Vierge Dorée am Honoratusportal der Kathedrale von Amiens," *Zeitschrift für Kunstgeschichte* 36 (1973), pp. 217–65.

Ernst Kitzinger, "The Byzantine Contribution to the Western Art of the Twelfth and Thirteenth Centuries," Dumbarton Oaks Papers 20 (1966), pp. 25–67.

Peter Kurmann, *La façade de la cathédrale de Reims, Architecture et sculpture des portails, Étude archéologique et stylistique* (Lausanne, 1987).

Brigitte Kurmann-Schwarz and Peter Kurmann, *Chartres, Die Kathedrale* (Regensburg, 2001).

Nicole Levis-Godechot, *Chartres révélée par sa sculpture et ses vitraux* (Paris, 1987).

Wilhelm Lübke, *Geschichte der Plastik*, vol. I (Leipzig, 1870).

Emile Mâle, *L'Art religieux du XIIIe siècle en France, Etude sur l'iconographie du moyen âge et sur ses sources d'inspiration*, 8th edn. (Paris, 1948).

Christoph Markschies, *Gibt es eine Theologie der gotischen Kathedrale? Nochmals: Suger von Saint-Denis und Sankt Dionys vom Areopag*, Abhandlungen der Heidelberger Akademie der Wissenschaften, Philosophisch-historische Klasse (Heidelberg, 1995).

Erwin Panofsky, *Abbot Suger on the Abbey Church of St.-Denis and Its Art Treasures*, 2nd edn. (Princeton, 1979).

Hans Reinhardt, *La Cathédrale de Reims* (Paris, 1963).

Willibald Sauerländer, "Antiqui et Moderni at Reims," *Gesta* 42 (2003), pp. 19–37.

——, "Vom Gelächter des Teufels zur Ironie der Philosophen," *Jahrbuch der Bayerischen Akademie der Schönen Künste* 13 (1999) pp. 30–70.

——, *Gotische Skulptur in Frankreich 1140–1270* (München, 1970).

——, *Das Jahrhundert der grossen Kathedralen 1140–1260* (München, 1989).

——, *Das Königsportal in Chartres, Heilsgeschichte und Lebenswirklichkeit* (Frankfurt, 1984).

——, "Die kunsthistorische Stellung der Westportale von Notre-Dame in Paris," *Marburger Jahrbuch für Kunstwissenschaft* 17 (1959), pp. 1–56.

——, "Über Physiognomik und Porträt im Jahrhundert Ludwigs des Heiligen," in Martin Büchsel and Peter Schmidt, eds., *Das Porträt vor der Erfindung des Porträts* (Mainz, 2003), pp. 101–21.

——, "Reims und Bamberg," *Zeitschrift für Kunstgeschichte* 39 (1976), pp. 167–92.

——, "Sculpture on Early Gothic Churches: The State of Research and Open Questions," *Gesta* 9 (1970), pp. 32–48.

——, *Von Sens bis Strassburg* (Berlin, 1966).

Whitney S. Stoddard, *The Sculptors of the West Portals of Chartres Cathedral, Their Origins in Romanesque and Their Role in Chartrain Sculpture (Including the West Portals of Saint-Denis and Chartres)* (Harvard, 1952; repr. New York and London, 1987).

Robert Suckale, "Die Bamberger Domskulpturen," *Münchner Jahrbuch* 38 (1987), pp. 27–82.

——, "Die Unbrauchbarkeit der gängigen Stilbegriffe der französischen gotischen Architektur des 12. und 13. Jahrhunderts," in Friedrich. Möbius and Helga Sicurie, eds., *Stil und Epoche, Periodisierungsfragen* (Dresden, 1989), pp. 231–50.

Jan Svanberg, "The Gothic Smile," *Künstlerischer Austausch. Artistic Exchange, Akten des XXXVIII.* Internationalen Kongreses für Kunstgeschichte, Berlin, July 15–20, 1992, ed. Thomas W. Gaehtgens, vol. II (Berlin, 1993), pp. 357–70.

Jean Villette, *Les Portails de la cathédrale de Chartres* (Chartres, 1994).

Eugène-Emmanuel Viollet-le-Duc, *Dictionnaire raisonné de l'architecture française du XIe au XVIe siècle*, vol. 8 (Paris, 1866).

Wilhelm Vöge, *Die Anfänge des Monumentalen Stiles im Mittelalter, Eine Untersuchung über die erste Blütezeit französischer Plastik* (Strasbourg, 1894).

——, "Die Bahnbrecher des Naturstudiums um 1200," in Erwin Panofsky, ed., *Bildhauer des Mittelalters, Gesammelte Schriften* (Berlin, 1958).

William Bert Wadley, "The Reims Masks, A Reconstruction, Stylistic Analysis and Chronology of the Corbel Sculptures on the Upper Stories of Reims" (Ph.D. thesis, University of Texas at Austin, 1984).

Carolyn Joslin Watson, "The Origins of the Headmaster of the Royal Portal of Chartres Cathedral," *South-eastern College Art Conference Review* 12 (1995), pp. 363–81.

Gothic Manuscript Illustration: The Case of France

Anne D. Hedeman

During the thirteenth century, Paris, the French capital, was one of the largest cities in Europe and, arguably, the center of European manuscript production. Home to a powerful court and to one of the preeminent universities in Europe, Paris was a market for a broad range of manuscripts, and thus was a leader and model for all of Europe.

As a result of these particular circumstances, French manuscripts, particularly Parisian ones, have long been the focus of scholarly analysis and serve as an appropriate case-study for methodological approaches to Gothic manuscript illustration. This chapter will describe how some recent methodological approaches have built on fundamental studies of style to shape and reshape our perception of Gothic book production. It will track how the interest in codicology, genre studies, and interdisciplinarity have posed new questions about the production and consumption of the illuminated book.[1]

Style

Stylistic analysis remains a central component of art historical practice and an essential foundation for other approaches to the book. Volumes by Vitzthum and Porcher established broad parameters for discussion of French style in the Gothic period to 1300, which subsequent scholars have refined and are just beginning to replace.[2] In his posthumously published book, Robert Branner combined information drawn from diverse sources ranging from liturgical usage and historical associations to property records from the Abbey of St Geneviève

to anchor groups of manuscripts in Paris and to create a picture of book production in the capital. He grouped and localized stylistically related manuscripts around securely dated and localized nuclei, defining a series of at least 20 "ateliers" whose work he described in an extensive series of appendices and illustrated in more than 400 images. His book remains an important contribution and a starting point for scholars working on Parisian material, but it has a central flaw: it assumes that manuscripts were produced by ateliers made up of a master artist and multiple assistants who were in charge of the book's execution.[3] There is little evidence for the existence of such large ateliers in Paris. Indeed several subsequent studies of Parisian book production have used external documentary evidence in conjunction with careful codicological analysis (see discussion below) to suggest that manuscript production and decoration in Paris was probably overseen by a coordinator, usually a *libraire* (bookseller) affiliated to the university of Paris, who would subcontract work to small family businesses of artists.[4] Thus, differences in styles in manuscript paintings were probably due to a *libraire* distributing individual segments of a manuscript to diverse artists as part of regular working practices, rather than an artistic atelier that was unable to meet its deadlines hurriedly farming sections of the book out to another atelier. Further, we know that many of these artists practiced their craft in distinctive sections of Paris, most typically the Rue Neuve Nostre Dame near the cathedral and the Rue Erembourg de Brie near St Séverin on the left bank.

But where can we find stylistic information about other centers in France or in the French orbit? To the bibliographic overview given by Bräm we must add François Avril's contribution to the catalogue for the 1998 Parisian exhibition, *L'art au temps des rois maudits*, which sketches a broad outline of distinct Parisian and regional styles.[5] In his catalogue essay, Avril suggests that French regional styles of high quality emerge after St Louis's death in 1270, first in the powerful fiefs in the north, such as Amiens, Arras, Cambrai, Saint-Omer, Thérouenne, Saint-Quentin, and Soissons (all equally in the stylistic orbit of the Netherlands, England, and the Rhineland), in Metz in Lorraine (an imperial city), and in Toulouse, the center of French power in Languedoc and a university town which produced a significant number of law books toward the end of the thirteenth century. Avril cautions that the Parisian model, in which *libraires* supervise book production, is not appropriate for other regions of France where artists did not experience the job security offered by a diverse and large clientele for books. Avril admits that there is a lot about the artist's life, social status, and working methods that we simply do not know. His catalogue entries of 27 Parisian manuscripts and 38 from other centers concentrate on stylistic analysis, at which he excels, and outline the state of research on each manuscript's text, its documentary or liturgical localization, and its patronage. The beauty of the non-Parisian manuscripts exhibited in *Les rois maudits* whets the appetite for Alison Stones's forthcoming book, which will focus on the thirteenth century and broaden our background on manuscripts produced in centers of French influence outside Paris.

Codicology

Since its début in the 1970s as an auxiliary discipline in manuscript studies, codicology, or the archaeology of the book, broadened the understanding of artistic practice in the Gothic period. Codicology's concern with all aspects of book production has produced scholarship that explores different facets of artistic practice. Analyses of production – from the preparation and ruling of parchment; to the scribe's writing of the text leaving spaces for illustration, decorated initials, or marginalia; to the binding of the book – have clarified the artist's place in book production and emphasized the importance of careful observation and study of manuscripts themselves. Although there is a long tradition of studying indications to artists in manuscripts and artist's drawings, scholars have begun to pay renewed attention both to model books and to the use of written directions to illuminators and of marginal sketches that guided the artists in the illustration of both familiar and new texts.[6] Scholars also examined other marginal marks and notes to piece together what they reveal about individual artists' organization of their work. For instance, Stirnemann and Gousset have discovered color notes and signs that prescribe decorative patterns to be used in painting backgrounds for initials and miniatures, marginal indicators for alternating of color in flourished initials, indications for payment that reveal medieval technical vocabulary for describing initials, and marks designed not for payment as Branner had previously speculated, but to remind an artist of the number of initials he was to paint on a bifolium or gathering of bifolia entrusted to him for illustration.[7] One interesting aspect of their research to date is the suggestion that the systems devised to indicate color seem highly personalized in the Gothic period. Data derived from analyses like these may eventually be used in combination with connoisseurship to aid stylistic attribution. For instance, Stirnemann's analysis of filigrane initials in manuscripts securely attributed to Paris and to the regions of lower Champagne and upper Burgundy shows the utility of secondary decoration as an indicator of the localization of books.[8]

Codicological analysis can also establish broader parameters for understanding book production in the Gothic period. In a masterful book, historians Mary and Richard Rouse combined codicological study of surviving manuscripts produced by the Parisian book trade, analysis of documents involving individual commissions and individual participants in the book trade (the scribes, illuminators, bookbinders, parchment-sellers, paper-sellers, and *libraires*), and evidence drawn from modern research on the textual and art historical content of the manuscripts to describe the Parisian book trade from the thirteenth to early sixteenth centuries.[9] Their discoveries show how fruitful the integrated study of all aspects of a manuscript can be, making clear that knowledge about the place and the social network within which scribes, illuminators, bookbinders, parchment-sellers, and *libraires* plied their trades helps us ask appropriate questions of the

manuscripts we study. Thus, for instance, their book makes substantial contributions to such long-standing art historical topics as the debate about the identity of "Master Honoré" and of the Papleu Master (whom the Rouses suggest might be Honoré d'Amiens and his son-in-law Richard de Verdun), or the role of centers of patronage in the dissemination of illuminated texts.[10]

The organization of the Parisian book trade under the loose regulation of the university and in response to diverse types of patronage was probably not replicated elsewhere in France in the Gothic period. Nonetheless, there is more to do to analyze production in other French centers using an interdisciplinary approach comparable to that employed by Richard and Mary Rouse. Future interdisciplinary publications will doubtless result from the foundations provided by books like the analysis of the production of art in St Omer that is based upon a thorough analysis of the rich archives in St Omer, Lille, and Arras.[11]

Interdisciplinary Approaches and the Emerging Study of Secular Illustration

One of the most fruitful developments in art historical manuscript studies from the last quarter of the twentieth century is the proliferation of interdisciplinary analyses grounded in the manuscripts themselves. Such analyses assume diverse shapes; their focus ranges from study of literary genre, narrative, reception, or patronage, to topics inspired by postmodernism, like recent studies of marginalia. Despite their different methodologies, most start from a careful examination of individual manuscripts and develop through active engagement with other fields, either through collaboration with colleagues from historical or literary studies or through the exploration of shared questions.[12]

Recent publications on the *Bible moralisée*, a book containing densely illuminated excerpts from the Bible accompanied by paired pictorial and textual commentary, show how valuable it can be when scholars from distinct fields employ different methodologies to approach a literary genre. Until 2000, most scholars first saw these manuscripts in facsimiles of either the French version (of Vienna Österreichische Nationalbibliothek, Codex Vindobonensis 2554) or of one of the three-volume Latin manuscripts (the copy now preserved as Oxford, Bodleian Library, MS Bodley 270b; Paris, Bibliothèque nationale de France, Ms. lat. 11560; and London, British Library, MSS Harley 1526–27).[13] The priority given these manuscripts by their publication shaped analysis of the text and image of the literary genre as a whole, reinforcing the philological contention that editing (or in this case, publishing) is interpretation.[14]

John Lowden returned to the manuscripts, examining the seven earliest *Bibles moralisées*, each decorated with thousands of images, within the frame of their production and consumption in order to offer a fresh appraisal of the relationships between them.[15] His book presents a complex picture of the evolution and interaction of individual manuscripts, and tracks the afterlife of diverse *Bibles*

moralisées as they move through the hands of sequential owners in France, England, and Spain. He combines a codicological analysis of all seven manuscripts in volume one with a careful analysis in volume two of the potential modes of viewing and reading of the book of Ruth, which they all share. Lowden successfully evokes multiple audiences for the *Bible moralisée* and begins to address questions concerning the authorship of the text and the relationships between textual and visual narratives in the diverse manuscripts. He sketches diverse audiences: authors and artists who actively consume and respond to the works of their predecessors; kings, queens and princes who dip into the books; and other owners who treasured the work, unbound, for years, possibly without even reading or looking at it.

Lowden's examination of the book of Ruth across the multiple copies of the *Bible moralisée* dispels some long-held myths. He questions whether the text of the *Bible moralisée* was constructed systematically by a university master or theologian, as scholars have postulated since the 1920s. He observes that the text of the manuscript family was not fixed; rather it was rethought for each manuscript in "an additive process that was followed in search of 'improvement'." Further, he suggests that images had priority, particularly in the earliest French manuscript. The pictures were painted first by accomplished artists who knew the Bible better than the caption's writers did, and who, in the commentary's illustrations, constructed images of "reality" by shaping new artistic conventions. Lowden shows that the seven early *Bibles moralisées* were not produced as copies of a prior authoritative model, but as a series of variations on a theme. His analysis links both the texts and the images of these manuscripts in a chain of production in which written word and painted image "improve in various ways on their predecessors."

Lowden's findings encourage further research into both the construction and the reception of these books. If as he suggests, the corpus has little influence outside its textual "family," why is that? Does the sophistication of the visual referencing described in these volumes find an echo in biblical illustration from other manuscripts painted by the same Parisian artists?

A book by Sara Lipton, a historian, complements Lowden's and contributes a different perspective on how the images of the *Bible moralisée* construct meaning.[16] Less concerned with artistic practice than with the *Bible moralisée*'s role in internalizing and shaping contemporary political attitudes, Lipton examined the visual and verbal representation of Jews in the two earliest manuscripts (Vienna Österreichische Nationalbibliothek, Codex Vindobonensis 2554 and 1179). Her analysis successfully evokes visual imagery's potential to create a rhetorical structure, a visual language of signs, that shaped the meaning of the moral teachings embodied in the manuscript. Unlike Lowden, Lipton is not as invested in establishing the priority of images, as in showing their rhetorical power in partnership with their text and with contemporary political attitudes. She argues that the contemporary subjects of the new commentary images and their texts in the *Bible moralisée* challenged artists and authors to translate familiar biblical

scenes into visually associated thirteenth-century equivalents. She establishes how these thirteenth-century scenes are linked to their visual biblical analogue and its textual caption, but at the same time, are distinct from them. Her readings of the visual and textual signs employed to bridge gaps between biblical past and French present allowed her to unravel one thread: "the unarticulated, but influential factors underlying French Jewish policy."

Lipton reveals herself to be a sensitive viewer of images and a formidable historian as she tracks the visualization of verbal abstractions, even those with a long exegetical tradition, as they take a vividly contemporary and secular turn. In modernizing, the pictures incorporated and redeployed anti-Jewish imagery of a type traditionally classed as popular, and represented the behaviors of bad kings and philosophers, heretics, and misguided students as "Jewish" behavior.

If Lowden is right, most medieval readers would dip into the book, rather than read it from cover to cover as Lipton did. For them, the "piling on, broadening, and deepening of the anti-Jewish themes" may not have been as evident as it was to Lipton or, arguably, to those who constructed the manuscript in the first place. Nonetheless, readers in the thirteenth century would doubtless recognize the modernity of the book and its discrete anti-Semitic elements, even when they experienced just one or two pages at a time.

Recent publications on vernacular romance and *chansons de gestes* by scholars working across disciplinary boundaries also reshaped analyses of images in secular manuscripts. The manuscripts of Chrétien de Troyes attracted significant attention in the 1990s, when the collaborative team of Busby, Nixon, Stones, and Walters brought out a two-volume corpus. This assembled analytical essays by 18 scholars, catalogue descriptions of the 45 extant manuscripts of Chrétien de Troyes, reproductions of all the miniatures, and selected reproduction of the range of scribal hands and decorative initials in the manuscripts.[17] Almost simultaneously, Sandra Hindman published a sociopolitical reading of seven of the manuscripts that, together with Busby's corpus, raised important questions about the reception of manuscripts.[18]

Hindman's book and Stones's and Busby's articles in their corpus have the greatest utility to art historians trying to understand Arthurian imagery.[19] Their contributions were ably described in a review article by Huot, who noted their significance for the study of the medieval reception of Chrétien and their methodological importance in showing how an integrated analysis of the evidence provided by the medieval book provides a context for literary reception.[20] Huot signaled Stones's fundamental contribution in identifying and describing the stylistic hands that produced manuscripts of Chrétien's texts and others. She was stimulated by Hindman's and Busby's explorations of oral and literate culture and their relationships to manuscripts of Chrétien's romances. While Hindman analyzed the Chrétien manuscripts as embodying both prose-type and verse-type illustrations, Busby suggested that the reception of prose and verse had been assimilated by the thirteenth century so that the mere inclusion of illustrations in thirteenth-century copies of Chrétien's verse romance suggests the appropriation

of the later prose text models. Busby noted that the illuminated Chrétien manuscripts date not from Chrétien's lifetime, but later – from precisely the period in which the illuminated prose Lancelot-Grail cycle and other prose Arthurian texts proliferated. He postulated that the intertextual relationship between thirteenth-century prose romances and Chrétien's verse romances helps explain why certain scenes popular in prose romance were chosen for illustration when Chrétien's text finally received pictures. Huot described the challenge that Hindman's and Busby's findings pose to students of secular material:

> Medieval readers did not approach Chrétien in a vacuum; they read his works through the intervening lens not only of the subsequent *Continuations* [of Chrétien's text], but also of prose romance. That these altered modes of receiving twelfth-century romance should be reflected in manuscript format and illustration is perhaps not surprising: nonetheless, it is an important point whose ramifications have yet to be fully explored.[21]

Huot's discussion of Hindman's and Busby's work suggests a way to explore both the construction of these manuscripts and their reception. One avenue for further research would be to examine the visual communities within which the artists worked – the imagery that they knew and manipulated – in order to explore the impact of visual vocabulary on shaping the reception of both Chrétien's verse romance and Arthurian prose romance. Stones has shown that the artists who illustrated these texts also illustrated epic, song, romance, and books for private devotion and for liturgical use, and she has begun to explore visual modes used for sacred and secular texts in the early thirteenth century. She discusses the shared patterns that artists used for diverse literary genres in a series of publications where she suggests that visual motifs frequently take on a status independent of their textual genre so that these building blocks of visual narrative are neither sacred nor secular.[22]

Blurred Literary Genres and the Study of Imagery

The interpenetration of sacred and profane texts and images are an intriguing area for further research. Are there situations where motifs did not gain independence of their origins as illustrations of the sacred or profane? If so, could these motifs be used by artists to make an intentional *intervisual* reference to an alternate literary genre? Did artists ever deliberately create a secular image with a sacred resonance or a sacred image that has a secular resonance? Are there cases where such references are undeniable and where it is clear that their function was to shape a reader's response?

A recent publication suggests that this could happen – at least in a pair of thirteenth-century manuscripts: the Morgan Picture Bible (New York, Pierpont Morgan Library, M. 638) and a mid-thirteenth-century Flemish psalter (Los

Angeles, Getty Museum, Ms. 14).[23] Mann describes how artists visualized bib-
lical tales in the Morgan Picture Bible. He analyzes the contribution that the
manuscript's lively and detailed painted style makes to the visual cycle's narrative
structure and to the relationship between the manuscript's vivid scenes of battle
and the literary descriptions of battles in *chansons de gestes*. He also describes an
intriguing feature of the Morgan Picture Bible that helped solidify the chivalric
reception of the images: the use of inscriptions on the blades of five swords.[24]
Some inscriptions make sense in the context of the manuscript, as, for instance,
when the inscription "Golias" on the sword with which David beheads Goliath
in the Morgan Picture Bible clarifies that David used the giant's own sword to
execute him. Others only make sense within a broader secular frame within
which, as Mann indicates, biblical battle scenes seemingly exploit "the epic
character of their textual sources to transform sacred history into a tale
of great deeds and heroic actions."[25] Thus Mann describes how many sword
inscriptions found in the Morgan Picture Bible and in the Getty Psalter, such as
"IOIOUSE", "COURTE," and "DURNDAL," were derived from the *Song of Roland*,
in which they are the swords of Charlemagne (Joyeuse), Ogier le Dane
(Courtrain), and Roland (Durendal).

　The blurring of genres that these inscriptions accomplish, particularly in the
Morgan Picture Bible, is powerful. While the introduction of the inscriptions –
originally the only words written in the manuscript – conflates biblical heroes
and French epic warriors, this conflation operates on a generic level in the
Morgan Picture Bible. Only in the Getty Psalter (fig. 20-1) does a named figure,
David, bear a labeled sword; "Durndal" associates him with Roland. In the
Morgan Picture Bible, by contrast, the book's designer seems to have been
careful to give named swords only to anonymous soldiers: one of Saul's emis-
saries sent to kill David bears the sword marked "Courte" (fig. 20-2, upper
register), one of David's soldiers wields "Odismort" (fig. 20-3), and a Philistine
uses "Ioiouse" (also fig. 20-3).[26] The anonymity of the soldiers bearing the
swords in the Picture Bible makes it more likely that the swords' inclusion
would successfully foster a generic literary association between biblical history
and *chansons de gestes*, rather than a specific association between the biblical King
David and Charlemagne. This is different from the practices in court ceremonial,
where comparisons were explicit by the reign of Philip III when the royal sword
used in the coronation ceremony was first identified as "Joyeuse," the sword of
Charlemagne, in order to associate Capetian rulers specifically with their most
famous Carolingian ancestor.[27]

　The Getty Psalter and Morgan Picture Bible are not by the same artist, but
the artists who painted these manuscripts clearly practiced within an environ-
ment in which the classic battles of *chansons de gestes* and of the Bible were freely
associated by painters and readers.[28] Through the semiotic sign of the inscribed
sword, artists economically and deliberately secularized sacred imagery and
contextualized the artistic vocabulary of lively battle scenes, so that viewers of
biblical imagery would see the pictures through the lens of "the narrative structure

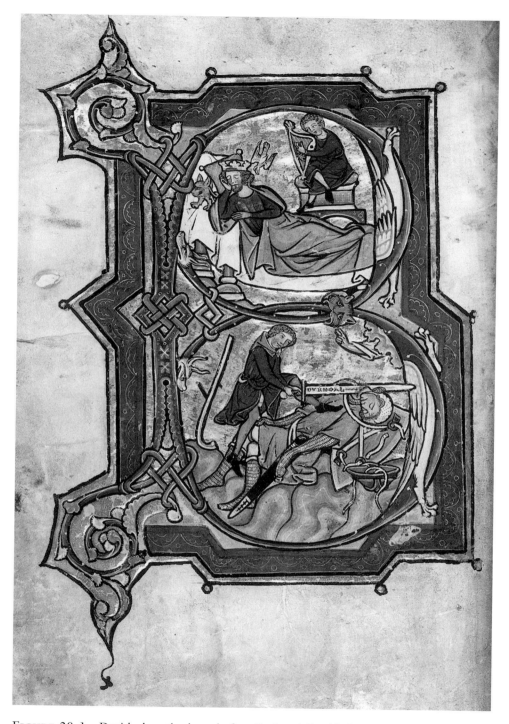

FIGURE 20-1 David plays the harp before Saul and David slays Goliath, from Psalter.
J. Paul Getty Museum, Los Angeles, MS 14, fol. 16v. Reproduced courtesy of the
J. Paul Getty Museum.

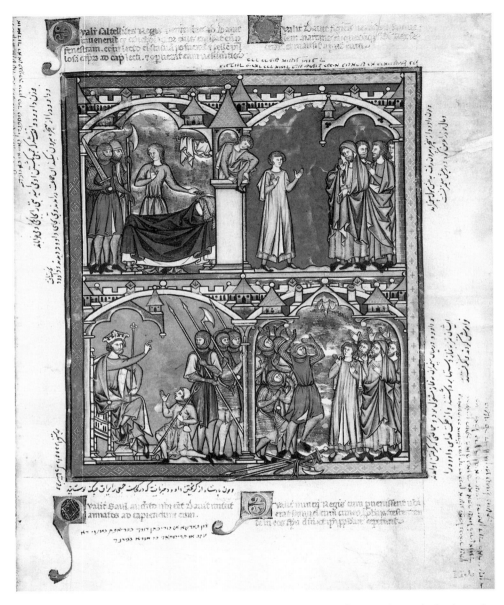

Figure 20-2 Michal's ruse for saving David's life; David flees to Samuel; Saul sends armed men to kill David; Saul's messengers throw down their arms and prophesy, from Morgan Picture Bible. New York: Pierpont Morgan Library MS M. 638, fol. 31. Photo: Pierpont Morgan Library.

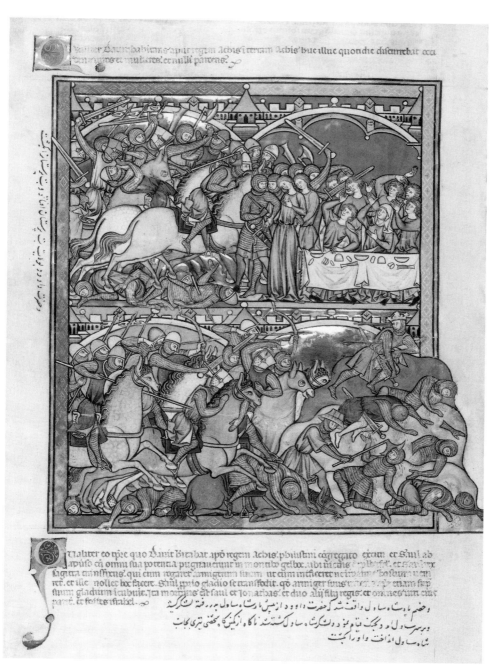

FIGURE 20-3 David attacks feasting Amalekites; Saul and three of his sons fall before the Philistines, from Morgan Picture Bible. New York: Pierpont Morgan Library, MS M. 638, fol. 34v. Photo: Pierpont Morgan Library.

of French romance."[29] In this case, motifs function very differently from the neutral "shared artists' patterns" that Stones described for the early thirteenth century when secular illustration was neither as elaborate nor as sophisticated as sacred illustration.

What happens during the course of the thirteenth century as time passes and secular illustration becomes more elaborate? Were deliberate blurrings of boundaries between religious and romance illustrations more common? What was the relationship between these genres and the illustration of newly emerging historical texts in prose vernacular? Gabriel Spiegel established a theoretical framework for addressing this question in a series of articles and a book that consider French vernacular historical writings.[30] Her book explores the ideological underpinnings of the shift from verse epic and prose romance to prose historiography with its development of a language of "fact," and her articles model ways to approach medieval histories as literary forms that incorporate signs of both the historical period and the social forces that generated them.[31]

The points Spiegel makes about texts raise interesting questions about the manuscripts that contain them. Manuscripts are physical objects made at specific moments that mediate between readers, with their external and diverse appropriations of a text, and the text itself. From an art historical standpoint, the imagery adapted and devised for the earliest copies of a new text and the very different imagery devised for later copies of the same text are of interest. How does the selection and deployment of illustration change the historical meaning and reception of a secular text as it moves through time and is claimed by different audiences? Enough groundwork has been done on illuminated manuscripts of individual texts to facilitate this inquiry, and research now looks across genres and finds purposeful interaction between them.[32]

Consideration of a pair of related images from a *Grandes Chroniques de France* and a *Roman de Troie* will exemplify the important contribution that imagery can make in signaling relationships between texts. In her study of the corpus of illuminated copies of the *Roman de Troie*, Morrison has shown that the earliest illuminated manuscript of the verse romance (Paris, Bibliothèque nationale de France, Ms. fr. 1610) was painted in Paris in 1264, probably for a member of the Capetian court. Ten years later, the first *Grandes Chroniques de France* (Paris, Bibliothèque St Geneviève, Ms. 782), a prose chronicle, was made in Paris and presented to King Philip III.[33] Both of these illuminated books were illustrated almost 100 years after the translation of the *Roman de Troie* from Latin into French, at the exact time that vernacular history was first being deployed in the service of the Capetian kings of France.[34]

The visual relationship between the first illuminated *Roman de Troie* (fig. 20-4) and the introductory miniature of the first *Grandes Chroniques* (fig. 20-5) parallels the development that took place in Arthurian romance almost 40 years earlier.[35] In both cases there was a lag in the illustration of one text until a moment when its themes and stories spark renewed interest and other texts incorporating them appear. Thus the manuscripts of Chrétien de

FIGURE 20-4 Priam dispatches Paris to Greece; Paris sets sail; Paris captures Helen at the Temple of Venus; Massacre of Greeks. Leaf exised from *Roman de Troie*. S'Heerenberg. Stichting Huis Bergh.

FIGURE 20-5 Priam dispatches Paris to Greece; Paris sets sail; Paris captures Helen at the Temple of Venus; Paris and Helen set sail for Troy, from *Grandes Chroniques de France*. Paris: Bibliothèque Sainte-Geneviève, MS 782, fol. 2v. Photo: Bibliothèque Sainte-Geneviève.

Troyes are first illuminated well after Chrétien's death but contemporaneously with the emergence of illuminated prose romances like the Lancelot-Grail cycle. The *Roman de Troie* is first illustrated well after its appearance, but contemporaneously with the *Grandes chroniques de France*. Both the Trojan romance and the chronicle incorporate illustrations featuring the story of Troy, which was of increasing ideological significance to St Louis and to the Capetian court in the late thirteenth century.

Morrison cautions us that this migration of imagery between what modern scholars see as distinct genres of romance (poetic fiction) and chronicle (prose fact) should remind us that our modern distinction between fiction and history was more permeable in the Middle Ages. Language used in the dedicatory poem (fol. 326v) to the first *Grandes chroniques* reinforces this observation, describing the text as "le romanz qui des rois est romez" (the *roman* [romance?] that is written in French about the kings).[36] The intervisual relationship between the first illustrated *Roman de Troie* and the first *Grandes chroniques* signals a relationship that was understood much better in the late thirteenth than in the early twenty-first century. Thus the analysis of the imagery in the visual cycles of these manuscripts in relation to each other is essential for a true historical understanding of the texts' deployment in the thirteenth century.[37] Points of harmony and disjuncture between the pictures and their texts are essential guides to modern scholars who are interested in recuperating ideological and intertextual relationships.

The independent visual narrative of the *Roman de Troie* recasts the story to emphasize the related themes of "the perfidy of the Greeks, the importance of leadership, and above all, the heroism of Hector."[38] The third full-page miniature of the romance (fig. 20-4) is a negative representation of Paris' impulsive gesture that led to the second destruction of Troy. Its upper register emphasizes the folly of King Priam who listens to his son Paris volunteer to be sent to Troy. Those around Paris react strongly: Paris' brother Hector, who was concerned about the greater strength of the Greek forces, and his sister Cassandra, who predicted the destruction of Troy if Paris took a Greek wife, appear beside their brother. The middle register shows the arrival of the Trojans outside the Greek city, and the lower represents Paris' embrace of Helen, visualizing the "love at first sight" that led to her abduction, and the ignoble massacre of Greeks in prayer at the temple.[39]

Not more than ten years after the *Roman de Troie* was illuminated, an artist devising pictures for the new *Grandes chroniques* turned to it as an appropriate visual source for the chronicle. He reconceptualized the *Roman de Troie*'s illustration to fit the chronicle's expressed goal of offering the young King Philip III examples of good and bad kingship to emulate and to shun.[40]

The frontispiece of the *Grandes chroniques* (fig. 20-5) is clearly a variation on the image of the *Roman de Troie*. This image accompanies a text that states that the Trojan King Priam sent his son Paris to carry off Queen Helen in order to avenge an earlier slight by the Greeks. The book's designer edited the model

from the *Roman de Troie* to promote that message. In the upper register, Paris kneels alone before King Priam before setting sail for Troy. The lower register reconceptualizes Priam's and Helen's meeting in the temple; it does not emphasize their impulsive love at first sight, so much as the forceful abduction that was Paris' act of revenge.[41] Helen's crown emphasizes her superior social status to Paris, and Paris grabs her wrist in a classic gesture of rape. His embrace of her shoulder with his right arm may be a residual influence of his model, for it offers Helen protection in a gesture that recalls the embrace in the *Roman de Troie*. The protective embrace is repeated in the final scene when they sail to Troy.

The changes between these illustrations were subtle, but deliberate. They manage to give the adaptation of the image in the first *Grandes chroniques* a different resonance than it had in the *Roman de Troie*. At the same time the images preserve the overt intervisual reference between them, which, for Morrison, signaled an intertextual relationship, a reference to the *Roman de Troie* as a "prologue" to the *Grandes chroniques de France*.[42]

As secular imagery became more sophisticated during the course of the thirteenth century, it seems that interrelationships between the illustrations of newly emerging texts and their venerable predecessors were increasingly common. We cannot prove that such intervisual relationships were always significant. However, there is ample evidence that they often were, and, as a result, interdisciplinary study of all aspects of Gothic manuscripts – but especially the visual – is increasingly important for any medievalist who hopes to recuperate an understanding of the past.

Notes

1 For a prior state of research, see Bräm, "Buchmalerei des 13. und 14. Jahrhunderts." [For other important approaches, see, in this volume: chapter 3 on reception by Caviness, chapter 4 on narrative by Lewis, chapter 9 on patronage by Caskey, and chapter 6 on gender by Kurmann-Schwarz. On Romanesque manuscript illumination, see chapter 17 by Cohen in this volume (ed.).]

2 See Vitzhum von Ekstaedt, *Die Pariser Miniaturmalerei* and Porcher, *Les Manuscrits à peintures*.

3 See, for instance, how Branner structures artistic attribution in his appendices: "In the case of collaboration between shops, each part of a manuscript is listed under the atelier responsible for it with a cross reference to the other shop or shops concerned; I have, however, given fuller information on the manuscript, with bibliography, under the atelier I consider to be the one receiving the commission for it" (*Manuscript Painting*, p. 200).

4 For Parisian book production in the late twelfth century, see Avril, "À quand remontent les premiers ateliers?" and de Hamel, *Glossed Books*.

5 See Paris, Grand Palais, *L'Art au temps des rois maudits*, pp. 256–334.

6 See for instance the classic studies: Martin, "Les Esquisses des miniatures," and *La Miniature française*; Berger and Durrieu, "Les Notes pour l'enlumineur." More recently, see Stones, "Indications écrites"; Alexander, "Preliminary Marginal Drawings," and *Medieval Illuminators*. For artists' model books, see Scheller, *Exemplum*.

7 See Stirnemann, "Nouvelles pratiques," and "Reflexions sur des instructions"; Gousset and Stirnemann, "Marques, mots, pratiques" and "Indications de couleur."

8 See Stirnemann, "Fils de la Vierge," and "Quelques manuscrits."

9 Rouse and Rouse, *Manuscripts and their Makers*.

10 See the discussion of Maitre Honoré and Richard of Verdun and the discussions of "hubs" in very different cases: the controlled dissemination of early copies of Adenet le Roi's works and Girart's *Meliacin* through the productions of one *libraire*, and the dissemination of early copies of the *Somme le Roi* created by a variety of *libraires* through a patronage network at the court of Philip the Fair. For this, see ibid., pp. 127–72.

11 Gil and Nys, *Saint-Omer gothique*.

12 Some have termed this move a "new philology" or "a postmodern return to the origins of medieval studies" in manuscript culture. For this, see the introduction to a special issue of *Speculum* dedicated to the new philology: Nichols, "Philology in a Manuscript Culture," p. 7. [On the marginal, see chapter 13 by Kendrick in this volume (ed.).]

13 See for example, de Laborde, *La Bible moralisée illustrée*; Haussherr, *Bible moralisée*; and Guest, *Bible moralisée*. Guest presents a concise state of research on the manuscript and translates all the French captions into English.

14 See Hult, "Reading it Right."

15 See Lowden, *Making of the Bibles Moralisées*.

16 Lipton, *Images of Intolerence*. Lipton's sophisticated arguments about the manipulation of Jewish representation in the individual texts and images of the two earliest *Bibles moralisées* is unaffected by Lowden's re-dating of the French copy of the *Bible moralisée* in Vienna to be earlier than the Latin copy in Vienna.

17 Busby et al., ed., *Les Manuscrits de Chrétien de Troyes*.

18 Hindman, *Sealed in Parchment*.

19 See ibid.; Stones, "Artistic Context"; Busby, "Illustrated Manuscripts," "Text, Miniature."

20 Huot, "Rereading the Manuscripts."

21 Ibid., p. 106.

22 See, for instance, Stones, "Secular Manuscript Illumination," "Sacred and Profane Art," "Arthurian art since Loomis," and "Illustrating Lancelot and Guinevere."

23 For the following, see Mann, "Picturing the Bible."

24 These inscriptions were first observed by ffoulkes in Cockerell et al., *Book of Old Testament Illustrations*. He identified the inscriptions on the blade of Goliath's sword as "Golias" (in the scene of David beheading Goliath, fol. 28v), and transcribed other inscriptions on fols. 31 and 34v. On fol. 31 in the scene in which Saul's soldiers seek to arrest David, one soldier holds a sword inscribed, "Courte." Multiple inscriptions appear on fol. 34v, where in the upper register, one of David's men cleaves the skull of an Amalekite with a sword labeled "Odismort," while a Philistine in the lower register cleaves the head of an Israelite with "Ioiouse" and Saul falls upon his sword "Eidisam."

25 For this and the following, see Mann, "Picturing the Bible," pp. 55, 179 n.23, 59 n.48.

26 When named figures bear named swords in the Morgan Picture Bible, the swords clarify the story; for instance David uses Goliath's sword and Saul falls on his own sword, the as yet unidentified "Eidisam" – perhaps a corrupt version of "his?"

27 Only in the late thirteenth century was the sword used in the French coronation ceremony first identified as "Joyeuse," Charlemagne's sword, in Guillaume de Nangis' description of Philip III's coronation in 1270 from his late thirteenth-century chronicle of the life of Philip III. See Zeller, "Les Rois de France."

28 Much work needs to be done to identify where the artists painting these manuscripts worked. The Getty Psalter was made for the usage of Bruges, while current theories about the origins of the Morgan Picture Bible waver between Northern France and Paris. For the state of research, see Noel and Weiss, eds., *The Book of Kings*, pp. 15–18, and articles in Hourihane, ed., *Between the Picture and the Word*.

29 Mann, "Picturing the Bible," p. 55.

30 See Spiegel, *Romancing the Past*. Spiegel's seminal articles on "Political Utility in Medieval Historiography," "Genealogy: Form and Function in Medieval Historiography," "Social Change and Literary Language: The Textualization of the Past in Thirteenth-Century Old French Historiography," "Medieval Canon Formation and the Rise of Royal Historiography in Old French Prose," and "History, Historicism, and the Social Logic of the Text," have been published with others in a volume: Spiegel, *The Past as Text*.

31 Spiegel, "History, Historicism," pp. 25–6.

32 For publications of corpora, see for instance, Buchthal, *Historia*; Oltrogge, *Histoire ancienne*; Jung, *La Légende de Troie*. For examples of research that examines the development of visual cycles within specific historical contexts, see Hedeman, *Royal Image*; Morrison, "Illuminations."

33 For discussion of this manuscript, see Hedeman, *Royal Image*, pp. 11–29.

34 Morrison, "Illuminations," pp. 92–5.

35 See the discussion of Busby's findings above at note 20.

36 For discussion of this passage, see Guenée, "*Les Grandes Chroniques*. In the *Grandes Chroniques*, "*roman*" seems to function as a term referring to the French vernacular, rather than to its modern meaning of "romance." It seems that when the *Grandes Chroniques* were written for presentation in 1274, they were described by this flexible term that was able to include *romans d'antiquités* like the *roman de Troie* and the sequence of emerging vernacular histories charted by Spiegel which culminated in the *Grandes Chroniques*.

37 Morrison, "Illuminations," pp. 104–5.

38 For analysis of the complete cycle of the first *roman de Troie*, see ibid., pp. 106–33.

39 For identification of the scenes, see Morrison, "Illuminations," pp. 112–13.

40 In what follows I am revising material I have published in light of Morrison's analysis. See Hedeman, *Royal Image*, pp. 12–14; Morrison, "Illuminations," p. 103.

41 For the analysis of these gestures that follows, see Garnier, *Le Langage de l'image*, plates 106–7. For nuanced analysis of the gesture of a rapist seizing a woman's wrist, see Wolfthal, "Hue and a Cry."

42 Morrison, "Illuminations," p. 104.

Bibliography

Jonathan J. G. Alexander, "Preliminary Marginal Drawings in Medieval Manuscripts," in Xavier Barral I Altet, ed., *Artistes, artisans et production artistique au moyen âge*, vol. 3: *Fabrication et consommation de l'oeuvre* (Paris, 1990), pp. 307–12.

——, *Medieval Illuminators and their Methods of Work* (New Haven, 1992).

François Avril, "À quand remontent les premiers ateliers d'enlumineurs laïc à Paris?" *Dossiers Archéologiques*, 16 (1976), pp. 36–44.

Samuel Berger and Paul Durrieu, "Les Notes pour l'enlumineur dans les manuscrits du moyen age," *Bulletin et Mémoires de la Société nationale des antiquaires de France*, 53 (1893), pp. 1–20.

Andreas Bräm, "Buchmalerei des 13. und 14. Jahrhunderts in Frankreich, Flandern, Hennegau, Maasland und Lothringen. Literaturbericht 1970–1992," *Kunstchronik*, 46 (1993), pp. 35–47.

Robert Branner, *Manuscript Painting in Paris During the Reign of Saint Louis: A Study of Styles* (Berkeley, 1977).

Hugo Buchthal, *Historia Troiana* (London, 1971).

Keith Busby, "The Illustrated Manuscripts of Chrétien's 'Perceval'," in Busby et al., *Les Manuscrits de Chrétien de Troyes*, Faux Titre 71, 2 vols. (Amsterdam and Atlanta, 1993), vol. 1, pp. 351–63.

——, "Text, Miniature, and Rubric in the 'Continuations' of Chrétien's 'Perceval'," in Busby et al., *Les Manuscrits de Chrétien de Troyes*, Faux Titre 71, 2 vols. (Amsterdam and Atlanta, 1993), vol. 1, pp. 365–76.

Keith Busby, Terry Nixon, Alison Stones, and Lori Walters, eds., *Les Manuscrits de Chrétien de Troyes*, Faux Titre 71, 2 vols. (Amsterdam and Atlanta, 1993).

Sydney C. Cockerell, Montague R. James, and Charles J. ffoulkes, *A Book of Old Testament Illustrations of the Middle of the Thirteenth Century Sent by Cardinal Bernard Maciejowski to Shah Abbas the Great, King of Persia* (Cambridge, 1927).

François Garnier, *Le Langage de l'image au Moyen Âge: Signification et symbolique*, (Paris, 1982).

Marc Gil and Ludovic Nys, *Saint-Omer gothique: Les arts figurative à Saint-Omer à la fin du Moyen Âge 1250–1550: peinture – sculpture – vitrail – arts du livre* (Valenciennes, 2004).

Marie-Thérèse Gousset and Patricia Stirnemann, "Marques, mots, pratiques: Leur signification et leurs liens dans le travail des enlumineurs," *Vocabulaire du livre et de l'écriture au moyen âge*, ed. Olga Weijers, (Turnhout, 1989), pp. 34–50.

——, "Indications de couleur dans les manuscrits médiévaux," in *Pigments et colorants de l'antiquité et du moyen âge* (Paris, 1990), pp. 189–98.

Bernard Guenée, "*Les Grandes chroniques de France: Le Roman aux roys (1274–1518)*," in *La nation*, vol. 1 part 2, *Les Lieux de la mémoire*, Pierre Nora, ed. (Paris, 1986).

Gerald Guest, *Bible moralisée: Codex Vindobonensis 2554, Vienna Österreichischen Nationalbibliothek*. Commentary and translation by Gerald Guest (London, 1995).

Christopher de Hamel, *Glossed Books of the Bible and the Origins of the Paris Booktrade* (Woodbridge and Totowa, NJ, 1984).

Reiner Haussherr, ed., *Bible moralisée: Codex Vindobonensis 2554 der Österreichischen Nationalbibliothek*, 2 vols. (Graz, 1973).

Anne D. Hedeman, *The Royal Image: Illustrations of the "Grandes Chroniques de France", 1274–1420* (Berkeley and Los Angeles, 1991).

Sandra Hindman, *Sealed in Parchment: Rereadings of Knighthood in the Illuminated Manuscripts of Chrétien de Troyes* (Chicago, 1994).

David Hult, "Reading it Right: The Ideology of Text Editing," in Marianne Brownlee, Kevin Brownlee, and Stephen Nichols, eds., *The New Medievalism* (Baltimore, 1991), pp. 113–30.

Sylvia Huot, "Rereading the Manuscripts of Chrétien de Troyes," *Medievalia et Humanistica* n.s. 23 (1996), pp. 99–111.

Colum Hourihane, ed., *Between the Picture and the Word: Essays in Commemoration of John Plummer* (University Park, 2005).

Marc-René Jung, *La Légende de Troie en France au Moyen Âge: analyse des versions françaises et bibliographie raisonée des manuscrits* (Basel, 1996).

Alexandre de Laborde, *La Bible moralisée illustrée conservée à Oxford, Paris et Londres: Reproduction intégrale du manuscrit du XIIIe siècle accompagnée de planches tirées de Bibles similaires et d'une notice*, 5 vols. (Paris, 1911–17).

Sara Lipton, *Images of Intolerance: The representation of Jews and Judaism in the Bible moralisée* (Berkeley, 1999).

John Lowden, *The Making of the Bibles Moralisées*, 2 vols. (University Park, Penn., 2000).

C. Griffith Mann, "Picturing the Bible in the Thirteenth Century," in William Noel and Daniel Weiss, eds., *The Book of Kings: Art, War, and the Morgan Library's Medieval Picture Bible* (Baltimore, 2002), pp. 39–59.

Henry Martin, "Les Esquisses des miniatures," *Revue archéologique* 4 (1904), pp. 17–45.

——, *La Miniature française du XIIIe au XVe siècle* (Paris and Bruxelles, 1924).

Elizabeth Morrison, "Illuminations of the *Roman de Troie* and French Royal Dynastic Ambitions (1260–1340)" (Ph.D. thesis, Cornell University, 2002).

Stephen Nichols, "Introduction: Philology in a Manuscript Culture," *Speculum* (1990) pp. 1–10.

William Noel and Daniel Weiss, eds., *The Book of Kings: Art, War, and the Morgan Library's Medieval Picture Bible* (Baltimore, 2002).

Doris Oltrogge, *Die Illustrationszyklen zur "Histoire ancienne jusqu'à César" (1250–1400)* (Frankfurt am Main, 1989).

Paris, Grand Palais, *L'Art au temps des rois maudits: Philippe le Bel et ses fils, 1285–1328* (Paris, 1998).

Jean Porcher, *Les Manuscrits à peintures en France du XIIIe au XVIe siècle* (Paris, 1955).

Richard Rouse and Mary Rouse, *"Illiterati et uxorati" Manuscripts and their Makers: Commercial Book Production in Medieval Paris, 1200–1500* (Turnhout, 2000).

Robert W. Scheller, *Exemplum: Model-Book Drawings and the Practice of Artistic Transmission in the Middle Ages (ca.900–ca.1470)* (Amsterdam, 1995).

Gabrielle Spiegel, *The Past as Text: The Theory and Practice of Medieval Historiography* (Baltimore: The Johns Hopkins University Press, 1997).

——, *Romancing the Past: The Rise of Vernacular Prose Historiography in Thirteenth-Century France* (Berkeley and Los Angeles, 1993).

Patricia Stirnemann, "Fils de la Vierge: l'initiale à filigranes parisienne, 1140–1314," *Revue de l'art*, 90 (1990), pp. 58–73.

——, "Nouvelles pratiques en matière d'enluminure au temps de Philippe Auguste," in Robert-Henri Bautier, ed., *La France de Philippe Auguste. Le temps des mutations* (Paris, 1982), pp. 955–80.

——, "Quelques manuscrits en langue romane et le style Manerius," in Busby et al., *Les Manuscrits de Chrétien de Troyes*, Faux Titre 71, 2 vols. (Amsterdam and Atlanta, 1993), vol. 1, pp. 195–226.

——, "Reflexions sur des instructions non iconographiques dans les manuscrits gothiques," in Xavier Barral I Altet, ed., *Artistes, artisans et production artistique au moyen âge*, vol. 3: *Fabrication et consommation de l'oeuvre* (Paris, 1990), pp. 351–5.

Alison Stones, "Arthurian Art Since Loomis," in W. van Hoecke, G. Tournoy, and W. Verbeke, eds., *Arturus rex, Acta Conventus Lovaniensis 1987*, vol. 2 (Leuven, 1991), pp. 21–78.

——, "The Artistic Context," in Busby et al., *Les Manuscrits de Chrétien de Troyes*, Faux Titre 71, 2 vols. (Amsterdam and Atlanta, 1993), vol. 1, pp. 227–322.

——, "Illustrating Lancelot and Guinevere," in Lori J. Walters, ed., *Lancelot and Guinevere: A Casebook* (New York, 1996), pp. 125–57.

——, "Indications écrites et modèles picturaux, guides aux peintres de manuscrits enluminés aux environs de 1300," in Xavier Barral I Altet, ed., *Artistes, artisans et production artistique au moyen âge*, vol. 3: *Fabrication et consommation de l'oeuvre* (Paris, 1990), pp. 321–34.

——, "Sacred and Profane Art: Secular and Liturgical Book Illumination in the Thirteenth Century," in Harald Scholler, ed., *The Epic in Medieval Soceity: Aesthetic and Moral Values* (Tübingen, 1977), pp. 100–12.

——, "Secular Manuscript Illumination in France," in Christopher Kleinhenz, ed., *Medieval Manuscripts and Textual Criticism* (Chapel Hill, 1976), pp. 83–102.

Georges Vitzhum von Ekstaedt, *Die Pariser Miniaturmalerei von der zeit des hl. Ludwig bis zu Philipp von Valois und ihr Verhältnis zur Malerei in Nordwesteuropa* (Leipzig, 1981 [1907]).

Diane Wolfthal, "'A Hue and a Cry': Medieval Rape Imagery and its Transformation," *Art Bulletin* 75 (1993), pp. 39–64.

Gaston Zeller, "Les Rois de France, candidats à l'Empire: Essai sur l'idéologie imperiale en France," *Revue historique* 173 (1934), pp. 273–311, 497–534.

Further Reading and Viewing

In the field of French thirteenth-century manuscript studies there are still many manuscripts that have been neither published nor fully examined. While this chapter gives a methodological introduction to the field of Gothic art history, careful study of individual manuscripts is an essential beginning. The following offer a start.

Keith Busby, *Codex and Context: Reading Old French Verse Narrative in Manuscripts*, 2 vols. (Amsterdam, 2002).

Alison Stones, *Gothic Manuscripts: The Thirteenth Century*, A Survey of Manuscripts Illuminated in France, ed. Jonathan Alexander and François Avril (Turnhout, forthcoming).

Websites of individual libraries and museums provide increasing coverage of manuscripts. A new web portal, Euromuse (<www.euromuse.net>), gives access to information about current and forthcoming exhibitions in European museums. Numerous independent sites offering imagery of individual manuscripts can be accessed through web portals like the website of the International Center of Medieval Art (ICMA) (<www.medievalart.org>). For 20 years the Institut de recherche et d'histoire des textes (IRHT) in Paris has

surveyed and documented illuminated manuscripts in French libraries, and the results of their efforts appear on two websites: *Liber Floridus* and *Enluminures*. *Liber Floridus* (<http://liberfloridus.cines.fr>) currently allows access to every picture in illuminated manuscripts housed in the Bibliothèque Sainte-Geneviève and the Bibliothèque Mazarine in Paris. Its ambitious goal is to digitalize and make accessible manuscript illumination in all French university libraries. *Enluminures* (<http://www.enluminures.culture.fr/>) offers access to a visual database drawn from manuscripts in municipal libraries in France. It is searchable by title, author, subject, type of decor, types of literature, or manuscript location.

Glazing Medieval Buildings
Elizabeth Carson Pastan

Rather surprisingly in view of his focus on narrative, Wolfgang Kemp begins his study of medieval stained glass with an analysis of the armature, the iron grid that fixes a window into the aperture of a building. For Kemp, however, the armature's compartments both discipline the scenes and also create patterns that encourage new readings.[1] In similar fashion, the subdivisions of this chapter are intended to organize the extensive literature, while permitting some of the color and character of the scholarship to shine through.[2]

Medium

Stained-glass scholarship begins with the material form of the windows. The distinctive properties of medieval glass, including issues of nomenclature and technique, its inherent fragility, and integration into an architectural setting are central concerns.

While the designation "stained glass" remains in widespread use and will therefore be used throughout this chapter, it is an inaccurate term, since the staining of glass did not come into general use until the early fourteenth century.[3] Up through *c*.1300 the molten silicate mixture was colored in the mass.[4] While still in cooking pots, the glass was tinted by the addition of metallic oxides, which is why the term "pot-metal glass" is more precise.[5] Earlier English scholars insisted, however, that "painted glass" is the best description,[6] since it is the vitreous pigment applied to the surface of the panes of glass that provides the expressive detail in a glass composition (figs. 21-1, 21-2).[7]

The fragility of stained glass, perhaps its most self-evident characteristic,[8] has far-reaching consequences, not the least of which is the arbitrary nature of its preservation in major medieval monuments. Anticipating more recent scholarship on the subject, Jean Lafond pointed out that although Chartres Cathedral

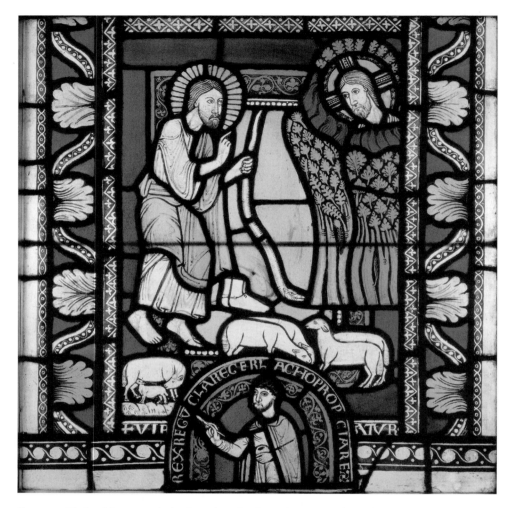

FIGURE 21-1 Moses and the Burning Bush with image of Gerlachus, stained glass, *c*.1150–60. Attributed to the abbey church of Arnstein an der Lahn. Münster: Westfälisches Landesmuseum für Kunst und Kulturgeschichte, loan from a private owner.

may be noteworthy now for its high rate of extant glass, there were once many other important glazing programs.[9] Then too it is the fragility of the medium that has necessitated the disciplinary preoccupation with first determining the authenticity of any glass composition before proceeding into any further investigation.[10]

This characteristic also means that many glazing programs include glass from several different eras. Some of these successive additions are accommodations

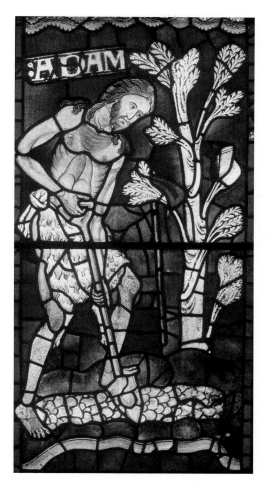

FIGURE 21-2 Adam laboring, stained glass, originally in the northwest choir clerestory of Canterbury Cathedral, *c*.1178–80. Reproduced courtesy of The Dean and Chapter, Canterbury.

to the earlier glass,[11] while others are "corrections" to a prior program. In an important study of the latter, Meredith Lillich drew attention to the grisailles, or colorless ornamental windows, which were added to the choir of Chartres Cathedral from the mid-thirteenth century on, undoubtedly to bring in more light.[12]

Sometimes, older glass was deliberately reused in new architectural settings. At Regensburg Cathedral, older scenes of the Genealogy of Christ (*c*.1230s) were recombined in the south transept façade (1330s) given by the Auer family in a new composition with bishops and saints whose theme seems to reflect the family's strong ties to the cathedral chapter.[13] Besides Regensburg, examples of such "recycled" glass have been found in Chartres, Châlons-sur-Marne, Erfurt, Exeter, Moulins, Munich, Ratisbonne, Rouen, Strasbourg, Troyes, Vendôme, York, and elsewhere.[14] It is highly unlikely that the incorporation of older glass resulted simply from cost-saving measures; indeed, the survival of the venerable older images may have been regarded as nothing short of miraculous, given the odds.[15]

Not one of the terms used to refer to stained glass conveys the fact that it is fundamentally an architectural art (fig. 21-3).[16] A glass composition is dull before light passes through it, unifying its painted and leaded components. However glorious the paint handling, a stained-glass panel is complete only after being set upright into a building's walls and flooded with light.[17] The transformative properties of light on glass have given rise to myriad symbolic interpretations,[18] including the metaphor, most famously attributed to Bernard of Clairvaux (*c*.1090–1153), which compared light passing through glass without breaking it to the miracle of Virgin Birth, whereby Mary was penetrated by the Word of God and yet remained a virgin.[19] But it is noteworthy how often discussions of medieval

FIGURE 21-3 View of windows from the northern choir ambulatory of Troyes Cathedral, including medieval grisaille second from left, first quarter of the thirteenth century. Reproduced courtesy of C. Lemzaouda, CNRS-Centre André Chastel.

architecture, while readily conceding that light held metaphysical associations, stop short of discussing the actual glass compositions through which the light passes.[20]

Correspondences between glass and architecture originate in the fact that glaziers and masons worked hand-in-hand.[21] This means that dating a building can help establish the glass chronology, and vice versa.[22] Scholars have also noted more specific reciprocal influences. Madeline Caviness observed progressive compositional changes in the clerestory figures from St Remi of Reims (*c*.1175–81) that are most logically explained by an accommodation between the window designs and the large interior space in which they would be viewed.[23] In addition, the fashion in later thirteenth-century glazing programs for framing figures with architectural canopies united the window compositions to elements in architectural interiors, including choir screens and reliquaries.[24]

Also related to the coordination of glass and its architectural environment is the issue of interior illumination. In a pioneering article of 1949, for example, Louis Grodecki argued that so readily do we equate stained glass with Gothic translucency, we have failed to notice that the light levels in Romanesque buildings are much the same as in early Gothic buildings, despite the fact that Romanesque apertures are fewer and smaller. Noting the change in palette from earlier windows with their paler hues to the use of more deeply saturated color in Gothic monuments, Grodecki concluded, "between approximately 1140 and 1260 . . . the opening up of the architecture has as its corollary the tendency of the glass to darken."[25]

Studies focusing on grisailles also have implications for the luminosity of a given monument.[26] At Troyes Cathedral (fig. 21-3), the colored historiated windows in the ambulatory chapels are flanked by grisailles in the narrower apertures at the opening to each chapel, providing both visual continuity across glazing campaigns that spanned half a century (*c*.1200–45) and a practical means of allowing in more light.[27] A major transformation took place soon after the mid-thirteenth century, when widespread use of grisailles within each window to offset the colored panels considerably lightened the overall palette.[28] Another significant change occurred by the early fourteenth century with the invention of silver stain, a painted application of a silver-sulfide compound that turns yellow when fired onto the glass.[29] This embellishment also favored the use of the relatively more translucent uncolored glass (which reads as white) that optimally offset the golden hues of the stain.

Discussions of color in medieval architecture suggest that major developments in stained glass do not correspond well with the style categories "Romanesque" and "Gothic."[30] The consistency of light levels in monuments of the twelfth and early thirteenth centuries argues for continuity rather than change, and major developments in Gothic glass such as the lightening of the palette or the invention of silver stain are unsatisfactorily reflected in sub-designations such as "Rayonnant."[31]

Medieval References

Arguably the most important work in the historiography of medieval glass is *De Diversis Artibus*, written by the monk Theophilus Presbyter in the mid-to-late 1120s.[32] This treatise consists of three chapters on artistic techniques noteworthy for their preciosity of effect: manuscript illumination, stained glass, and metal-work.[33] Theophilus' observations on glassmaking, the first original medieval text on the subject, signal the arrival of stained glass as a recognized form of artistic embellishment.[34] While Theophilus' text might be characterized as a recipe book, his accompanying prologues, like the treatises of his Benedictine contemporaries, seek to justify the craftsman's labor by arguing for the cultivation of God-given artistic talent and by emphasizing the role of art in devotion.[35]

Theophilus' chapter on glass, however, lacks details about workshop production.[36] Whereas he implicitly endorses the notion of a versatile monk-craftsman, just decades later Abbot Suger of St Denis established the position of a glazier to ensure the upkeep and repair of the abbey windows,[37] which suggests that the necessary skills were not always readily available.[38] Apart from one reference to a boy who assists in the workshop,[39] Theophilus implies that a single craftsman created all aspects of the window. While this may have been the case when Theophilus was writing, studies based on mid-twelfth and early thirteenth-century windows at St Denis and Chartres, respectively, have uncovered evidence that multiple artists collaborated closely on the windows' execution.[40] This suggests that discussions in which Theophilus' work is used as evidence of how the craft was practiced in different regions and in subsequent decades, particularly the fifteenth and sixteenth centuries with their written contracts and stratified system of specialists, can be highly misleading.[41]

Inscriptions, which Theophilus also mentions,[42] are another source of knowledge about windows. These include the names of personages depicted in the windows, such as Adam from the genealogical windows (*c*.1178–80) once in the clerestory of Canterbury Cathedral (fig. 21-2);[43] dedications from donors;[44] artists' signatures;[45] and biblical commentary.[46] An early example probably from the abbey of Arnstein an der Lahn (*c*.1150–60),[47] and now at the Westfalisches Landesmuseum in Münster, suggests some of the interpretive possibilities of inscriptions. In one of the panels (fig. 21-1), the artist-donor Gerlachus, paintpot in hand, inscribes a rhyming plea: "REX REG[UM] CLARE GERLACHO PROP[I]CIARE" ("May the distinguished King of Kings look favorably on Gerlachus").[48] As noted by Lech Kalinowski, the paintbrush Gerlachus holds is echoed in the biblical scene of Moses and the burning bush above, where Moses' staff, which was turned into a serpent and back again by the Lord, appears to be an equally potent implement.[49] Kalinowski's interpretation of the partial inscription in this panel, "VIR . . . ATUR," as "Virga Versatur" ("The rod is transformed") suggests a learned and artistically self-conscious commentary on the revelatory potential of the painter's brush.

Later inscriptions make explicit connections to the liturgy,[50] and to devotional practices, as may be demonstrated by the theme of St Anne teaching the Virgin to read in English medieval glazing programs.[51] In the example from Stanford-on-Avon (fig. 21-4), the book Anne holds out to her daughter is inscribed with the opening words of the Hours of the Virgin for Matins, "DOMINE LABIA MEA APERIES," ("Lord, open my lips"). Such images must have helped shape

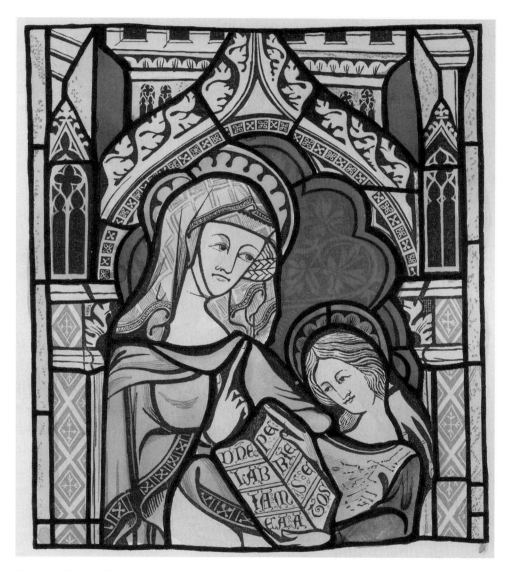

FIGURE 21-4 Charles Winston, watercolor after St Anne Teaching the Virgin with inscribed book, from Stanford-on-Avon, *c.*1325–40. Reproduced from Charles Winston, *Memoirs Illustrative of the Art of Glass-Painting* (London, 1865), plate 12b.

expectations about literacy and teaching, offering compelling visual models for reading and for maternal solicitude.[52]

Medieval literature makes regular references to stained glass, and these suggest some of the ways that windows were viewed and also how window glass served as a common point of reference.[53] The medieval metaphor comparing light penetrating glass without breaking it to the Virgin birth enjoyed literary popularity, including Rutebeuf's thirteenth-century verse play about Theophilus,[54] and was even evoked to portray sensual attraction in Chrétien de Troyes's twelfth-century romance, *Cligès*.[55] The rise in the popularity of medieval theater has been read into the account of an Easter play performed outside Beverly Minster in *c*.1220, describing how eager boys were going to break through the stained glass in order to see the performance in the churchyard.[56] A passage in the *Tale of Beryn*, the anonymous fourteenth-century continuation of the *Canterbury Tales*, satirizes pilgrims' ability to comprehend the twelfth-century images now "spatially and cognitively" far above them in the clerestory windows of Canterbury Cathedral (fig. 21-2).[57] William Langland's 1362 poem *Piers Plowman* ridicules the expensive practice of donating a window in order to proclaim one's good works.[58]

Despite the skeptical view of its role present in some of these references, stained glass continued to be a vital aspect of later medieval visual culture. The skillful adaptation of artists' cartoons into windows within Dürer's circle, its selective but continuing use in Italian Renaissance buildings, the ubiquity of stained-glass roundels in later medieval households and civic buildings, and the widespread diffusion of motifs in the fifteenth and sixteenth centuries, to name only a few examples, demonstrate its ongoing importance.[59]

Revivals

In England, the dissolution of monasteries under Henry VIII (1536–41) began a series of iconoclastic outbreaks that mobilized antiquarians early.[60] Richard Marks pointed to "an almost unbroken series of detailed church notes made by scholars of national status, as well as local worthies"[61] on the glazing of Northamptonshire's 100 or so churches executed prior to 1559, and this is by no means exceptional among English parishes.

The declining fortunes of stained glass on the Continent are suggested by the chapter title in Pierre Le Vieil's 1774 treatise on glass painting, "Reasons for the Decadence of Glass & Responses to the Difficulties cited in order to excuse or bring about its Abandonment." Le Vieil concedes that dissatisfaction with glass was understandable since his generation, better educated than its predecessors, found it difficult to read in darkened church interiors. He recommends allowing the crepuscular light of the windows to inspire a "religieuse horreur," or failing that, placing the principal scene of a window onto a clear new ground, an operation that he himself was hired to perform at the cathedral of Notre-Dame in Paris.[62]

Even Alexandre Lenoir, whose Musée des monuments français opened in Paris in 1795 and offered one of the earliest exhibitions to include medieval stained glass, arguably accomplished as much harm as good. At St Denis, for example, he extracted numerous stained-glass panels from the abbey church, carried them by oxcart to Paris, and rearranged those that survived the journey for exhibit.[63] When Lenoir's museum was dissolved in 1816, as much as three-quarters of the glass he took from St Denis was irreparably shattered, sold off to dealers, or lost.[64]

In the revivals of the nineteenth century, each country responded differently. In England, brisk sales of medieval glass, largely imported from Germany and the Low Countries, created a favorable climate for appreciation of the medium.[65] As Lafond trenchantly observed, only in England could one study the entire history of stained glass through first-rate examples, many of them imported.[66] French restorers, facing the daunting task of restoring glazing programs devastated by centuries of neglect, and having discovered in the wake of the French Revolution that they could no longer make medieval glass,[67] turned to Theophilus, who was translated into French for the first time.[68] In German-speaking countries, the Romantic movement cultivated the medieval past as a high point of culture, a positive climate further enhanced by the linkage of the liturgical revival with governmental commissions.[69] Given this history, it is not surprising that the first dedicated exhibitions of medieval stained glass occurred relatively early in Germany (1827) and England (1865).[70]

These diverse contexts help explain the character of nineteenth-century publications on glass. English scholarship, which may be epitomized by the work of Charles Winston (1814–64), combined technical understanding of the medium with diversity of taste. While he praises German and Flemish sixteenth-century glass,[71] his drawings are primarily taken from English examples (fig. 21-4).[72] Winston, a lawyer by training, had managed to concoct superior colored glasses, although the new glass creations he supervised for Glasgow Cathedral were much criticized.[73] Eugène-Emmanuel Viollet-le-Duc (1814–79) oversaw major campaigns of restoration throughout France and wrote one of the most influential scholarly articles on stained glass, replete with acute practical suggestions, such as how colors could be effectively combined,[74] and how glass would "read" in an architectural setting.[75] Yet his notion that a restoration should reestablish a monument in a complete state, even if such a state never existed at any given moment,[76] and his championing of twelfth-century glazing techniques over what he saw as the decadent techniques of later centuries, indicate the complexity of his outlook.[77] German scholars, such as Heinrich Oidtmann (1861–1912), were particularly technically adept. A practicing physican, Oidtmann oversaw the glass studio in Linnich established by his father and wrote numerous scientific papers about the medium.[78] Oidtmann both discovered and restored the glass from Arnstein an der Lahn (fig. 21-1),[79] and he also built a working glass-firing oven after Theophilus' account.[80]

The individual contributions of Winston, Viollet-le-Duc, and Oidtmann are used here to stand for a generation of gifted nineteenth-century scholars. Their appreciation of medieval glass fostered inventories and documentary images, and contributed to its preservation.[81] Yet their histories of medieval glazing often put the glass from their own region at the forefront of the medium's development. Insights derived from the close study of glass were marshaled into practical applications, but the actual restorations left something to be desired.[82]

Twentieth-century Scholarship

In 1906, Emile Mâle decried the lack of sufficient photographs of stained glass.[83] His call for a "corpus" of reproductions of medieval glass was all the more credible because he had regularly found examples of the iconographic themes he analyzed in stained glass.[84] Mâle's quest for more systematized resources was paralleled in Germany by the establishment of the Deutsche Vereins für Kunstwissenschaft in 1908. By the 1930s, a group within the Vereins under the direction of Paul Frankl had begun to oversee the systematic photographic documentation of German window cycles.[85]

Despite its 1949 publication date, Bernard Rackham's study of Canterbury Cathedral has been called "the summation of nineteenth-century achievements."[86] Rackham reviewed the building history, described the iconographic program, and laid out a chronology, but he omitted other kinds of documentation, including the restoration history of the glass and comprehensive photographs of the rich ornamental repertoire.[87] These deficits are not present in Yves Delaporte's study of the glass of Chartres Cathedral of 1926, with its complete restoration history and three volumes of documentary photographs by Etienne Houvet.[88] Both of these monographs, however, lack a systematic framework for studying glass; an index of this lack of standardization is the fact that neither of these works gives the dimensions of the windows they examine.

Notwithstanding the tremendous contributions of scholars such as Rackham and Delaporte, let alone the important regional surveys of glass written in the first part of the century,[89] stained glass was not truly established as an art historical discipline until after World War II. The devastating wartime losses suffered by glazing programs throughout Western Europe drew attention to the need for rigorous techniques of analysis and photographic documentation to aid in glass preservation.[90] In addition, initiatives begun in 1947 led to the founding in 1952 of the Corpus Vitrearum Medii Aevi, an international body devoted to studying medieval stained glass, with the stated goal of publishing all Western medieval stained glass according to clearly prescribed standards.[91] Exemplifying this effort was the collegial international participation in the exhibition of medieval stained glass in France (1953),[92] which in turn helped shape the official guidelines for subsequent Corpus publications.[93]

The first Corpus Vitrearum publications drew upon earlier scholarship.[94] Hans Wentzel's volume on Swabian glass, for example, was based on work he

did while working for the Deutsche Vereins. Although his original text was destroyed in Berlin in 1945, the galley proofs served as the basis of the first German Corpus volume (1958).[95] Similarly, the first French Corpus volume (1959) relied upon the labor of Monuments historiques, the French department dedicated to historic preservation, which oversaw the disposing of some 150,000 panels of glass throughout France for safekeeping during the war and assembled superb documentary photographs before remounting the glass.[96] England, where the first volume did not appear until Hilary Wayment's publication on King's College Chapel (1972), had less well-established national research initiatives.[97]

While a number of Corpus Vitrearum publications are monographs,[98] the regional surveys are a particularly useful means of covering a wide area with extant medieval glass in dispersed locations.[99] These surveys do not seek to promote the notion of regional schools of glass painting, although this remains a useful approach for some areas.[100] In a recent publication on glass in Normandy, for example, the authors highlighted the striking diversity of glass-painting styles in the region, drawing on evidence offered by civic statutes and the relatively late establishment of confraternities of glass painters to make the point that, in contrast to other more closed artistic environments, there were no rules banning craftsmen from outside the area.[101]

Another accomplishment of these volumes has been to document glass that no longer survives. As Jean Lafond noted in reference to the Scandinavian publication:[102]

> Denmark would not be known as one of the pre-eminent regions for stained glass because today only one of its parishes can show a window that remains in place. More recently, however, archeological excavations and restoration campaigns have brought proof that once all of its churches would have possessed at least one stained-glass window.[103]

The museums of Stockholm, like other cities including Brussels and New York with large collections of stained glass from elsewhere,[104] recall another goal of the Corpus Vitrearum: to provide a provenance for dispersed works. This has been an especially important issue for the American Corpus Vitrearum, where the role played by collectors who imported medieval glass has become a focus of investigations.[105]

Current Trends

Because of its late establishment as a discipline, the study of glass is sometimes associated with a preoccupation with archaeological and taxonomic issues at the expense of newer methodologies, even by scholars who focus on it.[106] Yet recent stained-glass scholarship shares thematic interests with current work in the medieval studies field, including a concern with so-called marginal art, as

exemplified by studies of apparently whimsical subjects in window borders, peasants, the sado-erotic display of female subjects, and heresy.[107] In addition, scholars who work closely on a particular site sometimes have strong affinities for issues in glass studies.[108]

As a monumental and public art form, stained glass holds an innate attraction for scholars interested in notions of representation[109] and in questions of audience response.[110] Scholars in other fields who use examples taken from stained glass, however, run the risk of failing to recognize certain key demands of the field. Ultimately, a window cannot be assimilated to a painted canvas or billboard and isolated completely from its iconographical and devotional environment. As Peter Kurmann and Brigitte Kurmann-Schwartz note, interdisciplinary approaches must respect the physical evidence of the building.[111]

Recent scholarship on the stained glass of Chartres Cathedral serves as a useful benchmark for discussing trends in the literature, not only because so much medieval glass has survived there but also because of the stimulus provided by its ongoing conservation.[112] Contributions anchored in a close analysis of the glass continue,[113] but they have been joined by studies with broader "sociological" agendas.[114] While heraldry is among the traditional means for dating and determining the patronage of a window,[115] recent studies draw on heraldry to consider notions of corporate identity and social ideology.[116] Newer analyses also reassess the representations of workers at the base of many of the windows,[117] the nature of the iconographic "program,"[118] and how the subjects promote and advertise the relics owned by the cathedral.[119] In these works, the windows are often interpreted in an active role, as projecting an ideal of social harmony not attained at the time the windows were created,[120] or as giving new impetus to the liturgy through their celebration of little-known saints.[121] Narratology is a substantial topic of investigation by Kemp, and also in Madeline Caviness's work asking whether the biblical scenes in the windows really served as a teaching tool for the illiterate, for which Chartres provides evidence.[122] An important conclusion to emerge from these studies is the degree to which glass narratives operate independently of any single textual source, often drawing from contemporary social practices.[123] This scholarship is remarkable for the fact that the essential subject is no longer the medium itself. Questions of how glass is made, the authenticity of various constituent parts, and their date in relation to other works of art, while always important, have become less prominent in part because there is now an established literature to provide a foundation for more interpretive studies.[124]

In the nearly 900 years since Theophilus, medieval glass has withstood all kinds of natural disasters, iconoclastic outbreaks, wars, restorations, and scholarly agendas. This brief survey, while it can scarcely do justice to the rich literature on medieval stained glass, is intended to draw attention to frequently overlooked complexities inherent in the nature of the medium, to identify broad historiographic trends, and to suggest some of the current issues in the study of this most dazzling monumental art.

Notes

1 Wolfgang Kemp, *Sermo Corporeus: die Erzählung* (Munich, 1987); cited hereafter in English trans. as idem, *Narratives*: see pp. 3–41. [On narrative, see chapter 4 by Lewis in this volume (ed.).]

2 On glass historiography, see Caviness, *Stained Glass before 1540* and *Stained Glass Windows*.

3 See note 30 on silver stain.

4 With the exception of reds, which are laminated or "flashed": Johnson, *Radiance of Chartres*, pp. 53–66; Newton and Davison, *Conservation of Glass*, pp. 57–9.

5 On techniques of glassmaking, see Eva Frodl-Kraft, *Glasmalerei*; Lafond, *Vitrail*, pp. 51–92; Grodecki, *Vitrail roman*, pp. 11–35; Strobl, *Glastechnik*, pp. 73–127; Brown/O'Connor, *Glass-Painters*, pp. 47–64; Marks, *Stained Glass in England*, pp. 28–40; Caviness, *Stained Glass Windows*, pp. 45–57.

6 Winston, *Inquiry*, vol. 1, p. xix; Le Couteur, *English Mediaeval Painted Glass*, p. 1.

7 On paint, see Grodecki, *Vitrail Roman*, pp. 29–34, Ills. 13–21; Strobl, *Glastechnik*, pp. 94–8, Ill. 10; Caviness, *Stained Glass Windows*, pp. 51–3, Ills. 1–3.

8 See Newton, *Deterioration and Conservation*.

9 Lafond, *Vitrail*, p. 74; Kurmann and Kurmann-Schwarz, "Chartres," p. 140.

10 Among others, see Hayward and Caviness, "Introduction," pp. 16–17; Raguin and Zakin, *Stained Glass before 1700*, pp. 38–44.

11 Caviness, "Convenientia"; Perrot, "Verrières du XIIe," pp. 44–50; Cothren, "Restaurateurs et créateurs."

12 Lillich, "A Redating."

13 Fritzsche, *Mittelalterlichen Glasmalereien*, vol. 1, pp. 14–20, 212, 220–3.

14 Lafond, *Le Vitrail*, pp. 74–80; Caviness, "Convenientia"; Bouchon, "Belle-Verrière"; Cothren, "Seven Sleepers"; Lillich, "Remembrance." On the glass from Troyes, see Pastan, "Fit for a Count."

15 See, for example, Delaporte and Houvet, *Les Vitraux*, vol. 1, p. 3, n.10 on windows lost in the fire of 1194.

16 Argued by the glass painter Sowers, "12th-century Windows"; Raguin, "Visual Designer."

17 Viollet-le-Duc, "Vitrail," pp. 378–80 and 411–29, Ills. 19–27.

18 Grodecki, "Fonctions"; Hayward, "Stained-Glass Windows"; and Lillich, "Monastic Stained Glass," pp. 224–6.

19 Grodecki, "Fonctions," p. 40.

20 Among others, see Simson, *The Gothic Cathedral*, pp. 50–8. [On Gothic architecture, see chapter 18 by Murray in this volume (ed.).]

21 Marks, *Stained Glass in England*, p. 37; Kurmann and Kurmann-Schwarz, "Chartres," p. 134.

22 Pastan, "Process and Patronage."

23 Caviness, *Sumptuous Arts*, pp. 107–16.

24 Kurmann-Schwarz, "L'Architecture et le vitrail." Also see Becksmann, *Architektonische Rahmung*; Scholz, "Ornamentverglasungen der Hochgotik."

25 Grodecki, "Vitrail et l'architecture," p. 24. On color, see Gruber, "Quelques aspects," pp. 72–7; Gage, "Gothic Glass"; Lillich, "Monastic Stained Glass"; Caviness, "Twelfth-Century Ornamental Windows"; Perrot, "La Couleur et le vitrail."

26 On grisailles, see Lafond, "Le Vitrail du XIVe siècle"; Zakin, *French Cistercian Grisailles*; Grodecki and Brisac, *Gothic Stained Glass*, pp. 153–64; Lillich, *Armor of Light*, pp. 6–9.

27 Pastan, "Process and Patronage," pp. 217–19; Pastan and Balcon, *Les vitraux du choeur*.

28 Gruber, "Quelques aspects"; Lillich, "The Band Window"; Marks, *Stained Glass in England*, pp. 124–36; Brinkmann and Lauer, "Mittelalterlichen Glasfenster."

29 On silver stain, see Lafond, "Essai historique"; Lautier, "Les débuts"; Lillich, "European Glass around 1300," pp. 37–61, includes Addendum responding to Lautier.

30 On limitations of period style, see Caviness, "Images of Divine Order."

31 Grodecki and Brisac, *Gothic Stained Glass*, p. 10.

32 Theophilus, *Diversis Artibus*. Other editions: Caviness, *Stained Glass before 1540*, pp. 16–17.

33 Caviness, *Stained Glass Windows*, p. 46.

34 For important precedents, see Frank, *Glass and Archaeology*, pp. 17–42. On Roman glass, see Harden et al., *Glass of the Caesars*; Strobl, *Glastechnik*, pp. 22–4. For ninth-century evidence, see Lafond, *Vitrail*, pp. 18–50; Grodecki et al., *Vitrail roman*, pp. 37–56 and new discoveries of early glass in Caviness, *Stained Glass Windows*, p. 40.

35 Van Engen, "Theophilus Presbyter."

36 Cothren, "Suger's Stained Glass Masters," p. 51.

37 Suger, *Abbot Suger* 34, p. 77; Grodecki, *Les Vitraux de Saint-Denis*, p. 29. Also see Lafond in Aubert, *Les Vitraux*, p. 84.

38 Brown and O'Connor, *Glass-Painters*, p. 21.

39 Theophilus, *Diversis Artibus* 6, p. 41.

40 Cothren, "Suger's Stained Glass Masters," pp. 47–51; Lautier, "Peintres-verriers."

41 Brown and O'Connor, *Glass-Painters*, pp. 21, 23, 44–5. On changing practices, see Lillich, "Gothic Glaziers." For contracts in later English examples, see Marks, *Stained Glass in England*, pp. 20–7. On specialization, see Grodecki, *Documents*, esp. p. 24.

42 Theophilus, *Diversis Artibus* 19, p. 49.

43 Caviness, *Christ Church*, pp. 17–18.

44 Becksmann, "Fensterstiftungen."

45 Perrot, "Signature des peintres-verriers."

46 For example, Suger, *Abbot Suger* 34, pp. 74–7.

47 Oidtmann, *Rheinischen Glasmalerein*, 1, pp. 32–3, 70–2; Becksmann, "Fensterstiftungen," pp. 65–7; Grodecki et al., *Vitrail roman*, pp. 151–61; Kalinowski, "Virga"; Becksmann, *Deutsche Glasmalerei*, vol. 1, cat. no. 2, pp. 41–3.

48 Kalinowski, "Virga," p. 19, n.67, on translation.

49 Ibid., pp. 11–13, 15–17; for a different reconstruction, see Becksmann, *Deutsche Glasmalerei*, vol. 1, p. 42, Ill.38.

50 Marks, *Stained Glass in England*, pp. 78–85.

51 Ibid., p. 75.

52 Sheingorn, "The Wise Mother."

53 Frankl, *Gothic*, pp. 159–205.

54 Grodecki, "Fonctions," p. 40, n.17.

55 Ibid., p. 40, n.18.

56 Kemp, *Narratives*, pp. 148–9.

57 Quoted in Camille, "When Adam Delved," p. 247.

58 Quoted in Winston, *Inquiry*, vol. 1, pp. 409–11; Caviness, *Stained Glass Windows*, p. 60.

59 Scholz, *Entwurf*; Butts and Hendrix, eds., *Painting on Light*; Luchs, "Stained Glass"; Husband, *Luminous Image*; Hérold and Mignot, *Vitrail*.

60 Marks, *Stained Glass in England*, pp. 229–46.

61 Marks, *Medieval Stained Glass*, p. xliii.

62 Le Vieil, *L'Art*, pp. 81–2; Lafond in Aubert, *Les Vitraux*, pp. 14–15.

63 Grodecki, *Les Vitraux de Saint-Denis*, pp. 42–6.

64 Viollet-le-Duc, "Vitrail," p. 374, n.1. See also Jane Hayward in Crosby et al., *The Royal Abbey of Saint-Denis*, p. 61.

65 Raguin, "Revivals," pp. 311–12; Marks, *Stained Glass in England*, pp. 229–46; Shepard, "Our Fine Gothic Magnificence."

66 Lafond, *Vitrail*, p. 140.

67 Pastan, "Restoring Troyes Cathedral," pp. 155–9; Raguin, "Revivals," pp. 312–19.

68 L'Escalopier, trans. *Théophile*.

69 Frankl, *Gothic*, pp. 447–9; Raguin, "Revivals," pp. 322–5; Becksmann, *Deutsche Glasmalerei*, vol. 1, pp. 31–3.

70 Geerling, *Sammlung*; Waring, *Catalogue of Drawings*.

71 Winston, *Inquiry*, vol. 1, esp. pp. 186–226.

72 Ibid., vol. 2.

73 Sewter, "Place of Charles Winston," pp. 84–5, 86–90.

74 Viollet-le-Duc, "Vitrail," pp. 386–7, 397–9, 410.

75 Ibid., pp. 378–80 and 411–29, Ills. 19–27.

76 Viollet-le-Duc, "Restauration," p. 14.

77 Pastan, "Restoring Troyes Cathedral," pp. 159–64.

78 Ludwigs, "Chronik."

79 Oidtmann, *Rheinischen Glasmalerei*, vol. 1, p. 70 and Ills. 20, 28–32 and I–III.

80 Ibid., pp. 37–8 and Ill. 55; photograph in Stephany et al., *Licht*, p. 214 and Becksmann, *Deutsche Glasmalerei*, vol. 1, p. 32, Ill. 24.

81 Important inventories include Baron Ferdinand de Guilhermy, "Notes sur diverses localités de la France," Paris, BN MS Nouv. Acq. Fr. 6094–6111, and idem, "Voyages en Allemagne, Belgique, Hollande, Angleterre et Italie," Paris, BN MS Nouv. Acq. Fr. 6123. Also the collection of Winston's drawings in London, BL Add. MS 35211, 1–4, and the albums in BL, Add. MS 33846–849.

82 Raguin, "Revivals," pp. 314–19; and Becksmann on the restorations of Fritz Geiges, "Zum Problem," pp. 180–4.

83 Mâle, "La Peinture sur verre," p. 372.

84 Mâle, *Religious Art in France*.

85 Waetzoldt, "Glasmalerei," pp. 12–14.

86 Caviness, *Early Stained Glass*, p. 6.

87 Rackham, *Ancient Glass*.

88 Delaporte and Houvet, *Les Vitraux*.

89 Among these works, all still cited: for Germany, the second posthumous volume of Oidtmann, *Rheinischen Glasmalereien* (1929), completed by his son; for England,

Le Couteur, *English Mediaeval Painted Glass*, for Austria, Franz Kieslinger, *Gothische Glasmalerei in Österreich bis 1450* (1928); for Switzerland, Hans Lehmann, *Geschichte der Luzerner Glasmalerei von den Anfängen bis zu Beginn des 18. Jahrhunderts* (1941); and for Belgium, Jean Helbig, *Die Glaschilderkunst in Belge* (1943).

90 Hahnloser, "Zur Einfürung," p. 11, mentions the sense of obligation the war imposed upon scholars.

91 Grodecki, "Dix Ans," p. 24; Frodl-Kraft, "Das Corpus Vitrearum," p. 4. Also see Grodecki, "Stained Glass Atelier" articulating methods of glass analysis.

92 Grodecki, *Vitraux de France.*

93 Frodl-Kraft, "Das Corpus Vitrearum," pp. 3–4.

94 For overviews of Corpus publications, see Grodecki, "Livres récents"; Waetzoldt, "Glasmalerei," pp. 18–21; Caviness, *Stained Glass Windows*, pp. 30–8. Also Caviness, "Beyond the Corpus Vitrearum."

95 Noted in Waetzoldt, "Glasmalerei," p. 15. Wentzel, *Die Glasmalereien.*

96 Aubert, *Les Vitraux*, pp. 7–8.

97 Wheeler, *The British Academy*, pp. 108–16; Wayment and Harrison, *Windows of King's College Chapel.*

98 Lafond, *Les Vitraux*; Caviness, *Christ Church*; Fritzsche, *Mittelalterlichen Glasmalereien.*

99 Frodl-Kraft, *Mittelalterlichen Glasgemälde*, considered a model of clarity and organization.

100 On regional schools, see Knowles, *Essays*, pp. 54–98; Lillich, *Armor of Light*, esp. pp. 321–4. Hebgin–Barnes, *Medieval Stained*, p. li, and Marks, *Medieval Stained Glass*, p. lxiv, insist on the absence of an indigenous style in the regions they survey.

101 Bey et al., *Les Vitraux de Haute-Normandie*, p. 42.

102 Andersson et al., *Die Glasmalereien.*

103 Lafond, *Vitrail*, p. 73.

104 Helbig, *Les Vitraux médiévaux*, pp. 17–42; Hayward, *English and French Medieval Stained Glass.*

105 Hayward and Caviness, "Introduction," pp. 14–16; Hayward, "Introduction," pp. 32–47; Caviness, "Learning from Forest Lawn"; Raguin and Zakin, *Stained Glass Before 1700*, vol. 1, pp. 49–59.

106 Cothren, "Suger's Stained Glass Masters," pp. 52–3; Caviness, *Sumptuous Arts*, pp. xix–xx; Raguin, "Architectural and Glazing Context."

107 Freedman and Spiegel, "Medievalisms Old and New," pp. 677–704; Hardwick, "Monkey's Funeral"; Camille, "When Adam Delved"; Caviness, *Visualizing Women*, pp. 100–19; Pastan, "Tam haereticos quam Judaeos." [On the marginal, see chapter 13 by Kendrick in this volume (ed.).]

108 Among others, see Brown, "Chapels and Cult"; Prache, "Vitrail de la Crucifixion."

109 Bryson, *Word and Image*, pp. 1–28, admittedly serving as a foil for his analysis of nineteenth-century canvas painting.

110 Camille, "When Adam Delved," where he considers how biblical representations of labor (fig. 2) would read differently to medieval viewers, with an eye to the Peasant's Revolt of 1381.

111 Kurmann and Kurmann-Schwarz, "Chartres," p. 144.

112 Basic reference: Grodecki et al., *Vitraux du centre*, 2, pp. 25–45. On restorations, see Perrot, "Verrières du XIIe"; Lautier, "Peintres-verriers."

113 See note 112, as well as Lillich, "A Redating"; Pastan and Shepard, "Torture of Saint George"; Lautier, "Les Arts libéraux."

114 An approach once greeted with reticence: Frodl-Kraft, "Stained Glass from Ebreichsdorf," p. 403.

115 Lillich, "Early Heraldry." [On patronage, see chapter 9 by Caskey in this volume (ed.)].

116 Perrot, "Le Vitrail, la croisade"; Brenk, "Bildprogrammatik." Also (not on heraldry per se), see Bugslag, "Ideology and Iconography," and Abou-El-Haj, "Program and Power."

117 Williams, *Bread*. For an overview, see Pastan and Shepard, "Torture of Saint George," p. 27.

118 Manhes-Derembe, *Vitraux narratifs*, esp. pp. 37–40, 72–3; contrast Delaporte, *Chartres*, vol. 1, pp. 11, 133.

119 Kurmann and Kurmann-Schwarz, "Chartres," pp. 134–6; Caviness, "Stained Glass Windows in Gothic Chapels"; Lautier, "Reliques." Also Shortell, "Dismembering Saint Quentin."

120 Williams, *Bread*, pp. 137, 141–2.

121 Mahnes-Deremble, *Vitraux narratifs*, pp. 32–3, 75–8.

122 Kemp, *Narratives*, esp. pp. 91–151; Caviness, "Biblical Stories." Also Cothren, "Theophilus" and "Who is the Bishop?"; Jordan, *Kingship*, argues that narrative strategies in the glazing of the Sainte-Chapelle of Paris resemble those in contemporaneous prose cycles.

123 Cothren, "Theophilus," p. 333; Caviness, "Biblical Stories," pp. 145–7.

124 Contrast Hérold and Mignot, *Vitrail*.

Bibliography

Corpus Vitrearum Medii Aevi is abbreviated as CV throughout. Each of the selected CV works listed below by author has a complete listing of publications to date: see recent "Status of CV Publications" in Raguin and Zakin, with Pastan, *Stained Glass Before 1700*, vol. 2, pp. 295–6.

Barbara Abou-El-Haj, "Program and Power in the Glass of Reims," in Wolfgang Kersten, ed., *Radical Art History, Internationale Anthologie, Subject: O. K. Werckmeister* (Zurich, 1997), pp. 22–33.

Aaron Andersson, Johnny Roosval, C. A. Nordman, A. Roussell, and S. Christie, *Die Glasmalereien des Mittelalters in Skandinavien*, CVMA Scandinavia (Stockholm, 1964).

Marcel Aubert et al., *Le Vitrail français* (Paris, 1958).

—— et al., *Les Vitraux de Notre-Dame et de la Sainte Chapelle de Paris*, CV France, 1 (Paris, 1959).

Rüdiger Becksmann, *Die architektonische Rahmung des Hochgotischen Bildfensters, Untersuchungen zur obberrheinischen Glasmalerei von 1250–1350* (Berlin, 1957).

——, *Deutsche Glasmalerei des Mittelalters: Bildprogramme, Auftraggeber, Werkstätten*, 2 vols. (Berlin, 1992).

——, "Fensterstiftungen und Stifterbilder in der deutschen Glasmalerei des Mittelalters," in *Vitrea Dedicata: Das Stifterbild in der deutschen Glasmalerei des Mittelalters* (Berlin, 1975), pp. 65–85.

——, "Zum Problem der Ergänzung, Komplettierung und Rekonstruktion Mittelalterlicher Glasmalereien," in Erich Stephany et al., *Licht, Glas, Farbe: Arbeiten in Glas und Stein aus den rheinischen Werkstätten Dr. Heinrich Oidtmann* (Aachen, 1982).

Martine Callias Bey et al., *Les Vitraux de Haute-Normandie*, CVMA France, Recensement 6 (Paris, 2001).

Chantal Bouchon et al., "La 'Belle-Verrière' de Chartres," *Revue de l'Art* 46 (1979), pp. 16–24.

Beat Brenk, "Bildprogrammatik und Geschichtsverständnis der Kapetinger im Querhaus der Kathedrale von Chartres," *Arte medievale*, 2nd series, 5 (1991), pp. 71–95.

Ulrike Brinkmann and Rolf Lauer, "Die mittelalterlichen Glasfenster des Kölner Domchores," in *Himmelslicht. Europäische Glasmalerei im Jahrhundert des Kölner Dombaus (1248–1349)*, ex. cat. (Cologne, 1998), pp. 23–32.

Elizabeth A. R. Brown, "The Chapels and Cult of Saint Louis at Saint-Denis," *Mediaevalia* 10 (1988, for 1984), pp. 279–331.

Sarah Brown and David O'Connor, *Glass-Painters* (Toronto, 1991).

Norman Bryson, *Word and Image, French Painting of the Ancien Régime* (Cambridge, 1981).

James Bugslag, "Ideology and Iconography in Chartres Cathedral: Jean Clément and the Oriflamme," *Zeitschrift für Kunstgeschichte* 61 (1998), pp. 491–508.

Barbara Butts and Lee Hendrix, with Scott C. Wolf, eds., *Painting on Light, Drawings and Stained Glass in the Ages of Dürer and Holbein*, ex. cat. (Los Angeles, 2000).

Michael Camille, "'When Adam Delved': Laboring on the Land in English Medieval Art," in Del Sweeney, ed., *Agriculture in the Middle Ages: Technology, Practice, and Representation* (Philadelphia, 1995), pp. 247–76.

Madeline Harrison Caviness, "Beyond the Corpus Vitrearum: Stained Glass at the Crossroads," *Compte Rendu: Union académique internationale*, 72ème session (Bruxelles, 1998), pp. 15–39.

——, "Biblical Stories in Windows: Were they Bibles for the Poor?" in Bernard S. Levy, ed., *The Bible in the Middle Ages: Its Influence on Literature and Art* (Binghamton, New York, 1992), pp. 103–47.

——, *Christ Church Cathedral Canterbury*, CV Great Britain, 2 (London, 1981).

——, "'De convenientia et cohaerentia antique et novi operis': Medieval conservation, restoration, pastiche and forgery," in Peter Bloch, ed., *Intuition und Kunstwissenschaft, Festschrift für Hanns Swarzenski* (Berlin, 1973), pp. 205–21.

——, *The Early Stained Glass of Canterbury Cathedral, ca.1175–1220* (Princeton, 1977).

——, "Images of Divine Order and the Third Mode of Seeing," *Gesta* 22 (1983), pp. 99–120.

——, "Learning from Forest Lawn," *Speculum* 69 (1994), pp. 963–92.

——, *Stained Glass Windows* (Turnhout, 1996).

——, "Stained Glass Windows in Gothic Chapels, and the Feasts of the Saints," in Nicolas Bock et al., eds., *Kunst und Liturgie im Mittelalter* (Rome, 2000), pp. 135–48.

——, *Sumptuous Arts at the Royal Abbeys in Reims and Braine: Ornatus Elegantiae, Varietate Stupendes* (Princeton, 1990).

——, "The Twelfth-Century Ornamental Windows of Saint-Remi in Reims," in Elizabeth C. Parker, ed., with Mary B. Shepard, *The Cloisters, Studies in Honor of the Fiftieth Anniversary* (New York, 1992), pp. 178–93.

——, *Visualizing Women in the Middle Ages, Sight, Spectacle, and Scopic Economy* (Philadelphia, 2001) pp. 100–19.

Madeline Harrison Caviness, with Evelyn Ruth Staudinger, *Stained Glass before 1540: An Annotated Bibliography* (Boston, 1983).

Michael W. Cothren, "The Iconography of Theophilus Windows in the First Half of the Thirteenth Century," *Speculum* 59 (1984), pp. 308–41.

——, "Restaurateurs et créateurs de vitraux à la cathédrale de Beauvais dans les années 1340," *Revue de l'art* 111 (1996), pp. 11–24.

——, "The Seven Sleepers and the Seven Kneelers: Prolegomena to a Study of the Belles Verrières of the Cathedral of Rouen," *Gesta* 25 (1986), pp. 203–26.

——, "Suger's Stained Glass Masters and their Workshop at Saint-Denis," in George Mauner et al., eds., *Paris, Center of Artistic Enlightenment.* Papers in Art History from Penn State University 4 (1988), pp. 46–75.

——, "Who is the Bishop in the Virgin Chapel of Beauvais Cathedral?" *Gazette des Beaux-Arts* 125 (1995), pp. 1–16.

John D. Le Couteur, *English Mediaeval Painted Glass* (London, 1926).

Sumner Crosby et al., *The Royal Abbey of Saint-Denis in the Time of Abbot Suger (1122–1151)*, ex. cat., The Metropolitan Museum of Art (New York, 1981).

Yves Delaporte and Etienne Houvet, *Les Vitraux de la cathédrale de Chartres: Histoire et description*, 4 vols. (Chartres, 1926).

John van Engen, "Theophilus Presbyter and Rupert of Deutz: The Manual Arts and Benedictine Theology in the Early Twelfth Century," *Viator* 11 (1980), pp. 147–63.

Charles de l'Escalopier, trans. *Théophile, prêtre et moine: Essai sur divers arts* (Paris, 1843).

Susan Frank, *Glass and Archaeology* (London, 1982).

Paul Frankl, *The Gothic, Literary Sources and Interpretations through Eight Centuries* (Princeton, 1960).

Paul Freedman and Gabrielle Spiegel, "Medievalisms Old and New: The Rediscovery of Alterity in North American Medieval Studies," *American Historical Review* 103 (1998), pp. 677–704.

Gabriela Fritzsche, *Die Mittelalterlichen Glasmalereien im Regensburger Dom*, 2 vols., CV Germany, 13 (Berlin, 1987).

Eva Frodl-Kraft, "Das Corpus Vitrearum, 1952–1987: Ein Rückblick," *Kunstchronik* 41 (1988), pp. 1–12.

——, *Die Glasmalerei: Entwicklung-Technik-Eigenart* (Vienna, 1979).

——, *Die Mittelalterlichen Glasgemälde in Niederösterreich. Bibliographie und historische Dokumentation*, CVMA Austria, 2 (Vienna, 1972).

——, "The Stained Glass from Ebreichsdorf and the Austrian 'Ducal Workshop'," in Elizabeth C. Parker, ed., with Mary B. Shepard, *The Cloisters, Studies in Honor of the Fiftieth Anniversary* (New York, 1992).

John Gage, "Gothic Glass: Two Aspects of a Dionysian Aesthetic," *Art History* 5 (1982), pp. 36–58.

Christian Geerling, *Sammlung von Ansichten alter enkaustischer Glasgemälde nebst erlauterndem Text* (Cologne, 1827).

Catherine Grodecki, *Documents du minutier central des notaries de Paris: Histoire de l'art au XVIe siècle (1540–1600)*, vol. 1 (Paris, 1985).

Louis Grodecki, "Dix ans d'activité du Corpus Vitrearum," *Revue de l'Art* 51 (1981), pp. 23–30.

——, "Fonctions spirituelles," in Aubert et al., *Le Vitrail français* (Paris, 1958), pp. 39–45.

——, "Livres récents sur l'art du vitrail," *Revue de l'art* 10 (1970), pp. 97–8.

——, "A Stained Glass Atelier of the Thirteenth Century: A Study of Windows in the Cathedrals of Bourges, Chartres and Poitiers," *Journal of the Warburg and Courtauld Institutes* 11 (1948), pp. 87–111.

——, "Le vitrail et l'architecture," *Gazette des Beaux-Arts* 36 (1949), pp. 5–24.

——, *Vitraux de France, du XIe au XVIe siècle*, exh. cat., Musée des arts décoratifs (Paris, 1953).

——, *Les Vitraux de Saint-Denis*, CV France, Etudes 1 (Paris, 1976).

Louis Grodecki et al., *Les Vitraux du centre et des pays de la Loire*, CV France, Recensement 2 (Paris, 1981).

Louis Grodecki, with Catherine Brisac, *Gothic Stained Glass, 1200–1300*, trans. Barbara D. Boehm (Ithaca, 1985).

Louis Grodecki, with Catherine Brisac and Claudine Lautier, *Le Vitrail roman* (Fribourg, 1977).

Jean-Jacques Gruber, "Quelques aspects de l'art et de la technique du vitrail en France; dernier quart du XIIIe siècle, premier quart du XIVe," *Travaux des étudiants du groupe d'histoire de l'art de la Faculté des lettres de Paris* (Paris, 1928), pp. 71–94.

Hans Hahnloser, "Zur Einfürung," in Ellen J. Beer, ed., *Die Glasmalereien der Schweiz vom 12. bis zum Beginn des 14. Jahrhunderts* (Basel, 1956).

Donald B. Harden et al., *Glass of the Caesars*, ex. cat. (Milan, 1987).

Paul Hardwick, "The Monkey's Funeral in the Pilgrimage Window, York Minster," *Art History* 23 (2000), pp. 290–9.

Jane Hayward, "Introduction" in Hayward and Walter Cahn, *Radiance and Reflection: Medieval Art from the Raymond Pitcairn Collection* (New York, 1982).

——, *English and French Medieval Stained Glass in the Collection of The Metropolitan Museum of Art*, 2 vols., ed. Mary B. Shepard and Cynthia Clark, CV USA, 1 (London, 2003).

——, "Stained-Glass Windows," in Florens Deuchler, eds., *The Year 1200, 2: A Background Survey* (New York, 1970), pp. 67–9.

Jane Hayward and Madeline H. Caviness, "Introduction," in Caviness, ed., *Stained Glass Before 1700 in American Collections: New England and New York*, CV USA, Checklist 1, Studies in the History of Art, vol. 15 (Washington, DC, 1985), pp. 10–19.

Penny Hebgin-Barnes, *The Medieval Stained Glass of the County of Lincolnshire*, CVMA Great Britain, Summary Catalogue, 3 (Oxford, 1996).

Jean Helbig, *Les Vitraux médiévaux conservés en Belgique, 1200–1500*, CV Belgium, 1 (Brussels, 1961).

Michel Hérold and Claude Mignot, eds., *Vitrail et arts graphiques XVe–XVIe siècles*, Les Cahiers de l'Ecole nationale du Patrimoine, 4 (Paris, 1993).

Timothy G. Husband, with Ellen Konowitz and Zsuzsanna van Ruyven-Zeman, *The Luminous Image, Painted Glass Roundels in the Lowlands, 1480–1560* (New York, 1995).

J. R. Johnson, *The Radiance of Chartres: Studies in the Early Stained Glass of the Cathedral* (London, 1964).

Alyce A. Jordan, *Visualizing Kingship in the Windows of the Sainte-Chapelle* (Turnhout, 2002).

Lech Kalinowski, "*Virga Versatur*, Remarques sur l'iconographie des vitraux romans d'Arnstein-sur-la-Lahn," *Revue de l'art* 62 (1983), pp. 9–20.

Wolfgang Kemp, *The Narratives of Gothic Stained Glass*, trans. Caroline Dobson Saltzwedel (Cambridge, 1997).

John A. Knowles, *Essays in the History of the York School of Glass-Painting* (London, 1936).

Peter Kurmann and Brigitte Kurmann-Schwarz, "Chartres Cathedral as a Work of Artistic Integration: Methodological Reflections," in Virginia Chieffo Raguin et al., eds., *Artistic Integration in Gothic Buildings* (Toronto, 1995), pp. 131–52.

Brigitte Kurmann-Schwarz, "L'Architecture et le vitrail aux XIIe et XIVe siècles," in *Mémoire de Champagne* 3 (2001), pp. 196–203.

Jean Lafond, "Essai historique sur le jaune d'argent," in *Trois études sur la technique du vitrail* (Rouen, 1943), pp. 39–116.

——, "Le Vitrail du XIVe siècle en France, Etude historique et descriptive," in Louise Lefrançois-Pillion et Jean Lafond, *L'Art du XIVe siècle en France* (Paris, 1954), pp. 185–237.

——, *Le Vitrail: Origines, technique, destinées*, ed. Françoise Perrot, rev. edn. (Lyon, 1988).

Jean Lafond, with Françoise Perrot and Paul Popesco, *Les Vitraux de l'église Saint-Ouen de Rouen*, CV France, 4 (Paris, 1970).

Claudine Lautier, "Les Arts libéraux de la 'librarie' capitulaire de Chartres," *Gesta* 37 (1998), pp. 211–16.

——, "Les Débuts du jaune d'argent dans l'art du vitrail ou le jaune d'argent à la manière d'Antoine de Pise," *Bulletin monumental* 158 (2000), pp. 89–107.

——, "Les Peintres-verriers des bas-côtés de la nef de Chartres au début du XIIIe siècle," *Bulletin Monumental* 148 (1990), pp. 7–45.

——, "Les Vitraux de la cathédrale de Chartres: Reliques et image," *Bulletin monumental* 161 (2003), pp. 3–96.

Meredith Parsons Lillich, *The Armor of Light: Stained Glass in Western France, 1250–1325* (Berkeley, 1993).

——, "The Band Window: A Theory of Origin and Development," *Gesta* 9 (1970), pp. 26–33.

——, "Early Heraldry: How to Crack the Code," *Gesta* 30 (1991), pp. 41–7.

——, "European Glass around 1300: The Introduction of Silver Stain," reprint in *Studies in Medieval Stained Glass and Monasticism* (London, 2001), pp. 37–61.

——, "Gothic Glaziers: Monks, Jews, Taxpayers, Bretons and Women," *Journal of Glass Studies* 27 (1985): 72–92.

——, "Monastic Stained Glass: Patronage and Style," in Timothy G. Verdon, ed., *Monasticism and the Arts* (Syracuse, 1984), pp. 207–54.

——, "A Redating of the Thirteenth-Century Grisaille Windows of Chartres Cathedral," *Gesta* 11 (1972), pp. 11–18.

——, "Remembrance of Things Past: Stained Glass Spolia at Châlons Cathedral," *Zeitschrift für Kunstgeschichte* 4 (1996), pp. 461–97.

Alison Luchs, "Stained Glass above Renaissance Altars: Figural Windows in Italian Church Architecture from Brunelleschi to Bramante," *Zeitschrift für Kunstgeschichte* 48 (1985), pp. 177–224.

Kurt H. Ludwigs, "Chronik," in Erich Stephany et al., *Licht, Glas, Farbe: Arbeiten in Glas und Stein aus den rheinischen Werkstätten Dr. Heinrich Oidtmann* (Aachen, 1982), pp. 207–17.

Emile Mâle, "La Peinture sur verre en France," in André Michel, ed., *Histoire de l'Art depuis les premiers temps chrétiens jusqu'à nos jours* (Paris, 1906), vol. 2.

——, *Religious Art in France, The Thirteenth Century: A Study of Medieval Iconography and its Sources*, ed. Harry Bober, trans. Marthiel Mathews (Princeton, 1984).

Colette Manhes-Deremble, *Les Vitraux narratifs de la cathédrale de Chartres: Etude iconographique*, CV France, Etudes 2 (Paris, 1993).

Richard Marks, *The Medieval Stained Glass of Northamptonshire*, CV Great Britain, Summary Catalogue 4 (Oxford, 1998).

——, *Stained Glass in England during the Middle Ages* (Toronto, 1993).

Roy G. Newton, *The Deterioration and Conservation of Painted Glass: A Critical Bibliography*, CVMA Great Britain, Occasional Papers, 2 (Oxford, 1982).

—— and Sandra Davison, *Conservation of Glass* (London, 1989).

Heinrich Oidtmann, *Die rheinischen Glasmalereien vom 12. bis zum 16. Jahrhundert*, 2 vols. (Düsseldorf, 1912–29).

Elizabeth Carson Pastan, "Fit for a Count: The Twelfth-Century Stained Glass Panels from Troyes," *Speculum* 64 (1989), pp. 338–72.

——, "Process and Patronage in the Decorative Arts of the Early Campaigns of Troyes Cathedral, *c.*1200–1220s," *Journal of the Society of Architectural Historians* 53 (1994), pp. 215–31.

——, "Restoring Troyes Cathedral: The Ambiguous Legacy of Viollet-le-Duc," *Gesta* 29 (1990), pp. 155–66.

——, "'Tam haereticos quam Judaeos': Shifting Symbols in the Glazing of Troyes Cathedral," *Word & Image* 10 (1994), pp. 66–83.

Elizabeth Carson Pastan and Sylvie Balcon, *Les Vitraux du choeur de la cathédrale de Troyes (XIIIe siècle)*, CVMA France (2006).

Elizabeth Carson Pastan and Mary B. Shepard, "The Torture of Saint George Medallion from Chartres Cathedral in Princeton," *Record of The Art Museum Princeton University* 56 (1997), pp. 10–34.

Françoise Perrot, "La Couleur et le vitrail," *Cahiers de civilization médiévale* 39 (1996), pp. 211–15.

——, "La Signature des peintres-verriers," *Revue de l'art* 26 (1974), pp. 40–5.

——, "Les Verrières du XIIe siècle de la façade occidentale, étude archéologique," *Les Monuments historiques de la France* 1 (1977), pp. 37–51.

——, "Le Vitrail, la croisade et la Champagne: réflexion sur les fenêtres hautes du choeur à la cathédrale de Chartres," in Yvonne Bellenger and Danielle Quéruel, eds., *Les Champenois et les croisades* (Paris, 1989), pp. 109–30.

Anne Prache, "Le Vitrail de la Crucifixion de Saint-Remi de Reims," in Sumner McKnight Crosby et al., *Etudes d'art medieval offerts à Louis Grodecki* (Paris, 1981), pp. 145–54.

Bernard Rackham, *The Ancient Glass of Canterbury Cathedral* (London, 1949).

Virginia Chieffo Raguin, "The Architectural and Glazing Context of Poitiers Cathedral: A Reassessment of Integration," in Raguin et al., eds., *Artistic Integration in Gothic Buildings* (Toronto, 1995), pp. 167–71.

——, "Revivals, Revivalists, and Architectural Stained Glass," *Journal of the Society of Architectural Historians* 49 (1990), pp. 310–29.

——, "The Visual Designer in the Middle Ages: The Case for Stained Glass," *Journal of Glass Studies* (1986), pp. 30–9.

—— and Helen Jackson Zakin, with Elizabeth Carson Pastan, *Stained Glass before 1700 in the Collections of the Midwest*, 2 vols., CV USA, Part 8 (London, 2001).

Hartmut Scholz, *Entwurf und Ausführung: Werkstattpraxis in der Nürnberger Glasmalerei der Dürerzeit*, CV Germany, Studien 1 (Berlin, 1991).

——, "Ornamentverglasungen der Hochgotik," in *Himmelslicht. Europäische Glasmalerei im Jahrhundert des Kölner Dombaus (1248–1349)*, ex. cat. (Cologne, 1998), pp. 51–62.

A. Charles Sewter, "The Place of Charles Winston in the Victorian Revival of the Art of Stained Glass," *Journal of the British Archeological Association* XXIV (1961).

Pamela Sheingorn, "'The Wise Mother': The Image of St. Anne Teaching the Virgin Mary," *Gesta* 32 (1993), pp. 75–8.

Mary B. Shepard, "'Our Fine Gothic Magnificence': The Nineteenth-Century Chapel at Costessey Hall (Norfolk) and its Medieval Glazing," *Journal of the Society of Architectural Historians* 54 (1995), pp. 187–9.

Ellen M. Shortell, "Dismembering Saint Quentin: Gothic Architecture and the Display of Relics," *Gesta* 36 (1997), pp. 32–47.

Otto von Simson, *The Gothic Cathedral, Origins of Gothic Architecture and the Medieval Concept of Order*, rev. edn. (Princeton, 1962).

Robert Sowers, "The 12th-century Windows in Chartres: Some Wayward Lessons from the 'Poor Man's Bible,'" *Art Journal* 28 (1968–9), pp. 168–72.

Erich Stephany et al., *Licht, Glas, Farbe: Arbeiten in Glas und Stein aus den rheinischen Werkstätten Dr. Heinrich Oidtmann* (Aachen, 1982).

Sebastian Strobl, *Glastechnik des Mittelalters* (Stuttgart, 1990).

Suger, *Abbot Suger, On the Abbey Church of St.-Denis and its Art Treasures*, ed. Erwin Panofsky, 2nd edn. (Princeton, 1979).

Theophilus Presbyter, *De Diversis Artibus*, ed. C. R. Dodwell (London, 1961).

Pierre le Vieil, *L'Art de la peinture sur verre et de la vitrerie* (Paris, 1774).

Eugène-Emmanuel Viollet-le-Duc, "Vitrail," in *Dictionnaire raisonné de l'architecture française du XIe au XVIe siècle*, vol. 9 (1868), pp. 373–462.

——, "Restauration," in *Dictionnaire*, vol. 8 (1866), pp. 14–34.

Stephan Waetzoldt, "Glasmalerei des Mittelalters, Ein Kapital deutscher Wissenschaftsgeschichte," in *Vitrea Dedicata: Das Stifterbild in der deutschen Glasmalerei des Mittelalters* (Berlin, 1975), pp. 11–22.

J. B. Waring, *Catalogue of Drawings from Ancient Glass Paintings by the Late Charles Winston Esq. of the Inner Temple*, ex. cat., The Arundel Society (London, 1865).

Hilary Wayment, with Kenneth Harrison, *The Windows of King's College Chapel, Cambridge; A Description and Commentary*, CVMA, Great Britain, Supplementary 1 (London, 1972).

Hans Wentzel, *Die Glasmalereien in Schwaben von 1200–1350*, CVMA Germany, 1 (Berlin, 1958).

Mortimer Wheeler, *The British Academy, 1949–1968* (London, 1970).

Jane Welch Williams, *Bread, Wine and Money* (Chicago, 1993).

Charles Winston, *An Inquiry into the Difference of Style observable in Ancient Glass Paintings, especially in England, with Hints on Glass Painting*, 2 vols. (Oxford, 1867).

Helen Zakin, *French Cistercian Grisailles* (New York, 1979).

22

Toward a Historiography of the Sumptuous Arts

Brigitte Buettner

When Giorgio Vasari published the second edition of his *Lives of the Most Eminent Painters, Sculptors and Architects* in 1568, architecture, painting and sculpture were brought together as the sister arts whose common father, *disegno*, was held by the "father" of modern art history to be the equivalent of the most God-like principle and least matter-bound element in a human being, the intellect.[1] And even as Vasari allowed other media to make anecdotal showings on the primeval scene of art, his theoretical emphasis leaves no doubt that these lesser siblings were best tossed into the unenviable bag of the mechanical arts. Thus expelled, the products of goldsmiths, ivory carvers, or enamelers found no place in the discipline's founding narrative. It was to be a tenacious prejudice. Perceived to be ensnared by the bonds of physicality, devoid of stories to tell, lacking the freedom of the painter's brush or the virile impact of the architect's conceit, the so-called minor arts were pushed to the edges, literally confined to a decorative role. That explains why we still lack an adequate terminology with which to designate them as a class of objects; and why the substitution of the charged labels of "minor," "industrial," "applied," or "decorative" art with more neutral designations has not done away with the stigma of a devaluation in aesthetic worth, seemingly attendant upon the shift to both smaller size and costly materials. The precarious status of what here will be called the sumptuous arts is in fact so deeply etched into the historiography of medieval art that virtually all influential and best-known academic medievalists have concentrated on the major arts (book illumination being assimilated as a medieval variant of painting), while most of the scholars evoked in this chapter belong to the world of museums and are unlikely to be household names even to other medievalists.

The Medieval Ornatus

There is much evidence, both written and visual, that the relationship between the different forms of artistic expression was very much the reverse during the Middle Ages. Sumptuous objects were the locus of an intensive investment – aesthetic, financial, functional, and otherwise – and their sheer quantity, filling church and palace interiors, must have been staggering. For the most part, we have to rely on written evidence to reconstitute that original splendor in our mind's eyes, since only a fraction of these works of art, religious and secular, has withstood the vagaries of time, if often in painfully fragmentary or altered condition.

Because medieval society was to a large extent an oral one, rituals were of paramount importance in the ordering of its practices and beliefs. Rituals, however, do require objects for their performance, and with no church vessels to receive that most precious of all substances, the body and blood of Christ, there could have been no liturgy, no way to commemorate the Passion of Christ that re-enacted the regenerative communion between the divine and the human. Along with Romanesque ciboria and Gothic monstrances exquisitely wrought into miniature buildings, chalices studded with gleaming gems occupied pride of place on the altar. They were flanked by a wealth of other vessels and splendid altar crosses, the signs that made Christ present, and were collectively known as the *ornatus* (or *ornamenta*) of a church.[2]

Without brilliantly adorned reliquaries to protect the remains of the most exemplary champions of the Christian faith, there likewise would have been no cult of saints, no pilgrims, no donations, sometimes no elaborate church buildings at all. Reliquaries, such as the famous "Majesty" of St Foi at Conques (fig. 22-1), are benefiting from historians' renewed efforts to unravel medieval piety, and are currently one of the more richly studied categories of medieval art.[3] Earthly rulers needed brilliant external trappings – a political *ornatus* of sorts – just as much to make their status manifest. But while regalia, that is, crowns, orbs, scepters, mantels, and the feudal swords and spurs, rank as a major group of medieval sumptuous arts, only a few individual pieces, like the crown of the Holy Roman Empire (fig. 22-2), now part of the Imperial Treasury housed in the Schatzkammer in Vienna, have been at the center of intensive study and debates.[4]

That the only artist ever to attain sainthood was a goldsmith, Eligius (Eloy) (d.660), court artist to two Merovingian kings, later bishop of Noyon and still the patron saint of goldsmiths, is further proof of the high status that his craft enjoyed during the Middle Ages. In Romanesque and Gothic times, many well-regarded churchmen are reported to have excelled in this medium (whether myth or fact is irrelevant here). The best-known case is that of Bernward (d.1022), the canonized abbot of the powerful Benedictine abbey of St Michael at Hildesheim and an energetic patron who commissioned, among other things, a pair of magnificent bronze doors and a monumental bronze column to serve as

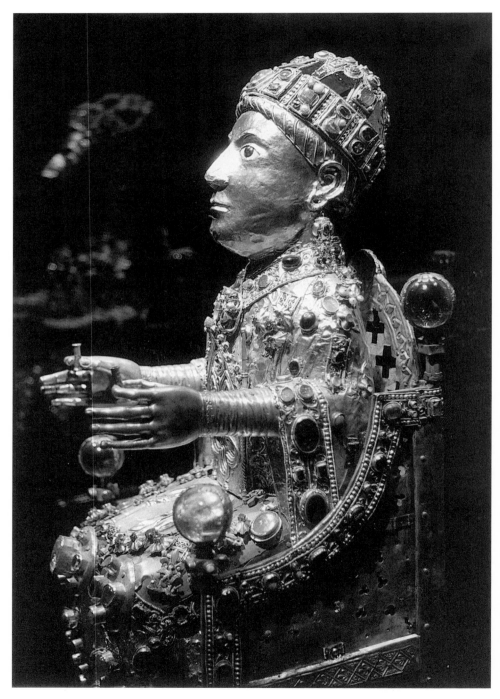

FIGURE 22-1 Reliquary statue or "Majesty" of St Foi, ninth to twelfth century, wood, gold sheeting, precious stones; Conques: Church of St Foi, treasury. Photo: Bildarchiv Foto Marburg/Art Resource, NY.

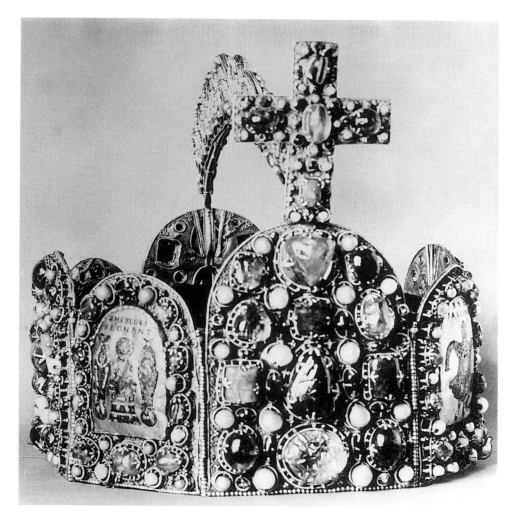

FIGURE 22-2 Crown of the Holy Roman Empire, late tenth/eleventh century, gold, enamels, precious stones. Vienna: Kunsthistorisches Museum, Schatzkammer. Photo: Bildarchiv Foto Marburg/Art Resource, NY.

a base for a now lost Crucifix. The prestige of goldsmiths, who handled one of the rarest, most resplendent, and therefore auratic substances, is also demonstrated by the fact that the first documented case of an ennobled artist is that of Raoul, goldsmith to King Philip the Fair. Other goldsmiths are known by name, either because they proudly signed their works, such as Nicolas of Verdun (d.1205) or Hugo d'Oignies (d.c.1240), or because they are mentioned in written documents, such as Guillaume Boucher, the early thirteenth-century Parisian goldsmith who, having been taken captive, found himself in the distant Mongol capital of Karakorum, where he fashioned for Mangu Khan a much

admired silver fountain, shaped like a tree whose branches dispensed wine and other intoxicating beverages. And though it has not been conclusively proven, scholars like to believe that Roger of Helmarshausen, an artist of Mosan origins to whom several accomplished works from the first quarter of the twelfth century can be ascribed, is the author of the *De Diversis Artibus*, arguably the most important medieval treatise on the arts. Signed with the fancy-sounding Greek pseudonym Theophilus Presbyter, this elegantly written technical tract, prefaced by considerations about the theological import of the artist and his creations, provides invaluable insights into the working methods of painting (Bk. 1), stained glass (Bk. 2), and, in the most extensive part, of metalworking (Bk. 3).[5]

The elevated social and aesthetic status of the sumptuous arts is finally corroborated by the role they played in the most pointed artistic controversies of the day. During the first millennium, disagreements over what constituted legitimate and illegitimate visual practices had rumbled around representational images. After the year 1000, the crux of disputes concerning things visual shifted to objects and expense. In the most famous of these, the eloquent Suger (d.1151), abbot of the French royal abbey of St Denis exchanged, albeit indirectly, verbal bullets with the equally charismatic Cistercian Bernard of Clairvaux (d.1153). Bernard notoriously championed an attitude of minimalist restraint in matters seductive to fleshly eyes. In a wide-ranging tract on monastic customs sent as a letter in 1125 to a fellow monk, William of St Thierry, and now known as the *Apologia*, he aired his objections to mainstream Benedictine monasticism, including his fundamental opposition to what he deemed to be its excessive artistic policies. And while his views on the "deformed beauty and yet beautiful deformity" of cloister capitals easily count as the most frequently cited excerpts of medieval art criticism, it needs to be stressed that it is the "things shining in beauty," those that should be mere "dung" to monks, which made him quiver more than anything else with disparagement. Bernard acknowledged that a priest's mission differs from a monk's, and that pastoral care can excuse the need to "stimulate the devotion of carnal people with material ornaments."[6] Nonetheless, in an argument that would ring with renewed urgency in the ears of Protestant reformers, he stigmatized the use of "idols" (e.g., reliquaries) whose main ostensible purpose was, as he saw it, to extract money from gullible congregations.

What Bernard rejected was the traditional justification for the commission of ornate works of art as a proper means to honor God (*ad honorem Dei*), a position that garnered support from many of his contemporaries. Some of them additionally subscribed to the idea, tempered by the heady vapors of neo-Platonic mysticism, that material beauty was a manifestation of divine glory. Suger proved to be the most vigorous partisan of this line of argument, and, untiring impresario as he was, he made sure that his opinions and record of achievements would be widely known and remembered by writing them down. His autobiographical accounts devote little attention to what matters most to our eyes: his

decisive contribution to the shaping of Gothic architecture, sculpture, and stained glass. Instead, Suger goes to great lengths to justify spending vast amounts of energy and money to make artful *vasa sacra*, adorned with the rarest precious stones that he could secure. And it is during moments of rapt contemplation of objects like the chalice, crafted of a delicately variegated fluted sardonyx bowl, an antique spolia to which his goldsmiths added a showy silver-gilt foot and rim (fig. 22-3), that the abbot waxes most poetic:

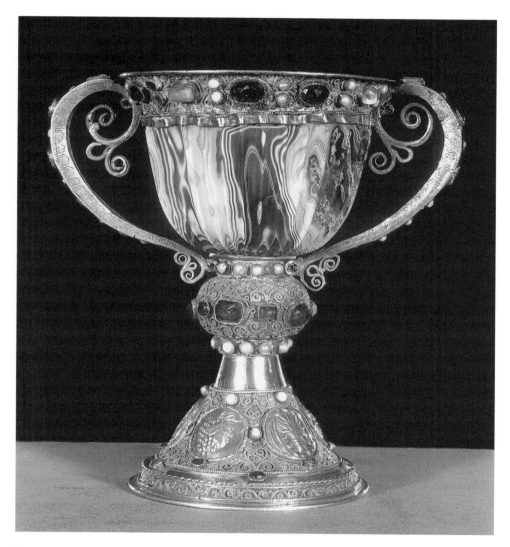

FIGURE 22-3 Chalice of Abbot Suger, second/first century BCE sardonyx cup; mounting in silver gilt with filigree, precious stones and glass insets, *c.*1140. Washington: National Gallery of Art, Widener Collection 1942.9.277. Photo: National Gallery of Art.

> Thus, when – out of my delight in the beauty of the house of God – the loveliness
> of the many-colored gems has called me away from external cares, and worthy
> meditation has induced me to reflect, transferring that which is material to that
> which is immaterial, on the diversity of the sacred virtues: then it seems to me that
> I see myself dwelling, as it were, in some strange region of the universe which
> neither exists entirely in the slime of earth nor entirely in the purity of Heaven; and
> that, by the grace of God, I can be transported from this inferior to that higher
> world in an anagogical manner.[7]

Suger was not alone in defending the aesthetic experience on account of its
anagogic power, its redemptive ability to lift us up from coarse, polluted materiality
and propel us toward spiritual ethereality. Although less lyrically inclined, William
Durandus, bishop of Mende (d.1296), also endorsed it; and he added, again
contra Bernard, that the faithful precisely need to divest themselves of what is
most coveted so as to combat humankind's innate avarice. The first of the three
books of his *Rationale Divinorum Officiorum* offers an extensive symbolical
interpretation of all the constituent parts of a church, its architectural elements,
painted and sculptural decor as well as of the "ornament of the altar," the vessels
to house the host, the altar cloths, phylacteries (or reliquaries), candlesticks,
crosses, banners, and books needed to perform the service (I, 3: 24–50). The
fact that he understands, for example, an altar cross placed between two candle-
sticks to represent Christ straddling the Jews and Gentiles makes his a simplified,
user-friendly system of interpretation. Unsurprisingly, it enjoyed an enduring
success. Not only does it survive in many manuscript copies, but was also one of
the first books to leave the printing press and, finally, can boast of an early
English translation published in 1843 by John Mason Neale and Benjamin
Webb, founders of the undergraduate club dubbed the Cambridge Camden
Society, primarily remembered for its unremitting crusade in the name of a High
Church revival in Anglican England and its parallel embrace of a hard-edged
nostalgia for the medieval past.

The Age of Rediscovery

Burdened with the double handicap of being medieval and mechanical, the
sumptuous arts were to be a latecomer, and often a timid one, in the great
movement initiated by pioneer antiquarians and amateurs that led to the redis-
covery of the Middle Ages in the course of the seventeenth and eighteenth
centuries. A decisive early spark fomenting the interest in "national antiquities"
came somewhat fortuitously with the much-publicized excavation of the tomb,
complete with beautifully wrought insignia and items of personal adornment, of
the Merovingian King Childeric in Tournai (Belgium) in 1653. A century later,
Childeric's objects, incongruously mixed with Egyptian beetle ornaments, promin-
ently figured in the capacious five-volume *Les Monumens de la monarchie françoise*

published between 1729 and 1735 by Bernard de Montfaucon (1655–1741), the first visual atlas to document the succession of French reigns during the medieval period.[8] Montfaucon had been trained by the eminent medieval paleographer and Church historian Jean Mabillon in the learned world of the Benedictine congregation of St Maur, and edited and translated Origen, St John Chrysostom, and Athanasius before moving into the uncharted waters of visual documents. Compared to the immense success of the earlier *L'Antiquité expliquée et représentée en figures*, his survey of the "barbarian" centuries, recovered from oblivion, as he himself claims, not because of any intrinsic artistic value, inspired so little interest that he was never able to bring it to completion. However, the parts that saw publication turned out to be path-breaking, and were subsequently used by anyone wanting to visualize the formative stages of the French monarchy, brought to life through fine reproductions of funerary monuments, seals, coins, miniatures, tapestries, and regalia. Even more interesting is the fact that, regardless of its numerous historical inaccuracies, Montfaucon's method of embedding, indeed of dissolving artistic objects into a more general historical context is premonitory of very contemporary historiographic developments.

More squarely rooted in the nascent discipline of art history, the lavishly illustrated *Histoire de l'art par les monumens, depuis sa décadence au IVe siècle jusqu'à son renouvellement au XVIe siècle* was written by the French savant and Roman expatriate Seroux d'Agincourt (1730–1814), and published posthumously once the upheavals of the Revolution had settled. Unlike Montfaucon's contextualist framework, Seroux arranged works of art according to independent series, wedded together by an internal logic – the succession of styles. Hundreds of attractive plates containing several thousands of elegant if overtly classizicing line engravings were made after originals that were sent to him by an extensive network of correspondents. The major arts, mostly of Italian origins, tower above the handful of specimens in other media, such as the superb Carolingian altar frontal executed by Master Voulvinus, rendered from different points of view across a number of plates; some coins and small-scale ivories here and there; and the forlorn Romanesque chalice from the abbey of Weingarten, signed by Magister Conradus, which Seroux chose to place at the center of the single plate (pl. 29) illustrating "Works executed out of Italy from the commencement of the decline to the 14th century."

The wholesale destruction of medieval art, reviled as the epitome of the unsavory alliance between Church and aristocracy, during the French Revolution did not fail to produce its opposite: the desire to preserve. Formed in that iconoclastic crucible, early collectors and students of medieval objects included the Lyonnais painter Pierre-Henri Révoil (1776–1842). A pupil of Jacques-Louis David, he modified his teacher's neo-Classicism to initiate the first truly neo-medieval movement; and propped the credibility of the so-named Troubadour Style by filling his canvases with colorful imitations of the objects that he avidly collected (what he nicely called his "cabinet de gothicités," bought in 1828 by the Louvre). More decisively, the Revolution spawned the first public

museum of medieval art created by Alexandre Lenoir as the Musée des monu-
ments français (1794–1816). In its period rooms one could admire medieval
sculptural ensembles saved from the Jacobin hammer as works of art, that is,
stripped as much as possible of any liturgical or monarchic associations. Inspired
by it, Alexandre du Sommerard (1779–1842) founded the first museum of
medieval and Renaissance decorative arts in 1832 by opening up his growing
collection to the public, suggestively displayed in the rooms he rented in the
Hôtel de Cluny in Paris, the present-day site of the Musée national des arts du
moyen âge.[9] Here the tone was a different one, as viewers were coaxed into
discovering broad facets of medieval life exemplified by objects illustrating the
religious sentiments or the art of warfare, and by romantic domestic interiors
arranged into collage-like installations. The best part of the collection consisted
in works from the fifteenth and sixteenth centuries, yet Sommerard had been
able to secure such unique earlier pieces as the Visigothic votive crowns, then
recently excavated at Guarrazar in Spain, or the golden altar frontal from the
cathedral of Basel commissioned in the early eleventh century by emperor Henry
II. After Sommerard's death, the collection was bought by the state, then at the
height of the conservative climate ushered in by the restoration of the Orléans-
Bourbons monarchy, under which the vogue for the "age of saint Louis" reached
a passionate climax.

By then, the fashion for the "Gothik" age ran high throughout Europe, often
fueled by reactionary, nationalistic, and sectarian religious agendas. Gothic archi-
tectural follies had of course been imparting an exotic frisson to English parks
since the late eighteenth century, but now churches and secular buildings steeped
in the Gothic idiom sprang up everywhere, like so many pinnacled mushrooms.[10]
Somewhat paradoxically, the most decisive opportunity for a wider public to
become acquainted with more rarefied medieval visual relics than cathedrals was
given when the "Great Exhibition of the Works of Industry of all Nations"
opened its doors in 1851 outside London. The magnificent glass and iron
"cathedral" erected by William Paxton, and quickly nicknamed the Crystal Palace,
sheltered more than 100,000 industrial and natural products as well as handicrafts
sent, or extorted, from all over the world. Amid this extravagant celebration of
British colonial might, only one specific time period had the – now suspect –
honor of being singled out: the centrally located Medieval Court designed
and overseen by Augustus Welby Northmore Pugin (1812–52), who by that
time had completed not only the neo-Tudor Windsor Castle, but also churches,
both major and minor, inclusive of their furnishings. To us, Pugin's room
(fig. 22-4), chock-full with church vessels and secular plate, with tapestries,
furniture, sculpted objects, and jewelry, all jostling for space and the viewer's
attention, may be reminiscent of an Ali Baba's cavern. Contemporaries, how-
ever, hailed its aesthetic unity, finding it "attractive" and "picturesque" despite
the "clumsy contrivances of the middle ages" it sheltered. In reality, the items
on display were a fantasy. For they had been designed "in the mediaeval style"
by Pugin and his associates in the fastidiously archeological manner for which he

of the general public for whom the Museum had been built," William M. Milliken, then director of the Cleveland Museum of Art, bought the best pieces.[15] Swarzenski went on to mount a more comprehensive and equally successful show on the "Arts of the Middle Ages, 1000–1400" a decade later, when he was in charge of the medieval collection at Boston's Museum of Fine Arts (MFA); a show only surpassed in 1970 with the Metropolitan Museum's Centennial exhibition "The Year 1200," for which hundreds of magnificent objects crossed the ocean. Even more important in our context is Swarzenki's son, Hanns. He had joined his father at the MFA in 1948, and is the author of *Monuments of Romanesque Art*, a textbook that, despite drab reproductions and a terse introduction, had the merit of revealing to American readers many marvels of what he classified as "church treasury art." Broader in chronological scope, yet narrower in methodology with its avowed espousal of an "unrepentant history of style," was the 1972 contribution by Peter Lasko, long-time director of London's Courtauld Institute and one of the finest connoisseurs of medieval small-scale art, to the widely read Pelican History of Art.[16]

The feverish reconstruction era after World War II did propel medieval objects into the center of an exhibition activity whose momentum continues to this day. And, keeping pace with a general trend in art history, each major exhibition was almost required to be enshrined in substantial and steadily weightier catalogues, gorged with glossy color illustrations. In France, the tone was given by 1964's hugely popular *Les Trésors des églises de France*, which assembled in the rooms of the Musée des arts décoratifs in Paris the exorbitant number of 649 reliquaries and *vasa sacra*. In the introductory essay to the catalogue, Jean Taralon, an official of the government agency in charge of historic preservation, the Commission des monuments historiques, and who in 1954 had overseen the restoration of the reliquary statue of St Foi, confidently stated that the "arts previously qualified as minor" were now firmly embedded in the mainstream of medieval art. In retrospect, one has to wonder if these little-known riches, marshaled from grand cathedrals to obscure parish churches, were summoned for scholarly reasons or if to attest to a glorious past that could spread its healing balm on a country recovering from the humiliation of military defeat and the stain of Fascism.

It is postwar Germany, however, that has supplied the best up-to-date information on medieval sumptuous arts. Ambitious exhibitions have been mounted there almost every year, perhaps in this case too as a not-so unconscious strategy to reach an innocent past, an empire whitewashed of imperialism. Remarkable in size, some also experimented with unorthodox displays. "Rhein und Maas," for instance, curated by Anton Legner, did away with glass cases and put the massively bejeweled Mosan reliquary shrines directly in contact with viewers, one imagines, to great psychedelic effect (fig. 22-5). Typically, the German exhibitions have invited metalwork and ivories, textiles and daily artifacts made of humbler materials to play a leading role alongside their better-known sister arts in the interpretation of particular cultural areas,[17] individual patrons,[18] or

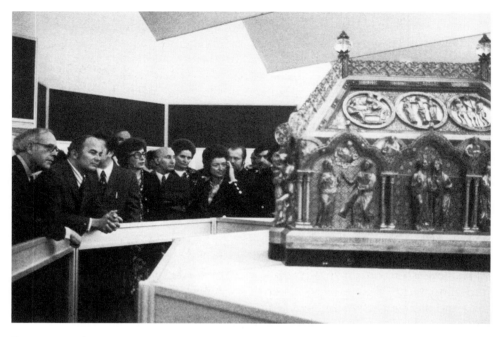

FIGURE 22-5 Viewers looking at Nicolas of Verdun's Shrine of the Virgin, "Rhein und Maas" exhibition, Cologne 1972. Reproduced from the exhibition catalogue, ed. Anton Legner, ill. 59.

specific time-periods.[19] Drawing on the expertise of scholars in a wide range of disciplines, they have regularly featured essays by some of the best specialists of medieval sumptuous arts, including Hermann Fillitz, Renate Kroos, Anton Legner, Anton von Euw, and Hiltrud Westermann-Angerhausen.

A comparable move from catalogues tilted toward stylistic and technical concerns to ones that encourage a thematic approach has taken place in other countries as well, albeit more sporadically. Thus, one can compare the inter-disciplinary 1987 exhibition devoted to the Gothic period in England, "The Age of Chivalry," to its earlier and methodologically more limited counterpart, "English Romanesque Art." Other accomplishments in the same vein include Peter Barnet's "Images in Ivory" and Henk van Os's evocatively titled "The Way to Heaven," which had the additional merit of featuring little-known reliquaries loaned from the Hermitage Museum. For it needs to be said that one of the unfortunate consequences of the dominance of exhibition catalogues in this field has been to leave objects that are neither part of the exhibition circuit nor housed in prestigious institutions languishing in barely accessible treasuries, as insufficiently documented as they were in the nineteenth century. Furthermore, the pre-eminent medieval production centers, such as Paris, Limoges, or Cologne and the Mosan region, have tended to obscure other

geographic areas and, especially, more "peripheral" countries like Scandinavia or Eastern Europe.[20]

Toward an Academic Renaissance?

As these last examples show, the recent decades have been ones of hybrid undertakings, which straddle the corpus and the exhibition catalogue on the one hand, and more academic writings on the other. The thousands of surviving enamels and ivories are now extensively catalogued and embedded in a larger interpretative framework that takes into account, besides traditional questions regarding technique and style, the organization of production methods, aspects of patronage, and, if appropriate, iconographic programs.[21] Instead of focusing on a particular medium, other publications proceed chronologically, such as Johann Michael Fritz's impressive examination of Gothic metalwork, which brings together detailed information on more than 800 objects with a significant, sociologically inflected introduction that examines issues of use, function, production, and consumption.[22] Yet other publications center on a particular category of objects, among which the work of Ronald Lightbown, a former curator at the Victoria and Albert Museum, can be singled out. His *Mediaeval European Jewellery*, for instance, catalogues the objects that were in his care, all the while drawing an admirably thick picture of the production, collecting and uses of jewelry.

In conclusion, a few thematically oriented publications can be retained. Methodologically unique was the fruit of the collaboration between the innovative if politically fraught historian Percy Ernst Schramm, whose interest in visual realities was awakened during his contacts with the effervescent circle formed around Aby Warburg in Hamburg, and the manuscript specialist Florentine Mütherich. Their *Denkmale der deutschen Könige und Kaiser* reverted to the literal meaning of monument (that is, memorial). It led them, somewhat provocatively, to exclude from their study any large-scale representations to rely instead on reliquaries, manuscripts, regalia, and even musical instruments, in sum, on any object upon which rulers' "eyes have rested, across which their fingers have glided." In a correspondingly unprecedented move, Schramm and Mütherich extended the notion of patronage to include objects obtained by inheritance, purchase and gift, with the refreshing if slightly disconcerting result that a Carolingian reliquary possessed at a later date, say, by emperor Henry II was taken to be the latter's monument.

Special mention should be made of Marie-Madeleine Gauthier, who, in addition to her many publications on Limoges enamels, wrote an early multidisciplinary study on the cult of relics and pilgrimages across medieval Europe.[23] Her *Highways of the Faith* remains one of the best introductions to the subject, especially for the skillful way in which it relates reliquaries to all sorts of physical movements – travels across Europe and Outremer; long-distance trade and military

confrontations that brought raw materials, ready-made objects as well as artistic motifs from East to West; the translations of relics, staged like triumphal processions; the political transactions underlying the collecting of such desirable rarities.[24] It is appropriate, however, to end this survey by mentioning two recent publications that herald a new direction. The first is *The Medieval Art of Love* by Michael Camille, an art historian of terrific and untiring talent, who left us prematurely after having single-handedly renewed many of the questions we ask of medieval art. Though above all a scholar of manuscripts, in this book he takes into account a broad range of media – Limoges and ivory caskets, jewels and textiles, miniatures and paintings – in order to grasp how medieval artists and viewers embodied in concrete things the "manufacture of desire." The second is Herbert Kessler's energizing survey *Seeing Medieval Art*, which likewise dispenses with the conventional framework of separating medieval art by media; moreover, it gives the question of materiality, so fundamental for the understanding of the sumptuous arts, pride of place in the first chapter.

To overcome the misguided view that considers such complex achievements of the sumptuous arts as the reliquary of St Foi or the crown of the Holy Roman Empire to be minor artistic manifestations will indeed require an understanding of the full spectrum of medieval representational possibilities. If we are to reckon with their powerful visual impact, we will need to make a more deliberate effort to shift our attention away from mere problems of style and authorship; and will have to attend to these objects' sophisticated combination of techniques and visual languages, their multifaceted religious and political functions, the theoretical challenges they pose for a discipline whose key conceptual tools were forged by the study of architecture, on the one hand, the figurative arts, on the other. Centuries of patient, often arduous scholarly inquiries may have bequeathed to us a considerable inheritance of accumulated knowledge, but little, all too little, of it has been renewed by fresh theoretical insights and bolder debates. Only when questions about ritual functions, the politics of gendered patronage, the economics and metaphorics of raw materials, or the sumptuous arts' role within the larger cultural landscape are routinely taken up will the memorable objects that lent their ornamental luster to churches, palaces, and people be promoted to fully fledged historical subjects of our current Middle Ages.

Notes

1 In his first edition, published in 1550, Vasari gave more credit to goldsmithing, at least as an idiom in which many important painters or sculptors had been trained. It is likely that he downplayed its importance in the later edition as a consequence of his animosity toward his rival Benvenuto Cellini, then the most celebrated goldsmith.

2 They have been studied in their liturgical function by Braun, *Der christliche Altar* and *Das christliche Altargerät*. See also Sauer, *Symbolik des Kirchengebäudes*, and, in English, McLachlan, "Liturgical Vessels and Implements."

3 In this case, aided by the spirited hagiographic documentation of St Foi's tireless miracle-working activity, as recorded in the first two books of the *Liber miraculorum sancte Fidis* written in the early twelfth century by Bernard of Angers. Translated by Sheingorn, *The Book of Sainte Foy*; and for the critical edition of the original text, Robertini, *Liber miraculorum*. On reliquaries more generally, see Braun, *Die Reliquiare*; Gauthier, *Highways of the Faith*; Legner, *Reliquien in Kunst und Kult*; *The Way to Heaven*, ex. cat.

4 Fillitz, *Die Schatzkammer in Wien*, as well as the broader historical perspectives by Schramm, *Herrschaftszeichen*, to which can be added the exhibition catalogue *Krönungen: Könige in Aachen*.

5 Also known as the *Schedula diversarum artium*, following the title provided by the great Enlightenment writer Gotthold Ephraim Lessing, who discovered this manuscript while he was librarian to the Duke of Brunswick in Wolfenbüttel. English translation by Dodwell, *The Various Arts*; Latin edition with German translation of Book 3 by Erhard Brepohl, *Theophilus Presbyter*.

6 See Conrad Rudolph, *Things of Greater Importance*, for the text, translation, and a detailed examination of the art historical implications of Bernard's *Apologia* in the context of contemporary monastic culture.

7 Suger, *Abbot Suger*, pp. 62–5. [On *spolia* in general, see chapter 11 by Kinney in this volume (ed.).]

8 Montfaucon abundantly recycled the graceful watercolors made by Roger de Gaignières (1642–1715), an earlier student of medieval art, who by the end of his life had assembled a collection numbering several thousand drawings documenting medieval tombs, portraits, and costumes. As many of the works reproduced by Gaignières have since been lost, his documentation has become an irreplaceable source of information. The Bibliothèque nationale de France (Paris) is in the process of digitizing it to make it available online.

9 He published its contents in the lavish Du Sommerard, *Les Arts au moyen âge*, completed after his death by his son Edmond. For early collectors and scholars of medieval art in France, see *Le "Gothique" retrouvé avant Viollet-le-Duc*, ex. cat. [On the modern medieval museum, see chapter 30 by Brown in this volume (ed.).]

10 [On medieval revivals, see chapter 29 by Bizzarro in this volume (ed.).]

11 *The Crystal Palace and Its Contents, Being an Illustrated Cyclopaedia of the Great Exhibition of the Industry of All Nations, 1851* (London, 1852), pp. 215–16. For Pugin's ideas in this realm, see his beautifully contrived publications, *Designs for Gold and Silversmiths* and, with Bernard Smith, the *Glossary of Ecclesiastical Ornament*.

12 The texts assembled by Frank, *Theory of Decorative Art*, offer a handy overview of these debates.

13 Texier, *Dictionnaire d'orfèvrerie*; Laborde, *Glossaire français*; Gay, *Glossaire archéologique*.

14 Molinier died before the completion of his work, and the fifth and last volume on tapestries was published by Jules Guiffrey.

15 Quoted after Bruhn, "William M. Milliken and Medieval Art," p. 197.

16 Swarzenski, *Monuments*, and Lasko, *Ars Sacra*, a title borrowed from a German exhibition on early medieval sumptuous arts mounted in 1950 in Munich.

17 For instance, *Kunst und Kultur in Weserraum*; *Rhein und Maas*; *Europas Mitte*.

18 Such as *Bernward*, 1993; *Kaiser Heinrich II*, 2002. [On patronage, see chapter 9 by Caskey in this volume (ed.).]

19 Still unsurpassed in scope and impact is *Ornamenta Ecclesiae*, 1985; see also *Das Reich der Salier*.

20 An exception is Hungary, whose objects have been studied by Kovács, notably in *The Hungarian Crown* and *Romanesque Goldsmiths' Art*. Sumptuous arts also lag behind in web-based projects, which are making vast visual databases available for other media. For an exception, see the government-sponsored online exhibition of Limoges enamels at <http://www.culture.gouv.fr/emolimo/emaux.htm>.

21 Gauthier, *Émaux* and *Émaux méridionaux* (the second tome, covering the years 1190–1216, is in preparation); *Enamels of Limoges*, ex. cat.; Gaborit-Chopin, *Ivoires*. See also Randall, *Masterpieces of Ivory* and *The Golden Age of Ivory*.

22 Fritz, *Goldschmiedekunst*; to complete with Lüdke, *Die Statuetten*. For another important inquiry on the social status of goldsmiths and their workshop practices, see Claussen, "Goldschmiede des Mittelalters."

23 [On pilgrimage art, see chapter 28 by Gerson in this volume (ed.).]

24 [On collecting in the Middle Ages, see chapter 10 by Mariaux in this volume (ed.).]

Bibliography

Exhibition catalogues (in chronological order)

Arts of the Middle Ages, ed. Georg Swarzenski (Boston, 1940).

Les Trésors des églises de France, ed. Jacques Dupont (Paris, 1965).

Kunst und Kultur im Weserraum, 800–1600, 2 vols., ed. Bernard Korzus (Münster, 1967).

The Year 1200: A Centennial Exhibition at the Metropolitan Museum of Art, 2 vols., ed. Florens Deuchler and Konrad Hoffmann (New York, 1970).

Rhein und Maas, Kunst und Kultur, 800–1400, 2 vols., ed. Anton Legner (Cologne, 1972–3).

Le "Gothique" retrouvé avant Viollet-le-Duc, ed. Louis Grodecki (Paris, 1979–80).

English Romanesque Art, 1066–1200, ed. George Zarnecki, Janet Holt, and Tristram Holland (London, 1984).

Ornamenta Ecclesiae: Kunst und Künstler der Romanik, 3 vols., ed. Anton Legner (Cologne, 1985).

Age of Chivalry: Art in Plantagenet England, 1200–1400, ed. Jonathan Alexander and Paul Binski (London, 1987).

Das Reich der Salier, 1024–1125, ed. Konrad Weideman (Sigmaringen, 1992).

Bernward von Hildesheim und das Zeitalter der Ottonen, 2 vols., ed. Michael Brandt and Arne Eggebrecht (Hildesheim, 1993).

Enamels of Limoges, 1100–1350, ed. John P. O'Neill (New York, 1996).

Images in Ivory: Precious Objects of the Gothic Age, ed. Peter Barnet (Detroit, 1997).

Europas Mitte um 1000, 3 vols., ed. Alfried Wieczorek and Hans-Martin Hinz (Stuttgart, 2000).

Krönungen: Könige in Aachen, Geschichte und Mythos, 2 vols., ed. Mario Kramp (Mainz, 2000).

The Way to Heaven: Relic Veneration in the Middle Ages, ed. Henk van Os (Baarn, 2000).

Kaiser Heinrich II, 1002–1024, ed. Josef Kirmeier (Suttgart, 2002).

General

Joseph Braun, *Der Christliche Altar in seiner geschichtlichen Entwicklung*, 2 vols. (Munich, 1924).

——, *Das Christliche Altargerät in seinem Sein und in seiner Entwicklung* (Munich, 1932; repr. Hildesheim, 1973).

——, *Die Reliquiare des christlichen Kultes und Ihre Entwicklung* (Freiburg im Breisgau, 1940).

Erhard Brepohl, *Theophilus Presbyter und die mittelalterliche Goldschmiedekunst* (Vienna, 1987).

Heather McCune Bruhn, "William M. Milliken and Medieval Art," in Elizabeth Bradford Smith, ed., *Medieval Art in America: Patterns of Collecting, 1800–1940* (University Park, 1996), pp. 195–8.

Michael Camille, *The Medieval Art of Love: Objects and Subjects of Desire* (New York, 1998).

John Cherry, *Goldsmiths*, Medieval Craftsmen (London, 1992).

Peter Cornelius Claussen, "Goldschmiede des Mittelalters," *Zeitschrift des Deutschen Vereins für Kunstwissenchaft* 32 (1978), pp. 46–86.

William Durand, *Rationale Divinorum Officiorum*, Corpus Christianorum, Continuatio Medievalis, CXL, 3 vols., ed. A. Davril and T.M. Thibodeau (Turnhout, 1995); partial trans. of bk. 1 as *The Symbolism of Churches and Church Ornaments*, John Mason Neale and Benjamin Webb (Leeds, 1843).

Jacob von Falke, *Geschichte des deutschen Kunstgewerbes* (Berlin, 1888).

Hermann Fillitz, *Die Schatzkammer in Wien: Symbole Abendländischen Kaisertums* (Salzburg, 1986).

John Fleming and Hugh Honour, *The Penguin Dictionary of the Decorative Arts*, new edn. (London, 1989).

Isabelle Frank, *The Theory of Decorative Art: An Anthology of European and American Writings, 1750–1940* (New Haven, 2000).

Johann Michael Fritz, *Goldschmiedekunst der Gotik in Mitteleuropa* (Munich, 1982).

Danielle Gaborit-Chopin, *Ivoires du moyen âge* (Fribourg, 1978).

Marie-Madeleine Gauthier, *Emaux du moyen âge occidental* (Fribourg, 1972).

——, *Les Routes de la foi: Reliques et reliquaires de Jérusalem à Compostelle* (Paris, 1983).

——, *Highways of the Faith: Relics and Reliquaries from Jerusalem to Compostela*, trans. J. A. Underwood (Secaucus, NJ, 1986).

Marie-Madeleine Gauthier, with Geneviève François, *Emaux méridionaux: Catalogue international de l'œuvre de Limoges*, vol. 1: *L'Epoque romane* (Paris, 1987).

Victor Gay (completed by Henri Stein), *Glossaire archéologique du moyen âge et de la renaissance* (Paris, 1887–1928).

Adolph Goldschmidt, *Die Elfenbeinskulpturen aus der Zeit der Karolingischen und Sächsischen Kaiser, VIII.–XI. Jahrhundert*, 2 vols., Denkmäler der deutschen Kunst (Berlin, 1914–26; repr. Berlin 1969–70).

——, *Die Elfenbeinskulpturen aus der romanischen Zeit, XI.–XIII. Jahrhundert*, 2 vols., Denkmäler der deutschen Kunst (Berlin, 1923–6; repr. Berlin 1972–5).

Henry Havard, *Histoire de l'orfèvrerie française* (Paris, 1896).

Herbert L. Kessler, *Seeing Medieval Art* (Peterborough, Ont., 2004).

Raymond Koechlin, *Les Ivoires gothiques français*, 3 vols. (Paris, 1924).

Éva Kovács, *The Hungarian Crown and Other Regalia* (Budapest, 1980).

——, *Romanesque Goldsmiths' Art in Hungary* (Budapest, 1974).

Jules Labarte, *Histoire des arts industriels au moyen-âge et à l'époque de la renaissance*, 1st edn. (Paris, 1872–5); Eng. trans., *Handbook of the Arts of the Middle Ages and Renaissance* (London, 1855).

Léon de Laborde, *Glossaire français du moyen âge à l'usage de l'archéologue et de l'amateur des arts, précédé de l'inventaire des bijoux de Louis, duc d'Anjou, dressé vers 1360* (Paris, 1872).

Paul Lacroix (pseudonym Bibliophile Jacob), *Les Arts au moyen-âge et à l'époque de la renaissance*, 2nd edn. (Paris, 1869); Eng. trans., *The Arts in the Middle Ages and at the Period of the Renaissance* (London, 1870).

Peter E. Lasko, *Ars Sacra, 800–1200*, Pelican History of Art (Harmondsworth, 1972; 2nd edn., New Haven, 1994).

Anton Legner, *Reliquien in Kunst und Kult zwischen Antike und Aufklärung* (Darmstadt, 1995).

Otto Lehmann-Brockhaus, *Schriftquellen zur Kunstgeschichte des 11. und 12. Jahrhunderts für Deutschland, Lothringen und Italien*, 2 vols. (Berlin, 1938; repr. New York, 1971).

——, *Lateinische Schriftquellen zur Kunst in England, Wales und Schottland, vom Jahre 901 bis zum Jahre 1307*, 5 vols. (Munich, 1955–60).

Ronald W. Lightbown, *Mediaeval European Jewellery, With a Catalogue of the Collection in the Victoria and Albert Museum* (London, 1992).

Dietmar Lüdke, *Die Statuetten der gotischen Goldschmiede: Studien zu den "autonomen" und vollrunden Bildwerken der Goldschmiedeplastik und den Statuettenreliquiaren in Europa zwischen 1230 und 1530*, 2 vols. (Munich, 1983).

Elizabeth Parker McLachlan, "Liturgical Vessels and Implements," in Thomas J. Heffernan and E. Ann Matter, eds., *The Liturgy of the Medieval Church* (Kalamazoo, 2001), pp. 369–429.

Émile Molinier, *Histoire générale des arts appliqués à l'industrie du Ve à la fin du XVIIIe siècle*, 5 vols. (Paris, 1896–1919).

Bernard de Montfaucon, *Les Monumens de la monarchie françoise, qui comprennent l'histoire de France, avec les figures de chaque règne que l'injure des temps a épargnées*, 5 vols. (Paris, 1729–33).

Augustus Welby Northmore Pugin, *Designs for Gold and Silversmiths* (London, 1836).

Augustus Welby Northmore Pugin, with Bernard Smith, *Glossary of Ecclesiastical Ornament and Costume, compiled from ancient authorities and examples* (London, 1844; rev. edn. 1846).

Richard H. Randall, *Masterpieces of Ivory from the Walters Art Gallery* (New York, 1985).

——, *The Golden Age of Ivory: Gothic Carvings in North American Collections* (New York, 1993).

Adolf Reinle, *Die Austattung deutscher Kirchen im Mittelalter: Eine Einführung* (Darmstadt, 1988).

Luca Robertini, *Liber miraculorum sancte Fidis* (Spoleto, 1994).

Conrad Rudolph, *The "Things of Greater Importance": Bernard of Clairvaux's Apologia and the Medieval Attitude Toward Art* (Philadelphia, 1990).

Joseph Sauer, *Symbolik des Kirchengebäudes und seiner Ausstattung in der Auffassung des Mittelalters, mit Berücksichtigung von Honorius Augustodunensis, Sicardus und Durandus*, 2nd rev. edn. (Freiburg, 1964).

Percy Ernst Schramm, *Herrschaftszeichen und Staatssymbolik: Beiträge zu Ihrer Geschichte vom dritten bis zum sechzehnten Jahrhundert*, 4 vols. (Stuttgart, 1954–78).

Percy Ernst Schramm and Florentine Mütherich, *Denkmale der deutschen Könige und Kaiser: Ein Beitrag zur Herrschergeschichte von Karl dem Grossen bis Friedrich II, 768–1250* (Munich, 1962).

Jean-Baptiste Seroux d'Agincourt, *Histoire de l'art par les monumens, depuis sa décadence au IVe siècle jusqu'à son renouvellement au XVIe siècle*, 6 vols. (Paris, 1811–23); Eng. trans., *History of Art by its Monuments, From its Decline in the Fourth Century to its Restoration in the Sixteenth*, 3 vols. (London, 1847).

Pamela Sheingorn, *The Book of Sainte Foy* (Philadelphia, 1995).

Elizabeth Bradford Smith, ed., *Medieval Art in America: Patterns of Collecting, 1800–1940* (University Park, 1996).

Alexandre (and Edmond) du Sommerard, *Les Arts au moyen âge, en ce qui concerne principalement le palais romain de Paris, l'Hôtel de Cluny, issu de ses ruines, et les objets d'art de la collection classée dans cet hôtel*, 5 vols., 1 atlas, and 1 album (Paris, 1836–48).

Suger, *Abbot Suger on the Abbey Church of St-Denis and Its Art Treasures*, ed. Erwin Panofsky, 2nd edn. (Princeton, 1979); new critical edn., Suger, *Œuvres*, ed. Françoise Gasparri, 2 vols. (Paris, 1996–2001).

Hanns Swarzenski, *Monuments of Romanesque Art: The Art of Church Treasures in North-Western Europe* (Chicago, 1954).

Jacques Rémy Antoine Texier, *Dictionnaire d'orfèvrerie, de gravure et de ciselure chrétiennes, ou de la mise en œuvre artistique des métaux, des émaux et des pierreries*, in J.-P. Migne, *Encyclopédie théologique*, vol. 27 (Paris, 1857).

Theophilus Presbyter, *The Various Arts*, ed. and trans. Charles Reginald Dodwell, (London, 1971; repr. Oxford, 1986).

Eugène-Emmanuel Viollet-le-Duc, *Dictionnaire raisonné du mobilier français de l'époque carlovingienne à la Renaissance*, 6 vols. (Paris, 1858–75).

East Meets West:
The Art and Architecture
of the Crusader States

Jaroslav Folda

Introduction

Historiographically the origins of the modern study of Crusader architecture and art can be located in French scholarship during the nineteenth century. The beginnings of the modern European rediscovery of Syria-Palestine are associated with the scholars who followed Napoleon's campaigns in the Near East from May 1798 to August 1799. Shortly thereafter, J. F. Michaud began the publication of his *Histoire des croisades*, starting in 1812, drawing attention to the history of the Crusaders in the Levant.[1] Study of the material culture of the Crusaders was begun in terms of coinage, and the first attempt at a comprehensive study appeared in 1847 by Louis Felicien de Saulcy.[2] Interest in the Crusaders was indirectly intensified in France during the Crimean War (1853–6), in which one of the major issues was French protection of Christian pilgrims to Jerusalem and the holy sites under the Capitulations of 1620 and 1740, firmans signed by the Ottoman sultan. Four years later, in 1860, the count Charles-Jean-Melchior de Vogüé (1829–1916), published a pioneering study entitled *Les Eglises de la terre sainte*.[3] This book marked the beginning of modern research into the art and architecture of the Crusaders in the Holy Land.

The Study of the Art of the Crusaders
in the late Nineteenth Century

De Vogüé approached the study of Crusader churches as the work of French architects who produced buildings in three phases: phase 1, from 1099 to 1187;

phase 2, from 1187 to 1291; and phase 3, on Cyprus from the thirteenth to the fifteenth century. Essentially, he argues for the importation of Romanesque architecture from Western Europe as the basis of Crusader architecture, and he sees the development of Crusader art as controlled by French artistic ideals (fig. 23-1).[4] As he saw it, the Crusaders brought Romanesque architecture with them, but he was well aware of two aspects that influenced it in its new setting. First, the local climate, materials, and local masons were different from those in France, and second, the fact that local Christians also had their own distinctive architectural traditions.

De Vogüé thereby opened the discussion of Crusader architecture in the Holy Land, focusing on ecclesiastical architecture. Emmanuel-Guillaume Rey followed in 1871 with the first extended discussion of Crusader castles and fortifications.[5] Rey began his study by surveying the Crusader States geographically with reference to the main Crusader fortifications. Then he introduces the main characteristics of the castles, differentiated as he interprets the origins of their design into three schools: the first that of the Hospitallers, the second that of the Templars, and the third, which was a combination of types from the first two including certain Western features.

Rey in fact published a number of important studies on the Crusader Levant, including a book entitled *Les Colonies franques de Syrie aux XIIe et XIII siècles*, which appeared in 1883.[6] Here he clearly presents the Crusaders in the Holy Land as a colonial experience in a multicultural setting and he provides a comprehensive historical geography that comments on all major known Crusader sites. He also expands the picture of Crusader artistic interests in the Levant quite significantly, based especially on written sources, particularly the *Assises de Jérusalem* and the diplomatic documents of the major chanceries, joined by a selection of the Arab chroniclers. And he has interesting and comparatively extensive comments on Crusader art.

Work on the history of the Crusades, the culture of the Crusaders, and Crusader monuments continued in the last 25 years of the nineteenth century by English and German as well as French scholars. One of the most important publications was a new and remarkably comprehensive study of Crusader coins by Gustave Léon Schlumberger. Published in 1878 with a supplement in 1882, this work remained a standard text into the latter part of the twentieth century, and can still be consulted with profit.[7] Many of the publications we have are found in the form of archaeological reports, e.g., the *Survey of Western Palestine*.[8] By this means the repertoire of sites published is enlarged somewhat, but the focus of the *Survey* was on antiquity, biblical and classical, and there are relatively few Crusader monuments. Also, Hans Prutz published a work of cultural history hard on the heels of Rey's later (1883) work, but he is not as interested in the artistic material and contributes more to the study of the military orders in the Crusader States, especially the Teutonic Order.[9] But in 1896 there was Charles Diehl, a scholar of quite a different background, an orientalist who studied Byzantium and Byzantine Art, who discussed "Les

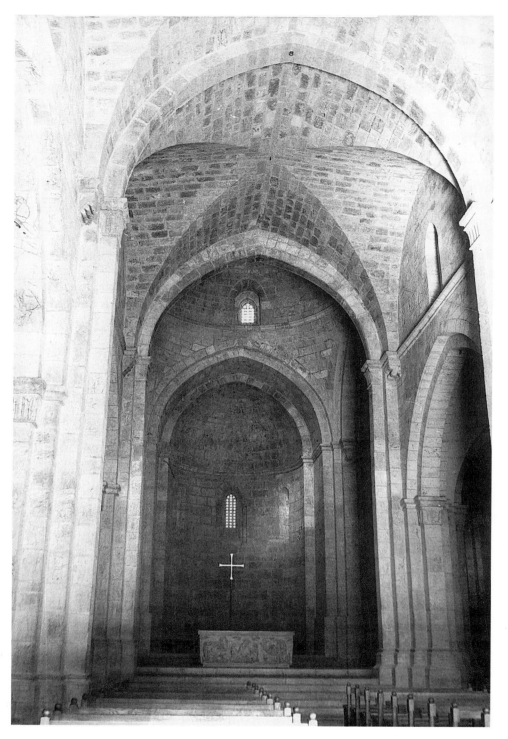

FIGURE 23-1 Interior of nave looking east, Church of Saint Anne, Jerusalem, mid-twelfth century. Photo: J. Folda.

Monuments de l'Orient Latin" in a lecture, published as an article a year later.[10] In a sense he summarized and epitomized the French view of the Crusaders at the *fin de siècle*. What is striking about his view of the Crusader East is that France and the Frankish Levant are linked so closely. The Crusader States are conceptualized as if they were a massive projection of medieval French civilization directly into the Near East.

The Study of the Art of the Crusaders in the Early Twentieth Century

French archaeologists worked intensively in the Holy Land in the first third of the twentieth century. Of particular interest for Crusader monuments was the work of Fathers Hugues Vincent and F.-M. Abel in Jerusalem,[11] and that of Father Prosper Viaud in Nazareth.[12] Vincent and Abel devoted a substantial part of their investigations to the Crusader monuments, and, in particular, the Church of the Holy Sepulchre, for which they provided the first comprehensive study with detailed plans and measured drawings, quite different from the art historical study of the church published by Karl Schmaltz in 1918.[13] In Nazareth, Viaud produced a similar study of the foundations of the Crusader Church of the Annunciation, and combined that with the dramatic discovery of the famous Nazareth Capitals (fig. 23-2). It was on the solid foundations of these and earlier works that Camille Enlart (1862–1927) arrived in the Holy Land, in the period of the French and British Mandates, to pursue his investigations.[14] His research, carried out between 1921 and 1927, resulted in the publication of *Les Monuments des croisés dans le royaume de Jérusalem*, the first comprehensive study of the art and architecture of the Crusaders in the Holy Land.[15]

Enlart's approach to the study of the Crusader monuments was distinct from those of his distinguished predecessors in three important ways. First, Enlart addressed the study of Crusader art and architecture as a mature scholar, someone who had extensive experience working in Europe and the Near East. Second, Enlart was commissioned to study the Crusader monuments by the Académie des inscriptions et belles-lettres, so he received the full support and cooperation of the Mandate authorities. Third, Enlart defines his agenda at the start of chapter 1, where he states his intention to study the influence of the West on the Levant in the Latin Kingdom, the last chapter of a vast inquiry he had started 30 years before.[16] Thus Enlart makes clear that he was pursuing his art historical inquiry in effect backwards in chronological time, having started with Lusignan Cyprus (1191–1474), to which he had devoted a major study published in 1899,[17] turning then to the Frankish art, culture, and history of the Crusader States in Syria-Palestine, 1098–1291, in the 1920s.

One important aspect of Enlart's approach was that, in the context of the early years of the twentieth century, he was arguing against the idea that artistic creativity and its influence basically flowed East to West.[18] Furthermore, though

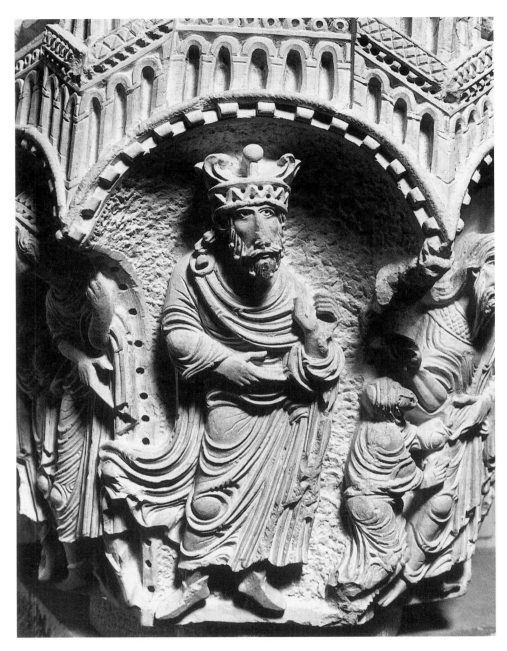

FIGURE 23-2 King Hyrtacus from the St Matthew Capital, Crusader Shrine of the Annunciation, Nazareth, *c*.1170s/early 1180s. Photo: Garo Nalbandian.

he was intensely Francocentric in his outlook, he nonetheless saw and understood some of the complexities and independent characteristics of the art of the Crusaders on the mainland. Basically, Enlart saw the architecture of the Crusaders as Romanesque French in origin, but he recognized the Eastern character of much that he found in French Romanesque. As a context for this architecture, Enlart clearly understands the Crusader States to be essentially French colonies. He also sees Cyprus and the Crusader States as fundamentally and closely interconnected after 1191/2.

Enlart identifies the years of greatest prosperity for the Latin Kingdom as between 1131 and 1174, when also significant art was produced. Soon after that, in 1187, the difficulties begin. Only Frederick II, who reopened the holy sites to Christians between 1229 and 1244, and Louis IX, who rebuilt fortifications and churches while in residence in 1250–4, are identified as bright spots in the deepening gloom. Between 1265 and 1291, he sees the history of the Crusader States as an unbroken stream of losses and defeats at the hands of a series of powerful Mamluk sultans. Despite this bleak picture, however, Enlart recognizes the existence of significant Crusader artistic work in the thirteenth century, especially churches and fortifications, some executed by specific artists and architects. He is the first to think in terms of Crusader work by individual, identifiable artists, but he identifies them essentially as Frenchmen working in the Holy Land. Enlart imagines that most were transient; few came East as settlers. Even though the identifiable Western masters were few, he does not entertain the idea of resident Frankish settlers who were artists, despite his recognition of the existence of masons' marks, some with signatures – indeed in one case with Armenian signatures.[19]

On the problem of how Crusader architecture develops, Enlart's basic conception of the nature of architecture (and in effect the art) of the Crusaders is revealed. The same basic stylistic change seen in France from Romanesque to Gothic is found in the Crusader East.[20] For Enlart, the developments in the East are parallel to those in the West; he basically sees the Latin Kingdom and Lusignan Cyprus as part of a French cultural continuum linked to France.

It is evident that the level of sophistication of Enlart's analysis and method enormously enlarged and deepened the terms of the art historical discussion. Not only did he begin the ongoing examination of the nature of Crusader artists and workshops, and masons' marks, based on concrete evidence, but he also brought Crusader art into the forum of discourse on larger issues such as East–West problems, the nature of artistic "schools," and ideas of artistic development in medieval art. Enlart effectively introduced Crusader art as a potential new chapter in the history of European medieval art. It was a phenomenon he dramatically revealed with the aid of 196 plates and 598 figures. It was also an art he argued to be much more complex than previously suspected. It is important to realize further that he recast the shape of the argument from one that focused on the art of the Crusaders as the art of the pilgrimage sites to that of a colonial French (and Italian) art in the Crusader States with a focus on

"architecture réligieuse et civile." His achievement was such that he must be regarded as the founding father of the study of Crusader art. What de Vogüé began, Enlart brought to a full conceptual realization, but the architectural work remained incomplete in regard to Crusader fortifications.

In 1927 Enlart "passed the baton" to his younger colleague Paul Deschamps (1888–1974), handing him the opportunity and the responsibility to study the Crusader castles in Syria-Palestine. The first of his three volumes, on Crac des Chevaliers, came out in 1934; the last, though dated 1973, appeared posthumously after Deschamps died in 1974.[21]

The achievements of Deschamps and his architects were remarkable. Not only did their fieldwork produce the most accurate and useful measured drawings of these complex constructions, but also the photographic documentation is invaluable. Photographs for the study of Crusader art had become a reality in the mid-nineteenth century, and Louis de Clercq produced four albums on Antioch and the Holy Land, including one entire volume on Crusader castles.[22]

What Deschamps achieved still serves to help guide us in identifying twelfth-century masonry from that of the thirteenth. And even though the work of Paul Deschamps represents for the larger world of Crusader studies the culmination and final flowering of the pioneering French view that Crusader and French were somehow equivalent in the medieval Near East, his legacy along with that of Camille Enlart was to provide us all with a fully structured historical paradigm of Crusader architectural and artistic developments. Even if the French approach overall consistently subordinated the figural arts to architecture in methodology, the work of Enlart and Deschamps is still today an essential and important entrée into the world of Crusader art and architecture, but one that requires serious revision in light of new finds.

The Study of Art of the Crusaders before and after World War II

In the 1930s new views and different perspectives on Crusader art and architecture had begun to emerge. Already before Deschamps published his first two volumes, T. E. Lawrence had written a thesis, mainly on twelfth-century Crusader castles, as an undergraduate at Jesus College, Oxford. Lawrence's work was eventually published posthumously, in 1936.[23] Lawrence basically knew nothing of Deschamps's work, and although Deschamps had read Lawrence's study, he only referred to it once in passing in his volume on *La Défense du royaume de Jérusalem* in 1939.[24] Lawrence's thesis is still worth reading, but it is more celebrated in the English-speaking world than elsewhere, partly because of the fame of the author. But Lawrence was a bell-weather for another prominent Englishman and fellow Oxonian, whose historical work would approach the art of the Crusaders in the Holy Land from a new point of view. Thomas Sherrer Ross Boase, writing in 1939, proposed the following idea: "in sculpture, painting

and architecture, the West and the East meet and effect exchanges in Palestine: there was also a similar interaction in literature."[25]

Tom Boase (1898–1974) turned his attention to Crusader art with increasing intensity from the late 1930s until his death in 1974, the same year as Paul Deschamps. Boase broke new ground in his 1939 article by interpreting the art of the Crusaders against a European rather than primarily a French background. He also proposed the idea that there was a genuine exchange of artistic ideas between the Western art the Crusaders brought with them and the art of the Levant, which the Crusaders found. Boase was the first in effect to suggest that what identified Crusader art was the multiplicity and diversity of its sources. While he himself never used the term "Crusader art," he paved the way for others to coin it.

Shortly after the end of World War II, in 1950, Boase wrote the first version of a study that would only be published in 1977, three years after his death, in volume four of *A History of the Crusades*. In the meantime, between 1950 and 1974, Boase would also publish two books on the art and history of the Crusaders which clearly indicated how dramatically the field was changing.[26] By contrast to his introductory article in 1939, Boase attempted a comprehensive survey of the material in his chapters for volume four.[27] Whereas he does not in effect enlarge the corpus of architecture published by Enlart and Deschamps, he does enlarge it significantly in terms of other media in the chapter entitled "Mosaic, Painting, and Minor Arts," reflecting the fruits of recent scholarly work.

It will become evident there were major changes in the study of the art of the Crusaders between the 1930s and 1977. Among the important contributions made by Tom Boase himself, we can cite, first, the extensive use of color plates to illustrate his wide-ranging 1967 and 1971 texts.[28] These plates are effective in conveying a real sense of the building materials and the sites, the terrain and the overall setting.[29] Secondly, Boase explores the idea of East–West interchange that he introduced, discussing how Crusader figural works were influenced by Byzantine and even Arab art. Thirdly, Boase expands on the work of his predecessors by enlarging on their French frame of reference and spending a quarter of his discussion on figural arts they did not know. In dealing with newly introduced material, Boase is cautious, but he focused on the importance of Byzantine influence for painting, unlike the Church architecture. Finally, Boase attempts to distinguish thirteenth-century work from that of the twelfth century in all media.

The Study of the Art of the Crusaders from 1957 to the Present

Three areas have emerged as central to the study of the art of the Crusaders since the 1950s when Boase was working.

Crusader figural arts including painting and the decorative arts

Hugo Buchthal (1909–96) and Kurt Weitzmann (1904–93), two prominent German scholars trained as Byzantinists, introduced Crusader manuscript illumination and Crusader panel painting, respectively, into the discourse on Crusader art and architecture. Buchthal[30] built a corpus of 21 illustrated Crusader manuscripts and he also had important things to say about the nature of this art and the artists in the twelfth and the thirteenth century:

> Miniature painting in the Crusading Kingdom . . . was not a colonial art. It had a distinctive style of its own, which was not derived from any single source, but emerged as the result of copying illuminations from a variety of Byzantine and western manuscripts, and of developing certain features of these models in a highly original and individual manner. . . . The masters of Jerusalem or Acre were either foreigners themselves, Frenchmen or Italians who had been specially recruited for work in Outremer, or Frankish natives who had perhaps served part of their apprenticeship at Constantinople, or in some well-known scriptorium in the Latin West. Not only did they work in their own native tradition but, more often than not, they were also given models to copy which had been imported from a different region of the Latin West, or from Byzantium. They were thus bound to produce works in which several different styles are superimposed on one another. . . . Thus miniature painting in the Crusading Kingdom developed into a very composite art, subject to influences which were the result of local conditions, and which differed with each succeeding generation. . . . The surprising thing is . . . that, in spite of the obvious lack of continuity, something like a local style and a local tradition of unmistakable identity should have emerged at all.[31]

This "local style" and "local tradition of unmistakable identity" is what Buchthal identified as "Crusader art" (fig. 23-3).

Kurt Weitzmann also discussed Crusader painting shortly thereafter, in two pioneering articles on Crusader icons.[32] In these two publications Weitzmann presented 43 images from a total of 26 newly attributed Crusader icons from the Monastery of St Catherine on Mount Sinai, combined with two model books and two other icons, one on Cyprus and one now in Grottaferrata, which he called possibly Crusader. In the earlier, 1963, article Weitzmann compared a crucifixion image in one of the Acre manuscripts published by Buchthal to various "Western-influenced" crucifixion icons at Sinai he was presenting. He concluded with an important formulation of the artistic phenomenon that also built on Buchthal's earlier comments:

> Attempts to distinguish the nationalities of the icon painters may not always be successful, simply because Italian and French artists working side by side and apparently having models from both countries available, gradually developed a style and iconography which, when fused with Byzantine elements, resulted in what one might simply call Crusader art.[33]

Figure 23-3 Christ mosaic in the Calvary Chapel, Church of the Holy Sepulchre, Jerusalem, mid-twelfth century. Photo: J. Folda.

Thus Buchthal and Weitzmann effectively first conceived or coined the terms "Crusader manuscript illumination" and "Crusader art" with regard to newly recognized book and panel painting, and substantially broadened the concept of the artists' origins in the publications just mentioned. Notably, these innovations hinged on the study of painting, most of which was dated to the thirteenth century, a medium heretofore little associated with the Crusaders after 1187. It is not too strong to say that this new material revolutionized the study of Crusader art and the publications by these two scholars laid the foundations for and marked the turning point into what we might describe as the current discourse on the art of the Crusaders.

The publication of this new material also stimulated other contributions on painting, e.g., a study of seven manuscripts illustrated by an artist trained in Paris who came to Acre to work in a good French Gothic style, a painter we now call the "Paris-Acre Master."[34] There is also a systematic study of the twelfth-century column paintings in the Church of the Nativity in Bethlehem, with magnificent plates, and a study on the famous mosaics in the same church is also well advanced by the same scholar.[35] A survey of the entire corpus of approximately 120 "Western-influenced icons" in the Monastery of St Catherine on Mount Sinai is included in the two-volume synthesis on the art of the Crusaders, the second volume of which has just been published.[36] Bianca Kühnel has renewed attention to the Crusader "minor arts."[37] Revived interest in the Crusaders and their art can also be seen as part of the impetus for several major international exhibitions in recent years, such as those in Rome and Toulouse (1997),[38] Milan (2000),[39] and Mainz-Mannheim (2004).[40]

The study of Crusader archaeology and material culture

The second area is the archaeological work that has dealt with Crusader material since the time of C. N. Johns and his excavations during the 1930s at 'Atlit, including the Templar castle and the fortified town.[41] Johns' successor in the Crusader States has been Denys Pringle, who along with his magisterial corpus of Crusader churches in the Latin Kingdom, in progress, has also published many other important studies, e.g., on domestic architecture and fortified towers in the context of crusader settlements.[42] Invigorated by the archaeological enthusiasm and accomplishments of Israeli scholars following the establishment of the State of Israel in 1948, major new archaeological work has added important new dimensions to the study of Crusader art and architecture. The survey work of Meron Benvenisti, stimulated by the historical studies of Joshua Prawer, has been followed by the contributions of Ronnie Ellenblum and Adrian Boas.[43] For specific sites we find important contributions: the work of V. Corbo and Martin Biddle at the Church of the Holy Sepulchre in Jerusalem;[44] B. Bagatti has contributed important material at Nazareth, leading to further studies;[45] Eliezer and Edna Stern are leading a team currently excavating at Acre.[46] Pottery has therefore become a major focus of attention for scholars like D. Pringle,[47]

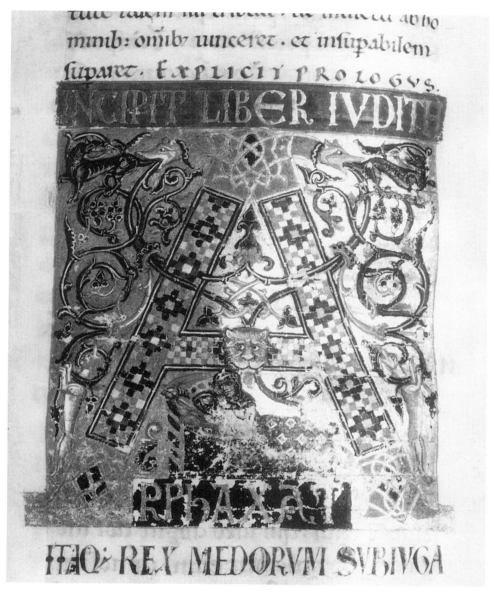

FIGURE 23-4 Initial "A," for the book of Judith, with the scene of Judith decapitating Holofernes, from Bible of San Danieli del Friuli, late twelfth century, possibly from Antioch. Biblioteca Guarneriana, MS III, fol. 131v. Photo: J. Folda.

A. Boas,[48] and E. Stern, and a recent exhibition in Jerusalem of Crusader work has included examples of the pottery as well as other finds.[49] Clearly, archaeological work has been important and increasingly fruitful for the study of the art and architecture of the Crusaders.

The debate over the nature and development of Crusader art

The third area of great importance for the study of Crusader art is the discussion that has been going on since the 1950s dealing with the concept of "Crusader Art" and the artists who made it. The late Otto Demus began the debate in an important review of volume IV of *A History of the Crusades*, when he stated:

> [I]t is . . . questionable whether this label [Crusader art] should be used at all for the sum total of the art that originated in the Crusader territories. . . . Some branches may be legitimately designated in this way, especially miniature and icon painting . . . but others do not seem to qualify for such a definition. There is, for instance, hardly such a thing as "Crusader Sculpture," the few surviving works being stylistically so heterogeneous that they cannot be brought under a common heading.[50]

At the same time that Demus was writing, Hans Belting was mounting a serious challenge to the idea of Crusader art from a different point of view. Belting introduced the idea of a "lingua franca" in art, that is, the existence of works of art in which painters working in the Mediterranean region integrated fully understood Byzantine principles with certain Western European characteristics so seamlessly that we cannot discern the artist's place of origin.[51] It is in effect an artistic lingua franca on the linguistic model.

Belting enlarged on his characterization of the artistic lingua franca in his papers for the session on "Near East and West in Thirteenth-Century Art" in the Acts of the 24th International Congress of the History of Art held in Bologna in 1979.[52] He proposed that certain thirteenth-century works exemplified an art neither Western nor Byzantine, but which developed a new synthetic language of components difficult to distinguish. This art, in his view, was distinct from the old notion of the Italian *maniera greca* which lacked specificity. By contrast, the art of the lingua franca was very specific and could also be called the art of the Mediterranean commonwealth of Venice.[53] Finally, Belting asserted that we must reserve the idea of Crusader art for the twelfth century.[54]

As the debate continued, Kurt Weitzmann was not willing to relinquish either the idea of the *maniera greca* when dealing with the issue of Italian painting in the Byzantine manner, or the idea of "Crusader art" as distinct from the *maniera greca*, or, for that matter, the lingua franca in the thirteenth century.[55] But these questions about Crusader art in the thirteenth century as related to the idea of an artistic lingua franca also raised again the issue of who the Crusader artists may have been. In 1979, Marie-Luise Bulst, in her study of the mosaic decoration in the Church of the Holy Sepulchre in Jerusalem, stated forthrightly that Crusader art is better and more correctly characterized as the "art of the Frankish colonialists in the Kingdom of Jerusalem."[56] In particular, she points out that it was not the Crusaders, that is, the actual *crucesignati*, who came as soldiers and/or pilgrims, who built, painted, or sculpted the works we call Crusader art.

It was mainly the resident Franks, and the Italians from Genoa, Pisa, and Venice, that is, the settlers. They were Western Europeans who came and stayed, some to intermarry, and their children, who generated the art either as patrons or even as the artists.[57] Finally, she asserts, the Kingdom of Jerusalem remained a Western colony, and this colonial outlook characterized Crusader art in the twelfth century.

This proposal, limited as it is, made an important contribution to the idea of who the Crusader artists were, because it focuses attention on the importance of the settlers and their resident offspring. This view complements the ideas of Weitzmann and Buchthal,[58] and marks an important change by challenging the assumption that Crusader artists were all originally from Western Europe. The implications of Bulst's idea are, if spelled out further, that Crusader artists could be the offspring of second or later generation settlers, born in the Latin Kingdom and trained there.

Along with this expanded idea of who the Crusader artist could be, the debate intensified on what the background and training of these artists may have been, and what we could know about it. When Buchthal and Weitzmann first proposed their idea of Crusader art and its style, they envisioned the notion that the Crusader artists were Westerners who came to the East. There they developed into Crusader style painters by gradually learning to combine Byzantine style and technique with their own native tradition. In contrast to this view, Valentino Pace, writing in 1986, argued that "the very nature of 'Crusader painting' eludes all efforts to verify the nationality of its artists; we could go so far as to say that if the origin of the artist can really be detected, his work must no longer be labeled as 'Crusader'."[59] In effect, therefore, Pace maintains the identifiability of Crusader art in the thirteenth century, but it appears that he is thinking of the Crusader artist as a manifestation of the lingua franca artistic idea.

A number of other scholars have entered this discussion since the 1980s. A range of their ideas can be indicated with regard to a "Crusader" icon of St Sergios with a kneeling female donor, a work probably done in the 1260s in Acre, but now in the collection of St Catherine's on Mount Sinai.[60] When Weitzmann first published this icon, he thought at first that it was done by an Apulian painter working at Sinai, but then he immediately wondered if the painter might not have been a southern Italian with strong Venetian training.[61] Meanwhile, Doula Mouriki proposed that the artist was not Crusader at all, but instead was a Cypriot of Syrian background working at Sinai.[62] Alternatively, Lucy-Anne Hunt, also recognizing Syrian characteristics, suggested it was done by a Syrian Orthodox painter working in the County of Tripoli, comparing it to local wall paintings.[63]

Expanding on this issue before her untimely death, Mouriki challenged Weitzmann's proposal that approximately 120 icons now at St Catherine's Monastery on Mount Sinai could be called "Crusader" on the basis of what she

identified as Weitzmann's criteria: (1) executed by a (Crusader) Western artist, (2) produced in Crusader territory, and (3) commissioned by a Crusader donor.[64] She has been joined in this discussion by Robin Cormack, who writes that "as a consequence of her [Mouriki's] systematic studies on the icons of Cyprus and Sinai, she reached the conclusion that the category of Crusader icons which Weitzmann had proposed should be almost entirely deconstructed."[65] Mouriki had already concluded in 1986 that, "we may wonder if Crusader painting, according to the traditional definition, is a less substantial reality than has been assumed."[66]

In the face of these challenges, and other comments on the nature of especially thirteenth-century art in the Mediterranean world, clearly some reconsiderations are in order. As one example, Annemarie Weyl Carr, looking at the situation from the vantage point of medieval Cyprus, added her voice to those validating and problematizing the idea of the artistic lingua franca. In 1995 she wrote, "On many levels – of style, iconography, ornament, Morellian detail – thirteenth-century Cyprus belongs with Syria and South Italy to an artistic commonwealth."[67] Earlier, from her point of view based on the art of the Eastern Christians in the Near East, Lucy-Anne Hunt had written, "The art historical concept of 'Crusader' art is grounded . . . in a pre-occupation with colonialization from a western point of view. It is envisaged as a composite, the output of western artists of different nationalities confronting Byzantine art."[68]

Drawing on the stimulus of this debate, further reassessment of the art of the Crusaders is being carried on in the work of Jaroslav Folda, among others. In a paper given at Dumbarton Oaks in 2002, he proposed the following prolegomenon to a full reevaluation. When Kurt Weitzmann formulated his idea about Crusader icons in 1963, he said, as we quote again here: "attempts to distinguish the nationalities of the icon painters may not always be successful, simply because Italian and French artists working side by side and apparently having models from both countries available, gradually developed a style and iconography which, when fused with Byzantine elements, resulted in what one might simply call Crusader art."[69] In fact, what Folda proposes is that "what we normally have in a Crusader workshop is, not 'Italian and French artists working side by side,' but *Crusader artists working side by side*, although obviously they may reflect different artistic traditions in their backgrounds and training, and they may be also working with local eastern Christian artists as well."[70] The important evidence for this reconsidered interpretation is the works of art themselves and their – the artists' – remarkable immersion in the Byzantine and Levantine circumstances of their training, development, working conditions, and patronage, as well as the functions of their art.

It is of course possible that from time to time, a young western artist may have come to Acre, for example, and joined the painting establishment. Such an artist theoretically could have learned the Crusader style on the spot, transforming

whatever early training he might have already received. The problem is that we have few, if any, documented examples of such an artist.[71]

The conclusion this suggests in light of the debate outlined above, is that the imbedded assumptions about the nature of Crusader artists as being transplanted Westerners, whether French or Italian, should be reconsidered. In fact, the evidence of the overwhelming number of paintings in manuscripts and icons of the thirteenth century suggests these artists should be thought of as born in Crusader territory in the Near East of possible Frankish or Italian ancestry, and perhaps representing second or later generations of settler stock. They were apparently trained in the Near East, primarily by Crusader masters. Accordingly, the styles they worked in should be characterized, not as, e.g., Veneto-Byzantine or Franco-Byzantine styles, but as Veneto-Byzantine Crusader styles, or Franco-Byzantine Crusader styles.

Although we have very few if any *documented* examples of such a Crusader-born and trained artist among the book and icon painters heretofore identified as Crusader, we do have documented evidence of one Western artist who left Paris and came to Acre to work in the 1280s. This artist, whom we now refer to as the Paris-Acre Master, appears to have been a French painter trained in Paris in the 1270s. When he came to Acre to work *c*.1280, he was fully developed and mature and he essentially retained the Parisian Gothic style in which he had been trained during his entire time in the Latin Kingdom.[72]

What the work of the Paris-Acre Master forces us to reflect on is this. As a documented Western painter working in Acre, he is comparatively rare, among those so far identified as Crusader. This is an important fact, contrary to the assumption that all or most Crusader artists were Westerners. What characterized his work is that he maintained his mature personal Parisian Gothic style despite his Eastern surroundings and his various Crusader patrons. Therefore, in light of the fact that his work is so unusual in Crusader Acre during the 1280s, it appears highly unlikely, in the absence of other clearly documented evidence, that an artist who came from the West, already mature and fully formed as a painter, suddenly, or even gradually, would become an artist working in a developed Crusader style. That is, it is unlikely that such a Western artist came to Acre and suddenly, under the impact of Byzantine and Levantine training and influence, began working in a fully developed Crusader style, e.g., a Veneto-Byzantine Crusader style, a South Italian-Byzantine Crusader style, a Franco-Byzantine Crusader style, or some other Byzantine-influenced Levantine Crusader style.

This brings us to the current point in the state of the question concerning certain major aspects of the study of the art of the Crusaders in the Holy Land between 1098 and 1291. Clearly, many important aspects of Crusader art are presently under serious study and discussion and certain issues remain unresolved, so we can expect many new developments in future years. But here we now have space only to offer a few concluding remarks.

Conclusion

Study of the art of the Crusaders in the Holy Land has had a rich development starting in the mid-nineteenth century, leading to its current flourishing state. When scholarly work began, attention was more focused on architecture and more on the twelfth century; recently we have been dealing more with the figural arts in the thirteenth century. Major questions pertaining to the issue, "What is Crusader Art?" are currently a central focus of concern.

More work – archaeological and art historical – is clearly needed in the areas that were the counties of Tripoli and Edessa and the Principality of Antioch. The art of the Crusaders in other important areas of the Near East, especially on Cyprus and in the Latin Empire of Constantinople and the Morea, has also received new attention, but there is much work that needs to be done in these areas as well. Greater knowledge about the art of the Crusaders on Cyprus and in the Latin Empire will help clarify the nature and development of the Art of the Crusaders in the Holy Land.

Notes

1 Michaud, *Histoire des Croisades*, in three volumes; then expanded to seven volumes (6th edn., 1824–9, repr. 1966–8).
2 de Saulcy, *Numismatique des Croisades*.
3 de Vogüé, *Eglises de la Terre Sainte*.
4 [On Romanesque architecture, see chapter 14 by Fernie in this volume (ed.).]
5 Rey, *Etude sur les monuments*.
6 Rey, *Les Colonies franques*. See also, idem, "Etude sur la Topographie."
7 Schlumberger, *Numismatique de l'Orient Latin*.
8 Warren and Conder, *Survey of Western Palestine*, and Conder and Kitchener, *Survey of Western Palestine*.
9 Prutz, *Kulturgeschichte der Kreuzzüge*. Book 5, part II, deals with "Die bildenden Künste bei den Franken und die Einwirkung der Kreuzzügge auf die bildenden Künste im Abendlande," pp. 416–35, 566–7.
10 Diehl, "Les Monuments de l'Orient Latin."
11 Vincent and Abel, *Jérusalem*.
12 Viaud, *Nazareth*.
13 Schmaltz, *Mater Ecclesiarum*, knew the work of Vincent and Abel and made good use of it.
14 Enlart started on the basis of the studies by de Vogüé and Rey, and he also relied heavily on the work of Guérin, *Description géographique*.
15 Enlart, *Les Monuments des Croisés*, in 2 vols., with two albums, containing 196 plates.
16 Enlart, *Les Monuments*, vol. 1, p. 1.
17 Enlart, *L'Art gothique*, in two vols., recently translated into English: Enlart, *Gothic Art and the Renaissance*, with an introduction by Nicola Coldstream. [On the art and architecture of Lusignan Cyprus, see chapter 24 by Papacostas in this volume (ed.).]

18 It was Josef Stryzgowski in Vienna most prominently who was advocating the Eastern origins thesis in a series of publications after 1900.

19 Enlart, *Les Monuments*, vol. I, pp. 22–5. For signatures, he mentions twelfth century examples such as Ode, Ogier, Johannes, Jordanis, and refers to Armenian signatures at Nazareth (ibid., pp. 24–5)

20 [On Gothic architecture, see chapter 18 by Murray in this volume (ed.).]

21 Deschamps, *Les Châteaux des croisés*.

22 Folda, "Crusader Art and Architecture." Volume 2 of Louis de Clercq's albums, *Voyage en Orient: Chateaux du temps des Croisades* (1859–60), dealt with the Crusader castles.

23 See Lawrence, *Crusader Castles*, which is the essential new edition of his thesis, with detailed scholarly notes by D. Pringle. Lawrence had made numerous notes and revisions on his thesis but died before any final changes were made. Pringle's annotated edition is essential for understanding the state of the thesis at the time of publication and the thoughts of the author in regard to the issues he addressed.

24 Deschamps, *Les Châteaux des croisés*, vol. 2, p. 122 n.1.

25 Boase, "The Arts in the Latin Kingdom," p. 20. [On Romanesque and Gothic sculpture, see chapters 15, 16, and 19 by Hourihane, Maxwell, and Büchsel, respectively, in this volume (ed.).]

26 Boase, *Castles and Churches* and *Kingdoms and Strongholds*.

27 Boase, (chapter III) "Ecclesiastical Art in the Crusader States in Palestine and Syria: A. Architecture and Sculpture, B. Mosaic, Painting and Minor Arts," (chapter IV) "Military Architecture in the Crusader States in Palestine and Syria," (chapter V) "The Arts in Cyprus: A. Ecclesiastical Art," and (chapter VI) "The Arts in Frankish Greece and Rhodes: A. Frankish Greece (with D. J. Wallace), B. Rhodes," in Hazard, *History of the Crusades*, vol. IV, pp. 69–195, 208–50.

28 Boase, *Castles and Churches*, 24 color plates. Actually Paul Deschamps was the first to use color photography to illustrate his book, *Terre Sainte Romane*, but there are only four color plates printed in a strangely dark process that gives the scenes an eerie abandoned look.

29 Boase engaged Dr Richard Cleave to do the photography. Cleave's excellent photographs were part of a large archive he amassed over a period of many years on the Near East, eventually surpassing Alistair Duncan's photo collection.

30 Buchthal, *Miniature Painting*.

31 Ibid., pp. xxxii–xxxiii. [On Romanesque and Gothic manuscript illumination, see chapters 17 and 20 by Cohen and Hedeman in this volume (ed.).]

32 Weitzmann, "Thirteenth-Century Crusader Icons," and "Icon Painting in the Crusader Kingdom."

33 Weitzmann, "Thirteenth-Century Crusader Icons," p. 182.

34 Folda, *Crusader Manuscript Illumination*. This "Crusader" artist, first dubbed the "Hospitaller Master", can now be seen to have more to do with Paris and less to do with the Hospitallers leading to a change in nomenclature.

35 Kühnel, *Wall Painting*.

36 Volume 1: Folda, *The Art of the Crusaders*; volume 2: idem, *Crusader Art in the Holy Land*.

37 Kühnel, *Crusader Art of the Twelfth Century*, pp. 61–153.
38 Rey-Delqué, *Le Crociate* (French edition: *Les Croisades*).
39 Piccirillo, ed., *In Terrasanta*.
40 Siede, ed., *Die Kreuzfahrer*.
41 The material published in the 1930s and in 1950 by Johns has now been assembled with his work on two other fortifications in Jerusalem and at Qal'at ar-Rabad in Jordan, introduced and edited by D. Pringle: *Pilgrims' Castle*. For a discussion of archaeological contributions to Crusader studies, mainly after 1985, see Porëe, "La Contribution de l'Archéologie."
42 See Pringle, *The Red Tower* and *Secular Buildings*.
43 Benvenisti, *Crusaders in the Holy Land*; Ellenblum, *Frankish Rural Settlement*; Boas, *Crusader Archaeology*.
44 Corbo, *Il Santo Sepolcro*; Biddle *The Tomb of Christ*.
45 Bagatti, *Excavations in Nazareth*, and, with E. Alliata, *Gli scavi di Nazaret*. Building on the new finds in vol. II, see, Folda, *The Nazareth Capitals*.
46 See, e.g., Stern, "Excavation of the Courthouse Site."
47 See, e.g., Pringle, "Medieval Pottery."
48 Boas, "Import of Western Ceramics."
49 Rozenberg, ed., *Knights of the Holy Land*.
50 Demus, review of *A History of the Crusades*, vol. IV, pp. 636–7.
51 Belting, "Zwischen Gotik und Byzanz."
52 Belting, "Introduction," and "Die Reaktion der Kunst des 13. Jahrhunderts auf den Import von Reliquien und Ikonen."
53 Belting, "Introduction," p. 3.
54 Ibid., p. 1.
55 Weitzmann, "Crusader Icons," pp. 143–4.
56 Bulst-Thiele, "Die Mosaiken."
57 [On patronage, see chapter 9 by Caskey in this volume (ed.).]
58 See Buchthal, *Miniature Painting* and Weitzmann, "Thirteenth-Century Crusader Icons," and "Icon Painting in the Crusader Kingdom."
59 Pace, "Italy and the Holy Land," p. 334.
60 Folda, entry on the Icon of St Sergios from Sinai (BYZ3910), in Evans, ed., *Byzantium*.
61 Weitzmann, "Icon Painting in the Crusader Kingdom," pp. 71–3.
62 Mouriki, "Thirteenth-Century Icon Painting."
63 Hunt, "A Woman's Prayer."
64 Mouriki, "Icons," pp. 117–18.
65 Cormack, "Crusader Art," p. 165. Cormack is joined in this view by Zeitler, "Two Iconostasis Beams," pp. 223–7.
66 Mouriki, "Thirteenth-Century Icon Painting in Cyprus," p. 77.
67 Weyl Carr, "Images of Medieval Cyprus," pp. 97–8.
68 Hunt, "Art and Colonialism," p. 69.
69 Weitzmann, "Thirteenth Century Crusader," p. 182.
70 Folda, "The Figural Arts."
71 Ibid.
72 Weitzmann, "Thirteenth-Century Crusader Icons," and "Icon Painting in the Crusader Kingdom."

Bibliography

Important published bibliographies for Crusader studies and the art of the Crusaders in the Holy Land may be found in the appropriate section in Jaroslav Folda, *Crusader Art in the Holy Land, from the Third Crusade to the Fall of Acre, 1187–1291* (Cambridge and New York, 2005).

B. Bagatti, *Excavations in Nazareth: from the beginning till the XII century*, vol. 1, trans. E. Hoade (Jerusalem, 1969).

B. Bagatti, with E. Alliata, *Gli scavi di Nazaret: dal secolo XII ad oggi* (Jerusalem, 1984).

H. Belting, "Introduction," and "Die Reaktion der Kunst des 13. Jahrhunderts auf den Import von Reliquien und Ikonen," *Il Medio Oriente e l'Occidente nell'arte del XIII secolo*, Atti del XXIV Congresso Internazionale di Storia dell'Arte, vol. 2 (Bologna, 1982), pp. 1–10, 35–53.

——, "Zwischen Gotik und Byzanz," *Zeitschrift für Kunstgeschichte* 41 (1978), pp. 217–57.

Meron Benvenisti, *The Crusaders in the Holy Land* (Jerusalem, 1970).

M. Biddle, *The Tomb of Christ* (Phoenix Mill, 1999).

A. J. Boas, *Crusader Archaeology: The Material Culture of the Latin East* (London, 1999).

——, "The Import of Western Ceramics to the Latin Kingdom of Jerusalem," *Israel Exploration Journal* 44 (1994), pp. 102–22.

T. S. R. Boase, "The Arts in the Latin Kingdom of Jerusalem," *Journal of the Warburg and Courtauld Institutes* 2 (1938/9).

——, *Castles and Churches of the Crusading Kingdom* (London, 1967).

——, *Kingdoms and Strongholds of the Crusaders* (London, 1971).

H. Buchthal, *Miniature Painting in the Latin Kingdom of Jerusalem* (Oxford, 1957).

Marie Luise Bulst-Thiele, "Die Mosaiken der 'Auferstehungskirche' in Jerusalem und die Bauten der 'Franken' im 12. Jahrhundert," *Frühmittelalterliche Studien* 13 (1979), pp. 442–71.

C. R. Conder and H. H. Kitchener, *The Survey of Western Palestine: Memoirs of the Topography, Orography, Hydrography and Archaeology*, vol. I, *Galilee*, vol. II, *Samaria*, vol. III, *Judaea* (London, 1881–3; repr. Kedem, 1970).

V. C. Corbo, *Il Santo Sepolcro di Gerusalemme, aspetti archeologici dalle origini al periodo crociato*, 3 parts (Jerusalem, 1982).

R. Cormack, "Crusader Art and Artistic Technique: Another Look at a Painting of St George," in M. Vassilaki, ed., *Byzantine Icons: Art, Technique and Technology* (Heraklion, 2002).

O. Demus, review of *A History of the Crusades*, vol. IV, in *Art Bulletin* 61 (1979), pp. 636–7.

Paul Deschamps, *Les Châteaux des croisés en Terre Sainte* (Paris; vol. 1, *Le Crac des Chevaliers*, 1934; vol. 2, *La Défense du Royaume de Jérusalem*, 1939; vol. 3, *La Défense du Comté de Tripoli et de la Principauté d'Antioche*, 1973).

——, *Terre Sainte Romane* (Abbaye Ste-Marie de la Pierre-Qui-Vire, 1964; rev. edn., 1990).

Charles Diehl, "Les Monuments de l'Orient Latin," *Revue de l'Orient Latin* 5 (1897), pp. 293–310.

R. Ellenblum, *Frankish Rural Settlement in the Latin Kingdom of Jerusalem* (Cambridge, 1998).

C. Enlart, *L'Art gothique et de la Renaissance en Chypre*, 2 vols. (Paris, 1899).

——, *Gothic Art and the Renaissance on Cyprus*, trans. D. Hunt (London, 1987).

——, *Les Monuments des Croisés dans le Royaume de Jérusalem: Architecture religieuse et civile*, 2 vols., Haut Commissariat de la République Française en Syrie et au Liban: Service des Antiquités et des Beaux-Arts, Bibliothèque Archéologique et Historique, T. VII, VIII (Paris, 1925 and 1928), with two albums (Paris, 1926).

Helen C. Evans, ed., *Byzantium: Faith and Power (1261–1557)* (New York, 2004).

Jaroslav Folda, *The Art of the Crusaders in the Holy Land, 1098–1187* (Cambridge, 1995).

——, "Crusader Art and Architecture: A Photographic Survey," in K. M. Setton, *A History of the Crusades*, vol. IV, ed. H. W. Hazard (Madison and London, 1976), pp. 281–8.

——, *Crusader Art in the Holy Land, from the Third Crusade to the Fall of Acre, 1187–1291* (Cambridge, 2005).

——, *Crusader Manuscript Illumination at Saint Jean d'Acre, 1275–1291* (Princeton, 1976).

——, "The Figural Arts in Crusader Syria and Palestine, 1187–1291: Some New Realities," *Dumbarton Oaks Papers* 58 (2005).

——, *The Nazareth Capitals and the Crusader Shrine of the Annunciation* (University Park and London, 1986).

V. Guérin, *Description géographique, historique et archéologique de la Palestine* (Paris; *Judée*, in 3 vols., 1868–9, *Samarie*, in 2 vols., 1874–5, *Galilée*, in 2 vols., 1880; repr. 1969).

Lucy-Anne Hunt, "Art and Colonialism: The Mosaics of the Church of the Nativity, Bethlehem (1169), and the Problem of 'Crusader' Art," *Dumbarton Oaks Papers* 45 (1991).

——, "A Woman's Prayer to St Sergios in Latin Syria: Interpreting a Thirteenth-Century Icon at Mount Sinai," *Byzantine and Modern Greek Studies* 15 (1991), pp. 106–10.

C. N. Johns, *Pilgrims' Castle ('Atlit), David's Tower (Jerusalem) and Qal'at ar-Rabad ('Ajlun)*, introduced and ed. D. Pringle (Aldershot, 1997).

B. Kühnel, *Crusader Art of the Twelfth Century* (Berlin, 1994).

G. Kühnel, *Wall Painting in the Latin Kingdom of Jerusalem* (Berlin, 1988).

T. E. Lawrence, *Crusader Castles*, ed. with notes by D. Pringle (Oxford, 1988).

J. F. Michaud, *Histoire des Croisades*, 3 vols. (Paris, 1817–19; 6th edn., 7 vols. Paris, 1824–9; repr. 1966–8).

D. Mouriki, "Icons from the 12th to the 15th Century," in K. Manafis, ed., *Sinai: Treasures of the Monastery* (Athens, 1990).

——, "Thirteenth-Century Icon Painting in Cyprus, *The Griffon* n.s. 1–2 (1985–6), pp. 66–71.

V. Pace, "Italy and the Holy Land: Import-Export. I. The Case of Venice," in V. P. Goss, ed., The *Meeting of Two Worlds* (Kalamazoo, 1986).

M. Piccirillo, ed., *In Terrasanta: dalla Crociata alla Custodia dei Luoghi Santi* (Milan, 2000).

B. Porée, "La Contribution de l'Archéologie à la connaissance du monde des Croisades (XIIe–XIIIe siècle): l'exemple du Royaume de Jérusalem," in M. Balard, ed., *Autour de la Première Croisade* (Paris, 1996), pp. 487–515.

R. D. Pringle, "The Medieval Pottery of Palestine and Transjordan (AD 636–1500): An Introduction, Gazeteer and Bibliography," *Medieval Ceramics* 5 (1981), pp. 45–60.

——, *The Red Tower (al-Burj al-Ahmar), Settlement in the Plain of Sharon at the Time of the Crusaders and the Mamluks, AD 1099–1516* (London, 1986).

——, *Secular Buildings in the Crusader Kingdom of Jerusalem, An Archaeological Gazetteer* (Cambridge, 1997).

H. Prutz, *Kulturgeschichte der Kreuzzüge* (Berlin, 1883).

E.-G. Rey, *Les Colonies franques de Syrie aux XIIe et XIIIe siècles* (Paris, 1883; repr. New York, 1972).

——, *Etude sur les monuments de l'architecture militaire des Croisés en Syrie et dans l'ile de Chypre* (Paris, 1871).

——, "Etude sur la Topographie de la Ville d'Acre au XIIIe Siècle," *Mémoires de la Société nationale des antiquaires de France*, 39 (1879), pp. 115–45, with a "supplément", *Memoires SNAF*, 49 (1888), pp. 1–18.

M. Rey-Delqué, *Le Crociate: L'Oriente e l'occidente da Urbano II a San Luigi, 1096–1270* (Milan, 1997).

——, *Les Croisades*, trans. I. Baudet et al. (Milan and Toulouse, 1997).

S. Rozenberg, ed., *Knights of the Holy Land: The Crusader Kingdom of Jerusalem* (Jerusalem, 1999).

Louis Felicien de Saulcy, *Numismatique des Croisades* (Paris, 1847; repr. 1974).

G. Schlumberger, *Numismatique de l'Orient Latin* (Paris, 1878; supplement, Paris, 1882).

Karl Schmaltz, *Mater Ecclesiarum: Die Grabeskirche in Jerusalem* (Strassburg, 1918).

K. M. Setton, ed., *History of the Crusades*, vol. 4, ed. H. W. Hazard (Madison and London, 1976).

I. Siede, ed., *Die Kreuzfahrer: Europe's Encounter with the Orient* (Mainz-Mannheim, 2004).

E. Stern, "Excavation of the Courthouse Site at 'Akko: The Pottery of the Crusader and Ottoman Periods," *Atiqot* XXXI (1997), pp. 35–70.

P. Viaud, *Nazareth et ses deux églises de l'Annonciation et de Saint-Joseph* (Paris, 1910).

H. Vincent and F.-M. Abel, *Jérusalem: Recherches de topographie, d'archéologie et d'histoire* (Paris; vol. II, *Jérusalem nouvelle*, fasc. I–II, 1914; fasc. III, 1922; fasc. IV, 1926).

M. de Vogüé, *Les Eglises de la Terre Sainte* (Paris, 1860; repr. 1973, with an introduction by J. Prawer).

C. Warren and C. R. Conder, *The Survey of Western Palestine: Jerusalem* (London, 1884).

K. Weitzmann, "Crusader Icons and Maniera Greca," in I. Hutter, ed., *Byzanz und der Westen* (Vienna, 1984), pp. 143–4.

——, "Icon Painting in the Crusader Kingdom," *Dumbarton Oaks Papers* 20 (1966), pp. 51–83.

——, "Thirteenth-Century Crusader Icons on Mount Sinai," *Art Bulletin*, 45 (1963), pp. 179–203.

A. Weyl Carr, "Images of Medieval Cyprus," in P. W. Wallace, ed., *Visitors, Immigrants, and Invaders in Cyprus* (Albany, 1995).

B. Zeitler, "Two Iconostasis Beams from Mount Sinai," in A. Lidov, ed., *The Iconostasis: Origins – Evolution – Symbolism* (Moscow, 2000).

Gothic in the East: Western Architecture in Byzantine Lands

Tassos C. Papacostas

Background

Medieval Western art and architecture were transplanted to the islands and around the shores of the eastern Mediterranean as a result of the Crusades. The objective of this chapter is to trace the development of the study of this art in territories previously under Byzantine rule where the Crusaders established states in the late twelfth and thirteenth centuries (Cyprus, Aegean islands, Greek mainland, Constantinople).[1] The coverage of this wide geographical area will necessarily be uneven, for it is conditioned by the chronological limits imposed by the editors of this volume, by the nature and extent of the surviving material, and of course by the scholarly interest the latter has attracted over the years. Thus, relatively little will be said about mainland Greece, even less about the Aegean islands and Constantinople, while Cyprus will loom large in the discussion, focused mainly on architecture. I hope the reasons for this will become clear in the course of what follows.

Any discussion of the art of these lands in a volume devoted to Romanesque and Gothic art is bound to raise some pertinent questions: What is the relationship between what one might classify as "Gothic" and "Crusader"? Are they identical or do they merely overlap? Does one form a subdivision of the other? What do we mean exactly when we talk of the art of the principality of the Morea or of the Lusignan kingdom of Cyprus? Gothic is certainly part of it, but not necessarily identical with it, for the artistic production of the Latin states was much more diverse. Although perhaps easier to distinguish "Gothic" in architecture, in other art forms the borders are much more blurred, with the Byzantine heritage of these lands playing a defining role.[2]

The kingdom of Cyprus was established after the island's conquest during the Third Crusade (1191) and survived into the late fifteenth century. Its longevity thus surpassed that of any other Crusader state – with the exception of some Venetian colonies in the Aegean. What is more, the island kingdom led a rather stable existence, and for a short period it became remarkably prosperous too. The same cannot be said of the post-1204 creations further west. In sharp contrast to the unified centralized state of Lusignan Cyprus, it was fragmentation of the political landscape which characterized the southern Balkans and the Aegean, with Venice, and to a lesser extent Genoa, playing a leading role, especially in the islands. The former ruled Crete (1205–1669), Euboea (1209–1470), and other scattered outposts, while the latter established colonies mainly in the eastern Aegean. The Latin empire of Constantinople and the kingdom of Thessalonike were both short-lived (1204–61 and 1204–24 respectively). The duchies of Athens (1205–1456) and of the Archipelago (1207–1566) struggled for both stability and prosperity with frequent changes of rule. Only the principality of the Morea (1204–1460) comes somewhat close to the Cypriot experience, with its feudal organization imposed on a predominantly Greek Orthodox indigenous population over a relatively large territory under a ruling class of Western origin. Yet the fates of the Morea and Cyprus were far from alike: whereas the thirteenth century marked the apogee of the principality under the Villehardouins, followed by a period of slow decline, Cyprus witnessed its most glorious days in the fourteenth century. This is unavoidably reflected in the two regions' artistic output.

The conditions prevailing earlier in the various newly conquered territories varied enormously and affected the subsequent artistic and especially building activity. The case of Constantinople was unique: when the Latin empire was established, it took over a large metropolis, ancient capital and nerve center of an old empire, where there was no real need for new constructions. Indeed, there is little evidence of building activity during the short life of the Latin empire, although it has to be said that the production of portable works of art at that time still remains little known. In Cyprus and the Morea, however, the situation was altogether different. In the former the new settlers found a relatively prosperous island, although its infrastructure was presumably not up to standard for the requirements of an independent kingdom with a resident aristocracy and a royal court. This is abundantly clear from the fact that the Byzantine past of the main urban settlements has almost entirely disappeared under a Gothic layer. So much so that, although Cyprus cannot compete with Syria in the field of Crusader military architecture, its cities nevertheless offer the largest and most elaborate specimens of ecclesiastical architecture in the Latin East (fig. 24–1). The island also provides the best example of Gothic monastic architecture surviving in this part of the world: although partly in ruins, the abbey of Bellapais preserves its fourteenth-century refectory, one of the largest still standing anywhere, in almost pristine condition.[3]

One would expect to encounter a similar situation in the Morea too. The evidence, however, suggests otherwise. The group of religious buildings, all in a

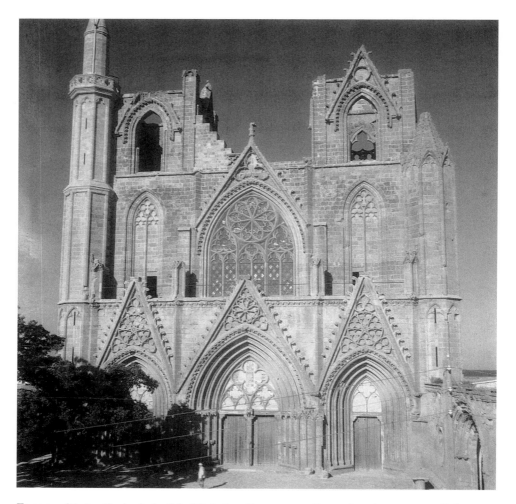

FIGURE 24-1 Cathedral of St Nicholas, Famagusta. Reproduced courtesy of The Conway Library, Courtauld Institute of Art, London. Photo: Robert Byron.

ruinous state now, is very small and not particularly impressive in terms of architectural elaboration. The most important among them, the church at Isova and St Sophia at Andravida (the cathedral of the principality's capital city), were large but rather plain timber-roofed basilicas, with vaults over their sanctuaries only. Although the Cistercian church at Zaraka was vaulted throughout, like the other churches it lacks the careful construction and rather elaborate ornamentation of the Cypriot examples. On Cyprus, few castles were built because of both the protection provided by the sea and the centralized character of the state, lacking powerful feudal lords. In the Morea, on the other hand, conditions were quite different and some 50 castles survive from the principality's days. Like the

three castles of the Kyrenia mountains in Cyprus, but unlike those in Syria-Palestine, these are mostly roughly built strongholds with few architectural pretensions, much altered in subsequent centuries, and little documented in the sources. As a result, their chronology remains very difficult to establish. What is more, their state of preservation is usually rather poor. In fact, this is a recurrent problem with the monuments of mainland Greece and the islands, which have suffered enormously from neglect, wanton destruction, but most regrettably from careless restoration.

The architectural legacy of Lusignan Cyprus also suffered serious losses which started occurring early on, as a result of both natural disasters and military confrontation. But the most serious documented losses are due to defensive needs imposed by the Ottoman threat during the Venetian period: in 1567 several important buildings in Nicosia, including the Dominican abbey which housed the royal tombs, and dozens of churches, were demolished by the authorities when it was decided to replace the old (mostly fourteenth-century) walls by a modern defensive system in anticipation of an attack.[4]

After 1571 the Ottomans took over the major centers of Latin settlement and power on the island, namely Nicosia and Famagusta. Thus, by a strange twist of fate, many of those Gothic structures which survived over the centuries did so because of their conversion into mosques and their subsequent maintenance by the new masters, although most of their figural decoration was destroyed (fig. 24-2). Travelers to the island occasionally mentioned or depicted the most conspicuous among them.[5] But despite a steady, albeit limited, flow of visitors, in particular during the eighteenth century, Cyprus, unlike Greece, never became part of the Grand Tour, both because of the relative geographical remoteness of the island and because of the distinct lack of standing classical remains. Thus it remained isolated from the scholarly world of Western Europe, where in any case interest in Gothic architecture was not developed until the later eighteenth and the nineteenth centuries.

Early Scholarship

Scholarship on Cyprus witnessed a dramatic surge in the course of the nineteenth century. A massive history of the Lusignan kingdom based on extensive and original archival research was published by Louis de Mas Latrie (1815–97).[6] His notes on the monuments of that period, taken during his visit in 1846, were subsequently used by Melchior de Vogüé (1829–1916) who included a very short overview of the Lusignan material in his pioneering book on the churches of the Holy Land (1860). In this, the work that signaled the beginning of scholarly research into Crusader architecture, de Vogüé described very briefly the main buildings of Nicosia and Famagusta as well as the abbey at Bellapais. He devoted a longer section to Hospitaller Rhodes and its numerous, mostly fifteenth-century monuments.[7]

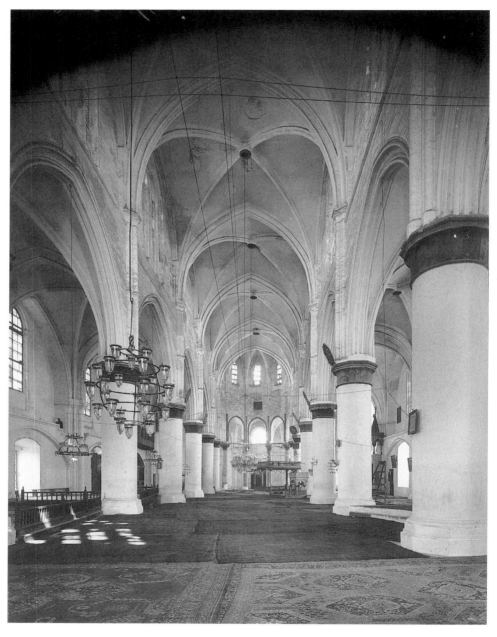

FIGURE 24-2 Cathedral of St Sophia, Nicosia. Reproduced courtesy of The Conway Library, Courtauld Institute of Art, London. Photo: C. J. P. Cave.

In 1862 he led himself an expedition to Cyprus. His principal aim, however, was to extend Ernest Renan's Phoenician mission to the island.[8] He was accompanied by, among others, a young Frenchman, Edmond Duthoit (1837–89), whom Viollet-le-Duc had recommended as draughtsman to the mission. Duthoit was genuinely impressed by the island's medieval buildings, both Byzantine and Gothic. To him we owe the first extensive visual record of these structures: during his four-month tour the indefatigable Duthoit made dozens of accurate drawings and watercolors of churches, monasteries, fortifications, archaeological sites, and city views, as well as a few measured drawings. The significance of Duthoit's work remains undervalued: it lies not only in its sheer quality, but more importantly in that it depicts buildings which have since been altered beyond recognition, restored, or have simply disappeared. It is all the more amazing then that this unique collection of well over one hundred drawings remained virtually unknown, as it lay buried in the archives of the Musée de Picardie at Amiens until the 1990s, when it was rediscovered and published.[9] There is little doubt that had Duthoit's work become available in the 1860s it would have certainly precipitated the study of the island's medieval heritage. In the event this had to wait until the end of the century.

Meanwhile Emmanuel-Guillaume Rey (1837–1916), who had already been to Cyprus in 1857 and later helped de Vogüé in his mission by providing maps and sketches, was emulating the latter's work and at the same time complementing it with a study of military architecture in the Holy Land. Unlike his mentor, however, Rey included in his 1871 publication an extensive report on the major castles, fortifications, and watch-towers of Cyprus, some of it derived from second-hand information provided yet again by Mas Latrie, but also by de Vogüé himself and by Duthoit.[10]

De Vogüé, and to a certain extent Rey, treated the Cyprus material as a mere appendix to the Holy Land, and this from a primarily French point of view. Both were of course products of their age, and in their mind the Crusades, and by extension their legacy in the Levant, were part of French history. As we shall see below, this attitude persisted for a long time and is mirrored in more recent scholarship. But the era of French domination in Crusader art history on Cyprus was soon to be challenged, although by no means eclipsed, by scholars from the new power that came to rule the island.

In 1878 the administration of Cyprus was entrusted to the British empire. For the first time British scholars were drawn to the archaeology of the new and little-known acquisition. Like some of his French predecessors, Edward L'Anson arrived initially in search of classical remains. Not surprisingly the sheer presence of the Gothic monuments diverted his attention. In November 1882 he presented a report to the Royal Institute of British Architects in London, which was then published together with notes, sketches, and a small number of measured drawings by Sydney Vacher.[11] These plans and sections were the first to be published for the main Gothic churches of Cyprus (Rey had published only two attractive albeit inaccurate plans of the castles at St Hilarion and Buffavento).

Vacher provided a reconstruction of the western façade of the cathedral at Famagusta too, and the report was supplemented with 97 inscriptions from funerary slabs already published by Mas Latrie.[12] Despite L'Anson's RIBA presentation, British interest in the Gothic monuments of Cyprus was rather slow to develop.

Still, the 1890s were a period of considerable activity, not least for members of the colonial administration: Major J. Chamberlayne Tankerville, later governor of Kyrenia, published in 1894 some 300 fragments from funerary slabs preserved in five churches of Nicosia, in a corpus dedicated to Mas Latrie. Cyprus preserves by far the largest number of such sepulchral monuments in the Latin East and this was the first and only attempt to supplement the information provided by their inscriptions with genealogical tables and numerous drawings.[13]

In September 1896 Charles Diehl (1859–1944), well known as a historian of Byzantium, visited Cyprus while on a cruise in the eastern Mediterranean. In a brief report published shortly thereafter he focused on Famagusta where he disembarked, but, just like earlier scholars, he remained completely oblivious to the existence in the medieval period of cultures other than that of the Latin rulers of the island.[14] This was also the attitude of the man to whom the study of Western architecture on Cyprus undoubtedly owes the most.

Camille Enlart

Camille Enlart (1862–1927) visited Cyprus only a few months before Diehl, from February to June 1896, under the auspices of the Ministère de l'instruction publique et des beaux-arts.[15] He arrived on the island with a deep knowledge of medieval architecture and sculpture, especially those of his native France. His extended field trip resulted in a two-volume work, published in 1899 and dedicated to the Marquis de Vogüé.[16] Two years earlier he had also published a brief survey of a somewhat arbitrary selection of Gothic monuments in Greece. His assessment was most severe: "lorsque des architectes nourris de l'enseignement des maîtres gothiques français ont eu l'occasion de construire sur le sol de la Grèce, ils ont donné à peu-près la mesure de ce que leur art pouvait produire de plus faible."[17] This is a far cry from his enthusiastic comments about the Cypriot monuments, to which he returned in 1901 in order to conduct limited excavations in Famagusta and Nicosia.[18] Back in France, he was soon appointed director of the Musée de sculpture comparée (now the Musée des monuments français at the Trocadéro), where among the exhibits illustrating the evolution of French sculpture were included several panels with drawings, watercolors, and photographs demonstrating the successful export of French art to faraway Cyprus.[19] Enlart continued throughout his career to analyze and reassess the material he gathered in Cyprus. In a book published in 1920 on medieval cities from the Baltic to the Mediterranean, after a short passage on Paphos, he dedicated

a long chapter to Famagusta, bringing together testimonies from the written record with evidence from its numerous monuments.[20]

Enlart's contribution to the study of Crusader art on Cyprus cannot be overestimated. Not only was he the first to investigate in detail the numerous Gothic buildings, producing the first ever comprehensive study for the monuments of any period on the island, but in his lifelong work on the propagation of medieval French art outside its cradle he also used extensively a recent tool which was to become indispensable in art historical studies, namely photography, and in fact he was among the first art historians to do so during his extensive travels.[21]

One should bear in mind that, despite the brief earlier studies mentioned above, at the time of Enlart's visit relatively little was known about Gothic in Cyprus. Unlike his later and ground-breaking work on the kingdom of Jerusalem, which was greatly helped by the work of earlier archaeologists and art historians, Enlart had pretty little to rely on for Cyprus. He nevertheless surveyed some 50 sites all over the island, although obviously his attention was focused on the main towns, Famagusta and Nicosia. His *L'Art gothique et la renaissance* opens with an engaging discussion on the origins and evolution of Gothic in Cyprus which contains the main conclusions of his research. It remains to this day the most important attempt to place the architecture of the Lusignan kingdom within its context, which for Enlart was bound to be predominantly French, for the precedence of France in Crusader art was taken for granted: the main areas of influence were identified as Northern France, Champagne, and Southern France, with Catalan and Venetian input admitted for the end of the period. His photographs for the most part are the first ever published of these monuments and remain an important witness to their state in the late nineteenth century, before the various repairs carried out under British administration.[22] His approximately 40 measured drawings, with very few exceptions, have still to be superseded by more detailed and accurate versions.

Our judgment of Enlart's work, more than one century after its publication, cannot ignore subsequent research. It is thus clear, for example, that the small group of churches in the Karpas peninsula, which he mistakenly identified as Romanesque and dated to the twelfth century, is in fact of much earlier date and has no relation whatsoever to Western architecture.[23] Some of his identifications have also been questioned, and the phases into which he divided the Gothic of Cyprus have been revised.[24] Enlart was unavoidably a man of his times. Today's concerns with cultural interchange and the contribution of indigenous communities are, not surprisingly, absent from his agenda. This is surely due to a great extent to his emphasis on architecture, to the detriment of other forms of artistic expression where such factors may have played a more dominant role. Had Enlart been able to examine closely the panel paintings and monumental decorations in rural chapels of the Lusignan era, virtually unknown at the time, he would have certainly formed a rather different opinion.

The Twentieth Century

We have seen above that there is a continuous thread from Mas Latrie, the first to have brought to the attention of the outside world the existence of the striking monuments of Lusignan Cyprus in the mid-nineteenth century, to Enlart at the turn of the century, through de Vogüé, Renan, Duthoit, Rey, and Tankerville. This virtual line of succession, built on the sharing of information among scholars who often relied on each other's work, came to an end in the early twentieth century. Its last and little-known representative was, not surprisingly, also a Frenchman. Achille Carlier, just like Enlart, was a student at the French School in Rome and subscribed fully to his illustrious precursor's views: he placed the Gothic of Cyprus firmly in the context of French medieval art, whose staunch and militant defender he was soon to become with his journal, *Les Pierres de France*, aimed at drawing attention to the need for the protection and careful restoration of the Gothic monuments of his homeland.[25] Carlier is known to have made detailed large-scale measured drawings of the cathedral in Famagusta and to have compiled a photographic dossier of Gothic architecture on the island. Nevertheless, his 1933 field trip resulted in only one published article. What is more, this appeared in a journal little known to art historians and appears to have had little impact. Significantly though, it was introduced by Paul Deschamps (1888–1974), who held the same post as Enlart earlier, that of director of the Musée de sculpture comparée, and to whom Enlart had entrusted toward the end of his life the study of Crusader castles in Syria-Palestine which he had not been able to undertake himself.[26]

Carlier's article appeared under the telling title *Les Villes françaises de Chypre*, and its aim was, not surprisingly, to demonstrate the predominantly French character of the urban landscape of Lusignan Cyprus, and in particular of Famagusta. Stating his case in even stronger terms than his earlier compatriots and with extraordinary enthusiasm, Carlier boldly declared Cyprus the "province de l'archéologie française la plus authentique et la plus brillante."[27] No doubt Enlart would have wholeheartedly agreed. Interest in the Crusader monuments of Cyprus during the nineteenth century had of course been inextricably linked to, and was indeed seen as forming an integral part of, the study of Crusader art on the mainland. This was not a perspective much in view in the work of our next major figure.

George Jeffery's (1855–1935) career in Cyprus dates to the years between Enlart's and Carlier's field trips. An architect by training, active in Jerusalem for a while and particularly keen on medieval architecture, Jeffery first visited Cyprus at about the same time as Enlart; he soon settled on the island to become its first Curator of Ancient Monuments (1903–34). In 1897 he produced the first (a short article) in a long series of works on Cypriot monuments published over almost four decades.[28] Unlike Enlart, however, Jeffery's perspective on medieval architecture was resolutely Cypriot in the sense that the wider picture, whether

within a Crusader, French Gothic, or Constantinopolitan framework, was not a main concern of his. He was indeed more interested in the preservation of all testimonies of past civilizations – be they products of the Byzantine, Lusignan, Venetian, or Ottoman period – threatened by neglect or outright demolition in the changing rural and urban landscape of the early British period.

Thus, his magnum opus was a survey of all buildings of historical significance on the island.[29] The heritage of the Lusignan centuries of course looms large throughout the book, which remains to this day a standard work of reference, not least because of its almost exhaustive coverage in particular of the rural areas, a hitherto *terra incognita* as far as this type of study is concerned. Jeffery also published detailed short studies of individual buildings, some with accurate measured drawings on a scale much more appropriate for their meticulous study than that used by Enlart.

By the middle of the twentieth century, attitudes toward the Crusades were changing in contemporary historiography. The largely sympathetic views of the nineteenth century were being replaced by a more skeptical and sometimes openly negative assessment.[30] In Crusader art history the focus was slowly moving away from architecture to embrace the study of hitherto neglected forms, mainly manuscripts and icons. As far as Cyprus is concerned, no substantial art historical study was to appear, however, until well into the second half of the century. In the meantime, on a practical level little had been done in the early years of the British administration, despite Jeffery's valiant efforts to protect from vandalism and to strengthen structures in a parlous state. A severe lack of funds and the reluctance of the colonial government to invest in the study and preservation of the island's medieval heritage hampered any individual efforts to that effect. It was only in the 1930s that a considerable increase in activities involving both limited excavations and repairs took place.[31] The unsatisfactory situation prevailing earlier changed to a great extent as a result of the creation of the Department of Antiquities in 1935. The island's Lusignan heritage remained at the top of the agenda for both its Directors before Independence, during the short tenure of J. R. Hilton (1935) but especially during A. H. S. Megaw's long and productive period at the helm of the Department (1936–60).[32]

The monuments of Greece, especially those in the Peloponnese and Crete, were attracting far more attention in the opening decades of the century. Following Enlart's short article of 1897, Giovanni Gerola carried out a large detailed study of the monuments of the period of Venetian rule on Crete[33] and Ramsay Traquair published an article on the castles of Laconia and a longer survey of the principal churches of Frankish Greece, the latter heavily and often inappropriately dependent for the dating of monuments on Enlart's Cyprus book.[34] But it was left to André Bon to carry out detailed research in the 1920s and '30s on the monuments of the Peloponnese, doing for the Morea what Enlart had done for Cyprus. This was published as part of a larger work on the history, topography, and archaeology of Frankish Morea; what is more, unlike Enlart, Bon was well acquainted with the earlier history and monuments of the

region too, on which he also published the main work of reference.[35] His *Morée franque*, however, did not appear in print until the late 1960s.[36] The work of another pioneer on the art history of the Crusader East had a similar fate.

Tom Boase (1898–1974) was commissioned to write the chapters on Crusader art in the Latin East for Kenneth Setton's *History of the Crusades* in the 1940s. Using the ample photographic and other documentation gathered by David Wallace in the 1930s, Boase gave a succinct and, in its assessment, rather dismissive overview of churches, castles, sculpture, and painting in Constantinople, Euboea, Crete, the Aegean islands, and the Greek mainland. For Rhodes, dealt with in a separate section, the stress lay on the high quality of the late medieval Hospitaller monuments compared to what survives on mainland Greece, although time and again Boase deplores the destruction and inappropriate restoration which most of these structures underwent and which often hampers their proper study. His assessment of the Cypriot material was much more positive.[37]

Based on Enlart, for whose work he had immense respect, Boase provided an overview of the architecture of the Lusignan kingdom. By the 1940s the island's Byzantine monuments and its frescoes and icons from the Lusignan era had become better known compared to Enlart's days half a century earlier, thanks to a couple of important recent publications.[38] These provided Boase with additional material with which to assess the art of the period. Hence his great contribution: as in the case of his studies on the arts of the Latin kingdom of Jerusalem, for the first time an attempt was made to view all forms of artistic production together, as a whole. In the case of Cyprus this meant the dramatic expansion of the corpus of Crusader works of art beyond the Gothic churches and their sculptural decoration: it introduced for the first time into the discussion fresco cycles, icons, illuminated manuscripts, and even textiles and ceramics. The only regret one might express about this novel approach is that it was not carried even further, that these works of art and the attempted synthesis were not discussed in greater detail. But Boase innovated in another respect too, largely as a result of his forays into the world of art forms other than architecture: the vital input of sources other than the West, emanating from local traditions, was now being considered, and has remained a constant preoccupation of scholarship ever since. Through no fault of his, the fourth volume of Setton's *History*, with the chapters on Syria-Palestine, Cyprus, Rhodes, and mainland Greece, appeared with some revisions only in 1977, almost three decades after their conception.

At about the same time appeared a monograph which remains to this day the standard book of reference on Gothic churches in Greece. Beata Kitsiki-Panagopoulos's study was largely based on Bon, Gerola, and Enlart for the Peloponnese, Crete, and Cyprus respectively, focusing on the Cistercian and Mendicant monasteries and offering a concise overview of the material.[39] The following decades witnessed the partial excavation of the church of St Sophia at Andravida and Peter Lock's pioneering studies on the castles and fortified

towers of Frankish Greece.[40] More recently the monastery at Zaraka in the Peloponnese has been the focus of an in-depth archaeological investigation.[41]

On Cyprus, in the meantime, a lot had changed since Jeffery's days. The new independent state established on the island in 1960 was struggling to build its cultural identity, an undertaking fraught with complex difficulties in view of the antagonism between the island's two main ethnic and religious communities. This situation is partly reflected in the work of the Department of Antiquities. A strong focus on pre-Classical and Byzantine archaeology is both obvious and understandable after 1960. This is not to say that the Gothic monuments were neglected; on the contrary, work initiated earlier under A. H. S. Megaw was being pursued. But now there seemed to be more competition for both atten-tion and, crucially, funds. Megaw himself started excavating in the late 1960s the site known as Saranda Kolones at Paphos, where the remains of a substantial Crusader castle were identified.[42] In 1969 the Department invited UNESCO experts to investigate the structural condition of the major Gothic monuments and to present plans for their preservation.[43] This work was interrupted by the events of 1974. Indeed, politics had been interfering with the Department's work since the first years after Independence.[44] But 1974 marked a major turn-ing point and imposed a situation which obtains to the present day: following the military confrontation on the island, the Department of Antiquities had no access to monuments in the northern sector. The new authorities established there, although eager to do their best to preserve these structures, which are not merely tourist attractions but very often living places of worship, lack both the resources and access to archival material for information on work carried out in the past.[45] It comes as no surprise then that the 1970s and most of the '80s did not witness much activity, either on the ground or in terms of scholarship.

The late 1980s and '90s on the other hand saw a slow resurgence of interest in the Lusignan period from both within and outside the island. New editions of important sources appeared, an English translation of Enlart made his work accessible once again, and several symposia and exhibitions were organized. Their focus was on cultural, social, ecclesiastical, and economic history, on the sources, manuscripts, icons, and frescoes. Indeed, in these fields great progress was being made, especially as far as painting is concerned, in particular by Doula Mouriki, Annemarie Weyl Carr, and Jaroslav Folda.[46] Architecture figured at best on the sidelines, largely as a result of the political situation which hindered further study of the main monuments. An overview of Gothic architecture, published by Monique Rivoire-Richard in 1996, is largely descriptive and offers very little in terms of interpretation of the material.[47] A few studies published by Nicola Coldstream, although extremely helpful and novel in their approach, cannot compensate for this lack.[48]

It was only more recently that steps were taken to redress the situation. A small number of excavations put Cyprus on the map of medieval archaeo-logy: two urban sites are currently being investigated in Nicosia as a result of rescue excavations necessitated by the construction of public buildings, while

archaeological surveys nowadays pay much more attention to medieval material than in the past.

Perspectives and Future Directions

There are several reasons behind the relative neglect of Gothic art in both Greece and Cyprus. One has to do with its *Kunstlandschaft* which remains notoriously difficult to determine, should one wish to do so. More than a century ago, Enlart had presented this art primarily as part of French Gothic. Others, as we saw earlier, viewed it as part of the art of the Crusaders, ultimately emanating again from France and stretching from the Holy Land in the east to mainland Greece in the west over a long period extending to the Ottoman conquest of Rhodes and Cyprus in the sixteenth century. Even in this context, however, this art remained secondary to that of Syria-Palestine. In addition, when along the way the strong French connection was challenged in favor of a more nuanced assessment which laid emphasis on the variety of sources of inspiration and influence, its inherent complexities with the resulting difficulties of approach were revealed.

A more significant factor affecting the study of Gothic in these lands is related to its place within the wider field of medieval art. To put it bluntly, is there any reason why a historian of medieval art outside of this region should bother to look at it? Textbooks of Gothic art and architecture barely contain a footnote about Cyprus, let alone Greece. Paul Frankl in his influential *Gothic Architecture*, written in the 1950s, states that only buildings which affected the evolution of style are considered in his book. Not surprisingly, there is hardly a word about Crusader architecture.[49] Enlart's legacy was in this respect short-lived. A new approach was signaled by Nicola Coldstream's *Medieval Architecture*.[50] Here, for the first time, Cyprus is put on the same footing as other peripheral regions of Western architecture and is often mentioned, mostly in relation to the expansion of medieval European architecture outside of Western Europe. This seems indeed to be the main interest of the Gothic of Cyprus and Greece from a Western perspective.

Our material offers little or no information on the organization of building campaigns, on church decoration and furnishings which have long disappeared, and rather little on patronage too.[51] Its importance lies rather in issues such as the logistics of transplantation, the process of selection of models, and the economics of realization of these monuments, to the extent that these can be traced. The unavoidable conclusion then is that the art whose study is discussed here is of importance primarily from a local point of view, within the context of medieval art in former Byzantine lands. Yet even this is still largely ignored. Although in Greece the problems witnessed on Cyprus with its ethnic division are absent, scholarship has remained reluctant to view it as part of the country's heritage, which, admittedly, is immensely richer for other historical periods.

The future of the field is difficult to predict. Nevertheless, some very recent developments on Cyprus allow for considerable optimism. The political deadlock on the island seems to be inexorably moving toward its resolution. Monuments and sites of archaeological significance in the north will eventually become accessible to scholars from both the other side of the island and from outside. And current scholarship shows that there is no lack of archaeologists and art historians willing to delve into their study.

One of the most original recent contributions comes from a scholar based in the north of the island. Alpay Özdural studied in detail the proportions and structure of St George of the Latins in Famagusta, Enlart's favourite church on the island, in order to identify the measuring module used in its construction.[52] Such investigations may help trace the origin of master masons and point toward a possible direction for future research. Other strands are provided by the work of Jean-Bernard de Vaivre. His original research on some of the lesser-known monuments of military architecture and on sculptural decoration indicate that there are several issues left unexplored by Enlart which merit further investigation with potentially rewarding results.[53] The same author, with a team of French scholars under Jean Richard, is preparing a new edition of Enlart's original text and illustrations, augmented with the addition of a study incorporating the results of subsequent scholarship. Still, despite these recent advances much remains to be done. Museums need catalogues, the material requires corpora and photographic surveys, ideally along the lines of Denys Pringle's excellent work on the Holy Land.

Famagusta, with its walls and often well-preserved but ill-dated churches and other structures, provides an ideal example of a medieval city to be studied as a whole, placing its buildings and their decoration within the evolution of its urban fabric and its economic fortunes. The post-medieval building phases of the cathedrals in Nicosia and Famagusta, repaired and altered in the Venetian and Ottoman periods, remain to be disentangled. The obscure chronology of other important buildings such as the Bedestan in Nicosia and St George of the Greeks in Famagusta (fig. 24-3) could do with some help from limited excavations.

A major problem in the evolution of Gothic architecture on Cyprus still remains to be fully understood: this is the change in style which occurred in c.1300. At about the same period a new type of iconography was introduced for the kingdom's coinage, replacing the previous, Byzantine-style coins. The possibility of links between these changes and political events needs to be further investigated. For it is at that time that the kings of Cyprus acquired the crown of Jerusalem (1268), while the last Crusader strongholds on the Syrian coast were disappearing one after the other. And it is at Acre that a new style of manuscript illumination also appeared, shortly before the city's fall in 1291. The role of refugees from Acre in developments on Cyprus remains as intriguing as it is unexplored.[54]

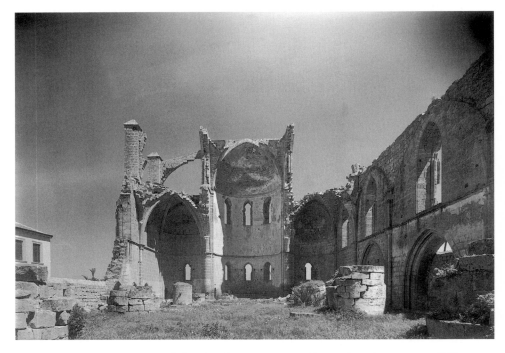

FIGURE 24-3 St George of the Greeks, Famagusta. Reproduced courtesy of The
Conway Library, Courtauld Institute of Art, London. Photo: C. J. P. Cave.

As mentioned above, one of the most exciting aspects of the art imported
in former Byzantine lands is that of its models and its interaction with local
traditions. A comparison between the artistic production of various regions
(in particular the Morea and Cyprus) and with other areas where a similar
process took place could open new perspectives. The kingdom of Jerusalem and
Norman Sicily come to mind, although the outcome there was very different.
Yet, tracing the analogies between the art promoted by the Hautevilles, the
Villehardouins, the Lusignans, and the kings of Jerusalem – an extremely complex
task – could shed light on the fascinating processes of adoption and adaptation
within local parameters unique to each area.

Notes

ABSA Annual Bulletin of the British School at Athens
ARDA Annual Report of the Director of Antiquities (Nicosia)
CCEC Cahiers du centre d'études chypriotes (Paris)
CRAI Académie des inscriptions et belles-lettres. Comptes-rendus des séances
JRIBA Journal of the Royal Institute of British Architects
ΚΣ Κυπριακαὶ Σπουδαὶ (Nicosia)
RDAC Reports of the Department of Antiquities, Cyprus

1 [On the art and architecture of the other Crusader States, see chapter 23 by Folda in this volume (ed.).]

2 [On Gothic architecture and French Gothic manuscript illumination, see chapters 18 and 20 by Murray and Hedeman, respectively, in this volume (ed.).]

3 Jeffery, "The refectory of Bella Paise Abbey."

4 Grivaud, "Nicosie remodelée."

5 Severis, *Travelling Artists*.

6 Mas Latrie, *L'Histoire de l'île de Chypre*; see also Papadopoullos, "Le Développement des études chypriotes."

7 De Vogüé, *Les Églises de la Terre-Sainte*.

8 Bonato, "Melchior de Vogüé."

9 Severis and Bonato, *Along the Most Beautiful Path*. Only his now lost drawings of Bellapais had been published earlier, by Camille Enlart, who acquired them from de Vogüé: see Bonato, "Chypre dans les archives," pp. 210–11.

10 Rey, *Etudes*, pp. 229–52.

11 L'Anson and Vacher, "Mediæval and other buildings"; see also Severis, *Travelling Artists*, pp. 182–3. Many more unpublished drawings and photographs are preserved in the Drawing Collection of the RIBA.

12 Mas Latrie, "Notice d'un voyage," and *L'Ile de Chypre*, pp. 340–401.

13 Chamberlayne, *Lacrimae Nicossienses*.

14 Diehl, "Les monuments de l'Orient Latin."

15 On Enlart's career and pivotal role in the study of Crusader art, see Folda, *The Art of the Crusaders*, pp. 10–11, and Coldstream, "Camille Enlart."

16 Enlart, *L'Art gothique*.

17 "When architects trained by French Gothic masters got the opportunity to build on Greek soil, they more or less produced the poorest possible specimens of their art": Enlart, "Quelques monuments," p. 309.

18 Enlart, "Fouilles dans les églises," and "L'Ancien Monastère."

19 Enlart, *Le Musée de Sculpture*, p. 147. Later on, casts of Gothic sculpture from Cyprus were added.

20 Enlart, *Villes mortes*, pp. 131–62.

21 Most of his negatives are now held at the Médiathèque de l'architecture et du patrimoine in Paris.

22 Many more were taken by Enlart but remain unpublished.

23 Discussion of this issue, with bibliography, in Papacostas, *Byzantine Cyprus*, vol. 1, pp. 145–6.

24 Coldstream, "Camille Enlart," p. 6.

25 *Les Pierres de France. Organe de la société pour le respect et la protection des anciens monuments français*, published between 1937 and 1953.

26 Folda, *The Art of the Crusaders*, pp. 11–12.

27 Carlier, "Les villes françaises de Chypre."

28 Bibliography in Cobham, *An Attempt*, pp. 28–9.

29 Jeffery, *A Description*.

30 Constable, "Historiography of the Crusades."

31 Relevant reports in *RDAC* 1936 (published in 1939) and 1937–9 (published in 1951); du Plat Taylor, "A Thirteenth-Century Church."

32 Rouché, "Prehistory," in Herrin et al., eds., *Mosaic. Festschrift*. A list of Megaw's publications appears in the same volume (pp. 181–3).

528 ■■■ TASSOS C. PAPACOSTAS

——, "Art in the Latin East, 1098–1291," in Jonathan Riley-Smith, ed., *The Oxford Illustrated History of the Crusades* (Oxford, 1995), pp. 141–59.

——, "Crusader Art in the Kingdom of Cyprus, 1275–1291. Reflections on the State of the Question," in Nicholas Coureas and Jonathan Riley–Smith, eds., *Cyprus and the Crusades. Papers Given at the International Conference "Cyprus and the Crusades," Nicosia, 6–9 September, 1994* (Nicosia, 1995), pp. 209–37.

Paul Frankl, *Gothic Architecture* (Harmondsworth, 1962; revised by Paul Crossley, Yale University Press, 2002).

Giovanni Gerola, *I Monumenti veneti nell'isola di Creta*, 4 vols. (Venice, 1905–17).

Gilles Grivaud, "Nicosie remodelée (1567). Contribution à la topographie de la ville médiévale," *Επετηρίδα του Κέντρου Επιστημονικών Ερευνών* 19 (1992), pp. 281–306.

Paul Hetherington, "The 'Larnaca Tympanum' and its Origins: A Persisting Problem From 19th-Century Cyprus," *RDAC* (2000), pp. 361–78.

Brunehilde Imhaus, "Un Monastère féminin de Nicosie: Notre-Dame de Tortose," in Michel Balard, Benjamin Z. Kedar and Jonathan Riley-Smith, eds., *Dei gesta per Francos. Etudes sur les croisades dédiées à Jean Richard* (Aldershot, 2001), pp. 389–401.

——, "Tombeaux et fragments funéraires médiévaux de l'île de Chypre," *RDAC* (1998), pp. 225–31.

George Jeffery, *A Description of the Historic Monuments of Cyprus* (Nicosia, 1918).

——, "The Refectory of Bella Paise Abbey, Cyprus," *JRIBA* 22 (1915), pp. 181–5.

Beata Kitsiki-Panagopoulos, *Cistercian and Mendicant Monasteries in Medieval Greece* (Chicago and London, 1979).

Peter Lock, "Castles and Seigneural Influence in Latin Greece," in Alan V. Murray, ed., *From Clermont to Jerusalem. The Crusades and Crusader Societies 1095–1500* (Turnhout, 1998), pp. 173–85.

——, *The Franks in the Aegean, 1204–1500* (London and New York, 1995).

Peter Lock and Guy D. R. Sanders, *The Archaeology of Medieval Greece*, Oxbow Monograph 59 (Oxford, 1996).

Louis de Mas Latrie, "Notice d'un voyage archéologique en Orient," *Bibliothèque de l'école des Chartes* 7 (1845–46), pp. 489–544.

——, *L'Histoire de l'île de Chypre sous le règne des princes de la maison de Lusignan*, 3 vols. (Paris, 1852–61).

——, *L'île de Chypre, sa situation présente et ses souvenirs du Moyen Age* (Paris, 1879).

Arthur H. S. Megaw, "A Castle in Cyprus Attributable to the Hospital?," in Malcolm Barber, *The Military Orders. Fighting for the Faith and Caring for the Sick* (Aldershot, 1994), pp. 42–51, with earlier bibliography.

Catherine Otten-Froux, "Notes sur quelques monuments de Famagouste à la fin du moyen-âge," in Judith Herrin, Margaret Mullett and Catherine Otten-Froux, eds., *Mosaic. Festschrift for A. H. S. Megaw*, British School at Athens Studies 8 (London, 2001), pp. 145–54.

Alpay Özdural, "The Church of St George of the Latins in Famagusta: A Case Study on Medieval Metrology and Design Techniques," in N.Y. Wu, ed., *Ad Quadratum. The Practical Application of Geometry in Medieval Architecture* (Aldershot, 2002), pp. 217–42.

Tassos Papacostas, "Byzantine Cyprus: The Testimony of its Churches, 650–1200," 3 vols. (D.Phil thesis, University of Oxford, 1999).

Theodore Papadopoullos, "Le Développement des études chypriotes comme branche internationale des sciences historico–philologiques," *Chypre: La Vie quotidienne de l'antiquité à nos jours. Actes du colloque, Musée de l'Homme* (Paris, 1985), pp. 135–8.

Athanasios Papageorgiou, "Crusader Influence on Byzantine Art in Cyprus," in Nicholas Coureas and Jonathan Riley-Smith, eds., *Cyprus and the Crusades. Papers Given at the International Conference "Cyprus and the Crusades", Nicosia 6–9 September 1994* (Nicosia, 1995), pp. 275–94.

Gianni Perbellini, "Le Fortificazioni del regno di Cipro nello stato veneto (X–XVI sec.)," *ΚΣ* 50 (1986), pp. 193–225.

Joan du Plat Taylor, "A Thirteenth-Century Church at Nicosia, Cyprus," *Antiquity* (December 1932), pp. 469–71.

Denys Pringle, "Architecture in the Latin East, 1098–1571," in Jonathan Riley-Smith, ed., *The Oxford Illustrated History of the Crusades* (Oxford, 1995), pp. 160–83.

Emmanuel-Guillaume Rey, *Etudes sur les monuments de l'architecture militaire des Croisés en Syrie et dans l'île de Chypre* (Paris, 1871).

Monique Rivoire-Richard, "Ἡ γοτθικὴ τέχνη στὴν Κύπρο," in T. Papadopoullos, ed., *Ιστορία τῆς Κύπρου*, 5.2 (Nicosia, 1996), pp. 1415–54.

Charlotte Roueché, "The Prehistory of the Cyprus Department of Antiquities," in Judith Herrin, Margaret Mullett, and Catherine Otten–Froux, eds., *Mosaic. Festschrift for A. H. S. Megaw*, British School at Athens Studies 8 (London, 2001), pp. 155–66.

Chris Schabel, "Ο Camille Enlart και οι Κιστερκιανοί στον Πύργο," *RDAC* (2003), pp. 401–6.

Rita Severis, "Edmond Duthoit: An Artist and Ethnographer in Cyprus, 1862, 1865," in Veronica Tatton–Brown, ed., *Cyprus in the 19th Century AD. Fact, Fancy and Fiction. Papers of the 22nd British Museum Classical Colloquium, December 1998* (Oxford, 2001), pp. 32–49.

——, *Travelling Artists in Cyprus, 1700–1960* (London, 2000).

Rita Severis and Lucie Bonato, *Along the Most Beautiful Path in the World. Edmond Duthoit and Cyprus* (Nicosia, 1999).

Carl D. Sheppard, "Excavations at the Cathedral of Haghia Sophia, Andravida, Greece," *Gesta* 25 (1986), pp. 139–44.

George Soteriou, *Τὰ βυζαντνὰ μνημεῖα τῆς Κύπρου. Α. Λεύκωμα* (Athens, 1935).

David Talbot Rice, *The Icons of Cyprus*, Courtauld Institute Publications on Near Eastern Art 2 (London, 1937).

Ramsay Traquair, "Frankish Architecture in Greece," *JRIBA* 31 (1923), pp. 33–50, 73–86.

——, "Laconia I. Mediaeval fortresses," *ABSA* 12 (1906), pp. 259–76.

——, "Mediaeval Fortresses of the North-Western Peloponnesus," *ABSA* 13 (1907), pp. 268–81.

Jean-Bernard de Vaivre, "Datation des campagnes de construction des édifices élevés par les Hospitaliers à Kolossi en Chypre," *CRAI* (2000), pp. 249–58.

——, "Les Eglises jumelles de Famagouste," *Monuments et mémoires publiés par la Fondation Eugène Piot*, 82 (2003), pp. 139–71.

——, "La Forteresse de Kolossi en Chypre," *Monuments et mémoires publiés par la Fondation Eugène Piot* 79 (2000), pp. 73–155.

——, "Identifications hasardeuses et datation de monuments à Famagouste: le cas des 'églises jumelles des Templiers et des Hospitaliers'," *CRAI* (2002), pp. 45–55.

——, "Sculpteurs parisiens en Chypre autour de 1300," in Michel Balard, Benjamin Z. Kedar and Jonathan Riley–Smith, eds., *Dei gesta per Francos. Etudes sur les croisades dédiées à Jean Richard* (Aldershot, 2001), pp. 373–88.

——, "Sur les sites des châteaux disparus de Sigouri et de Gastria en Chypre," *CRAI* (1998), pp. 1007–29.

——, "Le Tympan du portail central de la cathédrale Sainte-Sophie de Nicosie," *CRAI* (2001), pp. 1031–42.

Melchior de Vogüé, *Les Eglises de la Terre-Sainte* (Paris, 1860), pp. 378–89.

Annemarie Weyl Carr, "Correlative Spaces: Art, Identity, and Appropriation in Lusignan Cyprus," *Modern Greek Studies Yearbook* 14/15 (1998/9), pp. 59–80.

——, "Images of medieval Cyprus," in Paul W. Wallace, ed., *Visitors, Immigrants, and Invaders in Cyprus*, Institute of Cypriot Studies, University at Albany, State University of New York (New York, 1995), pp. 87–103.

Michael D. Willis, "The Larnaca Tympanum," *ΚΣ* 45 (1981), pp. 15–28.

Netice Yildiz and Cengiz Y. Toklu, "Assessment of the Gothic Monuments in North Cyprus for Conservation and Restoration Purposes," *Advances in Civil Engineering, 4th International Congress, 1–3 November 2000* (Famagusta, 2000), vol. 1, pp. 185–95.

Architectural Layout: Design, Structure, and Construction in Northern Europe

Marie-Thérèse Zenner

Introduction

One of the most creative periods in architecture occurred in Northern Europe in the years 1000–1300. New approaches to layout in monastic churches and urban cathedrals constitute an essential aspect of Romanesque and Gothic originality.[1] The historical challenge of understanding these changes in design and construction is made all the greater, however, due to a relative lack of period documents, of collected bibliography,[2] and an in-depth study embracing this entire period.[3] A lack of unity exists within the field as well, where Gothic is typically deemed superior to Romanesque; yet Gothic could not have existed without preceding generations of building in ashlar. Understanding of stone structures presents a special challenge today, since techniques of stone building are only taught for restoration work; medieval design techniques and the building culture itself are rapidly disappearing even within the oral tradition. A general lack of appreciation for the experimental process in medieval science, more specifically, for applied mathematics and its use of approximations, presents another hurdle to a reassessment of early knowledge of physical matters. Finally, with current academic trends seeking international relevance within a global society, European medieval architecture fares less well than at its zenith in the mid-twentieth century. Yet the most advanced studies have been produced in the last few years. An embracing overview "connecting the dots" between

architectural phases, scholarly approaches, and disciplines may offer new clarity and direction and, ultimately, enhance the discipline's future growth.

Architectural Layout

The concept of layout has many interpretations, reflecting the prevailing philosophy and state of the discipline. Historical studies began with the plan's general form,[4] and continued with comparative development of major formal elements,[5] typically with stylistic grouping by region or nation.[6] Functional typologies of layout have focused on pilgrimage[7] and recently again on liturgy.[8] Another renewed theme is the psychological effect of space.[9] Formal studies led to investigations of symbolic or iconological meaning, whereby a layout "quotes" an earlier edifice (in plan, elevation, orientation, or implicit meaning).[10] Archetypal references, such as Solomon's Temple and Noah's Ark, merit more attention.[11]

From the earliest times, layout has also meant design concept, although this presents methodological problems. To name only five: (1) well into the twentieth century, plans of built monuments typically consisted of symmetrically disposed spaces delineated using just a few measurements taken in situ; (2) many from outside (and within) academia have tried their hand at drawing on such plans, by applying a priori concepts of proportion or geometry; (3) since these plans are typically small scale (not to mention potential distortion from any reproduction process), the applied designs cannot comply with rigorous margins of error; (4) knowledge of medieval practical geometry is still insufficient to justify use of any a priori concept; (5) most importantly, such designs do not take into account wall thickness, hence implications for a three-dimensional structure in elevation. In the past two decades, techniques in monumental archaeology,[12] and the measured survey, specifically, the computer-aided survey and drawing with AutoCAD,[13] make it theoretically possible to integrate detailed studies in design, structure, and construction. In fact, one cannot exist without the other – one point of view is insufficient in analyzing any complex subject. Together, they may lead us back to an understanding of the design concept in a given monument and, perhaps eventually, of medieval design principles, aided by the as yet unwritten history of practical geometry.

Primary Sources

The stone monuments remain the first and final record. In addition to textual sources on building,[14] five primary sources provide essential background for research on medieval architecture. Spanning the first millennium and then some, these parchment records speak to concepts in measurement, design, layout, mechanics, mathematics, and the quantified sciences: Vitruvius, the *Corpus*

agrimensorum Romanorum (CAR), the Plan of St Gall, the Latin Euclid tradition, and the Portfolio of Villard de Honnecourt.

Vitruvius

Marcus Vitruvius Pollio's treatise *De architectura* (*c.33/22* BCE)[15] requires little introduction, as it is the only extant treatise on Roman building. While it is not yet clear what explicit effect Vitruvius' text may have had on medieval readers or builders,[16] it provides us with a fundamental, contextual basis. Of special relevance are his sections on the general education of the architect, which should include mathematics and astronomy, on proportion and number in particular,[17] on mechanics,[18] and on the orientation and selection of ground for a building site.

Corpus agrimensorum Romanorum

The *Corpus agrimensorum Romanorum* (CAR), a manuscript collection dating from the first to sixth centuries CE, is even more fundamental, as a source for medieval practical geometry, drawing upon an ancient tradition of land surveying with related problems of measurement and geometry, all amply illustrated.[19] Vitruvius' treatise and the CAR may be compared to Roman technical writing, in particular, building manuals[20] and other practical treatises, such as Marcus Terentius Varro's *Rerum rusticarum* (first-century BCE), as well as Roman scientific writing.

Plan of St Gall

A design for a Benedictine monastery, the complex plan associated with St Gall (Switzerland) is the earliest extant medieval architectural drawing (*c.817/19*).[21] Apart from several other ninth-century plans,[22] there is a gap of 400 years before the next explicit illustration of an architectural concept. For this reason alone, it is invaluable.[23] The plan may be considered in terms of Vitruvius' advice on orientation and planning, and the CAR's graphic representation of structures and land division.

Latin Euclid

Along with the Bible, the *Elements* is the most printed work in Western culture.[24] It summarizes geometric principles known during the time of Euclid of Alexandria (*c.325–c.265* BCE). The Latin manuscript tradition was deemed insignificant, and virtually all scholarly attention has been directed to the Greco-Arabic tradition, transmitted to Northern Europe in the second quarter of the twelfth century. Important new work on the dispersed textual transmission has been done to correct this historical blind spot.[25] Between the eighth and

eleventh centuries, the Latin Euclid manuscript tradition was reconsolidated from mixed practical-scholarly sources, including the CAR and Gerbert,[26] principally in Corbie and the Lorraine.[27] Connections have since been made between Latin Euclid and medieval architecture.[28]

Portfolio of Villard de Honnecourt

The portfolio of Villard de Honnecourt (Paris, Bibliothèque nationale, MS Fr 19093, *c.*1220/35) is a minuscule manuscript of drawings commented in Picard and Latin.[29] Yet it has immeasurable value as the earliest known graphic record of concepts in architecture *and* mechanics – at least for post-Roman Europe. In many ways, it appears to illustrate a medieval "Vitruvius,"[30] and the so-called technical folios (added by other hands post-1220/35) appear to derive from Latin Euclid.[31] The best analyses to date, albeit unorthodox, address the drawings within the context of the medieval system of apprenticeship, *Compagnonnage.*[32] The portfolio, together with the other four primary sources, constitutes the roots of the practical geometry tradition, which remained in use until at least the twentieth century.

Hereafter. this chapter examines major themes: the technical education of the builder (applied mathematics and associated use of instruments, the practical geometry tradition); moving from design to execution (structure and construction); and, finally, mathematically based design concepts (dimensions, geometry).

Technical Education of the Builder: Introduction

Discussion of medieval building layout is often reduced to debating the existence of a technical secret or theory of architecture. Frankl's 1945 article played a pivotal role in bringing the question of a builder's "secret" to the forefront in America.[33] His major work in this domain (*The Gothic*, 1960)[34] continued a German tradition of research on the building lodges, or *Bauhütten*.[35] Much has been written within the field to discount this as a Romantic idea, recasting the builders' knowledge as rote technical know-how.[36] In general, historians outside the field of medieval architecture dismiss medieval builders as mindless laborers, lacking any knowledge of physical forces or theory of structure other than through trial and error. One still ongoing debate is the problem of moving from plan to elevation at Milan Cathedral (begun 1386),[37] which by all accounts is after the culmination of Gothic technique. A fresh, better-informed look at scientific and technological knowledge, particularly, in view of the Latin Euclid tradition and the importance of geometry to all the quantified sciences,[38] when Romanesque and Gothic masterpieces were being built in the North, would be of great value.[39]

A parallel theme has been the builder's training and the socio-economic context. Arguably, the culminating study in the *Bauhütten* tradition was the

1952 dissertation by Booz, published in 1956, and much read by specialists.[40] Better-known, general studies on *les bâtisseurs* appeared contemporaneously in France and England.[41] Since the early twentieth century, however, most scholars tended to focus on the "problem" of the architect's identity (mason or carpenter).[42] After identity came education, specifically, the builders' mathematical knowledge, a subject long dominated by John Harvey and Lon Shelby.[43] In spite of his dedication to the subject, Shelby misunderstands the masons' legend about Euclid and the Bible, in comparing it with theoretical and intellectual works:[44] the medieval records do not function within the realm of linear, narrative thought, but rather in terms of symbols, metaphors, and codes.

Re-evaluation of the builder's education would be useful, taking into account new work on literacy, the quadrivium, and mechanical arts.[45] Work on the art of memory, oral transmission of knowledge, and professional guilds merits attention.[46] Although monopoly of apprenticeship was suppressed in France in 1919,[47] at least one traditional form of *Compagnonnage* survives today, with its esoteric rituals, rhymes, and songs serving collective identity, but also as mnemonic devices and passwords for guarding trade secrets.[48] Traditionally, art historical inquiry dismisses popular sources in favor of theological or literary explanations; one example is the continued, iconographic misidentification of two embracing figures that appear to serve as a *Compagnonnique* signature on one of the most accomplished Northern Romanesque façades (fig. 25-1).[49] It is time for the discipline to embrace the socio-anthropological and cultural history of the medieval builders[50] and their self-avowed non-European aspects.[51]

Technical Education of the Builder: Applied Mathematics and Instruments

Architectural history, in general, would benefit from greater access to the history of medieval mathematics, quantified sciences, and related instruments: arithmetic, finger calculus, abacus; calendar and *computus*; geometry, field- and earth-measurement (*Erdmessung*); orientation of churches vis-à-vis cardinal directions, winds, astronomy,[52] and the astrolabe. More specifically for building practice: the duodecimal system, carpenters' runes, masons' marks,[53] and instruments for design (compass, dividers, straightedge, square),[54] layout (measuring sticks, sighting instruments, rope),[55] and construction (level, plumb rule, templates, the art of stereotomy).[56]

Another instrument merits attention: Villard's portfolio shows use of an isosceles right triangle (built of wood?) for measuring the height of a distant tower (fig. 25-2). Similarly, one could use an astrolabe with the alidade set at 45°; this instrument and knowledge of triangle theory were available in Northern Europe prior to 983 CE; use of precisely the same dimensions in both the plan and vault heights of a Burgundian church, St Etienne in Nevers (*c.*1068/74–*c.*1090), offers evidence for their rapid spread to the building arts well before Abbot Suger oversaw the new apse at St Denis (*c.*1140/1).[57]

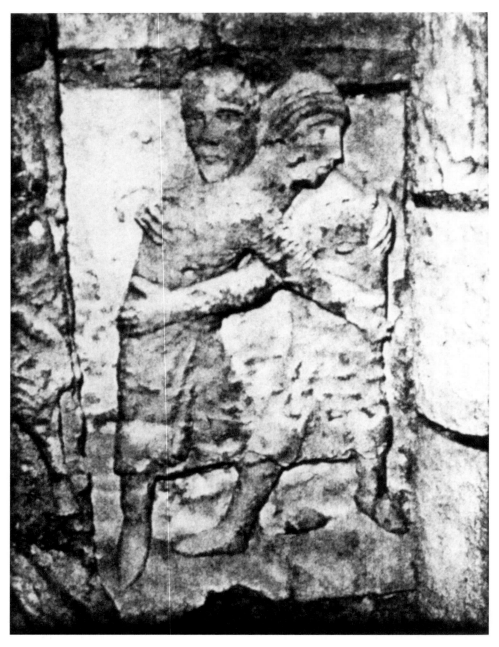

FIGURE 25-1 Two men embracing, relief sculpture, west façade, Notre-Dame-la-Grande, Poitiers, *c.*1100/30. Photo: Marie-Thérèse Zenner.

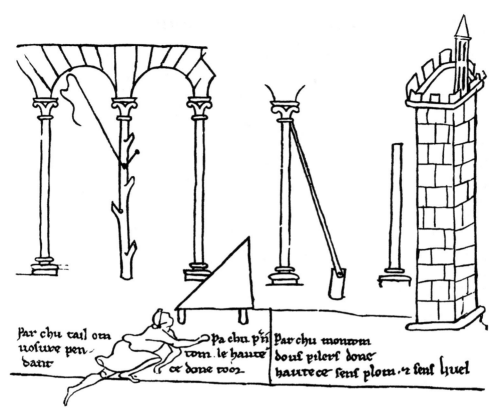

FIGURE 25-2 Man sighting height of tower, *c.*1220/35. Paris: Bibliothèque nationale de France, MS Fr 19093, fol. 20v, detail. From Lassus, *Album de Villard*, 1858, reprint. Éditions Leonce Laget, 1976.

Technical Education of the Builder: Practical Geometry

It would appear that medieval science functioned according to the principle: Geometry is a means of relating three-dimensional objects in terms of a physical law that translates into a two-dimensional plane. The practical geometry tradition, consolidated from the five primary sources in the eighth to eleventh centuries, continued to serve well into the twentieth century for the same type of applications since antiquity (land surveying, mechanics, technical drawing, navigation).[58] The elegance of geometry stems from its ability to function independently of arithmetic for the purposes of drawing and layout.[59] For example, the technical problem of measuring a column was handed down through the centuries (fig. 25-3).[60] A medieval contribution was the geometric determination of appropriate wall thickness for a barrel vault or rib vault;[61] wall thickness

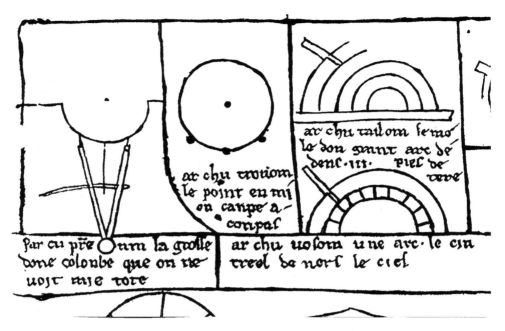

FIGURE 25-3 Technical drawing on how to measure a column, addition to portfolio of Villard de Honnecourt, post-1220/35. Paris: Bibliothèque nationale de France, MS Fr 19093, fol. 20r, detail. From Lassus, *Album de Villard*, 1858, reprint. Éditions Leonce Laget, 1976.

is one of the most important and least recognized aspects of practical geometry prior to the Late Gothic or Renaissance periods.[62]

Much more study is required to produce a history of practical geometry from late antiquity,[63] including the Gothic philosophical/theological/theoretical texts,[64] and numerous drawings on parchment, plaster, or stone, sketchbooks, and instruction booklets principally from the later Gothic period.[65] After Branner, Bucher, and Shelby, German studies of the drawings concentrated on modes of representation, largely under the direction of Roland Recht.[66] Future studies should take into account the larger context of technical drawing.[67] While the medieval tradition essentially culminated with Dürer's *Underweysung der Messung*,[68] studies of sixteenth-century technical texts by Rodrigo Gil de Hontañón, and others, offer valuable insight into the medieval graphic tradition of *l'art du trait* (the art of tracing): stereotomy, drawings of tracery, plans, or elevations.[69]

Design to Execution: Structure and Construction

Apprenticeship under *Compagnonnage* focused on *l'art du trait*, for it would appear that medieval builders conceived of and aimed to guarantee the structural

stability of a three-dimensional solid through geometry.[70] A great deal of scholarly attention has been given to the argument of structure-as-function and the anti-rationalist response.[71] Whether conceived as moving upwards from plan to elevation – or downward from vaults to buttressing into the foundations – structural stability originates in, and is encoded by, the plan. A plan can describe a three-dimensional structure simply by delineating relative proportions of spaces, preferably including the buttressing and wall thickness. As structure implies construction, so the development of the elevation may vary in function of the period, the builders' knowledge, and financial resources.

For example, one of the most striking elevations is found in the aforementioned Romanesque church at Nevers. A pilgrimage-type church, Nevers is distinguished as the earliest known example of a triple elevation (i.e., with clerestory) under a barrel vault. Yet, the design dispensed with heavy exterior buttressing through the use of (a) exceptionally fine ashlar set under compression; (b) axial distribution within a dynamic wall structure (i.e., transverse bonding stones and blind wall arcades); working in conjunction with perpendicular counterthrust from (c) the earliest known, functional interior flying buttresses.[72] Archaeological evidence shows that this proto-Gothic elevation and structural system were known when the plan was established. A measured survey showed that both plan and elevation are related through three principal measures. In this experimental building, it would appear that geometry determined structural stability.[73] The geometric relation of plan and elevation needs to be investigated for other buildings, but any study of layout should begin with the monumental archaeology.

Design Concepts: Dimensions

Two mathematical approaches to layout are number or geometry.[74] Number (or rather dimensions) can imply measure, hence metrology.[75] Site-specific use of measure may be rediscovered through a measured survey, which in turn raises questions of interpretation of precision and accuracy.[76] Recent topics in metrology include continuity of foot measures,[77] application of scale,[78] investigation of monuments,[79] or general metrological theory.[80] Number can be proportion (the relation of two or more measures). Proportion continues to be one of the most studied aspects of architectural design, in particular for medieval layouts.[81] Number can also be symbolic number (e.g., as a plan module), a current topic in the third quarter of the twentieth century.[82]

Design Concepts: Geometry

Studies in geometric architectural design have three aspects, with some overlap: *Ad quadratum/Ad triangulum*, other geometric forms, and Euclidian. A legacy of *Bauhütten* studies, the *Ad triangulum* method as propagated by Georg Dehio[83] influenced generations of German scholars.[84] Quadrature seems to have held

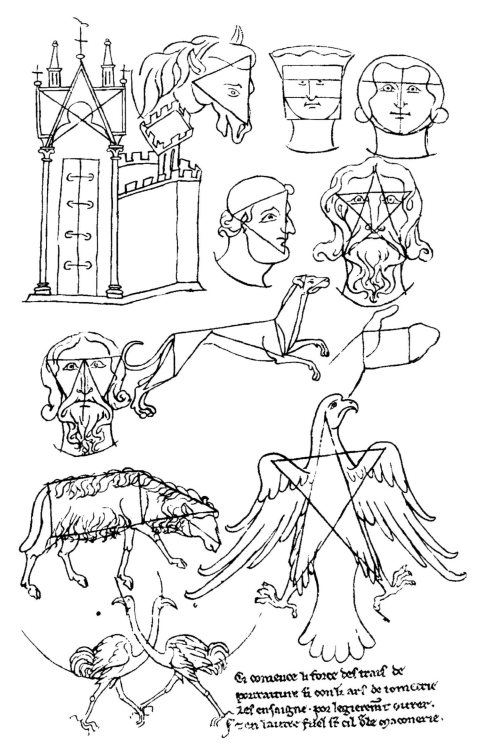

Ci comence li force des traif de
portraiture ti conli arf de tomectui
lef enfaigne · por legieremt outrer ·
f en lautre fdel ft cil bte oyaconerie ·

FIGURE 25-4 Mnemonic devices for principal geometric rules, *c.*1220/35. Paris: Bibliothèque nationale de France, MS Fr 19093, fol. 18v. From Lassus, *Album de Villard*, 1858, reprint. Éditions Leonce Laget, 1976.

even longer interest. While many works have gone unnoticed,[85] that of Maria Velte (1951) received critical attention in Germany and abroad.[86] Decades later, design analysis through quadrature is once again drawing significant scholarly interest.[87]

Design analysis using other geometric forms has included the circle, oval, and pentagon, sometimes in relation to quadrature.[88] A major recent study proposes use of the Platonic solids, but the analysis employs isolated angles from solids (an anti-Platonic idea in itself), which, as with most studies, do not address wall thickness.[89] Quite simply, plans which do not integrate structure would never stand up. Our experience with *Compagnonnage* suggests that whole forms, specifically, the combination of circle, square, and triangle, were used for their simplicity, beauty, and meaning, while a five-pointed star on the entire plan validates its integrity.[90] Quite interestingly, a computer-generated analysis of an early Gothic monastic church arrived at just such a combination.[91]

Finally, the question of Euclidian geometry and medieval design. Traditionally, both architectural and mathematical literature categorically rule out knowledge of Euclid during the Romanesque and early Gothic periods, as well as its applicability to practical geometry during all periods.[92] Yet, structure and design were integrated in the case of the eleventh-century church at Nevers, apparently through Euclid. Specifically, the maximum and minimum measures of vault heights were initially used as radii in the plan to determine wall thicknesses;[93] these circles were set out according to Euclid proposition 1.1 (*vesica piscis*), as recalled by an animal device in the thirteenth-century portfolio of Villard (two flamingoes, bottom left, in fig. 25-4).[94] The same proposition can be used to generate a square and equilateral triangle, creating a pattern that we propose served as a means to determine the three proportional measures, used to guarantee structural stability of this experimental three-dimensional solid, the elevation of St Etienne in Nevers.[95]

We have seen that that medieval architectural layout has multiple facets and that its study can take many paths. A comprehensive overview of what is known and awareness of what is not yet known will allow the insightful student to pose the most appropriate questions. For we only find answers to those questions posed. Finding the most relevant and innovative questions to pose is key to advancing historical research.

Notes

AB	Art Bulletin
AJA	American Journal of Archaeology
BM	Bulletin monumental
BurlM	Burlington Magazine
GBA	Gazette des Beaux-Arts
JSAH	Journal of the Society of Architectural Historians
ZfK	Zeitschrift für Kunstgeschichte

1 This chapter focuses on ecclesiastical layout, since relatively little has been done on layout of military or civil buildings from this period. [On Romanesque and Gothic architecture in general, see chapters 14 and 18 by Fernie and Murray, respectively, in this volume (ed.).]

2 Surprisingly, there is no bibliography or historiography of Gothic architectural studies; for the Romanesque, Davies, *Romanesque Architecture*, presents a limited list of books, without critical assessment. Two works provide key sources as of the 1980s: von Naredi-Rainer, *Architektur und Harmonie*, bibliography, pp. 232–86, treats the five primary sources named in this chapter, as well as building construction, in addition to all things Number; Binding et al., "Bibliographie," covers many works on medieval building by thematic division. References hereafter are designated by "NR-year" or "BI-item number." Additional sources will be signaled throughout; abbreviated citations refer to items in our bibliographies.

3 The most complete study of Gothic design, emphasizing mathematics: Müller, *Grundlagen gotischer*, pp. 14–120; appendices 3, 6, and 7, pp. 289–96. Cf. Binding et al., *Baubetrieb im Mittelalter*: "Planung," pp. 171–234, and "Vermessung," pp. 339–54. Both manuals treat structure and construction. An alternate approach, with a short section on design in spite of its subtitle, is Conrad, *Kirchenbau im Mittelalter*, pp. 73–84, 126–32. Among textbooks, the best illustrated and accessible work is Coldstream, "Structure and Design," in *Medieval Architecture*, pp. 55–81. One work of collected studies embraces the period in question: Courtenay, ed., *Engineering of Medieval Cathedrals*. Another work with valuable technical insight, although sometimes lacking in understanding of things medieval, is by an historian of applied mathematics: Sakarovitch, *Epures d'architecture*.

4 For example: Weise, *Studien zur . . .* ; Lehmann, *Der frühe deutsche Kirchenbau*; Götz, *Zentralbau*.

5 Bandmann, *Die Bauformen*, exemplifies a traditional presentation organized according to formal elements; see especially Frankl, with Crossley, *Gothic Architecture*.

6 For example: Deshoulières, *Eléments datés*; Ottaway, "Traditions"; and is characteristic of textbooks: Calkins, *Medieval Architecture*, chs. 10–15.

7 Stalley, *Early Medieval Architecture*, ch. 7. [On the pilgrimage, see chapter 28 by Gerson in this volume (ed.).]

8 Kohlschein et al., eds., *Heiliger Raum*; Faupel-Drevs, *Vom rechten Gebrauch*, discusses sources, including Durandus von Mende (1230/1–1296), after Sauer (see n.10 below).

9 Breysig (NR-1915); Murray et al., "Plan and Space."

10 On the historiography, see Crossley, "Medieval Architecture," with reference to Sauer (1902, 2nd rev. edn., NR-1924); Krautheimer (1942); Bandmann (NR-1951a,b [review by Robert Branner, *AB* 35 (1953), pp. 307–10]). [On formalism in general, see chapter 5 by Seidel in this volume (ed.)]

11 See the excellent study, von Naredi-Rainer, *Salomos Tempel*, with other works by Bandmann (passim); reviewed by Hartmann-Virnich, *BM* 155:2 (1997), pp. 169–71. Among recent textbooks, see Stalley, *Early Medieval Architecture*, ch. 3; Coldstream, *Medieval Architecture*, ch. 5. On the Mystic Ark, see Conrad Rudolph (forthcoming).

12 A comprehensive approach optimizes historical insight, as shown in Zenner, *Methods and Meaning*. The dissertation (1989–94) involved: a measured survey (see p. 18 n.35), dimensional analysis (appendices 2–4, pp. 357–69), standard structural

study (under guidance of Robert Mark, appendix 5, pp. 370–93), historiographies of measuring bond (pp. 112–21), and dating by tooling marks (pp. 190–7), followed by a survey of coursing heights (pp. 122–47; table 2, pp. 394–405, appendix 6, pp. 406–47), as well as stone-by-stone dating of building and restoration phases (pp. 147–83; chs. 5–6; conclusion, pp. 335–9). Zenner was the first to apply the latter technique to a medieval monument, based on Jean-Claude Bessac's typo-chronology of stoneworking tools (1986, BI-14.2); cf. BI-14.1 to BI-14.34; cf. Doperé, "Etude de l'évolution," with reference to 1996 article. For the state of the discipline of monumental archaeology (i.e., full documentation and scientific analysis of standing fabric), see Baud, *Cluny*; for its historiography and scope, see Zenner, *Methods and Meaning*, pp. 11–19; and Grossmann, *Einführung*, esp. pp. 26–35. On material science, see *Archaeometry*. AVISTA sponsors international conferences on use of materials in medieval architecture: wood and stone (1999), metal (2002), brick (2005); the third volume in the AVISTA series is Bork, ed., *De Re Metallica*; cf. BI, sections 13–16 on materials. Recent research has focused on technical aspects such as scaffolding: Tardieu and Reveyron, *L'Echafaudage*; cf. BI-17.1 to BI-17.12; and Huerta, ed., *Proceedings*.

13 Electronic surveys came late to medieval architectural studies: Davis et al., "Mechanics and Meaning," continues Neagley's work begun in 1988 (cf. Wiemer, n.91 below). On the advantages and dangers of CAD, see Zenner, "AutoCAD as an Exploratory Device." Refer to CSA subject index for related topics such as retrieving dimensions from CAD drawings and models; and n.76 below on the subjective aspect of modern technology.

14 Most recently, Parsons, *Books and Buildings*; Weyer-Davis, *Early Medieval Art*; Frisch, *Gothic Art*; Frankl (NR-1960, BI-17.4); Mortet, *Recueil de textes*; and per Kruft (as in n.16 below), p. 452 n.42, to name the most current printed sources. Each building has its own potential archives held in libraries, architect's offices, or the local presbytery.

15 Rowland et al. eds. *Vitruvius*; earlier editions (p. xiv).

16 Kruft, *History of Architectural Theory* [BI-10.18], pp. 30–40, concludes there was no theory and little influence from Vitruvius during the period in question. On medieval theory, see Germann, *Vitruve*; on transmission: Reynolds and Weiskittel, "Vitruvius"; the most comprehensive study is Schuler, *Vitruv im Mittelalter*, with discussion of *Ars mechanica* and bibliography.

17 With regard to architecture: Conant (NR-1968b; BI-6.12); Heitz, "Vitruve et l'architecture"; Tcherikover, "A Carolingian Lesson,"; Hausmann, "*Inque pares numeros omnia convenient*"; and to mathematics: Pottage, "Vitruvian Value of Pi"; Frey, "Médiétés."

18 Fleury, *La Mécanique de Vitruve*, includes basic bibliography on ancient civil and military engineering.

19 The best introduction is Dilke, *Les Arpenteurs*; on illustrations, Carder, *Art Historical Problems* (1978); and Bouma, *Marcus Iunius Nypsus*, for editions and on surveying instruments, to which we add Folkerts, "Visierkunst," and Mortet and Tannery, "Un Nouveau Texte" (1896).

20 Plommer, *Vitruvius*.

21 On earlier plans, see Horn and Born (NR-1979, BI-9.1), 1:53–65, 66–7; and especially Kleinbauer, "Pre-Carolingian Concepts"; along with Badawy, "Ancient Constructional Diagrams"; Haselberger, "Architectural Likenesses"; cf. Sakarovitch,

Epures d'architecture, pp. 17–35; Müller, *Grundlagen gotischer*, pp. 21–9; appendix 5, pp. 292–3.

22 Binding et al., *Baubetrieb im Mittelalter*, pp. 173–9.

23 The extensive bibliography and debates may be summarized by citing the fundamental study by Horn and Born (NR-1979, BI-9.1 [with review]), and the dissertation (1981, BI-9.9), published in 1992 by Jacobsen, with conclusions on modularity, proportion, and number (pp. 33, 321–332). For an overview of the planning, see Sanderson (1985, BI-9.13). Among recent works, see Kendall, "Plan of St Gall"; cf. BI-9.1 to BI-9.18.

24 In addition to editions by Heath, after Heiberg, see the dynamic modern illustrations online at <http://aleph0.clarku.edu/~djoyce/java/elements/elements.html>.

25 Folkerts, *Euclid in Medieval Europe*; Stevens, "Euclidian Geometry," including on the medieval tradition of illustrations.

26 Bubnov, ed., *Gerberti*; Lindgren, *Gerbert von Aurillac*.

27 For a concise summary, see Zenner, "Imaging a Building," esp. 223–7, 224 n.20 (on Corbie, particularly Ullman, 1964), n.21 (on the Lorraine); and Folkerts' collected studies, *Essays* (2003).

28 Zenner, "Imaging a Building." pp. 231–6.

29 The definitive critical edition is Hahnloser (NR-1972 [with reviews], BI-11.5); the critical bibliography by Barnes (1982, BI-11.1) has continuous updates at <www.villardman.net>; cf. BI-11.1 to BI-11.8. Barnes's new critical edition and color facsimile should be forthcoming with Ashgate in 2006.

30 Suggested in Frankl (see n.14 above), p. 37; Kruft, *History of Architectural Theory*, p. 37 and n.83, quibbles with it; Sakarovitch, *Epures d'architecture*, p. 37, categorically dismisses it. Greater knowledge on the history and transmission of civil and military engineering, and the interrelations with architecture, are required.

31 Zenner, "Imaging a Building," p. 234.

32 Bechmann, *Villard*, aided by Renaud Beffeyte, a *Compagnon* initiated in the same tradition as Villard (see n.46 below). Cf. Sakarovitch, *Epures d'architecture*, pp. 35–51, 127–30.

33 Frankl (NR-1945, BI-6.16), p. 47, pointed to the late Gothic booklets as evidence for a "secret."

34 Frankl (NR-1960, BI-17.4), esp. 110–58.

35 For instance, Frankl (NR-1945, BI-6.16), p. 46 n.1, cites Janner (NR-1876, BI-2.12). Other notable works: von Heideloff (NR-1844, BI-2.10, also: -10.12); Durach (NR-1928; 1930, BI-2.3); an architect and member of the "Wiener Bauhütte," Discher (NR-1932, BI-3.11); and on the state of the question in the first issue of *Architectura*, Habicht (1933, BI-2.9). Influential works by Dehio and Velte will be discussed under triangulation.

36 In a review of Briggs (see n.42 below), Pevsner had already dismissed this idea (1930/31, BI-5.32 [cited here after Habicht, p. 81 n.1]). In an otherwise exemplary analysis of design principles, Bucher (NR-1968, BI-8.10), pp. 50, 71, propagates the error that Euclidian knowledge was only available in the mid-thirteenth century, and dismisses the idea of a secret; followed by Shelby (NR-1976), who argued at length against a "secret"; cf. Recht (1980, BI-5.35).

37 See Ackerman (NR-1949, BI-6.3), following Frankl (NR-1945, BI-6.16); cf. Beaujouan, "Calcul d'expert." Müller, *Grundlagen gotischer*, *passim*, plus appendix 16, pp. 304–5; ch. 14 in Courtenay, ed., *Engineering of Medieval Cathedrals*;

Sakarovitch, *Epures d'architecture*, pp. 50–1, concludes the medieval masons' "secret" would consist in the knowledge how to move from plan to elevation (p. 51).

38 On the lack of distinction between sciences and the overarching place of geometry, see Zaitsev, "The Meaning." Ackerman's conclusions on the necessary juncture of *ars* and *scientia*, versus the Milanese confusion between physical sciences, should be reviewed in this light: (NR-1949, BI-6.3), pp. 102–8, esp. 102, 107.

39 The beginnings of such a reappraisal come from disperse sources: Turnbull, "Ad Hoc Collective Work" offers a reassessment of theory versus practice, as well as modern prejudices and medieval knowledge; Huerta, "Medieval '*Scientia*'," affirms a masterly body of knowledge, albeit without explicit written record, for the earlier medieval periods.

40 Booz (NR-1956, BI-1.13), with reviews by Busch (NR-1957), Branner (NR-1958b), and others.

41 Du Colombier (NR-1953 [with review by Branner]; 1973 edn., in BI-1.16, also: -8.16); and Gimpel (1958; 1980, BI-1.23), with numerous editions and translations up to the present; in a second wave, Coldstream, *Masons and Sculptors*. From at least 1933, the more elusive work of Knoop and Jones on the guilds paralleled the German historiographic tradition in the search for Masonic origins (NR-1933; 1967, BI-5.26); on lodge rules, idem et al. (NR-1938, BI-10.17).

42 Mortet, *La Maîtrise d'œuvre*; Lefèvre-Pontalis (1911, BI-5.28a); Briggs (1927; 1974 ed., BI-5.9); in the *Journal of the RIBA*: Knoop and Jones, "The Rise of the Mason Contractor," and "The Decline of the Mason-Architect"; and Harvey, "The Mediaeval Carpenter"; Pevsner (NR-1942a, BI-5.33); Anfray, "Les Architectes des cathédrales"; Lefrançois-Pillion, *Maîtres d'œuvre*. In Germany, Kletzl (1935, BI-5.25); and recently again, Binding, *Der früh- und hochmittelalterliche Bauherr*, with review by Schuler, *Scriptorium*; idem, "*Architectus*; cf. BI-5.1–BI-5.45.

43 Multiple works on education by Harvey (1945–86) and Shelby (1964–87) are cited in the thematic bibliography, in addition to numerous others by Shelby under Instruments, and Practical Geometry.

44 Shelby (1975, BI-6.40), pp. 133, 135, 136, 137, 143.

45 In general, Murdoch et al., eds., *The Cultural Context*.

46 On memory, the classic work is Yates, *The Art of Memory*; cf. Carruthers, *Book of Memory*. On oral tradition and ritual, see Beffeyte, "The Oral Tradition"; cf. Terrenoire, "Villard de Honnecourt." On trade secrets, see Long, *Openness*.

47 Lecotté, *Essai bibliographique*; followed by Bayard, *Le Compagnonnage*.

48 The author has been privileged to witness rites in France and Switzerland in the presence of leading European figures of the *Enfants de Salomon*, a group which identifies with Villard de Honnecourt. *Compagnonnage* existed or moved to other countries in Europe, then to the New World; the Carpenters' Company of Philadelphia is one such, albeit publicly unacknowledged, offshoot. See Peterson, ed., *Rules of Work*, whose introduction begins with the topic of trade secrets (p. ix).

49 Proust, "Des Images à lire," pp. 266–8, "Les Deux Personnages enlacés," and ill. 337.

50 Recent research on oral transmission includes Schottner, *Die 'Ordnungen'*.

51 Ethnomathematics may serve to show potential differences with mainstream Western culture: Ascher, *Mathematics Elsewhere*, and earlier work; Selin, ed., *Mathematics Across Cultures*.

52 McCluskey, *Astronomies and Cultures*; Haselberger, "Geometrie der Winde"; Obrist, "Wind Diagrams and Medieval Cosmology."

53 Heinzmann et al., eds., *Runica*. For signs in masonry work, see Kraack et al., eds., *Bibliographie zu historischen Graffiti*; and the CIRG: <http://users.skynet.be/sky98372/cirg.html>; cf. BI-3.1 to BI-3.59; and Alexander, "Villard de Honnecourt."

54 Instruments for design: Mortet, "Note historique"; Funck-Hellet, *De la proportion*; Shelby, "Medieval Masons' Tools, II"; Sené, "Les Equerres"; idem, "Un Instrument de précision" (1970b); idem, "Quelques instruments" (1972); Meckseper (NR-1983, BI-11.8); Wu, "Hugues Libergier".

55 Instruments for layout: measuring tools: Binding (1985, BI-6.7); early medieval sighting instruments: Würschmidt, "Geodätische Messinstrumente"; on staking out: Paquet, "Les Tracés directeurs," esp. pp. 61–3.

56 Instruments for construction: Shelby, "Medieval Masons' Tools, I"; on templates: Booz (NR-1956, BI-1.13), pp. 96-104; Shelby (NR-1971, BI-1.52); Adams, "The Use of Templates"; Binding et al., *Baubetrieb im Mittelalter*, pp. 229–34 (cf. 1986, BI-14.3). Use of templates implies the art of stereotomy: Shelby (1969, BI-6.38); Lalbat et al., "De la stéréotomie"; Müller, *Grundlagen gotischer*, pp. 121–83; and Sakarovitch, *Epures d'architecture*, esp. pp. 35–51; bibliography, pp. 400–20; cf. Sanabria, "From Gothic to Renaissance Stereotomy"; cf. BI-14.1 to BI-14.34 on stoneworking.

57 Zenner, "Imaging a Building," pp. 230–1, 232–3, 238–9.

58 On geometry in post-medieval experimental science, see Bennett, "Practical Geometry"; and Janich, "Was heißt eine Geometrie operativ begründen?"

59 Shelby (1975, BI-6.40), p. 137, implies Euclid's arithmetic formula for a circumference is inherently superior to the geometrical solution given by Roriczer. But if working within a proportional plan, without dimensions, the latter is more useful.

60 Mortet, "La Mesure des colonnes"; Wirth, "Bermerkungen"; cf. Müller, *Grundlagen gotischer*, p. 127, ill. 103.

61 Explanation of the diagram in Villard's portfolio (fol. 21r) is found in Beffeyte, "The Oral Tradition," pp. 113–15, ills. 5.16–5.18.

62 Shelby (1975, BI-6.40), p. 141, discusses it in Roriczer's text (cf. Shelby NR-1977, BI-8.88); Zenner, "Imaging a Building," p. 244 n.95, on Francesco di Giorgio's factor for calculating wall thickness; Huerta, "The Medieval '*Scientia*'," pp. 568–73, is not aware of the evidence in Villard, but treats Late Gothic and post-medieval rules in Germany, England, and Spain. The question of wall thickness and laying the ground stone should be examined together (cf. BI-7.1 to BI-7.5).

63 On Latin Euclid and Villard's portfolio: Martines, "*Gromatici veteres*"; one of the first studies to treat Gerbert and architecture was Sarrade, *Sur les connaissances mathématiques*. Scattered studies include: Mortet et al., "Un Formulaire du 8e siècle"; Halleux, "Les Géomètres mosans"; idem et al., "Formules d'architectes."

64 See, foremost, the short study by Homann, ed., *Practical Geometry*; with appendix on *De arca Noe morali*, and bibliography of principal editions of other medieval practical geometry texts: Hahn (1982), Victor (1979), Busard (1965), Curtze (1897). An important analysis of all sources may be found in Presas i Puig, *Praktische Geometrie*.

65 Connections between practical geometry and the design principals of Gothic architectural drawings were made, particularly by Branner and Bucher in the 1960s and 1970s; Shelby focused on the geometrical knowledge in Villard and the Late Gothic booklets in the 1970s (references in bibliography).

66 A dissertation by Pause (NR-1973, BI-8.77), followed by Recht, "Sur le dessin," and multiple articles in Recht, ed., *Les Bâtisseurs*, along with Schöller on tracings (1989b, BI-8.84a; cf. BI-8.84), provides complete bibliography. Cf. Binding, "Architekturdarstellung"; Binding et al., *Baubetrieb im Mittelalter*; cf. BI-8.1 to BI-8.99. Other documentation of tracings includes: Bessac, "Tracés et épures gravés"; Davis, "On the Drawing Board." More recent work on drawings: Recht, *Le dessin d'architecture*; idem, "La Circulation des artistes"; and Neagley, "Late Gothic Architectural Drawing," with introduction by Thelma K. Thomas, pp. 88–9.

67 See Müller, *Grundlagen gotischer*; idem, "Le Dessin technique;" Knobloch, "Technische Zeichnungen," illus. on pp. 67–9. Cf. Sanfaçon, "Le rôle des techniques," in (1982, BI-1.1), pp. 93–130.

68 Dürer, *Géométrie*, and facsimile of the 1525 edition (NR-1971); idem, *De symmetria*, 1532/*Underweysung der Messung*, Nuremberg, 1538 [electronic resource], comm. by David Price (Oakland, California, 2003), with searchable text.

69 Sanabria, *Evolution and Late Transformations*; Sakarovitch, *Epures d'architecture*, up to the nineteenth century; Huerta, "The Medieval '*Scientia*'," up to the sixteenth century. Cf. technically oriented studies of Gothic in Müller, *Grundlagen gotischer*.

70 Refer to an experimental study of structural forces broaching the gulf between civil and military engineering, expressed in terms of medieval geometry: Zenner, "Structural Stability," with abstract and addendum online at <www.nexusjournal.com/conferences/N2002-Zenner.html>. In general, on techniques and geometry of construction, see Müller, *Grundlagen gotischer*, pp. 121–68; cf. BI-1.1 to BI-1.62, esp. BI-1.32 (Kimpel, 1983).

71 A useful summary of the literature up to 1949 is in Ackerman (NR-1949, BI-6.3), esp. pp. 84–5; more recently, see Courtenay, ed., *Engineering of Medieval Cathedrals*, chs. 1–2; cf. Müller *Grundlagen gotischer*, pp. 184–246, appendices 8–14, pp. 296–303. See also Courtenay: introduction, chs. 8–9 on walling and foundations. Further studies on structure may be found in Courtenay's bibliography, and in Armi, *Design and Construction*; cf. BI-12.1 to BI-12.38 (statics). Other recent work includes Fitchen, *Building Construction* (cf. BI-1.19, also: -12.14); Mainstone, "Structural Analysis"; Theodossopoulos and Sinha, "Structural Masonry."

72 As demonstrated by Zenner, *Methods and Meaning*, esp. pp. 338–9, 390–3; cf. idem, *Saint-Étienne de Nevers*, pp. 30–3.

73 See Zenner, "A Proposal," in Wu, ed., *Ad Quadratum*, pp. 25–55.

74 See Sbacchi, "Euclidism and Theory of Architecture," online at <www.nexusjournal.com/Sbacchi.html>; cf. Gelernter, *Sources of Architectural Form*, esp. ch. 3; and BI-6.1 to BI-6.48.

75 Metrology is a vast historical sub-discipline; for basic bibliography to 1978, see "Historical Metrology," repr. in Fernie, *Romanesque Architecture*; cf. Arens (NR-1938, BI-6.4), Hecht (NR-1965 to 1979d; BI-6.22 to BI-6.25, and BI-9.3); Überwasser (NR-1928 to 1953, esp. NR-1935, BI-6.44); also the series of acts, *Ordo et Mensura* (St Katharinen, 1991–).

76 Eiteljorg, II, "How Should We Measure?" online at <www.nexusjournal.com/Eiteljorg.html>.

77 Rottländer, "Zum Weiterleben antiker Masseinheiten."

78 Hiscock, "Design and Dimensioning."

79 Witthöft, ed., *Die historische Metrologie*.

80 Fernie, "A Beginner's Guide," repr. in idem, *Romanesque Architecture*; Kidson, "A Metrological Investigation."

81 For a mathematical history of proportion in architecture, see Presas i Puig, *Praktische Geometrie*; a useful reference is Herz-Fischler, *A Mathematical History*; cf. Graf (NR-1958, BI-6.1, a bibliography on proportion), and von Naredi-Rainer, *Architektur und Harmonie*.

82 For example, Beaujouan (NR-1961), Conant (NR-1960/61), Heitz (NR-1973, NR-1976), Meyer (NR-1975), Sunderland (NR-1959/73), and later, Zimmerman, ed., *Mensura. Mass, Zahl* (1984).

83 Dehio (NR-1894 [with review]; NR-1895a; NR-1895b).

84 For example, dissertations by Hoeber (NR-1906) and Thomae (NR-1933 [with review]).

85 Lund (NR-1921), Rosenau (1934, BI-8.82), Roosval (NR-1944); and von Rothkirch, *Die Bedeutung.*

86 Velte (NR-1951 [with multiple reviews], BI-8.96), notably by Ackerman, *AB* 35 (1953), pp. 155–7, who had recently contributed to the debate on Milan Cathedral (NR-1949, BI-6.3).

87 Witness the first volume in the AVISTA series: Wu, ed., *Ad Quadratum*; also Lyman, "*Opus ad triangulum*."

88 The circle: Mössel (NR-1926 [with multiple reviews]); Paquet, "Les Tracés directeurs"; Zenner, "A Proposal." The oval: Chappuis, "Utilisation du tracé ovale". The pentagon: Shortell, "Plan of St Quentin."

89 Unfortunately, although an expensive production, Hiscock, *The Wise Master Builder*, suffers from the methodological problems that plague medieval design studies (discussed in our definition of layout). In contrast, the older discipline of classical archaeology has produced a model work based on personal measured surveys: Jones, *Principles of Roman Architecture.*

90 These forms appear on the title page of Discher (NR-1932, BI-3.11); cf. Bilheust, *L'Art des bâtisseurs romans*; and Bilheust et al., *Les Tracés des maîtres d'oeuvre.*

91 Wiemer and Wetzel, "A Report on Data Analysis," p. 458, ill. 11; cf. Wiemer, "Die computergetützte Proportionsanalyse."

92 See response in Zenner, "Imaging a Building," pp. 220–2, 231–6.

93 Zenner, "A Proposal," p. 49, ill. 2.6; p. 50, ill. 2.11; this is the first known (geometric) calculation of wall thicknesses prior to the Late Gothic (refer to n.62 above).

94 See Zenner, "Villard de Honnecourt", as well as the expanded English version.

95 Ibid.: in *Pour la Science*, p. 109, ill. 2b; in *Nexus Network Journal*, ills. 8–9.

Bibliography

Thematic

Vitruvius

Georg Germann, *Vitruve et le Vitruvianisme*, (NR-1980 [with reviews], BI-10.9), 2nd edn. (Darmstadt, 1987; trans. Lausanne, 1991).

Leighton D. Reynolds and S. F. Weiskittel, "Vitruvius," in Reynolds, ed., *Texts and Transmission* (Oxford, 1983), pp. 440–5.

Stefan Schuler, *Vitruv im Mittelalter* (Cologne, 1999).

Corpus agrimensorum romanorum

Jelle Bouma, *Marcus Iunius Nypsus* (Frankfurt am Main, 1993), with editions: Blume et al. (1848–52); Thulin (1911a, 1913); Butzmann (1970); studies: Cantor (NR-1875); esp. Thulin (1911c); drawings, Carder (1978).

James Nelson Carder, *Art Historical Problems of a Roman Land Surveying Manuscript* (New York, 1978).

Oswald A. W. Dilke, *Les Arpenteurs de la Rome antique* (1971; rev. edn., François Favory, Sophia Antipolis, 1995).

Victor Mortet and Paul Tannery, "Un Nouveau Texte des traités d'arpentage et de géométrie d'Epaphroditus et de Vitruvius Rufus," 1896, repr. in Paul Tannery, *Mémoires scientifiques*, vol. 5, 1922 (repr., Paris, 1996), pp. 29–[81]; cf. Bubnov, *Gerberti* (1899), pp. 518–51.

Plan of St Gall

Walter Horn and Ernst Born (NR-1979, BI-9.1).

Werner Jacobsen (BI-9.9; published: Berlin, 1992).

W. Eugene Kleinbauer, "Pre-Carolingian Concepts of Architectural Planning," in Marilyn J. Chiat et al., eds., *The Medieval Mediterranean* (St Cloud, Minnesota, 1988), pp. 67–79.

Latin Euclid

Menso Folkerts, *Euclid in Medieval Europe*, ed. Wesley M. Stevens (Winnipeg, 1989); online at <www.math.ubc.ca/people/faculty/cass/Euclid/folkerts/folkerts.html>; and *Essays in Early Medieval Mathematics* (Aldershot, 2003), including CAR.

Wesley M. Stevens, "Euclidian Geometry in the Early Middle Ages," in Marie-Thérèse Zenner, ed., *Villard's Legacy* (Aldershot, 2004), pp. 229–63.

Marie-Thérèse Zenner, "Imaging a Building: Latin Euclid and Practical Geometry," in John J. Contreni et al., *Word, Image, Number* (Florence, 2002), pp. 219–46, 7 ills.

Portfolio of Villard de Honnecourt

Carl F. Barnes, Jr., (1982, BI–11.1), a critical bibliography now online with continuous updates at <www.villardman.net>.

Roland Bechmann, *Villard de Honnecourt* (1991; 2nd rev. edn. Paris, 1993).

Hans R. Hahnloser (NR-1972 [with multiple reviews], BI-11.5).

Technical education of the builder: introduction

Ackerman (NR-1949, BI-6.3).

Renaud Beffeyte, "The Oral Tradition and Villard de Honnecourt," in Marie-Thérèse Zenner, ed., *Villard's Legacy* (Aldershot, 2004), pp. 93–120.

Paul Booz (NR-1956 [with multiple reviews], BI-1.13, also: -6.10, -8.5, -10.1).

Paul Frankl (NR-1945, BI-6.16), (NR-1960, BI-17.4).

John Harvey, "Geometry and Gothic Design," *Transactions of the Ancient Monuments Society* 30 (1986), pp. 43–56; (NR-1972, BI-5.20, also: -8.33), with bibliography of his earlier work.

Douglas Knoop and Gwilyn Peredur Jones (NR-1933; repr. 1967, BI-5.26); idem, and Douglas Hamer (NR-1938, BI-10.17).

Lon R. Shelby (1964, BI-5.39), (NR-1970, BI-5.40), (1975, BI-6.40), (NR-1976); "Geometry," in David L. Wagner, ed., *The Seven Liberal Arts* (Bloomington, 1983), pp. 196–217; "Masons and Builders," in *Dictionary of the Middle Ages* (New York, 1987) 8:172–80.

David Turnbull, "The Ad Hoc Collective Work of Building Gothic Cathedrals with Templates, String, and Geometry," *Science, Technology, and Human Values* 18:3 (1993), pp. 315–40.

Technical education of the builder: applied mathematics and instruments

Günther Binding (1985, BI-6.7).

Charles Funck-Hellet, *De la proportion – L'équerre des maîtres d'œuvre* (Paris, 1951).

Claude Lalbat et al., (1987, BI-11.7, also: -14.14a), and "De la stéréotomie médiévale, pt. 2, *BM* 147:1 (1989), pp. 11–34.

Cord Meckseper (NR-1983, BI-11.8).

Victor Mortet, "Note historique sur l'emploi de procédés matériels et d'instruments usités dans la géométrie pratique au moyen-âge (10e–13e siècle)," in *IIe Congrès international de philosophie*, 1904 (Geneva, 1905), pp. 925–42.

Alain Sené, "Les Equerres au moyen-âge," *95e Congrès national des Sociétés savantes*, Archéologie (Reims, 1970), pp. 525–48; [1970b, 1972: see Wu].

Lon R. Shelby "Medieval Masons' Tools, I, The Level and the Plumb Rule," *Technology and Culture* 2 (1961), pp. 127–30; (1969, BI-6.38, also: -8.87a, -12.32), (NR-1971, BI-1.52, also: -10.28, -14.27); [1965: see Wu].

Nancy Wu, "Hugues Libergier and his Instruments," *AVISTA Forum Journal* 11.2 (1998/9), pp. 7–13; repr. in *Nexus Network Journal* 2.4 (2000), pp. 93–102, online at <www.nexusjournal.com/Wu.html>, sites: Sené (1970b, 1972), Shelby (1965), among others.

Technical education of the builder: practical geometry

Günther Binding, *Baubetrieb im Mittelalter* (1993; 2nd edn. Darmstadt, 1997): pp. 171–234, 339–54.

Robert Branner (NR-1963, repr. in Courtenay [cited under Structure]).

François Bucher (NR-1968, BI-8.10, also: -10.2), (NR-1972, BI-8.12, also: -10.4), (NR-1979, BI-10.5).

Robert Halleux, "Les Géomètres mosans des 10e et 11e siècles et leurs modèles antiques," *Fédération des cercles d'archéologie et d'histoire de Belgique. Annales du 44e congrès* (Huy, 1976), pp. 565–70; idem et al., "Formules d'architectes dans les receptaires et les manuscrits d'arpentage de l'Antiquité et du haut moyen-âge," in Patricia Radelet-de Grave et al., *Entre mécanique et architecture* (Basel, 1995), pp. [48]–66.

Santiago Huerta, "The Medieval '*Scientia*' of Structures: The Rules of Rodrigo de Hontañón," in Antonio Becchi et al., *Towards a History of Construction* (Basel, 2002), pp. 567–85.

Victor Mortet, "La Mesure des colonnes à la fin de l'époque romaine d'après un très ancien formulaire," *Bibliothèque de l'Ecole des Chartes* 57 (1896), pp. 277–324; idem et al., "Un formulaire du 8e siècle pour les fondations d'édifices et de ponts d'après des sources d'origine antique," *BM* (1907), pp. 442–65.

Werner Müller, *Grundlagen gotischer Bautechnik* (Munich, 1990), pp. 14–120; appendices 3, 6, and 7 (pp. 289–96).

Peter Pause (NR-1973, BI-8.77).

Roland Recht, ed., *Les Bâtisseurs des cathédrales* (Strasburg, 1989), esp. articles by Müller, Recht, and Schöller; and Recht, "Sur le dessin d'architecture gothique," in Sumner McKnight Crosby et al., eds., *Etudes d'art médiéval offertes à Louis Grodecki* (Paris, 1981), pp. 233–50.

Joël Sakarovitch, *Epures d'architecture. De la coupe des pierres à la géométrie descriptive 16e–19e siècles* (Basel, 1998).

Sergio Sanabria, *The Evolution and Late Transformations of the Gothic Mensuration System*, Ph.D. thesis, 3 vols., Princeton, 1984 (Ann Arbor, 1984).

Wolfgang Schöller (1989, BI-8.84a).

Lon R. Shelby (NR-1972, BI-6.39, repr. in Courtenay [cited under Structure]), (NR-1977 [with review], BI-8.88, also: -10.29); idem, and Robert Mark (NR-1979, BI-8.87, repr. in Courtenay [cited under Structure]).

Karl-August Wirth, "Bermerkungen zum Nachleben Vitruvs . . . ," *Kunstchronik* 20:9 (1967), pp. 281–91.

Design to execution: structure and construction

Lynn Courtenay, ed. *The Engineering of Medieval Cathedrals* (Aldershot, 1997).

Werner Müller, *Grundlagen gotischer Bautechnik* (Munich, 1990).

Marie-Thérèse Zenner, *Methods and Meaning of Physical Analysis in Romanesque Architecture: A Case Study, Saint-Etienne in Nevers*, Ph.D. thesis, 3 vols., Bryn Mawr College, 1994 (Ann Arbor, 1994), vols. 1–2; illustrated summary in *Saint-Etienne de Nevers. Un ancien prieuré de Cluny dans le Nivernais*, CAMOSINE, no. 80 (Nevers, 1995).

Design concepts: dimensions

Eric Fernie, *Romanesque Architecture: Design, Meaning and Metrology* (London, 1995).

Peter Kidson, "A Metrological Investigation," *Journal of the Warburg and Courtauld Institutes* 53 (1990), pp. 71–97.

Paul von Naredi-Rainer, *Architektur und Harmonie: Zahl, Mass und Proportion in der abendlandischen Baukunst* (Cologne, 1982).

Albert Presas i Puig, *Praktische Geometrie und Kosmologie am Beispiel der Architektur*, Algorismus, vol. 27, ed. Menso Folkerts (Munich, 1998).

Rolf C. A. Rottländer, "Zum Weiterleben antiker Masseinheiten und Methoden der Bauplanung im Mittelalter," in Peter Dilg et al., *Rhythmus und Saisonalität* (Sigmaringen, 1995), pp. 433–46.

Harald Witthöft, ed., *Die historische Metrologie in den Wissenschaften* (St Katharinen, 1986).

Albert Zimmerman, ed., *Mensura. Mass, Zahl, Zahlensymbolik im Mittelalter* (Berlin, 1984).

Design concepts: geometry

Georg Dehio (NR-1894), (NR-1895a), (NR-1895b).

Nigel Hiscock, *The Wise Master Builder* (Aldershot, 2000).

Maria Velte (NR-1951 [with multiple reviews], BI-8.96).

Wofgang Wiemer and Gerhard Wetzel, "A Report on Data Analysis of Building Geometry by Computer," *JSAH* 53:4 (1994), pp. 448–60.

Nancy Y. Wu, ed., *Ad Quadratum* (Aldershot, 2002).

Marie-Thérèse Zenner, "Villard de Honnecourt et la géométrie euclidienne," *Pour la Science*, Dossier no. 37, Les sciences au moyen-âge (October 2002/January 2003), pp. 108–9; expanded version, "Villard de Honnecourt and Euclidean Geometry," *Nexus Network Journal* 4:4 (2002), pp. 65–78, online at <www.nexusjournal.com/Zenner.html>.

General

Janet Adams, "The Use of Templates in Gothic Architecture," *Bulletin of Research in the Humanities* 83:2 (1980), pp. 280–91.

Jennifer S. Alexander, "Villard de Honnecourt and Masons' Marks," in Marie-Thérèse Zenner, ed., *Villard's Legacy* (Aldershot, 2004), pp. 53–69.

Marcel Anfray, "Les Architectes des cathédrales," *Les Cahiers techniques de l'art* 1 (Paris, 1947).

C. Edson Armi, *Design and Construction in Romanesque Architecture* (Cambridge, 2004).

Marcia Ascher, *Mathematics Elsewhere* (Princeton, 2002).

Alexander Badawy, "Ancient Constructional Diagrams in Egyptian Architecture," *GBA* 107 (1986), pp. 51–6.

Günter Bandmann, *Die Bauformen des Mittelalters* (Bonn, 1949).

Anne Baud, *Cluny* (Paris, 2003).

Jean-Pierre Bayard, *Le Compagnonnage en France* (Rennes, 1977; 2nd edn. Paris, 1990).

Guy Beaujouan, "Calcul d'expert" (1963), in *Par raison des nombres* (Aldershot, 1991).

Jim Bennett, "Practical Geometry and Operative Knowledge," *Configurations* 6 (1998), pp. 195–222.

Jean-Claude Bessac, "Tracés et épures gravés dans l'ancienne cathédrale Saint-Just de Narbonne (Aude)," in *Actes du Colloque international de glyptographie de Cambrai* (Braine-le-Château, 1985), pp. 35–55.

Henri Bilheust, *L'Art des bâtisseurs romans*, Cahiers de Boscodon 4, 5th rev. edn. (Boscodon, 1990).

Henri Bilheust et al., *Les Tracés des maîtres d'oeuvre*, Livret no. 4, 2nd edn. (Boscodon, 1997).

Günther Binding, "Architekturdarstellung," in *Lexikon des Mittelalters*, vol. 1 (Munich, 1980).

——, *Der früh- und hochmittelalterliche Bauherr* (1996; 3rd edn. Darmstadt, 1999).

Günther Binding et al., *Baubetrieb im Mittelalter* (1993; 2nd edn. Darmstadt, 1997).

——, "Bibliographie zum mittelalterlichen Baubetrieb Westeuropas," *Zeitschrift für Archäologie des Mittelalters* 16/17 (1988/99), pp. 185–98.

Robert Bork, ed., *De Re Metallica* (Aldershot, 2005).

Nicolaus Bubnov, ed., *Gerberti . . . Opera mathematica* (1899; repr. Berlin, 1963).

Robert G. Calkins, *Medieval Architecture* (New York, 1998).

Mary Carruthers, *The Book of Memory* (Cambridge, 1990).

René Chappuis, "Utilisation du tracé ovale," *BM* 134 (1976), pp. 7–36.

Nicola Coldstream, *Masons and Sculptors* (Toronto, 1991).

——, *Medieval Architecture* (Oxford, 2002).

Dietrich Conrad, *Kirchenbau im Mittelalter, Bauplanung und Bauausführung* (1990; 3rd edn. Leipzig, 1998).

Lynn Courtenay, ed., *The Engineering of Medieval Cathedrals* (Aldershot, 1997).

Paul Crossley, "Medieval Architecture and Meaning," *BurlM* 130 (1988), pp. 116–21.

Martin Davies, *Romanesque Architecture: A Bibliography* (New York, 1993).

Michael T. Davis, "On the Drawing Board: Plans of the Clermont Cathedral Terrace," in Nancy Y. Wu, ed., *Ad Quadratum* (Aldershot, 2002), pp. 183–204.

Michael T. Davis et al., "Mechanics and Meaning," *Gesta* 39 (2000), pp. 159–80.

François Deshoulières, *Eléments datés de l'art roman en France* (Paris, 1936).

Frans Doperé, "Etude de l'évolution des techniques de taille . . . pendant le 15e siècle," in Patrice Beck, ed., *L'Innovation technique* (Paris, 1998), pp. 234–6.

Albrecht Dürer, *Géométrie*, ed. Jeanne Peiffer (Paris, 1995).

Harrison Eiteljorg, II, "How Should We Measure an Ancient Structure?," *Nexus Network Journal* 4:4 (2002), pp. 14–20.

Kirstin Faupel-Drevs, *Vom rechten Gebrauch der Bilder im liturgischen Raum* (Leiden, 2000).

John Fitchen, *Building Construction Before Mechanization* (Cambridge, Mass., 1986).

Phillipe Fleury, *La Mécanique de Vitruve* (Caen, 1993).

Menso Folkerts, "Visierkunst," in *Lexikon des Mittelalters* (Munich, 1997), vol. 8, pp. 1727–30.

Paul Frankl, with Paul Crossley, *Gothic Architecture* (1962; rev. edn. New Haven, 2000).

Louis Frey, "Médiétés et approximations chez Vitruve," *Revue archéologique* 2 (1990), pp. 285–330.

Teresa Grace Frisch, *Gothic Art, 1140–c.1450* (Englewood Cliffs, NJ, 1971).

Mark Gelernter, *Sources of Architectural Form* (Manchester, 1995).

Wolfgang Götz, *Zentralbau . . . in der gotischen Architektur* (Berlin, 1968).

G. Ulrich Grossmann, *Einführung in die historische Bauforschung* (Darmstadt, 1993).

John Harvey, "The Mediaeval Carpenter and his Work as an Architect," *Journal of the RIBA* 45 (1938), pp. 733–43.

Lothar Haselberger, "Architectural Likenesses," *Journal of Roman Archaeology* 10 (1997), pp. 77–94.

——, "Geometrie der Winde," in *Stadt und Umland . . . Archäologischen Bauforschung 7* (Mainz, 1999), pp. 90–100.

Axel Hausmann, "*Inque pares numeros omnia convenient*: Der Bauplan der Aachener Palastkapelle," in Paul L. Butzer et al., eds., *Karl der Grosse und sein Nachwirken*, 2 vols. (Turnhout, 1997), vol. 1, pp. 321–66.

Wilhelm Heinzmann et al., eds., *Runica, Germanica, Mediaevalia* (Berlin, 2003).

Carol Heitz, "Vitruve et l'architecture du haut moyen-âge," in *La Cultura antica . . .*, 2 vols. (Spoleto, 1975), vol. 2, pp. 725–57.

Roger Herz-Fischler, *A Mathematical History of the Golden Number* (New York, 1998).

Nigel Hiscock, "Design and Dimensioning in Medieval Architecture," in Rainer S. Elkar et al., eds., *Vom rechten Mass der Dinge* (St Katharinen, 1996).

Frederick A. Homann, S. J., ed., *Practical Geometry [Practica Geometriae] Attributed to Hugh of St Victor* (Milwaukee, 1991).

Santiago Huerta, ed., *Proceedings of the First International Congress on Construction History*, 3 vols. (Madrid, 2003).

Peter Janich, "Was heißt eine Geometrie operativ begründen?" in Werner Diederich, ed., *Zur Begründung physikalischer Geo- und Chronometrien* (Bielefeld, 1979), pp. 59–77.

Mark Wilson Jones, *Principles of Roman Architecture* (London, 2000).

Calvin B. Kendall, "The Plan of St Gall: an Argument for a 320-foot Church Prototype," *Mediaeval Studies* 56 (1994), pp. 277–97.

Franz Kohlschein et al., eds., *Heiliger Raum* (Münster, 1998).

Eberhard Knobloch, "Technische Zeichnungen," in Uta Lindgren, ed., *Europäische Technik* (1996; 2nd edn. Berlin, 1997), pp. 45–64.

Douglas Knoop and Gwilyn Peredur Jones, "The Decline of the Mason-Architect," *Journal of the RIBA* 44:19 (1937).

——, "The Rise of the Mason Contractor," *Journal of the RIBA* 43 (1936), pp. 1061–71.

Detlev Kraack et al., eds., *Bibliographie zu historischen Graffiti* (Krems, Austria, 2001).

Hanno-Walter Kruft, *A History of Architectural Theory* (London, 1994).

Roger Lecotté, *Essai bibliographique sur les Compagnonnages* (1951; repr. Marseille, 1980).

Louise Lefrançois-Pillion, *Maîtres d'œuvre* (Paris, 1949).

Edgar Lehmann, *Der frühe deutsche Kirchenbau . . . Raumanordnung bis 1080* (Berlin, 1938).

Uta Lindgren, *Gerbert von Aurillac* (Wiesbaden, 1976).

Pamela O. Long, *Openness, Secrecy, Authorship* (Baltimore, 2001).

Thomas W. Lyman, "*Opus ad triangulum* vs. *opus ad quadratum*," in Xavier Barral i Altet, ed., *Artistes, artisans*, 3 vols. (Paris, 1986), vol. 2, pp. 203–19.

Stephen C. McCluskey, *Astronomies and Cultures* (Cambridge, 1998).

Rowland J. Mainstone, "Structural Analysis, Structural Insights, and Historical Interpretation," *JSAH* 56 (1997), pp. 316–40.

Giangiacomo Martines, "*Gromatici veteres*," *Ricerche di storia dell'arte* 3 (1976), pp. 3–23.

Victor Mortet, *La Maîtrise d'œuvre* (Caen, 1906).

——, *Recueil de textes*, rev. edn. (Paris, 1995).

Werner Müller, *Grundlagen gotischer Bautechnik* (Munich, 1990).

——, "Le Dessin technique," in Roland Recht, ed., *Les Bâtisseurs des cathédrales* (Strasburg, 1989), pp. 236–54.

John Murdoch et al., eds., *The Cultural Context of Medieval Learning* (Boston, 1975).

Stephen Murray et al., "Plan and Space . . . ," *JSAH* 49 (1990), pp. 44–66.

Paul von Naredi-Rainer, *Architektur und Harmonie* (Cologne, 1982).

——, *Salomos Tempel . . .* (Cologne, 1994).

Linda Neagley, "A Late Gothic Architectural Drawing," in Elizabeth Sears et al., eds., *Reading Medieval Images* (Ann Arbor, 2002), pp. 90–9.

Barbara Obrist, "Wind Diagrams and Medieval Cosmology," *Speculum* 72 (1997), pp. 33–84.

John Ottaway, "Traditions architecturales dans le nord de la France," *Cahiers de civilisation médiévale* 23:2 (1980), pp. 141–72.

Jean-Pierre Paquet, "Les Tracés directeurs des plans," *Les Monuments Historiques de la France* 9:2 (1963), pp. 59–84.

David Parsons, *Books and Buildings* (Jarrow, 1988).

Charles E. Peterson, ed., *The Rules of Work of the Carpenters' Company . . . 1786* (Princeton, 1971).

Hugh Plommer, *Vitruvius and Later Roman Building Manuals* (London, 1973).

John Pottage, "The Vitruvian Value of Pi," *Isis* 59 (1968), pp. 190–7.

Evelyne Proust, "Des images à lire, admirer, méditer," in Marie-Thérèse Camus et al., eds., *Notre-Dame-la-Grande de Poitiers* (Paris, 2002), pp. 266–8.

Roland Recht, "La Circulation des artistes, des oeuvres, des modèles," *Revue de l'art* 120 (1998), pp. 5–10.

——, *Le Dessin d'architecture* (Paris, 1995).

Wolfgang von Rothkirch, *Die Bedeutung des quadratischen Schematismus* (Alternburg Thür, 1933).

Ingrid D. Rowland et al., eds. *Vitruvius* (Cambridge, 2001).

Joël Sakarovitch, *Epures d'architecture* (Basel, 1998).

Sergio Sanabria, "From Gothic to Renaissance Stereotomy," *Technology and Culture* 30:2 (1989), pp. 266–99.

Marie-Thérèse Sarrade, *Sur les connaissances mathématiques des bâtisseurs de cathédrales* (Paris, 1986).

Michele Sbacchi, "Euclidism and Theory of Architecture," *Nexus Network Journal* 3:3 (2001), online at <www.nexusjournal.com/sbacchi.html>.

Alfred Schottner, *Die "Ordnungen" der mittelalterlichen Dombauhütten* (Münster, 1994).

Stefan Schuler, "*Architectus, Magister Operis, Wermeistere*," *Miltellateinisches Jahrbuch* 34:1 (1999), pp. 7–28.

——, "Review," *Scriptorium* 51 (1997), pp. 390–7.

Helaine Selin, ed., *Mathematics Across Cultures* (Dordrecht, 2000).

Ellen M. Shortell, "The Plan of St Quentin," in Nancy Y. Wu, ed., *Ad Quadratum* (Aldershot, 2002), pp. 123–48.

Roger Stalley, *Early Medieval Architecture* (Oxford, 1999).

Joëlle Tardieu and Nicholas Reveyron, *L'Echafaudage dans le chantier médiéval* (Lyon, 1996).

Anat Tcherikover, "A Carolingian Lesson in Vitruvius," in Eric Fernie et al., eds., *Medieval Architecture and its Intellectual Context* (London, 1990), pp. 259–67.

Marie-Odile Terrenoire, "Villard de Honnecourt: culture savante, culture orale?," in Xavier Barral i Altet, ed., *Artistes, artisans*, 3 vols. (Paris, 1986), vol. 1, pp. 163–81.

D. Theodossopoulos and B. P. Sinha, "Structural Masonry," *Progress in Structural Engineering and Materials* 6:1 (2004), pp. 10–20.

Georg Weise, *Studien zur . . . Basilikengrundrisses* (Heidelberg, 1919).

Caecilia Weyer-Davis, *Early Medieval Art, 300–1500* (Toronto, 1986).

Wolfgang Wiemer, "Die computergetützte Proportionsanalyse am Beispiel von Planaufnahmen," *Architectura* 28 (1998), pp. 107–55.

Nancy Y. Wu, ed., *Ad Quadratum* (Aldershot, 2002).

Joseph Würschmidt, "Geodätische Messinstrumente," *Archiv der Mathematik und Physik* 19 (1912), pp. 315–20.

Francis Yates, *The Art of Memory* (Chicago, 1966).

Evgeny A. Zaitsev, "The Meaning of Early Medieval Geometry," *Isis* 90 (1999), pp. 522–53.

Marie-Thérèse Zenner, "AutoCAD as an Exploratory Device," *CSA Newsletter* 11:2 (Fall 1998), <http://csanet.org/newsletter/fall98/nlf9803.html>.

——, "A Proposal for Constructing the Plan and Elevation of a Romanesque Church Using Three Measures," in Nancy Y. Wu, ed., *Ad Quadratum* (Aldershot, 2002), pp. 25–55.

——, "Structural Stability and the Mathematics of Motion in Medieval Architecture," in Kim Williams et al., eds., *Nexus IV: Architecture and Mathematics* (Fucecchio, 2002), pp. 63–79.

<div align="center">

26

Sculptural Programs
Bruno Boerner

</div>

The most impressive and elaborate works in the history of fine arts undoubtedly include the imposing sculptural programs that are found on the façades of Gothic cathedrals.[1] Some of these can be found in England, e.g., on the façade of Wells, and some in Germany. The most imposing examples are, however, to be found in Northern France.[2] The portals of Amiens Cathedral have more than 40 larger-than-life-size jamb figures that are accompanied by numerous smaller sculptures in the tympana, archivolts, and the base level floor. Similar designs can be seen in the transepts of the cathedrals of Chartres and Paris. This development reached its climax in Reims Cathedral, where the sculptural program extends over all stories of the façade and even to the interior of the western façade. Because of their continuing presence in the centers of so many medieval towns, these programs retained their fame and their modern study began in the nineteenth century.

The term "sculptural programs" implies that these series of figures are interrelated and based on a unifying concept, that they are not just an arbitrary collection of figures. It assumes that the sculptors, who often remained anonymous in the High Middle Ages, were not alone in being responsible for the planning but that others who were not artists but members of the clergy participated as well. These latter commissioned the construction of the cathedrals with their figural representations and bore the institutional responsibility for them.

Although modern art historians have often interpreted these sculptural programs in a rather political way, which will be demonstrated later in this chapter, almost all of the programs have a theological basis. One should be aware that the methodological approach taken by art historians to disclose the concepts behind these figural series is characterized by fundamental difficulties. On the one hand, there are only very few medieval texts about the contents of such "programs." On the other, sources provide only very rare and vague information about the authors of the figural programs. The question arises which of the

theological texts that were written in great numbers in the Middle Ages can be reasonably attributed to the sculptural series from a historical point of view. It is often problematic to take only one medieval text as the conceptual basis of a sculptural series. Although portal programs were "read" in the Middle Ages, this involved quite a different concept of reading than that of a continuous text. Apart from some narrative reliefs, portal programs are not read from left to right; a more complex type of reception is involved. The compositional structure of a sculptural portal program may offer the "reader" several approaches in various directions. There are horizontal, vertical, and even centripetal reading directions because the most prominent representation, e.g., a *Majestas Domini* (Christ in Majesty) or the coronation of Mary, is arranged in the central tympanum of the portal.[3] Virtually all other elements of the image in the framing and lintel of doors or in the archivolts are oriented towards this central representation.

The Beginning of the Iconographic Research of Sculptural Programs

The earliest iconographic research of medieval cathedral sculptures is closely connected with the name of Emile Mâle. The great French scholar published his main work about Gothic cathedral cycles at the turn of the nineteenth and twentieth century.[4] It was Mâle's credo that art in the Middle Ages was regarded as a method of teaching. The world of religious images was a *Biblia Pauperum*, a Bible of poor men, for him. He thought that the uneducated laity visually learned everything from the images and associated this with their religious belief.

> Everything that was of interest to humanity was taught to them by the glass paintings and the portal statues in the churches: the history of the world since its creation, religious doctrines, the exemplary deeds of the saints, the hierarchy of virtues, the manifoldness of the sciences, the arts and the handicrafts.

The basic intention of Mâle's book was to show that all medieval teachings had been plastically represented in many ways in the cathedrals. Since Mâle regarded the sculptural ensembles of the cathedrals as an "encyclopedia of knowledge," he organized and presented the huge iconographic material of the cathedral façades in accordance with the structural pattern of the most extensive encyclopedia of the Middle Ages – the *Speculum Maius* (*Great Mirror*) written by the Dominican friar Vincent of Beauvais. Because Mâle was convinced that the plan of this mirror reflected the divine plan, he used the same four subdivisions of Vincent's work for the four main parts of his study about the iconography of cathedrals. Thus he dealt with images of flora and fauna under the heading the "Mirror of Nature," explaining the symbolic meaning of individual animal and plant species. He discusses representations of seasonal labor and the seven liberal

arts in the chapter "Mirror of Science." The section about the "Mirror of Morals" is dedicated to the virtues and vices. The major part of his study is dedicated to the "Mirror of History," which combines scenes of the Old and New Testaments, the apocrypha, legends of the saints, and events of salvation history as well as the Last Judgment.

Although Mâle was a pioneer in the iconographic research of the cathedrals, he could build on essential preliminary work, for there had already been a very strong interest in medieval art in the early nineteenth century. In the 1830s, for example, important restoration work was beginning to be undertaken in the restoration of many of the cathedrals that were slowly falling into decay, with sculptures that had often been severely damaged during various civil disorders.

Often, romantic writers spearheaded these initiatives. One of the most prominent was Victor Hugo, who directed attention in his novel *Notre-Dame de Paris* to the portals of the cathedral of the French capital and demanded its restoration, which was started in 1843. Restoration of the sculptural programs made it necessary to get an idea of the original appearance of the sculptures and their figural programs. As this was not easy, the results varied greatly. A comparatively successful approach to the medieval condition was probably the restoration of the Notre-Dame portals in Paris by Jean-Baptiste Lassus and Eugène Viollet-le-Duc. They attempted to produce a reconstruction that was as authentic as possible. However, the result was greatly influenced by the Gothicism of their time. On the other hand, Lassus consulted historic descriptions of the old Paris, e.g., those written by Abbé Lebeuf and Guillot de Montjoie, to form a notion of the original appearance of medieval figural programs, thus demonstrating historic intuition and understanding.[5]

The enthusiasm for the Middle Ages in these years also resulted in the publication of numerous new journals that mainly dealt with the research of medieval cultural monuments and critically watched over their restoration. These are, above all, the *Annales archéologiques* published by Didron, the *Bulletin monumental*, the publications of the *congrès archéologiques de France* and the *Revue de l'art chrétien*. Many medieval sculptural programs were examined and described in these publications for the first time, although the iconographic analyses of the stone ensembles were often very limited. They were mostly restricted to discovering the meaning of the symbolic contents of individual motifs. At the same time, a large number of studies were made that were an attempt to explain Christian art as a whole, in particular Christian art of the Middle Ages. Among the most significant publications were Didron's *Iconographie chrétienne* from 1845 and X. Barbier de Montault's *Traité d'iconographie chrétienne* in 1870. These publications formed the basis on which Mâle could build his studies. One of the authors – Adolphe-Napoléon Didron (1806–67) – had played a particularly important role. Mâle used the structure of studies that Didron introduced and which included the headlines of nature, science, morals, and history that were in accordance with the structure of the *Speculum maius* by Vincent of Beauvais. He knew that Didron had already interpreted the sculptural cycles of

the cathedrals as an encyclopedia of knowledge. However, Mâle did not agree with Didron in attributing an absolute value to the order of the *Speculum maius*. Mâle used the structure of the *Speculum maius* to discover the deeper meaning of the iconography of the thirteenth century by attempting to decipher and explain their logical order. Generally, and above all from the present point of view, he demonstrated much more of a historic-scientific approach than Didron had done. It is amazing how he associated theological texts written in the Middle Ages with the iconography of the cathedrals, in the process demonstrating his own superb scholarship. Even today, a hundred years after its first edition, *L'Art religieux du XIIIe siècle en France* is an essential encyclopedia for all those who deal with the iconography of the Middle Ages.

However, the time and conditions in which the great French scholar carried out his studies must not be neglected. Emile Mâle had also been influenced by the efforts at Catholic renewal at the end of the nineteenth century. The fact that his studies were not completely free of apologetic interests already becomes obvious in the methodological preliminary remarks of his work. Concerning the relation between religious art and theological literature, he said:

> Literary amour-propre – the pride of authorship was unknown to the early Middle Ages. It was plain that a doctrine belonged not to him who expounded it but to the Church as a whole. . . . It follows that the apparently immense library of the Middle Ages consists after all of a very few works. Ten well chosen books might almost literally be said to take the place of all others. The commentators on the Old and New Testaments are summarised in the *Glossa ordinaria* of Walafrid Strabo. . . . The whole of the symbolic liturgy is in the *Rationale divinorum officiorum* of Gulielmus Durandus. The spirit and method of the old preachers live again in the *Speculum Ecclesiae* of Honorius of Autun. Sacred history, as then understood, is found in the *Historia Scolastica* of Peter Comestor and in the *Legenda aurea* of Jacobus de Voragine, profane history in the *Speculum historiale* of Vincent of Beauvais. All that was known of the physical world is summarised in the *Speculum naturale*, and all that was known of the moral world in the *Summa Theologica* of St Thomas Aquinas, epitomised in the *Speculum morale*. A reader familiar with these works will have penetrated the depths of the mediaeval mind.[6]

It seems Mâle intended to neglect the developments and different views in theological thinking. He perceived medieval art as a perfect world, which had been free of the vanities of modernism, in which the word of God was still purely revealed in writing and images. On the other hand, modern medievalists know very well that the theologians of the Middle Ages had their own culture of dispute, including controversies and discussions.[7] Even the role of images was the subject of discussion.[8] Moreover, it is a well-known fact that the thirteenth century in particular was characterized by dramatic developments concerning central questions of theology and philosophy. Unfortunately, it seems that these methodical findings are not always incorporated into scholarly investigations of art. Even today, art historians often choose any medieval or patristic text as the

basis to explain a given program, although the text is related to the program only in regard to its content, without any demonstrable historical relationship. They justify their approach by stating or suggesting that the work in question surely existed in the relevant library of the monastery or chapter at the time the cycle was made. As a result, the explanation of the monumental image cycles of the Middle Ages has often been based on the same authors over and over again, such as Rupert of Deutz, Honorius of Autun or Hugh of St Victor. In this regard, it would be quite beneficial for modern iconographic research to develop a more detached and critical view of Mâle's heritage.

In relation to the main subject of this chapter, there is another reason to ask about the actual benefit of Mâle's study, and this is, in essence, that he rarely examined the sculptural programs as independent conceptual systems. It was not the individual ensemble of statues that formed an encyclopedia of knowledge for him, but cathedral art as a whole. Mâle seldom studied the relations within one single sculptural program to discover its specific overall meaning. In his book on the art of the thirteenth century, his primary method was to isolate a single iconographic motif from its total context and compare it with similar motifs of other cycles. If, for example, he compares the relief-cycle of the virtues and vices in the Last Judgment portal at Chartres with those of Paris, Amiens, Sens, and Laon, the "Mirror of Morals" is finally formed. The substantial relation of these images of virtues and vices to the other elements of the Chartres Last Judgment program – as well as a possible interpretation of the sculptural program as a whole – is of only minor importance for Mâle in his study.

However, there were also scholars at that time who had an interest in the specific overall message of a portal program. In 1847, Auguste-Joseph Crosnier (1804–80), for example, presented his interpretation of the iconography of the sculptural cycles of Vézelay at the Société française d'archéologie, which was published one year later in the *Congrès archéologiques de France*. In the tympanum of the main entrance, Crosnier discovered the Mission of the Apostles as the central theological motif. He found that there is a strong relationship in medieval portal sculptures between the tympanum motif and the secondary representations that embellish its architectural frame, something that was the case for Vézelay. Crosnier believed he discerned the establishment of the Church as the principal theme of the sculptural decoration in all parts of the doorway.[9]

German art historians of the nineteenth century also showed an early interest in the interpretation of medieval sculptural programs, e.g., Karl Schnaase in his extensive *Geschichte der bildenden Künste* that was first published in the years 1843–64 (second edition 1866–75). Schnaase's work was not only the first history of art that comprised all epochs, it also became the standard survey of art history in Germany in the nineteenth century.[10]

Although Schnaase devotes only a small part of his work to medieval sculptural programs, he studied the aesthetic significance and structure of portal programs far more completely than anyone before him. In his book, he mentions the Gothic portal cycles of Fribourg (Breisgau), Strasbourg, Amiens, and

Chartres, dedicating much of his attention to the main entrance of Fribourg Cathedral.[11] This is quite important with regard to his conclusions and his terminology of sculptural cycles, because this sculptural program in south-west Germany is quite different from its High Gothic French equivalents. This is particularly true for the architectural framework. The main portal of Fribourg Cathedral does not open out from the façade, properly speaking. Instead, the main portal, complete with tympanum and stepped figural jambs, is deeply recessed in a porch tower that dominates the west end (fig. 26-1). The sculptural program of the portal proper continues along the side walls of the porch entrance, while the main wall into which the portal proper is set functions as their background. In other words, the very physical environment in which the viewer perceives the sculptural program differs fundamentally from that of most French portal systems. The observer no longer stands in front of a sculptural ensemble. He finds himself within a three-dimensional ensemble of images that directs his eyes not only forward and upward but also sideways and to the back. Thus it is not incidental that Schnaase mentions the term "spatial symbolism" when talking about the significance of portal cycles. Moreover, he does not use the term "portal program," but "composition" to describe the programmatic, mental, artistic, and architectural whole of the sculptural program. It must be admitted that with the Fribourg porch cycle, which was completed by the end of the thirteenth century, Schnaase dealt with one of the most complicated iconographic sculptural systems of the High Middle Ages. The walls of the porch are decorated with statues of the Seven Liberal Arts, female saints, Old Testament figures, the Wise and Foolish Virgins, and the strange figure of the Prince of This World whose front shows a seductive youth while his back is covered with toads and snakes. Exceptionally, the tympanum combines scenes of Christ's childhood, Passion, and the Last Judgment (fig. 26-2). The center of the tympanum shows a representation of the crucifixion as the main motif. However, it does not appear within a narrative context of the Passion, but is the central component of a Last Judgment scene, acting to separate the chosen and damned that flank either side.

Schnaase found a reasonable explanation for this unusual composition:

> To sum it up, the relief contains the history of salvation and judgment, earth and heaven, in such a way that the course of worldly events – although part of the past from the human perspective – fuses with the outcome of the separation of the righteous and the wicked on the last day as the cause of judgment.

Schnaase thus believes he sees the causal connections of the events of the history of salvation in the portal of Fribourg Cathedral, and in this regard declares that the "laws of composition" are symbolic – probably wishing to express that there is no need to search for a narrative logic in this composition. According to Schnaase, the figures are in a close internal relation in this "spatial symbolism."

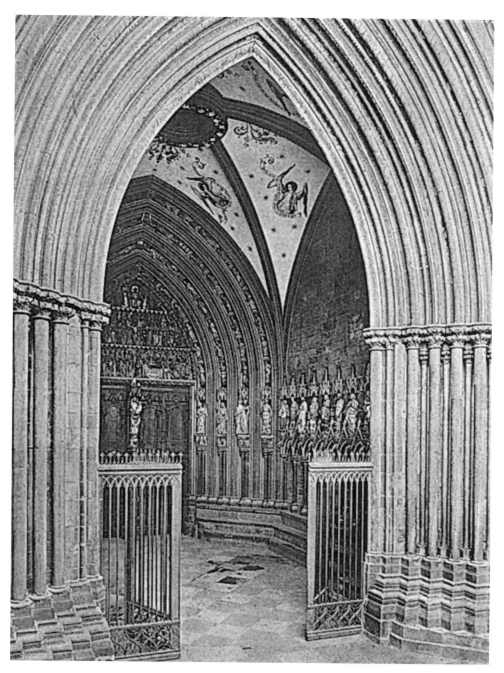

Figure 26-1 Porch entrance, Fribourg Cathedral.

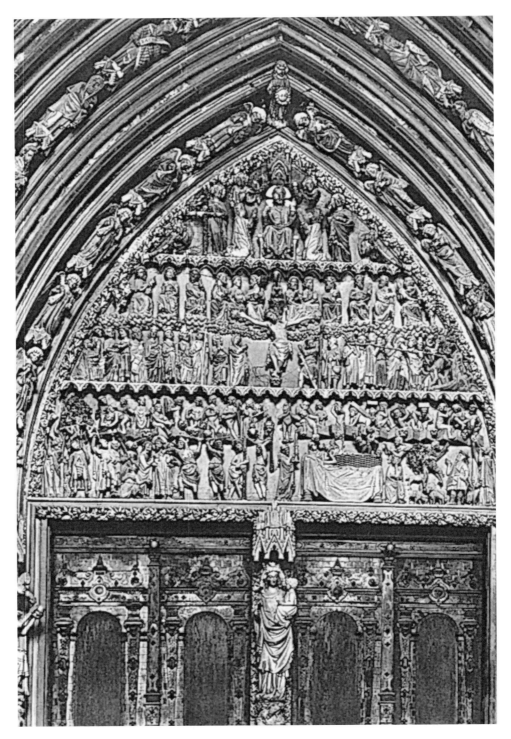

FIGURE 26-2 Tympanum, west portal, Fribourg Cathedral.

In these sculptural cycles, which should be thought of in a "truly artistic sense," Schnaase sees a "great, unique beauty" that is not based on the rational element alone, but on the interpenetration of plastic and architectural elements as well. Only a refined "sense of architecture" makes it possible to express the inner relation between the individual figures, says Schnaase. He regarded these figural cycles as a "tool to express the deepest thought with a sculptural clarity" that exceeds even the written word.

Schnaase's aesthetic considerations of the sculptural cycles include very interesting aspects regarding the design and construction phases. This involves a closer consideration of the cooperation between the artists and the authors of the programs. Schnaase was convinced that the artists could not be the "authors" of these comprehensive and profound "compositions"; they lacked the necessary scholastic and theological background. Therefore, scholarly clergymen undoubtedly gave orders for the leading motifs. But, Schnaase underlines, as the "plan" was further advanced, the artists' judgment became necessary again, so that, in the end, the whole piece could only be realized on the basis of the "mutual understanding of both parties."

It is fascinating to observe the various aesthetic positions of the early nineteenth century that are involved in Schnaase's aesthetic considerations on sculptural programs. On the one hand, one can detect traces of a romantic artistic concept in the adoration of the deep sensation that "these simple masters" (i.e., the sculptors) convey, transforming the dry symbolic relations between the various components into a wealth of liveliness and grace. On the other, basic elements of Hegelian aesthetics emerge in the idea that the beauty of these "compositions" results from the interplay of spirit and sensation, and that "the deepest thought" is expressed with "sculptural clarity," something that had been impossible in other arts. What is new is Schnaase's conclusion that this interplay was brought about by harmonious cooperation between theologians and sculptors. Finally, he even infers that "medieval art reached its climax in these compositions" in that it succeeded in "vividly presenting the great thoughts dominating the Church, the state, and science to the soul without the usual heavy scholastic formulae."

Later, German art historians only rarely achieved the complexity of Schnaase's interpretation of medieval sculptural programs. One of the reasons is the fact that the scholars researching the iconography of churches were closely associated with the clergy. Their primary task was to decipher the symbolic theological contents of the individual images. In other words, they searched for textual sources that helped interpret the persons and events depicted. They attempted to establish a history of iconographic types that offered a basis for the more or less clear classification of the representations.

In the early twentieth century, art historians in the circle of Aby Warburg began to expand considerably the expectations made in the basic analysis of works of art, and to regard works of art as social and cultural phenomena. These new aspects culminated in the three-stage interpretative model developed by

Erwin Panofsky, who introduced ideological, general religious, and political beliefs into the analysis of the meaning of artworks. Nearly all of these innovative, and mostly Jewish, scholars, to whom modern iconographic research owes so much, left Germany because of the anti-Semitic regime, with most of them going to England or America. Among them was Adolf Katzenellenbogen, a pupil of Erwin Panofsky, who gave decisive impulses to the new interpretation of sculptural cycles.

Chartres Cathedral

Katzenellenbogen's research allows us to take a closer look at one of the most prominent Gothic sculptural programs – Chartres Cathedral. It has two parts. The first is the sculptural embellishment of the royal entrance with its three portals, which was built in the middle of the twelfth century and reintegrated into the west façade of the new structure which became necessary after the fire in 1194. The second consists of the sculptures of the transept façades which extend over six portals of the new structure. The tympanum of the central portal on the older west façade shows Christ in Majesty accompanied by the symbols of the four evangelists and surrounded by the twenty-four elders in the archivolts. The two lateral portals are dedicated to the Incarnation and the Ascension of Christ. The central part of the north transept, which was built at least five decades later, is decorated by a portal showing the coronation of the Virgin Mary. This portal is flanked by two entrances, the left of which shows images of Christ's childhood while the right depicts scenes from the Old Testament. Episodes from the lives of Job and Solomon decorate the tympanum of the right portal. In the central portal of the south transept, opposite the Coronation of the Virgin in the north transept, we find a depiction of the Last Judgment. The lateral portals here are dedicated to the martyrs and confessors of the Church.[12]

The questions that Katzenellenbogen raises concerning the sculptural program go far beyond the questions that Emile Mâle, for example, asked:

> It is the purpose of this study to investigate a number of basic questions not yet, or not yet fully, answered. They concern above all the main ideas governing the iconography of the various programs, their connection with specific historical and ideological situations, and the relation of cycles carved at different times. To state these questions briefly: What is the skeletal frame, so to speak, which sustains and gives structure to the multiple parts of the programs? What are its literary sources? Could the liturgy have contributed its share? To what extent are certain facets of church history, current theological, philosophical, and political concepts reflected in the choice of subject matter?[13]

Adolph Katzenellenbogen believes that the west portals represent the basic doctrines of religious belief: Incarnation, Ascension, and the Second Coming of

Christ. One of the major difficulties that iconographic research of the sculpture of Chartres Cathedral has repeatedly faced is the identification of the famous jamb figures of the royal portal. In the first half of the eighteenth century, Bernard de Montfaucon recognized them as the French kings and queens of the Merovingian dynasty. Emile Mâle, however, identified the figures as the royal ancestors of Christ. An influential fact was that the figures are accompanied by Moses, who is the only figure that could be identified beyond doubt by its attribute, the stone tablets, and who could therefore be related to the Old Testament. Katzenellenbogen interprets these jamb figures both as Christ's ancestors and the spiritual forefathers of the French kings. So the Old Testament statues of the royal portal, prophets, kings, and queens, represent the harmony between *regnum* and *sacerdotium*. This harmony, which most closely guarantees the welfare of the Church, is for Katzenellenbogen one of the threads linking the three cycles of the façade and the transept wings. He generally considers the three façade programs as a unit, joined together by the representation and the meaning of the main persons. The three cycles "depict, like a *Summa*, the total essence of Christ in all its conceptual ramifications. . . . The Virgin Mary, the Lady of Chartres, was honored in the lateral tympanum of the Royal Portal as Theotokos and *Sedes Sapientiae*. She received a prominent place on the transept wings. In the scene of her Triumph she is glorified in her own right and as the type of the Church." This Church is "shown as the Bride of Christ and as His Body. She is shown triumphant and militant. She is exemplified by her foremost members, the Community of Saints."[14] Katzenellenbogen shows that the planners of the sculptural programs drew inspiration from different sources: from the Bible, from legends, from the liturgy, from the dogmas of the Church, from theological exegesis, and not least from political and philosophical concepts. He underlines the importance of the great teachers of the school of Chartres and sees their ideas alive in the sculptural decoration. So he realizes an "indissoluble link between a great center of learning and a great center of art."[15]

Not all researchers who studied the sculptures of Chartres after Katzenellenbogen believe that the royal portal was supposed to be reintegrated into the new part after the fire of 1194. Van der Meulen and Hohmeyer propose that the Last Judgment of the south transept portal was originally carved for the central west portal. Only when plans were changed were the already complete sculptures removed to their current position.[16] Almost all researchers assume that plans had been changed several times during the conception phase of the transept portals. And so did Katzenellenbogen, even though he finally interprets the result as a very harmonious ensemble whose parts display strong associations to each other. The most recent large-scale study of the iconography of the Chartres transept sculptures, published by Martin Büchsel in 1995, suggests a very complex history of its planning and making. Even though Büchsel cannot detect any conceptual associations between the transept façades and the royal portal, he – like Katzenellenbogen – starts from the fact that the latter was from the very beginning to be retained in the west façade after the fire in 1194. He

believes that the initial planning focused on the reconstruction of the south transept façade with its three portals with sculptural decoration, and which faced the town, as the new main entrance of the cathedral. At that time, it was planned that its central portal was to be decorated with a coronation scene of the Virgin Mary that would be flanked by a Last Judgment together with an Epiphany. This disposition was modeled on the example of Laon, from where the sculptors would have been sent to Chartres. Only after the plans had been changed several times was the arrangement as we know it today decided upon. The Last Judgment was placed in the middle of the south transept, and the newly planned part on the north transept would house the coronation of the Virgin Mary and the Epiphany portal. To complete the six entrances, the confessors' portal and the martyrs' portal on the south and the Job and Solomon portal on the north (which exclusively consists of figures of the Old Testament) would be added. The tympanum of the latter shows the derision of Job and the lintel displays the judgment of Solomon. While Katzenellenbogen had already recognized the typological reference in this portal, which – in his opinion – points to the Epiphany portal and the coronation of the Virgin Mary portal, Büchsel goes one step further. For him, this portal is the hinge on which all parts of the now built sculptural program of the transept are based. It "comments" on the other portals of the transept and is a "universal program" that refers to every aspect that is expressed in the remaining portals. In the Christ types of Solomon, Job, Gideon, etc., it comments also typologically the main components of the Last Judgment: judge, passion, victor, and intercession. The prefigurations of the Church – i.e., the Queen of Sheba, Esther, Judith, Sarah, and Tobit's wife – correspond with the exegetical types of Christ.[17] The Church recognizes Solomon, i.e., Christ, as the true king enthroned by God. Moreover, Büchsel found that the typological references of the Job and Solomon portal could equally be detailed historical references. In this connection, he builds on the theses of Katzenellenbogen and Levis-Godechots. The latter proposed that Job's friends could be interpreted as the Albigenses who represented a very real danger for the Church at that time.[18] The fact that Gideon is shown in a suit of armor gives rise to Büchsel's idea that this may be associated with crusaders and crusades. From the fact that the type of the Antichrist, Holofernes, is presented with an antique emperor's head, Büchsel inferred an allusion to the Roman emperor who had often been accused of not being the representative of God but of being the Antichrist in the investiture controversy.[19]

However the question remains open whether a uniform sculptural program can still be assumed after the numerous changes of plans that are supported by archeological observations. Brigitte and Peter Kurmann have a very pragmatic view in this respect. They believe that the programs had been conceived and designed accordingly before the final assembly. But, they believe, it is possible that these sculptures were rearranged and combined differently afterwards, and even reworked where necessary – owing to structural and conceptual requirements.[20]

Comparison of the Romanesque and Gothic

What distinguishes the Gothic from the Romanesque sculptural cycles in France is their greater consistency.[21] Two types of programs dominated the Gothic style. One of them is found in almost every façade of the cathedrals of the Île-de-France and its environment. On the one hand is the portal of the coronation of the Virgin Mary, which was first executed in Senlis in 1170, and on the other hand is the Last Judgment, whose quasi-canonical program was fully worked out in the Chartres transept and the west façade in Paris. Also, the system of architectural elements of the portal programs had been more or less regularized in the Gothic period, beginning with the early Gothic west portals of St Denis and Chartres. With only a few exceptions, sculptural decorations are now arranged in the archivolts, the tympanum, the lintel, the trumeau, the door frames, and the jambs where the sculptures were made as jamb figures.

The Romanesque sculptural cycles, however, have a different appearance. There is no consistent principle according to which the sculptures are arranged in the architectural layout of the buildings. Instead, you can find a wide range of architectural frames for the sculptural cycles. In the west of France, the images of the Announcement of the Last Judgment are often found in the archivolts only. At Conques and Autun, the programs spread over large-area tympana. At Moissac and Beaulieu, the porch walls are also decorated with reliefs. Arles follows its very own principle with its antique porticus, which provides space for a wide-ranging cycle. St Gilles has a similar layout. Consistent program types are much less typical for the Romanesque style than for the Gothic period. One can refer to simpler cycles in which only a few image elements are grouped around a Majestas Domini, or special regional forms such as the archivolt programs of the Aquitaine. Apparently, the so-called Last Judgment portals of Autun, Conques, and Beaulieu are also dedicated to a dominant main motif. However, even this reading is debated among scholars, as the example of Beaulieu shows. There are actually some particular features in this representation of the Last Judgment. These features allow Peter Klein, and with him Yves Christe, to assume that it is not the Last Judgment that is depicted in the tympanum of the portal but the Second Coming of Christ (which immediately precedes the Last Judgment), according to Matt. 24: 29–31: "and then shall all the tribes of the earth mourn, and they shall see the Son of Man coming in the clouds of heaven with power and great glory." Only the resurrection of the dead (Rev. 20: 12–13) and the Twelve Apostles as the assessors of the Last Judgment (Matt. 19: 28) have a direct reference to the Last Judgment, which has not yet begun.[22]

Of course, it can be questioned whether it is reasonable to make a distinction between the Christ of the Second Coming and Christ the Judge in medieval portal programs that represent the Last Judgment. Or is it more useful to assume that Romanesque tympana have a much more synthetic character that points to several incidents in the salvation history? There are other examples of

Romanesque portal programs, the main subject of which is not completely clear to iconographers. One of them is the middle portal of the porch of the Abbey Church of Vézelay. In its central part, the tympanum depicts Christ in a mandorla. Beams of light project from Christ's hands to the heads of his disciples, who stand on either side of him. While Crosnier, as I have mentioned, wrote in 1847 that this represented the Mission of the Apostles, Emile Mâle identified it as a representation of Pentecost – to be more precise, as the descent of the Holy Spirit upon the Apostles.[23] Mâle gave iconographic parallels, such as a miniature from Cluny that was made about the same time and a twelfth-century image in the apse of St Gilles at Montoire. Mâle, in turn, was contradicted by Fabre, who defended Crosnier's interpretation of the Mission of the Apostles and stated that it is not possible that Christ was depicted in a pentecostal image.[24] Adolf Katzenellenbogen recognized a combination of several themes in the tympanum. For him, it is a combination of the wonder of the outpouring of the Holy Spirit with Christ's ascension and the Mission of the Apostles, while Joan Evans focused on "the redemption of the world through the blood of Christ."[25]

Methodical Aspects

The direction of the discussions about the contents of sculptural programs naturally depends on the specific questions researchers ask about them. During recent decades, for example, it has been very popular to inquire into patronage, the specific ritual and liturgical context, or the political functions of sculptural cycles.[26] This approach may be considered the heritage of Panofsky and Katzenellenbogen. Concerning the political reading, the ensembles were first interpreted as the expression of Church politics, for example, the struggle between official Church and heretical groups already mentioned.[27] Or the cycles are supposed to be specifically designed to serve as a summons to go on crusades. After Katzenellenbogen's study, Christian Beutler saw this as the solution of the interpretation problem of Vézelay.[28] In his opinion, the original tympanum initially showed the commemoration of the descent of the Holy Spirit on the day of Pentecost. During the years of the Second Crusade, he believes, a decision was made to change the tympanum and add the Christ on the Throne to motivate people for the crusade.[29] Searching for the "hidden intentions" of the representations, researchers sometimes also presumed very detailed political ambitions of the clergy who formed the background of the program concepts. Michael D. Taylor attempted to analyze the political meaning of the main portal of Vézelay (which he interprets as a scene of Pentecost) as an effort to prevent the neighboring powers of the monastery, the Count of Nevers and the Bishop of Autun, from making reprisals on the monastery. According to this argument, the scene of Pentecost should be understood as representing the monastery itself: "[Pentecost] embodies the principle for the monastery's existence and legitimates its struggle for independence from secular power. . . . The image

thus defines the community, its spiritual basis, and, in the face of attacks, its rights and privileges."[30]

Other methodological trends from the various disciplines of intellectual history have recently influenced the art historical study of medieval portal programs, including French structuralism. For example, in 1984 Jean-Claude Bonne analyzed the Romanesque portal of Conques with its representation of the Last Judgment, employing a strongly structuralist and semiotic approach.[31] It was Bonne's major concern that the formal structures in the great tympanum relief themselves should be recognized as statements or meaning; i.e., content and form must not be separated. He calls his approach *analyse syntaxique*, which refers to an analysis of the plastic and chromatic properties of the portal insofar as they are structures of meaning in themselves.[32] Bonne attempted to establish specific analytic categories for this method. These categories all refer to the formal and compositional characteristics of the tympanum, used by Bonne for the portal of Conques for the first time. He describes one of these categories as compartmentalization (*compartimentage*), or that which circumscribes the division of the overall relief into single segments. The theme of the Last Judgment is, according to Bonne, a very good example of how *compartimentage* functions in the task of giving figures and things their correct places.

Other methodologies with origins in literary studies have also had an influence in the area of portal programs. Among them is reception theory, "whose focus is not the identity and significance built into the work of art, but the manner in which these characteristics are registered by the audience to which it is addressed."[33]

In conclusion, it can be noticed, generally, that both the methodical approaches and the specific issues related to the study of medieval sculptural programs depend also upon the specific socialization of the individual researcher. This means that those studies were influenced to no insignificant degree by the trends of social sciences, the humanities, and philosophy of science at the time when they were written. Schnaase's studies on the sculptural program of Fribourg are marked by late Romantic and Hegelian trends of around 1850 and Mâle's iconographic methodical considerations reflect, as we have seen, to a certain extent the intentions of the French Renouveau Catholique of the late nineteenth century. German and French researches into medieval sculpture in the first decades of the twentieth century were often influenced by nationalistic trends. Furthermore, in the 1960s until the 1980s the question of the political intentions behind the sculptural programs can also be explained by the specific interests of that time. In more recent years even specific aspects of gender studies have been examined in connection with medieval portal programs.[34]

However, the difficulty mentioned earlier in this chapter continue to be felt. We do not know enough about the people behind these programs. Hardly any of the program authors can be identified reliably today. The role played by Abbot Suger of the Benedictine Abbey Church of St Denis is probably a very special case. For example, the iconographic program of the west portals of his

abbey church are attributed to him.[35] Laurence Brugger-Christe has proposed a remarkable thesis about the sculptural programs of the Cathedral of Bourges.[36] This thesis can convincingly ascribe the sculptural program of the west façade to the works of a converted Jew (*olim judeaus*) Guillaume de Bourges, who was deacon of the cathedral during its construction. It would be desirable if such attempts to add further details to the specific historic environment of medieval sculptural programs were successful more frequently.

Notes

1 In the Middle Ages, sculptural cycles also decorated jubes, pulpits, cloisters, etc. For recent summaries of the state of research of the latter see Parker, *The Cloisters*, especially Forsyth, "Monumental Arts." The present chapter, however, focuses on the figures adorning the façades of churches. [On Gothic sculpture in general, see chapter 19 by Büchsel in this volume (ed.).]
2 See Sauerländer, *Gothic Sculpture*.
3 Concerning the vertical reading direction, Katzenellenbogen, *Sculptural Programs*, p. 15, draws attention to the fact that the central axis in the Chartres tympana and archivolts has an "ideographic function."
4 Mâle, *L'Art réligieux du XIIIe siècle*.
5 Leniaud, *Jean-Baptiste Lassus*, provides extensive information about Lassus and his Gothic image.
6 Mâle, *The Gothic Image*, p. xiv.
7 Flasch, *Einführung*, illustrates this topic very vividly.
8 For discussion about the role of images in the twelfth century, see Rudolph, *Things of Greater Importance*. [On Gregory the Great and image theory in Northern Europe during the twelfth and thirteenth centuries, see chapter 7 by Kessler in this volume (ed.).]
9 Crosnier, "Iconographie." See Nayrolles, "Deux approches," pp. 214–17.
10 For Schnaase see Karge, "Das Frühwerk Karl Schnaases."
11 For the following, see Schnaase, *Geschichte der Bildenden Künste*, pp. 290ff.
12 For the state of research of the sculptural programs of Chartres, see Kurmann and Kurmann-Schwarz, *Chartres*.
13 Katzenellenbogen, *Sculptural Programs*, p. 8.
14 Ibid., pp. 101, 102.
15 Ibid. [For more on the sculptural program of Chartres, see chapter 19 by Büchsel in this volume (ed.).]
16 Hohmeyer and van der Meulen, *Chartres*.
17 Büchsel, *Skulpturen des Querhauses*, p. 88ff. [On art and exegesis, see chapter 8 by Hughes in this volume (ed.).]
18 Levis-Godechot, *Chartres révélée*, p. 153.
19 Büchsel, *Die Skulpturen des Querhauses*, p. 89.
20 Kurmann and Kurmann-Schwarz, *Chartres*, pp. 266ff.
21 [On Romanesque sculpture, see chapters 15 and 16 by Hourihane and Maxwell, respectively, in this volume (ed.).]
22 Klein, "Eschatologische Portalprogramme"; Yves Christe, "Le Portail de Beaulieu."

23 Mâle, *L'Art réligieux du XIIe siècle*, p. 326f.
24 Fabre, "L'Iconographie de la Pentecôte."
25 Katzenellenbogen, "Central Tympanum at Vézelay"; Evans, *Cluniac Art*, pp. 70f.
26 For patronage, see, for example, Gaposchkin, "The King of France"; Gillerman, "The portal of St.-Thibault-en-Auxois"; Kurmann and Kurmann-Schwarz, "Das mittlere." For the relevance of ritual and liturgical matters, see, for example, Nolan, "Ritual and Visual Experience"; Horste, *Cloister Design*; Seelye-McBee, *Sculptural Program*; Sauerländer, "Reliquien, Altäre und Portale"; Fassler, "Liturgy and Sacred History." [On patronage, see chapter 9 by Caskey in this volume (ed.).]
27 See Lyman, "Heresy."
28 Katzenellenbogen, "Central Tympanum at Vézelay." For the state of research of the Vézelay Program, see Diemer, "Das Pfingstportal von Vézelay."
29 Beutler, "Das Tympanon zu Vézelay."
30 Taylor, "The Pentecost at Vézelay," p. 13. See also Diemer, "Das Pfingstportal von Vézelay," p. 94.
31 Bonne, *L'Art roman*.
32 Ibid., p. 18. [On formalism, see chapter 5 by Seidel in this volume (ed.).]
33 Cahn, "Romanesque Sculpture," pp. 45, 46. For this approach, see also the other articles in Kahn, ed., *The Romanesque Frieze*, and Altmann, "The Medieval Marquee." [On reception, see chapter 3 by Caviness in this volume (ed.).]
34 Smartt, "Cruising Twelfth-Century Pilgrims," for example, studies the iconography of Romanesque sculpture at Moissac from a gay perspective.
35 See Gerson, "Sugar as Iconographer."
36 Brugger, *La Façade de Saint-Etienne de Bourges*.

Bibliography

Charles F. Altmann, "The Medieval Marquee; Church Portal Sculpture as Publicity," *Journal-of-Popular-Culture* XIV/1 (1980), pp. 37–46.

Xavier Barbier de Montault, *Traité d'iconographie chrétienne* (Paris, 1870).

Christian Beutler, "Das Tympanon zu Vézélay. Programm, Planwechsel und Datierung," *Wallraf-Richartz-Jahrbuch* 29 (1967), pp. 7–30.

Bruno Boerner, *Par caritas par meritum, Studien zur Theologie des gotischen Weltgerichtsportals in Frankreich – am Beispiel des mittleren Westeingangs von Notre-Dame in Paris* (Fribourg, 1998).

Jean Claude Bonne, *L'Art roman de face et de profil (le tympan de Conques)* (Paris, 1985).

Laurence Brugger, *La Façade de Saint-Etienne de Bourges: le Midrash comme fondement du message chrétien* (Poitiers, 2000).

Martin Büchsel, *Die Skulpturen des Querhauses der Kathedrale von Chartres* (Berlin, 1995).

Walter Cahn, "Romanesque Sculpture and the Spectator," in Deborah Kahn, ed., *The Romanesque Frieze and its Spectator: The Lincoln Symposium Papers* (1992), pp. 44–60.

Yves Christe, "Le Portail de Beaulieu. Étude iconographique et stylistique," *Bulletin archéologique du comité des Travaux Historiques et Scientifiques* 56 (1970), pp. 57–76.

Auguste-Joseph Crosnier, "Iconographie de l'église de Vézelay," *Congrès archéologiques de France 1847* (1848), Sens 14, pp. 219–30.

Adolphe Napoléon Didron, *Iconographie chrétienne, histoire de Dieu* (Paris 1843); Eng. trans.: *Christian Iconography: The History of Christian Art in the Middle Ages* (London, 1851–86).

Peter Diemer, "Das Pfingstportal von Vézelay. Wege, Umwege und Abwege einer Diskussion," *Jahrbuch des Zentralinstituts für Kunstgeschichte* 1 (1985), pp. 77–114.

Joan Evans, *Cluniac Art of the Romanesque Period* (Cambridge, 1950)

Abel Fabre, "L'Iconographie de la Pentecôte. Le portail de Vézelay, les fresques de Saint-Gilles de Montoire et la miniature de «lectionnaire de Cluny»," *Gazette des Beaux Arts* 65, (1994) pp. 33–42.

M. Fassler, "Liturgy and Sacred History in the Twelfth-Century Tympana at Chartres," *The Art Bulletin* LXXV (1993), pp. 499–520.

Kurt Flasch, *Einführung in die Philosophie des Mittelalters* (Darmstadt, 1987).

Ilene Forsyth, "The Monumental Arts of the Romanesque Period: Recent Research," in Elizabeth Parker, ed., *The Cloisters: Studies in Honor of the Fiftieth Anniversary* (New York, 1992), pp. 3–25.

Cecilia M. Gaposchkin, "The King of France and the Queen of Heaven: The Iconography of the Porte Rouge of Notre-Dame of Paris" *Gesta* 39:1 (2000), pp. 58–72.

Paula Lieber Gerson, "Sugar as Iconographer. The Central Portal of the West Façade of Saint-Denis," *Abbot Sugar and Saint-Denis. A Symposium* (New York, 1986), pp. 183–98.

D. Gillerman, "The Portal of St.-Thibault-en-Auxois: A Problem of Thirteenth-Century Burgundian Patronage and Founder Imagery," *The Art Bulletin* 68:4 (1986), pp. 567–80.

M. F. Hearn, *Romanesque Sculpture: The Revival of Monumental Stone Sculpture in the Eleventh and Twelfth Centuries* (Ithaca, NY, 1981).

Jürgen Hohmeyer and J. van der Meulen, *Chartres: Biographie einer Kathedrale* (Köln, 1984).

Kathryn Horste, *Cloister Design and Monastic Reform in Toulouse: The Romanesque Sculpture of La Daurade* (Oxford, 1992).

Deborah Kahn, ed., *The Romanesque Frieze and its Spectator: The Lincoln Symposium Papers* (London, 1992).

Henrik Karge, "Das Frühwerk Karl Schnaases: zum Verhältnis von Ästhetik und Kunstgeschichte im 19. Jahrhundert," in Antje Middeldorf-Kosegarten, ed., *Johann Dominicus Fiorillo: Kunstgeschichte und die romantische Bewegung von 1800* (Göttingen, 1997), pp. 402–19.

Adolf Katzenellenbogen, "The Central Tympanum at Vézelay. Its Encyclopedic Meaning and Its Relation to the First Crusade," *The Art Bulletin* 26 (1944), pp. 141–51.

——, "Iconographic Novelties and Transformations in the Sculpture of French Church Façades, *ca.*1160–1190," *Studies in Western Art* (Princeton, 1963), vol. 1, pp. 108–18.

——, *The Sculptural Programs of Chartres Cathedral* (Baltimore, 1959).

Calvin B. Kendall, *The Allegory of the Church: Romanesque Portals and Their Verse Inscriptions* (Toronto, 1998).

Peter K. Klein, "Eschatologische Portalprogramme der Romanik und Gotik," in Herbert Beck and Kerstin Hengevoss-Durkop, eds., *Studien zur Geschichte der europäischen Skulptur im 12./13. Jahrhundert* (Frankfurt, 1994), pp. 397–411.

Peter Kurmann and Brigitte Kurmann-Schwarz, *Chartres, la cathedrale* (Saint-Léger-Vauban, 2001).

——, "Das mittlere und südliche Westportal der Kathedrale von Meaux: Repräsentanten der Pariser Plastik aus dem zweiten Viertel des 14. Jahrhunderts und ihr politischer Hintergrund," *Zeitschrift für Schweizer Archäologie und Kunstgeschichte* 43/1 (1986), pp. 37–58.

Jean-Michel Leniaud, *Jean-Baptiste Lassus (1807–1857) ou le temps retrouvé des cathédrales* (Genève, 1980).

N. Levis-Godechot, *Chartres révélée par sa sculpture et ses vitraux* (Vineul-Saint-Firmin, 1987).

Thomas Lyman, "Heresy and the History of Monumental Sculpture in Romanesque Europe," in Herbert Beck and Kerstin Hengevoss-Durkop, eds., *Studien zur Geschichte der europäischen Skulptur im 12./13. Jahrhundert* (Frankfurt, 1994), pp. 45–56.

Emile Mâle, *L'Art réligieux du XIIe siècle en France* (Paris, 1922).

——, *L'Art réligieux du XIIIe siècle en France: étude sur l'iconographie de moyen âge et sur ses sources d'inspiration* (Paris, 1898); Eng. trans. by Dora Nussey, *The Gothic Image: Religious Art in France in the Thirteenth Century* (New York, 1958).

Jean Nayrolles, "Deux approches de l'iconographie médiévale dans les années 1840," *Gazette des Beaux Arts* 6:128 (1996), pp. 201–20.

Kathleen Nolan, "Ritual and Visual Experience in the Capital Frieze at Chartres," *Gazette des Beaux Arts* 6:123 (1994), pp. 53–72.

Elizabeth Parker, ed., *The Cloisters: Studies in Honor of the Fiftieth Anniversary* (New York, 1992).

Conrad Rudolph, *"The Things of Greater Importance": Bernard of Clairvaux's Apologia and the Medieval Attitude Toward Art* (Philadelphia, 1990).

Willibald Sauerländer, "Architecture and the Figurative Arts: The North," in *Cathedrals and Sculpture* (1999), pp. 298–338.

——, *Gothic Sculpture in France, 1140–1270* (New York, 1972).

——, "Reliquien, Altäre und Portale," in Nicolas Bock, ed., *Kunst und Liturgie im Mittelalter*, Römisches Jahrbuch der Bibliotheca Hertziana 33 (Beiheft, 1999/2000), pp. 121–34

——, "Romanesque Sculpture in its Architectural Context," in Deborah Kahn, ed., *The Romanesque Frieze and its Spectator: The Lincoln Symposium Papers* (London, 1992), pp. 16–43.

——, "Sculpture on Early Gothic Churches: The State of Research and Open Questions" *Gesta* 9 (1970), pp. 32–48.

Wilhelm Schlink, *Der Beau-Dieu von Amiens. Das Christusbild der gotischen Kathedrale* (Frankfurt, 1991).

Carl Schnaase, *Geschichte der Bildenden Künste*, vols. I–VII (Düsseldorf 1843–64).

Henrietta Seelye-McBee, *The Sculptural Program of the Hemicycle Capitals in the Church of St.-Nectaire* (North Carolina, 1979).

Linda Seidel, *Songs of glory; The Romanesque Façades of Aquitaine* (Chicago and London, 1981).

Daniel Smartt, "Cruising Twelfth-Century Pilgrims," in Whitney Davis, ed., *Gay And Lesbian Studies in Art History* (New York, London, Norwood, Adelaide, Haworth, 1994), pp. 35–55.

Michael D. Taylor, "The Pentecost at Vézelay" *Gesta* 19 (1980), pp. 9–15.

M.-L. Therel, *Le Triomphe de la vierge-église* (Paris, 1984).

P. Williamson, *Gothic Sculpture 1140–1300* (Yale, 1995).

Rita Wood, "The Romanesque Doorways of Yorkshire, with Special Reference to that at St. Mary's Church, Riccall," *Yorkshire Archaeological Journal* 66 (1994), pp. 59–90.

Cistercian Architecture

Peter Fergusson

Few areas of medieval study have seen a more rapid expansion in the past 25 years than the scholarship on Cistercian architecture. Older general histories of medieval architecture, if they presented the Order's work at all, placed it as a coda to Romanesque or Gothic on account of its reductive forms and style, and even, on occasion, described its artistic interests as anti-art.[1] More recent work accepts the distinctiveness of Cistercian architecture and positions it in critical reassessments of the architecture of the High Middle Ages.

This dramatic re-evaluation is best explained by a welcome confluence of inter-disciplinary studies. Historians have greatly broadened knowledge of the Order's documentary, legislative, and archival history, throwing new light on its institutional character and the developing nature of its monastic ideals. At the same time, archaeologists have employed new techniques to examine Cistercian buildings, recovering a range of material formerly believed to be irretrievably lost, their work aided, ironically, by the ruined nature of many Cistercian sites which offer opportunities for study denied by most in-use buildings. And architectural historians have combined traditional analysis with contextual interests and theory to open up new interpretative approaches. Mutually stimulating each other, these different disciplines have progressively revitalized studies of Cistercian architecture.

Historiographical Origins

The Cistercians never lacked for historians. From the Order's beginnings 900 years ago, men set down accounts of the foundation of individual houses, chronicled their development, wrote *vitae* of their venerated brethren, and collected charters and deeds, many containing an occasional reference to buildings. For the purposes of this chapter these references will be deemed the sources of

Cistercian history and are distinguished from the commentaries on those sources, or from histories that aim to shape a narrative of architecture from them. The latter literature is largely post-use, written after the monasteries had closed. In most cases closure resulted from external events such as the destruction of the Hundred Years War in parts of France.[2] A century later, the Reformation terminated communal life in entire countries like England. Where Catholicism continued, as in Spain, Portugal, Hungary, Bohemia, Italy, and much of France, monastic institutions survived for another 250 years until their doors were closed during the convulsions at the end of the eighteenth century.[3] Few abbeys enjoy unbroken histories, although in Austria communities at Heiligenkreuz and Zwettl live in the same buildings and work the same granges as did their brethren 800 years ago.

A longer historiographical tradition is associated with the Order's English houses than those in other European countries. Record-keeping was part of Henry VIII's Suppression (1535–9). Visitations of religious houses began in the preceding decade with the intention of establishing their material holdings and assessing the income from their lands. The ensuing compilation of lists included monastic libraries and the registering of armorial devices carved on tombs or buildings (to identify aristocratic patrons). John Leland, for instance, who held the title of King's Antiquary, traveled for these purposes in the late 1520s. He made notes on their buildings and topography (Cistercian as well as those of other orders) with the intention of gathering the material into a book to be entitled *Laboriouse Journey and Serche of Johan Leylande for Englandes Antiquities*, although the project was never realized.[4] Leland's collecting impulse illustrates, however, a distinctive turn of mind, one marked by a valuing of the past (as distinct from the King and his Commissioners' valuing of assets).[5]

Antiquarianism

In the Tudor period, the main areas of focus were place names, genealogy, or documents (rather than topographical concerns). Following the Suppression, the mass of material from the monastic past drew the interest of collectors like Matthew Parker (1504–75), Master of Corpus Christi College, Cambridge and later Archbishop of Canterbury. A similar impulse in the following generation led to the establishment of institutions such as the College of Antiquaries in 1586.[6] In these circles, the sense was widespread that material loss had meant as well loss of historical memory, the consequence of what Aston calls the "royal guillotining of the monastic past."[7] Material loss is easier to track. The recusant poet, John Donne, punned on Henry's suppressions (made according to different categories of institutional size – Lesser and Greater):

> So fell our Monasteries, in one instant growne
> Not to lesse houses, but, to heapes of stone

Most of England's 64 Cistercian houses met Donne's description. In the immediate aftermath of the Suppression, conditions may be glimpsed from the inventories of buildings and their contents, or from accounts of demolitions including mob ransackings, as happened at Roche in south Yorkshire.[8] The "heapes of stone" were reused variously, for gentry houses, road building, coastal defences, etc. The last had been the fate of Quarr on the Isle of Wight, but, at a space of 70 years, Sir John Oglander, conversing with one of the former monks and moved by his description of the beauty of the dismantled church now covered by a field of corn, hired "soome to digge to see whether I myght find ye fowndation butt could not."[9]

Oglander's efforts aside, most historians began with the collection of charters, endowments, and privileges of destroyed houses. The first systematic gathering of such material appeared in Dugdale and Dodsworth's three-volume *Monasticon Anglicanum* (1655–73).[10] These men left no doubt about their views on the Suppression. Dugdale referred to it as a "barbarous generation" which had subverted "those godly structures . . . whereby England was so much adorned."[11]

In France, a little after Dugdale, Dom Germain at St Germain-des-Près in Paris started what would eventually become the *Monasticon Gallicanum* for the Benedictine houses of the Congregation of St Maur.[12] Cistercian houses still in use like Clairvaux drew accounts from visitors such as the Queen of Sicily (1517), and Abbé Lebeuf 200 years later.[13] They mentioned details like the number of stalls in the church interior, recorded inscriptions, and commented on architecture.

The same antiquarian interests underlay the foundation of academies, for instance of the Académie des inscriptions et belles-lettres (1663), whose goals included the recording of "antiquités et monuments de la France." The same occurred in Sweden in the 1690s. At the regional level, abbés like Dom Georges Viole (d.1669) recorded both archival and site information on Cistercian foundations in the diocese of Auxerre, an interest marked later in the travels of Martène and Durand (published and illustrated in 1717).[14] In England such regional interests had become so numerous that it took William Nicholson in 1696–9 three volumes to record their bibliography in *The English Historical Library*.

The antiquarian movement was steered by a range of interests. In the mid-eighteenth century in England it was the garden arts that led landowners to incorporate derelict monastic buildings into landscape schemes. Most famously at Rievaulx (fig. 27-1) and Fountains in Yorkshire, or at Tintern in South Wales, wrecked structures of 200 years earlier suddenly became newly perceived as stirrers of memory of a lost and distant past. Although desolation fired the Romantic imagination, other responses were encouraged, including sacro-political readings. Historical narratives relating to England's medieval and contemporary history were triggered at Rievaulx where the architecture was seen as exemplifying the country's original, indigenous architecture.[15]

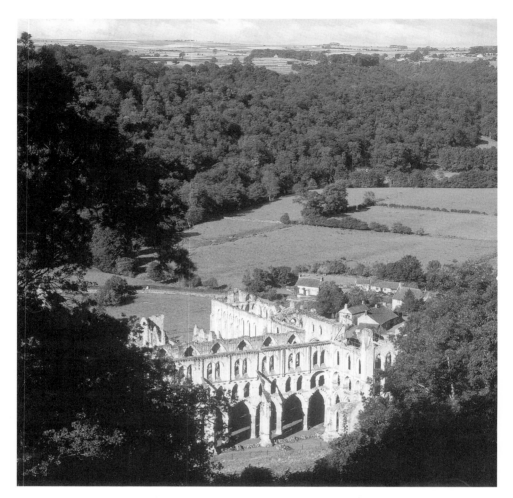

FIGURE 27-1 Rievaulx Abbey, Yorkshire, England. A viewing platform was constructed along the escarpment above the ruin and alleys were cut through the tree'd slope to give a sequence of staged views. Photo reproduced courtesy of English Heritage.

The Rise of Archaeological Interests

The late 1700s saw the old antiquarian tradition gradually displaced. It was not long before landscaped ruins attracted the faulting gaze of critics.[16] William Gilpin, for instance, pilloried the aesthetic intentions of Lord Scarborough at Roche and John Aislabie at Fountains. The latter's creation of grassed parterres in the former cloister and construction of a circular pedestal for a heathen sculpture in the choir, drew the comment "a Goth may deform when it exceeds the power of art to amend."[17]

Opinion divided not only on how to treat Cistercian ruins, but also on how to view them. Those interested in the aesthetic effect were advised to adopt a distant view, while a close-up view was recommended for those wanting a more "authentic" reading. Artists provided for both tastes. Gilpin with his *Valley of the Tweed with Melrose Abbey* (1786) or W. Cooke with *Netley Abbey* (1806) rendered ruins in a large scaled topography, while John Carter supplied close-up views. Carter was supported by Richard Gough, the Director of The Society of Antiquaries of London, whose advocacy of greater accuracy in topographic drawing appeared in the first number of *Archaeologia* (1770).

Print collectors of both types of views were numerous. In Germany they included artists like Caspar David Friedrich who, in turn, was part of the antiquarian circle associated with University of Greifswald under the leadership of Ludwig Kosegarten (1758–1818).[18] Kosegarten led tours to ruined sites, inspected tombs, and discussed architecture; he also translated English antiquarian and garden theory texts into German, such as Gilpin's *Observations on the Western Parts of England* (1798), translated in 1805. Social anarchy in France spurred such efforts; seen through the bloodied lens of the French Revolution, investigation of the past resonated with values of stability and cultural permanence.

John Carter's drawings and written observations appeared in more than 350 papers contributed to the *Gentleman's Magazine*. A number lambasted cathedral restoration and exposed the eccentricities of their errant chapters, but Carter's discerning eye included Cistercian remains. Visiting Jervaulx in Yorkshire in 1806, he despaired over the "havocked down" condition of its "unintelligible . . . ruins," but 15 years later he hailed the site's clearance undertaken by John Claridge, the agent of the owner, the Earl of Aylesbury.[19] Claridge's work, among the earliest at a Cistercian site, allowed Carter to measure the church, list tombs, record architectural detailing, and propose periods of work for the plundered building.

For Carter, monastic remains held value for their intrinsic qualities as well as for their powers of connection and association. The same interests prevailed in France, manifested in the founding of the Société française d'archéologie in the early 1830s and of numerous regional societies such as Arcisse de Caumont's Société des antiquaires de Normandie which made an early visit to Mortemer.[20] These bodies organized tours, published accounts of visits, and investigated monastic remains.

Much of the work before 1850 lacked a precise method of analysis, in particular a controlled way of coordinating archaeological, architectural, and historical material. In England, this need was supplied by Robert Willis (1800–78) whose immensely impressive methods are still influential. As professor of engineering at Cambridge University, Willis approached medieval architecture from a markedly different background. Extensive travels in Germany, France, and Italy allowed him to formulate broad questions on such matters as style or the origin of Gothic.[21] But it was his publications of standing buildings that established new analytical standards, notably his two-part study of Canterbury Cathedral.[22] By

accurately phasing constructional sequences, Willis was able to read out from the walls a demonstrable fabric history, an essential step in the construction of history.

Empirical Studies

Cistercian studies emerged prominently in the mid-nineteenth century. In France, regional architectural surveys prompted by the Congrès archéologique included Cistercian sites, notably those published for the Aube by A.-F. Arnaud in 1837, for the Soissonnais and Laonnois by Jean Lequeux in 1859, and for the Aisne by Edouard Fleury in 1882.[23] Monographs on specific sites also began appearing in several countries: on Longpont by Abbé Poquet (1869), on Buildwas in England by John Potter (1846), and on Villers-en-Brabant in Belgium by Charles Licot (with Emile Lefèvre) (1877) (fig. 27-2).[24] Licot's interests had begun in

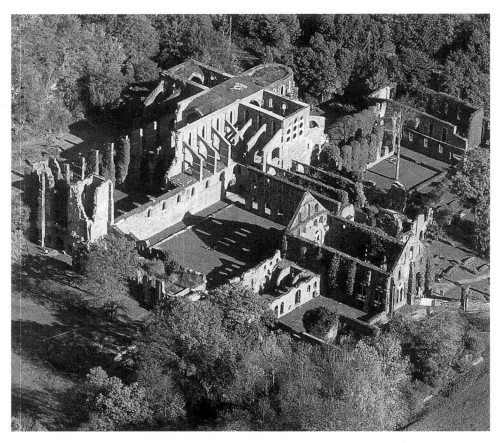

FIGURE 27-2 Villers-en-Brabant, Belgium. One of the most complete Cistercian ruins, Villers was also the first site to be taken under state control in 1892. Photo reproduced courtesy Editions Racine/Thomas Coomans.

1870 and his long efforts to persuade the state to assume responsibility for the site were finally realized in 1892. Although these lines of enquiry were site-specific, broader questions were also examined. In Germany, theoretical discussion focused on whether the Order's architecture embodied Romanesque values, or undermined them through the importation of French Gothic, an issue discussed by Schnaase in 1856, de Roisin in 1859, and Dehio and von Bezold at the end of the century.[25] A larger issue also surfaced: the hypothesis of a Cistercian architecture with its own distinctive forms. Early advocates of this idea in England were Sharpe (in 1874) and in France Viollet-le-Duc in the first volume of his *Dictionnaire* (in 1875).[26]

Underlying these interests were several interrelated developments in archaeology, guardianship, and scholarship. The process is most clearly seen in England where the country's industrial and political ascendancy provided the wealth and authority within Europe to propel study forward.

Archaeological developments were dominated by Sir William St John Hope, a polymath who also held the influential position of Secretary of The Society of Antiquaries of London, and Harold Brakspear, his sometime collaborator. Hope's work spanned more than 40 years during which he excavated nearly 30 sites, 6 Cistercian, and others belonging to the Benedictines, Cluniacs, Augustinians, Premonstratensians, Templars, Carthusians, Friars, and an Augustinian nunnery. This prodigious activity provided unique comparative site information and led Hope to identify 'standard' series of building plans for the different orders.[27] Although many sites showed little more than grass-overgrown earthworks, Hope exploited these conditions to dig small trenches seldom more than 0.5 meters in width to follow foundations or explore important intersections. His goal was the recovery of the plan of the entire site rather than the claustral nucleus. Hope's archaeology was developed by Brakspear. Working more slowly and with a wider remit, Brakspear realized that area excavation (rather than Hope's trenching) allowed for the recognition of earlier buildings on the site of their successor buildings.[28] Taking over Hope's excavation at Waverley south of London, the Cistercians' first foundation in Britain, Brakspear discovered the remains of the community's early church and claustral buildings lying beneath later buildings. His development of what is now called "vertical archaeology" continues a century later. In subsequent campaigns at Waverley, Brakspear focused on such hitherto neglected areas as the inner and outer courts or on buildings like the lay brothers' infirmary.[29]

A second contribution came from the rise of state guardianship. Until the early twentieth century all Cistercian sites were privately owned. Neglect had led to serious losses; at Kirkstall the church's crossing tower had collapsed in 1779, and at Byland the south transept subsided into a pile of rubble in 1822. Physical deterioration illustrated the need of standards to govern their care. They were provided by the Government Office of Works, established in 1882 by an Act of Parliament. Its statutory powers proved inadequate, however. Reorganization had to wait for a new Act in 1913 – the Ancient Monuments Consolidation and

Amendment Act – to provide for enforceable maintenance. Credit for the new legislation belongs to Sir Charles Peers. Following World War I (1914–18), Peers encouraged private owners to place their crumbling monastic structures into government guardianship, and established the procedures and policy regarding their stabilization and care. Major Cistercian sites acquired by Peers were Rievaulx (1918), Roche (1921), Byland (1922), and Furness (1923).

Guardianship encompassed also the allied areas of presentation and publication. For the latter the most readily intelligible parts of former monasteries were the church and cloister and where these survived as ruins, they were secured by Peers at the expense of the less well-preserved inner and outer courts (which were pre-empted for entry booths and then, later, for parking lots). Less defensible were Peers's ruthless clearance policies. At both Rievaulx and Byland more than 100,000 tons of collapsed floors and overturned walls dating from the Suppression were emptied out with the tragic loss of much primary evidence. For publication, Peers devised the site *Guide*, a genre of writing and scholarship different from that of the archaeological paper in which Hope, Brakspear, and others presented their findings.[30] As austere as the sites themselves, the *Guides* offered a bare bones history followed by a lucid description of the visible physical remains presented in itineraries that paid little attention to original circulation or to precinct organization. For nearly 50 years this mode of presentation predominated, and was followed, albeit with many broadening additions, by Nikolaus Pevsner in his influential *Buildings of England* series.

A third element in the development of Cistercian studies came from scholarship. Excavation results and guardianship clearances were by definition site-specific. It was left to John Bilson to bring together the growing body of Cistercian material. His two book-length studies of Cistercian architecture dominated the English literature for the next 50 years.[31] Bilson was an architect by profession, and he saw Cistercian architecture with an architect's eye for detail, and it was detail that became the tell-tale marker of influence and chronology. But he was in close contact with scholars in France, attending the annual meetings of the *congrès archéologique*, and his meticulously footnoted texts were rich in comparative material drawn from France and other European countries. Bilson's awareness of the Order's documents and legislation led him to see a broader context for its architecture than that suggested by Sharpe. Influence from Burgundy (where the Order had started) was combined with local building traditions familiar to the mason builders. Surprisingly, Bilson rarely phased standing fabrics, the method pioneered by Willis 50 years earlier. Without a clear timeline of construction, it was difficult to plot influence or to consider the reasons for building changes.

Like Bilson, other scholars in Europe turned to broader treatments of the Cistercians. In 1911 Herman Rüttiman published his study of the role played by the Order's legislation on its architecture.[32] The next year saw the appearance of Sigurd Curman's *Bidrag till Kännedomen om cistercienserordens byggnadskonst*

(Stockholm, 1912), and four years later of both Hans Rose's *Die Baukunst der Cisterzienser* (Munich), and Paul Clemen's, *Die Klosterbauten der Cistercienser in Belgien* (Berlin). Rose's study moved beyond matters of archaeology, morphology, or style to make links to architectural theory related to Romanesque and Gothic architecture.

Studies of Cistercian architecture by country mostly followed World War II. By far the most influential was Marcel Aubert's 1943 two-volume *L'architecture cistercienne en France*. The book followed Aubert's many publications of the late 1920s and '30s of individual sites. It also resulted from a decade-long collaboration with the Marquise de Maillé. Even though it was she who undertook much of the travel, photography, negotiation with owners (even during the early war years), and fieldwork, her name was not paired with Aubert's as co-author. Their influential study moved systematically from historical matters to consideration of the life of the monks and *conversi* (lay-brothers), and then to architecture. For the last, which constituted the major part of the book, architecture was broken down into elements – plans, elevations, vaults, decoration, etc. – which were examined developmentally. Volume two covered conventual structures. Nothing as comprehensive had been attempted before.

Six years later Père Anselme Dimier published his *Recueil de plans d'églises cisterciennes* (with a supplementary volume in 1967), a pan-European corpus of 700 plans that greatly stimulated wider study of Cistercian material.[33] Eydoux's study of the Order's German houses followed.[34] An old problem of method soon surfaced. From their founding, the Cistercians equated architecture with their monastic reform.[35] By the 1120s St Bernard in his *Apologia* had distinguished between monastic architecture and one serving lay people.[36] The idea of a distinct monastic architecture rooted in the Cistercian experience was supported by early documentary accounts which ordained that buildings were to be erected according to the *forma ordinis*. Furthering unity was the Order's legislation which prohibited certain architectural features (high towers for example). The problem was how to distinguish distinctive Cistercian elements, particularly when attention moved from plans (where some degree of formal unity could be discerned) to elevations (where a far wider range of variation prevailed). Complicating matters for the latter was the Order's penchant for incorporating into its architecture progressive and conservative forms, and the proclivity of individual houses to embrace regional elements.

During the 1950s and '60s German scholars proposed a more diverse paradigm to replace the notion of a single monolithic Cistercian style. To explain development they argued for the primacy of the filiation (the means through which the Order had controlled its growth in a genealogy stemming from the original five mother houses). Each filiation fostered certain characteristics that were then transmitted within their dependent families of daughter houses. Particular attention fell on Bernard's rebuilding of Clairvaux (Clairvaux II) in the Champagne in the mid-1130s (fig. 27-3) and its influence on the Clairvaux family of more than 150 filiated houses.

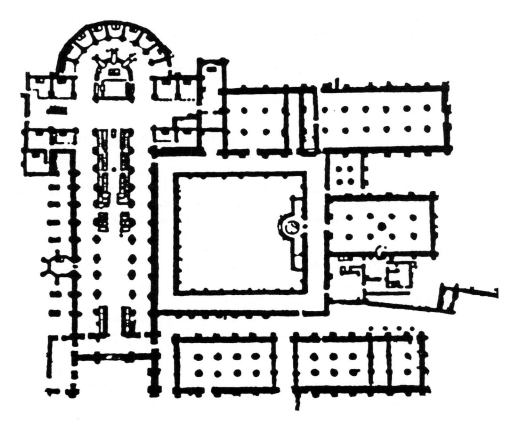

FIGURE 27-3 Engraving of Clairvaux, France by C. Lucas (1708), after Dom Milley.

According to Karl Heinz Esser, a new style of architecture was initiated at Clairvaux II.[37] Although details of the church were largely unknown, Esser argued that it formed the prototype followed within the filiation and was reflected at Himmerod, Clairvaux's second foundation in Germany established in 1135 and which he had excavated. In turn, Clairvaux II inspired Eberbach in Germany in the 1140s and, in France, Fontenay in 1147 (fig. 27-4) and Noirlac in the early 1150s. Esser coined the term "Bernardine" to cover this group. His ideas were notably expanded by Hanno Hahn, whose influential book of 1957 added further defining elements to the Bernardine paradigm: barrel-vaulted main vessels, aisles with transverse barrel vaults, and lower volumes for the east end and transepts (from those in the nave).[38] For the layout of the churches, Hahn hypothesized a modular system of proportions which he deduced from the plans and which he argued were based on a square module, one of three units, the other of four.

Discussion of the Bernardine church continued for several decades. Some scholars refined Hahn's ideas, accepting his proportional theories and attempting to take account of variations. Others, including his German colleagues, were

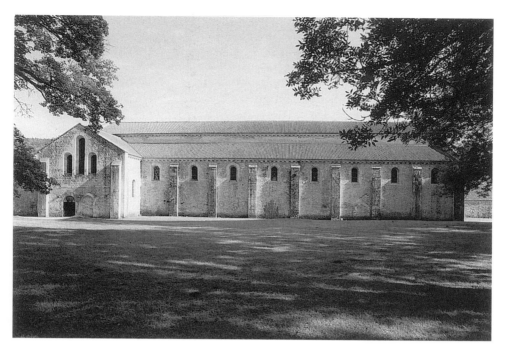

FIGURE 27-4 Fontenay (Côte d'Or), France. Fontenay illustrates the modest scaled overall form, with square-ended terminations, a low presbytery, and a tower-less crossing and window-less barrel vaulted nave associated with the "Bernardine" church.

more critical. They pointed to widespread variations from the proposed Bernardine norms even within the filiation of Clairvaux and, more damagingly, doubted the evidence about Clairvaux II.[39] Hahn had based his ideas on previously published plans, although these turned out to be only loosely accurate. When the churches were precisely measured, doubt fell upon Hahn's neatly drawn modular schemes.

Alternative interpretative models emerged in the 1980s. Some linked the Order's early churches to the wider reform movements prior to Cîteaux, such as those associated with Grandmont, Hirsau, and the Augustinian canons, or those with related histories like the Victorines. Others sought a model in Rome and the reform impulse associated with notions of the *primitiva ecclesia* which were closely associated with the Cistercian Pope, Eugenius III (1145–53).[40]

While the Bernardine debate preoccupied many scholars, others had turned their attention toward the Order's later architecture. In 1970 Wilhelm Schlink investigated the third generation of Cistercian churches, notably Cîteaux III where the choir was rebuilt (1188–93) with an east end marked by a straight-ended choir and ambulatory chapels returned behind it.[41] Three years later Wolfgang Krönig published his *Altenberg und die Baukunst der Zisterzienser*. Cîteaux's plan was popular among the Order's German houses. Clouding the proposed role of Cîteaux, however, was that of another mother house, Morimond,

where a similar east end had been developed, arguably earlier, a position espoused by Nicolai and Kennedy in the mid-1990s.[42]

Working free from the filiation paradigm, two scholars took discussion of Cistercian architecture in fresh directions. In England, Christopher Wilson re-engaged the question of the Order as missionaries of Gothic. Restricting his study to the north of England, he argued persuasively that the second phase of the choir of York Minster (late 1150s) shows knowledge of French Gothic that can only have been gained through the study of recent Cistercian buildings in the north.[43] In France, Caroline Bruzelius related the Order's thirteenth-century churches, notably the abbey of Longpont, to contemporary cathedral construction.[44] Bishops of influential dioceses like Soissons, Noyon, and Laon had served as founders of a number of the Order's important monasteries. The abbey churches close to these centers were viewed as conscious monastic variants of cathedral prototypes.[45] In turn, they influenced other houses. Thus Longpont influenced Royaumont and Vauclair, and they, Villers-en-Brabant, as Coomans has shown. In sequence, Villers inspired other abbeys such as Aulne, Val-Saint-Laurent, St Bernard-sur L'Escaut. In Germany, Altenberg and Walkenried could be seen in the same way.[46] For the latter, lack of agreement over the French sources has seen alternatives offered based on Cologne or on an amalgam of Rhenish and Ile-de-France precedents.[47] Similar derivations have been proposed by Stuart Harrison for the north of England around 1200, with Jervaulx serving as the source for ideas at the choir of Fountains, then at Meaux, and, outside the Order, in the collegiate foundation at Beverley. In this model, Cistercian identity is seen through a range of local centers.

Widening the Focus

One characteristic of the expanding literature, whether focused on the twelfth or thirteenth century, was its preoccupation with a single building type: the church. While no one doubted the importance of the church or its role in the daily lives of the communities that used it on average for around four to five hours a day, could a definition of the Order's architecture rest on the church alone? What of the other buildings within the monastic precinct, which, for an average-sized house, numbered more than 50? Were they also distinctive? How were the walled precincts used (which in larger houses comprised 70–90 acres), and how was use demarcated and shaped? In fact, should the monastic complex be seen as an integrated whole, the physical expression of Cistercian spiritual as well as economic and social forces? Driving this widened focus have been discoveries in archaeology, changed notions of architectural history, and pioneering historical research.

For archaeology, new technical and fieldwork methods shifted the goals of the discipline. Grid methods of excavation, pioneered by Mortimer Wheeler and later refined in the open area, and stratigraphic procedures worked out by Axel

Steensberg in Denmark presented different questions and provided different answers from those derived from earlier trenching techniques (which destroyed much stratigraphic evidence).[48] Archaeology now became university-based and led, for instance, in France to the establishment in the 1950s of the Centre de recherches archéologiques médiévales (CRAM) at the Université de Caen. New equipment, like flotation tanks for soil sampling and sieving, made it possible to recover objects like seeds, fish bones, and the like. From these came information about Cistercian agriculture, diet, disease, and health. The wide range of finds nurtured, in turn, material culture as a central aspect of study. A little later, photogrammetry and rectified photography provided for more accurate recording and phasing of structures and these, when allied with computer-assisted design (CAD), allowed for the production of drawings for easy manipulation and up-dating of data. Field surveying revealed how these large-walled precincts were used and how their use differed from region to region. Through combinations of geophysical surveying such as resistivity, magnotometry, and ground penetrating, radar knowledge emerged about buildings long disappeared (fig. 27-5). Such methods are quicker and cheaper than digging and they leave the evidence undisturbed for later generations (when different and more sophisticated techniques may be expected to extract more evidence).

As results from the new archaeology accumulated, a greater sensitivity to the overall monastic environment emerged. It also became possible to revisit periods of the Order's architecture that seemed irrecoverable as little as 20 years ago, such as the first architecture of the Cistercians, that is, the temporary timber structures that preceded their permanent stone replacements. These raised questions about settlement practices, since much of the architecture connected to these years, particularly prior to 1150, adhered to unusual, even idiosyncratic, forms. In England, discoveries at Fountains in the early 1980s, at Sawley a little later, and at Rievaulx in the 1990s have thrown new light on the subject.[49]

Changes in architectural history have also resulted in new areas of investigation. The architecture constructed by Cistercian women religious, for example, was almost completely ignored in the post-World War II expansion of Cistercian interests. This indefensible neglect has begun to change prompted by the rise of women's studies in the 1970s.[50] In a related development, French theorists like Michel Foucault and Pierre Bourdieu have led scholars to seek gendered readings of both men's and women's institutions.[51]

Attention has thus moved away from large-scale narratives of Cistercian architecture and back toward studies based on individual sites.[52] A series of outstanding monographs have marked the last 25 years of the twentieth century, culminating in Thomas Coomans magisterial, 600-page study of Villers-en-Brabant (2000).[53] The compass guiding such studies has swung toward the contingent and the local. In the process, many traditional generalizations about Cistercian architecture have needed qualification such as the notion of strict, centralized control backed by the Order's statutes or by official annual visitation.

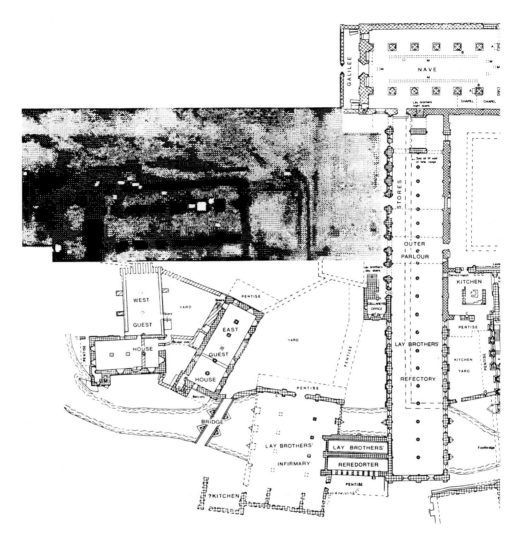

FIGURE 27-5 Fountains, Yorkshire, England. The plan of the west end of the church and laybrothers' range with the buried foundations of the large guest house in the Inner Court revealed in 1992 by resistivity surveying. The building lies under the immaculate sward that has fronted the ruin since the eighteenth century.

In keeping with these interests, scholars now routinely investigate such topics as building materials (and the quarries from which they come), economics and production, landscape, water systems, regional influences, patronage, propaganda, burial, liturgy, and cults.[54] These have much to tell us about the non-physical aspects of architecture, about the conditions that resulted in a foundation or the support of a particular house. On the other hand, as the questions posed have become more interdisciplinary and complex, so architectural concerns have

become less emphasized. With architecture equated with a convergence of external factors or represented as a text in the history of values, awareness has faded of its material presence. Every building is the physical record of the work of masons and master masons, of design decisions worked out on site, of traditional as well as new processes, or of responses to particular materials and craft traditions.

The diversity of modern-day approaches sees some scholars revisiting old problems with the help of new questions, others turning to previously ignored buildings within the monastic precinct, others again re-appraising overlooked evidence. For the first, reception theory has provided fresh insights.[55] So also have related considerations of architecture from the point of view of its users (from the inside out rather than the other way around) thereby rectifying its astonishing omission stemming from the positivist bias of the nineteenth century.[56] For the second, applications of typology and iconography to buildings such as the Chapter House, Refectory, Infirmary, or Gatehouse, have broadened understandings previously based on style or architectural detail. To take one example, the Chapter House, the most important building type after the church, took different forms and even monumental scale in some countries such as England. There, four of the seven Yorkshire houses constructed large chapter houses each dramatically different from the other; the puzzle becomes how to understand why within a given region certain communities and patrons favored one form over another, and why these practices differed from those in the rest of Europe.[57] A third approach has tackled overlooked evidence such as loose or detached stonework on ruined sites. Such material has been routinely removed, sometimes to be stacked in walls, or even spread across surrounding fields (obscuring outlying earthworks in the process). Removal usually occurred in a building-by-building sequence, and recovery of the loose stonework can be related to this as well as to furnish a wealth of vanished information to enlarge our knowledge of wrecked buildings. An early pioneer in England in the 1980s was Stuart Harrison, whose skills of lithic recognition have allowed for the graphic reconstructions of complete elevations, or of features like rose windows, choir screens, and cloister arcades, often with surprising and sometimes confounding results.[58]

In another shift of focus, attention has moved from a predominant concentration on the twelfth century. Although Cistercian beginnings remain fundamental to an understanding of the Order, it by no means follows that its architecture was set in principle by this experience. Likewise, to see the Order's later architecture as a progressive departure from norms established by St Bernard not only diminishes the role of other important figures in the Order, but assumes a trajectory in which founding idealism degenerates into establishment decay. More open-minded approaches show later centuries as ones of revival as much as decline. The early sixteenth century, for instance, saw active building in countries like England. Such adaptations and reshapings need to be seen within their own periods as part of monastic development.[59] The same can be said of

Cistercian work in Spain (although outside the scope of this chapter) where both the sixteenth and seventeenth centuries constituted something of a golden age, and in France, with the reform movements of Rancé in the seventeenth century and La Trappe in the nineteenth.

Change was always part of the Cistercian movement and its architecture. By the fourteenth century the substitution of individual spaces for communal ones is often presented in moralizing terms as reflecting comfort, rather than the monks' different educational backgrounds and interests, or other institutional factors. For the last, the most remarkable change concerns the lay brothers who, in the first two centuries of the Order's history, were central to the reform and whose buildings constituted nearly the entire western half of the monastery.[60] Their disappearance in the late thirteenth century ruptured Cistercian life, changing many aspects of monastic practice, economy, and internal organization. The architectural ramifications of this upheaval need to be seen as an institutional response to the new realities of monastic life.

In the past half century years historians have done much to re-evaluate and reorient study of the Order. Although their contributions fall outside the scope of this chapter, mention needs to be made of four areas where historians have provided architectural historians with fundamental new material. The first concerns the Order's early documents and the light they shed on its institutional reform, an area notably advanced in the work of Leclercq, Lefèvre, van Damme, and Waddell.[61] A second area centers on Cistercian legislation. Previously seen as a monolithic phenomenon, it is now revealed, thanks to the scholarship of Waddell and others, as evolving in piecemeal fashion, with statutes put together over time and in the face of changing circumstances.[62] A third area, explored by McGuire, Burton, and Berman, focuses on settlement, patronage and the variable acquisition of lands (and income).[63] The last area concerns Cistercian customs and practices, a subject spurred by Choisselet and Vernet's publication of the *Ecclesiastica Officia*.[64] In the light of this fuller history, much has had to be rethought about the Order's architecture.

Lastly, it is worth mentioning that changes in the study of Cistercian architecture have left their mark on the perception and presentation of sites. Public visits are now many times more frequent than they were 50 years ago and with their increase have come altered expectations. When Cistercian sites first stirred interest more than 250 years ago, they were linked to notions of the Sublime. In the present, the ruins evoke different responses. For some they are valued as educational tools, for others as prompters of personal responses to distant periods (achieved through interactivity or re-enactments), for others again, as tourist and consumer magnets. One marker of change is the provision of amenities, such as the site museum. The standing remains are there contextualized with local history complete with topographical drawings and artifacts of material culture. Paradoxically, few museums have shown interest in laying claim to excavated material unearthed in the nineteenth or twentieth century when sites were unsecured, and which was sent for safe-keeping to national or regional

museums (where it usually languishes in storage).[65] Public interest has raised anew the broader issue of the ruin. Its inherent incompleteness has always challenged visualization. While reconstruction remains taboo, a reaction to the over-zealous nineteenth-century work of Viollet-le-Duc in France and Giles Gilbert Scott in England, a recent alternative has opened up with the advent of computer modeling. Mediating between Shakespeare's celebration of "bare ruined choirs" and the visitor's wish to grasp the original whole from surviving fragments, animation increasingly fills the ruin's silent spaces with commentary, chant and period music, and visual aides.

Notes

It is a pleasure to acknowledge the help of friends and colleagues, notably Conrad Rudolph, Caroline Bruzelius, Terryl Kinder, Stuart Harrison, and Lilian Armstrong, who undertook the arduous task of reading drafts and suggesting improvements. Others listened to my ideas (and often corrected them), or supplied me with further bibliography. To all of them I am grateful.

1 For modern corrections of this view, see Talbot, "Cistercian Attitude"; Rudolph, *Things of Greater Importance*. [On Romanesque and Gothic architecture, see chapters 14 and 18 by Fernie and Murray, respectively, in this volume (ed.).]
2 Denifle, *La Désolation des églises*; Réau, *Les Monuments détruits*; Himmelein, *Alterkloster – Neueherren*.
3 Lekai, "French Cistercians and the Revolution."
4 Smith, ed., *The Itinerary of John Leyland*.
5 Aston, "English Ruins and History"; Duffy, *The Stripping of Altars*.
6 Evans, *History of the Society*, pp. 9–10.
7 Aston, "English Ruins and History," p. 232.
8 See the five inventories made at Rievaulx within a 9-month period for the Earl of Rutland in Fergusson and Harrison, *Rievaulx Abbey*, pp. 177–86; these pages are based on the work of Glyn Coppack who was the first to realize the value of this information. For an eye-witness account of the events at Roche, see Dickens, "Tudor Treatises."
9 Long, ed., *The Oglander Memoirs*, p. 199.
10 Volume I for the English Cistercian houses, volume II for the Scottish foundations.
11 *Monasticon Anglicanum* (1846), p. 492.
12 His work did not appear for another 150 years, with additions by Peigné-Delacourt.
13 de Jubainville, *Etude sur l'état*; T. Kinder, "Les Eglises médiévales."
14 Martène and Durand, *Voyage littéraire*.
15 Charlesworth, "The Ruined Abbey." A further factor, fear of a resurgent Catholicism, may be connected to the Jacobite rebellion of 1745 led by the Young Pretender, Charles Edward; see Fergusson and Harrison, *Rievaulx Abbey*, pp. 188–9; Janowitz, *England's Ruins*.
16 Buchanan, "Science and Sensibility."
17 Gilpin, *Observations*, vol. 2, pp. 177–80.
18 Reusch, "Caspar David Friedrich."

19 For Carter's first visit, see *Gentleman's Magazine* 76 (1806), pt. 2, pp. 626–7; for his second, *Gentleman's Magazine* 91 (1821), pt. 2, pp. 603–6.

20 De Toulza et al., eds., *Le "Gothique"*.

21 Buchanan, "Robert Willis."

22 Willis, *Architectural History*; "Architectural History of the Conventual Buildings."

23 Arnaud, *Voyage archéologique*; Lequeux, *Antiquités religieuses*; Fleury, *Antiquités et monuments*.

24 Abbé Poquet, *Monographie de l'abbaye*; Potter, *Remains of Ancient Monastic Architecture*; Licot and Lefevre, *Abbaye de Villers-la-Ville*.

25 Schnaase, *Geschichte der Bildenden*, p. 439; de Roisin, "Les missionaires"; Dehio and von Bezold, *Die Kirchliche Baukunst*, p. 537.

26 Sharpe, *Architecture of the Cistercians*; Viollet-le-Duc, *Dictionnaire raisonné*, pp. 263–82.

27 Coppack, *Abbeys and Priories*, pp. 22–3.

28 His work drew on ideas developed by Pitt-Rivers and Flinders Petrie. On Brakspear's importance for archaeology, see ibid., pp. 24–5.

29 Brakspear's publication of the abbey remains definitive.

30 The Guides' line of descent has not been established. Topographical guides are known a century earlier, and archaeological societies had supplied members with site synopses. Neither supplies a clear prototype of Peers' Guides. See Ousby, *The Englishman's England*.

31 Bilson, "The Architecture of Kirkstall Abbey"; "The Architecture of the Cistercians."

32 Rüttiman, *Der Bau- und Kunstbetrieb*.

33 Dimier, *Recueil de plans d'églises*; for his wider studies, see *L'Art cistercien* and *L'Art cistercien hors de France*. Dimier's lifetime of work and publication resulted in several important anthologies; see Chauvin, *Mélanges à la mémoire*.

34 Eydoux, *L'Architecture*.

35 The understanding of this issue has been transformed by Untermann, *Forma Ordinis*.

36 The subject is well treated by Rudolph, *Things of Greater Importance*.

37 Esser, "Uber den Kirchenbau." For an assessment of this phase of study, see Untermann, *Forma Ordinis*, pp. 29–32.

38 Hahn, *Die frühe Kirchenbaukunst*; also Untermann, *Forma Ordinis*, pp. 30–1.

39 For Hahn's critics, see Schmoll, "Zisterzienser-Romanik"; Swartling, "Cistercian Abbey Churches"; and Stalley, *Cistercian Monasteries*, pp. 56–7.

40 Fergusson and Harrison, *Rievaulx Abbey*, pp. 80–1.

41 Schlink, *Zwischen Cluny und Clairvaux*.

42 Nicolai, "Morimond et l'architecture cistercienn"; also Kennedy, "Gothic Architecture."

43 Wilson, "The Cistercians."

44 Bruzelius, *L'Apogée de l'art gothique* (printed earlier in *Analecta Cisterciensia* 35, (1979), pp. 3–204.

45 See the new definition given to her work by Sandron, *La Cathédrale de Soissons*, pp. 199ff., who draws attention to the institutional relation between Longpont and Soissons Cathedral.

46 Branner, *St Louis and the Court Style*, pp. 132–4; Krönig, *Altenberg*, pp. 83–7; Nicolai, *Libido aedificandi*.

47 Davis, "The Choir of the Abbey of Altenberg."

48 Bonde and Maines, "The Archaeology of Monasticism."
49 Compare the limited material available to Schaefer, "The Earliest Churches," with Coppack et al., "Sawley Abbey," esp. pp. 29–34. See also the observations of Untermann, *Forma Ordinis.*
50 Kulke, "Zwischen ordens-tradition"; Gilchrist and Mytum, eds., *Archaeology of Rural Monasteries;* also Gilchrist, *Contemplation and Action.* Aside from theoretical work, see archaeological investigations in France: Bonde and Maines, "The Archaeology of Monasticism," p. 799.
51 [On gender and medieval art, see chapter 6 by Kurmann-Schwarz in this volume (ed.).]
52 One important exception is the important survey by Untermann (*Forma Ordinis*).
53 Coomans, *L'Abbaye de Villers-en-Brabant.*
54 The breadth of interests may be glimpsed in Ruckert, ed., *Maulbronn.* [On patronage, see chapter 9 by Caskey in this volume (ed.).]
55 Seeger, *Zisterzienser und Gotikrezeption.* [On reception, see chapter 3 by Caviness in this volume (ed.).]
56 See particularly Kinder, *L'Europe cistercienne.*
57 See Fergusson and Harrison, "The Rievaulx Abbey Chapter House." For studies of the other structures, see the bibliography in Fergusson and Harrison, *Rievaulx Abbey,* under Fergusson, and in Coomans's treatment by building type.
58 Harrison, "Kirkstall Abbey"; see also "Grey Abbey."
59 Coppack, "The Planning of Cistercian Monasteries."
60 Many new insights into their life and role within the community during these years are emerging from Waddell's invaluable publication (*Cistercian Laybrothers*) of the *Usus conversorum.*
61 The publications of all these scholars are most easily accessed in Waddell, *Narrative and Legislative Texts.*
62 See Waddell's work cited in ibid.
63 McGuire, *The Cistercians in Denmark*; Burton, *The Monastic Order*; Berman, *Medieval Agriculture.*
64 Choisselet and Vernet, *Les Ecclesiastica Officia.*
65 [On the modern medieval museum, see chapter 30 by Brown in this volume (ed.).]

Bibliography

Abbé Poquet, *Monographie de l'abbaye de Longpont* (Paris, 1869).

A.-F. Arnaud, *Voyage archéologique et pittoresque dans le département de l'Aube,* 2 vols. (Troyes, 1837).

M. Aston, "English Ruins and History: The Dissolution and the Sense of the Past," *Journal of the Warburg and Courtauld Institutes* 36 (1973), pp. 231–55.

C. H. Berman, *Medieval Agriculture, the Southern French Countryside, and the Early Cistercians* (Philadelphia, 1986).

J. Bilson, "The Architecture of the Cistercians, with special reference to some of their earlier churches in England," *Archaeological Journal* 66 (1909), pp. 185–280.

——, "The Architecture of Kirkstall Abbey, with some general remarks on the architecture of the Cistercians," *The Publications of the Thoresby Society* 16 (1907), pp. 73–141.

S. Bonde and C. Maines, "The Archaeology of Monasticism: A Survey of Recent Work in France, 1970–1987," *Speculum* LXIII (1988), pp. 794–825.

H. Brakspear, *Waverley Abbey* (Guildford, 1905).

R. Branner, *St Louis and the Court Style in Gothic Architecture* (London, 1965).

C. A. Bruzelius, *L'Apogée de l'art gothique: L'église abbatiale de Longpont, et l'architecture cistercienne au début du XIIIe siècle* (Citeaux, 1990).

A. Buchanan, "Robert Willis (1800–1875) and the Rise of Architectural History" (Ph.D. thesis, University of London, 1994).

——, "Science and Sensibility: Architectural Antiquarianism in the Early Nineteenth Century," in M. Myrone and L. Peltz, eds., *Producing the Past: Aspects of Antiquarian Culture and Practice, 1700–1850* (Aldershot, 1999), pp. 169–86.

J. Burton, *The Monastic Order in Yorkshire 1069–1215* (Cambridge, 1999).

M. Charlesworth, "The Ruined Abbey: Picturesque and Gothic Values," in S. Copley, ed., *Politics in the Picturesque: Literature, Landscape, and Aesthetics since 1770* (Cambridge, 1994), pp. 62–80.

B. Chauvin, *Mélanges à la mémoire du Père Anselme Dimier*, 6 vols. (Arbois, 1982–7).

D. Choisselet and P. Vernet, *Les Ecclestiastica Officia: Cisterciens du XIIe siècle* (Reiningue, 1989).

T. Coomans, *L'abbaye de Villers-en-Brabant* (Brussels, 2000).

G. Coppack, *Abbeys and Priories* (London, 1990).

——, "The Planning of Cistercian Monasteries in the Later Middle Ages: Evidence from Fountains, Rievaulx, Sawley, and Rushden," in J. Clark, ed., *The Religious Orders in Pre-Reformation England* (Woodbridge, 2002), pp. 197–209.

G. Coppack et al., "Sawley Abbey: The Architecture and Archaeology of a Smaller Cistercian Abbey," *Journal of the British Archaeological Association* 155 (2002), pp. 22–114.

M. Davis, "The Choir of the Abbey of Altenberg: Cistercian Simplicity and Aristocratic Iconography," in M. P. Lillich, ed., *Studies in Cistercian Art and Architecture*, vol. 2 (1984), pp. 130–60.

G. Dehio and G. von Bezold, *Die Kirchliche Baukunst des Abendlandes*, vol. 1 (Stuttgart, 1892).

P. H. Denifle, *La Désolation des églises, monastères et hôpitaux en France, pendant la guerre de Cent ans*, 2 vols. (Paris, 1897–9).

A. G. Dickens, "Tudor Treatises," *Yorkshire Archaeological Society Record Series* 125 (1959), pp. 123–6.

A. Dimier, *L'Art cistercien* (Paris, 1962).

——, *L'Art cistercien hors de France* (Paris, 1971).

——, *Recueil de plans d'églises cisterciennes*, 2 vols. (Grignan and Paris, 1949).

E. Duffy, *The Stripping of Altars: Traditional Religion in England 1400–1580* (New Haven, 1990).

H. K. Esser, "Uber den Kirchenbau des hl. Bernhard von Clairvaux. Eine Kunstwissenschaftliche Untersuchung aufgrund der Ausgrabungen der romanischen Abteikirche Himmerod," *Archiv für mittelrheinische Kirchengeschichte* 5 (1953), pp. 195–222.

J. Evans, *A History of the Society of Antiquaries* (London, 1956), pp. 9–10.

H. P. Eydoux, *L'Architecture des églises cisterciennes d'Allemagne* (Paris, 1952).

P. Fergusson and S. Harrison, "The Rievaulx Abbey Chapter House," *Antiquaries Journal* 74 (1994), pp. 211–55.

——, *Rievaulx Abbey: Community, Architecture, Memory* (London, 1999), pp. 177–86.

E. Fleury, *Antiquités et monuments du département de l'Aisne*, 5 vols. (Paris, 1882).

R. Gilchrist, *Contemplation and Action: The Other Monasticism* (London, 1995).

R. Gilchrist and H. Mytum, eds., *The Archaeology of Rural Monasteries*, British Archaeological Reports, 203 (1989).

W. Gilpin, *Observations on Mountains and Lakes of Cumberland and Westmoreland* (London, 1892).

H. Hahn, *Die frühe Kirchenbaukunst der Zisterzienser* (Berlin, 1957).

S. Harrison, "Grey Abbey, County Down: a New Architectural Survey and Assessment," *Journal of the British Archaeological Association* 155 (2002), pp. 115–67.

——, "Kirkstall Abbey: The Twelfth Century Tracery and Rose Window," in L. Hoey, ed., *Yorkshire Monasticism*, British Archaeological Association Conference Transactions (1995), pp. 73–8.

V. Himmelein, *Alterkloster-Neueherren*, 3 vols. (Stuttgart, 2003).

A. Janowitz, *England's Ruins: Poetic Purpose and the National Landscape* (Cambridge, 1990).

Arbois de Jubainville, *Etude sur l'état intérieure des abbayes cisterciennes, et principalement de Clairvaux* (Paris, 1858).

A. Kennedy, "Gothic Architecture in Northern Burgundy in the 12th and early 13th Centuries" (Ph.D. thesis, Courtauld Institute of Art, London University, 1996).

T. Kinder, "Les Eglises médiévales de Clairvaux," in *Histoire de Clairvaux: actes du colloque de Bar-sur-Aube/Clairvaux, 1990* (Bar-sur-Aube, 1991), pp. 205–30.

——, *L'Europe cistercienne* (Zodiaque, 1999).

W. Krönig, *Altenberg und die Baukunst der Zisterzienser* (Altenberg, 1973).

W.-H. Kulke, "Zwischen ordens-tradition und Stifter-Repräsentation – die frügotische architektur der zisterciensichen Frauen klöster in Südfrankreich," *Münster* 55 (2002), pp. 167–75.

L. Lekai, "French Cistercians and the Revolution," *Analecta Cisterciensia* XXIV (1968), pp. 86–118.

J. F. M. Lequeux, *Antiquités religieuses du diocèse de Soissons et de Laon* (Paris, 1859).

C. Licot and E. Lefevre, *Abbaye de Villers-la-Ville de l'Ordre de Cîteaux* (Brussels, 1877).

W. H. Long, ed., *The Oglander Memoirs* (London, 1888).

B. P. McGuire, *The Cistercians in Denmark* (Kalamazoo, 1982).

E. Martène and U. Durand, *Voyage littéraire de deux religieux bénédictins de la Congrégation de Saint-Maur*, vol. 1 (Paris, 1717).

B. Nicolai, *Libido aedificandi: Walkenried und die monumentale Kirchenbaukunst der Zisterzienser um 1200* (Braunschweig, 1990).

——, "Morimond et l'architecture cistercienne en Allemagne," *Bulletin Monumental* 151 (1993), pp. 181–98.

I. Ousby, *The Englishman's England* (Cambridge, 1990).

J. Potter, *Remains of Ancient Monastic Architecture* (London, 1846).

L. Réau, *Les Monuments détruits de l'art français*, vol. 1 (Paris, 1969).

J. J. K. Reusch, "Caspar David Friedrich and National Antiquarianism in Northern Germany," in M. Myrone and L. Peltz, *Producing the Past: Aspects of Antiquarian Culture and Practice* (Aldershot, 1999), pp. 95–114.

F. de Roisin, "Les Missionaires de l'art gothique en Allemagne au XIIe siècle," *Bulletin Monumental* 25 (1859), pp. 708–30.

P. Ruckert, ed., *Maulbronn zur 850 jährigen Geschichte des Zisterzienerklosters* (Stuttgart, 1997).

C. Rudolph, *The Things of Greater Importance* (Philadelphia, 1990).

H. Rüttiman, *Der Bau- und Kunstbetrieb der Cistercienser unter dem Einflusse der Ordensgesetzgebung im 12. und 13. Jahrhundert* (Bregenz, 1911).

D. Sandron, *La Cathédrale de Soissons, Architecture et Pouvoir* (Paris, 1998).

J. O. Schaefer, "The Earliest Churches of the Cistercian Order," in M. Lillich, ed., *Studies in Cistercian Architecture*, vol. 1 (1982), pp. 1–12.

W. Schlink, *Zwischen Cluny und Clairvaux* (Berlin, 1970).

J. A. Schmoll, "Zisterzienser-Romanik: Kritische Gedänken zur jüngsten Literatur," *Formositas Romanica* (1958), pp. 153–80.

K. Schnaase, *Geschichte der Bildenden Künst im Mittelalter*, vol. 3 (Düsseldorf, 1856).

U. Seeger, *Zisterzienser und Gotikrezeption: die Bautätigkeit des Babenbergers Leopold VI in Lilienfeld und Klosterneuburg* (Munich, 1997).

E. Sharpe, *The Architecture of the Cistercians* (London, 1874).

J. T. Smith, ed., *The Itinerary of John Leyland* (Carbondale, 1964).

R. Stalley, *The Cistercian Monasteries of Ireland* (New Haven and London, 1987).

I. Swartling, "Cistercian Abbey Churches in Sweden and 'The Bernardine Plan'," *Nordisk medeltid, Konsthistoriska studier tillägnade Armin Tuulse*, Stockholm Studies in the History of Art, 13 (1967), pp. 193–8.

C. H. Talbot, "The Cistercian Attitude Towards Art: The Literary Evidence," in C. Norton and D. Park, eds., *Cistercian Art and Architecture in the British Isles* (Cambridge, 1986), pp. 56–64.

G. A. de Toulza et al., eds., *Le "Gothique" retrouvé avant Viollet-le-Duc*, ex. cat. (Paris, 1979).

M. Untermann, *Forma Ordinis. Die mittelalterliche Baukunst der Zisterzienser* (Munich, 2001).

E. Viollet-le-Duc, *Dictionnaire raisonné de l'architecture française du xie au xvie siècle*, vol. 1 (Paris, 1875).

C. Waddell, *Cistercian Laybrothers Twelfth Century Usages with Related Texts* (Brecht, 2000).

——, *Narrative and Legislative Texts from Early Cîteaux* (Cîteaux, 1999).

R. Willis, *The Architectural History of Canterbury Cathedral* (Oxford, 1845).

——, "The Architectural History of the Conventual Buildings of the Monastery of Christ Church in Canterbury," *Archaeologia Cantiana* 7 (1868), pp. 1–206.

C. Wilson, "The Cistercians as 'Missionaries of Gothic' in Northern England," in C. Norton and D. Park, eds., *Cistercian Art and Architecture in the British Isles* (Cambridge, 1986), pp. 86–117.

Art and Pilgrimage: Mapping the Way

Paula Gerson

As with many aspects of Romanesque and Gothic art history in the West, study of the relationship of pilgrimage to art is less than a century-and-a-half old.[1] Early studies were centered on monumental architecture and sculpture along the pilgrimage roads through France and Spain to Santiago de Compostela.[2] But, more recently, scholarly interest has turned toward the experience of the pilgrim at the *loca sancta*. This includes relics, shrines, and reliquaries on the one hand and pilgrim badges and souvenirs on the other.[3]

The Pilgrimage Routes to Santiago de Compostela and its Monuments

The historiography of the earliest studies on art and pilgrimage in Northern Europe involves the early studies of both Romanesque art and twelfth-century French literature. These two disciplines intersected early in the twentieth century. Both focused on the pilgrimage to Santiago de Compostela and on a text now known as the *Pilgrim's Guide to Santiago de Compostela*.[4] The *Pilgrim's Guide*, written in the twelfth century, lists the routes to the shrine of St James and is the earliest witness in the West of a pilgrim's response to architecture and sculpture.[5]

Although known to earlier scholars, the *Pilgrim's Guide* gained prominence with its publication in 1882 by Fita and Vinson.[6] The guide lists four routes through France that joined together at Puenta la Reina in Spain and continued across northern Spain to Santiago de Compostela in the northwest of the peninsula (fig. 28-1).[7] The easternmost route passed through Orléans, Tours, Poitiers, the Santonge, and Bordeaux. It joined the routes that began at Vézelay and Le Puy at Ostabat near St Jean-Pied-de-Porte in the Pyrenees. The route that

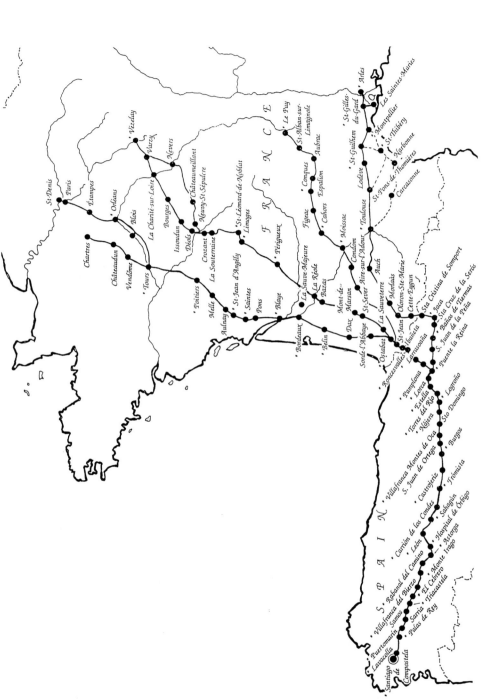

FIGURE 28-1 Map of the pilgrimage routes to Santiago de Compostela. From Annie Shaver-Crandell, Paula Gerson, and Alison Stones, *The Pilgrim's Guide to Santiago de Compostela: A Gazetteer* (London, 1995).

began in Vézelay went through Bourges, Limoges, Périgueux, and St Sever, meeting the others at Ostabat. Beginning in Le Puy, the third route went through Conques, Cahors, and Moissac before joining the first two routes at Ostabat. Once joined, these routes crossed the pass at Roncesvalles, descended through Pamplona and continued west to Puente la Reina. The westernmost route came through Arles, St Gilles, St Guilhem, Toulouse, Oloron-Ste-Marie, crossed the Santa Christina pass, descended to Jaca and continued to Puente la Reina. Here it joined the three routes that had crossed the Pyrenees at Roncesvalles. The single route through northern Spain passed through Estella, Logroño, Sto Domingo de la Calzada, Burgos, Frómista, Sahagún, León, crossed the pass of El Cebrero and descended finally to Santiago de Compostela. In consulting maps of France and Spain, it is quite evident that many major Romanesque monuments can be found along these five routes.

Enter Joseph Bédier, the brilliant literary scholar of the late nineteenth and early twentieth century. Bédier seems to have been the first scholar to conceive of the pilgrimage routes presented in the *Pilgrim's Guide* as the paths of transmission of culture. In exploring the roots of the literary form of the epic in the twelfth century, Bédier envisioned the pilgrimage roads as the arteries along which intellectual life traveled in the eleventh and twelfth centuries.[8] Although first presented (between 1908 and 1913) in a literary context, the concept was rapidly adapted to Romanesque architecture and sculpture.

We must now step back a few years. In 1892, Abbé Bouillet published an article in which he noted similarities in the architecture of St Sernin, Toulouse, the cathedral of Santiago de Compostela, and St Foi at Conques.[9] These buildings formed the core of what has come to be known as "the pilgrimage-type church." Discussions of other relationships between the Romanesque art of France and Spain by both Camille Enlart and Emile Bertaux appeared in 1905 and 1906 in André Michel's *Histoire de l'Art*.[10]

It is in the decade of the 1920s that Bédier's literary concepts were applied to the nascent history of medieval art. Emile Mâle is the first scholar to bring together Bédier's theory concerning the role of the pilgrimage routes through France and Spain with the earlier architectural studies.[11] First published in 1922, Mâle's extensive study of twelfth-century art added three monuments to Abbé Bouillet's original three "similar" churches: St Martin at Tours, St Martial at Limoges and St Sauveur at Figeac.[12] Mâle fostered the concept of a pilgrimage school of architecture, noting that one building of the "pilgrimage type" was found on each of the French roads described in the *Pilgrim's Guide*. He wrote: "our most famous sanctuaries were spotted along the four routes."[13] Mâle seems to be the first to speak of art "traveling" along the pilgrimage roads.[14] While not stated directly in this way, the same concept is implicit in Arthur Kingsley Porter's ten-volume *Romanesque Sculpture of the Pilgrimage Roads*, published in 1923, only one year after Mâle's volume appeared. The role played by the pilgrimage routes took on even greater significance in articles published by Porter between 1923 and 1926.[15]

By the end of the 1920s, the pilgrimage routes to Santiago de Compostela were established as the primary force in the development of Romanesque architecture and sculpture. Using this model, one might envision artists and builders wending their ways along these routes plying their varied trades. The concept of the "pilgrimage-type church" was completely accepted and enjoyed unusual success through most of the twentieth century. We can note its inclusion in Kenneth John Conant's influential *Carolingian and Romanesque Architecture*.[16] The diagram containing the five comparative plans published by Conant (fig. 28-2) has become a standard visual document for all classroom discussions of pilgrimage.

The model of the pilgrimage routes as conduits of stylistic developments in monumental art and architecture from the late eleventh century through the first half of the twelfth century seemed to bring together a number of broad cultural movements. The pilgrimage to Santiago de Compostela dramatically increased during the early years of the *Reconquista*. At the same time we see the maturing of Romanesque architecture and the rebirth of monumental architectural sculpture. This model has been combined with the other prevalent model for discussing Romanesque architecture and sculpture – the "regional styles" model. Together, they present an overarching order that appears to explain artistic developments in France and Spain.

The concentration on the pilgrimage routes to Santiago de Compostela, from its beginning in the early decades of the twentieth century, has had many consequences. Certainly it focused attention on Romanesque art to an extent not seen earlier. Although this was positive, other consequences were not.

Relying on this paradigm has allowed scholars to ignore the complexity created by the extraordinarily diverse examples of architecture and sculpture as well as developments in other areas of Europe. Ultimately, this has distorted the evidence presented by the actual buildings and their sculptural programs.[17] In addition, Porter's work, in particular, led to an explosion of nationalistic debate concerning whether or not Romanesque art and architecture was "invented" first in Spain or France. Since the 1960s and 1970s, the nationalistic fervor has decreased, and arguments presented are more sophisticated. In the second half of the twentieth century, the main scholars concerned with these issues were Durliat, Lyman, Moralejo Alvarez, and Williams.[18] The bibliography here is considerable and depends almost entirely on issues of the style and chronology of the monuments cited.[19]

It is only since the 1980s that scholars have seriously questioned the paradigm of the pilgrimage routes, and there are many issues to question. Here, it is somewhat easier to discuss architecture and sculpture separately.

In architecture, the primary aspect of the "pilgrimage-type church" has been the presence of a ground plan that provides for a ring of peripheral spaces surrounding the central core of the basilica. A pilgrim visiting such a church might enter in the west, then proceed through the north aisle to the transept,

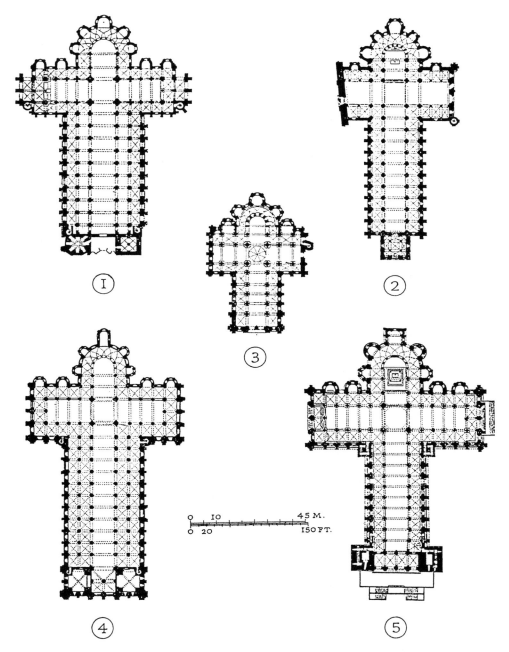

FIGURE 28-2 Comparative plans of "pilgrimage-type" churches (after Conant): St Martin, Tours (1); St Martial, Limoges (2); St Foi, Conques (3); St Sernin, Toulouse (4); Santiago de Compostela (5).

where it would be possible to visit any transept chapels. It would then be possible to continue around the ambulatory, again visiting any ambulatory chapels, or perhaps descend to a crypt to venerate relics kept there. The pilgrim could then continue around the south transept to the south aisle and return to the western entrance of the building to exit. In traversing this path, the pilgrim would not disturb the processions or the liturgical activities taking place in the main spaces of the church.

When we consider Mâle's pilgrimage churches (St Sernin, Toulouse, Santiago de Compostela, St Martial at Limoges, St Martin at Tours, and St Foi at Conques), the basic ground plans are similar, and for good reason. All were coping with similar problems of traffic and liturgy.[20] But does the ground plan make the church? It is important to note here that only St Sernin, Santiago de Compostela, and St Foi stand today. St Martin was destroyed in 1796, as was St Martial in the French Revolution. Knowledge of both buildings depends primarily on eighteenth-century ground plans, drawings, and nineteenth- and twentieth-century excavations.[21] Thus, while we can be certain of some of the similarities in ground plans, we cannot be certain of many aspects of the elevation, structural systems, wall openings, spaces, and volumes, all elements that are not so dependent on liturgy and function.[22] St Foi is instructive in this regard. Although St Foi at Conques shares a similar ground plan with St Sernin and Compostela, its nave is much shorter. As a result, the experience of space is quite different. Standing at the entrance to St Foi, the visitor experiences the verticality of the space and not the long horizontal space of St Sernin or Compostela. The vertical emphasis is strengthened as well, because the crossing tower is so much closer to the entrance and appears more important in the visual organization of the space.[23]

As our knowledge of eleventh-century architecture expands, it becomes clear that elements said to be part of the "pilgrimage-type church" have precedents. The secondary space provided by the aisles is a perfect solution for any church with relics, whether a major pilgrimage church or not. Similar ground plans can be found in a number of churches begun earlier in the eleventh century and too far north to be considered on the pilgrimage routes to Santiago de Compostela as described in the *Pilgrim's Guide* (for example, Jumièges and St Remi, Reims). This has been convincingly argued by Isidro Bango Torviso.[24] As well, experiments with annular crypts from Old St Peter's to St Philibert at Tournus can be seen as prototypes for the arrangement of aisles, ambulatory, and chapels in the pilgrimage-type churches.[25]

One very serious failing of the pilgrimage route model was its restriction to architectural developments in France and Spain and to the five routes to Santiago de Compostela. Not only did this distort our understanding of the development of Romanesque architecture, it also left out the many experiments involved in solving the problems of providing access to pilgrims at other churches. Major pilgrimage shrines in France and Spain were not considered (e.g., St Bénigne, Dijon; Mont-St-Michel; Sto Domingo, Silos). Nor were monuments

in England considered (St Cuthbert, Durham; St Fridewide, Oxford), nor in the Lowlands or in Germany (Aachen, Cologne).[26]

In addition, the over-concentration on just the major monuments on the routes through France and Spain ignored the network of small hostels and churches that gave aid to pilgrims. They, too, must be considered in any real study of the relationship between architecture and pilgrimage.[27]

As is the case with architecture, study of Romanesque sculpture and pilgrimage began with the early twentieth century work by Bertaux, who signaled the relationship between southern France and Spain, as well as by Mâle and Porter.[28] On one level, the issues with monumental sculpture are not quite as complex since, compared to architecture, there was very little monumental architectural sculpture in stone before the end of the eleventh century.[29]

For sculpture, the first massive display of Romanesque monumental sculpture on a church portal occurred on the south and north transepts of Santiago de Compostela.[30] Sculpture in a similar style is found at St Sernin, Toulouse, a building close to Compostela in architecture and prominent on the route from Arles. The consuming questions asked by scholars of the early twentieth century concerned the birthplace of the new style: was it Spain or France? Paul Deschamps came down decidedly on the side of France, with Arthur Kingsley Porter and Manuel Gómez-Moreno supporting Spain. The other major figure in this debate, Georges Gaillard, held a somewhat middle position structured on simultaneous development.[31] The debate raged through most of the first half of the twentieth century, based, as it had been for architecture, on issues of style and chronology, with heavy injections of nationalism.

There is no question that sculptors did travel on the pilgrimage route between Toulouse and Santiago. Some of the same hands appear at St Sernin, Jaca, León, Frómista, and Compostela.[32] Claimed relationships among Santiago, Moissac, and Conques are not nearly as clear-cut.[33] However, finding such long-distance road relationships among the monuments on the other routes to Santiago de Compostela is nearly impossible. The existence of excellent photographic resources and the publication of the Zodiac series on Romanesque art have allowed scholars to look more intensively and comprehensively at Romanesque sculpture.[34] The Zodiac volumes in particular, with brightly lit images and organized by region, point up the coherence of local styles and local workshops. Use of these sources seems to have contributed to the erosion of interest in the pilgrimage roads as a major force in the development of Romanesque sculpture.

The pilgrimage routes to Santiago de Compostela, in fact, followed some of the main Roman roads in France and, to a lesser degree, in Spain. These were well-traveled roads and, thus, important sites for the construction of religious houses. Monasteries and cathedrals with important relics situated along main roads were more accessible, and they attracted travelers and pilgrims alike, many willing to donate gifts to the saint honored. The more pilgrims there were, the greater the income from them. More money meant that funds might be

available for building campaigns and decorating programs. As is generally the case, artists go where the money is, no matter the road on which that job may be found. Thus it seems that the most important factors in the relationship of the pilgrimage roads to sculpture and architecture are relics and money rather than the specific roads themselves.

Changing the Focus

The second half of the twentieth century witnessed an explosion of interest in pilgrimage in many disciplines, especially anthropology, cultural and social history, hagiography, and religious studies.[35] These fields have reinvigorated studies of pilgrimage and art.

Thus, it is not surprising to see a critical shift in approach to art and its relationship to pilgrimage. The first indication of this change for the pilgrimage to Santiago de Compostela could be seen in the 1985 exhibition, "Santiago de Compostela: 1000 ans de Pèlerinage Européen" in Ghent. In the exhibition and catalogue that accompanied it, the pilgrimage, and objects related to it, were treated in a more comprehensive manner and offered rich areas of investigation. The geographic areas covered were not restricted to France and Spain, but included most of Western Europe, even as far as Poland. The time frame extended well into the fifteenth century and beyond. Included in the exhibition were classes of objects that had not been given prominence previously in discussions of the art of the pilgrimage routes (reliquaries, pilgrims' badges, and souvenirs). As well, it brought medieval hospices for pilgrims into the discussion of architecture. This approach is also seen in the catalogue from the 1993 exhibition, "Santiago, Camino de Europa," held in Santiago de Compostela.[36]

Important in this change of approach was Marie-Madeleine Gauthier's 1983 book *Routes de la foi*. This volume, devoted to reliquaries found along the pilgrimage routes, signaled an attempt to turn attention more deeply on those objects for which pilgrims specifically made their journeys.[37]

It was, of course, the saints and their relics that drew pilgrims to sites of cult. Thus, the medieval shrine has become more important, along with studies of the medieval participant and viewer.[38] This has had the added benefit of widening the study of art and pilgrimage from Spain and southern France in the Romanesque period to include art of the Gothic period, and has extended the geographic range to shrines in England, northern France, Germany, and the Lowlands.[39] Now, too, attention is slowly turning toward local pilgrimages of various kinds. These studies seem to be of greater interest in current scholarship than the kind of studies concerned with style and chronology that consumed an earlier generation. Much of the new scholarship appears in recently published volumes drawn from presentations at conferences and recent dissertations.[40]

Art, Architecture and the Pilgrims' Goal

In exploring the pilgrim's experience at the *loca sancta*, a number of different approaches have been rewarding. The anthropologist Simon Coleman and art historian John Elsner have collaborated on a number of studies of shrines from Walsingham to Sinai, with some emphasis on the pilgrim, space, and the use of spaces.[41]

Recent studies of pilgrimage architecture place emphasis on architecture as a setting for the saint's shrine rather than as an example of a development within architectural history. Although not previously considered in these terms, new studies have included the architecture of cloisters as spaces that could serve as saints' shrines. While in some cases it is clear that lay persons had access to such cloisters, it is not at all clear to what extent this was common practice.[42]

English scholars have been very active in this aspect of pilgrimage studies. John Crook has written a number of articles on specific English shrines, in addition to his broad survey covering many monuments in England, France, and Italy.[43] Shrines in England have also been of concern to Ben Nilson.[44] In general, concentrated examination of specific buildings and their cults have replaced the more general attempt to develop an all-encompassing theory. See, for instance, the very welcome studies on Sto Domingo de la Calzada, on the pilgrimage route to Santiago de Compostela, but now treated in terms of its own development as a site of cult.[45] As well, concerns of local pilgrimage and architecture are being explored.[46]

The general interest in the study of medieval tombs has brought a new focus to tombs created for saints within their architectural setting.[47] While saints' tombs seem to have been placed in areas that were not generally open to laity in the early medieval period, this certainly does not seem to have been the case from the twelfth century on.[48] With the growth of pilgrimage movements in Northern Europe (and perhaps the need for income from pilgrims), greater efforts are apparent in providing physical connection between tomb and pilgrim.

A study of a number of French tombs in their settings can be found in the work of Sabine Komm.[49] Individual tombs are the subject of many of the essays in the issue of the *Cahiers de Saint-Michel de Cuxa* devoted to the cult of saints.[50] Of particular interest is a series of essays in *Decorations for the Holy Dead*, edited by Stephen Lamia and Elizabeth Valdez del Alamo. Some essays in this volume discuss the decoration that mediated or directed the pilgrims' visit to the tomb. Other essays are specifically concerned with the intense interaction of the pilgrim with the saint's tomb.[51] Discussions of such physical interactions can be found as well in articles by Stephen Lamia and Ben Nilson.[52] Nilson also includes examples of *ex votos* found in sanctuaries including wax body parts and shaped candles, although these are discussed in terms of offerings rather than in terms of the possible visual effect on the visitor.[53]

Reliquaries have increasingly received scholarly attention, although primarily in the context of metalwork studies and as cult objects rather than as objects of cult related to pilgrimage.[54] There are, to date, only a few instances, as at St Foi, Conques, in which cultic activities involving reliquaries and groups of reliquaries have been explored in terms of the pilgrims' experience.[55]

Saints' tombs were fairly large objects, generally made of durable materials like stone. As such, close proximity does not seem to have been problematic. Reliquaries made of precious materials and covered with gems were a different matter, and there seems to have been considerable variation in how close a pilgrim might come.

Some larger reliquaries were on "permanent" view, as was the reliquary of St Giles described in the *Pilgrim's Guide to Santiago de Compostela* or the martyrs shrine that Abbot Suger had made for his new chevet.[56] As Ellen Shortell has pointed out, there are a number of instances in the early thirteenth century when saints' bodies, previously kept in crypts, were translated into reliquaries in the upper parts of churches specifically for display.[57]

Many smaller reliquaries were placed on altars in chapels, and could be visited by pilgrims. Other reliquaries might be closed up in treasuries and brought out for special occasions, as on the feast day of a saint or for processions. In some instances, intimacy was possible and (perhaps when crowds were small) a reliquary was brought out to be kissed. Scott Montgomery has discussed this practice for the reliquary head of St Just. However, when crowds were large, reliquaries might be displayed from a tower as at St Servatius, Maastricht.[58] Reliquaries in procession would also have been seen at a distance, and special souvenir mirrors were sold to pilgrims in order to catch the reflection of the relic in its glittering reliquary.[59] It seems clear that the experience of pilgrims was quite varied, depending on time and place, and we await further research on tombs and reliquaries as they relate to pilgrimage.

Pilgrim's Badges and Souvenirs

Another very important group of objects that has come increasingly to the attention of scholars, especially since about 1985, is pilgrim badges. Collected from at least the nineteenth century, these small, seemingly inconsequential objects were made mostly of lead or of pewter with a heavy tin content, although some were made of silver and bronze. They were produced from the twelfth to the sixteenth century, reaching their height of popularity in the fourteenth and fifteenth centuries.[60] They now have been liberated from dusty storerooms to take an important place in the study of the visual and material culture of pilgrimage.[61]

Kurt Köster began publishing articles concerning pilgrims' badges in the late 1950s, although little attention was paid to these objects.[62] Brian Spenser's publications on badges begin in the 1960s.[63] Both Köster and Spenser have concentrated attention on the artifacts themselves and their meaning for the

pilgrim. The works published by Esther Cohen turn attention to the control and sale of pilgrim badges. Cohen underscores the fundamental importance in understanding the economic role these badges played in pilgrimage.[64]

Pilgrims' badges came to greater attention with the 1985 exhibition, "Santiago de Compostela, 1000 ans de Pèlerinage Européan." The exhibition contained about 100 scallop shells and metal badges, and the catalogue includes an essay by Kurt Köster on these in addition to the catalogue entries on specific badges.[65] Important work by A. M. Koldeweij began to appear in 1987 and by Denis Bruna in 1990.[66] There were many new finds of badges, especially in the Netherlands in the 1990s.[67] The publication by H. J. E. van Beuningen, A. M. Koldeweij, and D. Kicken of *Heilig en Profaan 1* in 1993 and *Heilig en Profaan 2* in 2001 introduced many of the new finds and essays on the badges, and Denis Bruna's 1996 catalogue of the badges at the Cluny Museum have brought the subject into greater focus.[68]

Pilgrims' badges can be understood on many levels. Sewn or pinned on garments, they identified the pilgrim as someone for whom safe passage should be accorded and to whom hospitality should be offered.[69] They certainly had an apotropaic or talismanic nature and could be used to ward off danger and illness. After the pilgrim arrived home, they might be used as objects of meditation for private devotion.[70] Since so many badges have been found in rivers or buried in the mud of river banks, some have proposed an *ex voto* function.[71] This may be a difficult thesis to sustain since many profane ornaments (also with attachments so that they could be worn) have been found in the same locations as the pilgrims' badges themselves.[72]

With so many new and excellent publications of these small objects, the subject of pilgrim badges and souvenirs can add significantly to our understanding of Romanesque and Gothic art and pilgrimage.

Conclusion

The interest of scholars concerned with the relationship of art to pilgrimage in northern Europe during the Romanesque and Gothic periods has changed considerably since the early part of the twentieth century. Early discussions began in the 1920s. Generated by a literary model, art historians conceived of the pilgrimage routes to Santiago de Compostela as the conduits along which Romanesque architecture and sculpture developed. Questions of the style and chronology of monuments along these routes occupied scholars for decades, with answers frequently colored by nationalism: did the style originate in Spain or France? In this debate, other pilgrimage sites in Northern Europe were almost totally ignored, as were monuments of the later medieval period.

For much of the twentieth century, the model presented by the pilgrimage routes remained a powerful construct for ordering our knowledge of Romanesque art, bolstered especially by sculpture found on monuments along the route between Toulouse and Santiago de Compostela. However, by the 1980s,

many new studies in the field of architectural history had appeared, and more photographs of eleventh- and twelfth-century sculpture were available. With closer examination, the paradigm of the pilgrimage routes was found to be limiting and misleading. By concentrating on a small number of monuments along these routes, the evidence of the development of Romanesque art and architecture was distorted.

At about the same time that the early twentieth-century model was found to be faulty, new ideas about the relationship of art to pilgrimage emerged. The focus of these current studies has shifted dramatically.

By the 1980s influences from other disciplines within medieval studies indicated new possibilities for understanding the relationship of art to pilgrimage, and they have been more concerned with the experience of the pilgrim. The geographic range has expanded as well as the time period, bringing us into the later Middle Ages. New studies now emphasize the effect of architecture, sculpture, tombs, and reliquaries on the pilgrim, as well as those objects, especially badges and souvenirs, that were taken home by the pilgrim and incorporated into the visual culture of everyday life.

Rather than imposing an artificial model on monuments, today's scholars prefer to understand pilgrimage art from the pilgrim's point of view.

Notes

My involvement with the pilgrimage routes to Santiago de Compostela began many years ago when Alison Stones and I, after our first year or so of teaching, decided to travel these roads during a summer vacation. In subsequent years, many pilgrimages to Santiago de Compostela followed with my friend and colleague Annie Shaver-Crandell, during which we photographed the monuments that could be seen along the roads in the twelfth century, when the *Pilgrim's Guide to Santiago de Compostela* was written (see note 4 below). Ideas concerning art and pilgrimage developed during those travels, and I owe a great debt to both Alison and Annie for our discussions and for the time spent sorting out and clarifying ideas. Some of the information presented here concerning the pilgrimage to Santiago de Compostela draws on introductory material in our *Gazetteer* (see note 4 below) as well as in Paula Gerson, "Le Guide du pèlerin de Saint-Jacques de Compostelle." My thanks are due also to Elizabeth Valdez del Alamo, who kindly read a draft of this essay and offered good and wise counsel, as always.

1 While some would consider Spain in Southern Europe rather than Northern, the subject of this volume, the historiography of art and pilgrimage, would be impossible without discussion of Spain in the late eleventh and twelfth centuries.

2 The literature on the cult of St James in general and its relationship to pilgrimage is enormous. Very valuable, although not primarily for issues of art, are two bibliographic volumes: Davidson and Dunn–Wood, *Pilgrimage in the Middle Ages* and Davidson and Dunn, *Pilgrimage to Santiago de Compostela*. [On Romanesque architecture and sculpture, see chapters 14, 15, and 16 by Fernie, Hourihane, and Maxwell, respectively, in this volume (ed.).]

3 [On relic collections, see chapter 10 by Mariaux in this volume (ed.).]

4 Shaver-Crandell et al., *The Pilgrim's Guide to Santiago de Compostela: A Gazetteer*, hereafter cited as *Gazetteer*, and Gerson et al., *The Pilgrim's Guide: A Critical Edition*, hereafter cited as *Critical Edition*. The *Pilgrim's Guide* is the fifth text in a five-part compilation that contains other texts on the cult of St James. Although originally referred to as the *Codex Calixtinus* (for the purported author Pope Calixtus II), a more accurate name is the *Liber Sancti Iacobi*.

5 Gerson et al., *Critical Edition*, vol. II. In chapter 8 ("The Bodies of Saints which are at Rest along the Road to Saint James which Pilgrims Ought to Visit," pp. 32–65), the author of the guide mentions and describes a few tombs (St Gilles, St Front), the setting and decoration of St Leonard of Noblat and the architecture of St-Martin at Tours. Chapter 9 ("The Characteristics of the City and the Basilica of St James the Apostle of Galicia," pp. 66–91) is entirely devoted to a discussion of the architecture, sculpture and church furniture of the Cathedral of Santiago de Compostela.

6 Fita y Colomé and Vinson, eds., "Le Codex de St Jacques, Livre IV," pp. 1–20; 225–68; 268–70. Fita y Colomé and Vinson published their edition before the fourth book, the Pseudo-Turpin, was reunited with the rest of the texts in the Compostela manuscript. Thus they refer to the *Guide du Pèlerin* (the actual Book V) as Book IV.

7 See Gerson et al., *Critical Edition*, vol. II, pp. 10–11 and notes on pp. 146–8.

8 Bédier, *Les Légends épiques*, especially vol. 3. But see also Lavergne, *Les Chemins de Saint-Jacques*.

9 Abbé Bouillet, "Ste-Foy de Conques."

10 Enlart, "L'Architecture romane," and Bertaux, "La Sculpture chrétienne."

11 Mâle, "L'Art du moyen-âge," and more thoroughly in *L'Art religieux du XIIe siècle*, ch. 8, pp. 281–313. See the English translation with updated notes: Mâle, *Religious Art in France*, ch. 8, pp. 282–315.

12 Mâle, *L'Art religieux du XIIe siècle*, pp. 297–300 (Eng. trans.: pp. 299–302). St Sauveur at Figeac is dropped out of the group later.

13 Ibid., p. 288 (p. 289).

14 Ibid., p. 6 (p. 5).

15 Porter, *Romanesque Sculpture*; "Spain or Toulouse? and other Questions"; "Leonese Romanesque."

16 Conant, *Carolingian and Romanesque Architecture*. The diagram of the five churches is fig. 28 on p. 94. Conant's interest in the cathedral of Santiago de Compostela went back to his early trips to Spain. See also *Early Architectural History* and the translation and reissue, *Arquitectura románica da Catedral* with excellent commentary by Serafín Moralejo Álvarez, "Notas para unha revisión da obra de K. J. Conant," on pp. 221–36.

17 This is evident from even a cursory look through the monuments in Shaver-Crandell et al., *Gazetteer*.

18 The question was reopened by Lyman, "Pilgrimage Roads Revisited," and answered by Durliat, "Pilgrimage Roads Revisited?" See also Williams, "Spain or Toulouse?" and Moralejo Alvarez, "San Martín de Frómista."

19 Shaver-Crandell et al., *Gazetteer*, p. 100 nn.11–16, and bibliography. For a bibliography of Marcel Durliat's work, see *De la création à la restauration. Travaux*

d'histoire de l'art offerts a Marcel Durliat pour son 75e anniversaire (Toulouse, 1992). For Serafín Moralejo Alvarez, see the new collected edition of his works, Angela Franco, ed., *Patrimonio artistico de Galicia y otros estudios. Homenaje al Prof. Serafín Moralejo Alvarez*, 3 vols. (Santiago de Compostela, 2004).

20 See the important article by John Williams, "La Arquitectura del Camino de Santiago." Williams discusses matters of cult in determining architectural form.

21 For St Martin, see Shaver-Crandell et al., *Gazetteer*, pp. 374–6. For St Martial, see pp. 225–6.

22 Note that there are, in fact, differences even in the ground plans. While St Martin and St Sernin have double side aisles, Santiago, St Martial and St Foi have single side aisles. Also, St Martial had no aisles at the north and south terminals of its transepts.

23 Differences among the monuments also extend to building materials and the changes required by, for instance, the brick of St Sernin and the stonework of Santiago de Compostela.

24 See the analysis of plans by Isidro Bango Torviso in "Las Llamadas iglesias." See also "El Camino de Santiago."

25 For a brief survey of the early experiments see, in addition, Stalley, *Early Medieval Architecture*, pp. 149–53.

26 On these issues, see the chapter on pilgrimage architecture in ibid., pp. 147–65 and the bibliographic essay on this subject, p. 253.

27 Most early studies of hostels are of local institutions and appear in regional journals. For an early attempt to place hostels and hospices in a broader context see Lambert, "Ordres et confréries." It is only since around 1985 that scholars have seriously explored hostels and hospices. See the exhibition catalogue *Santiago de Compostela: 1000 ans de Pèlerinage Européen* (Ghent, 1985), esp. pp. 252–73. See also Jetter, *Das europäische Hospital*. Most recently, see the dissertation by Morelli, "Medieval Pilgrim's Hospices," with excellent bibliography.

28 See above, notes 10, 11, and 15.

29 I do not include here the free-standing stone crosses of Ireland and the British Isles.

30 See Shaver-Crandell et al., *Gazetteer*, pp. 336–46, with bibliography on pp. 343 and 346. The sculpture is described in the *Pilgrim's Guide*. Much of the sculpture originally on the north transept portal was moved to the south in the eighteenth century. The author of the *Guide* also includes a description of the sculpture originally planned for the west façade.

31 Paul Deschamps, "Notes sur la sculpture romane"; Gómez-Moreno, *El arte románico español*; Gaillard, *Les Débuts*. See the analysis by Durliat, *La Sculpture romane*, pp. 8–10, and a review of the issues by Valdez del Alamo, "Ortodoxia y Heterodoxia," pp. 12–14, and notes 27–63 on pp. 25–6.

32 See notes 18 and 19 above and Shaver-Crandell et al., *Gazetteer*, p. 100 n.16.

33 See Durliat, *La Sculpture romane*, pp. 44–169 for these relationships.

34 The early volumes in this series published at La Pierre-qui-Vire covering French Romanesque monuments appeared in the 1960s.

35 Sumption, *Pilgrimage*, still remains a classic in the field. Brown, *The Cult of Saints*, has also been very influential in turning attention to the role of saints and the development of the cult of relics. The essays and the catalogue of the 1984 exhibition *Wallfahrt kennt keine Grenzen* at the Bayerischen Nationalmuseum, edited by Lenz Kriss-Rettenbeck and Gerda Möhler, indicated some new ways in which to

approach pilgrimage and art. The anthropological aspects of Christian pilgrimage were presented by Victor and Edith Turner, *Image and Pilgrimage*, and more recently Turner, *Blazing the Trail*. However, see also the critique of the Turners' work in Eade and Sallnow, eds., *Contesting the Sacred*. See also Coleman and Elsner, "Contesting Pilgrimage."

36　Moralejo Alvarez and López Alsina, eds., *Santiago*. See the essays (each with full bibliographic notes), that continue to explore the theme of the cult of St James in many parts of Europe: France (Humbert Jacomet, pp. 55–81), Germany (Klaus Herbers, pp. 121–39), Italy (Paolo G. Caucci von Saucken, pp. 83–97), the Lowlands (Jan van Herwaarden, pp. 141–59), Britain and the passage by boat (Brian Tate, pp. 161–79) and Scandanavia (Vincente Almázan, pp. 181–91). The catalogue includes a number of objects not in the 1985 exhibition.

37　Gauthier, *Routes de la foi*. This volume was translated into English by J. A. Underwood with the title, *Highways of the Faith* (Secaucus, 1986).

38　Freedberg, *The Power of Images*. [On reception, see chapter 3 by Caviness in this volume (ed.).]

39　Note the volume edited by Blick and Tekippe, *Art and Architecture*.

40　See, for example, Bynum and Gerson, "Body-Part Reliquaries"; "Le Culte des saintes à l'époque préromane et romane," *Les Cahiers de Saint-Michel de Cuxa* 29 (1998); "Les Pèlerinages à travers l'art et la société a l'époque préromane et romane," *Les Cahiers de Saint-Michel de Cuxa* 31 (2000); Lamia and Valdez del Alamo, eds., *Decorations for the Holy Dead*; and Stopford, ed., *Pilgrimage Explored*. Two interesting dissertations that, taken together, indicate the importance of a multidisciplinary approach, are McGrade, "Affirmations of Royalty," and Ciresi, "Manifestations of the Holy."

41　Coleman and Elsner, "Pilgrimage to Walsingham and the Re-Invention of the Middle Ages." See their notes for additional bibliography.

42　See the articles by Elizabeth Valdez del Alamo, Leah Rutchick, and Leslie Bussis Tait in Lamia and Valdez del Alamo, eds., *Decorations*, pp. 111–63.

43　Crook, *Architectural Setting*.

44　Nilson, *Cathedral*. As might be expected, Canterbury has generated considerable interest. See Tatton-Brown, "Canterbury."

45　*La Cabecera de la Catedral calceatense y el Tardorrománico hispano; Actas del Simposio en Santo Domingo de la Calzada* (Santo Domingo de la Calzada, 2000); Isidiro Bango Torviso, *La Cabecera*.

46　See for instance, Cassagnes-Brouquet, "Culte des saintes."

47　For a review of a number of recent books on tombs, see Holladay, "Tombs and Memory."

48　While restriction of laity to tombs does not seem to have been the case in the early Christian period, it does seem to be the case during the early medieval period. See Hahn, "Seeing and Believing." The situation for the eleventh century is not clear.

49　Komm, *Heiligengrabmäler*. See also Stratford, "Le Mausolée"; Mallet and Perry, "Les Tombeaux."

50　*Les Cahiers de Saint-Michel de Cuxa* 29 (1998): see Andre Bonnery, "Le Sarcophage-reliquaire de Saint Saturnine, à Saint-Hilaire d'Aude," pp. 53–62; Francesca Español, "Le Sepulchre de Saint Ramon de Roda: utilisation liturgique du Corps Saint," pp. 177–87; Richard Bavoillot-Laussade, "Les Avatars du corps de Guilhem et le culte du fondateur de Gellone," pp. 189–217.

51 Lamia and Valdez del Alamo, *Decorations*: see especially Rocío Sánchez Ameijeiras, "Imagery and Interactivity: Ritual Transaction at the Saint's Tomb," pp. 21–38 and Daniel Rico Camps, "A Shrine in its Setting: San Vincente de Ávila," pp. 57–76.

52 Lamia, "Souvenir," and Nilson, "The Medieval Experience."

53 Nilson, "The Medieval Experience", pp. 104–12.

54 As, for instance, the catalogue of the exhibition at the Schnütgen-Museums, *Ornamenta Ecclesiae: Kunst und Künstler der Romanik* (Cologne, 1985). For an overview of literature on the cult of relics see Bynum and Gerson, "Body-Part Reliquaries," pp. 3–7.

55 See Remensnyder, "Legendary Treasure" and "Un Problème de cultures ou de culture?"; Ashley and Sheingorn, "An Unsentimental View"; Sheingorn, *The Book of Saint Foy*; Garland, "Le Conditionnement."

56 For the reliquary of St Gilles, see *Critical Edition*, vol. II, pp. 37–41 and notes 38–56 on pp. 173–74 with bibliography.

57 Shortell, "Dismembering Saint Quentin," esp. p. 44 n.4.

58 Montgomery, "*Mitte capud meum*," pp. 51–2 and fig. 4.

59 For these interesting objects, see Bruna, *Enseignes de pèlerinage*, pp. 16–17, and Köster, "Insignes de pèlerin."

60 Bruna, *Enseignes de pèlerinage*, pp. 13–14. However, the individual badge can be difficult to date since shrines used the same format over many years.

61 See Bruna's discussion of the nineteenth-century antiquary, Arthur Forgeais and the objects found in the dredging of the Seine in the 1840s: *Enseignes de pèlerinage*, pp. 20–6. Important collections are found in museums in Paris, London, Prague, and Düsseldorf. Very important, as well, is the private van Beuningen collection, with many new finds. See Koldeweij, "Lifting the Veil," esp. pp. 164–8 for historiography.

62 See the bibliography in Bruna, *Enseignes de pèlerinage*, p. 376.

63 Ibid., p. 381.

64 Cohen, "In haec signa," "In the Name of God and of Profit," and "Roads and Pilgrimage."

65 *Santiago de Compostela, 1000 ans de Pèlerinage Européan* (Ghent, 1985). Köster's essay is found on pp. 85–95.

66 See Bruna, *Enseignes de pèlerinage*, for full bibliographies. For Koldeweji's work, see p. 378 and for Bruna's, p. 371.

67 Koldeweij, "Lifting the Veil," esp. p. 166.

68 Van Beuningen and Koldeweij, eds. *Heilig en Profaan 1*; van Beuningen et al., eds., *Heilieg en Profaan 2*; Bruna, *Enseignes de pèlerinage*.

69 However, towards the end of the period of their popularity in the sixteenth century, they seem to have been misused by vagabonds and frauds. See Koldeweij, "Lifting the Veil," esp. pp. 181–5.

70 See Bruna, *Enseignes de pèlerinage*, pp. 16–17 and Köster, "Kollektionen"; and Koldeweij, "Pilgrim Badges."

71 Bruna, *Enseignes de pèlerinage*, p. 16.

72 This is a difficult problem. Recently, Mellinkoff, *Averting Demons*, vol. 1, pp. 39–55, has argued for an apotropaic function. Other scholars have been more cautious, especially concerning the erotic nature of some of the secular badges. See Koldeweij, "Lifting the Veil," p. 167 and note 25, and pp. 185–7.

Bibliography

Kathleen Ashley and Pamela Sheingorn, "An Unsentimental View of Ritual in the Middle Ages, or, Sainte Foi Was No Snow White," Journal of Ritual Studies 6:1 (1992), pp. 63–85.

Isidiro Bango Torviso, *La Cabecera de la Catedral de Santo Domingo de la Calzada* (Madrid, 2000).

——, "El Camino de Santiago y el estilo románico en España," *Aspectos didácticos de Geografiá e Historia* (Arte) 8, Universidad de Zaragoza (1994), pp. 135–66.

——, "Las Llamadas iglesias de peregrinacion o el arquetipo de un estilo," *El Camino de Santiago, Camino de las Estrellas* (Santiago de Compostela, 1994), pp. 11–75.

Joseph Bédier, *Les Légends épiques. Recherches sur la formation des chansons de geste*, 4 vols. (Paris, 1908–13).

Emile Bertaux, "La Sculpture chrétienne en Espagne des origines au XIVe siècle," in André Michel, ed., *Histoire de l'art depuis les premiers temps chrétiens jusqu' à nos jours*, 2, 1 (Paris, 1906), pp. 214–93.

H. J. E. van Beuningen and A. M. Koldeweij, eds., *Heilig en Profaan 1, 1000 Laatmiddeleeuwse Insignes uit de collectie H. J. E van Beuningen*, Rotterdam Papers 8 (Cothen, 1993).

H. J. E. van Beuningen, A. M. Koldeweij, and D. Kicken, eds., *Heilieg en Profaan 2, 1200 Laatmiddeleeuwse Insignes uit openbare en particuliere collectives*, Rotterdam Papers 12 (Cothen, 2001).

Sarah Blick and Rita Tekippe, eds., *Art and Architecture of Late Medieval Pilgrimage in Northern Europe and the British Isles*, 2 vols. (Brill, 2005).

Abbé Bouillet, "Ste-Foy de Conques, St-Sernin de Toulouse et St-Jacques de Compostelle," *Mémoires de la société nationale des antiquaires de France*, 6th ser., 3 (1892), pp. 117–28.

Peter Brown, *The Cult of Saints: Its Rise and Function in Latin Christianity* (Chicago, 1981).

Denis Bruna, *Enseignes de pèlerinage et enseignes profanes* (Paris, 1996).

Caroline Walker Bynum and Paula Gerson, "Body-Part Reliquaries and Body Parts in the Middle Ages, *Gesta* 36:1 (1997).

Sophie Cassagnes-Brouquet, "Culte des saintes et pèleringes en Bourgogne du XI au XIII siècle," *Les Cahiers de Saint-Michel de Cuxa* 29 (1998), pp. 63–77.

Lisa Victoria Ciresi, "Manifestations of the Holy as Instruments of Propaganda: The Cologne Dreikoenigenschrein and Aachen Karlsschrein and Marienschrein in Late Medieval Ritual" (Ph.D. thesis, Rutgers University, 2003).

Esther Cohen, "'In haec signa': Pilgrim-Badge Trade in Southern France," *Journal of Medieval History* 2 (1976), pp. 193–214.

——, "In the Name of God and of Profit: The Pilgrimage Industry in Southern France in the Late Middle Ages" (Ph.D. thesis, Brown University, 1976).

——, "Roads and Pilgrimage: A Study in Economic Interaction," *Studi medievali* 21 (1980), pp. 321–41.

Simon Coleman and John Elsner, "Contesting Pilgrimage: Current Views and Future Directions", *Cambridge Anthropology* 15, 3 (1991), pp. 63–73.

——, "Pilgrimage to Walsingham and the Re-Invention of the Middle Ages," in Jennie Stopford, ed., *Pilgrimage Explored*, (Woodbridge, 1999).

Kenneth John Conant, *Arquitectura románica da Catedral de Santiago de Compostela*, trans. J. G. Beramendi (Santiago de Compostela, 1983).

——, *Carolingian and Romanesque Architecture, 800–1200* (Harmondsworth, 1959).

——, *The Early Architectural History of Santiago de Compostela* (Cambridge, Mass., 1926).

John Crook, *The Architectural Setting of the Cult of Saints in the Early Christian West, c.300–1200* (Oxford, 2000).

Linda Kay Davidson and Maryjane Dunn-Wood, *Pilgrimage in the Middle Ages: A Research Guide, Garland Medieval Bibliographies* (New York, 1993).

——, *The Pilgrimage to Santiago de Compostela: A Comprehensive Annotated Bibliography, Garland Medieval Bibliographies* (New York, 1994).

Paul Deschamps, "Notes sur la sculpture romane en Languedoc et dans le Nord de l'Espagne", *Bulletin Monumental* 82 (1923), pp. 305–51.

Marcel Durliat, "The Pilgrimage Roads Revisited?," *Bulletin Monumental* 129:2 (1971), pp. 113–20.

——, *La Sculpture romane de la route de Saint-Jacques de Conques á Compostelle, Comité d'études sur l'histoire de l'art de la Gascogne* (Mont-de Marsan, 1990).

J. Eade and M. J. Sallnow, eds., *Contesting the Sacred: The Anthropology of Christian Pilgrimage* (London, 1991).

Camille Enlart, "L'Architecture romane," in André Michel, ed., *Histoire de l'art depuis les premiers temps chrétiens jusqu' à nos jours*, 1, 2 (Paris, 1905), pp. 1–588.

F. Fita y Colomé and J. Vinson, eds., "Le Codex de St. Jacques, Livre IV", *Revue de linguistique et de littératures comparées* 15 (1882).

David Freedberg, *The Power of Images* (Chicago, 1989).

Georges Gaillard, *Les Débuts de la sculpture romane espagnole: Leon, Jaca, Compostelle*, (Paris, 1938).

Emmanuel Garland, "Le Conditionnement des pèlerins au moyen-âge: l'example de Conques," *Les Cahiers de Saint-Michel de Cuxa* 29 (1998), pp. 155–75.

Marie-Madeleine Gauthier, *Routes de la foi* (Fribourg, 1983).

Paula Gerson, "Le Guide du pèlerin de Saint-Jacques de Compostelle: auteurs, intentions, contextes", *Cahiers de Saint-Michel de Cuxa* 31 (2000), pp. 5–16.

Paula Gerson, Jeanne Krochalis, Annie Shaver-Crandell, and Alison Stones, *The Pilgrim's Guide: A Critical Edition*, vol. I: *The Manuscripts*, vol. II: *The Text* (London, 1998).

Manuel Gómez Moreno, *El Arte románico español. Esquema de un libro* (Madrid, 1934).

Cynthia Hahn, "Seeing and Believing: The Construction of Sanctity in Early Medieval Saints' Shrines," *Speculum* (1997), pp. 1079–106.

Joan Holladay, "Tombs and Memory: Some Recent Books," *Speculum* 78:2 (2003), pp. 440–50.

Dieter Jetter, *Das Europäische Hospital: von spätantike bis 1800* (Cologne, 1986).

A. M. Koldeweij, "Lifting the Veil on Pilgrim Badges," in Jennie Stopford, ed., *Pilgrimage Explored* (Woodbridge, 1999), pp. 161–88.

——, "Pilgrim Badges Painted in Manuscripts: A North Netherlandish Example," in K. van der Horst and J.-C. Klamt, eds., *Masters and Miniatures, Proceedings of the Congress on Medieval Manuscript Illumination in the Northern Netherlands* (Doornspijk, 1991), pp. 211–18.

Sabine Komm, *Heiligengrabmäler de 11. Und 12. Jahrhunderts in Frankreich: Untersuchung zu Typologie und Grabverehrung* (Worms, 1990).

Kurt Köster, "Insignes de pèlerins et objets de devotion," in *Rhine-Meuse, art et civilization, 800–1400*, ex. cat. (Cologne and Brussels, 1972), pp. 146–60.

——, "Kollektionen metallener Wallfahrts-Devotionalien und kleiner Andachtsbilder, eingenärt in spätmittelalterliche Gebetbuch-Handschriften," *Erlesenes aus der Welt des Buches* (Weisbaden, 1979), pp. 77–130.

Elie Lambert, "Ordres et confrèries dans l'histoire du pèlerinage de Compostelle," *Annals du Midi* 55 (1943), pp. 369–403.

Stephen Lamia, "Souvenir, Synaesthesia, and the sepulcrum Domini," in Elizabeth Valdez del Alamo with Carol Stamatis Pendergast, eds., *Memory and the Medieval Tomb* (Aldershot, 2000), pp. 19–41.

Stephen Lamia and Elizabeth Valdez del Alamo, eds., *Decorations for the Holy Dead*, International Medieval Research 8. Art History Subseries 1 (Turnhout, 2002).

A. Lavergne, *Les Chemins de Saint-Jacques en Gascogne* (Bordeaux, 1887).

Thomas W. Lyman, "The Pilgrimage Roads Revisited," *Gesta* 8:2 (1969), pp. 30–44.

Michael McGrade, "Affirmations of Royalty: Liturgical Music in the Collegiate Church of St. Mary in Aachen, 1050–1350" (Ph.D. thesis, University of Chicago, 1998).

Emile Mâle, "L'Art du moyen-âge et les pèlerinages," *Revue de Paris* (1920), pp. 767–802.

——, *L'Art religieux du XIIe siècle en France. Étude sur l'origine de l'iconographie du Moyen Âge*, 7th edn. (Paris, 1966 [1922]). See the English translation with updated notes.

——, *Religious Art in France, The Twelfth Century. A Study of the Origins of Medieval Iconography*, trans. Marthiel Mathews, ed., Harry Bober (Princeton, 1978).

Géraldine Mallet and Patrick Perry, "Les Tombeaux de saintes à l'époque romane: quelques examples," *Les Cahiers de Saint-Michel de Cuxa* 29 (1998), pp. 113–20.

Ruth Mellinkoff, *Averting Demons: the Protective Power of Medieval Visual Motifs and Themes*, 2 vols. (Los Angeles, 2004).

Scott B. Montgomery, "Mitte capud meum . . . ad matrem meam ut osculetur eum: The Form and Meaning of the Reliquary Bust of Saint Just," *Gesta* 36:1 (1997), pp. 48–64.

Serafín Moralejo Alvarez, "San Martín de Frómista en los orígenes de la escultura románica europea," Jornadas sobre el románico en la provincia de Palencia, 5–10 agosto de 1985 (Palencia, 1986), pp. 27–37.

Serafín Moralejo Alvarez and Fernando López Alsina, eds., *Santiago, Camino de Europa, Culto y cultura en la peregrinación a Compostela*, ex. cat. (Santiago de Compostela, 1993).

Laura Good Morelli, "Medieval Pilgrim's Hospices on the Road to Santiago de Compostela," 2 vols. (Ph.D. thesis, Yale, 1998).

Ben Nilson, *Cathedral Shrines of Medieval England* (Woodbridge, 1998).

——, "The Medieval Experience of the Shrine," pp. 95–122, in Jennie Stopford, ed., *Pilgrimage Explored* (Woodbridge, 1999).

Arthur Kingsley Porter, "Leonese Romanesque and Southern France," *Art Bulletin* 9 (1926), pp. 235–50.

——, *The Romanesque Sculpture of the Pilgrimage Roads*, 10 vols. (Boston, 1923).

——, "Spain or Toulouse? and other Questions," *Art Bulletin* 7 (1924) pp. 3–25.

Amy Remensnyder, "Legendary Treasure at Conques: Reliquaries and Imaginative Memory," *Speculum* 71 (1996), pp. 884–906.

——, "Un Problème de cultures ou de culture? La statue-reliquaire et les jocas de sainte Foy de Conques dans le Liber miraculorum de Bernard d' Angers," *Cahiers de civilization médiévale* 33 (1990), pp. 351–79.

Santiago de Compostela: 1000 ans de Pèlerinage Européen, ex. cat. (Ghent, 1985).

Annie Shaver-Crandell, Paula Gerson, and Alison Stones, *The Pilgrim's Guide to Santiago de Compostela: A Gazetteer* (London, 1995).

Pamela Sheingorn, *The Book of Saint Foy* (Philadelphia, 1994).

Ellen Shortell, "Dismembering Saint Quentin: Gothic Architecture and the Display of Relics," *Gesta* 36:1 (1997), pp. 32–47.

Roger Stalley, *Early Medieval Architecture* (Oxford, 1999).

Jennie Stopford, ed., *Pilgrimage Explored* (Woodbridge, 1999).

Neil Stratford, "Le Mausolée de Saint Lazare d'Autun," *Le Tombeau de Saint Lazare et la sculpture romane à Autun après Gislebertus*, Ville d'Autun, Musée Rolin, 8 June–15 September 1985 (Autun, 1985), pp. 39–41.

Jonathan Sumption, *Pilgrimage: An Image of Medieval Religion* (London and Totowa, 1975).

Tim Tatton-Brown, "Canterbury and the Architecture of Pilgrimage Shrines in England," in Colin Morris and Peter Roberts, eds., *Pilgrimage: The English Experience from Becket to Bunyan* (Cambridge, 2000).

Victor Turner, *Blazing the Trail: Way Marks in the Exploration of Symbols*, ed. Edith Turner (Tucson, 1992).

Victor and Edith Turner, *Image and Pilgrimage in Christian Culture: Anthropological Perspectives* (New York, 1978).

Elizabeth Valdez del Alamo, "Ortodoxia y Heterodoxia en el estudio de la Escultura Románica Española: Estado de la cuestión," *Anuario del Departamento do Historia y Teoría del Arte*, UAM, 9–10 (1997–8).

John W. Williams, "La Arquitectura del Camino de Santiago," *Compostellanum* 29:3–4 (1984), pp. 267–90.

——, "'Spain or Toulouse?' A Half Century Later: Observations on the Chronology of Santiago de Compostela," Actas del XXIII Congreso Internacional de Historia del arte, Granada, 1973, I (Granada, 1976), pp. 557–67.

"The Scattered Limbs of the Giant": Recollecting Medieval Architectural Revivals

Tina Waldeier Bizzarro

In 1813, the English antiquary William Gunn referred to the Roman *spolia*, reused to formulate round-styled buildings throughout Europe, as "the scattered limbs of the giant," poorly reassembled. Launching the theme that Mary Shelley's novella, *Frankenstein: The Modern Prometheus* would treat five years later, Gunn inaugurated the most significant corporal metaphor for nineteenth-century historicism: an organism assembled from the dead remains of the past – recharged, resuscitated, and rendered monstrous. Gunn's large corpus of Romanesque buildings appeared to him very like the hybrid behemoth brought to life by science's antihero, Victor Frankenstein. They were massive, deformed, inhumanly proportioned, gloomy, and recollected from Roman leftovers, with human industry, nearsightedness, and *naiveté*.[1]

Both the beast and the beastly Romanesque were baptized and reified as products of nineteenth-century historicist understanding, an ontology in which all creation arose a priori from the past and was ineluctably bound – morally, genetically, and stylistically – to its origins. This historical perspective provided the psycho-philosophical scaffolding and link not only for the understanding of the round-arched style, but also for the nineteenth-century revival of medieval architecture and its concomitant historiography. Medieval architectural styles, Gunn reckoned, *were the first revivals* – albeit monstrous – *of Classical Roman forms*.

It was not the antiquaries' tomes, however, but the *roman*, a product of early modern Europe, which proved the most fertile aesthetic and critical battle-ground upon which medieval architecture and civilization died, was resurrected,

and transmogrified, like Frankenstein's hybrid. Thirteen years after Gunn, Victor Hugo published his robust *Notre-Dame de Paris*, a novel which quickly became a monument in its own right, establishing itself as a pre-eminent medievalizing text. Hugo was among the first and arguably the most significant French writer to revive and sculpt the medieval, textually positioning his audience both literally and figuratively above his lost medieval stone hulk. The period of *media aetas* had come to a close in 1830, 348 years, 6 months, and 15 days after the inaugural events of the novel in 1482. The fabric of time had been rent. In reviving the moribund medieval, Hugo had perforce to refashion it, and his romantic vision of medieval architecture and society still commands us.[2]

Victor Hugo was more romanced by the dark, inscrutable forces of medieval buildings than edified by their rational structure. Into the dense and exotic web of *Notre-Dame*'s medieval fabric, Hugo wove his own monster – hunchbacked, mute, splay-footed Quasimodo, the embodiment of the primitive Romanesque crypt. Esmeralda, the gypsy enchantress, personified its more popular Gothic features. Hugo's beloved pile became a synecdoche for all medieval churches, at once horrific and sublime, lugubrious and joyfully transcendent, symbolic of eternal paradise and the gulf of hell. It was the avatar of Christian sacred space until suppressed by Gutenberg's book.[3]

For this novelist and incisive architectural critic, *Notre-Dame* was stylistically transitional, with its Romanesque base and Gothic middle, each characterized by its generative design element. The crushing incubus of the round style's broad and massive barrel vault, glacially nude and majestic in its simplicity, formed a cave-like, nearly Egyptian architectural space. This face of Janus looked back and spoke to the political authoritarianism and resolute theocracy of *Roman* Catholicism. Notre-Dame's Gothic "upper torso," tall, airy, and penetrated by color, was the intrepid, unbridled, bourgeois, and democratic product of modern France.[4] Hugo's antitheses internationally reoriented medieval architectural criticism and defined the critical rubrics not only for Romanesque and Gothic architecture, but also for their nineteenth century revival styles.[5] Hugo's novel became the most widely read book in France; his interpretation of medieval architecture seeped into the collective unconscious and, in little time, became common international currency.

This clinical retrovision of the early years of the European nineteenth century, this art of looking backward for inspiration, occurred because the fabric of tradition and memory had been ruptured, and the speed of time had increased. Man's relationship to the past was no longer as casual and familiar as it had previously been, and man's connection to the past weakened as he excavated it. This nascent medievalism, which became a pervasive cultural phenomenon, was a self-conscious experiment, away from the centrifugal Classical center of ritualized architectural patterns, forms, and meanings. A certain degree of aesthetic schizophrenia set in, in which the traditional Classical object of pleasure was shunted aside, and the medieval, unnatural and supernatural, incorporated opposition into its aesthetic. Neo-medieval construction became asexual or inert,

and the spectator was guilt-ridden with fear of the new replica. One new factor responsible for the change in critical attitudes was Christianity. Restored after the schisms of the Reformation and the French Revolution, it forced redemption into the future and determined a critical nexus of anxiety throughout medieval revival historiography.

The novel and historiography marched hand-in-hand in the Romantic era, both with a prophetic dimension, celebrating the essential relativity of life and history. Both stood weeping, to paraphrase Panofsky, at the graveside of the Middle Ages, hoping to resurrect its soul. Historicism, the belief that history marches on in a clear pattern guided by visionary leaders and divine providence, directing us closer to an ultimate goal, was the defining ideal of both. It was within this philosophical context of the unity of historical phenomena in an evolutionary pattern of deliverance, promising the unique identification of the nation, that medieval revival became possible and forced changes in historiographical patterns.

The architectural metalanguage of criticism continued to prioritize the Classical architectural legacy, albeit periodically *sotto voce*, and concomitantly directed critical opinion against medieval revivalism. It is out of the tension between the popular, romantic craving for the historicizing medieval and the established textual and academic culture of Classical architecture that clear principles regarding exclusion and inclusion of medieval revival developed *c.*1820. This tension is at the center of any investigation of medieval revival criticism.[6] The fluidity of historical memory – relative, redefined by time and type, and representative of various types of memory – shapes perception. The ethos of a building or type of buildings is, in some form of intellectual and psychological addition or multiplication, the sum of the critical accounts or memories of it. These contentions direct an investigation of the shifting critical issues which came to bear on medieval revival styles.

Back to the Medieval Future or A "Theatre of Outworn Masks"?

Constructs of historicism undergirded stylistic manifestations. Until recently and despite its century-long volume of pan-European, American, and other national production, nineteenth-century architecture, patronizingly classified as historicist, has been dismissed by listings and datings, which categorized its multivalent revivals under ambivalent rubrics. Somehow, neo-medieval creations were mistakes architects would not have made had they seen into the crystal ball of modernism. Today Viollet-le-Duc, Ruskin, Pugin, and Revival architects of *c.*1780–1920 are not so easily dismissed.[7]

Gothic architecture, which is currently determined as the European and continental pointed style of the mid-twelfth through the fifteenth centuries, has had a more resolved and independent, if not positive, critical history than its

Romanesque predecessor of *c*.1000–1150. Their critical histories, and to a large degree their stylistic characteristics, remained conjoined and conflated under the common portmanteau, "Gothic," through 1820.[8] No sooner had the fork in the historiographical road divided them by name than their critical fates diverged, and they were chosen as model architectural languages in which to tell a nineteenth-century story. Gothic Revival dominated that of its ugly, dumpy, round-styled sister, now rendered nearly invisible through anonymity, despite astute critical and visual sources from the fifteenth century onward, that had singled her out as the older, more residually classical, medieval style.

Charles Eastlake's groundbreaking analysis of the Gothic Revival in England defined the terms of a critical dialogue which dominated architectural literature until about a generation ago, vis-à-vis characterization, periodization, and aesthetic verdict.[9] For the discerning Eastlake writing in the thick of Victorian eclecticism, the revival of pointed architecture in England *c*.1780 was not simply an episode in the history of taste but rather the British national style destined to supersede all others. Architectural expression of "an age when art was pure and genuine," the Gothic became, for the next century, the architectural quintessence of England, whose history and institutions had descended in a continuous pattern from their murky medieval source.[10]

Eastlake determined a first "survival" phase from *c*.1600 to 1750, when English architects such as James Essex set to restoring their moldering Gothic legacy, and when others continued to build after pointed-style models. Secondly, he traced an underdeveloped, unselfconscious, pre-Puginian revival from *c*.1750 to 1840, a revival without archaeological pretension, induced by Horace Walpole and punctuated by James Wyatt. During this period, architects like John Nash, Robert Smirke, and Thomas Rickman, who were not concerned enough with "correct, honest Gothic building," often produced "melancholy" results.[11]

Eastlake's third watershed period occurred when the talented Charles Barry, assisted by A. W. N. Pugin, rebuilt London's neo-Gothic Houses of Parliament (1840–88) and when illustrated professional weeklies such as *The Builder* (1843) began not only to advance the taste of architectural students and the general public for this new style but also to lay a foundation for its more scholarly treatment. G. G. Scott, Matthew Hadfield, and Richard Carpenter, et al., emerged as competent in the neo-Gothic mode. Finally, Eastlake traced a period from about 1860 to 1870 during which the number of Gothic Revival buildings nearly doubled over those built in the preceding decade. By then, claimed Eastlake, "the grammar of an ancient art . . . (had been) mastered."[12]

Every cause has its martyrs, but before 1928, the Gothic Revival had fewer than most. In the 56 years between Eastlake's seminal assessment and Clark's Revival monograph, there was no significant text in English interpreting England's neo-Gothic legacy. In order to fill this critical lacuna and to raise the Revival to a level of critical significance, Clark, while not relieved of the aesthetic force of Eastlake's formulations, introduced several new concepts which pivoted scholarship in new directions for the next 75 years. The most consequential were

his pronouncements that not only was the Gothic Revival "the most widespread and influential artistic movement which England . . . [had] ever produced," but also "perhaps the one purely English movement in the plastic arts."[13] These many neo-Gothic monuments, "monsters . . . unsightly wrecks stranded upon the mud flat of Victorian taste," deserved to be excavated from their critical neglect and studied as historical documents, "irrespective of their beauty."[14] The more art-historically objective Clark alleviated the neo-Gothic of two centuries of critical opprobrium, precisely *because* it had once captivated England's aesthetic imagination.

The Houses of Parliament, "the first neo-Gothic buildings which . . . [England] can call great," transformed the style from a popular, non-professional experiment in cottage-building, or "pure Batty Langley" to a national, English style.[15] Clark thus positioned the Revival critically front and center. The aesthetic ambivalence toward Gothic since fifteenth-century Italian criticism had relegated it to history's critical basement was reconciled within Clark's nationalizing assessment.[16] While Clark reiterated pejorative appraisals, dubbing London's previously acclaimed Houses of Parliament, "a great necropolis of style," he redirected art historical commentary. By accounting for neo-Gothic "mistakes" as perhaps lifeless and derivative, but ultimately respectable due to their significance for a nineteenth-century audience, he argued their importance as reflections of England's national and religious, post-Puginian sentiment. Clark thus placed himself firmly within the nineteenth-century linguistic dialogue regarding the origins and nature of style, critically oriented away from Vitruvian notions of architecture as natural, monogenetic, and cyclical. Instead, operating within a still-current paradigm of architecture as language, Clark viewed style as socially or behaviorally determined and as representative of the behavior and society of man and not his genetic roots.[17]

Herein lay Clark's trailblazing critical impact. Clark assessed Gothic Revivalism as a movement, intrinsic to English society, an idea foreign to the historicizing eighteenth- and nineteenth-century consciousness and rooted within his early twentieth-century critical context. Furthermore, Clark rewrote Eastlake's account of Pugin as a Catholic villain who recognized the principles of good architecture but who perverted them to the service of religious bigotry. Establishing Pugin's historical importance as a revival apologist, Clark argued that Pugin had fortified the Gothic with principles of a Christian socialist nature because he had understood how Gothic Revival architecture functioned as a symbolic vehicle for promoting religious and social views; not all Revivalists had followed the rules of honesty and truth to structure which Pugin had set forth in his *Contrasts* (1836) and in his *True Principles* (1841). In pleading for an architectural rationale based on truth, honesty, and economy in materials, structure, and decoration, *Pugin had connected art with morality.*

Pugin's Revival *apologia* became a foundation for later nineteenth-century rationalist theories in England and France as well as a preamble to the modern movement. Following Eastlake, Clark certified that for better or critical worse,

neo-Gothic was a way-station on the road to modernism and that Pugin's philosophical dicta had forged this connection. Pugin, the modern Vitruvius, granted architecture a new moral standard. From the late nineteenth through the middle of the twentieth century, pioneers of architectural modernism from Great Britain's Morris, Shaw, Webb, and Mackintosh, to Belgium's van de Velde, Austria's Wagner and Loos, and America's Wright, worked their way through Gothic Revival architecture to arrive at sound, modern concepts of design informed by Puginian and Ruskinian philosophy. Architectural historians from Clark to Hitchcock and Pevsner established this. These two dicta changed not only the course of Revival criticism but also that of modern architectural criticism.

Although the "picturesque Gothic Revival" before Pugin abounded in examples of castles with dysfunctional portcullises and drawbridges, Clark noted that after 1840, the severity of Pugin's, the Ecclesiologists', and the Cambridge Camden Society's "ethical Gothic Revival" righted the wrongs of the adolescent neo-Gothic. "For such ideas," argued Clark, "Pugin deserves our gratitude."[18] Clark underlined, *de nouveau*, the importance of the theologically rigorous Oxford Movement and Cambridge Camden Society, that small, pietistic architectural society which generated two important Revival precepts: the importance of sacramentality (a prescriptive, functionalist, clerical view which militated for architectural features best facilitating the liturgy and worship), and the conviction that honest architecture could only result from the handicraft of honest men.[19] Emblazoned in their motto, "Good men build good buildings," this ideal determined critical thinking. Henceforth, the builder's moral sentiment, like that of the virtuous medieval mason, came directly to bear on architecture's style, morality, and ultimate value. The international history of the Arts and Crafts Movement through the buildings of Le Corbusier and F. L. Wright cannot be understood without reference to this critical Revival watershed; henceforth, the reform of art led the reform of society.[20]

Finally, Clark carefully defined the critical contribution of that apostle of taste, John Ruskin, to medieval Revival. Ruskin's accessibility, eloquence, and international popularity ranked him as a chief Victorian architectural critic and apologist.[21] The Protestant Ruskin succeeded in "disinfecting Gothic architecture" by disassociating it from Rome. Even though Ruskin was antagonistic to the Gothic Revival at mid-century, he was remembered by Clark and until today as one of the originators of Revival doctrines. Like Pugin, Ruskin inspired contemporary architects to build strong, honest, articulated structures. He differed, however, in one particular point which would define an important dialectic of modern architecture: *ornament*. Less was not yet more for the Victorian Ruskin. To add some medievalizing chimneys or to vary the size of a building's many ogival windows was, for the sensitive and neurasthenic Ruskin (who sneered at Paxton's Crystal Palace), to give a building style.[22] Clark's readers are left with a bittersweet taste for the failed Gothic Revival. Though it "changed the face of England . . . [with its] Gothic lodging-houses, and insurance companies, [its]

Gothic everything . . . [it left behind] a wilderness of deplorable architecture."[23] Taste would not swing back from the horizontal to the vertical until the early twentieth century.

A mid-century landmark architectural history, H. R. Hitchcock's volume on the nineteenth and twentieth centuries represents critical thought on neo-medieval architecture through the 1970s. Developing out of what Hitchcock termed "Romantic Classicism," formed between 1750 and 1790 in France and exported throughout the US, Europe, and Russia, all nineteenth-century architecture fell roughly under this catchall rubric – including the countercurrent "picturesque" and medieval revivals. Revival styles were considered "aberrations" which launched the "chaos of nineteenth-century eclecticism."[24] Despite Clark's apologetic legacy, these neo-styles horrified Hitchcock and his generation, enamored, by mid-century, of architecture's modern movement.

Only the study and exploitation of new materials culminating *c.*1850 lay outside the realm and aesthetic of revivalist modes for Hitchcock, as it had for Pevsner, and represented modern architecture's salvation. Hitchcock blamed some of the neo-Gothic frivolity on its patrons, who requested it as a cheaper alternative to the "more noble Grecian." Whether Gothic church, baronial manor house, or castellated prison or bridge, neo-Gothic was aesthetically cast as indecorous, indistinct, and inappropriate. It had, Hitchcock agreed, improved during the 1830s, according to the legitimizing principles of the "Romanist" Pugin's *Contrasts* (1836) and had become brittle and absolute after 1840 with the Anglican Church's doctrinaire application of Pugin's principles. Only with Barry's Houses of Parliament did the Gothicists accomplish, proclaimed Hitchcock echoing Eastlake, "one of the grandest academic products of the nineteenth century."[25]

Characteristic of his taxonomically driven, formalist generation and of the continued aesthetic ambivalence toward the neo-medieval, Hitchcock generated a plethora of new stylistic terminologies for the neo-Gothic offshoots of his "Romantic Classicism": Georgian Gothick, Late Georgian Picturesque, Norman, Rustic Cottage, Italian Villa, pre-Victorian, Early Victorian, Puginian Gothic, High Victorian Gothic, and Queen Anne. All of these rubrics variously applied to a neo-Gothic mode which had "accepted": irregularity, variety of silhouette, coloristic decoration, plastically complex organization, textural exploitation of traditional rustic materials, and a picturesque point of view.[26] Hitchcock appreciated the functional doctrines of the Gothic Revival and its devotion to honest expression. We must build in a certain way, he argued, because it is right, not because it is pleasing.

Michael Charlesworth's 2002 study addressed English Gothic novels, architecture, and medieval architectural criticism in a three-volume interdisciplinary compilation, rare in Revivalist literature. One new idea emerging from this magisterial anthology is that violence committed against the monastic orders, medieval architecture, and the Catholic population of Reformation England engendered a collective guilt which appeared in latent and symbolic form in the

Gothic novel and in literature on the Revival. Gothic architecture, Charlesworth argued, was a setting conducive to the dramatic play of guilt and produced, in these dark novels of *c.*1760 through 1820, spectacular cruelty and heinous crimes. The mythic Gothic castle, a bridge to the past riddled with horror, was the literary *scaenae frons*, for this play of bad conscience. Gothic Revival architects, in a desire for distance from associations of crime, transgression, and cruelty, created an antiseptic neo-Gothic which mimicked and recalled the old but was physically and chronologically free of the former's guilt.

Many international scholars who investigated the origins of the Gothic allied themselves to this architectural revival cause, affecting the debate in a way that favored the architect's whitewashed neo-Gothic. Based on his vast compendium of sources, Charlesworth argued that the English, more than any other nation, raised the stakes of the Revival and, in order to sustain its literary thrust, transformed it into a living experience – from dressing up like monks à la Sir Francis Dashwood for evenings of drinking at Medmenham Abbey, to surveying surviving monasteries, to building neo-Gothic buildings with emotion, religious feeling, and in the chaste and honest spirit of the medieval craftsman.[27] Eventually, the neo-Gothic became a way of life through Pugin, Ruskin, and onto William Morris, father of the modern movement.

The Gothic Revival was a more important and complex issue in Protestant countries, including the United States and Australia, where Catholic religion and thought had been either extirpated and replaced or never cultivated across a wide portion of the population.[28] Medieval revival came to bear differently on each nation in a complex mix of politics, religion, and national identity, and the history of the Gothic Revival in Catholic France was very different from its English, German, or American counterpart. The suppression of things medieval, aristocratic, or ecclesiastical during the French Revolution came much later to France than had the Reformation to England. This delayed the spirit of revival until the years around 1830, when the taste for renewal was ripe and in large part borrowed or imported from England.[29] Additionally, the French medieval revival manifested itself rather in an intense program of restoration, often resulting in almost complete rebuilding.[30]

Neo-Romanesque: The Ugly, Dumpy, Elder Sister or Avatar of Modernism?

During the high noon of the English neo-Gothic, the *Ecclesiologist* militated for a more functional Gothic church. The prescriptive nature of the Gothic Revival affected the revival of Romanesque architecture which had neither a champion like Pugin or Ruskin nor was promulgated anywhere by a society with a written platform. Associated with a lack of Gothic sophistication, the neo-Romanesque, pan-European like its mother style, developed between *c.*1830 and 1910 throughout England, Europe, the US, and elsewhere. In an ironic twist of critical fate,

adaptive neo-Romanesque forms – though given much shorter historiographical shrift – outlived their Gothic forebears and became the structural bearers of meaning for the modern movement.

Early nineteenth century definitions of the Romanesque stressed its two unifying cultural characteristics. First was its *romanitas*, as emerging nations of Europe were united in the development of a civilization which was substantially defined by imperial Roman ideals, laws, and architectural forms. Second, a Romanesque melting together of antique Roman and Christian forms effectuated a quintessential historicizing moment when antique forms became infused with new meaning – as Gunn had explained for England and de Gerville had claimed for France.

Terminological ambivalence accounts for the early critical vacuum. Romanesque encompassed and was called by its alternative labels: Byzantine, Lombard, Norman, Saxon, Rhenish, and *Rundbogenstil*. In today's scholarship, discussions of the neo-Romanesque still suffer by association from what the French antiquary Gidon termed, "*la maladie de la nomenclature.*"[31] Far less culturally determined, far more elusive of definition and origin, and far more geographically widespread, the "primitive" Romanesque was beset by the same critical issues as its distant "Roman" relative. Doomed to chronic inferiority by historicizing, neo-Classical theorists who judged any post-antique or post-Renaissance style as devolved from the Classical ideal, medieval and neo-medieval architecture remained prisoners of this perspective through a scholarly generation ago.

Another complicating factor was the Romanesque sculptural program which has traditionally been conceived of as integral to, defined by, and defining of its architectural context.[32] Another ascribed Romanesque stylistic characteristic was its integration of a large-scale sculptural program within its monumental space for the first time since Roman antiquity. Despite this international understanding, Romanesque architecture has traditionally been separated from its accompanying sculptural program in critical discussion. Its hydrocephalic heads and stocky bodies, its uncanonic "orders," and its wild effusion of unruly, flattened, plant ornament created a house of natural horror. Strangling and overwhelming its station, Romanesque sculpture and ornament had no comfortable place within Classical terminology or taxonomy. The easiest way to deal with these strange bedfellows was to separate sculpture from discussions of its historicizing albeit devolved architectural setting.

Christianity had disturbed the harmony between man and nature; it had upped the Classical ante by claiming a higher spiritual value and realm than man's natural state. This dichotomous, idealistic belief system undermined the very basis of Classical architecture – a system designed to reflect a balanced, body-centered belief in its anthropocentric, modular, symmetrical proportions. The passionate struggle for grace and against sin informs medieval sculpture, which displays incoherent, fragmented, subversive, inauthentic, and polychromatic fantasy.[33]

The Romanesque Revival is best traced in predominantly Protestant Germany and the US, where its political uses presented newly empowered groups with forms expressing change within a traditional architectural language and value system. The Romanesque Revival developed, stimulated by and within the shadow of Gothic Revival. It reflected a renewed international appreciation of medieval forms manifest in: the restoration and preservation of medieval buildings, the organization and institutionalization of the architectural establishment and journals from 1830 on, increased travel, and developments in photography.[34] However, no major definition of neo-Romanesque appeared in the journals spawned by this movement.

Between 1846 and 1876, most American architecture was round-styled. Qualitatively the most significant nineteenth-century style, it has been ignored in much critical literature, perhaps because many examples of neo-Romanesque have been demolished. Terminological ambivalence has not facilitated consistent classification and study. The historiography of the neo-Romanesque was launched with Robert Dale Owen's praise of James Renwick's design for Washington's Smithsonian Institution (1846), which style, Owen heralded, deserved being "named as a National Style of Architecture for America."[35] For Owen and other early commentators, neo-Romanesque fulfilled the American aesthetic desiring picturesque irregularity, flexibility, economy, simplicity, and Republicanism. It was not too fancy or exotic a stylistic or decorative choice. Owen credited the Englishman Thomas Hope and subsequent antiquaries as having predisposed German, English, and hence American taste for the round style.[36]

By 1842, the neo-Romanesque was suggested as a model for "occasional adoption" in the US and England, as illustrated in the work of R. Upjohn, who "converted" to Romanesque with his Church of the Pilgrim in Brooklyn. Emerging proponents of this style advocated its classic beauty, durability, relative economy of materials, and rapid execution. The 1853 publication of the Congregationalist Church's *Plans for Churches* signaled "America's testimony to neo-Romanesque popularity."[37] While developing architectural journals discussed Romanesque Revival, there was no commanding historical or aesthetic stylistic assessment until the mid-twentieth century. Mary Woods accounted for Americans' sidelining of the discussion of past historical styles and their relative value until *c.*1920–50 claiming its divisiveness and that Americans were more concerned with the "dangers than the privileges of history."[38] Works such as Samuel Sloan's *City and Suburban Architecture* indicated the incipient popularity of the round style in American secular building.[39]

C. L. V. Meeks's article was the first monograph on the American neo-Romanesque, establishing the architects involved and a chronology and typology of American neo-Romanesque buildings, classifying them as round-arched with Lombard bands and arcades resulting in either "Byzantine" or "Norman" styles, or as "Italian Villa," a round-arched style combined with pilasters and entablatures. On the basis of little previous incisive scholarship,

Meeks determined the primary building types in the round-arched style: churches, governmental buildings, markets, retails stores, homes, hospitals, schools, railroad stations, and churches of non-liturgical Protestant congregations such as Congregationalists, Methodists, Unitarians, and Presbyterians.[40] Probing the nature and rationale of America's choice of the round-style, Meeks determined its inherently easier design process, its relative lack of detail, and the consequent ease of establishing archaeological "correctness" in this more "stripped down" neo-style. Meeks suggested Germany's *Rundbogenstil* revival as a source of American stylistic appreciation.

Most recently, P. Kent's comparative overview of revival literature from 1830 to 1910 classified Romanesque Revival as a complex international movement, which varied from country to country and region to region, with its years of greatest popularity between 1875 and 1900. Relying on the few studies since mid-century, Kent defined neo-Romanesque as a style which provided newly empowered groups with architectural options and legitimacy, and characterized its stylistic polarities: primitive and progressive; crude and artistic; nationalist and internationalist; legitimate and subversive.[41] Neo-Romanesque forms served in developing an industrial architectural idiom for American urban centers. This resulted in buildings clad in medievalizing forms. Increasing numbers of building types converted to or were conceived of, *de novo*, in the neo-Romanesque. Kent enlarged Meeks's building type list with warehouses, hotels, office blocks, art galleries, and natural science or ethnographic museums. What these types shared was their need to accommodate new forms within progressive, innovative designs. The "commercial deployment" of the neo-Romanesque ran on the wheels of urban, industrial, commercial, and financial progress.[42]

The signature neo-Romanesque of the Beaux-Arts-trained Henry Hobson Richardson, a highly rusticated, irregularly and compactly massed, Francophilic style, took the US by storm and lent legitimacy to the round style there and abroad. Richardsonian Romanesque (*c.*1870–90) was, however, "but a flower on a well-rooted stalk," as Richardson had derived much from American architectural developments.[43] The revived round style had become critically associated with American qualities of rugged individualism, innovation, entrepreneurialism, and industry. Richardson and Chicago School architects such as Sullivan, Burnham, and Root accommodated new building types to this secure, classically resonant, divested medieval style. A happy marriage of simple form and practical content took place. Thrifty, seasoned, and pragmatic, the neo-Romanesque was the environment and signature of the solid American marketplace.[44] From today's perspective, the vitality of the Romanesque continues, as it plays a distinct and significant role, having seeded ideas of postmodernism.

Rundbogenstil, a German stylistic epithet designating the early nineteenth century revived round style of Germany and central Europe, makes no real sense in discussions of Romanesque Revival in the US or English-speaking countries. It has recently become more widely used in English-language publications perhaps because of its simple and broad meaning, its more simple stylistic

characteristics, and because it was coined specifically for the revived epiphany of the German medieval *romanisch.*

While critical commentary regarding the American preponderance for and leadership in the neo-round style resulted of a national inclination for this simpler medievalizing style, the inverse was true for Germany. While the round styles of both nations were similar in many respects in form and composition and while German and American examples resulted in a larger corpus of Revival buildings than anywhere else, the theoretical and political processes that led to these similar results were altogether different.

Early German adoption of and apologies for the *Rundbogenstil* responded to a pervasive national insecurity, rooted in Napoleon's destruction of medieval monuments. *In What Style Should We Build?* was the imperative and interrogatory title of Heinrich Hübsch's book announcing Germany's anxiety over "the crisis of present-day architecture."[45] The resolution to this two-decade long controversy was not to create, *ex novo,* but to imitate in the *Rundbogenstil.* Revival of the round style in Germany was more careful and programmatic than anywhere else, and by 1859 it was touted as the German national product.

The architectural histories of Franz Kugler and disciple Wilhelm Lübke definitively established the *Rundbogenstil* for Germany.[46] For Lübke and for generations to follow, the pure and exact round style, having been engendered by Saxon imperial rule, embodied, "the strong, independent feeling of the German people . . . because . . . [it took] an especially deep root in Germany . . . and sank . . . profoundly . . . into the national life."[47] Politics, theory, and round-style architecture were inextricably bound in Germany's historiographies. In the years following the establishment of the German Empire in 1871, the *Rundbogenstil* became a national choice under Hohenzollern patronage.[48]

Barbara Miller Lane's study on "romantic nationalism" is one of very few significant twentieth-century theoretical studies on German medieval revival. Lane refuted the widely held tenet that modern European architecture resulted in a continuous and linear progression away from historical models and toward modernist styles such as the German Bauhaus. She also took to task the traditional and exclusive association of nationalism with neo-Classicism, providing a compelling account of *Rundbogenstil* revivalism, linked perhaps even more closely to German nationalism, populism, and innovation until well into the 1930s. Focusing on the continuities in German architectural history over the past 130 years, she argued that Germany both valued forms which suggested a distant medieval past as well as tended toward innovation in technology and building design in order to define its modernity.[49] The very burden of its historical discontinuity, Lane argued, led Germany to prioritize medieval *Rundbogenstil* forms.

Kathleen Curran's groundbreaking book on Romanesque Revival in Germany, England, and the US from *c.*1825 to 1875, took the German *Rundbogenstil* as its point of departure. In a complex disentangling of its international historical, religious, and political roots, Curran traced the origins of the first round-styled

revival to the Munich and Karlsruhe of Ludwig I and the architectural theories of Hübsch, and mapped its rapid spread to England and the US.[50] Influential Americans such as R. Dale Owen, Horace Mann, and Henry Barnard sought German architectural models. Curran uncovered an international circle of friends at the epicenter of the early *Rundbogenstil* in Germany and the US, including Hübsch, C. von Bunsen, and Friedrich Wilhelm IV, inter alia.[51] This comprehensive archiving led Curran to determine that the primary patrons of the *Rundbogenstil* were German monarchs and members of the English and American Protestant Church hierarchy. The concerns of these powerful men were both "secular and sacred": to spiritually reinvigorate a Protestant Church threatened by increasing industrialization and to reinvent state institutions.[52]

All stylistic roads led to Rome for budding German medievalists and neo-Classicists – all part of the late Romantic movement. All good nineteenth-century Germans since Winckelmann and Mengs went to drink at Rome's fountain, returning with a thirst to create their own national style. The revival of the round style rode this wave of appreciation for Classical shapes and styles. The thorny debates regarding the developing concept of style were integral to the establishment of the *Rundbogenstil* in Germany. International aesthetic repercussions of this broad subject aside, this matrix generated theories of a national German style based on a mixture of materialist ideas regarding structure, purpose, materials, and technology. Seen within this complex and voluminous literature, the *Rundbogenstil* takes its place as an historicizing episode in German history – no less Frankensteinian than Gunn's or de Gerville's "new" styles. Germany's *Rundbogenstil*, a less slavishly sculptural and more angular style than the French or English, was nonetheless a "monster" whose limbs were more "successfully" surgically fused.

The issue of terminology guided this tower-of-Babel debate as *Rundbogenstil* replaced the current *neugriechische*, *byzantinisch*, and *romanisch* because of its widespread use in English and French. The recent terminological resurrection of *Rundbogenstil* by scholars of German neo-round-styled architecture continues the terminological historiography as Germany and America's national redefinitions continue.[53] All told, the Romanesque Revival of Germany and the US led the insecure German nation and the young American republic toward confident twentieth-century identities.

The history of taste is a history of ways of seeing. This critical review reveals how successive generations valued their medieval legacies and their revivals. The template of our current understanding of medieval and revival architecture was formed when the medieval was first being resurrected, and this double birth continues to inform contemporary architectural style *and* theory. Modern and postmodernist architecture depends on Romanesque and neo-Romanesque spatial achievements, bold masonry work, and architectonic mural surfaces. Our understanding responds to other ideals such as our sensitivity to this moody, medieval place in time and how we envision ourselves vis-à-vis this past – politically, socially, and spiritually.

As quintessential architectural icons of Christianity, neo-medieval styles embodied the religious cradle and matrix of safety, nourishment, and peace in modern revivalist and contemporary memory. This architectural locus of the divine incorporated the first and final anchor, the portal to life and death. The medieval church has become part of the collective typology of the holy, an avatar of spiritual haven. It has become the greatest integrating architectural repository for the thoughts and aspirations of mankind. Our need to chronically revive this archetype of spirituality is fundamental to an understanding of medieval revivals in the West. This is why fairy tales often had medieval architectural environments – to house their battles where good triumphs over evil, in a land far away, once upon a medieval time. Life-sized Romanesque and Gothic sculpture turns us back on ourselves, and in the words of Henri Focillon, humanizes the celestial.

On the other hand, all of life's insecurities come to bear on these stylistic archetypes. The medieval church is the *locus in quo* where death, accident, disease, and loss are mediated. Transformation and transcendence await the faithful in medieval and medievalizing building. For today's student of architecture, medieval and neo-medieval buildings are no longer mistakes that post-Renaissance criticism would have us forget or bury. These buildings, formerly five centuries or so of architectural *faux pas*, were not bad architecture, revived by foolish nineteenth-century architects. They have determined the shape of modern architecture and architectural history due to the historical patterns they established and spurned. We continue our interest in the moldering Middle Ages as the study of who we were informs who we are.

Notes

1 [On *spolia*, Romanesque architecture, and Gothic architecture, see chapters 11, 14, and 18, by Kinney, Fernie, and Murray respectively, in this volume (ed.).]

2 Despite the fact that Prosper Merimée despaired of the novel, and Goethe thought it too schematic, *Notre-Dame de Paris*'s (1831) popular influence was swift and international, undergoing four English translations (1833–9). Gothic novels in England by Walpole and Radcliffe predated Hugo's, but none concerned itself as intrinsically with medieval architectural criticism. In his Revival monograph, K. Clark recognized the considerable literary component of England's Gothic Revival and accounted for its "failure" in its literary over-determination. French critics tended to more intrinsically mix the literary and architectural manifestations of revivalism.

3 Hugo was an initiator of medieval restoration. He took to task the vandals of medieval buildings in *Guerre aux démolisseurs* (1829) and *La Bande noire* (1824), railing against the revolutionary and Bourbon destruction. From 1835 through 1848, Hugo served on the Commission des arts et monuments, re-established after the Revolution to oversee medieval restoration, and he oversaw the restoration of Chartres. See Léon, *La Vie des monuments français* and Emery, *Romancing the Cathedral*, pp. 1–10, in which Emery traced the late nineteenth-century rise in popularity of the cathedral.

4 Hugo, like Gunn and C. de Gerville who invented the neologism, *l'architecture romane* (1818), defined the Romanesque as having been born in the late Roman Empire and having died with the Conqueror. The Gothic ended during the reign of King Louis XI (1461–83). Contemporary French architectural historians, writers, and politicians were quick to follow Hugo's lead and claim the Gothic for France. Ludovic Vitet echoed Hugo's words almost verbatim when he claimed that Gothic architecture was bourgeois, free, French, and Christian (*La République sera chrétienne, ou elle ne sera pas* (Paris, 1874)). F.-R. de Chateaubriand had anticipated and stimulated the mania of the medieval with his *Génie du Christianisme* (1802), extolling Gothic architecture, based more on the vague and mystical *frisson* it produced in the viewer than on its formal qualities. *L'architecture romane* became the logical relative of the eleventh-century French vernacular. The French were, however, more interested in the conservation of medieval monuments than in their revival.

5 With respect to the complex theoretical question of revival vs. survival in architecture, the late eighteenth and early nineteenth centuries were marked by the psychic pain of death and detachment from the Middle Ages. Panofsky's seminal chapter in *Renaissance and Renascences in Western Art*, as well as the collective bulk of neo-Classical literature which prioritizes any Classical manifestation, continued to direct opinion and scholarship on revivalism toward a negative evaluation of the impact and artistic quality of any non-Classical revival. Just as the Carolingian *renovatio* and the twelfth-century "proto-renaissance" were not, according to Panofsky, quantitatively or qualitatively as significant as the fifteenth-century Italian Renaissance, *neither were its artistic manifestations as valid*. Since long before Panofsky and probably since just before Vasari, the Italian Renaissance and Classical antiquity have been incontrovertibly linked. Panofsky confirmed that no good, liberal renascence ignored the universal, Classical past which was unhampered by religious or dogmatic prejudice. I would argue that the crucial difference between the early nineteenth century revivals and that of the Italian Renaissance was not their chronological or philosophical perspective, which was at least as great as that of the fifteenth century, but their level of Romantic self-consciousness, which bred guilt and shame rather than optimism. Unlike the link the Italian Renaissance forged with antiquity, medieval revivals of the modern period did not fashion a golden middle age to which they wished to return. Their interpretation of history was dominated rather by a quasi-religious belief in progress, a quasi-apocalyptic belief in the future which the Middle Ages could inform. Panofsky's ancient and Classical "Arcadia" was now displaced into the medieval future.

6 Even before the medieval revivals of 1780, the neo-Classical movement in which Flaxman, Gunn, David, Quatremère de Quincy, et al. participated, had challenged Classicism as a too-narrowly defined language of structure and decorative elements, initiating an historicizing investigation of the dominant aesthetic of Classicism. Additionally, the expanding parameters of the known world worked to weaken the hegemony of the Classical ideal over others. Lavin, in *Quatremère de Quincy*, investigated the priority of Egyptian architecture in late eighteenth-century architectural criticism. This debate was the battleground for the meta-question of the origins of all Western architecture. Lavin claimed that a new view of architecture's origins resulted with Egypt's archaeological study. This view begged the question of truth in origins as a determinant of the true nature of reality or architectural style and substituted the social, linguistic model which still scaffolds architectural criticism.

7 I must cast my net widely around the critical reception of neo-Romanesque and neo-Gothic, which spanned two centuries and many countries. I have chosen to prioritize English criticism of the neo-Gothic and German and American criticism of the neo-Romanesque for reasons of their predominant and cardinal status, sheer volume of monuments and commentary, and leading architectural trends. While the Gothic was arguably a northern phenomenon, the Romanesque was pan-European and widely exported. The intersection of these two critical corpora, therefore, seemed logical and practical in this context. I have restricted myself to landmark and seminal studies which have fashioned the direction and tenor of architectural criticism.

8 Most educated or sensitive viewers conceived of the round style as a primitive version of the pointed until the mid-nineteenth century when the Gothic Revival was in full swing. See my study, *Romanesque Architectural Criticism*, chs. 1 and 2, for a discussion of the absence of medieval stylistic subdivisions before the seventeenth century. See also Frankl, *The Gothic*.

9 Eastlake's *History of the Gothic Revival* adduced primary sources from the seventeenth through nineteenth centuries.

10 Ibid., p. 71. Eastlake criticized Ruskin for his proposal (*Modern Painters*, 1854), to choose a British national architectural style from among: Pisan Romanesque, *Trecento* Florentine, Venetian Gothic, or English Decorated, objecting to their unworkability and foreign origins.

11 Ibid., p. 95. Rickman's terminology (Saxon, Norman, Early English, Decorated, and Perpendicular styles) in *An Attempt to Discriminate the Styles of Architecture in England* (London, 1817), took quick hold in England.

12 Ibid., p. 372.

13 Clark, *The Gothic Revival*, p. 7.

14 Ibid., p. 7.

15 Ibid., pp. 98, 133.

16 More recently, Germann, *The Gothic Revival* continued Clark's terminological evaluation.

17 See Lavin, *Quatremère de Quincy*, on the link between language and architecture, whose bibliography is lengthy. I cite only a few significant examples in this regard: Dynes, "Art, Language, and Romanesque"; Eco, *Search for the Perfect Language*. McEwen, *Socrates' Ancestor*; Guillerme, "The Idea of Architectural Language."

18 Clark, *The Gothic Revival*, pp. 142–3.

19 The Cambridge Camden Society, founded by Cambridge's Trinity College graduates J. M. Neale and Benjamin Webb, was dedicated to the reform of Church architecture and antiquities, the revival of ritual arrangements, and the restoration of medieval architecture. After its dissolution by the Anglican clergy (1845), the group changed its name to the Ecclesiological Society, continuing to publish its monthly vademecum, *The Ecclesiologist*.

20 One of the first publications of Morris's Kelmscott Press was Ruskin's *Stones of Venice* (1851). Clark, *The Gothic Revival*, p. 202, called Morris's chapter, "The Nature of Gothic," "one of the noblest things written in the nineteenth century."

21 Clark observed that Ruskin, in his prodigious writings (39 vols.), crystallized many critical ideals already formulated by Pugin. Ruskin published his *Seven Lamps of Architecture* in 1849, his *Stones of Venice* (2 vols.) from 1851 to 1853, and his *Lectures on Architecture and Painting* in 1854.

22 Clark, *The Gothic Revival*, pp. 196–8.

23 Ibid., p. 214.

24 Hitchcock, *Architecture*, p. 21.

25 Ibid., p. 150.

26 Hitchcock did investigate American neo-Gothic, considering it "feeble parable(s) of English originals" (ibid., p. 155). A more positive evaluation of Gothic Revival in the US would have to wait for American scholars such as M. Trachtenberg and I. Hyman, *Architecture from Prehistory to Post-Modernism*.

27 English Catholics were placed under various legal sanctions from the Reformation through 1829, when Catholics were emancipated. See Charlesworth, ed., *The Gothic Revival*. Hugo and many French critics to follow blamed the overwhelming influence of Italian Renaissance forms for the suppression of the French Gothic.

28 I agree with Trachtenberg's assessment of the Italian Gothic, in "Gothic/Italian 'Gothic'," as never having been really "Gothic" according to its reified definition from mid-century onward. He argued that fourteenth-century Italians eclectically and self-consciously gothicized various types of buildings, to various expressive ends, never having swallowed the gray Gothic pill. His vision of the pan-European Romanesque as a "sustained conflict between historicist and modernist tendencies," is a brilliant one and strikes at the very essence of the issue of revivalism from the fourth century onward, as suggested by Gunn. One could argue that *after Greece, all Western styles are revivals!* Italy's revival of antiquity (Roman, Byzantine, or Moorish) is more characteristic of that nation's historical aesthetic choices. I have chosen to deal in greater depth with the literature of countries whose revival of either the Romanesque or Gothic styles and accompanying critical literature are consistent, long-lived, exemplary, and characteristic.

29 See Bizzarro, *Romanesque Architectural Criticism*, chs. 3 and 8. From Napoleon's Empire through the Restoration, neo-Classical forms remained in favor. There were some French Gothic Revival buildings, such as St Jean-Baptiste, St Clothilde, and St Bernard in Paris, Notre-Dame de Bon Secours in Rouen, and St Nicholas in Nantes, but far fewer than in England. Viollet-le-Duc's "restoration" of the ramparts of Carcassonne and his work on the château de Pierrefonds was exceptional. During *la belle époque*, a new discourse on Gothic developed casting it as a tower of reason and Celtic design.

30 Viollet-le-Duc repudiated the idea of revival in the preface to his *Dictionnaire raisonnée de l'architecture française (1854)*. Passionate about the Gothic, he delved the structural secrets of its neo-Gothic application. Architect to the Service des monuments historiques, he restored the medieval churches at Vézelay, Amiens, St Denis, Chartres, and Reims, "correcting" each. See K. Murphy, *Viollet-le-Duc at Vézelay* (University Park, 2000). A number of French architects worked in both the neo-Gothic: Anatole de Baudot, St Jean de Montmartre, Paris; and neo-Romanesque styles: Claude Naissant, Notre-Dame de la Gare, Ivry, 1855; Victor Baltard, St Augustin, Paris, 1860–7; Gustav Guérin, Chapelle des Lazaristes, Tours, 1861; Théodore Ballu, St Ambroise, Paris, 1863–9; Paul Abadie, Sacré-Coeur, Paris, 1872–1919; Emile Vaudremer, St Pierre de Montrouge (1864–70), and Léon Vaudoyer, Cathédrale la Major de Marseille (1852). Paul Abadie, "*l'homme néo-romane*," restored St Front de Périgueux. Foucart et al., in *Paul Abadie*, p. 11, have claimed that Abadie was to a great degree responsible for the institutionalization of architectural restoration on a grand scale which inaugurated the important

French rubric and discussion of *patrimoine*, addressed in the four-volume *Les lieux de mémoire* (Paris, 1997).

31 M. F. Gidon, "L'Invention du terme 'l'architecture romane' par Gerville (1818)," *Bulletin de la Société des Antiquaires de la Normandie* 36 (1935), p. 285.

32 The pioneering work of J. Bony on the Norman "*mur épais*" (*Bull. Monu.*, 1939) and of E. Armi on the southern First Romanesque continuous order (*JSAH*, 34, 1975) have patterned Romanesque scholarship. [On sculptural programs in general, and Romanesque and Gothic sculpture in particular, see the essays by Boerner, Hourihane, Maxwell, and Büchsel in this volume (ed.).]

33 M. Camille discussed the pioneering role of M. Schapiro's scholarship in renewing appreciation of the Romanesque ("How New York Stole the Idea"). Camille assessed American scholarship before Schapiro, when formalist poetics echoed nineteenth-century romantic visions of the medieval. Schapiro reckoned that medieval and modern art shared aesthetic goals, repositioning both into the center of "high art" discussions. Camille argued that medieval sculpture was popular like its modern American counterpart because of their rugged individualism and depersonalization.

34 Kent, "The Meaning of the Romanesque Revival" (Ph.D. thesis, Bryn Mawr College, 1993), pp. 50–5, reported that there was more written on architecture between 1850 and 1900 than previously.

35 Owen, *Hints on Public Architecture*, p. 109.

36 Watkin, *Rise of Architectural History*, pp. 68–9, took up Owen's argument.

37 According to Steege, "The Book of Plans," pp. 227–31, this book was the Congregationalists' analogue to *The Ecclesiologist* and a catalyst in disseminating neo-Romanesque.

38 Woods, "History," p. 77.

39 S. Sloan, *City and Suburban Architecture* (Philadelphia, 1859). Meeks, "Architectural Education," p. 31 pointed out that nine-tenths of Sloan's examples are of the round style.

40 Meeks, "Architectural Education," p. 18. She named the major architects: Renwick, Upjohn, Tefft, Sloan, Windrim, and H. H. Richardson.

41 Kent, *Meaning of the Romanesque*, p. 156, analyzed neo-Romanesque criticism in England, the US, and Australia. He argued that Romanesque Revival was closely allied to other modernizing movements and that modernists drew on neo-Romanesque forms in developing their new aesthetic. See also O'Gorman, *H. H. Richardson*, and Miller Lane, "National Romanticism."

42 Kent, *Meaning of the Romanesque*, p. 77.

43 Meeks, "Architectural Education," p. 33.

44 Kent, *Meaning of the Romanesque*, pp. 79–80.

45 Hübsch, *Bau-Werke*, p. 1, as quoted in *In What Style Should We Build?* (Santa Monica, 1992).

46 Kugler, *Handbuch der Kunstgeschichte*, and Lübke, *Geschichte der Architektur*.

47 Lübke, *Geschichte der Architektur*, p. 470.

48 Miller Lane, "National Romanticism," pp. 111–47.

49 Ibid., pp. 111–47.

50 Curran, *The Romanesque Revival*, p. xxiv.

51 Ibid., p. xxvii.

52 Ibid., p. xxv.

53 Ibid., pp. 17–21.

Bibliography

T. W. Bizzarro, *Romanesque Architectural Criticism: A Prehistory* (Cambridge, 1992).

M. Camille, "How New York Stole the Idea of Romanesque Art," *Oxford Art Journal* 17 (1994), pp. 65–75.

M. Charlesworth, ed., *The Gothic Revival 1720–1870: Literary Sources and Documents*, 3 vols. (East Sussex, 2002).

K. Clark, *The Gothic Revival* (New York, 1962 [1928]).

K. Curran, *The Romanesque Revival: Religion, Politics, and Transnational Exchange* (University Park, 2003)

W. Dynes, "Art, Language, and Romanesque," *Gesta* 28 (1989), pp. 5–10.

C. Eastlake, *A History of the Gothic Revival* (Watkins Glen, 1979 [1872]).

U. Eco, *The Search for the Perfect Language* (Oxford, 1994).

E. Emery, *Romancing the Cathedral: Gothic Architecture in Fin-de-Siècle French Culture* (New York, 2001).

B. Foucart et al., *Paul Abadie, Architecte, 1812–1884, Exposition, Musée d'Angoulême. 21 octobre–13 janvier, 1985* (Angoulême, 1984).

P. Frankl, *The Gothic: Literary Sources and Interpretations Through Eight Centuries* (Princeton, 1960).

G. Germann, *The Gothic Revival in Europe and Britain* (Cambridge, 1972).

M. F. Gidon, "L'Invention du terme 'l'architecture romane' par Gerville (1818)," *Bulletin de la Société des Antiquaires de la Normandie* 36 (1953), pp. 268–88.

J. Guillerme, "The Idea of Architectural Language: A Critical Inquiry," *Oppositions*, Fall (1977), pp. 21–6.

H. R. Hitchcock, *Architecture: Nineteenth and Twentieth Centuries* (New York, 1977 [1958]).

H. Hübsch, *Bau-Werke*, 2 vols. (Karlsruhe, 1838).

H. Hübsch, R. Wiegmann, C. A. Rosenthal, J. H. Wolff, and C. G. W. Böttischer, *In What Style Should We Build? The German Debate on Architectural Style* (Los Angeles, 1992 [1828]).

P. Kent, "The Meaning of the Romanesque Revival" (Ph.D. thesis, Bryn Mawr College, 1993).

F. Kugler, *Handbuch der Kunstgeschichte* (Stuttgart, 1842).

B. Miller Lane, "National Romanticism in Modern Germany," in R. A. Etlin, ed., *Nationalism in the Visual Arts* (Hanover, 1991).

S. Lavin, *Quatremère de Quincy and the Invention of a Modern Language of Architecture* (Cambridge, 1992).

P. Léon, *La Vie des monuments français: Destruction, restauration* (Paris, 1951).

W. Lübke, *Geschichte der Architektur von den ältesten zeiten bis zur Gegenwart* (Leipzig, 1855).

I. K. McEwen, *Socrates' Ancestor* (Cambridge, 1993).

C. L. V. Meeks, "Architectural Education in America," *Architects' Yearbook* 2 (1947).

K. Murphy, *Memory and Modernity: Viollet-le-Duc at Vézelay* (University Park, 2000).

P. Nora, ed., *Les Lieux de memoire*, 3 vols. (Paris, 1997).

J. O'Gorman, *H. H. Richardson. Architectural Forms for an American Society* (Chicago, 1987).

R. D. Owen, *Hints on Public Architecture* (New York, 1978 [1849]).

E. Panofsky, *Renaissance and Renascences in Western Art* (Stockholm, 1965 [1952]).

T. Rickman, *An Attempt to Discriminate the Styles of Architecture in England from the Conquest to the Reformation* (London, 1817).

S. Sloan, *City and Suburban Architecture* (Philadelphia, 1859).

G. Steege, "The Book of Plans and the Early Romanesque Revival in the United States: A Study in Architectural Patronage," *JSAH* 46 (1987), pp. 215–27.

M. Trachtenberg, "Gothic/Italian 'Gothic': Toward a Redefinition," *JSAH* 50 (1991), pp. 22–37.

M. Trachtenberg and I. Hyman, *Architecture from Prehistory to Post-Modernism* (Englewood Cliffs, 1986).

E. Viollet-le-Duc, *Dictionnaire raisonné de l'architecture française du xie au xvie siecle*, vol. 1 (Paris, 1875).

D. Watkin, *The Rise of Architectural History* (London, 1980).

Mary N. Woods, "History in Early American Architectural Journals," in *The Architectural Historian in America 35* (Hanover, 1990).

The Modern Medieval Museum

Michelle P. Brown

What is a museum? It is a place where materials are collected, curated, classified, and conserved. I am writing about the modern medieval museum from the perspective of a curator of illuminated manuscripts working within a large national library (the British Library) – an international repository of global memory and identity. This may not seem the obvious vantage-point from which to survey the scene, but in fact it is. Illuminated medieval manuscripts are in themselves the largest repositories of medieval art. A single book, such as the Sherborne Missal (British Library, Additional MS 74236) made for Sherborne Abbey (Dorset) at the beginning of the fifteenth century, and which contains 694 pages, could fill an art gallery in its own right if its leaves were disbound and viewed as panel paintings. Such a mode of viewing would, however, emphasize the artistic merit at the expense of an understanding of the book as artifact and as a portal to the past – a complex meeting-ground for the various aspects of human currency in ideas, literature, faith, science and technology, craftsmanship, patronage, economics, and other facets of social contact and contract. Such manuscripts are also at the forefront of developments in interpretative access and electronic articulation. For the medievals perfected the arts of manipulating and signaling the principles of hypertext and intertextuality long before our electronic age. The complex interrelationships between word, sound, and image lie at the core of their modes of communication, record, and self-image.[1] Not surprisingly, manuscripts such as the unique copy of the Anglo-Saxon epic *Beowulf*,[2] the Archimedes Palimpsest,[3] the Book of Kells,[4] the Utrecht Psalter,[5] and the St Alban's Psalter[6] have become the vehicles by which the frontiers of humanities computing and digital imaging are being advanced.

The challenges of accessing, ordering, and preserving information, verbal and visual, underpinned the creation of the very first museum – the Cage of the

Muses, the great library of Alexandria. Its founder during the 280s BCE, the Hellenic ruler of Egypt Ptolemy I (assisted by Demetrius of Athens), introduced the age-old adage "knowledge is power" when he recognized that in order not only to effectively conquer but also to rule other peoples, it was necessary to understand them. As Luciano Canfora has outlined in his discussion of the Alexandrian Museum, the key to this lay in acquiring access to their group knowledge and identity in the form of their written and artistic record.[7] Thus the Hebrew Bible was translated by a team of scholar-scribes into a Greek copy for the library – the Septuagint and some 400,000 papyrus scrolls (this figure does not represent individual works, most of which each filled a number of scrolls) were assembled from around the known world to form the first "universal" library. The first classification systems were devised by its custodians, notably Eratosthenes and Callimachus, to bring order to this otherwise unfathomable pool of knowledge: the method they originated being a subject-based division.[8] In this ordering lay the origins of the epistemic systematization advocated by Foucault which continues to inform much of the compartmentalized organization and teaching of academic disciplines and the study of human culture.

It is therefore ironic, if explicable, that as a result of the extension of such principles of rationalization most of the world's great collections of medieval books now reside not in museums, but in libraries. This raises a potential dilemma for professional library managers.

They do not run museums per se, but are part of a vibrant international information community and are faced with the challenges of selection and preservation of our written and recorded knowledge, which escalates giddily in its annual volume, and of balancing the requirements of local and remote users with a wide range of backgrounds and needs: schools and teachers, lifelong learners, higher educational institutions and their faculties and students, professional bodies, media, and the business community. A heritage front-end can, and often should, be an integral part of such information edifices, acknowledging that there is no statute of limitations on history and that every item is a brick in the ever-growing wall of human knowledge and achievement and that books containing art are, nonetheless, books. Maximizing the impact of a heritage component of such collections, by exposing and interpreting them through exhibitions, educational outreach, publication, and the web to heighten public and governmental awareness and to enrich lives, can make them an effective showcase for the work and aims of the institution as a whole. However, the very range of opportunities available to us today is thrown into stark relief against the pragmatic, logistical, and financial restraints imposed by competition for limited resources. Faced with more material and more potential than ever, we are also faced with the responsibility of more choice and decision-making.

Theoretically, the great library of Alexandria, tragically consumed by fire, the perennial enemy of libraries (we still construct firewalls to protect our virtual archives), could today (or perhaps tomorrow) be reconstructed and extended on the internet to form an integrated, searchable global museum in which written

and recorded knowledge and art and artifacts could be combined and suspended within a perpetual state of virtual preservation. In fact, this is at best a long way off. The funding needed to prepare or convert records into a unified electronic standard and to digitize the materials themselves would be prohibitive, even if international cross-disciplinary standards were agreed upon. The long-term costs of maintaining and supplementing such a global site would also be crippling, as would the serious issues of electronic preservation which, at present, would require the construction of a "dark cave" of mythical propensities to allow electronic data to be perpetually preserved, refreshed, and accessed by new hardware in order to give it more than a 10-year archival shelf-life. Add to that the amount of international diplomacy which would be required in order to overcome issues of collaboration, ownership, rights, and compensation for any lost revenue generation (which, have no doubt, is necessary to help such institutions maintain their roles and invest in their futures) and we see that we are faced with a vision which may be as innovative as that of Ptolemy II but is equally doomed to be a victim of human conflict, divergent aspirations and limited resource.

If a global museum is still but a dream, there are, nonetheless, optimistic and inspiring moves toward making as much material freely available on the Net as possible. What does it matter if one has to access several sites and watch them grow and develop over the years, in response to changes in scholarship, technology, and public need, rather than getting a one-stop-shop uni-cultural overview? The diversity may in fact ensure continued response to challenge and debate. Posing the question is often as important as obtaining the answer.

So much for the future: what of the past? How did the knowledge, art, and artifacts of the Middle Ages feature in the development of museums and libraries? Some of the greatest collections of such materials were assembled during the medieval period itself. The seventh-century Anglo-Saxon nobleman-turned-monastic founder, Benedict Biscop, traveled to Rome and Gaul no fewer than five times during his adult life and on each trip brought back to his foundations of Monkwearmouth and Jarrow in Northumbria paintings, relics, icons, and books to adorn their churches (built *more romanum* in stone by masons and glaziers from Gaul). In so doing he also founded one of the best libraries of the early Middle Ages, which allowed Bede, who entered the twin foundation as a boy of 7, to become one of the foremost scholars of his day and an internationally best-selling author throughout the Middle Ages. Likewise, the collection of ancient Roman and early medieval artifacts assembled by Abbot Suger of St Denis formed an invaluable stimulus to the French contribution to Romanesque and early Gothic art. For the churches of medieval Europe and of Byzantium and the Near East were the museums of their day: places where books, art, and other artifacts were assembled, studied, and gave rise in their turn to the creation of new works and styles. In this respect they were the descendants of the ancient temple libraries, such as the ancient Egyptian Ramesseum. Their buildings and the works that adorned them, some of which have remained

in situ, continue to serve a "museum" and heritage function alongside their prime concern – the celebration of a living faith tradition. Cathedral treasuries such as those at Cologne, Trier, Reims, Siena, Florence, Pisa, and Durham display their remaining portable artifacts to the public and some have customized display facilities such as that built to display the famous *Mappa Mundi* at Hereford Cathedral or museum conversions of existing buildings such as that adjacent to the palatine chapel of Aachen and in the Catharijneconvent in Utrecht.

The dismantling or reformation of ecclesiastical structures, such as occurred during the 1530s in England with the Dissolution of the Monasteries, or in late eighteenth-century France as part of the Revolution, occasioned massive losses and redistribution of materials. The method of disposal had a major impact upon the composition and structure of later collections. In England we hear reports of "tailors and small boys" ravishing the remnants of great monastic libraries for waste vellum for pattern-making and play, of the desecration of shrines and seizure of loot by Henry VIII's commissioners (followed by further destruction a century later during the iconoclasm of the English Civil War), of the salvaging of venerated books, relics, and icons by Catholic recusants, and witness the attempts of collectors such as Archbishop Matthew Parker and the parliamentarian Sir Robert Cotton and their scouts to mop up and save whatever they could. In France the more organized coup led to many ecclesiastical treasures being gathered into the regional *musées* and *biblothèques des departements*.

Private collections have always been a factor in the construction of museums. The libraries and lapidariums of Roman senators were replaced by the collections amassed by clerical and secular figures such as Benedict Biscop, Suger, the Duc de Berry, and John, Duke of Bedford. They were not primarily antiquarians, but active patrons who collected works from their own and former times as part of a living agenda in which cultural property and consumption bolstered their own positions and/or those of the establishments they represented. Dissemination of knowledge, such as scripture, or of political ideology was also an implicit part of what motivated the retention or production of the works which we in turn seek to preserve in our collections for our own reasons, whether public or private. At the interface of both spheres stood not only the Church but also the medieval heads of state: royalty. Charlemagne's emphasis upon collecting and absorbing the content and signaling the stylistic and iconographic influence of Classical and early Christian texts and art was an integral part of his "imaging" of a transitory empire. Otto II's interest in things Byzantine accompanied his dynastic union with the ancient eastern Roman Empire through his marriage to Theophanou, and signaled his own aspirations for revived Western imperialism. The early tenth-century ruler of Anglo-Saxon England, Athelstan, and his grandfather Alfred the Great, likewise collected Carolingian works and patronized the development of local styles based in part upon such icons of imperialism, and upon other items culled from their indigenous past and that of their Celtic neighbors, as part of their agendas of spiritual reform

and political reunification following Viking invasion and settlement. King Henry III of England looked to contemporary thirteenth-century France and the patronage of his royal counterpart, St Louis (with his newly constructed reliquary of royalty, the Sainte-Chapelle) as one of his main referential sources of imagery, and even extended his collecting interests to natural history – counting an elephant amongst the denizens of his menagerie at the Tower of London, whilst in the later fifteenth century Edward IV turned to the Netherlands as the principal acquisition market for his manuscripts, some of which were bought "off-the-peg" and customized for him. The Hungarian monarch Matthias Corvinus signaled his identity as a Renaissance prince by incorporating humanist tomes into his impressive library and the French king François I included Leonardo in the international *equipe* assembled to adorn his court, whilst Bona Sforza, the focus of one of the leading Renaissance courts, surrounded herself with works by her fellow Italians. The palaces of Europe became evolving, living museums.

"Modern" Protestant rulers such as Henry VIII and Elizabeth I may have reacted against the medieval theocracy and its artifactual and intellectual legacy, but even in the new England it lingered on in the cathedrals and the vestiges of their libraries, behind the lime-wash applied to the walls of parish churches, in private collections, and even in the earlier parts of the royal collection itself. An appreciation of the legacy of the Middle Ages was also nurtured amongst those intent upon studying the past in order to inform the Protestant present, such as Archbishop Parker and the biblical and linguistic scholars of his circle (such as Joscelyn and Nowell) and those who combined a sense of history with the nascent connoisseurship and acquisitiveness of the true collector, such as Sir Robert Cotton (who, with Parker, was responsible for saving much of what remains of Anglo-Saxon culture owing to his interest in religion and in the origins of parliamentary democracy[9]) and Elias Ashmole.

Cotton and Ashmole formed remarkable and celebrated versions of that seventeenth-century phenomenon, the "Cabinet of Curiosities," symbolizing the expanding horizons of geographical, natural, and intellectual knowledge during that trade-oriented age. Cotton's collection focused upon books, coins, and medals, whilst Ashmole's favoured antiquities and objets. They both became the foundation-stones of leading museums: the British Museum in London and the Ashmolean Museum in Oxford, one a national facility and the other the core of a university collection. Cotton's heirs bequeathed the collection to the nation, but the grateful nation, unwilling to invest, placed it in storage at Ashburnham House (adjacent to Westminster Abbey) until one fateful night in 1731 when fire destroyed part of this unique collection. This, and the bequest and preferential purchase of other collections (that belonging to Hans Sloane, the royal physician, and the Harley Collection assembled by the Earls of Oxford and the Royal Collection itself – all incorporating significant numbers of medieval manuscripts), eventually led to the foundation of the British Museum in 1753.[10] At its inception this was essentially a superb library with a cabinet of curiosities and some stuffed zoological specimens. The latter migrated to South

Kensington during the Victorian period to found the Natural History Museum, whilst the "curiosities" were augmented by the collecting exploits of figures such as Lords Elgin and Hamilton and of the Egypt Exploration Society. The British Museum Library also continued to grow apace, with the bequest or purchase of other major collections, such as the King's Library assembled by George III, and the legal deposit of any new books published in the UK in accordance with the Copyright Act. The holdings of Western manuscripts continue to expand by bequest or purchase as part of the Additional manuscript sequence or through the Egerton purchase fund. It became apparent that the library was outgrowing the museum, and vice versa, and in 1973 the British Library was formed by Act of Parliament, comprising the British Museum Library, the Science Reference Library, the Document Supply Centre, and various other official repositories. The medieval manuscripts remained within their collections, along with the printed books, maps, and other written materials with which they had been assembled. Prints and Drawings and Antiquities remained at the British Museum.

The development of public collections elsewhere followed along similar lines, with medieval manuscripts forming part of libraries rather than museums. Sometimes, as at the Vatican, these two functions remain contiguous and are housed within the same architectural complex. Nonetheless, the nineteenth-century passion for specialized function and its enduring legacy means that there are all too few places where one can see medieval painting in manuscripts on display to the public, let alone in a museum-like context alongside works of the period in other media. With the exception of the custom-built British Library, few of the larger national, state, or university libraries contain permanent gallery space suitable for the exhibition of these materials. Their display has to be undertaken in accordance with stringent modern conservation guidelines on environmental conditions, with the requisite carefully monitored and controlled temperature, humidity, and lighting levels necessary to ensure that such fragile materials can safely be exhibited without unduly prejudicing their long-term life expectancy. Any such exhibition policy also has to be balanced against other demands on the manuscripts from readers needing to access the originals in reading rooms, for photographic orders and the creation of surrogates, and from other venues internationally staging special exhibitions and requiring loans.

One thing that has to be remembered is that the conditions for display, access, handling, and conservation of materials in different media vary. One set of procedures, of research expertise (whether academic or technical) or of contingency and treatment plans in the event of an emergency, cannot suffice for all materials. The environmental specifications for illuminated manuscripts, whose jewel-like colors are held onto the page only by beaten egg-white which clings to a moving surface of prepared calf, sheep, or goatskin whose big ambition is to return to the curved shape of the animal in the field, are not the same as those applicable to a recently excavated object of water-logged wood with metal attachments, for example. The degree of specialism required to study and

preserve such wide-ranging materials is significant. This does not mean, however, that research need be restricted to any one medium. Acquiring the appropriate set of skills, such as palaeography and codicology as well as the linguistic and art historical skills necessary for the study of illuminated manuscripts, does not mean that a researcher competent in those areas should not acquire those necessary for other areas of study or, if appropriate, construct an informed historical overview or synthesis. To deny this would be to confine the researcher to mastering the scales without ever playing a musical composition, let alone actually composing one. Conversely, not every good musician necessarily makes a good composer. What museums and libraries do, in the present context, is to provide access to the hypothetical notes and the instruments, namely the primary research materials, the evidential base.

Leaving the public arena to return to the private, the Grand Tour did much to foster an appreciation of the past amongst the cognoscenti of eighteenth-century Europe, enriching the collections of many a country house and university college. The trend was continued and carried to new collecting heights by the wealthy American traveler of the nineteenth and twentieth centuries. The civic museums and galleries of many an American town boast collections assembled by local worthies during their visits to Europe or via the art and antiquities market which proliferated from this time. Such collections occasionally feature a few objects from the Middle Ages as part of a mini survey of art history: a Greek vase here, a Frankish buckle there, a Limoges enamel casket, an ivory mirror case, a German Gothic aquamanile, a quattrocento panel painting or two, a Dutch still-life, some French Impressionist works – the shopping list is predictable, but has meant that a basic overview of Western art history has been made available to many aspiring students and that the essential human contact between ourselves and the peoples of the past has occurred through these portals, or rather chinks, in the fabric of time and has fired the imagination and the thirst for knowledge.

Sometimes these collections have been world-class; constructed under the guiding hand of an expert in the field. Pierpont Morgan's interest in medieval and renaissance manuscripts brought New York a remarkably fine collection, endowed with a fine building to match, which is again being remodeled to meet contemporary needs and opportunities. In Boston the steel heiress Isabella Stewart Gardner (1840–1924) sought the assistance of the notable art historian Bernard Berenson to construct her eclectic but aesthetically superior collection of medieval and Renaissance antiquities which she housed in a reconstructed Venetian palazzo. The public was admitted on select days, by limited ticket, during her lifetime and on her death it became a public institution which still delights visitors and whets the appetite to visit the actual sites where such wonders were made and used (and where even the flower arrangements are maintained in accordance with the late patron's personal wishes).

Displaying the materials within reconstructed or fictional fabricated room settings can undoubtedly assist in achieving this effect, as the Cloisters ably

demonstrates. This fabrication of a medieval monastery was built in the 1930s in Fort Tryon Park as an offshoot of the Metropolitan Museum of Art in New York, principally to house the medieval collections of George Gray Barnard and John D. Rockerfeller.[11] Here rooms and whole cloisters from medieval France and Spain have been transported and reconstructed to form an incomparably informative and aesthetically satisfying display context. Sadly this could only be achieved at the cost of denuding the actual sites of their fabric as well as the artifacts which had already been dispersed in the face of the vicissitudes of history.

The most extreme example of this is perhaps Hearst Castle, where the collection assembled by the media tycoon Randolph Hearst was treated as an interior designer's play-box. The fixtures and fittings of many a medieval church and palace were adapted to fit their new *mise-en-scene* as a backdrop to Hurst's lavish entertainments, illuminated by lamps adorned with shades formed of the leaves of medieval choirbooks. More successful, therefore, is the Musée des thermes et de l'hôtel de Cluny in Paris, where a wide range of medieval art, much of it from the Île de France itself, has been preserved and can be seen in an authentic, *in situ* late medieval building. The great royal palace of the Louvre itself has also become a sympathetic and absorbing showcase for part of the French national collections (as has the medieval castle housing the Musée nationale des antiquités nationales at St Germain-en-Laye) and in adapting this important historic building a major contribution to modern museum design has been made. The new galleries not only allow the medieval collections to be well displayed in chronological or media-based themes, but also whole complexes to be reconstructed, such as the impressive early Christian Coptic church from Bawit, and the excavated foundations of the original medieval fortress of the Louvre to be revealed and themselves become a massive exhibit.

In another Parisian arrondissement lies another admirable French contribution to the study of medieval culture, the Palais de Chaillot, where casts and museum quality replicas have been painstakingly assembled of many of the monumental sculptures and frescoes of Europe, in which the Middle Ages figure large. This offers an unrivalled opportunity of studying a wide range of material from disparate locations side by side, without divorcing the original monuments from their topographical contexts. A sense of place is an essential part of understanding and appreciating the historical and social context of such works and visiting a study collection can never compensate for its absence. Used in tandem, however, they offer an invaluable opportunity for gaining insight. The Victoria and Albert Museum in London also has a fine cast court and in Scotland the production of casts is proving a valuable component in the fight to conserve and preserve the outstanding corpus of Pictish sculptures produced during the first millennium CE.

The effects of weathering and of pollution are escalating apace and concerns over the long-term impact of interventionist conservation have engendered a variety of solutions: gathering the sculptures themselves into museums, whether

the outstanding collections in the little site museums at Meigle and St Vigeans (themselves important find spots for part of their assemblages) or the National Museums of Scotland in Edinburgh; leaving the sculpture in the field but frequently encasing it within a protective structure (1930s concrete sheds and postmodernist hi-tech glass boxes both serve the function but equally restrict vision in frequent squalls of driving rain); or taking the sculpture into a nearby building, such as a church, and placing a cast *in situ*, thereby retaining a link to the landscape whilst preserving the original.

Other important collections assembled by private individuals can be seen, for example, at the Schnütgen Museum in Cologne, devoted to medieval ecclesiastical art and housed in a converted Romanesque church; the Rothschild Collection at Waddesdon Manor, built for Baron Ferdinand Rothschild in the late nineteenth century in the style of a French chateau (reusing architectural fittings from authentic French buildings) in England's rural Buckinghamshire as a venue for entertaining and showcasing his collection; the custom-built Gulbenkian Museum in Lisbon, Portugal; the Burrell Collection in Glasgow with its award-winning building incorporating a modern cloister for the display of stained glass; and the Malibu ranch house (constructed in the 1970s to resemble the Roman Villa de Papiri, suitably adapted to natural disaster-proof display standards which would have been the envy of the original inhabitants of Herculaneum and Pompeii) which contained the collection of the oil tycoon J. Paul Getty (1892–1976) and the major new complex housing the J. Paul Getty Center in Los Angeles. These are good examples of how public benefaction on the part of collectors has led to the endowment of important museums and has enabled the preservation, intact, of collections which have much to tell us not only concerning the objects they contain but of the history of collecting itself and of the historical period in which they were amassed. They have become the latter-day pyramids to personal achievement that they were intended to be, but in so doing serve to celebrate much wider human achievement.

The nineteenth and twentieth centuries, and the warfare, imperialism, social upheavals, philanthropy, and market forces which characterized them, led to the redistribution of significant slices of the world's cultural property. Many private and public collections were established or expanded as a result of this. Some of these have been broken and circulate periodically through the auction houses, whose scouts are ever vigilant for opportunities to stimulate trade, or occasionally appear on the market in their entirety. A sad aspect of the trade is that, even in this age when the integrity of the artifact in all its aspects is increasingly appreciated, medieval manuscripts are frequently broken up to enable their miniatures to be sold separately and the reputations of the various (and mostly anonymous) craftspeople who worked on them talked up to the status of "masters" in order to obtain higher market prices for them as "artworks." This can be tantamount to robbing the Sutton Hoo burial mound of its helmet and high-status metalwork, or Tutankhamun's tomb of its key treasures, without seeking to learn anything from the sites as a whole. Likewise, artifacts continue

to be illegally traded out of certain countries (such as Italy) and evidence of their history and provenance suppressed. The corpus of ancient and medieval material, especially metalwork, continues to grow as sites are excavated and finds conserved and acquired by local or national museums. Financial constraints, however, mean that excavations are seldom adequately funded or mounted on other than major known sites or on an immediate rescue basis within a very short time-scale. Work traditionally undertaken by the archaeological units of public museums, local authorities, and universities is also increasingly bid for by independent companies which can carry implications for the long-term preservation, publication, and retention of finds and information.

The rising popularity of metal-detecting as a hobby and as a business has also escalated tremendously over the last few decades, with an accompanying growth in website trading of antiquities. Legal loopholes have been tightened in certain areas, such as law of Treasure Trove, and in Britain the recent introduction of the Portable Antiquities Scheme has successfully encouraged many metal-detectors to register their finds and to seek expert opinion concerning them. This allows museum professionals at least to monitor what is being found and where, and sometimes leads to follow-up excavation of sites to determine their nature and importance. It has also stimulated something of a sense of community in the metal-detecting fraternity and lessened the divide between this and the professional archaeological, museum, and university communities. Nonetheless, many important items have been traded out of their countries of origin without being revealed to the authorities or taken into account intellectually, let alone being offered to museums for purchase.

One further development on the archaeological front which might usefully be mentioned is the growing trend to establish museums on site, to enable a fuller understanding of them in their entirety. Successful examples include that at Sutton Hoo, where recent excavations have significantly extended our understanding of the famous ship burial discovered in the 1930s and how it fits into a bigger cemetery containing not only other seventh-century high-status burials furnished with opulent grave-goods, but a slightly later felons or ritual burying ground, and how it relates to other local settlement sites such as the palace at Rendlesham. The major Pictish site at Tarbat in Easter Ross, Scotland, is also extending our knowledge of this mysterious but artistically productive people, with the descendant of the church which was the central focus of the site serving as a showcase for many of the finds and as an educational forum. At Rosekilde in Denmark a specially constructed museum houses some of the Viking longships and trading vessels, its glazed sides affording evocative views of the home waters they sailed.

Heritage facilities are increasingly becoming a feature of the urban and rural scenes. These may range from medieval Irish tower houses, lovingly restored, converted and staffed by local enthusiasts and furnished with some local artifacts and social history memorabilia, to archaeological and vernacular architecture reconstruction parks (such as Craggaunowen near Limerick in Ireland where

Celtic ring-forts and artificial islands – crannogs – can be viewed, or the Weald and Downland Museum at Singleton in Sussex, England, where buildings from all periods of the region's history are rescued in the face of demolition and reconstructed) and small specialist museums (such as Bede's World at Jarrow in Northumberland, England, adjacent to the church where Bede worshiped around 700, which houses some of the finds excavated on the site, reconstructed models and interactive facilities). Some, such as "The House of Manannan" beside the medieval site of Peel Castle on the Isle of Man and the community Heritage Centre at Lindisfarne on Holy Island in Northumberland, England, have helped to pioneer "the object-less museum," which does not exhibit actual objects of the period but which explores them and their context through the display of graphics and the use of film and interactive technology. Funding for such initiatives has been gained from a variety of sources, including regional development funds (such as those administered by the European Union), central or local government, and national participative schemes for the funding of community initiatives and the arts (such as the UK's Heritage Lottery Fund), and charitable enterprises (such as the UK's National Art Collections Fund and the National Heritage Memorial Fund which commemorates those who have given their lives for their country by contributing to the acquisition and preservation of its heritage). The charitable giving and acknowledgement of civic responsibility to the arts has also played a significant role in establishing and developing many museums. The US has been particularly active in fostering this role and European governments are now acknowledging the importance of taxation incentives to foster this sort of public involvement in maintaining heritage and the arts to supplement or to compensate for shortfalls in government funding and commercial revenue.

"Heritage" is also increasingly being recognized as a means of attracting publicity and generating tourism. This can play an essential role in the regeneration of a site, a place, a region, or a nation. It can also be a quick route to media coverage and a source of political leverage. Recent years have witnessed a flurry of campaigns for the restitution of cultural heritage, the focuses of which have ranged from the Elgin Marbles and the Benin Bronzes to Ethiopic manuscripts, Native American artifacts, and books and other objects found in named sites but subsequently incorporated into other, often national, collections. The implications of such campaigns are complex and manifold and raise a range of legal, ethical, intellectual, and economic issues. Each varies in its precise nature, but one thing remains constant – the need to remember that the overarching concern must be the preservation of the artifact itself and appropriate levels of access which will allow it to speak to the present generation without unduly compromising its life expectancy so that it can continue its dialogue with future generations, all of which come to it with new questions, new perceptions, and new technologies. Addressing such concerns requires a high level of expertise in order to interpret and to conserve the material and, rather than being a fast track to funding, these responsibilities entail a great deal of investment

and commitment to the long-haul. Disaster planning and adequate security provision have to be part of the equation, as well as the establishment of appropriate environmental and display facilities, as well as a context for continued research and dissemination of information to specialists and public alike. Larger institutions are often best placed to serve this function in respect of particularly important or vulnerable materials and also often fulfill a function of transcending their purely local significance and placing it in a wider context of time and space.

The history of collecting and the wish to preserve important collections intact to allow them to speak of the age in which they were assembled or to honor terms of bequest can also be an important factor. Continuing to acquire material for a nation and to prevent or monitor its export is also often deemed the preserve of larger collections which could not fulfill this, or their other functions of custodianship and conservation to the contested items or to the legions of the regionally "unloved" or unclaimed objects, if unduly weakened. Cultural restitution also raises the thorny question of whether it is appropriate to turn back the clock of history and, if so, where to stop it in any given case. It is often far from clear or uncontroversial where artifacts, especially those cloaked with the comparative anonymity of medieval craftsmanship, were actually made and they have often traveled a great deal, generating rival claims on the part of their various intermediate homes. The more recent an act of appropriation or alienation, the more emotive and pressing the call or impetus to restitution may be, but there is no statute of limitations upon history and locally contained holocausts and injustices are not automatically outweighed by those of international stature. The legality of the current situation has to play a significant factor in any such debate.

Collaboration and partnership between museums, libraries, galleries, other repositories, local interest groups, and educators (at all levels) is an essential part of the present and future of the profession and the web is playing an increasingly important part in this equation. Material can be shared, assemblages or individual artifacts which have been broken up over the course of time can be virtually reunited, and items can be virtually restored to their original appearance or context without intruding upon their actual state of preservation. Thus a manuscript partially broken up as binder's waste in the aftermath of the Dissolution, its leaves now scattered amongst several libraries and private collections, could be digitally reconstituted and any damaged leaves virtually restored by image manipulation – if all the parties could be persuaded to participate and if the necessary project funding were forthcoming. New technology also potentially allows vast collections of material, much of it confined to the study collections housed in museum basements and out-housed storage facilities or to library stacks, to be opened up to the public without undue handling of original materials. This also allows the researcher to do as much preliminary work as possible before needing access to the sources themselves. Thus the British Museum's "Compass" project, for example, seeks to mount a broad cross-section

of its treasures on the web, whilst libraries such as the British Library, the Pierpont Morgan, and the Hague are in the process of mounting complete electronic catalogues with accompanying digital images of their illuminated manuscripts on the web. Most major museums and libraries now have websites where at least some of their treasures can be viewed. IT can also help overcome some of the didactic restrictions of displaying such materials. Looking at an object in a glass case offers a valuable encounter with the original, but can be frustrating, especially when the object in turn is a book of which only one opening of many can be displayed at one time. Gallery interactives have been developed in order to allow objects to be viewed on screen, sometimes as three-dimensional images which can be virtually rotated and examined from all angles, or, as with the British Library's "Turning the Pages" system,[12] to simulate the experience of physically turning the vellum pages on screen and leafing through the book (initially only 20 or so of the major openings because of expense, but the system is being developed in such a way that whole books can be affordably mounted upon it). Such solutions also enable audio so that text and music can be explored and so that extra information can be given, beyond the constraints of a single case label. Digital surrogates of iconic treasures can also be made available in special display contexts at heritage facilities connected with their stories if the preservation and security requirements of the originals, or legal circumstances, dictate that they are best kept elsewhere.

Surrogates are never a complete alternative to encountering original artifacts, however, and responsibly exhibiting them, when the occasion permits, remains a crucial element in firing the imagination and interest of the public. In an age when there are fewer and fewer opportunities to study the Middle Ages as part of the general education system, and even at graduate level, but when, paradoxically, media and popular entertainment interest have never been higher, the thrill of coming face to face with the past and connecting, through the witness of a site or artifact, with the lives of those who inhabited it is essential for the subject's continued existence and regeneration. This chapter has touched upon some of the places where medieval materials can be seen displayed on a permanent or semi-permanent basis, some more didactically or comprehensively than others. The special temporary exhibition is a valuable adjunct to this. National and international loans programs are escalating in every major repository as more and more requests to borrow items for exhibition are received. In the medieval sphere these can vary from blockbuster exhibitions in which as many as possible of the major treasures representative of a particular period or theme are gathered together, affording a unique opportunity of viewing them in relation to one another, for purposes of study or connoisseurship. The exhibitions held in London between 1984 and 2003 surveying medieval British art are a good example of this.[13] Likewise, the Bibliothèque nationale de France's exhibitions,[14] and "Les Fastes du Gothique," held at the Grand Palais in Paris by la Réunion des musées nationaux et la Biblliothèque nationale in 1981–2,[15] their "L'Art au temps des rois maudits Philippe le Bel et ses fils 1285–1328" held there in

1998,[16] and the Louvre's examination of the reign of King Charles VI;[17] several exhibitions devoted to the Carolingian Empire;[18] and exhibitions focusing upon Byzantine culture.[19]

Other shows have successfully focused upon a single work as their theme and as a springboard into an exploration of its age.[20] Some have sought to transcend their themes and take a more interdisciplinary, cross-cultural approach, even crossing the perennial East/West divide, as in the case of the stimulating and challenging display on world faiths at the Chester Beatty Gallery in Dublin Castle, "Europa und der Orient 800–1900" held in Berlin in 1985,[21] the British Library's "Painted Labyrinth: The World of the Lindisfarne Gospels,"[22] and "Treasures from the Ark. 1700 Years of Armenian Christian Art,"[23] "Memory and the Middle Ages," staged at the Boston College Museum of Art in 1995,[24] the catalogue of an exhibition entitled "Mirror of the Medieval World", held to celebrate the medieval galleries and collections of New York's Metropolitan Museum of Art,[25] and the string of exhibitions organized across Europe in 1997 by the European Science Foundation as part of their five-year "Transformation of the Roman World" project.[26] Others have focused primarily upon technique, using advances in technology and conservation as a starting point for examining objects, such as "Art in the Making. Italian Painting Before 1400", held at the National Gallery in London in 1989.[27] Increasingly, multiple venue exhibitions are being staged as part of collaborative funding initiatives.

The constraints of lending such unique and often fragile materials are such, however, that the same exhibits are only seldom loaned to more than one venue in succession. Gone are the days when important exhibitions and priceless objects went on world tours, such as "Treasures of Ireland. Irish Art, 3000BC–AD1500", which in two incarnations toured during 1977–81 to New York, San Francisco, Pittsburgh, Boston, Philadelphia, Paris, Cologne, Berlin, Amsterdam, and Copenhagen, as well as being exhibited at the National Museum in Dublin.[28] One of its star exhibits, the Book of Kells, thankfully no longer travels at all. Some successful two-venue shows are still staged, such as "The Golden Age of Dutch Manuscript Painting", shown at the Rijksmuseum het Catharijneconvent in Utrecht and the Pierpont Morgan Library in New York in 1989–90,[29] and "Illuminating the Renaissance. The Triumph of Flemish Manuscript Painting in Europe", staged at the J. Paul Getty Museum in 2003 and at the Royal Academy of Arts in London in 2003–4,[30] with requisite variations to the exhibits at either venue.

The conceptualization of an exhibition, whether temporary or permanent, actual or virtual, is of prime importance, for it impacts upon education, public perception, and, on occasion, political will. Museums, libraries, and galleries and their displays, publications, and outreach programs have been known to both reflect and help direct the way in which a given subject area is studied. They can be fruitful meeting grounds for a wide range of disciplines and outlooks and a testing place for matching aspiration and resource. In short, they help us to write history, to record it, and to direct its future. They are powerful social

mechanisms, capable of misrepresenting as well as mirroring our identities. As the repositories of our collective memory they are the stuff of which civilizations are formed – the way in which we shape them, use them, and invest in them in the future will help to serve as an indication of the extent to which we value, or merely pay lip service to, the very concept of civilization.

Notes

1 As explored by Carruthers, *Book of Memory*, and Clanchy, *From Memory to Written Record*.
2 British Library, Cotton MS Vittellius A. xiv; see Kiernan, *Electronic Beowulf*.
3 Private Collection, on loan to the Walters Art Gallery, Baltimore.
4 Dublin, Trinity College Library, MS 58.
5 Utrecht, University Library, MS 32 (ed. Van der Hoerst, Noel, and Wüstefeld, 1996), CD-Rom.
6 St Godehard's Church, Hildesheim, see <http://www.abdn.ac.uk/stalbanspsalter/index.shtml>.
7 Canfora, *The Vanished Library*.
8 Callimachus's *Catalogues of the Authors Eminent in Various Disciplines* were arranged with six sections devoted to poetry and five to prose, his categories including epics, tragedies, comedies, historical works, works of medicine, rhetoric and law, and miscellaneous works; ibid., p. 39.
9 See Tite, *Manuscript Library*, and Brown, "Sir Robert Cotton."
10 Miller, *That Noble Cabinet*.
11 Rorimer, *The Cloisters*.
12 Examples of which may be viewed via <www.bl.uk>.
13 "1066. English Romanesque Art." Hayward Gallery, 1984 (ed. Zarnecki, Holt, and Holland); "The Golden Age of Anglo-Saxon Art 966–1066." British Museum and British Library, 1984 (ed. Backhouse, Turner, and Webster); "Age of Chivalry. Art in Plantagenet England 1200–1400." Royal Academy of Arts, 1987–8 (ed. Alexander and Binski); "The Making of England: Anglo-Saxon Art and Culture AD 600–900," British Museum and British Library, 1991 (ed. Webster and Backhouse); "Gothic Glory. Late Gothic Art in England 1400–1547," Victoria and Albert Museum, 2003 (ed. Marks).
14 "Les Manuscrits à Peintures en France 1440–1520," Paris, 1993–4 (ed. Avril and Reynaud) and "Jean Fouquet, Peintre et Enlumineur du xve siècle," Paris, 2003 (ed. Avril).
15 "Les Fastes du Gothique. Le siècle de Charles V," 1981–2 (ed. Baron, 1981).
16 "L'Art au temps des rois maudits Philippe le Bel et ses fils 1285–1328," 1998 (ed. Gaborit-Chopin).
17 In 2004 (ed. Delahaye).
18 "Karl der Grosse. Werk und Wirkung," Aachen, 1965 (ed. Lübke); "La Neustrie. Les pays au nord de la Loire, de Dagobert à Charles le Chauve," Musées et Monuments départmentaux de Seine-Maritime, 1985 (ed. Périn and Feffer); "799. Kunst und Kultur der Karolingerzeit, Karl der Grosse und Papst Leo III in Paderborn," Paderborn, 1999 (ed. Stiegemann and Wemhoff).

19 "Byzantium. Treasures of Byzantine Art and Culture," British Museum, 1994 (ed. Buckton) and "Byzantium: Faith and Power," Metropolitan Museum, New York, 2004.

20 For example, "The Utrecht Psalter in Medieval Art," Utrecht, 1996 (ed. Van der Hoerst, Noel, and Wüstefeld), and "Painted Labyrinth: The World of the Lindisfarne Gospels," British Library, 2003 (ed. Brown); or the permanent installation focusing upon the Book of Kells at Trinity College Library, Dublin.

21 Ed. Sievernich and Budde.

22 See note 20.

23 Ed. Nersessian, 2001.

24 Ed. Netzer and Reinburg.

25 Ed. Wixom, 1999.

26 Ed. Webster and Brown, 1997.

27 Ed. Bomford, Dunkerton, Gordon, and Roy, 1989.

28 Ed. Ryan 1983.

29 Ed. Marrow, Defoer, Korteweg, and Wüstefeld, 1989.

30 Ed. Kren and McKendrick, 2003.

Bibliography

L. Aagaard-Mogensen, ed., *The Idea of the Museum: Philosophical, Artistic and Political Questions* (Lewiston, NY, and Queenstown, Ontario, 1988).

J. Blatti, ed., *Past Meets Present: Essays About Historic Interpretation and Public Audiences* (Washington, DC and London, 1987).

Michelle P. Brown, "Sir Robert Cotton, Collector and Connoisseur?" in M. P. Brown and S. McKendrick, eds., *The Illuminated Book in the Later Middle Ages. Studies in Honour of Janet Backhouse* (London and Toronto, 1997), pp. 281–98.

N. Burt, *Palaces for the People: A Social History of the American Art Museum* (Boston and Toronto, 1977).

P. Cabanne, *The Great Collectors* (London, 1963).

Luciano Canfora, *The Vanished Library. A Wonder of the Ancient World* (London, 1989).

Mary J. Carruthers, *The Book of Memory. A Study of Memory in Medieval Culture* (Cambridge, 1990).

Michael Clanchy, *From Memory to Written Record. England 1066–1307*, 2nd edn. (Oxford, 1993).

Carol Duncan, *Civilizing Rituals. Inside Public Art Museums* (London, 1995).

W. E. Howe, *A History of the Metropolitan Museum of Art* (New York, 1912).

O. Impey and A. MacGregor, eds., *The Origins of Museums: The Cabinet of Curiosities in Sixteenth and Seventeenth-Century Europe* (Oxford, 1985).

I. Karp and S. Levine, eds., *Exhibiting Cultures: The Poetics and Politics of Museum Display* (Washington, DC, and London, 1991).

Kevin Kiernan, ed., *Electronic Beowulf* (London, 1999).

A. McClellan, *Inventing the Louvre: Art, Politics, and the Origins of the Modern Museum in Eighteenth-Century Paris* (Cambridge, 1994).

Edward Miller, *That Noble Cabinet. A History of the British Museum* (London, 1973).

James R. Rorimer, *The Cloisters. The Building and the Collection of Mediaeval Art in Fort Tryon Park* (New York, 1951).

M. S. Shapiro and L. W. Kemp, eds., *Museums: A Reference Guide* (New York, 1990).

Daniel J. Sherman and Irit Rogoff, eds., *Museum Culture. Histories, Discourses, Spectacles* (London, 1994).

Colin G. C. Tite, *The Manuscript Library of Sir Robert Cotton*, The Panizzi Lectures (London, 1993).

David McKenzie Wilson, *The British Museum. Purpose and Politics* (London, 1989).

——, *Showing the Flag. Loans from National Museums to the Regions* (London, 1992).

Index